Neblette's Handbook of Photography and Reprography
Materials, Processes and Systems

Neblette's Handbook of Photography and Reprography

Materials, Processes and Systems

Seventh Edition

Edited by
John M. Sturge

VNR **VAN NOSTRAND REINHOLD COMPANY**
NEW YORK CINCINNATI ATLANTA DALLAS SAN FRANCISCO
LONDON TORONTO MELBOURNE

Van Nostrand Reinhold Company Regional Offices:
New York Cincinnati Chicago Millbrae Dallas

Van Nostrand Reinhold Company International Offices:
London Toronto Melbourne

Manufactured in the United States of America

Published by Van Nostrand Reinhold Company
135 West 50th Street, New York, N.Y. 10020

Published simultaneously in Canada by Van Nostrand Reinhold Ltd.

15 14 13 12 11 10 9 8 7 6 5 4 3

Library of Congress Cataloging in Publication Data

Neblette, Carroll Bernard.
 Neblette's Handbook of photography and reprog-
raphy.

 First published in 1927 under title: Photography,
its principles and practice.
 Includes bibliographical references and index.
 1. Photography. 2. Copying processes.
I. Sturge, John M. II. Title. III. Title: Hand-
book of photography and reprography.
TR145.N4 1976 770 76-43356
ISBN 0-442-25948-4

DEDICATION

This volume is dedicated to the memory of Professor C. B. Neblette, who was engaged in preparation of this Seventh Edition at the time of his death in 1974. Involved in photographic education for many years, "C.B." had provided inspiration to many students, and he was warmly esteemed by his colleagues and by photographic scientists in government and industry.

The following words of appreciation are taken from the obituary published by the Society of Photographic Scientists and Engineers in its journal:

C. B. Neblette, known as the 'father of photographic education', had gained international respect and acclaim as an educator and writer At the time of his death, he was Dean Emeritus of the College of Graphic Arts and Photography and Director Emeritus of the School of Photographic Arts and Sciences, of Rochester Institute of Technology During his years of leadership, the School of Photographic Arts and Sciences grew from its beginnings as a diploma program training students primarily for entry into the photographic industry to its present status as the only institution in the country offering three separate photographic majors Professor Neblette brought outstanding educators from centers of the photographic industry to the Institute's School of Photographic Arts and Sciences. He supervised the design of the photographic facilities of the New Rochester Institute of Technology campus

From Assistant Editor of *The Camera* in 1923 and 1924, Professor Neblette went on to write extensively in the interests of photographic education. His first book of 1927 is now in its sixth edition as *Photography, Its Materials and Processes* He had served as Consultant to the Department of Defense and as the Chairman of the Committee on Photographic Reconnaissance in 1960 and 1961. He had been made an Honorary Fellow of the Royal Photographic Society, an Honorary Member and Fellow of the Photographic Society of America, and a Life Fellow of the Society of Photographic Scientists and Engineers.

The completion of this Seventh Edition is a lasting tribute to Professor Neblette on the part of the contributors, who continued their writing after "C.B." 's death much as if he were still directing the effort.

PREFACE

For more than fifty years this has been the outstanding reference work on photographic technology. Now the expanded seventh edition, completely rewritten, provides today's most comprehensive and up-to-date single source of information on photography and reprography. Accordingly, much of the subject matter covered in the present edition involves materials, techniques, and scientific principles not known, or even anticipated, in 1927, when the first edition was published; or, for that matter, at the time of publication of the sixth edition, in 1961. The new title recognizes the growing importance of *reprography:* the reproduction of flat originals.

The aim of the seventh edition, as it was in the earlier editions, is to provide the reader with an accurate and comprehensive survey of contemporary photographic and reprographic sciences and applications. Unlike earlier editions, a systems emphasis has been added, expanding the treatment of material and processes. Chapters on optics, cameras, and exposure meters, included in the sixth edition, have been omitted; equipment is discussed only in conjunction with specific systems. The historical chapter has been enlarged and updated to provide a measure of perspective. The remaining sixth edition chapters have been extensively rewritten; in many cases, by new contributors. Completely new chapters have been added to cover recent developments in both fields.

This book is as authoritative as it is broad in coverage. Each of its twenty-four chapters is written by one or more leading specialists in photography and reprography. All in all, the book represents the efforts of twenty-four such specialists, most of them new to this edition.

A work of the scope of the present volume is only possible through the combined efforts of a number of specialists, and the group selected by Professor Neblette has indeed proved itself.

John M. Sturge assumed the editorship following the untimely death of Professor C. B. Neblette. Mr. Sturge has been employed at Xerox since 1965, and at present is a Product Marketing Manager in Microsystems.

Prior to Xerox, Mr. Sturge was employed at Cornell Aeronautical Laboratories as an Optical Systems Engineer, with principal involvement in coherent and incoherent information storage and retrieval. At Rochester Institute, he achieved a BS in Photographic Science in 1961 and received an M.S. in Management Science from Rensselaer Polytechnic Institute in 1965.

ACKNOWLEDGMENTS

Completion of this edition has only been possible through the efforts of many individuals. My total gratitude is extended to all contributors for their painstaking excellence.

My family, my wife Judi for her encouragement and support, my daughter Melissa, and especially my son Scott whose untimely death in April 1975 was a source of inspiration to me for the completion of my editorial responsibilities.

Vivian Walworth for her invaluable support and assistance. C. B. Neblette for his confidence and trust. Alberta Gordon for her professional excellence.

This book represents my personal dedication to all who participated in its completion, with special remembrances to:

C. B. NEBLETTE AND SCOTT A. STURGE

JOHN M. STURGE

CONTENTS

1

HISTORY OF PHOTOGRAPHIC PROCESSES

C. B. Neblette*

EARLY RECORDS OF THE PHOTOCHEMICAL ACTION OF LIGHT

The earliest record of the action of light that has come down to us is found in the works of Aristotle.[1] In his book *On Colors*, Chapter 5, he writes: "Those parts of plants, however, in which the moisture is not mixed with the rays of the sun, remain white Therefore all parts of plants which stand above ground are at first green, while stalk, root, and shoots are white. Just as soon as they are bared of earth, everything turns green . . . Those parts of fruit, however, which are exposed to sun and heat become strongly colored."

Aristotle refers also to the advantageous effect of light in the formation of a purple dye. This is the famous dye of antiquity which was so highly esteemed that it was reserved by the rulers of Tyre for royal use only. A writer of the third century, Philostratos, wrote, "The purple of Tyre looks dark and derives its beauty from the sun, which gives it the shade of a pomegranate blossom." Another, at about the same time, wrote, "The purple color becomes first class only if the material is exposed to the sun, because the rays of the sun add great fire which darkens the color, and the brilliancy is brought to its greatest perfection by the fire from above."[2]

Many have professed to see in the writings of the alchemist references to the darkening of both silver nitrate and silver chloride by *light*, but the alchemist did not eliminate heat or the atmosphere as darkening agents. The first to definitely prove that silver nitrate darkens upon exposure to light was Johann Heinrich Schulze, professor at the University of Altdorf, in 1727. Schulze heated silver nitrate in an oven and found that it did not darken, thus eliminating heat as the darkening agent. He applied paper stencils to a bottle containing a solution of silver nitrate mixed with chalk and on exposure to light found the letters of the stencil reproduced in the heavy precipitate. Schulze's account of his investigations, published at Nuremberg[3a] in 1727, did not have a wide circulation, but his *Chemische Versuche*, published after his death in 1745, went through several editions.[3b]

Beccarius, at the University of Turin, followed Schulze in proving that the darkening of horn silver, an imperfect form of silver chloride, darkens on exposure to light (1757).[4] Dr. William Lewis repeated Schulze's experiments in England and published his findings in his *Philosophical Commerce of Arts* (1763).[5]

In 1772, Joseph Priestley, in his *History and Present State of Discoveries Relating to Vision, Light and Colours*, referred to the work of Schulze, Beccarius, and others.[6] It was from Priestley and also from Lewis, whose notebooks were acquired by Josiah Wedgwood, that his son, Thomas Wedgwood, learned of the light sensitivity of silver nitrate.

The Swedish chemist, Carl Wilhelm Scheele, in 1777 studied the darkening of silver chloride in the prismatic spectrum and discovered that it darkened more rapidly in the blue and violet. From his studies of the decomposition of silver chloride, he concluded that the darkened deposit consisted of silver.[7]

Hagemann (1782) and Senebier (1782) each studied the effect of light on various resins.[8] Hagemann reported that guaiacum turned blue upon exposure, and Senebier

*Deceased.

found that some, like mastic and sandarac, faded and that others, including gamboge, gum ammoniac and guaiacum, darkened. It is not known, however, if any of this work was known to Niépce, whose first attempts in photolithography (1817) were with guaiacum.[9]

THOMAS WEDGWOOD

The history of photography begins with Thomas Wedgwood.[10] In 1802 he and Humphrey Davy published a paper entitled "An Account of a Method of Copying Paintings Upon Glass, and of Making Profiles by the Agency of Light on Nitrate of Silver," in the *Journal of the Royal Institution*.[10c] In this paper, Wedgwood described how he was able to make copies of tracings, leaves, and similar objects on paper sensitized with silver nitrate. It darkened when exposed to light to produce a reversed (negative) image. Attempts to use a camera obscura failed, as did all attempts to fix the image. Wedgwood concluded, "Nothing but a method of preventing the unshaded parts of the delineation from

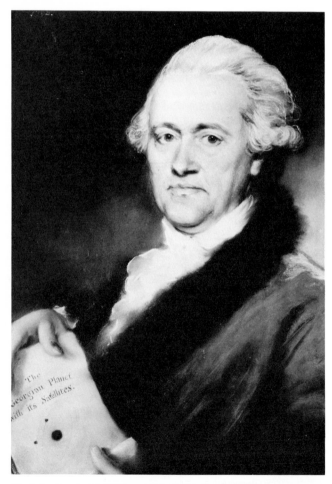

Sir John Frederick William Herschel, who studied the interaction of light and silver salts, introduced hypo as a fixing agent, devised the first blueprint process, and first proposed the use of the word "photography."

being colored by exposure to the day is wanting, to render the process as useful as it is elegant."

Wedgwood died in 1805 without having found a fixing agent. The *Journal of the Royal Institution* had a limited circulation, and Wedgwood's paper passed unnoticed. Those who followed—Niépce, Talbot and Daguerre—were unaware of it. But it would not have been of much value to them, for all three soon surpassed Wedgwood, and two of the three found a fixing agent.

DISCOVERY OF A FIXING AGENT

What neither Wedgwood nor Davy could find in 1802 was discovered in 1819 by Sir John Herschel.[11] In a paper, "On the Hyposulphurous Acid and its Compounds," published in the *Edinburgh Philosophical Journal*, he wrote, "Muriate of silver (silver chloride), newly precipitated, dissolves in this salt (hyposulphite), when in somewhat concentrated solution, in large quantity and almost as readily as sugar in water."

Herschel's paper was unknown to Niépce, Daguerre or Talbot, despite the fact that Brande's *Manual of Chemistry*, a leading work of reference at the time, contained in the edition of 1821 a reference to Herschel's paper and in later editions the statement "Hyposulfite of soda . . . Its aqueous solution readily dissolves chloride of silver."

Herschel showed Talbot the fixing properties of hypo on February 1, 1839. Talbot wrote in his notebook for February 18 that it "Answers very well." Talbot wrote Biot, of the French Academy, on February 20 about the new fixing agent given him by Herschel, but did not disclose that it was hypo until March 1.

NICÉPHORE NIÉPCE

Joseph Nicéphore Niépce experimented with a number of processes over a period which extended from 1816 to his death in 1831.[12] His first experiments were with silver nitrate. With this he was able to produce a negative image in a camera obscura, but the exposure was several hours and he could find no way of removing the unexposed silver nitrate to render the image permanent. In the search for a substance which would be bleached by light and produce a positive rather than a negative image, he experimented with manganese dioxide and with phosphorus, both without success.

Niépce's experiments in lithography suggested asphaltum, whose light sensitivity had been observed by Hagemann in 1782. In 1822 Niépce used asphaltum on glass to copy an engraved picture of Pope Pius VII. In 1824 he used it on stone, etched the stone and made proofs from the inked surface, as in lithography. To adapt his process to the camera obscura he used pewter plates, and when Lemaitre, who was printing his plates, complained that pewter was too soft, he changed to copper. The Museum of the Royal Photographic Society, London, has three plates produced by Niépce before

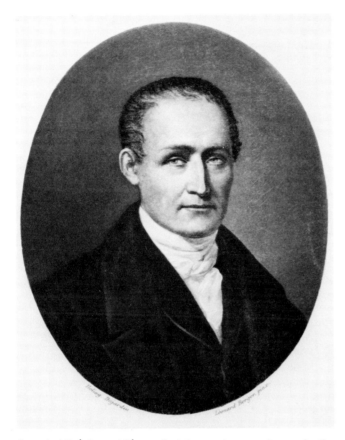

Joseph Nicéphore Niépce, first to produce an image in the camera and first to produce a lasting photographic image.

1827. All are copies of engravings. The University of Texas has a pewter plate which, according to Helmut and Alison Gernsheim, was made directly in the camera obscura with an exposure of 10 to 12 hours in 1826.

In France, Niépce is generally recognized as the inventor of photography, although his process was not practical. His "heliographic process," in which metal plates were coated with asphaltum, exposed and etched, then printed like an etching on copper, can justly claim to be the beginning of photogravure.

THE DAGUERREOTYPE PROCESS

The first practical process of photography was the *daguerreotype* of Louis Jacques Mandé Daguerre (1839).[13] The process, details of which were made public at a joint meeting of the Academie des Sciences and the Academie of Beaux-Arts in Paris, August 19, 1839, was based upon the light sensitivity of silver iodide. The process produced a positive image directly and used a silver-coated plate of copper. There were five operations:

1. Cleaning and polishing the silver surface of the plate to a mirrorlike finish.
2. Sensitizing in a wooden cabinet, in which the polished silvered surface of the plate is exposed to iodine to form silver iodide.
3. Making the exposure. Originally, with the lenses used by Daguerre, the exposure for a subject in bright sunshine was 6–10 min.
4. Developing the latent image. Daguerre had discovered both the latent image and a method of development. To bring out or develop the latent image, the exposed plate is placed in a cabinet over a tray of heated mercury. The mercury attaches itself to the exposed silver iodide to produce an amalgam of silver and mercury, which forms a positive image.
5. Fixing. The unexposed silver iodide is removed by fixing in hypo. Daguerre had first used a solution of common salt (NaCl), but prior to the publication of the details of the process had learned of the use of hypo from Biot.

Improvements followed rapidly. The first of importance was a toning process which greatly increased the contrast of the image. The process consisted in treating the fixed image in a solution of sodium hyposulfite and gold chloride (Fizeau, 1840).[14]

Herschel, studying the sensitivity of silver nitrate, silver chloride, and silver bromide in the solar spectrum, found that the response with wavelength increased in that order, and in 1840 he concluded, "We must create a new photography of which silver bromide will form the basis."[15] Within a year Goddard in London and Kratochwila and the Natterer brothers in Vienna independently described methods of obtaining greatly

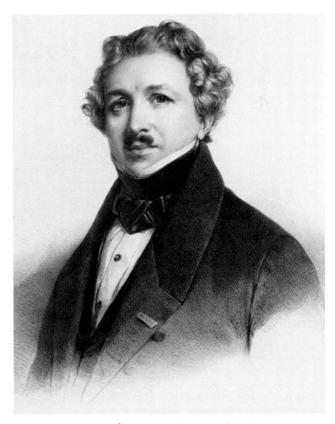

Louis Jacques Mandé Daguerre, inventor of the daguerreotype.

DESCRIPTION

OF THE

DAGUERREOTYPE PROCESS,

OR

A SUMMARY

OF

M. GOURAUD'S PUBLIC LECTURES,

ACCORDING TO THE PRINCIPLES OF

M. DAGUERRE.

———

WITH A

DESCRIPTION OF A PROVISORY METHOD FOR TAKING

HUMAN PORTRAITS.

═══

BOSTON:
DUTTON AND WENTWORTH'S PRINT.
............
1840.

Fig. 1. Title page of an American manual of the Daguerreotype process.

increased sensitivity through the use of mixtures of iodide and bromide, or bromide, chloride and iodide combined, in the sensitizing of the daguerreotype plate.[16] With this development and the 1840 introduction by Voigtlander of Petzval's $f/3.6$ portrait lens, which reduced the exposure to about a minute, portrait photography spread rapidly throughout the civilized world.[17] (Fig. 1)

Herschel Uses the Word Photography

The word *photography*, from the Greek *phos* (light) and *graph* (to draw), was suggested by Herschel in a paper "On the Art of Photography, or The Application of the Chemical Rays of Light to the Purpose of Pictorial Representation," presented before the Royal Society (London) on March 14, 1839. The term was adopted im-

mediately by the French physicist Arago and used by him when the details of the daguerreotype process were made public at a meeting of the Académie des Sciences later in 1839.[18] Many professional portrait photographers, however, used the term *daguerreotypist* for many years.

PHOTOGENIC DRAWING—A NEGATIVE-POSITIVE PROCESS

Photogenic Drawing, the first negative-positive process, was described by William Henry Fox Talbot in a paper presented to the Royal Society (London) on January 31, 1839—seven months before the daguerreotype.[19a,b] For the negative, Talbot bathed paper in a solution of common salt and silver nitrate. Camera exposures required several hours, but copies of drawings could be made by contact printing in a few minutes. After the exposure the negative was fixed in a solution of common salt, washed and dried. From the negative a positive print was made by contact printing onto sensitized paper. Talbot had made four advances over Wedgwood, whose prior work he acknowledged. He had found (1) that silver chloride darkens more rapidly than silver nitrate and (2) that it darkens more rapidly with an excess of the halide, (3) that the image can be "fixed" in a solution of common salt, and (4) that a positive image can be obtained by printing from the negative onto sensitized paper. Sodium chloride

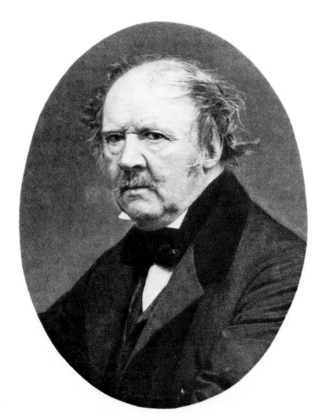

William Henry Fox Talbot, inventor of the first negative-positive process of photography.

was replaced by hypo as a fixing agent within a few weeks after Talbot had been informed by Herschel of its properties.

In 1841 Talbot obtained a British patent for a process which he termed *calotype* (Greek *kalos*, meaning beautiful—i.e., beautiful picture). In this process the paper for the negative was first sensitized with a solution of silver nitrate and then with a solution of potassium iodide to form silver iodide. When dry, the paper was brushed with a solution containing acetic acid, silver nitrate and gallic acid, rinsed briefly in water and dried. The exposure in full sunshine was from 5–10 minutes with a lens aperture about $f/30$. Brushing the paper after exposure with the solution of acetic acid, silver nitrate and gallic acid brought out the latent image. Talbot had found a developing agent in gallic acid. After fixing in hypo, washing and drying, contact prints were made from the negative on paper sensitized with silver chloride.[19c,d]

The portrait lens of Petzval reduced the exposure of Talbot's negative to one or two minutes, making portraits possible. The daguerreotype process was much preferred, however, for professional portraiture because of the sharpness of the image.

NEGATIVE PROCESSES ON GLASS—WET COLLODION

It was obvious to all that a negative on a transparent medium such as glass would produce sharper images than a paper negative, but the problem was to find a substance that would hold the silver halide to the glass plate. The first workable process was described by Niépce de Saint-Victor, a cousin of Joseph Nicéphore Niépce, in 1847.[20] He coated his plates with the whites of eggs (albumen) containing potassium iodide. When dry, the plates were sensitized by immersion in a solution of silver nitrate. After exposure, the plate was developed in a solution of gallic acid and fixed in hypo. The exposure, however, was much longer than for the daguerreotype.

In 1851, a more practical process, using collodion, was published by Frederick Scott Archer of London.[21] It was not a simple process, nor was it convenient, but it produced sharp negatives from which any number of positive prints could be made on silver chloride printing-out paper. It soon replaced all other processes, including the daguerreotype.

In the collodion process potassium or ammonium bromide and iodide are added to collodion, which is then poured onto a clean glass plate to obtain an even coating. As the solvents in the collodion evaporate, the collodion "sets" sufficiently to adhere to the glass. The coated plate is then sensitized by immersion in a solution of silver nitrate, placed in a plate holder which is inserted in the camera, and the exposure made. After the exposure the plate is developed immediately in a solution of pyrogallol and silver nitrate, fixed in a solution of hypo, washed and dried. The collodion process is often termed *wet* collodion because the entire operation of coating the plate, making the exposure, and processing

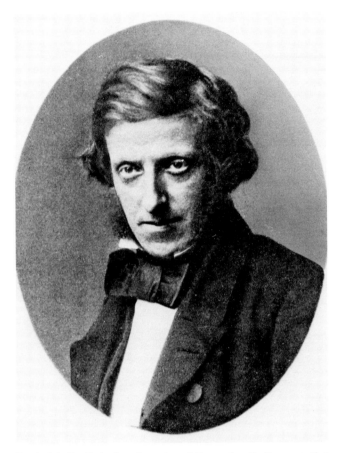

Frederick Scott Archer, inventor of the wet collodion negative process.

must be completed without allowing the collodion to dry. Once dry, it can no longer be processed.[22] (Fig. 2)

SILVER PRINTING-OUT PROCESSES

The silver chloride impregnated paper used by Talbot to make prints from calotype negatives was replaced soon after 1850 by albumen paper. Paper coated with egg whites containing salt was sensitized in a solution of silver nitrate. After exposure the image was toned with gold (a technique adopted probably from the daguerreotype), fixed in hypo and washed. The use of albumen to coat paper appears to have been suggested by Blanquart-Évrard.[23] Albumen paper produced a sharper image because the image formed in the albumen layer rather than in the fibers of the paper. At first the paper was coated by the photographer, but around 1870 it was found that the albumen layer could be preserved with citrates, and albumen-coated paper ready for sensitizing in a solution of silver nitrate became available.

An almost identical process, except for the use of collodion (*collodio-chloride* paper), was described by Simpson in 1865, but papers of this type were not widely used until placed on the market about 1886.

A formula for a printing-out paper using gelatin was published by Abney in 1882,[24] and gelatino-chloride

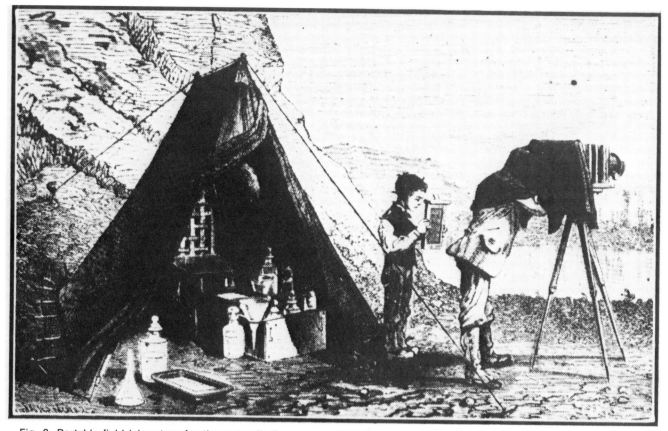

Fig. 2. Portable field laboratory for the wet collodion process (from Thompson, *History and Handbook of Photography*, 1874).

paper was introduced in England by Ilford, Ltd., in 1885 and in other countries soon after.

Collodion and gelatin printing-out papers which could be sold ready for use, requiring no sensitizing, replaced albumen paper after 1890 and remained in use until they were superseded by developing-out papers.[25]

COLLODION POSITIVE PROCESSES

Archer, in his paper on the wet collodion process,[21] pointed out that the negative appears as a positive when placed against black velvet, the grayish-white of the silver image forming the highlights and the black velvet visible through the transparent areas of the collodion image forming the shadows. The first to apply this phenomenon practically were Adolph Martin in Paris (1852–1853)[26] and James Ambrose Cutting in Boston (1854), who patented a process for making what came to be called *ambrotypes*.[27a] The positives on glass were mounted in plush cases, similar to those used for daguerreotypes, and were produced in large quantities for about two decades. Many family "daguerreotypes," particularly in the post-Civil War period, are actually wet collodion positives on glass.

Martin also described the use of blackened metal plates in place of glass. This system was patented in the United States by Hannibal Smith in 1856, and japanned metal plates were placed on the market by Griswold of Peekskill, New York. The process was known as the *melainotype* or, more frequently, as the *ferrotype* or *tintype*.[27a,b] These processes were used by photographers in parks, at fairs and at scenic vacation spots for many years. I remember one at Charlotte Beach Park in Rochester, New York, as late as 1932. Black metal plates coated with gelatin emulsion replaced wet collodion for this purpose towards the end of the nineteenth century.

COLLODION EMULSION

Sayce and Bolton, in 1864, described a process of working with collodion in which the silver nitrate was added to the collodion before coating, thus eliminating the separate silver bath. Plates prepared in this manner were slower than wet collodion, and the process was not widely adopted except for photo-mechanical processes, where a green-sensitive "orthochromatic" collodion emulsion, developed by Albert of Munich, was used for color reproduction for many years.[28]

DRY COLLODION PROCESSES

The inconvenience of the wet collodion process (Fig. 3), particularly out of doors, prompted a search for a dry

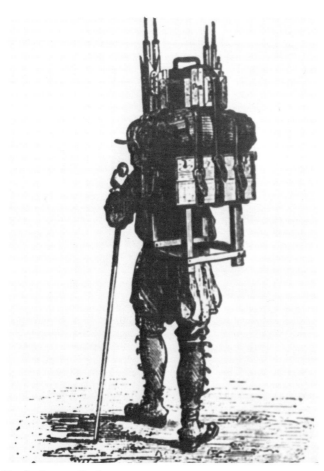

Fig. 3. A wet collodion process photographer in the field (from an early manual).

GELATIN EMULSION[33]

Robert Bingham, in his book *Photogenic Manipulation*, published in 1850, described a workable process with gelatin,[34] but this was overshadowed by the wet collodion process which appeared the following year. In 1868 W. H. Harrison, another English experimenter, attempted to make a gelatin emulsion but could not obtain a uniform coating on the glass plate.[35] Dr. R. L. Maddox described a gelatin process in the *British Journal of Photography* in 1871 which was workable but too slow to compete with wet collodion.[36]

Two years later Burgess advertised gelatin emulsion in the same journal.[37] Burgess was the first to show that good negatives could be made on gelatin emulsion. It met with a mixed reception; some had good results, but many complained of uneven coating, the long times required for the coated plates to dry, fog, and the difficulty of estimating the proper exposure. Burgess claimed that most of these difficulties were experienced by those who had not followed his directions; whatever the cause, the venture was unsuccessful. Richard Kennett of London, who placed coated dry plates on the market in 1873, was equally unsuccessful.[38]

In 1873, J. King recommended the shredding and

Richard Leach Maddox, who pioneered in the preparation of gelatin emulsions.

plate process, which would permit the glass plate to be coated, dried and exposed at a later time.

Taupenot, in 1855, described a process in which the glass plate, after having been coated in the usual way and immersed in the silver bath, was washed briefly, coated with albumen and dried.[29] The plates would keep for several weeks but were much slower than wet collodion.

A similar process using gelatin was patented in England by Norris (1856).[30] "The Norris Dry Plates, ready for use, are sold in all the larger towns of England and are said to give good results", according to a report published in 1862.

In the *tannin* process of Russell (1861) the sensitized collodion plate was washed, then placed in a solution of tannin and dried.[31] The process was simpler and more reliable, and it produced better negatives than the other methods. At first the plates were developed with a developer containing silver nitrate, as was the practice with wet collodion, but the following year Russell found that the plates could be developed in pyrogallol and ammonia without silver nitrate.[32] This was the beginning of alkaline development, which was to become of major importance with the introduction of gelatin emulsions.

All of these processes required more exposure than wet collodion and found only limited use.

washing of the chilled emulsion to remove the by-products of the emulsification process,[39] and in the very same issue of the *British Journal of Photography* J. Johnston proposed the use of an excess of soluble bromide in the formation of silver halide,[40] both steps of great importance. In 1877, Johnston recommended the use of ammonia in emulsification as a method of increasing the sensitivity of the emulsion.[41] The next year Charles Bennett reported that a gelatin emulsion far more sensitive than wet collodion could be produced by heating the emulsion.[42]

In 1878 Bennett Dry Plates were placed on the market by the Liverpool Dry Plate Company. That same year Wratten and Wainwright began the manufacture of dry plates in London and soon established an international reputation for excellence. These two were followed by Mawson and Swan at Newcastle-on-Tyne, by Monckhoven in Ghent, Schleussner in Frankfurt and John Carbutt of Philadelphia. George Eastman began the manufacture of dry plates in Rochester in 1880, as did Cramer and Norden in St. Louis. Other manufacturers of note established in these early years were Otto Perutz (1882), Lumière in Lyons (1882), M. A. Seed in St. Louis (1883), Hauff in Fuerbach (1890) and the company Allgemeine Gesellschaft für Anilin Fabrikation, later called Agfa, in Berlin (1893).

The beneficial effect of ammonia observed first by Johnston was greatly advanced by Monckhoven and by Eder in Vienna.[43] A further important addition to the technology of gelatin emulsion was the study by Abney, in 1880, of the effect of the addition of a small quantity of potassium iodide to the bromide in precipitation.[44] Today the use of iodide is almost universal.

FILM BASE

The first satisfactory photographic film was produced by John Carbutt of Philadelphia in 1888 by coating sheets of celluloid produced by John W. Hyatt of Newark, New Jersey. The next year roll films on a base prepared by dissolving nitrocellulose in methanol with camphor and amyl acetate were placed on the market by George Eastman in Rochester, New York.[45,46] A patent covering the transparent film base was granted in December of that year.[47]

The film was designed for use in a new camera, the Kodak, ® making 100 circular pictures 2½ in. (6.5 cm) in diameter. It sold for $25 loaded with one roll of film. When the roll had been exposed, the camera was returned to the company for processing. The prints, made at first on a gelatin printing-out paper, were sent to the customer along with the camera and a new roll of film. Extensively promoted by advertising featuring the slogan "You press the button, we do the rest," the Kodak was a huge success and the beginning of a new era in photography.

In 1898 a patent for a photographic film, which had been originally applied for in May, 1887, by Reverend Hannibal Goodwin, of Newark, was finally granted by the U.S. Patent Office.[48] The rights to the Goodwin patent were acquired by the Ansco Company of Bing-

George Eastman, inventor of amateur camera using rolls of sensitized paper and film; founder of the Eastman Kodak Co.

hamton, New York, which promptly charged the Eastman Kodak Company with infringement of the Goodwin patent. A long legal battle which ensued was finally settled in 1914, when the courts upheld the validity of the Goodwin patent.

Daylight loading film was patented by S. N. Turner, a camera maker of Boston. His company was purchased by the Eastman Kodak Company, and daylight loading roll films were placed on the market in 1894. Rights to the film pack, invented by Parker B. Cady in 1894, were also acquired by the Eastman Kodak Company. Noncurling film with a gelatin coating on the side opposite the emulsion was introduced in 1903.

Nitrocellulose film base is highly flammable, and from 1910 on it was gradually replaced with cellulose acetate except where the physical properties of the cellulose nitrate base were important, as in the motion picture industry. Later, bases having the required tensile strength and stability were made from cellulose esters, including cellulose acetate propionate, cellulose acetate butyrate and cellulose triacetate. Since World War II, polyethylene terephthlate has been widely used under such trade names as *Cronar* (Dupont) and *Estar* (Kodak). It is stronger and tougher than the acetate bases and less subject to dimensional change.

SPECTRAL SENSITIZATION[49]

The spectral sensitivity of the silver halides is limited essentially to the blue and violet regions of the spectrum, so

A Transparent Film

※ ※ ※ ※ *for Roll Holders.*

The announcement is hereby made that the undersigned have perfected a process for making transparent flexible films for use in roll holders and Kodak Cameras.

The new film is as thin, light and flexible as paper and as transparent as glass. It requires *no stripping*, and it is wound on spools for roll holders.

It will be known as *Eastman's Transparent Film*, and will be ready for market on or about July 1st. Circulars and samples ready, and will be sent to any address on receipt of 4 cents in stamps.

The Eastman Dry Plate and Film Co.

Rochester, N. Y.,

June 15, 1889

Fig. 4. An early advertisement for Eastman's roll film.

that such brilliant colors as yellow, orange and red were not recorded on collodion plates and the early dry plates. In 1873 Vogel discovered that an emulsion to which the dye coralline had been added to prevent halation had sensitivity to yellow and green light.[50] Further work by Vogel resulted in the discovery of a more powerful sensitizer for the green, isoquinoline red, in 1882. Its mixture with quinoline blue (cyanine), which sensitized to the orange and red, was used in Vogel's "*azaline*" plates, the first which might be called panchromatic.[51] The sensitivity was very low, however, and the sensitized plates did not keep well. Meanwhile, Waterhouse, in 1875, had discovered in eosin a good sensitizer for green,[52] and in 1883 Tailfer and Clayton placed dry plates sensitized with eosin on the market.[53] In 1884 Eder discovered that another dye of the eosin group, erythrosin, was a much better sensitizer for the green and yellow.[54] Orthochromatic and isochromatic plates sensitized with erythrosin remained on the market through the first quarter of the twentieth century.

By this time it was clear that the best sensitizing dyes were derivatives of cyanine, and Miethe and Traube in Berlin and E. König at Höchst a/M began to make and test new cyanine dyes as photographic sensitizers. In 1902 Miethe and Traube introduced a new class of green and yellow orthochromatic sensitizers, which became known as the *isocyanines*.[55] These were followed by König's isocyanine dyes of extended range, which were used extensively in orthochromatic films,[56] and by *carbocyanine* dyes, which were excellent sensitizers for the orange and red. Of this series *pinacyanol*, discovered by Homolka in 1905, was outstanding, and it remained in general use as a panchromatic sensitizer for about 20 years.

The work of Hamer in the laboratories of Ilford, Ltd., and of Brooker in the Kodak Research Laboratories produced new dyes which could be used together to complement or enhance one another. These combinations led to new supersensitive panchromatic films and plates with a more uniform and higher sensitivity than the older films. In 1933 an important new class of cyanine dyes, known as the *merocyanines*, was discovered independently by Brooker and by Kendall at Ilford, Ltd.[57] The carbocyanines and merocyanines are of continuing importance in current sensitization technology.

Hermann Wilhelm Vogel, who discovered spectral sensitization of silver halides by the addition of dyes.

HYPERSENSITIZATION

In the early days of aerial photography there was a need for panchromatic materials of higher sensitivity than were then available. Jacobsohn[58] recommended hypersensitization with ammonia and ammoniacal silver chloride (1929). Dersch and Dürr[59] found that exposure to mercury for several hours increased the speed of a panchromatic material by two times, but not all emulsions responded. Wightman and Quirk[60] found that a dilute solution of hydrogen peroxide increased the effective speed, but the process was not sufficiently reliable for practical employment. Mueller and Bates[61] found that a number of acids (acetic, oxalic, and sulfurous) used after exposure and directly before development increased the effective speed with Metol-hydroquinone-borax developers. Simmons found that exposure to sulfur dioxide before development increased the speed by two to four times.[62] Interest in hypersensitizing declined rapidly after the introduction of supersensitive panchromatic emulsions in 1931.

METHODS OF DETERMINING EMULSION SPEEDS

When commercial dry plates began to appear on the market, the plates of the different manufacturers differed in speed, and a method of measuring and expressing speed became necessary. To meet this need, Warnerke devised a sensitometer consisting of a scale of graded density steps with numbers (1880).[63] The plate was exposed behind this to a phosphorescent plate which was activated by burning a fixed quantity of magnesium. English dry plate makers adopted the Warnerke sensitometer and marked their plates with numbers indicating the sensitivity. In Germany, Scheiner (1894) devised a sensitometer with 21 steps in a rotating sector, using a lamp burning amyl acetate for the exposure.[64] With both of these sensitometers, speed was based upon the exposure required for the first visible density (the so-called *threshold* speed).

The first method to relate speed to the exposure required for good tone reproduction was outlined in a paper published by Hurter and Driffield in 1890.[65] In this paper they described a sensitometer producing nine exposures from a standard candle, the development of the plate under standardized conditions, the measurement of the densities of the developed image in a densitometer, the graphic representation of the relation between exposure and density in the $D \log E$ curve, and the use of inertia as the measure of speed.

The work of Hurter and Driffield has had a profound effect on the development of photographic science. Their procedures, greatly refined over the years, are still followed, and the $D \log E$ curve is as useful today as when it first appeared in 1890. Their method of measuring speed was adopted throughout the English-speaking world, and the speeds of plates for years were expressed in *H and D numbers*. In time, however, lack of standardization in the equipment and methods made the H and D speeds published by different manufacturers meaningless as a basis of comparing the actual speeds of their plates.

In 1931 the German photographic industry discarded Scheiner speeds, which also had become meaningless, and adopted an industry-wide system (DIN), in which speed was based on the exposure required for a density of 0.1 above the fog density.

Jones and his co-workers in the Kodak Research laboratories, operating on the principle that speed should be based on the exposure required to produce a negative which will make a satisfactory print, reached the conclusion that speed must be based on density differences rather than any single density.[66] In 1939, as a result of these studies, the Eastman Kodak Company adopted a method of measuring speed based on the minimum useful gradient, and in 1947 the American Standards Association adopted this method as an American standard. Difficulties arose with this system, however, and in the interests of international agreement the American Standards Association adopted a new system of ASA speeds in 1960 which, like the DIN method, based speed on the exposure required for a density of 0.1 above fog with a specified degree of development.[67] This method was adopted also by the British Institute for Standards (BSI speeds) and by the German photographic industry for new DIN speeds.

DEVELOPING PAPERS

Bromide paper was advertised in 1874 by the Liverpool Dry Plate Company, but it apparently was of poor quality. In 1881 formulas for silver chloride paper emulsions were published by Eder and Pizzighelli of Vienna.[68] They pointed out the superiority of silver chloride papers over those of silver bromide, the deep blacks of the image on a silver chloride paper being much more pleasing than the grayish black of bromide papers. They also pointed out that warm tones could be obtained with different developers. For their work Eder and Pizzighelli were awarded the Progress Medal of the Royal Photographic Society of Great Britain in 1884. Soon afterward bromide paper was being produced by several manufacturers, including the Eastman Dry Plate and Film Co. at Rochester. The Eastman Company was the first to coat paper by machinery (1884) and to produce it on a large scale.

Although slower than bromide paper, the first chloride papers were too fast for contact printing. Baekeland, using an unwashed emulsion, produced a slower paper for contact printing, which was placed on the market in 1893 under the trade name *Velox.* ® Used chiefly by amateurs and photofinishers, it was followed by papers for professional portraiture, and within a decade the developing papers had largely replaced collodion and gelatin printing-out papers.

The use of a substratum of barium sulfate (*baryta*) to produce a white glossy paper, according to Eder,[69] was introduced by the Neue Photographische Gesellschaft of

Berlin in 1894. The Eastman Kodak Company introduced a matte bromide paper the same year, produced by adding starch to the emulsion. Methods of controlling the exposure scale of emulsions for developing papers by the addition of iodide to increase contrast or bromide to lower contrast had been indicated by Eder and Pizzighelli.[68] The commercial introduction of developing papers in varying degrees of contrast (Grades 1, 2, 3, etc.) was an important step forward. It made the development of the negative by controlled time practical and prepared the way for the general acceptance of panchromatic negative materials, which, because of their sensitivity, could not be developed by inspection.

The first multicontrast paper, *Multigrade*,® was produced by Ilford, Ltd., in 1940. This paper, based on the work of Renwick,[70] was coated with two emulsions of different contrast, one spectrally sensitized and the other blue-sensitive only. The contrast of the print was controlled by the use of filters which determined the participation of each emulsion in formation of the image. Additional papers employing the same basic principle have since been placed on the market by other manufacturers.

DEVELOPERS FOR GELATINO-BROMIDE EMULSIONS

The developers used in the wet collodion process were of the type known in the literature of photography as "physical" developers, the developing solution containing silver nitrate, a reducing agent and an acid. The silver image was formed by reduction and deposition of silver from the solution onto the exposed silver halide. The reducing agent was either ferrous sulfate (Robert Hunt, 1844) or pyrogallol (1,2,3-trihydroxybenzene) (Regnault and Liebig independently, 1851).[71] An alkaline developer of pyrogallol and ammonia, recommended by Burgess for gelatin emulsion in 1873, was generally adopted as dry plates replaced wet collodion. The use of sodium sulfite as a preservative of pyrogallol (Berkeley, 1882),[72] was an important step forward, not only in the use of pyrogallol but with other organic developing agents that followed. Pyro-ammonia with sodium sulfite as a preservative came into general use after 1882. Gradually the volatile ammonia was replaced by the alkaline carbonates, and pyro-soda became the favorite negative developer.

The developing properties of hydroquinone (1,4-dihydroxybenzene) were discovered by Abney in 1880, and pyrocatechin (1,2-dihydroxybenzene) was found to be a developing agent by Eder and Toth the same year. Following these discoveries, there was great activity in the search for new developing agents.[73]

Some of the more important early developing agents were:

Compound	Introduced by	Trade Name
2,4-Diaminophenol dihydrochloride	Andresen and Bogisch (1891)	Amidol
p-Aminophenol	Andresen (1888)	Rodinal, Azol

Compound	Introduced by	Trade Name
4-Amino-2-hydroxymethyl-phenol	Hauff (1901)	Edinol
N-Methyl-p-aminophenol sulfate	Bogisch (1891)	Metol
N (p-hydroxyphenyl) aminoacetic acid	Bogisch (1891)	Glycin
p-Phenylenediamine	Andresen (1888)	
Chlorohydroquinone	Lüppo-Cramer (1899)	Adurol
1-amino-2-naphthol-6-sulfonic acid sodium salt	Andresen (1889)	Eikonogen
N-methyl-o-aminophenol + hydroquinone	Bogisch (1896)	Ortol

Of these, only hydroquinone, n-methyl-p-aminophenol sulfate (Metol, Elon) and p-phenylenediamine are used extensively today.

The familiar combination of Metol and hydroquinone originated around the beginning of the century as a developer for papers. At first the advantages of the combination were thought to be due simply to the complementary characteristics of the two as developers. Later it was learned that the two form a superadditive combination; i.e., their activity together is greater than the sum of their activities separately. The phenomenon of superadditivity had been observed earlier by Lüppo-Cramer in combinations of gallic acid and Metol.[74] Combinations of Metol and hydroquinone were studied intensively by Reinders and Beukers[75] and later by Levenson[76] and by James.[77] The combination of Phenidone and hydroquinone shows the effect to an even greater degree than Metol and hydroquinone.

With the introduction of the precision 35 mm camera came the search for a developer which would produce finer grain negatives than did developers then in use. The first to achieve wide popularity was a Metol-hydroquinone developer using an excess of sodium sulfite as a silver halide solvent and borax as the alkali. This was the famous D-76 formula, introduced by Capstaff in 1927 and still in widespread use. In 1929 Crabtree and Henn published a Metol-hydroquinone formula using potassium thiocyanate as a silver halide solvent. Formulas employing Metol alone and with sodium bisulfite were later described by Henn and Crabtree (1944).[78] None of these equaled the original D-76 formula in popularity.

The use of p-phenylenediamine as a fine grain developer was recommended by A. and L. Lumière and Seyewetz in 1904, and o-phenylenediamine was recommended by Seyewetz in 1936.[79] Developing solutions employing p- or o-phenylenediamine in conjunction with Metol or glycin for greater energy with less loss of emulsion speed were published by Sease (1933), Lowe (1936), Champlin (1937), and others.[80] As fine grain emulsions improved, interest in this type of developer diminished.

The formation of an image of tanned gelatin in developing with pyrogallol was observed and patented by Swan (1879)[81] and again by Warnerke in 1881.[82] Haddon and Grundy, in 1896, pointed out that the tanning of the gelatin was associated with the oxidization products of

the developer and varied with the amount of sodium sulfite used.[83]

Pontius (1951) made an extensive investigation of tanning developers and the effectiveness of gallic acid, ascorbic acid and other additions to the developer.[84] Practical application of these findings was made in the preparation of gelatin reliefs for dye transfer color printing.

COLOR DEVELOPMENT

The existence of a colored dye image in negatives developed in pyrogallol as a by-product of the oxidation of the developing agent used in the reduction of silver halide was noted by Alfred Watkins in 1896.[85] Homolka found that several indoxyl and naphthol developers produced strongly colored images.[86] Developers of this type, producing color images directly, are known as *primary* color developers.

Far more important is secondary color development, in which the dye image is formed by the reaction of the oxidation products of the developer with a second component, known as a *coupler*, or *color-former*. The first in this field were Fischer and Siegrist (1914), using para-phenylenediamine or paraminophenol and couplers with active methylene or methine groups to form indamine, indophenol, indoaniline or azomethine dyes.[87] They patented the use of such coupler developer processes for the production of prints in color and for three-color photography. The application of color development to three-color photography did not become important commercially, however, until 1935, when *Kodachrome* was placed on the market by the Eastman Kodak Company.

CONTROLLED NEGATIVE PROCESSING

Hurter and Driffield pointed out in 1890 that the only control the photographer has in development, once it has begun, relates to the density range, and that he cannot, by modification of the developer, alter the relations of the densities to one another. Photographers were slow to accept this thesis, and there was much "tinkering" with the developing solution until well into the twentieth century.

About the beginning of the century the idea that the time of development could be fixed for a given emulsion, developer and temperature was advanced, and in 1902 the Eastman Kodak Company introduced the Kodak Film Tank, in which the film was rolled into a light-tight plastic spool in a light-tight wooden box and then inserted in a metal tank, where it was developed for a fixed time at a given temperature. But time and temperature development remained for several years strictly "for amateurs." Ferguson (1906) studied the relation between the temperature of the solution and the time of development,[88] and Alfred Watkins published periodically in the *Watkins Manual* tables showing the time of development for commercially available plates and films in a number of selected developers at varying temperatures.[89] Development by time and temperature control did not become general in professional practice, however, until the increasing use of panchromatic emulsions made development by inspection impractical.

In commercial practice, plates and, later, sheet films were placed in hangers and developed in open tanks surrounded by a larger tank containing water to maintain the desired temperature. Continuous processing machinery, in which film is developed, fixed, washed and dried, became common in the processing of motion picture film after 1930 but was not widely employed for roll or sheet film until about 25 years later.

COMBINED DEVELOPMENT AND FIXATION—MONOBATHS

In 1889 W. D. Richmond reported on what he called "concurrent development and fixation," in which sodium thiosulfate and ammonium thiocyanate were added to a pyro-ammonia developer.[90] His results were not wholly unsuccessful, but he reached the conclusion that the process could not equal the usual methods of processing. After World War II there was a revival of interest in combined development and fixing as a means of simplifying processing and providing rapid processing.

Newman, in a review of the progress made up to 1959, concluded that little had been accomplished,[91] but at about the same time studies by Levy, Barnes, Haist and others using Phenidone resulted in the formulation of practical monobaths for use with specific emulsions.[92]

STABILIZATION PROCESSING

Stabilization, which may be conveniently described as fixation without washing, is based upon the conversion of the unexposed silver halide into compounds relatively inert to light, heat and humidity. Bogisch, in 1893, observed that an exposed and developed image, fixed in an acidic solution of thiourea, was quite stable without washing.[93] Years later, interest in the subject developed in the search for rapid access methods of obtaining a visible image. Russell, Yackel and Bruce investigated stabilizing agents in 1950,[94] as did Levinos and Burner in 1951.[95] The most important application of stabilization processing is in rapid print production, using a developing paper in which the developing agents are incorporated in the emulsion. The paper is processed within 15 to 20 sec in a machine which applies an alkali for development, followed by a stabilizing solution. The stabilized image has a life of several months but can be fixed and washed later if a permanent image is required.

REVERSAL PROCESSING

The reversal of the image in processing was first described by C. Russell in 1862.[96] James Waterhouse

discovered the reversal of the image by the addition of thiocarbamide to a developer in 1890.[97] R. Namias, in 1899, described a modification of Russell's process which is essentially the process in use today: after exposure and development, the negative image was removed in an acidic solution of potassium permanganate, the plate reexposed and the remaining silver halide developed to form a positive image. This process was adopted by A. and L. Lumière for the reversal processing of the *Autochrome* plate in 1907. The first widespread application of reversal processing was for amateur 16 mm motion pictures (*Cine-Kodak film*), based on the work of J. G. Capstaff and introduced by Eastman Kodak Co. in 1923.[96]

DESENSITIZATION

In 1920 Lüppo-Cramer announced that negative materials could be developed in a bright yellow light following immersion in a solution of phenosafranine, a desensitizing dye.[98] This dye, however, had the property of imparting a reddish stain which was difficult to wash out, and about a year later Schuloff, at the Höchst Dye Works, found a colorless, nonstaining desensitizer, which was placed on the market as *pinakryptol*.[99] Later, other dyes which were more effective desensitizers were discovered. These were introduced as *pinakryptol green* and *pinakryptol yellow*. By this time, however, development by control of time was coming into general use, and interest in desensitizing and desensitisers declined rapidly.

FIXATION

In addition to sodium, potassium and ammonium thiosulfates, the corresponding thiocyanates, cyanides, sodium sulfite, ammonia, thiourea and allylthiourea have been used as fixing agents. Both hypo and potassium cyanide were in general use with the wet collodion process. Sodium thiosulfate (hypo) was used almost exclusively for gelatin emulsions until a few years ago, when ammonium thiosulfate, which fixes faster, became available at lower cost. It now competes with hypo.

The chemistry of the silver sodium thiosulfate complexes formed in the interaction of the silver halides and hypo has been under investigation since the time of Herschel. Among the more comprehensive reviews of early studies relating to fixation processes is that of Baines.[100]

A simple solution of hypo in water was used for fixing for many years. In 1889 the addition of citric or acetic acid and sodium sulfite was recommended by Lainer to prevent staining.[101] The use of potassium metabisulfite or sodium bisulfite, however, found wider application in practice. Later still the acid fixing bath was superseded by the acid fixing and hardening bath. The chemistry and properties of acid fixing and hardening baths containing alum as hardener have been studied by Sheppard and Houck, Russell and Crabtree, and Crabtree, Eaton and Muehler.[102]

WASHING

In a flowing stream of water, hypo diffuses from the emulsion layer exponentially with time. Hickman and Spencer found, however, that developing papers require longer washing times than negative materials,[103] and this was confirmed by Crabtree, Eaton and Muehler.[104]

Lumière and Seyewetz, in 1902, recommended solutions of ammonium persulfate, potassium percarbonate and sodium peroxide to reduce the time of washing.[105] Amor recommended sodium hydroxide, hydrogen peroxide and ammonium persulfate as hypo eliminators;[106] while Crabtree, Eaton and Muehler recommended ammonia, sodium carbonate and bicarbonate, and sodium hydroxide.[104,107]

INTENSIFICATION AND REDUCTION

Before developing papers in various contrast grades became available, negatives were developed by inspection to the density range suitable for the printing paper. When an error was made in development, the negative was *intensified* to increase density and contrast or *reduced* to lower density and contrast. The usual method of intensification involved bleaching the negative in a solution of mercuric chloride and potassium bromide and redeveloping, or blackening, in ammonia, sodium sulfite or silver cyanide. A single-solution intensifier of mercuric iodide formulated by Lyte (1853) was later improved by Lumière and Seyewetz and by Shaw.[108] C. Welborne Piper (1904) published directions for intensification with chromium,[109] and J. B. Wellington (1911) developed a method of intensifying with silver which was later improved by Crabtree and Muehler.[110]

Of the many different methods of reduction that appear in the literature only ferricyanide-hypo (Farmer, 1883), permanganate (Namias, 1900) and persulfate (A. and L. Lumière, 1898) have been of lasting interest.[111] Persulfate reducers have been studied extensively because, unlike other reducers, persulfate reduces the higher densities much more than the lower densities, making it particularly useful with negatives of excessive contrast.[112,110b]

PRINTING PROCESSES EMPLOYING IRON OR OTHER METALLIC SALTS

Some compounds of iron, platinum, chromium, mercury, uranium, cobalt, cerium, molybdenum, nickel and tungsten are sensitive to light, and many have been studied for use in printing processes. A few salts of iron, platinum and chromium have been of commercial importance.[113]

Herschel worked out (1842) a number of printing processes based on the reduction of ferric salts to ferrous state by exposure to light.[114] The most important of these are the familiar *blueprint* and the positive blueprint, or *cyanotype*, both of which have been used for many years in the reproduction of engineering drawings.

Herschel also worked out processes in which ferrous salts formed by the action of light are used to reduce noble metals from solutions of their salts. The iron-silver process described by Herschel was developed by Shaw-cross (1889) and Arndt and Troost (1895) into the *Vandyke* process, used to make negative copies of engineering drawings for subsequent blueprint reproduction,[115a] and by Nicol (1889) into the *Kallitype* process for continuous tone photographic printing.[115b] The most important printing process based on the reduction of other metals by ferrous salts was *platinotype* (Willis, 1873), in which paper coated with potassium chloroplatinite and ferric oxalate is exposed and the image developed in a solution of potassium oxalate.[116] Removal of the ferric salt in a weak solution of hydrochloric acid results in a final image of platinum. Willis founded the Platinotype Co., which manufactured, in addition to platinum paper, a silver-platinum paper, known as *Satista*, and *palladiotype*, which produced a final image in palladium. Commercial exploitation of the platinotype process ceased soon after World War I.[117]

Mungo Ponton (1839) described a printing process in which paper was soaked in a solution of potassium chromate, dried and then exposed to light, forming a brownish image which could be fixed by washing in water to remove the unexposed bichromate.[118] The poor gradation made the process useless.

The discovery that colloids containing dichromate become insoluble on exposure to light was made by Talbot in 1852, and this insolubilization is the basis of all printing processes employing the light-sensitive chromium compounds.[119] Talbot patented a photo-engraving process which used the hardened image in gelatin-dichromate coated over copper as a resist during etching.

In 1858 John Pouncy exhibited prints to the London Photographic Society made on paper coated with gum arabic containing carbon as pigment and sensitized with potassium dichromate.[120] Washing in water removed the soluble gum and pigment, leaving the insoluble image, but it was of poor quality because some of the pigment washed out in the halftones as well as in the highlights. Swan (1864) overcame this problem by an image transfer process which inverted the layer before washing.[121] The process became known as *carbon printing* from the use of finely divided carbon as the black pigment. This was the first successful printing process to employ a dichromated colloid. Materials for the process were placed on the market by the Autotype Company of London, which, using other pigments, eventually supplied papers for prints in more than 30 different colors, including the magenta, cyan and yellow required for making subtractive color prints from three-color separation negatives.

Around the turn of the century Pouncy's method was revived by a number of workers as the *gum-bichromate process*. Washing out of the halftones was avoided by using thin layers of pigmented gum and building up the image to a full range of tones by multiple printing.

In 1855 Alphonse Poitevin patented a process of photo-mechanical printing which became known as a *collotype*.[122] In this process a plate is coated with albumen and gum arabic and potassium dichromate. After exposure the surface of the plate is thoroughly dampened. The water is absorbed by the unexposed portions of the layer but rejected by the portions which have been exposed to light and thus rendered insoluble. A greasy ink is then applied to the plate, and this adheres to the dry areas but not to those which have absorbed water. The inked plate is then placed in a flatbed printing press with a sheet of paper and the ink transferred to the paper.

In 1904 Rawlins described as *oil printing* a process similar to collotype except that the ink was applied manually with a brush, which allowed considerable control over the tones of the image.[123] The sensitive coating was on a paper base, and the oil print was viewed directly, not transferred.

E. Howard Farmer found (1884) that the dichromates could be reduced by the silver of a developed image and gelatin thus hardened imagewise. In 1898 Manly patented a process of making pigment prints, using this reaction to produce an image in reduced dichromate by contact with a print on bromide paper. This process was introduced by Manly as *Ozobrome*, and it was revived by H. F. Farmer in 1919 as *carbro*, which subsequently was used by many workers for printing from color separation negatives.[124]

Meanwhile E. J. Wall had pointed out (1907) that the Ozobrome print could be used as a basis for oil printing, and from this suggestion C. Welborne Piper developed the *bromoil* process, which quickly replaced the earlier oil processes.[125] A silver image was treated with dichromate and ferricyanide, then pressed in contact with a pigment tissue to produce a hardened image in the tissue, which could afterward be washed and finished as a carbon print.

DIAZO PROCESSES

Negative working photographic processes based on the light-sensitivity of diazo compounds were described by West (1884), Feer (1889), Andresen (1886), and others, but these processes found no practical application.[126] The positive print process of Green, Cross, and Bevan (1890) and other processes by Andresen (1895) and Schoen (1899) met a like fate.[127] The first commercially successful process was patented by Gustav Kögel (1917), who introduced the diazo oxides, a new group of compounds with greater sensitivity to light and superior fastness of color, together with a coupler requiring only ammonia for dye formation.[128] The rights to the process were acquired by Kalle, and the paper was placed on the market in 1923 under the trade name *Ozalid*. Diazotype papers have now almost completely replaced the blueprint for copying plans and engineering drawings. Diazotype films, often referred to as foils, are widely used for preparation of large transparencies for overhead projector use, and the high resolution of the diazo materials has resulted in their application to microfilm reproduction.[129]

DIFFUSION TRANSFER PROCESSES

Liesegang observed (1898) that silver nitrate in one layer diffused into another layer containing a developing agent and was reduced.[130] He saw no practical application for the observation, and it was soon forgotten. Stevens and Norrish (1938) observed the migration of silver from a silver halide emulsion to a layer of gelatin on another plate. The silver which had transferred was developed in an acid Metol physical developer to produce a positive image.[131]

The initial steps towards the development of a diffusion transfer process for document copying were made by André Rott, who was associated with Gevaert (Belgium), in 1939, and by Edith Weyde of Agfa (Germany) about 1940.[132]

The first practical application of the process to document copying came in 1949 with the introduction by Agfa of materials for the *Copyrapid* process and a machine for automatic processing of these materials produced by Trikop, G.m.b.H., of Stuttgart from the patents of Eisbein.[133] Gevaert's Gevacopy process was introduced in 1950. Licenses for the manufacture of the materials and equipment were granted to firms in other countries, and by 1960 the use of diffusion transfer office copying machines was widespread.[132]

E. H. Land of Polaroid Corporation reported in 1947 on a system of *one-step photography* based on transfer of a soluble silver complex and reduction of the transferred silver to form a positive image, and he demonstrated a camera and a photographic process that produced a finished positive print directly from the camera.

"From the point of view of the user, the camera was to look essentially like an ordinary camera, the process was to be dry, the film was to be loaded in one of the usual ways, the positive print was to look essentially like a conventional paper print, and this print was to be completed within a minute or two after the picture was taken."[134]

The first Polaroid Land Camera, the Model 95, was a roll film model making $3\frac{1}{4} \times 4\frac{1}{4}$ in. prints in the camera in 60 sec. Placed on the market in 1948, it was an instant success. The first film had an equivalent ASA speed of 100 and the prints were sepia. Black and white materials were made available in 1950. The original orthochromatic emulsion was replaced by new, higher speed panchromatic films in 1955. A film with speed equivalent to 3000 ASA was placed on the market in 1959, and the processing time was reduced from 60 to 10 sec. In 1961 P/N (positive-negative) material producing a usable negative, as well as a print, was introduced as a film packet in a special film holder for use with 4×5 in. cameras. Later black and white films for Polaroid cameras include high contrast materials for line copy, transparency films and a speed 10,000 film for use in oscillography.[135]

Polacolor, a multilayer film producing prints in color in 60 sec, was introduced in 1963, and in 1972 Land announced the *SX-70* color system. *Polacolor 2* followed in 1975. These films, described in detail in a later chapter, are based on the use of dye developers, colored compounds which are either oxidized and immobilized in the negative or transferred to a receiving layer to form positive images.[135]

COLOR PHOTOGRAPHY—DIRECT PROCESSES

In 1810 Seebeck, of Jena, found that silver chloride on paper, exposed to the spectrum while wet, reproduced the different colors faintly. Occasionally, with both the daguerreotype and wet collodion, color images would be obtained, but the colors disappeared on fixing. Herschel (1840), Becquerel (1847–1855), Niépce de Saint-Victor (1851–1866), among others, investigated light-interference processes of this type further, and Niépce de Saint-Victor displayed *heliochromes*, color photographs on "chlorinated" silver plates, in 1862 and 1867.[136]

In 1891 Lippman, of Paris, described a method of interference photography based on very fine-grained silver bromide emulsions, in which the color image could be made permanent. The process is interesting theoretically, but the limitation of low speed makes it little more than a laboratory experiment. Nevertheless, the Lumières showed a color portrait of this type in Geneva in 1893, and more were exhibited at the Paris Exposition of 1900.[137]

Another approach to direct color photography is through the bleaching of dyes. An early worker in this field was J. H. Smith, of Zurich, whose results were sufficiently promising to lead him to place *Utocolor* paper on the market in 1907 as a means of making color prints from Autochrome color transparencies.[138] The process was difficult to control, however, and the paper was soon withdrawn.

THREE-COLOR PHOTOGRAPHY

An alternative approach to color reproduction is to record the colors of the subject photographically to represent the red, green, and blue-violet color sensations and to produce from three such black and white images three superimposed projected color images to recreate the colors of the original.[138b,139] The first to attempt such an *additive color* process was the English physicist, James Clerk Maxwell (1861).[140] In a lecture given at the Royal Institution (London), Maxwell and his assistant, Thomas Sutton, made three photographs of a knot of colored ribbons, one through a red solution acting as a light filter, one through a green filter solution, and a third through a blue filter solution. From these negatives he made three positives on glass plates, which he projected on a screen, superposing the three images by means of three lantern slide projectors, each one projecting its slide through the filter solution that had been used in making the negative. In this way Maxwell produced, albeit imperfectly, a projected image in color of the ribbons he had photographed.

Ducos du Hauron (1862, 1869) designed three-color mirror cameras, in which all three negatives could be

made through one lens at the same time,[141] but it was several years before a practical camera could be made, and plates sufficiently sensitive to orange and red were not available until 1885. He pointed out also that the three-color camera could be used in reverse as a viewing instrument to form an image in color from glass transparencies made from the three negatives (photochromoscope). Frederick Ives, of Philadelphia, developed the three-color camera and viewing instrument into a workable system, but his *Kromskop* (1891) was too difficult for general use.[142]

Color prints from negatives of still life exposed in an ordinary camera or in a three-color camera were first made by the carbon process,[121] using tissues with pigments of the proper colors and superimposing the three pigment images. Later, processes of three-color printing based on the toning of silver images, on dyed gelatin reliefs, and the mordanting of dyes were developed. The most successful of these were three-color carbro[124] and dye transfer processes.[143]

SCREEN PLATE PROCESSES

In the meantime the screen plate process, suggested originally by du Hauron,[144] had been developed into a practical process for transparencies in color. Although it required about 60 times the exposure of black and white negative materials and the screen absorbed more than 90% of the light, requiring strong light sources for viewing and projection, the *Autochrome* plate of A. and L. Lumière of Lyons (1907) was for years the only really practical process of color photography.[145] Three-color photo-engravings from Autochrome transparencies were used by magazines in both editorial illustration and advertising. The Autochrome plate was eventually replaced with a similar product on film base under the trade mark *Filmcolor*, which remained in production until the advent of multilayer color films in 1936.

The lenticular screen process is essentially a screenplate process in which the screen is formed optically on the emulsion during the exposure.[146] This process was developed in France by Berthon (1909)[147] and by Keller-Dorian (1914)[148] and was acquired by the Eastman Kodak Company for 16 mm amateur color cinematography (*Kodacolor*,[149] 1928). Kodacolor* was superseded in 1935 by the first commercial multilayer film, *Kodachrome*,[150] which is described in the following section.

EARLY MULTILAYER COLOR NEGATIVES

In 1897 du Hauron patented a method of making three-color separation negatives in one exposure with an ordinary camera using three emulsions placed in contact with one another.[151] The first glass plate, with the glass side toward the lens, was coated with a blue-sensitive

emulsion; next, a green sensitive emulsion on a thin film base, followed by a red filter and another glass plate with a red-sensitive emulsion on the side facing the lens. This was the first *tripack*.

To improve the sharpness of the images of the green and red color separation negatives, Selle (1899) patented a method in which the tripack was to consist of only two emulsions.[152] The one in front would be a highly transparent blue-sensitive emulsion, the second an emulsion sensitized with two sensitizing dyes, one of which, soluble in water, penetrated the emulsion layer and sensitized to green, while the other, soluble in alcohol, sensitized only the upper portion of the emulsion layer. In this way the red separation negative would be recorded near the surface of the emulsion and the green separation in the same emulsion below it.

J. H. Smith produced a tripack in 1903, in which the three emulsions were coated on a single support and separated by collodion layers.[153] The emulsions were stripped apart for processing. Schinzel, in 1905, proposed an integral tripack, also termed a *monopack*, in which the three emulsions were to be coated in succession on a single support and were to contain dyes which would form the final image,[154] but his method of producing dye images was not practical, nor were those of Sforza, who suggested much the same thing in 1910.[155]

COUPLER DEVELOPER MONOPACK PROCESSES

Fischer (1912) suggested the use of color development as a means of forming the color images, the coupler for one dye being included in each of the three emulsions.[156] This process, however, could not be made to work well at the time because the couplers could not be confined to a single layer and diffused into adjacent layers.

The first successful coupler developer process utilizing a multilayer monopack film was *Kodachrome*®*, which was introduced by the Eastman Kodak Company as a 16 mm motion picture film in 1935 and as 35 mm film for color slides in 1936.[150] The film included three emulsion layers and a yellow filter layer of colloidal silver between the first and second emulsion layers. The wandering of couplers from one image layer to another, which had defeated previous attempts to process a multilayer film by color development, was overcome in Kodachrome, which did not incorporate couplers in the film. The color images were developed separately in sequence after the three negative images had been developed and removed by bleaching.

Meanwhile, in Germany, Agfa had succeeded in preventing the diffusion of the couplers from one emulsion layer to another by weighting them with long chain substituents, which made it possible to follow Fischer's original plan for a multilayer film with the couplers incorporated in the negative. A reversal film for color trans-

*The name Kodacolor was later assigned to subtractive color materials.

*Not to be confused with an earlier Eastman Kodak two-color process which had also used the name Kodachrome.

Leopold D. Mannes and Leo Godowsky, co-inventors who developed the Kodachrome process, shown in their laboratory in 1922.

parencies was placed on the market in 1936 as *Agfacolor®*.[157] In processing, the film is developed to produce silver images in all three emulsions. It is then exposed and developed in a color developer, in which the residual silver is converted to silver and the respective couplers combine with oxidized developer to form the three dye images. After color development, the silver images are bleached and removed.

Later (1942) a different method of solving the coupler control problem was found in the laboratories of the Eastman Kodak Company. The couplers were not dispersed directly into the emulsion but were first dissolved in an oily liquid and then dispersed in the emulsion. This method was first used in *Kodacolor®*, a negative color film placed on the market in 1942;[158] and later in *Ektacolor®* (1949), also a negative color film, and in *Ektachrome®* (1948), a reversal film for transparencies. Ektacolor represented an important step forward in the use of colored couplers to correct the color deficiencies of the dye images produced by color development.[159]

Multilayer color films for the production of color transparencies by reversal processing and for color negatives, as well as positive films and papers for prints from color negatives, are now being made in all parts of the world.

REFERENCES

1. J. M. Eder, *Geschichte der Photographie*, 4th Ed., W. Knapp, Halle, 1932; E. Epstean trans., *History of Photography*, Columbia University, New York, 1945, p. 3.
2. Ref. 1, p. 10.
3. (a) J. H. Schulze, *Acta physico-medica Academiae Caesariae Naturae Curiosorum*, **1**: 528 (1727) Observatio 233. English translation in *Photogr. J.* **38** (N.S. 23): 53 (1898).
 (b) Ref. 1, Chapt. 10, "The Life of Johann Heinrich Schulze."
4. (a) Beccarius, *De Bononiensi Scientarium et Artium Institute atque Academia Commentarii*, **4**: 74 (1757).
 (b) Ref. 1, pp. 87–88.
5. (a) W. Lewis, *Commercium philosophico-technicum*, London, 1763, p. 350.
 (b) Ref. 1, p. 92.
6. (a) J. Priestley, *The History and Present State of Discoveries relating to Vision, Light and Colours*, London, 1772, Part vi.
 (b) H. Gernsheim and A. Gernsheim, *The History of Photography*, McGraw-Hill, New York, 1969, p. 38.
7. (a) C. W. Scheele, *Chemische Abhandlung von der Luft und dem Feuer*, Uppsala and Leipzig, 1777. Translation *Chemical Observations and Experiments on Air and Fire*, London, 1780.
 (b) Ref. 6 (b), pp. 32–33.
8. Ref. 1, pp. 102–103.
9. ibid., Chapt. 19.
10. (a) Ref. 6(b), Chapt. 4.
 (b) Ref. 1, pp. 134–141.
 (c) T. Wedgwood and H. Davy, *Journal of the Royal Institution*, **1**: 170 (1802).
11. (a) J. Herschel, *Edinburgh Philosophical Journal*, **1**(8): 396 (1819).
 (b) Ref. 1, p. 170.
12. (a) Ref. 1, Chapt. 19.
 (b) Ref. 6(b), Chapt. 5.
13. (a) L. J. M. Daguerre, *Historique et description des procédés du daguerréotype et du diorama*, Paris, 1839.
 (b) Ref. 1, Chapts. 20–29.
 (c) Ref. 6(b), Chapts. 6, 10–13.
 (d) I. Pobborarsky. *Study of Iodized Daguerreotype Plates*, Report No. 142, Graphic Arts Research Center, Rochester Institute of Technology, Rochester, N.Y. 1971.
14. (a) H. L. Fizeau and L. Foucalt, *Compt. rend.*, **18**: 746 (1844).
 (b) Ref. 1, p. 254.
15. J. Herschel, *Phil. Trans. Roy. Soc.*, London, **1**: 1 (1840).
16. Ref 1, pp. 275–278.
17. (a) Ref. 1, Chapts. 34 and 35.
 (b) B. Newhall, *The Daguerreotype in America*, Duell, Sloane and Pearce, New York, 1961. Revised edition by New York Graphic Society, New York, 1968.
 (c) R. Taft, *Photography and the American Scene*, New York, 1938. Reprinted by Dover, New York, 1964.
18. Ref. 1, Chapt. 30.
19. (a) W. H. F. Talbot, *The Athenaeum*, Feb 9, 1839.
 (b) W. H. F. Talbot, *The Pencil of Nature*, Longman, Brown, Green & Longmans, London, 1844. Facsimile edition with introduction by B. Newhall, DeCapo Press, New York, 1969.
 (c) W. H. F. Talbot, Brit. Patent 8842 (1841).
 (d) Ref. 6(b), Chapt. 7.
20. (a) *Compt. rend.*, **25**: 589,785 (1847).
 (b) Ref. 1, Chapt. 41.
21. F. S. Archer, *The Chemist*, **2** (new series): 257 (1851).
22. (a) F. S. Archer, *The Collodion Process on Glass*, London, 1852.
 (b) T. F. Hardwich, *Manual of Photographic Chemistry, Including the Practice of the Collodion Process*, London, 1861.
 (c) I. B. Current, "Sensitometric Study of the Collodion Process," *SPSE News*, July–Aug 1962, **5**: 5 (1962).
23. Blanquart-Évrard, *Compt. rend.*, **30**: 663 (1850).
24. W. de W. Abney, *Photogr. News* **26**: 300 (1882).
25. W. de W. Abney and H. P. Robinson, *The Art and Practice of Silver Printing*, London, 1888.
26. A. Martin, *La Lumière*, 1852, pp. 99, 114.
27. (a) Ref. 6 (b), pp. 236–8.
 (b) E. M. Estabrooke, *The Ferrotype and How to Make It*, Gatchel & Hyatt, Cincinnati & Louisville, 1872. Reprinted by Morgan and Morgan, Hastings-on-Hudson, 1972.
28. Ref. 1, Chapt. 48.
29. J. M. Taupenot, *Compt. rend.*, **41**: 383 (1855).
30. R. H. Norris, Brit. Patent 2,029 (1856).

31. C. Russell, *Photogr. News*, **5:** 135 (1861).
32. C. Russell, *The Tannin Process*, London, 1863.
33. E. Ostroff and T. H. James "Gelatin Silver Halide Emulsion: A. History," *J. Photogr. Sci.*, **20:** 146 (1972).
34. R. Bingham, *Photogenic Manipulation*, London, 1850.
35. W. H. Harrison, *Brit. J. Photogr.*, **15:** 26 (1868).
36. R. L. Maddox, ibid., **18:** 422 (1871).
37. ibid., **20:** 348 (1873).
38. R. Kennett, Brit. Patent 3782 (1873).
39. J. King, *Brit. J. Photogr.*, **20:** 542 (1873).
40. J. Johnston, ibid., **20:** 544 (1873).
41. J. Johnston, *Brit. J. Photogr. Almanac*, 1877, p. 95.
42. C. Bennett, *Brit. J. Photogr.*, **25:** 146 (1878).
43. (a) J. M. Eder, *Theorie und Praxis der Photographie mit Bromsilbergelatine*, 1881.
 (b) Ref. 1, Chapt. 59.
44. W. de W. Abney, *The Practical Working of the Gelatine Emulsion Process*, London, 1880.
45. C. Ackerman, *George Eastman*, Houghton Mifflin, Boston, 1930.
46. B. Newhall, "The Photographic Inventions of George Eastman," *J. Photogr. Sci.*, **3:** 33 (1955).
47. H. M. Reichenbach, U.S. Patent 417,202 (1889).
48. H. Goodwin, U.S. Patent 610,861 (1898).
49. W. West, "The First Hundred Years of Spectral Sensitization", *Photogr. Sci. Eng.*, **18:** 35 (1974).
50. H. W. Vogel, *Ber. Deut. Chem. Ges.*, **6:** 1302 (1873).
51. H. W. Vogel, *Photogr. Mitt.*, **21:** 52, 87, 106, 131, 269 (1884).
52. J. Waterhouse, *Brit. J. Photogr.*, **22:** 450 (1875).
53. Tailfer and Clayton, Fr. Patent 152,615 (1882).
54. J. M. Eder, *Photogr. Korr.*, **21:** 95, 120, 311 (1884).
55. A. Miethe and A. Traube, Ger. Patent 142,926 (1902).
56. E. König, *Z. Wiss. Photogr.*, **1:** 174 (1903); *Photogr. Korr.*, **40:** 311 (1903); ibid., **41:** 108 (1904).
57. (a) J. D. Kendall, Brit. Patent 428,222; 428,359 (1935).
 (b) L. G. S. Brooker, U.S. Patent 2,078,233 (1937).
 (c) C. E. K Mees, *From Dry Plates to Ektachrome Film*, Ziff-Davis, New York, 1961, p. 124.
58. K. Jacobsohn, *Brit. J. Photogr.*, **76:** 315 (1929).
59. F. Dersch and H. Dürr, *J. Soc. Motion Picture Engrs.*, **28:** 178 (1937).
60. (a) E. P. Wightman and R. F. Quirk, *J. Franklin Inst.*, **203:** 261 (1927); **204:** 731 (1927).
 (b) S. E. Sheppard, W. Vanselow and R. F. Quirk, *J. Franklin Inst.*, **240:** 439 (1945).
61. F. W. H. Mueller and J. Bates, *Phot. Soc. Amer. J.*, **10:** 586 (1944).
62. N. L. Simmons, U.S. Patent 2,368,267 (1945).
63. Ref. 1, pp. 450–451.
64. ibid, p. 452.
65. (a) F. Hurter and V. C. Driffield, *J. Soc. Chem. Ind., London*, **9:** 455 (1890).
 (b) W. B. Ferguson, *The Photographic Researches of Ferdinand Hurter and Vero C. Driffield*. Royal Photographic Society, London, 1920.
66. L. A. Jones and C. N. Nelson, *J. Opt. Soc. Amer.*, **30:** 93 (1940).
67. "American Standard Method for Determining Speed of Photographic Negative Materials," PH 2.5-1960, Amer. Stds. Assoc., New York, 1960. Revised edition PH 2.5-1972, Amer. Nat'l. Stds. Inst., New York, 1972.
68. (a) J. M. Eder and G. Pizzighelli, *Vienna Acad. of Sci.*, **83:** 144 (1881).
 (b) Ref. 1, pp. 443–445.
69. Ref. 1, p. 442.
70. F. F. Renwick, *Photogr. J.*, **80:** 320 (1940).
71. Ref. 1, pp. 325, 330–331.
72. H. B. Berkeley, *Photogr. News*, **26:** 41 (1882).
73. D. R. White and J. R. Webber, "Developers and Theory of Development," B. Dudley and K. Henney, *Handbook of Photography*, McGraw-Hill, New York, 1939. pp. 328–337.
74. H. Lüppo-Cramer, *Photogr. Korr.*, **27:** 161 (1900).
75. (a) W. Reinders and M. C. F. Beukers, Ber. VIII. Intern. Kongr. Wiss. u. Angew. Phot., Dresden, 1931, J. Eggert and A. von Biehler, (Eds.), J. Barth, Leipzig, 1932, p. 171.
 (b) W. Reinders and M. C. F. Beukers, *Photogr. J.*, **74** (N.S.58): 78 (1934).
76. G. I. P. Levenson, *Photogr. J.*, **88B:** 102 (1948); **89B:** 2, 13, (1949); **92B:** 109 (1952).
77. (a) T. H. James, *Phot. Soc. Am. J. (Photogr. Sci. Tech.)* **19B:** 156 (1953).
 (b) W. E. Lee and T. H. James, *Photogr. Sci. Eng.*, **6:** 32 (1962).
78. R. W. Henn and J. I. Crabtree, *Phot. Soc. Am. J.*, **10:** 727 (1944).
79. A. Seyewetz, *Brit. J. Photogr.*, **83:** 487 (1936).
80. (a) V. B. Sease, *Camera (Phila.)*, **47:** 1 (1933).
 (b) E. Lowe, *Zeiss Mag.*, **2:** 75 (1936).
 (c) Champlin, *Champlin on Fine Grain*, Camera Craft, San Francisco, 1937.
81. J. W. Swan, Brit. Patent 2969 (1879); *Brit. J. Photogr.*, **27:** 212 (1880).
82. L. Warnerke, Brit. Patent 1436 (1881).
83. A. Haddon and F. B. Grundy, *Brit. J. Photogr.*, **43:** 356 (1896).
84. R. B. Pontius, *Phot. Soc. Am. J. (Photogr. Sci. Tech.)* **17B:** 76 (1951).
85. A. Watkins, *Photogr. J.*, **36:** 245 (1896).
86. B. Homolka, *Brit. J. Photogr.*, **54:** 136, 216 (1907).
87. R. Fischer and H. Siegrist, *Photogr. Korr.*, **51:** 18 (1914).
88. Ferguson, *Photogr. J.*, **46:** 182 (1906); **50:** 412 (1910).
89. A. Watkins, *Brit. J. Photogr.*, **41:** 120, (1894); **49:** 1025 (1902); **55:** 646 (1908); **57:** 387 (1910).
90. W. D. Richmond, *Brit. J. Photogr.*, **6:** 827 (1889).
91. A. A. Newman, ibid., **106:** 44, 66 (1959).
92. (a) M. Levy, *Photogr. Sci. Eng.*, **2:** 136 (1958).
 (b) J. C. Barnes, ibid., **5:** 204 (1961).
 (c) G. Haist, *Monobath Manual*, Morgan and Morgan, Hastings-on-Hudson, N.Y., 1966.
93. A. Bogisch, *Photogr. Arch.*, **34:** 310 (1893).
94. H. D. Russell, E. C. Yackel and J. S. Bruce, *Phot. Soc. Am. J. (Photogr. Sci. Tech.)*, **16B:** 59 (1950).
95. S. Levinos and W. C. Burner, *Photogr. Eng.*, **2:** 148 (1951).
96. Ref. 57(c), pp. 171–175.
97. J. Waterhouse, *Brit. J. Photogr.*, **37:** 601, 613 (1890).
98. (a) Lüppo-Cramer, *Photogr. Korr.*, **57:** 311 (1920).
 (b) Lüppo-Cramer, *Negativentwicklung bei hellem Lichte; Safraninverfahren*, Leipzig, 1922.
99. R. Schuloff, Ger. Patent 396,402 (1922).
100. H. Baines, *J. Photogr. Sci.*, **3:** 175 (1955).
101. A. Lainer, *Photogr. Korr.*, **26:** 171 (1889); **26:** 273, 311 (1889).
102. (a) S. E. Sheppard and R. C. Houck, *J. Soc. Motion Picture Engrs.*, **31:** 67 (1938).
 (b) H. D. Russell and J. I. Crabtree, ibid., **18:** 371 (1932).
 (c) J. I. Crabtree, G. T. Eaton and L. E. Muehler, ibid., **35:** 484 (1940); **41:** 9 (1943).
103. (a) K. C. D. Hickman and D. A. Spencer, *Photogr. J.*, **62** (N.S. 46): 225 (1922).
 (b) K. C. D. Hickman, ibid., **63** (N.S. 47): 208 (1923).
 (c) K. C. D. Hickman and D. A. Spencer, ibid., **64** (N.S. 48): 549 (1924); **64** (N.S. 48): 553 (1924).
104. J. I. Crabtree, G. T. Eaton and L. E. Muehler, *Photogr. J.*, **80:** 458 (1940).
105. A. and L. Lumière and A. Seyewetz, *Bull. Soc. Franc. Phot.*, **18:** 270 (1902).
106. A. E. Amor, *Brit. J. Photogr.*, **72:** 18 (1925).
107. J. I. Crabtree, G. T. Eaton and L. E. Muehler, *Phot. Soc. Am. J.*, **9:** 115, 162 (1943).
108. A. and L. Lumière and A. Seyewetz, *Bull. Soc. Franc. Phot.*, **15:** 471 (1899).
109. C. Welborne Piper and D. J. Carnegie, *Amateur Photographer* **40:** 336 (1904); **41,** 453, 473 (1905).
110. (a) J. B. Wellington, *Brit. J. Photogr.*, **58:** 551 (1911).
 (b) J. I. Crabtree and L. E. Muehler, *J. Soc. Motion Picture Engrs.*, **17:** 1001 (1931).
111. (a) R. Namias, Intern. Congress for Applied Chemistry, Paris, 1900.
 (b) A. and L. Lumière and A. Seyewetz, *Bull. Soc. Franc. Phot.*, **14:** 395 (1898); **15:** 226, 399 (1899).
112. (a) G. I. Higson, *Photogr. J.*, **61:** 237 (1921).

(b) J. I. Crabtree and L. E. Muehler, *Brit. J. Photogr.*, **79**: 106, 122, 151, 169, 184 (1932).

113. (a) C. B. Neblette, "Printing Out Processes," Chapt. 26 in *Photography, Its Materials and Processes*, 6th ed., Van Nostrand Reinhold, New York, 1962.
 (b) J. Kosar, *Light-Sensitive Systems: Chemistry and Application of Nonsilver Halide Photographic Processes*, Wiley, New York, 1965.

114. J. Herschel, *Phil. Trans.*, 1842.

115. (a) H. Denstman, *Reprographics*, **2**: 6 (1964).
 (b) J. Thomson, *Amer. Photogr.*, **17**: 422 (1923).

116. W. Willis, Brit. Patent 2,011 (1873); 2,800 (1878); 1,117 (1880).

117. Ref. 1, pp. 543–546.

118. (a) M. Ponton, *The Edinburgh New Philosophical Journal*, July, 1839.
 (b) Ref. 6 (b), p. 337.

119. (a) Ref. 1, Chapt. 79.
 (b) Ref. 113 (b), Chapt. 2.

120. (a) *J. Photogr. Soc.*, **5**: 90 (1858).
 (b) Brit. Patent 780 (1858).

121. J. W. Swan, Brit. Patent 503 (1864); *Photogr. News*, **8**: 85 (1864).

122. A. Poitevin, Brit. Patent 2,815 (1855).

123. G. E. Rawlins, *Photography*, **20**: 490 (1905).

124. (a) Brit. Patent 10, 026 (1898).
 (b) Ref. 1, Chapt. 81.

125. (a) E. J. Wall, *Photogr. News*, **51**: 299 (1907).
 (b) C. W. Piper, ibid., **52**: 150 (1907).

126. (a) R. B. West, *Anthony's Phot. Bull.*, **15**: 335 (1884).
 (b) A. Feer, Ger. Patent 53,455 (1889).

127. (a) A. G. Green, C. F. Cross and E. J. Bevan, *Brit. J. Photogr.*, **37**: 657 (1890); Ger. Patent 56,606 (1890).
 (b) M. Andresen, *Photogr. Korr.*, **32**: 284 (1895).
 (c) M. Schoen, Ger. Patent 111,416 (1899).

128. G. Kogel and H. Neuenhaus, U.S. Patent 1,444,469 (1923).

129. Ref. 113b, Chapt. 6, "Diazotype Processes."

130. R. E. Liesegang, *Photogr. Korr.*, **448**: 9 (1898).

131. G. W. W. Stevens and R. G. W. Norrish, *Photogr. J.*, **78**: 513 (1938).

132. (a) A. Rott, Brit. Patent 614,155 (1939); U.S. Patent 2,352,014 (1944).
 (b) Norw. Patents 66,994 (1942); 69,510 (1944).
 (c) A. Rott and E. Weyde, *Photographic Silver Halide Diffusion Processes*, Focal, London and New York, 1972.

133. (a) *Foto-Kino-Technik*, **4**: 25 (1950).
 (b) T. T. Hill, "Reprographic and Web Transfer Processes," Chapt. 11, this volume.

134. E. H. Land, *J. Opt. Soc. Amer.*, **37**: 61 (1947).

135. E. H. Land, H. G. Rogers and V. K. Walworth, "One-Step Photography," Chapt. 12, this volume.

136. (a) *Photogr. Korr.*, 1867, p. 190.
 (b) Becquerel, *Photogr. Arch.*, **9**: 299 (1868).
 (c) Ref. 1, pp. 664–670.

137. (a) E. Valenta, *Photogr. Korr.*, **29**: 432 (1892).
 (b) Ref. 1, pp. 670–72.

138. (a) J. H. Smith, *Photogr. J.*, **50**: 141 (1910).
 (b) J. S. Friedman, *History of Color Photography*, American Photographic, Boston, 1944. Reprint edition, with appendix containing more recent references and notes by L. Varden, Focal, London and New York, 1968, pp. 497–498.
 (c) Ref. 1, p. 675.

139. (a) E. J. Wall, *The History of Three-Color Photography*, American Photographic, Boston, 1925. Reprint edition, Focal, New York and London, 1970.
 (b) R. M. Evans, W. T. Hanson, Jr., and W. L. Brewer, *Principles of Color Photography*, Wiley, New York, 1953, Chapt. 8.

140. Ref. 139 (a), pp. 2–4.

141. (a) D. du Hauron, *Les Couleurs en Photographie, Solution du Problème*, Paris, 1869.
 (b) Ref. 139 (a), Chapt. 3, "Still Cameras and Chromoscopes."

142. (a) F. E. Ives, U.S. Patent 432,530 (1890); 531,040 (1894); *Brit. J. Photogr.* **44**: 665 (1897).
 (b) Ref. 141 (b).

143. (a) Ref. 139 (a), Chapt. 14.
 (b) Ref. 138 (b), Chapt. 26.
 (c) G. E. Matthews, *Photogr. J.*, **86A**: 80 (1946).

144. D. du Hauron, Fr. Patent 83,061 (1868).

145. (a) A. and L. Lumière, *Compt. rend.*, **138**: 1337 (1904).
 (b) Brit. Patent 22,988 (1904);
 (c) A. and L. Lumière, *Brit. J. Photogr.*, **51**: 605 (1904); ibid, **52**: 92 (1905).
 (d) Ref. 139 (a), Chapts. 17–19.

146. (a) Ref. 139 (a), pp. 666–677.
 (b) Ref. 138 (b), Chapt. 17.

147. (a) R. Berthon, Brit. Patent 10,611 (1909).
 (b) R. Berthon, *Brit. J. Photogr.*, **57**: 421 (1910).

148. (a) A. Keller-Dorian, Fr. Patent 466,781.
 (b) A. Keller-Dorian, Brit. Patent 24,698 (1914).
 (c) *Brit. J. Photogr.*, **63**: 117 (1916).
 (d) A. Keller-Dorian, U.S. Patent 1,214,552 (1917).

149. (a) J. G. Capstaff and M. W. Seymour, *Trans. Soc. Motion Picture Engrs.*, **12**: 940 (1928).
 (b) C. E. K. Mees, *J. Franklin Inst.*, **207**: 1 (1929).

150. (a) L. D. Mannes and L. Godowsky, Jr., *J. Soc. Motion Picture Engrs.*, **25**: 65 (1935).
 (b) L. D. Mannes and L. Godowsky, Jr., U.S. Patent 2,113,329 (1938).
 (c) Ref. 149 (b).
 (d) E. R. Davies, *Photogr. J.*, **76**: 248 (1936).

151. (a) D. du Hauron, *La Triplice Photographique*, Paris, 1897, p. 214.
 (b) D. du Hauron, Fr. Patents 216,465; 250,862.

152. G. Selle, Brit. Patent 12,516 (1899).

153. J. H. Smith, Ger. Patent 185,888 (1903).

154. K. Schinzel, *Brit. Photogr.*, **52**: 608 (1905); Austrian Patent 42,478 (1908).

155. F. Sforza, *Photogr. Coul.*, **5**: 209 (1910); *Brit. J. Photogr.*, **57**, Col. Photogr. Supp. **3**: 65 (1910).

156. R. Fischer, Brit. Patent 15,055 (1912); *Brit. J. Photogr.*, **60**: 595, 712 (1913).

157. (a) Brit. Patent 455,556 (1936).
 (b) Ref. 138 (b), Chapt. 11.

158. C. E. K. Mees, *J. Franklin Inst.*, **233**: 41 (1942).

159. W. T. Hanson, Jr. and P. W. Vittum, *Phot. Soc. Am. J.*, **13**: 94 (1947).

GENERAL REFERENCES

J. M. Eder, *Geschichte der Photographie*, 4th Ed., W. Knapp, Halle, 1932; E. Epstean trans. *History of Photography*, Columbia University, New York, 1945.

J. S. Friedman, *History of Color Photography*, American Photographic, Boston, 1944. Reprint edition, with appendix containing more recent references and notes by L. Varden, Focal, London and New York, 1968.

H. Gernsheim and A. Gernsheim, *The History of Photography*, 2nd ed., McGraw-Hill, New York, 1969.

J. Kosar, *Light-Sensitive Systems: Chemistry and Application of Non-Silver Halide Photographic Processes*, Wiley, New York, 1965.

C. E. K. Mees, *From Dry Plates to Ektachrome Film*, Ziff-Davis, New York, 1961.

B. Newhall, *The History of Photography*, 2nd ed., Museum of Modern Art, New York, 1964.

B. Newhall, *On Photography. A Source Book of Photo History in Facsimile*, Century House, Watkins Glen (N.Y.), 1956.

B. Newhall, *Latent Image. The Discovery of Photography*, Doubleday, Garden City (N.Y.), 1967.

G. Potonniée, *The History of the Discovery of Photography*, Paris, 1925. English translation by Edward Epstean, Tennant and Ward, New York, 1936.

E. J. Wall, *The History of Three-Color Photography*, American Photographic, Boston, 1925. Reprint edition: Focal, New York and London, 1970.

2

THE PHOTOGRAPHIC EMULSION

F. W. H. Mueller

Gelatin silver halide emulsions were invented by amateur experimenters whose results were published in the photographic journals. But soon after the commercial manufacture of dry plates began the methods used became closely guarded trade secrets. This situation prevailed until some more light was shed on gelatin and emulsion technology after World War II when a search team of British and Americans collected data on the methods employed in the German photographic industry prior to 1945. These findings were published in the B.I.O.S.[1] and F.I.A.T. Reports.[2]

The first systematic research into the preparation of photographic emulsions was carried out at the U.S. Bureau of Standards. This led to the publication of a series of papers which were recently reprinted in book form.[3] An early American book on emulsion techniques was published in 1941 by T. Thorne Baker.[4] Since that time a number of textbooks on the theoretical aspects of the photographic processes have appeared. Among the best known are *The Theory of the Photographic Process* by Mees and co-workers;[5a-c] *Photographic Theory*, a collection of papers edited by A. Hautot;[6] the earlier editions of this handbook;[7] the latest edition of Glafkides[8] *Chemistry and Physics of Photography* (in French), Duffin's[9] *Photographic Emulsions*, and the recent trilogy of the *Foundations of the Photographic Processes with Silver Halides* (in German), edited by Frieser, Haase and Klein[10] (referred to as FHK in this chapter). The gradually increasing availability of English translations of the work of Russian scientists (Focal Press Series) Zelikman and Levi,[11] Deryagin and Levi,[12] Lyalikov,[13] and Kirillov[14] is all the more gratifying be-

cause the Russian authors have placed some emphasis on the symbiosis of scientific and technological efforts. The recent bibliography of reviews on *Silver Halide Systems* (1960-70) by Hanson[15] is also helpful in locating information pertinent to this chapter (218 refs.).

During the past two decades, a number of international congresses and symposia[16-24] have stimulated worldwide scientific exchange in the photographic field, thus rapidly spreading knowledge and accelerating progress. Many of the technological advancements are also reflected in an increasing number of photographic patent disclosures.

THE PHOTOGRAPHIC EMULSION

In general terms, commercial photographic materials comprise conventional and nonconventional types. The latter do not contain silver salts as the light-sensitive material. The former still consist of suspensions of silver halide micro-crystals in gelatin (derived from collagen), or gelatin substitutes, or extenders which are compatible synthetic polymers. Also, binder-free systems are known. The silver halide dispersions in gelatin solution are misnamed "emulsions," a term, however, now generally accepted. The variety of types of pretreated supports on which liquid emulsions of all types can be coated or deposited is discussed in Chapter 6.

A typical high speed film has an emulsion layer about 10 μm thick, most frequently coated on a dimensionally stable and flexible support. It may contain an average of 5×10^8 microcrystals, or "grains" per cm^2 of mixed silver

halides of a particle size range of 0.02 to 4 μm. The dried emulsion layer must be nontacky, abrasion and reticulation resistant and yet remain easily penetrable by the processing liquids. The developer must rapidly convert those grains carrying a latent image produced by light, or by certain other radiation, thus amplifying it by a factor of 10^9. This process is a chemical reduction of a certain amount of silver halide contained in the layer to a visible, or printable silver image. After removal of unexposed silver halide grams by fixation, e.g., in a thiosulfate solution, the resulting image normally will be a negative picture, such as of a portrait, or a radiograph; or, following reversal processing, a positive image. So-called "direct positive" emulsions are described later in this chapter.

The preparation of photographic emulsions has gone through a continuous evolution. The number of emulsion ingredients has steadily increased with the diversification in the use of photographic materials. During the past decade new manufacturing techniques had to be introduced to meet demands for rapid-access of photographic records of all types. This led to films suitable for development in automatic, high temperature, roller-transport processors as well as to image-transfer emulsion packs for amateur "instant" black and white and color photography.

The multitude of applications of photography require many variations in emulsions. Emulsions designed for the graphic arts processes, for microfilming, for positive printing, for radiography, to mention only a few, are quite different in their photographic characteristics but almost all contain crystals of silver halide mixtures dispersed in a layer of dried gelatin.

EMULSION INGREDIENTS

Silver Halide Carriers (Gelatin, Modified Gelatins and Synthetic Polymers)

Gelatin, a natural amphoteric protein derived from collagen, consists of amino acids chained together by a peptide bond (—CO—NH—). Gelatin is made mostly from calf and pork skins or from bones for edible, pharmaceutical and photographic purposes. The favorable physical, chemical and photographic properties, which caused gelatin to remain the dominating vehicle for silver halide for more than a century, are numerous. In view of existing textbooks,[25,26] only the briefest characterization of the role of gelatin in the photographic emulsion is presented.

Warm gelatin solutions in concentrations at least above 3% solidify when the temperature is lowered below 27–28°C. This "gel" formation permits the coating of emulsion layers on selected supports by "setting" the emulsion with chilled air and drying it to a predetermined thickness. The latter depends on the silver/gelatin ratio, emulsion viscosity, the coating speed and coating technique employed and other factors. The thickness of the dried layer ranges from a few μm to thicker layers of over 30 μm and higher for certain purposes (e.g., nuclear particle track recording materials).

Gelatin acts as a silver halide carrier by being adsorbed on the surfaces of the silver halide grains during the emulsification; it also restrains the crystal growth without inhibiting it. Thus, gelatin is responsible for the permanence of the suspension of the grains. Its concentration in the formula influences crystal size and its size distribution which is formed during the subsequent physical ripening. It has been suggested that gelatin molecules simultaneously become adsorbed on several grains and thus hold them in suspension, but very little energy is required to displace gelatin from the crystal. In the absence of gelatin the differentiation of developability between exposed and nonexposed grains would almost disappear probably because gelatin protects the latent image from rapid fading caused by aerial oxidation.

During emulsification gelatin forms an elastic "hull" around the silver halide grains permitting their growth, whereas polyvinyl alcohol[27] when used as a carrier forms a very rigid shell around the grain, thus preventing the necessary crystal growth during the physical ripening. Adsorbed gelatin does not cover the total grain surface so that other ingredients, such as chemical and spectral sensitizers, and/or stabilizers, can be coadsorbed or can react with the silver halide surface. Gelatin, however, may compete with certain emulsion ingredients for adsorption on the silver halide surface. Gelatin, and also gelatin hydrolysates, bind silver and other metal ions through their functional groups (α- and ϵ-amino, imidazole, guanidyl, the thio-ether group of methionine and carboxyl groups). The gelatin's capacity for binding metal ions is related to the location of the isoelectric point on the pH scale. Gelatin (except for the intentionally inertized type) contains photoactive impurities which exert either a sensitizing or a restraining effect. Effective sensitizers occurring in many gelatins are reducing agents and labile sulfur-containing compounds, such as allyl-isothiocyanate, the latter discovered by Sheppard in 1925;[28a-c] one type of restrainer has been identified as nucleic acids and their fragments, such as purines and pyrimidines (Ref. 56e, p. 82).

In the past gelatin manufacturers could not quantitatively control the amounts of active gelatin impurities. This placed the burden of maintaining product quality and uniformity on the photographic industry. Formerly, this difficulty was overcome by "blending" various types of gelatins possessing different photographic properties. To eliminate this cumbersome procedure, the idea of inertizing gelatin was proposed by Steigmann in 1934,[29] a procedure which would remove the photoactive impurities from the natural gelatins. Many years later, inert gelatins became commercially available which adequately respond to the addition of artificial sensitizers and restrainers. Inert gelatins can now be adapted to the formulations of various types of emulsions.

Analytical methods for determining the chemical and physical properties of gelatin have been advanced in recent years.[30-32] Also, special laboratory techniques have been developed for predicting the photographic

behavior of gelatins in emulsions, for instance, a nephelometric method, by Ammann-Brass.[33a-c]

One of the formerly most important properties of gelatin, its thermoreversibility of gel formation, appears not so essential any more. The property of gelatin solutions, however, to set to a firm gel at a lower temperature, is still an indispensable requirement for the coating of emulsion layers. The latter property is not readily and economically matched by synthetic polymers. Also, the intrinsic property of a dried gelatin layer to swell again and permit the penetration of the processing liquids remains a very useful feature. In addition, the swollen layer must remain completely insoluble and abrasion-resistant at high temperatures. This property of gelatin is further enhanced by the incorporation of hardening agents. Gelatin at high pH binds not only silver ions, but also gold and other noble metal ions[186,187] by chelate formation, a fact which may impede the sensitizing action of such ions under certain conditions.

In spite of what has just been said in favor of natural gelatin as a silver halide vehicle, a technological need for chemically modified gelatins (so-called gelatin derivatives) arose. Desired modifications are effected by chemical reactions of the functional basic and acid groups of the gelatin molecule. Such gelatin derivatives[9,25] facilitate the flocculation of emulsion by a simple pH adjustment prior to washing. Gelatin derivatives may also control the degree of hardening by certain hardening agents. Addition of 8–14% of certain polymeric gelatin derivatives permits a reduction of the silver content in x-ray emulsions by 25% and produces higher speed according to Lyalikov, et al.[208] The literature on gelatin derivatives has grown rapidly in recent years.

A few words are necessary about the addition of gelatin hydrolysates to photographic emulsions as a partial replacement of gelatin itself. Hydrolysates of gelatin or other proteins have been advocated many years ago for various purposes, such as lowering emulsion fog during storage, to stop chemical sensitization, or to increase the silver/gelatin ratio.[34] Dubiel[35] described a strong sensitizing effect of enzymatically hydrolyzed gelatin, allegedly to the extent of rendering other chemical sensitizers superfluous. This somewhat unusual finding should receive further experimental confirmation.

Attempts to completely replace gelatin by polymers of amphoteric or nonamphoteric character have paralleled the effort to prepare inert gelatins.[25] Considerable progress has been made in replacing gelatin during emulsification, for instance with copolymers of acrylic acids and their derivatives[36,37] and copolymers of acrylic acids with vinyl imidazoles.[38] Certain terpolymers consisting of monomers of acrylic acid, acrylamide and vinyl imidazole[39a,b] resemble the behavior of inertized gelatin and allow the growth of silver halide microcrystals during the emulsification process. All synthetic polymers which do not set upon chilling, require the addition of natural bulk gelatin as a coating aid. When, for instance, film and paper emulsions are made with polyvinyl alcohol (PVA) as a silver halide

carrier, the addition of a nitrogeneous additive, or a modification of the PVA molecule, becomes necessary to promote crystal growth but a setting agent may be required. Cellulose phthalate ethers[40a,b] have been disclosed as complete gelatin substitutes for photographic emulsions but have not become a commercial reality.

Silver Halides and Solvents

Straight or mixed silver halide crystals differ in their crystallographic structure, morphology and their thermal, mechanical, electrical and optical behavior. A single kind of silver halide is rarely used in a modern photographic emulsion; a mixture of halides obtained by coprecipitation is usually preferred. Mixed crystals possess more lattice imperfections and defects which increase their photographic sensitivity. Silver chloride, a colorless salt, is sensitive only to ultraviolet radiation. Contact printing paper emulsions can consist of pure silver chloride, but are usually coprecipitated with some percentage of bromide. The sensitivity of AgBr, a pale-yellow compound, extends to the wavelengths of visible light (400–500nm). Silver iodide by itself is not very light-sensitive, but iodide ions play a very useful role in increasing the photographic sensitivity of AgBr. When iodide is coprecipitated with AgBr up to approximately 10 mol % of bromide, the number of crystal imperfections increases and the spectral response is extended to the longer wavelengths; the response to chemical sensitization is increased and fog suppressed— all indispensable features in the formulation of medium and high speed emulsions. The crystals of AgCl and AgBr posses a face-centered, cubic structure, with lattice constants of 5.54×10^{-8} cm for the former and 5.75×10^{-8} cm for the latter. AgI can crystallize in the cubic and hexagonal system. Silver fluoride, being too soluble, is not normally used, whereas silver thiocyanate (possessing a solubility product between AgCl and AgBr) is an emulsion ingredient which can be used either in coprecipitation or can function as a ripening accelerating agent.

Among the metal ions which may be coprecipitated with silver halides, either in "doping" amounts or in larger quantities, are Cd^{2+}, Pb^{2+} Cu^{2+}, or Tl^{+}, to increase contrast or speed; also complex ions of rhodium, platinum, iridium and palladium salts.

The addition of ammonia to AgBr/I emulsions is frequently employed. Ammonia is rarely added to AgCl emulsion because of the high solubility of the resulting complex salt. Depending on the method selected for the ammonia addition, substantial modifications of the nucleation, grain growth and grain size distribution, as well as the crystal form, are obtainable. Most commonly, the ammonia is first reacted with silver nitrate to the positively charged silver diammine complex $(Ag(NH_3)_2)^{+}$; thereupon this silver salt solution is percolated into the alkali halide mixture. Alternatively, ammonia can also be added during the later stages. In ammonia emulsions, the high alkalinity permits the reduction of silver ions to

silver and/or the formation of Ag_2S (if sulfur compounds are present), whereas in neutral emulsions, surface chemical sensitization does not normally occur before after-ripening. Oversensitization results in fog. Formulations with ammonia are commonly used for high speed negative and x-ray emulsions; they are microscopically recognizable by the more nearly spherical shape of the silver halide grains. Other silver halide solvents, such as ethylene diamine, produce cubic crystals.[8] The solubilities of AgBr in ammonia solution of various concentrations at 24°C have been determined.[33a] Neutral and acid emulsions are usually precipitated with an excess of Br^- ions, which above a concentration of 2×10^{-4} moles per mole of silver halide begins to act as a AgBr solvent through anion complex formation ($AgBr_2^-$, $AgBr_3^{2-}$ and $AgBr_4^{3-}$). Thus, the change of the Br^- ion excess during the emulsification and/or the incorporation of iodide ions are versatile tools to influence the grain growth, or the grain size distribution during physical ripening, although precipitation with a temporary excess of silver ions (pAg < 6.0) is practiced for special emulsions.

Chemical Sensitizers

Chemical sensitizers are normally added during the after-ripening step, that means after the emulsion has been washed to remove the unwanted by-products. As we shall see later, the sensitizing agents are indispensable for reaching some of the desired emulsion characteristics such as high speed and contrast, whereas graininess, resolving power and others are not influenced. Chemical sensitizers rarely interfere with spectral sensitizers (cyanine dyes) which are added to make emulsions sensitive to the longer wavelength of the visible and infrared spectrum. Recently Vanassche[189] could prove that dyes whose energy of the exited level is situated near the conduction band lowers the desensitization in the intrinsic (blue) region of the silver halide spectrum.

Chemical sensitizers are usually classified into *labile sulfur, reduction* and *precious metal compounds*. Only the first two occur as "natural" sensitizers in gelatins.

Similar in effect to the sulfur sensitizer, isolated by Sheppard[28a] in 1926, are many other inorganic and organic sulfur compounds.[28b-d] Innumerable labile sulfur, selenium or tellurium compounds have been patented since for sensitizing purposes. It has been shown, however, that a simple alkali or ammonium thiosulfate appears to be quite effective in practice.[8,9,10,25] The reducing compounds occurring naturally in certain gelatins comprise carbohydrates and related products, and certain aldehydes and ketones.[8,9] Among the artificial *reduction* sensitizers, stannous salts,[42] sulfites,[43] polyamines,[44] spermine,[45] hydrazine,[46] and many others were found to be effective.

Gold salt sensitization was discovered by Koslowsky in 1936,[47] and later by Waller,[48] and others. Among suitable gold compounds are potassium chloroaurite, alkali and ammonium dithiocyanato-aurite, dithiosulfato-aurite (or their corresponding aurates), 2-auro-sulfo-benzo-thiazole and others. Noble metals of the platinum group (Pd, Ir, Rh) were also patented as sensitizers, or antifoggants and to minimize reciprocity law failure.[49,51]

Other speed-increasing compounds are known which may not be typical sensitizers, but may act as *development accelerators* or modifiers. They comprise (1) the so-called "onium" compounds consisting of quaternary ammonium, sulfonium and phosphonium salts,[52a-e, 53a-c] and (2) chemical compounds such as the polyethyleneoxy compounds (PEO) of the general formula: $R-(OCH_2CH_2)_nOH$, or $H(OCH_2CH_2)_nOH$ discovered by Blake in 1948.[54a,b] The number of patented polyalkylene-oxycompounds of various configurations has been increasing ever since. Specific examples are enumerated in a U.S. patent by Luckey.[55]

Emulsion Restrainers and Stabilizers

Soon after Sheppard's discovery of sulfur sensitizers in gelatin, it was surmised by Steigmann,[29] on the basis of experimental observations, that gelatins—particularly those made from hides—also contain "restraining" (antisensitizing*) impurities. Such restrainers can, in some emulsion formulations, counteract or inhibit the grain growth and sensitizing effects. Some of these "restrainers" were later identified as polynucleic acids[8,9,10] and their decomposition products. Among them, the purines, adenine and guanine, were found to be particularly active and occur in somewhat larger amounts in hide than in bone gelatins.[25] Besides nucleic acids, other presumably cystine-containing compounds or muco-proteins may also act as restrainers in certain types of emulsions. Long before the actual identification of nucleic acids was accomplished, emulsion chemists had, on an empirical basis, introduced artificial restrainers (sometimes also called stabilizers or antifoggants**).

Typical stabilizers are compounds which terminate chemical sensitization after a chosen after-ripening period. The earliest patented compounds comprised heterocyclics with silver salt forming imino- or mercapto-groups (thiazole, triazoles, tetrazoles, mercaptopyrimidines, purines, pyrazoles and many others). These types of compounds form very insoluble silver salts which are strongly adsorbed on the silver halide grain. Most of them, however, depress the sensitivity of the emulsion or retard its development when used in high speed iodobromide emulsions. On the other hand, 5-methyl-7-hydroxy-triazaindolizine,† discovered by Birr[56a-e] as a stabilizer, is only slightly adsorbed on the grain and does not retard development. This compound and related structures are among the best stabilizers known. Other stabilizers are known which are not adsorbed on the silver halide and may act by exerting an oxidizing effect

*Not to be confused with spectral "antisensitizers."
**The definitions are not precise, but see Ref. 23.
†Now called 4-hydroxy-6-methyl-1,3,3a,7-tetrazaindene.

on fog nuclei of silver or gold, such as the benzene thiosulfonates.[57]

Divalent metal salts, such as cadmium, cobalt, mercuric, zinc and manganese salts, have been used as stabilizing agents, more often in silver chloride emulsions.[9]

It may be well to point out that development accelerators, such as polyalkylene-oxycompounds and onium salts when used as emulsion additives, require specific stabilizing agents. While mercapto compounds and mercury salts in AgBr emulsions were often found to be too powerful, they seem to be useful in combination with the above agents.[58a]

Other Emulsion Addenda (Spectral Sensitizers, Color Couplers, Surfactants, Hardeners and Miscellaneous Substances)

Chemical additives added just prior to coating comprise a large number of substances, which exert various functions indispensable to the production of commercially useful photographic products. The incorporation of spectral sensitizers and color couplers (for color products) and their mode of action is discussed separately in this book. By comparison, the additives described below are of relatively lesser photographic importance, but nevertheless are necessary for obtaining the desired physical characteristics of photographic materials during the coating and drying operations.

When an emulsion is coated, a *wetting* and/or *spreading* agent is required for obtaining uniform coating thickness and for the elimination of coating defects (bubbles, repellency spots, streaks, etc.). Saponin has often been used for this purpose, but a multitude of newer *surfactants* are available. Some have to be specifically selected, not only for the type of coating technique or method practiced, but also for the product; may it be a black and white film, or paper, or a color product. Multilayer color films and color paper have greatly increased the physical-chemical requirements for surfactants to assure compatibility with color couplers. For further details the reader will have to refer to textbooks on emulsion and coating technology.[8,9,11,12] *Antistatic agents* are needed to protect the sensitized films from exposure marks due to the discharge of static electricity occurring either during manufacturing or in the consumer's hands. While experience in selecting surfactants and antistatics has led to certain rules, no complete theory regarding their mechanism has evolved. For illustration, rather than exhaustive treatment of antistatic agents, see Glafkides[8] or the patent literature.

Modern films and papers have to be designed to withstand a high temperature in automatic processing machines. This demand has greatly increased the requirement for abrasion resistance of the emulsion layer or its surface and back-coatings. Excessive swelling, reticulation and abrasion sensitivity of the coated layers are controlled by the addition of *hardening agents.* The specifications for good hardening agents are stringent because hardening must be accomplished without altering the sensitometric properties, without raising fog, or decreasing the silver covering power, or inducing brittleness during storage. Furthermore, the addition of a hardener before coating should not increase the viscosity of the emulsion as this would cause difficulty in obtaining a coating of uniform thickness. While the principle of protein (gelatin) hardening, which involves crosslinking the reactive groups of the gelatin molecule, has been known for a long time, the search for better hardening agents has been a continuous effort. Many chemical structures have been investigated and patented, comprising both inorganic and organic compounds. Established hardening agents are aluminum and chromium sulfates, which act by complexing the carboxyl groups of gelatin, or formaldehyde, glyoxal and diketones (diacetyl), dialdehydes or their precursors which crosslink via free amino groups of the gelatin molecule. One of the preferred dialdehydes is glutardialdehyde,[5c] useful both for addition to emulsions and photographic developers. Its mechanism has been described by Q. W. Decker et al.[190] Aldehydes and ketones are, however, being supplemented by newer types of crosslinking agents, such as sulfonyl halides, isocyanates, carbodiimides, epoxides, aziridines or nondiffusing (polymeric) hardeners, such as starch-dialdehydes suitable for multilayer coatings. The chapter by Pouradier and Burness in Mees and James[5c] gives an earlier review of hardening agents and their action. Incidentally, gelatins whose free basic or acid groups are chemically changed do not show, of course, the normal response to the above-mentioned hardening agents.

The selection of effective, nondiffusing gelatin *plasticizers* is as critical as the choice of hardening agents. Gelatin plasticizers are needed to keep motion picture films, microfilms and roll films flexible under low temperature and low humidity conditions. The incorporation of a soluble humectant like glycerol is not sufficient, because it is eliminated in the processing of the film. Modern plasticizers fall into the chemical category of the ethylene glycols and their derivatives[6,9] The patent literature is voluminous on photographically acceptable gelatin plasticizers.

Quite a number of miscellaneous emulsion ingredients are needed for various auxilliary purposes. All emulsions require the addition of *disinfectants*, mostly phenolic compounds, to keep them free from bacterial attack.[6,8,9,25] Some high-resolution emulsions require filter or *screening* dyes to reduce light scattering within the emulsion layer, whereas light, reflected from the support, is normally eliminated by an *antihalation* back-coating or an emulsion underlayer. The dyes used for this purpose must be, of course, photographically inert and irreversibly destroyable, or very soluble in the processing baths. For orthochromatic emulsions a red dye, e.g., acid fuchsine, may suffice, for panchromatic ones a single blue-green dye or a mixture of dyes to produce gray, e.g., selected triphenyl methanes are necessary. In roll films, antihalation coatings simultaneously serve as

noncurling (N.C.) layers. In cine films, the base itself or the substratum may be stained (gray base) to reduce halation. If colloidal carbon is used, the antihalation layer must be physically removable from the film prior to or during processing.[8] In reversal films, the antihalation layer may contain colloidal silver which is removable in an oxidizing bleach bath. *Matting agents*, such as rice starch or colloidal silica, are added to paper emulsions for producing a matte surface, and to negative (portrait) emulsions to facilitate pencil retouching. Photographic papers which are dried on polished plates or drums for securing a high gloss often acquire an undesirable color due to deterioration of the image silver (so-called *plumming* or *bronzing*). This can be prevented by the incorporation of toning agents, such as mercapto-, oxo- and thio-diazole[9] and others. Such tone modifiers are also indispensable in the silver salt diffusion transfer process to overcome an unpleasant brownish image tone. On the other hand, some photographers prefer warm-tone images in portrait papers. These can be produced either by design of the emulsion, by developer additives,[8] or by submerging the finished print in a special toning bath.

Finally, certain developer agents may be added to black and white paper emulsions which need only activation in an alkaline bath to develop the latent image. Some of such papers lend themselves to the so-called *stabilization-processing;*[5c] a method, however, which does not produce a permanent image without subsequent washing.

Complex color developers used in dye image transfer processes (Polaroid) are likewise emulsion additives, but their function will not be discussed here.

THE EMULSION MANUFACTURING PROCESS

General Procedure

The preparation of silver halide emulsion comprises a number of sequential operations which, in principle, have remained the same over the years, although the technology practiced in the individual steps has continuously advanced.

The basic manipulations involve (1) the mixing or *emulsification*, i.e., nucleation and precipitation; (2) the *physical ripening;* (3) *washing*, i.e., the removal of unwanted by-products of the chemical reactions and solvents, if used; (4) the *second* or *after-ripening*; (5) *coating* and *drying*. The *finishing*, i.e., cutting the coated material into rolls, sheets and packaging them, consists of mechanical operations which will not be discussed in this chapter.

Since these basic operations have been previously described, (Ref. 6, pp. 15–54), the following discussion mentions some newer approaches as far as they have become public knowledge. While the sequence of the operations is discussed step by step as if they were independent of each other, it should be noted that they are in reality interdependent. For instance, steps (1) and (2) may have a decisive influence on (4);

also, the technique employed in (3) may have a bearing on (4) and (5).

The possible physical and chemical variations in steps (1), (2) and (4) are almost inexhaustible, but they follow nevertheless an established pattern, which can, to some degree, be mathematically formulated.[11,12] In spite of this, a great deal of practical experience is required in emulsion design to handle the variables in order to meet the highly specialized demands of present-day photographic products for black-and-white and color photography. Maintenance of product uniformity and quality is, of course, indispensable for success in a highly competitive market.

Chemicals and water of the highest purity,* rigid control of pH, pAg (negative log of silver ion concentration), and temperature at all stages of the process are mandatory for reproducibility of quality. The use of inert reaction vessels, regulated agitation, and tight specifications for coating and drying conditions are operational necessities. Filtered air (also monitored for radioactivity) in the plant to avoid contamination, lint-free protective clothes for operators, and relentless attention to cleanliness of equipment and machines are prerequisites for minimizing product defects such as spots, blemishes, and streaks. Defect analysis has been improved by use of atomic absorption spectra, the transmission and scanning electron microscopes, infrared and emission spectroscopy and x-ray diffraction.

Whether emulsions are manufactured in a batch process, or in a continuous one, depends on the volume. Semiautomatic manufacturing procedures may be economically attractive. Methods for continuous emulsion manufacture were investigated and described years ago by Kikuchi, et al.[59a,b] and Russian scientists quoted by Kirillov.[14]

Emulsification

Modern formulations usually call for a mixture of silver halides. These are precipitated in the selected ratios in a gelatin warm water solution. Gelatin likewise can vary in its concentration. The chief reaction is very simple:

$$AgNO_3 + MX \longrightarrow AgX + MNO_3$$

where

$$M = \text{alkali ion or } NH_4^+$$
$$X = Cl^-, Br^-, I^-, SCN^-$$

In *developing-out* emulsions (i.e., requiring chemical development) a halide excess is customarily but not necessarily employed. The mode of addition of the water-soluble ingredients can be varied, for instance (1) by single-jet (silver salt \longrightarrow halide mixture), (2) by double-jet (simultaneous addition of the silver and halide solutions), and (3) by inverse addition (halide

*Water for emulsion washing purpose should have a moderate but standardized mineral content to prevent excessive water uptake by the gelatin.

solution \longrightarrow silver nitrate solution). The mode and rate of addition, the temperature, the presence, or absence, of a silver halide solvent like ammonia, the pAg and pH, and the relative ratios of the selected halides regulate the formation of crystallization nuclei, the crystal growth, the particle size frequency distribution during the emulsification and the physical ripening. A number of different emulsion formulas are cited by Glafkides[8] as examples. The B.I.O.S. and F.I.A.T. reports[1,2] also disclose some emulsion formulas.

While the general function of gelatin has been discussed, it must be again pointed out that the nature of the gelatin and its concentration has a great influence on the degree of dispersion of the silver halide particles during emulsification. As a rule, only a part of the required gelatin need be present during the mixing stage. The higher the gelatin concentration during silver halide formation, the smaller the average size of the particles. The nucleation and particle size is also affected by the rate of agitation during the initial mixing.[9,69]

Double-jet additions produce fewer crystallization nuclei and thus yield narrower grain size frequency distribution than single-jet additions. Increasing iodide concentration reduces the grain size and narrows the size frequency distribution.[9] Raising the emulsification temperature normally increases crystal growth and produces faster but coarser-grained emulsions.

Developing-out emulsions are subdivided into acid, neutral and ammonia emulsions. Acid, nonwashed fine-grain, high contrast chloro-bromide emulsions are used mostly for low speed contact printing papers. These are several 100 times less sensitive than washed and ripened neutral or ammonia emulsions. The fastest emulsions are of the chemically sensitized iodo-bromide type generally required for high speed negative portrait, color and x-ray emulsions. Except for x-ray emulsions, the majority of emulsions are, in addition, spectrally sensitized with cyanine dyes which further increase their effective speed.

The inverse addition, i.e., the addition of halide solutions to the $AgNO_3$ solution and subsequent adjustment of the pAg, was formerly believed to fog the developing-out emulsion. This technique is now successfully practiced for making nuclear particle track recording emulsions of the finest grain.[61a,b] More recently Zelikman[60] described inverse addition even for the fastest emulsions provided the pAg is properly controlled. Grain growth in the presence of Ag^+ ions is presumed to be also due to Ostwald ripening. The other emulsion category consists of the so-called *print-out* emulsions, which are made with an excess of a soluble silver salt (e.g., silver citrate).

Physical Ripening

After the initial mixing of the ingredients during emulsification, some of the crystallization nuclei formed will grow larger immediately during the following physical ripening process and some will dissolve again. This phenomenon, occurring during a digestion period at an elevated temperature, involves two known principles: the so-called Ostwald ripening and coalescence.[5c] Actually, the emulsification and physical ripening processes occur, to a large extent, simultaneously.

The end results of the first two phases in the preparation of emulsions are manifested by grain size frequency distribution curves of various shapes which determine the basic emulsion characteristics, including the resolving power. The grain size distribution will not be substantially altered during the after-ripening aiming at increased speed and contrast.

Ultrasonic treatment of silver halide emulsions during the different stages of emulsion making has been repeatedly explored and discussed.[8,11] It appears that no beneficial results have been obtained which cannot be achieved with conventional means. In a recent paper, however, Kortnev, et al.[191] claims an increase of crystal surface imperfections, lowering of average grain size and increasing emulsion speed by ultrasonic vibration.

Removal of the Reaction By-products (Washing)

After the termination of physical ripening the reaction by-products are mainly alkali or ammonium nitrate, or ammonia, if present, or an excess of soluble halide. These compounds must be removed before the after-ripening can proceed with efficiency. The high Br^- ion barrier layer formed in neutral or acid emulsions around the grain inhibits the reaction of some chemical sensitizers with the silver halide grain surface. Furthermore, the coating and drying of an unwashed emulsion on film, glass or water-resistant paper would result in the crystallization of salts on the surface of the emulsion layer. On paper, however, these salts are sufficiently adsorbed on the paper fibers, so that emulsion washing is usually not required. Unwashed acid silver chloride emulsions respond to chemical ripening without the danger of excessive fog in the presence of excess halide. Modern high-speed chloro-bromide paper emulsions, however, require thorough washing before chemical ripening has the maximum beneficial effect. The washing can be controlled by the measurement of either the electrical conductivity of the wash water or of the residual silver ion concentration.[9] Incomplete removal of residual ammonia or excess bromide in high speed negative emulsion can lead to fog and intolerable loss of sensitivity during film storage before use.

The technology of emulsion washing has changed over the years. Formerly, the chilled and shredded emulsion, in "noodle" form, was freed from soluble salts and solvents in a very time-consuming washing process by diffusion (osmosis). An additional disadvantage of "noodle-washing" is the fact that the large water up-take during this operation did not permit an

economic concentration of the emulsion which is absolutely necessary for the control of the silver halide coating weight needed in modern film products. Therefore, this technique has been gradually displaced by (1) coagulation, or flocculation, of the liquid emulsion by means of a salting-out process with inorganic salts (sodium or ammonium sulfate), or (2) by suitable organic gelatin coagulants, such as, for example, sodium dodecyl alcohol sulfate,[9,62] or certain polymers such as polystyrene sulfonate and other copolymers.[63] A large variety of other flocculating agents have been cited in the patent literature. After flocculation, the granular precipitate is redispersed in water and washed by agitation, decantations or centrifugation. The control of the granulate is rather critical to guarantee the redispersibility of the precipitate in a concentrated gelatin solution (reconstitution process). A still simpler technique makes use of certain gelatin derivatives as a dispersing medium, e.g., a phthalated gelatin,[9,64,65] requiring only a pH adjustment for flocculation and redispersion.

Russian technologists have referred to a washing method by gravitational sedimentation.[13] Kirillov, et al.[14] described continuous sedimentation in specially designed equipment. Titov[66] recommended an omission of washing after physical ripening by neutralizing ammonia, when present, with nitric acid and converting an excess of KBr to silver bromide by silver nitrate. Following the after-ripening, a brief "equilibrium wash" is prescribed to lower the salt concentration to prevent crystallization on the support. This procedure is claimed to have practical advantages and allegedly lowers the manufacturing cost by avoiding loss of silver.

The equivalence point of silver bromide in pure water at room temperature is approximately 10^{-6} mol/l. Gelatin solutions bind silver ions, both in a reversible and an irreversible manner. In the latter case, silver is formed (normally less than 2 μmol per 1 g gelatin); in the former case, a silver-gelatin complex formation takes place, the extent of which depends on the duration of the washing, the pH and temperature. Accidental over-washing leads to fog by a breakdown of the silver gelatinate, unless corrected by addition of bromide ions or other Ag^+ ion binding agents to re-establish the specified pAg value which assures optimum chemical ripening and good keeping quality of the final product.

Second or After-Ripening Process

During the after-ripening operation (or second digestion) the washed emulsion is held, while being continuously agitated, at an elevated temperature (e.g., between 45–75°C) at a specified pH and pAg value for a period of 30–60 min while often more gelatin, chemical sensitizers and other ingredients are added. The action of chemical sensitizers, first observed empirically by use of above mentioned "active" gelatins,

was already outlined. Later it was discovered that some photographic gelatins did not produce the desired speed increase, in spite of the analytically detectable presence (or artificial addition) of sulfur compounds. This led to the discovery of the presence of restrainers counteracting or even totally blocking the ripening or after-ripening effect. The interaction between sensitizing and restraining "natural" microconstituents is still not completely clarified (see especially Ref. 33e.).

In industrial practice, a multitude of artificial sensitizers, restrainers, stabilizers, antifoggants, development accelerators and other addenda are presently exploited in the after-ripening process. These ingredients as well as strict control of pAg, have greatly contributed to the advance of emulsion technology. A combination of several chemical sensitizers (e.g., sulfur and gold; or sulfur, gold and a reduction sensitizer) can produce an additive effect under certain conditions. Care must be taken that no "over-digestion"[192] takes place which would lead to fog or a speed decrease. Formerly, the chief method available to the emulsion chemist to stop the ripening process was the addition of a strongly restrained gelatin (so-called *stop-gelatin*), a method which has been replaced by judicious choice of modern synthetic stabilizers, which terminate the ripening action at the desired stage.

Emulsion Coating and Drying

The fully ripened and stabilized emulsion may be immediately coated or held for some time in a cool room to accommodate plant coating schedules. It is important that the sensitometric and physical characteristics of the flocculated and ripened emulsion should remain stable during this limited period of time. The storage stability of the coated and dried emulsion is regulated by the addition of the coating finals mentioned. With the exception of the spectral sensitizers, which must be adsorbed on the grain surface, some coating addenda may also be conveniently and effectively incorporated in an adjacent layer: e.g., in a surface coating or emulsion undercoating. After the emulsion has been dried to a thin, hardened layer of uniform thickness on the film or paper, rather drastic physical changes have taken place, which exert a pronounced influence on the product's keeping quality (aging behavior) as well as on its physical behavior (curl, brittleness, swelling rate, etc.). The thickness of the wet emulsion layers, varying greatly with the type of emulsion, may range between 30–500 μm; after drying, it has been reduced ten times or more.

The structure and properties of the dried emulsion layer depend also on the temperature and the duration of drying. One distinguishes a gel structure (slow drying at low temperature) and a sol structure (fast drying at a temperature of approximately 50°C). There are, of course, also transition forms. The swelling characteristics of these two forms are different. Gelatin always retains a certain amount of water, depending on the

relative humidity of the air. At very low humidity emulsion layers can shrink, become brittle with a marked tendency to curl. The hardening has relatively little influence on the absorption of water vapor but reduces considerably the swelling of the layer during processing; also, the pH and salt concentration have a strong influence. The swelling of an unhardened layer depends on the concentration of the gelatin solution before coating.[5c]

Surface coatings with plain gelatin solutions for abrasion protection, filter and separation layers (e.g., in color films) are only 1–3 μm thick. Modern color films consist of an assembly of 11–12 layers and are coated with sophisticated coating equipment; for example, with a slide (cascade) hopper, or an extrusion coater.[60] Simpler coating methods are still in use, such as trough coating, transfer roller coating, air knife coating and other techniques. Schematic descriptions of coating equipment are given by Deryagin, et al.,[12] Duffin,[9] Zelikman[60] and in the patent literature.

Coating speeds vary with paper and with film emulsions and cover a wide range which is usually kept as an industrial secret—the patent literature speaks, in extreme cases, of 500–600 fpm and faster.

A perusal of the contents of Deryagin and Levi's book[12] will convey an impression of the problems that can be encountered in modern coating technology, their physicochemical analysis and respective control.

Besides the reduction of the thickness of the emulsion layer after the drying, other drastic changes have occurred: the temperature is dropped 20–30°C, the water content is reduced to about 10–12% in the dried gelatin layer; also, the emulsion surface which is in contact with air and atmospheric impurities, is increased many times. This means that a shift of the physicochemical equilibria from the wet to the dry emulsion must be anticipated and the emulsion adjusted to produce an optimal pH and pAg in the dried layer. For a satisfactory keeping quality possible oxidation of sensitivity specks (particularly those consisting of metallic silver) at high humidity storage must be counteracted by stabilizers and/or antioxidants to keep the original sensitometric characteristics constant. As to details of steps to be taken for this purpose refer to Walther,[67] Sheberstov and co-workers.[68a,b]

GENERAL TRENDS AND ADVANCES IN EMULSION TECHNOLOGY

In the preceding sections a more or less schematic description of the preparation of photographic emulsions of the various types was presented for the benefit of the less-initiated reader. The increasing demands for more sophisticated applications of photography have always given impetus to further research in emulsions, both scientifically and technologically. A progress review in emulsion techniques for the period 1945–60 was given by Mueller.[194] A new trend evolved in the 1960s which encompassed professional, x-ray and amateur films of all types. It emerged as a result of the pressing need to speed up processing, i.e., shorten access time to the visible image, a feature desired in almost all photographic applications. This trend manifested itself not only by the introduction of automatic processing equipment, particularly roller transport processors[69] constructed for high temperature processing and fast drying, but products had to be redesigned to meet these new conditions. Conversion to thinner, but often silver-richer emulsion layers became necessary, as well as higher emulsion hardening to eliminate abrasion and reticulation.

While no effort is made here to determine the priority of discoveries of improved emulsion techniques, they are discussed in somewhat chronological sequence.

Earlier methods of obtaining specific emulsion characteristics were accomplished chiefly by choice of ingredients and by mixing manipulation producing the desired grain size distribution and suitable chemical ripening. Another method consisted of blending emulsions of different "characteristic curves," or the "double coating" of emulsion layers of different photographic properties, either on one side of the support to extend exposure latitude, or on both sides of the film base, as in x-ray film, to increase the image density. These conventional methods of film design rarely required direct interaction between individual silver halide grains, if we ignore the special case of "infectious" development in graphic art film emulsions in so-called "lith" developers.[70] Emulsion technologists later discovered that the solvent action and formulations of certain developers could be utilized to further improve photographic properties, particularly speed and contrast, by what we may call "grain-interactions." These apparently can take place either by mixing specially designed emulsions or even by "adjacency effects" between two emulsion layers. For examples see Thompson,[71] Russell,[72] Klein et al.[73] The exact mechanism of grain-interactions occurring during the preparation, or the processing, of emulsions is not yet completely understood, but a number of speculations exist which are referred to below. Another interesting discovery had been made even earlier, leading to the controlled design of emulsions producing either mostly internal latent image[74] or predominantly surface latent image. The latter are mainly chemically sensitized emulsions. Mixing of both types in certain proportions resulted, according to Luckey,[75a,b] in improvements in speed and contrast. For an explanation, it was earlier proposed that development by-products migrate from exposed surface-sensitized grains to unexposed internally sensitized neighborhood grains where they induce the development of the otherwise undevelopable grains with concomitant increase in the silver density.

The increasing knowledge of the topography of the latent image in the emulsion microcrystals, as well as the recognition of the importance of structural imperfections,[5c,9,76] provided new tools which led to advanced emulsion design. Systematic studies of crystal habit and morphology of crystal growth, of the behavior of mixed crystals and their response to selective chemical and spectral ripening methods has formed a broader

foundation for emulsion technology. Again, within the scope of this chapter, a discussion must remain limited to illustrations of the more outstanding developments.

As mentioned, the Ostwald recrystallization process is one of the phenomena which plays a role in every emulsion formula, but it was practiced within relatively narrow limits until a decade ago. It appears that it was Prokhotskii, in 1960–62,[77a–c] who first described a silver chloride "shell" (or envelope) formation around a coarse-grained silver bromide "core" produced through extended Ostwald digestion at high temperatures (80°C). Such layered, or laminated grains were found useful for studying the role of the chemical composition of different grain regions in the photographic process. At about the same time, Moisar, et al.,[78a,b] showed experimentally that sensitivity or fog centers of various types could be buried within the grain at a certain depth forming a sensitive core and that an insensitive shell could be precipitated around it. Earlier, Hirsch[79] had demonstrated that an iodide-rich core of an AgBr emulsion grain was recognizable under the microscope by a coloration in the center of the grain through iodine release upon photolysis. In the mid-sixties, the core and shell grain emulsions became the subject of a number of patents which aimed at minimizing the reciprocity law failure,[80] or were useful in the production of direct-positive emulsions,[81] and in the design of reversal color films.[82] It is evident that the core and shell emulsion principle, also called "covered grain" emulsions (CG) in some patents, provided new possibilities to manipulate various characteristics of an emulsion, particularly in so-called "monodisperse" systems.[83,213–215]

Another more recent observation by Moisar[84] led to the recognition that the relative size and crystal habit (cubes or octahedra made under selected pAg and pH control) play a far greater role than previously assumed. The different crystallographic forms possess a different capability to accept sulfur and gold sensitization for increased speed, in particular if used in combination with selected spectral sensitizers. Moisar reported that the formation of Ag_2S specks proceeds at a higher rate (first order reaction) on the (111) crystallographic face than on the (100) face where it is initially autocatalytic. This results in a pronounced difference in the degree of dispersion of the sensitivity specks which affects the photographic properties. It should be noted that Sheppard, et al.,[28] had already pointed out in 1925 that too large a number of Ag_2S nuclei, particularly on the octahedral faces, resulted in a loss of sensitivity, probably through competition for the trapping of electrons. It has now been established that the topography and chemical nature of both the sensitivity centers and the latent image centers depend on the crystal form, its size, the number of structural defects and the chemical composition of the crystals; the iodide content being a major factor.[6,9,11]

This brief but by no means complete review of more recent emulsion research reveals some guidelines for advanced emulsion technology which is also reflected in the patent literature.

The Preparation of Selected Special-Purpose Emulsions

DIRECT POSITIVE EMULSIONS

A direct positive (autopositive) emulsion is designed to produce a positive image with clear highlight tones upon chemical development rather than the customary negative image. This autopositive image is differently formed from the positive obtainable by "reversal" development or by an image transfer method discussed later. Direct positive emulsions can be based on well-known image reversal effects, such as solarization, Clayden, Villard and other effects. Incidentally, these effects and their variations can be broadly correlated with the ratio of the internal/external speed of the silver halide crystals as shown by Jenkins, et al.[193] Solarization is induced either by prefogging of the silver halide emulsion with light (flashing) or by a treatment during the manufacture with strong chemical fogging agents, such as, for example, formaldehyde, hydrazine or sodium arsenite. More recently the nonhardening fogging thiourea dioxide[85] and amino-boranes were patented[86] as fogging agents, in both cases in combination with a desensitizing compound. Other direct positive emulsions are based on the "dye-sensitized Herschel effect."[5c,87] Low speed direct positive emulsions of silver chloride coated on transparent thin paper for document copying may give way to nonsilver electrophotographic copying methods, whereas high speed autopositive papers, coated on water-resistant paper (polyethylene-laminated stock) for portrait photography and other uses are still based on silver salts. Incidentally, this material must be used in cameras provided with a prism to achieve a lateral reversal of the image.

A number of patents claim precious metal complex salts of rhodium, iridium and others for the purpose of promoting image reversal[83,89] in various emulsion systems. Trautweiler[90a,b] investigated the effect of iridium and found that it is most effective in inert gelatins. The mechanism of these "promoters" is not completely understood, but they may provide internal electron traps in the silver halide crystal. Rhodium and iridium salts were also patented as *antikinking agents* (pressure mark eliminators) in direct positive emulsions.[91]

A number of other methods, or variations from above procedures to produce direct positive emulsions are referred to by Glafkides.[8] More recent techniques for making high speed direct positive emulsions, described by Porter, et al.,[80,81] Illingsworth,[92] and Berriman,[213] involve "covered grain" emulsions and appear of special interest.

In a review "On the Properties of Holes in Silver Halide," Galvin[94] reported that high speed solarized (direct positive) emulsions must contain a suitable compound such as, for instance, phenosafranine to provide electron traps, and also fog centers which are composed at least partly of gold. The influence of various emulsion characteristics on reversal sensitivity (i.e., speed in a solarized emulsion) was recently discussed by Vanassche and co-workers.[210]

PRINT-OUT EMULSIONS

The older, low speed print-out emulsions, used without fixing today mainly by portrait photographers as proof paper, are of relatively simple design. They consist of a nonwashed silver chloride emulsion containing an excess of soluble organic silver salt, ordinarily silver citrate. They produce a positive image when exposed under a negative; no development or post-exposure is required. For image permanence a fixing step is needed.

In 1950, Dybvig, et al.[95] published a special washed print-out emulsion formula which was about 100 times faster to ultraviolet radiation than ordinary proof paper. The effective speed of Dybvig's emulsion could be further increased with a red light post-exposure. When used in combination with an intensifying screen, gamma ray doses of about one Roentgen (R) could be detected.

Print-out emulsions intended for recording oscillographic traces are of a more complex design than proof papers. They record a moving high intensity light spot, first as an invisible trace at a writing speed up to 10,000 in./sec (maximum spot velocity); the imprinted latent trace is subsequently photo-developed by a post-exposure to low intensity light. The density of the photodeveloped trace can be further intensified by the simultaneous application of heat. A post-exposure desensitizes the background of the emulsions, so that the recorded trace stands out distinctly and sharply. If permanence of the recorded trace is not essential, no fixing is needed, although some oscillographic materials are so designed that they can be stabilization-processed,[5c] or fully chemically processed. Hunt,[96] and also Jacobs,[97] have discussed the behavior of photo-developable papers and suggested possible operating mechanisms. Weyde[98] suggested that the Clayden effect could be utilized for photo-developable emulsions. Many patents have disclosed other similar features in the formulation of direct emulsions. Admixtures of lead, tin, cadmium, copper and bismuth salts, frequently as their iodides, are revealed.[99a,b; 100-102] Alternatively, coprecipitation of such metal salts with silver halide is also mentioned. The incorporation of selected complex salts of the platinum group has also been patented.[103] It seems essential that inorganic (sodium nitrite) or organic halogen acceptors of a variety of chemical structures are present in the emulsions for optimal performance.[104,105a] Direct-writing emulsions are normally ultraviolet sensitive, but can be spectrally sensitized to respond to the light sources used in oscillographic equipment.[105b]

Oscillographic papers, although not of the print-out type are also available for recording multicolored traces on a single paper web.[200a,b] In this case, the emulsion must contain suitable color formers. The color trace recording papers always require a wet color processing procedure.

Many more patents than those cited for illustration have been issued pertaining to photodevelopable direct-writing emulsions.

VARIABLE CONTRAST PAPER EMULSIONS

One way to manipulate contrast in a single paper was patented by Fischer[106] in 1912, who proposed to mix a contrasty blue-sensitive silver halide emulsion with a soft, orthochromatically sensitized emulsion, or to superimpose these two emulsions by coating them on the same paper and expose the composite system with blue or yellow light, or a light mixture of both to obtain the desired print contrast. At that time, emulsion shortcomings and the lack of nondiffusing spectral sensitizing dyes prevented Fischer's system from becoming successful, although his principle was sound. May it suffice to state here that if two emulsions are mixed, they should have the same speed when exposed in their respective optimal sensitivity region. They should also produce about the same silver image tone and have the same development rate to produce the intended contrast grade. No equalization of contrast between the two emulsion components must occur. It was Renwick[107] who solved some of the difficulties. He used the intrinsic property of silver chloride emulsion to yield more contrast than silver bromide.

According to Renwick's patent, a nonsensitized silver bromide is mixed with an orthochromatically sensitized silver chloride emulsion. If a green printing light is used, the picture is recorded in the green-sensitized silver chloride layer. If the printing is done with blue-violet light, the softer silver bromide emulsion component will record the picture. With yellow filters of various densities, intermediate degrees of contrast can be readily obtained. The speed of the nonsensitized emulsion must be twice as high to get a balanced image. Potter and Hagaman[108] discovered somewhat later that a variable contrast paper can be made with a single chloro-bromide emulsion when the dye is added in less than the quantity normally required for maximum spectral sensitization. After washing the emulsion, the dye will remain preferentially adsorbed on the larger grains. In this system, the green printing light will produce soft gradations and the blue-violet light affecting the smaller nonsensitized grains will produce the higher contrast. Again, by combinations of filters, prints of intermediate gradation from various negative densities can be obtained. If two emulsions are used, it has been found possible to selectively sensitize both emulsions with nondiffusing dyes which have sensitizing maxima sufficiently apart to permit exposures with filtered light in the corresponding spectral regions.

A number of patents have been issued claiming special spectral sensitizers for variable contrast materials. A multicontrast emulsion employing colorless UV absorbers has been described by Herzhoff, et al.[109] For other types of variable contrast emulsions see ref. 6, pp. 86, 87.

Contrast control in printing negatives can also be achieved by optical means such as pre- or post-exposure of the print paper.[110]

NEGATIVE-POSITIVE IMAGE DIFFUSION TRANSFER EMULSIONS

The history and technology of the silver salt diffusion transfer processes are extensively reviewed by Rott and Weyde.[111] During the last decade, the evolution of the black/white image transfer process to the production of color prints by dye-transfer has taken place (Polaroid Color Process) as described in Chapter 12.

Into the category of black/white silver salt diffusion transfer also falls the *Bimat** process, described by Tregillus,[112] and by Tarkington,[113] which is very suitable for photographic applications by remote control required in space explorations and for military reconnaissance. In the Bimat system, a contact web carries not only the development promoting nuclei but also the processing chemicals after presoaking in imbibants. When the web is placed in intimate contact with the exposed negative film, the formation of a positive image of excellent quality by silver salt diffusion takes place in the web. The original negative can also be preserved.

NUCLEAR TRACK EMULSIONS

Emulsions specially designed for recording ionizing particles have become an important research tool in nuclear physics. The general emulsion characteristics of nuclear emulsions are those of very fine grain, low fog, either silver chloride or silver bromide dispersions in gelatin, or in polyvinyl alcohol and other binders, covering a particle size range from $0.1–0.5\,\mu$m. They are coated with various emulsion thicknesses, from $50–2000\,\mu$m. Some of the thicker layers are available without a permanent support and are used in multiple sandwich form interleaved with thin paper for registration of cosmic radiation. Laboratory emulsions have been described by Demers.[114] Commercial formulations are discussed by Glafkides.[8] In order to obtain a narrow grain size distribution of small grains with uniform size, double-jet addition of concentrated solutions of the reactants, preferably with a potentiometric control of the pAg, must be practiced. A pAg value somewhat below the pAg iso-electric point of 5.8 (at 50°C) appears to be optimal.[8] Nuclear emulsion can be sensitized with gold salts or triethanolamine (TEA), either by addition to the emulsion[69] or by a hypersensitizing pretreatment. Gold salts have been observed to counteract the regression of the latent image. The mechanism of TEA is still under debate but appears to be one of reduction sensitization, or halogen absorption, helpful to build up the sublatent image centers, and thus increase the number of developable grains along the path of a particle in the emulsion. Cadmium salts and/or artificial restrainers appear to be desirable ingredients in nuclear emulsions to keep the silver halide grain small and uniform. The washing of

*Tradename, Eastman Kodak Co., Rochester, N.Y.

nuclear emulsions can be carried out by flocculation with methanol or sodium sulfate. Since grain clumping is very detrimental for sharp trace records, an absolutely complete redispersion of the silver halide grain must be achieved. Some nuclear emulsions can also be impregnated with lithium borate to stop slow neutrons. Beryllium, bismuth and uranyl salts may be used for similar purposes.

Certain dyes have been found to act as chemical sensitizers in nuclear emulsions (erythrosine, eosine, acridine orange, etc.).[8] For additional information, reference should be made to publications by Narath,[115] Heimann,[116] Barkas,[117] Cüer,[118] Zelikman, et al.[11]

EMULSIONS FOR USE WITH X-RAYS

The general characteristics and applications of medical and industrial films are discussed by Seeman (Chapter 22). Emulsions exposed with calcium tungstate intensifying screens, as in medical radiography, are preferably ammonia iodo-bromide emulsions strongly chemically sensitized for maximum speed. They possess an average particle size of $1.5–2.0\,\mu$m. Some formulations suitable for high speed medical x-ray emulsions are found in Glafkides,[8] Duffin[9] and Gahler.[57] To achieve keeping quality of at least 12 months, x-ray emulsions require sophisticated stabilization techniques.

Industrial x-ray films used with lead screens are iodo-bromide emulsions, which may contain silver halide crystals doped with small quantities of lead, cadmium and thallium salts.[8] The possible mechanism of the effect of foreign metal ion incorporations has been discussed in the literature.[119b,120–122] In industrial x-ray films for use in high voltage or gamma radiography, gold sensitization has been found to substantially increase the speed.[123]

For use in rapid roller transport processor system (total processing time 60–120 sec), special x-ray emulsions, highly hardened with glutaraldehyde and/or its bis-sodium bisulfite in the developer, were disclosed by Barnes, et al.[69] They contain considerably less gelatin than previous x-ray films and have a total silver content of about 600–1300 mg/ft[2] for double-coated films.

BLACK AND WHITE INFRARED EMULSIONS

Emulsions sensitive to the infrared radiation are produced by sensitizing with tri, tetra and pentacarbocyanines (see Chapter 4). Some of the emulsions are designed for special applications; for example, aerial, satellite and medical photography normally require high speed emulsions while those for certain scientific purposes, such as spectroscopy, must produce images with fine-grain and high resolving power. The keeping quality of emulsions sensitive to the far infrared is limited and the judicious use of chemical stabilizers, which are compatible with the sensitizing dyes, is essential.

A detailed specification for the preparation of a far infrared (10,600 Å) emulsion was described by Corben, et al.[124] The structure of the cyanine sensitizing dye, the grain-size distribution and the resolving power of the emulsion, as well as its response to hyper-sensitization with ammonia, are given by Corben.

MISCELLANEOUS EMULSIONS FOR PROFESSIONAL AND SCIENTIFIC PURPOSES

While grainless emulsions were designed by Lippmann in 1891 for interference color photography, they have not lost their importance for research purposes in many fields, such as spectroscopy, laser beam recording, printed circuit making, autoradiography, reflection holograms, and others. Actually, Lippmann emulsions, while appearing transparent, are not grainless. They comprise grain sizes from 10–50 nm and have been prepared in gelatin either from pure single silver halides (AgCl, AgBr or AgI) or their mixtures. To obtain this ultrafine grain, double-jet addition of the reactants in very dilute solutions is practiced, preferably in the presence of strong grain growth inhibitors of the imidazole or mercapto class. The maintenance of a constant pAg near the equivalence point is as critical as it is for nuclear emulsions. Lippmann emulsions can be chemically and spectrally sensitized or hypersensitized (gold salts and TEA) in order to increase their intrinsic low speed. The resolving power, depending on the formulation, can range between 2000 and 5000 lines/mm. Three different formulations of Lippmann emulsion are given by Glafkides.[8] The same textbook indicates that ultrafine grain emulsions have been prepared by bromination of colloidal silver dispersions in gelatin and subsequent sensitization by impregnation with chemical sensitizers. Other nonhalide silver salts, such as silver pectinate,[125] or water-fixable silver mercaptides,[126] have been patented recently for producing fine-grain emulsions.

Silver halide emulsions which are designed for recording ultraviolet radiation must be prepared with a minimum of gelatin. The reason is that gelatin, when used in normal concentration, would filter out most of the UV radiation to be recorded. Ultraviolet plates and films are used in spectroscopy, biology, astronomy, etc. Two methods have been used to eliminate the detrimental absorption by gelatin. The older method (Schumann) called for an emulsion with the minimum of gelatin. The other method employs a silver chloride emulsion with either a surface coating containing a substance which is excited to strong fluorescence by UV radiation, or is impregnated with solutions of aesculine, or salts of salicylic acid, anthracene, fluorene, etc. More recently, spiropyran compounds have been patented[127] for this purpose. Formulations for the preparation of UV recording emulsions have been disclosed by Glafkides.[8]

Another method to obtain a special UV radiation sensitive emulsion—superior to those sensitized with salicylates—was described by Audran.[128] It is prepared by centrifugation of a liquid emulsion onto the wall of a cylindrical vessel. A thin layer, rich in silver halide, is formed. When this deposit is transferred to a suitable film base, the external "face" is highly sensitive to UV radiation.

EMULSIONS FOR GRAPHIC ARTS

Information about the design of so-called "lith" emulsions (lithography) is widely scattered in the patent literature. The stringent requirements of the graphic arts have led to very complex systems consisting of special emulsions which must be mated to special developers. The latter are low-sulfite, formaldehyde-bisulfite hydroquinone developers producing the so-called "infectious" development.[70] The prime requisites of emulsions for line and halftone reproduction are not only extremely high contrast but very sharp halftone dot rendition. Such emulsions are of the silver chloro-bromide class, possessing 60–90% silver chloride, 40–10% bromide, sometimes also a small percentage of iodide. They are highly hardened emulsions. In order to obtain fine grain and narrow grain-size distribution, double-jet addition of the ingredients and pAg control in the neighborhood of the isoelectric pAg point are used. The earlier methods described for improving the contrast of chloro-bromide emulsions are co-precipitation of the silver halides with cadmium halides, or with small quantities of rhodium complex salts.[8] These addenda normally produce a certain loss of speed. The first cadmium-free "lith" films to eliminate pollution of water with toxic metal salts were marketed in Japan together with more stable "lith" developers.[195] In more recent patents the incorporation of a variety of polyalkylene-oxycompounds and organosilicon block polymers[129,130] is disclosed which are claimed to improve contrast and dot sharpness with increased development latitude in "lith" developers. The longer development induction period (speed loss) can be compensated for by the simultaneous addition to PEO compounds and quaternary salts,[131,132] or with pyrazolones.[133] The mechanism of the interplay of these addenda in "lith" developers is not yet completely understood.

The "Clayden" effect[5c] has also been used to prepare so-called *prescreened* or *autoscreened* emulsions,[134a,b] which allow the preparation of halftone negatives from continuous tone positives without the use of the conventional halftone screen in the camera.

THERMOGRAPHIC DRY SILVER SALT SYSTEMS

During the past decade, a new version of a silver salt print-out system appeared on the market with film and paper products. It is a completely dry process. The exposed areas are developed by heating to a temperature of 90–150°C. Depending on the product design, a negative or positive image can result. The heat-developed

material apparently does not require stabilizing or fixation.

This thermographic process may have grown out of Sheppard and Shely's[135] discovery in 1964, which was further advanced by Morgan and Shely.[136a,b] According to these patent disclosures, the dry silver salt process consists of a dispersion of silver salts of long-chain organic acids of low light-sensitivity. Specifically they are moisture-stable silver "soaps," such as silver behenate (a fatty acid salt containing 22 carbon atoms), or silver stearate, in a vinyl or cellulosic resin. The silver soaps are surface-treated with halogen acids, or ionizable organic halogen compounds, in such a manner that only a few percent of the organic silver salt is converted into silver halide *in situ.* It is the silver halide that undergoes photolysis to silver which apparently catalyzes the reduction of the silver soaps during heat development. A mild reducing agent (e.g., hydroquinone) must be present to accelerate the silver image formation. Low molecular weight acids, such as benzoic or salicylic acid, serve as antifoggants in the system. Interestingly, the mere mixture of the silver soap with silver halide is only marginally operative, unless the components are extensively ball-milled. The silver halide can be chemically and spectrally sensitized to reach a speed of ASA 1.0. The thermographic silver salt emulsions show a resolving power of approximately 1600 cycles/mm, good covering power and gamma values up to 10 with a maximum density of 4. The developing time of the daylight stable systems is 3–20 sec at a temperature of 250–280° F. The products possess a keeping quality of at least six months. The inventors propose, as a probable explanation, a synergistic association of silver halide with the silver salts of the long-chain fatty acids. Presumably, the hydrophilic polar silver ions in the oriented arrangement of the layer face each other but are separated from other adjacent planes by the interspacing of the hydrophobic organic radicals of the fatty acids. Incidentally, an observation of Levinos, cited by Dybvig, et al.,[95] indicated that print-out silver can catalyze the decomposition of organic silver salts when heated and thus can produce an exposure latensification; a similar catalysis seems to occur in the dry silver salt system. Regardless of the theory, the new thermographic silver salt system led to novel "convenience" products for contact and projection printing. The new products are also used for continuous and halftone reproductions of graphic art material and duplication of tactical aerial reconnaissance pictures. Other thermographic silver salt systems have been reviewed[137] or patented recently.[138a,b]

BINDER-FREE SILVER HALIDE MATERIALS

While both gelatin- and polymer-free silver halide plates or films were made for scientific purposes prior to 1960, they became commercial products during the past decade. Some of these processes employ an impregnation of anodized aluminum foils with silver nitrate solution, reduction and halogenation to silver halide in the aluminum oxide surface.[139] The silver halide thus formed can be chemically and spectrally sensitized. Such sensitized foils or sheets are used for name plates, dials, scales and reticules. Silver halide can also be deposited "in vacuo" on rigid or flexible supports;[140] such products may be used for recording ion beams, charged particles and mass spectra. The speed of the binder-free systems is less than ASA 1. So-called "on the spot" silver halide layers prepared by a base impregnation technique are claimed to have speeds between ASA 1–5.[141] Peisach[142] disclosed a binder-free print-out system prepared by vacuum deposition of silver and conversion with boron trifluoride to silver fluoride. In 1973 Hirsch, et al.[196] described photographic layers (deposits) prepared by filtration of AgBr sols through "Millipore"-filters,* pervious to particle sizes of $0.07–0.10 \, \mu m^2$. These deposits were stabilized against fog with extremely small quantities of gelatin (0.004–0.008%), but resembled, nevertheless, conventional gelatin-based fine-grain emulsions, which can be sensitized, latensified, etc. Among the suggested applications is the monitoring of tritium radiation in autoradiography. Previous reviews on binder-free silver salt systems are found in the literature.[6,56e]

The Scientific Principles of the Emulsion-Making Process

The various phases of emulsion manufacture described earlier comprise two major operations: the mixing process (also called emulsification or precipitation) of silver halides and the after-ripening. The mixing involves nucleation, initial crystal growth, Ostwald ripening (physical digestion) and often recrystallization. The nature of these events is primarily a physical one, except for the formation of the silver halide itself. During the mixing operation, crystallographically well-defined microcrystals are formed. The treatments of these crystals in the after-ripening are predominantly chemical reactions, as will be described later. Upon exposure, the action of light releases electrons and positive holes within the crystals which must be trapped to prevent recombination, otherwise no developable latent image would be created. See Chapter 3 for a description of the mechanism of latent image formation and Chapter 5 for a description of latent image development.

THEORY OF EMULSIFICATION (MIXING, PHYSICAL RIPENING)

One of the first theories of the formation of a solid phase from a supersaturated solution was developed by Weimarn (1914) and served as an approach to explain the phenomena encountered in the precipitation of a photographic emulsion. The Weimarn theory is discussed by

*Trade name, Millipore Corp., Bedford, Mass.

Lyalikov,[13] who was unable to verify Weimarn's theory or to assign a general validity to the work of other earlier investigators.

The presentation of the results of later theoretical work (Volmer, Gibbs, Dunning, Berry and co-workers and others) as cited in textbooks[5c,10] leads to the conculsion that, at the present time, neither the rate of nucleation, nor the total number of nuclei, can be quantitatively determined in single-jet emulsions because the necessary prerequisite, namely, the knowledge of the magnitude of supersaturation and its change with time, seems to be still lacking. A publication by Berry and co-workers[197] on the fundamental mechanism occurring during double-jet silver halide precipitation comprising nucleation, growth of crystals, Ostwald ripening and recrystallization contains much data on these phenomena and many references.

A model system claimed to be more reproducible than the double-jet addition was used by Gutoff[143a,b] who chose the technique by Bransom, et al. [144] employing a continuous well-mixing crystallizer under steady-state conditions. With this apparatus, Gutoff has arrived at a more accurate mathematical expression for the nucleation rate both in neutral and ammoniacal iodo-bromide emulsions. One feature of iodide/bromide coprecipitation (up to 5 mol %) in this system stands out: iodide increases the nucleation rate by about a factor of 10; at the same time, the crystal growth rate decreases because a larger number of crystals are formed. In the AgI/Br system, prepared in the presence of ammonia, the growth rate of untwinned regular crystals (at a low Br^- ion excess) increases with increasing ammonia concentrations. Iodide in an ammonia system (in contrast to the neutral system) decreases the crystal growth rate. Faster agitation reduces the nucleation rate, whereas higher temperatures increase it.

The *physical ripening process* immediately follows or simultaneously begins with the nucleation in single-jet emulsions. It can be governed by two mechanisms: (1) the Ostwald ripening—a well-known physical principle and (2) the coalescence of grains. The Ostwald ripening rests on the fact that, in a given system, containing different particle sizes, the smaller particles dissolve and the size of larger particles increases. The details of this physical principle are adequately described in textbooks.[5e,10] Certain types of substances can either decrease the rate of Ostwald ripening (restrainers) or can accelerate it (silver halide solvents). Mathematical relations have been established for the recrystallization (grain growth) process by a number of investigators (Sheppard and Lambert, Lyalikov, Wagner and others) cited in FHK.[10]

The coalescence, or cohesion, of grains is assumed to take place when the particles approach each other to a distance a little larger than twice the radius of the particle. The mathematical approaches taken by various investigators to develop an expression covering the coalescence phenomenon are summarized in FHK.[10] Coalescence of grains appears to be favored by rapid precipitation, particularly at low gelatin concentration, the presence of active gelatins, or by octahedral crystal shape of the grains.[10]

As mentioned, the iodide content during the emulsion has a pronounced influence on the grain size distribution. Schematic graphic presentations of the iodide/bromide coprecipitation have been shown by James and Higgins,[145] also by Duffin.[9] Systematic work on the elucidation of the mechanism of this coprecipitation was carried out by Chateau and collaborators.[146] Berry and Marino[147] experimentally established that the less soluble silver iodide is precipitated first when silver nitrate is added by single-jet to the halide mixture solution. During the continuation of the mixing process, the AgI redissolves and is redistributed within the silver bromide crystals. This recrystallization probably never reaches an equilibrium. The iodide admixture produces increased response to most types of chemical and to certain spectral sensitizers and influences the latent image distribution within the grain, alters the reciprocity effect and increases the tendency to solarization. Galvin[94] indicates that Γ ions on the grain surface increase interstitial Ag^+ ions and silver ion vacancies ($Ag \square^-$). Γ ions can also act as hole traps; in larger concentrations they inhibit development.

GRAIN SIZE AND GRAIN SIZE DISTRIBUTION

It has been long known that a relationship exists between the crystal size and size frequencies and the basic photographic characteristic of an emulsion. The size of emulsion grains cover, normally, a range from submicroscopical to approximately 5 μm diameter particles. The electron microscope has made it possible to explore crystal sizes, crystal habits, their structure and developability.[148] Low speed emulsions show an average grain size of 0.5–1.0 μm, whereas high speed emulsion may contain crystal sizes up to 3 μm. Size frequency distribution curves and tables of average grain size of commercial emulsions of various types are found in the literature.[5e,145]

The methods of determination of the grain sizes and of the plotting of grain histograms or size frequency curves are cumbersome, although some semiautomatic equipment and particle size analyzers have been developed and described.[5e,149,198] For the design of an emulsion with a specified grain size distribution, the chief parameters are the selection of the rate, mode and order of addition of the components, their respective concentration, control of pAg, the gelatin concentration, the use of silver halide solvents, and, in particular, the variation of the iodide content.

For a theoretical interpretation, the grain size frequency distribution curves have to be expressed by mathematical functions. It was observed earlier that experimentally established curves resembled probabilty functions of a Gauss-type, although many commercial emulsions reveal skewed shapes. Many attempts were made in the past to modify earlier probability functions

for obtaining greater accuracy. Berry, et al.[150] pointed out, however, that older publications on grain size distribution and interpretations have today only phenomenological interest because the principles of crystal growth were not even qualitatively known at earlier times. Later on, it was indeed shown that at least the initial size frequency distribution can be represented by a Gauss-type distribution relative to the grain diameter or to the logarithm of the grain diameter. Klein[151] could confirm this observation for most existing emulsions. In a closed system (no substance added after the initial precipitation), the grain size distribution is governed by the Ostwald recrystallization only. With increasing ripening time, the initially narrow Gauss distribution curve begins to broaden on the abscissa first symmetrically, thereafter the curve becomes asymmetric and assumes different shapes, depending on whether the system is predominantly controlled by diffusion or reaction-kinetically. In an open system (additional reactants introduced but no formation of new nuclei) the grain growth likewise depends on the diffusion or reaction-kinetic mechanism. In the latter case homodispersity is approached by extended physical ripening.

Many emulsification conditions are used in practice which lead to an overlap of the two mechanisms not allowing a quantitative analysis of the growth kinetics.

Moisar[152] has shown that controlled crystal growth, producing predominantly mono-disperse emulsions (cubic or octahedral crystals), is possible by keeping the pAg value at a constant predetermined level. Incidentally, mono-disperse emulsions are well-suited for model experiments of a great variety, although they are still atypical of most high speed emulsions.

In conclusion, no generally valid relationship seems to exist between the size of an individual grain and its sensitivity. The latter depends on other factors besides size. In a chemically sensitized emulsion, it is conceivable that a smaller grain may be more sensitive than a larger one, because of a statistical distribution of the sensitivity specks. As a rule, however, the emulsion speed is proportional to the size of the grains—larger ones absorb more light. The larger the range of the emulsion grain sizes, the wider is its exposure latitude. On the other hand, a slow speed, contrasty emulsion has a narrow grain size distribution with a small average grain size.

Klein[153] established an equation indicating that the intrinsic sensitivity of an individual grain increases with the probability of light absorption of the grain volume, independent of chemical sensitization. Finally, it should be kept in mind that each grain acts as an individual during the act of latent image formation and during development. With increasing exposure, the number of developable grains increases.

Study of the chapters in Mees-James[5c] and in the FHK textbook[10] on the subject of the silver halide grain and its size frequency distribution, as well as the cited bibliography, is recommended for deeper penetration into these important physico-chemical aspects of emulsion design.

MECHANISM OF CHEMICAL SENSITIZATION

Much evidence has been obtained that at least some of the mechanism of chemical sensitization comprising reduction, sulfur, and gold sensitizers is interlocked with that of latent image formation. The reaction products of the primary exposure, namely the photoelectron and the positive hole released by a quantum of light, must be prevented from recombination by trapping them within the crystal or on its surface. Without use of chemical sensitizers of any kind or doping metal ions, which produce trapping centers, an emulsion, particularly one made with inert gelatin, would remain very insensitive. Nonsensitized emulsions which consist of nonannealed crystals possessing dislocations and other structural imperfections, may show so-called *primitive* speed.[16] The fundamental question whether chemical sensitizers produce electron traps (Gurney and Mott theory) or hole traps (Mitchell) has been reviewed by Malinowski.[154] At present, it seems that both mechanisms can be operative, depending on the specific conditions of the emulsion preparation. Moisar[199] and co-workers contributed much to our knowledge on sensitivity centers (ripening and fog nuclei) of all types. It seems that gold and Ag_2S nuclei, depending on the location in the silver halide crystal (internal or external), affect the topography of the latent image, whereas reduction sensitization leads to an increase in speed during the exposure without influencing the latent image topography. This observation supports the conclusion that gold and sulfur sensitization leads to deep electron traps, whereas reduction sensitization produces hole or electron traps, depending on the size and location of the silver nuclei.

It follows that the chemical nature of sensitivity specks and their action is more complex than previously assumed. Many properties of the emulsion besides speed, contrast and fog are influenced, namely high and low reciprocity law failure, solarization, latent image stability and others.

Normally, chemical sensitizers do not interfere with spectral sensitizers but may compete with the adsorption of stabilizing agents or chemically interact with them.[45e] Since the mechanism of chemical sensitization has been extensively and repeatedly reviewed within the past decades,[6,10,24,153,155,156] only recent or very important references are cited.

REDUCTION SENSITIZATION

An increase in emulsion speed by reduction sensitization (sodium sulfite) was first experimentally demonstrated by Carroll and Hubbard in 1932,[3] although the term reduction sensitization was not coined before Lowe, et al.[16] published their studies in 1951. Many gelatins contain trace amounts of various organic substances which produce metallic silver specks or nuclei, within or on the surface of the grain. Wood[157] could

demonstrate that digestion even with inert gelatin at pAg 3 could produce silver nuclei which are presumably the end products of all typical reduction sensitizers. The size of the silver specks is critical for their behavior. If these nuclei remain uncharged, they act most likely as hole traps; should they become associated with Ag^+ ions or aggregate with Ag_2S specks, they can act as deep electron traps, as recently shown by Tani.[93a,b] Later Spencer[200] reported that charges of reduction-sensitized silver specks can hardly be neutral but, depending on the sensitizing condition, may be either negative (hole traps) or positive (electron traps). The action of reduction sensitizers has been discussed frequently in the past[8,9,10,24,76,155,156] and lately by Vanassche.[210]

SULFUR SENSITIZATION

The concepts of the mechanism of sulfur sensitization have gone through quite an evolution since Sheppard discovered it in 1925. Under various emulsion making conditions, labile sulfur compounds may produce silver sulfide on the crystal surface in form of specks, or clusters or monomolecular "islands." As shown by a number of investigators and previously reviewed by Mueller,[156] there is no direct correlation between the sensitivity of the emulsion and the analytically detectable quantities of silver sulfide. Only the silver sulfide built into the lattice surface of the silver halide is photographically effective. If silver sulfide is excessively formed intergranularly, it leads to stain only.[56e] The work of Frieser et al.[159] with ^{35}S-thiosulfate further elucidated the mechanism of sulfur sensitizing. Moisar[160a–c] experimentally demonstrated that the mechanism for the formation of Ag_2S specks is different for cubic and octahedral crystallographic faces of emulsion crystals.

Over a period of many years, Soviet scientists under the leadership of Chibisov[158a,b] have developed and defended a different concept of the mechanism of chemical sensitization. They theorized on the basis of much experimental work that chemical sensitizers, particularly sulfur sensitizers, act only as catalysts for a reduction of silver ions in areas of structural imperfection within and on the surface of silver halide crystals. In a recent (English text) review, Chibisov, et al.[201] emphasized that the nature of chemical sensitivity is closely related to the mechanism of the latent image formation. The silver nuclei aggregates are assumed to form in a supersaturated solution of metallic silver in the silver halide crystal and undergo a phase transition from few atom particles (sub-latent image) via colloidal silver aggregates (latent image) to over-sized silver specks (fog nuclei). Finally, a metallic (crystalline) stage of the silver nuclei is reached which no longer catalyzes development (solarization). The Russian theory has attractive features and deserves a critical evaluation.

In conclusion, many scientists favor the view that sulfur sensitization appears to lead to silver/silver sulfide nuclei serving as deep electron traps, although the rate of reaction, the size and topography of the specks can be quite differnt. [5a–c,6,10,24,156–58,160a–c]

GOLD SALT SENSITIZATION

The photographic effects of the addition of minute quantities of certain gold salts (expressed as milligrams gold/gram mol of silver) have been intensively studied since the discovery of their substantial sensitizing effect[47] which occurs without increase in the grain size of the emulsion. This remarkably versatile effect is now widely used in modern emulsion technology. While certain gold salts are useful in sensitizing *non*-ripened chloro-iodo-bromide emulsion,[202] gold salts are, as a rule, added during the after-ripening of washed iodo-bromide emulsions to obtain maximum increase in speed or contrast or both. This increase occurs in the intrinsic sensitivity range of silver halide and does not interfere with spectral sensitization. Gold sensitization is also useful in increasing the response of emulsions to high-voltage x-rays or gamma radiation[123] or to nuclear particle recording. Emulsions, not gold-sensitized during their preparation, can be hypersensitized or latensified by bathing the layer in suitable gold salt solutions.[212] Furthermore, it proved fortuitous that judiciously dosed gold sensitization acted additively to reduction and sulfur sensitization. Aside from the favorable influence on the speed, soluble and insoluble gold salts affect other emulsion properties. They can, for instance, suppress or eliminate the Herschel effect and decrease the high intensity reciprocity law failure, but they normally do not suppress solarization.

In view of the great technological importance of the gold effect, its mechanism has been extensively studied and discussed in comprehensive reviews.[163–167] To illustrate the variety of suggested modes of action of gold salts, the major concepts are outlined under 1–7:

1. Gold salts may react with preformed silver sulfide specks or with adsorbed silver thiosulfate to form gold sulfide or mixed silver/gold sulfide specks. The latter may serve as hole traps. Gold sulfide appears to induce less fog than silver sulfide upon storage or development.
2. Alkali dithiosulfate-aurate (I) becomes adsorbed on the silver halide grain, decomposes during after-ripening and "injects" aurous ions into interstitial lattice positions, where they can capture photo-electrons.[207]
3. Association of gold or silver ions or atoms with silver sulfide centers may form deep electron traps.
4. Silver atom aggregates (occurring as "ripening silver" or as latent image silver) can reduce gold ions to more stable gold nuclei (perhaps remaining associated with some silver atoms) which fog

less than silver. This electro-chemical conversion to metallic gold stabilizes the sensitivity centers against oxidation.

5. Gold specks apparently catalyze the latent image development more effectively than silver specks, presumably through better developer adsorption.[211a,b] "Over-sized" gold specks, however, will lead to fog during development.

6. Increasing exposure of gold sensitized emulsions leads to an increase in the gold content of the latent image nuclei—Spracklen.[163]

7. The gold sensitizing mechanism in silver chlorobromide emulsions follows a different pattern; cadmium ions suppress gold sensitization; addition of iodide or ferrous ions accelerate decomposition of gold complexes according to Katsev, et al.[202]

The addition of small quantities of precious metal salts other than gold, such as of the salts of palladium, platinum, rhodium, iridium, and others, is now apparently widely practiced according to the patent literature. The salts of elements of Group VIII of the periodic system can, under certain conditions, produce stabilizing, sensitizing or desensitizing and other specific effects e.g., solarization. Relevant and more recent papers offering speculative explanations of the mechanisms have been published by Bahnmüller,[168] Sakai and Baba,[169] also lately by Tani.[203] It seems not unlikely that the noble metal salt additives produce internal or external electron traps causing sensitization or desensitization, depending on the chemical and structural composition of silver halide crystals.

MECHANISM OF DEVELOPMENT ACCELERATORS IN EMULSIONS

The synergistic action of developer mixtures and the effect of development accelerators in the processing baths will be discussed in Chapter 5. Some of these development accelerators or modifiers can be advantageously added to the emulsion itself. Long-chain quaternary ammonium salts (e.g., lauryl pyridinium bromide) were first described in 1938 as developer accelerators.[170a,b] As mentioned earlier sulfonium and phosphonium salts were patented as emulsion additives to increase speed. It is assumed that these cationic agents are strongly adsorbed on the surface of silver halide grains and decrease the normally existing bromide ion charge barrier around the grain, thus resulting in a shortening of the developer induction period. The magnitude of the effect of these agents depends on the type and charge of the developer. Willems[171] believes that a lowering of the surface tension of water by long-chain quaternary "onium" compounds also contributes to the development acceleration. Some of the "onium" compounds, however, are incompatible with spectral and chemical sensitizers, probably for reasons of competition for available space for adsorption on the silver halide surface.

Blake's[54a,b] long-chain polyethylene-oxy compounds (PEO),* were at first introduced as silver halide "sensitizers." They can indeed produce substantial speed increase, particularly in high speed, iodide-rich emulsions but appear to act in most cases by development acceleration rather than by true sensitization. This is the case regardless whether the PEO compound is present in the emulsion or in the developer. A large variety of PEO compounds show this effect. It is more pronounced in superadditive hydroquinone developers (Metol-hydroquinone or phenidone-hydroquinone), whereas, in developers containing hydroquinone alone PEO compounds retard development. The induction period increases lowering the toe speed and improving the contrast.[172] This development retarding action has been assumed to result from an interference of PEO compounds with adsorbed semi-quinone which catalyzes development particularly in "lith" developers.[173a,b] As in the case of quaternary salts, the number of photographically effective PEO compounds described in the patent literature has grown rapidly.

Wood[188a,b] did not believe at first that the development accelerating effect of PEO compounds was due to desorption of gelatin from the silver halide grain. Recently this was contradicted by Inaba and Kumai,[204] although Kumai, et al.[176a-d] had earlier suggested an interaction of PEO compounds with iodide ions liberated during development. A number of other theories as to possible PEO mechanisms have been proposed by Sheberstov, et al.[177] Oguchi, et al.[178] and Churaeva, et al.[179a,b] Herz[174] assumed that adsorbed PEO compounds may facilitate the attraction of developer anions, postulating that PEO compounds have a pseudo-cationic character. Van Veelen, et al.[175] believe that PEO compounds reduce the hydrophobicity of the gelatin layer adsorbed on the grain. This multitude of opinions calls for more research to clear up the actual mode of action of these agents. Many PEO compounds require the addition of powerful antifoggants in order to suppress fog, a fact amply illustrated in the literature,[9,56e] to obtain an optimal balance between development acceleration and fog retardation.

Compounds such as urea, salicylates and other agents, which cleave hydrogen bonds in gelatin, facilitate developer penetration by increasing the swelling of the emulsion layer, thus "simulating" development acceleration. These compounds should not be confused with the above described development accelerators.

MECHANISM OF STABILIZATION

The dramatic and continuing increase in sensitivity of photographic emulsions of almost all types produced by the above described techniques, as well a the pro-

*e.g., "Carbowaxes" (Union Carbide Corporation).

gressing displacement of the cellulose triacetate film support with the dimensionally stable "polyester" (polyethylene-terephthalate) base, required new emulsion stabilizers. The incorporation of developers and development accelerators in the emulsion and the need for high temperature processing further increased the demand for better stabilization. The more frequent use of inertized gelatins in emulsion formulations necessitated the search for novel stabilizers in the after-ripening to assure the stability of sensitometric properties and the prevention of fog on aging. Since the mechanism of emulsion stabilizers and antifoggants were previously reviewed,[23] and have now been discussed in great detail in a book by Birr,[56e] it should suffice to present here only a summary of the existing major concepts of the mode of action of these important emulsion additives. The earliest theory may be still valid in some cases, namely that compounds, mostly of the heterocyclic class, which form insoluble silver salts (e.g., benzotriazole, nitrobenzimidazole, etc.) are strongly adsorbed to silver halide. This adsorption is due to either irreversible chemisorption (Wulff, Wendt, Matthies as cited in ref. 56e) or due to reversible electrostatic attraction of compounds possessing certain dipole configurations (Sheppard, et al., cited in ref. 56e.) This "envelope" was thought to prevent the further formation of ripening of fog nuclei or causing a retardation of the reduction of the silver halide during development. This concept, however, is not adequate to explain the function of other very effective antifoggants which are little or not adsorbed, neither on the silver halide nor on sensitivity nuclei consisting of silver, gold or silver sulfide.

Battaglia[180] recently indicated on the basis of a new technique (linear potential sweep voltammetry and chronopotentiometry) that the solubility of silver salts of substituted benzotriazole showed no correlation with antifogging action. Battaglia concluded that there may be a kinetic interaction with silver and silver bromide surfaces. The larger the observed cathode potential shift in the electrochemical reduction, the greater is the antifogging effect in the developer. Furthermore, experience has shown that strongly adsorbed compounds, regardless by what mechanism, produce an immediate speed loss in AgI/Br emulsions or cause a gradual desensitization upon aging.

When Birr discovered in 1934 the 5-methyl-7-hydroxy-triazaindolizine (new nomenclature: 4-hydroxy-6-methyl-1,3,3a,7-tetrazaindene) he observed that this compound is only little adsorbed on AgBr (although quite extensively on AgCl), but nevertheless suppressed fog effectively without causing any loss of speed or retardation of development. Birr explained this desirable behavior by the observed desorption of residual, undecomposed sensitizer anions (e.g., thiosulfate ions) and the rapid reaction of the latter with the silver salt of the tetrazaindene. This leads to the formation of Ag_2S particles in the gelatin matrix surrounding the grains. If ripening nuclei are not firmly attached to the silver halide lattice, they are inactive.

This mechanism appears quite plausible in spite of its complexity. For more details Chapter 5 ref. 56e, should be consulted.

Wood's[181] assumption, based on heat of adsorption measurements, that the tetrazaindene compound may at least partially become adsorbed on Ag_2S specks on the grain surface, cannot be ruled out, but whether this adsorption plays a major part in the stabilization mechanism is still uncertain.

Ivanov and other Soviet scientists[205a-c] revealed certain fused ring systems such as benzothiazolotetrazoles which do not form insoluble silver salt but are adsorbed on silver halide by dipole formation via a tautomery of the tetrazole ring structure. They are described as effective but selective stabilizers. For more details see refs. 23 and 56e.

Other useful stabilizers, which are not adsorbed on the grain and do not retard development, fall into a category of compounds which probably adjust the redox potential of the emulsion during the after-ripening stage. Gahler's[57] experimental models illustrate this concept: sodium benzene thiosulfonate can oxidize silver and gold nuclei and reduce fog in this manner. Many other patented stabilizers may exert a selective oxidizing effect on silver fog nuclei. Faelens, et al.[182] have shown that excess chemical sensitizers can interact with gold compounds and suppress fog. Some other possible interactions of stabilizer with certain emulsion ingredients were previously pointed out.[23] The suppression of "aerial fog" during development (e.g., by phenosafranine) may be based on the fact that the latter impedes the growth of the silver nuclei to fog nuclei according to Tani.[183] Attractive hypotheses for the antifogging action of noble metal salts (in larger than sensitizing quantities) have not been offered as yet, whereas the stabilization with cadmium or lead salts may be due to reduction of the number of interstitial Ag^+ ions in the crystal lattice.[76] Certain stabilizers are not compatible with spectral sensitizers and suppress speed by displacing the cyanine dyes.[56e]

In summary, the major mechanisms currently advocated to play a role in stabilization are the following:

1. Adsorption of the stabilizing agent on the silver halide surface in competition with the products of chemical sensitizers, thus changing the size and topography of the sensitivity specks which, in turn, control speed and keeping quality.
2. Adsorption of the stabilizer on the sensitivity specks themselves, preventing their further growth into fog centers.
3. Decrease of oversized (fog-producing) silver or gold specks by oxidants to smaller (nonfogging) metal aggregates.[57]
4. Desorption of excess chemical sensitizer anions and reaction with silver ions in the zone closely surrounding the grain (Birr's mechanism as explained above; also Berendsen, et al.[206])
5. Possible displacement of fog specks for the silver halide by solvent action.
6. Pseudo-stabilizers.[23]

Reference should also be made to a Russian review of stabilizers and their action (1945–66) with 425 references by Shvink, et al.[184]

OUTLOOK

A study of photographic literature over several decades indicates that the initially slow evolution in emulsion making from an art toward a more exact science of emulsion design has gained momentum over the years. It is, therefore, important that emulsion technologists keep abreast of new descriptive material in the literature and in patents, and retain a genuine interest in the theoretical aspects of all phenomena encountered in the emulsion making process. The knowledge of the status of the theories of chemical sensitization, of latent image formation and, its distribution in the silver halide crystal, as well as its development is important for the understanding of photographic science and the advance of emulsion technology. While the development of nonsilver halide processes should be encouraged for many sound reasons, it is believed that photography based on silver halide emulsions will continue to retain a strong position for years to come and may still lead to new and unforeseeable applications.

REFERENCES

1. B.I.O.S. British Intelligence Objective Sub-Committee Reports.
2. F.I.A.T. Field Intelligence Agency, U.S. Reports, Technical.
3. B. H. Carroll, D. Hubbard and C. M. Kretschmar, *Photographic Emulsions*, Focal, London, 1968.
4. T. Thorne Baker, *Photographic Emulsion Technique*, American Photographic, Boston, 1945.
5. (a) C. E. K. Mees, *The Theory of the Photographic Process*, Macmillan, New York, 1942.
 (b) C. E. K. Mees, *The Theory of the Photographic Process*, 2nd Ed., Macmillan, New York, 1954.
 (c) C. E. K. Mees and H. T. James, *The Theory of the Photographic Process*, 3rd Ed., Macmillan, New York, 1966.
6. A. Hautot (ed.), *Photographic Theory*, Liège Summer School, 1962; Focal, London, 1963.
7. C. B. Neblette, (ed.), *Photography, Its Materials and Processes*, 5th Ed. (1952), 6th Ed. (1962) Van Nostrand Reinhold, New York.
8. P. Glafkides, *Chimie et Physique Photographiques*, 3rd Ed., Paul Montel, Paris, 1967.
9. G. F. Duffin, *Emulsion Chemistry*, Focal, London, 1966.
10. H. Frieser, G. Haase, E. Klein, *Grundlagen d. Photogr. Prozesse m. Silber Halogeniden*, Akadem. Verlagsges., Vols. 1–3, Frankfurt (M.), 1968.
11. V. L. Zelikman and S. M. Levi, *Making and Coating of Photographic Emulsion*, Focal, London, 1964.
12. B. V. Deryagin and S. M. Levi, *Film Coating Theory*, Focal, London, 1964.
13. K. S. Lyalikov, *The Chemistry of Photographic Mechanisms*, Focal, London, 1967.
14. N. I. Kirillov, *Problems in Photographic Research*, Focal, London, 1967.
15. P. P. Hanson, "Emulsion and Silver Halide Systems, Bibliography of Reviews (1960–70)," *Photogr. Sci. Eng.*, 15: 501-9 (1971).
16. *Photographic Sensitivity*, Symp. Bristol, 1950, Butterworth, London (1951).
17. *Colloque des Emulsions Photographiques*, Paris, 1951, *Rev. d'Optique Théoretique et Instr.*, 1953.
18. *Science and Application of Photography*, Centen. Conference, London, 1953. Royal Photogr. Soc., London (1955).
19. *Wissenschaftl. Photographie*, Intern. Konf. Köln, 1956, O. Hellwich, Darmstadt (1958).
20. *Photographic Science*, Symp. Zürich, 1961. Focal, London (1963).
21. *Photographic Science*, Symp. Torino, 1963. Focal, London (1965).
22. *Photographic Science*, Symp. Paris, 1965. Focal, London (1967).
23. *The Photographic Image*, Intern. Congr. Tokyo, 1967. Focal, London (1970).
24. *Photographic Science*, Preprints, Intern. Congr. Moscow, 1970.
25. R. C. Croome and F. C. Clegg, *Photographic Gelatin*, Focal, London 1965.
26. G. Reich, *Kollagen*, Th. Steinkopff, Dresden, 1966.
27. F. Evva, *Z. Wiss. Photogr.*, 47: 145 (1952).
28. (a) S. E. Sheppard, *Photogr. J.*, 65 (N.S. 49): 380 (1926).
 (b) S. E. Sheppard, U.S. Patent 1,574,944 (3/2/26).
 (c) S. E. Sheppard, U.S. Patent 1,673,499 (4/5/27).
 (d) S. E. Sheppard, U.S. Patent 2,410,689 (11/5/46).
29. A. Steigmann, *Photogr. Korr.* 70: 184 (1934).
30. G. Russell, *Chemical Analysis in Photography*, Focal, London, 1966.
31. *Standard Methods for the Sampling and Testing of Gelatins*, Gelatin Manufacturers Institute of America, 516 Fifth Ave., Room 507, New York, N.Y. 10017.
32. Commission on Testing Methods for Photographic Gelatin, *Pagi Method*, 2nd Ed., Tokyo, 1964 (English).
33. (a) H. Ammann-Brass, *Kolloid Z.*, 110: 105-25, 161-75 (1948).
 (b) H. Ammann-Brass, *The Photographic Image*, Focal, London, 1970.
 (c) H. Ammann-Brass, *Photogr. Korr.*, 106: 5-12; 22-32 (1970).
 (d) H. Ammann-Brass, *Z. Wiss. Photogr.*, 55: 103-13 (1961).
 (e) H. Ammann-Brass (Ed.), "Restrainers in Photographic Gelatins," *IAG Repts.* (*Internationale Arbeitsgemeinschaft*), Fribourg, Switz. (1971).
34. C. Schleussner, Ger. Patent Appl. 470,924 (U.S. Dept. Com., P. B. Report 84460, fr. 6104-61).
35. E. Dubiel, *J. Photogr. Sci.*, 16: 21 (1968).
36. W. G. Lowe, et al., U.S. Patent 2,632,704 (3/24/53).
37. S. H. Merrill, et al., Brit. Patent 1,057,976 (2/8/67).
38. W. G. Lowe, et al., U.S. Patent 2,541,474 (2/13/51).
39. (a) T. Yano, *Bull. Soc. Sci. Photogr.*, Japan, 18: 20-6 (English) (1968).
 (b) T. Yano, *Photogr. Korr.*, 104: 123 (1968).
40. (a) R. H. Talbot, et al., Brit. Patent 724,827 (4/23/55).
 (b) R. H. Talbot, et al., U.S. Patent 2,964,405 (12/13/60).
41. H. Ammann-Brass, *Z. Wiss. Photogr.*, 55: 103 (1961).
42. B. H. Carroll, U.S. Patent 2,487,850 (11/15/49).
43. B. H. Carroll, et al., *J. Bur. Stand. (Wash.)*, 12: 329-44 (1934).
44. W. G. Lowe, et al., U.S. Patent 2,518,698 (8/15/50).
45. W. G. Lowe, et al., U.S. Patent 2,521,925 (9/12/50).
46. R. E. Stauffer, et al., U.S. Patent 2,415,974 (5/6/47).
47. R. Koslowsky, *Z. Wiss. Photogr.*, 46: 65 (1951).
48. C. Waller, et al., U.S. Patent 2,399,083 (1946).
49. W. F. Smith, et al., U.S. Patent 2,448,060 (1948).
50. (a) A. P. H. Trivelli, et al., U.S. Patent 2,566,245 (1951).
 (b) A. P. H. Trivelli, et al., U.S. Patent 2,566,263 (1951).
51. R. E. Stauffer, U.S. Patent 2,598,079 (1948).
52. (a) B. H. Carroll, U.S. Patent 2,271,622 (1942).
 (b) B. H. Carroll, U.S. Patent 2,271,623 (1942).
 (c) B. H. Carroll, et al., U.S. Patent 2,288,226 (1942).
 (d) B. H. Carroll, U.S. Patent 2,334,864 (1943).
 (e) B. H. Carroll, U.S. Patent 2,410,690 (1943).
53. (a) D. J. Beavers, U.S. Patent 2,940,851 (1943).
 (b) D. J. Beavers, U.S. Patent 2,940,555 (1943).
 (c) D. J. Beavers, U.S. Patent 2,944,898 (1943).
54. (a) R. K. Blake, U.S. Patent 2,423,549 (1948).
 (b) R. K. BLake, U.S. Patent 2,441,389 (1948).
55. G. W. Luckey, U.S. Patent 3,397,987 (1968).
56. (a) E. J. Birr, *Schweiz. Photorundschau*, 26: 111, 437, 465 (1961).
 (b) E. J. Birr, *Photogr. Korr.* 99: 163 (1963).
 (c) E. J. Birr, *J. Photogr. Sci.*, 17: 91 (1969).

(d) E. J. Birr, *Chimia*, **24** (4): 125 (1970).

(e) E. J. Birr, *Stabilization of Photographic Emulsions*, Focal, London, 1974.

57. S. Gahler, *Veröffl. Wiss. Lab.*, *VEB.*, Wolfen, X, **63** (1965).
58. (a) B. H. Carroll, U.S. Patent 2,728,664 (1955).
 (b) B. H. Carroll, U.S. Patent 2,728,666 (1955).
 (c) B. H. Carroll, U.S. Patent 2,728,667 (1955).
 (d) B. H. Carroll, U.S. Patent 2,251,299 (1956).
59. (a) S. Kikuchi, et al., *Sci. Ind. Photogr.*, **23**: 41 (1952).
 (b) S. Kikuchi, et al., *Sci. Ind. Photogr.*, **25**: 345 (1954).
60. V. L. Zelikman, *Zh. Nauchn. i Prikl. Fotogr. i Kinematogr.*, **12**: 379-95 (1967). (Work of Russian scientists in the field of emulsion technology during the last decade)
61. P. Demers, *Can. J. Phys.*, **32**: 538 (1954).
62. C. Waller, et al., U.S. Patent 2,489,341 (11/29/49).
63. (a) W. Himmelmann, et al., Ger. Patent Appl. 1,085,422 (10/16/58).
 (b) W. Himmelmann, et al., also F.I.A.T., P. B. Report 19920.
64. A. A. Newman, *Chem. Products*, **20**: 4, 157 (1957).
65. F. A. Mason and R. E. Withrington, *Photographic Materials*, Reports on the Progress of Appl. Chem., **L**: 99 (1965).
66. A. A. Titov, *Kinofototekhnika*, **7**: 5, 58 (1941).
67. W. Walther, *Z. Chem.*, **4**: 367-74 (1964).
68. (a) V. I. Sheberstov, *Zh. Nauchn. i Prikl Fotogr. i Kinematogr.*, **4**: 100-5 (1959).
 (b) V. I. Sheberstov, *Zh. Nauchn. i Prikl Fotogr. i Kinematogr.*, **5**: 10-14 (1960).
69. J. C. Barnes, et al., U.S. Patent 3,545,971 (12/8/70).
70. J. A. C. Yule, *J. Franklin Inst.*, **239**: 221 (1945).
71. T. R. Thompson, et al., U.S. Patent 3,050,391 (12/30/51).
72. F. J. Russell, U.S. Patent 3,140,179 (7/7/64).
73. E. Klein, et al., Ger. Patent Appl. 1,169,290 (1962).
74. E. P. Davey and E. B. Knott, U.S. Patent 2,592,250 (1952).
75. (a) G. W. Luckey, et al., U.S. Patent 2,996,382 (8/15/61).
 (b) G. W. Luckey, et al., U.S. Patent 3,397,987 (8/20/68).
76. J. W. Mitchell, *Rept. Progr. Phys.*, **20**: 433 (1957).
77. (a) Yu. M. Prokhotskii, et al., *Zh. Nauchn. i Prikl. Fotogr. i Kinematogr.*, **5**: 363 (1960).
 (b) Yu. M. Prokhotskii, et al. ibid. **7**: 148-50 (1962).
 (c) See also Ref. 60 (Zelikman).
78. (a) E. Moisar, *J. Photogr. Sci.*, **13**: 46 (1965).
 (b) E. Moisar, Ger. Patent Appl. 1,169,290 (1962).
79. H. Hirsch, *J. Photogr. Sci.*, **10**: 129, 134 (1962).
80. H. D. Porter, et al., U.S. Patent 3,206,313 (9/14/65).
81. H. D. Porter, et al., U. S. Patent 3,317,322 (5/2/67).
82. C. Beckett, et al., U. S. Patent 3,505,068 (4/7/70).
83. E. Klein, et al., Brit. Patent 1,027,146 (4/27/66).
84. E. Moisar, *J. Photogr. Sci.*, **14**: 181 (1966). Also, Ref. 10, Vol. 2, 685.
85. P. J. Hillson, Brit. Patent 911,639 (3/6/59).
86. C. R. Burt, DT. 1,927,182 (1/2/70).
87. P. J. Hillson, *J. Photogr. Sci.*, **10**: 182-7 (1962).
88. H. A. Wark, U.S. Patent 2,717,833 (1955).
89. Y. Hayakawa, et al., DT. 2,003,037 (1969).
90. (a) T. Trautweiler, Thesis, Zürich (1968).
 (b) T. Trautweiler, *J. Photogr. Sci.*, **11**: 276 (1963).
91. C. E. Burt, U.S. Patent 3,445,235 (5/29/69).
92. B. D. Illingsworth, U.S. Patent 3,632,340 (1/4/72).
93. (a) T. Tani, *Photgr. Sci. Eng.*, **15**: 28, (1971).
 (b) T. Tani, ibid, **15**: 181 (1971).
94. J. P. Galvin, ibid., **16**: 69-77 (1972).
95. H. T. Dybvig, et al., *Photogr. Sci. Eng.*, **8**: 127-33 (1954).
96. H. D. Hunt, *Photogr. Sci. Eng.*, **5**: 104 (1961).
97. J. H. Jacobs, *Photogr. Sci. Eng.*, **5**: 1 (1961).
98. E. Weyde, *Z. Wiss. Photogr.*, **48**: 39 (1953).
99. (a) H. D. Hunt, U.S. Patent 3,033,682 (1959).
 (b) H. D. Hunt, U.S. Patent 3,033,678 (1959).
100. T. A. Scott, U.S. Patnet 3,047,392 (1960).
101. J. F. Byrne, U.S. Patent 3,123,474 (1964).
102. J. H. Bigelow, U.S. Patent 3,449,125 (1969).
103. R. E. Bacon, U.S. Patent 3,547,647 (1970).
104. T. Takei, et al., Ger. Patent 1,177,004 (1962).
105. (a) E. E. McBride, U.S. Patent 3,287,136 (1966).
 (b) E. E. McBride, U.S. Patent 3,287,137 (1966).

106. R. Fischer, Brit. Patent 15,054 (1912).
107. F. Renwick, U.S. Patent 2,202,026 (1940).
108. R. S. Potter, et al., U.S. Patent 2,280,300 (1942).
109. P. Herzhoff, Ger. Patent 1,140,812 (1/18/61).
110. H. Berghaus, *Mitt. Forschungslab. Agfa II*, 198, Springer, Heidelberg (1958).
111. A. Rott and E. Weyde, "Photogr. Silver Halide Diffusion Transfer Processes," Focal, London (1972).
112. L. W. Tregillus, *J. Photogr. Sci.*, **15**: 44-54, 129-36 (1967).
113. R. G. Tarkington, *Photogram. Eng.*, **31**: 126-30 (1965).
114. P. Demers, *Ionographie*, Press Univ., Montréal, 1958.
115. A. Narath, *The Preparation of Nuclear Emulsions*, Forsch.-Ber., Land Nordrhein-Westfalen 975, 1961, p. 36
116. G. Heimann, *Studies of the Production of Nuclear Emulsions*, Berlin Univ., Thesis (1960); *Nucl. Sci. Abstr.*, **18**: 2754 (1964).
117. W. H. Barkas, *Nuclear Research Emulsions*, Vol. I, "Technique and Theory," Academic, New York (1963).
118. P. Cüer, V. Conf. Nucl. Photogr., Cern, Geneva (Sept 1964), Proc. **1**: 45 (1964).
119. (a) Y. Wakayabashi, *Photogr. Sci. Eng.*, **4**: 1-4 (1960).
 (b) Y. Wakayabashi, *J. Soc. Sci. Photogr. Jap.*, **20**: 49, 102, 137 (1957).
120. E. T. Larson, et al., *J. Phys. Chem.*, **57**: 802 (1953).
121. C. R. Berry, et al., *Photogr. Sci. Eng.*, **11**: 411 (1967).
122. F. H. Claes, et al., ibid., **12**: 207 (1963).
123. H. Hoerlin, et al., *J. Opt. Soc. Amer.*, **40**: 236 (1950).
124. L. Corben, et al., *J. Photogr. Sci.*, **15**: 265 (1967).
125. Fuji Film Co., Brit. Patent 1,218,847 (1/13/71).
126. G. M. Haist, Ger. Patent 1,169,291 (12/3/69).
127. J. E. Taylor, et al., U.S. Patent 3,413,234 (1968).
128. R. Audran, *Wiss. Photogr.*, Intern Konf. Köln, (Sept 1956), (O. Hellwich, Darmstadt, 1958).
129. K. M. Milton, U.S. Patent 3,294,537 (1966).
130. C. A. Goffe, U.S. Patent 3,433,639 (1969).
131. N. F. Beach, et al., Brit. Patent 1,078,748 (1968).
132. D. E. Piper, U.S. Patent 2,886,437 (1959).
133. T. Suga, et al., U.S. Patent 3,576,637 (1971).
134. (a) J. A. C. Yule, et al., U.S. Patent 2,708,626 (1955).
 (b) E. A. Mac William, U.S. Patent 2,756,148 (1956).
135. J. W. Shepard, et al., U.S. Patent 3,152,903 (10/13/64).
136. (a) D. A. Morgan, et al., U.S. Patent 3,457,075 (7/22/69).
 (b) D. A. Morgan, Int. Symp. Tokyo, Prelim. Reports. SPSE 1-4 (Nov. 1973)
137. Inst. Graphic Communications, Oct. 1970, **1**(2): 14.
138. (a) K. Ohkubo, et al., U.S. Patent 3,635,719 (1972).
 (b) R. D. Lindholm, U.S. Patent 3,700,458 (1973).
139. E. Wainer, *Photogr. Eng.*, **2**: 161 (1951).
140. Tech. Operations, Inc., *Chem. Eng. News*, **39**: 44 (1961).
141. A. Shepp, et al., *Photogr. Sci. Eng.*, **7**: 48 (1963).
142. J. M. Peisach, U.S. Patent 3,505,066 (4/7/70).
143. (a) E. B. Gutoff, *Photogr. Sci. Eng.*, **14**: 248 (1970).
 (b) E. B. Gutoff, *Photogr. Sci. Eng.*, **15**: 189-199 (1971).
144. S. W. Bransom, et al., Discussions Faraday Soc., **5**: 83 (1959).
145. H. T. James and G. C. Higgins, *Fundamentals of Photographic Theory*, Morgan and Morgan, New York, 1960.
146. H. Chateau, et al., (3 papers), Intern. Konf. Köln, 1956, (Verlag O. Hellwich, Darmstadt, 1958).
147. C. R. Berry and S. J. Marino, *Photogr. Sci. Tech.*, (2), **2**: 149 (1955); (2) **4**: 22 (1956).
148. E. Klein, *Mitt. Forsch. Lab.*, Agfa, Leverkusen, **II**: 43, Springer Verlag, Heidelberg (1958).
149. G. Klinger, et al., *Intern. Conf. Sci. Photogr.*, Torino, 1967 (Focal, London, 1965).
150. C. R. Berry, et al., *J. Appl. Phys.*, **33**: 1900 (1962).
151. E. Klein, *Mitt. Forsch. Lab.*, Agfa, Leverkusen, **I**: 10, Springer Verlag, Heidelberg (1955).
152. E. Moisar, *Photographic Science*, Symposium Paris, 1965. (Focal London, 1967, pp. 262-3).
153. E. Klein, et al., *Mitt. Forsch.*, Agfa, Leverkusen, **I**: 30, Springer Verlag, Heidelberg (1955).
154. J. Malinowski, *Photogr. Sci. Eng.*, **14**: 112 (1970).
155. F. Dersch, *Chimia*, **22**: 353 (1968).
156. F. W. H. Mueller, *Photogr. Sci. Eng.*, **13**: 323 (1969).
157. H. W. Wood, *J. Photogr. Sci.*, **3**: 169 (1955).

158. (a) K. W. Chibisov, *Photogr. Korr.*, 5. Sonderheft, O. Hellwich, Darmstadt (1962).
　　(b) K. W. Chibisov, *J. Photogr. Sci.*, **18:** 73–90 (1970).
159. H. Frieser and E. Ranz, *Ber. Bunsenges. Phys. Chem.*, **68:** 389 (1964).
160. (a) E. Moisar, *J. Photogr. Sci.*, **14:** 181 (1961).
　　(b) Ref. 10, pp. 685, 747.
　　(c) E. Moisar, *Photogr. Korr.*, **106:** 149–60 (1970).
161. W. Bahnmüller, *J. Photogr. Sci.*, **16:** 35–37 (1968).
162. P. A. Faelens, et al., *Photogr. Korr.*, **104:** 137–45 (1968).
163. D. M. Spracklen, *J. Photogr. Sci.*, **9:** 145 (1961).
164. F. W. H. Mueller, *Photogr. Sci. Eng.*, **10:** 338 (1966).
165. (a) P. A. Faelens, *Sci. Ind. Photogr.*, **27:** 4, 121 (1956).
　　(b) P. A. Faelens, *J. Phys. Chem.*, **66:** 2611 (1962).
166. W. Bahnmüller, *Photogr. Korr.*, **105:** 149–53 (1969).
167. D. Walther, *Veröffl. Wiss. Photogr. Lab.*, Wolfen, Vol. **X:** 23–62, Hirzel, Leipzig (1965).
168. W. Bahnmüller, *Photogr. Korr.*, **104:** 169–84; 194–98 (1968).
169. H. Sakai, et al., *Bull. Soc. Photogr.*, *Japan*, **17:** 12 (1967) (English text).
170. (a) D. Lottermoser, et al., *Kolloid-Z.*, **82:** 319 (1938).
　　(b) D. Lottermoser, et al., *Kolloid-Z.*, **83:** 37 (1939).
171. J. Willems, et al., *Photogr. Sci. Eng.*, **6:** 39 (1962).
172. P. J. Hillson, *Photogr. Sci. Eng.*, **13:** 165–70 (1969).
173. (a) H. W. Wood, *J. Photogr. Sci.*, **12:** 5–14 (1964).
　　(b) H. W. Wood, *J. Photogr. Sci.*, **13:** 39–45; 177–84 (1965).
174. A. H. Herz, et al., *J. Colloid Sci.*, **16:** 199 (1961).
175. G. F. VanVeelen, et al., *J. Photogr. Sci.*, **13:** 226 (1967).
176. (a) A. Kumai, et al., *J. Photogr. Sci.*, **18:** 91, Pt. I (1970).
　　(b) A. Kumai, et al., *ibid.* **18:** 131, Pt. II (1970).
　　(c) A. Kumai, et al., **18:** 176, Pt. III (1970).
　　(d) A. Kumai, et al., **18:** 220, Pt. IV (1970).
177. V. I. Sheberstov, et al., *Zh. Nauchn. i Prikl. Fotogr. i Kinematogr.* **12:** 207–216, 362–64 (1967).
178. M. Oguchi, et al., *J. Soc. Sci. Photogr. Japan*, **26:** 73 (1963).
179. (a) A. M. Churaeva, et al., *Zh. Nauchn. i Prikl. Fotogr. i Kinematogr.*, **6:** 139 (1961).
　　(b) A. M. Churaeva, et al., *Zh. Nauchn. i Prikl. Fotogr. i Kinematogr.*, **9:** 122 (1964).
180. C. J. Battaglia, *Photogr. Sci. Eng.*, **15:** 275 (1970).
181. H. W. Wood, *J. Photogr. Sci.*, **14:** 72 (1966).
182. P. A. Faelens, et al., *J. Phys. Chem.*, **66:** 2411 (1962).
183. T. Tani, *Photogr. Sci. Eng.*, **15:** 181 (1971).
184. N. A. Shvink, et al., *Usp Nauchn. Fotogr.*, **14:** 35 (1970).

185. A. Rott and E. Weyde, *Photographic Silver Halide Diffusion Processes*, Focal, London, 1972.
186. H. Borginon, *J. Photogr. Sci.*, **19:** 14–17 (1971).
187. K. Tanaka, *J. Photogr. Sci.*, **21:** 134–38 (1973).
188. (a) H. W. Wood, *J. Photogr. Sci.*, **12:** 15 (1964).
　　(b) H. W. Wood, *ibid.*, **13:** 39–45 (1965).
189. W. Vanassche, *J. Photogr. Sci.*, **21:** 180–6 (1973).
190. Q. W. Decker and P. D. Sherman, "Glutaraldehyde. Structure and its Relation to Protein Crosslinking," Technol. Series, Union Carbide, Apr 10, 1970.
191. I. A. Kortnev, et al., *Akust. Ul'trazvukovaza Tekh.*, **7:** 16–18 (1972); *C.A.* **79,** 25632 (1973).
192. G. F. Farnell, et al., *J. Photogr. Sci.*, **21:** 241–45 (1973).
193. R. I. Jenkins, et al., *J. Photogr. Sci.*, **20:** 167–73 (1972).
194. F. W. H. Mueller, *Progress in Emulsion Techniques 1945-1961* (Zürich Symposium 1961), Focal, London, 1963.
195. T. Hara, *Offset-Praxis*, **13:** 58–60 (1973).
196. H. Hirsch, et al., *J. Photogr. Sci.*, **21:** 187–91 (1973).
197. R. C. Berry and D. C. Skillman, *J. Photogr. Sci.*, **16:** 137–47 (1968).
198. A. B. Holland, et al., *Photogr. Sci. Eng.*, **17:** 295–8 (1973).
199. E. Moisar, *Photogr. Korr.*, **106:** 149–160 (1970).
200. H. E. Spencer, *J. Photogr. Sci.*, **20:** 143–5 (1972).
201. K. V. Chibisov, et al., *J. Photogr. Sci.*, **21:** 125–33 (1973).
202. A. Katsev, et al., *Photogr. Korr.*, **106:** 133–41 (1970), (English text).
203. T. Tani, *Photogr. Sci. Eng.*, **17:** 306–14 (1973).
204. Y. Inaba and A. Kumai, *J. Photogr. Sci.*, **17:** 499–502 (1973).
205. (a) B. M. Ivanov, *Zh. Nauchn. i Prikl. Fotogr. i Kinematogr.*, **7** (1): 164–6 (1962).
　　(b) B. M. Ivanov, et al., *ibid.*, **8:** 253–61 (1963).
　　(c) L. F. Avramenko, et al., *ibid.*, **8:** 419–26 (1963).
206. R. Berendsen, et al., *J. Photogr. Sci.*, **13:** 171 (1965).
207. P. A. Faelens, et al., *Photogr. Korr.*, **102:** 53, 75 (1966).
208. K. S. Lyalikov, et al., *Tr. Leningr. Inst. Kinoinzh.*, **19:** 61–69 (1972); *C. A.* **78:** 130549 (1973).
209. (a) C. E. Johnson, et al., U.S. Patent 3,615,424 (10/26/71).
　　(b) F. Farren, et al., U.S. Patent 3,409,436 (11/15/68).
210. W. Vanassche, et al., *J. Photogr. Sci.*, **22:** 121–30 (1974).
211. (a) D. C. Shuman, et al., *Photogr. Sci. Eng.*, **15:** 42–47 (1971).
　　(b) D. C. Shuman, et al., *ibid.*, **15:** 119–27 (1971).
212. T. H. James, et al., *PSA J.*, **14:** 349 (1948).
213. R. W. Berriman, U.S. Patent 3,367,778 (2/6/68).
214. E. Moisar, et al., *Ber. Bunsenges. Phys. Chem.*, **67:** 356 (1968).
215. E. Moisar, *Photogr. Korr.*, **106:** 149 (1970).

3

THE SILVER HALIDE GRAIN AND THE FORMATION OF THE DEVELOPABLE IMAGE

W. West

The silver halide photographic emulsion is unique among photochemical image-forming systems in its sensitivity; moreover, unlike purely electrical systems of recording radiation, it can accumulate the radiation impression over a relatively long exposure period. The following chapter is intended to outline how these properties of silver halides are realized on the atomic and molecular scale. The primary photochemical change in an emulsion grain involves a very small fraction of silver and halide ions in the crystallite and no change in the grain can be discerned by ordinary visual observation. The high sensitivity of the emulsion depends on the fact that the primary change can be amplified by a factor of about 10^9 by development, which can reduce to metallic silver all the silver ions in an exposed grain. The condition of developability induced by exposure is called the *latent image*. The latent image is stable and exposed emulsions have been successfully developed several decades after exposure.

The processes accompanying exposure of the emulsion grain and the formation of the latent image are still not completely understood, but much research, especially since the seminal work of Gurney and Mott in 1938,[1] has probably revealed the main outlines of these processes. The predominance of the silver halides among photochemical light-sensitive systems arises from peculiarities in the chemical and physical behavior of silver halide crystals, and some knowledge of the nature of these crystals is a necessary preliminary to the understanding of the photographic process.

PHOTOLYSIS OF SILVER HALIDES

Prolonged exposure of silver chloride or silver bromide crystals to visible or ultraviolet light causes the crystals to darken, the products of the photolysis being particles of colloidal silver and halogen—the characteristic lines of silver metal appear in the x-ray diffraction spectrum of the darkened product and the halogen can be identified chemically. The over-all photolytic change can be expressed by the equation:

$$AgBr + h\nu \longrightarrow Ag + 1/2\ Br_2 \qquad (1)$$

where $h\nu$ represents a quantum of the actinic radiation, h is Planck's constant, 6.6256×10^{-27} erg sec and ν is the frequency of the radiation in $1/sec$, $h\nu$ therefore possessing the dimensions of energy. The rate of darkening is much increased if the halogen is removed as fast as it is formed by exposing in the presence of reducing agents like sodium nitrite, or in vacuum. It has been found that one silver atom per quantum absorbed is formed in the photolysis of certain silver bromide and silver chloride emulsions.[2] Similarly, a bromine yield of one atom per quantum absorbed was found in the photolysis of silver halide emulsions without binding agent in the presence of sodium nitrite,[3] and of gelatin-free silver bromide crystals in vacuum.[4]

The photolytic silver halide reaction is used to form visible images in "*print-out*" paper, in emulsions well provided with halogen acceptor.

CHEMICAL NATURE AND SIZE OF THE LATENT IMAGE

Extrapolating back many orders of magnitude from the heavy exposures required to produce print-out silver to those used to form latent image, one might reasonably infer that the latent image consists of minute silver particles, so small as to defy detection even by the electron microscope. Consistent with the assumption that the latent image consists of reduced silver particles is the observation that for development to occur, the reduction-oxidation potential of the developer must be somewhat above that of silver at the silver ion concentration of the emulsion; that is, the developer must be a slightly stronger reducing agent than one that would reduce silver ion at the pAg of the emulsion in contact with massive silver. In general, no fact regarding latent image formation or the initiation of development is inconsistent with the supposition that the latent image is formed by the aggregation of silver atoms, sometimes about a center of silver sulfide;[5] in gold-sensitized emulsions, gold may also be incorporated in the latent image.[5]

Microscopic observation of the development of exposed grains shows that reduced silver begins to appear at a small number of sites on the grain surface, suggesting that the latent image centers have been built up at these sites. As to the size of the latent image center, various studies, of low intensity reciprocity failure[6,7] and of the shape of the characteristic photographic density versus exposure curves of emulsions,[6,8-10] suggest that an isolated single silver atom in a silver halide crystal is unstable, dissociating rapidly to a silver ion and an electron. A particle containing two silver atoms appears to be stable over at least a day or two, but is not ordinarily developable. This center is called the sub-developable latent image, or the latent sub-image.[8]

The reality of the sub-image is shown by, among other ways, the fact that it can be enlarged to a developable latent image by a carefully controlled post-exposure, insufficient in itself to form latent image.[8,9] Sensitometric studies suggest that the permanently stable latent image contains about twice as many silver atoms as the sub-image. There is probably no sharply defined minimum size for a developable center, since developability depends on the activity of the developer and the conditions of development, but a small number of silver atoms near four seems necessary to form a latent image center. Consistent with this conclusion is the observation that 10 to 20% of the grains in the most sensitive grain classes of fast negative emulsions are rendered developable by the absorption of 4 quanta, although the average number of quanta necessary per grain is considerably higher.[11]

Surface and Internal Latent Image

In normal development the latent image acted on is mostly in the grain surface, in contact with the developer. The interior of an exposed grain also often contains latent image centers. Since the sulfite present in most developers is a solvent for silver halide, sulfite-containing developers can etch a little below the surface and develop subsurface internal image thus exposed to their action. In studies of the distribution of latent image between the surface and interior of the grains, surface latent image is revealed by a developer containing no silver halide solvent, such as a solution of ascorbic acid and Metol in water.[12] To study the internal image, the surface latent image is first removed by oxidation with a bleach such as potassium ferricyanide. The slight attack of ferricyanide on the internal image can be inhibited by addition of the dye phenosafranine to the bleaching solution.[13] After being washed, the surface-bleached film, if it contains internal latent image, can be developed in a normal Metol-hydroquinone developer to which sodium thiosulfate has been added to etch into the interior of the grains.

The reality of internal latent image centers is vividly emphasized in macroscopic crystals of silver bromide in the form of sheets about 0.1 mm thick. After sectioning through an exposed sheet crystal by etching or cleaving at low temperature, developable latent image can be found as far as 40 μ below the exposed surface, far beyond the range of which light can penetrate with appreciable intensity.[14]

Before chemical sensitization, iodobromide emulsions with grain size appropriate to negative speeds show very little surface latent image after exposure, but contain a relatively large amount of internal latent image. As sulfur sensitizing proceeds, the surface sensitivity increases while the internal sensitivity decreases. As an example of results obtainable by the separation of surface and internal latent image, the ratio of surface to internal sensitivity at room temperature and at low temperatures is illustrated in Fig. 3-1.[15] The data for the figure apply to a slow, fine-grain emulsion, but the change in the ratio with temperature is general. The surface sensitivity is strongly reduced at low tempera-

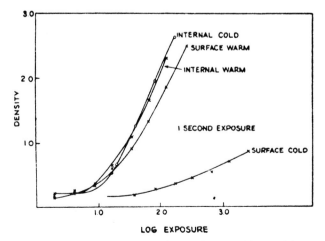

Fig. 3-1. Characteristic curves for surface and internal latent image in an emulsion at room temperature and at the temperature of liquid air (after Berg, Marriage and Stevens[15]).

ture, while the internal sensitivity is little changed at low temperature. As will be discussed in connection with latent image formation, little or no latent image is formed at liquid air temperature, photoelectrons being trapped mostly at internal sites, but not neutralized by silver ions to form silver atoms. As the emulsion is warmed to room temperature before development, neutralization occurs with the formation mostly of internal latent image centers.

Size Distribution of Latent Image Centers

The distribution of latent image with respect to the size of the centers depends on the intensity of the exposing light and on the temperature at which the exposure is made. It is assumed that development is carried out at about room temperature. At low intensities of exposure at room temperature the sub-image is not efficiently formed, but once a sub-image center has by chance appeared, it tends to act as the nucleus for deposition of silver atoms generated by further exposure. At low intensities, therefore, a few relatively large silver centers will be formed by exposure, and most of these centers will be developable, and relatively few will be left as sub-image. At higher intensities the efficiency of formation of sub-image centers will increase; more will be formed in the grain, and the silver atoms generated by further exposure will be distributed over a number of competing sub-image nuclei. Hence a given amount of luminous energy (the product of the light intensity and the duration of the exposure) will produce more and smaller latent image centers at high intensities of exposure than at low, and also relatively more sub-image at the higher intensity. Grains exposed at high intensities for short times can therefore be *latensified*, i.e., the sub-image centers can be enlarged to developable size by a subsequent exposure at low intensity[15] or by chemical means, such as bathing in a solution of a gold salt or by prolonged development in an active developer.[16] Post exposure enlarges sub-image centers by deposition of photo-generated silver atoms, bathing in a gold solution by deposition of chemically produced gold atoms, and vigorous development adds silver atoms formed in the grain because of the injection of electrons from the reducing agent in the developer.

In a similar manner the inefficiency of the formation of latent image at low intensities can be overcome by applying a short flash pre-exposure, insufficient to produce developable centers, but providing sub-image centers that facilitate latent image formation by acting as preformed nuclei for the growth of larger centers.

As already mentioned, the latent image centers resulting from exposures at very low temperature are formed, for the most part, during the warming to room temperature preceding development. The direct products of the exposure at low temperature are mostly trapped photoelectrons and their positively charged counterparts; as the temperature rises after exposure, trapped electrons are freed and silver ions become

mobile so that silver atoms and larger aggregates may be formed. Hence, for a given exposure, measured by the product of intensity and time, irrespective of the intensity, the electrons involved in the formation of sub-image will be at a relatively high concentration, and the nucleation stage in the formation of latent image centers will be efficient. The situation resembles that prevailing during a high intensity exposure; hence an exposure at low temperature at any intensity will give a relatively large number of small latent image centers along with undevelopable sub-image particles.

Reciprocity Failure

It will be observed that the efficiency of a given exposure, $I \times t$, where I is the intensity and t the duration of the exposure, in producing photographic effect, that is, in producing latent image, depends on the intensity of the radiation. This relationship occupies an important place in photography, both theoretically and practically, under the designation of *Reciprocity Failure*; that is, the failure to achieve a given photographic image density by reciprocal adjustment of intensity and exposure time, all other parameters remaining constant. At low intensities and correspondingly long exposure times reciprocity failure originates in inefficiency of formation of sub-image centers which serve as nucleating agents for the further growth of the silver particle to developable size. High intensity reciprocity failure arises from high dispersion throughout the volume of the grain of the reduced silver centers formed by exposure, which can include a fraction present as undevelopable centers, originating in dispersal of the electrons liberated by the exposure among a large number of competing nucleating centers.

Reciprocity failure will be a recurrent theme in the subsequent development of the theory of latent image formation. The sensitometric aspects of the phenomenon are discussed in the section on "Photographic Exposure Effects on the Latent Image" at the end of this chapter.

THE IDEAL SILVER HALIDE CRYSTAL

The predominance of the silver halides among photochemical light-sensitive systems for the recording of information originates in the peculiarities of behavior of ionic and photoelectronic charge carriers in these crystals and in the next sections we shall outline our present knowledge of the scene and actors in the primary photographic process.

Silver chloride and silver bromide have the same type of ionic structure as sodium chloride crystals; the silver ions and halide ions are arranged alternately in a cubic lattice, the ions of one sign being distributed over a face-centered cube. Each ion is surrounded by six of the other kind. The lattice parameter, that is, the distance between like ions on the cube face, is 5.55Å for the chloride and 5.77Å for the bromide. Mixed crystals

of silver chloride and silver bromide can be prepared in all proportions, the lattice parameter increasing linearly with the content of bromide. At temperatures below 147°C silver iodide is dimorphous, existing as hexagonal crystals with a lattice of the wurtzite type and as metastable cubic crystals with a lattice of the zinc blende type. In both crystal types each ion is surrounded tetrahedrally by four of the other ions. Above 147°C silver iodide undergoes a change in phase to a structure in which the iodide ions are in a body-centered cubic lattice and the silver ions are disordered throughout the structure.

Iodide ions can be incorporated in solid solution in silver bromide only to a limited degree. The maximum amount of iodide in mixed crystals of silver iodobromide in equilibrium depends on the temperature according to the equation I_{max} (in mole %) = 31.2 + 0.165 $(t-25)$, where t is the temperature in °C.[17] Only up to about 10% of iodide can be present in equilibrium in mixed crystals of silver iodochloride. The mixed crystals of silver iodobromide are cubic, with a lattice parameter increasing with the iodide content.[18]

THE REAL SILVER HALIDE CRYSTAL AND ITS DEFECT STRUCTURE

A crystal with a perfectly regular lattice structure is an idealization. Any real crystal contains defects in the regularity of its lattice and foreign impurities which determine much of its dynamic physical and chemical behavior.

Point Defects

One class of defect in an ionic crystal consists of a missing ion at a lattice site or an additional ion at an interstitial site, that is, at a site between the regular lattice sites. In silver chloride and silver bromide the point defects are introduced by the removal of a silver ion from a lattice site, leaving a silver ion vacancy at the lattice site, as shown in Fig. 3-2. Since the crystal as a whole is electrically neutral, the charge on any lattice ion must be compensated by the opposite charges of the surrounding ions, so that the lattice ions may be regarded as electrically neutral. The removal of a lattice cation into an interstitial position leaves excess negative charge at the lattice vacancy and places a compensating positive charge at the interstitial site. The positively charged interstitial ion and the negatively charged cationic vacancy are called *Frenkel defects*, after the person who first proposed them. Another type of defect, called the *Schottky defect*, consists of vacancies in both the cationic and the ionic lattices. Schottky defects predominate in alkali halide crystals, but do not occur, except possibly near the melting point, in silver halide crystals in thermal equilibrium.

Energy is required in the formation of these defects, but the increase in entropy introduced by the disorder causes them to be spontaneously formed in the perfect

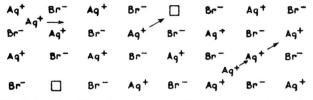

Fig. 3-2. Interstitial silver ions and silver ion vacancies in the crystal lattice of silver bromide.

crystal at temperatures above absolute zero, the energy being derived from the thermal vibrational motion of the lattice ions. At room temperature and at temperatures considerably above room temperature, the cohesive forces holding the lattice ions together are too great to permit translational motion of the lattice ions, whose motion is limited to oscillations about their equilibrium positions. A lattice silver ion can, however, move relatively easily into a neighboring cationic vacancy, or an interstitial ion can push a lattice silver ion into a new interstitial site, as indicated by the arrows in the diagram of Fig. 3-2. One of the physical manifestations of these ionic motions is the existence of a temperature-dependent electrolytic conductivity, which turns out to be of great importance for the photographic process. This conductivity is sometimes called the dark conductivity of the silver halides, in contra-distinction to photoconductivity, observed only on exposure of the crystal to light. The value of the transport number for the ionic conductivity shows that only the motion of silver ions, and not that of bromide ions, contributes to the electrolytic current,[19] consistent with the conclusion that the defects in silver halide crystals are of the Frenkel type. At temperatures above room temperature the conductivity, σ, of purified crystals of silver bromide increases with temperature, T, with a close approximation according to the exponential equation

$$\sigma = A\,e^{-E/kT} \qquad (2)$$

where $A = 1.8 \times 10^5 / \Omega$ cm, $E = 0.79$ eV and k is the Boltzmann constant, 8.62×10^{-5} eV/(°K-mol) (Fig. 3-3). Below room temperature the conductivity is greater than that calculated from Eq. (2) and depends on the purity of the sample. At low temperatures the conductivity is determined by impurity ions which in that range outnumber the intrinsic interstitial ions and vacancies; at higher temperatures the conductivity is determined by the interstitial silver ions and the vacancies, which then outnumber the impurity ions.

The magnitude of the intrinsic ionic conductivity depends on the energy of formation of the Frenkel defects, E_F, and on the energy that must be supplied to move the defects through the lattice, U_i and U_v for the interstitial ions and cationic vacancies, respectively. The exponential term in Eq. (2) contains these energy parameters, the theoretical expression for the conductivity being

$$\sigma = (K/T)e^{-(E_F/2kT)} \cdot [e^{-U_i/kT} + e^{-U_v/kT}] \qquad (3)$$

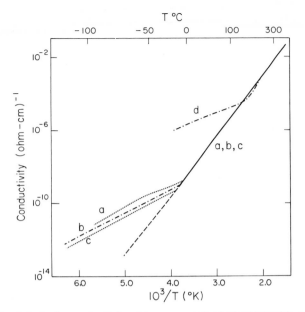

Fig. 3-3. Ionic conductivity of large crystals of silver bromide as a function of temperature. Curves a, b and c are for nominally pure crystals evidently containing different amounts of divalent impurity. The impurity determines the conductivity in the "extrinsic region," which, for these crystals, begins somewhat below room temperature. Curve d is for a sample containing 0.028 mole% of $CdBr_2$ added to the silver bromide. Note the slight decrease in conductivity caused by the Cd^{2+} at temperatures above that at which the large increase begins to appear.

where K is a constant.* The energy constants cannot be evaluated separately from the temperature variation of conductivity of pure silver bromide but, as is indicated later in this discussion, the migration energies can be found from the temperature-dependence of the conductivity of silver halides containing divalent impurities and the impurity content. These being known, the energy of formation of the defect pair can be found from Eq. (3). The energy parameters for the electrolytic

*The intrinsic electrical conductivity of the crystal depends on the number, charge and mobility of the interstitial ions and vacancies. The expression for the mobility as a function of temperature contains pre-exponential parameters including the vibration frequencies of the charge carriers and the lattice parameter of the crystal, the values of which are not greatly different for the interstitial ions and the vacancies. To a good approximation they can therefore be included in the constant K of Eq. (3) along with pre-exponential terms related to the number of carriers.[19a]

conductivity of large crystals of silver halides are summarized in Table 3-1. The first value in each column is calculated on the assumption of no association between the oppositely charged Cd^{2+} ions and the silver ion vacancies, the second is corrected for the effects of association, since the associated pairs form neutral defects that do not contribute to the conductivity. As Table 3-1 shows, a relatively large energy is required to form an interstitial ion and the corresponding vacancy, while the activation energies for migration are similar to those for diffusion in liquid solution. The activation energy for motion of interstitial ions is less than for that of the vacancies, hence the electrical mobility and the diffusion rate of interstitial ions is considerably greater than those of the vacancies. The contribution of the vacancies to the conductivity is small, and Eq. (3) practically reduces to Eq. (2), except for the slowly varying dependence of the pre-exponential factor on $1/T$, with $E = \frac{1}{2} E_f + U_i$. This does not imply that the motion of vacancies, though slower than that of the interstitial ions, is insignificant in the photographic process; on the contrary, it will turn out that the migration of both types of defect is important.

In equilibrium, the concentrations of interstitial ions and of silver ion vacancies are determined by a relation of the same form as that for a solubility product,

$$c_i c_v = K = \text{constant } e^{-E_F/kT} \tag{4}$$

where c_i and c_v are the concentrations of interstitial ions and vacancies, respectively, and K is a constant at a given temperature. Strictly, the energy of formation of the Frenkel pairs should be replaced by the free energy of formation, but since the thermal entropy change in forming the defects from the lattice is small, as is the volume change, the E_F term in the exponential is adequate for calculating the order of magnitude of the defect concentration. For relatively large crystals of silver bromide[21]

$$K = 3.1 \times 10^5 e^{-1.22 eV/kT} \quad \text{(mol fraction)}^2 \tag{5}$$

In pure silver bromide the concentration of the interstitial ions is the same as that of the vacancies. The value of kT at $300°$ K is 0.026 eV, hence, in thermal equilibrium at $300°$ K the concentration, in mole fraction, of each of the defects is $(3.1 \times 10^5 e^{-47})^{1/2} = 4 \times 10^{-8}$. Of each mole of silver ions in the crystal, the fraction 4×10^{-8} is present as interstitial ions and the same fraction as vacancies. Since the molar volume of AgBr at

TABLE 3-1. ACTIVATION ENERGIES FOR FRENKEL DEFECTS IN SILVER HALIDES.[20]

	Energy of Formation, E_F		Energy of Interstitial Motion, U_i		Energy of Vacancy Motion, U_v	
	kcal/mol	eV	kcal/mol	eV	kcal/mol	eV
AgCl	38.9, 32.9	1.68, 1.42 1.44[a]	3.4, 3.2	0.15, 0.14	7.7, 8.6	0.33, 0.37
AgBr	29.2, 25.9	1.27, 1.07	3.4, 2.6	0.15, 0.11	8.3, 5.5	0.35, 0.24

[a]H. Abink and D. Martin, Jr., *J. Phys. Chem. Solids,* **27**: 205 (1966).

$300°$K is 29.5 cm^3, the number of interstitial ions in large crystals of AgBr is $(4 \times 10^{-8} \times 6.02 \times 10^{23})/29.5/\text{cm}^3 = 8 \times 10^{14}/\text{cm}^3$. At room temperature, then, large crystals of pure silver bromide contain between 10^{14} and 10^{15} interstitial silver ions and siver ion vacancies per cm^3.

The mobility of the ionic charge carriers in large crystals of silver bromide at room temperature, that is, the rate of drift of the carriers in, or opposite to the direction of an electric field, of unit strength, 1 V/cm, according as the charge is + or –, is 4×10^{-3} cm^2/V-sec for the interstitial ions and 6×10^{-4} cm^2/V-sec for the cationic vacancies.[22]

The values of dark conductivity and of ionic mobilities just discussed are derived from measurements of conductivity on crystals very much larger than the microcrystals of photographic emulsions. In general, the surface of a crystal represents a state different from the volume, and the very large ratio of surface to volume for emulsion grains raises the question to what extent information derived from measurements on bulk material will apply to microscopic crystals. Early observations indicated values of the dark conductivity of compacted powders of silver bromide several hundred times greater than that of large crystals. The clearest information on the electrolytic conductivity of emulsion grains is derived form Hamilton and Brady's observations on the rate of decay of an applied electric field pulse in the grains.[23,24] Analysis of the decay curves, which depend on the ionic conductivity, showed that emulsion grains were about 100 times as conductive as large crystals. That the high conductivity was caused by the motion of silver ions in or near the surface was shown by the fact that an adsorbed layer of a compound such as phenylmercaptotetrazole, that complexes strongly with silver ions, reduced the ionic conductivity of emulsion grains to values approaching that of large crystals. Emulsion grains, in spite of the fairly small number of interstitial ions and vacancies indicated by Eq. (5) in their small volume of, say, 10^{-13} cm^3, do not suffer from any deficiency of mobile silver ions.

Impurity Defects

Large effects on the physical, chemical and photochemical properties of crystals are often caused by the introduction of small amounts of foreign atomic or ionic impurities. Cationic impurities can be introduced, usually in limited quantities, as substitutions for silver ions in the silver halide lattice, and similarly limited amounts of anionic impurities, such as S^{2-}, may probably substitute for Br$^-$ in the lattice. A type of impurity defect that can greatly influence the concentration of interstitial silver ions and vacancies is a substitutional divalent cation, such as Cd^{2+} or Pb^{2+}. The foreign ion can be introduced by fusing a small quantity of CdBr$_2$ or PbBr$_2$ with the silver bromide, but there is evidence that the most carefully purified silver halides contain

divalent cations, and emulsion grains which, from their mode of formation, are probably less pure than the most carefully purified large crystals, probably contain divalent ion and other foreign ion impurities.

If a Cd^{2+} is substituted for a Ag^+ in the lattice, the double positive charge can no longer be neutralized by the surrounding bromide ions, so that the impurity site bears an effective positive charge of unity. Since the crystal as a whole is neutral, some adjustment must be made in the neighborhood of the Cd^{2+}; in the silver halides the adjustment consists in the appearance of a silver ion vacancy, which bears an effective unit negative charge, the vacancy being generated, for example, by migration of a lattice silver ion to the surface, as in Fig. 3-4. A silver ion vacancy is created for each substitutional divalent cation introduced. The equilibrium condition of Eq. (4) persists, and a reduction of the concentration of interstitial ions must take place. If the concentration of Cd^{2+} present as substitutional impurity is 10^{-3} mol %, the mole fraction of vacancies is increased from its value about 10^{-8} in the pure crystal to 10^{-5}, and that of interstitial ions reduced to 10^{-10}, at room temperature. The total number of mobile defects is greatly increased and, although the mobility of the vacancy is less than that of the interstitial ion, the net result is a relatively great increase in dark conductivity after some fall at very low concentrations of the divalent ion reflecting the smaller mobility of the vacancy. At sufficiently high concentration of divalent impurity, practically all the ionic conductivity originates in the motion of vacancies. As the temperature of a crystal containing such quantities of divalent impurity is raised, only the mobility and not the number of charge carriers is increased and the energy of migration of the vacancies can be calculated from the slope of the log conductivity versus $1/T$ curve. The ionic mobilities in Table 3-1 were deduced in this way.

At low temperatures, starting about room temperature for purified silver bromide, the unavoidable divalent impurities determine the value of the conductivity, hence the bends in the curves in Fig. 3-3 in the so-called "structure-sensitive" or "extrinsic" temperature region. If divalent ions are intentionally added, the deviations

Fig. 3-4 Effect of substituting a divalent cation for a silver ion in the silver bromide lattice. The additional positive charge is compensated for by the appearance of a cationic vacancy for every divalent ion in the crystal.

from the "intrinsic" part of the curve set in at higher temperatures then for nominally pure material.

Traces of impurity can have large effects on the photochemical sensitivity of silver halides. Divalent impurities like Cd^{2+} or Pb^{2+} can affect sensitivity by their effect on ionic motion. Since silver ions must move in forming particles of silver atoms, the photolytic sensitivity of cadmiated silver bromide is reduced from its value in pure crystals.[25,26] Other impurities, such as Cu^+ or Fe^{2+} substituted for Ag^+ in the lattice (the latter also exerting the effect of a divalent impurity) can affect sensitivity because of their chemical tendency to lose electrons with an increase in valence, with effects on electronic motion within the crystal.

Dislocations

Besides point defects in the crystal lattice, extended defects have a marked effect on the mechanical and physicochemical properties of crystals. Dislocations constitute an important class of linear defects in the crystal structure. An edge dislocation is illustrated diagrammatically in Fig. 3-5. A crystal is assumed to be subjected to a shearing stress from the left, as indicated by the arrow. Slip occurs along the dotted horizontal plane and the atoms in the upper part of the crystal are displaced in the direction of the stress, in this illustration by one lattice spacing. The effect of the displacement is to introduce an extra vertical half plane of atoms, terminating at the slip plane D. The edge of the incomplete plane, which is perpendicular to the direction of slip, is the dislocation line, or simply, the dislocation.

Near a dislocation the crystal is strained. The ions above the dislocation are in a state of compression, those below in a state of tension. Chemical activity tends to be increased at dislocations; for example, the points of emergence of edge dislocations at the surface

Fig. 3-5. An edge dislocation in a crystal. J is a jog in the dislocation line.

of a crystal can often be located by preferential etching about these points of the crystal in a suitable solvent. Impurity atoms and ions, especially if they differ much in dimensions from the crystal ions, tend to segregate at dislocations.

Figure 3-5 illustrates a "jog" in a dislocation line, i.e., a site at which the line passes from one slip plane to a parallel slip plane below, or above. If the terminal ion at the jog of the lowest row of ions in the extra plane is a silver ion, it behaves toward charges in the crystal some little distance away as if it had an effective charge of $+\frac{1}{2}$ elementary charges, and similarly a bromide ion at a jog has an effective charge of $-\frac{1}{2}$ elementary charges.[27] Such sites might trap electrons and their positively charged electronic counterpart, positive holes, and participate in the initiation of latent image.

Jogs on dislocation lines can be sources of interstitial silver ions and silver ion vacancies. A silver ion at a jog site can more readily move into the lattice as an interstitial ion than a regular lattice ion, since, after motion begins, the restoring force tending to move it back arises from the electrostatic attraction of the $-\frac{1}{2}$ elementary charge on the bromide ion of the new incipient jog site, whereas the restoring force acting on a displaced lattice silver ion is the whole elementary negative charge. Similarly a silver ion vacancy can readily be formed by the jumping of a lattice silver ion just below a bromide ion jog site into the empty site in the dislocation line adjacent to a terminal bromide ion.

Corresponding to the jog on a dislocation line in the interior of the crystal is a kink on a step or terrace in the surface, as illustrated diagrammatically.

$$
\begin{array}{l}
+ \; - \; + \; - \; , \qquad\qquad - \; + \; - \; + \\
- \; + \; - \; + \; - \; + \; - \; + \longrightarrow - \; + \; - \; + \; - \qquad - \; + \\
\qquad\qquad\qquad\qquad\qquad\qquad + \\
+ \; - \; + \; - \; + \; - \qquad\qquad + \; - \; + \; - \; + \; -
\end{array}
$$

The edge of the step runs perpendicularly to the plane of the paper. As for a jog in a dislocation, a silver ion at a kink site bears an effective charge of $+\frac{1}{2}$ elementary charge, and a bromide ion $-\frac{1}{2}$ elementary charge. Such sites therefore act as sources for interstitial ions and silver ion vacancies, as illustrated in the diagram.

As was clearly shown by Hedges and Mitchell,[28] dislocations contain favored sites for silver formation in silver halide crystals exposed to light. These authors introduced a model photographic system consisting of relatively large sheet crystals of carefully purified silver bromide made from the melt; the sheet thickness was about 0.1 mm. Microscopic examination of the crystals after exposure at print-out levels showed that the photolytic silver in partially annealed crystals appeared internally in a roughly hexagonal pattern corresponding to the network of dislocations in the crystal. The photolytic silver had "decorated" the dislocations and revealed their pattern. Similar observations at latent image levels of exposure showed that developed silver particles were also concentrated along the disloca-

tions, indicating that latent image centers had formed preferentially at sites in the dislocations.

The presence of dislocations in emulsion grains has been inferred by Berry[29] from x-ray diffraction and directly observed by transmission electron microscopy by Hamilton.[30] Not all emulsion grains contain dislocations but some contain five to ten, and a correlation exists between the amount of internal latent image and the number of dislocations per grain.[29] Surface latent image was found in grains containing no dislocations. In iodobromide grains nonuniformities in iodide concentration may lead to strains likely to produce dislocations.[31]

Twinning

Berriman and Herz[32] drew attention to the occurrence of twinned crystallites in emulsion grains and their possible significance as sites of localized chemical activity. A twinned crystal is a structure in which two or more crystals are joined together in definite mutual orientation about one or more common crystallographic planes, called the plane(s) of twinning. In silver bromide, twinning takes place on an octahedral plane, and double twinning may occur on two parallel octahedral planes.[30,33,34] A twin is formed on an octahedral face when a new layer is added during growth with the ions in positions misplaced with respect to those in the parallel layer two lattice spacings away, with a consequent reversal in the stacking sequence in the layers subsequently added. After some layers of the twin have been added, the stacking may be reversed again to the original mode, and the crystal is doubly twinned on octahedral planes. A three-layered crystal is formed in which the two outer layers are in the same orientation, while the inner layer, usually thinner, has an orientation rotated by 180° about an axis normal to the twinning planes. A re-entrant trough is formed on the periphery of the crystals which facilitates rapid tabular growth parallel to the twinning planes.

The connection between twinning and dislocations was elucidated by Hamilton.[30] It was shown that the dislocations were charged (jog sites), and photolytic silver was formed at sites in the dislocations. But photolytic silver was also formed with a layer structure parallel to the twinning planes away from dislocations. Hamilton suggests that high concentrations of interstitial silver ions formed near the twin planes facilitate the initiation of silver build-up.

INTRINSIC ELECTRICAL DOUBLE LAYERS AT SILVER HALIDE SURFACES

In the interior of a silver bromide crystal, interstitial silver ions and silver ion vacancies are formed simultaneously and only the energy of formation of the defect pair can be evaluated from analysis of the temperature variation of the ionic conductivity. We have seen, however, that point defects can be generated in-

dependently at kink sites in the surface and at jog sites on dislocations, and Frenkel[35] pointed out that in general positive and negative point defects could arise independently at the surface of an ionic crystal. A lattice silver ion at the surface can jump to a site on top of the original surface, leaving a vacancy in the surface which may migrate into the interior. The energy required to create a vacancy in the interior by this process can be defined as the energy of formation of the vacancy. Lattice silver ions at the surface may migrate into the interior leaving a vacancy at the surface. The energy required to cause the surface silver ion to leave the surface so that it can migrate freely in the interior can be defined as the energy of formation of the interstitial ion. These processes of forming point defects in the interior of the crystal are quite independent of each other, and the energies necessary for the formation of the defects of opposite charge are not necessarily equal. Their sum is the energy of formation of the defect pair as tabulated in Table 3-1. Several theoretical studies of the effects of the independent formation of point defects in ionic crystals have recently been made.[36-39]

If the free energy of formation of the interstitial ion is less than that of the cationic vacancy, interstitial ions will migrate from the surface into the interior of the crystal, leaving the surface negatively charged and forming a diffuse positive space charge under the surface. This process will continue until electrochemical equilibrium is attained, when the effect of the electrical field generated by the separation of charge balances the thermodynamic tendency for the process to occur. Similarly, if the free energy of formation of the cationic vacancy is less than that of the interstitial cation, an equilibrium double layer of charge will be generated at the surface, positive at the surface and negative within. Similar space charge fields will be set up around dislocations in ionic crystals.

Experimental evidence for space charge fields about dislocations in large crystals of silver chloride has been obtained.[40] Pulsed indentations were made on the surface which cause charged dislocations to move away from the surface, and the sign of the charge on the dislocations can be deduced from the change in potential of an electrode on the other side of the crystal. At temperatures above about 60°C the dislocations were positively charged, indicating that in silver chloride the free energy of formation of the vacancies is less than that of the interstitial ions. The free energy of formation of the vacancies in silver chloride was estimated to be 0.58 eV; hence, since the free energy of pair formation is 1.44 eV, the free energy of formation of the interstitial ion in silver chloride is 0.86 eV.

The existence of a potential difference between the surface and the interior of silver bromide crystals about 0.1-mm thick has been shown by the study of the distribution of latent image near the surface.[41,42] The crystal was exposed in the presence of an electric field strong enough to displace the photoelectrons formed at and near the exposed surface completely across the crystal to the opposite surface. On development of the resulting latent image, it was found that practically none of the electrons reached the rear surface but that they were concentrated

in a thin layer immediately below that surface. The surface seemed to be negatively charged, with a counterbalancing positive space charge below. The inference is that silver ions migrate preferentially from the surface of silver bromide into the interior, forming a positive space charge, and leaving an excess of negatively charged vacancies at the surface. The free energy of formation of interstitial silver ions in silver bromide at room temperature therefore appears to be less than that of the vacancies. The results are consistent with Hamilton's observations of high ionic conductivity of emulsion grains near the surface.[23,24]

From studies of the x-ray diffraction of silver bromide crystallites, Berry and Skillman concluded that the concentration of interstitial silver ions just under octahedral surfaces of silver bromide was greater than under cubic surfaces.[43] This observation, along with Hamilton's evidence for large concentrations of mobile silver ions near the twin boundaries of tabular crystals of octahedral habit,[30] suggests that octahedral silver bromide emulsion grains may contain relatively more mobile silver ions than cubic grains, with some consequent differences in photographic behavior of these two classes of grains.

The small thickness of emulsion grains may interfere with the full development of the surface potential to the values observed in large crystals (approximately 20,000 V/cm at the surface of sheet crystals of silver bromide), but a strong electric field tending to displace positive charges in the crystal to the surface and negative charges formed at or near the surface into the interior is nevertheless probably present. This field can have important photographic consequences, as will be discussed in connection with the formation of the latent image.

THE ACTION OF LIGHT ON SILVER HALIDES— THE ABSORPTION SPECTRUM

The underlying factor controlling the chemical or physical effects of light in matter is the absorption spectrum of the material. It does not necessarily follow that the variation of photochemical or photophysical sensitivity with wavelength will follow the variation of absorption, since the efficiency of utilization of the absorbed energy is not necessarily the same at all wavelengths; part may be degenerated as heat. Nevertheless only absorbed light can cause a physical or chemical change and the absorption spectrum of a substance is therefore a fundamental characteristic in determining these changes.

The absorption spectra of silver halide crystals are discussed in Chapter 4, in connection with the spectral distribution of photographic sensitivity of emulsions, which actually does run approximately parallel with the absorption spectra. Figure 4.1 (p. 74) shows the absorption spectra of silver chloride and silver bromide at room temperature as measured on large crystals. Starting with low values of the absorption coefficient at about wavelength 500 nm, the absorption of the bromide increases through the blue and violet spectral regions, becoming intense in the ultraviolet. Silver chloride begins to

absorb at shorter wavelengths than the bromide, absorption being very low at wavelengths longer than about 430 nm, whereas iodobromide crystals continue to absorb to wavelengths somewhat longer than does the bromide. There is no sharp cut-off in absorption, but for practical photographic purposes silver bromide emulsions are insensitive to wavelengths longer than about 490 nm; the practical limit for iodobromide emulsions containing about 3% iodide is about 520 nm, increasing slightly with increasing iodide content, and for chloride emulsions the limit is about 420 nm. Thick crystals of silver bromide exhibit photophysical and photochemical sensitivity to considerably longer wavelengths than emulsion grains; for example to the green mercury line of wavelength 546 nm.

As the temperature is lowered, absorption decreases in the long wavelength tail of the absorption band and more or less sharp peaks appear at shorter wavelengths. A doublet structure appears in some bands very similar in quantum energy separation to the doublet structure of the ground state of the free halogen atom. This suggests that the excitation process accompanying absorption in these bands involves an electron closely associated with the halogen atom.

An interesting relation between the intensity of absorption in the long wavelength tail of the absorption band of silver bromide, the wavelength or frequency, and the temperature was found by Urbach.[44,45] The absorption coefficient is proportional to $e^{-h\nu/kT}$, where ν is the frequency of absorption and therefore $h\nu$ is the photon energy of the absorbed light, T is the absolute temperature and k is Boltzmann's constant. A plot of the logarithm to the base e of the absorption coefficient against the photon energy is linear with a slope of $-1/kT$. The relationship, now called Urbach's Rule, has been found to apply to the absorption edge of many semiconductors.

Excitation Processes in Silver Halides

The absorption of electromagnetic radiation by matter can be understood in terms of the concepts that radiation consists of quanta of energy of magnitude $h\nu$, (where ν is the frequency of the radiation and h is Planck's constant), whose motion is governed by a wave equation. The particle aspect of radiation is emphasized in the term "photon" for the quantum. In absorption of radiation by matter, the photon disappears, and its energy appears as a state of higher energy of the atoms or molecules of the matter. The excitation process induced by the absorption of visible and ultraviolet radiation involves an increase in the potential and kinetic energy of electrons in the atoms or molecules. Sufficiently energetic photons may liberate an electron completely from the atom, while less energetic photons increase the electronic energy without expelling an electron from the atom.

The excitation processes in silver halide crystals induced by light absorption can be described by means of the simplified energy diagram of Fig. 3-6. The zero of energy is taken as that of an electron in vacuum. An

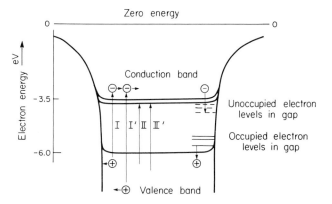

Fig. 3-6. Electronic energy levels in the silver bromide crystal.

electron in the crystal is retained under the influence of binding forces within the potential walls representing the boundaries of the crystal, hence all energies of electrons in the crystal are negative. The more negative the energy, the more tightly bound is the electron in the crystal. The most loosely bound, and therefore most readily excited electrons in silver bromide are the 4p electrons of the bromide ions. In the dark, at room temperature and to moderate temperatures above, the crystal is in its lowest electronic state, the highest energy levels of which are those of the valence electrons of the bromide ions. The outer electrons of the silver ions and the electrons of the inner shells of both ions are in lower levels than the bromide valence electrons and thus do not appear in the diagram.

In an isolated bromide ion in its lowest electronic state the energy of a single valence electron has a specific discrete value, but in the crystal the overlap of electronic orbitals of the closely packed ions causes the levels occupiable by a single electron to spread into a practically continuous band containing as many levels as there are bromide ions in the crystal. This band is called the valence band of energy levels. An electron in the valence band cannot be regarded as associated with any one bromine nucleus, but belongs to the crystal as a whole, in which it moves in the potential field determined by the periodic arrangement of the ions.

In the lowest electronic state, or ground state of the crystal, all the levels of the valence band are occupied by electrons. Although the electrons are not localized, no electronic conductivity is possible, since to maintain the constant electronic energy of the ground state, any increase in momentum of an electron under the action of an applied electric field must be balanced by an equal change in the opposite direction. The crystal in its ground state is therefore an insulator.

In the isolated ion there would be a discrete excited energy level separated from the ground level by an energy gap. Similarly in the crystal there is an excited state derived from energy levels separated by a gap from the valence band, broadened into a practically continuous band. By the absorption of radiation of appropriate frequency an electron may be excited from the valence band into the excited band. Again the electrons are not associated with any single atomic nucleus. But at the light

intensities available, not more than a few of the excited levels will be occupied by electrons, and in an electric field an electron can gain momentum and energy, moving upwards in the excited band, without necessitating any counterbalancing change, that is, the crystal in the excited state becomes an electrical conductor. The excited band of energy levels is therefore called the conduction band. Absorption of visible or ultraviolet light by silver halides induces electronic photoconductivity.

The energy scheme of the ideal crystal consists therefore of the valence band and the conduction band separated by an energy gap representing states that electrons in the perfect crystal are unable to assume. The defects, however, in the real crystal may possess electronic energy levels in the gap. Since the defect concentration is low, these levels will be single, distributed through energy values in the gap, or, at most, comprise narrow bands of discrete levels. The surface itself differs from the regular lattice in the interior; bromide ions in the surface will be expected to lose electrons more readily than in the interior, and bromide ions at kink sites or the points of emergence of dislocations, still more readily. Easily oxidizable ions, such as Cu^+ or Fe^{2+}, will lose electrons more readily than the bromide ions in the valence band, and hence will possess occupied energy levels in the gap. Occupied energy levels in the gap are indicated by short full lines in Fig. 3-6. Unoccupied electronic levels, indicated by dotted lines in the figure, may also be present in the gap.

The absorption of a photon may excite an electron from a level in the valence band to one in the conduction band, when the electron is now free to move throughout the crystal. Two such transitions are denoted as I and I' in Fig. 3-6. Transition I, from a high level in the valence band, corresponding to absorption in the long wavelength edge of the absorption band, is of low intensity. It is referred to as an indirect transition, from a circumstance depending on the nature of the electronic levels in the valence band whereby such an electronic transition can occur only with the simultaneous absorption or emission of energy in the form of phonons, the quantized cooperative lattice vibrations in the crystal. Transition I', relatively intense, and excited by ultraviolet radiation, is permitted as a purely electronic transition, and is referred to as a *direct transition*. For further information on the nature of the absorption spectra of silver halides, reference may be made to books such as F. C. Brown, *The Physics of Solids*, Benjamin, New York, 1967, or R. S. Knox, *Theory of Excitons*, Academic Press, New York, 1963.

After the excitation of an electron into the conduction band, the valence band contains an unoccupied electronic level, which is equivalent to a nonlocalized positive charge of magnitude equal to the electronic charge. In the English language literature this nonlocalized charge is called a *positive hole*, but the German term, translated as "defect electron," is also illuminating with respect to its origin.

From the chemical point of view, the positive hole can be thought of as a bromine atom dissolved in the silver halide crystal. Because of the overlap of the electronic

orbitals of neighboring bromide ions, such a bromine atom cannot remain localized; an electron from a neighboring bromide ion very rapidly jumps into the atom, and in this way, by purely electronic motion and without any motion of a bromine nucleus, the "bromine atom" moves rapidly through the crystal, carrying with it an elementary positive charge. The charge can be thought of as the effect of the positive ionic charges surrounding the "hole," which are now uncompensated after the removal of the excited electron into a distant part of the crystal.

Since the levels of the valence band are not completely occupied by electrons after the formation of the hole, the application of an electric field can cause the hole to change its momentum and energy without necessitating a counterbalancing change, that is, the moving hole can yield an electric current. The excited state of the crystal induced by transitions from the valence band to the conduction band is therefore photoconductive both from the motion of free electrons and free holes, the relative contributions of the two carriers depending on their lifetimes in the free state and their mobilities. We shall find later that the photoelectrons make by far the greater contribution to the photoconductivity of silver halides as normally observed, but we shall also find that the motion of the holes is of great importance with respect to the formation of latent image.

In transitions II of Fig. 3-6 an electron is excited from a level in the valence band to a state in which it is not completely free from the attraction of the hole. The resulting state of excitation is called an *exciton*. Like the transitions from valence band to conduction band, exciton transitions may be indirect, II, or direct, II'. The state of excitation represented by the exciton also migrates rapidly through the crystal by energy exchange between the ionic sites in the crystal. Since the electron and hole in the exciton are bound by Coulombic forces much as are the electron and proton in the hydrogen atom, the exciton state is not photoconductive. It is analogous to an excited state in an isolated molecule, in contrast to an electronically dissociated state. The energy required to dissociate the exciton to a free electron and a free hole is small, and at room temperature, dissociation to the free charge carriers seems to occur readily by thermal agitation.

Approximately one free electron is produced in silver halide crystals per quantum absorbed throughout the absorption band of the halide in the visible and near ultraviolet regions.[46-49] The absorption spectrum of the halides apparently include transitions to the conduction band or, if excitons are produced, they are efficiently dissociated. The quantum yield of hole production in silver bromide at room temperature is also about unity, though somewhat smaller than that of the electrons.[49] In explanation of the discrepancy between the quantum yields of electrons and holes, it has been suggested that some of the absorption transitions involve generation of an exciton that dissociates to a free electron and an immobile hole.[49]

The energy value of the top of the valence band of an ionic crystal with reference to the zero level can be determined from a measurement of the long wavelength threshold for the photo-emission of an electron from the crystal into vacuum, since the energy in the threshold quantum represents the minimum energy required to eject an electron from near the surface of the crystal into vacuum. Actually, at temperatures above absolute zero, neither the highest level of the valence band nor the lowest level of the conduction band are precisely fixed, but the experimental threshold of the external photoelectric effect gives the effective top of the valence band of silver bromide as about 6 eV below zero.[50] If the quantum energy for the practical long wavelength limit of photographic sensitivity of silver bromide, namely 2.5 eV, is taken as a measure of the energy difference between the highest level of the valence band and the lowest level of the conduction band, the bottom of the conduction band is 6 – 2.5 = 3.5 eV below the zero level.

LIFETIMES AND MOBILITIES OF ELECTRONIC CHARGE CARRIERS—TRAPS

We may now inquire as to the fate of free electrons and free holes produced in silver halides by the absorption of radiation. Excited states of matter can persist for only a relatively short time. If no other process intervenes, an electronically excited state generated by relatively strong absorption of radiation will revert to the ground state, with the emission of the excitation energy as fluorescence, in a period of the orders of 10^{-9} to 10^{-6} sec, the shorter time being associated with the higher intensity of the absorption process. In ionic crystals, deactivation of electronically excited states occurs much more rapidly by radiationless processes than by emission of light and, although fluorescence is observed under some conditions in silver halides, it is not the result of a simple recombination of free electrons with free holes. In any case, unless some other process interferes, recombination of the holes and electrons in an excited crystal will occur in some way, and the absorption of radiation will have no permanent effect on the crystal.

As already discussed, there may be occupied and unoccupied electronic levels in the energy gap. In Fig. 3-6 localized occupied electron levels are depicted above the valence band. If a free hole approaches the site of such a level, a certain probability exists that the electron may drop down in energy to fill the hole, generating a lattice bromide ion, and the positive charge of the hole is represented by the now vacant localized intergap level. For example, if the intergap level was a substitutional Cu^+ in the silver halide lattice, the exothermal passage of an electron from the Cu^+ to the hole would generate a lattice bromide ion and a Cu^{2+} ion. The Cu^{2+} in the lattice has an effective charge of +1 elementary charge, which takes the place of the charge of the originally free hole. The charge of the hole is now located at a fixed site—the originally free hole has been trapped.

Occupied electron levels in the energy gap may therefore act as hole traps, and the unoccupied level left after the transfer of the electron from the intergap level constitutes a trapped hole. A trapped hole is of lower

energy than a free hole, since energy is evolved in the trapping process, hence the direction of increasing hole energy in Fig. 3-6 is opposite to that of increasing electron energy.

In a similar way, vacant electronic levels in the energy gap may act as traps for free electrons, since energy will be evolved if an electron in the conduction band falls into the localized level. For example, as has been already discussed, a silver ion at a jog in a dislocation or at a kink in a surface terrace, because of its $+\frac{1}{2}$ elementary charge, exerts a Coulomb attraction for an electron and therefore constitutes a localized vacant electronic level which can trap a free electron. Similarly a bromide ion at a jog or kink, because of its $-\frac{1}{2}$ charge can attract a hole and trap it by the exothermal transfer of an electron.

Trapping and untrapping are reversible processes. If the energy required to eject an electron or hole from the trap is only a small multiple of the average thermal energy of an ion, that is, only a small multiple of kT, trapping and detrapping will occur at comparable rates and the trap is shallow. At room temperature the value of kT is about 0.026 eV, whereas at 90° K, kT is 0.0078 eV; an electron or hole in a shallow trap at room temperature will be fairly deeply trapped at the temperature of liquid nitrogen and still more deeply at the temperature of liquid helium.

An approximation to the mean time, t, that a charge remains in a trap of depth E_t at temperature equilibrium can be got from the expression

$$n = 1/t = \nu\, e^{-E_t/kT} \qquad (6)$$

where n is the number of escapes per sec, ν is of the order of magnitude of the frequency of ionic vibrations in the crystal, about $10^{12}/\text{sec}$, k is the Boltzmann constant and T the absolute temperature. Thus, if the trap depth is 0.1 eV, a trapped charge carrier will be liberated in about 10^{-10} sec at room temperature and in about a month at liquid nitrogen temperature, while the liberation time from a trap of depth 1 eV at room temperature is of the order of 10^4 sec, i.e., several hours.

A trapped hole can act as a trap for an electron and vice versa. Such sites are called *recombination centers.* If electrons and holes can be trapped independently without recombination, a permanent change may be brought about in a crystal by exposure to light, by subsequent reactions of the trapped charges; but if the traps merely act as recombination centers, no permanent change will be induced by exposure. We shall find that this principle lies at the root of latent image formation in silver halides.

LIFETIMES AND MOBILITIES OF ELECTRONS AND HOLES IN SILVER HALIDES

Since electrons and positive holes are the primary products of exposure to light in silver halides, a knowledge of the behavior of these entities is necessary to an understanding of the processes of latent image forma-
tion. Important characteristics of charge carriers in a crystal are the period of free existence of the carrier, during which it can contribute to electronic conductivity, and the mobility, which is a measure of the rate at which charges move in an electric field. An electric field imposes a unidirectional component on the random thermal motion of carriers, so that electrons drift in the direction of the field and holes in the opposite direction. The *drift mobility*, μ_D, is the net displacement per second of the carrier in or opposite to the direction of an imposed field of strength 1 V-cm, according to the sign of the charge. The units of mobility are centimeter per second per (volt per centimeter), i.e., $\text{cm}^2/\text{V-sec}$.

Ultimately an electron and hole will be permanently trapped independently, or they will recombine at a recombination center. Their period of free existence is called their lifetime. If shallow traps are present, the electron will be repeatedly trapped and thermally released before it is permanently trapped, so that it spends part of its lifetime in the traps. If a microscopic mobility, μ_m, is defined, which depends on the displacement of the electron in the field while it is free, the actual rate of drift in the field in the presence of shallow trapping, determining the drift mobility, will be less than that corresponding to the microscopic mobility. The microscopic mobility is closely related to a mobility that can be calculated from the Hall effect, which involves the displacement of the electron in a magnetic field. Close approximation of the measured values of the drift and the Hall mobilities indicates the absence of much multiple trapping in shallow traps. For further information on the theory of electron and hole mobilities, reference is made to works on semiconductors, such as W. Shockley, *Electrons and Holes in Semiconductors*, p. 206, Van Nostrand Reinhold, New York, 1950.

In silver chloride and silver bromide crystals experimental observations show that electrons and holes are trapped independently and that bimolecular recombination is not important in determining their lifetimes at the intensities of normal photographic exposures. On the simplest assumption that the permanent traps are of uniform depth and at a concentration not significantly reduced by the trapping, an initial concentration, c_0, of charge carriers diminishes in time because of the trapping, according to the first order equation

$$c_t = c_0\, e^{-t/\tau} \qquad (7)$$

where c_t is the concentration at time t and τ is a constant which can be shown to be equal to the mean lifetime of the carrier before permanent trapping.

The mean lifetimes of electrons and holes in silver halides can be determined by methods based on a fundamental method of investigating the behavior of photocarriers in crystals introduced by Haynes and Shockley[51] which will be outlined in the section on latent image formation. Briefly, the crystal is exposed to a short flash of light in the presence of an electric field pulse that can be synchronized with the flash or delayed by a short interval from the flash. In the presence of the field, electrons or holes are displaced into the interior of the crystal,

according to the direction of the field. If the field is delayed, only carriers still free at the instant of application of the field are displaceable, giving rise to an electric current proportional to the concentration of free electrons which can be measured as a function of the delay. From the magnitudes of the current as a function of the delay period, the time dependence of the concentration of photo-carriers can be calculated. Some chemical effects of displaceable carriers, such as the formation of displaced latent image centers or the formation of print-out silver, may also be used to determine the photo-carrier concentration and its time dependence.

The drift mobility of photoelectrons and photoholes can also be measured by the method of Haynes and Shockley, with the use of the chemical method as an indicator of the displacement of the carriers by the field. If a field pulse of strength E volts/cm and duration t sec displaces the carrier through a distance d cm, the drift mobility $\mu_d = d/Et$. It is also possible by electrical means to measure the time required for a carrier to move completely across a crystal of known thickness from the illuminated surface under the influence of a known field strength.

It is found that electron and hole mean lifetimes in large crystals of silver halides depend much on the chemical purity and the state of crystal perfection. For example, the lifetime of electrons increases as the crystal is annealed. The mean lifetime of electrons in carefully purified silver chloride and silver bromide at room temperature is about 0.5 μsec, although much greater in crystals that have been heated in oxygen.[49,52-54] They are smaller in highly strained crystals, suggesting that sites on dislocations are deep electron traps.

Electron mobilities in large crystals of silver halides vary with the sample much less than does the lifetime. At room temperature the drift mobility of electrons in large crystals of silver chloride is about 50 cm²/V-sec,[51,52] and in silver bromide about 70 cm²/V-sec, values not much less than those of the Hall mobilities. The drift and Hall mobilities of electrons increase with decreasing temperature, remaining close in magnitude, and reach a maximum value at about –180°C; as the temperature is lowered further, the drift mobility falls off in value from the Hall mobility because of shallow trapping.[52]

The lifetime of holes in large crystals of silver bromide varies greatly with the purity and the degree of perfection of the crystals. In contrast to their effect on the lifetime of electrons, the presence of dislocations increases the mean lifetime of holes; hole lifetimes exceeding 50 μsec have been observed in strained large crystals of silver bromide.[55] In large annealed crystals, or in highly purified crystals partly annealed by aging at room temperature, hole lifetimes from 1 or 2 to about 20 μsec have been observed.[49,55,56]

Free holes migrate in silver bromide crystals at a rate only a few percent that of the electrons, the drift mobility at room temperature being about 1 cm²/V – sec and much less dependent on the sample than is the lifetime.[54,55,57,58,59] As for the electrons, the drift mobility of holes in silver bromide at room temperature is not very different from the Hall mobility, indicating little shallow trapping before final capture of the hole.[60]

By an adaptation of the method of Haynes and Shockley,[51] Hamilton and Brady have succeeded in measuring the characteristics of electrons and holes in silver bromide emulsion grains.[61,62] The mean lifetime of electrons in the grains is similar to that in large crystals, varying somewhat with exposure conditions from less than 0.5 μsec to 3 μsec; but the mobility in the grains, 0.2 cm²/V-sec, is much less than in large crystals. Much repetitive trapping in shallow traps is indicated. Moreover, while in large crystals the charges associated with the permanently trapped electrons are neutralized relatively slowly, in about 100 μsec by the motion of interstitial ions,[49] in the grains neutralization by mobile silver ions in a period of the order of a microsecond constitutes the permanent trapping act itself. This difference in the rate of neutralization of trapped photoelectrons in the interior of large crystals and in emulsion grains reflects the high concentration of mobile silver ions at the grain surface already alluded to and emphasizes the dominance of the surface in determining the ionic and electronic properties of emulsion grains.

Relatively long lifetimes ~15 μsec, similar to those in some large crystals, are found for the holes in emulsion grains and, as for the electrons, the drift mobility $\mu_d = 10^{-3}$ cm²/V-sec is much lower than in large crystals, indicating much temporary trapping at shallow trap sites. Nevertheless, in the grains as in the large crystals, electrons migrate more rapidly than holes, but the holes outlive the electrons.

As possible traps for electrons and holes in "pure" silver halides, silver ions and bromide ions at jog sites in dislocations and at kink sites in surface terraces, carrying effective charges of $+\frac{1}{2}$ and $-\frac{1}{2}$ electronic charges respectively, have already been mentioned.[27] Since, as was pointed out by Seitz,[27] the trapping of an electron at a site of charge $+\frac{1}{2}$ changes the charge to $-\frac{1}{2}$, which, after reaction with an interstitial ion, is restored to the original $+\frac{1}{2}$, the electron trap constituted by a silver ion at a kink site or jog is reset after the formation of a silver atom at the site, a circumstance favorable to nucleation and growth of a latent image center. Similarly, when a positive hole is trapped by a Br^- at a jog or kink site, the subsequent approach of a silver ion vacancy resets the trap and facilitates the liberation of a bromine atom at the site.

Impurities may also act as traps. The purest silver halide yet made contains impurities; especially significant for hole trapping are oxidizable ions, such as Cu^+ or Fe^{2+}. The decrease in the lifetime of holes caused by annealing large crystals has been attributed to the dispersal, as point defects throughout the volume of the crystal, of aggregates of Cu^+ or Fe^{2+} that had condensed on dislocations in the unannealed material, and were therefore less effective as traps than when dispersed.[55,56] It seems rather likely that substitutional Cu^+ and Fe^{2+} in the silver halide lattice cause much of the permanent trapping of positive holes in large crystals, and possibly also in emulsion grains, which are probably less pure than carefully purified large crystals.[55,56,63,64]

MECHANISM OF LATENT IMAGE FORMATION

A striking feature of the photographic sensitivity of emulsions is the very low sensitivity of the grain surface, unless sensitivity has been induced by a "finishing" operation in which the liquid emulsion is digested with an "active" gelatin or with small amounts of a chemical sensitizer added to the emulsion. Chemical sensitizers most commonly used are sulfur compounds which on digestion yield silver sulfide in some form at the surface of the grain. Increased sensitivity may also be induced by digesting the emulsion with small amounts of reducing agents, such as stannous chloride, when the active material is presumed to be minute aggregates of silver atoms.

In the *concentration speck theory* of chemical sensitization by sulfur compounds, Sheppard and his co-workers proposed that the sensitization process produced minute specks of silver sulfide on the grain surface which acted as nuclei for the formation of latent image centers by concentrating a number of silver atoms formed by exposure throughout the volume of the grain in a single aggregate.[65] Implicit in this hypothesis is the recognition that photochemically reduced silver dispersed through the grain as atoms or as insufficiently large aggregates is unable to induce development. The concept that in silver halides the products of the photochemical action formed in the whole volume of the grain can be concentrated to form localized development centers is still fundamental to the theory of photographic sensitivity, although later work has modified and greatly amplified our understanding of the details of the concentration process.

In 1938 Gurney and Mott[1] advanced a comprehensive theory of photographic sensitivity based on a synthesis of modern concepts of the behavior of ionic crystals with the earlier concepts of the concentration speck theory.

The assumptions of this theory were that exposure to light absorbed by the silver halide produces in the crystal free electrons of high mobility and free positive holes of lower mobility. (No quantitative data on the lifetimes and mobilities of electrons and holes in silver halides were available at that time.) An unfinished emulsion grain contains few electron traps and exposure of such a grain would result mostly in recombination of the electrons and holes, with no net change in the grain. In a chemically sensitized emulsion, however, silver sulfide sensitivity specks on the grain surface trap the photoelectrons. Having captured an electron, the sensitivity speck, assumed to be initially neutral, becomes negatively charged. The charged speck attracts a positively charged interstitial silver ion present in the crystal with which it combines to form a neutral silver atom at the sensitivity center. A second electron is trapped at the same speck and similarly neutralized and by repetition of the electronic and ionic steps a silver center large enough to initiate development is eventually formed. Efficient formation of latent image centers in this way requires that the negatively charged incipient latent image center be neutralized by a silver ion rather than by a hole. How this occurs is not discussed—it is assumed that the holes diffuse to the surface, where they may be discharged as bromine atoms, with the accompanying formation of interstitial ions that migrate away. Accumulation of bromine at the surface may be prevented by reacting it with gelatin.

This mechanism of latent image formation obviously leaves some questions unanswered. The chief question is the precise way in which the competition between interstitial silver ions and positive holes for trapped electrons works out in favor of the silver ions. The quantitative data necessary for the resolution of such questions have accrued only within the last decade or so. Nor was it widely realized in 1938 that an unfinished emulsion grain is, in general, by no means insensitive when internal sensitivity is considered. Nevertheless, in spite of some *ad hoc* assumptions in the Gurney-Mott mechanism, its fundamental concept of a two-stage electronic-ionic build-up of latent image has in some form dominated all subsequent models of latent image formation, and later experimental studies have been in remarkable accord with Gurney and Mott's intuitions. The concept of latent image build-up by repetitive steps of separate electronic and ionic motion has been called the *Gurney-Mott principle.*[66]

The production of mobile photoelectrons in silver halides down to the temperature of liquid helium is shown by the existence of photoconductivity down to that temperature, but the practical disappearance of the dark ionic conductivity at temperatures below about $-140°C$ shows that ionic motion practically ceases at low temperatures. These differences in the temperature coefficient of electronic and ionic motions were utilized by Webb and Evans[67] to separate the electronic and ionic steps in latent image formation. The surface sensitivity of photographic emulsions is much reduced when exposures are made at low temperature, with development at room temperature (Fig. 3-7). During exposure at $-186°C$, according to the Gurney-Mott hypothesis, the immobility of interstitial ions would prevent latent image formation—photoelectrons would remain trapped throughout the volume of the crystal without forming silver atoms. Some of them recombine with trapped holes, with the emission of fluorescence, and are permanently lost for forming the latent image. The low sensitivity observed to exposures at $-186°C$ arises from latent image centers formed by the combination of residual trapped electrons with interstitial ions during warming to room temperature before development. If, however, the exposure at low temperature is applied in successive portions, separated by warming to room temperature and recooling, more latent image is formed than when the exposure is not interrupted, in amounts increasing with the number of interruptions. During the warming periods the trapped electrons are neutralized by interstitial silver ions, forming silver atoms and larger aggregates; on recooling, the silver centers are more efficient electron traps than the original trapping centers, loss by recombination is diminished, and the sensitivity increases after each interruption. More recent studies of rate of development of emulsion grains exposed at low temperatures suggest that some latent image may be formed at temperatures slightly above $-196°C$, possibly by neutralization of

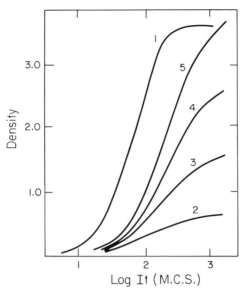

Fig. 3-7. Characteristic curves for an emulsion, comparing sensitivity at room temperature and at -186°C, and the increase in sensitivity at low temperatures of exposure if the exposure is applied in installments and the emulsion warmed to room temperature after each partial exposure (after Webb and Evans[67]).

Curve	Temperature of exposure (°C)	Duration of exposure
1	20°	160 sec, in 1 installment
2	-186°	160 sec, in 1 installment
3	-186°	160 sec, in 2 equal installments
4	-186°	160 sec, in 4 equal installments
5	-186°	160 sec, in 8 equal installments

trapped electrons by silver ions in their immediate neighborhood.[68]

The Experiment of Haynes and Shockley

The reality of electronic motion in the formation of latent image and of print-out silver was vividly shown by an experiment of Haynes and Shockley.[51] If the photographic process depends on the primary formation of free electrons it should be possible to displace the electrons from their sites of origin by exposing the crystal in the presence of an appropriately directed electric field. Hence, if the experiment is performed on a large crystal, latent image centers or print-out silver particles will appear in the interior of the crystal in regions remote from the absorption region near the surface of incidence, or even on the opposite surface. In the original experiment, the displacement of print-out silver particles was examined, but the method has also been applied to the displacement of latent image centers, with a great diminution of the time required.

At room temperature a static electric field applied to a large silver halide crystal decays in a period of about 100 microsec because of neutralization of the field-induced charges by the mobile silver ions and silver ion vacancies in the crystal. The crystal is therefore placed

Fig. 3-8. Crystal and electrode arrangement for exposing a large silver halide crystal in the presence of an electric field according to the method of Haynes and Shockley.[51]

between the plates of a condenser, as shown in Fig. 3-8, and exposed to short flashes, 1 or 5 microsec in duration, of strongly absorbed radiation in the presence of a pulsed electric field synchronized with the light flash and of the same duration. The light pulses with their synchronized field pulses were applied at the rate of 1000 per second and the exposure was continued until visible darkening of the crystal by photolytic silver was observed. No appreciable ionic motion occurs within the duration of such short field pulses but the much more mobile electronic charges drift in the field, the electrons in one direction, the holes in the opposite. In such an arrangement the metal electrodes may be separated from the crystal by thin layers of an insulator such as Dupont Mylar Polyester Film; corrosion of the electrodes by photolytic bromine is thus prevented.

In the absence of a field, darkening was confined to a thin layer near the surface of incidence. If the field is directed so as to displace negative charges into the interior, photoelectrons, according to the Gurney-Mott scheme, will be drawn into the interior and photoholes will be displaced toward the surface of incidence. If the field is insufficiently strong to displace electrons completely across the crystal before the termination of their lifetimes, they will be trapped within the volume of the crystal and neutralized by silver ions during the dark, fieldless intervals and build up latent image centers and ultimately particles of photolytic silver. The stronger the field, the greater the displacement of the electrons into the crystal, with corresponding displacement of latent image centers and of visible darkening. These theoretical expectations were experimentally fulfilled. The rate of displacement of the column of print-out silver at constant field strength was measured and the value of the drift mobility of the negative photocharges determined as 49.5 cm^2/V-sec in large silver chloride crystals at room temperature. This value is consistent with the motion of an electron and much too large to apply to ionic motion.

A beautiful confirmation of electronic motion in these experiments is provided by a measurement of the displacement of the photolytic silver in a magnetic field directed perpendicularly to the electric field. From the displacement, the Hall angle and the Hall mobility of the carrier can be determined. In silver chloride, the Hall mobility of the negative photocarriers was found to be

51 ± 3 cm^2/V-sec at room temperature. The Hall mobility depends on the effects of the electric and magnetic fields on a carrier while it is moving, and is quite independent of any time that it may spend in temporary traps. The approximate equality of the Hall and drift mobilities of electrons in silver chloride therefore shows that little temporary trapping occurs in large crystals at room temperature. Subsequent observations have verified this circumstance both for electrons and holes in large crystals of silver chloride and silver bromide at room temperature and to temperatures considerably below.

Haynes and Shockley's method was soon applied to emulsion grains by Webb,[69] whose work has been greatly extended by Hamilton and co-workers.[61,62] Figure 3-9 shows an electron micrograph of a large emulsion grain in gelatin exposed to the print-out level with simultaneous pulses of light and electric field. The direction of the field (from positive to negative potentials) is shown by the arrow near the 1-micron mark indicating the magnification. The masses of photolytic silver are unsymmetrically distributed toward the side of the grain to which electrons would be displaced. Outside the periphery of the grain, on the side opposite that on which the photolytic silver was concentrated, a diffuse cloud of darkening indicates the appearance of photolytic bromine in the gelatin, especially marked in the region indicated by the large arrow. The irregular outline of the grain in this region shows that the surface was eroded during the exposure. Positive holes, probably trapped by silver ion vacancies near the surface, escaped as bromine atoms into the gelatin and an equal number of lattice silver ions assumed interstitial positions and migrated into the interior, both processes creating cavities in the crystal.

Hamilton and Brady's application of the method to determine the ionic conductivity of emulsion grains by studies of the rate of decay of pulsed fields has already been discussed in connection with the important result that the concentration of mobile silver ions at the surface

Fig. 3-9. Electron micrograph of a photographic grain printed out in the presence of an electric field, showing displaced photolytic silver, the bromo-gelatin cloud and irregular outline (arrow) (after Hamilton and Brady[23]).

of emulsion grains is many times greater than the equilibrium concentration in the interior of a large crystal.[61,62] Similarly, the application of the method to determine lifetimes and mobilities of electrons and holes in large crystals of silver bromide has already been discussed, displaced latent image being used to indicate the motion of electrons and displaced bleaching of pre-introduced silver centers to indicate the motion of holes.[54,57-59]

Recent Developments in the Mechanism of Latent Image Formation

In a series of experimental and theoretical studies of photographic sensitivity, Mitchell, retaining the Gurney-Mott principle of a two-stage electronic-ionic process in latent image formation, concluded that the earlier mechanism was inadequate in two main respects. He thought that an electrically neutral silver sulfide center was unlikely to constitute a deep electron trap, and also that, on the basis of the concentration of silver ions in silver bromide indicated by the dark conductivity of large crystals, the concentration of interstitial silver ions in the small volume of an emulsion grain would be too low to permit the neutralization of trapped electrons, as described by Gurney and Mott.[70-74] Mitchell proposed that adsorbed silver sulfide centers at the surface of the grain acted as relatively deep hole traps, trapping the holes before, on the average, the electrons are trapped. The trapped hole is neutralized by the migration away from it of a silver ion as an interstitial ion, the hole becoming a neutral bromine atom and eventually, by association with a bromide ion, Br_2^- The danger that the trapped hole might act as a recombination site for an electron is thus removed and at the same time an interstitial silver ion is formed which can now participate in the trapping of an electron, for example, at a silver ion at a kink or jog site. The resulting isolated silver atom is unstable, but if, before it dissociates into a silver ion and an electron, a second interstitial ion liberated by the discharge of a trapped hole should approach the electron-trapping site, a second photoelectron could be captured and neutralized, forming a stable two-atom silver center, the sub-image center already discussed. Repetition of these processes yields a three-atom silver center. This is assumed to combine spontaneously with a silver ion to form a tetrahedral Ag_4^+ center, which, in Mitchell's scheme, is the stable latent image. Capture of an electron by this center forms a neutral Ag_4 center, which can readily grow by repeated adsorption of silver ions and electron capture.

Recent studies of such fundamental parameters of latent image formation as electron and hole lifetimes and mobilities and the concentration of mobile ions in emulsion grains, and of an inherent electric field at the surface of silver halide crystals affecting the concentrations of ionic charges and the behavior of photocharges, have suggested current viewpoints of the pri-

mary photographic process that are essentially greatly amplified versions of the processes proposed by Gurney and Mott, applying both to photoelectrons and to photoholes.[49,75–77]

The experimental evidence leading to this conclusion, based on observations of the lifetimes, mobilities, and trapping of electrons and holes in silver halides already described in this chapter, is summarized in the following paragraphs and in Table 3-2.

Independent Trapping of Electrons and Holes in Emulsion Grains and in Large Crystals. Except at very high light intensities, electrons and holes are trapped independently according to their respective mobilities and lifetimes both in emulsion grains and in large crystals. Recombination is not an important factor in either system. The small distances in emulsion grains, however, will tend to make recombination at recombination centers and regression of already formed silver atoms by attack of holes more probable than in large crystals. In fact, evidence for recombination in silver iodobromide emulsion grains at high light intensities is provided by measurements of the photoconductivity of emulsions, a measure of the concentration of free photoelectrons in the grains.[78] Whereas at normal photographic intensities the photocurrents are linear in intensity, indicating independent trapping of the photoelectrons, at high intensities they tend toward a dependence on the square root of the intensity, indicating recombination of holes and electrons after saturation of the independent trapping centers.

TABLE 3-2. MOBILITIES AND LIFETIMES OF CHARGE CARRIERS IN AgBr AT ROOM TEMPERATURE.

Drift mobility of electrons in large crystals	$75 \text{ cm}^2/\text{V-sec}$	(53), (54)
Drift mobility of electrons in emulsion grains	$0.2 \text{ cm}^2/\text{V-sec}$	(61)
Mean lifetime of electrons in large crystals and in emulsion grains	$10^{-7} - 10^{-5} \text{ sec}$	(49), (54), (61)
Hall mobility of holes in large crystals	$1.7 \text{ cm}^2/\text{V-sec}$	(60)
Drift mobility of holes in large crystals	$1 \text{ cm}^2/\text{V-sec}$	(54), (55), (57–59)
Drift mobility of holes in emulsion grains	$10^{-3} \text{ cm}^2/\text{V-sec}$	(61)
Mean lifetime of holes in large crystals and in emulsion grains	$(2-20) \times 10^{-6} \text{ sec}$	(49), (55), (56), (61)
Drift mobility of interstitial silver ions in large crystals	$4 \times 10^{-3} \text{ cm}^2/\text{V-sec}$	(79)
Drift mobility of silver ion vacancies in large crystals	$6 \times 10^{-4} \text{ cm}^2/\text{V-sec}$	(79)
Diffusion coefficient of neutral hole complexes in large crystals	$3 \times 10^{-7} \text{ cm}^2\text{-sec}$	(80)

In emulsion grains and in large crystals of silver bromide, of a pair of electronic charge carriers formed by absorption of a photon, the electron on the average is permanently trapped before the hole.

In emulsion grains there is much shallow trapping, (indicated by the very low ratio of drift mobility to microscopic mobility, about $75 \text{ cm}^2/\text{V-sec}$, but neutralization of an electron while in a shallow trap is readily effected by the plentiful supply of mobile silver ions near the surface.[62] Trapping of electrons seems to occur mostly at crystal imperfections such as kink sites or jogs in dislocations, but in large crystals, holes are not greatly affected by imperfections. Data on large crystals derived from electrical measurements usually refer to conditions in the interior, whereas the influence of surface conditions is preponderant in emulsion grains.

In large crystals the separation between trapping and neutralization both of electrons and holes is especially clear. The charge carriers are trapped within a period of microsec, but neutralization requires a period of about 100 microsec, the time associated with the neutralization of charges by the motion of interstitial ions and vacancies in these crystals.[49] The concentration of interstitial ions and vacancies in large crystals, approximately $8 \times 10^{14}/\text{cm}^3$ at room temperature,[63] is evidently sufficient to ensure the independent neutralization of electrons and holes at moderate intensities.

The lifetime of free holes is several times greater than that of the electrons in grains and in large crystals, and free holes, although much less mobile than electrons, are, in large crystals, more mobile than interstitial ions. The competition between holes and interstitial silver ions as neutralizing agents for trapped electrons is, however, determined by the product of their mobilities and concentrations, and in large crystals exposed at moderate intensities, the high concentration of interstitial ions in comparison with that of holes makes neutralization of an electron by an ion more probable than by a hole. According to Hamilton and Brady's estimate of the mobility of holes in emulsion grains, they have little advantage over the interstitial ions even in mobility, which in any case would overwhelm the holes in the neutralization of electrons because of their relatively high concentration.

There is a certain degree of symmetry between the trapping of electrons and their neutralization by interstitial silver ions and the trapping of holes and their neutralization by silver ion vacancies. The symmetry even extends to the production, under certain conditions, of visible images in the same crystal, initiated by electron trapping and hole trapping, respectively. Photolytic silver is formed by successive neutralizations of trapped electrons. In silver bromide crystals containing Cd^{2+}, the photolytic silver image in the interior is overlaid by a visible image caused by the scattering of light by regularly oriented pits formed in the surface.[26] The pits seem to be formed by the localized escape of bromide from sites near the surface at which positive holes were trapped and neutralized by silver ion vacancies.

Repetitive localized hole trapping and neutralization by vacancies participate in the formation of this image in the same way as repetitive electron trapping and neutralization by interstitial ions form the photolytic silver image. Thus exposure of cadmiated crystals of silver bromide produces a visible hole-induced image in the form of missing material in the crystal that is complementary to the visible electron-induced silver image. The escape of bromine from sites near the surface at which holes have been trapped and neutralized by silver ion vacancies probably also occurs in pure crystals of silver bromide, but is especially marked in cadmiated material because of the great concentration of vacancies introduced to compensate for the positive charge of substitutional Cd^{2+} sites. As will be discussed later, the significance of hole capture and neutralization of silver ion vacancies in latent image formation has been emphasized by Malinowski.[76]

Significance of Photovoltaic Effect in Silver Halides. It might be objected that conclusions on the trapping of holes and electrons based on measurements using strong electric fields might be of uncertain relevance to the normal photographic process in that the applied field itself might influence the nature of the trapping processes. It is therefore significant with respect to the theory of latent image formation that the same conclusions are necessitated by observations of photovoltaic potentials generated in dry silver halide crystals insulated from electrodes in the absence of an applied field.[49,77] Exposure of large crystals of silver bromide to light strongly absorbed by the bromide or by an adsorbed layer of sensitizing dye, induces an electrical potential difference originating in a double layer of charges, positive at the surface and negative in the interior. When absorption is confined to a thin layer at or near the surface, photoelectrons diffuse into the interior more rapidly than the holes until an equilibrium potential difference is set up between the interior and the surface, the so-called *Dember potential*. It has been shown that, for a given exposure, the number of electrons displaced by preferential diffusion into the interior in the absence of an applied field is the same as the number of electrons that would be displaced completely across the crystal to a collecting electrode in the presence of a sufficiently strong applied field. Even when, in the absence of an applied field (the normal photographic condition), electrons and holes in large crystals are separated only by the diffusion distance of the electrons, they move and are trapped independently and there is little recombination. The conclusions on the behavior of photocharges in silver halides based on electrical measurements involving strong applied fields are therefore valid for normal photographic conditions.

Dember potentials have been measured in normal photographic emulsions, both in the regions of intrinsic sensitivity and of spectral sensitization by dyes.[81] Good correlation between the Dember potentials and photographic sensitivity of emulsion-grains as functions of wavelength was found.

Intrinsic Surface Potential of Silver Halides. The intrinsic double layer of ionic charges at the surface of silver halide crystals already discussed under the general ionic properties of these crystals may also have important photographic consequences.[40-42] In the first place, since the potential arises from the independent creation at the surface and at dislocations of interstitial silver ions and silver ion vacancies with different free energies of formation, it is a factor in producing high concentrations of mobile ions near the surface, so important in the formation of latent image in emulsion grains. The strong field between the negatively charged silver bromide surface and the diffuse internal positive space charge (20,000 V/cm in large crystals[42]) will cause positive holes to migrate readily from the interior to the surface, where they may escape as bromine or be removed by a halogen acceptor. Electrons will tend to move into the interior unless deep electron traps are provided at the surface. Both factors will conspire to produce low surface sensitivity and relatively high internal sensitivity in unfinished emulsion grains, as is frequently observed.

Complexes with Positive Holes

The relation between the drift mobility μ_d of a charge carrier and its diffusion coefficient, according to an equation derived by Einstein, is

$$D = (kT/e)\,\mu_d = 0.026\,\mu_d \text{ cm}^2/\text{sec at } 300°\text{K, for } e = 1 \quad (8)$$

D is the diffusion coefficient, kT is the product of the Boltzmann constant and the absolute temperature and e is the number of elementary charges on the carrier.[82] Since the drift mobility of positive holes at room temperature is about 1 cm^2/V-sec, measured for motion in pulsed electric fields of 1 to 20 μsec in duration, the diffusion coefficient of free holes at room temperature is about 0.026 cm^2/sec. If, however, the diffusion coefficient of holes is estimated from mobility measurements by static electrical experiments on holes injected into silver halides from a halogen atmosphere at temperatures below 150°C, values are found 4 to 5 orders of magnitude less than those calculated from the mobility in transient fields.[83,84] Similar low values for the apparent diffusion coefficient of holes are observed in experiments in which the migration of holes from a source is followed, in the absence of an applied electrical field, by their chemical bleaching effect on silver particles preintroduced into the silver halide crystal.[85,86] Moreover, diffusion ranges up to 0.5 mm have been found for holes in such experiments, very much larger than the value consistent with the observed lifetimes of holes of a few microsec. For example, the diffusion range appropriate to a lifetime of 10 μsec and a diffusion coefficient of 0.026 cm^2/sec is 5×10^{-4} cm, according to Einstein's diffusion equation

$$x^2 = D\tau \quad (9)$$

where x is the mean displacement of the diffusing particle in time τ.

This discrepancy has been comprehensively studied by Malinowski and co-workers.[76,86,87] They used wedge-shaped crystals on the rear surface of which silver had been deposited by evaporation in vacuum to form developable nuclei. The other side, on exposure, gave slitlike sources of holes which diffused into the crystal, eventually reaching the rear side where they attacked the silver centers. After development, bleached slitlike images appeared against a background of developed silver induced by the unattacked silver centers. Analysis of the bleached images permitted calculation of the diffusion coefficient of the bleaching entities. As already mentioned, this turned out to be much lower than that calculated from the mobility of free holes in transient electrical experiments. This method can also be adapted to determine the mobility and lifetime of holes in transient fields.

The abnormalities regarding the apparent diffusion coefficient and the anomolously great diffusion length of holes were resolved by Malinowski and co-workers as follows. For some microsec after excitation, most of the photoholes generated in large crystals wander freely through the crystal with a mobility, at room temperature, of about 1 cm^2/V-sec and the corresponding diffusion coefficient, of the order 10^{-2} cm/V-sec. They are then trapped at relatively shallow traps of depth about 0.44 eV, as determined by the temperature coefficient of the mobility in short pulse transient fields.[45,55] The primary trapping may possibly occur at impurity centers, such as Cu^+ and Fe^{2+}, as already discussed in the general section on trapping processes.[55,56,63,64] The trapped charges are more slowly neutralized, in about 100 microsec in large crystals,[49] most likely by silver ion vacancies, yielding hole-vacancy complexes in which the hole is bound with an energy of 0.71 eV estimated from the temperature coefficient of the mobility in static fields.[84] The complex is effectively a neutral center which can migrate in the crystal with the diffusion constant appropriate to an ion, many orders of magnitude less than that of a free hole; its lifetime is not at all related to that of a free hole. The complexes are in thermal equilibrium with free holes and free cationic vacancies, and at room temperature it is estimated that, at equilibrium, the mole fraction 10^{-4} of all the holes present (free plus complexed) is free. Hence the low apparent mobility of holes; in static experiments in which they reach thermal equilibrium with the vacancies; the hole is free for a very small fraction of the time required for the measurement.

It seems probable that the time required for the neutralization of holes by forming the complex in emulsion grains is considerably less than in large crystals because of the high concentration of vacancies at the surface, in the same way as the electrons are rapidly neutralized by the high concentration of interstitial ions. A few microseconds after the absorption of a photon there are no rapidly mobile positive charges that might recombine directly with photoelectrons.

The hole-vacancy complexes diffuse to the surface, where the hole may escape as a bromine atom and react with gelatin or other halogen acceptor, the resulting excess silver ion migrating as an interstitial ion into the interior. There is, however, a period after the capture of the photoelectron over which the incipient latent image center is vulnerable to attack by holes, mostly in the complexed state, or by bromine atoms at the surface. Hence, by regression of silver atoms, isolated or in small aggregates, to silver ions by the attack of holes or bromine atoms, inefficiencies of latent image formation arise, especially at the surface. Unfinished emulsion grains usually show very low surface sensitivity. These inefficiencies can be partly overcome by chemical sensitization.

The question left unanswered by Gurney and Mott of why positive holes did not overwhelmingly recombine with trapped photoelectrons, appears to be answered in some detail in terms of the two recently recognized factors: (1) the high concentration of interstitial ions and vacancies at the surface of emulsion grains, along with (2) the relative immobilization of positive holes by complexing with silver ion vacancies.

Formation of Latent Image Centers

Since neither the trapped electrons nor the trapped holes in silver halides act to any great extent as recombination centers for the electronic carrier of opposite sign, the first step in latent image formation, the production of silver atoms and hole complexes, must be fairly efficient in emulsion grains without chemical sensitization, in accord with the reasonably high internal sensitivity of many unfinished emulsions. The existence of low-intensity reciprocity failure, as already discussed, shows that no stable product is formed in an emulsion grain by the absorption of one quantum of visible or ultraviolet light.[6,8] Isolated silver atoms in silver halides are unstable, rapidly dissociating into an electron and an interstitial silver ion. Trautweiler has suggested that this instability arises from the high dielectric constant, about 12, of silver halide crystals.[88] The first stable center to appear in the grain on exposure is the sub-image center, stable over some days, but not itself developable. The reciprocity failure characteristic curve at low intensities can be accounted for on the assumption that the sub-image is formed by the absorption of two quanta,[6] and the simplest assumption about the size of the sub-image center is that it contains two silver atoms. The dissociation energy of Ag_2 in the gaseous phase is 1.6 eV[89] and the value is probably similar in silver halide crystals. Latent image formation therefore occurs in two stages, a nucleation stage leading to the formation of the stable sub-image, and subsequent growth of this nucleus to a developable center.[8] Moreover, the growth stage itself exhibits reciprocity failure at high intensities, showing that the formation of a latent image center from the sub-image center requires the cooperative action of at least two

photons.[8,90] Hence the stable latent image probably contains at least four silver atoms.

There is little direct experimental evidence on the detailed mechanism of the build-up of the stable latent image center after the capture and neutralization of the first photoelectron. The stable two-atom silver center must be formed by the capture of an electron by a silver atom before the latter has dissociated and neutralization by a silver ion, and further growth could occur by repetition of these processes. In the early stages of latent image formation, the capture of the electron is reversible, but as the number of silver atoms in the particle increases, the strength of binding of an electron in the particle increases, that is, the trap depth increases. Once the stable sub-image has been formed, growth to the developable center is fairly efficient. At high intensities of exposure, competition between numerous sub-image centers for further photoelectrons tends to keep the latent image centers small and also the ratio of undevelopable sub-image centers to latent image centers increases, with the introduction of high-intensity reciprocity failure, as already discussed.

It has been suggested that complexing of minute silver particles with interstitial silver ions may be an important step in the build-up of latent image centers.[71,88,91] Trautweiler suggests[88] that after the formation of the first silver atom at a preferred site such as a kink site, there is a certain probability of the atom combining with an interstitial silver ion before it dissociates, forming the more stable Ag_2^+. This is also a deeper electron trap than the original trapping site. The sub-image center Ag_2 is then formed by the trapping of an electron. This, in turn, complexes to form Ag_3^+ which by capture of a third photoelectron forms the still undevelopable Ag_3 center. Ag_4^+ is now formed by complexing with a silver ion, and this center by capture of a fourth photoelectron yields a developable silver particle, that is a particle which may capture, not only a photoelectron but also an electron donated by the reducing agent in the developer. It seems quite possible that the latent image centers in emulsion grains may be a mixture of Ag_4^+, Ag_4 and larger aggregates. Further growth of the center by accretion of electrons and silver ions is highly efficient, leading ultimately to the observed yield of one silver atom per quantum absorbed in the formation of print out silver.

Computer Investigations of Latent Image Models

Many attempts have been made to express the observed characteristic curves of developed density versus exposure for photographic emulsions in terms of kinetic or statistical analyses of postulated models of latent image formation. Computer methods of analysis of complex physical situations can deal with more complicated and realistic models than could earlier mathematical treatments in terms of analytical functions; and Bayer and Hamilton have introduced computer methods to the latent image problem.[92-94] The computer generates a random sequence of events simulating processes that might occur during and after exposure of a grain, and gives, as the final result, the number and size distribution of silver specks in the grain. Models containing the various individual processes discussed in the previous pages are used, including reversible trapping, neutralization of trapped electrons by ionic motion, recombination, regression, thermal dissociation of single silver atoms, permanent hole trapping and permanent electron trapping, and the effect of the physical conditions, such as intensity, duration and temperature of the exposure can be determined. Reference must be made to the original literature for details of this powerful method of investigating photographic phenomena.

Chemical Sensitizing

The relatively low sensitivities of most unfinished emulsions, as gaged by normal development which acts mostly on latent image centers at the grain surface, shows that latent image formation at the surface is not an efficient process. A given exposure, the product of the exposure time and the intensity of the actinic radiation, usually forms less latent image at low intensities and long exposure times, and also at high intensities and short exposure times than at an intermediate range of intensities and times, the phenomena of low intensity and high intensity reciprocity failure.

Low sensitivity at low intensities implies inefficiency in the nucleation stage of latent image formation. Usually this inefficiency does not originate in a deficiency of primary electron trapping sites or of interstitial silver ions, though these factors might arise in special cases. The most inefficient process in the nucleation stage is the formation of the two-silver-atom center from unstable silver atoms, as indicated, for example, according to Trautweiler's scheme,[88] by the equilibria of Eq. (9), in which θ and ϕ indicate thermal and photoprocesses, respectively, and e is an electron.

$$Ag_i^+ + e \underset{\longrightarrow}{\overset{\theta}{\longleftarrow}} Ag \underset{\longrightarrow}{\overset{Ag_i^+, \theta}{\longleftarrow}} Ag_2^+ \underset{\theta}{\overset{e, \theta}{\rightleftarrows}} Ag_2$$

If the rate of absorption of photons is low the equilibria are displaced toward the left. In addition, the centers containing silver atoms are vulnerable to regression by attack of free holes or hole complexes. Any means of deepening the original electron traps, or of stabilizing the silver atom against thermal dissociation, or of inhibiting regression will increase the sensitivity of the emulsion at low intensities.

Sulfur Sensitization

In the Gurney-Mott mechanism, silver sulfide was considered to be present as a minute speck acting as a deep electron trap, Mitchell, however, objected that the chemical nature of silver sulfide was inconsistent

with its being a deep electron trap in the uncharged state and proposed that a main function of silver sulfide as a chemical sensitizer was to act as a hole trap.[66] It could also tend to stabilize silver atoms formed in the interstices of the silver sulfide center, which Mitchell considered were probably groups of adsorbed molecules along terraces in the grain surface. A suggestion that the sensitizing action of silver sulfide originated in the removal of bromine had already been made by Hickman.[95]

Experimentally, there is no doubt that silver sulfide can act as a trap for holes or as a halogen acceptor. Solarization, a reduction in the developed density at high exposure levels from its value at lower exposures attributed to attack of latent image by bromine accumulating at the surface, is inhibited by sulfur sensitization. But sulfur sensitization also increases latent image formation under conditions in which positive holes cannot be present. For example, in an experiment of the type introduced by Haynes and Shockley, when electrons were displaced to the rear surface of a sheet crystal by a strong electric field and holes to the front, latent image was formed on the rear only if it had been previously sulfur-sensitized. Clearly the sensitizer in this experiment acted as an electron trap or as a stabilizer of silver atoms.[54] In another experiment, a layer of silver sulfide introduced into the middle of a sheet crystal parallel to the surfaces was found to stop further diffusion into the crystal of both photoelectrons and holes liberated near the surface of incidence, evidently acting as a trap for both carriers.[14]

Matejec has suggested that the efficiency of silver sulfide as an electron trap could be increased by an adsorbed silver ion,[91] and in Mitchell's scheme, silver ions rendered mobile when a silver sulfide center captured a hole would be available for the formation of silver atoms, possibly in the interstices of the silver sulfide center. However, as the experiment just described shows, coupling of silver atom formation with hole capture is not a necessary feature of sulfide sensitization.

Although sulfur sensitization, like any form of chemical sensitization, usually reduces low-intensity reciprocity failure, it has been found to increase high-intensity reciprocity failure in bromide emulsions.[5,96a,b]

A comparison has been made between the statistical distribution in numbers and topographical situation of latent image centers and of sensitivity centers, respectively, on the surface of silver bromide emulsion grains, for sulfur sensitization and for reduction sensitization.[97] The latent image centers were enlarged by arrested development so as to be visible in the electron microscope. In highly sensitized sulfur-sensitized grains, which exhibited high-intensity reciprocity failure, the distribution of latent image centers was random, though not quite random in less highly sensitized grains. Presumably the distribution of sensitivity centers was random, as was shown experimentally for the centers introduced by reduction sensitizing. It seems very probable that the latent image centers formed in sulfur sensitized grains are built up at the sites of the sensitivity centers, and that these sites act as electron traps as proposed by Gurney and Mott; the sensitivity centers, however, are more likely to be groups of adsorbed molecules of silver sulfide rather than three-dimensional specks. When, as after strong sensitization, many sensitivity centers are present, competition of the centers for the photoelectrons produced at high intensity leads to the formation of a relatively high proportion of sub-developable silver centers, with a consequent increase in high intensity reciprocity failure over that observed in grains less highly sulfur-sensitized.

In the computer-analysis of latent image formation,[92] the observed effects of sulfur sensitization could be simulated by a moderate increase in trap depth and in the stability of isolated silver atoms. Even in the sensitized emulsion, trap depths for electrons about 0.25 eV were indicated; the sulfide center, according to this analysis, is not a very deep trap and by no means a permanent trap.

On the whole, the centers introduced by sulfur sensitizing appear to be able to act both as electron traps and stabilizers of silver atoms and as hole traps; their function in a specific exposure probably depends on the nature of the emulsion and on the conditions of exposure. At low intensities and in the early stages of latent image build-up, electron trapping is probably predominant, and in the solarizaton region, hole trapping must be important.

As already mentioned, sulfur sensitization enhances surface sensitivity at the expense of internal sensitivity. Surface sulfide sensitivity centers, or of the somewhat deeper electron traps associated with the original traps as the latent image begins to form, apparently compete overwhelmingly with internal centers at dislocation jogs or near twin planes, in the build-up of latent image centers.

REDUCTION SENSITIZATION

Reduction sensitization is effected by digesting the emulsion with small quantities of reducing agents, such as stannous chloride, both surface and internal sensitivity being increased by the process.[98] The sensitivity centers are probably minute silver particles, below developable size, formed by the injection of electrons from the reducing agent molecule into the grain. One might anticipate, therefore, that they might assist latent image formation by acting as nuclei for further aggregation of silver atoms by electron trapping and neutralization by silver ions. Spencer and co-workers, however, showed that the distribution in numbers and location of the latent image centers in reduction-sensitized emulsion grains was quite different from that of the sensitivity centers, unlike the case for sulfur sensitization.[97] The reduction centers were first enlarged to developable size by bathing the emulsion in a gold solution, and then further enlarged by incipient development so as to become visible in the electron microscope. The latent

image centers were subjected only to incipient development to be rendered recordable by the electron microscope. The distribution of reduction centers over the grain surface was random, whereas that of the latent image was strikingly different; namely, one latent image center per grain. The latent image centers are apparently not formed at the sites of the reduction sensitivity centers. If both latent image centers and sensitivity centers were looked at after long exposure, only one large center per grain could be seen—a latent image center. Apparently, reduction sensitivity centers were destroyed during exposure. The inference is that in this emulsion, reduction sensitivity centers function as hole traps, while photoelectrons are trapped at some other site at which a latent image center is formed. In this case, latent image formation is facilitated, not by providing deeper traps, but by inhibiting regression caused by the attack of positive holes.

Why the reduction sensitivity center, which must be at least Ag_2^+, if not Ag_2, differs in its behavior from a sub-image center seems to be still unexplained. Some evidence was, in fact, found for latent image formation at the site of the sensitivity center in strongly reduction-sensitized grains,[97] the center apparently acting as an electron trap. Tani[99] has adduced evidence that reduction sensitization centers function as hole traps in some types of emulsion grain when the sensitivity center is electrically neutral, and as electron traps in others when the center is positively charged by association with a silver ion.

Effect of Oxygen and Moisture on Latent Image Formation

The presence of oxygen in the environment of the grains of an emulsion during exposure decreases the sensitivity, especially at low intensities of the exciting radiation.[100,101] If oxygen is removed by evacuation, the effects on sensitivity are complicated by removal of water from the emulsion and its atmosphere, since it has long been known that sensitivity is affected in a somewhat complicated manner by the humidity of the atmosphere in which the exposure is made; high humidities always reduce sensitivity.[102] In the bromide emulsions studied by Lewis and James[100] it was found that the presence of oxygen during exposure, either alone or with moisture, was the chief cause of low-intensity reciprocity failure. When the reciprocity failure was strong, as in an unfinished bromide emulsion exposed at very low intensity, exposure in vacuum increased sensitivity by 100-fold, but had little effect on the sensitivity of the same emulsion exposed to the same light energy at higher intensities. The sensitivity of a reduction-sensitized emulsion of small low-intensity failure was little affected by evacuation, although the low-intensity reciprocity failure characteristic of sulfur-sensitized emulsions practically disappeared when exposures were made in vacuum.

It seems therefore that oxygen can interfere with the nucleation stage of latent image formation. A possible mechanism is that adsorbed oxygen molecules on the grain surface, by acting as alternative electron traps to those that capture the first photoelectron in latent image formation, effectively remove the electron from the chain of latent image build-up processes. The presence of oxygen may also favor the dissociation of single silver atoms to electrons and silver ions by capturing the electrons. Hamilton has suggested that in an oxygen environment some of the occupied electronic levels in the energy gap may transfer their electron to an adsorbed oxygen molecule. The now empty level can function as a deep hole trap, facilitating recombination of free photoelectrons. Removal of oxygen removes the deep hole traps.[103]

Photographic Exposure Effects on Latent Image

The latent image formed by exposure of a photographic emulsion is normally used to produce a negative image, from which a positive can be made by exposing a second emulsion in contact with, or by projection through, the negative. Under special conditions, however, latent image may be destroyed during exposure, in which case a direct positive image may be produced on development. Bright parts of the scene appear as light images against a darker background of developed silver that forms the image of the less bright parts of the scene.

Solarization

Solarization is a decrease in the density of developed silver with increased exposure of the emulsion. As exposures are increased from zero, the density of developed silver increases to a limiting value, as described by the characteristic curve of the emulsion. Further exposure frequently causes a decrease in the developed density, the phenomenon of solarization. Some emulsions show the effect much more strongly than others. The reversal tends to decrease with prolonged exposure and, in fact, developed density may begin to increase again with increasing exposure. Solarization may be eliminated if the developer contains a solvent for silver halide, suggesting that latent image destruction is confined to the grain surface. Internal latent image is not usually subject to solarization. The reversal is also eliminated by exposing in the presence of halogen acceptors added to the emulsion, such as hydrazine or sodium nitrite. It may be accentuated by the addition to the emulsion of excess sensitizing dye.[104] The phenomenon has been used in practice to obtain direct positive images with a single exposure and development.

The association of solarization with surface image, and the suppressive effect of halogen acceptors, suggest that the reversal is caused by the destruction of latent image centers by bromine that accumulates at the surface at high levels of exposure. Other mechanisms have been proposed, such as coagulation of latent

image centers into silver particles less efficient in inducing development, but they do not readily explain the elimination of solarization by halogen acceptors.

The Villard Effect

The Villard effect, named after its discoverer (1899), is a reversal of the developed density produced by exposure of an emulsion to x-rays, α-particles or even to light of high intensity, caused by a subsequent longer exposure to light of moderate intensity.

The Villard reversal is best observed in strongly solarizing emulsions and, like solarization, is eliminated by making the second exposure, or both exposures, in the presence of a halogen acceptor like sodium nitrite.[105]

The mechanism of the Villard effect is not clearly understood. It seems likely, from the effect of halogen acceptors in eliminating it, that the reversal is similar to solarization. Surface latent image centers of small size produced by the first exposure are attacked by bromine resulting from the diffusion of positive holes from the interior to the surface during the second exposure.

The Herschel Effect

The Herschel effect, as now usually understood, is a decrease in the developed density produced in an emulsion by a normal exposure to blue or ultraviolet light followed by a high exposure to red or infrared light. The effect was first observed by J. Herschel in 1840 as a bleaching of print-out silver in a silver chloride emulsion.

The spectral region effective for the Herschel reversal in bromide emulsions extends throughout the red into the near infrared beyond 1200 nm, with maximum efficiency at about wavelength 800 nm; at wavelengths shorter than about 750 nm, the Herschel bleaching occurs in competition with latent image formation by the heavy red exposures required. Surface latent image centers are evidently destroyed by absorption of red and infrared radiation, although, as will be discussed later, there is no loss of total silver when the reversing exposure is made at room temperature; the reversal is caused by a decrease in particle size or complete destruction of surface latent image centers and redistribution elsewhere of the silver atoms.

The reversal tends to be strong when the latent image centers attacked by the red light are likely to be small, as when the reversing exposure is made simultaneously with that to blue light, or when a sulfur-sensitized emulsion, showing relatively great low-intensity reciprocity failure is compared with the corresponding unsensitized emulsion.[5,96] Conversely, the reversal decreases as the size of the latent image centers formed by the first exposure increases, for example, by latensification.[106]

The visible darkening attributed to the formation of colloidal particles of photolytic silver by prolonged exposure of silver bromide crystals is bleached by exposure to red light (the original Herschel effect).[107,108,109] The effective absorption band of the photolytic silver is broad, extending from the long wavelength tail of the silver halide absorption band into the near infrared, with a maximum absorption about 700 nm. If monochromatic light within this band is used in the bleaching exposure, the absorption spectrum of the photolytic silver measured after the bleaching shows a bleached-out band at the same wavelength as that of the exciting monochromatic light. The photolytic silver in these crystals seems to be formed as colloidal particles of various sizes, each size class exhibiting a characteristic absorption wavelength. Selective destruction of particles of a given size class by monochromatic light of long wavelength gives rise to the narrow bleached-out band. The bleaching of visible photolytic silver seems analogous to the Herschel effect on latent image, and the spectral region effective in the Herschel reversal of emulsions then represents the absorption spectrum of latent image centers.

Gurney and Mott suggested a mechanism of the Herschel effect consistent with later observations.[1] A latent image center in silver halide, having absorbed a photon, ejects an electron into the conduction band in a manner analogous to the ejection of electrons into vacuum from metallic silver exposed to ultraviolet light in the external photoelectric effect. The residual positively charged center then loses a silver ion, which wanders off as an interstitial ion. Recombination of the electron and the ion will occur at some site with regeneration of the silver atom, unless one of the pair is permanently trapped in another way. In this way, the latent image center loses silver atoms one by one until it is reduced below developable size, and silver atoms are regenerated at other sites in the grain.

On this hypothesis, the photon energy of the wavelength of maximum Herschel reversal will equal approximately the average energy required to excite electrons from latent image centers into the conduction band of silver bromide. This value is 1.54 eV, the quantum energy equivalent of wavelength 800 mn. This also represents the depth as an electron trap for free electrons of the center $Ag^+_{(n-1)}$, where n is the number of atoms in an average latent image center.

The data previously quoted on the effect of the size of the latent image center on the magnitude of the Herschel reversal are clearly consistent with this mechanism. More specific physical and sensitometric evidence for the model can be adduced:

1. Photographic emulsions which have been heavily exposed within the intrinsic absorption band of the silver halide show additional photoconductivity when excited by red light; probably representing the electron emission stage of the Herschel effect.[109a]

2. The appearance of free electrons during the destruction of latent image centers in crystals of silver bromide by exposure to red light has been shown by the following experiment.[111] Latent image centers pre-introduced into the crystal by exposure to blue light were bleached by exposure to flashes of red light in

the presence of an electric field synchronized with the light flashes and directed parallel to the surface of incidence. In such an experiment in which the second exposure is made to blue light, bleaching of latent image centers takes place both within the area exposed to light and laterally to this area, towards the negatively charged electrode. In this case the bleaching is caused by positive holes attacking the silver centers, the holes being mobile in the electric field. When the second exposure is made to red light, bleaching is strictly confined to the illuminated area, and at the same time (as also when the second exposure is made to blue light), additional latent image centers are formed laterally to the exposed region, toward the positive electrode, as the result of the migration of free electrons from the exposed area in the applied electric field. The bleaching by red light is not caused by the attack of positive holes, but is consistent with loss of silver ions and the liberation of free electrons which form silver centers elsewhere in the crystal.

A similar experiment has been performed on the bleaching of visible photolytic silver centers formed deep in the interior of a large crystal of silver chloride by ultraviolet exposure in the presence of an electric field.[110] Subsequent exposure to red light in the absence of a field bleached the original silver centers, but visible silver particles reformed as sharp dense borders of colloidal silver at the edges of the bleached region. Free electrons and silver ions liberated in the red-exposed region evidently diffused out of the illuminated volume, but recombined at centers just outside this volume, regenerating colloidal silver particles.

3. The study of the effect of lowering the temperature of the blue and of the long wavelength exposure from room temperature to that of liquid air or liquid nitrogen has been important in the development of the theory of latent image formation.[67,112,113] In all cases, the reversal is observed by developing the emulsion at room temperature after the two exposures. Briefly, if latent image is actually formed by the first exposure, either by exposing at room temperature or at low temperature and then warming, a red exposure at liquid nitrogen temperature produces no reversal. Electrons can be liberated by red light from silver centers at low temperature, but the kinetic energy available does not permit silver ions to leave the centers, and recombination of electrons and silver ions occurs at the original centers. Reversal is observed if the blue exposure is made at low temperature and the red exposure at room temperature, the Gurney-Mott mechanism of the reversal working on the latent image centers formed during the intermediate warm-up period. Strong reversal is observed if both exposures are made at the temperature of liquid nitrogen. In this case, the rate of loss of developability during the reversing exposure follows the second order rate equation, consistent with loss of latent image (formed during the warming before development) by bimolecular recombination of electrons and holes.[113] Unlike the situation when the reversing exposure attacks latent image, there is loss of potential silver atoms when both exposures are made at low temperature. To the Gurney-Mott mechanism of reversal by photodissociation of silver centers followed by redispersal of the silver must be added the mechanism of bimolecular recombination of electrons and holes, effective when both exposures are made at low temperature under conditions in which no silver centers are formed.

4. The redistribution of silver centers accompanying the Herschel reversal is made evident in the *Debot effect*.[114] An emulsion containing only internal image centers as a result of a previous exposure and removal of surface latent image by chemical bleaching was exposed to red light. A normal Herschel reversal of the internal image was observed along with increased surface sensitivity. Electrons ejected by the reversing exposure were trapped in the surface and, by combination with silver ions that had migrated from the interior, formed surface latent image. This process probably occurs in normal emulsions showing the Herschel effect, but since finished emulsions contain more surface than internal latent image after exposure, the loss of developability by disintegration of surface centers outweighs any gain from the redistribution of silver from disintegrated internal centers.

The reversing exposures necessary to destroy latent image by the Herschel effect are about 10^6 times that required to form the latent image.[67] The Herschel effect, however, is without reciprocity failure and there is no toe in the reversal-time curve,[115] indicating high efficiency of the photodisintegration in terms of the radiation absorbed by the latent image centers. During the reversal, the silver atoms appear to be lost by a series of one-quantum hits, and the large incident energy required is a result of low absorption by the latent image centers rather than of any intrinsic inefficiency of the process.

Becquerel Effect

Although not a reversal phenomenon, the Becquerel effect may be noted at this point since it may be related to the Herschel effect. In the early days of photography, E. Becquerel observed that silver halide grains, darkened by previous exposure, were sensitive to visible light of long wavelengths—photolytic silver acts as a spectral sensitizer. The mechanism of the effect has not been clarified. One step, as suggested by Sheppard,[116] seems likely to be photo-ejection of an electron from a particle of photolytic silver, as in the Herschel effect. The Becquerel effect, however, involves more than a redistribution of photolytic silver, since the total amount of reduced silver is increased in the process. Sheppard suggested that, in some unknown way, the presence of a silver speck might lower the energy required to remove an electron from a neighboring bromide ion. It has recently been shown[117] that growing particles of photolytic silver make room for themselves in the silver halide crystal by pushing away disks of the halide along definite crystallographic directions from the site at which they are growing, generating

dislocations on which bromide ions might be caused to eject electrons into the conduction band by the absorption of quanta of long wavelengths, leaving a trapped positive hole on the dislocation. These are the primary products of normal spectral sensitization (see p. 97) and additional silver would be formed by the usual process of combination of interstitial silver ions with electrons. The observation that the quantum yield of silver production in the Becquerel effect is increased in the presence of halogen acceptors[118] suggest that positive holes are indeed formed in the process.

The Clayden Effect

In the Clayden effect, as first observed (1900), a localized exposure at high intensity and short duration (0.001 sec or less), such as from a lightning flash imaged on the emulsion, is followed by a longer diffuse exposure at moderate intensity. After development, the parts subjected to the initial flash show a lower density than the surrounding background. The effect is sometimes referred to as the "black lightning effect," since, after printing, a lightning flash appears black against a lighter background.

The high-intensity exposure desensitizes the emulsion toward a subsequent exposure. The explanation of the effect in best accord with experimental studies is that the high-intensity exposure produces a high concentration of internal latent image centers and sub-image centers, which compete with surface sensitivity centers for photoelectrons liberated during the second exposure. Hence a given exposure in the preflashed region of the emulsion produces less latent image there than if the flash had been omitted. According to this mechanism, the surface desensitization caused by the flash should be accompanied by a complimentary sensitization with respect to formation of internal latent image, as has been observed experimentally.[15]

The magnitude of the Clayden effect depends much on the processing; hydroquinone-formaldehyde surface developers are suitable.

Practical use of the Clayden effect for document copying and for photographic masking has been suggested.

Solarizable emulsions exposed to light of low intensity have been found to be desensitized to a subsequent exposure by a high-intensity flash.[119] The effect has been called the Low Intensity Desensitization (L.I.D.) effect. Its mechanism has also been attributed to surface desensitization towards the second exposure caused by the competition of internal silver centers generated by the first exposure.[120]

The Sabattier Effect

In the Sabattier effect (1860) a photographic film is exposed image-wise, partially developed, washed but not fixed, then re-exposed to diffuse light and again developed; a positive image, or a combination of a posi-

Fig. 3-10. The Sabattier effect. At the left is the negative image formed by the first exposure and development; at the right is the partially reversed image. (Photographs by Robert Bellows)

tive and negative image is obtained. Reversal of the image is caused mostly by the screening action of the negative image formed by the first exposure, which is, in effect, printed on the underlying emulsion by the second exposure and development. Some desensitization associated with the first development may contribute to the reversal, possibly caused by metallic silver diffusing through the emulsion.[121]

Use is made of the Sabattier effect by pictorialists to produce partially reversed images as in Fig. 3-10. In handbooks of practical photography, in which details for achieving pictorial effects by the Sabattier effect are given, the process is often incorrectly referred to as solarization.

The Albert Effect

The Albert effect (1899) is obtained by applying a heavy image-wise exposure to a silver bromide emulsion, bathing the exposed emulsion in an oxidizing agent, such as chromic acid, and re-exposing to diffuse light; development yields a positive image of the first exposure. The mechanism is probably similar to that operating in the Clayden effect; the first exposure causes image-wise desensitization of the grain surface towards the diffuse exposure by introducing competitive internal silver centers.[122] The function of the oxidation process is to remove most of the dense surface latent image caused by the heavy first exposure. This step is unnecessary in the Clayden effect, since the brief high-intensity first exposure producing the internal desensitizing centers forms few surface latent image centers. The significance of internal silver centers in the Albert effect is shown by the disappearance of the effect if the oxidizing agent is active enough to attack internal silver centers by injecting holes into the grain, for example, an acid permanganate bleach.

An additional mechanism has been proposed for the Albert effect, dominant in some emulsions, according to the state of chemical sensitization.[123] It is suggested

that reduced silver accumulating around the sensitivity centers during the heavy first exposure separates these centers from the crystal. Bleaching removes this silver layer and detaches the sensitivity center from the crystal, in this way reducing sensitivity to a subsequent exposure of the grains most heavily exposed during the image-wise exposure.

The Reciprocity Effect

If in a photochemical process the product observed is formed directly by the absorption of a quantum of radiation by an atom or a molecule, the amount of product formed is proportional to the total radiant energy absorbed by the reactant, which is proportional to the product of the intensity I and the duration t of the irradiation. This product, It, is the exposure. Hence, under these conditions, there is a reciprocal relation between the intensity and the duration of the exposure, and such a photochemical change is said to conform to the *reciprocity law of photochemistry*. The law was introduced by Bunsen and Roscoe in 1862 on the basis of certain experimental observations, including a study of the visible darkening of light of silver chloride paper. The law is not at all generally true. The observed product of a photochemical reaction is frequently the result of a series of thermal reactions involving the primary photochemical products, and then the conditions of applicability of the law do not, in general, hold.

In photography, the photochemical consequence of interest is the density of the developed silver. Reciprocity would then require that a given photographic density could be achieved at different intensities by corresponding reciprocal adjustments of the exposure duration. This is not true, in general, for photographic exposures to visible or ultraviolet light, although it is true for exposures to x- and γ-rays,[124] and also for the production of visible photolytic silver in chloride paper and for the Herschel effect.[115] Emulsions subjected to ordinary photographic exposures are relatively less sensitive, at both higher and lower intensities of exposure, than at an optimum intensity and exposure time, and the deviations from reciprocity between intensity and duration of exposure are called high- and low-intensity reciprocity failure, respectively.

Commercial emulsions are designed so that the optimum exposure is in the intensity range at which they are intended to be used. The optimum intensity is usually from about 0.1 to 10 meter-candles at exposure times of 0.1 to 0.01 sec. The exposure required at very high intensity may be 1.5 to 4 times that for the optimum intensity and at low intensity the exposure may have to be increased up to about 10 times that for optimum intensity to produce the same density.[125] In commercial emulsions high-intensity reciprocity failure is a less serious practical problem than failure at low intensities.

Reciprocity failure is usually represented graphically by plotting on a logarithmic scale the values of the exposure, log It, required to produce a given density of

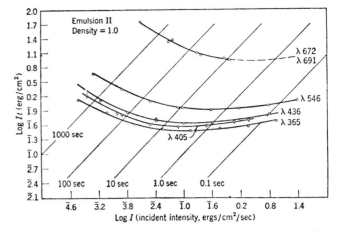

Fig. 3-11. Reciprocity failure curves for a representative spectrally sensitized and chemically sensitized negative emulsion (after Webb[126]).

developed image as a function of intensity. Figure 3-11 illustrates a family of these curves for the production of density 1.0 in a chemically and spectrally sensitized emulsion exposed to radiation of different wavelengths. This type of representation was introduced by Kron, and the diagrams are sometimes referred to as Kron diagrams. If there were no reciprocity failure, the same exposure would produce the specified density at all values of intensity, that is, the curve would be a straight line parallel to the log I axis. Instead, at a certain value of log I, the curves show a minimum in log It, representing the optimum intensity of exposure. The rising branch on the low-intensity side of the minimum represents low-intensity reciprocity failure, and that on the high-intensity side represents the high-intensity failure. The parallel lines at 45° to the axes (on an equal logarithmic scale) are lines along which the exposure time is constant.

The curves for different wavelengths in Fig. 3-11 are displaced parallel to each other along the lines of constant exposure time. If the same data are plotted as log It against log t, the curves for different wavelengths are displaced vertically and run parallel to each other. The reciprocity failure of an emulsion is therefore the same for all wavelengths, whether in the region of intrinsic sensitivity or that of spectral sensitization.[126] This independence of reciprocity failure on wavelength is important in connection with the mechanism of spectral sensitization (p. 90). An exception in a spectrally sensitized emulsion without chemical sensitization has been noted.[127]

Low-intensity failure decreases as the temperature of exposure is decreased while high-intensity failure increases.[67,128] The sensitivity of emulsions to light of low intensity increases with decreasing temperature down to temperatures well below 0°C, and then tends to decrease. This behavior has been utilized, especially by astronomers, to decrease exposure times in the long exposures necessary to photograph, for example, a distant star of low luminosity. The temperature of the photographic plate is maintained at about –40°C.

Reciprocity failure disappears at very low exposure temperatures, but the sensitivity itself is much reduced at such temperatures (see p. 108).

The *internal image* in unfinished emulsions frequently shows only low-intensity reciprocity failure; at higher intensities the internal sensitivity of such emulsions frequently exceeds that of the surface.[15]

Mechanism of Reciprocity Failure

Reciprocity failure indicates some greater inefficiency in latent image formation at intensities lower or higher than the optimum intensity. The difference in the effect of lowering the temperature of exposure on the two branches of the reciprocity curve suggests that different mechanisms are operative at low and high intensities. As already discussed in this chapter, the latent image formed at low intensity consists of a small number of relatively large centers per grain, mostly on the surface, whereas that formed at high intensities is highly dispersed as a large number of small latent image centers along with undevelopable sub-image centers. This difference in the nature of the latent image formed at low and at high intensities of exposure is reflected in the *Cabannes-Hofmann* development effect, in which grains exposed at low intensity develop more rapidly than grains in the same emulsion subjected to the same exposure at high intensities. The build-up of latent image centers involves first a nucleation stage followed by a stage of growth, and the small number of large developable centers with few sub-image centers at low intensity suggests an inefficiency in nucleation but efficient growth once a nucleus has appeared. The multitude of small developable and sub-image centers formed at high intensities of exposure suggests efficient nucleation and inefficient growth.

The prime inefficiency in nucleation is the instability of silver atoms in silver halide crystals because of ready thermal dissociation to silver ions and free electrons. If the electron is permanently removed, as by recombining with a trapped positive hole, or by reacting with an adsorbed oxygen molecule, it is lost for latent image formation, and low-intensity reciprocity failure appears. Exposure in vacuum may largely remove the failure.[100] The first stable photoproduct in a silver halide crystal is a center containing two silver atoms.[6,7] This then can serve as a nucleus for further growth. A two-atom center will be formed if, before a single silver atom has dissociated, a second photon is absorbed by the grain causing the addition of a second silver atom to the first. The decreasing probability of this process as the intensity of the radiation is reduced is the cause of low-intensity reciprocity failure.[6,10] As the temperature of the exposure is lowered and single silver atoms become more stable, the chance that a grain will absorb a second photon during the lifetime of a silver atom will increase, nucleation will be facilitated, and low intensity failure will diminish, as is observed.

A second source of low-intensity reciprocity failure has been recognized.[129] Halogen formed during the exposure in a grain in which latent image began to form early in the exposure can diffuse to surrounding grains and attack silver atoms and other silver centers. Nucleation in the attacked grains is inhibited and low-intensity reciprocity failure is introduced. Halogen acceptors in the emulsion decrease this effect. Both types of low-intensity failure have been found in an unfinished bromide emulsion.[130] The emulsion showed a very strong low-intensity failure, which was greatly reduced in the presence of a halogen acceptor, such as acetone semicarbazone, but only to a limiting value. That part of the failure eliminated by halogen acceptor is ascribed to intergranular diffusion of photolytic bromine, and the residual failure, unaffected by halogen acceptor, to the thermal instability of single silver atoms.

High-intensity reciprocity failure originates in intensity-dependent inefficiencies in the growth of latent image centers from stable but undevelopable silver nuclei by the sequential trapping of photoelectrons and their neutralization by mobile silver ions. Growth of the silver center can continue only if the rate of electron trapping does not exceed the rate at which silver ions can neutralize the trapped electrons.[131] Otherwise, an electron approaching the negatively charged center is repelled, and may be trapped at another shallower trap, probably in the interior of the crystal, or it may recombine with a positive hole. At high intensities of exposure, electrons are liberated too rapidly for the silver ions to neutralize them at the rate necessary for the growth of large silver centers, hence they lead to the formation of a relatively large number of small latent image centers and undevelopable sub-image centers, many in the interior where they cannot initiate normal development. Recombination with positive holes, which occurs at a rate proportional to the square of the intensity, may also set in at high intensities, but even if there were no loss of reduced silver, sensitivity would be reduced at high intensity because of the dispersal of latent image centers. As the temperature of the exposure is lowered, the mobility of silver ions decreases, the intensity at which neutralization by silver ions fails to match the trapping of electrons becomes lower, and hence, high-intensity reciprocity failure sets in at lower intensities.

The low sensitivity of emulsions without chemical sensitizer results in a rate of release of photoelectrons too low for latent image growth to be inhibited by an inadequate rate of neutralization by silver ions even at relatively high intensities, and the high intensity branch of the reciprocity curve may be absent for these emulsions. Since sulfur-sensitizing centers are efficient electron traps,[97] nucleation is efficient in sulfur-sensitized emulsions. The numerous nucleating centers compete among themselves for photoelectrons and the growth of any one silver center is inhibited and the resulting highly disperse assembly of small latent image and sub-image centers is the condition in which high intensity reciprocity failure arises. Hence, sulfur sensitization, although usually increasing the level of sensitivity at all intensities, also introduces high-intensity reciprocity failure.[5,96a,b] In agreement with the notion of high dispersal of photo-generated silver centers in sulfur-sensitized

grains, it is found that high-intensity failure can be reduced, but not eliminated, by gold-latensification after exposure.[96]

Berg pointed out[131] that if an exposure is so intense and of so short a duration that all the photoelectrons liberated are trapped before any can be neutralized by the motion of silver ions, further increase of intensity or shortening of exposure time at constant energy can introduce no further inefficiency in the build-up of latent image centers. The high-intensity branch of the reciprocity curve should therefore flatten out when this condition is reached. At very low temperature of exposure, this situation exists at all intensities and reciprocity failure vanishes. Berg found that at sufficiently short exposures at room temperature, the high-intensity branch of the reciprocity curve indeed flattened out and eventually ran parallel to the log-intensity axis. The *Berg bend-over point* in the reciprocity curve occurs at an exposure time approximately equal to the time elapsing between the liberation of an electron and its neutralization by a mobile silver ion. In the emulsions studied by Berg the bend-over occurred at exposure times of about 10^{-5} sec at room temperature.

Intermittency Effect

If a photographic exposure is applied in a number of interrupted installments of constant intensity, the resulting photographic density is not, in general, the same as that produced by a continuous exposure of the same total energy at the same intensity. This intermittency effect depends on the frequency of interruptions and was shown by Webb to be wholly a consequence of reciprocity failure arising from a frequency-dependent variation of the effective intensity of the interrupted exposure.[132] At low frequencies of interruption, the effective intensity is the actual intensity of the individual installments and there is no difference between the photographic effect of the interrupted exposure and that of a continuous exposure of the same energy at the intensity of the light flashes. At high frequencies of interruption, over a range starting at a critical frequency, the effective intensity of the exposure is that averaged over the bright and dark periods. Between these frequency ranges, the effective intensity assumes a continuous series of intensity-dependent values, decreasing with increasing frequency. The photographic effect of an interrupted exposure of given total energy, therefore, varies with the frequency according to the reciprocity failure characteristic of the emulsion at the different effective intensities prevailing at the different frequencies.

If the intensity of the individual flashes of an interrupted exposure is below the optimum intensity of the reciprocity curve, the photographic effect of equi-energy exposures will be determined by the low-intensity reciprocity branch of the curve. At low frequencies starting from zero, the exposure required to produce a given density will be constant over a certain range, then, with increasing frequency, will begin to rise as the effective intensity decreases. When the critical frequency is attained, the exposure required to produce the fixed density will again become constant, at a higher level than for the low frequency constant range. If, on the other hand, the intensity of the individual flashes is well above the optimum of the reciprocity curve, the effective intensity at low frequency will correspond to a point relatively high up in the high-intensity failure branch, and as, with increasing frequency of interruption and decreasing effective intensity the emulsion becomes relatively more sensitive, the exposure necessary to produce a given density decreases again to a limiting value at and above the critical frequency. In this case, the photographic effect of the interrupted exposure is greater than that of an equi-energy exposure of intensity equal to that of the individual flashes.

Webb[132,133] has attributed the equivalence of the high-frequency interrupted exposure to that of a continuous exposure at the average intensity of the interrupted exposure to the circumstance that in this range of frequencies the haphazard reception of photons by an emulsion grain during the continuous exposure is reproduced in the interrupted exposure. He concluded that at the critical frequency approximately one photon was absorbed per emulsion grain during the bright interval.

REFERENCES

1. R. W. Gurney and N. F. Mott, "The Theory of the Photolysis of Silver Bromide and the Photographic Latent Image," *Proc. Roy. Soc.*, **164 A:** 151 (1938).
2. J. Eggert and W. Noddack, "The Test of the Quantum Equivalence Law in Some Silver Halide Emulsions," *Z. Phys.*, **31:** 922 (1925).
3. R. Mutter, "The Photolysis of Binder-free Silver Bromide (Bromine Evolution)," *Z. Wiss. Photogr.*, **26:** 193 (1929).
4. G. W. Luckey, "Vacuum Photolysis of Silver Bromide and Silver Chloride," *J. Chem. Phys.*, **23:** 882 (1955).
5. A. Hautot and H. Sauvenier, "The Nature of Sensitivity Centers, Latent Image Centers and Fog Centers," *Sci. Ind. Photogr.*, (2), **28:** 1 (1957).
6. J. H. Webb, "Low Intensity Reciprocity Failure in Photographic Emulsions. I. Energy Depth of Electron Traps in Latent Image Formation, Number of Quanta Required to Form Stable Sublatent Image," *J. Opt. Soc. Amer.*, **40:** 3 (1950).
7. E. Katz, "On the Photographic Reciprocity Failure Law and Related Effects. I. The Low Intensity Failure," *J. Chem. Phys.*, **17:** 1132 (1949).
8. P. C. Burton and W. F. Berg, "A Study of Latent Image Formation by a Double Exposure Technique," *Photogr. J.*, **86B:** 2 (1946).
9. P. C. Burton and W. F. Berg, "Study of Latent Image Formation by a Double Exposure Technique, II. Internal Image," *Photogr J.*, **88B:** 84 (1948).
10. J. H. Webb, "Multiple Quantum Hits in a Critical Time Period," *J. Opt. Soc. Amer.*, **40:** 197 (1950).
11. A. Marriage, "How Many Quanta?" *J. Photogr. Sci.*, **9:** 93 (1961).
12. T. H. James, W. Vanselow, and R. T. Quirk, "Developers for Use in Determining the Distribution of the Latent Image," *PSA J.*, **19B:** 170 (1953).
13. E. A. Sutherns, "The Reliability of Bleaching Techniques for the Determination of Latent Image Distribution in Silver Bromide and Iodobromide Emulsions," *J. Photogr. Sci.*, **9:** 217 (1961).
14. W. West and V. I. Saunders, "Experimental Studies of the Mode of Action of Sensitizing Impurities in Thin Crystals of Silver Bromide," *Photogr. Sci. Eng.*, **3:** 258 (1959).
15. W. F. Berg, A. Marriage and G. W. W. Stevens, "Latent Image Distribution," *Photogr. J.*, **81:** 413 (1941).

16. T. H. James and W. Vanselow, "Dependence of Latensification Upon the Degree of Development of a Photographic Material," *PSA J.*, **15**: 688 (1949).

17. H. Chateau, M. C. Moncet and J. Pouradier, *Wissenschaftliche Photographie* (*Ergebnisse der Intern. Konf. fur Wissenschaftliche Photographie*, Koln, 1956) p. 20. W. Eichler, H. Friesser and O. Helwich (Eds.), Verlag Dr. O. Helwich, Darmstadt, 1958.

18. C. R. Berry and S. J. Marino, "Silver Halide Precipitation, III, Crystallographic Study of the Double Jet Method," *J. Phys. Chem.*, **62**: 881 (1958).

19. C. Tubandt and S. Eggert, "Electrical Conductivity in Solid Crystalline Compounds," *Z. Anorg. Allg. Chem.*, **40**: 196 (1920).

19. (a) N. F. Mott and R. W. Gurney," Electronic Processes in Ionic Crystals," 2nd Ed., Oxford, 1948, p. 40 ff., F. C. Brown, "The Physics of Solids," Benjamin, New York, 1967, p. 308.

20. I. Ebert and J. Teltow, "Ion Conduction and Lattice Disorder of Silver Chloride with Additions," *Ann. Phys.*, (6), **15**: 268 (1955).

21. F. A. Kröger, "The Thermodynamics of Imperfections in AgBr," *J. Phys. Chem. Solids*, **26**: 901 (1965).

22. P. Müller, "Ionic Conductivity of Pure and Doped AgBr and AgCl Single Crystals," *Phys. Status Solidi*, **12**: 775 (1965).

23. J. F. Hamilton and L. E. Brady, "Electrical Measurements on Photographic Emulsion Grains," *J. Appl. Phys.*, **30**: 1893 (1959).

24. J. F. Hamilton and L. E. Brady, "The Role of Mobile Silver Ions in Latent Image Formation," *J. Phys. Chem.*, **66**: 2384 (1962).

25. W. G. Burgers and J. N. Kooy, "Influence of Cadmium and Lead Halides on the Photosensitivity of Silver Halides," *Rec. Trav. Chim. Pays-Bas*, **67**: 16 (1948).

26. W. West and V. I. Saunders, "Photochemical Processes in Thin Crystals of Silver Bromide; The Distribution and Behavior of Latent Image and of Photolytic Silver in Pure Crystals and in Crystals Containing Foreign Cations," *J. Phys. Chem.*, **63**: 45 (1959).

27. F. Seitz, "Properties of Silver Halide Crystals," *Rev. Mod. Phys.*, **23**: 328 (1951).

28. J. M. Hedges and J. W. Mitchell, "The Observation of Polyhedral Substructure in Crystals of Silver Bromide," *Phil. Mag.* [VII], **44**: 223 (1953).

29. C. R. Berry, "Convergent Beam X-Ray Analysis of Mosaic Structure in Polycrystals," *J. Appl. Phys.*, **27**: 636 (1956).

30. J. F. Hamilton, "Electron Microscope Study of Defect Structure and Photolysis in Silver Bromide," *Photogr. Sci. Eng.*, **11**: 57 (1967).

31. C. R. Berry, "Crystal Imperfections and Electron-Trapping Sites in AgBr," *Photogr. Sci. Eng.*, **8**: 346 (1964).

32. R. W. Berriman and R. H. Herz, "Twinning and Tabular Growth of AgBr Crystals," *Nature*, **180**: 293 (1957).

33. C. R. Berry and D. C. Skillman, "Precipitation of Twinned AgBr Crystals," *Photogr. Sci. Eng.*, **6**: 159 (1962).

34. E. Klein, H. J. Metz, and E. Moser, "Twin Formation in AgBr and AgCl Crystals in Photographic Emulsions, I, Derivatives of the Ideal Crystal Form, II, Description of the Occurring Twin Types and Consequences for Crystal Growth," *Photogr. Korr.*, **99**: 99 (1963); **100**: 57 (1964).

35. J. Frenkel, *Kinetic Theory of Liquids*, Dover, New York, 1955, pp. 8, 37.

36. K. Lehovec, "Space Charge Layer and Distribution of Lattice Defects at the Surface of Ionic Crystals," *J. Chem. Phys.*, **21**: 1123 (1953).

37. J. D. Eshelby, C. W. A. Newey, P. L. Pratt and A. B. Lilliard, "Charged Dislocations and the Strength of Ionic Crystals," *Phil. Mag.*, [VIII], **3**: 75 (1958).

38. K. L. Kliewer, "Space Charge in Ionic Crystals—III. Silver Halides Containing Divalent Cations," *J. Phys. Chem. Solids*, **27**: 705 (1966).

39. E. P. Honig and J. H. Th. Hengst, "The Point of Zero Charge and Solid State Properties of Silver Bromide," *J. Colloid Interfac. Sci.*, **31**: 545 (1969).

40. L. Slifkin, W. McGovern, A. Fukai and J. S. Kim, "Electrically Charged Surfaces and the Photographic Process," *Photogr. Sci. Eng.*, **11**: 79 (1967).

41. V. I. Saunders, R. W. Tyler and W. West, "Space Charge Layer and Surface Sensitivity in AgBr Single Crystals," *Photogr. Sci. Eng.*, **12**: 90 (1968).

42. F. Trautweiler, "Surface Space Charge in Silver Bromide Crystals and its Bearing on the Photographic Process," *Photogr. Sci. Eng.*, **12**: 98 (1968).

43. C. R. Berry and D. C. Skillman, "Surface Structure and Epitaxial Growth in AgBr Microcrystals," *J. Appl. Phys.*, **35**: 2165 (1964).

44. F. Urbach, "The Long Wavelength Edge of Photographic Sensitivity and of the Electronic Absorption of Solids," *Phys. Rev.*, **92**: 1324 (1953).

45. F. Moser and F. Urbach, "Optical Absorption of Pure Silver Halides," *Phys. Rev.*, **102**: 1519 (1955).

46. W. Lehfeldt, "Electronic Conduction in Silver and Thalium Halide Crystals," *Göttingen Nachrichten, Fachgruppe II*, **1**: 171 (1935).

47. R. S. Van Heyningen and F. C. Brown, "Transient Photoconductivity in AgCl at Low Temperatures," *Phys. Rev.*, **111**: 462 (1958).

48. B. Zuckerman, "Quantum Efficiency Studies in Silver Bromide Single Crystals and the Effect of Dye Concentration on the Efficiency of Spectral Sensitization," *Photogr. Sci. Eng.*, **11**: 156 (1967).

49. V. I. Saunders, R. W. Tyler and W. West, "A Study of the Primary Photographic Process in Silver Bromide Crystals by Measurements of Transient Photocharge," *Photogr. Sci. Eng.*, **16**: 87 (1972).

50. E. A. Taft, H. R. Philip and L. Apker, "Photoelectric Emission from the Valence Band in Silver Bromide," *Phys. Rev.*, **40**: 876 (1958).

51. J. R. Haynes and W. Shockley, "The Mobility of Electrons in Silver Chloride," *Phys. Rev.*, **82**: 935 (1951).

52. R. Van Heyningen, "Electron Drift Mobility in Silver Chloride," *Phys. Rev.*, **128**: 2112 (1962).

53. J. Irmer and P. Süptitz, "The Drift Mobility and Lifetime of Photoelectrons in AgBr at Room Temperature," *Phys. Status Solidi*, **1**: K81 (1961).

54. V. I. Saunders, R. W. Tyler and W. West, "Displacement of Photoelectrons and Positive Holes in Sheet Crystals of Silver Bromide as Shown by Development Techniques," *J. Chem. Phys.*, **37**: 1126 (1962).

55. R. K. Ahrenkiel and R. S. Van Heyningen, "Life Time and Drift Mobility of Holes in AgBr," *Phys. Rev.*, **144**: 570 (1966).

56. N. Platikanova and J. Malinowski, "Trapping of Holes in Silver Bromide Single Crystals," *Phys. Status Solidi*, **14**: 205 (1966).

57. J. Malinowski and P. Süptitz, "Study Towards the Determination of the Properties of Defect Electrons in Silver Bromide," *Z. Wiss. Photogr.*, **57**: 4 (1963).

58. U. Heukeroth and P. Süptitz, "Lifetime and Drift Mobility of Defect Electrons in AgBr Crystals at Room Temperature, *Phys. Status Solidi*, **13**: 285 (1966).

59. M. Georgiev, "Surface and Volume Decay of the Concentration of Positive Holes in Silver Bromide," *Phys. Status Solidi*, **15**: 193 (1966).

60. R. C. Hanson and F. C. Brown, "Hall Mobility of Holes in AgBr," *J. Appl. Phys.*, **31**: 210 (1960).

61. J. F. Hamilton and L. E. Brady, "Electrical Measurements in Photographic Emulsion Grains, I, Dark Conductivity; II, Photoelectric Carriers," *J. Appl. Phys.*, **30**: 1893 (1959).

62. J. F. Hamilton and L. E. Brady, "Role of Mobile Silver Ions in Latent Image Formation," *J. Phys. Chem.*, **66**: 2389 (1962).

63. F. A. Kröger, "Hole Trapping and Ionization Energy of Native Acceptor Centers in AgBr," *J. Phys. Chem. Solids*, **27**: 1697 (1966).

64. W. F. Berg, "Note on the Mechanism of Latent Image Formation," *Photogr. Sci. Eng.*, **11**: 242 (1967).

65. S. E. Sheppard, A. P. H. Trivelli and R. P. Loveland, "Studies in Photographic Sensitivity, VI, The Formation of Latent Image, *J. Franklin Inst.*, **200**: 51 (1925).

66. J. W. Mitchell, "The Nature of Photographic Sensitivity," *J. Photogr. Sci.*, **5**: 49 (1957).

67. J. H. Webb and C. Evans, "An Experimental Study of Latent Image Formation by Means of Interrupted and Herschel Exposures at Low Temperature," *J. Opt. Soc. Amer.*, **28**: 249 (1938).

68. T. H. James, W. Vanselow and R. F. Quirk, "Effect of Temperature of Exposure on Photographic Sensitivity and Development Rate," *Photogr. Sci. Eng.*, **5**: 219 (1960).

69. J. H. Webb, "Ultrashort Light and Voltage Pulses Applied to Silver Halide Crystals by Turbine-Driven Mirror and Spark Gap Switch," *J. Appl. Phys.*, **26**: 1309 (1955).

70. J. W. Mitchell, "The Nature of Photographic Sensitivity," *J. Photogr. Sci.*, **5**: 49 (1957).

71. J. W. Mitchell, "The Photographic Process," *Rep. Prog. Phys.*, Physical Soc., London, **20**: 433 (1957).

72. J. W. Mitchell and N. F. Mott, "The Nature and Formation of the Photographic Latent Image," *Phil. Mag.*, [VIII], **2**: 1149 (1957).

73. J. W. Mitchell, "The Nature and Formation of the Photographic Latent Image," *J. Photogr. Sci.*, **9**: 328 (1961).

74. J. W. Mitchell "Some Aspects of the Theory of Photographic Sensitivity," *J. Phys. Chem.*, **66**: 2359 (1962).

75. J. F. Hamilton and L. E. Brady, "Some Aspects of the Mitchell Theory of Photographic Sensitivity," *Photogr. Sci. Eng.*, **8**: 189 (1964).

76. J. Malinowski, "The Role of Holes in the Photographic Process," *J. Photogr. Sci.*, **16**: 57 (1968).

77. Y. T. Tan and F. Trautweiler, "Nonlinear Photovoltaic Effect in Silver Bromide," *J. Appl. Phys.*, **40**: 66 (1969).

78. W. West and B. H. Carroll, "Photoconductivity in Photographic Systems," *J. Chem. Phys.*, **15**: 529 (1947).

79. P. Müller, "Ionic Conductivity of Pure and Doped AgBr and AgCl Single Crystals," *Phys. Status Solidi*, **12**: 775 (1965).

80. M. Georgiev and J. Malinowski, "Migration of Holes in Silver Bromide at Room Temperature," *J. Phys. Chem. Solids*, **28**: 931 (1966).

81. B. Levy, "Photoconductivity of Photographic Coatings—Dynamic Observations of Latent Image Processes," *Photogr. Sci. Eng.*, **15**: 279 (1971).

82. See, for example, W. Shockley, *Electrons and Holes in Semiconductors*, Van Nostrand Reinhold, New York, 1950, p. 299.

83. G. W. Luckey, "The Effect of Halogen Gases on the Electrical Conductivities of Silver Bromide and Silver Chloride," *Discussions Faraday Soc.*, **28**: 113 (1959).

84. E. Eisenmann and W. Jaenicke, "Migration and Phase Boundary Reactions of Positive Holes in Silver Bromide," *Z. Phys. Chem.*, *Neue Folge*, **49**: 1 (1966).

85. H. Kanzaki, "Behavior of Positive Holes in Silver Halides," in *Photographic Sensitivity*, Vol. 2, Mazuren, Tokyo, 1958, p. 181.

86. M. Georgiev and J. Malinowski, "Migration of Holes in Silver Bromide at Room Temperature," *J. Phys. Chem. Solids*, **28**: 931 (1967).

87. J. Malinowski, "Properties of Photoexcited Holes in Silver Bromide Crystals," *Contemp. Phys.*, **8**: 285 (1967).

88. F. Trautweiler, "Implications of a Quantum Model of the Latent Image," *Photogr. Sci. Eng.*, **12**: 138 (1968).

89. J. Drowart and R. E. Honig, "Mass Spectrometric Study of Copper, Silver and Gold," *J. Chem. Phys.*, **25**: 581 (1956).

90. P. C. Burton, "A Two-Stage Theory of the Density-Intensity-Time Relations for Single and Double Photographic Exposures," *Photogr. J.*, **88B**: 123 (1948).

91. R. Matejec, "Electrical Conductivity Measurements on Single Crystals of Silver Halides," *Z. Phys.*, **148**: 454 (1957).

92. B. E. Bayer and J. F. Hamilton, "Computer Investigation of a Latent Image Model," *J. Opt. Soc. Amer.*, **55**: 439 (1965).

93. J. F. Hamilton and B. E. Bayer, "Investigation of a Latent Image Model; Recombination of Trapped Electrons and Free Holes," *J. Opt. Soc. Amer.*, **55**: 528 (1965).

94. (a) J. F. Hamilton, "Latent Image Formation as a Probabilistic Process," *Photogr. Sci. Eng.*, **12**: 143 (1968).
 (b) "Some Models of Low Temperature Latent Image Formation," *Photogr. Sci. Eng.*, **14**: 122 (1970).

95. K. C. D. Hickman, "A Chemical Aspect of Sulfide Sensitivity," *Photogr. J.*, **67**: 34 (1927).

96. (a) H. E. Spencer and R. E, Atwell, "Sulfur Sensitization and High Intensity Reciprocity Failure of Silver Bromide Grains," *J. Opt. Soc. Amer.*, **54**: 498 (1964).
 (b) "Development Center and High Intensity Reciprocity Failure," *J. Opt. Soc. Amer.*, **56**: 1095 (1966).

97. H. E. Spencer, L.E. Brady and J. F. Hamilton, "Study of the Mechanism of Sulfur Sensitization by a Development-Center Technique," *J. Opt. Soc. Amer.*, **54**: 492 (1964).

98. W. G. Lowe, J. E. Jones and H. E. Roberts, "Some Chemical Factors in Emulsion Sensitivity," in *Fundamental Mechanisms of Photographic Sensitivity*, J. W. Mitchell (Ed.), Butterworths Scientific Publications, London, 1951, p. 112.

99. T. Tani, "Photographic Effects of Electron and Positive Hole Traps in Silver Halides, II; Reduction Sensitization in Octahedral Silver Bromide Grains," *Photogr. Sci. Eng.*, **15**: 181 (1971).

100. W. C. Lewis and T. H. James, "Effects of Evacuation on Low Intensity Reciprocity Failure and Desensitization by Dyes," *Photogr. Sci. Eng.*, **13**: 54 (1969).

101. T. H. James, "Effects of Environment on Latent Image Formation by Light," *Photogr. Sci. Eng.*, **14**: 84 (1970).

102. S. E. Sheppard and C. L. Graham, "Extragranular Factors in Photographic Sensitivity," *J. Franklin Inst.*, **230**: 619 (1940).

103. J. F. Hamilton, "Effect of Oxygen on Photographic Sensitivity, and the Mechanism of Spectral Sensitization," *Photogr. Sci. Eng.*, **13**: 331 (1969).

104. J. A. Leermakers, U.S. Pat. 2,184,013 (Eastman Kodak Co., 1939.)

105. H. Arens, "On the Villard Effect, III," *Z. Wiss. Photogr.*, **53**: 157 (1959).

106. L. Fortmiller, T. H. James, R. F. Quirk and W. Vanselow, "The Combined Effect of Infrared Radiation and Intensification upon the Photographic Latent Image," *J. Opt. Soc. Amer.*, **40**: 487 (1950).

107. R. Hilsch and R. W. Pohl, "The Photochemistry of Alkali and Silver Halide Crystals," *Z. Phys.*, **64**: 606 (1930).

108. R. Meyer, "Herschel Effect in Silver Chloride Crystals," *Naturwissenschaften*, **43**: 103 (1956).

109. F. C. Brown and N. Wainfan, "Photolytic Darkening and Electronic Range in Silver Chloride," *Phys. Rev.*, (2) **105**: 93 (1957).

109. (a) W. West and B. H. Carroll, "Photoconductivity in Photographic Systems, II—Some Applications to the Phenomena of Supersensitization, Desensitization and the Becquerel Effect," *J. Chem. Phys.*, **15**: 529 (1947).

110. P. Süptitz, "The Bleaching of Colloidal Silver in Silver Chloride," *Z. Wiss. Photogr.*, **53**: 201 (1959).

111. V. I. Saunders, R. H. Tyler and W. West, "Herschel Effect in Single Crystals of Silver Bromide," *J. Chem. Phys.*, **46**: 206 (1967).

112. W. F. Berg, "Latent Image Formation at Low Temperatures," *Trans. Faraday Soc.*, **35**: 445 (1939).

113. T. H. James, W. Vanselow, R. F. Quirk and F. Grum, "The Herschel Effect at −196°C," *Photogr. Sci. Eng.*, **7**: 226 (1963).

114. A. Hautot and H. Sauvenier, "The Debot Effect," *Sci. Ind. Photogr.*, (2) **20**: 286 (1949).

115. L. Falla, "The Photographic Herschel Effect. The Reciprocity Law in the Case of the Herschel Effect," *Bull. Soc. Roy. Sci. Liège*, **10**: 270 (1940).

116. S. E. Sheppard, "The Optical Sensitizing of Silver Halides by Colloidal Silver," *J. Franklin Inst.*, **210**: 387 (1930).

117. A. S. Parasnis and J. W. Mitchell, "Properties of Crystals of Silver Chloride Containing Traces of Copper Chlorides," *Phil. Mag.*, **4**: 171 (1959).

118. W. Meidinger, Quantum Yield of the Photolysis of Silver Halide in Photographic Films," *Z. Wiss. Photogr.*, **44**: 137 (1949).

119. R. E. Maurer and J. A. C. Yule, "A Photographic Low Intensity Desensitization Effect," *J. Opt. Soc. Amer.*, **42**: 402 (1952).

120. G. C. Farnell and R. G. Powell, "The Sensitometric Properties of Emulsions at a Low Level of Chemical Sensitization," *J. Photogr. Sci.*, **11**: 57 (1963).

121. G. W. Stevens and R. G. W. Norrish, "Border Effects Associated with Photographic Reversal Processes," *Photogr. J.*, **77**: 20 (1937).

122. G. W. Stevens, "The Mechanism of Photographic Reversal, Pt. II. The Albert Effect," *Photogr. J.*, **79**: 27 (1939).

123. J. R. Manhard and D. J. Frost, "The Albert Effect: I, The Dual Mechanism," *Photogr. Sci. Eng.*, **8**: 265 (1964).

124. (a) G. E. Bell, "The Photographic Action of X-rays," *Brit. J. Radiol.*, **9**: 578 (1936).
 (b) "The Photographic Action of Radium γ-rays," *ibid.*, **9**: 688 (1936).

125. J. L. Tupper, "Practical Aspects of Reciprocity Law Failure," *J. Soc. Motion Picture Television Engrs.*, **60**: 20 (1953).

126. J. H. Webb, "The Photographic Reciprocity Law Failure for

Radiations of Different Wavelengths," *J. Opt. Soc. Amer.*, **23:** 316 (1933).

127. P. B. Gilman, "Effect of Aggregation, Temperature and Super-sensitization on the Luminescence of 1,1'-Diethyl-2,2'-Cyanine Chloride Adsorbed to Silver Chloride," *Photogr. Sci. Eng.*, **12:** 230 (1968).

128. W. F. Berg and K. Mendelssohn, "Photographic Sensitivity and the Reciprocity Law at Low Temperatures," *Proc. Royal Soc.*, **168A:** 168 (1938).

129. W. F. Berg, "A New Cause of Low Intensity Reciprocity Failure," *Trans. Faraday Soc.*, **44:** 738 (1948).

130. H. E. Spencer and D. H. Shares, "Low Intensity Reciprocity Failure of a AgBr Emulsion: Effect of Halogen Acceptors," *J. Opt. Soc. Amer.*, **57:** 508 (1967).

131. W. F. Berg, "Reciprocity Failure of Photographic Materials at Short Exposure Times," *Proc. Royal Soc.*, **174A:** 559 (1940).

132. J. H. Webb, "The Relationship Between Reciprocity Law Failure and the Intermittency Effect in Photographic Exposure," *J. Opt. Soc. Amer.*, **23:** 157 (1933).

133. L. Silberstein and J. H. Webb, "Photographic Intermittency Effect and the Discreet Structure of Light," *Phil. Mag.*, **18:** 1 (1934).

4

THE SPECTRAL SENSITIVITY OF EMULSIONS, SPECTRAL SENSITIZATION, DESENSITIZATION AND OTHER PHOTOGRAPHIC EFFECTS OF DYES

W. WEST

INTRINSIC SPECTRAL SENSITIVITY OF SILVER HALIDES

The photographic sensitivity of an emulsion is determined by the relation between the density of the final developed image and the amount of radiant energy incident on the emulsion during exposure. Sensitivity is frequently expressed as the reciprocal of the incident energy density in ergs or in light quanta per square centimeter required to produce some specified photographic density of developed image above the fog level. The value of the sensitivity depends on the wavelength of the exposing radiation, and the variation of sensitivity with wavelength is called the spectral sensitivity of the emulsion.

Since photochemical changes depend on the absorption of radiant energy by the reactant, the spectral sensitivity of a photochemical system is related to the absorption spectrum. The physical processes induced by the absorption of light by silver halide crystals are discussed in Chapter 3. In Fig. 4-1 the visible and ultraviolet absorption spectra of large single crystals of silver halides at room temperature are expressed, on a logarithmic scale, as the absorption coefficient, α, as a function of wavelength.[1] The absorption coefficient of a homogeneous medium is determined by the relation $I = I_0 e^{-\alpha d}$, where I is the intensity to which a parallel beam of monochromatic radiation of intensity I_0 incident on the medium is attenuated after traversing a distance d cm within the medium. The dimensions of α are cm^{-1}, and it can be seen from the equation that α is numerically equal to the penetration distance within the medium at which the intensity of the radiation is reduced to $1/e$, 36.8% of its incident value. In general, α depends on wavelength, temperature and very slightly on pressure.

The dotted curve in Fig. 4-1 represents the wavelength dependence of relative photographic sensitivity, on a logarithmic scale, of a chemically sensitized silver bromide emulsion, derived from measurements of Eggert and Kleinschrodt.[2] The sensitivity curve of the emulsion layer has been normalized with respect to the absorption curve of the crystal, by placing the value of the logarithm of the sensitivity at wavelength 400 nm on the absorption curve. Except at wavelengths longer than about 500 nm, there is a general parallelism between the spectral sensitivity of the emulsion and the spectral absorption expressed in terms of the absorption coefficient. The parallelism becomes exact, in the spectral region between 400 and 500 nm, when the spectral sensitivity is compared, not with the absorption coefficient, but with the amount of light absorbed by the bromide in the emulsion layer—between 400 and 500 nm the photographic sensitivity of

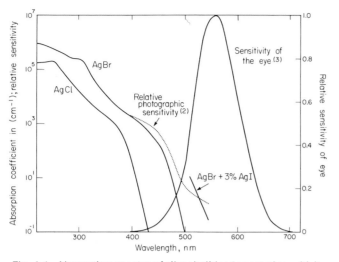

Fig. 4-1. Absorption spectra of silver halides,[1] spectral sensitivity of silver bromide,[2] and the relative sensitivity of the eye.[3]

silver bromide emulsions is directly proportional to the energy absorbed by the halide. At wavelengths greater than about 500 nm, the photographic sensitivity of emulsions assumes values greater than in proportion to the light absorbed at these wavelengths by the silver bromide, by amounts that increase with the degree of sulfur sensitization. The chemically sensitizing material, silver sulfide, confers a feeble absorption band at wavelengths longer than about 500 nm, additional to the intrinsic absorption at these wavelengths of the silver halide. This absorption can also be utilized to form latent image, the chemical sensitizer also acting as a spectral sensitizer to light of longer wavelength than those appreciably absorbed by the silver halide.

From Fig. 4-1 one sees that the absorption and photographic sensitivity of silver halides is confined to the blue and violet regions of the spectrum, and both extend throughout the ultraviolet, x-ray and γ-ray regions. There is no definite long wavelength limit to absorption or sensitivity, but for practical photography, undyed silver bromide emulsions are insensitive to wavelengths longer than about 480 nm and the limit for chlorides is about 420 nm. The sensitivity of iodobromide emulsions containing a few mol percent iodide extends to wavelengths somewhat longer than for either pure bromide or pure iodide, but in any case, towards normal photographic exposures, the intrinsic sensitivity of silver halide emulsions does not include wavelengths longer than those of the blue-green.

For comparison with the intrinsic sensitivity of silver halides, the relative spectral sensitivity of the eye is shown in the figure on an arithmetic scale,[3] from which it can be seen that silver halides are essentially color blind to green, yellow and red light.

SPECTRAL SENSITIZATION

Fortunately, for adequate tonal rendition of colored objects in black and white photography and for the whole process of photography in color, emulsions can be rendered sensitive to all wavelengths of the visible spectrum, or to any desired spectral region in addition to the blue, by adding an appropriate dye to the emulsion. Sensitivity to long wavelengths can, in fact, be extended to about 1300 nm, in the near infrared. The process of inducing sensitivity at longer wavelengths than those appreciably absorbed by the silver halide is called *spectral sensitization*, and the substances effective in inducing the long wavelength sensitivity are called spectral sensitizers. Chemical sensitizers increase the overall sensitivity of an emulsion, whether dyed or undyed, whereas spectral sensitizers increase the spectral region of response, in a manner that can be modified, similarly to the intrinsic sensitivity, by chemical sensitizers.

Spectral sensitization by dyes was accidentally discovered in 1873 by W. Vogel, who, in the course of a study of the sensitivity of collodion dry plates, observed to his surprise some sensitivity to green light, which he traced to the presence of a dye showing some absorption in the green. It had been added by the manufacturer, presumably to prevent halation. Vogel found other dyes to be effective as spectral sensitizers, or optical sensitizers, as he called them, including the dye cyanine, a sensitizer to red light, discovered in 1857 by C. Greville Williams, and the first to be synthesized of the class of cyanine dyes which constitute the most important group of spectral sensitizers in modern practice.

Spectral sensitization of photographic emulsions can be effected in a number of ways. The products of chemical sensitization, mainly silver sulfide or silver centers, also act, to some degree, as spectral sensitizers, and as early as 1880, Abney photographed the solar spectrum to the wavelength 1075 nm, using a collodion emulsion prepared under conditions that could have formed colloidal silver centers in intimate contact with the grains. For practical purposes, spectral sensitization is accomplished by adding one or more sensitizing dyes to the emulsion. Among the first useful dye sensitizers were eosin and erythrosine, and many other dyes, including azo dyes, such as Congo red, triphenylmethane dyes, such as ethyl violet, acridine dyes, oxazines and indulines were found to exhibit sensitizing properties. Cyanine and merocyanine dyes are now the most important classes of sensitizing dyes. The dye, usually dissolved in an organic solvent, is added to the emulsion just before application to the support. Sensitization can also be accomplished by bathing the plate or film in a dye bath. The concentration of dye depends on circumstances, but bathing for 3 to 4 min in a bath containing 2 ml of a stock solution of dye at a concentration of 1:1000 in methanol added to 100 ml water, followed by a rinse for 1 min in methanol and drying, is a representative procedure.

STRUCTURE OF SENSITIZING DYES

Organic dyes show three essential characteristics; an intense absorption of radiation in the visible, near ultraviolet or near infrared spectral regions, associated with an electronic transition; the capacity to be strongly adsorbed to fabrics or ionic crystals so as to resist washing

out; and a tendency to transfer the excitation energy that they acquire on absorption of radiation to other appropriate molecules or molecular systems. This latter transfer may, in principle, also involve the transfer of an electron. All of these characteristics are involved in the spectral sensitization of the photographic process.

The properties of dyes, in general, are intimately connected with a structure which can be written as:

$$A—(C=C)_n—C=B \longleftrightarrow A^+=(C-C)_n=C—B^-$$
$$(I)$$

A conjugated chain of carbon atoms connects two terminal atoms A and B, both of which can readily and reversibly donate or accept electrons. N, O and, as in the carotenes, C are the usual terminal atoms. The electron donating or accepting atoms may be of the same element, for example, N atoms, in which case they will differ in valence, one of the terminal atoms being electrically charged. A and B may also be atoms of different elements, such as N and O.

The electrons in dye molecules, the excitation of which by radiation gives rise to the visible and near ultraviolet spectra of these compounds, are called π-electrons, the most loosely bound electrons in these molecules. An essential feature of the π-electrons in a conjugated chain is that they are not localized about individual atomic nuclei, but can move throughout the whole chain. Various representations of this nonlocalization of π-electrons are possible. In the resonance description,[4] the molecule is thought of as switching between structures derived by interchanging single and double bonds, leading to the two structures of Formula (I), defined as the terminal structures, or by redistributing the π-electrons among the atoms in the chain in other ways, with the generation of additional structures, usually less stable than the terminal structures. The double headed arrow in the formula indicates that the actual molecule cannot be described by any of the valence bond structures separately, but is represented by simultaneous superposition of the various resonating structures.

In another representation, the "free electron model," the π-electrons are treated as an electron gas in a box constituted by the potential well arising from the charges of the atomic nuclei and those of the other electrons in the molecule. This theory has enabled quantitative predictions to be made regarding the spectra of dyes.[5]

Spectra have also been calculated by the molecular orbital method,[6] in which the π-electrons are considered to move in the field of the atomic nuclei and of all the other electrons, and the energy and probability distribution of a single electron in this field (the molecular orbital) is calculated from a summation of the orbitals of the electrons about each of the atoms in the chain, (linear combination of atomic orbitals). A set of one-electron molecular orbitals at discrete energy levels is derived, over which the π-electrons in the system are distributed, no more than two to an orbital. Under the influence of electromagnetic radiation, electronic transitions occur by excitation from an occupied to an unoccupied molecular orbital.

The free electron and molecular orbital models of the electronic structure of conjugated chain systems make no mention of "resonating structures"—the nonlocalization of the π-electrons is explicit from the start of the treatment. Nevertheless, although the resonance representation has not proved suitable for the calculation of dye spectra, it can be readily visualized and is often useful in suggesting a qualitative understanding of the spectra and the chemical reactivity of conjugated systems. We shall therefore return to Formula (I) in considering the three fundamental characteristics of dyes.

In the first place the structure is associated with intense color, and for this reason is called a *chromophore*. The terminal atoms of the chromophore, A and B, more or less readily gain or lose electrons, with a change in valence. They constitute the *auxochromes* of the system. For example, a common dye chromophore is:

$$>N—(C=C)_n—C=N^+< \longleftrightarrow >N^+=(C-C)_n=C—N<$$
$$(II)$$

in which one N atom is trivalent, with a lone pair of electrons, and an electron donor, the other, quaternary, and an electron acceptor. Similarly, in the chromophore of dyes of the oxonal class,

$$:O^-—(C=C)_n—C=O \longleftrightarrow O=(C-C)_n=C—O^-:$$
$$(III)$$

the auxochromic oxygen atom is present in the singly bonded, negatively charged, electron donating state O^- and in the doubly bonded, electrically neutral, electron accepting state $O=$. When the auxochromes are different states of the same atom, as in formulas (II) and (III), the chromophore is said to be symmetrical and the two terminal structures are of the same energy.

The auxochromic atoms may be different, as in the unsymmetrical chromophore of the amide system, (IV).

$$>N—(C=C)_n—C=O \longleftrightarrow >N^+=(C-C)_n=C—O^-:$$
$$(IV)$$

Here the N atom resonates between its uncharged, trivalent, electron-donating state and its positively charged, quaternary, electron-accepting state, and the O atom, between its uncharged, electron-accepting, divalent state and its negatively charged, electron-donating, monovalent state. In this case, both of the terminal resonance structures are, over-all, uncharged, but in the right hand structure there is a large separation of positive and negative charge, that is, one structure is more highly polar than the other. The terminal structures of unsymmetrical chromophores usually differ in energy.

The nonlocalization of the π-electrons in the chromophores of dye molecules is associated also with a high polarizability, that is, a high tendency for electrons to be displaced with respect to the atomic nuclei when the molecule is placed in an electric field, whether externally applied or as a result of an adjacent molecule. This circumstance, in turn, generates large intermolecular attractive forces between adjacent dye molecules, that is, large van der Waals forces, which, supplemented by the

tendency of the hydrocarbon part of dye molecules to separate from water, confer on dyes a tendency to form dimers and larger aggregates in aqueous solution, and to be adsorbed from solution on the surfaces of textile fibers or of ionic crystals such as silver halides. Interionic forces between dye ions and the oppositely charged ions in a crystal surface contribute to the adsorption forces. Aggregation and adsorption of dye molecules play an important part in spectral sensitization.

The third general characteristic of dyes, their tendency to transfer their energy of electronic excitation acquired by absorption of light to suitable acceptor molecules, is also connected with the delocalization of π-electrons. Absorption of radiant energy by dye molecules causes a relatively large displacement of electronic charge; while the molecule is in the radiation field, the excited electron behaves as a virtual oscillator, vibrating with the frequency of the light. The excited dye molecule, acting similarly to a radio antenna, generates an alternating electromagnetic field in its surroundings, which can communicate energy to other molecules in tune with the field, inducing electronic excitation and possible chemical change. This interaction can occur at separation distances between the energy-donor and the acceptor of many molecular diameters, but at separations much less than the wavelength of the light absorbed by the dye; the energy transfer is therefore to be distinguished from that in which a photon is emitted as fluorescence by the donor and absorbed by the acceptor. Dyes, in general, are effective sensitizers of photochemical reactions, often by the energy transfer just described. In addition to resonance transfer, we shall find that it is necessary to consider also a direct electron transfer from the donor to the acceptor as participating in spectral sensitization of the photographic process.

Other properties of dyes relevant to spectral sensitization will be illustrated with reference to the most important classes of sensitizers, cyanine and merocyanine dyes.

CYANINE DYES

In essence, cyanine dyes are cationic dyes containing two heterocyclic nuclei linked by a conjugated chain of variable length. A typical class of these dyes comprises the 2,2'-cyanine dyes, in which the heterocyclic nuclei are derived from quinoline, joined in the 2- and 2'-positions by the conjugated chain (Formula (V)).

$n = 0,1,2,3...$

(V)

In Formula (V), X^- is an anion, such as Cl^-, Br^-, I^-, p-toluenesulfonate, etc. The two quinoline nuclei may also be linked by the conjugated chain in the 4- and 4'-positions, giving 4-4'-cyanine dyes, or one nucleus may be linked in the 2-position and the other in the 4'-position, giving 2-4'-cyanine dyes. Many other nuclei

derived from heterocyclic bases can be used in the synthesis of cyanine dyes such as (a) thiazole, (b) thiazoline, (c) benzothiazole, (d) benzoxazole, (e) benzoselenazole, (f) benzimidazole, (g) indolenine, as well as naphtho-derivatives of the bases, such as (h) naphtho[1,2]thiazole.

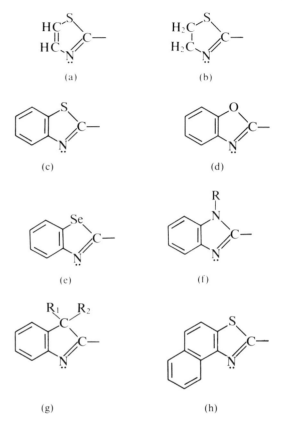

For example, symmetrical cyanine dyes derived from benzothiazole are

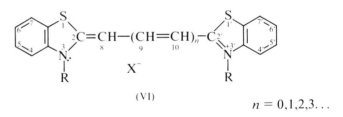

(VI)

$n = 0,1,2,3...$

The N atoms of both heterocyclic nuclei in cyanine dyes bear alkyl or other substituents, but only one is charged in a valence-bond formula such as (VI), although, in accordance with the principle of nonlocalization of π-electrons in conjugated chains, the charge may be regarded as shared by both N atoms. The various terminal nuclei of cyanine dyes differ in basicity, that is, in their tendency to donate electrons and assume a positive charge, hence, in unsymmetrical cyanine dyes, the heterocyclic nucleus of greater basicity will retain the greater share of the positive charge.

As ionic dyes, cyanines are soluble in polar solvents, such as alcohols, acetone, ethers, acetonitrile, nitromethane, chlorophenols, etc., and practically insoluble

in aliphatic and aromatic hydrocarbons. Some, especially as chloride, are fairly soluble in water.

The hydrogen atoms in the methine chain and in the heterocyclic nuclei may be substituted by alkyl or other groups. The methine group in the chromophoric chain may be replaced by the isoelectronic N atom, $-\ddot{N}=$, giving rise to azacyanines; for example,

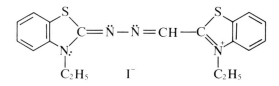

(VII) 8,9-Diaza-3,3'-diethylthiacarbocyanine iodide

Nomenclature of Cyanine Dyes

At least two systematic nomenclatures for cyanine dyes are used, as well as others reflecting the historic development of their synthesis. The system most commonly used in the literature in the English language is as follows.

Cyanine dyes derived form quinoline nuclei only are called simply cyanines, without specification of the nuclei, the points of linkage by the methine chain, 2 or 4, being indicated as already described. Cyanine dyes derived from the benzothiozole nucleus are thiacyanines; similarly oxacyanines, selenacyanines, thiazolocyanines, thiazolinocyanines and indocyanines contain nuclei derived from benzoxazole, benzoselenazole, thiazole, thiazoline and indolenine respectively. Both nuclei are designated for an unsymmetrical cyanine; for example, a dye containing quinoline and benzothiazole nuclei is called a thia-2'-cyanine, if the quinoline nucleus is linked at the 2'-position. The length of the methine bridge, that is, the value of n in Formulas (V) and (VI) is indicated by a prefix, according to the following table

n	Number of methine groups	Designation of dye
0	1	cyanine
1	3	carbocyanine
2	5	dicarbocyanine
3	7	tricarbocyanine
4	9	tetracarbocyanine
5	11	pentacarbocyanine

and so on to heptacarbocyanines, the cyanine dyes of longest chain length yet synthesized. The position of alkyl or other substituents in the molecule is indicated by designating the number of the skeletal atoms carrying the substituent, as illustrated in Formulas (V), (VI) and (VII).

In the second system, the chain length is indicated by enumerating the number of methine groups in the chain by the appropriate Greek numerical prefix. For example, in this system the dye in Formula (V), with $n = 0$ and X^- as iodide, is 1,1'-diethyl-2,2'-monomethinecyanine iodide, that with $n = 3$ is 1,1'-diethyl-2,2'-heptamethinecyanine iodide, while the dye of Formula (VI), with $n = 2$ and X^- as iodide is 3,3'-diethylthiapentamethinecyanine iodide.

Formula (VIII) is an example of an unsymmetrical cyanine dye.

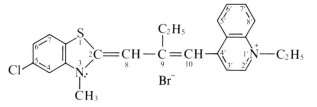

(VIII) 5-Chloro-1',9-diethyl-3-methylthia-4'-carbocyanine bromide or 5-Chloro-1',9-diethyl-3-methylthia-4'-trimethenecyanine bromide

The different classes of cyanine dyes derived from quinoline are sometimes referred to, especially in the German literature, by names given them when they were first synthesized. "Cyanine," the first cyanine dye to be made, is a 4,4'-simple cyanine; dyes called isocyanines were later found to be 2,4'-simple cyanines, while pseudo- or ψ-isocyanines turned out to be 2,2'-cyanines. The trivial names of a few sensitizing dyes are still sometimes used. *Pinacyanol* is 1,1'-diethyl-2,2'-carbocyanine iodide, *dicyanine* is 1,1'-diethyl-2,4'-carbocyanine iodide, *ethyl red* is 1,1'-diethyl-2,4'-cyanine iodide, *kryptocyanine*, a sensitizer to the extreme red and near infrared, is 1,1'-diethyl-4,4'-carbocyanine iodide, and *xenocyanine* is the corresponding tricarbocyanine iodide. *Neocyanine*, a sensitizer to the near infrared, contains three quinoline rings (Formula (IX).

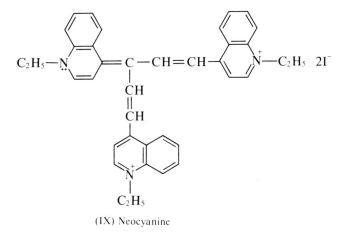

(IX) Neocyanine

Merocyanine Dyes

Merocyanine dyes form an important class of sensitizers in which the chromophore is electrically neutral, the auxochromes being two atoms of different electron-donating and accepting power. Usually N acts as the stronger donor and O as the stronger acceptor. The chromophore is then the amide chromophore of Formula (IV). The N atom is contained in a basic heterocyclic nucleus, such as those present in cyanine dyes, the O atom, in an acidic nucleus, such as rhodanine, 2-thiohydantoine, barbituric acid, thiobarbituric acid, 1,3-indanedione, pyrazoline-5-one and others. A typical example is:

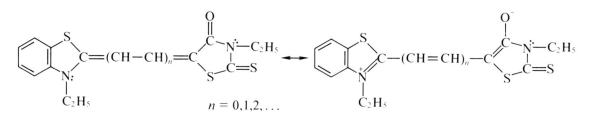

(X) A merocyanine dye vinylogous series

Merocyanines are usually very sparingly soluble in water, but are soluble in acetone, alcohols, and other polar solvents, and also in hydrocarbons and in carbon tetrachloride. They can be rendered soluble in water or in aqueous alkaline solution by addition of sulfonic acid or carboxylic acid groups, for example, as substituents in the alkyl group on the 3-N atom of the rhodanine nucleus in the dye series (X).

Other classes of dyes related to the cyanines, of interest in photography, are *hemicyanines*, and *styryl dyes*, illustrated by Formulas (XI) and (XII) respectively.

In reaction (XIII) the 2-methylbenzothiazolium salt provides the benzothiazole nucleus and the methine group of the chain, and the 2-iodoquinolinium ethiodide furnishes the remainder of the unsymmetrical cyanine 1',3-diethylthia-2'-cyanine iodide, the elimination of hydrogen iodide involved in the condensation being facilitated by the presence in the reaction mixture of the strongly basic triethylamine.

Symmetrical carbocyanines can be prepared by, among other ways, condensing 2 mol of the appropriate

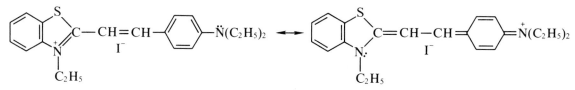

(XI) A hemicyanine dye vinylogous series. If $n = 1$, the dye is
2-*p*-Diethylaminovinyl-3-ethylbenzothiazolium iodide.

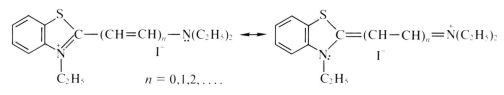

(XII) A styryl dye; 3-Ethyl-2-*p*-diethylaminostyrylbenzothiazolium
iodide

Styryl dyes, although now obsolete as spectral sensitizers, are still used as filter and backing dyes.

Synthesis of Cyanine Dyes

Cyanine dyes are prepared by a variety of reactions, but in general, two intermediates to supply the two heterocyclic nuclei are caused to react with the elimination of some simple molecule, such as HCl, alcohol, mercaptan or water. For example, quaternary salts of heterocyclic bases containing a methyl group in the 2-position, (in which a hydrogen atom is especially reactive), can be condensed with another quaternary salt containing an electron-attracting group in a reactive position, with the elimination of acid.

quaternary salt with 1 mol of ethyl orthoformate, which provides the central methine group of the chain.

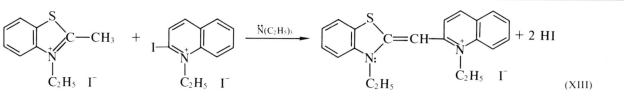

Merocyanines can be prepared by the reaction of intermediates containing an active methylene group adjacent to a carbonyl group with quaternary salts of heterocyclic bases containing an electron-accepting group, for example,

desensitization, a common effect of sensitizing dyes, although the effect is much more strongly exerted by other dye classes than the cyanines. Desensitization is discussed later in this chapter.

(XV)

Here an acetanilido derivative of a benzothiazolium salt is condensed in a basic medium with 3-ethylrhodanine to form a merocyanine, with the elimination of acetanilide and hydrogen iodide.[7]

SPECTRAL SENSITIVITY OF DYED EMULSIONS

By a suitable choice of sensitizing dyes, emulsions can be rendered sensitive to all wavelengths from those in the absorption band of the silver halide throughout the remainder of the visible spectrum into the near infrared region to about 1300 nm. The spectral sensitivity of photographic emulsions can be conveniently shown in "wedge spectrograms," illustrated in Figs. 4-2 and 4-3. The manner of obtaining these spectrograms is described in the chapter on sensitometry. It need here only be mentioned that the distance of the envelope of the positive image of the spectrum from the base at any wavelength is a measure, with some important qualifications discussed in the chapter on sensitimetry, of the sensitivity of the emulsion at that wavelength, on a logarithmic scale.

In Fig. 4-4 quantitative data are illustrated on the spectral sensitivity of an iodobromide emulsion, undyed, and with dyes extending sensitivity throughout the visible spectrum. The unit of sensitivity is the reciprocal of the exposure in ergs per cm^2 of approximately monochromatic radiation (the band width being determined by the slit width of the monochromator used in the measurement), required to produce a developed density of 0.6 above the density of fog plus that of the support. It will be noticed that, although the sensitizer confers sensitivity over a wide spectral range to which the undyed emulsion is insensitive, it actually causes some decrease in the sensitivity to blue light, absorbed by the silver halide. This decrease in sensitivity illustrates the phenomenon of

Manufacturers supply various types of emulsions in a variety of spectral sensitizations, from which a choice of sensitivity level, contrast, resolving power and granularity can be made according to requirements.

1. 3,3'-DIETHYL-THIAZOLINOCARBOCYANINE IODIDE

2. 3,3'-DIETHYLOXACARBOCYANINE IODIDE

3. 3,3'-DIETHYLTHIACARBOCYANINE IODIDE

4. 3,3'-DIETHYLSELENACARBOCYANINE IODIDE

5. 3,3'-DIETHYL-9-METHYLTHIACARBOCYANINE IODIDE

6. 3,3'-DIETHYL-4,5;4',5'-DIBENZOTHIACARBOCYANINE BROMIDE

7. 1,1'-DIETHYL-2,4'-CARBOCYANINE IODIDE

Fig. 4-2. Wedge spectrograms of a chlorobromide emulsion sensitized with carbocyanine dyes. (Mees, *The Theory of the Photographic Process*, Macmillan, New York, 1942.)

1. 1,1'-DIETHYL-4,4'-
 CARBOCYANINE IODIDE

2. 3,3'-DIETHYLTHIADICARBOCYANINE IODIDE

3. 3,3'-DIETHYLTHIATRICARBOCYANINE IODIDE

4. NEOCYANINE

5. 1,1'-DIETHYL-4,4'-
 TRICARBOCYANINE IODIDE

6. 12-ACETOXY-3,3'
 DIETHYLTHIATETRACARBOCYANINE PERCHLORATE

7. 12-ACETOXY-3,3'-
 DIETHYLTHIAPENTACARBOCYANINE PERCHLORATE

Fig. 4-3. Wedge spectrograms of a chlorobromide emulsion sensitized with infrared sensitizers. (*Mees, The Theory of the Photographic Process*, Macmillan, New York, 1942.)

Two main characteristics of the sensitizing dye determine its region of absorption and of sensitization: (1) the nature of the heterocyclic nuclei and (2) the length of the chromophoric chain. The state of aggregation of the dye adsorbed to the grain surface also influences the spectral region of absorption and sensitization.

From Figs. 4-2 and 4-3 it is seen that, among symmetrical cyanines of a given chain length, the spectral region of sensitization shifts steadily to longer wavelengths as the heterocyclic nuclei are varied from thiazoline, with a sensitization peak for the carbocyanine at 480 nm, through benzoxazole, benzothiazole, benzoselenazole, 2-quinoline, (not shown), to 4-quinoline, the carbocya-

nine of which shows its sensitization maximum at wavelength 740 nm. The spectra also illustrate how the fusion of benzene rings on the 4,5-positions of the benzothiazole nuclei extends absorption and sensitivity to longer wavelengths, (dye 6 versus dye 3). This effect is general for all nuclei, and the fusion may be accomplished at other positions than the 4,5-positions. With this set of carbocyanine dyes, sensitization over the whole visible spectrum can be effected.

A most important property of cyanine dyes for their use as photographic sensitizers is their ability to exist as vinylogous series of variable chain length for a given pair of nuclei. For each addition of a vinylene group, $CH=CH$, in the chain of a symmetrical cyanine, the absorption peaks in solution in organic solvents are shifted about 100 nm to longer wavelengths, and, provided no disturbance of the absorption spectrum of the adsorbed dye by the formation of large aggregates occurs, the sensitization peaks in emulsions are shifted by the same wave length interval. The effect of chain length on the positions of the absorption maxima in alcoholic solution and on the absorption and sensitization maxima in emulsions of the vinylgous series of thiacyanine dyes, from $n = 0$ to $n = 5$, is shown in Fig. 4-5. Interaction between the adsorbed dye molecules and the silver halide crystal causes the absorption spectrum of the dye in emulsions, and with it, the sensitization spectrum, to be displaced to long wavelengths by 30–40 nm (more for dyes with the longer chain lengths) with respect to the spectrum in alcoholic solution. The intensities of the absorption of the dyes in solution at the maximum are indicated, on a logarithmic scale, by the lengths of the lines representing the maxima. Up to $n = 3$, there is a steady increase in the molar extinction coefficient at the absorption maximum with chain length, as is to be expected theoretically. The apparent fall in absorptive power in the members of the series of longest chain length is probably not real, since in these dyes, various circumstances conspire to render the absorption coefficient at the maximum of absorption not a true measure of the total absorbing power.

From Fig. 4-5 it can be seen that the six members of the symmetrical thiacyanine dye series shown cover the

Fig. 4-4. Spectral sensitivity of an undyed (a), and of a panchromatically sensitized, (b), iodobromide emulsion.

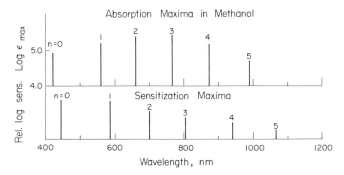

Fig. 4-5. Effect of the length of the methine chain of symmetrical cyanine dyes on the wavelength and intensity of the absorption maxima in methanolic solution, and on the sensitization and absorption maxima in silver halide emulsions.[8,9]

spectral sensitization of silver halides over the whole visible spectrum into the near infrared region.

Sensitization over a wide wavelength region is usually accomplished by adding to the emulsion a mixture of dyes, each sensitizing strongly at its own wavelength. The old term *"orthochromatic"* as a description of plates or films is still sometimes encountered—it indicates spectral sensitization through the green up to the yellow (originally achieved by the use of eosin as the sensitizing dye). Emulsions sensitive to all wavelengths of the visible spectrum are called *"panchromatic."*

EFFECT OF DYES ON SPEED AND CONTRAST

Sensitizing dyes not only confer sensitivity towards light of wavelengths absorbed by the dye but not appreciably by the silver halide, but usually also modify the intrinsic sensitivity of the emulsion to blue and violet light.

A common effect of the dye is desensitization, as illustrated in the region of intrinsic sensitivity in Fig. 4-4.

Since loss of sensitivity to blue light is often observed with dyes that show practically no absorption for blue light, desensitization cannot, in general, be attributed to a filter action of the dye.

The variation of sensitivity with wavelength in the region of spectral sensitization often follows approximately the spectral variation of absorption of the adsorbed dye. The wavelengths of absorption maxima are usually also sensitivity maxima. Exceptions, however, arise. The absorption spectrum of the sensitizer adsorbed on the surface of the emulsion grain may contain more than one band, which are not necessarily equally efficient in inducing photographic sensitivity. This matter is discussed in the section on quantum yield of sensitization (p. 91).

The contrast of a spectrally sensitized emulsion, as measured by γ may differ for light in the spectrally sensitized region from its value for blue light, but no rule applicable to all emulsions can be given for the variation of contrast with wavelength. The value of γ is frequently higher in the spectrally sensitized region than in the blue or violet. A factor tending to produce higher γ in the region of spectral sensitization is that the sensitivity conferred by the dye is proportional to the grain surface, since the adsorbed dye is confined to the surface, while the intrinsic sensitivity of the grain is proportional to its volume, since blue light is absorbed throughout the volume. The ratio of surface to volume is greater for small grains than for large, hence the ratio of spectral sensitivity to intrinsic sensitivity tends to be greater for small grains than for large. The smaller grains, which tend to exhibit less over-all sensitivity than large grains, contribute a large proportion of the developed image formed by the higher exposures. Hence, for a given grain-size distribution, a relatively greater developed density is obtained from these exposures to light absorbed by the dye than from light absorbed by the silver halide; that is, γ in the spectrally sensitized region is greater than for blue and violet light.

Other factors, however, may work in the opposite direction to that of the effect just described. One of the general factors determining γ is the distribution in depth of the exposed grains in the emulsion layer—when the grains absorb very strongly, as they do ultraviolet light, self-screening confines the exposed grains to the layer near the surface, and γ is lower than for more penetrating radiation. Such a self-screening effect may introduce a minimum in γ as a function of wavelength at the spectral sensitization peak of a dyed emulsion. Another factor in mixed emulsions such as iodobromides that may tend to oppose an increase in γ in the spectrally sensitized region is a relatively lower over-all sensitivity of the smaller grains associated with differences in the ratio of iodide to bromide in different grain-size classes. For detailed discussions of wavelength variation of sensitivity and γ of emulsions, see Refs. (10), (11), and (12).

HYPERSENSITIZATION OF SPECTRALLY SENSITIZED EMULSIONS

One of the factors governing the efficiency of spectral sensitization is the silver ion concentration of the emulsion—an increase in silver ion concentration (decrease in pAg) tends to increase the efficiency of sensitization.[13,14,14a] High silver ion concentration, however, tends to produce fog, especially at elevated temperature, and the limitations in the permissible silver ion concentration consistent with long term stability of the emulsion may render spectral sensitization less efficient than it could be at a higher silver ion concentration. It is practicable, however, to increase spectral sensitivity by *hypersensitizing* the coated, unexposed emulsion shortly before use, by methods that depend largely on increasing the silver ion concentration of the emulsion. Bathing the film for 1 min in a solution made by diluting 4 ml of concentrated ammonia (28%) to 100 ml with distilled water at a temperature not exceeding 13°C is a convenient procedure. The film should be dried as quickly as possible in a stream of dust-free air and used immediately. Acceleration of drying by rinsing in alcohol after bathing is advantageous. Triethanolamine can be used instead of ammonia. Hypersensitized plates tend to fog on keeping but they can be kept for some weeks in a refrigerator.

The response to hypersensitization depends both on the emulsion and the dye; the greatest increases tend to be realized in slower emulsions. In practice, hypersensitization is frequently used on emulsions containing sensitizing dyes for the infrared. Low intensity reciprocity failure is decreased by hypersensitization and the process is therefore specially useful in applications such as in astronomy or spectroscopy where low intensities of the available light impose long exposure times.

Ammonia hypersensitization appears to depend on its effect of increasing the concentration of silver ion at the grain surface. The ammonia dissolves some of the silver halide as the complex cation $Ag(NH_3)_2^+$, which is mostly retained in solution in the gelatin. On drying,

ammonia is lost and an excess of silver ion is left in immediate contact with the grain.

Bathing in water is sometimes nearly as effective as ammonia hypersensitizing for emulsions containing spectral sensitizers other than those for the far red or infrared.[13] For the latter emulsions, ammonia treatment is the more effective. Water bathing increases the silver ion concentration of the emulsion by removing soluble bromide.

While an increase in silver ion concentration seems to be the main factor in hypersensitization, other effects of the bathing treatment with ammonis, etc., have been recognized to participate in increasing sensitivity, such as removal of oxidation products or of desensitizing impurities in the sensitizing dye.[15]

FACTORS DETERMINING THE BEHAVIOR OF DYES AS SPECTRAL SENSITIZERS

Spectral sensitization depends on the fact that light energy absorbed by a sensitizing dye in close contact with the surface of a silver halide grain can be utilized to form latent image of the same nature as that generated by direct absorption of light by the silver halide. In some way not yet fully understood the energy absorbed by the dye is transferred in effect (either as energy or as an electron) to the silver halide in which it induces photographic sensitivity similar to that evoked by direct absorption of light by the silver halide. For practical photography the sensitizing dye must be adsorbed to the surface of the emulsion grain. Recent experiments show that a photographically efficient transfer of energy from a dye molecule to a silver halide crystal can occur when the dye is separated from the crystal surface by distances of 20 up to above 100Å. But, important as these observations are with respect to the theory of spectral sensitization, in a practical photographic layer, all of the spectral sensitization arises from dye molecules adsorbed to the surface of the grain.

The behavior of the dye as a spectral sensitizer can therefore be analysed with respect to the adsorption of the dye to the grain surface, the absorption of light by the adsorbed dye, and the mechanism of the transfer of the absorbed energy from the dye to the silver halide.

ADSORPTION OF SENSITIZING DYES TO SILVER HALIDES

The mobility of the π-electrons in the fundamental dye skeletal structure of cyclic and linear conjugated chains results in a high polarizability of dye molecules which are therefore centers of large attractive forces. These forces cause dye molecules to dimerize and form larger aggregates in suitable solvents, contributing to a relatively strong tendency of dyes to bind themselves to the surfaces of ionic crystals. In the latter case, the van der Waals or dispersion forces are supplemented by electrostatic forces between a dye ion and an ion of opposite sign

in the crystal surface and by coordination valance forces between atoms such as S, N and O in the dye molecule and ions such as silver ions in the adsorbing surface. The participation of electrostatic forces in the adsorption of ionic dyes to silver halide emulsion grains is shown by the fact that the adsorption of cationic dyes is inhibited at high silver ion concentration because of the electrostatic repulsion between the dye ion and excess silver ions in the grain surface, while similarly, high concentrations of bromide ion repress the adsorption of anionic dyes, such as erythrosine.

The adsorption of dyes to emulsion grains is quantatively expressed by the adsorption isotherm, measured in the liquid emulsion, that is, the curve relating, at constant temperature, the amount of dye adsorbed by a given amount of adsorbent with the concentration of free dye in solution in equilibrium with the adsorbed dye.[16-23] Known amounts of dye are added to a given volume of emulsion at constant temperature; after equilibration, the dyed grains are centrifuged from the residual gelatin solution and the amount of unadsorbed dye is measured, usually spectrophotometrically. The adsorbed dye is estimated by difference. It is also possible to determine an adsorption isotherm without centrifuging, essentially from the reflectance spectrum of the dyed emulsion.[20,21]

Typical adsorption isotherms of cyanine dyes in a coarse grain iodobromide emulsion at 40°C are shown in Fig. 4-6. The adsorption of many dyes, for example 1 and 3 in the figure, conform to the Langmuir type of isotherm,[24]

$$m/M = bc/(1 + bc) \qquad (1)$$

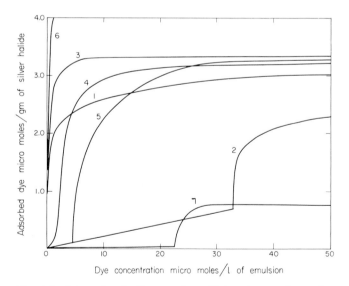

Fig. 4-6. Adsorption isotherms of sensitizing dyes on the grains of a photographic emulsion at 40°C. (1) 1,1'-diethyl-2,2'-cyanine iodide; (2) 1,1',3,3'-tetramethyl-2,2'-cyanine iodide; (3) 3,3'-diethylthiacarbocyanine iodide; (4) 3,3'-dimethyloxacarbocyanine iodide; (5) 3,3'-diethyloxacarbocyanine iodide; (6) 9-ethyl-3,3'-dimethyloxacarbocyanine iodide; (7) 4-[(1,3,3-trimethyl-2-indolinylidene) ethylidene] -3- methyl -1- phenyl- 5-pyrazolone. (After West, Carroll and Whitcomb.[18]

in which c is the concentration of free dye in equilibrium with an amount m of adsorbed dye on a definite mass of adsorbent, and b and M are constants. With increasing amounts of added dye the surface becomes saturated, as is shown by the limiting plateau in the isotherm; M is the saturation amount of adsorbed dye. In Langmuir's theory of the isotherm the available surface of the adsorbent is, at saturation, completely covered by a layer of adsorbate one molecule thick. For many dyes on emulsion grains, as for dyes 1, 3, 4 and 5 in Fig. 4-6, the saturation limit does correspond to complete monolayer coverage of the surface, although some dyes, like 6, are adsorbed as two or more layers, while 7 reaches saturation before the surface is completely covered by a close-packed monolayer—only a fraction of the surface is active in adsorbing this dye molecule.

The area occupied by an adsorbed dye molecule at saturation can be calculated from the value of the saturation limit if the surface area of the adsorbent is known, for example, from electron micrographs. From the isotherm of dye 3 in Fig. 4-6 the surface area of the grain occupied at saturation by one molecule of the dye 3,3'-diethylthiacarbocyanine iodide (Formula (VI), n = 1) was determined to be 76×10^{-16} cm^2, (76Å2). X-ray analysis of the crystal of this dye[25] shows that the heterocyclic nuclei and the trimethine bridge are coplanar, with the two N atoms on the same side of the bridge as in Formula (VI); the area of the dye cation lying flat is about 155Å2, the thickness of the ion is 3.7Å, the area of the edge of the ion is 68Å2 and that of the short end is 34Å2. The experimental value of the area occupied by a dye molecule at saturation coverage of the grain surface, 76Å2, shows that, if the saturation dye layer is one molecule thick, the molecules are adsorbed, not flat on the surface, but in an orientation in which the long edge of the cation is adjacent to the silver bromide surface and the molecular plane is highly tilted to the surface, the planes of adjacent molecules being mutually parallel. The detailed structure of a dye aggregate adsorbed to silver bromide has been determined by x-ray diffraction analysis, with general confirmation of this picture.[25a]

Most cyanine dyes are, at saturation, adsorbed to silver halides in the close-packed edge-on orientation. A measurement of the saturation plateau of cyanine dyes of known area is a convenient method of determining the specific surface of emulsion grains (the surface per unit weight of the grains). A suitable dye for such determinations is 1,1'-diethyl-2,2'-cyanine bromide or iodide, which at saturation occupies an area of 57Å2.[20,21]

The tendency to a co-planar arrangement of the atoms in the heterocyclic nuclei and the methine or polymethine bridge in cyanine dyes is the result of the fundamental co-planarity of the double and single bonds in the ground state structure of the ethylene molecule. Since all the carbon atoms in the chromophoric chain and in the heterocyclic nuclei are similar in this respect to those in ethylene, the molecular skeleton of cyanine dyes in the ground state tends to be co-planar, with the skeletal atoms stiffly held in the molecular plane. Bulky substituents in the molecule may, however, force the

skeletal atoms from co-planarity. For example, if methyl groups are substituted for hydrogen atoms in the 3- and 3'-positions of the quinoline nuclei of the 2,2'-cyanines, the nuclei are strongly forced from co-planarity with the

(XVI) 1,1',3,3'-tetramethyl-2,2'-cyanine iodide

methine bridge.[26] Even in 2,2'-cyanines containing H atoms in the 3- and 3'-positions it is shown by x-ray structural analysis of the molecules in the dye crystals that the quinoline nuclei are markedly twisted about the methine bridge.[25b,25c] Strong distortions from coplanarity of the chromophoric atoms have relatively large effects on stability, spectra, adsorption to silver halides and the sensitizing properties of cyanine dyes, as will be illustrated in subsequent discussion.

The van der Waals forces of dye molecules (largely "dispersion forces" whose quantum mechanical nature was discovered by London,[27]) are additively constituted from contributions of all the atoms in the molecule. Small additions of dye will therefore be adsorbed as isolated molecules in flat orientation on a plane surface but the more active adsorption sites in the surface of a silver bromide crystal are likely to be terraces in the crystal surface, at which the first dye molecules will be adsorbed with their molecular planes approximately parallel to the terrace walls and highly inclined to the general surface of the crystal. Such isolated dye molecules act as nuclei for the formation of a close-packed layer in edge-on orientation when, as more dye is added, the mutual dye-dye attraction begins to induce aggregation. Once the close packed layer begins to form, additional dye mlecules are readily incorporated by cooperative interaction. In the toe region of the isotherms of dyes 2, 4 and 5 in Fig. 4-6 the spectra show that the dye is present as isolated molecules, while the sudden change in slope at higher dye concentration, accompanied also by a sudden and often very marked change in the absorption spectrum, indicates the onset of the close-packed layer in edge-on orientation held by cooperative adsorption.

The limiting plateau for 3,3'-diethylthiacarbocyanine in a given emulsion is practically independent of the anion, even when the anion is as bulky as p-toluene sulfonate. The anions of adsorbed layers of cationic dyes seem to be disposed in a layer of counter ions outside the adsorbed dye layer.

Adsorption of dyes and of other addenda to the surface of emulsion grains takes place in competition with that of gelatin in the suspension medium. Both the rate of adsorption and the equilibrium amount of adsorbed dye on the grains increases as the gelatin content of the emulsion is lowered. Energy is expended in displacing

adsorbed gelatin as a dye is adsorbed to the grain surface, as is shown by the diminished heat of adsorption of the dye as the gelatin content of the emulsion is increased.[28]

Dye Structure and Adsorption

Adsorption of a dye to an emulsion grain depends on the competition between the various forces tending to bind the dye to the surface against those tending to bind the dye to water molecules or gelatin in the suspension medium. Within a given series of cyanine dyes, adsorbability to silver halide increases with increasing chain length, since the dispersion forces increase and the affinity of the dye molecules for water decreases as the chain length increases. For the same reasons, addition of a benzene ring in the heterocyclic nuclei increases adsorbability, as in the dye series of constant chain length whose heterocyclic nuclei are thiazole, benzothiazole and naphthothiazole, respectively. Oxacyanines are less adsorbable than thiacyanines of the same chain length, since the oxygen atom coordinates with silver ion less actively than the sulfur atom and forms hydrogen bonds with water more readily. Solubilizing groups in the dye structure, such as sulfonic or carboxylic acid groups, tend to lower adsorbability. Steric factors influencing the approach to the surface of strong binding centers in the dye molecule, such as the chromophoric chain or atoms like N or S, can have large effects on adsorption. For example, curve 2 in Fig. 4-6 shows the relatively low adsorbability of the highly nonplanar dye 1,1',3,3'-tetramethyl-2,2'-cyanine iodide compared with that of the less distorted, 2,2'-cyanine containing H atoms in the 3- and 3'-positions (curve 1). The adsorption of the thiacarbocyanines (XVIIa) and (XVIIb) to silver bromide crystallites in an aqueous suspension form an interesting illustration of structural effects on adsorption.[23]

(XVIIa)

(XVIIb)

The dye (XVIIa), containing a benzene ring fused to the 4- and 5-positions of the benzothiazole nuclei, proved

to be much more strongly adsorbed than dye (XVIIb), in which the additional ring is attached to the 6- and 7-positions, near the sulfur atom of the heterocyclic nuclei. This fact suggests that cyanine dyes derived from benzothiazole are, at saturation, adsorbed to silver halides with the edge of the dye cation containing the S atoms in contact with the surface. A large contribution to the adsorption forces is the relatively strong coordinate binding between the sulfur atoms of the dye and silver ions in the surface. In dye (XVIIa) the sulfur atoms can closely approach the surface in edge on adsorption, but the bulky benzene ring near the sulfur atoms in dye (XVIIb) inhibits the approach of the sulfur atoms to the surface in edge-on orientation and decreases the adsorption.

Adsorption and Sensitization

In normal photographic practice, spectral sensitization is caused practically entirely by dye adsorbed to the grain surface, unadsorbed dye in the gelatin being inert in sensitization. But beyond the necessity of adsorption for the occurrence of spectral sensitization there is no general correlation between the adsorbability of a dye and its efficiency as a sensitizer. A poorly adsorbed dye cannot, of course, yield high sensitivity in the region of spectral sensitization, but this does not imply low efficiency of sensitization in terms of the utilization of the energy absorbed by the dye. Dyes which are nonplanar with respect to the atoms of the chromophoric chain are relatively poorly adsorbed to silver halides, as illustrated for dye (XVI) in curve 2 of Fig. 4-6 and are also very inefficient sensitizers, but this inefficiency arises mostly from other factors than low adsorption.

EFFECT OF CONCENTRATION OF SENSITIZING DYE ON SPECTRAL SENSITIZATION

The variation of spectral sensitization with the concentration of the sensitizing dye on the emulsion grain surface is illustrated in Fig. 4-7 for two thiacarbocyanine dyes.[29] The sensitization is expressed as the reciprocal of the incident radiant energy of wavelength 640 nm, $1/E$, required to produce a specified density of developed image. The spectral sensitization increases initially with increasing concentration of the adsorbed dye, because of the increased absorption of red light. While, however, the absorption of light continues to increase with the concentration of dye, at a decreasing rate, asymptotically approaching 100%, the sensitization reaches a maximum value at a dye concentration at which only about 30% of the grain surface is covered with adsorbed dye. Beyond this, further increase in the concentration of dye causes a decrease in spectral sensitization, to nearly zero, in this emulsion, for one of the dyes illustrated. The decrease in spectral sensitization is the result of desensitization by the sensitizing dye, as illustrated in the region of intrinsic sensitivity in Fig. 4-4. Desensitization with

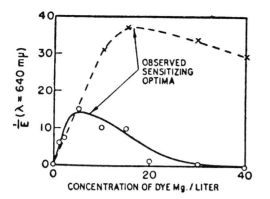

Fig. 4-7. Variation of spectral sensitization of two dyes with the concentration of dye in the emulsion. (o-3,3'-dimethyl-8, 10-di-m-toloxythiacarbocyanine bromide; x-5,5'-dichloro-3,3,9-triethylthiacarbocyanine bromide). (After Spence and Carroll.[29])

respect to the intrinsic sensitivity of the silver halide occurs over the whole course of dye addition, and competes with spectral sensitization until, beyond the concentration of dye for optimum spectral sensitization, desensitization in the spectrally sensitized region overwhelms the spectral sensitization.

The effects illustrated in Fig. 4-7 are general. With the exception of some dyes of shortest chain length, most dye sensitizers desensitize to a greater or less degree. Cyanine dyes of long chain length, used for spectral sensitization to far red and near infrared light are especially strong desensitizers.

ABSORPTION SPECTRA OF SENSITIZING DYES IN EMULSIONS

The importance of the absorption spectrum of dyes in emulsions lies in the fundamental law of photochemistry that only absorbed light can effect photochemical action, and therefore the spectral distribution of dye-sensitization is related to the absorption spectrum of the dye adsorbed to the surface of the emulsion grains. Frequently the spectral sensitivity curve of an emulsion as a function of wavelength runs parallel with the absorption curve, but not always. In the first place, the dye may be less efficient in inducing sensitivity per quantum absorbed than the silver halide, when the spectral sensitization, compared with the intrinsic sensitivity, will be at a lower ratio than that of the dye absorption to the intrinsic absorption of the silver halide. Secondly, the absorption spectrum of the adsorbed dye may be a composite of absorption bands from different types of aggregate which may not be equally efficient as sensitizers. The wavelength dependence of spectral sensitization will then not run completely parallel with the wavelength dependence of absorption. Sometimes, also, if the absorption of the dye at a maximum is very strong, filter action may reduce the contrast of the emulsion at the wavelength of maximum dye absorption.

The light transmitted by an emulsion is attenuated not only by absorption but also by scattering out of the

direction of the beam and by diffuse reflection towards the direction of incidence. Hence the absorption spectra of emulsions are rarely measured directly from the transmittance spectrum, but are calculated from spectrophotometric measurements of the fraction of light diffusely scattered and that transmitted by the coating, according to the equation: $A = 1 - T - R$, where A, T, and R are respectively the fractions of the incident light absorbed, transmitted and diffusely reflected, as functions of wavelength, by the emulsion layer.

In Fig. 4-8 are shown the absorption spectra of a cyanine dye at various concentrations adsorbed to the grains of an iodo-bromide emulsion, and on the left, the absorption spectrum of the silver halide in the emulsion. For comparison of absorption maxima of the adsorbed dye with that of the dye in dilute solution in methanol, the spectrum of the dye in solution is added; the ordinates for this spectrum are relative molar extinction coefficients, which manner of plotting tends to make absorption maxima relatively sharper than when plotted as fractional absorption.

The spectral sensitivity of the same emulsions is shown in Fig. 4-9 in the form of wedge spectrograms, in which the distance of a point on the profile from the base, at any wavelength, is approximately proportional to the logarithm of the sensitivity. The topmost spectrogram describes the spectral sensitivity of the undyed emulsion, and the others in descending order show the spectral sensitivity at increasing concentrations of dye in the

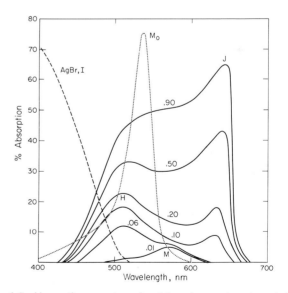

Fig. 4-8. Absorption spectra of a thiacarbocyanine dye at different concentrations in an iodobromide emulsion. (9-ethyl-3,3'-dimethylthiacarbocyanine bromide). M is the absorption maximum of the dye adsorbed as isolated molecules, and H and J are the maxima of the dye adsorbed as H- and J-aggregates respectively. The dashed curve is the absorption spectrum of the undyed emulsion and the dotted curve is the absorption spectrum of the dye in methanol solution. The numbers above the curves indicate the number of mg of dye per cm² of the emulsion coating.

Fig. 4-9. Spectral sensitization of 9-ethyl-3,3'-dimethyl thiacarbocyanine bromide at different concentrations in an iodobromide emulsion. The amount of dye per unit grain surface increases downwards in the series of spectrograms, and is the same as for the corresponding series of absorption spectra in Fig. 4-8.

emulsion, the corresponding absorption curves being shown in ascending order in Fig. 4-8.

In a general way, comparison of Figs. 4-8 and 4-9 shows that the spectral distribution of photographic sensitivity follows that of the absorption of radiation by the adsorbed dye; at low dye concentrations, the sensitivity maximum M at 575 nm coincides with the absorption maximum M at that wavelength, and the sensitivity maximum J at 640 nm at higher dye concentrations coincides with the absorption maximum J at the same wavelength. But detailed examination shows that the sensitivity and absorption curves are by no means accurately parallel; in particular, simple inspection shows that the photographic sensitivity at wavelength 510 nm, the sensitivity peak H, is considerably lower than in proportion to the strength of absorption at that wavelength. Light absorbed within the absorption band H is of lower efficiency in inducing photographic action than light absorbed within the M- and J- absorption bands of this dye.

In dilute methanol solution, the dye molecules are isolated from each other, and the spectrum is that of the isolated dye molecule in a polar environment. The valence electrons of the dye molecule occupy a series of molecular orbitals, each orbital characterized by its fixed energy value and the probability distribution of a single electron in it. The maximum number of electrons in an orbital, according to the Pauli exclusion principle, is two, of opposite spin. Each electron has a spin of $\pm\frac{1}{2}$, hence the total spin of a completely occupied molecular orbital is zero, while that of an orbital containing only

one electron is $\pm\frac{1}{2}$. In the ground state of a stable organic molecule, which usually contains an even number of electrons, its complement of valence electrons is distributed in pairs over the lowest molecular orbitals. Hence the total spin of the ground state is zero, a condition denoted spectroscopically as a *singlet state*. To a close approximation the visible and near ultraviolet spectra of dyes can be regarded as involving only the π-electrons, which are more loosely bound to the atomic nuclei than the other electrons in the molecule. In the absorption band of longest wavelength one of the electrons in the π-orbital of highest energy occupied in the ground state is excited to the unoccupied orbital of lowest energy. In this transition the electronic spin is unaltered; hence the excited state has a spin of zero and is a singlet state. The corresponding intense visible absorption band represents a singlet ← singlet transition. (The spectroscopic convention recommended to describe transitions between atomic or molecular quantum states is to write the state of higher energy first and to denote the direction of the transition by the direction of the arrow, ← for absorption, → for emission.)

Below the first excited singlet state of a dye there is an excited state in which the electron raised from the highest occupied to the lowest unoccupied orbital changes its spin. The total electronic spin of the dye molecule is now compounded of spins of the same sign in the formerly highest occupied orbital and in the partly occupied excited orbital, that is the total spin of the excited state is 1, a state spectroscopically described as a *triplet state*. The triplet ← singlet transition is, however, very feeble, and has not been observed in the absorption spectrum of cyanine dyes, although the corresponding triplet → singlet transition is well known as a phosphorescence emission spectrum.

The visible absorption spectra of dyes adsorbed to emulsion grains differ from those in organic solvents, and, moreover, usually change with the concentration of adsorbed dye, with corresponding changes in the spectral sensitization. A sensitizing dye at very low concentration in the emulsion, e.g., $0.01~\mu g/cm^2$ of coated emulsion, covering a few percent of the total grain surface, exhibits, as illustrated in Fig. 4-8, an absorption maximum M, displaced some 30–40 nm to the long wavelength side of the molecular maximum M_0 in methanolic solution. This band is attributed to dye molecules adsorbed in the monomeric molecular form, isolated from one another, but with their electronic energy levels perturbed by interaction with the silver halide surface so as to cause a shift to long wavelengths with respect to the spectrum of the isolated molecules in solution.[30] At the next higher concentration as illustrated in Fig. 4-8, a new absorption maximum H appears in the spectrum of the adsorbed dye, hypsochromically displaced (i.e., to short wavelengths) with respect to the monomeric band M. The concentration-dependence of the intensity of this band suggests that the absorbing species consists of aggregates of the dye molecules in which mutal interaction between the electronic levels of the incorporated monomers causes the observed shift of the band from the

position for the isolated molecule. Such aggregates have been called H-aggregates.[31] In Fig. 4-9 the H-band appears in sensitization, overlapping the long wavelength tail of the intrinsic sensitivity band of the silver halide. As has been already mentioned, the photographic efficiency of light absorbed within the H-band of the dye illustrated in Figs. 4-8 and 4-9 is lower than that of light absorbed within the M-band, a frequent, but not universal characteristic of H-bands.[32,33]

As the concentration of dye on the grain surface is further increased, another band begins to appear at longer wavelengths than the M-band, which has been called a J-band, characteristic of a J-aggregate, first observed in the spectrum of concentrated aqueous solutions of 1,1′-diethyl-2,2′-cyanine chloride independently by Jelley and by Scheibe.[34-36] It will be observed in Fig. 4-9 that the J-band first appears in sensitization as a low contrast "ghost," indicating that only a small fraction of the grains contain dye as J-aggregate. With increasing addition of dye, more grains contain the J-aggregate and the contrast increases, until finally, the J-band becomes the strongest feature in the sensitization spectrum.

Many cyanine and merocyanine dyes exhibit H-bands in emulsions and also in relatively concentrated aqueous solutions at room temperature, and, with diminishing intensity, above room temperature, until, at sufficiently high temperature they finally disappear. They are also observed in alcoholic solution below room temperature.[37] Detailed studies of the absorption spectra of dyes in aqueous solution and in emulsions show that the first aggregate to appear as the concentration of dye is increased is the dimer, absorbing at shorter wavelengths than the monomeric bands M_0 or M.[37-41] With increasing dye concentration the dimeric band weakens and an H-band appears at still shorter wavelengths, attributed to higher aggregates. In aqueous solution and in alcoholic solution at low temperatures the H-band of some dyes is resolved into components attributable, according to theories of dye aggregates, to the trimer, tetramer, etc,[38] but in emulsions the H-band, as in Fig. 4-8, is usually unresolved.

J-bands, characterized by their relative sharpness and by their bathochromic displacement from the monomeric band, (i.e. to long wavelengths) are more rarely observed than H-bands, though they are not at all uncommon among cyanine dyes. Much work, especially by Scheibe and co-workers, suggested that the J-band originated in a relatively large aggregate, reversible with temperature and concentration changes, composed of monomers packed approximately like the cards in a pack and held together by van der Waals forces. These structural concepts are amplified in the next section.

THEORY OF AGGREGATE SPECTRA

As has already been mentioned, dye molecules tend to exist in coplanar arrangements of the skeletal atoms in conjugated chains, leading to a flattish structure in which the dimensions of the molecular plane are large compared with the molecular thickness. Relatively strong van der Waals forces of the London type[27] tend to cause the molecules to associate into dimers and larger aggregated structures, in which the molecular planes are parallel, although they may adopt a more or less staggered configuration with respect to each other.[25a] Solvation forces between organic solvent molecules and dissolved dye molecules tend to inhibit this association; hence only the monomeric spectrum of dyes is usually observed in solution in organic solvents, although aggregation of cyanine dyes can occur in alcohol below room temperature. Dissolved in water, dye molecules tend to be pressed out from their aqueous environment, because of the large components of hydrocarbon nature in their structure, and associate together, forming first dimers and then larger aggregates at higher concentrations. This tendency of molecules containing large hydrocarbon parts in their structure to separate as aggregates from water has been called hydrophobic bonding, which can be regarded as a supplementary force to the van der Waals attraction in causing dyes to aggregate.[42] The high dielectric constant of water facilitates association by diminishing the electrostatic repulsion between similarly charged dye ions in the aggregate, and the linking of dye molecules through hydrogen bonds with water molecules may also participate. The van der Waals forces between dye molecules, although relatively strong for this type of binding, are much weaker than valence forces, and the aggregates in solution are readily broken down by dilution or by a moderate increase in temperature—the association is reversible.

In the absorption of light by a dimer, only one photon will be absorbed at the light intensities normally used in the measurement of absorption spectra, and the state of electronic excitation is shared between the two monomeric units in the dimer. The state of excitation can be visualized as switching rapidly between the two monomers. The quantum mechanical result of this exchange of electronic energy is that the excited energy level is split into two, symmetrically displaced to higher and lower energies with respect to the level of the isolated excited monomer.

The intensity of the absorption band associated with an electronic transition between two electronic levels is determined by the electric moment of the transition, which can be visualized as the product of the spacial displacement of the excited electron and its electrical charge. The interaction between the monomeric components in the excited dimer can be regarded as the interaction between the transition moments of the two monomers. In the simplest form of the theory the transition moments are considered to be point dipoles, a rather crude approximation to the situation in the actual dimer, in which the length of the transition dipole, a considerable fraction of the length of the monomeric chromophore, is comparable in length to the distance between the two interacting chromophores in the dimer.[43] Nevertheless, the simple model predicts the observed facts on the absorption spectra of aggregates qualita-

tively, and shows, for example, the essential difference between H- and J-aggregates.

In Fig. 4-10 are shown two arrangements of the monomers in a single-stranded aggregate. The horizontal lines represent the chromophores or the long molecular axes of the monomers, whose molecular planes are highly tilted towards the plane of the paper. In Fig. 4-10a the axis of the aggregate, denoted by the dotted line, is inclined at an angle α approaching 90° to the direction of the monomeric chromophores. In the other limiting case, the monomers are arranged approximately head to tail, so that the axis of the aggregate is highly tilted to the monomer chromophores, the angle α approaching 0°.

Consider first the dimer of type (a). The theory shows that when the dimer axis is highly inclined to the monomer axis, a strong absorption transition can occur from the ground state of the dimer to the higher of the two split excited levels, but the transition to the lower level is weak. Hence the absorption spectrum of the dimer in which the monomers are arranged like cards in a pack consists of a strong band displaced to higher-frequencies and shorter wavelengths than the monomeric band, with a relatively feeble band on the long wavelength side. Such spectra have been observed for a number of cyanine dyes in the dimeric state,[44] and the commonly observed dimer appears therefore to have a sandwichlike structure of two monomers with their molecular planes in contact, as determined by the van der Waals thickness of the molecules.

In the arrangement in which the axis of the dimer makes a small angle with the monomer axes, Fig. 4-10b, the strong absorption transition is from the dimeric ground state to the lower of the two split excited levels, hence the absorption band is displaced to long wavelengths from that of the monomer, with possibly a feeble band on the short wavelength side.

If the interacting monomeric transition moments are assumed to be point dipoles, the critical value of the angle α, above which an H band is generated and below which the aggregate absorbs at longer wavelengths than the monomer, is 55°.[43] Norland and co-workers[40] have calculated the interaction by a method more realistic in principle, determining the intermolecular interaction between the charge densities on the various atoms in the interacting monomers indicated by the wave function of the monomer. The Hückel molecular orbital approximation was used in the calculation of the wave function. The critical value for α was about 35°. The accuracy of this calculation, of course, depends on the validity of the approximation to the molecular wave function.

Larger one-strand aggregates than the dimer can be formed by addition of monomers to the dimer and by association of dimers. The number of excited energy levels split off from that of the excited monomer increases with the number of units in the aggregate, being equal to that number, but, for the card-pack arrangement in Fig. 4-10a, the strong absorption band is hypsochromic to the monomeric band, by a frequency interval increasing to a limit with the number of monomers in the aggregate. According to the point-dipole theory of the interaction, the frequency shift of the strong absorption band from the monomeric band is proportional to $(N - 1)/N$, where N is the number of aggregated monomers. Bird and co-workers resolved the H-band of a thiacarbocyanine dye into a series of components whose frequency was proportional to $(N - 1)/N$.[38,39] The frequency displacements from the monomeric band of the absorption bands of the dimer, trimer, tetramer, . . . infinite aggregate are therefore in the ratio 1, 1.33, 1.50, 1.60, . . . , 2.0, and this relation can be used to determine the size of the aggregates. The observed H-band on emulsion grains is probably formed from overlapping absorption bands of aggregates of different size in the approximately card-pack arrangement of Fig. 4-10a while the J-aggregate can be satisfactorily accounted for by the approximate head-to-tail model of Fig. 4-10b. Improving in principle on the point-dipole model of the transition moment by calculating the contribution to the transition moment of all the atoms in the conjugated chain and the interaction of these contributions from adjacent molecules in the aggregate, Norland and co-workers have calculated the frequency shifts for aggregates of various sizes and configurations and concluded that the angle α (Fig. 4-10) for the J-aggregate of a thiacarbocyanine dye adsorbed on the octahedral face of silver bromide is probably about 19°.[40]

In addition to dimers and aggregates containing the same monomer, *mixed dimers* and *aggregates* are observed, containing different monomers. For example, dimers may be formed in aqueous solution from a simple thiacyanine and a thiacarbocyanine, between cyanines containing different heterocyclic nuclei, or between a cyanine dye and a dye of a different class, such as methylene blue.[44] The absorption band of the mixed dimer occurs on the short wavelength side of the arithmetic mean of the absorption maxima of the dimers of the two parent dyes. Mixed J-aggregates, for example from thia-2'-cyanine dyes and 2,2'-cyanine dyes, are observed in concentrated aqueous solution and in silver halide emulsions. The mixed J-aggregate shows a sharp absorption maximum at a wavelength that shifts steadily from that of one parental J-aggregate to that of the other as the concentration of the second dye is increased. This behavior shows very clearly that the J-aggregate absorption band is a cooperative property of the whole molecular assembly.

The theory of the absorption spectra of aggregates outlined above applies to the linear or single-stranded structure. In concentrated aqueous solutions of 1,1'-diethyl-2,2'-cyanine chloride showing the sharp J-aggregate band at 575 nm (in contrast with the mono-

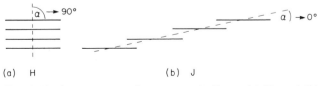

(a) H (b) J

Fig. 4-10. Arrangement of monomers in linear (a) H- and (b) J-aggregates, (schematic). The angle α in the H-aggregate may be less than 90°; down to 55° in one calculation,[43] down to 35° in another.[40]

meric maximum at 520 nm), threadlike structures are visible under the microscope[34] that suggest a relatively coarse multistranded arrangement of linear aggregates. Among H-aggregating dyes in aqueous solution[38] or in alcoholic solution at low temperature[37] H-bands exceptionally highly displaced from the monomeric band and sometimes exceptionally sharp[37] that appear at high concentrations of dye seem reasonably attributable to two- and multistranded H-aggregates. Monolayer aggregates adsorbed to a silver halide surface are essentially two dimensional crystals. Possible arrangements of the monomeric units of H- and J-aggregates adsorbed to silver halide surfaces have been considered by Bird and co-workers,[39] and Kuhn and co-workers have deduced an arrangement of the monomeric units in a brick pavementlike array in J-aggregates adsorbed to crystal surfaces.[45]

It seems likely that steric factors determine the relative tendencies of cyanine dyes to form H- or J-aggregates. Rigid planar monomers without large substituents projecting from the molecular plane are likely to glide into the card-pack arrangement of Fig. 4-10a, in which the van der Waals interaction is a maximum for a given separation between the monomers, yielding H-aggregates. This arrangement will be inhibited by deviations from planarity or by the introduction of bulky substituents projecting from the molecular plane, especially on the central atom of the trimethine bridge in carbocyanines, and such monomers will tend to form J-aggregates.[39,46] For example, thiacarbocyanines containing methyl or ethyl groups on the N-atoms of the benzothiazole nuclei and H on all the C-atoms of the trimethine bridge tend to form H-aggregates, but the introduction of ethyl groups on the meso C-atom of the bridge, as in 3,3'-dimethyl-9-ethylthiacarbocyanine bromide gives a strong tendency to J-aggregation. The carbocyanine derived from 2-quinoline, 1,1'-diethyl-2,2'-carbocyanine bromide, in which the length of the internuclear bridge is great enough to allow a planar structure of the molecule, readily forms H-aggregates but has only a slight tendency to form J-aggregates, whereas the corresponding monomethine dye, which is nonplanar because of mutual impingement of the 3- and 3'-H atoms, readily forms J-aggregates. Molecular models suggest that this J-aggregate may form a low pitched spiral in aqueous solution. Small structural changes sometimes have a large effect on the type of aggregation; for example, in contrast to the J-aggregating tendency of 1,1'-diethyl-2,2'-cyanine salts, the corresponding 1,1'-dimethyl dyes show a greater tendency towards H-aggregation in chloride emulsions, an illustration of the effect of the ethyl group projecting from the planes of the quinoline nuclei in preventing the slippage of the monomers into the strongly overlapping configuration characteristic of H-aggregates.

EXCITATION ENERGY PROPAGATION IN DYE AGGREGATES

When a dimer or larger aggregate absorbs a photon, one of the monomeric units will be electronically excited, but, because of the coupling between the individual chromophores through their interacting transition moments, the excitation energy does not remain localized on any one monomer, but is rapidly transferred from monomer to monomer in the aggregate. Such a running state of excitation in a polymolecular system is called an *exciton*. In an adsorbed dye layer, therefore, excitation energy can be rapidly propagated over distances large in comparison with the dimensions of the individual dye molecule. The velocity of propagation of the energy depends on the strength of the coupling between the chromophores in the structure, which depends on the regular periodicity of the units in the structure. The exciton is slowed down or possibly trapped, this is, localized at sites where the regular periodicity is disturbed, such as a missing or displaced monomer, or an impurity site; the excitation energy will then be emitted as fluorescence, degraded as heat, or transferred to some foreign acceptor. These concepts will be found important in connection with the mechanism of spectral sensitization.

MECHANISM OF SPECTRAL SENSITIZATION BY DYES

As described in Chapter 3, the primary photographic process induced by light absorbed by silver halide crystals is the liberation of free electrons and free positive holes, followed by neutralization of the electrons at suitable sites by combination with mobile silver ions to form silver atoms. Latent image centers are built up by repetitions of these processes. Holes, either free or as neutral complexes with silver ion vacancies, diffuse to the surface of the crystals, where they may escape into the gelatin, react with some of the photo-silver centers or electrons, with deleterious effects on sensitivity, or be rendered innocuous with respect to recombination or silver-regression by being trapped at suitable sensitivity centers.

Clues as to the general nature of spectral sensitization come from three fundamental sets of experimental facts.

1. Spectrally sensitized emulsions show photoconductivity in the region of sensitization that runs parallel in wavelength with the photographic sensitivity.[47–49a,58] In Fig. 4-11 are shown the relative fractional absorption, photoconductivity and photographic sensitivity of iodobromide emulsions spectrally sensitized by sensitizing dyes (I), (II), and (III). Photoconductive and photographic sensitivities run parallel in their wavelength dependence throughout the region of spectral sensitization, although the desensitization in the intrinsic region of photographic sensitivity by dye (III) is not reproduced in photoconductivity. The shapes of the photographic and photoconductivity curves are parallel to the light-absorption curves of the three emulsions, although the relatively low peak values of photoconductivity and photographic sensitivity conferred by dye (III) show that the efficiency of utilization of the absorbed light by that dye in producing photoconductivity and photographic sensitivity is relatively low.

Since photoconductivity in emulsions is mainly caused

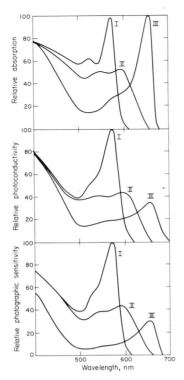

Fig. 4-11. Spectral absorption, spectral photoconductivity and spectral sensitivity of photographic emulsions, sensitized by three dyes.

by the motion of free electrons, the important conclusion to be drawn from the parallelism between photographic and photoconductive sensitivity induced by sensitizing dyes is that the light absorbed by the dye causes the liberation of electrons in the silver halide which ultimately form latent image centers in much the same way as those liberated by absorption of light within the intrinsic absorption band of the silver halide.

2. If the intensities of exposure of spectrally sensitized and chemically sensitized emulsions to light of different wavelengths are so chosen that equal photographic densities are produced in the same exposure time, the reciprocity failure curves are identical at all wavelengths, whether in the intrinsic or the spectrally sensitized regions.[50,51] Since reciprocity failure of an emulsion is determined by the rate of formation of latent image centers at different light intensities, this identity of the failure in the intrinsic and the spectrally sensitized regions shows that the photoelectrons generated by light absorbed by the dye are built up into latent image centers in exactly the same way as those formed by the intrinsic absorption of the silver halide. Taken together, the existence of sensitized photoconductivity running parallel with spectrally sensitized photographic sensitivity and the identity of the reciprocity failure in the spectrally sensitized region with that in the intrinsic region show that the process of latent image formation is the same in the two regions.

3. Spectral sensitization of the photolytic or "print-out" process, that is, the production by heavy exposures of visible darkening in silver halide emulsions, can occur without permanent change in the dye. Measurements show that the number of silver atoms produced in spectrally sensitized photolysis can exceed manyfold the total number of dye molecules in the emulsion. Since the absorption of a photon produces only one electron, the sensitizing molecules must produce electrons again and again to form reduced silver. For example, in the spectral sensitization of the photolysis of silver bromide emulsions by erythrosin up to 20 silver atoms were produced per dye molecule in the emulsion[52] and in some emulsions sensitized to the infrared as many as 160 silver atoms per dye molecule have been found.[53] If spectral sensitization involves a chemical change in the dye, such as the direct loss of an electron to the silver halide, the dye must be regenerated. In some circumstances, however, dye can be chemically changed by secondary processes, such as by attack by liberated bromine,[54,55] and in the spectrally sensitized photolysis of suspensions of silver halide in an aqueous medium, high ratios of photolytic silver atoms to dye on the silver halide crystallites are observed only in the presence of a halogen acceptor.[54]

EFFICIENCY OF SPECTRAL SENSITIZATION

Since the essential function of a sensitizing dye is to cause the appearance in the grain of electrons, under the stimulus of light absorbed by the dye but not by the silver halide, which can form latent image centers in the same way as those formed by direct absorption of light by the halide, the fundamental measure of the efficiency of the dye as a sensitizer is the number of electrons that appear in the grains per photon absorbed by the dye. It does not follow that every electron induced by dye absorption will be used to form latent image any more than that every electron generated in the intrinsic process appears ultimately as latent image, but the factors controlling the efficiency of latent image formation, such as the presence of electron and hole traps, are equally concerned in the intrinsic and in the spectrally sensitized processes, and the quantum yield of electron production in the silver halide by the dye is a true measure of the efficiency of the dye as a spectral sensitizer. Under some circumstances, in virtue of electron or hole trapping or of halogen acceptance, dyes may influence the formation of latent image, acting as chemical sensitizers or desensitizers, but such effects are independent of the spectral sensitization.

Very few measurements have been made on the absolute value of the quantum yield of electron production by sensitizing dyes adsorbed to silver halide. Direct measurements of the electronic charge generated in single crystals of silver bromide dyed with an oxacarbocyanine dye, exposed in the presence of an electric field synchronized with light flashes of wavelength absorbed by the dye but not appreciably by the silver halide showed that the quantum yield of sensitized electron production was 0.25 electrons per quantum absorbed by the dye, whereas, in the intrinsic process, the quantum yield was one electron per quantum absorbed by the silver halide.[56]

Similar values of quantum yields of electron production in the sensitized process, based on electrical measurements have been reported,[57] and a relative quantum efficiency of unity for electron production by a 9-ethyl thiacarbocyanine dye, compared with the efficiency in the intrinsic region, has been found by electrical measurements.[58]

A convenient measure of the sensitizing efficiency of a dye that can be computed from relatively simple photographic spectrosensitometric measurements is the *relative quantum efficiency of sensitization*.[29] This quantity is determined by comparing the number of quanta that must be absorbed by the dye to produce a specified photographic density with the number required by direct absorption by the silver halide to produce the same density. Since most spectral sensitizers do not absorb at wavelength 400 nm, it is convenient to compare the photographic result of the sensitizing dye with that produced in the dyed emulsion exposed to light of wavelength 400 nm and the relative quantum efficiency of sensitization, φ_r is then

$$\varphi_r = \frac{400 E_{400} A_{400}}{\lambda E_\lambda A_\lambda}. \quad (2)$$

E_λ is the incident radiant energy of wavelength λ, absorbed by the dye, in ergs cm^{-2}, required to produce the specified density, A_λ is the fraction of this radiation absorbed by the dyed emulsion and E_{400} and A_{400} are the corresponding quantities for the same coating for wavelength 400 nm. A judicious choice should be made with respect to the density of developed image at which the measurements are made, to avoid as far as possible effects of any difference in γ between the spectrally sensitized and the intrinsic region.

Experimental values of the relative quantum efficiency among different dyes vary between 0 and 1. There is a relatively small number of highly efficient dyes for which φ_r approaches unity, such as 9-methyl-3,3'-diethylthiacarbocyanine, a large number of moderately efficient dyes for which φ_r is about a few tenths, such as 3,3'-diethylthiacarbocyanine, and many dyes of lower efficiency.

Spectral sensitization by a dye adsorbed to silver halide always occurs in competition with other processes by which the electronic excitation energy of the dye is rendered photographically useless.

$$D + h\nu_a \longrightarrow D^* \qquad \text{Absorption of light,} A \quad (3)$$

$$D^* \longrightarrow D + h\nu_f \qquad \text{Fluorescence,} k_f, \tau_f \quad (4)$$

$$D^* \longrightarrow D + \text{heat} \qquad \text{Internal quenching,} k_i, \tau_i \quad (5)$$

$$D^* + Q \longrightarrow D + Q^* \qquad \text{External quenching,} k_e, \tau_e \quad (6)$$

$$D^* + (Br^-_{AgBr}) \longrightarrow D + p^+ + e^- \qquad \text{Sensitization,} k_s, \tau_s \quad (7)$$

The adsorbed dye in its ground state, D, is electronically excited to the higher singlet state, D*, at a rate equal to the rate of absorption of light, A (Eq. (3)). The excited dye molecule may lose its excitation energy in a number of competing ways. It may emit the energy as fluorescence (Eq. (4)); the energy may be lost by various radiationless internal deactivations, summarized as internal quenching (Eq. (5)), the excitation energy being degraded as heat and the dye molecule ultimately reverting to the ground state. The excitation energy may also be lost by resonance transfer to some foreign molecule, Q, in the surroundings (Eq. (6)) and only if it survives these deactivating processes can the excited dye interact with a bromide ion in the silver bromide surface to produce a free electron in the silver halide and a positive hole in some form (Eq. (7)). The various processes are characterized by rate constants k, and average times $\tau = 1/k$ for unimolecular processes and involving also the concentrations of the reactants in bimolecular processes.

On the assumption of steady state kinetics, the rate of the sensitization reaction (Eq. (7)), that is, the rate of appearance of free electrons in the silver bromide cyrstal, is:

$$\frac{k_s [Br^-_{AgBr}] A}{k_f + k_i + k_e [Q] + k_s [Br^-_{AgBr}]}$$

The quantum yield of sensitization φ is the rate of sensitization divided by the rate of absorption of light,

$$\varphi = \frac{k_s [Br^-_{AgBr}]}{k_f + k_i + k_e [Q] + k_s [Br^-_{AgBr}]} \quad (8)$$

or

$$1/\varphi = 1 + \frac{k_f + k_i + k_e [Q]}{k_s [Br^-_{AgBr}]} \quad (9)$$

Values of k_f, k_i or k_e greater than zero will reduce the quantum efficiency of sensitization below one photoelectron in the silver halide per quantum absorbed by the dye.

Loss of excitation energy by fluorescence of the dye is unimportant in emulsions, and in the absence of foreign quenchers, Q, the most important process competing with sensitization is internal quenching. Among most cyanine dyes unadsorbed to silver halide, direct internal conversion from the excited to the ground singlet state is the most probable mode of deactivation, deactivation to the ground state through the triplet being less probable.[59] Efficient spectral sensitizers are dyes which, in effect, transfer their electronic excitation energy to the silver halide rapidly enough to compete with internal quenching, whether the transfer takes the form of a direct electron transfer or of a resonance energy transfer. If in Eq. 6, $k_s [Br^-]$ equals k_i and losses by fluorescence and by external quenching are negligible, φ becomes $1/2$.

The clearest relation between skeletal dye structure and sensitizing efficiency is that dye molecules forced from coplanarity of the atoms in the chromophoric chain by the introduction of crowding substituents are of low sensitizing efficiency.[26,60] An example of such a dye is dye (XVI). Nonplanar dyes show the characteristics of rapid internal conversion; for example, if planar dyes of the same family fluoresce strongly in solution, as do many

dyes of the oxacyanine series, nonplanar dyes do not fluoresce; in fact, they quench the fluorescence of the planar dyes when added with them in solution. The nonplanarity is probably associated with torsional vibrations in the molecule to which electronic energy is rapidly transferred and degraded in heating the environment. When nonplanar dyes are adsorbed to silver halide, the ratio of k_i to k_s $[Br^-]_{AgBr}$ is high and the quantum yield of sensitization is low. Consistent with our definition of the quantum yield of sensitization in terms of the number of electrons appearing in the silver halide per quantum absorbed by the dye, nonplanar dyes are also very inefficient in sensitizing photoconductivity in silver halide emulsions. It is interesting that in sensitization of photoconductivity of ZnO, nonplanar dyes are as effective as planar ones;[61] evidently in that case the sensitization process is sufficiently rapid to compete even with a high tendency to internal degradation of excitation energy.

For a given dye the relative quantum efficiency of sensitization depends to some degree on the emulsion type, sometimes tending to decrease with increasing iodide content of iodo-bromides, on the silver ion concentration, increasing with increasing silver ion concentration[13,14,14a,55,62] on the dye concentration, on the state of aggregation of the dye, and on the wavelength of the exposing light. The relative quantum yield of sensitization is frequently found to be independent of wavelength. But wavelength dependence is also common since different aggregated states of a dye may possess different sensitizing efficiencies; H-aggregates are often of lower efficiency than less highly aggregated states,[32,33] as are some J-aggregates.[63] The curve of relative quantum yield versus wavelength in the spectrally sensitized region sometimes shows a structure somewhat resembling that of the absorption curve.[61,64,65] It seems likely that the variation of yield with wavelength arises in such cases from the presence of aggregates of different efficiency.

High relative quantum efficiency of sensitization does not, in itself, necessitate high spectral sensitivity, since desensitization by the dye depresses sensitivity throughout the whole spectral region, and high desensitization may be accompanied by high relative quantum efficiency of sensitization.[29] It is often their desensitizing tendency that makes dyes of other classes than the cyanines, such as triphenylmethane dyes, unimportant as sensitizers in modern practice.

SUPERSENSITIZATION

Certain substances, added to the emulsion with the dye, sometimes in relatively small amounts, greatly increase the spectral sensitization of some dyes. The addendum may itself be a dye, usually absorbing and sensitizing by itself at different wavelengths from the sensitizer, or it may absorb in the near ultraviolet. The effect is called *supersensitization.* If at any wavelength the increment in spectral sensitivity caused by the addition of a small amount of the addendum to the sensitizer exceeds the increment in sensitivity caused by the addition of the same amount of the addendum alone, supersensitization is indicated, and the addendum is a supersensitizer.

Supersensitization can be caused in various ways. The presence of the supersensitizer may cause an increase in absorption of light by the sensitizer; for example, J-aggregation of the sensitizer may be facilitated by the supersensitizer, with a resulting increase of absorption within the J-band and a corresponding increase in sensitivity, or adsorption of a relatively poorly adsorbed sensitizer may be increased with a corresponding increase of absorption of light and sensitivity within the absorption band of the sensitizer. The latter process may occur if the sensitizer and supersensitizer molecules are oppositely charged, leading to the formation of an adsorption complex or salt between the two components. The most important cause of supersensitization, however, is an increase in the efficiency of sensitization, as shown by an increase in the relative quantum yield. For example, the addition of a supersensitizer, 2-(p-diethylaminostyryl) benzothiazole, (XVIII),

(XVIII)

in the ratio 1/10 of that of the sensitizer 1,1'-diethyl-2,2'-cyanine iodide, (Formula (V), $n = 0$) increases, in some emulsions, the relative quantum yield of sensitization at the wavelength of the J-maximum from 0.02 to nearly 1.0. Spectacular supersensitizing effects are observed with nonplanar dyes; for example, the relative quantum yield of the highly nonplanar dye 1,1', 3,3'-tetramethyl-2,2'-cyanine iodide, dye (XVI), is increased by the presence of supersensitizers from an almost vanishingly low value below 0.001 to a moderately high value of 0.5.

Supersensitizers can act on sensitizers in the molecular, H- or J-aggregated states, but their most conspicuous effects appear when the dye is J-aggregated.[31,66] J-aggregates of low relative quantum yields of sensitization can usually be supersensitized. Some J-aggregated dyes, for example, benzimidazolecarbocyanines, possess relative quantum yields approaching unity, and these show little response to supersensitizers. The absorption of some dyes as J-aggregates is very little affected by the supersensitizer, but frequently, in the presence of a supersensitizer, the J-band is broadened and its maximum is displaced to shorter wavelengths. This effect is attributable to the action of the supersensitizer, which interposes itself in the aggregates, and breaks up large aggregates into smaller ones.[31,67,68]

Supersensitizers are often themselves sensitizers, but there is no general correlation between the sensitizing efficiency of a dye and its efficiency as a supersensitizer. If the supersensitizer absorbs light and sensitizes at wavelengths longer than the tail of the intrinsic silver halide band, its absorption and sensitization band can frequently be discerned in the general absorption and

sensitization spectra of the supersensitized emulsion, but sometimes the absorption band of the supersensitizer disappears, as, presumably, it participates cooperatively in the absorption of the whole supersensitizer-sensitizer dye layer.[31]

Photoconductivity of silver halide emulsions is effected in the same way by supersensitizers as is the photographic sensitivity—increases in photocurrents induced by light absorbed by sensitizing dyes are effected by the supersensitizer in a manner parallel to the increase in spectral sensitivity, clear proof that the action of the supersensitizer is to increase the capacity of the sensitizer to cause the appearance of free electrons in the silver halide crystal under the stimulus of light absorbed by the sensitizer.[47,48]

ANTISENSITIZATION

An effect the reverse of supersensitization is also observed—a small quantity of an added dye can drastically decrease spectral sensitization, without materially altering the absorption of the sensitizer. This effect is called *antisensitization.*[31] Although antisensitizers frequently also desensitize, as shown by a reduction in sensitivity in the intrinsic region, their effect on spectral sensitization is much greater than the normal desensitization of dyes, and antisensitization is a specific effect on the efficiency of sensitization by the sensitizing dye. For example, the antisensitizer 1,1,3,3'-tetramethyl-2,2'-cyanine iodide, dye (XVI), in a mole ratio of 2% of the sensitizer 1,1'-diethyl-2,2'-cyanine iodide, reduced the sensitivity of the emulsion in the spectrally sensitized region to half its value without the antisensitizer, without measurably affecting the sensitivity towards blue light. Added in a mole ratio of 10%, it reduced spectral sensitivity by 75% and sensitivity to blue light by only 8%.[31]

Except for its opposite photographic effect, antisensitization shows many of the characteristics of supersensitization. Both effects are marked at a low concentration of the agent compared with that of the sensitizer, both occur by altering the relative quantum efficiency of sensitization, and sensitizers in the J-state are most susceptible to the effects. Moreover, as will be discussed later in this section, a dye that acts as an antisensitizer with respect to one sensitizer may act appreciably, if not highly efficiently, as a supersensitizer to another. The effect of antisensitization, to a large degree, can be nullified by the presence of a supersensitizer.[31,48]

Nonplanar cyanine dyes are among the most efficient antisensitizers. An important clue to the mechanism of antisensitization is that its efficiency is a maximum when the absorption band of the antisensitizer coincides with that of the sensitizer or is at slightly longer wavelength. As the absorption maximum of the antisensitizer is displaced to increasingly longer wavelengths from that of the sensitizer, the efficiency of antisensitization decreases. No antisensitization is observed if the absorption maximum of the antisensitizer is more than 50 nm on the short wavelength side of that of the sensitizer. The conclusion

from these facts is that antisensitization occurs by a resonance transfer of electronic excitation energy from the sensitizer to the antisensitizer, in competition with the photographic transfer to the grain. The great tendency already mentioned of nonplanar dyes to undergo internal degradation of electronic excitation energy to vibrational energy in the ground state and ultimately to heat prevents them from transferring electronic energy to the silver halide with any efficiency—nonplanar dyes adsorbed to silver halide act as sinks for electronic excitation energy.

Antisensitization and supersensitization are not mutually exclusive properties of the same dye. If the condition that the sensitizer must be able to participate in a resonance transfer of excitation energy with the antisensitizer is not fulfilled, that is if the absorption spectrum of the nonplanar dye is at shorter wavelengths by more than 50 nm than that of the sensitizer, the nonplanar dye may act as a supersensitizer. Thus sterically crowded thiacyanines, whose absorption maxima are on the long wavelength side of that of sensitizing thiacyanines, invariably act as strong antisensitizers towards these sensitizers but may act as weak supersensitizers towards sensitizing 2,2'-cyanines, which absorb at wavelengths longer than do the thiacyanines. It is also true that in the very act of inhibiting sensitization, the antisensitizer itself frequently sensitizes within its own absorption band, feebly, indeed, but more strongly than if it were alone on the grain surface—the sensitizer, rendered ineffective in the combination, supersensitizes its antisensitizer. As for supersensitization, antisensitization is also manifested in photoconductivity.

MECHANISMS OF SUPERSENSITIZATION AND ANTISENSITIZATION

These apparently complex interactions between supersensitization and antisensitization can be readily explained in terms of a unified theory. To begin with supersensitization, two types of mechanism may be advanced a priori for the most important action of the supersensitizer, the increased relative quantum yield of sensitization.

1. The supersensitizer may interfere with the energy-degrative processes that compete with sensitization. The supersensitizer then functions before the sensitizing interaction between the sensitizer and the silver halide.

2. A supersensitizer might act so as to decrease the inefficiencies of latent image formation after the appearance of an electron in the silver halide, for example by interfering with recombination between electrons and positive holes, or with regression of silver centers by attack of positive holes. An effect of this sort, selective to the region of spectral sensitization, would be supersensitization. In normal chemically sensitized emulsions the chemical sensitizer seems to ensure the production and survival of latent image in both the intrinsic and spectrally sensitized processes, as is shown by the wavelength independence of reciprocity failure in such

emulsions.[50,51] But, as will be discussed in a later section of this chapter, the overall spectrally sensitized photographic process is not identical with the intrinsic process. The behavior of electrons is the same in the two processes, but whereas the holes are free in the intrinsic process, those associated with the spectrally sensitized process appear to be immobile, trapped in the surface. Strong evidence has been adduced that in emulsions deficient in chemical sensitization, an appropriate dye may act as an efficient trap for the positive holes generated in spectral sensitization, functioning therefore, when added with the sensitizer, as a supersensitizer.[69a,69b,69c]

Many aspects of supersensitization can be satisfactorily explained by the concept that in a closely packed adsorbed layer of dye molecules, electronic energy rapidly migrates from molecule to molecule in the layer as an exciton. The energy of the moving exciton is not likely to be transferred to the silver halide as excitation energy or as an electron, since it remains too short a time at any one location for the transfer interaction to be built up. Exciton traps, however, are present in the dye layer and can also be introduced by incorporating appropriate foreign molecules into the layer, which have the effect of localizing the excitation energy. Molecules of supersensitizing and antisensitizing substances incorporated into the layer of sensitizing dye constitute such exciton traps.[31,39,46,57,58,63,68]

The processes of supersensitization and antisensitization according to the mechanism of exciton trapping are illustrated in Fig. 4-12. The sensitizer is assumed to be adsorbed to the silver halide as a regularly oriented monolayer aggregate; the straight lines represent the directions of the individual molecular chromophores and the long axes of the dye molecules. The surface of the silver halide is represented by the plane of the paper, to which the molecular planes of the dye molecules are highly tilted. The left portion of the diagram refers to processes occurring in the pure dye layer. Incident photons $h\nu$ are absorbed by individual dye molecules, but the energy of excitation wanders rapidly through the dye layer as an exciton, as symbolized by the long arrows.[70] In a J-aggregate it is probable that the

excitation energy remains on any one monomer for a time less than the period of a molecular vibration, about 10^{-13} sec, since the unusual sharpness of J-bands indicates little coupling between the electronic and vibrational motion. The lifetime of the exciton in a pure dye layer appears to be about 10^{-9} sec, while the observed quenching of fluorescence of sensitizing dyes adsorbed to silver halide suggests that a sensitizing transfer of energy or of an electron requires about 10^{-11} or 10^{-12} sec.[71] As will be discussed later, the sensitizing interaction between the dye and the silver halide involves a localized site in the silver halide surface; hence some localization of the exciton in the dye layer adjacent to the surface site will be necessary for sensitization to occur. A dye molecule in a regularly oriented part of the adsorbed layer will not readily interact with the silver halide. The regularity of orientation of the dye layer is, however, disturbed at various types of sites, such as the end of an aggregated chain of molecules, missing or displaced monomers in the aggregate, highly vibrating distorted monomers present because of the distribution of thermal energy (represented by the bent molecule in the left section of Fig. 4-12), and adventitious impurity molecules. At such sites the exciton may be slowed down or even temporarily localized and undergo an energy transition. It may interact with the silver halide, transferring excitation energy or an electron, that is, spectrally sensitizing the halide. The trapped exciton may also be degraded to thermal motion by internal quenching,[63] this process being especially likely if the exciton meets a highly vibrating monomer in its ground electronic state. Bird, Rosenoff and co-workers[39,57,68] have emphasized the possibility that antisensitizing impurities in the aggregate may act as energy degradative exciton traps. The relative quantum yield of sensitization of 1,1'-diethyl-2,2'-cyanine iodide in the J-aggregated state is frequently about 0.1, indicating that the energy of about 10 absorbed photons is thermally degraded for every absorbed quantum utilized in sensitization.

Not all J—aggregates show low relative quantum efficiencies of sensitization; in these, sensitization competes successfully with internal quenching. The excitons in such aggregates must still be trapped before sensitization, but since competing processes are rare, the quantum yield of sensitization of the pure J-aggregate can be high. Such dyes are likely to fluoresce strongly in solution and in the J-aggregated state in solution or on inert substrates such as mica.

In an aggregate of highly nonplanar dye molecules internal quenching is so great that practically no sensitization occurs.

The middle portion of Fig. 4-12 illustrates the action of a supersensitizer as an exciton trap. The supersensitizer molecule acts as a disturbance in the regular periodicity of sensitizer monomers and an exciton may be trapped at the impurity site or in its vicinity, providing therefore a site suitable for a sensitizing transfer to the silver halide. It may also intercept an exciton before it has traversed the mean path length through the aggregate after which internal or external quenching occurs. The

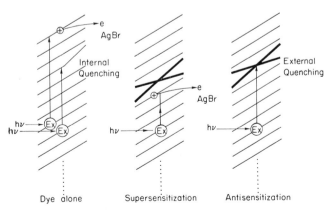

Fig. 4-12. The exciton model of spectral sensitization, supersensitization and antisensitization by dye aggregates (after West and Gilman[46]).

net result is an increase in the efficiency of sensitization in the presence of the supersensitizer. The great effect of supersensitizers in increasing the relative quantum yield of sensitization of strongly nonplanar dyes from negligible values to values of a few tenths must be attributed, in the exciton model of supersensitization, to their providing sensitizing sites competitive with sites of internal quenching. For example, if the mean free path of the exciton before internal quenching in the aggregated layer of the pure nonplanar dye were 20 monomer units, and isolated supersensitizer molecules were now introduced at such a concentration that the mean free path the exciton before meeting a supersensitizer molecule were less than 20 monomers, a large increase in relative quantum efficiency of sensitization could be effected. The mean free path before internal quenching for strongly nonplanar dyes is small compared with that for planar or near-planar dyes, hence the concentrations of supersensitizer necessary to exert the effect with nonplanar dyes is relatively larger than with the others, as is experimentally observed.

It is clear that supersensitizers, to act in this way, must be capable of dissolving in the aggregated layer of sensitizer, and if the energy of the original exciton is transferred to the supersensitizing molecule, the latter must not show a marked tendency to internal degradation of excitation energy. If, however, a foreign molecule in the dye layer can be excited by resonance transfer from the exciton, acting as an exciton trap, and then degrades the excitation energy as heat to the surroundings, no sensitization of silver halide can occur; the foreign molecule than acts merely as an energy sink. Such a molecule functions as an antisensitizer, as is illustrated on the right hand section of Fig. 4-12. Nonplanar dyes whose electronic excitation energy is equal to or less than that of the sensitizer are strong antisensitizers. Frequently, however, a nonplanar dye strongly desensitizing a J-aggregated sensitizer, shows itself a small but apreciable sensitization, many times greater than does the dye alone at the same concentration. The antisensitizer is supersensitized by the antisensitizee. For example, the strongly nonplanar dye (XVI), while greatly diminishing the sensitivity of J-aggregated 1,1′-diethyl-2,2′-cyanine iodide, shows in the dye mixture a small sensitization band corresponding to its absorption band in emulsions, while the dye alone shows no measurable sensitivity. The difference in excitation energy between the sensitizer and the antisensitizer in this case is .04 eV or about $1.6 \, kT$ at room temperature, the nonplanar dye having the lower excitation energy. There is a finite chance that the excitation energy acquired by absorption of light by an isolated nonplanar dye molecule will be transferred to the J-aggregated sensitizer layer before it is thermally degraded within the nonplanar molecule. Because of the relatively lower internal quenching of the sensitizing dye molecule than of the nonplanar molecule, the lifetime of this exciton will be longer than that in the aggregate of nonplanar dye which would have formed if the same amount as was incorporated as isolated molecules or small aggregates in the J-aggregated sensitizer had

been added to the emulsion grains alone. The J-aggregated sensitizer acts as a supersensitizer toward the antisensitizer.

Finally, if the excitation energy of the nonplanar dye is over 3 or 4 kT greater than that of the sensitizer, practically no antisensitization by resonance transfer can occur, but the nonplanar dye can still act as a perturbation in the regular periodicity of the aggregated layer of sensitizer, slowing down or trapping the exciton in its vicinity, and facilitating sensitization. In this way, nonplanar thiacyanine dyes, whose absorption maximum in emulsion is about 500 nm, may act as weak supersensitizers towards aggregated 2,2′-cyanines, whose maxima in emulsions is about 575 nm, while strongly antisensitizing dyes absorb near 500 nm.

To sum up, the mechanism of exciton trapping, coupled with consideration of the effect of the ratio of the sensitization and internal quenching factors, $k_s[\mathrm{Br}^-_{\mathrm{AgBr}}]/k_i$ of Eqs. (5) and (6) for highly nonplanar compared with planar or slightly nonplanar molecules, appears to give a satisfactory explanation of the multifarious effects observed in supersensitization and antisensitization—the efficiency of small ratios of supersensitizer or antisensitizer in the effects, the fact that an antisensitizer may itself be somewhat supersensitized in the act of supressing the sensitivity of the sensitizer, and the transition from antisensitization into supersensitization when a resonance transfer of excitation energy from sensitizer to the foreign molecule is no longer possible.

SUPERSENSITIZERS AS CHEMICAL SENSITIZERS

Besides acting as spectral sensitizers, dyes, acting as chemical sensitizers, can increase the general sensitivity level of emulsions. These effects are greatest when the emulsion is not otherwise chemically sensitized by labile sulfur compounds or is undersensitized. For example, marked chemical sensitizing effects of aggregated oxacarbocyanines and other dyes have been found in underfinished emulsions.[72] This effect of dyes decreases as sulfur sensitization increases with time of ripening. The Capri blue effect, to be described in the section of this chapter on desensitizing dyes, is an example of chemical sensitization by dyes.

Gilman has recently shown that such a chemical sensitization, selective to the spectrally sensitized region, can be effected by dyes described as supersensitizers, and has concluded that supersensitization in these cases can at least partly be attributed to the action of the dye as a trap for positive holes.[69] Part of the evidence is that the sensitizer 1,1′-diethyl-2,2′-cyanine chloride, adsorbed in the J-state on the grains of silver chloride or silver bromide emulsions, exhibited, on exposure to radiation within its visible absorption band at low temperature, an emission band at 700 nm shown to be associated with a bimolecular process. Gilman proposes that the process is a radiative recombination of photoelectrons injected by the excited dye molecule into the silver halide in the act

of spectral sensitization with the corresponding positive hole left in the dye layer. Such a recombination at room temperature could be a factor in the observed low sensitizing efficiency of this dye. The presence of supersensitizers greatly decreased the intensity of the recombination emission, suggesting that the supersensitizer discharged or inactivated the positive holes generated in the spectral sensitization. If these holes were more rapidly attacked than those produced in the region of intrinsic sensitivity, a selective promotion of latent image formation in the region of spectral sensitization would be effected by the supersensitizer, the observed effect.

The nature of the reaction between the positive hole and the supersensitizer is not definitely known. Presumably the supersensitizer acts as an irreversible hole trap. Proximity of the hole generated in spectral sensitization to the supersensitizer could account for the more rapid removal of these holes than those produced in the intrinsic region. In the trapping of a hole by a supersensitizer molecule, an electron must be transferred from the supersensitizer to the hole. It is therefore satisfactory with respect to this mechanism of supersensitization that the polarographic half-wave oxidation potentials of several supersensitizers compared with their conjugate sensitizers show that the electron-donating capacity of the supersensitizer is greater than that of the sensitizer, indicating ready passage of an electron from the supersensitizer to the hole derived from a sensitizer molecule.[69b]

The mechanisms of supersensitization by exciton-trapping and by hole-trapping are not mutually exclusive; both mechanisms could operate simultaneously.

THE ENERGY REQUIREMENTS FOR SPECTRAL SENSITIZATION

The essence of spectral sensitization of the photographic process is that a latent image center of the same nature as that generated by the absorption of blue light or light of shorter wavelength by the silver halide is formed by the absorption of light by the sensitizer of longer wavelength and therefore of lower energy per quantum. The smallest quantum energy that will induce intrinsic sensitivity, for practical purposes at about 500 nm for an iodo-bromide emulsion, is 2.45 eV or nearly 57,000 cal/mol, while the quantum energy at 600 nm is 2.05 eV or 47,500 cal/mol, and slightly less than 1 eV or 23,000 cal/mol at the present known limit of spectral sensitization about 1300 nm. A fundamental question regarding spectral sensitization is therefore how the process occurs with the deficiency of quantum energy from that required for the intrinsic process. A second fundamental question arises as to the detailed mechanism by which the excitation energy absorbed by the dye induces the photographic process in the silver halide. The primary intrinsic process is the photogeneration of a free electron and a free hole; the spectrally sensitized process certainly produces a free electron. If the primary spectrally sensitized process requires only one quantum for each elementary process

(and there is, in general, no good evidence to the contrary) it would seem, in the light of the smaller quantum energy required, that in some way the positive hole associated with spectral sensitization must differ from that associated with the intrinsic process.

The band scheme of energy levels in silver halide has already been discussed (Fig. 3-6). We shall find that besides the nonlocalized electron levels constituting the valence and conduction bands, the localized electron levels in the energy gap between the two nonlocalized bands are of special importance in spectral sensitization. Occupied localized electron levels are associated with impurities or with bromide ions at kink sites in surface terraces or at jogs in dislocation lines and unoccupied localized levels are associated with silver ions at kink sites and jogs. In Chapter 3 it was shown that an occupied localized electron level in the energy gap above the valence band acted as a trap for positive holes, and such a level, when unoccupied because of a jump of the electron into a free hole in the valence band, constitutes a trapped hole. Similarly, unoccupied electron levels below the conduction band are traps for electrons in the conduction band, and, when occupied, constitute trapped electrons.

An electron in a localized level in the energy gap may be excited into the conduction band with the expenditure of less energy than is required for a transition to the conduction band from the valence band. Hence an electron may be excited from a localized level to the conduction band by the absorption of a quantum of longer wavelength than is required for excitation from the valence band. It appears to be necessary to invoke such excitations from localized surface sites in the silver halide crystal to account for spectral sensitization.[73] The absorption spectrum associated with such transitions, on the long wavelength side of the tail of the band associated with transitions from regular lattice sites, is exceedingly feeble, but when a surface state is coupled with a molecule of a sensitizing dye to form a unitary system, the high absorption coefficient of the dye can be drawn on to bring about the observed spectral sensitization.

It has long been realized that spectral sensitization of silver halide could be effected by (1) a direct electron transfer from the optically excited adsorbed dye molecule to the silver halide, or (2), by a resonance energy transfer from the dye to the crystal, causing excitation of an electron from a site in the crystal into the conduction band. The energy levels of the dye and silver bromide involved in spectral sensitization are shown in Fig. 4-13. In the dark, electrons are confined within the dye molecule or the halide crystal by the potential walls indicated qualitatively in the diagram. If, as in case A, on the left of the figure, the excited electronic level of an adsorbed dye that absorbs red light is above the bottom of the conduction band of silver bromide, there will be a tendency for the excited electron to leave the dye molecule for the wider spaces open to a free electron in the conduction band of the silver halide. The electron must tunnel through the potential barrier separating the dye and the silver halide but it has been shown by Dörr and Scheibe

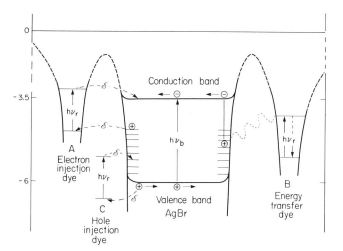

Fig. 4-13. Electron energies, in eV, in silver bromide and in adsorbed dyes, illustrating (A) spectral sensitization by electron transfer, (B) spectral sensitization by energy transfer; (C) spectral sensitization of hole injection, according to the positions of the electronic levels of the dyes relative to those of the silver bromide $h\nu_b$ is a quantum of blue light and $h\nu_r$, one of red light.

that if the barrier width is 3.5Å, a reasonable value for the distance between the electron in the dye chromophore and the silver halide surface, and as high as 2 eV, there is a high probability that the electron will tunnel from the dye to the silver halide, under the conditions of case A, within the lifetime of the excited dye molecule.[74] In case A, the ground level of the dye must be on a level with a state of the silver bromide in the energy gap, well above the top of the valence band. After the transfer of the excited electron from the dye molecule, an unpaired electron is left in its ground state. The dye molecule has been chemically changed to an electron-deficient free radical which constitutes the primary positive hole associated with the sensitization process, balancing the electron in the conduction band of the silver halide. This positive hole is trapped in the dye layer; motion of the hole into the interior of the crystal would require an electron in the valence band to jump into the incompletely occupied orbital in the ground state of the dye, a process which, for a red-absorbing dye in case A, requires a prohibitive energy of thermal activation. It is, however, possible for an electron to pass to the dye free radical from an occupied electronic level in the gap of the silver halide on a par with the ground dye level, such as an electron in an energy-rich surface bromide ion site, regenerating the dye and transferring the positive charge to the surface site. The positive hole is now trapped in the surface of the silver halide, being unable to move into the interior of the crystal because of the high activation energy required.

The products of this primary step in spectral sensitization by electron transfer are therefore a free electron in the conduction band of the silver halide and a positive hole trapped in the surface of the silver halide, although possibly free to move in the surface. The electron can participate in the formation of a latent image center in the same way as described in Chapter 3 for the intrinsic

process and the hole may eventually react with a chemical sensitizer in the emulsion. Among possible chemical sensitizers must be included adsorbed dye molecules, with which the trapped hole may react to form a brominated dye product, the positive charge now appearing as a mobile interstitial silver ion. Opposing latent image formation are possible recombination of the trapped hole with the free electron or attack of silver centers by the hole. The occurrence of such processes is shown by the fact that the presence of chemical sensitizers increases sensitivity in the region of spectral sensitization in the same kind of way as it increases the intrinsic sensitivity of silver halides.

Spectral sensitization by energy transfer is illustrated in case B, on the right of the diagram of Fig. 4-13. In this case the excited dye level need not necessarily coincide with a conduction level of the silver halide, but the excited dye molecule must be in resonance with a localized surface site from which an electron may be excited into the conduction band with the energy available in the excited dye molecule. A transfer of energy from the excited dye to the surface site is then possible—the dye molecule reverts to its ground state, a free electron appears in the conduction band and a trapped positive hole is formed in the surface.

The products of the primary process in spectral sensitization by electron transfer and by energy transfer are of similar nature; a free electron and a trapped positive hole at the dye-crystal interface. In electron transfer the primary photohole is a dye free radical, from which a trapped "bromine positive hole" may be formed in the silver halide surface by electron transfer to the free radical; in energy transfer the primary positive hole is a "bromine positive hole" in the surface. If the lifetime of the dye free radical is appreciable, electron transfer is in principle distinguishable from energy transfer by identifying the free radical; otherwise, the two mechanisms are indistinguishable when the sensitizing dye is adsorbed to the silver halide surface. The ground level of the dye may lie below the top of the valence band, as in case C of Fig. 4-13. (For convenience in drawing the figure the potential wall between the dye and the silver halide surface has been omitted for this case and the dye energy levels have been placed nearer the surface than for cases A and B. It is not implied that in case C the dye is closer to the surface than in the other cases.) If in case C the dye molecule is optically excited, an electron may leave the valence band of the silver halide and enter the partially unoccupied orbital of the ground state of the dye, generating a free positive hole in the silver halide and an electron-rich (chemically reduced) dye free radical. In this case the dye sensitizes positive hole production in the silver halide, with the formation at the same time of a trapped electron, primarily in the form of the reduced dye free radical. In inverse analogy with the regeneration of the dye in sensitization by electron transfer from the dye to the silver halide, case A, the dye in case C may be regenerated by the passage of an electron from the level of the dye radical to an equi-energy unoccupied surface

level of the silver halide. The processes occurring in hole injection by an adsorbed dye molecule into silver halide are antisymmetrical to those occurring in electron injection. In hole injection, the products are a free hole and a trapped electron in the dye-silver halide interface; in electron injection, a free electron and a trapped hole in the interface are formed.

Hole injection by energy transfer from a dye whose energy levels are those of case C is also possible, with the excitation of an electron from the valence band to an unoccupied surface level in the energy gap, yielding a free hole and a trapped electron in the halide surface. Electron injection by energy transfer is also possible in this case, if there is an occupied electron level in the gap from which the electron can be excited to the conduction band with the energy available in the excited dye molecule.

Spectrally sensitized transitions of an electron from occupied to unoccupied levels in the gap are also formally possible. For example, a dye molecule whose ground state is above the valence band of the silver halide and whose excited state is below the conduction band could formally produce a trapped electron and a trapped hole by electron transfer to unoccupied surface levels and electron withdrawal from occupied surface levels respectively. The same products could be formed by energy transfer to a suitable surface site in resonance with the excited dye molecule, while resonance transfer to other surface sites could produce free electrons and trapped holes or free holes and trapped electrons. When both electrons and holes are trapped in the surface in close proximity, the efficiency of latent image formation will likely be small because of recombination of holes and electrons or regression of silver centers by attack by the surface holes.

SOME THEORETICAL CONSIDERATIONS ON THE RATE OF ENERGY TRANSFER

In trying to work out mechanisms of spectral sensitization, it is useful to bear in mind some theoretical concepts underlying energy and electron transfer between donor and acceptor systems. Only the briefest outline of some of these concepts can be provided here. References 75–81 discuss in detail energy transfer in photochemical sensitization.

If an electronically excited molecule D* is near an unexcited molecule A whose electronic excitation energy is the same as that of D, the excitation energy may oscillate between the equi-energy (degenerate) systems D* + A and D + A*. The two systems are then in resonance, or D and A may be said to be in resonance. Energy transfer between the donor D* and the acceptor A other than by the emission and absorption of radiation can arise because of two effects. If the donor and acceptor are sufficiently close for their electronic orbitals to overlap appreciably, the electrons share orbitals of both molecules to some degree, and there is a probability that an excited electron initially on D will appear on A

(energy transfer by exchange). The quantum mechanical potential energy of the interaction between the two degenerate systems that causes the exchange depends on the degree of overlap of the wave functions at the separation distance and on that distance, but not on the intensity of the absorption spectra of the donor or acceptor. Exchange transfer is a short range effect, falling off very rapidly as the separation exceeds the van der Waals distance of closest approach. It might, however, make a significant contribution to the transfer of excitation energy from an adsorbed dye layer to a substrate like a silver halide crystal containing surface sites in resonance with the dye molecule.

The other factor concerned in energy transfer is a long-range effect originating in the interaction between the transition dipoles and multipoles of the donor and acceptor. The transition dipoles can be regarded as virtual oscillators vibrating with a frequency equal to that of the spectral transition. The oscillating dipoles of the donor and acceptor tend to occur in synchronism, with a frequency somewhat less than that of the independent oscillators, and an attractive force exists between the two oscillators. The potential energy of the dipolar component of this electronic interaction is:

$$\beta_{\text{dipole}} \sim M_D M_A / r^3 \qquad (10)$$

where M_D and M_A are the transition dipole moments of the donor and acceptor respectively. The dipolar interaction between the donor and acceptor therefore depends on the intensities of the electronic absorption spectra, proportional to the square of the transition moments. The effect of the interaction is that electronic excitation energy passes between the two oscillators at a rate depending on the "coupling," that is, the magnitude of the potential energy of the interaction.

The expression for the interaction energy and the rate of energy transfer depend on the magnitude of the coupling. In *strong coupling*, the electronic interaction energy is greater than that of vibrational quanta and the electronic excitation oscillates between two resonating molecules at a rate, approximately $4\beta_e/h$, greater than the vibrational frequencies, the latter, of the order $10^{13}/$ sec. The electronic interaction in this case includes dipole terms and exchange terms, but no term depending on the intramolecular vibrations. Transfer of energy back and forth between the resonating molecules is so rapid that the excitation energy is practically completely delocalized, and donor and acceptor are indistinguishable. This condition represents exciton migration, already discussed in connection with the spectra and photographic behavior of dye aggregates.

Strong coupling causes marked changes in the shape and position of the lowest energy electronic spectra of the coupled system from those of the independent molecules, such as those that distinguish the visible spectra of dye dimers and aggregates from those of the monomers. On the other hand, the absorption spectra of dye molecules adsorbed as monomers on silver halides retain the essential shape of the monomeric band in dilute solution, showing indications of vibrational structure, although

shifted by some 20 nm to the longer wavelengths from the position in alcoholic solution. This shift is essentially a "solvent effect" associated with the higher refractive index of silver halide than of alcohol.[30] The spectra of dimers and higher aggregates of dyes adsorbed to silver halides are likewise similar to the corresponding spectra in aqueous solution. Adsorption has no profound spectral effect on dyes, and spectral sensitization of the photographic process does not involve strong coupling in the sense defined above.

In the *"weak coupling case"* the donor molecule carries out several vibrations before transferring its excitation energy, but does not collide with environmental molecules. The electronic distributions that determine the magnitude of the electrostatic interactions between the resonating molecular pair are now modulated by the intramolecular vibrations. The rate of energy transfer in this case is proportional to the electronic interaction energy multiplied by the square of the integral expressing the overlap of the vibrational wave functions of the donor and acceptor.

In the third coupling case recognized in the theory of resonance transfer, Förster's *"very weak coupling case,"*[75,76] the frequency of transfer is low not only in comparison with that of the intramolecular vibrations, but also in comparison with the frequency of the collisions with environmental molecules that bring about vibrational relaxation of nonequilibrium distributions of vibrational energy produced in the donor molecule by the absorption transitions. In condensed systems this relaxation rate is probably between 10^{12} and 10^{13}/sec. The excited donor will then be in the zero vibrational state, except for low frequency vibrations, although it may transfer excitation energy to an equi-energy vibrationally excited acceptor of lower electronic excitation energy.

In the very weak coupling case, the number of energy transfer events per second from an electronically excited donor D* to an acceptor A is proportional to the square of the electronic interaction energy β_e, according to the equation

$$n_{D^* \to A} = 2(h/2\pi)^{-2} \tau_{vib} \beta_e^2 S^2 \qquad (11)$$

where β_e, for resonance between strongly absorbing molecules in dilute solution, is the dipole contribution to the interaction energy, τ_{vib} is the vibrational relaxation time, and S is the product of vibrational overlap integrals between vibrations in the ground and excited states of the donor and acceptor, (Franck-Condon factors).[77,78] In terms of experimentally accessible data, Förster's equation for the rate of transfer between two very weakly coupled molecules in a solvent whose electronic spectrum is far removed from those of the donor and acceptor is

$$n_{D^* \to A} = \frac{9K^2 (\ln 10)}{128\pi^5 n^4 N' \tau_{\circ D} r^6} \int_0^\infty F_D(\nu) \epsilon_A(\nu) \frac{d\nu}{\nu^4} \qquad (12)$$

K is an orientation factor equal to $(2/3)^{1/2}$ for random orientation of donor and acceptor molecules, ν is the wave number in cm^{-1}, n is the refractive index of the solvent, N' is Avogadro's number per millimole, $\tau_{\circ D}$ is the intrinsic fluorescence lifetime of the donor, r is the distance between the interacting donor and acceptor molecules, $F_D(\nu)$ is the spectral distribution in quanta as a function of wave number of the fluorescence spectrum of the donor, normalized to unity, and $\epsilon_A(\nu)$ is the molar extinction coefficient of the acceptor. The rate of transfer of excitation energy between the donor and acceptor in dilute solution is therefore proportional to the overlap between the fluorescence spectrum of the donor and the absorption spectrum of the acceptor, and depends also on the intensity of the latter, and is inversely proportional to the sixth power of the separation distance between the donor and acceptor molecules.

The efficiency of resonance transfer can be expressed in terms of the critical radius r_0, the separation distance between the interacting molecules at which the probability of energy transfer becomes equal to that of deactivation of the donor by all other processes. With substitution of the numerical magnitudes in Eq. (12),

$$r_0 = \frac{8.8 \times 10^{-25}}{n^4} K^2 \Phi_D \int_0^\infty F_D(\nu) \epsilon_A(\nu) \frac{d\nu}{\nu^4} \qquad (13)$$

where Φ_D is the fluorescence quantum yield of donor in the solvent in the absence of the acceptor. Values of 50Å or more for r_0 are frequent for energy transfer in dilute solution.

If the donor and acceptor molecules are present in extended packed monolayers instead of in dilute fluid solution, Kuhn and co-workers have shown that the rate of transfer is inversely proportional to fourth power of the distance between the monolayers.[79-81]

It is not certain that the very weak coupling case applies to energy transfer from an adsorbed dye layer to resonating surface sites in silver halide crystals. The quenching of the fluorescence of strongly fluorescing sensitizers when adsorbed to silver halide suggests that the rate of spectrally sensitizing transfers of energy or of electrons from the dye to the silver halide is 10^{11} to 10^{12} sec, not greatly less than the rate of vibrational relaxation.[71] The coupling is certainly not strong, but might be intermediate between the weak coupling and the very weak coupling case. Moreover, an exchange contribution to the coupling may not be negligible, at a rate independent of the fluorescence characteristics of the donor and the absorption coefficient of the acceptor. On the other hand, energy transfer from dyes separated by relatively large distances from the surface of silver halide crystals by monolayers of long chain fatty acids has very probably been demonstrated by Kuhn and co-workers and found to be in accord with the predictions of the very weak coupling theory.

Rate of Electron Transfer

The direct transfer of an electron from an adsorbed dye molecule to the conduction band of silver halide depends on the ability of an electron in a dye molecule excited to a

state energetically equal to a level in the conduction band of the silver halide, because of its wave nature, to leak through a potential wall of considerable height, the surmounting of which by thermal energy would require a prohibitive energy of activation. The potential wall in question is that separating the dye molecule from the silver halide surface. The process is diagramatically illustrated in case A, Fig. 4-13 discussed by Dörr and Scheibe.[74] There is a finite probability that the electron will be found outside the confines of the dye molecule as represented by the potential wall, falling off exponentially with distance from the wall. Similarly, there is a probability that a conduction electron will be found outside the potential wall represented by the boundaries of the crystal. If the barrier between the dye molecule and the silver halide is sufficiently thin, there is an appreciable probability that the excited dye electron will be found at the crystal potential wall. It may then enter the crystal, occupying a conduction level.

If the barrier is square, the probability that an electron impinging against it will tunnel through, expressed by the transmission factor, T, is [82]

$$T \sim \frac{16E(V - E)}{V^2} \exp \left(- \frac{4\pi d}{h} \cdot [2m(V - E)]^{1/2} \right) \quad (14)$$

E is the total energy of the electron in the dye impinging on the barrier, from the left in Fig. 4-13, V is the height of the barrier, d, its thickness, m, the mass of the electron, and h, Planck's constant. The barrier height and the energy of the excited electron can be measured from the lowest level of the silver halide conduction band. V is unknown for the dye-silver halide system, but is unlikely to exceed about 2 eV. If the excited level of the dye is 0.1 eV above the bottom of the conduction band, $E = 0.1$ eV. The pre-exponential factor in Eq. (14) is then approximately unity. If the barrier thickness is taken as 4Å, a plausible value for the separation between the dye chromophore and the silver halide surface, the transmission factor of the barrier is between 10^{-2} and 10^{-3}, that is, the excited electron oscillating in the dye molecule can penetrate the barrier once in about 10^2 to 10^3 reflections at the barrier. Since the excited electron hits the barrier about 10^{14} times/sec, there will be 10^{11} to 10^{12} penetrations/sec. The frequency of penetration of the barrier is therefore some 100 to 1000 times the frequency of radiational deactivation of the excited dye molecule by fluorescence, about 10^9/sec. Electron transfer from the dye to the silver halide therefore competes efficiently with fluorescence and with all but the most rapid alternative radiationless deactivation processes. If then the excited dye level is on a par with a conduction level, sensitization by electron transfer from the adsorbed dye layer to the silver halide by tunneling through potential barriers as high as 2 eV will be possible.

EXPERIMENTAL STUDIES ON THE MECHANISM OF SPECTRAL SENSITIZATION

Recent experiments on the mechanism of spectral sensitization have centered round two main points, studies of the quantum yield of electron and hole production and the mobility of the carriers involved in spectral sensitization, and secondly, the problem of sensitization by electron transfer or energy transfer, or both, since the processes, in principle, are not mutually exclusive.

The mobility of the electrons and positive holes generated in spectral sensitization has been studied[56,83,84] in large sheet crystals of silver bromide made from the melt by the procedures of Mitchell.[85] Direct measurement of the photocharges formed in these crystals[56] showed that, whereas light absorbed by the silver bromide in the presence or absence of dye produced both free electrons and free holes capable of traversing the whole thickness of the crystal in an appropriately directed electric field, only the electrons formed by light absorbed by an adsorbed cyanine dye were so mobile; in spectral sensitization holes could not be displaced even by strong electric fields into the interior of the crystal. Fig. 4-14 illustrates the mobility of electron and holes in sheet crystals of silver bromide as determined by an application of the method of Haynes and Shockley outlined in Chapter 3.[86] The crystal is exposed through slits to flashes synchronized with the application of pulsed electric fields. A column of mobile photocharges is displaced by an appropriately directed field into the interior of the crystal. The course of the electron stream is shown by the latent image centers to which they give rise, which can be developed after sectioning the crystal. Similarly, holes can attack latent image centers preintroduced throughout the volume of the crystal and their course made visible as a bleached-out image against the background of developed silver formed in the unexposed parts of the crystal. The penetration of the columns of free electrons and free holes into the crystal is clearly shown in the two photomicrographs on the left of the figure which apply to a dyed crystal exposed to light absorbed by the silver bromide. The front of the crystal is at the bottom of the picture, and the increasing penetration of the photocharges into the interior with increasing field strength is clearly seen. The photomicrographs on the right of the figure apply to the case when the light was absorbed by the dye. Free electrons were formed, showing the same response to the field strength as those formed in the intrinsic photographic process, but no free holes can be discerned when the field was directed so as to displace mobile positive charges into the interior. It has been shown that positive holes capable of bleaching silver centers are indeed produced in the surface in the process of spectral sensitization, but not only are the primary holes unable to migrate into the interior but also they show no appreciable motion in the surface itself.[84] The holes produced in spectral sensitization by normal cyanine dyes appear to be completely immobile in the surface.

The nonmobility of the holes in normal spectral sensitization already predicted from energy considerations thus appears to be verified experimentally. The holes produced in this process are trapped more or less deeply. In fact, this trapping of the holes constitutes a large part of the driving force in spectral sensitization and can be regarded to compensate for the energy differ-

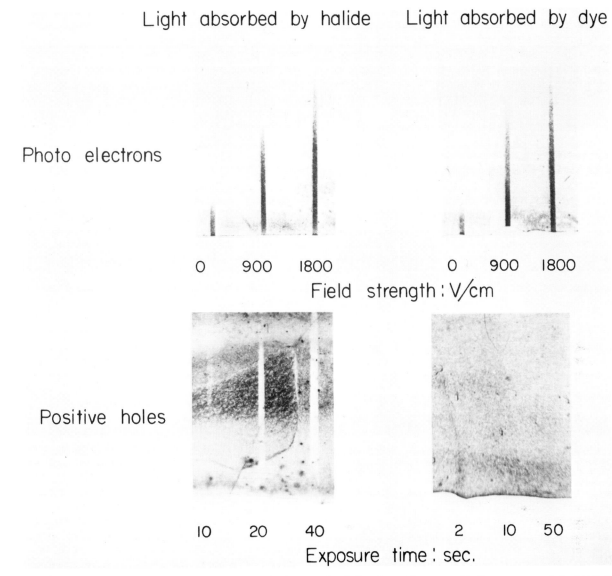

Fig. 4-14. Motion of electrons and positive holes in dyed single crystals of silver bromide exposed in the presence of electric fields. The photomicrograms refer to sections through the thickness of the crystal, the surface of incidence of the radiation being at the bottom of the micrograms. The fields are applied perpendicular to the surface of incidence, parallel to the sections. As the photocharges are displaced into the interior of the crystal from the surface of incidence, their path is recorded by their photographic effects, electrons producing developable latent image centers, and holes bleaching pre-introduced latent image centers. Free electrons of the same mobility are produced both in the region of silver bromide absorption and of dye absorption, but free holes are produced only when light is absorbed by the silver bromide, those produced in the spectrally sensitized process being trapped in the surface (after Saunders, Tyler and West[83]).

ence between the long wavelength quantum initiating spectral sensitization and that initiating the intrinsic photographic process.

If the electronic ground level of the sensitizing dye is not too high above the top of the valence band of the silver halide, the trapped positive hole primarily formed in spectral sensitization may be neutralized by the jump to the trapped hole of an electron from the valence band which has acquired the necessary energy from thermal fluctuations, with the appearance of a free positive hole in the valence band; that is, the trapped hole may subsequently be thermally liberated and become free to move through the volume of the crystal. Berriman and Gilman[87] have found that photoholes formed during

spectral sensitization by some dyes can move into the interior of emulsion grains and bleach internal silver centers, yielding, after internal development, spectrally sensitized positive images. It seems probable that these holes were thermally liberated from surface traps after the primary sensitization process of the production of free electrons and trapped positive holes.

In Fig. 4-13, case C, is shown how an optically excited dye itself, whose ground level is below the top of the valence band or a little above it, can withdraw an electron from the valence band, that is, inject a free positive hole. In this case, the electron transferred from the dye to the silver halide is trapped in the surface. Usually, in spectral sensitization, only one of the charge

carriers formed in the silver halide can be free. If the electron is free, the hole will be trapped, and vice versa. Only dyes whose ground and excited energy levels are both within thermally accessible range of the valence and conduction bands of silver halide can spectrally sensitize with the simultaneous appearance of free electrons and free holes, and in that case, at least one of these charge carriers must draw on thermal energy in addition to electronic excitation energy of the dye to appear free in the silver halide.

Since in normal spectral sensitization electrons appear in the conduction band of the silver halide, an energetic requirement for sensitization by a direct transfer of an electron from the dye to the silver halide is that the excited dye level match a conduction level, or be not more than a few kT at most below the bottom of the conduction band (that is, a few multiples of 0.026 eV at room temperature or of 0.006 eV at the temperature of liquid nitrogen). Various experimental studies of the energy levels of dye layers adsorbed to silver halide indicate that the first excited singlet level of sensitizing dyes such as pinacyanol, 3,3′-diethylthiacarbocyanine bromide, the corresponding di- and tricarbocyanines and rhodamine B match conduction levels of silver bromide. The determinations include the ionization potential of dye monolayers adsorbed to silver bromide measured from the threshold wavelength of the external photoelectric effect of the adsorbed dye,[90] (which fixes the energy of the ground state of the adsorbed dye with reference to that of an electron in vacuum, and therefore also of the excited state, since the energy difference is spectroscopically known), and contact potentials between the dye and silver bromide.[91] The ground level of dyes can also be deduced from the polarographic oxidation potential in solution, and the excited level from the corresponding reduction potential.[87,97]

The energy of the least strongly bound electron in the ground state of a dye molecule can be determined from the energy of the light quantum of longest wavelength capable of exciting emission of an electron from the dye into vacuum—the threshold wavelength for the external photoelectric effect. From comprehensive measurements of this quantity and also of the electron affinities of adsorbed dye molecules, Nelson and co-workers have concluded that sensitization of silver bromide by electron transfer from representative cyanine dyes is energetically possible.[90-91b] Using the same general methods, Meier came to a similar conclusion.[91c] However, measurements by Akimov and co-workers by similar techniques pointed to excited dye levels below the conduction band of silver bromide, and hence to spectral sensitization by energy transfer.[92] The discrepancy possibly arises from Akimov's use of lower sensitivity then Nelson's; threshold photoelectric emission might then be detected at longer wavelengths by the more sensitive apparatus than by less sensitive means, indicating higher values with respect to the energy of an electron in vacuum for the ground and excited states of the adsorbed dyes.

As the photoelectric threshold is approached from the high wavelength side the yield of photoelectrons falls exponentially with increasing wavelength and from a study of the slope of this exponential tail Nelson and co-workers have deduced that the energy values of the ground and excited states of adsorbed dyes are distributed over a band of energies of much greater width than that produced by thermal fluctuations. Sensitizing dyes with most of the band of excited levels above the conduction band of silver bromide could yet have some excited levels below; such dyes could sensitize well by electron transfer but also show some desensitizing effects by trapping photoelectrons from the silver halide conduction band, as is experimentally observed among efficient sensitizers. Similarly, dyes, most of whose excited levels were below the conduction band and are therefore desensitizers, might have some levels above the bottom of the conduction band and hence sensitize by electron transfer, though feebly under normal exposure conditions.[92a,92b]

The photoconductivity of photoconductors and semiconductors other than silver bromide, such as zinc oxide, gallium phosphide and many others can be spectrally sensitized by dyes. For example, dye-sensitized photocurrents are developed in electrolytic cells containing a dyed semiconductor as one electrode. Analysis of the photoresponse of such cells shows that the same dye can either donate electrons to or accept electrons from the semiconductor, according to the position of its energy levels with respect to those of the semiconductor.[93-95] For instance, the excited singlet level of 1,1′-diethyl-2,2′-cyanine bromide is above the conduction band of zinc oxide, and photoelectrons are found to flow from the dye to the zinc oxide. On the other hand, the ground level of the 2,2′-cyanine dye is below the top of the valence band of gallium phosphide. On illumination of the dyed electrode, electrons in this case are transferred from the valence band of the semiconductor to the partially unoccupied lower level of the excited dye molecule, forming reduced dye, with one extra electron, and free positive holes in the gallium phosphide. (Compare case C in Fig. 4-13). In these cases, sensitization of electron or hole currents by electron transfer of the dye to the semiconductor, or vice versa, seems well proved.

Theoretical calculations of energy levels of sensitizing dyes are also consistent with the possiblity of sensitization of silver bromide by electron transfer. Semiempirical[96-99b] and advanced[91a] molecular orbital calculations indicate the possibility of spectral sensitization of silver bromide by electron transfer into the conduction band from cyanine and xanthene dyes, and the impossibility of this process for dyes such as methylene blue. The blurring of the conclusions based on the sharp calculated energy levels of ideal systems, however, because of broadening of the levels introduced by interactions of adsorbed dyes with charged defects randomly distributed over the silver halide surface should be borne in mind.[92a,92b]

An increasing number of comparative studies of the spectral-sensitizing properties of dyes whose electronic energies are known experimentally, largely from oxida-

tion and reduction potentials, or theoretically, strongly suggests that sensitization occurs by electron transfer. As the excited levels of the dyes fall below the conduction band of silver bromide a "cross-over" is observed from efficient spectral sensitization to increasing desensitization, as is to be expected if sensitization occurs by electron transfer from dye to silver halide and desensitization involves the passage of the electron in the opposite direction.[87,99a,99b] (p. 106).

The observation, by electron magnetic resonance experiments[88] and by kinetic spectroscopy[89] of transient species formed during exposure of dye-sensitized emulsions is in accord with the electron transfer mechanism of spectral sensitization. The signals are attributed to the free radical (dye positive hole) derived by electron transfer from the excited dye molecule to the silver halide in sensitization, and from the ground state dye to a free photo-hole in the process of desensitization by hole-trapping (p. 107).

If the separation distance between a sensitizer and an acceptor exceeds about 8Å, sensitization must occur almost entirely by energy transfer, since at greater distances, the potential wall between the dye and the silver halide becomes impermeable to electrons. A donor molecule, however, can transfer energy to an acceptor at a distance of 50Å or more, if the fluorescence emission band of the donor overlaps an adequately strong absorption band of the acceptor. In dilute solution the probability of transfer varies inversely as the sixth power of the separation distance, while, if a donor molecule interacts with a planar sheet of large area of acceptors, the probability varies inversely as the fourth power of the perpendicular distance between the donor and the acceptor sheet (Eq. 12).[79,80,81]

Kuhn and co-workers introduced a method of investigating energy transfer at controlled separation distances between the donor and acceptor by separating monolayers of the interacting molecules by molecular spacers consisting of a known number of monolayers of long chain fatty acids. For example, a sensitizing dye can be separated from a silver bromide surface, such as an evaporated layer of silver bromide on a paper substrate or the surface of a sheet crystal, by first depositing a known number of fatty acid monomolecular layers on the surface and then depositing a monomolecular layer of dye on the fatty acid. The monolayers are applied by the well-known method of Blodgett and Langmuir.[100] Arachidic acid, $C_{19}H_{39}COOH$, is spread as a monolayer on the surface of an aqueous solution containing a suitable cation, such as Cd^{2+}, and successive monolayers can be applied to a substrate by successively immersing and withdrawing it through the fatty acid layer. Sensitizing cyanine dyes, also provided with long alkyl chains on the heterocyclic N atoms, can be placed as a monolayer on top of the fatty acid layer. Since the arachidic acid is 27Å long, a dye placed on two fatty acid layers applied to a silver bromide surface is separated by a distance of 54Å from the surface.

The method was first applied to the transfer of energy from an ultraviolet absorbing, blue-fluorescing oxacya-nine donor dye deposited on glass to a blue absorbing, green fluorescing acceptor dye, Trypoflavin, separated from the donor layer by fatty acid layers. When the system was exposed to ultraviolet light, absorbed only by the donor, only the donor fluorescence was observed when the separation was large (350Å), but with diminishing separation the blue fluorescence of the donor became weaker and the green fluorescence of the acceptor began to appear, until, at distances below 50Å the donor fluorescence practically disappeared and the acceptor fluorescence dominated the emission spectrum. Quantitative observations were in accord with the inverse fourth power law for the rate of transfer between the donor molecules and the acceptor layers as a function of their separation.[79]

Similar experiments have been performed on a silver bromide surface.[80,81] Photographic sensitivity was observed when the dye was separated from the silver bromide surface by distances as great as 100Å and the variation of spectral sensitivity with the separation distance was found to be inversely as the fourth power of the distance. Hence it seems very probable that energy transfer to silver halide from a sensitizing dye at a distance has been demonstrated. The chief experimental difficulty in these experiments is to ensure that the layers of dye and fatty acid are intact, so that when the dye is to be separated from the surface, no dye has reached the surface through imperfections in the separating layers.

It has been objected that the apparent spectral sensitization of the photographic effect in silver bromide by dyes separated from the crystal surface by many layers of fatty acid may be caused by dye that has come close to the surface through holes in the fatty acid layers.[100a,100d] Other workers, however, adhere to the views of Kuhn and co-workers.[100b,100c]

Proof of sensitization by energy transfer from a distant dye molecule does not in itself show that normal sensitization by a dye directly adsorbed to the silver halide surface occurs in this way, although, from an analysis of the distance-dependence of the efficiency of sensitization by an oxacarbocyanine dye it has been suggested that this dye in contact with silver bromide may sensitize mostly by energy transfer.[81]

A point of great interest in the theory of sensitization by energy and electron transfer is the nature of the surface sites of the silver halide which act as acceptors in energy transfer and as electron donors in the regeneration of dye molecules after electron transfer, about which little is firmly understood. At present, these sites are little more than logical necessities of the theories of sensitization, introduced to preserve conservation of energy, although the existence of surface sites is generally admitted in solid state theory.

Eggert suggested that sensitivity centers, such as those introduced by sulfur sensitizing, might act as surface states with energies within the energy gap of silver halide that could function in spectral sensitization by dyes.[101] Some increase in the ratio of spectrally sensitized sensitivity to that in the intrinsic region of a sulfur-

sensitized over that of the unsensitized emulsion was observed.[102] Such an effect, however, is not at all universal, sulfur sensitization usually having no effect on the ratio of spectrally sensitized to intrinsic sensitivity of bromide or bromoiodide emulsions.[103] An effect of sulfur sensitizing in increasing the sensitization ratio of chlorobromide emulsions with a high content of chloride has, however, been observed.[99b] Since sulfur sensitizing itself adds a small degree of long wavelength sensitivity to that of the emulsion without chemical sensitization, it is somewhat surprising that the sensitivity centers do not in general act as energy acceptors for sensitization by energy transfer. If, however, spectral sensitization occurs by electron transfer, the fact that electrons can be excited into the conduction band of silver bromide by the feeble absorption of sulfur sensitivity centers becomes irrelevant to spectral sensitization; and as centers to provide electrons for the restoration of the dye after electron transfer to silver halide, sulfide sensitivity centers might well be less effective than the much more numerous active bromide ion sites in the silver halide surface.

DESENSITIZING DYES AND DESENSITIZATION

It has already been mentioned that many spectral sensitizers decrease the sensitivity of the emulsion to light absorbed by the silver halide, although the dye may show no appreciable absorption in that spectral region. This desensitizing effect of sensitizing dyes seems to extend into the region of their spectral sensitization, as is suggested by the fall in spectral sensitivity observed as the concentration of sensitizer is increased beyond the optimum (Fig. 4-7). It is not uncommon for the sensitivity to blue light optimally sensitized with highly efficient thiacarbocyanine dyes to be reduced to 70 to 80% of its value in the undyed emulsion, and many sensitizing dyes cause greater desensitization. The desensitizing properties of sensitizing dyes increase with chain length. In most emulsions simple oxa- and thiacyanines show little or no desensitization; the corresponding carbocyanines desensitize appreciably, and some severely, and long chain dyes sensitizing for the far red and near infrared desensitize severely, except at low concentrations.

Besides dyes used as spectral sensitizers, various classes of dyes which, under normal conditions show, at most, only traces of spectral sensitization, desensitize emulsions very strongly. Among these dyes, usually called "desensitizing dyes" or "desensitizers," are phenazines, such as phenosafranine (XIX), and pinakryptol green (XX), oxazines, such as Capri blue (XXI), thiazines, such as

(XIX) Phenosafranine

(XX) Pinakryptol green

(XXI) Capri Blue

methylene blue (XXII), azacyanines, such as 9-aza-3,3'-diethylthiacarbocyanine iodide (XXIII), or the corresponding 9,10-diazathiacarbocyanine iodide, (VII), and nitrated derivatives of styryl or cyanine dyes, such as pinakryptol yellow (XXIV), and 3,1'-diethyl-6-nitrothia-2'-cyanine iodide (XXV).

(XXII) Methylene blue

(XXIII) 9-aza-3,3'-diethylthiacarbocyanine iodide

(XXIV) Pinakryptol yellow

(XXV) 3,1'-diethyl-6-nitrothia-2'-cyanine iodide

Some of these dyes have been used in practice to permit development to be performed in white light. The exposed film is immersed, in the dark, in a solution of the desensitizer for a few minutes, transferred to the developer and the development is continued in white light. The presence of the desensitizer prevents further forma-

tion of latent image, but, properly chosen, has little effect on the latent image formed before contact with the dye. Phenosafranine is a suitable dye for this purpose.

Desensitizing dyes of the classes illustrated in Formulas (XIX) to (XXV) are readily reduced, for example by zinc dust in pyridine solution in the cold. With the exception of the dyes containing the nitro-group, these dyes contain a N-atom in the chromophore separated by an even number of C-atoms from the terminal chromophoric N-atoms. A rule that such dyes are photographic desensitizers was first proposed by Kendall for desensitizing azacyanine dyes,[104] but *Kendall's rule* also applies to dyes in which the desensitizing N-atom is a member of a heterocyclic ring, for example, the $=\dot{N}$— atom in the phenazines, oxazines and thiazines. Among the azacyanine dyes, 9-azathiacarbocyanine iodide (XXIII) desensitizes strongly, and shows only traces of spectral sensitization in normal emulsions, while the isomer containing the aza N-atom on the adjacent C-atom does not desensitize strongly and is a moderately efficient spectral sensitizer.

Kendall's rule can be theoretically deduced. In the free electron[5] and molecular orbital models for the electronic distribution in cyanine dye chromophores, the value of the electron density oscillates along the C-atoms of the chromophoric chain. In the highest occupied orbital of a carbocyanine, the electron density at the central C-atom of the trimethine bridge is a minimum, and a maximum in the lowest unoccupied orbital. Kuhn[105] pointed out that substitution of the more electronegative $=\ddot{N}$— for $=CH$— at the central position would lower the energy of the orbital for which the electron density at that position was a maximum, without much affecting the energy of the orbital for which the electron density at the mezo-position was a minimum. Hence the introduction of the 9-aza substituent in thiacarbocyanine lowers the energy of the excited state from its value in the unsubstituted dye without much affecting the ground state, with a consequent displacement of the absorption maximum to longer wavelengths, as is observed. On the other hand, the C-atom in carbocyanines adjacent to the *meso*-atom is at a site of maximum electron density in the ground state and at a minimum in the excited state. Aza substitution at this site therefore lowers the energy of the ground state with reference to the unsubstituted dye, without much affecting the excited state, with a consequent displacement of the absorption to shorter wavelengths, as is again observed.

Dörr and Scheibe[74] suggested that while the excited level of unsubstituted thiacarbocyanines matched a conduction level of silver halide, making possible spectral sensitization by electron transfer, that of the *meso*-azathiacarbocyanine was lowered below the conduction band and could thus act as a trap for photoelectrons in the conduction band, with which the desensitizing action of the dye was assumed to be associated. No corresponding lowering of the excited level of 8-azathiacarbocyanine occurs, and no strong desensitization by electron trapping by this dye can take place. Desensitizing and sensitizing positions of the aza N-atom alternate in the

chromophoric chain of cyanine dyes, and the same arguments apply to dyes like the phenazines, in explanation of Kendall's rule.

Some General Properties of Desensitizing Dyes

The general chemical properties of methylene blue, phenosafranine, desensitizing azacyanines and similar dyes suggest that their desensitizing effect is connected with their ability to accept electrons. On the other hand, the chemical behavior of cyanine dyes of shorter chain length, some of which also desensitize appreciably, though usually much less efficiently than the dyes described as desensitizing dyes, does not suggest any great tendency of these dyes to trap electrons.

Nevertheless, the desensitizing behavior in emulsions of sensitizing cyanine dyes is remarkably similar to that of the strong desensitizers. For both sets of dyes, desensitization increases with decreasing silver ion concentration in the emulsion, and tends to be greater at low intensities than at higher intensities of exposure, i.e., the desensitizer increases low intensity reciprocity failure. Desensitization varies with emulsion type and grain size. Reduction sensitized or "silver sensitized" emulsions, in which the sensitivity centers are likely to be minute silver particles, are markedly more desensitized, both by sensitizing dyes such as thiacarbocyanines[106,107] and by dyes like phenosafranine[107] than are sulfur sensitized emulsions. Desensitizing dyes in a spectrally sensitized emulsion tend to desensitize to a greater degree in the region of spectral sensitization than in the region of intrinsic sensitivity; the desensitizer may possibly also act as an antisensitizer.

The strongly desensitizing dyes like phenosafranine and desensitizing azacyanines are not entirely incapable of spectrally sensitizing. Weak spectral sensitization by these dyes has been observed in some emulsions, which may be considerably increased by the presence of sodium nitrite or other halogen acceptors.[108,109]

Desensitization both by strongly desensitizing dyes like phenosafranine and by useful dye sensitizers is strongly inhibited if the exposure is made in the absence of oxygen. The effect was discovered by Blau and Wambacher[110] and has recently been studied in detail by James and co-workers.[111,111a] Desensitization is reduced both by the removal of water vapor and of oxygen during exposure, but a specific effect of oxygen is found. For example, an emulsion desensitized by phenosafranine when exposed in room air at 40% relative humidity to 1/5 of its sensitivity without dye was not at all desensitized when exposed to vacuum; addition of dry oxygen partly restored the desensitization.[111] Moreover, although phenosafranine was without spectrally sensitizing power towards these emulsions exposed in room air, the dye became a moderately efficient spectral sensitizer when the exposure was made in vacuum; the sensitization increased to a maximum with increasing dye concentration, passing through an optimum concentration for spectral sensitizing, much as in Fig. 4-7 for a typical

spectral sensitizer. Similar observations were made on emulsions containing typical thiacarbocyanine and thiadicarbocyanine sensitizers; exposure in vacuum decreased the desensitization and increased the spectral sensitivity.

The Mechanism of Desensitization

One of the clues on the nature of the desensitizing process is that photoconductivity of silver halide emulsions excited by the intrinsic absorption of the halide in room air, is not markedly diminished by the presence of photographically strongly desensitizing dyes such as phenosafranine, methylene blue, 9-azathiacarbocyanine or nitrocyanine dyes, and appreciable and sometimes high spectral sensitization by strongly desensitizing dyes exposed in room air is observed.[47,48,48a] Removal of oxygen, in general, is not required to allow strongly desensitizing dyes to act as spectral sensitizers of photoconductivity or to reduce the intrinsic desensitization of intrinsic photoconductivity. The desensitizing dye, therefore, does not greatly interfere with the primary production of free electrons by absorption of light within the absorption band of the silver halide, nor does it, in general, interfere with the primary stage of spectral sensitization, the transfer of energy or of an electron from the dye molecule to silver halide. In this respect, desensitizaton differs from antisensitization, which, according to the mechanism proposed earlier in this chapter, is an inhibition of the sensitizing interaction between the sensitizer and the silver halide. Desensitizing dyes must therefore act by interfering with the formation of latent image centers after the primary formation of electrons in the silver halide.

It is also clear that there is no rigid division between sensitizing and desensitizing dyes. Dyes commonly regarded as spectral sensitizers frequently desensitize, and dyes that strongly desensitize may spectrally sensitize under appropriate conditions.

The readiness with which strongly desensitizing dyes are chemically reduced, withdrawing electrons from reducing agents to form colorless compounds, has already been referred to. A quantitative measure of the relative reducibility of substances is the value of the normal reduction potential which for dyes in solution is most conveniently estimated from a measurement of the polarographic cathodic half-wave potential. The values of these potentials for strongly desensitizing dyes confirm the conclusion that they show a relatively great tendency to accept electrons.[97,98,112,113] Whereas the normal reduction potential of sensitizing cyanine dyes vary from about -1.52 V for the members of shortest chain length to about -0.9 V for dicarbocyanines, decreasing regularly with chain length, those for desensitizing dyes are less than -0.7 V (e.g., -0.29 V for methylene blue), that is, the strongly desensitizing dyes will accept electrons from the mercury cathode at a less negative potential than is necessary to drive electrons from the metal into typical sensitizing dyes.

It seems reasonable, therefore, to attribute the desensitizing effect of dyes like phenosafranine, Capri

blue and the like to electron trapping of the photoelectrons generated by exposure in silver halide, in competition with the trapping by sensitivity centers that leads eventually to the formation of latent image.[47,48,108a,113] The electron, trapped primarily as the extra electron of a semireduced dye free radical, would be rendered incapable of forming latent image. Direct experimental evidence for electron trapping in a photographic system by methylene blue has been observed in thin crystals of silver bromide provided with an adsorbed monolayer of that dye when exposed in air to radiation of wavelength 254 nm in the presence of an electric field. Fewer electrons were displaced into the interior of the crystal by the applied field in the presence than in the absence of the dye.[83]

To trap free electrons from silver halide, an adsorbed dye molecule must possess an unoccupied electron level below the conduction band of the silver halide. For dyes such as phenazines, oxazines, thiazines and desensitizing azacyanines, the unoccupied level is probably the excited level of the dye chromophore. The energetic position of such a dye desensitizing by the capture of photoelectrons from silver halide could therefore be similar to that illustrated in case B of Fig. 4-13. The ground state of the desensitizing dye could be below the top of the valence band, when it could sensitize the production of free holes. As will be discussed in connection with the destruction of latent image by dyes, phenosafranine can probably act in this way. Optically excited dyes whose excited level is below the conduction band of silver halide may be energetically capable of transferring excitation energy to an electron-occupied surface site in the silver halide, a possible mechanism of spectral sensitization by desensitizing dyes.

Among strong desensitizers are nitrocyanine dyes. In these, the electron trapping group must be the nitro group, which is known to form a semireduced free radical.[114] The nitro group, which is attached to the benzene rings of the heterocyclic nuclei, probably acts as a chromophore independent of the dye chromophore, with a ground level deep below the ground level of the dye chromophore, and an unoccupied level well below the conduction band of silver halides. The excited level of the dye chromophore of nitrated cyanine dyes of short chain length could be above the bottom of the conduction band of the silver halide, permitting electron transfer to the silver halide, while the low-lying unoccupied level of the nitro group would also cause desensitization by electron capture.

Since, however, oxygen and possibly water vapor play a vital role in desensitization, electron trapping by strongly desensitizing dyes cannot wholly explain the phenomenon. Possibly the semireduced dye radical transfers its extra electron to an adsorbed O_2 molecule forming O_2^- which reacts with other molecules in the environment.[110,111]

Among cyanine dye sensitizers, tricarbocyanines and dyes of longer chain length, whose normal reduction potential may be -0.8 V or lower,[113] might possibly act as electron traps, but there is no chemical evi-

dence suggesting that those of short chain length readily capture electrons. In spite of the similarity in the desensitizing behavior of short chain cyanines to that of strong desensitizers like phenosafranine, it seems likely that the mechanism of their effect is different. Hole trapping by the dye has been suggested as the origin of the desensitization by sensitizing dyes.[115,116] An electron passes from the ground level of the adsorbed dye molecule to a free photohole in the valence band of the silver halide, leaving a semioxidized dye free radical as the trapped hole. A free photoelectron, which, in the absence of the dye could initiate the formation of latent image, would then combine with the trapped hole, regenerating the dye. Hole capture by desensitizing dyes has been experimentally demonstrated in thin single crystals of silver bromide by the same method as electron capture by methylene blue.[83] The significance of oxygen and water vapor in the process still must be elucidated.

Chemical Sensitizing Effects of Desensitizing Dyes

In view of the many apparently contradictory effects in photography, it may not seem very surprising that under some conditions desensitizing dyes may show pronounced chemical sensitizing effects. The *Capri blue effect* is an increase in speed and contrast, first observed by Lüppo-Cramer, caused by small additions of the desensitizing dye Capri blue to unfinished iodobromide emulsions without spectral sensitization; larger amounts of the dye cause the normal desensitization.[117,118] The sensitization is confined to the surface image, the internal image being steadily increasingly desensitized as the concentration of the dye is increased from zero. The effect is shown by cyanine and merocyanine dyes of long chain length as well as by phenazines, oxazines and other strong desensitizers.[96,116] The effect has been universally observed in iodobromide emulsions but in pure bromide emulsions, only in the presence of reducing agents such as sodium nitrite, acetone semicarbazone or triethylenetetramine.[107]

In explanation of the Capri blue effect, Tamura and Hada[96] have suggested that at low concentrations of the dye, isolated dye molecules adsorbed at surface defect sites of the silver halide act as sensitivity centers by competing with the photoholes for the trapping of photoelectrons. On migration of a silver ion to the trapped electron, a silver atom is formed by electron transfer which may initiate latent image formation in the usual way. At higher concentrations, it is suggested that the dye is present as aggregates which retain the trapped electron until it reacts with a positive hole thus causing desensitization. Adopting this hypothesis for the action of the dye at low concentratoin, Tani has extended these concepts in considerable detail.[107]

Destruction of Latent Image by Dyes

If silver bromide emulsions without spectral sensitization are exposed, then bathed in a solution of phenosafranine, re-exposed, and developed, a positive image is formed selectively by light absorbed by the dye.[108,119] Similarly, fog centers introduced into an emulsion by reduction sensitizing can be selectively bleached by light absorbed by phenosafranine present in the emulsion, with the formation after development of a spectrally sensitized positive image against the unaltered fog background in the unexposed regions of the emulsion.[109,120]

This result probably arises from spectrally sensitized free hole production by the radiationally excited phenosafranine molecules. Molecular orbital calculations[97,98] indicate that the ground state of phenosafranine lies below the top of the valence band of silver bromide, and, on illumination of the dye, free holes can appear in the silver bromide by electron transfer from the valence band of the silver halide to the partially empty lower level of the excited dye molecule. (Fig. 4-13, case C) The dye molecule is reduced to a free radical anion. The positive hole can attack preformed silver centers, reducing them below developable size.[109,120] The products of sensitized hole formation are essentially a free hole and a trapped electron, the converse of the free electron and trapped hole formed in spectral sensitization of the silver image.

In addition to the selective reversal of latent image by light absorbed by desensitizing dyes, a reversal effect by these dyes which has no relation to the dye absorption spectrum has long been known. The latter process is carried out in the same way as for sensitized reversal by phenosafranine, but the destruction of developable silver centers is not limited to the wavelengths absorbed by the dye but extends, in iodobromide emulsions, into the red and infrared spectral regions; desensitizing dyes absorbing in the blue or violet can cause reversal to much longer wavelengths.[121,122] The desensitizer-induced reversal in emulsions of high chloride content is greatest for exposures to light in the yellow spectral region, irrespective of the absorption spectrum of the dye. Dyes effective in this type of reversal include pinacryptol yellow, pinacryptol green, triphenyl methane dyes such as malachite green or crystal violet, as well as the well-known desensitizers of the phenazine and oxazine classes.

It seems likely that the absorbing agent in this type of reversal is the silver centers preintroduced into the emulsion grains. It is known, for example, that the absorption of small silver centers in chloride emulsions is a maximum in the yellow region of the spectrum. The desensitizing dye then acts by accelerating the Herschel effect. On exposure to radiation of relatively long wavelength, the silver centers eject an electron into the conduction band and a silver ion wanders off, as in the normal Herschel effect. The desensitizing dye traps the electron, thus inhibiting recombination with the complementary silver ion, and making the dye-induced reversal much more rapid and much more complete than the normal Herschel reversal by red or infrared light. The wide spectral region of the accelerated reversal results from the wide distribution of size among the silver centers (see p. 64).

It seems likely that desensitizing dyes absorbing at wavelengths longer than the silver halide absorption edge may often cause reversal by the simultaneous operation of sensitized hole injection and the accelerated Herschel effect.

Fogging by Dyes

Some sensitizing dyes tend to fog the emulsion. The fogging effect increases with the length of the polymethine chain, and the fogging tendency of cyanine dyes of long chain length, coupled with their desensitizing effect, limits the quantity of these dyes that can be added to the emulsion as spectral sensitizers for the far red and infrared. A correlation has been noticed between the fogging tendency of dyes and their ability to complex with silver ions.[123]

Silver-digested and reduction-sensitized emulsions are especially susceptible to fogging, even by carbocyanines that have little effect on sulfur-sensitized emulsions;[106] a catalytic effect of silver centers on the growth of fog centers is suggested by this observation.

The fogging effect of sensitizing cyanine dyes on reduction-sensitized emulsions is remarkably similar to that of oxidizing agents, such as ferricyanine ion.[106] Wood suggests that the oxidizing agent preferentially attacks small silver centers and that the silver ion thereby formed is adsorbed by the larger centers.[106] These adsorbed silver ions are now readily reduced, either by the reduced form of the oxidizing agent, or possibly by a reducing agent present in traces in the gelatin and ineffective until the reducibility of silver ion is increased by the catalytic activity of silver. To account for an analogous fogging action of sensitizing dyes on reduction-sensitized emulsions, it may be suggested that electrons are slowly transferred thermally from the dye to silver ions adsorbed to silver centers, during storage of the emulsion, with consequent growth of the sensitivity centers into fog centers. Relatively high tendency to donate electrons implies a correspondingly high tendency to trap positive holes. If the first step in desensitization by sensitizing dyes is the capture of photoholes, as discussed under "Mechanism of Desensitization" (p. 107), one can understand the correlation that has been observed between the fogging action of sensitizing dyes and their dissensitizing effect.[124]

Methylene blue strongly fogs emulsions; from the concentration dependence of the effect it has been concluded that the dimer of the dye is the effective agent.[125]

Effect of Temperature on Spectral Sensitization

The sensitivity of photographic emulsions usually decreases with decreasing temperature and the fall in dye-induced spectral sensitivity is greater than that of the intrinsic sensitivity of the silver halide.[126-129a] At temperatures of about −40°C, however, diminished low intensity reciprocity failure may increase sensitivity at low intensities and long exposure times, an effect sometimes utilized in the long exposures required in astronomy.

The fall in spectral sensitivity at low temperatures represents a real decrease in the efficiency of formation of spectrally sensitized latent image in comparison with the efficiency of the intrinsic process, and cannot be attributed to decreased absorption of light by the sensitizing dye at low temperature (except, partly, at the long wavelength edge of the dye absorption band).[128] Nor is it a result of the lower rate of development of the latent image formed at exposure at low temperature, since the loss in sensitivity persists after prolonged development to completion.[129]

Both surface and internal sensitivity fall as the temperature of exposure is lowered, but the ratio of internal to surface sensitivity increases, in both the intrinsic and the dye-sensitized spectral regions, and the internal sensitivity of a fully finished emulsion exposed at −196°C may exceed the surface sensitivity. Sensitivity changes with temperature depend on the emulsion, on the dye and on development, but, as an example, the sensitivity of a sulfur sensitized iodobromide emulsion of medium speed was found to decrease from its value at 25°C to 30% of that value at −79°C in the intrinsic region and to 3% in the spectrally sensitized region, and at −196°C the values of the sensitivity in the two regions were 3% and 0.3%, respectively, of the room temperature sensitivity.[128]

Emulsions containing supersensitized J-aggregated sensitizing dyes show much less loss in spectral sensitivity when exposed at low temperatures than without the supersensitizer.[127]

Desensitization by sensitizing dyes of bromide or iodobromide emulsions exposed at −196°C is less than at room temperature,[127] but a chlorobromide emulsion was found to be as strongly desensitized at the low temperature as at room temperature. Most emulsions are less desensitized when exposed at −70°C than either at room temperature or at −196°C.

The reasons for diminished spectral sensitization and desensitization by sensitizing dyes at low temperatures of exposure are not well understood. A decrease in temperature may lower the probability of a sensitizing transfer of energy or of an electron, or it might increase inefficiencies of latent image formation after the sensitizing transfer selectively in the region of spectral sensitization, or both factors might intervene.

On the obviously oversimplified assumption that at constant intensity of exposure the sensitivity of a given emulsion at complete development is a measure of the rate of formation of the latent image, one may attempt to gage the order of magnitude of any energy of activation associated with spectral sensitization from the difference in sensitivity at room temperature and at −196°C. In fact, the plot of log sensitivity against $1/T$ is not linear between 25 and −196°C (though for

some emulsions it is linear between –80 and –196° C[128]) but it is clear that any energy of activation associated with spectral sensitization by dyes of moderate to high efficiency at room temperature is small, not more than about 0.05 eV. The apparent energy of activation for spectral sensitization by relatively inefficient dyes is higher.[129a]

To a first approximation, electron tunneling does not depend on the temperature, except in so far as the height and thickness of the potential wall might be affected, (Eq. 13), and Frieser and co-workers have suggested that these factors may contribute to the effect of temperature on spectral sensitization.[127] Similarly, if desensitization by sensitizing dyes occurs by the trapping of photoholes in the silver halide by the dye, followed by recombination of a photoelectron with the trapped hole, the first step in this process, the tunneling of an electron from the ground state of the dye into the valence band of the silver halide, could be inhibited at low temperature by changes in the parameters of the barrier, contributing to decreased sensitization at low temperature. Low energy barriers, surmountable by thermal activation, may also be involved in spectral sensitization. For example, an exciton formed in the grain surface by spectral sensitization might be thermally dissociated to yield a free electron; or thermal activation might be required as in Mitchell's scheme of spectral sensitization by energy transfer,[130] in which electrons simultaneously pass from a surface level of the silver halide to the incompletely occupied ground level of the excited dye molecule and from the excited level of the dye to a surface level of the silver halide slightly below the conduction band, and are then thermally excited into the conduction band, where they can initiate latent image formation.

Chemical sensitizing effects have been observed by dyes in exposures at low temperature. For example, sulfur-sensitized chlorobromide emulsions dyed with cyanine and merocyanine dyes which cause some desensitization at room temperature, show large increases in contrast when exposed to violet light at –196°C over the values at room temperature.[128] Large increases in speed and contrast effected by cyanine dyes, including nonplanar dyes, on exposure at –196°C have been observed by James in bromide and in iodobromide emulsions.[131]

REFERENCES

1. F. Moser and F. Urbach, "Optical Absorption of Pure Silver Halides," *Phys. Rev.*, **102**: 1519 (1955).
2. J. Eggert and F. G. Kleinschrodt, "Spectral Sensitivity of Photographic Layers," *Z. Wiss. Photogr.*, **39**: 165 (1940).
3. K. S. Gibson and E. P. T. Tyndall, *Nat. Bur. Std. (U.S.) Paper No. 475*, **19**: 131 (1923–1924).
4. L. G. S. Brooker, "Absorption and Resonance in Dyes," *Rev. Mod. Phys.*, **14**: 275 (1942).
5. H. Kuhn, "Free Electron Model of Absorption Spectra of Organic Dyes," *J. Chem. Phys.*, **16**: 840 (1948); **17**: 1198 (1949).
6. For fundamentals of molecular orbital theory as applied to spectra, the reader is referred to works such as G. Herzberg, *Electronic Spectra and Electronic Structure of Polyatomic Molecules*, Van Nostrand Reinhold, New York, 1966; J. N. Murrell, *The Theory of the Electronic Spectra of Organic Molecules*, Methuen, London, Wiley, New York, 1963; C. Sandorfy, *Electronic Spectra and Quantum Chemistry*, Prentice-Hall, New York, 1964; or chapters by A. B. F. Duncan and by F. A. Matsen, R. Becker and D. R. Scott in *Technique of Organic Chemistry*, Vol. IX, Part 1, "Chemical Applications of Spectroscopy," 2nd Ed., W. West (ed.), Wiley-Interscience, New York, 1968.
7. For detailed information on the preparation of cyanine and merocyanine dyes see F. M. Hamer, "The Cyanine Dyes and Related Compounds," in *The Chemistry of Heterocyclic Compounds*," Vol. 18, A. Weissberger (ed.), Interscience, 1964.
8. Data from *Theory of the Photographic Process*, 3rd Ed. Mees-James (eds.), Macmillan, New York, 1966, p. 204.
9. Dyes with $n = 0–3$ are members of the vinylogous series based on 3,3'-diethylthiacyanine; for $n = 4$ and 5, the dyes have rigidizing substituents in the chromophoric chain, D. W. Heseltine, U.S. Patents 2,756,227 and 2,739,900.
10. P. C. Burton, "Interpretation of Characteristic Curves of Photographic Materials," in *Fundamental Mechanisms of Photographic Sensitivity*, J. A. Mitchell (ed.), Butterworths Scientific Publications, London, 1951, p. 188.
11. G. C. Farnell, "The Variation of γ with Wavelength in the Visible Region," *J. Photogr. Sci.*, **2**: 145 (1954).
12. G. C. Farnell, "Relation between Sensitometric and Optical Properties of Photographic Emulsion Layers, with Particular Reference to the Wavelength Variation of Sensitivity," *J. Photogr. Sci.*, **8**: 194 (1960).
13. B. H. Carroll and D. Hubbard, "The Photographic Emulsion; the Mechanism of Hypersensitization," *J. Res. Nat. Bur. Std.* **9**: 529 (1932).
14. S. V. Natanson, "On the Possibility of Increasing the Effect of Sensitization," *J. Photogr. Sci.*, **10**: 9 (1962).
 (a) S. S. Collier and P. B. Gilman, "Effect of Dye Chain Length and Silver Ion Concentration on the Spectral Sensitization of Silver Bromide," *Photogr. Sci. Eng.*, **16**: 413 (1972).
15. I. I. Breido and A. A. Markelova, "Hypersensitization of Infrared Plates," *Zh. Nauchn. i Prikl. Fotogr. i Kinematogr.*, **6**: 19 (1961).
16. S. E. Sheppard, R. H. Lambert and R. D. Walker, "Optical Sensitizing of Silver Halides by Dyes, I, Adsorption of Sensitizing Dyes," *J. Chem. Phys.*, **7**: 265 (1939).
17. E. P. Davy, "Optical Sensitization and Adsorption of Dyes on Silver Halide," *Trans. Faraday Soc.*, **36**: 323 (1940).
18. W. West, B. H. Carroll and D. Whitcomb, "The Adsorption of Sensitizing Dyes in Photographic Emulsions," *J. Phys. Chem.*, **56**: 1054 (1942).
19. E. Klein and F. Moll, "Adsorption and Structure of Sensitizing Dyes," *Photogr. Sci. Eng.*, **3**: 232 (1959).
20. A. H. Herz and J. O. Helling, "Evaluation of Surface Spectra in Turbid Silver Halide Dispersions," *Kolloid- Z. Z. Polym.*, **218**: 157 (1967).
21. A. H. Herz, R. P. Danner and G. A. Janusonis, "Adsorption of Dyes and their Surface Spectra," in *Amer. Chem. Soc. Advances in Chemistry Series*, No. 79, 1968, p. 173.
22. T. Tani and S. Kikuchi, "On the Adsorption of 2,2'-Quinocyanine Halides to Various Silver Halides," *J. Photogr. Sci.*, **17**: 33 (1969).
23. B. Levi and N. Mattucci, "The Adsorption and Aggregation of Cyanine Dyes of AgBr," *Photogr. Sci. Eng.*, **14**: 308 (1970).
24. I. Langmuir, "The Adsorption of Gases on Plane Surfaces of Glass, Mica and Platinum," *J. Amer. Chem. Soc.*, **40**: 1361 (1918).
25. P. J. Wheatley, "The Crystallography of Some Cyanine Dyes," *J. Chem. Soc.*, p. 324 (1959); Part II. ibid., p. 4096.
 (a) D. L. Smith, "The Structure of Sensitizing Dye Aggregates Adsorbed on Silver Halides," *Photogr. Sci. Eng.*, **16**: 329 (1972).
 (b) H. Yoshioko and N. Nakatsu, "Crystal Structure of Two Photographic Sensitizing Dyes, 1,1'-diethyl-2,2'-cyanine iodide and 1,1'-diethyl-4,4'-cyanine bromide," *Chem. Phys. Letters*, **11**: 235 (1971).

(c) B. Dammeier and W. Hoffe, "The Crystal and Molecular Structure of N,N'-diethyl-pseudocyanine chloride," *Acta Crystallogr.* **B27:** 2364 (1971).

26. L. G. S. Brooker, F. L. White, R. H. Sprague, S. G. Dent, Jr. and G. VanZandt, "Stereic Hindrance to Planarity in Dye Molecules," *Chem. Rev.,* **41:** 325 (1947).

27. F. London, "On Centers of Van der Waals Attraction," *J. Phys. Chem.,* **46:** 305 (1942).

28. W. West, B. H. Carroll and D. L. Whitcomb, "Some Effects of Gelatin on the Adsorption of Sensitizing Dyes on Silver Halide Grain Surfaces," *J. Photogr. Sci.,* **1:** 145 (1953).

29. J. Spence and B. H. Carroll, "Desensitization by Sensitizing Dyes," *J. Phys. and Colloid Chem.,* **52:** 1090 (1948).

30. W. West and A. L. Geddes, "The Effect of Solvent and of Solid Substrates on the Visible Molecular Absorption Spectrum of Cyanine Dyes," *J. Phys. Chem.,* **68:** 837 (1964).

31. W. West and B. H. Carroll, "Energy Transfer in the Photosensitization of Photographic Emulsions: Optical Sensitization, Supersensitization and Antisensitization," *J. Chem. Phys.,* **19:** 417 (1951).

32. B. H. Carroll and W. West, "Optical Sensitizaton of Photographic Emulsions," in *Fundamental Mechanisms of Photographic Sensitivity,* Butterworths Scientific Publication, London, 1951, p. 162.

33. L. I. Levkoev, E. B. Lifshits, S. V. Natanson, N. N. Sveshnikov and Z. P. Sytnik, "On the Influence of Structure and some Physical Properties of Polymethine Dyes on their Sensitizing Action," *Wissenschaftliche Photographie,* p. 109, Verlag Dr. O. Helwich, Darmstadt, 1954.

34. E. E. Jelley, "Molecular, Nematic and Crystal States of 1,1'-Diethyl-ψ-cyanine Chloride," *Nature,* **139:** 631 (1937).

35. G. Scheibe, "Reversible Polymerization as the Origin of a New Kind of Absorption Band of Dyes," *Kolloid-Z.,* **82:** 1 (1938).

36. S. E. Sheppard, "The Effects of Environment and Aggregation on the Absorption Spectrum of Dyes," *Rev. Mod. Phys.,* **14:** 303 (1942).

37. W. West, S. P. Lovell and W. Cooper, "Electronic Spectra of Cyanine Dyes at Low Temperature—Monomeric and Aggregate Absorption Spectra," *Photogr. Sci. Eng.,* **14:** 52 (1970).

38. E. S. Emerson, M. A. Carlin, A. E. Rosenoff, K. S. Norland, R. Rodriguez, D. Chin and G. R. Bird, "The Geometric Structure and Absorption Spectrum of a Cyanine Dye Aggregate," *J. Phys. Chem.,* **71:** 2396 (1967).

39. G. R. Bird, K. S. Norland, A. E. Rosenoff and H. B. Michaud, "Spectra and Structure of Sensitizing Dye Aggregates," *Photogr. Sci. Eng.,* **12:** 196 (1968).

40. K. Norland, A. Ames and T. Taylor, "Spectral Shifts of Aggregated Sensitizing Dyes," *Photogr. Sci. Eng.,* **14:** 295 (1970).

(a) G. E. Fricken, "The Relation of J-Aggregate Frequency Shifts of Some Trimethine Cyanines to Dye Structure," *J. Photogr. Sci.,* **21:** 11 (1973).

41. A. H. Herz, R. P. Danner and G. A. Janusonis, "Adsorption of Dyes and Their Surface Spectra," in *Amer. Chem. Soc. Advances in Chemistry Series,* No. 79, 1968, p. 173.

42. K. K. Rohatgi and G. S. Singhal, "The Nature of Dye Aggregates," *J. Phys. Chem.,* **70:** 1695 (1966).

43. E. G. McRae and M. Kasha, "The Molecular Exciton Model," in *Physical Processes in Radiation Biology,* L. Augenstein, R. Mason, and D. Rosenberg, (eds.), Academic, New York, 1964, p. 23.

44. W. West and S. Pearce, "The Dimeric State of Cyanine Dyes," *J. Phys. Chem.,* **69:** 1894 (1965).

45. V. Czikkely, H. D. Fösterling, and H. Kuhn, "Light Absorption and Structure of Aggregates of Dye Molecules," *Chem. Phys. Letters,* **6:** 11 (1970).

46. W. West and P. B. Gilman, "Recent Observations on Spectral Sensitization and Supersensitization," *Photogr. Sci. Eng.,* **13:** 221 (1969).

47. W. West and B. H. Carroll, "Photoconductivity in Photographic Systems," *J. Chem. Phys.,* **15:** 529 (1947).

48. W. West, "Correlations between Photoconductive and Photographic Sensitivity," in *Fundamental Mechanisms of Photographic Sensitivity,* Butterworths Scientific Publications, London, 1951, p. 99.

(a) P. V. Meiklyar, M. D. Mirmil'shtein-Eberman, and A. A. Sadykova, "The Mechanism of the Action of Desensitizers," *Zh. Nauchn. i Prikl. Fotogr. i Kinematogr.,* **10:** 410 (1965).

49. B. Levy, "Photoconductivity of Photographic Coatings—Dynamic Observations of Latent Image Processes," *Photogr. Sci. Eng.,* **15:** 279 (1971).

(a) L. M. Kellogg, N. B. Liebert, and T. H. James, "Investigations of Photoconductivity in Photographic Films at 77 K with Microwave Methods," *Photogr. Sci. Eng.,* **16:** 115 (1972).

50. J. H. Webb, "The Photographic Reciprocity Law Failure for Radiations of Different Wavelengths," *J. Opt. Soc. Amer.,* **23:** 316 (1933).

51. J. H. Webb and M. Biltz, "The Photographic Reciprocity Law Failure for Radiations of Different Wavelength," *J. Opt. Soc. Amer.,* **38:** 561 (1948).

52. H. Tollert, "Quantitative Investigations of Some Photographic Effects," *Z. Phys. Chem.,* **140A:** 355 (1929).

53. J. Eggert, W. Meidinger, and H. Arens, "On the Mechanism of Photographic Sensitization," *Helv. Chim. Acta,* **31:** 1163 (1948).

54. S. E. Sheppard, R. H. Lambert and R. D. Walker, "The Mechanism of Optical Sensitization and the Quantum Equivalent," *J. Chem. Phys.,* **7:** 426 (1939).

55. S. V. Natanson, "On the Possibility of Increasing the Effect of Sensitization," *J. Photogr. Sci.,* **10:** 9 (1962).

56. V. I. Saunders, R. W. Tyler and W. West, "A Study of the Primary Photographic Process in Silver Bromide Crystals by Measurement of Transient Photocharge," *Photogr. Sci. Eng.,* **16:** 87 (1972).

57. B. Zuckerman, "Quantum Efficiency Studies in Silver Bromide Single Crystals and the Effect of Dye Concentration on the Efficiency of Spectral-Sensitization," *Photogr. Sci. Eng.,* **11:** 156 (1967).

58. B. Zuckerman and H. Mingace, "Spectral Sensitization, Supersensitization, and the Mechanism(s) of Dye-Sensitized Photoconductivity in AgBr Crystals," *J. Chem. Phys.,* **50:** 3432 (1969).

59. A. V. Buettner, "Radiationless Transitions in Cyanine Dyes," *J. Chem. Phys.,* **46:** 1398 (1967).

60. S. E. Sheppard, R. H. Lambert and R. D. Walker, "The Relation of Sensitizing to the Absorption Spectra and Constitution of Dyes," *J. Chem. Phys.,* **9:** 107 (1941).

61. H. Frieser and M. Schlesinger, "Analogous Considerations of Spectral Sensitization of Different Photographic Systems," *Photogr. Sci. Eng.,* **12:** 17 (1968).

62. B. H. Carroll and D. Hubbard, "Variables in Sensitization by Dyes," *J. Res. Nat. Bur. Std.,* **9:** 529 (1932).

63. W. West and B. H. Carroll, "The Effect of Impurities on the Optical Sensitization of the Photographic Emulsion," *J. Phys. Chem.,* **57:** 797 (1953).

64. R. Reuter and H. Riedel, "Spectral Investigations on Model Layers," V. Conf. on Scientific and Applied Photography, Budapest, 1966, p. 24.

65. H. Pietsch, D. Jäkel and W. Schneider, "The Relative Quantum Yield of Spectral Sensitization in its Dependence on the Dye Concentration and on Emulsion Type," V. Conf. on Scientific and Applied Photography, Budapest, 1966, p. 29.

66. R. Brünner, A. Graf, and G. Scheibe, "A New Class of Supersensitizers for Pseudoisocyanines," *Z. Wiss. Photogr.,* **53:** 214 (1959).

67. R. Brünner, A. E. Obert, G. Pick and G. Scheibe, "Mechanism of Supersensitization of Photographic Emulsions—A Contribution to the Problem of Energy Transfer," *Z. Elektrochem.,* **62:** 132, 146 (1958).

68. A. E. Rosenoff, K. S. Norland, A. E. Ames, V. K. Walworth, and G. R. Bird, "The Resolved Spectra of Small Cyanine Dye Aggregates and a Mechanism of Supersensitization," *Photogr. Sci. Eng.,* **12:** 185 (1968).

69. (a) P. B. Gilman, "The Luminescent Properties of 1,1'-diethyl-2,2'-cyanine, Alone and Adsorbed to Silver Halide," *Photogr. Sci. Eng.,* **11:** 222 (1967).

(b) P. B. Gilman, "Effect of Aggregation, Temperature, and Supersensitization on the Luminescence of 1,1'-diethyl-2,2'-

cyanine chloride Adsorbed to Silver Chloride," ibid., **12:** 230 (1968).

(c) P. B. Gilman, "Review of the Mechanisms of Supersensitization," ibid., **18:** 430 (1974).

70. J. Franck and E. Teller, "Migration and Photochemical Action of Excitation Energy in Crystals," *J. Chem. Phys.*, **6:** 861 (1938).

71. W. West, "An Experimental Study of the Significance of the Triplet State of Sensitizing Dyes in Optical Sensitization," in *Scientific Photography*, H. Sauvenier (ed.), Pergamon, London, 1962, p. 557.

72. H. Pietsch, D. Jäkel, N. Schneider and D. Trene, "Investigations about the Relative Quantum Yield of the Spectral Sensitization," in *Dye Sensitization* (Proc. Symp. Bressanone, 1967), W. F. Berg, O. Mazzucato, H. Meer and G. Semerano (eds.), Focal, London and New York, 1970, p. 170.

73. N. F. Mott, "Notes on Latent Image Theory," *Photogr. J.*, **88B:** 119 (1948).

74. F. Dörr and G. Scheibe, "Model Considerations on the Mechanism of Spectral Sensitization," *Z. Wiss. Photogr.*, **55:** 133 (1961).

75. Th. Förster, "Transfer Mechanism of Electronic Excitation," *Discussions Faraday Soc.*, No. 27: 7 (1959). In Fig. 3 of this reference, "sensitizer fluorescence" should read "acceptor fluorescence."

76. Th. Förster, "Delocalized Excitation and Excitation Transfer," in *Modern Quantum Chemistry*, O. Sinanoğlu (ed.), Academic, New York and London, 1965, p. 93.

77. G. W. Robinson and R. P. Frosch, "Theory of Energy Relaxation in the Solid Phase," *J. Chem. Phys.*, **37:** 1962 (1962).

78. G. W. Robinson and R. P. Frosch, "Electronic Excitation Transfer and Relaxation," *J. Chem. Phys.*, **38:** 1187 (1963).

79. K. H. Drexhage, M. M. Zwick, and H. Kuhn, "Sensitized Fluorescence after Radiationless Transfer through Thin Layers," *Ber. Bunsenges. Phys. Chem.*, **67:** 62 (1963).

80. H. Bücher, H. Kuhn, D. Mann, D. Möbius, L. von Szentpály and P. Tillman, "Transfer of Energy and Electrons in Assemblies of Monolayers," *Photogr. Sci. Eng.*, **11:** 233 (1967).

81. L. V. Szentpály, D. Möbius and H. Kuhn, "Proof of Energy Transfer and Absence of Electron Injection in Spectral Sensitization of Evaporated AgBr by Oxacarbocyanine," *J. Chem. Phys.*, **82:** 4618 (1970).

82. See, for example, W. Kauzmann, *Quantum Chemistry*, Academic, New York, 1957, p. 195.

83. V. I. Saunders, R. W. Tyler and W. West, "Mobility of Electrons and Positive Holes in Spectral Sensitization and in Desensitization of the Photographic Process by Dyes," *J. Chem. Phys.*, **46:** 199 (1967).

84. V. I. Saunders, R. W. Tyler and W. West, private communication.

85. P. V. McD. Clark and J. W. Mitchell, "Experiments in Photographic Sensitivity," *J. Photogr. Sci.*, **4:** 1 (1956).

86. J. R. Haynes and W. Shockley, "The Mobility of Electrons in Silver Chloride," *Phys. Rev.*, **82:** 935 (1951).

87. R. W. Berriman and P. B. Gilman, Jr., "Spectral Sensitization of Mobile Positive Holes," *Photogr. Sci. Eng.*, **17:** 235 (1973).

88. T. Tani, "Light-induced ESR Spectra of Dyes Adsorbed by AgBr Emulsion Grains," *Photogr. Sci. Eng.*, **19:** 356 (1975).

89. S. H. Ehrlich, "Influence of Dye Energy Levels on the Spectral Sensitization of Silver Bromide and the Initial Optical Transient Response of Dye Bleaching; A Conversion Efficiency Study," *Photogr. Sci. Eng.*, **20:** 5 (1976).

90. R. C. Nelson, "Electron Transfer Mechanisms of Spectral Sensitization," *J. Phys. Chem.*, **71:** 2517 (1967).

91. R. C. Nelson, "Contact Potential Difference between Sensitizing Dye and Substrate," *J. Opt. Soc. Amer.*, **12:** 1016 (1956).

(a) R. G. Selsby and R. C. Nelson, "The Ionization Energy of Cationic Cyanine Dyes," *J. Mol. Spectros.*, **33:** 1 (1970).

(b) J. W. Trusty and R. C. Nelson, "Electron Affinity of Sensitizing Dyes," *Photogr. Sci. Eng.*, **16:** 421 (1972).

(c) R. Meier, Spectral Sensitization, Focal, London, and New York, 1968.

92. A. Akimov, V. M. Brentsa, F. I. Vilesov and A. N. Terenin, "External Photoeffect from Sensitizing Dyes Adsorbed on Semiconductors," *Phys. Status Solidi*, **20:** 771 (1967).

(a) S. S. Choi and R. C. Nelson, "Experimental Tail and the Threshold for Photoionization of Sensitizer Dyes," *Photogr. Sci. Eng.*, **16:** 341 (1972).

(b) P. Yianoulis and R. C. Nelson, "Effect of Surface Defects in the Ionization Energies of Adsorbed Dye Molecules," *Photogr. Sci. Eng.*, **18:** 94 (1974).

93. H. Gerischer and H. Tributsch, "Electrochemical Investigations on Spectral Sensitization of ZnO Single Crystals," *Ber. Bunsenges. Phys. Chem.*, **72:** 437 (1968).

94. H. Tributsch and H. Gerischer, "Electrochemical Investigations on the Mechanism of Sensitization and Supersensitization of ZnO Single Crystals," *Ber. Bunsenges. Phys. Chem.*, **73:** 251 (1969).

95. R. Memming and H. Tributsch, "Electrochemical Investigations on the Spectral Sensitization of Gallium Phosphide Electrodes," *J. Phys. Chem.*, **75:** 562 (1971).

96. H. Tamura and H. Hada, "Desensitizing Action of Cyanine Dyes," in *Scientific Photography* (Proc. Intern. Coll. Liege, 1959) H. Sauvenier (ed.), Pergamon, London, 1962, p. 579.

97. T. Tani and S. Kikuchi, "Calculation of the Electronic Energy Levels of Various Photographic Sensitizing and Desensitizing Dyes in Emulsions," *Photogr. Sci. Eng.*, **11:** 129 (1967).

98. T. Tani, S. Kikuchi and K. Honda, "Modified Electron Transfer Mechanism for Spectral Sensitization in Photography," *Photogr. Sci. Eng.*, **12:** 80 (1968).

99. (a) D. M. Sturmer, W. S. Gaugh and B. J. Bruschi, "Crossover Studies, I, Calculated Cyanine Dye Energy Levels and Sensitization of Silver Halide," *Photogr. Sci. Eng.*, **18:** 49 (1974); "II, Effects of Emulsion Sensitization on Chemical and Spectral Sensitization by Dyes," ibid: 56 (1974).

(b) V. Vanasche, "The Effect of Chemical Sensitization and Halogen Composition on Spectral Sensitization," *J. Photogr. Sci.*, **21:** 180 (1973).

100. K. B. Blodgett, "Films Built by Depositing Successive Monomolecular Layers on a Solid Surface," *J. Amer. Chem. Soc.*, **57:** 1007 (1935).

(a) D. F. O'Brien, "Spectral Sensitization of Evaporated Silver Bromide by Monomolecular Layers of Cyananine Dyes," *Photogr. Sci. Eng.*, **17:** 226 (1973).

(b) R. Steiger, P. Junot, B. Kilchoer and E. Schumacher, "Spectral Sensitization of Pure and Doped Silver Bromide," *Photogr. Sci. Eng.*, **17:** 107 (1973).

(c) D. Möbius, "Spectral Sensitization of AgBr by Prefabricated Transferred Multilayer Systems," *Photogr. Sci. Eng.*, **18:** 413 (1974).

(d) K. H. Draxhage, "The Question of Energy Transfer in Spectral Sensitization of Silver Bromide; a Reinterpretation," *Photogr. Sci. Eng.*, **18:** 627 (1974).

101. J. Eggert, "On the Spectral Sensitivity of Photographic Layers. I," *Ann. Phys. VII* 4: 140 (1959).

102. J. Eggert and H. Pestalozzi, "On the Spectral Sensitivity of Photographic Layers, II," *Z. Elektrochem.*, **65:** 50 (1961).

103. B. H. Carroll, E. A. MacWilliam and R. B. Henrickson, "The Effect of Chemical Sensitization on Spectral Sensitization," *Photogr. Sci. Eng.*, **5:** 230 (1961).

104. J. D. Kendall,"The Chemistry of Sensitizers, Desensitizers and Organic Developers in Silver Halides," *Proc. 9th. Intern. Congr. Photogr.* 1935, p. 227.

105. H. Kuhn, "The Electron Gas Model in the Quantitative Interpretation of Light Absorption by Organic Dyes II, Part B. Perturbation of the Electron Gas by Hetero-atoms," *Helv. Chim. Acta*, **34:** 2371 (1951).

106. H. W. Wood, "Desensitization by Sensitizing Dyes," *J. Photogr. Sci.*, **3:** 170 (1955).

107. T. Tani, "Photographic Effects of Electron and Positive Hole Traps; I, Chemical Sensitization, Reducing Agents and Phenosafranine," *Photogr. Sci. Eng.*, **15:** 28 (1971).

108. A. Hautot and H. Sauvenier, "Optical Sensitization and Selective Reversal by Desensitizing Dyes," *Sci. Ind. Photogr.*, **29:** 401 (1958).

(a) A. Hautot and H. Sauvenier, "On the Mode of Action of Desensitizers," *Sci. Ind. Photogr.*, **23a:** 137 (1952).

109. T. Tani, "Modified Electron Transfer Mechanism for Spectral Sensitization, VI, Spectral Sensitization of Negative and Posi-

tive Image Formations by Phenosafranine in the Presence of Positive Hole Traps," *Photogr. Sci. Eng.*, **15**: 21 (1971).

110. M. Blau and H. Wambacher, "On the Mechanism of Desensitization of Photographic Plates," *Z. Wiss. Photogr.*, **33**: 191 (1934). "Photographic Desensitizers and Oxygen," *Nature*, **134**: 538 (1934).

111. W. C. Lewis and T. H. James, "Effects of Evacuation on Low Intensity Reciprocity Failure and on Desensitization by Dyes," *Photogr. Sci. Eng.*, **13**: 54 (1969).

 (a) T. H. James, "Modification of Spectral Sensitization by Alterations in Environment," *Photogr. Sci. Eng.*, **18**: 100 (1974).

112. S. E. Sheppard, R. H. Lambert and R. D. Walker, "Desensitization by Dyes in Relation to Optical Sensitizing by the Silver Halides," *J. Phys. Chem.*, **50**: 210 (1946).

113. J. Stanienda, "Polarographic Investigations of Cyanine Dyes," *Z. Phys. Chem.*, (Frankfurt), **32**: 238 (1962).

114. W. Kemula and R. Sioda, "Electrochemical Generation and Visible Spectrum of Nitrobenzene Free Radical Ion in Dimethylformamide," *Nature*, **197**: 588 (1963).

115. B. H. Carroll, "Our Present Understanding of Spectral Sensitization," *Photogr. Sci. Eng.*, **5**: 65 (1961).

116. T. Tani, "Photographic Effects of Electron and Positive Hole Traps in Silver Halides, III, Desensitization by Sensitizing and Desensitizing Dyes," *Photogr. Sci. Eng.*, **15**: 384 (1971).

117. H. Lüppo-Cramer, "Sensitization by Desensitizers," *J. Wiss. Photogr.*, **30**: 1, 241, 249 (1931).

118. H. Lüppo-Cramer, "On the Capri Blue Effect," *Photogr. Industrie*, **38**: 271 (1940).

119. B. H. Carroll and C. M. Kretchman, "Photographic Reversal by Desensitizing Dyes," *J. Res. Nat. Bur. Std.*, **10**: 449 (1933).

120. H. E. Spencer and R. E. Atwell, "Reduction plus Sulfur Sensitization and Latent Image Formation in a Model AgBr Suspension," *J. Opt. Soc. Amer.*, **58**: 1131 (1968).

121. A. Terenin, "On a Photographic Method in the Infrared," *Z. Phys.*, **23**: 294 (1924).

122. E. Mauz, "Reversal Phenomena Related to Desensitizers," *Z. Wiss. Photogr.*, **27**: 49 (1929).

123. S. Natanson, "The Interaction of Sensitizing Dyes with Silver Ions," *Acta Physicochem. URSS*, **21**: 430 (1946).

124. E. R. Bullock, *Chemical Reactions of the Photographic Latent Image*, Vol. I (Monograph no. 6, "The Theory of Photography"), Van Nostrand, New York, 1927.

125. S. Dähne, "The Spectroscopic Proof of Interaction between Methylene Blue and Silver Halide," *Z. Wiss. Photogr.*, **56**: 71 (1962).

126. C. H. Evans, "The Effect of Temperature upon the Spectral Sensitivity of Photographic Emulsions," *J. Opt. Soc. Amer.*, **32**: 214 (1942).

127. H. Frieser, A. Graf and D. Eschrich, "Investigations on the Temperature Dependence of Spectral Sensitization, Supersensitization and Desensitization of Photographic Layers," *Z. Elektrochem.*, **65**: 870 (1961).

128. W. West, "Temperature Dependence of Spectral Sensitization by Dye Series of Regularly Increasing Chain Length, and the Mechanism of Spectral Sensitization," *Photogr. Sci. Eng.*, **6**: 92 (1962).

129. W. Vanselow and T. H. James, "Note on the Temperature Dependence of Spectral Sensitizaton," *Photogr. Sci. Eng.*, **6**: 104 (1962).

 (a) T. A. Babcock, W. C. Lewis, P. A. McCue and T. H. James, "The Effect of Temperature on Photographic Sensitivity, II, Spectrally Sensitized Emulsions," *Photogr. Sci. Eng.*, **16**: 104 (1972).

130. J. W. Mitchell, "Photographic Sensitivity," *J. Photogr. Sci.*, **6**: 57 (1958).

131. T. H. James, "Some Effects of Environment on Latent Image Formation by Light," *Photogr. Sci. Eng.*, **14**: 84 (1970).

5

DEVELOPMENT AND AFTER PROCESS

R. W. Henn

NATURE OF DEVELOPMENT

Development is the process of making the photographic latent image visible. It is a catalyzed reduction of silver halide. When hydroquinone is the reducing agent and the halide is silver bromide, the reaction may be written

$$C_6H_4(OH)_2 + 2AgBr + 2OH^- \longrightarrow$$
$$C_6H_4O_2 + 2Ag^\circ + 2Br^- + 2HOH$$

(1)

or in more general form,

$$Red + AgX \longrightarrow Ox + Ag^\circ \qquad (2)$$

where AgX is any of the silver halides, Red is the reducing agent and Ox is its oxidation product.

A silver halide grain may be thought of as a lattice containing literally millions of silver ions and bromide ions. Upon exposure to light, a number of atoms of reduced silver are formed. These comprise the latent image. Since there may be 10 million or even 100 million unreduced silver ions for each silver atom of the latent image, the process of development in which all of the silver atoms in the grain are reduced produces a very large amplification. Development is thus the key to the great sensitivity of the silver halides.

The photographic developer comprises a reducing agent that, in the appropriate environment, has the proper chemical nature to reduce mainly the exposed grains (producing *image*) and to reduce relatively few unexposed grains (producing *fog*). The latent image serves as a catalyst—it is easier to form silver where

silver already exists. But the reducing agent and its environment must be carefully selected. The agent must have the correct reducing power (redox potential) and adsorption to the grain. Reduction on the latent image sites may be accomplished by either (1) deposition of silver ions from solution (*physical development*) or (2) movement of silver ions through the lattice (*chemical* or *direct development*).

The relative importance of these two types of development has varied historically. The daguerreotype process employed a type of physical development where mercury vapor was deposited on the latent image. Silver was deposited from a silver nitrate solution on the collodion (wet-plate emulsions). Then, with the introduction of gelatin emulsions, used in modern films and papers, chemical development dominated the field for a period. Now, however, both pure physical development and solution physical development are again of commercial importance.

In *pure physical development*, the silver, or occasionally some other metal, is supplied externally, that is, from the developing solution, and is deposited on the latent image. A physical developer contains a source of silver ion, a developing agent, a buffer to establish suitable pH, and perhaps an antioxidant. A number of sources of silver ion have been employed. Silver nitrate is reduced readily and is used with weak developing solutions such as Metol plus citric acid. The silver thiosulfate complex, on the other hand, yields only a low concentration of silver ions and is employed with more conventional alkaline developers. Physical developers containing silver thiosulfate were studied by Pontius and Cole.[1]

Jonker and his co-workers have made a study of physical developers and methods of stabilizing them.[2] The balance between spontaneous and catalyzed reduction of silver is delicate, and in order to obtain maximum stability they worked with a ferric-ferrous couple using the minimum difference in redox potential needed for development. Spontaneous deposition of silver ions on nonimage nucleating sites was reduced by using cationic surface-active agents, which were adsorbed to the nuclei and repelled the positively charged silver ion. They also added a nonionic agent to help disperse the cationic one.

Post-fixation physical development is the purest form of physical development. The silver halide grain is first dissolved, baring the latent image. Silver is then deposited from an external source on these nuclei. The silver halide is dissolved with a sodium thiosulfate solution; sodium sulfite is added, and the solution is made slightly alkaline to minimize loss of the latent image by oxidation. Even so, less emulsion speed is obtained than with direct chemical development. Important kinetic studies of physical development have been published recently by Matejec[3] and by Shuman and James.[4]

Physical development systems are applied to latent images other than those of the silver halides. For example, silver may be deposited on the latent image formed in titanium dioxide; this forms the basis of the Itek RS process.[5] Jonker and co-workers describe physical development of a variety of latent images, including those in diazo materials, dyes, and metal oxides.[6] They deposited silver directly on the image or on a reaction product of mercurous ion and the image. When physical development was prolonged, an electrically conducting layer was obtained. Electrically conducting images have also been deposited by other physical development systems including monobath solutions and a diffusion transfer system.

In *solution physical development*, the silver halide of the grain is dissolved and redeposited on the latent image or other nuclei. Some solution physical development commonly occurs simultaneously with chemical development, and indeed, may dominate in the later stages. James has investigated the importance of solution physical development for various developer addenda.[7] The presence of sodium sulfite and even of potassium bromide is adequate to cause some solution physical development. Fine-grain developers that incorporate thiocyanate or other solvents produce much physical development. Reversal systems use thiocyanates, amines, or hypo in the first developer to dissolve undeveloped grains in the area of high exposure so that they will not develop in the second developer.

Solution physical development occurs to the greatest extent in the image areas of low density where there is a plentiful supply of silver halide to be dissolved and redeposited. Electron micrographs and x-ray diffraction measurements show thickened filaments in these areas, and there is proportionally more silver than might be suspected by density measurements.

Monobaths contain silver halide solvents which dissolve the silver halide even as development proceeds. The dissolved silver is deposited on the developing filaments, increasing their diameter, but not adding greatly to density.

The *diffusion transfer systems* introduced by Rott and by Land have made solution physical development of great importance. These systems are described in detail in Chapter 12. They employ monobaths, i.e., developers containing the usual reducing agent, alkali, and also a strong silver halide solvent, typically sodium thiosulfate. When the system considered is silver bromide:hydroquinone:sodium thiosulfate, Eq. (1) applies to the exposed areas, and the reactions in the unexposed areas are:

$$AgBr + 3Na_2S_2O_3 \longrightarrow Ag(S_2O_3)_3^{5-} \qquad (3)$$

$$2Ag(S_2O_3)_3^{5-} + C_6H_4(OH)_2 \longrightarrow$$

$$2Ag^{\circ} + C_6H_4O_2 + 6S_2O_3^{2-} \qquad (4)$$

The catalyst for Eq. (1) is the latent image, whereas reaction (4) is catalyzed by nuclei in a receiver sheet or layer.

Direct Development. The term "direct development" is preferred to "chemical development" by James since physical development is also a chemical process. In contrast to physical development, where the silver ion is supplied from the solution, in direct development it is supplied from the grain itself. There are currently two principal theories as to how this occurs: the *triple interface* or *adsorption theory* and the *electrode theory*.

The triple interface theory considers the junction of the silver halide, the metallic silver of the latent image (or once development has commenced, the developing silver speck), and the developing agent. In order for the developer to act, it must be adsorbed to either the silver or the silver halide at this interface. The evidence is that it is adsorbed to the silver halide and not to the silver. For example, while *p*-phenylenediamine is adsorbed to the silver, it seems clear that hydroquinone is not; however, *p*-phenylenediamine, hydroquinone and all common developing agents appear to be adsorbed to the silver halide.

This theory is advanced by James,[8] continuing a lead initiated by Sheppard and his co-workers. A great many development effects may be related to the adsorption. The charge on the developing agent and a considerable number of addenda which affect adsorption, including dyes, quaternary surface active agents, and salts, all profoundly affect the rate of development. For example, hydroquinone, which exists as a negatively charged (−2) anion, develops only after an induction period. But when lauryl pyridinium cation bearing a positive charge is added to the developer, it is easily adsorbed and in turn adsorbs the hydroquinone and decreases the induction period. In addition to adsorption of the developing agent, adsorption of silver ion may occur at the interface.

The complex of the silver ion plus the developing agent is distorted at the site containing the latent image and the developing silver; the larger the site, the greater the distortion. This distortion lowers the activation energy required for the reaction; that is, development occurs preferentially at the latent image site, and takes place more readily, the larger the latent image.

The *electrode theory* considers the developing silver image as a type of electrode, through which electrons are transferred from the developing agent to reduce the silver halide in the crystal. Perhaps the clearest picture of this mechanism is in a model experiment performed by Jaenicke.[9] He used a silver plate coated with silver bromide as a cathode and a silver plate as an anode, immersed in developer. The developer was oxidized at the anode, silver reduced at the cathode, and a short-circuit current flowed between. That is, electrons were transferred freely from the developer to anywhere on the silver surface. Kinetic data were obtained with several developing agents and showed a similarity to those obtained in conventional development.

The electrode theory fits well into a modified Gurney-Mott latent image theory. In a relevant experiment, Klein and Matejec floated a crystal of silver bromide on water and placed a drop of developer on the surface.[10] The crystal was etched on the side opposite the developing silver, indicating migration of silver ions through the crystal and solution of the released bromide ions.

Both electrode theory and adsorption concepts are useful in interpreting photographic data and need not be mutually exclusive.

The Formation of Silver Filaments. The silver formed by physical development is deposited as spherical or oblong particles, or occasionally as well-defined prisms (Fig. 5-1). But a characteristic of direct development is the formation of a tangle of silver filaments in the region of the developing grain (Fig. 5-2). Except when supple-

Fig. 5-2. Filamentary silver produced by direct development of a photographic emulsion. The electron micrograph is at very high magnification; 1-mm. = about 150 A. (From C. R. Berry, *Photogr. Sci. Eng.*, **13:** 65 (1959).)

Fig. 5-1. Grains produced by post-solution physical development. The prismatic shape occurs under favorable growth conditions and extended development. The marker indicates 1μ m. (From T. H. James and W. Vanselow, *Photogr. Sci. Eng.*, **1:** 112 (1958).)

mented by physically deposited silver, these filaments have a remarkably uniform diameter, 190 or 200° A, or 70 silver atoms (Fig. 5-3). The formation of the filaments, which were first disclosed by electron microscopy, was initially very puzzling. But Berry has proposed a reasonable hypothesis: the silver atoms deposited at the several development sites first collect as a small sphere, owing to surface tension. Additional silver ions, arriving through the crystal lattice, add to the sphere, but as diffusion distances are increased, they are reduced at the base of the sphere before they have time to go farther than the sphere radius. The newly reduced atoms thrust the others out, causing the formation of the filament. He presents a strong case for possible achievement of proper balance of diffusion and reduction.[11]

THE DEVELOPING AGENT

A large number of reducing agents suitable for selective development of the latent image have been described. There have been two periods of greatest activity in this

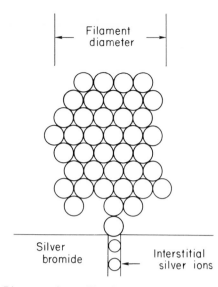

Fig. 5-3. Diagram of metallic silver growing at a silver bromide surface. (From C. R. Berry, *Photogr. Sci. Eng.*, **13**: 65 (1969).)

regard: (1) the early history of silver halide/gelatin photography when the aromatic developing agents were disclosed, and (2) the relatively modern period starting out with the introduction of Phenidone*) in 1941, followed by many nonconventional developing agents adapted to give strong superadditivity, low diffusion, high activity, etc., according to specialized needs of modern photography.

The most important aromatic developing agents in conventional photography today are hydroquinone (1); its isomer, catechol, and various derivatives (2,3); certain aminophenol derivatives such as N-methyl-*p*-amino-phenol (Metol) (4) and 2,4-diaminophenol; (Amidol) (5); *p*-phenylenediamine (6); and dialkylparaphenyl-enediamines such as (7), (8), and (9). Pyrogallol (10) and gallic acid (11) are of historical significance. Gallic acid is a weak developer for silver halide but is adequate for physical development and was used for wet-plate photography. It is also historically the first of the developing agents, being employed by Fox-Talbot in 1841. Pyrogallol was the dominant developer in early dry-plate photography and still finds some application in tanning developers.

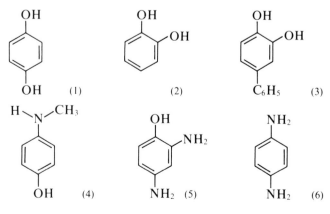

*Ilford trademark for 1-phenyl-3-pyrazolidinone.

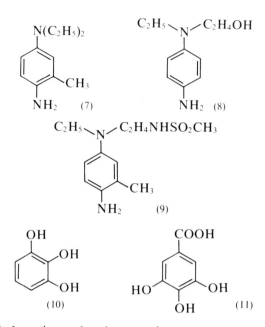

Hydroquinone has been an important developer for many years. It has some specialized uses alone but it is usually employed with other developing agents. The combinations with Metol (4) and with Phenidone form the basis of most modern developers.

The developing reactions of hydroquinone will be used to illustrate those of the aromatic agents in general, since all form quinones. The summary reaction is given in Eq. (1). However, development occurs stepwise:

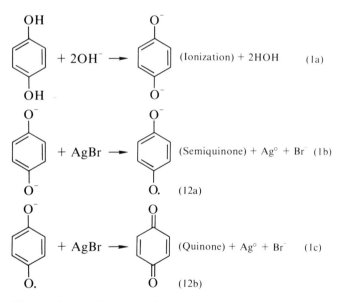

The quinone formed will react further. If sulfite is present, hydroquinone monosulfonate (13) is formed:

Otherwise hydroxylation may occur to produce hydroxyhydroquinone (14):

(1e)

(14)

Also, addition to the amino acids of the gelatin may be important:

(1f)

(15)

Reaction (1b) is relatively slow, while the semiquinone (12a) is a vigorous developer and reaction (1c) proceeds rapidly. Hydroquinone monosulfonate (13) is a very weak developer but when activated by Phenidone it may supplement hydroquinone development. It is also used as a "balancing developer" in color systems, to assist the action of p-phenylenediamines. Hydroxyhydroquinone (14) is an active developer giving much fog; its formation as a side reaction has been used by LuValle to explain various phenomena.[12]

The hydroquinone-amino acid reaction has only recently been described by James.[13] These aminohydroquinones are developers and developer accelerators, as well as being related to the tanning of gelatin.

Catechol and pyrogallol are tanning developers since their quinones react with the gelatin to harden it wherever development has occurred. The Russian workers have described extensively the developing and tanning properties of a number of naturally occurring catechols such as daphnetin (16).[14]

(16) (17)

While unsubstituted p-aminophenol has some historical importance, the monomethyl derivative, Metol,* (4) has greater activity and stability and is employed very extensively as a developer. Used by itself, it produces low-contrast images and is used in fine-grain and compensating developers. As mentioned before, it is most commonly combined with hydroquinone, the combination having higher activity than either one alone and producing useful and readily controllable contrast on a variety of films and papers. This popular combination is used to develop the majority of all films and papers today. 2,4-Diaminophenol, Amidol* (5), will develop in

*"Metol" and "Amidol," although commonly used generically, are Hauff trademarks.

approximately neutral solution and has especially high activity when very alkaline. Its solutions oxidize easily but it has found considerable application in the development of thick nuclear plates since image (gelatin) distortion is minimized at the low pH of the Amidol developer. The high activity of Amidol and its derivatives makes them of interest in diffusion transfer processing. An even more active agent, which has been commercially available, is Triamol (17).

p-Phenylenediamine (6) had considerable popularity in the 1930s and 1940s in fine-grain developers. In combination with considerable quantities of sulfite, it is capable of producing lower granularity (although at the expense of reduced emulsion speed) than other developers. Its low activity, high toxicity, and bad staining propensity have reduced the interest in this developer. The N,N-dialkyl-p-phenylene developers, such as (7), (8), and (9), are extremely important in the field of color development. Their quinones combined with various "couplers" yield dyes which form the basis of modern three-color photography.

A number of *heterocyclic compounds* have come into prominence as developing agents. By far the most important of these is 1-phenyl-3-pyrazolidinone (18). This compound was discovered to be a developer by Kendall, and is marketed by Ilford under the trademark of "Phenidone."[15] Used by itself, it produces low image density and has been recommended for giving a low-contrast image of full shadow detail. However, the principal use of Phenidone is in combination with hydroquinone. Low concentrations of Phenidone markedly accelerate the activity of hydroquinone developers and these Phenidone-hydroquinone (PQ) developers have found extensive application, often as replacement for the Metol-hydroquinone (MQ) developers. This property of two developers to in combination develop at a greater rate than when used separately is called *superadditivity*. Some advantages in use and capacity are reported, but it is difficult to demonstrate that "PQ" developers are less sensitive to bromide than "MQ" developers of equal activity. Unlike the aromatic developing agents, 1-phenyl-3-pyrazolidinone is not indefinitely stable in alkaline solution, but slowly hydrolyzes. This hydrolysis is not sufficiently rapid to limit its utility except when the liquid developer must be stored for long periods. The stability is improved if the molecule is substituted in the 4-position by methyl groups (19, 20); 4,4-dimethyl-3-pyrazolidinone is substantially free from hydrolysis.[16]

(18) (19) (20)

Certain aminopyrazoles are also of considerable interest. While 1-phenyl-3-aminopyrazoline is a weak developer, 1-(p-hydroxyphenyl)-3-aminopyrazoline and 1-(p-aminophenyl)-3-aminopyrazoline (21) provide superadditivity similar to that displayed by Phenidone. The 4-amino-5-pyrazolones (e.g., 22) are active de-

(21) (22)

velopers even in neutral or mildy alkaline solutions and have had considerable attention in Germany and in Russia.[17]

Ascorbic acid (23) may be thought of as a dihydroxy-dihydrofuran developing agent. It forms nearly colorless oxidation products and is valuable as an antioxidant as well as a developer. When used as a developer, it is combined with Metol (4) or Phenidone (18). Sulfite-free Metol-ascorbic acid developers are frequently employed in latent image studies, since they develop only the surface latent image. The hydroxytetronic acids and imides (24, 25) are closely related to ascorbic acid. They are also reported to be developers and antioxidants.[18]

(23) (24)

(25)

Metal developing agents are important for theoretical investigations. Theirs is the simplest of all developing reactions. For instance, chromous chloride is a selective developer.[19] The reaction for the development of silver chloride is:

$$CrCl_2 + AgCl \longrightarrow CrCl_3 + Ag° \qquad (5)$$

However, chromous chloride is so readily oxidized by air that it has little utility. Ferrous ion combined with various ligands, for example, ferrous oxalate and ferrous ethylenediaminetetraacetic acid complex, has been of considerable theoretical importance in investigation of developer mechanism. Similarly, titanium forms very good developers in complexes with ethylenediamine-tetraacetic acid. Neither iron nor titanium complexes produce as active developers as do the aromatic agents. A very active developer, but a difficult one to work with, is vanadous bromide, investigated by Roman and by Rasch and Crabtree.[20] Again the reaction is very simple:

$$VBr_2 + AgBr \longrightarrow VBr_3 + Ag° \qquad (6)$$

The developer can be recovered readily by electrolysis, which reduces the VBr^3 back to VBr^2. It is employed with hydrobromic acid in an extremely corrosive acid environment and has not found extensive application.

Dye Developing Agents. Developing agents that are also dyes are used in color diffusion transfer processes. Typically, these agents comprise hydroquinone, which is

attached through a resonance insulating ligand to an azo or other dye.[21] Compounds (26) and (27) are mentioned in the literature.[22] Following development of the silver image, the quinone formed remains in the negative layer, while the unreacted dye developer diffuses into the receiver, where it forms a positive dye image.

(26)

(27)

THE DEVELOPING ENVIRONMENT

The organic developing agents require an alkaline environment to be very effective. For example, in the case of hydroquinone, all or nearly all of the activity is due to the presence of the dianion (Eq. (1a)). which is not completely formed below a pH of 11.5-12. The weak development at lower pH values is quantitatively related to the amount of ionized hydroquinone present.[23] Aminophenols and phenylenediamines are only a little less dependent upon pH, since hydrogen ions are formed during development (Eq. (7)).

$$\text{(structure)} + 2AgBr \longrightarrow \text{(structure)} + 2Ag° + 2H^+ + 2Br^-$$

(7)

An alkali is therefore a normal part of the developing environment. The strength of the alkali will depend upon the nature of the developing agent and the activity required.

Two quantities are important: the degree of alkalinity or *pH* and the capacity or *buffer* action. Sodium sulfite supplies sufficient alkalinity for Amidol and for fine-grain Metol developers, that is, a pH of 7 or 8. Borax, $Na_2B_4O_7$, and sodium metaborate, $Na_2B_2O_4$, are mild alkalies useful in negative developers. They buffer in the pH range of 8.5 to 10 or slightly above. Sodium carbonate is a very useful alkali with pK_2 of about 10, that is, buffering at pH 9.5–10.5. It is an important alkali, used in paper developers and in many negative developers. Trisodium phosphate buffers well in the pH range of 11 to 12, and sodium hydroxide will buffer in the pH range of 12 to 14. Potassium and lithium salts act similarly to the sodium salts although a specific ion effect is sometimes ob-

served. For example, potassium salts will accelerate hydroquinone development more than sodium salts, and considerable differences may be noted in diffusion transfer systems.

As has been mentioned, the buffering action of the alkali, that is, the reserve of alkali available to neutralize the hydrogen ions formed in Eqs. (1) and (7), is important. This is why it is desirable to obtain a pH of 10 through employment of a considerable quantity of sodium carbonate rather than with very dilute sodium hydroxide. However, the developing agents themselves in combination with sodium hydroxide may buffer in useful ranges. For example, the pK values of hydroquinone are approximately 10.2 and 11.6, and certain developers containing high hydroquinone concentrations are well buffered in the pH range of 10 to 12 with no alkali other than sodium hydroxide.

The developing agents in the alkaline solution are subject to aerial oxidation and sodium sulfite is nearly universally added as an antioxidant. It serves two purposes: Besides preventing oxidation of the developing agent, it decolorizes the otherwise strongly colored quinones that are formed by reducing them to the sulfonates, Eq. (1d). Sometimes, however, the quinone is used for further reactions; then the sulfite concentration is kept very low. Ascorbic acid is also occasionally used as an antioxidant. Sodium sulfite is a good solvent for silver halides and its presence affects grain structure and helps reveal internal latent image.

All developers except those of the lowest activity contain an *antifoggant* or restrainer, which helps the developing agent to distinguish between exposed and unexposed grains. By far the most common antifoggant is potassium bromide. The concentration used varies with the activity of the developer.

There are several causes of fog, and antifoggants work by more than one mechanism. Crabtree and Dundon recognized four types of fog.[24] Their classification, slightly modified, comprises: (1) Emulsion fog. The ripening and sensitization of the emulsion produce sensitivity centers which the developer may not distinguish from latent image centers. (2) Developer fog. The various developing agents differ in their ability to distinguish between latent image and fog centers, and discrimination is reduced as the developer is made more active by increased alkalinity or temperature. (3) Physical development fog. The dissolved silver may be deposited on nonlatent-image centers. (4) Redox fog. A fogging oxidation product, such as a peroxyl radical, is formed. This is particularly likely to occur with aerial oxidation in the presence of traces of copper. It is also noted in aldehyde-containing developers.

Common antifoggants include potassium bromide and a number of heterocyclic nitrogen compounds, such as benzotriazole, 5-nitrobenzimidazole, and 5-nitroindazole. They probably act by adsorption to the silver halide. Thus bromide ion is strongly adsorbed, and the antifoggant activity of a series of benzotriazoles was directly related by Battaglia to their ability to adsorb to silver halide.[25]

The prevention of physical development fog is probably accomplished by adsorption of the antifoggant to any nonimage silver surface which is competing with the latent image. The very effective antifoggant 1-phenyl-5-mercaptotetrazole is very strongly adsorbed to silver. Typical redox antifoggants include azine dyes (phensosafranine, pinakryptol green) and anthraquinones. They enter into either a direct or an indirect redox reaction with the fogging agent.

It is not uncommon to find a calcium sequestering agent in the developer. Calcium salts may be introduced from the gelatin or from the water supply. The sequestrants prevent the formation of calcium precipitates (e.g., $CaSO_3$, $CaCO_3$) as sludges and scales in the solution, on the equipment, and on the film. Sequestering agents include the polyphosphates, such as sodium hexametaphosphate (Calgon), and amino acids, such as ethylenediaminetetraacetic acid and 1,3-diamino-2-propanoltetraacetic acid. Commercial developers also may contain alcohols as secondary solvents, specialized antistain agents, and tone modifiers.

A type of very concentrated developer employs an amine as the alkali and solvent for the developing agents, and the amine-sulfur dioxide addition product as a preservative.[26]

A developer is balanced to a particular application. For example, low-contrast negative developers and fine-grain developers operate at low pH and have little or no bromide. They develop the silver halide grains only partially. High-contrast, active x-ray developers have high concentrations of developing agents, are strongly alkaline, and contain much bromide.

Exhaustion and Replenishment

As a developer is used, the concentration of developing agent decreases, the alkalinity decreases, and the concentration of bromide increases, Eq. (1). All of these changes diminish its activity. This effect can be overcome initially by increasing development time, but it is usually more convenient to add a replenishing solution. This replenisher will contain higher concentrations of developing agent, additional alkali, and reduced concentrations of bromide or none at all. Under ideal conditions, for example, in motion picture and photofinishing negative development, where the load is quite constant, the chemical composition and photographic properties of the developer can be kept very constant.

IMAGE-FORMING REACTIONS OF DEVELOPING AGENTS

Tanning. The oxidation product of the developer may be used in a number of ways. For example, the quinones formed by oxidation of catechols and pyrogallol, and to a lesser extent, hydroquinone, react with the gelatin to harden it. Since the quinones are formed in the image area, the image areas are selectively hardened and the

nonimage areas are washed off or transferred to a receiver. The images have high contrast and this simplified processing procedure (develop and wash off) forms a very satisfactory way of reproducing engineering drawings. Alternatively, the remaining gelatin may be dyed and the dye transferred from the "matrix" to a suitable paper or film. This forms the basis of Technicolor and Kodak dye transfer processes. In the Verifax process, the softened gelatin and remaining silver halide and developing agent are transferred to a receiver, where they produce a positive image.

The semiquinone which is the first oxidation product of hydroquinone (Eq. (1b)) is an extremely active developer. When it is not removed, for example, by reaction with sulfite, the effect is autocatalytic and density is built up rapidly in an area where development has started. This is the basis of the *lith effect*, which is used in the high-contrast developers employed in lithography. The lith developers contain hydroquinone and usually formaldehyde bisulfite (or formaldehyde and sodium bisulfite) as a sort of sulfite buffer to give antioxidant action without interfering with the formation of the semiquinone.

The formation of semiquinone is very important in the phenomenon of *superadditivity*. For example, Phenidone (18) is oxidized to a relatively stable semiquinone. In a popular theory of superadditivity, Phenidone is pictured as adsorbed to the silver halide grain, where it reduces a silver ion and is in turn oxidized to the semiquinone. A secondary developing agent in the solution, such as hydroquinone or ascorbic acid, then transfers its electrons to the Phenidone semiquinone, reducing it back to Phenidone. The hydroquinone or ascorbic acid is used up, but a low concentration of Phenidone is all that is needed.

Dye Formation. A very important use of the oxidized developing agent is to form dyes, and indeed, this is the basis of most modern color print and transparency processes. Dialkyl *p*-phenylenediamines (7), (8), and (9) are oxidized by the silver halide to quinonediimines:

$$(28)$$

The quinonediimine in turn couples with proton-releasing compounds to form dyes:

$$(9)$$

The overall reaction is:

Dev + 4AgBr + Coupler \longrightarrow

$$\text{Dye} + 4Ag^\circ + 4HBr$$

$$(10)$$

After the dye is formed the silver is bleached out.

The original application of these reactions to photography is due to Rudolf Fischer, in 1912, but commercial use was delayed some years.[27] A number of important studies of mechanism and of structural effects have been made. The effect of substituents in *p*-phenylenediamines was studied by Bent and coworkers.[28] The wide variety of couplers has been classified by Vittum and Weissberger, who also discuss the chemistry of color development.[29] The patent literature has been reviewed by Tull and by Duffin and Mason.[30]

The three important classes of couplers are phenols, open-chain methylene couplers, and cyclic methylene couplers. 1-Naphthol and 4-chloro-1-naphthol, (31) and (32), are representative of phenols. The phenols may be thought of as reacting in the keto form, which corresponds to the generic formula for the coupler, Eq. (9). The same cyan-colored indaniline dye, (33), is produced

by reaction of either (31) or (32) with oxidized (7). 2',5'-Dichloroacetoacetanilide represents an open-chain methylene coupler. It produces the yellow azomethine dye, (34). Among cyclic methylene compounds are the pyrazolones, (35) and (36). Both couple to produce the same dye, the magenta-colored azomethine dye, (37).

Although (31) and (32) produce the same dye, (32) loses the chlorine atom and one proton, and requires only two molecules of silver bromide to form the dye. (Compare Eq. (11) with Eq. (10)).

$$Dev + 2AgBr + Coupler \longrightarrow$$
$$Dye + 2Ag^{\circ} + 2HBr + HCl \quad (11)$$

Compound (32) is called a *2-equivalent coupler.*

The azo pyrazolone, (36), is representative of *colored couplers.* The dye (37) absorbs not only in the desired green region, but also considerably in the blue. But the coupler (36) is yellow. The yellow dye is destroyed wherever development occurs, and the residual coupler forms a positive yellow mask which compensates for the unwanted blue absorption.

Couplers may be dissolved in the developer, as in the Kodachrome process, dispersed in oily globules in the emulsion, as in the Kodacolor process, or "weighted" to keep them in position and incorporated directly in the emulsion, as in Agfacolor and Anscocolor. An example is the cyan coupler (38).

STOPPING DEVELOPMENT

The developing step is often followed by an acid stop bath which neutralizes the alkalinity of the developer, stopping its further action uniformly and at the desired stage. It also prevents adverse reaction of the alkali with the aluminum of the fixing bath, which might produce scums, and dissolves any deposits of calcium sulfite or carbonate which may have formed on the film during the developing process. Acetic acid is almost universally employed. It is acid enough to rapidly neutralize the developer without producing excessive swelling; a pK of 4.7 makes it suitable for systems employing alum fixing baths which usually have a pH of around 4.5. Sodium sulfate may be added to the bath to minimize swelling. As the bath becomes exhausted, it can be restored by the addition of more acetic acid. The pH should be maintained between 4 and 5.5.

A bath containing chromium aluminum sulfate ("chrome alum") is occasionally employed to produce hardening as well as to stop development. It is rarely used with modern films, which generally contain hardeners in the gelatin layer.

FIXATION

The object of fixation is to dissolve the silver halide, producing a transparent layer and fixing the image against further action of light. A number of silver thiosulfate complexes have been isolated. However, the $Ag(S_2O_3)_3^{-5}$ ion is probably the important one in practical fixation. The equation for fixation of a silver bromide emulsion is

$$AgBr + 3\ Na_2S_2O_3 \longrightarrow Ag(S_2O_3)_3^{5-} + 6\ Na^+ + Br^- \quad (3)$$

This ion is very soluble and will diffuse from the film into the fixing bath; any remaining in the film can be readily washed out. However, if the silver concentration becomes excessive in the fixing bath, less soluble complexes are formed, such as the $Ag(S_2O_3)_2^{-3}$ ion or the $AgS_2O_3^{-1}$ ion. These are difficult to wash out and may remain in the processed film or paper, where they may eventually decompose to yield yellow silver sulfide stains in the highlight areas.

Ammonium thiosulfate can be used instead of sodium thiosulfate. It is a more active fixing agent, particularly with emulsions containing considerable silver iodide. Baths containing ammonium thiosulfate are usually known as "rapid fixers." They are now used widely and produce images as permanent as do sodium thiosulfate baths.

Sodium and ammonium thiosulfates are manufactured by dissolving sulfur in sodium sulfite or ammonium sulfite solution. This reaction is reversible and in the presence of acid, the baths tend to precipitate sulfur as a yellow-white colloid, Eq. (10). This "sulfurization" is avoided by adding sodium sulfite to the bath. The

sulfite is particularly important in acid fixing baths, such as those containing alum.

$$Na_2S_2O_3 \underset{}{\overset{H^+}{\rightleftharpoons}} 2Na^+ + \underline{S} + SO_3^{2-} \qquad (12)$$

A large number of fixing baths contain an aluminum hardening agent. This is commonly added as a potassium aluminum sulfate or "potassium alum," $K_2Al_2(SO_4)_4 \cdot 24H_2O$. However, aluminum chloride, aluminum nitrate, and other salts can be used. The aluminum hardens the gelatin, allowing subsequent washing without excessive swelling, but it has an undesirable side effect, a tendency to "mordant" the thiosulfate ion to the gelatin, making it difficult to wash out. Aluminum-containing fixing baths also usually contain acetic acid and boric acid to adjust the pH in the range of 4 to 5 where aluminum hardens effectively. The more acid the bath, the stronger the hardening, but the more difficult it becomes to wash out the thiosulfate from the processed material. The boric acid also acts as an efficient antisludging agent for the aluminum. Chromium and zirconium salts have been employed as alternatives to aluminum, but are much less important. Aldehydes have also been used as hardening agents, for example, in color processes.

MONOBATHS

The steps of development and fixation can be combined in a single bath. These are competing reactions for the silver halide and such baths are balanced so that development of the latent-image-bearing grains is rapid, followed by a slower fixation step. Even so, there is usually some loss of emulsion speed. The bath usually requires balancing for the particular emulsion with which it is to be used. The fixing and developing action is also dependent upon agitation and temperature. However, these factors are not necessarily critical and monobaths find extensive application because of their great convenience. Many developing agents have been employed in monobaths but highly alkaline solutions of Phenidone and hydroquinone are especially popular. The fixing agent incorporated in monobaths is almost always sodium thiosulfate, but baths containing many other fixing agents have been described. Newman[31] gives an extensive historical review of monobaths, and Barnes and co-workers[32] and Haist and co-workers[33] describe properties and mechanism. In addition to the developing and fixing of negative materials or prints, monobaths are used widely in diffusion transfer processing.

WASHING

The steps of fixing and washing serve to make the image permanent. Fixation dissolves the silver bromide and washing removes the remaining silver thiosulfate complexes and the thiosulfate ion. If the thiosulfate ion remains in the film, it may react with the silver image:

$$S_2O_3^{2-} + 2Ag^\circ \xrightarrow{Air} SO_3^{2-} + Ag_2S \qquad (13)$$

In this reaction, the silver has been oxidized, and the image may turn brown. Alternatively, silver sulfide may be formed from silver complexes retained in the processed material. This decomposition stains the highlights of the print or negative with yellow or brown silver sulfide.

The presence of thiosulfate ion introduces still another danger to image permanency. It markedly lowers the potential required for oxidation of metallic silver. Thus, the reaction becomes

$$Ag^\circ + O_2 \longrightarrow Ag_2O \xrightarrow{S_2O_3^{2-}} \text{thiosulfate complex} \qquad (14)$$

In this case, the image has truly "faded," that is, it has lost density. The oxidative attack on the silver image may either be uniform or occur spotwise in areas of lowest resistance.[34] If the dissolved silver is redeposited, it may form yellow or red areas and "mirrors" on the surface of the print or film.

Fortunately, the residual thiosulfate washes rapidly out of a gelatin layer, if there is no complication. It washes less readily out of paper base. As mentioned, aluminum hardening of the gelatin layer causes much more stubborn retention of the thiosulfate. Washout of the thiosulfate is a diffusion process and the rate of washout is improved by turbulence, for example, that obtained with spray washing and rotary washers. The rate of washing is also increased with temperature. Because washing is completed about 50% more rapidly at 70° F than at 40° F, wash water is often heated in commercial practice.

A number of means of promoting the washout of thiosulfate may be employed. (1) Alkali baths are very effective; however, they reduce the hardening action of the aluminum and the film may swell, causing physical damage during the washing and handling and slowing of the drying process. (2) The thiosulfate may be oxidized to sulfate. Less complete oxidation, to the thionate, is not satisfactory since the thionates can also decompose to form silver sulfide. The best agent for oxidation to the sulfate is hydrogen peroxide used in alkaline solution, for example, as with ammonium hydroxide.[35] The ammonia, of course, reduces the hardening action of the aluminum somewhat but the treatment gives highly permanent images. (3) Probably the safest and easiest way of promoting rapid washout of hypo is to use salt baths, which displace the thiosulfate ion from the gelatin matrix or paper fibers.[36] Thus, sea water, which contains chlorides and sulfates, will wash the thiosulfate from the film or paper more rapidly than will fresh water. However, it must be rinsed out since the chloride itself introduces some impermanency. Solutions of sodium sulfate and especially sodium sulfite are very effective in promoting washout. The film or paper is fixed, then bathed in these solutions and washed briefly. The effectiveness of a salt bath is illustrated in Fig. 5-4.

After washing the image free from hypo, it may be treated with a gold thiocyanate or a gold thiourea bath to convert the surface layer to gold metal, which is more resistant to oxidative fading. The silver filaments formed when silver chloride or silver bromide emulsions

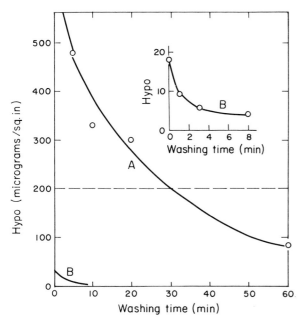

Fig. 5-4. The effect of a salt bath in promoting washout of thiosulfate. Curve A is for the unaided washing of a sheet film fixed in a hardening fixer. Curve B is for washout after bathing for 2 min in a 2% sodium sulfite solution. Curve B is enlarged in the insert figure.

are developed retain a layer of thiosulfate after fixation. But if iodide ion is present, as it is in emulsions containing silver iodide, the adsorbed layer is silver iodide rather than thiosulfate. Grains containing the iodide layer have been found less subject to oxidative attack than those with a layer of adsorbed thiosulfate on the filament.[37] The same improvement in permanency can be obtained by adding a low concentration of iodide to the fixing bath.

TESTING FOR IMAGE PERMANENCY

The most direct test for thiosulfate and silver ion remaining in the fixed and washed layer is conversion to silver sulfide. The presence of thiosulfate ion is detected by spotting the film or paper with a silver nitrate solution. The use of this reagent for quantitative measurements of thiosulfate in both paper and films has been described and the method is incorporated in American National Standards.[38] The tests are unambiguous and the presence of any very deep color indicates probable difficulty as the film or paper ages.

A quantitative test for the presence of thiosulfate is to convert it to the phenothiazine dye, methylene blue. This test can detect very low levels of residual thiosulfate. A third test, the mercuric chloride test of Crabtree and Ross, which had been employed for many years, has now been replaced by the silver nitrate and methylene blue tests in the American National Standards.[38]

The detection of residual silver ion, which may be present as a silver thiosulfate complex, is conveniently done by converting it to silver sulfide. In this case, the reagent is a dilute sodium sulfide solution. Again this reaction is very closely related to what may happen if silver ion is left in the emulsion, that is, silver sulfide may eventually be formed. The intensity of the stain of silver sulfide formed in the reaction is directly related to the intensity of the stain that could be formed on aging. A very dilute sodium sulfide reagent must be used to avoid staining by the reagent itself, and it must be made up fresh just before use, because it oxidizes on standing.

STABILIZATION PROCESSING

The unfixed image containing silver and silver halide is unstable, owing to the relatively rapid printout of the silver halide on further exposure to light. However, many other silver compounds are less sensitive to light printout. "Stabilization processing" comprises converting the silver halide to one of the less light sensitive complexes. The conversion may be fairly fast and the washing step is avoided, thus greatly reducing the processing time required. The principles of stabilization processing have been described by Russell, Bruce and Yackel.[39] Silver halide can be converted to silver salts of thiosulfate, thiocyanate, thiourea or various mercaptans. Ammonium thiocyanate, used in very high concentrations, effects an especially rapid conversion and is employed frequently in stabilization processing.

The "stabilized" image is much less permanent than the fixed and washed image. However, it is adequate for many applications. The image may printout on exposure to intense light, particularly at high humidity. The other danger is oxidative fading of the image; that is, the silver is more readily oxidized in the presence of the complexing agent which, as mentioned earlier, lowers the potential required for oxidation. The thiocyanates give considerable difficulty in this respect and a number of antioxidants and image-reactant additives have been suggested for preventing oxidation of the image.

REACTIONS OF THE PROCESSED IMAGE

Bleaches

Bleaching is the opposite of development. In development, silver ion is reduced to free silver whereas in bleaching, metallic silver is oxidized to silver ion. In fact, Eq. (1) may be thought of as reversible, that is, quinone plus silver yielding silver ion plus hydroquinone. However, this reversal is unlikely in practice, since an acid environment is required for quinone to act as a bleaching agent whereas hydroquinone acts as a reducing agent in an alkaline environment. Although quinone bleaches have been employed, the more typical bleaching agents are ferricyanides, dichromates, and permanganates.

When potassium or sodium ferricyanide acts as a bleaching agent, silver ferrocyanide, an insoluble compound, is formed. In order to dissolve the silver ferrocyanide, the film is fixed in hypo, or hypo or another

silver-complexing agent is added to the bath. Ferricyanides are used extensively in color processing, in toning, and in reducing baths. They will be mentioned again under these headings.

The ferricyanides have two disadvantages of some importance: they may be decomposed by light and air to form cyanide ions and thus introduce a waste disposal problem; also they react with hypo, so that it is difficult to make a combined bleaching and fixing bath. Ferric salts of ethylenediaminetetraacetic acid and some other related complexing agents are used as ferricyanide replacements to overcome these deficiencies. The ferric-EDTA complex plus hypo makes a stable bleach-fixing bath, capable of both bleaching the silver of the image and fixing out silver halide. Bleach-fixing baths are most often used in the processing of color prints. They are slow in action and various means of catalyzing their activity have been proposed.

Potassium dichromate is used as a bleach in strongly acid solution, that is, with sulfuric acid. It is a powerful bleach, and the silver sulfate formed is soluble in water. Nevertheless, it is usually followed by a sodium sulfite clearing bath to bleach orange dichromate stains and remove any residual silver salts. Dichromate bleaches are used in black and white reversal processing. Chloride or bromide is added if it is desirable to retain the silver. Dichromate bleaches are fairly corrosive and can cause dermatitis.

Potassium permanganate is a less important bleaching agent but it finds use in reducers and stain removers. It bleaches both silver and many organic compounds, such as oxidized-developer stains or ink stains. It forms a highly colored basic manganese dioxide, $MnO(OH)_2$. A clearing bath such as sodium bisulfite or an acid fixing solution is then used to remove this discoloration; the bisulfite reduces the manganese to the colorless, soluble divalent ion. Permanganate is used in a highly acid solution and offers some problem of stability, so the potassium permanganate and sulfuric acid are usually made up as separate solutions. If one desires to save the image, as in a bleach-and-redevelopment process, hydrochloric acid or another halide is added.

Another bleaching agent of some utility is hydrogen peroxide. This tends to soften gelatin in the region in which the silver is bleached. In the etch bleach process, hydrogen peroxide is combined with copper chloride to bleach the silver image and soften the gelatin in the region of the image, which is then washed out. The silver halide remaining can then be developed to produce a reversal image.

Copper chloride is also a useful bleach to remove both silver and any silver sulfide present. It is necessary to follow it with some type of fixing solution or to add a silver-complexing agent to the bath.

Mercuric chloride is a bleach used for image intensification systems. Its chemistry has been studied recently by Tavernier.[40] Mercuric chloride and mercuric iodide are employed in the preparation of semi-transparent images for spatial holography. The tanning of the gelatin provided by dichromate bleaches is also useful in this application, since it produces a diffraction pattern.

Reversal Processing

In this type of reversal processing, the negative image is developed conventionally. The developing bath may contain a silver halide solvent, such as thiocyanate or an amine, to remove unwanted silver halide. The image silver is then bleached with dichromate, "cleared in sodium sulfite," and the remaining silver halide is exposed to light and developed to give a positive image. Sometimes the exposing step is avoided by using a fogging redeveloper containing hydrazine, or a fogging agent such as potassium borohydride or sodium sulfide. In "halide reversal," the steps of re-exposure and redevelopment are skipped. The residual silver halide itself is used as the positive image; it has good density to specular illumination.

In reversal color processing, a first developer containing conventional black and white developing agents and extra silver halide solvent is used. This produces a negative image containing silver but no dye. The remaining silver halide is fogged by exposure to light or action of a fogging agent and developed in a dialkyl p-phenylenediamine developer of the type described earlier. This reduces the remaining silver and reacts with couplers, contained in either the emulsion or the developer, to form dye. Then all silver present in the negative and in the positive images is bleached, traditionally with ferricyanide. This produces a positive dye image.

In negative color processing, the dialkyl p-phenylenediamine is the only developer and reacts with the coupler to produce a negative dye and silver image. The silver is then bleached and the unused silver halide is fixed out.

Two reversal processes using a tightly adsorbed mercaptan will be described. While a number of heterocyclic mercaptans are mentioned, the most valuable in both processes appears to be 5-mercapto-1-phenyltetrazole. In the "photosolubilization" process, which has been the subject of many studies, the mercaptan is placed in the emulsion before exposure. It makes the grains difficult to fix. However, following exposure, those grains that have been exposed to light can be fixed out and the remaining grains developed to produce a positive image. The mercaptan has considerable desensitizing action so the emulsions are fairly slow. This process is due to Blake and his co-workers at DuPont.[41] Henn and King describe a short reversal process in which the negative image is developed conventionally and the remaining silver halide is developed in a solution containing the phenylmercaptotetrazole.[42] A blix bath is then employed, which bleaches the original silver but not that of the positive image, which is protected by the mercaptan. This system does not work well if the emulsion contains iodide because the iodide competes with the mercaptan for the grain surface.

There are a number of short reversal processes that depend upon latent image effects. These are dealt with in the section on latent image.

Toning

Changes in image tone may be produced by certain addenda in the developer; for example, potassium thiocyanate has been added to print developers to produce a blue-black tone. A variety of mercaptans and heterocyclic amines are mentioned in the literature as affecting image tone. They are especially useful in diffusion transfer processes, which otherwise give a brownish image.

In conventional toning processes, the silver image is chemically converted to another compound. One common method is to bleach the image, for example, with ferricyanide-bromide, and redevelop in a sulfiding bath containing sodium sulfide or a sulfiding agent such as thiourea plus caustic. Levenson deals with the sulfiding process in some detail.[43] Polysulfides can both oxidize the silver of the image and convert it to the sulfide. They work best with fine-grained images. The tone ranges produced by silver sulfide can vary from a yellow-brown to a near-neutral color, depending upon the grain size of the original image.

Silver images can be converted directly to silver selenide. A typical seleniding agent is potassium selenosulfate, produced by dissolving selenium in potassium sulfite. Again, this works best with fairly fine-grain images. It produces a range of brown and purple-brown tones.

Gold is another toning agent of some importance. It is employed with a complexing agent such as thiocyanate or thiourea which acts both to complex the silver and to keep the gold in the active aurous state. The gold baths can act directly on even fairly coarse-grained silver images to produce a blue tone. The treated images are strongly resistant to the action of oxidizing gases and are used when great permanency is desired.

A number of indirect toning methods involve bleaching the image to silver ferrocyanide and causing this to react with other agents. However, these processes are of slight interest in comparison with modern direct color photography.

Intensification

An image given additional density is said to be "intensified." One of the simplest and most direct methods is to use a physical developer of the type discussed earlier, containing a developing agent and silver thiosulfate. These solutions provide strong intensification of fine-grain images but are less effective on high-speed negatives. The quinone intensifier, which forms a deeply colored quinone-silver salt, is produced by adding hydroquinone to dichromate solution.[44] It gives very high intensification of coarse-grained images but is less effec-

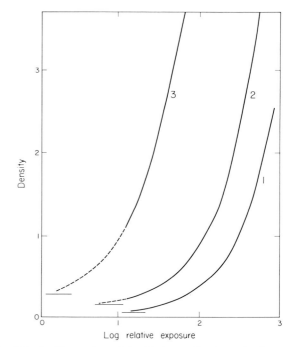

Fig. 5-5. An illustration of double intensification of a fine-grain x-ray film. Curve 1, unintensified; Curve 2, silver intensification; Curve 3, silver plus quinone intensification. The total gain in speed is about 1.5 log H.

tive on fine-grained images. It is possible to first intensify a fine-grain image with silver, and then as the image becomes coarser, to add quinone intensification, producing a very large effect (Fig. 5-5). Another powerful and usually reliable intensifier converts the image to ferriferrocyanide, Prussian blue.[45]

Two other intensifiers are worth mentioning. Bleaching in mercuric chloride followed by redevelopment produces a silver-mercury image of considerable intensity but no great permanency. A dichromate bleach followed by appropriate redevelopment gives a low degree of intensification, but one which can be repeated a number of times and is reasonably permanent.

Reduction

In the photographic, as opposed to the chemical, sense, reduction is the process of reducing the density of the image. This is usually accomplished by oxidation of the silver image in a conventional bleaching bath. Although various methods of selective reduction have been described, they are difficult in practice and probably two reducing baths accomplish most of today's requirements. The ferricyanide-hypo "Farmers" bleach removes excess density, as from overexposure. It is employed as a very dilute bath to produce clean highlights in prints. A somewhat stronger bath is used for films. It has very limited keeping properties when mixed, since the ferricyanide oxidizes the hypo.

An ammonium thiosulfate fixing bath tends to bleach silver in the presence of air, the more rapidly, the more acid the bath. When made strongly acid, as through the addition of citric acid, it forms a very good reducer whose action can be watched and controlled. It is effective in removing most yellow silver stains from prints or negatives with little attack on the image. If made even more acid and employed for longer times, it proportionally reduces the image and compensates for over-development. It acts more subtractively on prints and fine-grain films and can compensate for overexposure.

The Dye Bleach Process

A strongly acid bleaching bath tends to bleach dyes as well as silver, and Schinzel discovered in 1907 that the dyes could be selectively bleached in the region of the silver image. The Gaspar color process and, more recently, Cibachrome,® depend on this action. In these processes the emulsion contains silver halide and an azo dye. The image is developed conventionally, hardened to avoid attack by the strong acid baths, and then bleached in a bath containing hydrochloric acid, thiourea, and a catalyst such as dimethylquinoxaline. As mentioned, the dye is bleached in the region in which the silver image is bleached, while the remaining dye stays in the film or paper. Excess silver is then removed in a copper bleach bath and the silver halide is fixed out. The equation for the dye-bleach reaction can be written as

$$4Ag^\circ + RN = NR' + 4H^+ \longrightarrow$$

$$4Ag^+ + RNH_2 + R'NH_2 \quad (17)$$

Here $RN = NR'$ is the azo dye. The presence of oxygen, catalyst, and the silver-complexing agent is, however, essential to the process.

REFERENCES

1. R. M. Cole and R. B. Pontius, *Photogr. Sci. Eng.*, **5**: 154 (1961).
2. H. Jonker, A. Molenaar, and C. J. Dippel, *Photogr. Sci. Eng.*, **13**: 38 (1969).
3. R. Matejec, *Photogr. Korr.*, **104**: 153 (1968).
4. D. C. Shuman and T. H. James, *Photogr. Sci. Eng.*, **15**: 42 (1971).
5. a. G. L. McLeod, *Photogr. Sci. Eng.*, **13**: 93, (1969).
 b. Additional descriptions, ibid. **13**: 95, 103, 111, 120.
6. H. Jonker, et al., *Photogr. Sci. Eng.*, **13**: 1 (1969).
7. T. H. James and W. Vanselow, *Photogr. Eng.*, **7**: 90 (1956).
8. T. H. James, *Photogr. Sci. Eng.*, **14**: 371 (1970).
9. W. Jaenicke and F. Sutter, *Z. Elektrochem.*, **63**: 722 (1959).
10. E. Klein and R. Matejec, *Z. Elektrochem.*, **61**: 1127 (1957).
11. C. R. Berry, *Photogr. Sci. Eng.*, **13**: 65 (1969).
12. J. E. LuValle, *Photogr. Eng.*, **5**: 273 (1954).
13. T. H. James, *Photogr. Sci. Eng.*, **12**: 67 (1968).
14. a. E. F. Rul, M. S. Khaikin, L. G. Fedorina and G. V. Derstugan-off, *J. Photogr. Sci.*, **15**: 174 (1967).
 b. M. S. Khaikan, D. B. Shamilskaya and G. V. Derstuganoff, ibid., **15**: 241 (1967).
15. J. D. Kendall, U.S. Patent 2,289.367 (1942).
16. C. F. H. Allen and J. R. Byers, U.S. Patent 2,772, 282 (1956).
17. a. L. Burgardt and W. Pelz, *Mitt. Forschungs Lab.*, *Agfa Leverküsen-München*, **2**: 165, (1958).
 b. J. Eggert, U.S. Patent 2,163,781 (1939).
18. H. Muhr and A. J. Axford, Brit. Patent 783,727 (1955).
19. H. J. Price, *Photogr. Sci. Eng.*, **12**: 288 (1968).
20. a. P. Roman, Thesis, Sorbonne, Paris (1949).
 b. A. A. Rasch and J. I. Crabtree, *J. Soc. Motion Picture Television Engrs.*, **62**: 1 (1954).
21. W. E. Solodar, S. Lukas and M. G. Green, *J. Chem. Eng. Data*, **9**: 232 (1964).
22. E. R. Blout, et al., U.S. Patents 3,208,991, 3,218,312 (1965).
23. R. G. Willis and R. B. Pontius, *Photogr. Sci. Eng.*, **14**: 149 (1970).
24. M. L. Dundon and J. I. Crabtree, *Brit. J. Photogr.*, **71**: 701,719 (1924).
25. C. J. Battaglia, *Photogr. Sci. Eng.*, **14**: 275 (1970).
26. J. C. Barnes, G. W. Luckey and C. W. Zuehlke, Brit. Patent 958,678 (1964).
27. R. Fischer, Ger. Patent 253,335 (1912).
28. R. L. Bent, G. H. Brown, M. C. Glesmann, D. P. Harnish, C. G. Trimmel and A. Weissberger, *Photogr. Sci. Eng.*, **8**: 125 (1964).
29. P. W. Vittum and A. Weissberger, *J. Photogr. Sci.*, **2**: 81 (1954); **6**: 157 (1958).
30. a. A. G. Tull, *Brit. J. Photogr.*, **85**: 647 (1938).
 b. G. F. Duffin and L. F. A. Mason, *Rept. Appl. Chem.*, **43**: 83 (1958).
31. A. A. Newman, *Brit. J. Photogr.*, **106**: 44, 66 (1959).
32. J. C. Barnes, *Photogr. Sci. Eng.*, **5**: 204 (1961); J. C. Barnes, G. J. Johnston, and W. J. Moretti, **8**: 312 (1964).
33. G. M. Haist, J. R. King and L. H. Bassage, *Photogr. Sci. Eng.*, **5**: 198 (1961).
34. R. W. Henn and D. G. Wiest, *Photogr. Sci. Eng.*, **7**: 253 (1963).
35. J. I. Crabtree, G. T. Eaton and L. E. Muehler, *J. Photogr. Soc. Amer.*, **6**: 6 (1940).
36. R. W. Henn, J. I. Crabtree and N. H. King, *Photogr. Eng.*, **7**: 153 (1956).
37. a. R. W. Henn, D. G. Wiest and B. D. Mack, *Photogr. Sci. Eng.*, **9**: 167 (1965); **13**: 276 (1969).
 b. T. H. James, ibid., **9**: 121 (1965).
38. ANSI PH 4.8-1971; PH 4.30-1962, R1969.
39. H. D. Russell, E. C. Yackel and J. S. Bruce, *P.S.A. J.* (*Photogr. Sci. Tech.*), **16B**: 59 (1950).
40. B. H. Tavernier, *J. Photogr. Sci.*, **18**: 50 (1970).
41. a. R. K. Blake, *Photogr. Sci. Eng.*, **9**: 91 (1965).
 b. Additional descriptions, ibid., **9**: 96, 104, 108, 116.
42. R. W. Henn and N. H. King, *Photogr. Sci. Eng.*, **11**: 363 (1967).
42. G. I. P. Levenson, *J. Photogr. Sci.*, **17**: 211 (1969).
44. L. E. Muehler and J. I. Crabtree, *J. Photogr. Soc. Amer.*, **11**: 81 (1945).
45. J. Q. Umberger, U.S. Patent 2,662,014 (filed 1952).

6

MANUFACTURE AND PHYSICAL PROPERTIES OF FILM, PAPER AND PLATES

P. Z. Adelstein
G. G. Gray and
J. M. Burnham

Proper utilization of the photographic process requires an understanding of the properties of the sensitized photographic materials. In addition to sensitometric characteristics, the physical characteristics are equally important. It is on the basis of both economics and these physical characteristics that the decision must be made whether to use photographic film, paper or plates. Properties which are crucial in such a determination include transparency, rigidity, strength and dimensional stability. An understanding of these physical properties is enhanced if there is also some appreciation of the raw materials used and the methods of manufacture. These features of photographic film, paper and plates will be discussed in turn.

PHOTOGRAPHIC FILM

Photographic film is used where there is need for either a transparent base, dimensional stability, or high tensile and tear strength.

Raw Materials

Most photographic films consist of a light-sensitive emulsion layer coated onto a transparent plastic support.

There are several different plastics used in this application, each of which has its own distinctive advantages and disadvantages. It is because the requirements are so specific that relatively few materials have proved practical for film base. For many years, only certain cellulose esters were used, but recently several synthetic high polymer resin film supports have made their appearance.

Cellulose. Cellulose is not used in its untreated form as a film support. However, it is of vital importance in this field since it is the starting material for the cellulose esters. Cellulose is found in cotton linters, wood pulp and other naturally occurring materials. The purer forms of cellulose have an empirical composition which corresponds to $(C_6H_{10}O_5)_n$. The cellulose molecule consists of a long chain of glucose units which are linked together by 1-4 glycosidic oxygen bonds. According to Haworth,[1] the formula for cellulose is:

Staudinger[2] found that the degree of polymerization of cotton, as glucose units, is approximately 750 and, since each glucose unit has a combined equivalent weight of 162, the molecular weight for cotton cellulose is on the order of 120,000.

It should be noted that each glucose unit in the cellulose molecule contains three hydroxyl groups, which may be esterified.

Cellulose Nitrate. If cellulose is treated with a mixture of nitric acid, sulfuric acid and water, cellulose nitrate is obtained. Cellulose containing two and a fraction nitrate groups per glucose unit (11 to 12.4% nitrogen) is known as pyroxylin and was used for the first flexible photographic film base introduced in 1889. It has excellent physical properties but suffers from poor chemical stability[3] and great fire hazard.[4] For these reasons it was gradually replaced by "safety" base made from cellulose acetate and other slow-burning cellulose esters between 1930 and 1950. Nitrate film base is no longer manufactured in the United States. However, considerable quantities of processed nitrate film remain in storage and constitute a possible fire hazard. It also releases nitrogen oxide gases which have a very deleterious effect on other films stored in the same area.[5] Such films should be inspected frequently, and when yellow discoloration or the odor of nitric acid is detected, they should be copied on safety film and the original then destroyed.[6,7]

Cellulose "Diacetate". Organic esters of cellulose are prepared commercially by treating the cellulose with a mixture of an acid anhydride, as esterifying agent; an organic acid, as diluent; and an inorganic acid, as catalyst.[8,9] Cellulose acetate is produced by treating cotton linters or wood cellulose with a mixture of acetic anhydride, glacial acetic acid and a catalyst, such as sulfuric acid.

$$[C_6H_7O_2(OH)_3]_n + 3n(CH_3CO)_2O$$
$$\longrightarrow [C_6H_7O_2(OCOCH_3)_3]_n + 3nCH_3COOH$$

By partially hydrolyzing the triacetate first formed, with acetic acid and water, a product is obtained which contains 38% to 40% acetyl, or about two and a half acetyl groups per glucose unit. This product is often referred to as cellulose diacetate, but actually contains about 2½ acetyl groups per glucose unit. It is soluble in acetone and forms stable films on evaporation.

Cellulose diacetate film base was tried commercially before World War I but its use did not spread until after 1922 whem 16mm amateur movie film was introduced, for which a slow-burning safety base is essential. Its use increased until about 1940. However, it is no longer of major importance since it is less resistant to moisture

than other cellulose esters and is inferior in certain physical properties.

Mixed Cellulose Esters. Organic acid cellulose esters other than cellulose acetate were first used in 1931 in the manufacture of safety film base. Cellulose propionate and cellulose butyrate are more difficult to manufacture than cellulose acetate and suffer from the disadvantages of softness and low strength. However, the mixed esters, cellulose acetate propionate and cellulose acetate butyrate, give products with improved physical properties compared with cellulose diacetate and are easier to manufacture than cellulose propionate or cellulose butyrate.[10] These mixed esters are manufactured by including both acyl components in the esterification bath in the form of acids or anhydrides.

The properties of these mixed cellulose esters depend on (1) the particular acyl groups present, (2) the ratio of acetyl to propionyl or butyryl, (3) the degree of esterification (or conversely the degree of hydrolysis), and (4) the length of cellulose chain.[11] Figure 6-1 shows the chemical composition of cellulose acetates and propionates which are of interest as photographic film supports.[12] Point C represents the cellulose acetate propionate used for amateur color films. Cellulose acetate butyrate finds application in some professional sheet films. Within recent years, the mixed cellulose esters have been replaced in large part by some of the newer type film supports.

Cellulose Triacetate. Fully esterified cellulose triacetate containing three acetyl groups per glucose unit (44.8% acetyl) is shown at point D in Fig. 6-1. It has improved strength and toughness compared with both the diacetate and the mixed cellulose esters.[13] However, methylene chloride is about the only practical coating solvent for cellulose triacetate and it was not available in commercial quantities and at an acceptable price until after World War II. This difficulty retarded the use of cellulose triacetate for film base for a number of years. About 1948 a cellulose "triacetate" corresponding to point B came into use for safety film base in the United States.[12] This material has approximately 43.5% acetyl, the slight re-

Doree, "Methods of Cellulose Chemistry," D. Van Nostrand, Princeton, New Jersey, 1946.

Ott. "High Polymers," Vol. V, Cellulose and Cellulose Derivatives, Parts I and II, Interscience, New York, 1954.

Miles, *Cellulose Nitrate*, Interscience, New York, 1955.

Battista. Fundamentals of High Polymers. Van Nostrand Reinhold, New York, 1958.

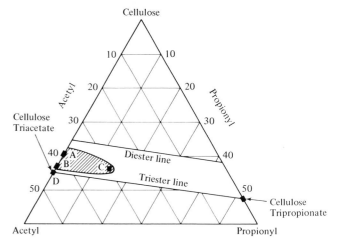

Fig. 6-1. Chemical composition of cellulose esters used in safety film base. A, cellulose diacetate; B, high-acetyl cellulose acetate; C, cellulose acetate propionate; D, cellulose triacetate.

duction in acetyl from the theoretical triacetate being necessary to obtain the desired solubility. The triacetate is manufactured in the same way as the diacetate, except that hydrolysis is stopped at an earlier stage. A similar type of cellulose triacetate film base is now manufactured in Europe and Asia.

Cellulose triacetate provided for the first time a safety base having sufficient toughness for 35mm motion picture film for theater use. Its introduction permitted the manufacture of nitrate base to be discontinued in the United States. Triacetate base is now widely used for many roll and sheet films as well as for motion picture films.

Polyvinyl Chloride. Although some cellulose esters are better than others for film base, their moisture-absorption characteristics result in dimensional changes with relative humidity which are objectionable in certain applications. Consequently, there has been a constant search among various synthetic resins for a plastic material that is unaffected by water and meets the other essential requirements for photographic film base. The first of these synthetic resins to find commercial application as a film support was a rigid polyvinyl chloride acetate. It consisted of approximately 90% vinyl chloride and 10% vinyl acetate and was used to a very limited extent for dimensionally stable graphic arts films between 1945 and 1955. It contained no solvent or plasticizer and was made by calendering between hot rolls. This material is very resistant to moisture, but suffers from a low softening temperature (about 70°C) and from brittleness. An even more serious difficulty is that it was not available in a clear, transparent form but only with a rough surface left by the calendering operation.

Commercial polymers contain 500 to 2000 monomeric units, which correspond to molecular weights of 50,000 to 200,000.

Although polystyrene is soluble in several solvents, it is not practical to cast it into film from solution. Instead it is cast from a melt. In its ordinary form, polystyrene is a rather brittle plastic and is quite unsuitable for film base. However, it was discovered that if a polystyrene sheet were biaxially oriented by stretching in both directions while heated, a remarkable improvement in flexibility occurred.[14]

Oriented polystyrene was introduced as a base for special graphic arts films in 1954 because of its improved dimensional stability.[15] It has excellent moisture resistance and adequate physical properties for most sheet films. However, polystyrene base was never used for aerial or motion picture film, partly because of its low tear resistance and tensile strength characteristics. Polystyrene is also susceptible to stress crazing,[16] sensitivity to which is increased by certain cleaning solvents and staging paints. It also has a low softening temperature (100°C), although not as low as that of polyvinyl chloride-acetate. For these reasons, polystyrene has been replaced by the newer polyester type bases.

Polyethylene Terephthalate. Polyethylene terephthalate is one type of a polyester which was used first as a fiber and is now commonly used for film base. The polymer was discovered by Whinfield and Dickson[17,18] in 1941, but its commercial development has come about largely since World War II. It is made from ethylene glycol and dimethyl terephthalate by ester interchange and polymerization with the elimination of methanol:[19] This polycondensation reaction requires a suitable

Polystyrene. Polystyrene was the second synthetic resin to find use as a moisture resistant film base. This material was not new, having been used for molded articles since 1935. The polymerization of styrene proceeds by heat alone or with the aid of catalysts:

catalyst and heat. As the reaction proceeds, a steady increase in viscosity occurs until the desired molecular weight of about 25,000 is reached.

Terephthalate polyester is insoluble in common solvents and so it is impractical to convert it to film base by solvent casting; instead it is cast from a melt. Polyethylene terephthalate may be amorphous or have various degrees of crystalinity depending on the heat treatment it receives. Excellent physical properties can be obtained by biaxial orientation and suitable heat treatment.[19,20]

Terephthalate polyester film appeared commercially in 1955 and has found a useful place in the graphic arts

Schildknecht, *Vinyl and Related Polymers*, Wiley, New York, 1952. Golding, *Polymers and Resins*, D. Van Nostrand, Princeton, New Jersey, 1959

Schmidt and Marlies, *Principles of High Polymer Theory and Practice*, McGraw-Hill, New York, 1948.

Boundy and Boyer, *Styrene, Its Polymers, Copolymers and Derivatives*, Van Nostrand Reinhold, New York, 1952.

industry in applications where dimensional stability is important.[21,22] It has also proven advantageous for industrial films for the reproduction of mechanical drawings and maps, not only because of its excellent size holding characteristics, but because its high tear strength means longer life for large sheets which must be handled frequently. Terephthalate polyester base is also widely used for x-ray film because of its ease of transport through automatic processing machines. Its toughness and dimensional stability has made it very suitable for aerial films,[23] while its high strength is of benefit for instrumentation films. It has not yet been used to any large extent in the motion picture field[24] because its low solubility creates a splicing problem.[25,26]

Terephthalate polyester film base and cellulose triacetate base rank as the two most widely used film supports in the world today.

Bisphenol-A Polycarbonate. Another polyester film base made from bisphenol-A polycarbonate appeared in Germany in 1957.[27,28,29] One method of preparing this polymer is to start with bisphenol-A which is dissolved in sodium hydroxide solution and treated with phosgene gas. A linear polycarbonate is obtained having a molecular weight up to 150,000:

suitable solvents to form a "dope." Plasticizers are added to the cellulose ester dopes to improve moisture resistance and reduce the burning rate.[34] Triphenyl phosphate is the most common plasticizer for all types of safety cellulose ester film base because it has good retention and is an effective flame retardant. It is used in amounts varying from 5 to 25% of the cellulose ester. These dope solutions are concentrated and very viscous, having the consistency of honey.

The dope solution is usually cast by spreading in a uniform layer on a large heated chromium-faced drum which rotates slowly. Plastic films are formed from the dope by either allowing the solvent to evaporate or by coagulation. The latter is accomplished by chilling a dope in which the polymer is barely soluble or by using a good solvent–poor solvent mixture and evaporating the former. The base becomes firm enough to be stripped off in a continuous sheet before the drum has made a complete revolution (Fig. 6-2). A continuous moving metal belt is also used as a casting surface in some machines. The base is then passed through a series of heated chambers to remove the remaining solvent. In this "curing" operation the tension on the sheet must be carefully controlled because stretching the base tends to orient the cellulose ester molecules in the direction of

Bisphenol-A polycarbonate has found applications in the molded plastics field because of its high impact strength.[30] It has some of the advantages of polyethylene terephthalate for film base (low moisture absorption and improved tear strength) and in addition it is soluble in methylene chloride. Hence, it can be cast from solvents in the same way as cellulose ester films. The polycarbonate can also be extruded from a melt if desired.

Bisphenol-A polycarbonate base has been used to a limited extent for graphic arts films because of its dimensional stability with respect to humidity. However, it lacks the stiffness, toughness, and lower thermal coefficient of polyethylene terephthalate. Very few if any films are coated on this support today.

Manufacture

Solvent Casting of Base. Photographic film base is manufactured either by solvent casting or by melt casting. All cellulose ester base is made by the solvent casting technique,[31,32,33] and polycarbonate base may also be produced by this method. The polymer is dissolved in

stretch. This in turn affects the mechanical and dimensional properties of the film.[35,36]

Where dimensional stability is important, as in motion picture negative films, additional precautions are taken to remove as much of the residual solvent from the support as possible. Film base for these products generally contains less than 1% residual solvent, whereas other types of cellulose ester base may contain up to 8% solvent.

Melt Casting of Base. Polystyrene and polyesters are impossible or impractical to cast from solvents. They can be converted to film base by the melt casting process. The physical properties of the base may be markedly improved by biaxial orientation.[37]

Methods proposed for the melt casting and biaxial orientation of polyesters, such as polyethylene tereph-

V. Stannett, *Cellulose Acetate Plastics*, Temple, London, 1950.
Bernhardt, Processing of Thermoplastic Materials, Van Nostrand Reinhold, New York, 1958.
Simonds, Weith and Schack, Extrusion of Plastics, Rubber and Metals, Van Nostrand Reinhold, New York, 1952.
Williams, *Polymer Science and Engineering*, Prentice-Hall, Englewood Cliffs, New Jersey, 1971.

Fig. 6-2. Schematic diagram of a machine for solvent casting of film base.

thalate, are described in the literature.[19,38] The molten polymer is fed into an extrusion hopper and forced through a long narrow slot onto the casting wheel (Fig. 6-3). The melt is cooled rapidly and then coated with a thin adhesive layer of a co-polymer dispersion. This is followed by the orientation process in which the sheet is stretched in both width and length at a carefully controlled temperature. The original sheet, therefore, must be several times the thickness desired in the finished film base. Stretching the sheet under proper conditions causes the long polymer molecules to become oriented in the plane of the film with resulting improvement in flexibility, strength and other physical properties.

The stretched polyethylene terephthalate film base is next "heat-set" by heating while under tension to a temperature above that used for orientation. Crystallization occurs and the density of the sheet increases. This treatment locks the polymer molecules into place so that subsequent shrinkage of the sheet, at temperatures up to the heat-setting temperature, is practically eliminated.

Surface Coatings on Base. There are at least four different types of surface coatings on the base.

1. Since gelatin emulsions do not adhere to film base, a subcoating (or adhesive layer) is necessary to prevent frilling of the emulsion layer when wet, or stripping and cracking when dry. The type of subcoating is very different for the cellulose ester supports and the polyethylene terephthalate supports.

Cellulose ester film base may be coated with a solution consisting of gelatin and cellulose nitrate, or acetate, dissolved in a mixture of organic solvents and water. During drying, the organic solvents and water evaporate, depositing on the film base a surface layer of gelatin and cellulose nitrate or acetate. The cellulose nitrate deposited results in good adhesion of the subcoating to the film base, whereas the gelatin present ensures good adhesion of the emulsion.

Polyethylene terephthalate may be subbed with a co-polymer layer applied to the film base surface with a thin gelatin layer over this co-polymer layer. The emulsion is subsequently applied on top of the gelatin layer. Typical terpolymer layers are composed of vinylidene chloride, acrylonitrile and itaconic acid.[39]

2. In addition to subadhesive layers, many photographic films have *curl control layers*. Film may curl

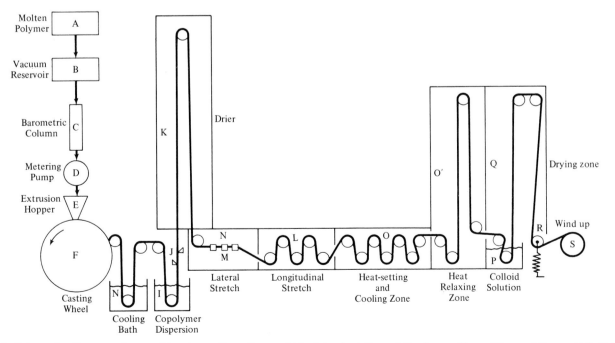

Fig. 6-3. Schematic diagram of a machine for melt casting and biaxial orientation of film base. (From Alles and Saner, U.S. Patent 2,627,088 (1953).

badly due to the contraction of the gelatin emulsion layer at low relative humidities. This curl is counteracted by treating the opposite side of the base so as to cause it to contract equally, but in the opposite direction. In roll film and sheet film, this noncurl coating usually consists of gelatin, whereas in motion picture film a certain degree of control is obtained by treating the back with solvents or solutions of cellulose esters which have a similar effect. In some cases, they also tend to reduce the susceptibility to static electrical discharges upon the unwinding of the roll.

3. Still other types of surface coatings are applications designed to provide *halation protection*. Halation protection is often provided in sheet and roll films by dyes added to the gelatin backing which absorb light but which are decolorized by the processing solutions. In motion picture negative, amateur movie, recording, and amateur roll film, where a gelatin backing might be objectionable, nonhalation properties are obtained by incorporating a suitable light-absorbing material either in a removable or nonremovable backing or in the film base itself.

Dyes for nonhalation backings must have high light absorption in the region of maximum emulsion sensitivity. They must also have no effect on the keeping properties of the film or on the development process. Some nonhalation dyes are completely bleached or removed during processing while others are of low density and are permanent.

4. A fourth type of surface coating are those designed specifically for *static protection*. These may be either highly conducting layers or layers containing matte particles which prevent close surface-to-surface contact and the resulting static generation upon separation.

Film Base Types. There are two basic polymers used today for photographic film base, namely the (1) cellulose triacetate or cellulose mixed esters and (2) polyethylene terephthalate. Each polymer type is manufactured in a variety of thicknesses, depending upon the product requirements.

The most common thicknesses and applications for the cellulose ester film bases are given in Table 6-1.

The base for amateur roll film must be thin enough to permit winding on a small diameter spool and enable the spool to carry the desired length of film. Film used in film packs must have high flexibility because of the sharp radius it must follow when the tab is pulled. Motion picture film requires a thicker base with higher toughness because it has to be transported repeatedly at appreciable speeds by mechanical teeth, which engage in perforations in the film. It must also have good dimensional stability or the film perforations will not mesh properly with the sprocket teeth. Sheet film for portrait or commercial use should be flat under all atmospheric conditions so that it will remain in the focal plane and handle properly. For this reason the base for sheet film is generally made thicker than for other types of film.

The standard thickness for the polyethylene terephthalate film supports are thinner than the corresponding cellulose ester base products because of the greater stiffness and strength of this polyester (Table 6-1).

The thin base polyester support has an advantage for aerial films where long roll lengths are a factor, but where toughness and tear strength are also needed. When dimensional stability is also a requirement, the thicker 0.0040-in. support is used. This is also true for lithographic and drawing reproduction films. X-ray films are used in the heavy 0.0070-in. gauge to provide the desired stiffness for automatic machine processing and to ensure flat film. This thickness also has the best dimensional stability.

Emulsion Coating. Film base is coated with emulsions in rolls 50 in. or more in width and lengths up to several thousand feet. Early techniques of coating used dipping, applicator rolls or doctor blades. These methods were limited in speed and in thickness control. More recent approaches suggested the application of emulsions by pumping the silver salts-gelatin-water mixture through the slot of a hopper.[40] Further improvements featured the coating of several emulsion layers simultaneously

TABLE 6-1. TYPICAL SUPPORT THICKNESSES FOR PHOTOGRAPHIC FILM.

Support type	Cellulose ester			Polyethylene terephthalate				
Nominal thickness, mils	3.5	5.2–5.6	8	2.5	3	4	4.7	7
μ	90	130–140	200	64	75	100	120	180
Aerial Film				x		x		x
Amateur Movie Films		x			x			
Amateur Roll Films	x	x						
Drawing Reproduction Films					x	x		x
Instrumentation Films		x		x		x		
Lithographic Films	x	x		x		x		x
Portrait and Commercial Films			x					x
Professional Motion Picture Films		x			x		x	
Micrographic Films		x	x	x		x		x
X-ray								x

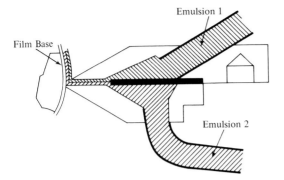

Fig. 6-4. Diagram illustrating principle of multiple layer emulsion coating hopper. (From Russell, U.S. Patent 2,761,418).

through a hopper (Fig. 6-4).[41] This technique allows the curing or drying of these layers simultaneously, thereby reducing the amount of drying equipment. Multiple emulsion layers can also be coated by forming a free-falling vertical curtain of liquid emulsion which impinges on the surface of the moving base.[42]

In addition to multiple emulsion layers for color films, the film base may be coated with a gelatin backing. This is for either curl control, halation protection or both, as described in the previous section. To protect the unprocessed emulsion surface from the photographic effects of abrasion, emulsion layers may be overcoated with a thin gelatin protective layer. It is apparent that the physical structure of photographic film can be quite complex.

It is important that the uniformity and thickness of the applied coatings be held to very rigid specifications because emulsion thickness is very important in controlling the photographic properties of the film. It is also essential that the coating be of uniform thickness over both the width and length of the roll and from one roll of base to another.

Immediately after coating, the film is chilled either by passage through a "chill box" containing refrigerated air or by contact with chilled drums. The emulsion which is normally fluid at temperatures above 90° F sets rapidly to a gel at temperatures of 50° F and below. It can be dried at temperatures approximating those of normal room air without remelting.

The sheet of chilled, coated film is conducted by automatic machinery to the drying room where it is either looped and dried in the form of festoons or carried over an arrangement of rollers continuously through the dryer. The emulsion is dried by clean air of the proper temperature and relative humidity. Drying is a very important operation because lack of uniformity in drying results in a variation in sensitivity.

Cutting and Packaging. The large rolls of film are slit into strips and cut to the desired size.[43] Elaborate testing and inspection of film is carried out at this point by methods which are complicated because film cannot be examined with ordinary illumination. The film is then packed for shipment.

Only specially purified packaging materials can be used because of the danger of chemical or radioactive contamination. Since the advent of the atomic bomb, radioactive fallout from test explosions sometimes contaminates paper and cardboard during their manufacture. Elaborate precautions are necessary to prevent the use of packaging materials containing radioactive particles, since these may expose spots on several layers of film.

The moisture content of the film at the time of packaging must be carefully controlled at some specified equilibrium relative humidity (RH), usually selected between 40 and 60%. Too low a moisture content may result in static marks, and too high a moisture content in tackiness or improper keeping properties. Protection of film against moisture vapor transfer either inward or outward during storage is virtually a necessity, and greatly improved packaging materials and methods have been developed in recent years for this purpose.

Physical Properties

Moisture Properties. A knowledge of the moisture relationships of photographic film is fundamental to an understanding of its physical properties.[35,36,44] At low moisture levels, photographic film can show brittleness, curl, static, or dimensional change; while at high moisture levels problems can arise due to sticking, ferrotyping or high friction.

It should be emphasized that it is the relative humidity, not the absolute humidity, which determines the moisture content of the components of photographic film. Figure 6-5 illustrates the moisture absorption of uncoated cellulose triacetate and polyethylene terephthalate film base. The lower water take-up of the latter is one of the advantages of this material. Properties of other supports are given in Table 6-2. The weight percent of moisture

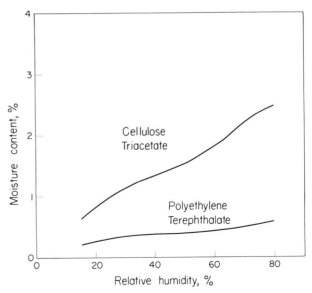

Fig. 6-5. Moisture content of film supports at 70° F.

TABLE 6-2. TYPICAL PROPERTIES OF SEVERAL SUPPORTS FOR PHOTOGRAPHIC MATERIALS.[a]

Property	Cellulose acetate propionate	Cellulose acetate butyrate	Cellulose triacetate	Polyethylene terephthalate	Bisphenol-A polycarbonate	Glass
Specific gravity	1.28	1.24	1.28	1.39	1.20	2.52
Refractive index, N_d	1.48	1.48	1.48	1.64	1.58	1.52
Water absorption, %	6.0	4.5	5.5	0.6	0.4	0.0
Linear swell in water, %	0.8	0.6	0.8	0.10	0.03	0.00
Tensile strength, psi	12,000	10,000	14,000	25,000	11,000	10,000
Ultimate elongation, %	40	50	35	110	90	0.1
Modulus of elasticity in tension, 10^5 psi	4.5	4.0	5.5	6.5	3.5	100
Folding endurance (MIT), No.	40	30	45	>10,000	140	0
Tear resistance, g	45	45	50	150	90	—
Heat distortion temp., °C	150	130	150	175	150	—
Volume resistivity, ohm-cm	10^{16}	10^{16}	10^{16}	10^{19}	—	—
Solubility[b]						
Methyl alcohol	S	S	W	N	N	N
Acetone	S	S	W	N	W–S	N
Methylene chloride	S	S	S	N	S	N
Heptane	N	N	N	N	N	N
Benzene	W	W	N	N	W–S	N

[a]Mechanical tests made at 70° F—50% relative humidity. Support thickness 0.005 in., except polyethylene terephthalate 0.004 in.
[b]S = soluble, N = no effect, W = swells.

in the gelatin layer is more than ten times greater than that in triacetate base (Fig. 6-6).[45] this figure also shows that a photographic emulsion absorbs less moisture than gelatin, the amount depending on the ratio of gelatin-to-silver halide. The greater water absorption of the emulsion layers compared to the base is also reflected in a greater dimensional change with change in relative humidity. This has an important bearing on curl and dimensional stability behavior which will be discussed later.

The percent moisture content of the photographic film falls between that of its individual components. It is not only very dependent upon the characteristics of its individual component layers, but also upon the relative thickness of the emulsion layers and the base. The greater the emulsion thickness, the greater is the water take-up. The strong dependence of moisture content upon the relative humidity and its relative independence on temperature is shown in Fig. 6-7 over a wide temperature range.[46] At constant relative humidity, the absolute humidity of the air decreases markedly as the temperature is lowered from 120° to 45° F, yet the moisture content of the film is relatively unaffected.

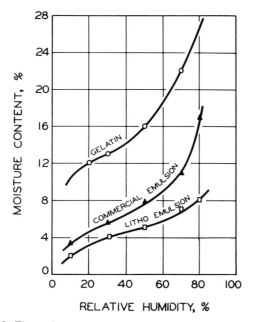

Fig. 6-6. The moisture content of several photographic emulsion layers at 70° F.

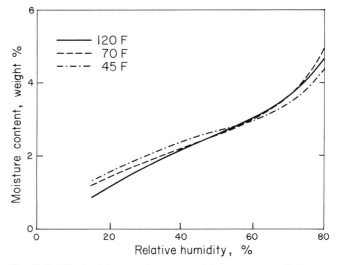

Fig. 6-7. Effect of temperature on moisture content of photographic film on cellulose triacetate base.

The steep slope of these moisture equilibrium curves above 60% RH is noteworthy because it is the clue to the many adverse effects of high relative humidities on film. To eliminate the difficulties which sometimes occur in photographic work under adverse humidity conditions, many professional photographic laboratories are now using automatically controlled air-conditioning equipment.

The graphs presented so far represent the equilibrium moisture content of materials. However, it is extremely important to recognize that the attainment of moisture equilibrium is a time-dependent process. The rate of moisture conditioning is very dependent upon the physical form of the film. A single strip can attain 90% of equilibrium in about one-half hour. However, a solid 16mm roll requires about a week, and wider rolls require still longer (Fig. 6-8).[46] When a roll of film conditions from one equilibrium relative humidity to another, the edges of the film condition first. Therefore, during the time of moisture conditioning, a moisture gradient exists across the width of the film as shown in Fig. 6-9 for a 70mm roll.

The moisture capacities of the different layers in photographic film play an important role in determining the drying behavior after processing. After immersion in processing solutions, the gelatin layers generally contain more water than the base, but they also dry more readily. It is, therefore, possible for the emulsion layers to be very dry when the film emerges from the drying cabinet and the triacetate base to contain an appreciable amount of water.[47] This does not happen with polyethylene terephthalate base because of its low water absorption, but film with a terephthalate base can be more easily overdried.

Mechanical Properties. The strength properties can best be evaluated by the standard tensile stress–strain curve (Fig. 6-10).[48] These properties are primarily determined by the characteristics of the base rather than the emulsion. Figure 12-10 reveals some important differences between polyethylene terephthalate and tri-

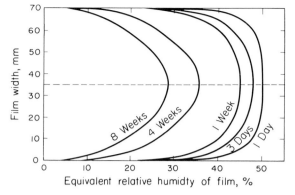

Fig. 6-9. Moisture gradients during conditioning of 70mm roll of polyethylene terephthalate base film from 50 to 5% RH at 70° F.

acetate base film. The yield strength, tensile strength at break and elongation at break are considerably higher for the former (see also Table 6-2). The area under the stress–elongation curve is a measure of toughness, there being approximately a five-fold advantage for the terephthalate polyester. The initial slope of the stress-strain curve is the Young's modulus and reflects the elastic stiffness of the material. Here again the polyethylene terephthalate is superior, having a value of 6.5×10^5 psi compared to 5.5×10^5 psi for the triacetate. The markedly superior strength properties of polyethylene terephthalate allows the manufacture of thinner film support compared to the corresponding triacetate base product. In fact, some photographic film on the terephthalate polyester is manufactured on support which is only 0.0015 in. in thickness.

The high toughness of polyethylene terephthalate is also reflected in the high tear strength of this material. A tear cannot be manually initiated in this film base and can be propagated only with difficulty. The excellent strength, toughness and tear resistance of polyethylene

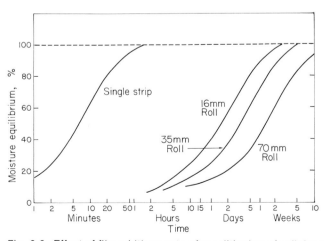

Fig. 6-8. Effect of film width on rate of conditioning of cellulose triacetate base photographic film at 70° F.

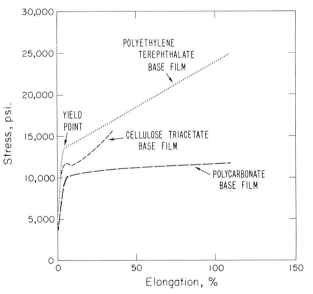

Fig. 6-10. Typical tensile stress-strain curves for photographic film tested at 70° F and 50% RH.

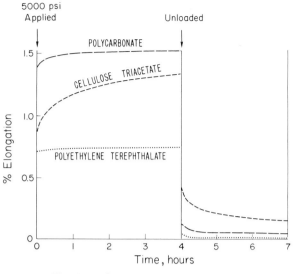

Fig. 6-11. Creep curves of film support.

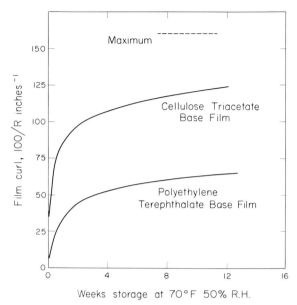

Fig. 6-12. Typical core set growth with storage time. Film wound on 1.25-in.-diameter core.

terephthalate makes it very suitable in applications where film breaks or tear-offs would be disastrous, such as in space photography.

The tensile stress–strain diagrams shown in Fig. 6-10 were obtained in a relatively short time span of a few minutes. When a load is applied over a period of hours or longer, the plastic film supports will show a permanent creep as illustrated by the creep curves in Fig. 6-11. When a tensile load is applied, there is an instantaneous elastic elongation which is inversely proportional to the Young's modulus.[49] Continued application of this load causes further elongation or creep which is much greater for the cellulose triacetate than for the polyethylene terephthalate. This behavior is manifested in practical applications by the greater tendency for the triacetate to flow under external forces or to conform to the core diameter when wound in a roll (Fig. 6-12). Although triacetate shows more core set than polyethylene terephthalate, the core set of the latter is more permanent. It is less easily removed by reverse winding or by photographic processing.

An extremely important mechanical property is film brittleness. Figure 6-13 illustrates the effect of relative humidity on the brittleness of photographic film determined by pulling a loop of film, emulsion side out, through a wedge.[50,51] Above 30% RH, film is not normally brittle; but below 20% RH, brittleness increases rapidly. This is because the gelatin of the emulsion becomes quite brittle at low moisture levels and a sudden crack in the emulsion tends to propagate through the base. Polyethylene terephthalate support has such a high flexibility and toughness that a brittle fracture of the emulsion seldom penetrates the base.

Low temperatures may also have an adverse effect on the flexibility of film. Again, polyethylene terephthalate support has less tendency for complete breaks than the

triacetate base film. However, the tendency towards emulsion cracks is essentially not determined by the support.

When photographic film must be used at either low relative humidity or low temperature, care should be taken not to run the film emulsion-side out over small diameter rollers. Perforated film is more subject to emulsion cracks than unperforated film.

Deformation. The most common type of film deformation is film curl. This is considered the lack of flatness such that the film does not lie in a single plane but takes the approximate shape of the arc of a circle. The inherent tendency of film to curl is caused primarily by the difference in contraction of the emulsion and the

Ferry, *Viscoelastic Properties of Polymers*, Wiley, New York, 1961.
Meares, *Polymers, Structure and Bulk Properties*, D. Van Nostrand, Princeton, New Jersey, 1965.

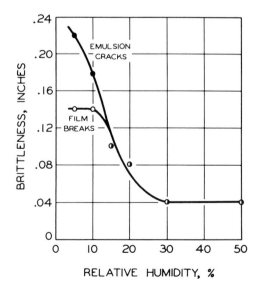

Fig. 6-13. The effect of RH on the wedge brittleness of cellulose triacetate base film at 70° F.

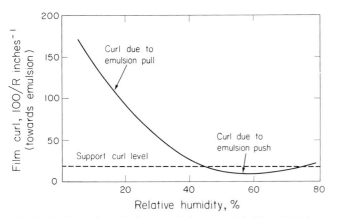

Fig. 6-14. Typical curl behavior of photographic film which has emulsion on one side only.

support when the humidity is lowered.[52] It is generally measured by clamping the film specimens against a template which is marked off with curves corresponding to different radius of curvature levels. Curl is expressed in units of $100/R$ where R is the radius in inches.[53,54]

As was pointed out previously, the curl of film can be reduced or eliminated by the use of gelatin backings which counterbalance the pull of the gelatin at low humidities. However, with some film types, gelatin backings are undesirable, and the film curl increases rapidly as the moisture content decreases (Fig. 6-14). At elevated humidities, the emulsion layers sometimes exert a small push on the support, forcing the curl towards the opposite side.

Film is subject to other types of deformation in addition to curl, e.g., buckle and flute.[55] Buckle occurs when the edges of a roll or the edges of a stack of film sheets become shorter than the interior as a result of differential shrinkage or differential loss of moisture. Flute is the opposite of buckle and occurs when the edges become longer than the center as a result of differential swelling or stretching. Curvature is another type of distortion which occurs when one edge of a strip of film is longer than the other edge.

Dimensional Stability. Dimensional stability is an all-inclusive term. The size changes that take place are quite complex and can occur for a number of reasons. The main ones are as follows:

1. Humidity size changes.
2. Temperature size changes.
3. Changes due to photographic processing.
4. Aging shrinkage.

Each will be discussed in turn, and typical magnitudes are given in Table 6-3.

Humidity Changes. When the relative humidity of the ambient air is raised, photographic film becomes larger in size. Conversely, when the humidity is lowered, the film becomes smaller. This is primarily a reversible or recoverable size change. As with the moisture content of film, this size change is dependent on the relative humidity and not the absolute humidity of the surrounding air.

The magnitude of the humidity size change is very dependent upon the composition of the film base.[22,23] Figure 6-15 illustrates the lower size change for the polyester type support compared to the cellulose ester support. This behavior is expected because of their difference in moisture properties. However, other factors are also very important, particularly the type of emulsion and the gelatin/base-thickness ratio.[45,56,93] The high water absorption of the emulsion layers is reflected in an increased humidity coefficient with increase in gelatin/base ratio.

While humidity changes are largely reversible, they are not completely so. Figure 6-16 illustrates that the dimensions of film are also dependent upon the direction from which the relative humidity was approached. Film is slightly larger when conditioned from a lower rather than a higher humidity. The reasons for this behavior are discussed in the literature.[45]

Temperature Changes. At high temperatures film is slightly larger and, as with humidity, this is largely a reversible change. The coefficient of thermal expansion of the cellulose ester base films is considerably larger than that of the polyester base films (Table 6-3).

TABLE 6-3. APPROXIMATE DIMENSIONAL CHANGE OF SEVERAL TYPES OF BLACK AND WHITE PHOTOGRAPHIC MATERIALS.

Base type	Cellulose triacetate	Polyethylene terephthalate			Paper	Glass
Base thickness, in.	0.005	0.0025	0.004	0.007	0.0025 to 0.015	0.03–0.25
Photographic material	Motion picture negative film	Aerial film	Lithographic, drawing reproduction film	Lithographic, drawing reproduction film	Photographic papers	Photographic glass plates
Humidity Coefficient, %/% RH	0.008	0.003	0.002	0.0015	0.004 to 0.014	0.000
Thermal Coefficient, %/°F	0.003	0.001	0.001	0.001	—	0.00045
Processing Dimensional Change, %	−0.07	−0.06 to +0.03	−0.03 to +0.03	−0.01 to +0.02	−0.8 to +0.2	0.00
Aging Size Change, % (1 year at room conditions)	−0.15	−0.04	−0.03	−0.02	—	0.00

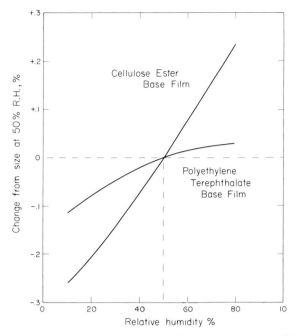

Fig. 6-15. Typical change in dimension of photographic films with RH.

Photographic Processing. Photographic films generally show either a small dimensional shrinkage or swell due to photographic processing. This change is caused by several factors. The cellulose ester films show a shrinkage due to leaching of residual solvents during processing. Additional influences which are important for the melt cast polyester supports are changes in the forces exerted by the gelatin layers on the support. Wetting and drying causes structural modifications in the gelatin, and removal of silver salts decreases the thickness and modulus. The net result is that even for dimensionally stable polyester type supports, the

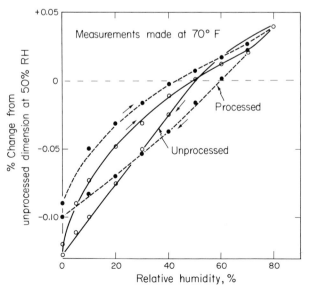

Fig. 6-16. Dimensional changes caused by RH change for unprocessed and processed polyester base film.

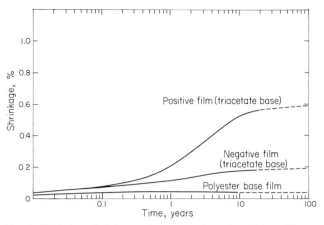

Fig. 6-17. Aging shrinkage of processed motion-picture film at 78° F and 60% RH.

dimensional-humidity loops for the unprocessed and processed film differ (Fig. 6-16).[94] The size change due to processing is the difference between any point within the solid loop (unprocessed film) and the dashed loop (processed film). The magnitude of size change depends upon the relative humidity of use, and the moisture history of both the unprocessed and processed films.

While the magnitude of processing size change is small, these changes can be important when very large sheets are employed or when extremely tight tolerances are required (e.g., aerial photogrammetry or graphic arts applications).

Aging. The cellulose ester films will shrink with aging due to loss of residual solvents. The magnitude of this shrinkage depends upon the amount and type of solvents remaining in the support.[57,58] The aging size change of the polyester is caused by the continual compressive (or squeezing) force of the emulsion on the base. With time, this plastic base will flow or creep (Fig. 6-11), but the aging shrinkage is very much lower than that found with the cellulose ester supports (Fig. 6-17). The thicker polyester supports offer more resistance to the emulsion forces and consequently show less shrinkage (Table 6-3). Aging shrinkage is increased by increase in storage temperature due to greater solvent release from the cellulose esters or from greater creep of the polyesters. High humidity storage may actually result in a slight swell for the polyester base films.

Film dimensional requirements for aerial photogrammetry are very demanding as the degree of film uniformity is of particular concern. Any dimensional change that does occur should be identical in all directions. The photogrammetrist is particularly sensitive to nonuniform dimensional changes. Laboratory studies have shown the superiority of the polyester type film support over the cellulose ester supports.[59–61,95]

Thermal Properties. There has been an increasing demand for photography at both low temperatures and high

Manual of Photogrammetry, 3rd Ed., American Society of Photogrammetry, 1966.

temperatures. Such conditions are found in the exploration of the extremities of the earth, deep oil wells, outer space, and various other scientific work. At low temperatures, brittleness is the usual physical limitation in the use of film. Brittleness increases gradually as the temperature decreases, but there is no specific temperature below which film cannot be used. It should be noted that even at temperatures below 32°F, moisture present in film has a beneficial effect on flexibility. Both still and motion picture photography can be successful at temperatures down to –60°F or below, provided that cameras are winterized (normal lubricants removed from moving parts) and that sufficient care is taken.[62,63]

At elevated temperatures, film gradually becomes softer, weaker, and more easily distorted either by the emulsion or by external stresses. Nevertheless, photographic recordings of instruments lowered into oil wells have been made at temperatures up to about 300°F. However, the film is somewhat distorted in even a few hours at this condition, and most types of photography are limited to considerably lower temperatures. In general the high temperature limit is determined by photographic deterioration of the film which can occur in a few days, rather than by physical weaknesses.[64]

Although flammability was a problem with the very early cellulose nitrate support, it is not with current cellulose ester and polyester materials. These current films pass the American National Standards Institute requirements for slow burning safety films.[65] These films do not ignite at temperatures as high as 900°F.

Surface Properties. Among the surface properties of importance are the abrasion resistance of the film while dry, the abrasion resistance while in processing solutions, the coefficient of friction, and electrical properties.

Dry Abrasion. Since the end use of photographic film is the information provided by the optical image, the need to protect the film surfaces is obvious.[66] Measurements of the haze produced by a stylus point have illustrated the relative ease with which dirt particles can cause damage.[53,66,67] Generally film supports have greater scratch resistance than most emulsions, and black and white emulsions have greater scratch resistance than color emulsions. Emulsions processed without hardener in the fixing bath may be more scratch resistant than if hardener were present.[68]

Abrasion damage can be avoided or minimized if care is taken to keep both the work area and the film clean.[69] For some applications film lubrication is recommended as this decreases the coefficient of friction and thus the tendency for abrasive damage.[67] A simple inclined plane friction test utilizing a paper clip as the contact area has been very useful in detecting film lubrication.[70]

Wet Abrasion. Wet photographic emulsions are quite sensitive to digs and fracture, and this sensitivity is particularly important during photographic processing.[71] Rough handling, dirt particles and contact with abrading surfaces must be avoided. The wet abrasion resistance of emulsion surfaces increases with the amount of hardener in the emulsion or in the processing solution. The resistance to wet abrasion is generally decreased as the processing temperature is increased.

Friction. Friction forces are important in the design of equipment which requires film transport. The level required depends on the particular application. High friction is required for drive rolls but high friction against camera gates can result in sticking. In continuous printers, low friction may cause slippage between the negative and duplicating films. In projectors, too low a friction can cause image unsteadiness and too high a friction can cause excessive wear on film perforations.[70] The importance of friction as it affects abrasion resistance has already been noted.[67]

Electrical Properties. Electrical properties of unprocessed films are of interest as they relate to the discharge of any static electricity and the generation of static marks on the processed film.[72] Although the electrical properties of photographic film are not solely due to surface characteristics, the surface properties are of paramount importance. When photographic film slides over a second material, such as rollers or guides in cameras, the separation of two dissimilar surfaces may cause a static charge. When the electrical conductivity is high, this charge can be dissipated. However, when the conductivity is low, this charge can result in a static discharge with the resultant fogging of the film. Unfortunately, low electrical conductivity can be a problem with some films at low humidities or at low pressures. This problem is aggravated by rapid relative movement between the film and the second surface. Static discharges may also occur during the rapid unwinding of a film roll.

To prevent static discharges, the relative humidity may be raised, the film speed may be decreased, or it may involve substitution of other materials which contact the film.

Chemical Stability. The chemical stability of photographic films is of interest if the processed photographic record is to be stored for any period of time. Poor chemical stability was one of the problems of the now obsolete cellulose nitrate support. However, the current cellulose ester and polyester based films[73] have excellent stability and, when properly processed, they meet the requirements of the American National Standards Institute for archival film.[74,75] These archival standards only apply to conventional black and white silver images. Color films may show dye fading with time and require more stringent storage conditions for preservation of the image.[46]

It must be recognized that satisfactory keeping behavior requires not only films of archival quality, but satisfactory storage conditions. These have been described by the American National Standards Institute for both microfilm[76] and for other film types.[77]

PHOTOGRAPHIC PAPER

Paper is generally used when an opaque base is required, where cost is important, or where the physical property requirements are not too severe.

Manufacture

Raw Materials. Although some photographic papers are made from rags, most of the high volume grades are made from wood fibers. A variety of wood pulps in both the hard and soft wood species are used. Pulps made using the sulfite process have been the primary source of supply; but recently, highly bleached Kraft pulps are finding more acceptance in this field. Pulp used in the manufacture of photographic paper must be highly purified to ensure permanent brightness and strength, and be free from foreign substances that would affect the photographic layers.

Most pulps contain blends of hardwood and softwood fibers. The dimensional stability and mechanical properties of the photographic paper are greatly influenced by the blend used. Softwood fibers vary between 0.1 and 0.2 in. in length and 0.0010 to 0.0025 in. in diameter. Hardwood fibers are smaller, averaging 0.04 to 0.08 in. in length and 0.0005 to 0.0020 in. in diameter.[78]

Paper is formed from an aqueous suspension of the fibers. Before formation of the sheet, itself, the slurry of fibers is refined in one or more types of equipment such as beaters, jordans, or disc refiners.[79,80] This treatment causes fibrilation, thereby increasing surface area, increases fiber flexibility and reduces fiber length. This contributes to greater paper strength and to a more uniform paper sheet.

A variety of chemicals can be used in photographic paper to increase dry and wet strength, and to increase resistance to penetration by coated layers and processing solutions. Gelatin and starch are usually added to the fiber slurry, and either sodium stearate or sodium rosinate is included as the basic sizing material. After the refining operation, either alum or alumium chloride is generally used to precipitate the stearate or rosin on the fibers. Since both the sizing material and the cellulose fibers are electrostatically negative, the positively charged aluminum ions attract the sizing to the fibers. Photographic paper must withstand the action of acid and alkaline processing solutions, and a wet strength agent such as melamine formaldehyde added to the fiber slurry accomplishes this purpose.

Paper Making. Although there are a number of types of paper-making machines, along with many variations and modifications, the general method is essentially the same for all. Figure 6-18 is a schematic diagram of a Fourdrinier paper machine.[80] The aqueous fiber slurry first passes through the screens (Y) to the headbox (X) and then out through an orifice or slice (Z) onto a moving, continuous wire screen (A). Water drains through the wire, leaving a fiber mat, and additional water is removed by suction boxes (G). The paper web then passes through several wet presses (K1K2 and P) to compact the sheet and remove more water. The remaining water is evaporated in the dryers (H) and the paper is then calendered (R) to impart the proper compaction and surface characteristics.

There are many factors in the paper machine which influence the structure of the paper sheet and consequently its physical properties. These include the consistency and temperature of the fiber slurry and the ratio of the slurry velocity at the slice and the moving wire speed. As the fiber slurry flows beneath the slice, the

Wet End of Machine

Dry End of Machine

Fig. 6-18. Schematic diagram of Fourdrinier paper machine: A, wire; B, couch roll; C, breast roll; D, table rolls; E, wire and stretch rolls; G, suction boxes and guide roll; H, dryers; J, press felt; K_1, K_2, first press; L, stretch rolls; M, rider roll; P, second press; R, calender stack; S, slitter; T, reel; U, universal reel stand; W, winder; X, headbox; Y, screen; Z, slice. (From J. H. Stephenson, *Manufacturing and Testing of Paper and Board*, Vol. 3, McGraw Hill, New York, 1953.)

fibers align themselves parallel to the direction of flow. The "combing" action of the wire on the fiber slurry tends to retain more fiber alignment in the machine direction on the wire side, while the fluid dynamics of the system reduces the tendency for fiber alignment through the thickness of the paper toward the face side.

In addition to removing water from the wet sheet, the wet presses perform two functions important to paper making. Fibers are pressed to within capillary distances of each other at crossing points. When water is evaporated from these capillaries in the drying operation, atmospheric pressure forces fiber surfaces within molecular distances of each other, thus promoting hydrogen bonding between adjacent fibers. The strength that paper develops is the result of these secondary valence bonds. The flow of water form the nip in each wet press also aligns fibrils (threadlike association of cellulose crystallites) on the surface of the fibers, parallel to the machine direction. Cross bonding of these fibrils on adjacent fibers contributes to a length–width imbalance of physical properties. This length–width imbalance is also augmented by a machine direction stretching of the paper as it passes through the dryer and calendering sections of the machine. The tendency of the paper to shrink in the cross direction is partially prevented by mechanical restraints. These factors create "dried-in-strains"[81] that can be partially relieved by subjecting paper to either high humidity or to a water soak.

The dryer sections of paper-making machines consist of an upper and lower tier of dryer drums. The paper is threaded alternately over an upper drum, then around a lower drum in sequence through the entire dryer section. The driving force is thus alternately from the wire side and from the face side. This differential drying can also create differential strains in the two sides of the paper that influence potential curl of the paper.

Surface Coatings. Although some photographic grades are sensitized after the paper-making operation without further treatment, many receive one or more treatments prior to application of the light-sensitive layer. A gelatin coat is sometimes applied to prevent excessive penetration of the light-sensitive layer (emulsion) and/or to ensure good adhesion of the emulsion layer to the paper. On other grades one or more layers of baryta (barium sulfate with a gelatin binder) are applied to improve opacity and brightness. These baryta coats are calendered when smooth glossy surfaces are required, or are embossed when textured surfaces are desired.

More recently, pigmented plastic layers are applied to the paper base instead of baryta layers. These layers prevent the paper base from absorbing moisture during photographic processing, reduce the drying load, and permit increased processing speeds. When these plastic layers are sufficiently smooth, the ferrotyping step normally employed with glossy photographs can be eliminated.

Photographic emulsions are applied to paper by methods which are very similar to those described for photographic film.

Paper Types. Papers for photographic bases differ in three particulars: thickness or weight, surface, and color.

Photographic papers may vary from 0.0025 to 0.015 in. in thickness. Different thicknesses of paper are usually classified by weight, a standardized measure of weight being pounds per 1000 square feet.[82] Various weights of paper are:

1. light weight (10 pound)
2. single weight (27 pound)
3. medium weight (40 pound)
4. double weight (50–55 pounds)

The thinnest of the lightweight grades is used for instrument recording work where maximum footage in small diameter rolls is important and in such fields as document and engineering drawing reproduction where the photographic reproduction is to be used as a printing master. Lightweight grades are also chosen where bulk and weight are considerations in filing and mailing and where a flexible sheet is required for folding or constant handling. Single weight paper is ordinarily used for small prints (e.g., snapshots) or for prints to be mounted to solid mounts. Double-weight papers are preferred for those left unmounted or not mounted solidly.

The surface of papers is greatly influenced by the degree of calendering. Some paper types, such as portrait grades, are embossed to impart the desired effect and then calendered lightly to preserve this surface. Paper surfaces are described by terms such as "texture" and "brilliance." Texture covers the smoothness of the sheet and ranges from descriptive terms such as "smooth" through "pebbled" or "fine-grained" to "silk" and "rough." Brilliance describes the sheen of the print and varies from "glossy" to "matte." The many commerically available photographic papers provide the user a variety of combinations of texture and brilliance to produce the desired end effect in the finished print.

The usual colors, or tints, are (1) white, (2) natural, or cream white, and (3) buff, also known as old ivory.

Physical Properties

Moisture Properties. Within the range of normal room temperatures (approximately 60° to 90° F), the moisture content of paper is largely determined by relative humidity. At higher temperatures, the moisture content is also influenced by temperature. The relationship between moisture content and relative humidity is an isotherm with separate curves for ascending and descending conditions. Although the equilibrium moisture content will vary with the type of pulps and the refining operation, Fig. 6-19 is typical for photographic papers. The sizing added in the paper-making operation significantly reduces the rates of water absorption, but the equilibrium levels are relatively unaffected. A comparison of Figs. 6-5 and 6-19 show the much greater moisture absorption of paper compared to plastic film supports. This is one reason for their lower dimensional stability.

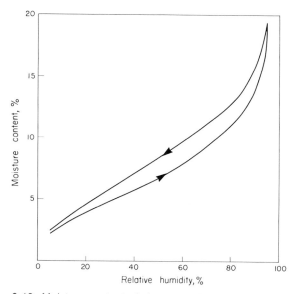

Fig. 6-19. Moisture content of photographic paper base at 70° F.

Mechanical Properties. As with film supports, many of the important mechanical properties of paper can be determined by the tensile stress–strain curve.[83] Typical stress–strain curves are shown in Fig. 6-20 for four photographic papers of different weights. (In the paper industry, tensile strength is expressed in pounds per inch of width for a given weight paper.)

It is apparent that the tensile strength of paper is greater in the length direction, but the elongation is greater in the width or cross direction. As discussed earlier, this anisotropic property of paper accrues from the nature of fiber structure, partial fiber alignment at the slice, machine direction alignment in the wet presses, and the stretching action through the drying sections. In the cross direction there is a direct relationship between tensile strength and weight of the paper, and an inverse relationship between elongation and weight of the paper. Although heavier papers in general also have the greater strength along the length, the kind of fiber, degree of bonding, and amount of strain hardening due to stretch also have an effect. Unlike many viscoelastic materials, paper does not exhibit a definite yield point.

Tensile strength of paper decreases as moisture content increases due to disassociation of bonds between fibrils on adjacent fibers. However, elongation of the paper increases with increasing moisture content since the fibers are more flexible. Although wet strength additives are used in the manufacture of photographic paper, disassociation of hydrogen bonds between fibers is so extensive in the aqueous solutions used to develop and fix the photographic image, that wet tensile strength can be as low as 30% of dry tensile strength. This value may range from 900 psi for the double-weight professional papers to 1500 psi for the thinner commercial papers.

Stiffness is another important property of photographic paper. Stiffness increases with weight of paper, and the length stiffness is significantly greater than stiffness in the cross direction. Orientation in the machine direction results in a higher lengthwise modulus of elasticity and accounts for this higher length stiffness.

Tear resistance is of particular interest in applications where webs of paper are transported over equipment such as in printing or in processing operations. Figure 6-21 illustrates the marked effect of paper weight on the force required to propagate a paper tear.[84] It is also apparent that tear propagation strength increases with increasing relative humidity. This relationship parallels that of tensile elongation. It must be recognized that the resistance various papers offer to continuation of a tear already started by an edge nick can be significantly different from the resistance to tear where no edge flaws existed prior to application of stress. In the latter case, the resistance to creation of a tear also increases with paper weight and relative humidity. Tear initiation forces are significantly greater in the machine or length direction than in the cross direction, whereas the tear propagation forces for photographic paper are similar. Therefore,

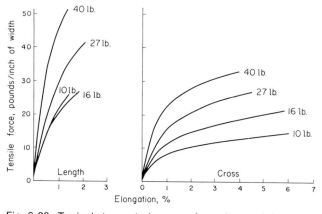

Fig. 6-20. Typical stress-strain curves for various weight papers.

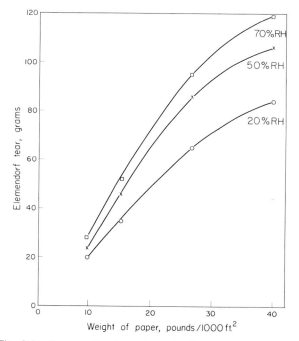

Fig. 6-21. Propagation tear strength of photographic paper.

it is apparent that propagation tear and initiation tear will not necessarily correlate.

The causes of brittleness in photographic paper are similar to those in photographic film. Although special addenda are added to photographic emulsions, emulsion layers are still relatively brittle and subject to cracking under adverse handling conditions. When photographic paper is flexed, surfaces on the outside of the curvature are under tension, and on the inside of the curvature are under compression. The magnitude of these tensile and compressive forces acting to crack photographic layers increases significantly as the paper thickness increases. As with photographic films, the resistance to emulsion cracking also decreases as the relative humdity decreases.

Deformation. Photographic paper is manufactured so that it is relatively flat between 30 and 60 % relative humidity. However, as discussed previously, emulsion layers tend to contract at low relative humidities. Consequently, at low humidities paper may exhibit a curl towards the emulsion side.[85] In fact, if paper is first subjected to high then low humidity conditions, emulsion-side curl can be severe.

When photographs are processed in cut sheet form, processing curl can be encountered. This is caused by the back or wire side of the paper becoming wet and beginning to expand prior to the expansion of the face side of the paper (under the emulsion layer). This can force the photographs into face curl (i.e., curl towards emulsion side). When liquid penetrates through the emulsion layer and wets the face side of the paper, it also begins to expand. Since wire side expansion occurs before the interior of the paper is wetted, this energy is expended against a fairly stiff mass, and part of the expansion occurs as an increase in thickness. Expansion of the face side of the paper occurs when the paper is limper, and final curl in the hypo or wash water can be toward the back of the paper. These types of curl are not as prone to appear with web processing on continuous machines and are not a problem with the newer plastic coated paper bases.

Post process curl can also be a problem if proper drying procedures are not followed. Since the gelatin in the emulsion layer can develop greater stress than the paper base on drying, conditions should be adjusted to dry the emulsion side before the wire side of the paper. This allows the wet paper to adjust to the emulsion contraction by a dimensional adjustment rather than by curling. In mechanical dryers, it is also important to dry the emulsion layer to moisture levels below that in equilibrium with ambient conditions. Continued drying of the emulsion layer without mechanical restraint will cause face curl particularly on thin paper supports.

Dimensional Stability. *Humidity Changes.* When cellulose absorbs moisture, it expands; and it shrinks when it desorbs moisture.[86] Dimensional changes of paper as a result of moisture exchange, however, are also influenced by the mechanical effects in the paper-making process. The level and nature of these moisture changes are a function of the paper grade, paper machine

design, operational variables, and vary across the width of the paper-making machine. A typical dimensional-humidity loop is shown in Fig. 6-22. As relative humidity increases, paper expands a significantly greater amount in the cross direction than in the machine direction because, during the paper-making operation, the paper was stretched in the machine direction and shrank in the cross direction. As the humidity decreases, the machine direction of paper follows a lower curve than it followed with increasing humidity due to release of dried-in strains. This results in a permanent shrinkage. However, in the cross direction the paper shows normal hysteresis behavior and follows a desorption curve of greater dimensions.

The release of these dried-in strains are not completely accomplished by many humidity cycles, nor by repeated soaking in water. These characteristics are typical of all machine-made paper and are not peculiar to photographic papers. Compressive strains in the thickness dimension of paper imposed by the calendering operation are also partially relieved (the thickness increases) in high humidity and to a larger degree in aqueous solutions.

The humidity size change of paper can range from 0.004 to 0.014% per percent relative humidity, depending upon the type of paper, the direction of testing, the humidity range, and whether the humidity is increasing or decreasing. The latter value is considerably higher than found with photographic film (Table 6-3).

Temperature Changes. The thermal coefficient of paper cannot be accurately determined since the thermal expansion is dwarfed by moisture changes when the temperature is varied. Thermal coefficients are much less important than humidity effects because of the relatively narrow temperature range in which these materials are generally used.

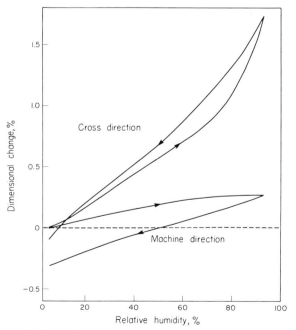

Fig. 6-22. Typical change in dimension of photographic paper with RH.

Photographic Processing. The size change of photographic paper due to processing may vary from +0.2 to –0.8%, depending on the type of paper and the paper direction. Of particular importance is the method of drying. If high temperature drying is used, it will tend to have greater contraction than under low temperature drying. If the paper is dried under tension, as for example between belts on a mechanical dryer or on a hot ferrotype drum, the expanded size of the wet paper will be maintained in the cross direction. The final dried print will actually be larger in this dimension than the original unprocessed sheet. In the case of very large sheets dried by hanging, the actual weight of the paper may counter contraction somewhat in the vertical dimension. Because of the orientation of the paper fibers during manufacture, the processing dimensional changes are generally greater in the lengthwise than in the widthwise direction.

Papers coated with plastic layers are considerably more water resistant. However, although these coatings improve the water resistance, it does not make the paper waterproof. With products of this type, dimensional stability is appreciably better than regular papers. If these type papers are exposed to processing solutions and wash water for long periods of time, the water repellent layer is penetrated, thereby losing its advantage. However, these times are considerably longer than recommended processing times.

To obtain the maximum dimensional stability of photographic paper, the paper should be conditioned prior to exposure to the same relative humidity that the processed print will be used. Size change due to processing can be minimized by air drying the prints at room temperature or by using a double belt heated drum dryer operating at the lowest required temperature. Processing times should also be kept as short as possible.

PHOTOGRAPHIC PLATES

Photographic glass plates are used where the ultimate in dimensional stability is required. This advantage must be balanced against the limitations of weight and fragility.

Manufacture

Photographic Plate Making. The glass used for photographic plates is made from soda, lime and silica. These materials are melted at high temperatures in an enclosed refractory furnace. The glass sheet is made from the molten material by mechanized drawing equipment which controls the width and the thickness. The glass solidifies as a supercooled liquid and has no molecular orientation or grain. Glass for photographic purposes must be clear, free from color, bubbles, striae and other imperfections, and reasonably flat.

Three types of glass are used for photographic plates.

1. Sheet glass is manufactured by flat drawing directly from the melt and then annealed. This method of production results in a brilliant fire-polished surface. Most photographic plates that are less than 0.25 in. in thickness are manufactured from sheet glass.

2. Polished plate glass is obtained by grinding and polishing glass to its desired thickness. It is characterized by excellent flatness, low waviness, but a less brilliant surface than sheet glass. This type of glass is usually supplied in thicknesses greater than 0.25 in.

3. Float glass is produced by floating a continuous web of glass on the surface of molten metal. This causes a very flat product and avoids pits which may be formed by grinding and polishing.

An emulsion coated directly on glass has a tendency to frill when wet or to strip off when dry. The surface of the glass, therefore, must first be treated to obtain good adhesion of the emulsion layer. The glass substratum ordinarily consists of a thin coating of gelatin strongly hardened by chrome alum, or chemical etching may be employed.

Glass plates are coated with emulsion by a machine which spreads a thin and uniform layer of emulsion over the glass plates as they are conducted past the coating apparatus on a moving belt. After being coated with the emulsion, the plates are carried on a movable belt through a cold chamber in which the emulsion is chilled and set to a gel. Upon reaching the end of the conveyor system, the plates are removed and dried under controlled conditions.

Plate Types. Photographic glass plates are characterized by their degree of flatness. Flatness has been defined in Federal specifications[87] as the departure from a true plane in decimal parts of an inch per linear inch of surface. However, for most commercial applications, flatness is defined in terms of "overall limits." They are expressed in inches and are defined as follows: All points on the glass surface (emulsion-coated side only) will be between parallel planes separated by a distance no greater than the "overall limit." The "overall limit" for each flatness type can be calculated from the formulas listed below. The four categories of glass plates are specified as follows:

1. Type I (Selected Flat glass base) shall have an overall limit of $7.1 \times 10^{-4} \times$ diagonal (inches). This type of glass is used where a lower order of flatness is acceptable, such as in photomicrography or graphic arts.

2. Type II (Ultra Flat glass base) shall have an overall limit of $3.5 \times 10^{-4} \times$ diagonal (inches). This higher degree of flatness finds use in photofabrication and photogrammetric stereo-plotting instruments.

3. Type IIa (Precision Flat glass base) shall have an overall limit of $3.5 \times 10^{-5} \times$ (diagonal)2 (inches). This degree of flatness is available on 0.060-in. thick glass only, and finds use primarily in photofabrication applications.

4. Type III (Micro Flat glass base) shall have an overall limit which is determined by the size of the plate. The various overall limits are defined in the table below:

Plate Diagonal (in inches)	Overall Limit
Up to and through 8	$4 \times 10^{-5} \times$ diagonal (inches)
Over 8, through 13	$5 \times 10^{-5} \times$ diagonal (inches)
Over 13, through 16	$6 \times 10^{-5} \times$ diagonal (inches)
Over 16, through 19 (applied to center 16 in. diameter)	$6 \times 10^{-5} \times$ diagonal (inches)

This type of plate is used where the very highest precision is required, such as in ballistic and aerotriangulation camera systems and for first-order stereoplotters. The flatness of this class is exceeded only by that found on high grade optical flats.

Glass plates are supplied in a range of nominal thicknesses, varying from 0.030 to 0.250 in., although all plate sizes are not available in each thickness. An American National standard specifies the more representative plate dimensions in current use.[88]

Physical Properties

Mechanical Properties. The mechanical properties of glass are compared to those of film support in Table 6-2. While it has satisfactory tensile strength, it has essentially no elongation. This results in a low toughness or brittle material. Glass is stronger under momentary stresses than under prolonged loading. It does not undergo plastic deformation.

Glass has very high stiffness as shown by the high value for modulus of elasticity. This property is the reason why glass resists the forces of the emulsion layer and exhibits a very high order of dimensional stability. However, glass can bend and in very precise work it is important that photographic glass plates be mounted so that they do not sag under their own weight.[89] Glass is harder than mild steel but can be scratched by hard steel.

Optical Properties. The need for optical clarity and freedom from blemishes in glass plates has already been pointed out. Glass has very high transmission characteristics, with a maximum of 91% in the visible region. The transmission falls off sharply in the ultraviolet, becoming opaque at 310 nm. In the infrared region, transmission extended to 2500 nm. The refractive index of glass is about 1.52.

Dimensional Stability. The dimensional stability of glass is unsurpassed by any other photographic material.

Humidity Changes. Glass does not absorb water or water vapor and consequently it does not exhibit any size change with humidity. As with photographic film and paper, the emulsion layers readily absorb moisture (Fig. 6-6). However, unlike these materials, the glass plates have sufficient stiffness to provide much more resistance to size change due to the contracting force of the emulsion layer. Under conditions of very large humidity changes, these emulsion forces can cause a slight bowing or bending of the glass.

Temperature Changes. Glass does have a coefficient of thermal expansion, but it is less than half that for the dimensionally stable polyester film base (Table 6-3). In practical applications, only very large temperature changes need to be considered. These dimensional changes are reversible.

Photographic Processing and Aging. Photographic glass plates do not show size change due to either processing or to aging.

Nonuniform Dimensional Changes. Glass plates used in aerial photogrammetry must exhibit uniformity of dimensional change. The very low order of magnitude of random dimensional displacements has been established by a number of studies.[59,90,91] These small changes are consistently less than found with photographic film. They are only of concern in applications requiring the very highest precision, such as analytical photogrammetry or special scientific applications.

Chemical Stability. The chemical stability of glass photographic plates is excellent. There are many examples of photographic plates dating back to the early nineteenth century which are in very good condition. However, as with film, good keeping characteristics also require good processing and good storage conditions. These have been described in an American National Standard.[92]

REFERENCES

1. W. N. Haworth and H. Machemer, "Polysaccharides," Part X. "Molecular Structure of Cellulose," *J. Chem. Soc.* Part II: 2270–2277 (1932).
2. H. Staudinger and I. Jurisch, "Micromolecular Compounds," *Kunstseide u. Zellwolle*, **21**: 6–9 (1939).
3. J. R. Hill and C. G. Weber, "Stability of Motion Picture Films as Determined by Accelerated Aging," *J. Soc. Motion Picture Engrs.*, **27**: 677–690 (Dec 1936).
4. R. H. Nuckolls and A. F. Matson, "Some Hazardous Properties of Motion Picture Film," *J. Soc. Motion Picture Engrs.*, **27**: 657–661 (Dec 1936).
5. J. F. Carroll and J. M. Calhoun, "Effect of Nitrogen Oxide Gases on Processed Acetate Film," *J. Soc. Motion Picture Television Engrs.*, **64**: 501–507 (Sep 1955).
6. J. W. Cummings, A. C. Hutton and H. Silfin, "Spontaneous Ignition of Decomposing Cellulose Nitrate Film," *J. Soc. Motion Picture Television Engrs.*, **54**: 268–274 (Mar 1950).
7. J. M. Calhoun, "Storage of Nitrate Amateur Still-Camera Film Negatives," *J. Biol. Photogr. Assoc.*, **21** (3): 1–13 (Aug 1953).
8. C. J. Malm, L. J. Tanghe and B. C. Laird, "Preparation of Cellulose Acetate: Action of Sulfuric Acid," *J. Ind. Eng. Chem.*, **38**: 77–82 (Jan 1946).
9. C. J. Malm and L. J. Tanghe, "Chemical Reactions in the Making of Cellulose Acetate," *J. Ind. Eng. Chem.*, **47**: 995–999 (May 1955).
10. H. T. Clarke and C. J. Malm, "Making Cellulose Esters and the Products Resulting Therefrom," U.S. Patnet 2,048,685 (July 1936).
11. C. J. Malm, C. R. Fordyce and H. A. Tanner, "Properties of Cellulose Esters of Acetic, Propionic and Butyric Acids," *J. Ind. Eng. Chem.*, **34**: 430–435 (Apr 1942).
12. C. R. Fordyce, "Improved Safety Motion Picture Film Support," *J. Soc. Motion Picture Engrs.*, **51**: 331–350 (Oct 1948).
13. C. J. Malm, J. W. Mench, D. L. Kendall and G. D. Hiatt, "Aliphatic Acid Esters of Cellulose," *J. Ind. Eng. Chem.*, **43**: 688–691 (Mar 1951).
14. J. Bailey, "Stretch Orientation of Polystyrene and its Interesting Results," *India Rubber World*, **118**: 225–231 (May 1948).
15. T. J. Farrell, R. F. Kugler and D. I. Mayne, "Photographic Element Having a Polystyrene Support," U.S. Patent 2,816,027 (Dec 1957).
16. B. Maxwell and L. F. Rahm, "Factors Affecting the Crazing of Polystyrene," *J. Soc. Plastic Engrs.*, **6**: 7–11 (Nov 1950).
17. J. R. Whinfield and J. T. Dickson, "Improvements Relating to the Manufacture of Polymeric Substances," Brit. Patent 578,079 (July 1941); Polymeric Linear Terephthalic Esters, U.S. Patent 2,465,319 (Mar 1949).
18. J. R. Whinfield, "Chemistry of Terylene," *Nature*, **156**: 930–931 (Dec 1946).
19. R. A. Hudson, "Production, Properties and Applications of the New British Polyethylene Terephthalate Film," *Brit. Plastics*, **26**: 6–9 (Jan 1953).

20. L. E. Amborski and D. W. Flierl, "Physical Properties of Polyethylene Terephthalate Films," *J. Ind. Eng. Chem.*, **45** (10): 2290–2295 (Oct 1953).

21. J. M. Centa, "Performance Characteristics of 'Cronar' Polyester Photographic Film Base," *Photogram. Eng.*, **21**: 539–542 (Sep 1955).

22. J. M. Centa, "Effect of Base and Emulsion Thickness on Dimensional Stability of Graphic Arts Film," *Proc. Tech. Assn. Graphic Arts*, Part A, **8**: 75–79 (May 1956).

23. J. M. Calhoun, P. Z. Adelstein and J. T. Parker, "Physical Properties of ESTAR Polyester Base Aerial Films for Topographic Mapping," *Photogram. Eng.*, **27**: 461–470 (June 1961).

24. D. R. White, C. J. Gass, E. Meschter and W. R. Holm, "Polyester Photographic Film Base," *J. Soc. Motion Picture Television Engrs.*, **64**: 674–678 (Dec 1955).

25. V. C. Chambers and W. R. Holm, "A Method for Splicing Motion Picture Film," *J. Soc. Motion Picture Television Engrs.*, **64**: 5–8. (Jan 1955).

26. R. W. Upson, E. Meschter and W. R. Holm, "A Method Using Dielectric Heating for Splicing Motion Picture Film," *J. Soc. Motion Picture Television Engrs.*, **66**: 14–17 (Jan 1957).

27. H. Schnell, "Polycarbonate, eine Gruppe neuartiger Thermoplastischer Kunststoffe," *Angew. Chem.*, **68**: 633–640 (Oct 1956).

28. L. Bottenbruch and H. Schnell, "Verfahen zur Herstellung Thermoplastischer Kunststoffe," Ger. Patent 959,497 (Mar 1955).

29. H. Schnell, "Linear Aromatic Polyesters of Carbonic Acid," *J. Ind. Eng. Chem.*, **51**: 157–160 (Feb 1959).

30. R. J. Thompson and K. B. Goldblum, "Polycarbonate Resin," *Mod. Plastics*, **15**: 131–135 (Apr 1958).

31. E. K. Carver, "The Manufacture of Motion Picture Film," *J. Soc. Motion Picture Engrs.*, **28**: 594–603 (June 1937).

32. S. E. Sheppard and P. T. Newsome, "Film Formation with Cellulose Derivatives," *J. Soc. Chem. Ind.*, **56**: 256–261 (Aug 1937).

33. D. Sheffield, "Enterprise in the Constable Country," *Brit. J. Photogr.*, **105**: 381–390 (July 1958).

34. C. R. Fordyce and L. W. A. Meyer, "Plasticizers for Cellulose Acetate and Cellulose Acetate Butyrate," *J. Ind. Eng. Chem.*, **32**: 1053–1060 (Aug 1940).

35. J. M. Calhoun, "The Physical Properties and Dimensional Behavior of Motion Picture Film," *J. Soc. Motion Picture Engrs.*, **43**: (4): 227–266 (Oct 1944).

36. J. M. Calhoun, "The Physical Properties and Dimensional Stability of Safety Aerographic Film," *Photogram. Eng.*, **13**: 163–221 (June 1947).

37. C. P. Fortner, "Biaxially Oriented Methacrylate and Polystyrene Sheet," *J. Soc. Plastics Engrs.*, **9**: 21–39 (May 1953).

38. F. P. Alles and W. R. Saner, "Manufacture of Photographic Films and Polymeric Linear Esters of Dicarboxylic Acids with Dihydric Alcohols," U.S. Patent 2,627,088 (Feb 1953).

39. F. E. Swindells, "Photographic Elements," U.S. Patent 2,698,235 Dec 1954).

40. A. E. Beguin, "Method of Coating Strip Material," U.S. Patent 2,681,294 (June 1954).

41. T. A. Russell, R. M. Wilson and C. R. Sanford, "Multiple Coating Apparatus," U.S. Patent 2,761,417 (Sep 1956).
 J. A. Mercier, W. A. Torpey and T. A. Russell, "Multiple Coating Apparatus," U.S. Patent 2,761,419 (Sep 1956).

42. D. J. Hughes, "Method for Simultaneously Applying A Plurality of Coated Layers by Forming a Stable Multilayer Free-Falling Vertical Curtain," U.S. Patent 3,508,947 (Apr 1970).

43. The cutting and perforating dimensions for most sizes of film have been standardized by the American National Standards Institute, Inc., 1430 Broadway, New York, N.Y. 10018, from whom copies of such standards may be obtained.

44. E. K. Colton and E. J. Wiegand, "Moisture in Photographic Film and Its Measurement," *Photogr. Sci. Eng.*, **2** (3): 170–176 (Oct 1958).

45. J. M. Calhoun and D. A. Leister, "Effect of Gelatin Layers on the Dimensional Stability of Photographic Film," *Photogr. Sci. Eng.*, **3** (1): 8–17 (Jan 1959).

46. P. Z. Adelstein, C. L. Graham and L. E. West, "Preservation of Motion Picture Color Films Having Permanent Value," *J. Soc. Motion Picture Television Engrs.*, **79**: 1011–1018 (Nov 1970).

47. B. C. Michener, "Drying of Processed Aerial Films," *Photogram. Eng.*, **29**: 321–326 (Mar 1963).

48. *American Society of Testing and Materials*, Tensile Properties of Thin Plastic Sheeting, D882-73. Copies of Standard may be obtained from ASTM Headquarters, 1916 Race Street, Philadelphia, Pa. 19103.

49. *American Society for Testing and Materials*, Testing Long-Time Creep and Stress Relaxation of Plastics Under Tension or Compression Loads at Various Temperatures, D674-56.

50. P. Z. Adelstein, "Wedge Brittleness Test for Photographic Film," *Photogr. Sci. Eng.*, **1**: 63–68 (Oct 1957).

51. American National Standard Method for Determining the Brittleness of Photographic Film, PH1.31 (1973).

52. J. Q. Umberger, "The Fundamental Nature of Curl and Shrinkage in Photographic Films," *Photogr. Sci. Eng.*, **1**: 69–73 (Oct 1957).

53. I. B. Current, "Equipment for Testing Some Physical Characteristics of Sensitized Materials," *Photogr. Eng.*, **5**: 227–233 (Oct 1954).

54. American National Standard Method for Determining the Curl of Photographic Film, PH1.29 (1971).

55. E. K. Carver, R. H. Talbot and H. A. Loomis, "Film Distortions and Their Effect Upon Projection Quality," *J. Soc. Motion Picture Engrs.*, **41**: 88–93 (July 1943).

56. P. Z. Adelstein, "Dimensional Stability of ESTAR Polyester Base Aerial Films," *Photogram. Eng.*, **38**: 55–64 (Jan 1972).

57. C. R. Fordyce, J. M. Calhoun and E. Moyer, "Shrinkage Behavior of Motion Picture Film," *J. Soc. Motion Picture Television Engrs.*, **64**: 62–66 (Feb 1955).

58. P. Z. Adelstein and J. M. Calhoun, "Interpretation of Dimensional Changes in Cellulose Ester Base Motion Films," *J. Soc. Motion Picture Television Engrs.*, **69**: 157–163 (Mar 1960).

59. J. M. Calhoun, L. E. Keller and R. F. Newell Jr., "A Method for Studying Possible Local Distortions in Aerial Films," *Photogram. Eng.*, **26**: 661–671 (Sep 1960).

60. P. Z. Adelstein and D. A. Leister, "Nonuniform Dimensional Changes in Topographic Aerial Films," *Photogram. Eng.*, **29**: 149–161 (Jan 1963).

61. P. Z. Adelstein, P. R. Josephson and D. A. Leister, "Nonuniform Film Deformational Changes," *Photogram. Eng.*, **32**: 1028–1034 (Nov 1966).

62. C. C. Shirley, "Navy Photography in the Antarctic," *J. Soc. Motion Picture Television Engrs.*, **52**: 19–29 (Jan 1949); "Deep-freeze Camera Prescriptions," *Ind. Photogr.*, **6**: 26–28 (Jan 1957).

63. T. R. Stobart, "Filming the Everest Expedition," *Brit. Kinematogr.*, **24**: 36–42 (1954).

64. D. M. Howell, "The Effect of Heat on the Sensitometric Characteristics of AEROGRAPHIC Super-XX Film," *Photogr. Eng.*, **5**: 248–254 (1954).

65. American National Standard Specifications for Safety Photographic Film, PH1.25 (1976).

66. American National Standard Methods for Determining the Scratch Resistance of Processed Photographic Film, PH1.37 (1963).

67. J. F. Carroll and J. O. Paul, "Test Methods for Rating Abrasion Resistance of Photographic Film," *Photogr. Sci. Eng.*, **5**: 288–296 (Sep 1961).

68. W. S. Suydam and A. G. Skove, "Scratch Resistant Parameters of Microfilm Emulsions," Proc. Thirteenth Annual Meeting National Microfilm Assoc., Annapolis, Maryland (1964).

69. D. W. Fassett, F. J. Kolb, Jr., and E. M. Weigel, "Practical Film Cleaning for Safety and Effectiveness." *J. Soc. Motion Picture Television Engrs.*, **67**: 572–589 (Sep 1958).

70. T. Anvelt, J. F. Carroll, Jr., and L. J. Sugden, "Processed Film Lubrication: Measurement by Paper Clip Friction Test and Improvement of Projection Life," *J. Soc. Motion Picture Television Engrs.*, **80**: 734–739 (Sep 1971).

71. J. T. Parker and L. J. Sugden, "Determining the Resistance of Photographic Emulsions to Damage During Processing," *Photogr. Sci. Eng.*, **7**: 41–47 (Jan 1963).

72. W. I. Kasner, "Causes and Prevention of Static Markings on Motion Picture Film," *J. Soc. Motion Picture Television Engrs.*, **67**: 513–517 (Aug 1958).

73. P. Z. Adelstein and J. L. McCrea, "Permanence of Processed ESTAR Polyester Base Photographic Films," *Photogr. Sci. Eng.*, **9**: 305–313 (Sep 1965).

74. American National Standard Specification for Photographic Film for Archival Records, Silver-Gelatin Type, on Cellulose Ester Base, PH1.28 (1973).
75. American National Standard Specification for Photographic Film for Archival Records, Silver-Gelatin Type, on Polyester Base, PH1.41 (1973).
76. American National Standard Practice for Storage of Processed Silver-Gelatin Microfilm, PH5.4 (1970).
77. American National Standard Practice for Storage of Processed Safety Photographic Film, PH1.43 (1976).
78. E. Ott and H. M. Spurlin, *Cellulose and Cellulose Derivations*, 2nd Ed., Part I, Interscience, New York, 1954, p. 454.
79. J. P. Casey, *Pulp and Paper*, 2nd Ed., Vol. II, "Papermaking," Interscience, New York, 1960.
80. J. N. Stephenson, *Manufacturing and Testing of Paper and Board*, Vol. 3, McGraw Hill, New York, 1953.
81. S. F. Smith, "Dried-In Strains in Paper Sheets and Their Relation to Cockling, Curling, and Other Phenomena," *Papermaker and Brit. Trade J.*, 119: 185–188, 190–192 (Mar 1950).
82. American Society for Testing and Materials, Basic Weight of Paper and Paperboard, D646-63T.
83. American Society for Testing and Materials, Tensile Breaking Strength of Paper and Paper Products, D828-60.
84. Technical Association to the Pulp and Paper Industry, Internal Tearing Resistance of Paper, T414ts-65.
85. R. F. Reed, *Curling of Lithographic Papers*, 1st Ed., Tech Bulletin No. 7, New York Lithographic Tech Foundation (June 1946).
86. J. P. Weidner, "The Influence of Humidity Size Change in the Diameter and Length of Sulfite Fibers," *Paper Trade J.*, 108: (1): 31–40 (Jan 1939).
87. Federal Specification GG-P-450A, Plates, Photographic, Diapositive, Glass, Black-and-White, (Nov 6, 1970).
88. American National Standard Dimensions for Photographic Dry Plates, PH1.23 (1974).
89. H. L. Oswal, "Flexure of Photographic Plates Under Their Own Weight and Some Modes of Support and Consequent Photogrammetric Errors," *Photogram. Record*, 2: 130–144 (Oct 1956).
90. J. H. Altman and R. C. Ball, "On the Spatial Stability of Photographic Plates," *Photogr. Sci. Eng.*, 5: 278–282 (Sep 1961).
91. J. M. Burnham and P. R. Josephson, "Color Plate Metric Stability," *Photogram. Eng.*, 35: 679–685 (July 1969).
92. American National Standard Practice for Storage of Processed Photographic Plates, PH1.45 (1972).
93. B. Meerkamper and A. B. Cohen, "Design and Application of Precise Electronic Gauge for Dimensional Changes in Films," *J. Photogr. Sci.*, 12: 156–167 (May–June 1964).
94. American National Standard Method for Determining the Dimensional Change Characteristics of Photographic Films and Papers, PH1.32 (1973).
95. R. H. Brock, Jr. and A. H. Faulds, "Film Stability Investigation," *Photogram. Eng.*, 29: 809–818 (Sep 1963).

7

DEVELOPING PAPERS

Ira B. Current

Except for specialized industrial purposes, developing papers have replaced all other methods of photographic printing in both black and white and in color. This is due primarily to the fact that they alone have the sensitivity for projection printing. Another important advantage is the availability of papers in various contrast grades for printing from negatives which differ in density range. Developing papers have been responsible for the success of roll films, time development and panchromatic emulsions. Development by time instead of by inspection of each negative became practical only after developing papers were made in different contrast grades, so that good prints could be made from negatives of different subjects developed for the same time. With the earlier printing processes it had been necessary to develop each negative separately so that the density range would be suitable for the one grade of paper that was available. As long as each negative had to be inspected during development neither roll film nor panchromatic materials could make much headway.

Developing papers consist of emulsions of silver chloride or silver chloride and silver bromide coated on a special photographic paper with usually a coating of barium sulfate in gelatin between the paper and the emulsion. Photographic emulsions, including those for developing papers, are discussed in Chapter 2. This chapter is concerned with the photographic characteristics of the emulsions of developing papers and the papers on which the emulsions are coated. Papers differ in two important respects from negative materials. With negative materials the color of the developed image is of minor importance, while in developing papers the color of the image, whether blue-black, black, warm black, or brown black, is a major consideration, and its response to chemical toners is an important emulsion characteristic that has no parallel in negative emulsions. Another difference is that the appearance of the image, unlike that of the negative, depends upon the surface and the color of the paper on which the emulsion is coated. While these differences are a matter of personal preference, they are important to the commercial success of a paper and in photographic paper technology.

THICKNESS AND WEIGHT

The paper for developing papers is different from commercial papers in its chemical purity. It must be free of substances which would sensitize, desensitize, or otherwise affect the photographic emulsion. It must withstand alkaline developers, acid fixing solutions, prolonged washing as well as chemical toners without becoming soft and drying with heat between canvas belts or on polished ferrotyping drums. The dry print should not curl excessively or be brittle and easily cracked. To meet commercial requirements it must be available in different weights (thicknesses) in a variety of surfaces and colors.

The term weight (light weight, single weight, double weight) is a means of designating the thickness of the paper. Light weight and document papers vary in weight per square meter from 45 to 110 g, single weight papers approximately 135 g/m^2 and double weight paper about 265 g/m^2. Papers of similar weight may vary in thickness because of differences in density. The thicknesses of papers produced in the United States conform to

American National Standard PH1.1-1968 *Designation for Thickness of Photographic Paper.*

The application of papers of different weights varies considerably. Ultra thin and document papers are used generally in reports, bound or unbound, where a thin paper that will not crack when bent sharply is essential. Single weight paper is used for most commercial prints and double weight paper for portraiture and for large size prints.

BARYTA COATING

With some papers the emulsion may be applied directly without any prior coating. Most papers, however, are first coated with barium sulfate in gelatin (baryta coating). The baryta coating serves to prevent the absorption of the emulsion by the paper, isolate it from any chemical impurities in the paper, and modify the surface appearance of the papers. From one to four coatings may be applied and, for a glossy paper, each layer may be separately calendered. The particle size of the barium sulfate is regulated as one of the factors affecting the "smoothness" of the paper surface prior to the coating with emulsion. In some cases the baryta coating is embossed with engraved rollers to produce special surfaces.

Photomicrographs of typical papers before coating with emulsion are shown in Fig. 7.1a-f.

Fig. 7-1b. Matted rawstock surface.

Fig. 7-1a. Glossy rawstock surface (calendered).

A matt surface can be produced by the addition of starch to the emulsion or the gelatin surface coating. Starch has been used for this purpose since 1893, but silicates and other substances may be used. The requirements for the matting agent are a suitable particle size, a low density (to prevent settling in the emulsion while it is being applied to the paper), a high refractive index, low covering power and it must be white or colorless and photographically inert.

Some papers are baryta coated without calendering to produce an image in which the modulation of the image is more the result of the surface texture rather than a variation in the absorption of the emulsion by the paper.

COLOR

Next to the surface of the paper the color is the most important subjective factor in the appearance of the print. The color of the paper affects primarily the "whiteness" of the highlights of the print but even this can have a decided influence on the subjective impression of color. The trend, however, is away from strongly colored papers, such as buff and pink, although such colors as cream white, cream and ivory are still available.

An important factor in the subjective effect of the color of the paper and the image is the color of the light

Fig. 7-1c. Surface of document rawstock.

Fig. 7-1e. Embossed baryta coated "K-Grain" surface.

Fig. 7-1d. Rough surface stock with felt structure.

Fig. 7-1f. Embossed baryta coated silk surface.

used in viewing the print. A white paper with a slight bluish tint, for example, will appear lighter in daylight than under tungsten illumination. On the other hand, a pink colored paper will appear brighter under tungsten illumination. This can lead to controversy between the photographer and his customer because one has examined the prints in daylight and the other under tungsten illumination. Viewing conditions have a pronounced effect on the apparent whiteness of the paper and on the density and contrast of the image. Standards for the viewing of photographic prints have been established by the American National Standards Institute[1] and by the Photographic Society of America.[2]

BRIGHTENERS

More important in modern practice are the "Brighteners" added to papers to intensify the white of the paper and, in effect, to extend the density scale of the print. These are colorless substances which absorb the ultraviolet and emit fluorescent energy in the blue region of the spectrum. The brightening is achieved through two effects: the "bluing" which changes the color of the paper away from yellow and a lightening effect which increases the luminance of the paper. Eugene Allen[3] has divided brightening substances into red shade and green shade brighteners. The green shade brighteners have a greater effect on lightening, while the red shade brighteners have more of a bluing effect. The brightening agents remain in the paper during processing and must therefore be substantive to gelatin or cellulose. It is possible also to add a brightening agent as a final rinse after the print has been processed.

With a given emulsion, a print made on a paper with a brightener will often give a different subjective tone reproduction than when the same emulsion is coated on a paper without a brightener. This is because the effect of the brightener is greater in the highlights than in the shadows where the effect is greatly reduced by the silver of the image. When prints are treated with a brightening solution after processing, both the highlights and the shadows are affected and the change is in the opposite direction.

DIMENSIONAL CHARACTERISTICS OF PHOTOGRAPHIC PAPERS

Papers expand during processing from 2 to 3% in one direction and somewhat less in the other, the difference being due to the structure of paper made in a continuous roll on a paper-making machine. When the paper dries without restraint it shrinks and the dry print is slightly *smaller* than at the time of exposure. On the other hand, prints dried on ferrotyping tins or drums are held in the expanded state and are somewhat *larger* than when exposed. There will be a difference in size in either case if some prints are made on sheets that have been cut from the roll in one direction and others in the opposite direction. A print 10 in. long, for example, will change

more if the 10 in. are across the width of the roll than along its length. The change, in either case, is usually too small to be of any concern except, as in map making, where prints are used as a basis for measurement.

In papers designed for map making it is important that dimensional changes in processing and drying be kept as small as possible. When the shrinkage is small in both directions, a value for shrinkage can be included in the calculations. There are more sophisticated photogrammetric techniques that can be used to take the differences in shrinkage into account and apply them to any dimension regardless of its deviation from the machine direction of the paper. Of more concern in precision photogrammetry is the random variation or "distortion" that can take place in some papers which is not related directly to the overall dimensions of the paper but affect only small areas of the image. The direction and magnitude of shrinkage, for example, may be different along the edges of the print, where the processing and drying stresses are greater than in the center.

Dimensional stability may be improved by laminating the paper with a material that does not respond to the variations in water content or equilibrium relative humidity. The laminate may consist of a metal foil, or a plastic material, having the desired low-shrink or expansion characteristics. The choice of paper-making machine and technique can effect dimensional stability. Papers have been produced on cylinder type machines (differing from the ordinary Fourdrinier machine), in which very short fibers are picked up with more random orientation on a series of cylinders, each cylinder yielding a thin form that is picked up by the next one resulting in a "lamination" of four or five thin formations. Because of the short fibers, and their lack of a particular orientation, a paper is produced that has both a relatively low shrinkage, and a low variation in shrinkage between machine and cross-machine directions.

WATER RESISTANT PAPERS

Another approach to the dimensional change problem, which also reduces the processing time by limiting the absorption of chemicals and water by the paper, is the lacquering of the paper prior to sensitizing. Laquering is effective in reducing the penetration from the front and back sides of the sheet, but it does not restrict penetration at the edges. This can present problems, but they can be solved by trimming the edges of the prints after they have been dried. Impregnation of the paper with a material that resists the penetration of the paper by water is another approach.

These plastic or resin coated papers are made in the usual manner on a Fourdrinier paper machine, and then hot extrusions of a polyethylene are applied to both sides of the paper to produce a smooth surface. The coatings are partially imbedded into the paper formation. The surface of the paper may be varied from a matt to glossy by the finish of the chilling rolls. These papers can produce prints with a high gloss without ferrotyping.

Pigments can be added to the polyethylene mix to improve color and opacity.

CURL AND BRITTLENESS

Other properties of photographic papers that are of concern to the user are curling and brittleness. Curling is caused by the differential stress between the paper and the emulsion. Prints made on papers with thin emulsion layers tend to curl less than those with a thick emulsion layer while light weight (thin) papers are, in general, more subject to curl because the paper has less resistance to the contraction of the emulsion on drying. In the case of film, curl has been found to be directly proportional to emulsion thickness and inversely proportional to the square of the thickness of the base and this is at least partly true of paper.

It is not practical to place a gelatin coating on the back of ordinary papers, as is done with film because it would interfere with the penetration of the processing solutions, the elimination of hypo in washing, and the escape of water in drying. A backing can be applied, however, to resin coated papers as these do not absorb water. Drying tends to "set" the paper so that prints dried on a drum drier, for example, with the emulsion side away from the drum have a slight backwards curl which tends to prevent curling. Prints dried on flat hot-bed driers usually show less curl than those dried by air on cloth racks or on blotters.

American National Standard PH1.29-1971, *Method for Determining the Curl of Photographic Film*, can be applied to the measurement of the curl of photographic papers, although this is not included in the scope of the standard. The standard defines curl value as $100/r$, where r is the radius of the circle formed by the curl (Fig. 7-2). When the curl is towards the emulsion side the values are positive (+) and when the curl is away from the emulsion side the values are negative (−). Since temperature and humidity affect curl, both must be measured and the values included in the report.[26]

When a coated paper is bent sharply the gelatin emulsion may be cracked. Cracking may also occur when attempts are made to flatten prints dried by heat, or at a low relative humidity. Brittleness tends to increase with the thickness of the emulsion and is generally less with light weight or document type papers than with single or double weight papers. Commercial flattening solutions or hygroscopic materials, such as ethylene glycol or glycerine, tend to reduce both curl and brittleness but may contribute to curl at low humidity. The methods described in American National Standard PH1.31-1971 *Method for Determining the Brittleness of Photographic Film* can be applied to paper when a means of specifying brittleness is required.

The tensile strength of the paper is of little importance to those who use paper in sheet form but becomes of considerable importance in machine processing when paper is used in long rolls. Water resistant papers tend to have greater tensile strength and there is not the difference in tensile strength in processing as with conventional papers. Friction, particularly from the back side of the paper, can also be a problem on continuous processing machines.

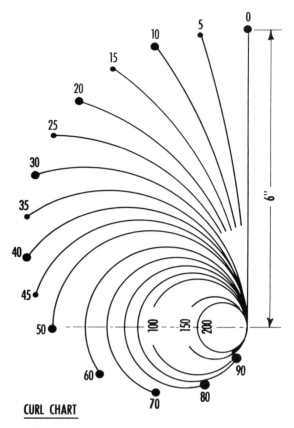

CURL CHART

Fig. 7-2. Curl chart at reduced scale. When the base line is 6 in. in length, the numerical curl value of a sample conforming to one of the lines is equal to the number adjacent to the line.

SHEET AND ROLL PAPERS

Developing papers are supplied in 18 sheet sizes from $2\frac{1}{2} \times 3\frac{1}{2}$ to 20×24 in., in packages of 25, 100, and 500 sheets, although in some cases there are variations in the packaging particularly in the larger sizes. The sizes, and the tolerances permitted, are covered by American National Standard PH1.12-1968, *Dimensions for Photographic Sheet Paper for General Use* (Inch Sizes). The sheets may be packaged with the emulsion sides all facing the same way, with the emulsion sides facing, or in other ways.

Paper in rolls for automatic printing and processing is covered by American National Standard PH1.11-1964 *Dimensions for Roll Photographic Paper* (*revised 1969*). The paper may be wound with the emulsion in or out, depending upon the requirements of the equipment. Since it is necessary to splice the end of one roll to another, printing equipment is designed to recognize holes in the paper preceding the splice and pass over the splice before resuming operation. The splices must have

the tensile strength required by the processing machinery and be unaffected by the processing solutions, washing or drying.

PAPER EMULSIONS

Paper emulsions are fine grain precipitates of silver chloride or silver chloride and silver bromide in gelatin. Slow emulsions for contact printing ordinarily consist of silver chloride and faster emulsions for projection printing a combination of silver chloride and silver bromide, although emulsions suitable for projection printing can be produced with silver chloride alone. Some emulsions for papers are prepared by reverse precipitation, the halide being added to the silver solution. In some cases the silver and halide solutions are added simultaneously and in other cases alternatively in installments. Precipitation is usually in a slightly acid solution rather than an alkaline solution as when preparing negative emulsions. Paper emulsions, unlike those for films, are not digested with heat or ammonia nor are they washed to remove the excess salts except for water resistant paper bases which may require some washing as these papers do not absorb the excess salts.

The color of the image, which varies with the average size of the developed silver particles, depends upon the conditions under which the silver halide grains are formed as does the contrast of the image. Image contrast may be controlled also by the addition of citric or other organic acids, cupric chloride, cadmium chloride and rhodium chloride; the last named being especially effective for high contrast emulsions. After-ripening is also employed to control both speed and contrast.

Stabilization of the emulsion to prevent undesired changes in storage of the coated paper, is a problem and iminazole, triazole, tetrazole, oxazoles, mercapto-benzthiazole or pyrimidine compounds are often used as stabilizers. With emulsions of silver chloride these stabilizing and antifogging agents tend to produce blue-black images.

Hardening agents, such as chrome alum or formaldehyde, are common additions and wetting agents are added for uniform development.

PAPER EMULSION REQUIREMENTS

Other than the sensitometric requirements, which will be discussed later, there are a number of requirements of an emulsion for a practical developing paper. It must be suitable for the paper producing an image with a good surface appearance. It must have good adherence to prevent blisters and frilling, the tendency of the emulsion to peel from the paper especially along the edges of the sheet. The emulsion has an influence on the formation of blisters within the paper because of its effect on the hardening of the paper. It must have a low sensitivity to pressure or "abrasion" marks will develop along with the image. With some emulsions and papers this may necessi-

tate a surface coating (anti-abrasion layer) over the emulsion. The emulsion also affects the tendency to curl and the brittleness of the coated paper. If designed for automatic exposing and processing machinery, the speed, and the rate of developing, fixing, washing and drying must be within the limits imposed by the equipment.

While most surface characteristics are governed by the paper base, the emulsion can influence the appearance as well as the difficulty experienced in hand work on the print, such as retouching, spotting, etching and hand coloring. The most significant emulsion factor is the type and amount of matting agent added to the emulsion to the surface layer, or both, at the time of coating. In some cases, emulsion grain size and type of gelatin used can have a noticeable effect on these properties, but most often the matting agent is the controlling factor. This can be quite critical—for spotters and retouchers adapt themselves to a certain "tooth"—and variations in this characteristic can be quite frustrating to them. While spotting is affected somewhat by the degree of matting, the "wettability" of the paper surface with respect to the spotting solution, can also be an important factor. Oil coloring is influenced by the surface texture of the stock, and is about equally affected by the matting employed in the emulsion and/or surface coating. The technique of the "colorist" often involves the application of the oil color, then removing all but the desired amount by means of a tuft of dry cotton. Excessive matting, or matting that has a pronounced tooth, will tend to hold the color much more than desired, and may even snag fibers from the tuft of cotton used in the blending and removal of color.

The emulsion can also have an effect on two important characteristics of gloss papers for ferrotyping. One of these is the brilliance of the gloss, although this is also affected by the nature of the paper base and the baryta surface. The second and perhaps more serious effect is the nonuniformity, or discontinuity, of the gloss produced when the prints are ferrotyped. This appears as a "pitting" or "flecking" of the surface, and may also be associated with "measle spotting" of the paper base. The aspects of the emulsion system that tend to cause this problem are not clearly understood, but there are indications that the pH of the emulsion, the type of gelatin used, and the presence of certain salts, wetting agents, and hardening agents can have an effect.

IMAGE TONE OR COLOR

One of the important attributes of developing papers is the tone, or color, of the image after processing and drying. Image tones are referred to as "blue-black," "cold," "olive," "warm," "neutral black," and a score of similar descriptors. "Cold" images appear more blue in character, and "warm" images are relatively more red. Actually, the colors are very subtle, and the tone of the image produced by a given emulsion and paper combination is very difficult to define. One effort in this

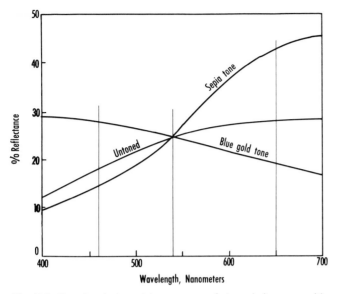

Fig. 7-3. Spectrophotometric curves of toned images with density adjusted to give a reflectance of 25% at 540 nm. The percent reflectances taken from 460 and 650 nm are used to trace out the vectors in Fig. 7-4.

Fig. 7-4. Starting at A, representing 25% reflectance, the vector for reflectance at 540 nm is plotted to 0 (in practice this is not necessary, since all of the curves have been made to coincide at 25%), 19% reflectance at 460 nm is plotted to the left, and 29% for 650 nm to the right to arrive at the point D. The lower diagram shows areas for the untoned, blue-gold toned and sepia toned prints plotted in Fig. 7-3.

direction has been to use spectrophotometric curves of the developed images, with the reflection density adjusted to a given value at a specified wavelength.[4] If numerical values are required for communication, optical reflection densities can be taken from the curves at specific wavelengths, such as at 460, 540, and 650 nanometers. The optical reflection densities at these three wavelengths will then give a partial description of the "warmth" of the tone of the image.

Another method of defining tone is to extend the above in a "vector" system such as that described by W. H. Carnahan.[5] Instead of using density values, reflectance values at specific wavelengths are plotted as three vectors on a grid resulting in a point on the grid whose coordinates define the tone of the silver image (Figs. 7-3 and 7-4).

Many contact papers give a neutral or blue-black image tone, although some of them have been formulated to give warm tones, sometimes capable of being defined as "olive." The chloro-bromide emulsions for professional portraiture are also considered to be "warm" in character; while the high speed enlarging papers yield "cold," "black" or "neutral" images. There are exceptions to these general rules, and it cannot be said that a paper in any tone category is the result of its chloride, bromide or iodide content.

THICKNESS OF EMULSION

The thickness of the emulsion, along with its degree of hardening, has a significant effect on the curl and brittleness of dried prints. One solution to these problems, if only a partial one, is to design an emulsion that has good photographic characteristics when it is coated with a minimum emulsion thickness. An additional advantage of a thinner emulsion coating is that the color of the gelatin itself is diminished, making the white areas of the print "cleaner" in appearance. Thin emulsions also tend to develop, fix, wash and dry more rapidly.

COLOR SENSITIVITY AND SAFELIGHTS

While the sensitivity of paper emulsions is primarily in the blue and violet, variable contrast papers are sensitive to yellow as well. Thus most slow contact papers can be handled in a bright yellow-green light, while an amber light is generally recommended for variable contrast papers and high speed projection papers. Safety, however, depends on the volume of light as well as the spectral transmission of the safelight and the recommendations of the manufacturer should be followed. The safety of any safelight depends upon the amount of exposure the paper receives and a recommended safelight will produce fog if the exposure is excessive. All papers are more sensitive when dry than during processing, so exposure to the safelight before development should be kept at a minimum.

Since safelight screens fade, tests should be made

periodically. Tests should also be made when an unfamiliar paper is used as its color sensitivity may be different. Tests of a safelight may be made following the procedure outlined in American National Standard PH2.22-1961, *Procedure for Determining the Safety Time of Photographic Darkroom Illuminaion.* This outlines a straightforward procedure involving masking off successive steps of the paper for exposures of 15, 30, 60, 120, and 240 seconds.

ADAPTATION OF THE PAPER TO THE NEGATIVE

Some papers, mainly those intended for professional portraiture, are made in only one contrast grade because the density range of the negative can be controlled by the lighting, exposure and development of the negative. Most other papers are made in several contrast grades (Fig. 7-5) so that good prints can be obtained from negatives which differ in the density range because of variations in the luminance range of the subject, or in exposure and development.

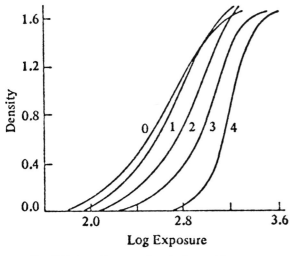

Fig. 7-5. Log *E* curves for photographic paper.

Statistical studies have shown that the paper which produces the best print should have a log *E* range* about 0.2 greater than the density range of the negative. A negative with a density range of 1.3, for example, should be printed on a paper with a log *E* scale of 1.5. In projection printing, the density range of the negative depends upon the specularity of the illumination and the negative which would require a contrast grade of 2 with an enlarger with condensing lenses may require a contrast grade of 3 with an enlarger using reflected diffuse light.

The log *E* scales of the different contrast grades of typical papers and of variable contrast papers used with the recommended filters are given in Table 7-1.

THE EXPOSURE SCALE AND IMAGE CONTRAST

The log *E* scale of a paper indicates the density range of the paper for which the negative is suitable. It is in no way an indication of the contrast of the print. The contrast of prints on papers with the same log *E* scale vary with the density range of the paper. The density range for the same emulsion will vary with the surface of the paper so that prints on a glossy paper will have greater contrast than those on a matte paper. Changes in the log *E* scale are often accompanied by changes in the density range of the paper. This is true of both graded and variable contrast papers. With some of the latter, the "contrast" difference between two filters is as much a difference in the density range of the print as in the log exposure scale. Even if both the log exposure scale and the density range of the paper are the same, differences in the curve shape, if considerable, may make a difference in the apparent contrast of the print.

The use of partial scales[6] is a step in the direction of defining the characteristics of these parts of the total scale. The effect of the shape of the characteristic curve on reproduction can be visualized by considering the two curves shown in Fig. 7-6. Both of these curves have the same exposure scale, that is the distance on the log *E* axis

*See Sensitometry of Photographic Papers, Chapter 8.

TABLE 7-1. PAPER GRADES AND LOG EXPOSURE SCALES.

Grade or filter number	Slow contact paper (Black tone)	Portrait paper (Warm tone)	Projection paper (Black tone)	Variable contrast paper	
				Black tone	Brown-black tone
0	1.7	—	1.6	—	—
1	1.5	1.5	1.4	1.6	1.4
1½	—	—	—	1.4	1.3
2	1.3	1.3	1.2	1.3	1.2
2½	—	—	—	1.2	1.2
3	1.1	1.1	1.0	1.2	1.1
3½	—	—	—	1.1	1.0
4	0.9	—	0.8	1.1	0.9
5	0.7	—	0.6		
No filter	—	—	—	1.4	1.2

Single grade, warm-tone portrait paper 1.2.

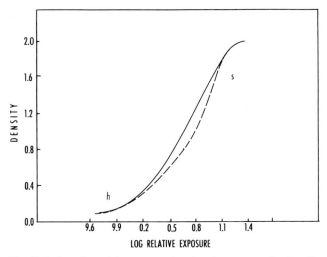

Fig. 7-6. Sensitometric curves showing two papers having the same log exposure scale, but having different tone reproduction characteristics.

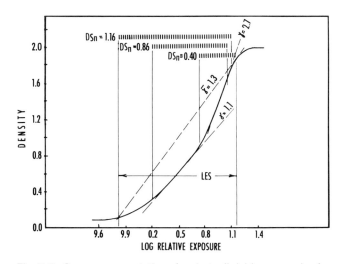

Fig. 7-7. Curve representative of a photo-finishing paper having capability of making prints from a range of negatives having different density scales. The short scale negative (DSₙ = 0.40) is printed on the shoulder of the curve making a dark print, but one having higher contrast than a lighter print on the same paper. On the other hand, a negative with a long density scale (DSₙ= 1.16) utilizes the entire scale of the paper.

between points *h* in the highlight region of the curve and *s* in the shadow region. However, the curve shown by a solid line has a more uniform gradation throughout most of its length. It has a $\gamma = 1.84$. The contrast between different densities representing equal increments of exposure near most of the middle of the negative density scale is relatively constant. The curve shown as a broken line, on the other hand, is divided into two distinct parts as far as gradation is concerned. The lower part of the curve has a considerably softer gradation, and the γ measured in this region is about 1.14. The upper part of the curve is considerably steeper in gradation, with a $\gamma = 2.72$. This latter curve is representative of that used with some success in the photofinishing industry and is capable of making acceptable prints from negatives differing considerably in density range. Referring to Fig. 7-7, a negative with a density scale of 0.40 can be exposed so as to develop to the densities in the shadow (or shoulder) region of the curve with fairly high contrast. The dark print will have good contrast, and in many cases will be representative of an exposure made under poor lighting conditions, where the subjective impression is dark. A negative with a density range of 1.16 would be made to utilize the full range of the paper exposure scale, with a "softer" gradation in the middle tones and highlights, even though the details in the heavy densities may have relatively higher contrast. High key subjects, such as snow scenes, and beach scenes, even though the density range may be somewhat lower than 1.16 (0.86, for example) can be printed relatively soft by lowering the exposure to print mostly on the lower part of the scale of the paper, even though maximum density may be sacrificed in the print.

A glossy black and white paper may have a maximum reflection density in the vicinity of 2.0, while a matte paper may have a maximum density as low as 1.2. A print on a matte paper with low reflection density will have lower contrast than one made on a paper with a glossy surface and having an equal exposure scale. Both of

these papers will be appropriate for a given negative having a density scale that matches their exposure scale, but the subjective appearance of the prints will be quite different. This is one of the factors entering into "print quality."

If an effort is made to increase the contrast of the matte print by choosing a paper grade with lower exposure scale, some of the negative densities will be beyond the exposure scale of the paper and be lost in the unmodulated minimum or maximum density regions.

On the other hand, a lower contrast can be had in a glossy print by choosing a paper with longer exposure scale, in which case the entire range of densities available from the paper will not be utilized. In most cases this would not be called a "good print," but this type of approach is sometimes used in making "high key" pictures.

Figure 7-8 shows families of sensitometric curves representing the speeds and gradations of products produced by a given manufacturer. Figure 7-9 gives

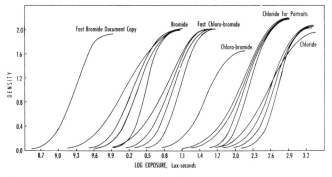

Fig. 7-8. Families of sensitometric curves representing the papers produced by a typical manufacturer.

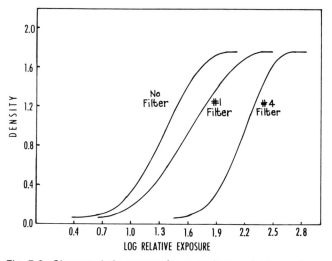

Fig. 7-9. Characteristic curves for a typical variable contrast paper. The exposure made with no filter produces a contrast between that of the exposures made with the #1 and #4 filters.

characteristic curves for a typical variable contrast paper.

There is no American Standard defining the different contrast grades of photographic papers. Paper grades (numbers) and the log exposure values for several papers of different types on the American market are given in the following table.

PAPER GRADE AND SPEED

With few exceptions, the speed of a paper emulsion varies with the contrast grade or, in the case of a variable contrast paper, with the filter. The following are typical examples:

Grade or filter	Slow contact paper	Projection paper	Variable contrast paper
0	80	—	—
1	64	5000	2500
1½	—	—	2500
2	40	3200	2500
2½	—	—	2500
3	32	2000	2000
3½	—	—	1600
4	20	1250	800
5	12	1000	
No filter			4000

EXPOSURE

Developing papers are exposed (1) in contact with the negative (*contact printing*) and (2) in a projection system forming an image of the negative on the paper (*projection printing*). In contact printing, prints exposed to a diffuse light source have a small, but noticeably higher contrast than when a direct (nondiffuse) light source is used. In projection printing the contrast of the print is usually lower with diffuse illumination than in contact printing because of flare in the projection system. On the other hand, with nondiffused illumination on the negative (a condensing lens system without ground or opal glass) the contrast is higher than with diffused light and higher (usually) than in a contact print from the same negative.

In projection printing, the higher image contrast with nondiffused illumination increases image sharpness but graininess is increased also along with scratches or other physical defects and retouching on the negative. Despite the frequent discussions of the advantage of one type of illumination over the other, the difference is simply one of print "contrast;" usually the difference of one paper contrast grade or, in the case of a single grade paper, a minor change in the time of development of the negative.

In commercial photofinishing the projection printers for small negatives (26mm x 26mm for example) often employ diffuse illumination and a special paper of the type represented by the solid line in Fig. 7-10. The broken line represents a corresponding paper for projection printing from larger negatives.

Developing papers should be exposed so as to develop to the required density within the time of development recommended for the paper and the particular developer used. By required density is meant the density of the image under normal viewing conditions not as it appears in the illumination of the printing room. An experienced printer, working under familiar conditions is able to estimate the exposure with sufficient accuracy from the appearance of the negative on the contact printer or the projected image on the enlarging easel. Less experienced workers resort to test strips. Some make use of exposure meters which measure either the total (integrated) density or a portion of the image, such as the highest or the lowest density. The studies by Tuttle[7] and by Jones and Nelson[8]

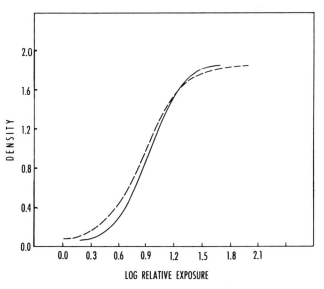

Fig. 7-10. Curves for photo-finishing papers. The dashed curve represents a paper used for printing from larger sized negatives with specular illumination; whereas the solid curve represents a paper used for printing small negatives (35mm and size-126) using diffuse illumination.

show that measurements of the integrated density correlate very well with the required exposure but that the minimum density is usually more reliable with negatives having an unusual distribution of density.

Automatic printers, as used in photofinishing, use photoelectric cells to measure the integrated density.[9] The indicated exposure can be related to the speed of the paper as determined sensitometrically but in practice the exposing mechanism is adjusted to the paper used, the time of development and the type of print desired. An overriding mechanism permits the operator to alter the exposure for negatives with an unusual distribution of density where the integrated density would result in either gross overexposure or underexposure of a part of the image.

In the LogEtronic® printer, tone reproduction in the print can be controlled by varying the exposure in accordance with the density of different portions of the image.[10] The exposure is made by a flying spot scanner passing in parallel lines from one side of the negative to the other. A photoelectric pick-up on the backside of the paper senses the light passing through the image, and feeds a control signal, based on the attenuation of the various areas of the picture, back to the cathode ray tube source. The spot intensity is increased for those areas where the density is high, and is decreased where they are low; this, in effect, compresses the density differences of large details in the negative, but has negligible effect on small details. The effect of the LogEtronic printer is shown in Fig. 7-11. These curves represent the effects of no masking and 40% masking on a #4 grade of paper. The degree and uniformity of light transmittance of the paper is important. A nonuniform coarse structure, larger than that of the flying spot, would register the pattern of the paper fibers in the print.[11]

Ordinarily when prints are individually exposed and processed the failure of the reciprocity law is not a problem as any reciprocity failure is lost in the variables of exposure and development. In automatic exposure and processing, however, any factor affecting the direct

relationship between the time of exposure and the total exposure ($i \times t$) can have a significant effect on the final result. Modern automatic printers operate with much shorter exposure times than is practical when the paper is exposed and processed by hand and, under these conditions, the *time* of exposure can affect both speed and contrast. Since reciprocity failure varies with the emulsion, no hard and fast rules can be given but, in general, reducing the time of exposure produces lower print contrast and an apparent increase in paper speed.

DEVELOPERS AND DEVELOPMENT

Metol-hydroquinone and phenidone-hydroquinone developers have replaced all other developers for papers except by those photographers seeking a special image color. For emulsions designed for black or blue-black images the developer contains a relatively large concentration of alkali for rapid development and sufficient potassium bromide to prevent fog. For warm tone papers less alkali is normally used and the amount of potassium bromide increased to restrain development and provide greater control over the color of the image. Warmer tones can be obtained on some warm-tone papers by using metol-glycin or metol-chloroquinol (Adurol) developers. With metol-hydroquinone developers an increase in the ratio of hydroquinone to metol increases the contrast, while an increase in the metol to hydroquinone ratio results in less contrast.[12] The change, however, is no more than a paper grade and is usually of interest only when a single grade paper is used.

The developer for continuous processing machines (Chapter 19) must have a long useful life without causing significant variation in speed, tone or contrast. The "start up" solution is the basic formula with potassium bromide and possibly a pH modifier to provide a "conditioned" developer for subsequent replenishment. In practice many requirements have to be balanced against one another. For example rapid development, desirable under some conditions, plus a high sulfite content for long life tends to produce a sludge which can deposit on prints. The replenisher has little or no potassium bromide as the restraining by-products of the development process must be maintained at a constant level.

Some developers used for machine processing use sodium hydroxide as an alkali to minimize the formation "measle" spotting and blisters. It is believed that sodium carbonate reacts with the acid in stop baths and fixing solutions causing the fibers of the paper to swell and hold the fixing solution more in some areas than others. These areas appear as translucent spots on wet prints and may disappear on drying only to reappear months later.

All paper developers change rapidly with use accumulating the by-products of development and the by-products of the unwashed emulsion absorbed by the paper. These all act as restrainers increasing the time of

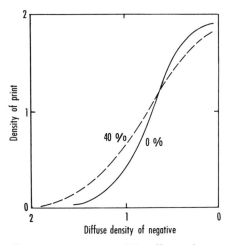

Fig. 7-11. These curves represent the effects of no masking and 40% masking on a #4 grade of bromide paper, using a feedback scanning printer, such as the Log-E-Tronic.

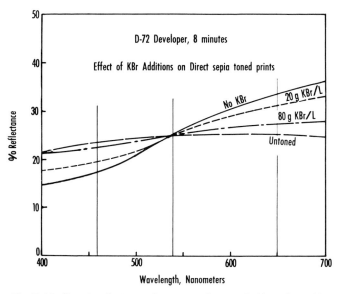

Fig. 7-12. Spectrophotometric curves of a toned chloro-bromide paper showing the change in color resulting from the additions of bromide to the developer, with extended developing time, when making the original black and white prints.

development. When prints are exposed and developed singly this leads to overexposure and underdevelopment as the developer loses its energy resulting in images of poor color and degraded shadows.

For a uniform tone and image quality the developer either must be maintained or discarded before the accumulated restrainers affect the image. The spectrophotometric curves in Fig. 7-12 show the effect of increasing amounts of potassium bromide in the developer with extended development on the sepia tone of a

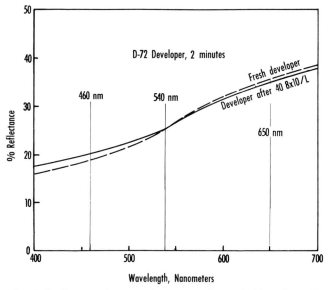

Fig. 7-13. Spectrophotometric curves of toned chloro-bromide paper showing the effects of partial "exhaustion" of the developer on the sepia toned prints. The tone of the prints from the used developer, containing additional amounts of bromide, are slightly colder than those from the fresh developer.

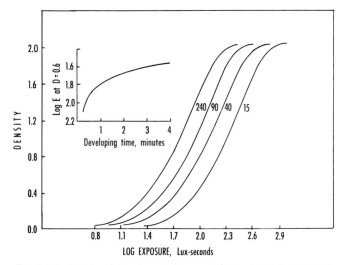

Fig. 7-14. Family of sensitometric curves for a chloride paper at various developing times.

chlorobromide paper. Fig. 7-13 shows the practical change towards a colder sepia tone of a print developed in a partially exhausted developer. (Vector Plots of the tone changes shown in Fig. 7-12, 7-13 and 7-16 are shown in Figure 7-17).

The rate of development depends upon the emulsion as well as the developer. Emulsion factors that affect the rate of development are the silver to gelatin ratio, the silver halide composition, the addition of development accelerators, the thickness of the emulsion coating and the type of hardening employed.

Figure 7-14 shows the effect of different times of development on the D log E curve of a silver chloride paper designed for contact printing, and Fig. 7-15 on a chlorobromide paper for projection printing. The chloride paper develops rapidly, the chlorobromide paper more slowly. In both cases the average gradient of the D-log E curve and the maximum density are lower in the early stages of development but as the time of

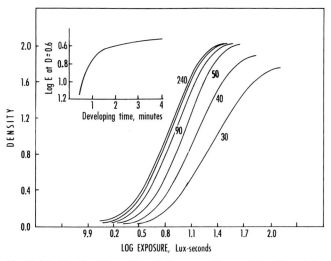

Fig. 7-15. Family of sensitometric curves for a chloro-bromide paper at various developing times.

development increases the curves of both papers show little change except for a shift to the left. In other words, the principal effect of increasing the time of development is to make the image darker. This is a desirable feature in a paper intended for the professional photographer who exposes and develops each print separately as differences in exposure, if they are not too great, can be corrected by changing the time of development. This flexibility in exposure and development is of less importance, however, in an emulsion designed for automatic exposure printers and continuous processing machinery using paper in rolls.

THE STOP BATH

The stop bath, usually a solution of acetic acid, stops development and prevents the carrying over of the alkaline solution into the acid fixing bath. If the stop bath is too acid or the prints are in the stop bath too long, "measle" spotting may occur and the retention of silver complexes by the fibers of the paper is greater thus increasing the time of washing.

In some continuous processors a stop-fix bath is substituted for the ordinary stop bath. Where this is done the stop-fix bath is usually the first of two fixing baths.

FIXATION OF PAPERS

The fine-grain emulsions of silver chloride and silver bromide used for developing papers fix much more rapidly than negative materials. Silver chloride and chlorobromide papers in a fresh fixing bath will fix in a minute,[13] however, the customary five to ten minutes is justified when prints are fixed in quantities and in a partially exhausted fixing bath. Papers which contain silver iodide require much longer for proper fixing. Prolonged fixation will not convert the silver halide into

soluble compounds if the bath is exhausted, and may result in (1) bleaching of the image, (2) a change in color, particularly if the print is toned (Fig. 7-16), and (3) also increases the time of washing.

Crabtree, Eaton and Muehler[14] have shown that the insoluble complexes of silver-sodium-thiosulfate formed in fixing are strongly adsorbed by the paper base and the fixing bath becomes incapable of fixing prints thoroughly long before its capacity to dissolve the silver halide of the emulsion is reached. In other words, both the emulsion and the paper must be fixed and the limit of the fixing bath is determined by the paper and not by the emulsion. This, however, does not apply to water resistant papers because the fixing solution is not absorbed by the paper unless fixation is prolonged.

If a single fixing bath is used, the limit for conventional papers is from 30 to 35 8 x 10 prints per gallon of the typical acid fixing and hardening bath. If two fixing baths in succession are used, it is possible to fix about 150 8 x 10 prints per gallon. Many processing systems employ two solutions; the first a used bath, the second a fresh solution. When the second solution can no longer be depended on it is substituted for the first bath, and replaced by fresh solution.

In large scale processing with continuous machinery, fixing baths, as well as developers, are usually maintained by replenishment. There is dilution of the fixing bath by carry-over from the stop bath and a carry-out on paper, leaving the fixing solution. Replenishment is usually based on the continuous addition of fresh solution. Electrolytic recovery of silver from the fixing bath is not only a source of income but increases the fixing capacity of the solution by removing accumulated silver.

The time required for fixation is usually of minor importance except in the case of continuous processing machines. The time depends upon (1) the emulsion, (2) the fixing bath, (3) the degree of agitation, the exposure of the print to the fixing solution and (4) the temperature. Both the time required for fixing and the capability of the

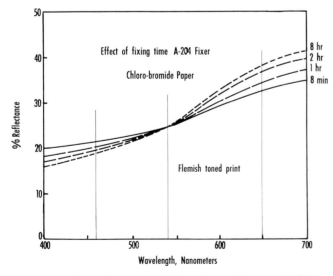

Fig. 7-16. Effect of extended fixing time on the tone of chloro-bromide paper toned in Flemish Toner.[R]

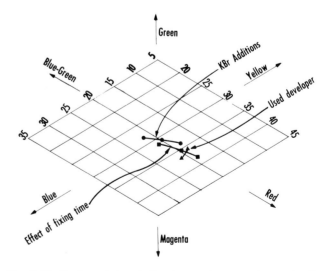

Fig. 7-17. Vector plots of the tone changes shown in the spectrophotometric curves from Figs. 7-12, 7-13 and 7-16.

solution can be determined, for a given set of conditions, by tests for the presence of silver halide in prints. Tests may be made with a solution of sodium sulfide or sodium selenosulfate, but as sodium sulfide reacts with the baryta coating on some glossy papers to produce a stain which invalidates the test, sodium selenosulfate is more reliable.[15] Spot tests may be made on the margin of a print, or on a piece of paper processed for test purposes, by applying a drop of a selenium toning solution diluted with five parts of water. After two or three minutes the solution remaining on the surface is removed with blotting paper and the spot examined. If more than a light cream-colored spot remains, the print has not been thoroughly fixed.

WASHING

Hypo and the soluble compounds formed in the process of fixation are easily removed from the *emulsion* of a developing paper. Developing papers on water resistant bases require only four to five minutes washing in a flowing stream of water. With conventional papers the problem in washing is not the removal of hypo and the thionate compounds from the emulsion but from the paper. Crabtree, Eaton and Muehler found that prints cannot be washed entirely free of hypo within a reasonable length of time, i.e., less than two or three hours unless a hypo eliminator of some kind is used.[16] Sodium sulfite or sodium sulfate are effective hypo eliminators which, in an ion exchange, expedite the removal of hypo and silver sodium thiosulfate complexes from the fibers of the paper.[17,18]

The composition of the fixing bath and the degree of hardening produced affect the time of washing and prints fixed in nonhardening baths wash more rapidly than those fixed in an acid hardening and fixing bath. The temperature of the wash water has a considerable influence. At temperatures below 50° F washing is so slow that a hypo eliminator must be used if the prints are to be washed free of hypo in a reasonable time. Higher temperatures will reduce the washing time but above 75° F the reduction is not sufficient to outweigh the danger of damage to the print in drying, although some specially hardened emulsions may be washed at higher temperatures. Single weight papers wash more rapidly than double weight because of the smaller amounts absorbed and the effect of the greater thickness on the diffusion process. At least as important is agitation of the prints, or the wash water, to ensure continuous exposure of both surfaces to water throughout the washing process. Tests of the completeness of washing can be made with a solution of silver nitrate, or a polysulfide toner, on an unexposed test strip processed as usual.[15]

METHODS OF INCREASING THE PERMANENCY OF PRINTS

The fading of silver images is the result of the partial conversion of the silver of the image to silver sulfide from (1) the decomposition of hypo left in the image from insufficient washing, (2) insufficient fixation which results in the formation of complex silver sodium-thiosulfates which decompose to form silver sulfide, or (3) attack by hydrogen sulfide, sulfur dioxide, and other gases generally present in the atmosphere, particularly in industrial localities. Fading from all sources, but particularly the last named, is greatly accelerated by high temperature and by moisture.

Prints made for historical or other records should be fixed in three successive fixing baths and thoroughly washed using a hypo eliminator to ensure the complete removal of hypo.

Fading due to external agents, may be reduced (1) by sulfide or gold toning, (2) by covering the print with a waterproof lacquer, and (3) by dry mounting rather than the use of water-miscible adhesives. The latter, being hygroscopic, tend to contribute to fading by attracting moisture to the image. Gold toning is generally preferable to sulfide toning, as the change in the color of the print is so slight with many papers as to be unimportant. In using a lacquer, care should be taken to use only one of those which have been tested and found to be free of any deleterious effect on the image.

Fine-grain, warm-tone images are more susceptible to change, as a rule, than black or blue-black images but there are exceptions as some warm tone paper emulsions incorporate a stabilizing substance, such as condensation products of formaldehyde and urea.

METHODS OF TONING

The salts of iron, tin, copper, uranium, mercury, nickel, vanadium, selenium, sulfur and gold have been used for the toning of developing papers[19,20] but only the last three are of importance.

One of the most widely used methods of sulfide toning is a solution of sodium polysulfide which reacts with the silver of the image to form sodium sulfide. The color of the toned image with a chloride paper is normally a yellow-brown and with chloro-bromide emulsions a warm brown. Emulsions of silver bromide tone only slightly. Emulsions containing tone modifiers may not produce satisfactory colors. The color with any paper that responds to sulfide toning depends upon exposure, development and fixing (Figs. 7-12, 7-13, 7-16, and 7-17). Prints made for toning should be darker than those not to be toned, as the toned image is not as dark in appearance as the black and white image.

A second method of sulfide toning, sometimes called the indirect method, consists in bleaching the print in a solution of potassium ferricyanide and potassium bromide, washing and converting the bleached image into silver sulfide in a solution of sodium or barium sulfide. As with polysulfide, the color of the toned image with chloride papers is a yellow-brown; chloro-bromide papers produce "sepia" colored images varying with the emulsion, the developer and the time of development. Bromide papers, in general, produce much warmer colors than with polysulfide direct toning.

Selenium toners produce dark brown, reddish brown or purple brown images on warm tone papers, depending on the emulsion, exposure and development. Little or no change in color is produced with black or blue-black emulsions but there is a slight intensification of the image. Toning is progressive and may be stopped at any time when the desired color has been reached.

Both sulfur and selenium toned prints are more permanent than untoned prints because silver sulfide and silver selenide are less subject to change than the silver of the developed image. Also, toning reveals inadequate fixing or washing immediately.

Toning in gold produces blue-purple colors on warm tone chloride or chloro-bromide papers. Bromide and other papers with a blue-black or neutral black image either show little change or blue-gray colors that are usually unsatisfactory. Generally, the warmer the color of the print, the more brilliant the toned image.

DRYING

With films only the water held in the emulsion must be removed; with prints the water is contained in both the emulsion and the paper. The weight of the absorbed water may very nearly equal that of the paper (from 0.6 to 0.8 times its dry weight), depending on the thickness of the paper. A drier on a continuous processor, operating at 10 ft/min, must remove about 2.8 kg (6.7 lb) of water per hour from an 8-ft width of paper. Water resistant papers absorb little water and dry much faster than conventional papers. At low relative humidities paper will dry by evaporation in an hour or so, but several hours may be necessary at high humidity. Prints hung up to dry or laid out on blotters curl badly. For faster drying, in commercial establishments, prints are placed on belts and dried in contact with heated rotating drums. Driers may be obtained with chrome plated, stainless steel surfaces for the drying of glossy papers with a high gloss (ferrotyping). Prints on semimatte and matte papers are dried with the emulsion side facing the belt. Papers to be dried on heated belt driers must be well hardened or the emulsion will stick to the belt or, in the case of glossy papers, to the surface of the heated drum. The hardening produced by a properly designed fixing and hardening bath which is reasonably fresh is usually adequate but a separate hardening bath is used with some continuous processors and may be required for some papers if sulfide toning is contemplated, as the toning solutions soften gelatin.

Drying rapidly with heat often leaves the paper brittle and easily cracked because of excessive dehydration but the pressure of the belts greatly reduces curling. Rapid drying sometimes results in a substantial loss in density due to a rearrangement of the particles of silver in the image to a form with less covering power (Fig. 7-18). This effect is usually termed "plumming" from the color of the higher densities. Many paper emulsions, particularly those designed for continuous processing machines, contain "antiplumming" agents. The obvious cure for the

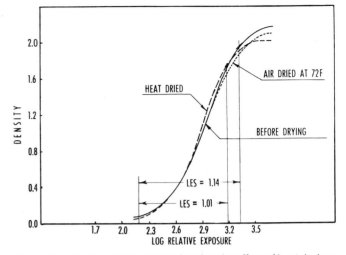

Fig. 7-18. Sensitometric curves showing the effect of heat drying on the density scale of some chloride or chloro-bromide papers. Heat drying tends to decrease shoulder densities, thus having the effect of shortening the exposure scale of the paper.

degradation of density and the change in color with rapid drying is to dry more slowly at a lower temperature but this is not always possible with continuous processors.

Prints dried on hot drum driers usually tend to lay flat but will curl later if the humidity is high. This can be avoided by keeping the prints under slight pressure or by mounting.

Some papers when dried rapidly by heat show a serious change in color when toned in selenium toners, the effect being to reduce the "richness" of the image and a colder color (Fig. 7-19).

Print straighteners pass the prints over steam and then over rollers to produce a "set" to the paper opposite to the curl. The process is more successful with thin papers coated with thin emulsion.

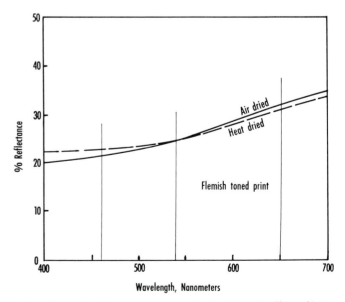

Fig. 7-19. Spectrophotometric curves showing the effect of heat drying on the color of a Flemish toned (selenium) print.

STABILIZATION PROCESSING

Stabilization processing of photographic papers is carried out where rapid availability of the prints is required, and print permanence is of secondary importance. It is of particular value in situations where wash water is scarce, such as in military activities. Instead of normal fixing to remove all undeveloped silver halides and washing to remove all residual chemicals, the developed print is treated in a stabilizing solution that converts undeveloped silver halides to colorless compounds that are stable to light and leaves both these silver compounds and unreacted stabilizer chemicals in the print. The requirements of a good stabilizer are (1) that silver complexes formed be light insensitive and transparent and (2) that neither they nor the unreacted stabilizer residue produce undesirable effects on the silver image nor on the gelatin layer, such as to make it tacky.[21-25]

The stabilized prints can be used for photomechanical reproduction, military briefing, preparation of reports, or for other relatively short term uses. While the images are considered to be transitory in that eventually stain levels may rise and image density diminish, some stabilized prints have a life of several years, if properly stored. After stabilization, washing is not usually considered necessary nor even desirable, although in cases where the emulsions to be stabilized are coated on film base rather than on paper, a brief rinse may be necessary to remove some excess stabilizer.

Sodium thiosulfate, itself, is an effective stabilization agent with many types of paper, the thionates remaining in the print meeting most of the requirements given above. A typical sodium thiosulfate formula would be represented by the following:

Sodium sulfite	15 g
Sodium bisulfite	50 g
Sodium thiosulfate crystals	300 g
Water to make	1 l

Another common stabilizer is thiourea, and a typical formula is the following:

Thiourea	16 g
Glycerol	5 cm³
Water to make	1 l

In using the thiourea stabilizer, an ordinary B&W developer, such as D-72, can be used to develop the image, followed by an acetic acid stop bath (32 cm³ glacial acetic acid per liter of water). The alkaline developer must not be allowed to contaminate the stabilizer since this will result in fog and stain. Fog will also occur if the alkali of the developer is not completely neutralized.

While most photographic papers and many films can be stabilized by conventional development and one of the stabilizers mentioned above, several photographic papers are manufactured specifically for stabilization processing. In these papers, hydroquinone or other developing agents are coated in the emulsion layer or gelatin protective surface layer. They are developed by immersion in an alkaline-sulfite solution and without rinsing passed directly into the stabilizing bath. If caustic alkali is used, development and stabilization are completed in very short order; i.e., table-top, roller processors performing this operation will turn out 8x10 in. prints in approximately 10 sec.

The most common stabilizers employed with today's stabilization type papers utilize an acidic solution of ammonium thiocyanate as the complexing agent. A typical basic formula is:

Water	700 cm³
Glacial acetic acid	50 cm³
Ammonium thiocyanate	200 g
Water to make	1 l

To this basic formula may be added additional compounds, such as alum hardening agents, and compounds that stabilize the image from attack by residual thiocyanate, such as phenyl mercaptotetrazoles or heavy metal compounds.

KEEPING PROPERTIES AND STORAGE OF PAPER

With age paper emulsions change in speed, in maximum density, in exposure scale and in increased tendency to fog in development. Emulsions differ greatly not only in the time span required for significant changes in characteristics but in the amount and direction of the change. In general, slow emulsions of silver chloride for contact printing have a longer shelf life than the faster chloro-bromide papers. Usually, the exposure scale increases with age and, in the case of variable contrast papers, the differences in image contrast with different filters is reduced. Associated with the increased exposure scale is a tendency for the maximum density to be lower than on fresh paper. There are changes also in speed and in the color of the image which tends to become colder, particularly when the prints are toned. Fog increases also and eventually it is no longer possible to obtain an image with clear whites.

The effect of age is not limited to sensitivity characteristics of the emulsion. Aging increases the brittleness and the tendency to curl of the paper. Paper which is difficult to use, because of excessive curl and brittleness, can sometimes be reconditioned for use by maintaining a relative humidity of 50% or more in the printing room..

When possible, the unopened packages should be kept at a temperature below 40°F, or in a deep freeze at 0°F. The packages should be given time to reach room temperature (5 to 6 hours) before being opened for use. Temperatures above 75°F are to be avoided if possible. Paper in unopened packages is not affected by high relative humidity, but open packages should be kept in a dry place.

GENERAL REFERENCES

Ansel Adams, *The Print*, Morgan & Morgan, Hastings-on-Hudson, N.Y., 1968.

A. Pearlman, *Pearlman on Print Quality*, Morgan & Morgan, Hastings-on-Hudson, N.Y., 1972.

The Print, Life Library of Photography, Vol. 3, Morgan & Morgan, Hastings-on-Hudson, N.Y., 1971.

C. I. Jacobson and L. A. Mannheim, *The Technique of the Positive*, Focal, London and New York.

Lou Jacobs Jr., Variable Contrast Papers. Amphoto, N.Y.

REFERENCES

1. American National Standard PH2.23-1961 (R 1-1969), *Lighting Conditions for Viewing Photographic Color Prints and Transparencies.*
2. PSA Uniform Practice No. 1, *J. Photogr. Soc. Amer.*, **35** (2): 146 (Feb 1969).
3. Eugene Allen, *J. Opt. Soc. Amer.*, **47** (10): 933 (Oct 1967).
4. Ira B. Current, "Some Factors Effecting Sepia tone," *PSA J.*, **15** (11): 784 (Nov 1949).
5. Walter H. Carnahan, "Measuring the Image Tone of Photographic Paper," *J. Photogr. Soc. Amer.*, **18B**: 7 (Mar 1952).
6. Walter H. Carnahan, *Photogr. Sci. Eng.*, **3**: 110 (1959).
7. C. Tuttle, *J. Soc. Motion Picture Engrs.*, **18**: 172 (1932).
8. L. A. Jones and D. N. Nelson, *J. Opt. Soc. Amer.*, **32**: 558 (1942); **38**: 897 (1948).
9. Lloyd E. Varden and Peter Krause, "Printing Exposure Determination by Photoelectric Methods," *American Annual of Photography*, **64**: 30 (1950).
10. D. R. Craig, "A Fully Automatic Servo-Controlled Scanning Light Source for Printing," *Photogr. Eng.*, **5**: 219 (1954).
11. J. L. Blackmer and J. C. Marchant, "System Analysis and Performance of A Feedback Scanning Printer," *Photogr. Sci. Eng.*, **2** (12): 225 (Dec 1958).
12. Lloyd E. Varden, "Two Tray Development," *Photogr. Tech.*, **2**: 32 (1940).
13. A. and L. Lumiere and A. Seyewetz, *Brit. J. Photogr.*, **71**: 108 (1924).
14. J. I. Crabtree, G. T. Eaton and L. E. Muehler, "Fixing and Washing for Permanence," *J. Photogr. Soc. Amer.*, **9**: 115, 162 (1943).
15. Processing Chemicals and Formulas, Eastman Kodak, Rochester, N.Y.
16. J. I. Crabtree, G. T. Eaton and L. E. Muehler, "The Elimination of Hypo from Photographic Images," *J. Photogr. Soc. Amer.*, **6**: 6 (1940); *Photogr. J.*, **80**: 458 (1940).
17. G. I. P. Levenson, "The Washing Power of Water," *J. Photogr. Sci.*, **15**: 215 (1967); **18**: 1 (1970).
18. C. I. Pope, "Determination of Residual Thiosulfate in Processed Film," *J. Res. Natl. Bur. Std.*, **67C**: 237 (1963).
19. Arthur Hammond, *How to Tone Prints*, American Photographic, Boston, 1946.
20. C. B. Neblette, "Toning of Developed Silver Images," Chapt. 24, *Photography, Its Principles and Practice*, 4th Ed., D. Van Nostrand, New York, 1942.
21. H. D. Russell, U.S. Patent 2,453,346 (1948).
22. A. H. Newman, "The Chemistry of Stabilization Processing," *Brit. J. Photogr.*, **114**: 1009 (1900).
23. S. Levinos and W. C. Burner, U.S. Patent 2,696,439 (1954).
24. R. S. Bruener, Thiourea and its Derivatives in Photographic Stabilization Processing, *J. Photogr. Sci. Eng.*, **4**: 186 (1960).
25. Cristopher Lucas and Harvey Hodes, Stabilization Processing with AFD-25, Acetic Acid and Thiourea, *J. Photogr. Sci. Eng.*, **6**: 294 (1952).
26. Ira B. Current, "Equipment for Testing Some Physical Characteristics of Sensitized Materials," *Photogr. Eng.*, **5** (4): 227–233 (1954).

8

SENSITOMETRY

Hollis Todd
and
Richard Zakia

Sensitometry is an experimental branch of applied photographic physics. The word means the measurement of sensitivity (of photographic materials), but during the century of its development the scope of sensitometry has been extended to include the study of many properties of photographic materials other than sensitivity.

The goals of a sensitometric test are answers to these general questions:

1. What is the relationship between the quantity of radiant energy received by the sample and the response of that sample?
2. How does processing, or other aftertreatment, affect the response (image)?

Because every significant factor in the photographic process affects the measured response (see Table 8-1) reliable inferences can be made only from carefully specified and controlled test procedures:

1. Sensitometric exposure: methods of supplying to the sample specified quantities of radiation;
2. Sensitometric processing: methods of chemical treatment of the exposed sample in specified, repeatable processes;
3. Densitometry: the measurement of the image;
4. Data reduction and data analysis.

Sensitometric tests are used by manufacturers to ensure conformance to specifications of successive batches of photographic materials for specific applications. A sensitometric test is also a sensitive method of checking the conformance to specifications of processing solutions.

The four-stage test sequence above implies that (based on past experiments) the response of the photographic material can be predicted for a given set of exposure and processing conditions. The user may, on the other hand, wish to make valid inferences about the exposure received by the material on the basis of image measurements. Such photographic "photometry" or "radiometry" ordinarily requires calibration of the photosensitive material at nearly the same time and under the same conditions as the experimental test. The calibration must be done with great care because photosensitive materials are nonlinear in response except over a very limited range of exposures. Moreover, they integrate energy over time and over wavelength in a complex, nonadditive manner: the images formed from two separate exposures cannot, in general, be summed to predict the image formed from the two exposures added together. Furthermore, in photographic photometry a reliably stable processing method is essential but difficult to achieve.

Another application of sensitometry is in the use of exposed "control" strips for monitoring an automatic processor. For this purpose, the exposure requirements are less stringent than for the preceding uses, since what is needed is an exposing method that is consistent, even if not precisely specified. The intent of the user of this type of sensitometry is merely to detect changes in the operation of the processor, and for this function any repeatable exposure at a reasonable level will suffice.

TABLE 8-1. FACTORS THAT MAY AFFECT THE MEASURED RESPONSE OF A PHOTOGRAPHIC MATERIAL.

Exposure (Level Constant)
1. Conditions (especially temperature and humidity) under which the material was stored.
2. Spectral energy distribution of the exposing radiation.
3. Rate at which the sample is irradiated (reciprocity and intermittency effects).
4. Conditions (especially temperature and humidity) at the time of exposure.
5. The size of the exposed area (especially in microsensitometry).
6. The exposure given to immediately adjacent areas (especially in microsensitometry and color sensitometry).

Processing Conditions
1. The time and storage conditions between exposure and processing (latent image growth or decay).
2. The chemical properties of the developer: pH; concentration of ingredients.
3. Type and degree of agitation.
4. Temperature of development.
5. Time of development.
6. Time and chemistry of fixation.
7. Drying method.

Image Measurement
1. Influx optics, i.e., the optical system that illuminates the sample.
2. The spectral energy distribution of the light source.
3. Efflux optics, i.e., the optical system that collects the light transmitted by (or reflected by) the sample.
4. The spectral response of the receptor of radiation.

SENSITOMETRIC EXPOSURE

Units of Measurement

Of the several dozen measures of radiant energy, only a few are important in sensitometry.

We distinguish first between *light* and radiant energy in general.[11,14] Light is that region of the electromagnetic spectrum which is capable of stimulating a visual response in the standard observer, and is defined by the photopic curve in Fig. 8-1. The curve shows the relative response of the standard observer under moderate light level conditions to equal physical quantities of radiation. The response falls to nearly zero at 400 nanometers (nm) and at 700 nm; thus, these are the nominal limits for wavelengths of light.

Photopic vision is associated primarily with the cones in the retina. Scotopic vision, however, involves the rods primarily and represents the response of the eye to low light levels. It is important to realize that when light measurements are made at low light levels error is involved, since light measuring instruments are based on the photopic response of the eye.

The spectral response curve of the eye is unique; no other light sensitive system has the same response although certain types of photocells (shown in Fig. 8-2) when properly filtered, come close to matching the photopic eye response. Such cells are used in light meters, densitometers and other physical instruments designed for measuring light.

Figure 8-3 represents response curves for photographic

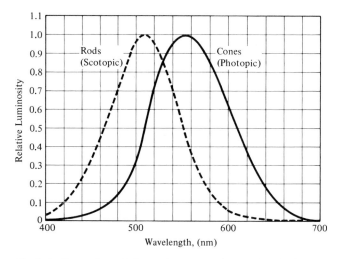

Fig. 8-1. Photopic and Scotopic response curve for the human eye.

film. The curves stress the fact that not only is the spectral response of the film different from that of the eye and photocells, but also there are differences in the spectral response of the different types of films. At best, photometric or photoelectric measuring devices give only a rough approximation of how a specific film will respond to light. This is true for film in cameras or film or paper in printers.

Photometric quantities are psychophysical, in that they are related to the integral of the product of the eye luminosity curve and the spectral energy distribution of the light source. Radiometric quantities, on the other hand, require in principle a measuring instrument that has a flat response—one that is unchanged with wavelength. A well-blackened thermopile approximates such a response over the visible spectrum, and may extend into the ultraviolet and infrared. Since the thermopile operates on the basis of a temperature elevation, the environment in which the instrument is placed usually affects the reading, and for this reason thermopiles are usually calibrated against a standard source of radiation.[14]

The basic concept in photometric or radiometric measurements is that of *flux*, the rate of energy flow through an aperture or on to a receptor like a photocell or area of film. In photometry, the unit of flux is the

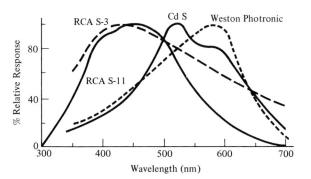

Fig. 8-2. Percent spectral response of four type of photoelectric cells.

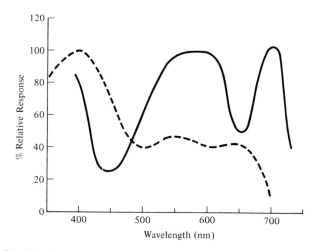

Fig. 8-3. Percent spectral response for two types of panchromatic photographic film. The solid curve represents a film intended for aerial photography while the dotted curve represents a film intended for terrestrial photography.

lumen. One lumen is the rate at which visually effective energy flows through an aperture of area r^2 placed at a distance r from a point source of unit intensity, i.e., one *candela* (new candle). The corresponding radiometric unit is usually the watt.

At the peak sensitivity of the standard observer, one watt (w) of energy is defined as equivalent to 680 lumens. Therefore, conversion from radiometric units to photometric units is possible if the spectral characteristics of the radiation source are known: $\phi = 680 \int_0^\infty P_\lambda \, V_\lambda \, d_\lambda$, where ϕ is the flux in lumens, P_λ is the energy in watts over a narrow wavelength band, and V_λ is the corresponding luminosity factor, as in Fig. 8-1.

Illuminance is the measure of the rate at which light energy is received by a receptor of unit surface area. The unit of measurement is the *lux:* lumens per square meter. (The equivalent unit meter-candle is more often encountered in sensitometric contexts). The corresponding radiometric concept is irradiance, measured in watts per unit area of receiving surface.

In photometric sensitometry, *exposure* means the measure of the light energy received by a unit area of the photosensitive material. It is the product of the illuminance and the time during which the energy is received: $H = E \times t$, where H is the exposure, E the illuminance, and t the time. The unit of exposure is lumen-seconds per square meter, or lux-seconds. The symbols used here correspond to those in the internationally recommended notation. The literature in sensitometry usually makes the defining equation for exposure read $E = I \times t$,[28] and the customary unit of exposure is meter-candle-seconds (mcs.) The corresponding radiometric unit is often watt-seconds per square meter.

To describe *sources* of light (as distinct from light incident upon a receptor), the concept is *intensity* (I) and the unit the *candela* (cd) which replaces the obsolescent candle (*c*). The intensity of a real source varies with direction; it is measured by comparison with a standard source, a blackbody operated at a temperature of 2042K.

By definition, one square centimeter of the standard source has an intensity of 60 candelas. One candela is equivalent to a light flux of one lumen in a unit solid angle (steradian).

In photography, the intensity of a *unit area* of a source (or a reflecting or transmitting surface) is especially useful. This concept is called luminance, and the unit is candelas (or candles) per square meter, or more commonly per square foot. Luminance is what is measured with the photographer's light ("reflectance") meter, if the photocell is filtered to duplicate the eye response, and if the meter has a restricted angle of view. For perfect diffusers (Lambertian surfaces), measured luminance is independent of distance and of direction of view. No real Lambertian surfaces exist, but blotting paper is a good approximation of such a surface. In addition, for Lambertian surfaces (and *only* for such surfaces) the total flux emitted per unit area of the surface (measured in lamberts or foot-lamberts) is related to luminance by the rule $M = \pi L$, where M is the number of lamberts and L is the luminance. If L is measured in candelas per square foot, M is measured in foot-lamberts. Also $M = ER$, where E is the illuminance on the surface, and R is the reflectance of the surface.

To a first approximation, the illuminance E on the photographic material in the camera is proportional to the subject luminance; the assumptions are that flare light is insignificant, and that the image is not a point. The illuminance can be estimated from the following relationship.[9,52]

$$E = \frac{10.76\pi L \, (f/v)^2}{F^2} \cos^4 \theta \cdot h \cdot T$$

where

E = illuminance on the film (lux, or meter-candles)
L = subject luminance (candelas per square foot)
f/v = bellows extension
θ = off-axis angle of the image
h = vignetting factor
T = lens transmittance
F = f-number

For an object on axis and at infinity, and assuming typical values for H and T, the relation simplifies to:

$$E \sim \frac{5L}{F^2}$$

In the purely psychological appraisal of an image, it is sometimes necessary to estimate the quantitative aspect of a sensation. The term *brightness* specifies the appearance of a surface seen as a light source, on a scale from dim to dazzling. The term *lightness* specifies the appearance of a surface seen as a reflector of light, on a scale from black to white. Brightness is properly applied to lamps; lightness is properly applied to surfaces such as skin, charcoal and snow. Lightness is measurable by reference to the scale of *value* in the Munsell system of color nomenclature.[6] Brightness is measurable (with difficulty) by subjective estimation of appearance on a scale from (perhaps) 0 to 100. (The term luminance is preferred to photometric "brightness.")

The preceding section is summarized in Table 8-2.

TABLE 8-2. ENERGY MEASURES USED IN SENSITOMETRY
(for conversions see Refs. 11 and 14).

Physical

 Radiant Flux (P): Unit: watt. Rate at which radiant energy flows through an aperture.

 Irradiance (E_e): Unit: watt per square meter. The rate at which radiant energy is received at a point.

 Radiant Intensity (J): Unit: watt per steradian. Rate at which radiant energy is emitted in a specific direction.

Psychophysical

 Luminous flux (ϕ): Unit: lumen. Rate at which light flows through an aperture.

 Illuminance (E): Unit: lumen per square meter (lux; meter-candle). The rate at which light is received at a point.

 Exposure (H):* Unit: lumen-second per square meter (lux-second; meter-candle-second). Quantity of light per unit area of a receptor.

 Intensity (I): Unit: candela (lumen per steradian). The rate at which light is emitted in a specific direction.

 Luminance (L): Unit: lumen per square meter per steradian. The rate at which light is emitted (or reflected) from a unit area in a specific direction.

 Luminous Emittance (luminosity) *(M):* Unit: lumen per square meter. The rate at which light is emitted (or reflected) into a hemisphere from unit area.

Psychological

 Lightness: The appearance of a surface seen as reflecting light on an arbitrary scale from black to white.

 Brightness: The appearance of a surface seen as a source of light on an arbitrary scale from dim to dazzling.

*Until recently the symbol for exposure in photographic literature was E. This has now been changed to H; thus the D-log E curve becomes the D-log H curve.

Methods of Obtaining Input Data

The initial step in a sensitometric test is to apply known exposures to the sample of photographic material. Of the following methods, the first is the most specific and the best-defined but is most remote from practice.

 1. A *sensitometer* is a specially-designed contact printer having as its sole purpose the production on a sample of a series of known, consistent and repeatable irradiances.[40,44,45,55,80] The design of sensitometers is discussed in some detail below.

 2. A transparent step tablet may be used in a printer, or a reflection gray scale in the photograph.[2,3] Such a device presents to the photographic material a series of irradiances having a known relationship, but the absolute values of the exposures will usually not be known. The relative input values obtained in this way are sufficient for process control purposes and most studies of tone reproduction.

 3. Luminance data obtained from the subject provide input information similar to that of method (2) above.[2] Small-spot photometric measurements of subject luminances require that the measuring device be visual, or that the photoelectric response duplicate that of the eye. Furthermore, flare must be negligible or measurable;

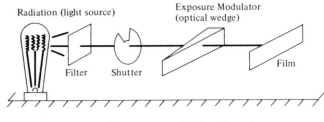

Fig. 8-4. Components of a Sensitometer.

this condition is not easy to meet. Subject luminance data are used for tone reproduction experiments.

Sensitometers

As shown schematically in Fig. 8-4, a sensitometer consists of:

(a) a source of radiation of stable and known intensity and quality;

(b) a shutter or other means of controlling the time of exposure;

(c) an exposure modulator* for varying the irradiance at the sample to produce a series of exposures.

 Filters are also used to adjust either the level of energy reaching the film or the spectral characteristics of the radiant energy.

Light Source

The light source must be of known intensity and spectral composition and it must be stable over a long period of time. Tungsten lamps with monoplane filaments consisting of vertical coils are quite satisfactory. When using clear bulbs with vertical coil filaments, the long dimension of the optical wedge must be horizontal.

 Tungsten lamps that have striated glass bulbs should be avoided since striations are a source of nonuniformity of irradiance. A large number of bulbs may have to be inspected in order to find an acceptable one.

 A lamp with a color temperature of 2850K has been adopted for sensitometers. This is a compromise between adequate spectral output (particularly in the blue) and lamp life.

 Each lamp used in a sensitometer must be individually calibrated to determine its lumen output. Calibration

*A calibrated transmission step tablet is often used as an exposure modulator. Such step tablets can be purchased from,

 Office of Standard Reference Materials
 Chemistry Building, Room B311
 National Bureau of Standards
 Washington, D.C. 20234

(The 1976 cost for such a tablet was $62.00)

These are 21-step tablets measuring 3½ x 25 cm and are calibrated according to American National Standard Visual Type VI-b. They have a density range from 0.0 to 3.0 and are calibrated by a method having a precision indicated by 1% or 0.01 density (3 standard deviations), whichever is greater.

data for lamps can be obtained from the U.S. Bureau of Standards, the lamp manufacturer, or from independent standardizing and testing laboratories. A properly calibrated lamp will provide a known lumen output and color temperature when it is operated at the voltage and current for which it was calibrated.

To maintain a consistent lumen output a voltage or current regulator is used. A current regulator is more effective than a voltage regulator, but requires a high quality meter operating at nearly full scale deflection.

Sources of light for sensitometric tests are specified in the following documents of the American National Standards Institute:

PH2.29-1967 defines photographic daylight, as a source with a correlated color temperature of 5500K, simulated with a controlled tungsten lamp and suitable filtering. The color quality of this source resembles that typical of outdoor illumination.[46] PH2.35-1969 describes tungsten lamps. PH2.9-1964 (R1969) describes two sources for testing medical x-ray films exposed to fluorescent screens.

If filters are used to isolate spectral bands, the irradiance data are usually only relative, since the absorption characteristics of the filters are rarely known with precision, and since these characteristics change with the temperature of the filter and with time.

No standards are available for exposures to electronic flash, flashlamps, mercury arcs, fluorescent lamps, etc.

Filters

Filters are used to reduce the level of light flux from the lamp or to change its spectral output.[7] A neutral density filter of 0.30 will reduce the light flux by a factor of two; a Wratten 78AA filter in front of a tungsten lamp of 2850K will alter its spectral distribution to that approximating 5500K daylight. Although this combination produces a reasonably good visual match to standard daylight, it does not yield a match of spectral energy distribution that is precise enough for exposing color materials. More appropriate filters for use with tungsten lamps are the Corning glass filter series 5900 or, preferably, the Davis-Gibson liquid filters.[42] These are more stable over a period of time than gelatin filters, but absorption characteristics may change with temperature. American National Standards Institute (ANSI) PH2.20-1960 or PH2.5-1960 lists formulas for making Davis-Gibson liquid filters. Figure 8-5 can be used to select a filter to change the effective spectral energy distribution for tungsten lamps, but is only very approximate for other sources.[50]

For precise usage, filters should be individually calibrated, preferrably spectrophotometrically. Furthermore, filters may change in absorption with environmental conditions (especially temperature) and may fade with use.

Table 8-3 lists some properties of various types of optical filters.

TABLE 8-3. SOME PROPERTIES OF OPTICAL FILTERS.

Physical characteristics	Example
Dispersing medium	
1. Gelatin	Wratten 92, 93, 94
2. Glass	Corning 5900
3. Liquid	Davis-Gibson
Optical mode	
1. Transmitting	Gelatin, glass & liquid filters
2. Reflecting	Graycard, grayscale
3. Transmitting/reflecting	Beam splitters
4. Interference	Dichroic mirrors

Thinness — The thinner the filter the less change in the optical path. Wratten gelatin filters are 0.1 mm thick.

Flatness — Optically flat filters are very expensive but necessary for critical optical work.

Stability — Inorganic absorbing molecules are more stable than organic. Most filters have organic absorbing molecules and their optical characteristics are changed by heat, humidity and radiation.

Spectral characteristics

Bandwidth	
1. Wide or broad band	about 100 nm or more
2. Medium band	about 50 nm
3. Narrow band	about 10 nm
4. Very narrow band	about 1 nm
Selectivity	
1. Somewhat nonselective	neutral density filters
2. Highly selective	color filters

Variability — Unless individually tested do not assume that filters with the same identification have the same spectral characteristics.

Function

Color Compensating filters (CC filters) are used to balance the color temperature of the light in an enlarger when making color prints.

Color Printing filters (CP filters) serve the same function as CC filters, but they are of lesser quality and cost and should not be used in the projected image optical path.

Color Separation filters are used to isolate the red, green and blue information from a color image or scene.

"Heat-Absorbing" filters are IR-absorbing, heat-dissipating filters.

Infrared (IR) filters are used to absorb light and transmit infrared radiation.

Light Balancing filters are used to adjust the color temperature of the light to that of the film in a camera. (Sometimes called conversion filters.)

Neutral density filters are used to nonselectively lessen the level of luminance in an optical system.

Photometric filters are used in visual photometry to balance the difference in the two parts of a photometric field.

Polarizing filters are used to control the reflection of light by limiting the transverse vibrations of light waves to a single plane.

Safelight filters are used to provide safe illumination with which to handle light sensitive materials without exposing (fogging) them.

Ultraviolet (UV) filters are used to absorb unwanted ultraviolet radiation.

Variable Contrast filters are used to adjust the color temperature of the light in an enlarger to effect shifts in contrast when printing on variable contrast black and white paper.

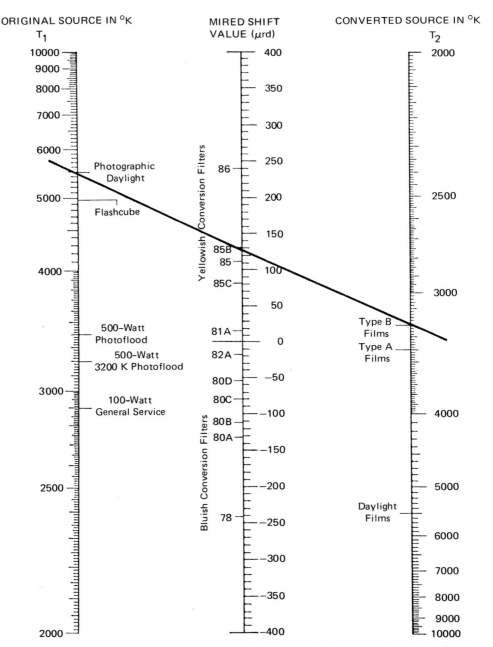

Fig. 8-5. The Mired Nomograph can be used to find the filter required for a particular conversion by placing a straightedge from an original source (T₁) to a second source (T₂) as illustrated above by the diagonal line. In the illustration, daylight illumination at 5500 K requires an approximate +130 mired shift to convert to Type B illumination at 3200 K. KODAK Daylight Filter No. 85B with a mired shift value of +131 meets this requirement. Source: Kodak Filters for Scientific and Technical Uses (1970) Publication No. B-3.

The neutrality of a filter is another factor of importance. A truly nonselective filter does not exist. All are selective for some wavelengths.

Figure 8-6 shows that a 1.0 ND dye filter is moderately selective, especially in its absorption of blue light and ultraviolet. Such a filter may be adequate for routine black and white sensitometry but is not adequate for high precision sensitometry and especially for testing color materials. For critical work one should use a variable area filter, a carbon or Inconel filter or a wire mesh screen. An Inconel filter is also nonselective in the infrared to about 2400 nm. In the near UV region Inconel coated on

quartz is acceptable. Figure 8-7 shows the spectral characteristics of four popular types of filters and Table 8-4 displays other useful information regarding these filters.

Note in particular that the light-scattering characteristics of these filters are expressed by the Callier "Q" factor, the ratio of diffuse density to specular density. The Inconel filter has the least scatter; the silver, the most. For a specific filter, its position in an optical system can affect the amount of radiation scattered at the exposure plane. Light scattering within a sensitometer or any exposing instrument is a serious problem for it adds

Fig. 8-6. Spectral density of 1.0 a wratten 96 neutral filter (solid line) compared with ideal neutral (dotted line).

Fig. 8-7. Spectral densities of neutral filters—photographic silver, wratten 96, inconel and M-Carbon all having a density of 1.0 to light.

nondirected light to the photographic material and can introduce errors.

Since most optical wedges (step tablets) are carbon (colloidal dispersions of carbon in gelatin) or silver (developed photographic silver images), what has been said about problems of selectivity and scatter applies. The selection of filters or wedges often involves a trade-off between selectivity and scatter. Colloidal carbon wedges, for example, are available as M-type or Wratten 96. The M type is less selective than the Wratten 96 but scatters more.

The problem of selectivity encountered with optical wedges is hard to avoid, but there are some alternatives. Unfortunately, they introduce other problems.

One can use the *inverse square law* and by varying the distance between the film and light source obtain a series of exposures. This technique is inconvenient and the range of possible exposures is limited. The inverse square law technique is useful for a small range of exposures with small increments.

Since the amount of light flux incident on a film can be attenuated by an aperture, a series of *apertures* can be used to provide a series of exposures. The light flux is directly proportional to the aperture area and is, there-

TABLE 8-4. ADDITIONAL INFORMATION ON FOUR TYPES OF NEUTRAL FILTERS.

Type of material	Composition	Suitable for image-forming beam	Callier "Q" factor			Minimum density[a]	Maximum density	Special characteristics and applications
			420 nm	550 nm	680 nm			
Inconel-Coated Density on glass	Thin, evaporated layer of Inconel alloy (Fe, Ni, Cr)	Yes	1.005	1.005	1.015	0.06	4.0	Works primarily by reflection. Can handle relatively high power
Inconel-Coated Density on quartz	Same as above	Yes	1.005	1.01	1.02	0.06	4.0	Same as above but best for ultraviolet region.
WRATTEN No. 96 Density	Dyes and small-particle carbon in gelatin	Yes	1.04	1.02	1.02	0.05	6.0	Primarily for use between 400 and 700 nm
M-Type Carbon Density	Large-particle carbon in gelatin	No	1.32	1.27	1.22	0.05	6.0	Primarily for sensitometric standards.
Photographic Silver Density	Silver particles in gelatin	No	1.40	1.41	1.40	0.05	4.05	Primarily for process-control sensitometry and attenuation.

[a]Including base density.

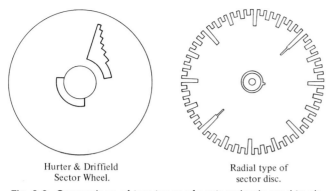

Hurter & Driffield
Sector Wheel.

Radial type of
sector disc.

Fig. 8-8. Comparison of two types of sector wheels used to obtain a series of illuminances.

fore, easily specified. Sensitometers incorporating this technique are often called "tube" sensitometers. Itek Corporation has made such an instrument commercially available. The range of illuminances is limited by the necessary accuracy required in making apertures (tubes) of very small diameters.

A rotating *sector wheel* or disc is another technique for obtaining a series of illuminances. The wheel used by Hurter and Driffield consists of a series of successive and contiguous apertures in which each aperture is half the angular size of the preceding one (see Fig. 8-8). The major problem with such a disc is that it causes intermittent exposures. The response of a photographic material to intermittent exposures is often different from that of a continuous exposure (intermittency effect). The use of a sector wheel designed with many apertures on the circumference (Fig. 8-8) and rotated at sufficient speed to exceed the critical frequency will practically eliminate the intermittency effect. Since the critical frequency requires a few thousand flashes during the total time of exposure, the use of such sector discs is restricted to low intensities so that exposure times of several seconds can be used. Such discs are often used in monochromatic sensitometers which involve low illuminances and long exposure times.[10]

A necessary filter when a tungsten lamp is used as a light source is an "infrared-absorbing, heat-dissipating" filter. In effect it converts radiant energy to heat energy. This type of filter, usually glass, protects other filters and optical components from the infrared radiation emitted by tungsten lamps.

Shutters

The shutter determines the duration of time the light flux is incident upon the film. A sensitometer shutter should be repeatable and of known duration to minimize exposure time variability. Camera shutters do not meet these sensitometric requirements. Most sensitometer shutters are mechanical. An exception is a sensitometer having an electronic flash tube which serves as its own shutter.

One type of mechanical shutter is a *gravity shutter* which consists of a free falling opaque plate with an

aperture or slot. It is simple, dependable, economical, and useful for exposure times of about 1/100 sec or shorter. A commercial sensitometer operating by gravity using a pendulum disc shutter is reported by G. A. Johnson.[45]

A *sector shutter* is another type of mechanical shutter. It consists of a sector disc which is continuously rotated by a synchronous motor and a suitable speed reducer. The angular size of the sector aperture and the rotational speed of the disc determine the exposure time. Rotating sector shutters are useful in a time range of about ½ sec to 1/200 sec. The Kodak Process Control Sensitometer uses this type.

With a *stationary-slit shutter* the film to be exposed and the optical wedge are placed together and moved past a fixed exposing slit. The advantage of this system is that it requires only a small area of illumination. The source can be close to the film and thus produce a high level of uniform illuminance. The Macbeth Quantalog® Sensitometer and the Herrnfeld operate on such a shutter principle. In the Macbeth sensitometer, however, the film is stationary and the slit shutter moves as shown in Fig. 8-9.

When long exposure times (½ sec or more) are needed, a shutter that is opened and closed by an electrical impulse from a timer is adequate. In designing an on-off shutter, it is advisable that its opening and closing time be small relative to the total exposure time.

When short exposure times of about 1/500 sec or shorter are needed, a nonmechanical shutter such as an electronic flashtube serves well as both a shutter and light source combination. The *electronic flashtube* is the simplest and most economical way to obtain these short exposures. The exposure duration is varied by varying the reactance of the electronic circuit. Two commercially-available sensitometers using electronic flash are those manufactured by Edgerton, Germeshausen and Grier and by Herrnfeld. Calibration of such sensitometers requires the use of a photometer which integrates the output of the source over time, and which has a very short time response characteristic. Furthermore, successive exposures made with these devices may be more variable

Film & Wedge

Slit

Track

Fig. 8-9. Macbeth Quantalog® Sensitometer. The carriage on which the slit and light source are located moves past a stationary film sample and sensitometric wedge. The exposure time is determined by the synchronous motor speed and the slit width used.

than those produced by a tungsten source and a mechanical shutter.

Alternatives to Sensitometers

Although exposures supplied by a well-designed and well-maintained sensitometer can be expected to be repeatable and accurate, they may not conform to practice and thus may not be completely valid. Practical tests can be made with a camera or printer using a transparent or reflecting test object. Commercially-available transparent step tablets produce a set of illuminances that are systematically changed by absorption over a range of about 1000-1 (3.0 in logs) in discrete increments. The increment is a factor of 2 for 11-step tablets, and a factor of $\sqrt{2}$ for 21-step tablets. The corresponding changes in log illuminance are 0.30 and 0.15. Ordinarily, only relative exposure values are known, although measurements of the unaltered illuminance at the exposure plane and knowledge of the exposure time permit conversion of the relative exposure data to "absolute" values.

Reflection gray scales serve a similar purpose for exposures made in the camera. Available gray scales have nonuniform increments, intended to make the ten gray scale patches about equally different to the eye. Typical values are: 0.0, 0.1, 0.2, 0.3, 0.5, 0.7, 1.0, 1.3, 1.6 and 1.9. The values are inversely related to the log luminance values; i.e., 0.0 is assigned to the lightest tone, which produces the greatest exposure on the camera film, and 1.9 to the darkest tone which produces the least exposure. The range of exposures is approximately 80 to 1, considerably smaller than that produced by the average outdoor scene.[10,28]

Still another alternative to sensitometric tests is available if luminance data can be obtained from the subject. Small-spot photometric measurements of subject luminances can be made with a visual instrument, or with a photoelectric device having a spectral response similar to that of the eye. Reliable data of this kind require that camera flare be negligible or measurable.

In practice photographic materials used in a camera are exposed to a wide range of spectral qualities of radiation; thus, the limited nature of a conventional sensitometric test using only one spectral energy distribution is apparent. The response of the material to a series of exposures to 5550K for example, or to standard tungsten light allows only limited inferences about the characteristics of the material. This is especially important for color materials for which optimal gray scale reproduction by no means indicates optimal reproduction of colors other than neutral. A more nearly complete test of a color material would require the use of a set of test patches chosen to be representative of the colors of interest, but the difficulty of evaluating the results makes such a test unattractive as a routine measure. A concise historical summary of the applications of color charts in evaluating the color reproduction properties of film can be found in C. B. Neblette's *Photography, Its Materials and Processes*, 6th edition, pp. 319f.

Linear vs. Logarithmic Input Data

In sensitometric tests, it is conventional to express exposure increments logarithmically. Thus, a common step tablet produces a set of exposure values equally spaced in increments equal to a log H change of 0.15; the exposure factor is $\sqrt{2}$, and the total log H change is 3.0, corresponding to a total interval of 1000X. Similarly, the typical outdoor scene is described as having a log luminance range of 2.2, indicating that the ratio of highlight to shadow luminance is about 160X.[10] An aerial scene, however, may have a total log luminance range of as little as 0.3.

The use of logarithmic values of exposure originated in the desire of Hurter and Driffield, the originators of the practice of sensitometry, to attack the problem of reproducing the *appearance* of objects in photographic images. They believed that the visual process is logarithmic, i.e., that lightness is directly related to the logarithm of the subject luminance. It is known now that this belief is only very approximately correct, and that the preservation of log luminance relationships in prints by no means guarantees correct simulation of appearance.[10,66] Nevertheless, logarithms are used in situations in which the appearance of the image is of interest, especially in tone reproduction studies.

On the other hand, in information-recording studies, a linear measure of input data may well be more significant than a logarithmic measure. Thus, it may be appropriate to use exposure (or number of quanta) rather than log H.

The effect of using a logarithmic scale of exposure values is to give equal weight to equal ratios of exposure. Thus the use of logs agrees with the f-number series of lens apertures, with the conventional series of camera shutter speeds, and with the standard series of film speeds. In the first two contexts, the factor is 2, a log change of 0.30, corresponding to an f-stop change; in the last the factor is the cube root of 2, a log change of 0.10, 1/3 stop.

Spectral Sensitometers

Conventional sensitometers usually expose photographic materials to light and other broad-band radiation. The density response of photographic materials exposed to such broad-band radiation does not provide information as to the part each spectral component of energy contributed to that density. One may desire to determine, for example, the density response of a material to the red, green and blue components. This can be done by making separate exposures through narrow-band filters. Gelatin filters like the Wratten 92, 93, and 94 are useful in isolating the red, green and blue portions of the light spectrum. For narrower bandwidths, interference filters can be used. To isolate UV and IR portions of the electromagnetic spectrum, the Wratten 18A (glass) and the Wratten 87 series and filters similar to them are employed.

In order to expose a photographic material to bandwidths of a few nanometers, a special sensitometer utiliz-

Fig. 8-10. Wedge spectrograph.

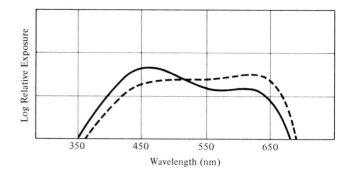

Fig. 8-12. Wedge spectrograms, same material, two different light sources.

ing gratings or prisms as dispersing components is necessary. Two such instruments are a *wedge spectrograph* and *monochromatic sensitometer* sketched in Figs. 8-10 and 8-11.

The wedge spectrograph is useful as a qualitative instrument in which the spectral response of a film to a specific light source is found. The film receives a simultaneous exposure to the entire spectrum of interest. The amount of radiant energy at each wavelength is usually not known. Furthermore, the spectral bands are not well isolated and therefore, not of high spectral purity. A tungsten lamp is often used as a light source. If the response of a film to UV radiation is important, then a source such as a mercury arc is necessary. In addition, special optical components (e.g., quartz) are required to pass the UV.

The images produced from exposures made in a wedge spectrograph are called wedge spectrograms. When comparing wedge spectrograms, it is essential to understand that they are qualitative and relative. Each represents the response of the film in a specific wedge spectrograph. If the light source is changed, the response of the film will differ as shown, for example, in Fig. 8-12.

Wedge spectrograms are produced quickly, and so are useful for routine test purposes. They are suitable for detecting gross differences among similar samples. They are not intended to show the spectral sensitivity of the photographic material independent of the source; because the energy falling on the sample is not known, only relative data are secured. A source of error is that the dispersed radiation is not often of high spectral purity, and flare light can be a problem.

A monochromatic sensitometer provides a sequential series of known exposures of high spectral purity. A thermopile is often used to determine the spectral radiant energy, and the energy so measured may be ex-

pressed in watt-seconds per square meter. (Light units, such as lux-second per square meter are based on psychophysical measurements and would be invalid). Such a sensitometer is a quantitative instrument since one can determine the spectral response of a photographic material independent of the exposing instrument.

The sensitometric strip obtained for each spectral region can be plotted as a D-log H curve. Exposure (H) would be determined by multiplying irradiance (watts per square meter) by time (t). Curves can then be evaluated in the same way as other D-log H curves, and determinations on how speed, contrast, etc., vary as a function of wavelength can be made.

Gamma vs. Wavelength

With broad-band exposures gamma is primarily a function of development for a particular film-developer combination. When the same film is exposed to narrow spectral bands of energy, gamma is found to be dependent on the spectral band used as well as development. A plot of gamma versus wavelength shows the direction and amount of change; such plots are as in Fig. 8-13, where the data are for two differently-sensitized panchromatic materials.[10] A practical consequence of this is that when film is being exposed to narrow bands of radiation it will be necessary to alter development times for each band if a constant gamma is desired for all bands. This has been common practice when making red, green, and blue separation negatives or positives. In reconnais-

Fig. 8-11. Monochromatic sensitometer (lenses omitted).

Fig. 8-13. For a specified development gamma varies with wavelength.

Fig. 8-14. Spectral sensitivity of an aerial type panchromatic film.

sance work where multiple-band cameras are used, altering development to obtain a constant gamma is extremely important to the validity of the data obtained.

Sensitivity vs. Wavelength

Just as there are many different ways of determining film speeds (see below) there are different ways of expressing spectral sensitivity. The criteria are similar. For example, film speed or sensitivity may be based on a fixed density, e.g., ASA speed on 0.1 density above base + fog. Many spectral sensitivity curves are based, on the other hand, on a density of 1.0 above base + fog. Figure 8-14 shows the spectral sensitivity of an aerial type film at a density of 1.0 above base + fog and 0.3 above base plus fog. Use determines the criterion. If the lower part of the D-log H curve is of importance, a density of about 0.3 should be used.

Single Layer Exposures of Color Film

There are times when it is desirable to expose individual layers of color film as in studying interimage effects between layers. This is extremely difficult since the spectral sensitivities of the cyan, magenta and yellow forming layers overlap.[28] If exposures are made in a sensitometer one may use narrow band filters whose bandwidth peaks are near the peak spectral sensitivity of the layer of film to be exposed. If, for example, the yellow-forming layer has a peak sensitivity at about 450 nm, a Wratten 94 blue filter having 30 nm bandwidth (440–470 nm) and peaking at about 450 nm may be used. A full scale of yellow dye alone will not be obtained since increasing exposure will expose the other layers. For example, since the magenta-forming layer also has sensitivity to blue light, magenta dye will form if the exposure to blue light is very great, causing the yellow scale to become reddish (yellow + magenta = red).

Exposure Effects

The definition of exposure as the product of the illuminance (or irradiance) and the time is necessary, but insufficient to specify the exposing situation, since it does not include:

1. A statement of the rate at which energy is supplied to the sample;
2. The spectral energy distribution of the radiation source;
3. The environmental conditions (especially temperature and humidity) during exposure;
4. The storage conditions and any time lapse between exposure and processing, which may produce changes in the latent image, and thus in the developed image.

Publications of the American National Standards Institute include the detailed considerations involved in sensitometric exposure. Examples are: PH2.2-1966 Sensitometry of Photographic Papers; PH2.5-1960 Speed of Photographic Negative Materials. Items (1) and (2) in the list above are exceptionally important.

Reciprocity Effects

The reciprocity "law" states that the photographic effect is dependent only on the total quantity of energy supplied to the photographic material, independent of the components of exposure (illuminance and time). The "law" implies that every absorbed quantum of radiation produces an effect, regardless of the rate at which quanta fall upon the sample. If the effect is defined as a measurable change in the material, the law holds only for: (1) relatively simple, one-step processes, such as in photoresists, diazo, and similar photosensitive materials; (2) silver halide emulsions irradiated with very high energy sources, such as x-rays and gamma rays.

For developed-out silver halide materials exposed to light, to infrared, or to ultraviolet, the measured photographic effect (density) is in general highly dependent upon the rate at which the material is irradiated; thus arises the concept of reciprocity-law failure (RLF).

(It is a common misconception that the equation $H = Et$, or $E = It$, is a statement of the reciprocity law. These equations, as indicated above, are in fact definitions of the term "exposure," and therefore never fail. What *does* fail is the response of the photographic material under unusual exposure conditions.)

As shown in Fig. 8-15, two major differences may result when the radiation is supplied to the sample at very low and very high rates: (1) The exposure needed to produce a specific density increases on either side of a rather flat minimum. Thus, if the irradiance is unusually great or small (and the corresponding time of exposure unusually short or long) the effective sensitivity of the material is reduced. (2) Since the curves for different densities are not parallel, the contrast of the material changes with exposure conditions. Since the intervals between the curves vary on either side of the minimum required exposure, the contrast of the material is changed, by analogy with a contour map of the earth's surface.

Fig. 8-15. Reciprocity law failure.

Conformance to the reciprocity law would be shown by a set of straight horizontal lines, which would indicate that the exposure needed to produce a given density would be unaltered with a change in irradiance.

A test of a photographic material at a constant level of irradiance and varying exposure times (a "time-scale" exposure series) would involve the intersections of the plotted curves with a vertical line at the specific value of irradiance. In general, the selection of a different value of irradiance would generate a different set of intersections, and thus a different relationship between log exposure and developed density. A similar test, but at a constant exposure time and varying irradiance, would involve a set of intersections along that diagonal line representing the time of exposure. Each different diagonal line would generate a different set of intersections.

The significance of the preceding paragraph is this: a photographic material responds in different ways to different exposure conditions. The complexity of the relationship indicated in Fig. 8-15 implies that any sensitometric test must be carried out under the most carefully controlled conditions. Furthermore, extrapolation of results from one level of irradiance to another is clearly wrong, although the error will be small near the minima of the curves in the figure.

Film speeds, to be discussed later, are usually based on optimum conditions of exposure. Any significant change from these conditions will affect the estimate of the sensitivity of the tested material.

The intermittency effect is a special case of reciprocity-law failure. If a sample of photographic material is exposed with successive flashes of light, the effect is usually different from that obtained by the use of a continuous exposure which is in magnitude equal to the sum of the flash exposures. The image density for an intermittent exposure will lie between two values: (1) the density produced by a continuous exposure at an irradiance equal to the average of the light and dark values of the intermittent exposure, and for a time equal to the sum of the times of the flash exposures; (2) the density produced by a continuous exposure at an irradiance equal to that of the flash, and for a time half that of the intermittent exposure. The intermittency effect disappears if the flash frequency exceeds a critical level.[10]

Other Exposure Effects*

That a photographic material does not respond in a simple additive manner is especially noticeable when a sample is supplied with two successive exposures of different spectral or time characteristics.

In the Herschel effect, the sequence is short wavelength (e.g., ultraviolet) followed by long wavelength (e.g., infrared). The effect may be lowered density (as compared with that from the shortwave exposure alone) especially in high density areas, and thus reduced image contrast. The Herschel effect is observed most readily with materials whose inherent sensitivity is small to the long wavelength radiation.

In the Clayden effect, the sequence is: an exposure at high irradiance and short time, followed by an exposure at low irradiance and long time. The image density may be lowered, even to the extent of reversal of portions of the image.

In the Sabattier effect, a second weak exposure (after the image-forming exposure) is given to the sample after brief development. After normal processing is completed, the image may be partially reversed, and often edges are enhanced in contrast. (The Sabattier effect is not to be confused with solarization, which is image reversal associated with extremely great exposures.)

II Sensitometric Processing

Processing is an important variable in determining the *rate* (gradient, slope, gamma, contrast index) at which the density increases as a function of exposure. To minimize variability in the testing of the response of a photographic material, therefore, it is essential that as much care be taken in processing film as in exposing it. This often means trading off the actual conditions in which the film will be processed for a standardized, less variable, processing condition. There are two existing sensitometric processing standards: one for processing film; (ANSI PH2.5-1960); and the other, paper (ANSI PH2.2-1966). Both are for black and white materials. As yet there are no ANSI standards for processing color materials.

The important factors that contribute to processing variability are time, temperature, developer composition, agitation and drying conditions. The first three factors are relatively easy to specify, measure and maintain. The last two, particularly agitation, are more elusive.

The function of agitation is to maintain a uniform quality of active developer solution adjacent to the film being processed. The difficulty in providing excellent agitation arises because the laminar layer of developer in contact with the film emulsion is adsorbed to it and held there by an appreciable force.

The laminar layer acts as a resistance or barrier, making it difficult for fresh developing agents to diffuse into the emulsion and developer by-products to diffuse

*These effects are presented in greater detail in Chapter 3 , "The Developable Image."

out. To minimize the thickness of this laminar layer so that fresh developing agents can diffuse into the emulsion requires vigorous and uniform agitation. If this is not present, the results are uneven densities (for uniformly exposed areas).[63]

Besides minimizing the thickness of the laminar layer of the developer adsorbed to the emulsion, agitation functions to maintain developer homogeneity in terms of its temperature and chemical constituents. This assures that all surface areas of the film emulsion have access to developer of nearly the same activity.

Methods of Agitation

ANSI PH2.5-1960 is intended for black and white pictorial film. It prescribes a result equivalent to that obtained by placing a strip of film which is attached to a glass plate inside a vacuum bottle, and rotating the bottle and inverting it according to a specified technique. Although the method is relatively simple, easy to implement and highly reproducible, it does not lend itself to large volume processing of sensitometric strips.

ANSI PH2.2-1966 is intended for black and white paper. It specifies that the sensitometrically exposed paper strips be securely taped to the bottom of a flat developing tray, and that the tray be carefully rocked in a prescribed manner at a rate of 7½ complete cycles per minute—a cycle being one motion which consists of raising each side of the tray two inches then lowering it.

Other methods of sensitometric processing, although not standard, are used and are recommended for large volume work. These include a water wheel technique, nitrogen burst, rotary agitators and paddle wheels.

Water Wheels

The details of this technique are described by Henn and Hughes. The processor is relatively simple consisting of a set of six glass tubes (containing the developer and sensitometrically exposed film strips) which are fastened radially (like spokes of a wheel) to a water-driven wheel and immersed in a temperature-regulated bath. Agitation is highly reproducible and little developer and film are required per test sample.[58]

Nitrogen Burst

Nitrogen gas released in short bursts from a distributor on the bottom of a processing tank can, if properly designed and maintained, provide excellent agitation. Critical features are the distribution and size of the gas orifices, the gas pressure, leveling of the tank and the consistency of the placement and number of film strips in the tank.

Rotary Agitators

Bates, Berley and Kowalak[56] designed a processor which uses rotating cylinders to provide agitation. About one liter of solution is required. Four sensitometric strips, emulsion inward, are placed around a cylindrical frame. A smooth cylinder with its surface a fraction of an inch from the film emulsion serves as the agitator. By rotating at speeds up to 1000 rpm, various levels of agitation can be achieved to simulate various cine film processors.[56]

Paddle Machine

This technique is recommended when large numbers of strips are processed together. Described in 1937 by Jones, Russell and Beacham,[61] it consists of several metal racks each holding ten vertically mounted strips. The racks are all lowered into the deep tank of developer solution at the same time, but each rack can be individually removed to attain various developing times. The agitation is provided by motor-driven paddles that move back and forth in very close proximity to the vertically-positioned sensitometric strips. To prevent vertical stratification of developer in the deep tank, a propeller is used to circulate the developer solution; it maintains a constant level of developer activity and temperature.

Developer Solution

In preparing the developing solution, it is probably unwise to trust prepackaged chemical mixtures which are likely to be variable in composition. Since mixed developing solutions change with time, they should be stored at low temperatures, but not so low as to cause precipitation of solid ingredients. To reduce variation among successive batches of developers, purified chemicals should be used, and they should be weighed with care. In preparing the solution, chemicals should be dissolved completely and in the proper order, and thoroughly mixed without having stirred air into the solution.

ANSI PH2.5-1960 prescribes the following developer formula as standard for sensitometric processing of black and white negative pictorial film.

Air-free distilled water	500.0	ml
Monomethyl para-aminophenyl sulphate	1.0	g
Sodium sulfite (anhydrous)	25.0	g
Hydroquinone	2.0	g
Sodium carbonate (anhydrous)	3.0	g
Potassium bromide	0.38	g
Air-free distilled water to make	1000.0	ml

After Development

Minimizing processing variability does not end with the correct preparation of the developer and adequate agitation. To stop development of the photographic image at the precise time, a bath of correct concentration and pH is required. The next step in black and white processing, the fixing bath, should be precisely timed and held to a minimum because many fixing baths slightly dissolve silver especially in fine grain emulsions. Fresh

fixers should be used to avoid stains. Drying should be consistent and uniform and is best done at low temperatures, since with heat the rate of drying within the emulsion is a function of the amount of silver developed and this varies within the image. If warm air circulation is used, incorporate a good dust filter and change it often. A wetting agent in the final rinse is helpful in avoiding water spots when the emulsion is drying.

Test for Uniform Processing

A critical test for checking the uniformity of a sensitometric process or any photographic process is to expose a film so that when it is developed it will have a density of about 1.0. Strips should be developed in several positions in a processing tank and replicated, then examined using a uniform light source, or by many density measurements made over the area of the strip. Nonuniformity of density beyond a random fluctuation of density of about 0.04 suggests need for improved processing.

Adjacency Effects

Although good agitation can ensure uniform densities in uniformly exposed areas of the film, it does little to minimize the processing effects that occur *within* the emulsion at the edge or border of two differently exposed areas. Such adjacency effects vary as a function of the exposure differential at the edge of the areas involved, the shape and size of the areas, proximity of the areas to each other, the type of emulsion used and the developer and the development conditions.[10,73] The distance over which such effects occur is less than a millimeter and the density change due to adjacency effects can vary as much as 0.4 density units. Since all image boundaries consist of edges, the potential for adjacency effects exists for all photographic images. Because the problem is basically one of diffusion of fresh developer into the emulsion and reaction products out of the emulsion, agitation can only play an indirect role by keeping the thickness of the laminar layer at the surface of the emulsion minimal.[28]

III Measurement of Density

Density

Density is a term used to describe the relationship between the amount of light (or other radiant energy) incident on a sample and the amount of transmitted or reflected light that is collected. Table 8-5 shows such a relationship.

Although transmittance, reflectance and opacity can be used to describe the relationship between the input and output of light as it passes through or is reflected

TABLE 8.5. RELATIONSHIPS BETWEEN TRANSMITTANCE, OPACITY AND DENSITY FOR SAMPLES TRANSMITTING AND REFLECTING LIGHT.

Transmittance	Reflectance
40 Lumens Input — Output 20 Lumens	40 Lumens Input — Output 20 Lumens
Transmittance (T) $$T = \frac{\text{Output}}{\text{Input}} = \frac{20}{40} = 50\%$$	Reflectance (R) $$R = \frac{\text{Output}}{\text{Input}} = \frac{20}{40} = 50\%$$
Opacity (O) $$O = \frac{\text{Input}}{\text{Output}} = \frac{40}{20} = 2$$	Opacity (O) $$O = \frac{\text{Input}}{\text{Output}} = \frac{40}{20} = 2$$
Density (D_T) $$D_T = \text{Log}_{10} \frac{\text{Input}}{\text{Output}}$$ $$D_T = \text{Log}_{10} 2 = 0.3$$	Density (D_R) $$D_R = \text{Log}_{10} \frac{\text{Input}}{\text{Output}}$$ $$D_R = \text{Log}_{10} 2 = 0.3$$

$$D = \text{Log}_{10} \frac{\text{Input}}{\text{Output}} = \text{Log}_{10} O = \text{Log}_{10} \frac{1}{T}$$

from a sample, density, which is a logarithmic notation, is preferred because:

1. The visual process is approximately logarithmic in its response; thus density can be related to the appearance of the image.

2. Densities are additive; thus when a photographic masking technique is used, the density of the mask and the density of the negative can be summed. The same can be said for filters which are specified in terms of density.

3. As a first approximation density is proportional to the amount of absorbing material in a sample, such as silver in a photographic emulsion.

When the term density is used in the context of photography, it is understood to mean optical density thus distinguishing it from other meanings in other disciplines.

Types of Density

There are many types of optical densities depending upon the conditions under which the measurement is made. The two major variables in density measurement are:

1. Geometric—the specific geometric characteristics of the optical system which determines the manner in which the radiant flux is supplied to the sample and collected from it.

2. Spectral—the specific spectral energy distribution of radiant flux incident on the sample and the spectral sensitivity of the receiver.

Generally speaking the geometric characteristics are most critical for materials which scatter light such as silver and vesicular images.[26] The spectral characteristics are most critical for color materials.[33,36]

Geometric Considerations

The illumination and collection angles used to measure the density of a sample determine in part the density value attained. Figure 8-16 indicates a generalized illumination and collection situation.

As the influx angle (g) nears zero degrees the illumination is called specular; similarly as the efflux angle (g')

nears 0° the collection is called specular. Conversely, as g and g' near 90° illumination and collection are called diffuse.

Three general categories of denisty are recognized based on the influx and efflux geometry.

Type of Density	Angle	
	Influx (g)	Efflux (g')
1. Specular	0°	0°
2. Diffuse	0°	90°
2. Diffuse	90°	0°
3. Doubly Diffuse	90°	90°

Although it is convenient to list three categories of density (specular, diffuse and doubly diffuse), it is important to recognize that there is a continuum of densities available which is a function of the specific influx and efflux angle. This is shown in Fig. 8-17.

The ANSI standard specifies a diffuse density as having an influx angle (g) of 90° and an efflux angle (g') equal to or less than 10°. Figure 8-18 shows an apparatus for obtaining ANSI Standard Diffuse Density Type V2b. It incorporates an integrating sphere and is based on the inverse square law. From Fig. 8-17 it is evident that density measurements made under such conditions are least variable if there are minor fluctuations in the influx/efflux geometry. There are no standards for doubly diffuse or specular densities.

Callier's Q

The relationship between diffuse and specular densities is given by Callier's Q which is expressed as the ratio of specular to diffuse density. A Q factor of 1.0 indicates that a photographic material has the same specular and diffuse density, i.e., density is not dependent upon the geometry of measurement. Color materials which are composed of dyes produce little scattering and have a Q factor near 1.0. Their measurement and use in a projection or printing system, therefore, are nearly unaffected by the geometry of the optical system. Films containing developed silver scatter light to varying degrees depending both on the size and dispersion of the developed silver grains. Size and dispersion of silver grains are determined by the particular type of film, developer, extent

Fig. 8-16. Geometry of density measurement.

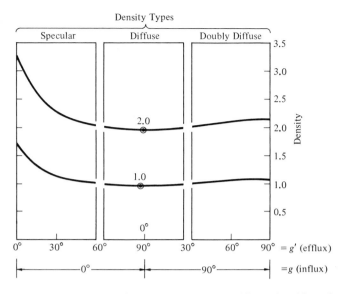

Fig. 8-17. Variation of density (relative to diffuse densities of 1.0 and 2.0) as a function of influx and efflux geometry for a moderately coarse grain film.

of development (gamma) and the level of density. The Q factor can vary from nearly 1.0 to more than 1.5 and greater. The more specular the optical system the higher the Q factor. Generally, an emulsion with a high speed rating will have larger size silver grains and therefore a higher Q factor than an emulsion with a slow speed rating. The effects on the characteristic curve are shown in Fig. 8-19.

Although slow speed films are not as dependent upon the geometry of measurement as high speed films, they are more spectrally selective and thus dependent more upon the spectral conditions of measurement.

Density measurements are made to obtain historical or predictive information on a process. The type of density measurement to be made is contingent upon the manner in which the density values are to be used. Measurements are valid to the extent that the geometric and spectral conditions of measurement are similar to those of the specific process for which the density information is to be obtained. Table 8-6 lists some of the possible types of density measurements that can be made. If one is interested in predicting the exposure necessary to print a negative then information on the printing density of that negative is needed. The predictive validity will depend on how closely the spectral characteristics of the light sources and receptors of the densitometer and printer are alike and also upon their geometric characteristics. Although there is an ANSI standard for printing density (Type P2-b), it is highly unlikely that it would be valid for predicting printing densities for a specific process.

At this point it should be abundantly clear that the density value for a given sample is a function of the geometric and spectral characteristics of the sample (as well as the image size—see Chapter 16). Rigid specifications of the conditions of measurement are essential.

McCamy[32] has suggested that density be specified in association with a functional notation specifying influx and efflux geometry and spectral characteristics. The notation is $D(g;S:g';S')$: D is density, g identifies the

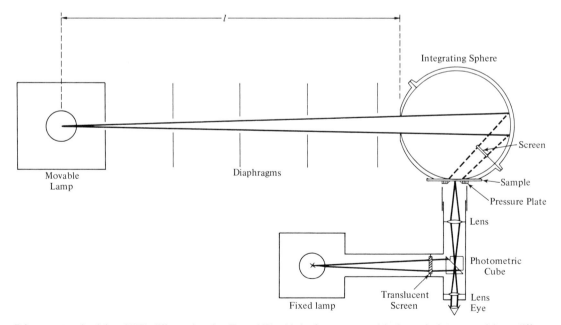

Primary standard for ANSI diffuse density Type V2b. Light from a movable lamp is integrated in a diffuse sphere and illuminates a sample. The brightness of this sample is compared to the brightness of a fixed lamp; the distance of the movable lamp is adjusted until both fields of brightness match. The luminance of the visual field must be not less than 1 ft-lambert when the comparison is made.

Fig. 8-18. Apparatus for integrating sphere method using inverse square law (ANSI PH2.19-1959).

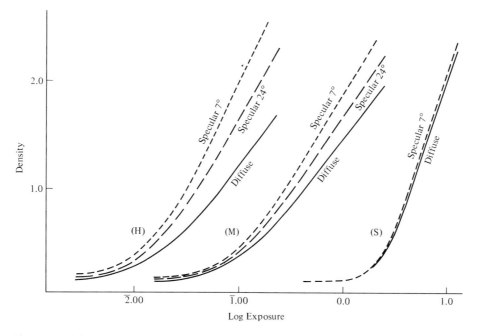

Fig. 8-19. The *D-Log-H* curve and the measurements derived from it (speed, gamma, etc.) depend upon the type of density measurement made. (Techbit No. 2, 1967)
Film Speed: High (H), Medium (M), Slow (S).
Granularity Classification: Moderately coarse grain, Medium grain, Fine grain.

influx geometry; S specifies the influx spectral energy distribution; g' is the efflux geometry; and S' is the efflux spectral response. In use, the notation for the ANSI Standard for diffuse transmission density would read: $D_T(90°;3000K: 10°;V)$, where

$g = 90°$,	meaning that the incident flux is uniformly distributed over a hemisphere;
$S = 3000K$	tungsten source is the illuminant;
$g' \leqslant 10°$,	meaning that the receptor angle of the system is equal to or less than $10°$;
$S' = V$,	i.e., the human photopic eye response, and thus a visual densitometer is described.

Photometric Equivalent

The photometric equivalent (P) is the ratio of developed silver per unit area (mass) to the diffuse density (D) of that mass (M).

$$P = \frac{M}{D}$$

Higgins[68] finds that:

For many film-developer combinations, the optical density is, to a good approximation, proportional to the mass of silver per unit area in the developed image. For some combinations, however, the relation between these two variables is distinctly nonlinear . . . the relationship between M and D is approximately

$$M = PD^n$$

where P is the photometric equivalent (or the reciprocal of the covering power of silver at a density of 1.0) and n is the degree of nonlinearity (determined by curve fitting). The value of n lies between 0.5 and 1.0 for most film development combinations.

Covering Power

Covering power is a measure of the effectiveness of the silver image in attenuating light or other forms of radiation. It is the ratio of diffuse density (D) to the mass of silver (M).

$$CP = \frac{D}{M}$$

Color Densities

There are two broad categories of color densities; *Integral* and *Analytical.*[6] Integral densities describe the integrated optical effect of all three layers of cyan, magenta and yellow dyes in a film, whereas analytical densities describe the optical effect of each dye layer separately. See Fig. 8-20 in which densities for the individual cyan, magenta and yellow dye layers and their combined effect are plotted against wavelength.

Integral Densities

There are several types of integral densities, each describing a specific kind of total response of a film in some optical system.

TABLE 8.6. VARIOUS POSSIBLE COMBINATIONS OF DENSITY.

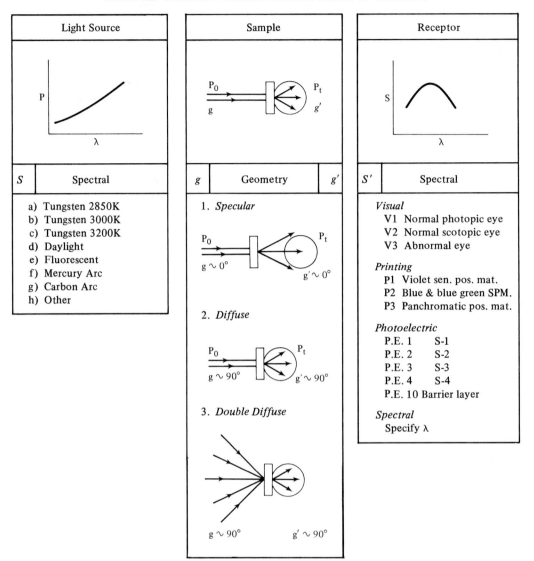

ANSI Standards
1. Diffuse Visual Density Type V1-b.
2. Diffuse Printing Density Type P2-b.

Integral Spectral Densities (ISD) indicate the total absorption of cyan, magenta and yellow dye at a specified wavelength. In Fig. 8-20 the ISD at 546 nm is 1.08. It is the sum of the analytical spectral densities (ASD) of the cyan, magenta and yellow dyes at that same wavelength (0.16 + 0.85 + 0.07). The fact that ISD = ΣASD is the basis for the mathematical transformation from the ISD, which is relatively easy to measure to ASD which is extremely difficult to obtain.

Printing Densities are used to predict printing exposures for a negative or positive transparency.

Exposure Densities[6] are used to predict effective camera exposures for a particular color sample. The predicted red, green and blue exposures are made relative to an ideal white patch as a reference.

Three-Filter Densities are suitable for comparisons of nearly identical samples. They are relatively simple to obtain and are widely used in process control studies in which a sample of sensitometrically-exposed film is processed at different times. Wratten 92, 93 and 94 red, green, and blue filters are often recommended for such measurements.

Colorimetric Densities are used to predict the visual colorimetric response produced when a color image is viewed. (The response of a densitometer is adjusted to match the colorimetric responses of a standard 1931

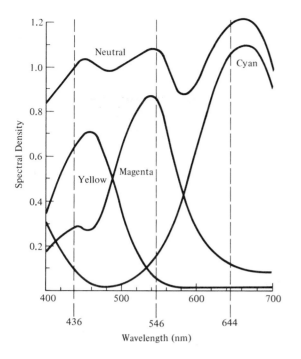

Fig. 8-20. Integral and analytical spectral densities for neutral color film having a visual neutral density of 1.0.

CIE observer). Such measurements are useful in evaluating motion picture films, slides and color prints.

Luminous Densities are used to predict the visual (luminous) response produced when a color image is viewed. The response of a densitometer is adjusted to match the luminosity response of a standard 1931 CIE observer.

Analytical Densities

In general, analytical densities describe the *composition* of each dye layer making up a color film, while integral densities describe the *performance* of the film.

Analytical Spectral Densities (ASD) are made with narrow-band filters at or near the peak absorptions of the cyan, magenta and yellow dyes of the color image. Unit concentration of the dye is that which produces a spectral density of 1.0 at or near the peak. In Fig. 8-20, the ASD of the yellow dye is 0.64. ASD are useful in quantitative studies or dye concentration, since such measurements are nearly proportional to the amount of dye per unit area of the image. ASD are used primarily in research and development contexts.

Equivalent Neutral Densities (END) define the amount of a given dye in terms of the visual density of the neutral that would be formed when sufficient amounts of the other two dyes of the process are added to it. In Fig. 8-20, each of the dyes has an END of 1.0. END values approximately indicate the appearance of a given sample. Thus if the END'S were cyan 2.0, yellow 2.0 and magenta 1.0, the sample would appear green.

Equivalent Neutral Printing Densities (ENPD) predict whether or not a sample made up of cyan, magenta and yellow dye will, when printed, generate a neutral print.

Density Transformations[6,35]

Analytical density measurements of the cyan, magenta and yellow layers of a color material are extremely difficult to obtain by direct measure. As indicated earlier, integral density measurements are relatively easy to obtain. Again, Fig. 8-20 shows the relationship between ISD and ASD; ISD = ΣASD. This is called the additivity rule; analytical spectral densities for a specific wavelength are additive. Beyond this, many dyes over a reasonable range obey the following laws:

1. Bouguer's law which states that, for a transparent colorant in which the concentration remains constant and homogeneous, the spectral density is proportional to the thickness of the medium.
2. Beer's law, which is similar but based on concentration. For a transparent colorant of constant thickness, the spectral density is proportional to the concentration. From Fig. 8-20 we can derive these data:

Wavelength	Analytical Spectral Densities		
	C	M	Y
644 nm	1.07	0.12	0.02
546 nm	0.16	0.85	0.07
436 nm	0.10	0.29	0.63

The data are then normalized to unit concentration which adjusts the values on the principal diagonal to 1.00:

	C	M	Y
644 nm	1.00	0.14	0.03
546 nm	0.15	1.00	0.11
436 nm	0.09	0.34	1.00

The data are then arranged in matrix notation:

$$D644 = 1.00 C + 0.14M + 0.03Y$$

$$D546 = 0.15C + 1.00M + 0.11Y$$

$$D436 = 0.09C + 0.34M + 1.00Y$$

In general form the matrix notation is:

$$\begin{matrix} D_r \\ D_g \\ D_b \end{matrix} = [a_{ij}] \begin{bmatrix} C \\ M \\ Y \end{bmatrix}$$

What is needed now is an expression giving ASD's (**C, M, Y**) in terms of the ISD (D_r, D_g, D_b);

$$\begin{matrix} C \\ M \\ Y \end{matrix} = [a_{ij}]^{-1} \begin{bmatrix} D_r \\ D_g \\ D_b \end{bmatrix}$$

The solution is found by determining the inverse of the matrix $[a_{ij}]$. Then the integral spectral densities (D_r, D_g and D_b) are known, and the ASD's are calculated by solving the coefficient matrix. The ASD for the cyan dye at 546 nm would be:

$$C = \frac{\begin{bmatrix} D_r & a_{12} & a_{13} \\ D_g & a_{22} & a_{23} \\ D_b & a_{32} & a_{33} \end{bmatrix}}{[a_{ij}]}$$

PROPORTIONALITY RULE

When the spectral densities for a given dye concentration (or thickness) are known, the same data for that dye at other concentrations can be readily calculated if a single spectral density at the new concentration is known. This follows from Beer's and Bouguer's laws; the ratio of spectral densities for two different dye concentrations or thicknesses is a constant.

$$\text{Proportionality Rule: } \frac{D_{\lambda_1}}{D_{\lambda_2}} = K$$

$$\text{Log } D \text{ Rule: } \text{Log } D_{\lambda_1} - \text{Log } D_{\lambda_2} = k$$

In log form the proportionality rule is known as the log D rule. If the log density is plotted against wavelength, the curve shapes for various concentrations will be the same. Since Beer's and Bouguer's laws fail at higher concentrations and thicknesses, the proportionality rule is valid only for a limited range of values.

Reflection Densities

Density is nearly proportional to dye concentration when spectral *transmission* densities are measured. The same situation does not hold for spectral *reflection* measurements, nor are spectral reflection densities additive. To transform integral spectral reflection densities to analytical densities, they must first be converted to transmission densities. A conversion curve derived by Pinney and Voglesong[35] allows such an exchange. The transmission densities so derived can then be transformed into analytical transmission densities which can be converted to analytical spectral reflection densities by using the same conversion curve.

Two major problems associated with reflection color prints are internal reflections and first surface reflections. Because of internal reflections, the slightest processing stain in a color print is amplified, thereby making it difficult to get good "whites" in the picture. First-surface reflections limit the level of black that can be obtained. Both types of reflections limit the tonal range available with photographs viewed by reflected light.

Densitometers

A densitometer is a specialized photometer designed and calibrated to give a logarithmic readout in density units. Figures 8-21 and 8-22 show the basic components of a densitometer: a light source; IR-absorbing filter; aperture; red, green, blue and visual filters; receiver; amplifier and recorder (lenses are not shown).

There are many different types of densitometers[7] depending upon their design and function (type of density to be measured):

Transmission densitometers measure the effect of a transparency on light being transmitted.

Reflection densitometers measure the effect of a non-transparency on light being reflected.

Black and White densitometers measure the effect of a sample on white light (400-700 nm).

Color densitometers measure the effect of a sample on white light and to selected portions of white light depending upon the color filter used.

Spectral densitometers (spectrophotometers) measure the effect of a sample on a narrow-band wavelength of radiation.

Microdensitometers measure the effect of a microarea of a sample on light.

Visual densitometers use the human eye to measure the effect of a sample on light.

Photoelectric densitometers use a photocell to measure the effect of a sample on light. Such instruments can be adjusted to give visual densities, printing densities, etc.

Direct Reading densitometers use photocells and give a density reading directly.

Null-type densitometers require the matching of two photometric fields to arrive at a density value. A visual densitometer is a null instrument.

Status Filters

Because the dyes used for similar color photographic materials are much alike, no matter by whom manu-

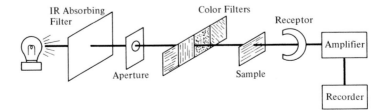

Fig. 8-21. Basic components of a transmission densitometer (lenses omitted).

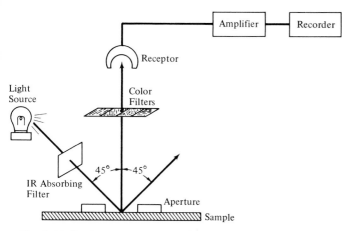

Fig. 8-22. Basic components of a reflection densitometer (lenses omitted).

factored, and because the photoelectric cells used in densitometers have similar spectral response characteristics, it has been possible to design filter sets that produce data that are useful predictors for different requirements. Such filter sets are called "status filters;" they are assigned letter designations, dependent upon their function, as shown in Table 8-7.

Calibration and Control

The error and variability of a densitometer should be determined.[30] A calibrated step wedge of known density values is used to adjust a densitometer so that there is minimum error in the measurements made. These calibrated wedges usually accompany new instruments or are available from manufacturers of densitometers or the National Bureau of Standards. It is good practice to check each instrument periodically and at several levels of density.

After the densitometer has been adjusted to give the correct density reading, the variability inherent in making repetitive measurements over a period of time should be determined. This can be done by using an uncalibrated step wedge as a reference plaque. Select and read at least two different levels of density on the plaque. Do this at least twice at random times each day. After approximately 15 days of such data collection, the average performance and variability of the instrument may be computed, and control charts prepared to which new data can be added in the future.

TABLE 8-7. STATUS FILTERS.

Filter status	Purpose of Measurement
A	Color transparencies intended for viewing
D	Color prints
G	Inks used in photomechanical reproduction
M	Color negatives
V	Visual densitometry

Data Analysis

The initial results from a sensitometric test are usually presented in the form of a functional relationship between log exposure and density.[69] For silver halide materials, each different development time (or each different temperature or degree of agitation) will typically generate a different relationship. Figure 8-23 shows a set of curves such as would be obtained from variations in development time. Such D-log H (D-log E, or "characteristic") curves, are often called H & D curves, after Hurter and Driffield who initiated the methods leading to such descriptions of film response to radiation.

The set of curves in the figure is for a negative black and white film, and represents the classical form of such curves, from which many modern materials often show significant departures. The important aspects of these curves are:

1. The slope at a point (or the average slope over a specified range of log H values). Slopes are associated with contrast rendition, signal detection, and detail reproduction. Large slopes imply enhancement in the image of subject contrast; small slopes imply reduction of image contrast *vis à vis* subject contrast.
2. The location of the curve on the log H axis, associated with film speed, or with "sensitivity."
3. The range of log H values over which the material produces a useful response, associated with latitude in exposure.
4. The range of density values which the material can produce, limited on the lower end by the base + fog level, and on the other by the maximum obtainable density.

Slope Analysis

As shown in Figure 8-23, for very small exposures the curves have zero slopes; no change in response occurs with changing log exposure values. The *toe* of the D-log H curve is that exposure region within which the slope increases with increasing log H, and the image contrast changes from zero to a maximum as the straight-line portion of the curve is reached. Within the straight line

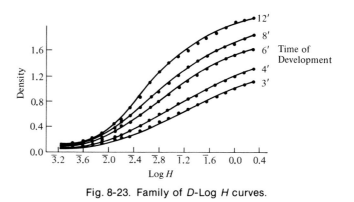

Fig. 8-23. Family of D-Log H curves.

(if it exists) image contrast is constant over a range of log H values, and at the maximum attainable for a given degree of development. Within the *shoulder* region of the characteristic curve (reached only with very great exposures) the slope and thus the image contrast fall with increased exposure level, until zero slope is reached at the maximum density of which the material is capable. (Some photosensitive materials with still greater exposures may produce decreased densities, thus negative slopes. This region of the D-log H curve is identified as the region of *solarization*.)

For classical photographic materials, exemplified in Fig. 8-23, the location on the log H axis of the toe, straight-line, and shoulder regions is little changed with development. Thus, if exposures have been made well to the left, on the zero-slope region of the curve, the slope remains at practically zero for any reasonable time of development. The inference is that underexposure of the material can hardly be corrected by increased developer activity or by increased time of development. There are, however, materials (e.g., photographic papers) which show a displacement of the curve to the left on the log H axis as development proceeds; such materials have speeds which vary with development conditions.

It is in the middle portion of the curves that pronounced changes in slope are found with changed development. From this has arisen the use of gamma (γ), the slope of the straight line of the D-log H curve, as a measure of the "degree of development." The value of γ specifies (but only for those exposures falling on the straight line) the relationship between the photographic image contrast (as measured by ΔD) and the optical image contrast (as measured by $\Delta \log H$), since $\gamma = \Delta D / \Delta \log H$. Thus, a gamma of 1.0 implies that the optical image contrast is duplicated in the photographic image for all straight-line exposures; a gamma of more than 1.0 indicates that the photographic image contrast is increased as compared with that of the optical image.

Gamma is used to specify the inherent contrast of a photographic material. Thus, lithographic films typically have very high gamma values, of the order of 5.0 or more; such films are called "high contrast." On the other hand, films intended for use in portrait photography attain a gamma of hardly 1.0, and are called "low contrast" films.

The measurement of gamma has its greatest utility in process control. In a repetitive processing situation, the attainment of a stable value of gamma with time (or with batch sequence) is a sign of development consistency. Also, in an experiment designed to compare two developers or two films, it is essential to develop the samples to nearly the same gamma before a sound inference can be made about any difference in film speed, graininess, etc.

The change in gamma with processing time, for a given set of processing conditions (temperature, agitation and chemistry) is shown schematically in Fig. 8-24. Gamma increases rapidly during the early stages of development, and reaches a maximum value (called gamma infinity) that is dependent primarily on the nature of the photographic material; developer composition mainly affects

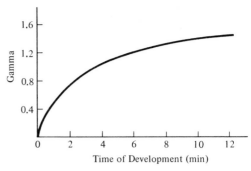

Fig. 8-24. Change in gamma with processing time.

the rate at which gamma increases. If development proceeds so far that an appreciable fog density is produced, measured gamma may fall from the maximum.

Contrast Index

Many modern negative materials have no straight line of significant extent; some double-coated emulsions have two straight lines. For such materials, gamma cannot be found or is without significance. Furthermore, for most photographic purposes, straight-line exposures in the negative are not required for excellence in the print. Optimum negative quality in this sense usually involves at least some exposures in the upper part of the toe of the D-log H curve.

For these reasons, contrast index[75] (CI) is replacing gamma; it is used for the same functions that gamma formerly served. Contrast index is an average slope; i.e., it is the slope of the straight line drawn between two points on the D-log H curve. The method of locating the two points was developed from the analysis of a large number of excellent negatives made on a wide variety of photographic materials.

The CI value is found by the use of a transparent template as shown in Fig. 8-25. The template is placed on the curve with the base plus fog reference line correctly located, and moved laterally until the same numerical value is found at the intersection of the curve with both the left-hand and right-hand arcs; this value is the contrast index.

The estimate of the value of CI changes only slowly with the lateral position of the template. Therefore, without the template an approximation to the CI can be found thus: use as the left-hand point a density 0.1 above base plus fog; from this point swing an arc with radius 2.0 in logs to intersect the curve; find the slope of a straight line connecting the intersection and the first point. The approximation to the correct value of CI is better as the CI is less.

Contrast index, Fig. 8-25, is preferable to gamma because it can be found for any negative curve, despite the absence of a straight line. In addition, the extent of the curve between the arcs of the template is the region of the D-log H curve within which subject exposures should lie for best negative quality. The concept of con-

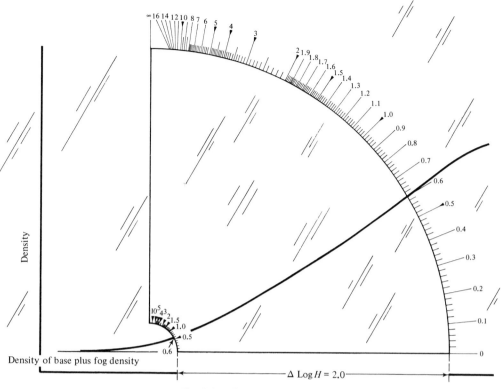

Fig. 8-25. Contrast index meter.

trast index has so far been applied only to monochrome (black and white) negative materials.

Although a constant value of CI (or gamma) indicates uniformity of processing, a constant value by no means implies that a set of negatives so processed have uniform printing characteristics, unless other factors (such as subject contrast and camera exposure level) are also uniform. For example, a negative of a flat (i.e., small luminance-ratio) subject will require a contrasty (hard) paper in printing to obtain a full range of tones in the print, whereas one of a contrasty subject will require a soft paper, even if both negatives have been processed to the same CI.

Film Speeds

Hurter and Driffield believed that film sensitivity, which is expressed numerically as a speed value, was a fundamental property of a photographic material. As now used, speed is simply a value on an arbitrary scale intended to assist the user of the material to set a camera (or a printer for print materials) so that he will obtain a satisfactory image. A film speed number is therefore part of a system which includes: the light meter and its method of use; the subject; the processing; the method of examining (or printing) the image; and the criterion of image quality.

Of special importance are the nature of the subject and the desired photographic result. Because of great differ-

ences in the applications of photography to different subjects, and because of different requirements, several dozen speeds have been invented for different uses.[76] All speeds have in common the selection of some criterion of image quality related to exposure, and the computation of the speed value by $S = k/H$ for arithmetic speeds, where H is the exposure which produces the desired result, and k is a constant which makes the number suitable for use with existing light meters and the system of shutter speeds and lens apertures. Logarithmic speeds, not in common use except in Europe, are computed by the general rule: $S = k - \log H/k'$, where k and k' are constants and $\log H$ is that which produces the requisite image.

Speeds may be roughly classified according to the region of the characteristic curve which is thought to be related to image quality:

1. Threshold speeds, based on the toe of the curve. Examples: the present standards for black and white negative materials and for color negatives.
2. Midtone speeds, based on the central region of the curve. Examples: photographic papers; color reversal materials.
3. High-density speeds, based on a point in the upper region of the curve. Examples: speeds for x-ray exposures to fluorescent screens; microfilm.

In Table 8-8 are summarized the essentials of the speed methods which have attained the status of standards. All are for still photography and for exposure to *light*. No

TABLE 8-8. STANDARD SPEED METHODS

Application	Method	Formula	Reference	Notes
I Black and white				
A Negative, Pictorial		$S = 0.8/H$	USAS PH2.5-1960	Commonly called ASA. Corresponds to BSI and DIN. Undefined except for a curve meeting the criteria shown in the figure.
B Negative, Aerial		$S = 1.5/H$	USAS PH2.34-1969	Commonly called Aerial Exposure Index (AEI).
C X-rays (Medical) (Industrial)		$S = 1/H$	USAS PH2.9-1964 (R 1969) USAS PH2.8-1964 (R 1969)	H is in roentgens when no fluorescent screen is used.

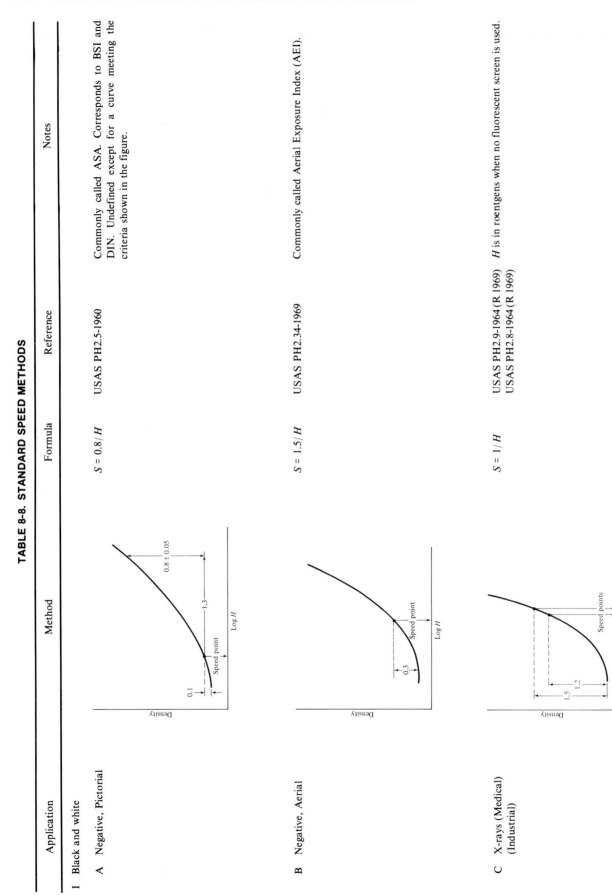

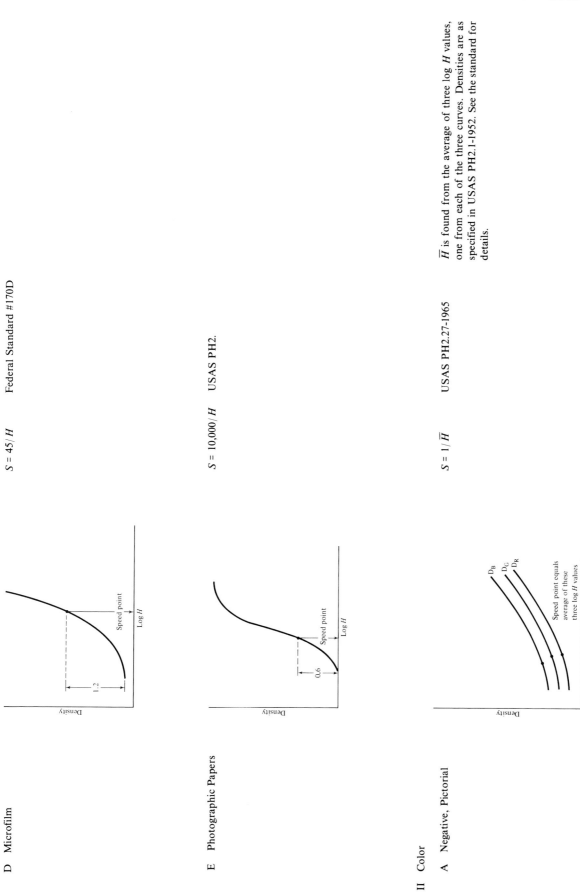

D Microfilm

$S = 45/H$ Federal Standard #170D

E Photographic Papers

$S = 10,000/H$ USAS PH2.

II Color

A Negative, Pictorial

$S = 1/\overline{H}$ USAS PH2.27-1965

\overline{H} is found from the average of three log H values, one from each of the three curves. Densities are as specified in USAS PH2.1-1952. See the standard for details.

TABLE 8.8. (Continued)

Application	Method	Formula	Reference	Notes
B Reversal, Pictorial	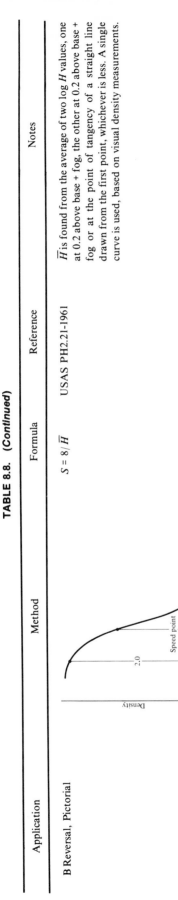	$S = 8/\overline{H}$	USAS PH2.21-1961	\overline{H} is found from the average of two log H values, one at 0.2 above base + fog, the other at 0.2 above base + fog or at the point of tangency of a straight line drawn from the first point, whichever is less. A single curve is used, based on visual density measurements.

TABLE 8-9. RELATIONSHIP BETWEEN ASA AND DIN SPEED INCREMENTS.

ASA Arithmetic	ASA Log	DIN
3200	10°	36
2500	9.5°	35
2000		34
1600	9°	33
1250	8.5°	32
1000		31
800	8°	30
640	7.5°	29
500		28
400	7°	27
320	6.5°	26
250		25
200	6°	24
160	5.5°	23
125		22
100	5°	21
80	4.5°	20
64		19
50	4°	18
40	3.5°	17
32		16
25	3°	15
20	2.5°	14
16		13
12	2°	12
10	1.5°	11
8		10
6	1°	9

standards exist as yet for motion picture photography or for exposures to ultraviolet or infrared.

Table 8-9 lists the ANSI Standard ASA speed increments and their approximate DIN Standard increments. ASA increments are given in both arithmetic and logarithmic values. The DIN values are log values which have a base 10, while the ASA log values have a base 2. A 3 unit change in DIN speed is the same as a 1 unit ASA log value change, i.e., the film speed changes by a factor of 2.

Speed Standards

Standards for speed specification such as the ASA speed are based on a single set of conditions and arrived at through sensitometric methods. Although such values are highly reliable (i.e., repeatable) they may not be valid (provide an index for correct exposure) for the manner in which some films are used in practice. Standard speeds pertain to a specified set of conditions, usually average conditions, for testing film. These are agreed

upon by the majority of manufacturers of films and by some users. Without standards there would be chaos; without an intelligent attitude towards the use of standards as simply a guide to actual practice there can also be chaos. Consider for a moment the conditions under which the ASA speed for black and white negative pictorial film is arrived:

1. *Film Selection*—To determine the speed of a particular type of film, the manufacturer has to first select samples of that film to test. He then assumes that film is representative of all the film that will be sold. For a particular roll of film the speed might vary by plus or minus about 1/3 stop. Thus a film rated at ASA 125 may range from 100 to 160 under the best of conditions.

2. *Film Storage*—Improper storage of film may affect film speed. The effect is usually a loss of speed.

3. *Sensitometric Testing*—The speed of the film is arrived at through a set of rigidly specified conditions of exposure, development, density measurement, and curve evaluation.

Exposure Illuminances—A tungsten lamp operating at a low color temperature of 2850K and by proper filtration converted to 5500K must be used. Such a source is never used for indoor photography and not always for outdoor photography. Most pictorial photography exposures consist of mixed lighting, sunlight, skylight, tungsten and the modification of these lights as they are reflected from different colored and textured surfaces.

Exposure time—The exposure time used must be between 1/20 to 1/80 sec. In practice it is not unusual to use times shorter or longer than these. This practice can result in reciprocity effects which mean that a film rated at 125 must be rated at less than 125 to get proper exposure. The greater the deviation from the sensitometric exposure time used, the greater the loss in rated film speed. In addition, if an intermittent exposure time is used one can expect additional loss. An intermittent exposure time can be the result of an intermittent source of light as well as an intermittent shutter arrangement.

Development—The developer used is unlike many used in practice. The same statement applies to the contrast index to which the film is developed.

Density Measurement—A densitometer is used to make a visual diffuse density measurement of the film. In practice the negative is usually printed in an enlarger or contact printer that has optical characteristics different from those found in a densitometer. If an enlarger is optically nearly specular, the difference between densitometric measurements and practice can be great.

Curve Evaluation—Unless the film is processed to the correct contrast index it is not possible to measure and specify an ASA speed. In practice films are developed to many different contrast indexes.

Another major consideration is the luminance ratio of the scene. The average outdoor ratio is 160:1. If a scene has a ratio higher or lower than this, adjustment of the ASA speed value can be made. With a ratio lower than average a higher speed number can be used.

This summary of some of the differences between sensitometric testing of film speed and conditions under which the film is used in practice should emphasize that standard speeds, as far as the practicing photographer is concerned, are only approximate guides to correct camera exposure settings.

Negative/Positive

There is more flexibility with film speed values for negative films (color or black and white) than with positive materials. Exposure levels for a camera negative material can be varied somewhat because the negative is not the end product and the tones in the final image can, within limits, be manipulated by selection of different print materials and exposures. The exposure flexibility of a negative material, however, is skewed; i.e., it is safer to give more exposure than less.[9,10]

High Contrast Materials

Photographic materials having high contrast (high gamma) such as lithographic films permit little to no error in exposure or processing. In general, for a given exposure range (input) the exposure flexibility decreases as gamma increases.

Latitude

The useful range of log exposures over which a photographic material functions is related to: (1) the maximum luminance range of the subject which can be accommodated; (2) for a subject of lesser range, the permissible variation in exposure level, and thus the care that must be taken in exposing a given material to a given subject.

The minimum and maximum useful exposures are no doubt determined by the minimum slope that provides the requisite image contrast in shadow and highlight tones respectively. For negatives of pictorial subjects, the minimum useful exposure is defined by the speed point. The maximum useful exposure has never been well-defined, if only because at such high densities image quality is poor due to reduced sharpness and resolution and greatly increased graininess. For this reason, in part, published D-log H curves for black and white negative materials rarely extend far enough into high exposure regions to show the maximum useful density.

Most materials for pictorial photograpy are capable of producing a D-log H curve with a slope greater than 0 over a log range of more than 4, corresponding to an exposure ratio of more than 10,000:1. Since the typical outdoor subject has a luminance range of about 2.2 in logs (this value being reduced by flare in the camera, often by more than 0.5 in logs) some tolerance is possible in camera settings without loss of information in the negative.

Latitude in exposure is this tolerance, usually expressed in stops (Fig. 8-26). Some loss in print quality,

Fig. 8-26. Latitude of a black and white pictorial negative film.

however, is always associated with a change in camera exposure from the optimum value, this loss being more severe with underexposure than with overexposure.[28] Latitude in exposure exists, therefore, only if less-than-optimum print quality can be accepted. Furthermore, this latitude is affected by subject contrast, being small or nonexistent for subjects of high contrast, and often very large—several stops—for subjects of low contrast.

Density Range

Corresponding to the range of log H values over which a photographic material functions is the range of output values (density) which it can produce. The minimum density is associated with the absorption of the base and fog (i.e., developed though unexposed silver halide or other sensitive substance.) This absolute minimum density will, for well-processed black and white negative materials, be near 0.1 or 0.2. In color negatives the masks which are present contribute heavily to the minimum density. In stabilization processes, the residual silver halide may cause a higher minimum density. Stain in color prints, the equivalent of fog, is to be avoided since it affects unpleasantly the reproduction of highlights. In any case, an abnormally high fog density limits the recording range at the low end of the scale of output values.

At the other end, as we have pointed out, the maximum density is, in practice, rarely attained with conventional negative black and white materials, and is often so high as to be difficult to measure with ordinary densitometers —i.e., above 4.0 and perhaps 6.0 with films used in lithography. Thus the potential output range of these

materials is greater than 4 in logs, or a transmittance ratio of more than 10,000:1. The magnitude of this range indicates that the limitations in information recording and retrieval for most photographic processes do not lie in the negative material itself, but rather in the information recovery methods, i.e., in the visual or densitometric techniques, or in the printing method. Black and white photographic papers can produce a density range of only a little over 2.0 at most and thus can hardly reproduce the typical outdoor subject. The range of visual densitometers is usually 3.0; photoelectric instruments in common use have a range of 4.0. A density difference of the order of 0.01 is visually detectable under the most favorable viewing conditions. Photoelectric densitometers can do about as well, but instrument variability limits the precision over time; a standard deviation of density values is typically 0.01–0.02 for a well-regulated photoelectric densitometer.

Sensitometry of Photographic Papers

Test exposures are given to samples on reflective bases similarly to those for samples on transparent bases, with these changes:

1. The light source should in most cases be matched to that in the printer. The standard calls for the use of a regulated tungsten lamp, operated at a color temperature of $3000 \pm 25K$.

2. The exposure time should correspond to that used in practice, inasmuch as reciprocity effects are pronounced with most papers. The standard requires a time between 0.1 and 10 sec.

Because of the usual short development time, conditions of processing need to be well-stabilized and controlled.

Reflection densitometers illuminate the sample at about 45° and collect the light reflected perpendicularly to the surface. The converse geometry produces the same measured value. Reflection density values are usually normalized; i.e., the instrument is zeroed on a fixed-out portion of the sample; in the absence of fog, all paper D-log H curves when so measured start at 0.0 density.

Typical D-log H curves for photographic papers are shown in Figure 8-27. The S-shaped curve has practically

Fig. 8-27. Log H curves for photographic paper.

no straight line, and attains a well-defined maximum density as exposure increases. The maximum density, and thus the potential tonal range, are determined mainly by the paper surface, essentially independent of paper grade. A glossy-surfaced paper can attain a maximum density over 2.0, and can thus produce a tonal range of over 100:1; a matte-surfaced paper, on the other hand, has a maximum density of about 1.3, and therefore can produce a tonal range of only about 20:1.

After a short development time, photographic papers (unlike negative materials in common use) show little change in slope; instead, the curve moves on the log H axis in the direction of reduced exposure, the equivalent of a speed increase. For this reason, development by inspection permits the compensation for slight under-exposure of the print material by increased development time (up to the point at which fog becomes significant).

Papers of different grade (contrast, i.e., hard or soft) differ primarily in the range of log H values over which they react, as shown in Fig. 8-27. The log H range for a 0 to 1 grade is about 1.7 to 1.5; for a grade 5 paper about 0.7. *Scale index* is the measure of the log H interval between the defined minimum and maximum useful exposures. According to ANSI specifications, the minimum useful point is at a density of 0.04; the maximum is at a density equal to 0.9 of the density at which the slope of the curve in the shoulder is 0.005, or at practically 0.9 of the maximum attainable density.

Since in the printing process the negative serves to modulate the input exposure values, to a first approximation the total negative contrast (the difference between the minimum and maximum densities in the negative) should equal the paper scale index.

The standard method of determining the speed of a photographic paper is based on a density of 0.60, the speed value being computed by: $S = 1000/H_D = 0.60$. Shadow speeds are sometimes reported for photographic papers, based on the exposure needed to produce the maximum useful density as defined in connection with scale index. The relation between the standard speed values and shadow speeds will be different for different paper grades because of the slope differences in the curves.

If a practical test is made in a printer with a transparent step tablet as the test object, attention should be paid to the following factors:

1. The $\cos^4 \theta$ law applies to projection printers as well as to cameras. Thus, there is normally a variation across the exposure plane with angle from the perpendicular according to this law. If the test object covers a significant angle, conventional density measurements of the test object do not really define the exposure changes at the exposure plane, and compensation should be made for this variation.

2. Flare afflicts a printing projection system much as it does a camera optical system. The effects of flare are in this case, however, more noticeable in the highlights of the print (regions of small print exposure). (See chapter on tone reproduction).

TABLE 8-10. ANSI STANDARDS AVAILABLE IN PHOTOGRAPHIC SENSITOMETRY.

20% discount will be allowed on the purchase of complete PH2 series. Binder available at $5.75 extra.

PH2.1-1952 (R1969) [a]Spectral Diffuse Densities of Three-Component Subtractive Color Films	2.25
PH2.2-1966 (R1972) [a]Sensitometry of Photographic Papers	3.25
PH2.3-1972 [a]Actinity or the Relative Photographic Effectiveness of Illuminants, Method for Determining the	3.50
PH2.4-1965 [a]Exposure Guide Numbers for Photographic Lamps, Method for Determining	2.75
PH2.5-1972 [a]Speed of Photographic Negative Materials (Monochrome, Continuous-Tone), Method for Determining (150 6)	3.50
PH2.7-1973 [a]Photographic Exposure Guide	3.00
PH2.8-1964 (R1969) [a]Sensitometry of Industrial X-ray Films for Energies up to 3 Million Electron Volts, Method for the	3.25
PH2.9-1974 [a]Sensitometry of Medical X-ray Films, Method for the	4.50
PH2.10-1965 (R1972) [a]Evaluating Films for Monitoring X-rays and Gamma Rays Having Energies up to 3 Million Electron Volts, Method for	2.75
PH2.13-1965 [a]Photographic Flash Lamps, Method for Testing	1.50
PH2.15-1964 [a]Automatic Exposure Control for Cameras	3.25
PH2.17-1958 [a] Diffuse Reflection Density	2.75
PH2.19-1976 Diffuse and Doubly Diffuse Transmission Measurements (Transmission Density) Conditions for	4.00
PH2.21-1972 [a]Sensitometric Exposure and Evaluation Method for Determining Speed of Color Reversal Films for Still Photography (*Agrees with ISO 2240*)	3.00
PH2.22-1971 [a]Safety Times of Photographic Darkroom Illumination, Methods for Determining	3.50
PH2.23-1961 (R1969) [a]Lighting Conditions for Viewing Photographic Color Prints and Transparencies (*Partially revised by PH2.31-1969*)	2.50
PH2.25-1965 [a]Photographic Printing Density (Carbon Step Tablet Method)	2.75
PH2.27-1965 (R1971) [a]Speed of Color Negative Films for Still Photography, Method for Determining the	2.25
PH2.28-1967 (R1973) [a]Evaluating Effective Spectral Energy Distribution of Blue Photoflash Lamps, Method for	2.75
PH2.29-1967 [a]Simulated Daylight Source for Photographic Sensitometry (*Agrees with ISO 2239*)	2.75
PH2.31-1969 [a]Direct Viewing of Photographic Color Transparencies (Partial Revision of PH2.23-1960)	3.75
PH2.32-1972 [a]Viewing Conditions for the Appraisal of Color Quality and Color Uniformity in the Graphic Arts	4.50
PH2.33-1969 [a]Determining the Resolving Power of Photographic Materials, Method for	10.50
PH2.34-1969 [a]Determining the Speeds of Monochrome Photographic Nevative Films for Aerial Photography, Method for	3.25
PH2.35-1969 Simulated Incandescent Tungsten Sources for Photographic Sensitometry (*Agrees with ISO 2241 and 2242*	*3.25*
PH2.36-1974 [a]Terms, Symbols, and Notation for Optical Transmission and Reflection Measurements (Optical Density)	3.50

[a]quantity and member discounts apply

Source: American National Standards Institute (ANSI), 1430 Broadway, New York, New York 10018.

(1976 prices, subject to change)

Sensitometric Tests of Radiation Other than Light

Methods for testing the response of photographic materials to light (as distinct from electromagnetic radiation in general) have over the last century received great attention and have been well standardized. Outside the visible spectrum, however, test methods have not been mastered, despite the increasing need for such methods.

The difficulties lie in the specification and measurement of the input irradiances. For light, there exist standard sources and defined units of measurement, as well as agreed-upon measurement techniques in the field of photometry. There are as yet no standard sources or measurement methods in the infrared or ultraviolet regions of the spectrum. Thermopiles which may have a flat response in the visible spectrum may be far from flat elsewhere in the electromagnetic spectrum, and thus the readings from thermopiles are affected by the spectral response of the devices used. Furthermore, thermopiles suffer from insensitivity and time lag, and require calibration with a standard source which is not yet available for other than light. Photoelectric devices are available with sensitivity to infrared and ultraviolet, but they have spectral response curves that are far from flat, they are relatively unstable with time, and they vary considerably from sample to sample.

Furthermore, outside the visible spectrum the problem of specifying the range of wavelengths needs to be mentioned. One can hypothesize a measuring device which would respond equally to equal irradiances completely independent of wavelength from zero to infinity. Clearly, a measurement made with such an instrument would be of little value without additional information about the spectral energy values. Some weighting function (analogous to the eye luminosity function for light) is called for, but that weighting function is not available. It is tempting but invalid to use the spectral sensitivity of the photographic material under test. Since in principle that spectral sensitivity is unknown (without experiment), the data are not ordinarily available. Also, the use of the spectral sensitivity of the material would result in a value of "exposure" different for every different type of material, and would thus confuse the desirable separation between exposure and response.

Altman, et al.[94] suggest, as a partial solution to this problem, the adoption of wavelength limits of 350 and 1200 nm, "that will be narrow enough to exclude unused radiation in the remote infrared and ultraviolet regions and yet not so narrow as to cause the problem of indeterminacy . . . (T)he indeterminacy problem afflicts the photometric speed system [based on measurements of light alone] whenever the source emits all or nearly all its radiation outside the wavelength limits (400 and 700 nm) of the photometric speed system An important requirement is that the wavelength limits used in calculating a speed be communicated to the persons who wish to use it as a basis for determining practical camera exposures." When these wavelength limits are used, the relationship between radiometric and photometric speeds depends only upon the spectral energy distribution of the source, and not on the spectral sensitivity of the photographic material under test.

A common approach to sensitometric tests with invisible radiation is to use a practical source of radiation (usually a mercury arc for ultraviolet[81] and tungsten lamps for infrared[78,80]) and a step tablet or a series of exposure times to produce an exposure series. In such a test the nonselectivity of the step tablet is of utmost importance; nonselectivity should not be assumed. (See the section on neutral filters.)

For x-rays the source must be operated under specified conditions. Correct voltage is especially critical. In American National Standard PH2.9-1964 (R1969) the spectral quality of the radiation is specified in terms of the half-value layer of aluminum; that is, the voltage is that for which the introduction into the beam of a layer of aluminum 2.0 mm thick (for dental x-rays) reduces the intensity to half its former value.

No material is neutral to x-rays; thus metal (aluminum or lead) step tablets, commonly used in sensitometric testing for the direct exposures of photographic materials to this radiation, do in fact subject the material to a different spectral energy distribution for each step of the tablet. Neutral absorbers for ultraviolet and infrared are also rare; specifically, silver step tablets which are suitable for attenuating light but not necessarily suitable for attenuating other radiation.

REFERENCES

General

1–5. Ansel Adams, *Basic Photography Series* (5 vols.), Morgan & Morgan, Dobbs-Ferry, New York.
 1. Book I, *Camera & Lens: The Creative Approach*, 1969.
 2. Book II, *The Negative: Exposure & Development*, 4th Ed., 1968.
 3. Book III, *The Print: Contact Printing & Enlarging*, revised, 1968.
 4. Book IV, *Natural-Light Photography*, 5th Ed., 1965.
 5. Book V, *Artificial-Light Photography*, revised Ed., 1968.
 6. R. M. Evans, W. T. Hanson and W. L. Brewer, *Principles of Color Photography*, Wiley, New York, 1953. (out of print)
 7. J. Woodlief Jr. (ed.), *SPSE Handbook of Photographic Science and Engineering*, Wiley, New York, 1973.
 8. Allan Horder (ed.), *The Ilford Manual of Photography*, Ilford, Essex, Great Britain, 1960.
 9. T. H. James, and G. Higgins, *Fundamentals of Photographic Theory*, 2nd Ed., Morgan & Morgan, Dobbs-Ferry, New York, 1968.
10. C. E. K. Mees and T. H. James (eds.), *Theory of the Photographic Process*, 3rd Ed., MacMillan, New York, 1966.
11. P. Moon, *The Scientific Basis of Illumination Engineering*, Dover, New York, 1961.
12. C. B. Neblette, *Fundamentals of Photography*, Van Nostrand Reinhold, New York 1969.
13. *Photographic Systems for Engineers*, Society of Photographic Scientists and Engineers, Washington, D.C., 1969.
14. John W. T. Walsh, *Photometry*, Dover, 1958.
15. J. A. C. Yule, *Principles of Color Reproduction*, Wiley, New York, 1967.

Sensitometry

16. T. A. Babcock, W. C. Lewis and T. H. James, "A Sensitometer Gaseous Mixtures with Controlled Temperature and Humidity," *Photogr. Sci. Eng.*, **15**: 75 (1971).

17. C. J. Bartleson and E. J. Breneman, "Brightness Reproduction in the Photographic Process," *Photogr. Sci. Eng.*, **11**: 245 (1967).

18. *Basic Photographic Sensitometry*, Du Pont, Wilmington, Delaware.

19. I. B. Current, "Sensitometry in Color Aerial Photography," *Photogram. Eng.*, **33**: 1143 (1967).

20. E. Drvodelic, "Sensitometric Methods for Testing Diazo Materials and their Properties," *Kem. Ind.*, **16**: 91 (1967).

21. Keith Hornsby, *Sensitometry in Practice*, Greenwood, London, 1957.

22. L. A. Jones, "Photographic Sensitometry, Part I," *J. Soc. Motion Picture Engrs.*, **17**: 491 (1931).

23. L. A. Jones, "Photographic Sensitometry, Part II," *J. Soc. Motion Picture Engrs.*, **17**: 695 (1931).

24. L. A. Jones and C. A. Morrison, "Sensitometry of Photographic Paper," *J. Franklin Inst*, **228**: 445 (1939).

25. Leopold Lobel and M. Dubois, *Sensitometry*, 2nd Ed., Focal, New York, 1967.

26. N. T. Notely, "Sensitometry and Densitometry of Vesicular Films," *Photogr. Sci. Eng.*, **11**: 2 (1967).

27. *Principles of Color Sensitometry*, Society of Motion Picture and Television Engineers, New York, 1963.

28. H. N. Todd and R. D. Zakia, *Photographic Sensitometry*, 2nd Ed., Morgan & Morgan, Dobbs-Ferry, New York, 1974.

29. R. A. Walker, "An Equal-Energy Scanning Spectrosensitometer," *Photogr. Sci. Eng.*, **14**: 421 (1970).

45. G. A. Johnson, "A Processing Control Sensitometer," *J. Soc. Motion Picture Engrs.*, **47**: 474 (1946).

46. D. B. Judd, D. L. MacAdam and G. Wyszecki, "Spectral Distribution of Typical Daylight," *J. Opt. Soc. Amer.*, **54**: 1031 (1964).

47. *Kodak Filters*, B-3, Eastman Kodak, Rochester, New York 1972.

48. *Kodak Plates and Films for Science and Industry*, P-9, Eastman Kodak, Rochester, New York (1970).

49. M. Levy, "Wide Latitude Photography," *Photogr. Sci. Eng.*, **11**: 46 (1967).

50. C. S. McCamy, "A Nomograph for Selecting Light Balancing Filters for Camera Exposure of Color Film," *Photogr. Sci. Eng.*, **3**: 302 (1959).

51. C. S. McCamy, "Proposed Recommended Practice for Description and Selection of Conditions for Photographic Specimens," *Photogr. Sci. Eng.*, **10**: 185 (1966).

52. A. Stimson, J. F. Scudder and C. N. Nelson, "Re-evaluation of Factors Affecting Manual or Automatic Control of Camera Exposure," *J. Soc. Motion Picture Television Engrs.*, **77**:24 (1968).

53. R. W. Tyler, J. J. DePalma and S. B. Saunders, "Determination of Total and Spectral Radiant Intensities of Tungsten Lamps," *Photogr. Sci. Eng.*, **9**: 190 (1965).

54. J. H. Webb, "A Mathematical Model for Photographic Exposure and Its Experimental Verification," *Photogr. Sci. Eng.*, **14**: 217 (1970).

55. D. R. White, "Two Special Sensitometers," *J. Soc. Motion Picture Engrs.*, **18**: 279 (1932).

Densitometry

30. ___, "Calibration of Densitometers Used for Black-and-White Photographic Density Measurement. SMPTE Recommended Practice," *J. Soc. Motion Picture Television Engrs.*, **79**: 347 (1970).

31. D. G. Kocher, "A Wide Dynamic Range Photometer for Film Densitometry," *J. Soc. Motion Picture Television Engrs.*, **80**: 481 (1971).

32. C. S. McCamy, "Concepts, Terminology and Notation for Optical Modulation," *Photogr. Sci. Eng.*, **10**: 314 (1966).

33. N. Ohta, "Reflection Density of Multilayer Color Prints. 1 Specular Reflection Density," *Photogr. Sci. Eng.*, **15**: 487 (1971).

34. J. E. Pinney and J. C. Kinard, "Simple Automatic Reflection Color Densitometer," *Photogr. Sci. Eng.*, **6**: 252 (1962).

35. J. E. Pinney and W. F. Voglesong, "Analytical Densitometry of Reflection Color Print Materials," *Photogr. Sci. Eng.*, **6**: 367 (1962).

36. S. A. Powers and O. E. Miller, "Pitfalls in Color Densitometry," *Photogr. Sci. Eng.*, **7**: 59 (1963).

37. M. H. Sweet, "Improved Procedure for the Contact Printing Method of Measuring Photographic Density," *J. Opt. Soc. Amer.*, **33**: 143 (1943).

38. D. M. Zwick, "Color Balance and Density Variations of Color Films Intended for Television," *J. Soc. Motion Picture Television Engrs.*, **80**: 88 (1971).

39. D. M. Zwick and D. L. Brothers, Jr., "Color Balance and Density of Films for Tungsten (Theatrical) and ARC (TV Preview) Projection," *J. Soc. Motion Picture Television Engrs.*, **81**: 1 (1972).

Exposure

40. W. Bornemann and C. Tuttle, "Intensity-Scale Sensitometer that Works at Intensity-Time Levels Used in Practical Photography," *J. Opt. Soc. Amer.*, **32**: 224 (1942).

41. P. D. Carman, "A Light Source for Sensitometry of Aerial Films," *Photogr. Sci. Eng.*, **13**: 376 (1969).

42. R. Davis and K. S. Gibson, "Filters for the Reproduction of Sunlight and Daylight and the Determination of Color Temperature," *Natl. Bur. Std. (U.S.) Mis. Publ.* 114.

43. C. H. Evans, "Intensity-Scale Monochromatic Sensitometer," *J. Opt. Soc. Amer.*, **30**: 118 (1940).

44. F. P. Herrnfeld, "Constant-Time, Variable-Intensity Microsecond Exposure Sensitometer," *J. Soc. Motion Picture Television Engrs.*, **70**: 500 (1961).

Processing

56. J. E. Bates, E. F. Berley and J. J. Kowalak, "Sensitometric Processing Machine with Rotary Agitation," *Photogr. Eng.*, **2**: 182 (1951).

57. George Eaton, *Photographic Chemistry*, 2nd. Ed., Morgan & Morgan, Dobbs-Ferry, New York 1965.

58. R. W. Henn and K. R. Hughes, "A Sensitometric Processing Machine Using Small Film Strips and Small Developer Volume," *Photogr. Sci. Eng.*, **2**: 81 (1958).

59. K. M. Hornsby, *Basic Photographic Chemistry*, Fountain, London, 1956.

60. C. I. Jacobson, *Developing*, Focal, New York, 1966.

61. L. A. Jones, M. E. Russell and H. R. Beacham, "A Developing Machine for Sensitometric Work," *J. Soc. Motion Picture Engrs.*, **28**: 73 (1937).

62. *Processing Chemicals and Formulas*, J-1, Eastman Kodak, Rochester, New York (1968).

63. W. C. Snyder, "An Investigation of Agitation in Continuous Immersion Film Process," *J. Soc. Motion Picture Television Engrs.*, **75**: 996 (1966).

64. L. E. West, "Water Quality Criteria," *Photogr. Sci. Eng.*, **9**: 398 (1965).

Data Reduction

65. N. Aebischer, "Measurement of Gamma Values," *Opt. Technol.*, **1**: 89 (1969).

66. L. D. Clark, "Mathematical Prediction of Photographic Picture Quality from Tone Reproduction Data," *Photogr. Sci. Eng.*, **11**: 306 (1967).

67. W. S. Grover and R. L. Grines, "Improved Method for Determining the Speeds of Photography Films by Pictorial Tests," *Photogr. Sci. Eng.*, **11**: 283 (1967).

68. G. C. Higgins, "Methods for Analyzing the Photographic System, Including the Effects of Nonlinearity and Spatial Frequency Response," *Photogr. Sci. Eng.*, **15**: 106 (1971).

69. "Plotting Data from Sensitometric Strips Exposed on Type 1b2 (Intensity Scale) Sensitometer, SMPTE Recommended Practice," *J. Soc. Motion Picture Television Engrs.*, **79**: 349 (1970).

70. L. A. Jones and C. N. Nelson, "Study of Various Sensitometric Criteria of Negative Film Speeds," *J. Opt. Soc. Amer.*, **30**: 93 (1940).

71. L. A. Jones, "The Evaluation of Negative Film Speeds in Terms Print Quality," *J. Franklin Inst.*, **227**: 297 (1939).

72. H. E. Morse, "Sensitometric Determination of Speed and Contrast for Microfilms," *National Microfilm Assn. J.*, **2**(3): 97 (1969 spring).

73. C. N. Nelson, "Prediction of Densities in Fine Detail in Photographic Images," *Photogr. Sci. Eng.*, **15**; 82 (1971).

74. C. N. Nelson and J. L. Simonds, "Simple Methods for Approximating Fractional Gradient Speeds of Photographic Materials," *J. Opt. Soc. Amer.*, **46**: 324 (1956).

75. C. J. Niederpruem, C. N. Nelson and J. A. C. Yule, "Contrast Index," *Photogr. Sci. Eng.*, **10**: 35 (1966).

76. H. N. Todd and R. D. Zakia, "A Review of Film Speeds," *Photogr. Sci. Eng.*, **8**: 249 (1964).

77. D. R. White, "Gamma by Least Squares," *J. Soc. Motion Picture Eng.*, **18**: 584 (1932).

Invisible Radiation

78. *Applied Infrared Photography*, M-29, Eastman Kodak, Rochester, New York (1968).

79. M. E. Baldwin, "A Quality Control Programme for Industrial X-ray Film," *X-Ray Focus*, **10**: 18 (1970).

80. Walter Clark, *Photography in Infrared*, 2nd Ed., Wiley, New York, 1946.

81. A. J. Drummond and D. P. Habib, "A Standard Ultraviolet and Visible Line Spectra Sensitometer," *Photogr. Sci. Eng.*, **9**: 228 (1965).

82. M. S. Htoo, "New Method for Photoresist Exposure Determination," *Photogr. Sci. Eng.*, **12**: 169 (1968).

83. J. Kastner, W. G. Cibula, J. Mackin and M. R. Rosmuny, "Simple Step-Sector X-Ray Sensitometer," *Photogr. Sci. Eng.*, **6**: 287 (1962).

84. Lewis Koller, *Ultraviolet Radiation*, 2nd Ed., Wiley, New York 1965.

85. Mattsson, "Simplified Sensitometry," *Acta Radiol.*, **10**: 252 (1970).

86. R. F. Newell, "A Low-Intensity Ultraviolet Sensitometer," *Photogr. Sci. Eng.*, **3**: 61 (1959).

87. A. K. Poznanski and L. A. Smith, "Practical Problems in Processing Control," *Radiology*, **90**: 135 (1968).

88. N. J. D. Smith, "The Sensitometric Evaluation of Dental Radiographic Film," *Brit. Dent. J.*, **129**: 455 (1970).

89. E. D. Trout, J. O. Kelly and S. F. Anderson, "A system for Periodic Testing of Film Processing," *Radiol. Technol.*, **43**: 15 (1971).

90. *Ultraviolet Photography and Fluorescence*, M-27, Eastman Kodak, Rochester, New York (1968).

91. W. W. VanAllen, "The Independent Sensitometry of Roentgenographic Films and Screens," *Photogr. Eng.*, **2**: 211 (1951).

92. P. J. Venier, "Conditions for Linearity Between Density and Exposure for Photographic Plates," *J. Opt. Soc. Amer.*, **59**: 444 (1969).

93. F. S. Weinstein, "RMS Error in Radiometric Measurements when a Photographic Emulsion is used as a Detector," *J. Opt. Soc. Amer.*, **59**: 108 (1969).

94. J. H. Altman, F. Grum and C. N. Nelson, "Photographic Speeds Based on Radiant Energy Units," *Photogr. Sci. Eng.*, **17**: 6 (1973).

Additional References

J. J. Dowdell and R. D. Zakia, *Zone Systemizer*, Morgan & Morgan, Dobbs-Ferry, 1974.

L. D. Stroebel and H. N. Todd, *Dictionary of Contemporary Photography*, Morgan & Morgan, Dobbs-Ferry, N.Y., 1974.

9

THE MICROSTRUCTURE OF THE PHOTOGRAPHIC IMAGE

M. Abouelata

INTRODUCTION

A silver image is formed when an emulsion composed of silver halide, suspended in gelatin and coated on a paper, glass, or plastic base, is exposed, developed and fixed. The image consists of silver particles, or grains, which depend primarily on the sizes of the silver halide crystals in the emulsion and range from a fraction of a micrometer to a few micrometers. In a high speed negative emulsion the largest masses of silver are seldom larger than 2.5 μm.

A color film is normally composed of three layers of silver halide emulsions. One layer is mainly sensitive to blue light and contains a yellow-forming color coupler, the other two layers are sensitive to green and red and contain magenta and cyan-forming color couplers, respectively. Through processing, the silver images formed in development are removed and replaced with superimposed yellow, magenta and cyan colored dye images. The dye images have essentially the same structure as the silver images they replace but the edges of the dye masses are more diffuse.

The photographic emulsion is band limited (particle size limits resolution) and contains a certain amount of noise. To understand the band limitation let us image a two-bar target, with varying spatial frequency, using a panchromatic emulsion. Fig. 9-1 shows the image formed when the emulsion is exposed to the luminance distribution of a two-bar target of three spatial frequencies, ω_1, ω_2, and ω_3 radians per millimeter ($\omega = 2\pi\nu$, ν is the spatial frequency in cycles/per millimeter). The frequencies are such that $\omega_1 < \omega_2 < \omega_3$. The exposed areas

of the frequency ω_1 are separated and result in an image whose transmission distribution is almost identical to the exposure distribution. As the frequency of the target increases to ω_2 or ω_3, there is less similarity between the image distribution and the object distribution. This degradation of the image is due to the scattering of the light which exposes adjoining areas making them developable, thus spreading the image. On the other hand the noise in a photographic emulsion is due to its finite grain.

To the unaided eye the microscopic masses of the metallic silver of the image formed, appears continuous, as shown at (1) in Fig. 9-2. However, inhomogeneity arising from the descrete nature of the silver deposit becomes apparent at a relatively small magnification. This inhomogeneity becomes more marked at increasing magnifications, as shown in the photomicrographs (2), (3), and (4). At about 2500X, the individual grains are separated. Except when special developers are used, these grains do not have the same size or shape as the crystals of silver halide from which they were formed, and indeed the electron microscope at a magnification of 25,000X shows that the grains have a filamentry structure as shown at (5), the nature of this structure varying with the developing agent.

The study of image degradation due to band limitation and noise in an image recording medium has become a challenging problem in the field of photographic science and engineering. While clarity in the reproduction of fine details has been regarded as important since the earliest days of photography, its importance has greatly increased in the last fifty years because (1) of the small

Fig. 9-1. The Microbehavior of a Photographic Emulsion.
$\omega_1 < \omega_2 < \omega_3$

camera and subsequent enlargement, (2) because of the increase in the variety and importance of the scientific applications of photography and (3) the need for greater precision in measurements made from the photographic image. These developments have made the search for more accurate and sophisticated methods of measuring the photographic image and the correlation of the physical measurements with the subjective evaluation of the image a major problem in photographic science.

Over the years many different terms have been used to describe the characteristics of a photographic image.

Many of these were subjective and many were simply different ways of describing the same thing. This chapter will employ the parameters in Tables 9-1 and 9-2 with the advantage and disadvantage of each in Tables 9-3 and 9-4.

ONE DIMENSIONAL IMAGE FORMATION

Consider a physical object characterized by the object function $\mathcal{E}(x)$. $\mathcal{E}(x)$ is the spatial illuminance distribution

TABLE 9-1. PARAMETERS USED IN IMAGE STRUCTURE EVALUATION FROM GRAIN-SIZE DISTRIBUTION.

Parameter	Basic Measuring Technique	Application
Graininess	Determine subjectively: 1. Viewing distance at which graininess disappears, or 2. Viewing magnification at which graininess disappears.	Subjective recognition of the inhomogeneity of a photographic image.
Selwyn Granularity	Statistical analysis of a microdensitometer trace of a uniformly exposed area of a photographic material. The trace is obtained with a single aperture of various sizes.	Objective recognition of the inhomogeneity of a photographic image.
Syzygetic Granularity	Statistical analysis of a microdensitometer trace with rectangular apertures of different sizes.	Objective characterization of the inhomogeneity of a photographic image.

TABLE 9-2. ADVANTAGES AND DISADVANTAGES OF THE PARAMETERS USED IN IMAGE EVALUATION FROM THE GRAIN SIZE DISTRIBUTION.[a]

Parameter	Advantages	Disadvantages
Graininess	Corresponds to the conditions under which a photographic image will be used.	Subjective measurement.
Selwyn Granularity	1. Objective measurement. 2. Repeatable. 3. Correlates with graininess.	Requires clean samples.
Syzygetic Granularity	1. Objective measurement. 2. Repeatable. 3. Correlates with graininess.	Cannot be properly used for evaluation of nonrandom grain patterns.

[a]The parameters used in image evaluation from the spatial frequency response are as shown in Table 9-3.

Fig. 9-3. Distribution Function of an Object.

Fig. 9-2. The photographic image at five degrees modification, (1) original size; (2) 25×; (3) 250×; (4) 2500×; (5) 25,000×.

of the object. The plot of $\mathcal{E}(x)$ as a function of x can be represented as shown in Fig. 9-3. As seen in Fig. 9-3, $\mathcal{E}(x)$ can be divided into a number of elements each of strength $\mathcal{E}(\eta)\Delta\eta$ so that total illuminance of the object is given by:

$$\mathcal{E}(x) \approx \sum \mathcal{E}(\eta)\,\Delta\eta \qquad (1)$$

Thus we can assume that the original object is a group of line objects having different strength $\mathcal{E}(\eta)\Delta\eta$. As $\Delta\eta$ gets smaller the summation in Eq. (1) agrees with the original object luminance.

When the object is imaged, each line object $\mathcal{E}(\eta)\Delta\eta$ has a line-spread function which is described by $s(x-\eta)$, where x is a coordinate around η. This is shown in Fig. 9-4. If $s(x)$ satisfied the condition

$$\int_{-\infty}^{+\infty} s(x)\,dx = 1 \qquad (2)$$

The contribution of one object element $\mathcal{E}(\eta)d\eta$ to an arbitrary point x is $\mathcal{E}(\eta)s(x-\eta)d\eta$. Thus, the total contribution to the point x from every line element of the object is the summation of each contribution, when linearity* condition is satisfied. Thus when $\Delta\eta$ is small, the

*A system is linear if and only if addition of inputs produces simply an addition of outputs, i.e., if $f_1(x)$ is an input that produces output $g_1(x)$, denoted by $f_1(x) \leftrightarrow g_1(x)$ and if $f_2(x) \leftrightarrow g_2(x)$, then $af_1(x) + bf_2(x) \leftrightarrow ag_1(x) + bg_2(x)$.

Fig. 9-4. Contribution of $\mathcal{E}(\eta)\,d\eta$ to the image at a point x.

TABLE 9-3. PARAMETERS USED IN IMAGE STRUCTURE EVALUATION FROM THE SPATIAL FREQUENCY RESPONSE.
(A summary of the major advantages and disadvantages of the parameters in this table are shown in Table 9-4.)

Parameter	Basic Measuring Technique	Application
Resolving Power	Visual determination of the resolution limit from images of various spatial frequencies.	Threshold spatial frequency of an optical or photographic system.
Acutance	Microdensitometer trace of an image of an edge exposure on a photographic material. Calculation of the normalized square average of the line spread function from the edge.	Characterization of the edge response of a photographic material by a single number.
Optical Transfer Function (OTF) (Sine Wave Response); Modulation Transfer Function (MTF).	1. Measurement of contrast reduction on images of sinusoidal targets of various spatial frequencies. 2. Fourier transform of the line spread function.	Spatial frequency response spectrum (OTF) or amplitude response spectrum (MTF), of imaging systems.
Square-Wave Response.	Measurement of contrast reduction from images of a line target of various spatial frequencies.	Spatial frequency response spectrum of an optical or photographic image.
Edge-Response Function.	1. Microdensitometer trace of an edge image. 2. Integral of the line spread function.	Evaluation of how an optical system or photographic material will reproduce a point image.
System-Modulation Transfer Function Acutance (SMTA).	1. Determination of the MTF of photographic image. 2. Mathematically correlate subjective image sharpness, the eye response, and the system magnification with the MTF of the image.	Determination of image sharpness with a single number.

TABLE 9-4. ADVANTAGES AND DISADVANTAGES OF VARIOUS PARAMETERS USED IN IMAGE EVALUATION.

Parameter	Advantages	Disadvantages
Resolving Power	Characterization of fine detail response of an optical system by a single number.	1. Results are affected by development. 2. Does not take film granularity into account. 3. High variability. 4. Threshold spatial frequency response measurement. 5. Response of various components of the system cannot be accurately determined.
Acutance	Characterization of the edge response of a photographic image by a single number.	1. Results are dependent on the film measurement 2. Does not take fine details into account.
OTF and MTF	1. Complete specification of the spatial frequency response of an optical or photographic system. 2. The response of each component of the system may be isolated. 3. The development effect may be calculated.	None
Square-wave response	1. Complete determination of the spatial frequency response of an optical or photographic system. 2. Response of various components can be separated.	Separation of the response is not easy.
Edge-response function	1. Graphical representation of the image that an optical or photographic system may produce. 2. Response of the optical or photographic system may be convoluted.	Relative Complexity of the mathematics involved.
SMTA	Characterization of image sharpness by a single number.	Fails to characterize some aspects of image sharpness.

image distribution $g(x)$ is given by

$$g(x) = \int_{-\infty}^{+\infty} \mathcal{E}(\eta) \, s(x - \eta) \, d\eta = \int_{-\infty}^{+\infty} \mathcal{E}(x - \eta) \, s(\eta) \, d\eta$$

$$= \mathcal{E}(x) * s(x) \qquad (3)$$

Equation (3) states that the image distribution $g(x)$ is the convolution of $\mathcal{E}(x)$ and the spread function of the system $s(x)$.

TWO DIMENSIONAL IMAGE FORMATION

When the object is characterized by the illuminance distribution $\mathcal{E}(x, y)$, i.e., the object is two dimensional, the image of the a point in the object is then characterized by a point spread function $p(x, y)$. Then, similar to the one dimensional case, the image distribution is given by

$$g(x, y) = \int_{-\infty}^{+\infty} p(x - \eta, y - \xi) \, \mathcal{E}(\eta, \xi) \, d\eta \, d\xi$$

$$= \int_{-\infty}^{+\infty} p(\eta, \xi) \, \mathcal{E}(x - \eta, y - \xi) \, d\eta \, d\xi$$

$$= \mathcal{E}(x, y) * p(x, y) \qquad (4)$$

In this case, the point spread function satisfies the condition

$$\int_{-\infty}^{\infty} \int_{-\infty}^{+\infty} p(x, y) \, dx \, dy = 1 \qquad (5)$$

We must note that, in case of incoherently illuminated or self-luminous objects (no phase relationship exist between the points of the object), the transfer channels are linear with respect to intensity. In case of coherent illumination (there exists a phase relationship between points of the object), the transfer channels are linear in complex amplitude of illumination.

RELATIONSHIP BETWEEN POINT-SPREAD FUNCTION AND LINE-SPREAD FUNCTION

Consider the point-spread function $p(x - \eta, y - \xi)$, which is displaced by $x = \eta$, $y = \xi$. Integrate $p(x - \eta, y - \xi)$ with respect to ξ, i.e.

$$\int_{-\infty}^{+\infty} p(x - \eta, y - \xi) \, d\xi = \int_{-\infty}^{+\infty} p(x', y') \, dy' = s(x') \qquad (6)$$

where $s(x')$ is the line-spread function of the system. Equation (6) implies that a two dimensional object which has a structure in the x-direction and no structure in the y-direction is imaged by the line-spread function $s(x')$. The relationship between the point-spread function and the line-spread function is as shown in Fig. 9-5. From

the figure, we see that the area of a section of $p(x, y)$ is equivalent to the corresponding height of $s(x)$.

THE MEASUREMENT OF MICRODENSITY

The measurement of the density of microscopic portions of the image requires a microdensitometer. There are several types but the basic optical design is shown in Fig. 9-6.[1-4]

The light source (1) can be of various types but is usually a tungsten lamp with a ribbon filament. A condensing lens (2) collects the light and projects it on the preslit (3) which defines the light beam incident on the illumination microscope and reduces flare. The illumination microscope (4) illuminates the density with a narrow reduced image of the preslit. The film stage (5) can be moved perpendicularly to the scanning slit to scan the density to be measured. The film stage can be rotated also for alignment of the sample. If the sample is transparent, the light is gathered by the reading microscope (6) and the image of the illuminated area is projected onto the postslit. If the density sample is on paper, or is to be examined by reflected light, the optical arrangement shown in Fig. 9.6A (ultrapack) is used to collect the light reflected from the sample and project it on the slit. The post-slit (7) defines the beam emerging from the reading microscope into a narrow axial beam and prevents flare. The phototube (8) converts differences in the light transmitted into differences in an electric current. Thus

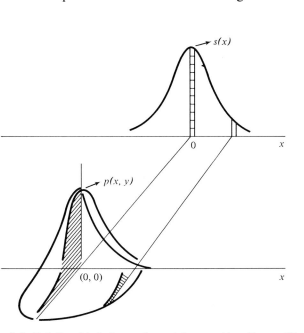

Fig. 9-5. Relationship between the point-spread function and the line-spread function of an imaging system.

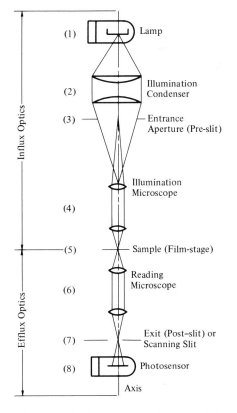

Fig. 9-6. General microdensitometer optical design.

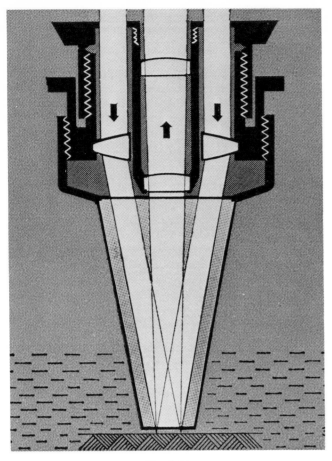

Fig. 9-6A.

the functional dependence of the phototube on time gives the variation of the transmittance or reflection, as a function of the distance along the density. The scanning is in a direction perpendicular to the length of the post-slit, as shown in Fig. 9-7.

Arrangement of the Microdensitometer for Microdensity Measurement

The slits in a microdensitometer can be adjustable or fixed. The adjustable slits are provided with a micrometer to allow a precise setting. All microdensitometers are equipped with a quantalog device which changes the

Fig. 9-7. Direction of scanning with a rectangular slit of length L and width W.

transmittance of the sample to optical density according to the equation

$$\rho = \log(1/t) \qquad (7)$$

Where, ρ is the optical density of the sample and t is its transmittance. Microdensitometers are also equipped with a chart recorder so that a density trace can be made. The slits of the microdensitometer can be rectangular or circular, depending on the information desired.

A typical arrangement of the post-slit and the pre-slit may clarify the question of setting up the micro-densitometer. Suppose we wish to use a pair of objectives, each of a magnification 10×. The eyepiece on the reading microscope has a 10× magnification. If we wish to scan the sample with a post-slit of 1 micrometer (1μm) effective width and 200 μm effective length, then the physical width of the post-slit is:

$$W_p = 1\ \mu m \times 10 \times 10 = 100\ \mu m$$

and the physical length of the post-slit is:

$$L_p = 200 \times 10 \times 10 = 20\ mm$$

The linearity of the microdensitometer is improved by overfilling the objectives of the microscope. For this reason the width of the pre-slit is usually (3/2) times the width of the post-slit. Thus

$$W_{pr} = (3/2) \times 1 \times 10 \times 10 = 150\ \mu m$$

Focusing of the Microdensitometer Optics:

The sample to be scanned by the microdensitometer must be in focus at all times during the scanning. Some microdensitometers are brought to focus by moving the influx optics and the efflux optics until the grains of the sample appear visually. New microdensitometers are equipped with an oscilloscope, so that maximum display of the phototube output corresponds to best focus.

The effect of focusing can be seen in Fig. 9-8 where we represent the edge scans when the edge is in focus and out of focus.

Alignment:

Consider a photographic sample which varies cosinusoidally in its optical transmittance, i.e.

$$t(x) = A \cos(\omega x) \qquad (8)$$

Where ω is the angular spatial frequency in radians per millimeter. The effective transmittance, $t_e(x)$, of the sample is then given by

$$t_e(x) = A \int_{x-L/2}^{x+L/2} \cos(\omega x)\, dx = AL\ \text{sinc}\,(\omega L/2) \cos(\omega x)$$

$$(9)$$

where L is the period of $t(x)$.

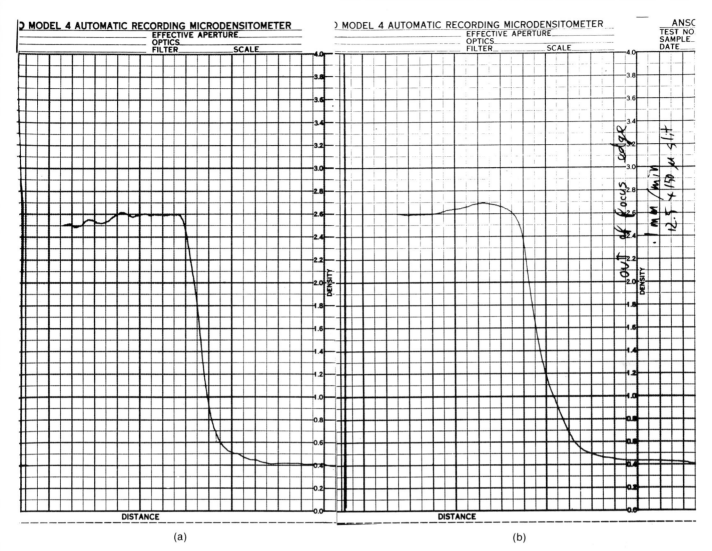

Fig. 9-8. Edge scans when the image is in focus (a) and out of focus (b).

From Eq. (9) we see that the response of the system L sinc $(\omega L/2)$ drops continuously as the frequency increases to

$$\omega_c = \frac{2\pi}{L} \qquad (10)$$

Under this condition, the slit width includes one whole cycle of the transmittance and the result averages to zero. Above ω_c, a frequency phase shift occurs. Thus the increase in the slit width decreases the system response. Defocusing of the sample will have the same effect.

The alignment of the film sample parallel to the scanning slit length is very critical especially when the slit length is much larger than its width.[5] Fig. 9-9 shows the proper alignment of a sample in the form of a photographic edge and the scanning slit.

If the slit is misaligned by an angle θ as shown in Fig. 9-10. The misalignment angle θ produces an error in the effective width of the slit, d, given by

$$\frac{d}{L} = \sin \theta$$

Fig. 9-9. The Relationship between the scanning slit, the edge and the direction of scanning.

Fig. 9-10. Misalignment of the slit by an angle θ relative to the edge.

or

$$d = L \sin \theta$$

if θ is very small, then

$$d = L\theta \tag{11}$$

Studies on the human eye have shown that alignment to about one degree is possible. Since $1° = 1/57.3$ radians,

$$d = L/57.3 = 0.0174\,L$$

Thus if we require that $d < w$, where w is the actual width, then

$$0.0174\,L < w$$

or

$$L/w \approx 57.3$$

Thus the error in alignment is small when the slit length L and its width w are related by:

$$L \cong 57.3\,w \tag{12}$$

A practical effective slit dimension for an edge scanning is $1\ \mu\text{m} \times 80\ \mu\text{m}$. The effect of slit alignment on the edge trace is as shown in Fig. 9-11.

Microdensitometer Calibration

Absolute density measurement is an uncertain process, and due to the different scattering properties of each photographic emulsion, a standard must be defined for each material. However, the problem is simplified by considering the effective exposure.

Let ρ be the optical density of a material, then the density of the exposure h is uniquely related by

$$\rho = f(\log h) \tag{13}$$

Where $f(\log h)$ represents the ρ-log h curve for the photographic material. The uncertainty in the exposure is in general relatively small, however we can safely assume that the optical density and exposure are uniquely related. In other words Eq. (13) may be written

$$\rho = f(\log \langle h \rangle) \tag{14}$$

Fig. 9-11. Effect of misalignment of the edge scan in comparison to the focused and properly aligned scan of Figure 9-8(a).

Since

$$\rho = \log (1/t) \tag{15}$$

Where t is the transmittance of the film sample. We must also note that:

$$\bar{\rho} = \langle \log (1/t) \rangle \neq \log \langle\langle (1/t) \rangle\rangle \tag{16}$$

A macrodensitometer measures the quantity on the right hand side of Eq. (16). Thus, a calibration technique which improves the estimate of the quantity related to effective exposure must be found. We must also keep in mind, aside from the statistical problem at hand, other effects increase the uncertainty. In the microdensitometer measurements, these effects are:

1. Random variation in emulsion inconsistency.
2. Nonuniformity in illuminance during sensitometric exposure.
3. Granularity in the scan, especially when a small effective aperture is used.

A calibration technique based on Eq. (16) is as follows:

1. Several controlled stepped exposures are made on a particular emulsion type.
2. The stepped wedges are then read with a macrodensitometer and the microdensitometer, to obtain a macrodensity ρ_{ma} and a microdensity ρ_{mi} for each step, respectively.
3. The difference $\bar{\delta}\rho = \rho_{mi} - \rho_{ma}$ is calculated for each step, and for each strip, and average $\bar{\delta}\rho$ is found.
4. Plot $\bar{\delta}\rho$ as a function of ρ_{ma}.
5. The curve obtained in step (4) is then smoothed by hand or by a working third degree polynomial to obtain a systematic function of $\delta\rho$ as a function of ρ_{ma}.
6. This error curve of $\bar{\delta}\rho$ is systematically added to ρ_{ma} to obtain the density values, the microdensitometer should have been measured.

Other calibration techniques such as obtaining the line-spread function of the microdensitometer from an edge trace, or obtaining $\log(1/t)$ may be used.

Use of the Microdensitometer

The microdensitometer is by far the easiest and the most widely used instrument for microdensity measurement and image quality evaluation. Other instruments such as modulation transfer meter, granularity meter, and interferometric techniques are rarely used.

POINT-SPREAD FUNCTION AND LINE-SPREAD FUNCTION OF A PHOTOGRAPHIC EMULSION

The spread function is the fundamental element of image forming systems.[6] One way to examine the image formed by a photographic system is to look at the image formed by a brightly illuminated point. In this case, we are examining the point-spread function, or a brightly illuminated narrow line, and hence the line-spread function. Thus we may define the point-spread function $p(x, y)$ of a photographic emulsion as the two dimensional exposure distribution within the emulsion, when it is exposed to a geometrical point of illuminance $\mathcal{E}(x, y)$ for a given period of time. Fig. 9-12 is a schematic diagram which illustrates the definition of the point-spread function. Similarly, the line-spread function of a photographic emulsion, $s(x)$, is defined as the one dimensional exposure distribution within the emulsion, when it is exposed to an infinitely narrow and infinitely long line of illuminance, $\mathcal{E}(x)$, for a given period of time (Fig. 9-13).

The reason that the spread function of an emulsion is expressed in terms of exposure is that neither the density nor the transmittance are additive, only the exposure or the illuminance of the film is additive. Additivity is necessary for Eq. (10) and Eq. (11) to hold true.

Fig. 9-12. Point-spread function of a photographic emulsion.

Since a line can be considered to be a series of points along a given direction, say, the y-direction, thus if we scan a line-spread function with a circular aperture, we receive illuminance from an infinite number of point-spread functions, one for each value of y, as shown in Fig. 9-14. Thus, the line-spread function $s(x)$ is found by integrating the point-spread function $p(x, y)$ with respect to y, i.e.

$$s(x) = \int_{-\infty}^{\infty} p(x, y)\, dy \qquad (17)$$

From the above equation, we see that, if $p(x, y)$ is not symmetrical, then $s(x)$ will depend upon the direction

Fig. 9-13. The line-spread function of a photographic emulsion.

Fig. 9-14. Scanning a line-spread function with a circular aperture along one direction.

of integration, and the line-spread function must be specified for different orientations. If $p(x, y)$ is symmetric, complete information is contained in $s(x)$, so that one can obtain $p(x, y)$ from $s(x)$ mathematically. Practically speaking the point-spread function of a photographic emulsion is symmetric and one seldom obtains the point-spread function experimentally.

Experimental determination of the line-spread function of photographic emulsions leads to two mathematical models for $s(x)$ which are representative of most materials. Without going into detail which is out of the scope of this chapter, we can summarize these models as follows:

(A) Photographic emulsions which are generally thick, are strongly diffusing. The line-spread function which represents these emulsions is given by

$$s_A(x) = (4.6/k) \, e^{-(4.6/k)|x|} \qquad (18)$$

where x is the distance in μm across the emulsion and k is the width of $s_A(x)$ at $(1/e)$ of its maximum value, which is usually normalized to unity. The value of k can be determined experimentally by placing an opaque bar with sharp edges and 15 μm wide across each step of a step tablet, and optically printing the combination on the sample with a good lens of large aperture. A ρ-log h curve is made from the processed sample with a microdensitometer, and the difference in density on each step between the light line produced by the bar and the surrounding part of the step is projected on the ρ-log h curve to give the corresponding value of Δ log \mathcal{E}.

Now, consider the opaque bar is of width b (see Fig. 9-15). The illuminance $d\mathcal{E}(x)$ in the center of the shadow coming from an element of thickness dx at a distance x from the edge is

$$d\mathcal{E} = 2\mathcal{E}_0(4.6/k) \, e^{-(4.6/k)(b/2 + x)} \, dx \qquad (19)$$

Fig. 9-15. Printing a sharp edge on a film sample.

Fig. 9-16. The line-spread function calculated according to Eq. (18) for $k = 30 \, \mu$m.

where \mathcal{E}_0 is the incident illuminance of the edge, and the factor 2 is introduced because the shadow receives light from both sides of the edge.

Integrating Eq. (19), we get

$$\mathcal{E}(x) = 2\mathcal{E}_0(4.6/k) \, e^{-(4.6/k)(b/2)} \int_0^{\infty} e^{-(4.6/k) \, x} \, dx$$

$$= 2\mathcal{E}_0 e^{-2.3b/k}$$

and $\Delta \ln \mathcal{E} = 2.3b/k$ or

$$k = 2.3b/\Delta \ln \mathcal{E} \qquad (20)$$

The value of k ranges between 15 μm and 40 μm.

The line-spread function calculated according to Eq. (18), for $k = 30 \, \mu$m is as shown in Fig. 9-16.

(B) Most modern emulsions, specially thin emulsions are only slightly diffusing at low exposures, but strongly diffusing at high exposures.[7,8] These emulsions cannot be represented by the line-spread function given by Eq. (18). The line-spread function which represents these emulsions is given by

$$s_B(x) = (4.6/k_1) \, \alpha \, e^{-4.6|x|/k_1} + (4.6/k_2)(1 - \alpha) \, e^{-4.6|x|/k_2}$$

$$(21)$$

where k_1 and k_2 are the widths at $(1/e)$ of the maximum $s_B(x)$. The factor α represents the share of the exposure of the first distribution. The line-spread function cal-

Fig. 9-17. The line spread function calculated according to Eq. (21) ($k_1 = 10 \, \mu$m, $k_2 = 50 \, \mu$m, $\alpha = 0.30$). The solid curves represent the two terms of Eq. (21).

culated according to Eq. (21), for $k_1 = 10$ μm, $k_2 = 50$ μm, and $\alpha = 0.30$ is shown in Fig. 9-17.

THE MODULATION TRANSFER FUNCTION (MTF) OF PHOTOGRAPHIC EMULSIONS

Let $\mathcal{E}(x)$ be a cosinusoidal spatial distribution of object illuminance, then the modulation M_0 of the object is defined by

$$M_0 = \frac{\text{Maximum illuminance} - \text{Minimum illuminance}}{\text{Maximum illuminance} + \text{Minimum illuminance}}$$

$$= \frac{\mathcal{E}_{\max} - \mathcal{E}_{\min}}{\mathcal{E}_{\max} + \mathcal{E}_{\min}} \qquad (22)$$

For example, let $\mathcal{E}(x)$ be given by

$$\mathcal{E}(x) = a_0 - a \cos(\omega x) = a_0 - R\ell(a\, e^{i\omega x}) \qquad (23)$$

Where ω is the angular spatial frequency in radians per millimeter, a_0 is the dc level, or the average amplitude, and a is the amplitude of $\mathcal{E}(x)$. The illuminance distribution of $\mathcal{E}(x)$ calculated according to Eq. (23) is as shown in Fig. 9.18. From Fig. 9-18 and Eqs. (22) and (23), we see that

$$M_0(\omega) = \frac{(a_0 + a) - (a_0 - a)}{(a_0 + a) + (a_0 - a)} = a/a_0 \qquad (24)$$

When the object is imaged, the ratio of the image modulation to that of the object at a particular frequency gives the sine-wave response of the imaging system, which may consist of a photographic emulsion and a camera, at that particular frequency. The sine-wave response is called the modulation transfer function of the system and usually abbreviated to MTF. Thus if $M_i(\omega)$ is the modulation of the image at a frequency ω and $F(\omega)$ is the MTF of the imaging system, then

$$F(\omega) = \frac{M_i(\omega)}{M_0(\omega)} \qquad (25)$$

If the object distribution is non-sinusoidal, we must first decompose the object distribution and the resulting image distribution into their sinusoidal components, then the MTF is calculated by using Eqs. (23), (24), (25). The decomposition of the distributions into their sinusoidal components is accomplished by Fourier analysis.

Fig. 9-18. Illuminance distribution of a cosinusoidal object.

Relationship between the MTF and the Line-Spread Function of the Imaging System

Let $\mathcal{E}(x)$ be a cosinsusoidal object distribution, i.e., $\mathcal{E}(x)$ is given by

$$\mathcal{E}(x) = a_0 - a \cos(\omega x) = a_0 - a\, R\ell(e^{i\omega x})$$

Let $s(x)$ be the line-spread function of the imaging system. Since the image distribution, $g(x)$, is found by convolving $\mathcal{E}(x)$ with $s(x)$, then

$$g(x) = \mathcal{E}(x) * s(x) = a_0\, A - a|S(\omega)|R\ell(e^{i(\omega x - \phi)})$$

$$= a_0\, A - a|S(\omega)| \cos(\omega x - \phi) \qquad (26)$$

where

$$s(\omega) = \mathcal{F}[s(\eta)] = \int_{-\infty}^{\infty} s(\eta)\, e^{-i\omega\eta}\, d\eta, A = \int_{-\infty}^{\infty} s(\eta)\, d\eta,$$

and ϕ is the phase angle. Thus the modulation of the image is then given by:

$$M_i(\omega) = \frac{a|S(\omega)|}{a_0\, A} \qquad (27)$$

Therefore the MTF, $F(\omega)$, of the system is given by

$$F(\omega) = \frac{M_i(\omega)}{M_0(\omega)} = \frac{|S(\omega)|}{A} \qquad (28)$$

Eq. (28) states that the MTF of a linear system is given by its normalized amplitude spectrum. The equation is normalized $A = \int_{-\infty}^{\infty} s(\eta)\, d\eta$ so that, at zero frequency, the MTF due to only optical effects is 1.0. However, development or chemical effects may increase the MTF of the system to a value higher than 1.0. The chemical effects, when they exist, are pronounced at low frequencies. It is possible to decompose the overall MTF to its chemical and optical components. This achievement is of great importance to the emulsion chemist.

As we see from Eq. (28), the MTF depends only on the amplitude spectrum of the line-spread function of the system. When the frequency spectrum (amplitude and phase spectrum) of the line-spread function of the system is considered, we speak of the optical transfer function, OTF, of the system.[9, 10] Thus the OTF of an imaging system is given by

$$F_0(\omega) = \frac{\mathcal{F}[s(\eta)]}{A} = \frac{S(\omega)}{A} \qquad (29)$$

and the relationship between the OTF and the MTF of the system is

$$|OTF| = MTF \qquad (30)$$

In practice, the MTF is plotted as a function of the spatial frequency, ν, in cycles per millimeter as the latter changes from zero to a maximum value. Thus, when the line-spread function is even, it is sufficient to Fourier transform half of it.

Decomposition of the MTF of a System into its Individual Components

The line-spread function $s(x)$ of the system is given by:

$$s(x) = s_1(x) * s_2(x) \qquad (31)$$

Where $s_1(x)$ is the line-spread function of the camera lens, and $s_2(x)$ is the line-spread function of the photographic emulsion used for imaging. By Fourier transforming both sides of Eq. (31), we get

$$\mathcal{F}[s(x)] = \mathcal{F}[s_1(x) * s_2(x)] \qquad (32)$$

Where \mathcal{F} is the Fourier transform operator. According to the convolution theorem of Fourier transform, Eq. (32) can be written

$$S(\omega) = S_1(\omega)\, S_2(\omega) \qquad (33)$$

Where

$$S(\omega) = \mathcal{F}[s(x)]$$

$$S_1(\omega) = \mathcal{F}[s_1(x)]$$

$$S_2(\omega) = \mathcal{F}[s_2(x)]$$

From Eq. (28) and Eq. (33), we see that the modulation transfer function of the film alone can be found by dividing the system MTF by the lens MTF, i.e.,

$$S_2(\omega) = \frac{S(\omega)}{S_1(\omega)} \qquad (34)$$

Eq. (34) is true as long as the system is linear. If the system is nonlinear, a mathematical model which takes into account the system nonlinearity must be used.

A Nonlinear Mathematical Model for Calculating the MTF of a Photographic Film

Consider an exposure on a film plane given by

$$h(x) = 1 - M(\omega) \cos (\omega x) \qquad (35)$$

Where $\omega = 2\pi\nu$; ν is the spatial frequency of the input exposure distribution, $M(\omega)$ is the system modulation (object, camera, emulsion, and microdensitometer), and x is the distance across the emulsion. In Eq. (35) we have omitted the constant time of exposure for simplicity without losing generality; and the exposure is characterized by the illuminance distribution on the film plane.

The characteristic curve of a processed film can be represented in two ways:

1. The usual ρ-log h curve.
2. The transmittance $t(x)$ as a function of $h(x)$.
 The t–h representation is particularly useful in our present discussion.

These two ways of representing the characteristic curve are schematically shown in Fig. 9-19, for $\gamma > 0$, i.e., a negative film. We see from Fig. 9-19 that the well-known

Fig. 9-19. Two representations of the characteristic curve of a photographic emulsion.

approximation to replace the almost straight line portion of ρ-log h curve by a line with average gradient has its counterpart in the t–h plane replacing it by a hyperbola. Thus the transmittance modulation is different from the corresponding exposure modulation. We must therefore attempt to calculate the transmittance modulation and then transform it to exposure modulation.

The straight portion of the ρ-log h curve is represented by

$$\rho = \gamma(\log h - \log h_0) \qquad (36)$$

where h_0 is the inertia point exposure, which is a constant, γ is the slope of the linear portion, and ρ is the optical density of the film. The relation between the optical density ρ and the transmittance t of the film is given by

$$\rho = \log (1/t) \qquad (37)$$

From Eqs. (35), (36), and (37), we get

$$\log (1/t) = \log [(1 - M(\omega) \cos \theta)/h_0]^{\gamma}$$

or

$$t = k[1 - M(\omega) \cos \theta]^{-\gamma} \qquad (38)$$

Where $k = h_0^{\gamma}$, a constant, and $\theta = \omega x$.

Expanding Eq. (38) using the binomial theorem, we get

$$t = k \sum_{j=0}^{\infty} (\gamma)_j M^j(\omega) \cos^j \theta \qquad (39)$$

where

$$(\gamma)_0 = 1, \quad (\gamma)_1 = \gamma, \quad (\gamma)_2 = \frac{\gamma(\gamma + 1)}{2!}$$

$$(\gamma)_j = \frac{\gamma(\gamma + 1)(\gamma + 2) \cdots (\gamma + j - 1)}{j!}$$

Let $c_j = (\gamma)_j M^j$, then Eq. (39) becomes

$$t = \sum_{j=0}^{\infty} c_j \cos^j(\theta) \tag{40}$$

Now,

$$\cos^j(\theta) = (\tfrac{1}{2})^j (e^{i\theta} + e^{-i\theta})^j = (\tfrac{1}{2})^j \sum_{m=0}^{j} \binom{j}{m} e^{i(j-2m)\theta} \tag{41}$$

Using Eqs. (41) and (40), we can write the transmittance t of the film in the form

$$t = k \left(Q_0 + \sum_{j=0}^{\infty} Q_j \cos j\theta \right) \tag{42}$$

Where the Q's are infinite series of the form

$$Q_0 = 1 + \tfrac{1}{2} c_2 + \tfrac{3}{8} c_4 + \tfrac{10}{32} c_6 + \tfrac{35}{128} c_8 + \tfrac{126}{512} c_{10} + \cdots$$
$$\simeq (10^4 + 5000 (\gamma)_2 M^2 + 3750 (\gamma)_4 M^4 + 3125 (\gamma)_6 M^6$$
$$+ 2734 (\gamma)_8 M^8 + 2460 (\gamma)_{10} M^{10}) \times 10^{-4}. \tag{43}$$

$$Q_1 = c_1 + \tfrac{3}{4} c_3 + \tfrac{10}{16} c_5 + \tfrac{35}{64} c_7 + \tfrac{126}{256} c_9 + \cdots$$
$$\simeq (10^4 \times (\gamma)_1 M + 7500 (\gamma)_3 M^3 + 6250 (\gamma)_5 M^5$$
$$+ 5469 (\gamma)_7 M^7 + 4922 (\gamma)_9 M^9) \times 10^{-4}. \tag{44}$$

$$Q_2 = \tfrac{1}{2} c_2 + \tfrac{4}{8} c_4 + \tfrac{15}{32} c_6 + \tfrac{56}{128} c_8 + \tfrac{210}{512} c_{10} + \cdots$$
$$\simeq (5000 (\gamma)_2 M^2 \, 5000 (\gamma)_4 M^4 + 4688 (\gamma)_6 M^6$$
$$+ 4375 (\gamma)_8 M^8 + 4102 (\gamma)_{10} M^{10}) \times 10^{-4}. \tag{45}$$

$$Q_3 = \tfrac{1}{4} c_3 + \tfrac{5}{16} c_5 + \tfrac{21}{64} c_7 + \tfrac{84}{256} c_9 + \cdots$$
$$\simeq (2500 (\gamma)_3 M^3 + 3125 (\gamma)_5 M^5 + 3281 (\gamma)_7 M^7$$
$$+ 3281 (\gamma)_9 M^9) \times 10^{-4}. \tag{46}$$

$$Q_4 = \tfrac{1}{8} c_4 + \tfrac{6}{32} c_6 + \tfrac{28}{128} c_8 + \tfrac{120}{512} c_{10} + \cdots$$
$$\simeq (1250 (\gamma)_4 M^4 + 1877 (\gamma)_6 M^6 + 2188 (\gamma)_8 M^8$$
$$+ 2344 (\gamma)_{10} M^{10}) \times 10^{-4}. \tag{47}$$

$$Q_5 = \tfrac{1}{16} c_5 + \tfrac{7}{64} c_7 + \tfrac{36}{256} c_9 + \cdots$$
$$\simeq (625 (\gamma)_5 M^5 + 1094 (\gamma)_7 M^7$$
$$+ 1406 (\gamma)_9 M^9) \times 10^{-4}. \tag{48}$$

$$Q_6 = \tfrac{1}{32} c_6 + \tfrac{8}{128} c_8 + \tfrac{45}{512} c_{10} + \cdots$$
$$\simeq (313 (\gamma)_6 M^6 + 625 (\gamma)_8 M^8$$
$$+ 879 (\gamma)_{10} M^{10}) \times 10^{-4}. \tag{49}$$

$$Q_7 = \tfrac{1}{64} c_7 + \tfrac{9}{256} c_9 + \cdots$$
$$\simeq (156 (\gamma)_7 M^7 + 352 (\gamma)_9 M^9) \times 10^{-4}. \tag{50}$$

$$Q_8 = \tfrac{1}{128} c_8 + \tfrac{10}{512} c_{10} + \cdots$$
$$\simeq (78 (\gamma)_8 M^8 + 195 (\gamma)_{10} M^{10}) \times 10^{-4}. \tag{51}$$

$$Q_9 = \tfrac{1}{256} c_9 + \cdots \simeq 39 (\gamma)_9 M^9 \times 10^{-4}. \tag{52}$$

$$Q_{10} = \tfrac{1}{512} c_{10} + \cdots \simeq 20 (\gamma)_{10} \times 10^{-4}. \tag{53}$$

Eq. (42) gives the transmittance of a negative film which was exposed to a cosinusoidal illuminance distribution and processed. It is clear from Eq. (42) that the transmitted wave is harmonically distorted, although the incident wave was perfectly cosinusoidal. The level Q_0 is given by Eq. (43). The amplitude of the fundamental frequency is given by Eq. (44). The amplitude of the second, third, . . . , tenth harmonics are given by Eqs. (45), (46), . . . , (53), respectively. The equations for the Q-values are infinite series, which are rapidly converging to zero, since $M(\omega)$ is always less than 1.0. Thus Eqs. (43) through (53) are the required equations for calculating the transmittance distribution of most photographic films.

Now, to calculate the MTF of a photographic emulsion using the previous equations, we start by defining the modulation of the system in terms of the film transmittance. Let $M_t(\omega)$ be the transmittance modulation of the system, then

$$M_t(\omega) = \frac{t_{\max} - t_{\min}}{t_{\max} + t_{\min}} \tag{54}$$

From Eqs. (40) and (52), we get

$$M_t(\omega) = \frac{k \left(Q_0 + \sum_{j=1}^{\infty} Q_j \right) - k \left(Q_0 + \sum_{j=1}^{\infty} (-1)^j Q_j \right)}{k(Q_0 + Q_j) + k(Q_0 + (-1)^j Q_j)}$$
$$= \frac{\sum_{j=0}^{\infty} Q_{2j+1}}{\sum_{j=0}^{\infty} Q_{2j}} \tag{55}$$

Since

$$t = k h^{-\gamma}; \quad k = h_0^{\gamma} \tag{56}$$

Thus, the modulation of the system in terms of exposure is given by

$$M(\omega) = \frac{h_{\max} - h_{\min}}{h_{\max} + h_{\min}} = \frac{h_0/t_{\min}^{1/\gamma} - h_0/t_{\max}^{1/\gamma}}{h_0/t_{\min}^{1/\gamma} - h_0/t_{\max}^{1/\gamma}}$$
$$= \frac{t_{\max}^{1/\gamma} - t_{\min}^{1/\gamma}}{t_{\max}^{1/\gamma} - t_{\min}^{1/\gamma}}$$
$$= \frac{\left(Q_0 + \sum_{j=1}^{\infty} Q_j \right)^{1/\gamma} - \left(Q_0 + \sum_{j=1}^{\infty} (-1)^j Q_j \right)^{1/\gamma}}{\left(Q_0 + \sum_{j=1}^{\infty} Q_j \right)^{1/\gamma} + \left(Q_0 + \sum_{j=1}^{\infty} (-1)^j Q_j \right)^{1/\gamma}} \tag{57}$$

Eq. (57) gives the modulation of the system (camera, film, and microdensitometer). When $\gamma = 1.0$, Eq. (57) is reduced to Eq. (55). In other words, only when $\gamma = 1.0$, the transmittance modulation $M_t(\omega)$ is equal to the exposure modulation $M(\omega)$, i.e., for $\gamma = 1.0$, we have

$$M(\omega) = M_t(\omega) = \frac{\sum\limits_{j=0}^{\infty} Q_{2j+1}}{\sum\limits_{j=0}^{\infty} Q_{2j}} \tag{58}$$

To find the MTF of the film alone, we divide by the combined modulation of the test chart, camera, and microdensitometer. Let $F(\omega)$ be the MTF of the film alone, and $M_0(\omega)$ be the combined modulation of the camera, test chart, and the microdensitometer, then

$$F(\omega) = \frac{M(\omega)}{M_0(\omega)} \tag{59}$$

When a sheet of printing paper is exposed to the negative the exposures on the paper are proportional to the transmittances of the negative. As we saw earlier, the transmittances of the negative are, in general, harmonically distorted even though the input exposure is perfectly sinusoidal.

We seek the MTF of the print material as it is modulated by the negative film. Let h' be the exposure incident on the print material. Then h' is proportional to the transmittance t of the negative film. Thus

$$h' = ct \tag{60}$$

where c is a constant and t is given by Eq. (42). However, the effective exposure on the print material is given by

$$h'' = k\left[Q_0 + \sum_{j=1}^{\infty} R_j(\omega)\, Q_j \cos(j\omega x)\right] \tag{61}$$

Where $R_j(\omega)$ is the combined modulation of the printer and the print material. Thus the modulation of the system in terms of h'' is given by

$$M''(\omega) = \frac{h''_{max} - h''_{min}}{h''_{max} + h''_{min}} = \frac{\sum\limits_{j=0}^{\infty} R_{2j+1}(\omega)\, Q_{2j+1}}{\sum\limits_{j=0}^{\infty} R_{2j}(\omega)\, Q_{2j}} \tag{62}$$

Now, let t' be the equivalent transmittance of the negative material and let h' be the corresponding equivalent exposure, then

$$t' = q'h'^{-\gamma} = q''h'' \tag{63}$$

where q' and q'' are constants, and γ is the slope of the linear portion of the ρ-log h curve of the negative film. The system modulation is then given by

$$M'''(\omega) = \frac{h'_{max} - h'_{min}}{h'_{max} + h'_{min}} = \frac{h''^{1/\gamma}_{max} - h''^{1/\gamma}_{min}}{h''^{1/\gamma}_{max} + h''^{1/\gamma}_{min}}$$

$$= \frac{\left[Q_0 + \sum\limits_{j=1}^{\infty} R_j(\omega)\, Q_j\right]^{1/\gamma} - \left[Q_0 + \sum\limits_{j=1}^{\infty} (-1)^j R_j(\omega)\, Q_j\right]^{1/\gamma}}{\left[Q_0 + \sum\limits_{j=1}^{\infty} R_j(\omega)\, Q_j\right]^{1/\gamma} + \left[Q_0 + \sum\limits_{j=1}^{\infty} (-1)^j R_j(\omega)\, Q_j\right]^{1/\gamma}} \tag{64}$$

Again, in the special case, when $\gamma = 1.0$ we get

$$M''' = M'' = \frac{\sum\limits_{j=0}^{\infty} R_{2j+1}(\omega)\, Q_{2j+1}}{\sum\limits_{j=0}^{\infty} R_{2j}(\omega)\, Q_{2j}} \tag{65}$$

The MTF of the print material alone is then given by

$$F_p(\omega) = \frac{M'''(\omega)}{M_s(\omega)} \tag{66}$$

Where $M_s(\omega)$ is the combined modulation of the camera, test chart, and the microdensitometer.

EXPERIMENTAL DETERMINATION OF THE MTF OF A PHOTOGRAPHIC FILM

In the previous sections we have discussed the mathematics of the modulation transfer function of a photographic or optical system or a system composed of photographic and optical systems. In this section we shall see how one may determine the MTF experimentally.

There are many ways of determining the MTF of an optical, or photographic system.[11-18] The two most widely used methods are (1) the sinusoidal target method and (2) the edge trace method.

Determination of the MTF of a Photographic Material Using a Sinusoidal Target

Fig. 9-20 is a schematic diagram which illustrates the method of determining the MTF of a photographic material using a sinusoidal target. In the diagram the sinusoidal target together with the step tablet are imaged on the film being tested. The target may be sinusoidal in transmittance; in this case the imaging is accomplished by a high quality lens or by contact printing. The target may also be sinusoidally varying in area; in this case a camera equipped with a cylindrical lens is needed for imaging. The function of the cylindrical lens is to change the area varying target to a corresponding transmittance target. Fig. 9-21 shows the imaging system when an area-varying sinusoidal target is used. The image produced on the film under test is scanned by the microdensitometer with an effective slit width of 1 μm and length of 200 μm. The maximum and minimum exposures at each frequency are found by reflecting the maximum and minimum densities at each frequency on the ρ-log h curve as shown in Fig. 9-20. The output modula-

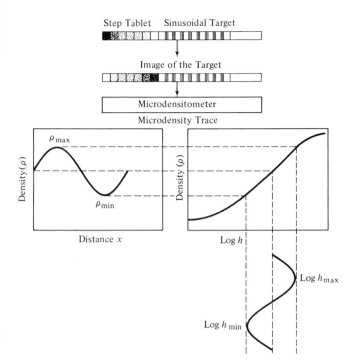

Fig. 9-20. Experimental determination of the MTF of a photographic film using a sinusoidal target.

tion is then calculated by using

$$M_i(\omega) = \frac{h_{max} - h_{min}}{h_{max} + h_{min}} \qquad (67)$$

If the input modulation at the frequency ω is $M_0(\omega)$, then the MTF, $F(\omega)$ at this frequency is given by

$$F(\omega) = \frac{M_i(\omega)}{M_0(\omega)} \qquad (68)$$

Where $M_0(\omega)$ is the combined modulation of the target, microdensitometer, and the imaging system.

Determination of the MTF of a Photographic Emulsion Using a Sharp Edge

We have seen that the modulation transfer function of a photographic silver image is the modulus of the Fourier transform of its line-spread function. Now, consider an

object in a form of a sharp edge. The illuminance distribution of such an edge is given by

$$\mathcal{E}_0(x) = \begin{cases} 1 & \text{for } x \geqslant 0 \\ 0 & \text{for } x < 0 \end{cases} \qquad (69)$$

The plot of $\mathcal{E}_0(x)$ as a function of x is shown in Fig. 9-22.

Let $s(x)$ be the line-spread function of the film under test. The image distribution of such perfect edge is then given by

$$\mathcal{E}_i(x) = \mathcal{E}_0(x) * s(x) = \int_{-\infty}^{+\infty} \mathcal{E}_0(\eta) s(x - \eta)\, d\eta$$

$$= \int_0^{\infty} s(x - \eta)\, d\eta = \int_{-\infty}^{x} s(\xi)\, d\xi \qquad (70)$$

where $\xi = x - \eta$. Eq. (70) states that the image distribution of a perfect edge, on a photographic emulsion, is the integral of the line-spread function of the emulsion. Differentiating both sides of Eq. (70) with repect to x we get

$$s(x) = \frac{d\mathcal{E}_i(x)}{dx} \qquad (71)$$

Recalling that the MTF of an optical or a photographic system is the modulus of Fourier transform of the line-spread function of the system, we then have

$$F(\omega) = A^{-1}\, |\, \mathcal{F}[s(x)]\, | = A^{-1} \left| \int_{-\infty}^{+\infty} s(x) e^{-i\omega x}\, dx \right| \qquad (72)$$

where $A = \int_{-\infty}^{+\infty} s(x)\, dx$, a constant

As we see from Eqs. (71) and (72), we can determine the MTF of a photographic emulsion using an edge analysis technique. This technique can be summarized as follows:

1. Prepare photographic edges and stepped exposures.
2. Scan the edge images and the step tablets with a microdensitometer.
3. Correct the edge data for the microdensitometer degradation.
4. Reduce the transmittance edge to exposure space.
5. Calculate the line-spread function, $s(x)$, of the emulsion by differentiating the $h(x)$ curve of the edge trace with respect to x.
6. Calculate the MTF of the film by Fourier transforming the line-spread function, $s(x)$, of the film.

Fig. 9-21. Imaging system for an area-varying sinusoidal target.

Fig. 9-22. Illuminance distribution of a sharp edge.

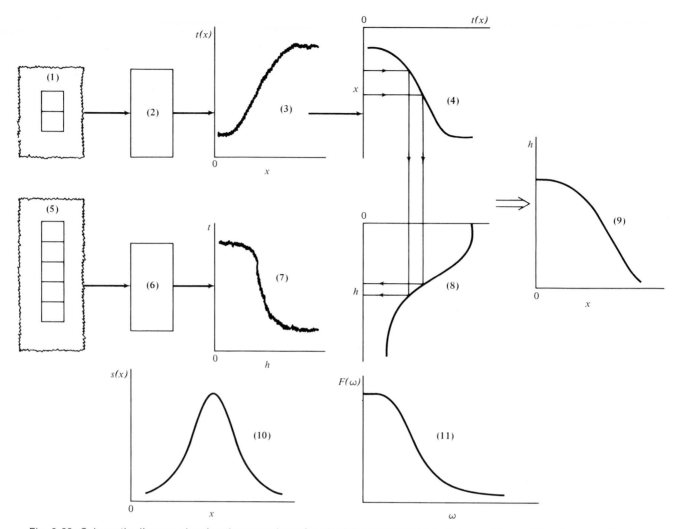

Fig. 9-23. Schematic diagram showing the procedures for obtaining the MFT of a photographic emulsion from an edge trace.

A schematic diagram showing the steps of evaluating the MTF of a photographic film is shown in Fig. 9-23.

Assuming that one can techniquely perfect steps (1) and (2), the computation procedures of the remaining steps are likely to influence the accuracy of the final result. Therefore it seems important to devote the remainder of this section to a detailed study of steps (3) through (6).

CORRECTION OF THE EDGE DATA FOR MICRODENSITOMETER DEGRADATION

The correction of the photographic edge transmittance for the microdensitometer degradation is found by obtaining the MTF of the microdensitometer under the conditions at which the photographic edge is to be scanned, then a correction function can be calculated.[19]

The procedure for obtaining the MTF of the microdensitometer is schematically shown in Fig. 9-24. As

seen in the diagram these procedures are:

1. Set up the microdensitometer with the same aperture and optics used in scanning the photographic edge image and photographic step tablet.
2. Scan a knife-edge to produce an edge trace $\mathcal{E}_i(x)$ that represents the step response of the microdensitometer.
3. The line-spread function $s_r(x)$ of the microdensitometer is found by differentiating $\mathcal{E}_i(x)$ with respect to x.
4. The MTF, $F_r(\omega)$ of the microdensitometer is then found by calculating the normalized amplitude spectrum of $s_r(x)$.

Fig. 9-25 shows a schematic diagram which illustrates how we can calculate the microdensitometer correction function, $c(x)$, from $F_r(\omega)$. As seen in Fig. 9.25, the procedure for calculating the correction function is as follows:

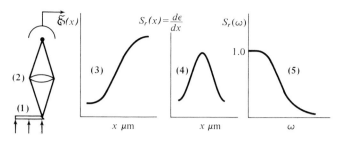

Fig. 9-24. Schematic diagram showing the steps involved in determining the microdensitometer MTF.

1. The MTF $F_r(\omega)$ of the microdensitometer is truncated at a frequency ω_m corresponding approximately to $1/10$ of $F_r(\omega)$.

2. We then calculate the reciprocal of the truncated $F_r(\omega)$, i.e. we find

$$F_c(\omega) = 1/F_r(\omega) \qquad 0 \leqslant \omega \leqslant \omega_m$$

3. Further computation with the sharply truncated function $F_c(\omega)$ will produce errors. Therefore, we must remove the sharp truncation of $F_c(\omega)$, by making it decrease gradually from approximately 10 to zero. This is accomplished by convolving $F_c(\omega)$ with an exponentially decreasing function of ω, i.e., we calculate a function $F'(\omega)$ such that

$$F'(\omega) = e^{-\omega} * S_c(\omega) = \int_{-\infty}^{+\infty} e^{-(\omega - \omega')} F_c(\omega') \, d\omega'$$

4. The correction function $c(x)$ is found by computing the inverse Fourier transform of $F'_r(\omega)$, i.e.,

$$c(x) = \mathcal{F}^{-1}[F'(\omega)] = (1/2\pi) \int_{-\infty}^{+\infty} F'(\omega) e^{i\omega x} \, d\omega \quad (73)$$

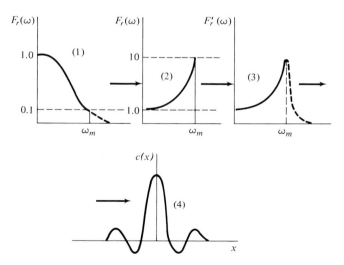

Fig. 9-25. Schematic diagram showing how the correction function, $c(x)$, due to the microdensitometer degradation can be calculated.

Once $c(x)$ is calculated, we are ready to compute the corrected edge image transmittance for the microdensitometer degradation. Let $t'(x)$ be the degraded photographic transmittance, then the actual transmittance, $t(x)$, of the photographic edge with the effect of the microdensitometer properly compensated for is obtained by convolving $c(x)$ with $t'(x)$, i.e.,

$$t(x) * c(x) = \int_{-\infty}^{\infty} t'(x - \eta) c(\eta) \, d\eta \qquad (74)$$

Now, let $h(x)$ be the exposure corresponding $t(x)$, then the line-spread function $s(x)$ is given by

$$s(x) = \frac{dh(x)}{dx} \qquad (75)$$

The MTF of the film is then given by Eq. (75), i.e.,

$$F(\omega) = A^{-1} |\mathcal{F}[s(x)]| \qquad (76)$$

where

$$A = \int_{-\infty}^{+\infty} s(x) \, dx$$

Since

$$s(x) = s'(x) * \frac{1}{c(x)}$$

Where $s'(x)$ is the line-spread function before correcting for the microdensitometer then

$$F(\omega) = A^{-1} \left| \mathcal{F}\left[s'(x) * \frac{1}{c(x)} \right] \right|$$

$$= \frac{|S'(\omega)|}{|S_r(\omega)|} \qquad (77)$$

Where $S_r(\omega)$ is the microdensitometer MTF. From equations (74) and (75), it can be seen that the convolution in the spatial domain is equivalent to dividing out by the microdensitometer MTF, $|S_r(\omega)|$.

REDUCTION OF THE TRANSMITTANCE OF THE PHOTOGRAPHIC EDGE TO THE EXPOSURE SPACE VIA THE STEPPED EXPOSURE

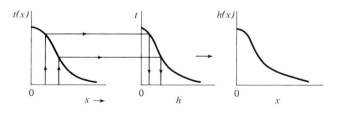

Since the line spread function of the emulsion must be expressed in terms of the exposure, or illuminance, we wish to transform the t–x curve of the edge image to an h–x curve by using the t–h curve obtained by stepped exposure.

Let us consider that we have $(n + 1)$ pairs of exposure-transmittance values:

$$(t_0, h_0), (t_1, h_1), (t_2, h_2),$$

$$\cdots (t_n, h_n) \text{ of the function } h = h(t)$$

Let h satisfy a polynomial of degree m, where $m < n$. Thus the value h_i of the function h is given by

$$h_i = a_0 + a_1 t_i + a_2 t_i^2 + \cdots + a_m t_i^m$$

$$= \sum_{j=0}^{m} a_j t_i^j \qquad (78)$$

Where the constants $a_0, a_1, a_2, \ldots, a_m$ are unknowns which are to be determined by the least squares method. According to this method we must have

$$\sum_{i=0}^{n} e_i^2 = \sum_{i=0}^{n} \left(h_i - \sum_{j=0}^{m} a_j t_i^j \right)^2 = \text{Minimum} \qquad (79)$$

By taking the partial derivative of Eq. (79) with respect to $a_0, a_1, a_2, \ldots, a_m$, respectively, we get

$$-2 \sum_{i=0}^{n} [h_i - a_j t_i^j] \, t_i^k = 0$$

Where $k = 0, 1, 2, \ldots, m$. Or

$$\sum_{i=0}^{n} h_i t_i^k = \sum_{i=0}^{n} t_i^k (a_0 + a_1 t_i + a_2 t_i^2 + \cdots + a_m t_i^m)$$

$$= a_0 \sum_{i=0}^{n} t_i^k + a_1 \sum_{i=0}^{n} t_i^{k+1} + a_2 \sum_{i=0}^{n} t_i^{k+2}$$

$$+ \cdots + a_m \sum_{i=0}^{n} t_i^{k+m} \qquad (80)$$

Now, let us set

$$u_k = \sum_{i=0}^{n} h_i t_i^k \quad \text{and} \quad v_k = \sum_{i=0}^{n} t_i^k \qquad (81)$$

in Eq. (81), we get

$$u_k = a_0 v_k + a_1 v_{k+1} + a_2 v_{k+2} + \cdots + a_m v_{k+m} \qquad (82)$$

where $k = 0, 1, 2, \ldots, m$. Eq. (82) is equivalent to the set of equations

$$
\begin{aligned}
u_0 &= a_0 v_0 + a_1 v_1 + a_2 v_2 + \cdots + a_m v_m \\
u_1 &= a_0 v_1 + a_1 v_2 + a_2 v_3 + \cdots + a_m v_{m+1} \\
&\ \ \vdots \qquad \vdots \qquad \vdots \qquad\qquad \vdots \\
u_m &= a_0 v_m + a_1 v_{m+1} + a_2 v_{m+2} + \cdots + a_m v_{2m}
\end{aligned} \qquad (83)
$$

Further, let

$$U = \begin{bmatrix} u_0 \\ u_1 \\ \cdot \\ \cdot \\ \cdot \\ u_m \end{bmatrix}, \qquad A = \begin{bmatrix} a_0 \\ a_1 \\ \cdot \\ \cdot \\ \cdot \\ a_m \end{bmatrix}$$

and

$$V = \begin{bmatrix} v_0 & v_1 & v_2 & \cdots v_m \\ v_1 & v_2 & v_3 & \cdots v_{m+1} \\ \cdot & \cdot & \cdot & \cdot \\ \cdot & \cdot & \cdot & \cdot \\ \cdot & \cdot & \cdot & \cdot \\ v_m & v_{m+1} & v_{m+2} & \cdots v_{2m} \end{bmatrix} \qquad (84)$$

Then Eqs. (83) can be written in the matrix form:

$$U = VA \qquad (85)$$

V is a square matrix whose determinant cannot be zero, and therefore must have an inverse V^{-1}. Multiplying both sides of Eq. (85) by V^{-1}, we get

$$A = V^{-1} U \qquad (86)$$

From Eq. (86), we can determine the constants a_0, a_1, \ldots, a_m and therefore we can determine the exposure as a function of the distance across the edge image.

DEVELOPMENT OF A SMOOTH LINE-SPREAD FUNCTION FROM THE NOISY EDGE EXPOSURE VALUES

The grains of the photographic emulsion are the carrier of the input illuminance. Thus the granularity of the emulsion produces modulation uncertainty, since it does not have a purely multiplicative or additive effect on the frequency content.[20,21] In other words the granularity or noise of a photographic emulsion produces a decrease or increase in the modulation at a particular frequency. We have two extremes:

1. *Low Spatial Frequency Region:* In the low spatial frequency region, the MTF is larger than the modulation uncertainty. In this case, the actual measurements lie around the true value in a roughly Gaussian distribution. Therefore, in this region, the accuracy is high and certain lack of precision exists. A certain spatial frequency region exists where the MTF is non-zero and less modulation uncertainty. In this region, the measurements gradually change from being Gaussian centered on the true value to being above the true value. This effect is a consequence of the fact that the MTF is always positive.

2. *High Spatial Frequency Region:* In the high spatial frequency region, the MTF is essentially zero, and the granularity results in positive modulation. This high frequency noise is associated with errors in the computational procedures and contains no information. Thus, in the determination of the line-spread function, it is

necessary to smooth out the high spatial frequency noise while leaving the other spatial frequency of interest unaffected. Therefore, the smoothing function in the spatial domain must correspond to a step function in the frequency domain.

The smoothing process can be accomplished either by multiplication in the frequency domain or by convolving in the spatial domain. The convolution technique is more accurate, and we will study it in greater detail.

Let $h'(x)$ and $h(x)$ be the smoothed and unsmoothed edge image exposures respectively, and $g(x)$ be the smoothing function. Then, $h'(x)$ is given by

$$h'(x) = h(x) * g(x) = \int_{-\infty}^{+\infty} h(\eta)g(x - \eta)\,d\eta \qquad (87)$$

As we said earlier, the smoothing function in the spatial domain must be such that its Fourier transform is a step function. In other words the smoothing function $g(x)$ must be such that

$$\mathcal{F}[g(x)] = \begin{cases} \pi/2\omega_c & \text{for } \omega = \omega_c \\ 0 & \text{for } \omega = \omega_c \end{cases} \qquad (88)$$

where ω_c is the spatial cut-off frequency in radians per millimeter. The function which satisfies Eq. (88) is a sinc function, i.e.,

$$g(x) = \text{sinc}\,(\omega_c x) \qquad (89)$$

According to Eq. (87), we are using the derivative of $g(x)$ rather than $g(x)$ itself, for smoothing; thus we are using the function

$$f(x) = \frac{dg(x)}{dx} = \frac{d}{dx}\,[\text{sinc}\,(\omega_c x)]$$

$$= (1/x)\,[\cos\,(\omega_c x) - \text{sinc}\,(\omega_c x)] \qquad (90)$$

for smoothing.

An improvement in the spread function computation may be made by convolving $h(x)$ with $f(x)\,e^{-x^2}$ instead of $f(x)$ alone.

As a last remark in this section; if we consider that the noise in a photographic emulsion is a random noise, then the noise spectrum increases linearly with the frequency. In this case the resulting uncertainty in the MTF of the film may be removed by the following means:

1. Reducing the noise of the edge image by scanning it with a larger effective aperture.
2. Averaging several independent MTF's.

ACUTANCE AND SHARPNESS OF A PHOTOGRAPHIC IMAGE

When an observer examines a photograph, the sharpest image is that which exactly resembles the original (except when special effects are desired). The property of a photographic material to reproduce the details of the original object with clarity may be defined as sharp-

Fig. 9-26. The illuminance distribution of a perfect edge.

ness. Now, consider a perfect edge. The illuminance distribution of such an edge is a step function as shown in Fig. 9-26. When the edge is contact printed on a photographic emulsion, and the resulting image is scanned by a microdensitometer, the image microdensity distribution may be represented by either one of the curves shown in Fig. 9-27. In Fig. 9-27, curve (1) represents a hypothetical case, where the light incident on the edge suffers no diffusion by the emulsion grains; on the other hand curve (2) represents the usual case, where the exposing light is diffused in the regions shielded by the edge. Clearly the image corresponding to curve (1) is sharper than the image which corresponds to curve (2). Therefore, from the curves of Fig. 9-27 we can see that a property of the edge trace must correlate with image sharpness. Sharpness is a subjective measure of one aspect of photographic image quality. As such it is dependent upon the individual observer and his environment. The objective quantity, based upon our understanding of the way the eye detects and evaluates sharpness, is the normalized mean square edge gradient and is called *acutance*.[22-25]

When an observer examines an image, the cones of the eye move back and forth across the edge in much the same way as fingers move back and forth across a piece of cloth when judging its roughness. The density gradient $d\rho/dx$ across this boundary becomes illuminance gradients in the image formed on the retina of the eye. The spatial illuminance gradients are converted into temperal illuminance gradients by the motion of the eye. These gradients are multiple stimuli for the cones of the eye.[26] Thus image sharpness depends on $(d\rho/dx)^2$ rather than $(d\rho/dx)$.

The method of calculating acutance is as follows: We

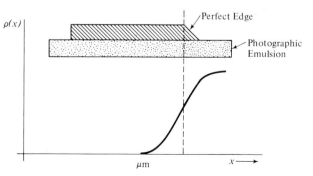

Fig. 9-27. Image distributions of a perfect edge.

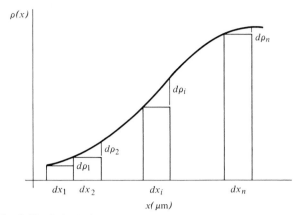

Fig. 9-28. Calculation of the acutance of a photographic emulsion.

choose two points A and B on the edge trace, as shown in Fig. 9-28, such that

$$g_A = g_B = (d\rho/dx)_A = (d\rho/dx)_B = 0.005. \qquad (91)$$

Divide the portion AB of the curve into n equal elements corresponding to dx_1, dx_2, \ldots, dx_n, and determine the density changes $d\rho_1, d\rho_2, \ldots, d\rho_n$ corresponding to these elements. Compute the average square gradient, using

$$\langle g^2 \rangle = \frac{\sum_{i=1}^{n} g_i^2}{n} \qquad (92)$$

where

$$g_i = (d\rho_i/dx_i) \qquad (93)$$

To account for the total density difference, Eq. (92) is normalized by dividing it by the density scale. Thus the acutance, A, of the photographic emulsion is given by

$$A = \langle g^2 \rangle / \rho_{AB} = \frac{\sum_{i=1}^{n} g_i^2}{n\rho_{AB}}; \rho_{AB} = \rho_B - \rho_A \qquad (94)$$

We must note that, although the distance x is measured in micrometers, the acutance is usually reported in the units "density/mm²." For this reason, the acutance obtained by Eq. (94) must be multiplied by 10^6 to conform with the way it is reported.

Equation (94) gives the acutance which correlates with sharpness for the majority of films. Since the acutance is the objective correlate of sharpness it should be measured on the final print, and its evaluation on the negative material is based on the assumption that a one-to-one correspondence exists between such an evaluation and the maximum acutance of the print.

Although the acutance has little value in evaluating the aerial image quality, Feldman and Hawkins[27] used it as a criterion for estimating lens quality.

The acutance of an emulsion can be increased, by bathing the film in a light-absorbing dye. When a monochromatic light is used, the resulting acutance varies with the absorption of light by the emulsion. In most photographic emulsions, the blue light is most strongly absorbed and the resulting acutance is higher than elsewhere in the spectrum.

SYSTEM MODULATION TRANSFER ACUTANCE (SMTA)

The acutance obtained from the edge image trace, has the fundamental disability of describing the performance of a photographic system (camera, film, etc.).[28,29] Although the spread function and its Fourier transform, i.e., the MTF, are useful techniques in evaluating the system, their use is limited by their complexity. The need for a single number, however incapable of evaluating the system completely, is very attractive to the workers in this area. A single number system which, to a certain extent, correlates with sharpness and can be used for evaluating a photo-optical system was established by Crane[30] in the decade of 1960s.

Consider a photo-optical system which consists of n elements, the nth element being necessarily a standard observer. An example of such a system is a photo-optical system consisting of the following elements:

(1) Camera, (2) Panchromatic negative material, (3) printer, (4) print material, (5) projector, (6) screen, and (7) observer.

Let the ith element of the system have a line-spread function:

$$s_i(x) = \exp(-x^2/\sigma_i^2) \qquad (95)$$

and magnification m_i. The magnification here is defined by

$$m_i = \frac{\text{Image width on the observer's retina}}{\text{Image width in the } i\text{th element}} \qquad (96)$$

The standard deviation, σ_i, in the spread function of the ith element is given by

$$\sigma_i = \frac{m_i b_i}{\sqrt{2\pi}} \qquad (97)$$

Where b_i is the area under the line-spread function $s_i(x)$. Since the Fourier transform of half of the normalized line-spread function of an optical or photographic element is the MTF of the element, thus Eq. (97) can be written in the form

$$\sigma_i = \frac{m_i}{2\sqrt{2\pi} \, a_i} \qquad (98)$$

Where a_i is the area under the MTF of the ith element, in units of mm⁻¹—the numerical value of the integrated MTF within the spatial frequency range from zero to that at which the MTF curve becomes negligible. Since the spread function is usually measured in micrometers and the frequency is measured in cycles per millimeter, we must multiply Eq. (98) by 10^3 and Eq. (96) becomes

$$\sigma_i = \frac{10^3 m_i}{2\sqrt{2\pi} \, a_i} \simeq 200 m_i/a_i \qquad (99)$$

Since the total variance of a system of n independent elements is the sum of the variances of each element, the total variance, σ^2, of our system is given by

$$\sigma^2 = \sum_{i=1}^{n} (200m_i/a_i)^2 \qquad (100)$$

According to information theory and photographic experience, a linear scale of perceptual effects may be derived from a logarithmic scale of physical quantities, thus the system modulation transfer acutance, SMTA, is given by

$$\text{SMTA} = c + d \log \left[\sum_{i=1}^{n} (200m_i/a_i)^2 \right] \qquad (101)$$

Where c and d are constants to be determined as follows: As we said earlier, the nth element is the observer. Thus from Eq. (96), $m_n = 1.0$. From the MTF data of the standard observer, $a_n = 79.62/$ mm. Therefore

$$(200m_n/a_n)^2 = 6.31 \text{ mm}^2$$

Now, for a perfect system, the area under the MTF curve of each component of the system is infinite. Thus Eq. (101), in this special case becomes:

$$\text{SMTA} = c + d \log (6.31)$$

If we put a scale of 100 for this ideal system, we get

$$100 = c + 0.8d$$

Now, let $c = 120$, then $d = -25$, and Eq. (101) can be written

$$\text{SMTA} = 120 - 25 \log \left[\sum_{i=1}^{n} (200m_i/a_i)^2 \right] \qquad (102)$$

When applying Eq. (102), the reader must be aware of the following limitations:[31, 32]

1. When motion affects picture sharpness, Eq. (102) must be modified by a term which allows for the image velocity and exposure time.

2. Eq. (102) does not allow for vibration of any element of the system. We may allow for this by obtaining the MTF curves with vibrational system.

3. Eq. (102) does not allow for the emulsion granularity. However, if no fine details are to be greatly magnified, then the granularity has only a negligible effect.

4. The effect of high contrast is not accounted for in the formula.

Finally, as was mentioned before, with this system an SMTA of 100 is graded excellent. Since we cannot detect a difference between an image which has an SMTA of 100 and one with an SMTA of 95, we cannot assign a scale which differs gradually by a number as small as 5. According to Crane,[30] a qualitative scale which differs by 10 can be reasonably established, so that:

99–90	good
89–80	fair
79–70	poor but acceptable
<70	very poor.

RESOLVING POWER OF OPTICAL AND PHOTOGRAPHIC SYSTEMS

The resolving power is the oldest single number method of evaluating the quality of an optical system, a photographic system, or both combined. The concept of resolving power was introduced about 1850 as a means of evaluating the performance of the telescope.

Consider two close point objects of equal luminance. When the two points are imaged with a lens of finite aperture, each point will be imaged as an Airy disc which is a series of dark and bright rings as shown in Fig. 9-29.

The radius, r, of the central ring is given by

$$r = 1.22\lambda f^{\#} \qquad (103)$$

where λ is the wavelength of the light incident on the lens aperture and $f^{\#} = f/d$ is the ratio of the focal length of the lens to the diameter of the lens aperture, or the f-number.

According to Rayleigh, the least distance, r, between two points at which the maximum of one pattern coincides with the first dark ring of the other and there is a clear indication of two separate maxima in the combined pattern is given by Eq. (103) and is taken as a measure of the lens performance. This is illustrated in Fig. 9-30.

Thus Eq. (103) gives the limit of the lens resolution. Therefore one may define the resolution of an optical or photographic system as the ability of the system to distinguish between two adjacent but different points. This is an important property of both optical systems and photographic materials, particularly in certain specialized applications of photography. As such it is *one* measure of the performance of an optical system or a photographic emulsion. It is not a complete measure of performance, however, and does not correlate very well with image sharpness. It can be shown easily that images with high resolution may not appear as sharp to the eye as those with lower resolution.[33-35] Resolving power remains useful in practice, however, as a simple means of indicating, in general terms, the performance of a photo-optical system.

Many different types of charts have been used for the measurement of resolving power; all, however, consist basically of a periodic structure of dark and light areas or bar charts. In testing optical systems, or photographic materials, a dark and a clear area constitute a cycle (not a line); while in television testing a dark *or* a clear area is called a line. If the target has a bar-to-space ratio of 1:1, the cycle corresponds to two lines.

The ratio of the luminance of the dark to the clear areas (the contrast ratio) is an important factor in the measurement of the resolving power as it varies with the contrast ratio. The ANSI standard includes two contrast ratios: (1) low contrast, with a ratio of 1:1.6 and (2) high contrast with a ratio of $1:10^2$.[35, 36]

The width of the dark and clear areas with respect to each other is important also; in most targets the ratio is

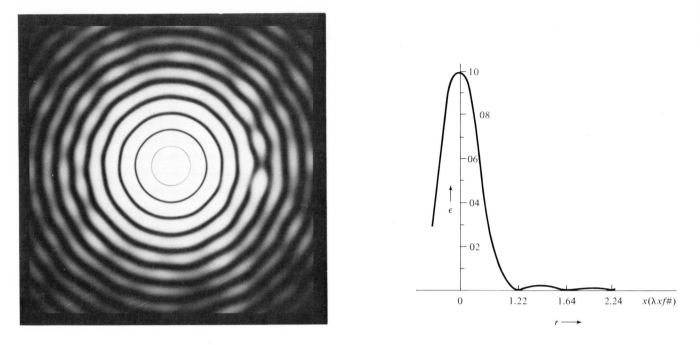

Fig. 9-29. Image of a point object.

1:1; i.e., the dark and the clear areas are the same width.[37,38]

As the width of the line spread function is proportional to the wavelength of the exposing illumination, the resolving power of a photographic material will depend upon the spectral energy characteristics of the radiation used as an illuminant.[39] Thus, if the measurements are to be applicable to practice, the light source used should correspond to practical usage.

IMAGING SYSTEM

The imaging system is usually a specially-constructed, precision-built camera which images the target at its

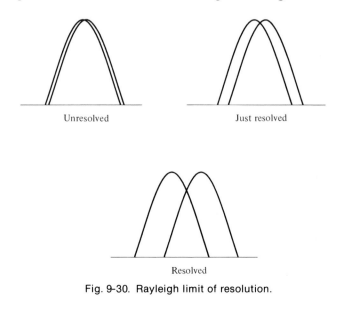

Fig. 9-30. Rayleigh limit of resolution.

back focal plane.[40] If the image is observed by the eye, the visual resolving power is measured; if a photographic record is made by placing a photographic emulsion in the image plane, the measurement includes both the resolving power of the optical system used to image the target and the emulsion and is usually termed the *photographic resolving power*. Ordinarily the resolving power is stated in terms of the image plane but in aerial photography the resolving power is usually given as the resolving power on the ground from a given altitude (*ground resolving power*). The angular resolving power is also of considerable interest in aerial photography.

In testing photographic emulsions, highly-corrected telescope or microscopic objectives are used[41] at an aperture which will give the optimum optical resolving power. The resolving power of the optical system should be as high as possible; at least twice that of the photographic emulsion. This is not difficult with the rapid emulsions used by amateur and professional photographers but becomes very difficult with certain high resolution emulsions for scientific applications.

Obviously if the film or plate is not in the plane at which the objective produces its sharpest image, the resolving power will be reduced. Flare in the optical system due to the reflection of light from the glass to air surfaces of the lens, from the lens mount or from inside the camera, all tend to reduce the resolving power and must be kept as low as possible.

In reading the image of test charts to determine the resolving power, well-corrected microscopic objectives are used. The magnification should approximate the resolving power expressed as cycles per millimeter. The ANSI standard[35] specifies a magnification of 0.5 to 1.0, the resolving power and a numerical aperture of not less than 0.001 times the resolving power.

Determinations of the resolving power from the image on the film or plate require experience in reading the image and may vary considerably with different observers.

RESOLVING POWER OF AN OPTICAL SYSTEM

The resolving power of an optical system is its ability to resolve fine details distinguishably. Thus, if a three bar target is imaged by an optical system and the finest pattern that can be seen resolved in the image plane is found to have a width ℓ, i.e., the distance between a bar and a space that can be seen just resolved is ℓ, then the optical or visual resolving power of the system is given by

$$R_0 = 1/\ell \text{ cycles/mm} \qquad (104)$$

ℓ_{ab} is measured in mm.

Resolving Power of a Photographic Emulsion

The resolving power of a photographic material is its ability to record fine details distinguishably. This definition implies that the emulsion resolving power is its limit of detectability of a signal such as the minimum separation between two square pulses in the image with no regard to deterioration of the contrast rendition. However, when the contrast rendition is specified, it will serve in the definition of the film resolving power. Thus if ℓ' mm is the smallest distance between a pulse and a space of the smallest image that can be seen under a microscope, then the photographic resolving power, R, is given by

$$R = 1/\ell' \text{ cycles/mm} \qquad (105)$$

Equation (105) gives the combined resolving power of the film and the optical system which images the target onto the film plane. The resolving power of the emulsion can be calculated from the empirical formula

$$1/R^n = 1/R_o^n + 1/R_e^n \qquad (106)$$

Where $n = 1.0$, 1.8, or 2.0. R_o and R_e are the resolving powers of the optical and the emulsion respectively. Eq. (106) is purely experimental and has no theoretical basis.

When a camera lens is at a height h from a resolving power target (see Fig. 9-31), and the finest pattern is seen to have a separation ℓ mm, then the resolving power in the image plane is given by Eq. (104), i.e.

$$R_0 = 1/\ell$$

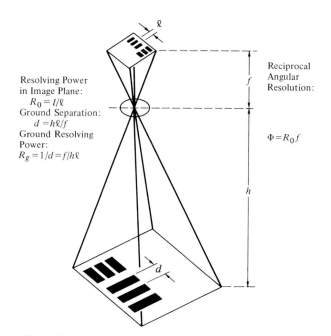

Resolving Power in Image Plane: $R_0 = 1/\ell$
Ground Separation: $d = h\ell/f$
Ground Resolving Power: $R_g = 1/d = f/h\ell$

Reciprocal Angular Resolution:

$\Phi = R_0 f$

Fig. 9-31. Ground resolving power and angular resolution.

and the ground separation, d, is given by

$$d = h\ell/f \qquad (107)$$

where f is the equivalent focal length of the camera lens. Thus the ground resolving power, R_g, is given by

$$R_g = 1/d = 1/(h\ell/f) = f/h\ell \qquad (108)$$

and the reciprocal angular resolution is

$$\phi = R_o f \qquad (109)$$

Factors Affecting the Resolving Power of a Photographic Material

Aside from the factors already discussed, namely the target, the optical system, flare, and focusing of the image, the resolving power of a photo-optical system is affected by (1) the emulsion, (2) the exposure, (3) processing conditions and, in aerial photography, by (1) atmospheric contamination and turbulence and (2) image motion.

The resolving power at either the optimum density, or a given density, varies inversely with the average grain size[42] and for a given amount of silver halide in milligrams of silver per square decimeter the resolving power increases as the amount of gelatin and the thickness of the coating are reduced.[43] Emulsions containing a high concentration of silver halide are highly turbid and scatter light more than those with a low concentration of silver halide. Typical line spread functions for emulsions of high and low turbidity are shown in Fig. 9-32. When two bars of the target at a distance ℓ apart are imaged by the emulsion, the distribution of the image in the two emulsions is as shown in Fig. 9-33. The resolving power is less as the scattering of light by the

Fig. 9-32. Line spread functions of two different emulsions. The curve in (a) represents turbid emulsion and relatively high absorption. The curve in (b) represents a slightly turbid emulsion for small scattering angles but highly turbid at large angles.

emulsion increases. In addition to the scattering of light in the emulsion, the resolving power can be affected by light reflected back into the emulsion from the back of the film base (*halation*) or from a camera pressure plate, or film holder, which reflects light. Most films have a light absorbing dye in the coating on the rear surface of the film base (*antihalation backing*), or in the film base itself (*gray base*), to reduce the effect of reflected light from the rear.

The resolving power can be improved, usually at the expense of emulsion speed, by the addition of a dye to the emulsion to reduce the effect of light scattering; for emulsions not optically sensitized a yellow dye is used.

The resolving power of a photographic emulsion increases with the exposure at first as the number of developed grains in the exposed areas increases up to a maximum and then decreases as the number of developed grains in the clear spaces increase. For high resolving power the emulsion must be able to produce lines of good density before the clear spaces begin to fill in. In general, this means emulsions with a high gamma and a short toe.

Huse, in 1917,[44] found a variation in resolving power with different developers but most workers since that time have found only small variations. Perrin and Altman,[45] however, did find that some fine-grain de-

Fig. 9-33. The images of parallel bars separated by distance $l = 1/R$, where R is the resolving power of the emulsion, as imaged by the two different emulsions represented by Fig. 9-32. Curve (a') indicates that the emulsion has low resolving power. Curve (b') indicates that the emulsion (b) has higher resolving power. It should be noted that emulsion (b) will give less sharp image than emulsion (a) because the large scattering at large angles. This indicates that sharpness and resolving power of emulsions do not necessarily correlate.

velopers gave somewhat higher values but this was not a characteristic of fine grain developers as a group for some produced images of lower acutance and resolving power.

The time of development has been found to have little effect except in the early stages of development when the density of the developed image is low. Strains in the gelatin produced by abnormally high temperatures in processing or drying and abrupt changes in temperature of the processing solutions have been found to reduce the resolving power appreciably.

Intensification increases the density of the image and usually the resolving power but those intensifiers which increase the lower densities more than the high may reduce the resolving power. Reduction, which decreases the density of the image, depends upon the method of reduction. Reducing solutions, such as ferricyanide-hypo, which act principally on the surface tend to reduce resolving power while reducers which lower contrast, such as ammonium persulfate, have little effect.[46, 47]

Few studies appear to have been made on the resolving power of either prints on paper or transparencies. Vifanski and Gorokhovski[48] found that the resolving power of the print shows little change with the contrast grade of paper. The situation depends, of course, on the method of printing. In contact printing the conditions are similar, but not identical, to those in printing from a sharp edge. In projection printing the optical performance of the system is an obvious factor of importance.

Resolving Power in Aerial Photography

Aside from the factors that have been discussed, the resolving power of the image in aerial photography is affected by (1) atmospheric contamination and (2) image motion. Atmospheric contamination is caused by dust and water in the atmosphere which, by lowering image contrast, reduces the resolving power of the photographic image. The effect of atmospheric contamination can be reduced by the use of panchromatic emulsions with yellow or orange filters or infra red emulsions with appropriate filters, as it is less in the long wave region from 700–900 nm. Turbulence in the atmosphere is greater in oblique than in vertical photography and increases with the altitude. Atmospheric turbulence causes image motion which can be minimized by using the shortest practical exposure time.[49]

To discuss the effect of image motion in aerial photography on resolving power, it is necessary to examine the relationship between the MTF of an emulsion and its resolving power.[50]

The usual mathematical model for the MTF of a photographic emulsion is given by

$$F_e(\omega) = \frac{1}{1 + (\omega/\alpha)^2} \tag{110}$$

Where ω is the frequency in radians per millimeter. The relationship between ω and the spatial frequency

ν in cycles per millimeter is $\omega = 2\pi\nu$. The constant α is a parameter which describes the scattering properties of the emulsion. Eq. (110) gives the MTF of a stationary emulsion. From Eq. (110) we see that, as the frequency increases $F_e(\omega)$ decreases until a certain limiting value F_{elim} is reached where the details in the image is no longer distinguishable. This limiting value corresponds to a frequency $R_e = \omega/2\pi$, which is the resolving power of the emulsion. At this limit of detectability, Eq. (110) yields

$$F_{\text{elim}} = \frac{1}{1 + (2\pi R_e/\alpha)^2} \qquad (111)$$

Solving Eq. (111) for R_e^2, we get

$$R_e^2 = (\alpha/2\pi)^2 \, (1 - F_{\text{elim}}) \qquad (112)$$

Let us assume a linear motion in the image so that a displacement d takes place in the image. The MTF of the emulsion when the image motion exists is then given by

$$F(\omega) = F_e(\omega) \, T(\omega) = \frac{T(\omega)}{1 + (\omega/\alpha)^2} \qquad (113)$$

Where $T(\omega)$ is the frequency response due to the linear motion alone. It can be shown that $T(\omega)$ is given by

$$T(\omega) = \text{sinc} \, (\omega d/2) \qquad (114)$$

We must note that when $T(\omega) = 1.0$, Eq. (113) is reduced to Eq. (110) which corresponds to a stationary emulsion. If no structure is detectable in the image, then $T(\omega) = 0$. In this case $\omega = 2\pi R_m$, where R_m is the resolution due to the image motion only. Thus if no structure is detectable Eq. (114) becomes

$$\text{sinc} \, (\pi R_m d) = 0 \qquad (115)$$

Hence $\pi R_m d = \pi$ or

$$R_m = 1/d \qquad (116)$$

Let R be the resolving power of the film when the image moves linearly, then we can calculate R in terms of α, d, and F_{elim} as follows:

$$\frac{1}{R^2} = \frac{1}{R_m^2} + \frac{1}{R_e^2} = d^2 + \frac{4\pi^2}{\alpha^2(1 - F_{\text{elim}})}$$

Or

$$R^2 = \frac{R_e^2}{1 + (d\alpha/2\pi)^2(1 - F_{\text{elim}})} \qquad (117)$$

From Eq. (117) we see that

1. If $d = 0$, (no motion takes place) then $R = R_e$
2. If d is larger than zero, the resolving power decreases. To see the order of magnitude of reduction in R, assume that $d = 2$ mm; $\alpha = O(100 \; \mu\text{m}^{-1})$, $F_{\text{elim}} = O(0.1)$, then $R/R_e = O(.999)$.*

*O means of order of.

Similarly, if vibration or any other random motion in the image takes place, the film resolving power will decrease.

Spurious Resolution

Let $t(x)$ be a sinusoidal function which represents the one dimensional transmittance distribution of a test-object. Let us assume that the object is imaged by a photo-optical system which has a line-spread function $s(x)$ defined by:

$$s(x) = \begin{cases} 1 & \text{for } |x| < b/2 \\ 0 & \text{for } |x| > b/2 \end{cases} \qquad (118)$$

Eq. (118) represents a unit step line-spread function as shown in Fig. 9-34.

The OTF of the system is then given by

$$F(\omega) = \frac{1}{b} \int_{-\infty}^{+\infty} s(x) \, e^{-i\omega x} \, dx = \frac{1}{b} \int_{-b/2}^{+b/2} e^{-i\omega x} \, dx$$

$$= \text{sinc} \, (\omega b/2) \qquad (119)$$

where $\text{sinc}(\omega b/2) = \sin(\omega b/2)/(\omega b/2)$, and $\omega = 2\pi\nu$ is the spatial frequency in radians per millimeter (ν is the spatial frequency in cycles per millimeter). The OTF, $F(\omega)$ of the system is as shown in Fig. 9-34.

As seen in Fig. 9-35, the OTF of the system has negative values. The negative values of $F(\omega)$ implies that the lines and spaces in the image and those in the object are in opposite phase, so the lines in the object appear where the spaces should be and vice versa. Thus the negative portion of the sinc function represents psuedo-resolution or *spurious resolution*.[51] It should be noted that curve $F(\omega)$ represents only the part of the illuminance distribution of the image that varies. Since there is a constant illuminance superimposed on the varying illuminance, frequencies at which $F(\omega) = D$ (D is a constant) have a uniform density greater than zero.

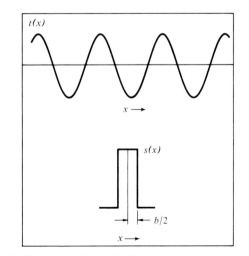

Fig. 9-34. Sinusoidal object distribution and the spread function of the imaging system.

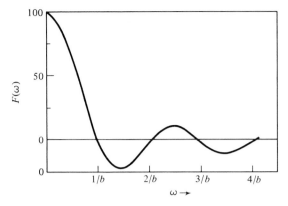

Fig. 9-35. The OTF of the system, Negative values of $F(\omega)$ represent spurious resolution.

(a)

(b)

Fig. 9-36. Prints made from a hexagonal resolving power target.

Spurious resolution can be seen by comparing the two prints of the hexagonal Schumann* target shown in Fig. 9-36. Fig. 9-36 (a) represents a print made from the target when the lens is at its best focus, while (b) is a print made when the lens is slightly out of focus. In this we can see that some lines of high frequency are resolved but lines of smaller frequency are not.

It is well known that the line spread function of many photographic materials is given by

$$s(x) = e^{-\alpha|x|}$$

Where α is a constant representing the scattering properties of the emulsion. Thus the OTF, $F_e(\omega)$ of the emulsion is given by

$$F_e(\omega) = \frac{\displaystyle\int_0^\infty e^{-\alpha x} \cos(\omega x)\, dx}{\displaystyle\int_0^\infty e^{-\alpha x}\, dx} = \frac{\alpha^2}{\omega^2 + \alpha^2} \quad (120)$$

From Eq. (120) we can see that the maximum OTF of the photographic emulsion is at $\omega = 0$, and decreases by ω^{-2} as ω increases. Thus $F(\omega)$ decreases asymptotically to zero as ω goes to infinity, as shown in Fig. 9-37. We can see from Fig. 9-37 and Eq. (120) that photographic emulsions are not responsible for spurious resolution. Therefore pseudoresolution is a phenomenon associated with the optical system. In general whenever the line-spread function of the optical system has a flat top, spurious resolution takes place.

RELATIONSHIP BETWEEN RESOLVING POWER AND INFORMATION CAPACITY OF PHOTOGRAPHIC MATERIALS

The use of information theory concepts is not new to the field of communication. One example of the application of information theory in photography is the study of the relationship between resolving power and the information capacity of photographic materials.

*G. Schumann, Rochester Institute of Technology.

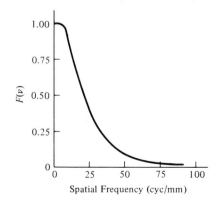

Fig. 9-37. A typical OTF curve for a photographic emulsion.

A bit of information in photography is stored as a dark or clear area on the emulsion. Thus the information capacity, c, of a photographic emulsion can be defined by

$$c = 1/a \text{ bits/mm}^2 \qquad (121)$$

where a is the smallest area in square millimeters that can be recognized as black or clear, provided that these two cases are equally probable.

In general, the information i associated with a message is defined by

$$i = \log_2 (n) \qquad (122)$$

Where n is the number of equally probable messages from which a particular message is chosen. For example, the number of equally probable messages in the arabic numerals is 10. The information associated with a randomly selected single numeral is

$$i = \log_2 (10)$$

Since $\log_2(N) = \log_{10}(N)/\log_{10}(2)$

$$i = \log_2 (10) = 1/0.301 = 3.322 \text{ bits} \qquad (123)$$

Eq. (123) is valid only for arabic numerals. Now, if the numerals can be stored as bits, then Eq. (123) predicts that the numeral requires 3.322 times as large as the smallest area that can be recognized as black or clear. If the small area and a numeral are both square, then the latter must have a dimension equal to $\sqrt{3.322}$ or 1.823 times the dimension of the square. Let us now assume that the recognition distance for an image is proportional to its size and the square and the numeral are enclosed by equal areas, then the square can be first resolved 1.823 further away.

Now, consider a high contrast bar target, at the optimum limit of resolution. This implies that, when the bars are just resolved, the photographic emulsion will have a resolving power R cycles/mm. We then superpose on this target a transparency of identical bands in such a way that the bands in the two targets are perpendicular. Then the original transparent bands become squares of alternate black and clear areas, each of size $1/2R$, as shown in Fig. 9-38. Since the eye can only average densities along a long band, these squares cannot be resolved because the averaging process is lost. According to McCamy,[52] for the squares to be resolved they must be twice as long on a side. Thus the smallest area that can be resolved must be

$$a = \left(2 \times \frac{1}{2R}\right)^2 = 1/R^2$$

and the information capacity of a photographic material is given by

$$c = 1/a = R^2 \qquad (124)$$

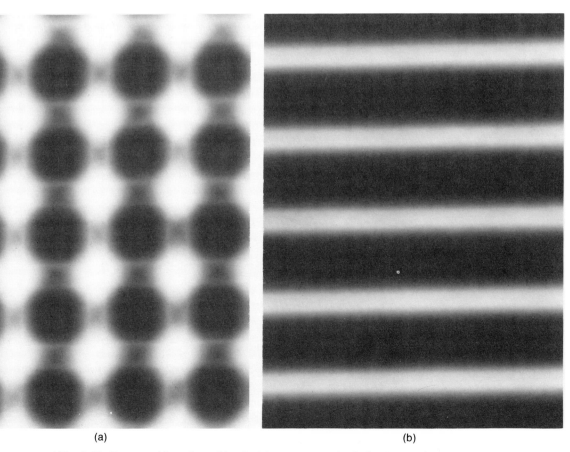

(a) (b)

Fig. 9-38. Superposition of two identical bar targets at the limit of resolution.

Since the units of R is usually cycles per millimeter, then the units of c are bits per square millimeter. Eq. (124) was established by McCamy and verified by Altman and Zweig[53] who considered the point spread-function of the image to be the smallest area for the storage of information. They determined the information capacity by reducing a target which consists of circles, squares, bars and letters to the limit of the emulsion capacity. However, Riesenfeld[54] showed experimentally that the information capacity of a photographic emulsion is given by

$$c \geqq R^2/2 \qquad (125)$$

The $>$ sign in Eq. 125 implies that c is slightly larger than $R^2/2$, if the emulsion has extremely fine grain. The technique he used is based on the assumption that the recognition of an image is proportional to its size, and can be summarized as follows:

1. A 3.5×4.0 in. alpha-numeric target, shown in Fig. 9-39, is viewed through a transparency illuminator.
2. The target is viewed at 14 ft from the illuminator, when all but the finest row is covered. The observer moves closer until he can identify each pattern. If at

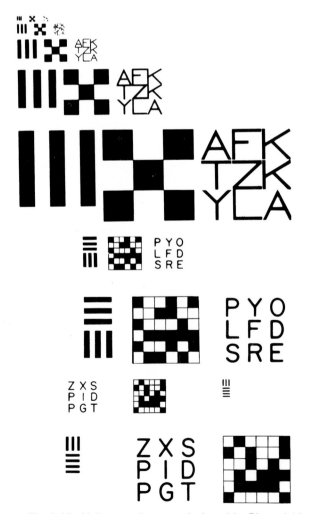

Fig. 9-39. Alphanumeric target designed by Riesenfeld.

7 ft from the illuminator the observer cannot identify a top pattern, a second pattern is uncovered and the process is repeated from a distance of 14 ft again, until the observer can identify the remaining patterns.

GRAININESS OF PHOTOGRAPHIC EMULSIONS

If a physical measurement is free from noise, one may recognize two neighboring signals indefinitely. However every true physical measurement is associated with noise. The noise in a uniformly exposed and uniformly processed film is mainly due to the random fluctuations generated by the irregular structure of the developed silver grains. Photographic noise is a physical quantity called granularity and graininess is its subjective correlate. Thus the graininess of a photographic emulsion may be defined as the subjective sensation of the inhomogeneity of the image seen by an observer.

When an observer looks at an enlarged image of a uniformly exposed and processed film sample from a distance, the image will appear uniform. This may result from the way in which the cones of the human eye detect graininess, i.e., as the eye moves back and forth scanning the sample with cones having a diameter of 1.5 μm, the temporal illuminance gradients of the surface of the cones, resulting from the spatial density gradients of the sample, are indistinguishable. But when the photograph is enlarged and the enlarged photograph is viewed closely, the sensation of graininess occurs.[55] Graininess in the silver image is due to the random grain distribution of the developed silver in a plane parallel to the image surface as well as perpendicular to it. The grain distribution of a uniformly exposed and processed enlarged microimage is shown in Fig. 9-40.

As graininess is subjective, it depends not only on the inhomogeneity of the silver deposit but on the properties of the human eye, the conditions under which the subject is examined and human psychology.

Since graininess is important in many applications of photography where enlargements of photographic images are employed, the literature on graininess is extensive. An important part of that literature is concerned with methods for the measurement of graininess.*

When prints are used, projection equipment of high precision and accurate focusing are essential. Matched negative densities must be used and the enlargements made on the same positive material, exposed and processed uniformly to the same overall density. Unless these conditions are rigorously met any interpretation of the results is subject to error.

A visual comparison of the two prints, under the same viewing conditions, provides a qualitative indication of any difference in graininess. A quantitative measure of the difference may be obtained by mak-

*The most convenient reference is C. E. K. Mees, *The Theory of the Photographic Process*, 2nd Ed., Chapt. 24, "The Structure of the Photographic Image," Macmillan, New York, 1954 (Chapt. 23 in the 3rd Ed.).

(a)

(b)

Fig. 9-40. Grain distribution of enlarged microimage. (a) Vertical cross-section. (b) Horizontal cross-section.

ing a series of enlargements at different degrees of magnification and selecting from the series the degree of magnification required for the first visible graininess. This clearly is a laborious process and one which is meaningless unless all the prints match. A simpler procedure is to make two matched prints, at a magnification which will result in graininess in both, and de-

termine, by visual examination, the viewing distance at which the graininess of the image disappears.

While such tests may be useful to the photographer, they lack the precision necessary for laboratory studies of graininess. In the *blending* method of Jones and Higgins[56] and Lowry[57] specially designed equipment is used to examine the negative density on a translucent screen at a distance of 2 m. The magnification is changed, the illumination being kept constant, until the granular structure of the image disappears. The linear magnification of the image under these conditions is called the *blending magnification,* m_b.

The usual procedure is to use a sensitometric strip and determine the blending magnification for each density. The graininess is expressed as 1000/(the blending magnification). The values for graininess obtained in this manner are then plotted against density to produce a curve of the type shown in Fig. 9-41, which represents three well-known 35mm films. To represent the graininess of an emulsion by a single number, a density of 0.8 is generally used. Graininess increases in the early stages of development as the number of developing grains increase. A maximum is reached at a density of 0.3 and 0.5 and then slowly declines as more and more of the developing grains complete development.[58]

This method of measuring graininess has a number of disadvantages. Aside from the specialized equipment required, it is slow, tedious, and subject to high subjective errors.[59] Hence there is effort to replace it with an objective method based on the determination of graininess from the granularity.

GRANULARITY OF PHOTOGRAPHIC EMULSIONS

Although the blending magnification method can be used as a subjective method for evaluating the graini-

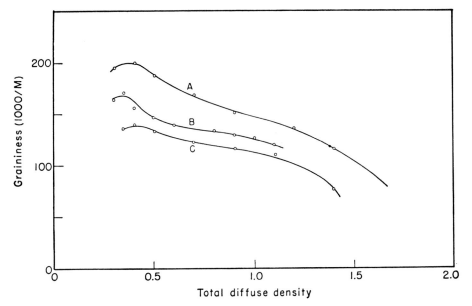

Fig. 9-41. Graininess (in terms of reciprocal of blending magnification M) curves of three common 35mm films. The speeds diminish from film *A* to film *C*.

ness of a photographic image, the need for an objective method is obvious. Physical methods are always characterized by reduction of variability and the capability of handling a large volume of samples in a short period of time.

As we said earlier, random fluctuations in the distribution of the particles of silver in the image results in random fluctuations in optical density ρ or transmittance, t, of a uniformly exposed and processed film. These fluctuations are the photographic noise or the *granularity* of the image. Image granularity and resolving power (band width) limitations must be included in order to render a finite information capacity in bits per square millimeter.

When a uniformly exposed and processed sample is scanned by a microdensitometer with a suitable circular effective aperture (50 μm in diameter, for example, the

fluctuation in density $\rho(x)$ as a function of the distance x across the sample is shown in the lower part of Fig. 9-42. If density readings are taken from the trace at periodic intervals separated by at least the diameter of the scanning aperture, the frequency distribution of such density values around the mean density $\bar{\rho}$ will be, for all practical purposes, Gaussian. This is shown in the upper part of Fig. 9-42, where the solid curve represents the experimental values and the broken curve is the theoretical Gaussian distribution. This result indicates that the probability density function $P(\rho) \, d\rho$ that the optical density of a uniformly exposed and processed photographic material lies between ρ and $\rho + d\rho$ is given by

$$p(\rho) \, d\rho = \frac{1}{\sigma(\rho)\sqrt{2\pi}} \mathrm{Exp} \left[\frac{-(\rho - \bar{\rho})^2}{2\sigma^2(\rho)} \right] d\rho \qquad (126)$$

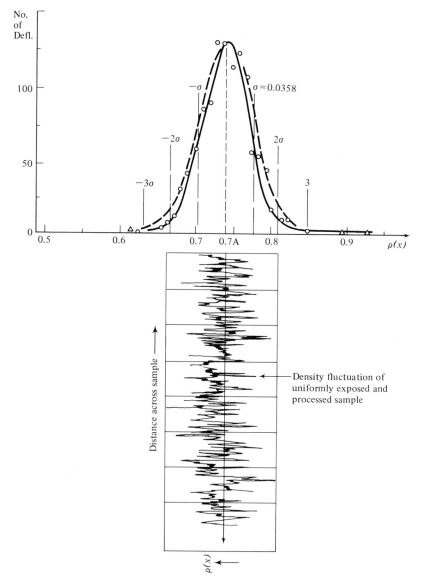

Fig. 9-42. Microdensitometer trace of a uniformly exposed and processed film sample (on the right) and its frequency distribution (solid curve on the left).

Where $\sigma(\rho)$ is the standard deviation in density and ρ is the average density. Thus the distribution function of the optical density ρ is given by

$$p(\rho) = \int_{-\infty}^{\rho} p(\rho') \, d\rho' \qquad (127)$$

So that the average density $\bar{\rho}$ is given by

$$\bar{\rho} = \frac{\int_{-\infty}^{+\infty} \rho p(\rho) \, d\rho}{\int_{-\infty}^{\infty} p(\rho) \, d\rho} \qquad (128)$$

and the variance $\sigma^2(\rho)$ in density is given by

$$\sigma^2(\rho) = \langle (\rho - \bar{\rho})^2 \rangle = \frac{\int_{-\infty}^{\infty} (\rho - \bar{\rho})^2 \, p(\rho) \, d\rho}{\int_{-\infty}^{\infty} p(\rho) \, d\rho} \qquad (129)$$

For discrete values of ρ, as in this case, $\bar{\rho}$ and $\sigma(\rho)$ are given by

$$\bar{\rho} = \frac{\sum_{i=1}^{\infty} \rho_i}{n} \qquad (130)$$

Where n is the number of density readings at equal distances across the film sample and

$$\sigma(\rho) = \sqrt{\frac{\sum_{i=1}^{\infty} (\rho_i - \bar{\rho})^2}{n-1}} \qquad (131)$$

On the assumption, obtained from experimental evidence, that the variation in the optical density of a uniformly exposed and processed silver image is Gaussian, mathematical models for the correlation of granularity and graininess were developed by Selwyn,[60] Van Kreveld,[61] Goetz and Gould,[62] and by Jones, Higgins and Stultz.[63]

The Van Kreveld equation for granularity is defined in terms of the transmittance of the film sample and is given by

$$g_k = \langle (t_1 - t_2) \rangle \qquad (132)$$

Where t_1 is the transmittance of area 1, and t_2 is the transmittance of adjacent area 2. The two areas 1 and 2 are equal, as shown below.

Fig. 9-43. Microdensitometer trace of a film sample.

Goetz and Gould Granularity

Goetz and Gould defined granularity as

$$g_g = 10^3 / \sqrt{2} \, \sigma(t) \qquad (133)$$

Where $\sigma(t)$ is the transmittance standard deviation of a uniformly exposed and processed film sample. $\sigma(t)$ is calculated from the $t(x) - x$ microdensitometer trace of the film sample such as shown in Fig, 9-43, by using the following equation

$$\sigma(t) = \langle (t - \bar{t})^2 \rangle = \sqrt{\frac{\sum_{i=1}^{n} (t_i - \bar{t})^2}{n-1}} \qquad (134)$$

Notice that g_g in Eq. (133) is independent of the area of the scanning aperture, contrary to what we shall see later when we discuss Selwyn granularity.

Selwyn Granularity

Let us assume that the grain distribution of a uniformly exposed and processed film can be approximated by an opaque and clear area located in the squares of a regular checkerboard matrix, as shown in Fig. 9-44. Let us assume that a section of the checkerboard is covered by a square aperture of area $a = \ell^2$, (ℓ is the length of a side). Let the section contain n squares, α of which are clear and β of which are opaque. Let each grain (square) have an area $r = b^2$ (b is the length of a side). Now, the probability of choosing a clear area from the large ensemble is given by

$$p = \alpha/n = \bar{t}$$

where t is the average transmittance. The total number of the squares in the area a is given by

$$n = a/r = t^2/b^2 = \alpha + \beta \qquad (135)$$

The probability that α squares out of the total n squares are clear is given by

$$p_n(\alpha) = \binom{n}{\alpha} p^\alpha q^{n-\alpha} \qquad (136)$$

Where $p = \bar{t}$ and $q = (1 - p) = (1 - \bar{t})$. For large n, we have

$$\bar{\alpha} = \sum_{\alpha=0}^{n} \alpha p_n(\alpha) = pn = \bar{t}n \qquad (137)$$

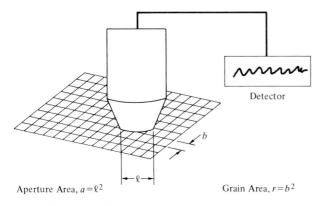

Aperture Area, $a = \ell^2$ Grain Area, $r = b^2$

Fig. 9-44. Checkerboard model of granularity.

and

$$\sigma^2(\alpha) = \langle (\alpha - \bar{\alpha})^2 \rangle = \langle \alpha^2 \rangle - \langle \alpha \rangle^2 = pqn = \bar{t}(1 - \bar{t})n$$

now

$$\sigma^2(t) = \langle (t - \bar{t})^2 \rangle = \langle t^2 \rangle - \langle t \rangle^2 = \sigma^2(\alpha)/n^2 \quad (138)$$

From Eqs. (137) and (138), we get

$$\sigma^2(t) = \frac{\bar{t}(1 - \bar{t})n}{n^2} = \frac{r\bar{t}(1 - \bar{t})}{a}$$

or

$$\sqrt{a}\,\sigma(t) = \sqrt{r\bar{t}(1 - \bar{t})} = \text{constant} \quad (139)$$

It can easily be shown that, the relationship between the standard deviation in density and that in transmittance is given by

$$\sigma(\rho) = 0.4343\,\frac{\sigma(t)}{\bar{t}}\left[1 + 3\left\{\frac{\sigma(t)}{\bar{t}}\right\}^2 + \frac{81}{5}\left\{\frac{\sigma(t)}{\bar{t}}\right\}^4 + \cdots\right] \quad (140)$$

When $\sigma(t) \ll 1$, then

$$\sigma(\rho) = 0.4343\,\sigma(t)/\bar{t} = 0.4343\,\frac{\sqrt{r\bar{t}(1 - \bar{t})}}{\sqrt{a}\,\bar{t}}$$

$$= \frac{0.4343}{\sqrt{a}}\,\sqrt{r(1/\bar{t} - 1)}$$

or

$$\sigma(\rho)\sqrt{a} = 0.4343\,\sqrt{r(1/\bar{t} - 1)} \quad (141)$$

Since

$$\rho = \log(1/t) = 0.4343\,\ln(1/t)$$

Then

$$1/t = e^{2.303\rho} = 1 + \frac{2.303\rho}{1!} + \frac{(2.303\rho)^2}{2!} + \cdots \quad (142)$$

Under our conditions, Eq. (142) can be approximated to the first two terms in the expansion, thus

$$1/t \cong 1 + 2.303\rho$$

or

$$1/\bar{t} \cong 1 + 2.303\bar{\rho} \quad (143)$$

From Eqs. (141) and (143), we get

$$\sigma(\rho) \cong \frac{0.659}{\sqrt{a}}\,\sqrt{\bar{\rho}r} = \text{Constant for a given density} \quad (144)$$

Thus the Selwyn granularity law is given by

$$g_s = \sqrt{a}\,\sigma(\rho) = \text{Constant} \quad (145)$$

Eq. (145) states that, at a given density, $\sigma(\rho)$ is inversely proportional to \sqrt{a}. Thus the plot of $\sigma(\rho)$ as a function of $1/\sqrt{a}$, is a straight line of slope g_s, as shown in Fig. 9-45. Eq. (145) is derived from the most simplified model of granularity. Other sophisticated models such as independent circular grains and overlapping circular grain models have been established, but will not be discussed here.

Eq. (145) is fulfilled when the flashed sample is single layer achromatic film, which satisfies the following conditions:

1. The sample is clean and uniform, i.e. the sample must be free from dirt, scratches, and density wedging. This condition is very hard to fulfill.

2. The area a of the scanning aperture must be much larger than the projected area of the grain.

According to Eq. (144), $\sigma(\rho)$ is proportional to $\sqrt{\rho}$. Therefore when we measure the granularity in terms of $\sigma(\rho)$, the average density of the sample must be speci-

Fig. 9-45. Relationship between the standard deviation in density $\sigma(\rho)$ and the size of the effective scanning aperture.

fied. We must also keep in mind that the electronic noise of the scanning instrument may contribute to the value of $\sigma(\rho)$. If the electronic noise is present, it can be measured by scanning without the sample in place. If σ_e is the electronic noise, $\sigma(\rho)$ is the photographic noise, and σ_t is the total noise, then $\sigma(\rho)$ is found from the equation

$$\sigma_t^2 = \sigma^2(\rho) + \sigma_e^2 \qquad (146)$$

The data sheets of film manufacturers often contain an RMS granularity value for the film. This value is commonly obtained from a uniformly exposed and processed film having a density of 1.0 which is scanned by a microdensitometer using an optical system with an aperture of $f/2$ and a circular opening of 48 μm in diameter. A root-mean-square value is derived from the trace which represents one standard deviation in density. This is multiplied by 1000 to give a whole number which is the RMS granularity. The equipment and methods used are described by Morris and Wait.[63a]

The RMS granularity indicates one's visual sensation of graininess at a magnification of 12X. A difference of 6% in RMS granularity corresponds to a just noticeable difference in graininess.

Failure of the Selwyn Law

Neither black and white prints and transparencies, nor radiographs or multicolor film images obey Eq. 145.

In contact prints and transparencies the grain pattern is not random since the grain pattern of the negative is superimposed on that of the positive material used in making the print. When the print is made by projection, the graininess is dependent on the optical system; i.e., the nature of the illumination (specular or diffuse), the lens, focusing and flare in the optical system. For a given negative, graininess tends to increase with the contrast of the print. It is most apparent in brilliant, sharply defined images and is greatly reduced by diffusion of the image.

In radiographs, secondary emission affects the value of $\sigma(\rho)$.

In multicolor negatives and transparencies, the distribution of the dye image is largely determined by that of the silver image which it replaces. Thus dye images, like silver images, are granular, but since they are partially transmitting, their density decreases towards the edge and, in this respect, are quite different from the silver image in which the silver grains are opaque and the variation from the center to the edge is minimal.[64]

When the Selwyn theory is not valid and we still wish to find the value of $\sigma(\rho)$ which will correlate with graininess, an appropriate aperture must be found for scanning the film sample. It is found by experiment that, if m_v is the magnification at which the image on the film is going to be viewed, and d is the diameter of the effective scanning aperture in micrometers, then the appropriate scanning aperture must have a diameter which satisfies the equation

$$m_v d = 576$$

For example, suppose the image on the film is to be viewed at 50X magnification, then the diameter d of the effective scanning aperture which is suitable for scanning the film is

$$d = 576/50 = 11.52 \; \mu m$$

Syzygetic Granularity

In an attempt to establish a better correlation between graininess as evaluated by the blending magnification method and a density measurement on a uniformly exposed and processed film, Jones, Higgins and coworkers introduced the so-called "syzygetic granularity".[63] Their reasoning may have been as follows: If one finds a pair of adjacent apertures which scan the film in a manner similar to that of the cones in the fovea of the human eye when it moves back and forth to detect graininess, then the average point-to-point density gradient will correlate with the film graininess.

As the eye scans a film sample, the physical quantity which controls the magnitude of the neutral response in the occular mechanism is the spatial luminance gradient, which is, in turn, proportional to $d\rho/dx$. Jones and Higgins called the quantity $d\rho/dx$ the $syzygetic$ density and gave it the symbol $S\Delta D$, so that

$$S\Delta D = \frac{d\rho}{dx} \qquad (147)$$

It is important to note that the distance dx on the film sample must correspond to the separation of areas that are imaged on adjacent cones in the fovea. In other words dx must be given by

$$dx = cm_b \qquad (148)$$

where c is the diameter of the cones which is estimated to be about 1.5 μm and m_b is the magnification between the eye retina and the sample. Thus a microdensitometer with effective scanning circular aperture of a diameter b_c equal to dx would be appropriate for the syzygetic granularity measurement.

The method used by Jones and Higgins for syzygetic granularity measurement is based on Eqs. (147) and (148), and can be summarized as follows:

1. A uniformly exposed and processed film sample is scanned by a microdensitometer provided with two adjacent circular apertures placed side by side and of the same effective area.

2. If the diameter size b_c of each aperture is equal to dx, defined by Eq. (148), then the average of the syzygetic density difference $\langle S\Delta D \rangle$ will be an objective measure of the sample graininess for any photographic material provided that the density is fixed at a given

Fig. 9-46. The threshold gradient sensitivity curve for the eye.

value for all the materials. The quantity $\langle S \Delta D \rangle$ is called syzygetic granularity.

3. As the density is varied and $\langle S \Delta D \rangle$ is found (the scanning apertures are at the critical diameter $b_c = dx$), Higgins and co-workers found that the plot of $\langle S \Delta D \rangle$ of all the films tested is given by the curve shown in Fig. 9-46.

Since the curve of Fig. 9-46 gives the values $\langle S \Delta D \rangle$ just distinguishable to the eye, it may be considered to represent a threshold gradient sensitivity function of the eye. Therefore, this curve serves as a basic for determining the graininess of any photographic material at any density ρ in the interval $0.05 \leqslant \rho \leqslant 2.52$.

To determine the graininess of any film sample in the density range $0.05 \leqslant \rho \leqslant 2.52$ from its syzygetic granularity $\langle S \Delta D \rangle$, we scan the film with several scanning apertures and calculate $\langle S \Delta D \rangle$ in each case. We then find the value $\langle S \Delta D \rangle$ for the sample at the density ρ which is equal to an $\langle S \Delta D \rangle$ value on the threshold gradient sensitivity curve. The diameter b_c of the aperture which corresponds to this condition is related to the blending magnification m_b. According to Higgins and co-workers,[63] m_b is then calculated from the equation

$$b_c = (1.5/m_b)(2000/17.8 - 1) \qquad (149)$$

Where 2000 corresponds to the distance 2000 mm used for observing the graininess. The quantities 1.5 and 17.8 correspond to the diameter of a cone (1.5 μm) and the focal length of the eye (17.8 mm) respectively.

As we can see, determining the syzygetic granularity is very involved and is not in wide use.[65-69]

GENERALIZED THEORY OF GRANULARITY

A more general theory of granularity, of which Selwyn and syzygetic granularity are special cases, is based on the autocorrelation of the transmittance distribution and on its Fourier transform.[65-69]

Consider a uniformly exposed and uniformly processed sample which has a transmittance distribution

$t'(x, y)$ and average transmittance $\bar{t'}$. The normalized transmittance distribution $t(x, y)$ of the film sample is then given by

$$t(x, y) = \frac{1}{\bar{t'}} [t'(x, y) - \bar{t'}] \qquad (150)$$

Since $t(x, y)$ is an aperiodic function, it cannot be represented as a Fourier series, but the grains in the emulsion are adequately represented by a stationary ergodic random function. Thus the power per unit area of the emulsion is finite and is given by

$$P = \lim_{f \to \infty} f^{-1} \left[\iint_f \left| t(x, y) \right|^2 dx \, dy \right] \qquad (151)$$

where f is the area of the film. The autocorrelation $u_{tt}(x, y)$ of the transmittance $t(x, y)$ is given by

$$u_{tt}(x, y) = \lim_{f \to \infty} f^{-1} \left\{ \iint_f t(\xi - x, \eta - y) t(\xi, \eta) \, d\xi \, d\eta \right\} \qquad (152)$$

where x and y are the correlation parameters. The Fourier transform of $u(x, y)$ is the Wiener spectrum $U(\omega_x, \omega_y)$, i.e.

$$U(\omega_x, \omega_y) = \int_{-\infty}^{+\infty} \int_{-\infty}^{+\infty} u_{tt}(x, y) e^{-i(\omega_x x + \omega_y y)} dx \, dy \qquad (153)$$

The variance σ_t^2 in the transmittance $t(x, y)$, is given by

$$\sigma_t^2 = \int_{-\infty}^{\infty} \int_{-\infty}^{\infty} u_{tt}(x, y) u_{ss}(x, y) \, dx \, dy \qquad (154)$$

Where $u_{ss}(x, y)$ is the autocorrelation of the point-spread function $s(x, y)$ of the optical system which scans the film sample.

It can be shown that Eq. (153) is equivalent to

$$\sigma_t^2 = \int_{-\infty}^{+\infty} \int_{-\infty}^{\infty} U(\omega_x, \omega_y) \left| F(\omega_x, \omega_y) \right|^2 d\omega_x \, d\omega_y \qquad (155)$$

Where $F(\omega_x, \omega_y)$ is the optical transfer function (OTF) of the optical system, i.e.

$$F(\omega_x, \omega_y) = a^{-1} \mathcal{F}[s(x, y)] \qquad (156)$$

Where a is the area of the spread function $s(x, y)$, i.e.

$$a = \int_{-\infty}^{\infty} \int_{-\infty}^{\infty} s(x, y) \, dx \, dy \qquad (157)$$

Let us now consider that the film is scanned by a circular aperture of diameter d, then

$$F(\omega_x, \omega_y) = a^{-1} \int_{-\infty}^{\infty} \int_{-\infty}^{\infty} s(x, y) e^{-i(\omega_x x + \omega_y y)} dx \, dy \qquad (158)$$

In polar coordinates, (r, θ) in the spatial domain and (ω, φ) in the frequency domain we have

$$x = r \cos \theta \qquad \omega_x = \omega \cos \varphi$$

$$y = r \sin \theta \qquad \omega_y = \omega \sin \varphi$$

$$x^2 + y^2 = r^2 \qquad \omega_x^2 + \omega_y^2 = \omega^2$$

$$dx \, dy = rd \, rd \, \theta \qquad d\omega_x \, d\omega_y = \omega d\omega \, d\varphi \qquad (159)$$

Using Eq. (159) in Eq. (158), we get

$$F(\omega_x, \omega_y) = a^{-1} \int_0^\infty \int_0^{2\pi} s(r, \theta) e^{-i\omega r(\cos \theta \cos \varphi + \sin \theta \sin \varphi)}$$

$$\cdot rd \, rd \, \theta$$

or $\qquad (160)$

$$F(\omega_x, \omega_y) = a^{-1} \int_0^\infty \int_0^{2\pi} s(r, \theta) e^{-i\omega r \cos (\theta - \varphi)} rd \, rd \, \theta$$

Since the aperture is isotropic, $F(\omega_x, \omega_y) \longrightarrow F(\omega)$ and $s(r, \theta) \longrightarrow s(r)$ and Eq. (160) can be written

$$F(\omega) = a^{-1} \int_0^\infty \int_0^{2\pi} s(r) e^{-i\omega r \cos \theta} rd \, rd \, \theta \qquad (161)$$

But

$$\int_0^{2\pi} e^{-i\omega r \cos \theta} \, d\theta = 2 J_0(\omega r) \qquad (162)$$

Where $J_0(\omega r)$ is the Bessel function of order zero. From Eq. (162) and Eq. (161), we get

$$F(\omega) = 2\pi a^{-1} \int_0^\infty s(r) J_0(\omega r) \, rdr \qquad (163)$$

For a circular aperture of diameter d, we have

$$s(r) = \begin{cases} 1 & \text{for } 0 \leqslant r \leqslant d/2 \\ 0 & \text{for } r > d/2 \end{cases}$$

and $a = \pi d^2/4$. Thus

$$F(\omega) = \frac{8}{d^2} \int_0^{d/2} r J_0(\omega r) \, dr \qquad (164)$$

setting $\omega r = z$ in Eq. (164), we get

$$F(\omega) = \frac{8}{\omega^2 d^2} \int_0^{\omega d/2} z J_0(z) \, dz \qquad (165)$$

From the recurrence relations of the Bessel function, we have

$$\int_0^\alpha z^n J_{n-1}(z) \, dz = [z^n J_n(z)]_0^\alpha \qquad (166)$$

Using Eq. (165) in Eq. (164) we get

$$F(\omega) = (4/\omega d) J_1(\omega d/2) \qquad (167)$$

From Eq. (167) and Eq. (155), we get

$$\sigma_t^2 = \frac{16}{d^2} \int_{-\infty}^\infty \int_{-\infty}^\infty U(\omega_x, \omega_y) \left| \frac{J_1(\omega d/2)}{\omega} \right|^2 d\omega_x \, d\omega_y \qquad (168)$$

In polar coordinates (ω, φ), we have

$$U(\omega_x, \omega_y) = U(\omega, \varphi)$$

and $d\omega_x \, d\omega_y = \omega \, d\omega \, d\phi$, thus

$$\sigma_t^2 = \frac{16}{d^2} \int_0^\infty \int_0^{2\pi} U(\omega, \varphi) \omega^{-1} |J_1(\omega d/2)|^2 \, d\omega \, d\varphi$$

$$(169)$$

If the emulsion is isotropic, it does not depend on φ, i.e. $U(\omega, \varphi) \longrightarrow U(\omega)$. Thus Eq. (169) is reduced to

$$\sigma_t^2 = \frac{32\pi}{d^2} \int_0^\infty U(\omega) \omega^{-1} |J_1(\omega d/2)|^2 \, d\omega \qquad (170)$$

Now, assuming that $U(\omega)$ is constant, U_0, as compared to $|J_1(\omega d/2)|^2$, Eq. (170) becomes

$$\sigma_t^2 = (8\pi^2 U_0/a) \int_0^\infty \omega^{-1} J_1^2(\omega d/2) \, d\omega \qquad (171)$$

Set $k = \omega d/2$ in Eq. (171), and we get

$$\sigma_t^2 = (8\pi^2 U_0/a) \int_0^\infty k^{-1} J_1^2(k) \, dk \qquad (172)$$

Using the general relation

$$\int_0^\infty J_n(bt) J_m(bt) \, t^{-p} \, dt =$$

$$\frac{(\frac{1}{2} b)^{p-1} \Gamma(p) \Gamma[\frac{1}{2}(n+m-p+1)]}{2\Gamma[\frac{1}{2}(-n+m+p+1)] \Gamma[\frac{1}{2}(n+m+p+1)] \Gamma[\frac{1}{2}(n-m+p+1)]}$$

We get

$$\int_0^\infty k^{-1} J_1^2(k) \, dk = \frac{1}{2} \qquad (173)$$

That Eq. (173) is correct can be seen graphically in Fig. 9-47. From Fig. 9-47 we see that $\int_0^\infty k^{-1} J_1^2(k) \, dk \cong \int_0^4 k^{-1} J_1^2(k) \, dk =$ area contained in the interval $0 < k < 4 \cong 0.4$.

From Eq. (173) and Eq. (172) we get

$$\sigma_t^2 = (8\pi^2 U_0/2a)$$

or

$$\sigma_t \sqrt{t} = \text{constant} \qquad (174)$$

We see from Eq. (174) that, Selwyn's law is valid only when the aperture size is much larger than the grain size. We also conclude from this equation that Eq. (154) or Eq. (155) is the general equation for calculating the granularity of photographic materials.

TABLE 9-5. APPLICATION OF IMAGE EVALUATION TECHNIQUES IN PHOTOGRAPPHC SYSTEMS[70-75]

Application	MTF and OTF	Granularity	Edge	Resolving power
Lens selection	3, 2	0	0	5, 2
Emulsion selection	3, 2	3, 2	3, 1	3, 1
Other components selection	3, 2	0	0	0
System design	3, 2	3, 1	0	4, 1
System evaluation	3, 2	0, 1	3, 1	4, 1
Operational performance	3, 2	0, 1	4, 2	5, 1
Production control of lens	3, 2	0	0	4, 2
Production control of systems	3, 2	0	3, 1	5, 1
Diagnosis	3, 2	0	3, 1	3, 1

5: much used, 4: used, 3: used to a limited extent, 2: has good potential, 1: has potential, 0: no application.

Fig. 9-47. Plot of $J_1^2(k)/k$ as a function of k.

In concluding this chapter, Table 9-5 indicates the various image evaluation parameters, their applications and the extent to which they are used. The potential of these parameters in diagnosing photo-optical systems is also indicated.

GENERAL REFERENCES

1. A. Sommerfeld, *Optics*, Academic, New York, 1954.
2. E. L. O'Neill, *Introduction to Statistical Optics*, Addison-Wesley, Boston, (1963).
3. H. Francon, *Modern Applications of Physical Optics*, Interscience, 1963.
4. Rudolf Kingslake (ed.), *Applied Optics and Optical Engineering*, Academic, New York, 1965.
5. Ron Bracewell, *The Fourier Transform and Its Applications*, McGraw-Hill, New York, 1965.
6. A. Cox, *Photographic Optics*, Focal, London and New York, 1966.
7. C. E. K. Mees and T. H. James, *The Theory of the Photographic Process*, Macmillan, New York, 1966.
8. W. J. Smith, *Modern Optical Engineering*, McGraw-Hill, New York, 1966.
9. N. S. Kapany, *Fiber Optics*, Academic, New York, 1967.
10. A. Bruce Carlson, *Communication Systems, An Introduction to Signals and Noise in Electrical Communication*, McGraw-Hill, New York, 1968.
11. T. H. James and G. C. Higgins, *Fundamentals of Photographic Theory*, Morgan & Morgan, Hostings-on-Hudson, 1968.
12. J. W. Goodman, *Introduction to Fourier Optics*, McGraw-Hill, New York, 1968.
13. B. Gold and C. M. Rader, *Digital Processing of Signals*, McGraw-Hill, New York, 1969.
14. H. P. Hsu, *Fourier Analysis*, Simon and Schuster, New York, 1970.
15. M. V. Klein, *Optics*, Wiley, New York, 1970.

REFERENCES

1. I. J. Kleinsinge, A. J. Derr and G. J. Giuffre, "Optical Analysis of A Microdensitometer System," *Appl. Opt.*, **3**: 1167 (1964).
2. J. H. Altman, "A Simple Non-Recording Microdensitometer," *Appl. Opt.*, **3**: 153 (1964).
3. J. H. Altman and K. F. Stultz, "Microdensitometer for Photographic Research," *Rev. Sci. Instrum.*, **27**: 1033 (1956).
4. A. W. Hartman, "Scanning Microscope Densitometer," *Rev. Sci. Instrum.*, **36**: 31 (1965).
5. R. A. Jones, "The Effect of Slit Misalignment on the Microdensitometer Modulation Transfer Function," *Photogr. Sci. Eng.*, **9**: 335 (1965).
6. R. Clark Jones, "On the Point and Line Spread Functions of Photographic Images," *J. Opt. Soc. Amer.*, **48**: 934 (1958).
7. H. F. Nitka and A. J. Derr, "Layer Thickness of Photographic Emulsions and Image Definition," *Photogr. Sci. Eng.*, **3**: 1 (1959).
8. D. H. Napper and R. H. Ottewill, "Studies on the Light Scattering of Silver Bromide Particles," *J. Photogr. Sci.*, **11**: 84 (1963).
9. R. H. Lamberts, "Relationship Between the Sine-Wave Response and the Distribution of Energy in the Optical Image of a Line," *J. Opt. Soc. Amer.*, **48**: 490 (1958).
10. G. C. Higgins and F. H. Perrin, "The Evaluation of Optical Images," *Photogr. Sci. Eng.*, **2**: 66 (1958).
11. M. Belder, J. Jespers and R. Verbrugghe, "On The Evaluation of the Modulation Transfer Function of Photographic Materials," *Photogr. Sci. Eng.*, **9**: 314 (1965).
12. G. Langner, "Investigations Regarding the Measurement of the Modulation Transfer Function and Possibilities for its Designation by a Numerical Value," *J. Photogr. Sci.*, **11**: 150 91963).
13. R. H. Lamberts, "Measurement of the Sine Wave Response of a Photographic Emulsion," *J. Opt. Soc. Amer.*, **49**: 425 (1959).
14. F. D. Smith "Optical Image Evaluation and the Transfer Function," *Appl. Opt.*, **2**: 335 (1963).
15. M. C. Goddard and R. G. Gendron, "An MTF Meter for Film," *Photogr. Sci. Eng.*, **13**: 150 (1969).
16. R. A. Jones, "An Automated Technique for Deriving MTF from Edge Traces," *Photogr. Sci. Eng.*, **11**: 102 (1967).
17. R. L. Lamberts and C. M. Straub, "Equipment for the Routine Evaluation of the Modulation Transfer Function of Photographic Emulsions," *Photogr. Sci. Eng.*, **9**: 331 (1965).
18. R. N. Wolfe, E. W. Marchand and J. J. De Palma, "Determination of the Modulation Transfer Function of Photographic Emulsions from Physical Measurements," *J. Opt. Soc. Amer.*, **58**: 1245 (1968).
19. R. A. Jones and J. F. Coughlin, "Elimination of Microdensitometer Degradation from Scans of Photographic Images," *Appl. Opt.*, **5**: 1411 (1966).
20. H. Frieser and H. Kramer, "The Dependence of the MTF of Photographic Films on their Optical Properties and on the Structure of the Emulsion Layer," *Photogr. Korr.*, **104**: 221 (1968).
21. H. F. Nitka and A. J. Derr, "Layer Thickness of Photographic Emulsions and Image Definition," *Photogr. Sci. Eng.*, **3**: 1 (1959).
22. G. C. Higgins and L. A. Jones, "The Nature and Evaluation of the Sharpness of Photographic Images," *J. Soc. Motion Picture Television Engrs.*, **58**: 277 (1952).

23. H. F. Nitka, "Considerations on Photographic Acutance," *Photogr. Eng.*, 7: 100 (1956).
24. F. H. Perrin, "Acutance—or How Sharp is a Photograph," *Image*, 5: 127 (1956).
25. H. Thiry, "Spectrophotometric Measurement of the Acutance of Photographic Materials," *J. Photogr. Sci.*, 11: 121 (1963).
26. R. N. Wolfe and F. C. Eisen, "Psychometric Evaluation of the Sharpness of Photographic Reproductions," *J. Opt. Soc. Amer.*, 43: 914 (1953).
27. C. L. Feldman and D. H. Hawkins, "Normalized Acutance as a Criterion for Testing Photographic Lenses," *Photogr. Sci. Eng.*, 3: 170 (1959).
28. G. C. Higgins and Robert N. Wolfe, "The Role of Resolving Power and Acutance in Photographic Definition," *J. Soc. Motion Picture Eng.*, 65: 26 (1956).
29. R. A. Jones, "Use of the Modulation Transfer Function to Diagnose Camera Faults," *Photogr. Sci. Eng.*, 15: 437 (1971).
30. E. M. Crane, "An Objective Method for Rating Picture Sharpness—SMT Acutance," *J. Soc. Motion Picture Television Eng.*, 73: 643 (1964).
31. H. Frieser and K. Biederman, "Experiments on Image Quality in Relation to Modulation Transfer Function and Graininess of Photographs," *Photogr. Sci. Eng.*, 7: 28 (1963).
32. H. Frieser, "Recent Studies on the Reproduction of Small Details in Photographic Emulsions," *Wissenschaftliche Photographic Ergebnisse Int. Korr. wiss. Photo. Koln 1956*, O. Helevich Verlag (1958), pp. 505–510.
33. F. H. Perrin, "Photographic Sharpness and Resolving Power," *J. Opt. Soc. Amer.*, 38: 1040 (1948); 41: 265 (1951); 41: 1038 (1951); 42: 455 (1952); 42: 462 (1952); 43: 780 (1953).
34. O. H. Schade, "An Evaluation of Photographic Image Quality and Resolving Power," *J. Soc. Motion Picture Television Eng.*, 73: 81 (1964).
35. ANSI PH 2.33 (1969). *Method for Determining the Resolving Power of Photographic Materials.*
36. O. Sandvick, "The Dependence of the Resolving Power of a Photographic Material upon the Contrast in the Object," *Photogr. J.*, 68: 313 (1928); *J. Opt. Soc. Amer.*, 16: 244 (1928).
37. F. H. Perrin and J. H. Altman, "Studies in the Resolving Power of Photographic Emulsion. VI. The Effect of the Type of Pattern and the Luminance Ratio in the Test Object," *J. Opt. Soc. Amer.*, 43: 780 (1953).
38. G. C. Higgins, R. N. Wolfe and R. L. Lamberts, "Relationship between Definition and Resolving Power with Test Objects Differing in Contrast," *J. Opt. Soc. Amer.*, 46: 752 (1956).
39. O. Sandvick and G. Silberstein, "Dependence of Resolving Power of a Photographic Material on the Wave Length of Light," *J. Opt. Soc. Amer.*, 17: 107 (1928).
40. F. H. Perrin and J. H. Altman, "The Resolving Power Camera in the Kodak Research Laboratories," *J. Opt. Soc. Amer.*, 41: 265 (1951).
41. F. H. Perrin and H. O. Hoadley, "The Design and Performance of an Apochromatic Resolving Power Camera Objective," *J. Opt. Soc. Amer.*, 38: 1040 (1948).
42. A. P. H. Trinelli and W. F. Smith, "Resolving Power and Structure in Photographic Emulsion Series," *Photogr. J.*, 79: 630 (1939).
43. H. F. Nitka and A. J. Deer, "Layer thickness of photographic Emulsions and Image Definition," *Photogr. Sci. Eng.*, 3: 1 (1959).
44. K. Huse, "Photographic Resolving Power," *J. Opt. Soc. Amer.*, 1: 119 (1917).
45. F. H. Perrin and J. H. Altman, "Studies in the Resolving Power of Photographic Emulsions. IV. The Effect of Development Time and Developer Composition," *J. Opt. Soc. Amer.*, 42: 455 (1952).
46. W. Scheffer, "Microscopical Researches on the Effect of the Persulfate and Ferricyanide Reducers," *Brit. J. Photogr.*, 53: 964 (1906).
47. F. H. Perrin and J. H. Altman, "Studies in the Resolving Power of Photographic Emulsions. V. The Effect of Reduction and Intensification," *J. Opt. Soc. Amer.*, 42: 462 (1952).
48. Yu K. Vifanski and Yu N. Gorokhovski, *Zh. Nauchn. i Prikl. Fotogr. i Kinematogr.* 4: 345 (1959).
49. C. F. Coulman, "Optical Image Quality in a Turbulent Atmosphere," *J. Opt. Soc. Amer.*, 55: 806 (1965).
50. D. P. Paris, "Influence of Image Motion on the Resolution of a Photographic System," *Photogr. Sci. Eng.*, 6: 55 (1962).
51. R. N. Hotchkiss, F. E. Washer and F. W. Rosberry, "Spurious Resolution of Photographic Lenses," *J. Opt Soc. Amer.*, 41: 600 (1951).
52. C. S. Mc Camy, *Appl. Opt.*, 4: 405 (1965).
53. J. H. Altman and H. J. Zweig, "Effect of the Spread Function on the Storage of Information on Photographic Emulsions," *Photogr. Sci. Eng.*, 7: 173 (1963).
54. J. Riesenfeld, *Photogr. Sci. Eng.*, 11: 415 (1967).
55. L. A. Jones and G. C. Higgins, "Some Characteristics of the Visual System of Importance in the Evaluation of Graininess and Granularity," *J. Opt. Soc. Amer.*, 37: 217 (1947).
56. L. A. Jones and G. C. Higgins, "Photographic Granularity and Graininess. V. A Variable-Magnification Instrument for Measuring Graininess," *J. Opt. Soc. Amer.*, 41: 41, 64 (1951).
57. E. M. Lowry, "An Instrument for the Measurement of the Graininess of Photographic Materials," *J. Opt. Soc. Amer.*, 26: 65 (1936).
58. D. M. Zwick, "Film Graininess and Density—A Critical Relationship," *Photogr. Sci. Eng.*, 16: 345 (1972).
59. L. A. Jones and G. C. Higgins, "Granularity and Graininess. VI. Performance Characteristics of the Variable-Magnification Graininess Instrument," *J. Opt. Soc. Amer.*, 41: 64 (1951).
60. E. W. H. Selwyn, "A Theory of Graininess," *Photogr. J.*, 75: 571 (1935).
61. Van Kreveld, "Objective Measurements of Graininess of Photographic Materials," *J. Opt. Soc. Amer.*, 26: 170 and J. C. Scheffer, 27; 100 (1937); and J. C. Scheffer, *J. Opt. Soc. Amer.*, 27 (1937).
62. A. Goetz and W. O. Gould, "The Objective Quantitative Determination of the Graininess of Photographic Emulsions," *J. Soc. Motion Picture Eng.*, 29: 510 (1927).
63. L. A. Jones, G. C. Higgins and K. F. Stultz, "Granularity and Graininess," *J. Opt. Soc. Amer.*, 45: 107 (1955).
63a. R. A. Morris and D. H. Wait, "Granularity: Its Measurement and Relationship to Graininess," *Journal of the SMPTE*, 80: 819 (1971).
64. D. Zwick, "Color Granularity and Graininess," *J. Photogr. Sci.*, 11: 269 (1963).
65. J. H. Altman, "The Measurement of RMS Granularity," *Applied Opt.*, 3: 35 (1964).
66. R. H. Ericson and J. Marchant, "RMS Granularity of Monodisperse Photographic Emulsions," *Photogr. Sci. Eng.*, 16: 253 (1972).
67. R. C. Jones, "New Method of Describing and Measuring the Granularity of Photographic Materials," *J. Opt. Soc. Amer.*, 45: 799 (1955).
68. P. H. Keck, "Graininess of Photographic Emulsions," *Photogr. J.*, 75: 521 (1955).
69. H. C. Schmitt and J. H. Altman, "Method of Measuring Diffuse RMS Granularity," *Appl. Opt.*, 9: 871 (1970).
70. J. H. Altman, "A Review of Image Structure and Related Concepts," *Image Technology*, 11: 62 (1969).
71. G. C. Brock, "A Review of Current Image Evaluation Techniques," *J. Photogr. Sci.*, 16: 241 (1968).
72. G. C. Higgins, "Methods for Analyzing the Photographic System, Including the Effects of Non-Linearity and Spatial Frequency Response," *Photogr. Sci. Eng.*, 15: 106 (1971).
73. F. H. Perrin, "Methods of Appraising Photographic Systems," *J. Soc. Motion Picture Television Eng.*, 69: 151 (1960); 69: 239 (1960); 69: 800 (1960).
74. R. Shaw, "Modern Methods of Evaluating the Quality of Photographic Systems," *Visual*, 1: 19 (1963).
75. K. F. Stultz and H. J. Zweig, "The Roles of Sharpness and Graininess in Photographic Quality and Definition," *J. Opt. Soc. Amer.*, 52: 45 (1962).

10

THE REPRODUCTION OF TONE

C. N. Nelson

In scientific or technical photography, the usual goal is to communicate information concerning the original subject. Communication theory[1-3] provides us with procedures for calculating the information storage capacity[4-7] of any photographic, electronic, electro-optical, or magnetic recording system. Application of these procedures to photographic systems can be useful as an aid in choosing appropriate lenses, photographic materials, and conditions of exposure, processing, and readout so that adequate storage capacity will be obtained. The information storage capacity is dependent on certain properties of the system, such as exposure latitude, gradient of the output density versus input log luminance curve, system modulation transfer function, and system granularity. The readout device may be a photoelectric scanner and recorder, but far more often it is the human visual system. As will be described in some detail in this chapter, the adaptation characteristics of human vision have an important influence on the gradient and density characteristics required in the photographs if they are to appear satisfactory to the user.

In pictorial photography, there usually is a desire not only to convey information but also to produce photographs that are especially pleasing and interesting. Again the adaptation characteristics of human vision play an important role in determining the physical properties required in the photographs if they are to have the desired effect.

The artistic aspects of pictorial photography involve mainly the choice of subjects, lighting, and composition. At this stage of the process, ingenuity and creativity are especially important. In the remaining stages, however, it is usually possible to rely on routine or semiroutine operations and rules that have been established by the experiences of successful photographers and confirmed by scientific studies[8-36] based on vision research and on practical tests involving the psychological scaling of preferences of human observers.

In view of the wide latitude allowable in the subject matter, composition, and lighting, it was surprising to those who carried out these studies to find that the preferred reproduction characteristics tend to lie within rather narrow limits. Images that lie outside these limits usually are rejected as unacceptable or poor by nearly all observers. Furthermore, the preferred objective tone reproduction characteristics depend on whether the photograph is to be viewed with a dark or a bright surround. For example, one of the remarkable discoveries is that the image density versus log scene luminance curve for black and white or color motion pictures or slide transparencies viewed on a screen in a darkened room should, because of the dark surround, have a gradient approximately fifty percent greater than that of corresponding images viewed with a bright surround. For transparency or reflection-type photographs viewed in a well-lighted room in which the luminances in the broad areas surrounding each photograph are approximately equal to the mean luminance of the photograph, the gradient should be approximately 1.0 to 1.1 and the density representing the reproduction of a diffuse white highlight should be much lower than the corresponding density of motion pictures of slide transparencies viewed in a darkened room.[9-11,14,15,22-26]

These required changes in gradient and density as a consequence of replacing a dark surround by a bright one were found to be due to an adaptive change in the threshold and mean level of the brightness-vs-luminance curve for the human visual system.[11,14-36] The subjective

contrast and brightness of the images remain approximately constant when these objective changes are made to compensate for the effect of the surround.

The term "subjective tone reproduction" means the reproduction of the brightnesses of the original scene. Brightness is the magnitude of the subjective visual sensation produced by light. Luminance is the magnitude or amount of light. A plot of the brightnesses of the various elements of the photograph against the brightnesses of the corresponding elements of the scene is called the subjective tone reproduction curve. Brightnesses are not directly measurable by instruments but are determined by psychological scaling procedures or calculated by means of formulas that relate brightness and luminance for various conditions of visual adaptation.

The term "objective tone reproduction" means the reproduction of the luminances of the original scene. The luminance of each element of a scene or photograph is a measure of the amount of light per unit solid angle arriving at the camera or the eye from a unit area of the element. Luminances can be measured accurately with a photoelectric photometer having a relative spectral sensitivity equal to that of the human eye. A plot of the luminances of the various elements of the photograph against the luminances of the corresponding elements of the scene is the objective tone reproduction curve. In practice, however, it has been traditional and convenient to plot instead the log luminances or the densites of the photograph against the log luminances of the original scene, and this function is also called the objective tone reproduction curve. The traditional reason for the use of the logarithmic scale is that the visual response, brightness, was thought to be a logarithmic function of luminance. It is now known that a power function describes the relation between brightness and luminance more accurately, and the prevalent use of log luminances and optical densities must be justified mainly on the basis of convenience.

PREFERRED OBJECTIVE TONE REPRODUCTION

The effect of the surround luminance on the preferred objective tone reproduction characteristics of photographs is illustrated in Fig. 10-1. Curve A applies when viewing images with a dark surround. Curve B applies when the surround is bright. Curve A is the objective tone reproduction curve for preferred motion pictures and slide transparencies viewed on a screen in a darkened room with an open-gate screen luminance of 25 to 100 millilamberts (approximately 25 to 100 footlamberts). This curve is an average result based on experiments[8,11,14] in which a number of observers made judgments of the quality of projected images differing systematically in average gradient, density level, and shape of the density-vs-log scene luminance curve. A variety of scene types was used involving both daylight and studio lighting. The results were surprisingly independent of the scene type and scene lighting. (We should note that moonlit scenes, outdoor evening scenes, and dim interiors were

Fig. 10-1. The objective tone reproduction curves for preferred photographs. Curve A: Slide transparencies and motion pictures viewed with a dark surround. Curve B: Slide transparencies and reflection-type prints viewed with a bright surround. The dashed reference line has a gradient of 1.00.

not used. The objective tone reproduction characteristics required to produce on the screen the subjective effect of a night scene, for example, would be very different from curve A.) The gradient of the middle portion of curve A is about 1.6 and its average gradient is about 1.3. The middletone gradient of 1.6 remained optimum even when the open-gate screen luminance was varied over the wide range of 5 to 200 millilamberts. The preferred mean density of the image did, however, depend on the screen luminance, being 0.2 lower than that of curve A when the screen luminance was 5 millilamberts and 0.1 higher than that of curve A when the screen luminance was 200 millilamberts. The densities shown for curve A are the effective densities for the various points in the image measured on the screen with a telescopic photometer. Consequently, they include the effects of stray light and projector specularity. The log luminances of the corresponding points in the original scene were measured with a telescopic photometer and checked by means of photographic photometry.

A curve essentially the same as curve A of Fig. 10-1 can be derived from a study of the processing conditions and sensitometric characteristics for the films used by professional motion picture engineers. Furthermore, the color reversal films used by millions of amateur and professional photographers for slide transparencies and motion pictures provide tone reproduction characteristics similar to those indicated by curve A. The optimum camera exposure for a color reversal film is related to the amount of light supplied by the projector used in viewing the images.[27]

Curve B in Fig. 10-1 shows the objective tone reproduction for preferred black and white transparencies viewed in a well-lighted room (illuminance of 1000 metercandles

or approximately 100 footcandles) using a transparency illuminator adjusted in luminance so that the mean luminance of the transparencies was approximately equal to the mean luminance of the surrounding areas of the room.[14] Curve B also represents the objective tone reproduction for preferred reflection-type prints, but it should be noted that reflection-type print materials often have maximum densities less than 2.00. Consequently, the actual curves for the chosen prints usually have shoulders as indicated by the dotted lines branching out from curve B. The dotted portions are believed to be the limitations of the photographic papers rather than the true preferences of the observers. The reflection-type photographs used in these studies[9,10,12-14] were viewed with an illuminance of 500 to 1000 metercandles. They were judged to be the best of a variety of photographs differing in average gradient, density level and curve shape. The surround luminances were those of the objects and walls of the lighted rooms in which the photographs were judged. The photographs were taken of a variety of outdoor and studio scenes, the luminances of which were measured with a telescopic photometer. The prints were measured with a reflection densitometer and the densities corrected for surface glare effects.[37]

When glossy color photographic papers are used to produce color prints from color negatives or, in experimental studies, to produce black-and-white prints from black-and-white negatives, they provide a means of obtaining dye images having maximum densities lying between 2.5 and 3.5 as measured with a traditional (45°, 0°) directional reflection densitometer. Photographic silver images on photographic paper sometimes have a maximum density as high as 2.1, but more generally less than 2.0 when measured with a densitometer of this type. When reflection prints are viewed in an average room with ordinary lighting geometry, however, the effective maximum densities are found to be only about 1.8 to 2.2 for glossy dye images and often less than 1.8 for glossy silver images. The effective densities of glossy, semimatte, and silk-finish prints are reduced by the specular reflections or glare light from the surface of the image. A reflection densitometer that includes these surface reflections in the measurements is described by Carnahan.[37] The readings obtained with this instrument are sometimes called average room viewing densities. These densities are pertinent in tone reproduction studies of reflection-type prints, and curve B of Fig. 10-1 was plotted in terms of these densities. Note that the maximum gradient of curve B is about 1.1.

From the studies of Hunt[31,32] and Hunt, Pitt, and Ward[33] it appears that the optimum objective tone reproduction curves for color reflection-type prints and color transparencies are very similar to the optimum curves for black and white reflection-type prints and transparencies. The difficulty usually experienced in taking proper account of surface glare in making reflection density and print luminance measurements is a major cause of uncertainties regarding optimum print characteristics, and further study of this problem is likely to be worthwhile.

An early theory of tone reproduction implied that the goal of practical photography should be to produce photographs having densities that follow the dashed line in Fig. 10-1. This line, which has a slope of 1.00 and differs considerably from curves A and B, has traditionally been used to define a photograph that would provide exact reproduction of the luminance ratios of the original scene. Actually, in order that this hypothetical photograph might reproduce specular highlight detail satisfactorily relative to diffuse highlight detail, its densities should follow a line with a slope of 1.00 but with densities at least 0.2 higher than those of the dashed line. If the log illuminance used on such a photograph were 0.2 greater than the log illuminance on the scene, the photograph would provide nearly exact reproduction of the luminance ratios and also the absolute luminances of the original scene. Exact luminance reproduction of a sunlit scene, on which the illuminance is about 100,000 metercandles (9300 footcandles), would therefore require that the illuminance on the photograph be extremely high: more than 160,000 metercandles. This high level is, of course, impractical. Photographs are usually viewed in homes, offices, or art galleries where the illuminance is ordinarily about *one-hundreth* that on a sunlit scene, or viewed in theaters where the luminance level corresponds to an even lower level of illuminance. It is because of the remarkable ability of the human eye to compensate for these low levels of lighting, by increasing its sensitivity, that we can see persons, objects, and photographs satisfactorily in the relatively dim lighting normally used in buildings.

VISUAL ADAPTATION

The surprisingly large differences in gradient and density between curves A and B in Fig. 10-1 are predictable from the brightness-vs-luminance curves for the human visual system if we assume that the observers involved in establishing these aims preferred photographs having the subjective appearance of well-lighted scenes in daylight. Presumably, two photographs of any particular scene should provide the same subjective contrast and brightnesses even if one is a transparency viewed with a dark surround and the other is a transparency or reflection-type print viewed with a bright surround.

The relation between brightness and luminance is very complex and not fully understood. It can, however, be represented reasonably well by means of a family of curves that define the effects of at least two distinct kinds of changes that occur automatically in vision: *direct adaptation* and *lateral adaptation*. The experimental work required to determine this family of curves involves psychological scaling of brightness ratios. The subjective task of evaluating brightness magnitudes or ratios is, of course, a difficult one. Only recently has the painstaking research carried on over the past several decades in laboratories of various universities, foundations and industries provided us with an adequate under-

standing of how to relate brightness and luminance. Some of the outstanding contributions to this understanding have been the experimental studies of Hartline[16-17] and his associates, Stevens[18-21] and his co-workers, Bartleson and Breneman,[15,22-25] Jameson and Hurvich,[28] Padgham and Saunders,[29] Onley,[30] and Hunt.[31] The experimental data of Bartleson, Breneman, and Hunt are especially applicable to photographic problems. The mathematical models suggested by Ratliff, Hartline, and Miller,[17] Jameson and Hurvich,[35] Marsden[36] and others have also been very helpful.

From these studies there has emerged a family of brightness-vs-luminance functions, the essential features of which are shown by the brightness-vs-log luminance curves of Fig. 10-2. Log luminance is used as the abscissa

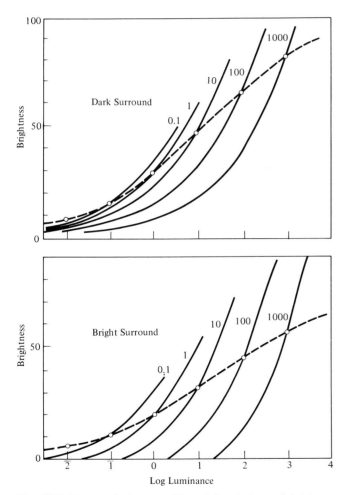

Fig. 10-2. Upper set of curves: The relation between brightness and log luminance when a small, uniform spot of light having a variable luminance is viewed in a dark surround. If several minutes are allowed for direct adaptation, to each luminance, the dashed curve applies. If the luminance is changed within a second or two, each solid curve indicates the brightness if the eye has been pre-adapted to the luminance marked in millilamberts near the curve. Lower set of curves: The relation between brightness and log luminance when the surround luminance is adjusted, successively, to be equal to each of the direct adaptation luminances expressed in millilamberts.

scale of the graph because it is easy to relate to the optical densities commonly used to express the characteristics of photographic materials. Direct adaptation is responsible for the sideways displacements of the solid curves of Fig. 10-2. This kind of adaptation is a relatively slow or sluggish process that is controlled mainly by the average luminance of areas viewed directly during the preceding ten seconds or longer. In a motion picture theater, the direct adaptation has nothing to do with the effect of the dark surround (unless the observer stares at the surround instead of the screen).

Direct adaptation can be thought of as an automatic gain control that slowly increases the sensitivity of the eye when there is a decrease in the average amount of light coming from the region being viewed directly, and slowly decreases the sensitivity of the eye when there is an increase in the average amount of light from that region. For example, when the light level is changed from that of sunlight to that of moonlight (a decrease of about 200,000 times) the sensitivity increases by a factor of more than 1000 times; that is, the response curve moves to the left (Fig. 10-2) a distance of more than 3.0 in log luminance units. A small part of the increase or decrease in sensitivity is caused by a change in pupil size. The main part of the change in sensitivity is thought to be caused either by a partial bleaching of the photopigments in the foveal and other regions of the retina in bright light and regeneration of these pigments in dim light, or by certain adaptive changes occurring elsewhere in the visual system.

Lateral adapation is a relatively rapid process. It is usually complete within a small fraction of a second after the light is changed. It is controlled by the luminances in a very wide field surrounding the small region at which the observer is looking at the moment. In a motion picture theater, the dark surround makes the screen image much brighter than it would be if the surround were bright. If the surround were suddenly made bright by increasing its luminance (without changing the screen luminances), the screen image would suddenly become much dimmer. This effect is caused by inhibitory electrical potentials[16,17] in the lateral nerve cells that interconnect the main channels in the optic nerve carrying signals from the photoreceptors in the retina to the brain. The magnitude of the effect is a nonlinear function of the luminances in an extremely wide field surrounding the point being viewed directly. The dark field surrounding the screen in a motion picture theater is usually many times larger than the screen image, and consequently nearly all of the strong inhibitory effect associated with a large bright surround is absent. There remains a residual inhibitory effect because the image itself acts as a surround field for each point in the image. Lateral adaptation is sometimes called inhibition, induction, or simultaneous contrast.

The large effect that lateral adaptation has on the relation between brightness and luminance can be appreciated by comparing the curves in the upper part of Fig. 10-2 with those in the lower part. It is seen that the effect of a bright surround is to lower each brightness-

vs-log luminance curve bodily. Brightness is *subtracted* from each of the upper curves, just as independent studies of inhibition in the nerve cells have suggested. Much of the low-gradient portion of each curve is thereby cut off by the inhibitory effect of a bright surround, because brightness cannot become negative.

The dashed curves in Fig. 10-2 indicate the brightness response when a period of several minutes is allowed for the eye to become fully adapted (by direct adaptation) to each new luminance level. Each solid curve, on the other hand, indicates the response when the eye rapidly scans the scene or the photograph while the eye remains adapted to the luminance corresponding to the abscissa value at the intersection of the solid curve with the dashed curve. The number shown along side each curve is the adapting luminance for that curve. The subjective contrast or slope of each curve is seen to be much greater when the luminances are scanned rapidly with the eye (solid curves) than when the luminance is changed slowly (dashed curves).

The brightness response functions of Fig. 10-2 can be described reasonably well by an equation of the form

$$B = b + AL^{1/3} - S \qquad (1)$$

where b is the residual brightness or "dark current" when all the luminances in the entire field are zero, L is the luminance of the small region being scanned (looked at directly) at the moment, A is the direct adaptation factor (automatic gain control), and S is the lateral adaptation or surround effect. If the eye has been scanning a photograph for many seconds and is fully adapted to it, and if L is expressed in millilamberts, the value of A is given approximately by

$$A = \frac{100}{(2.5 + L_{av}^{1/3})} \qquad (2)$$

where L_{av} is the average luminance of the photograph in millilamberts. The surround effect, S, is known experimentally for certain surrounds having uniform luminance. For nonuniform surrounds, the determination of S is too complex to be considered in detail here, but some indication of the procedure is given by

$$S = 100(s_1 L_1^{1/3} + s_2 L_2^{1/3} + s_3 L_3^{1/3} + \cdots s_n L_n^{1/3}) \qquad (3)$$

where L_n is the luminance at the point n in the surround, and s_n is a coefficient that depends on the angular position of the point n with respect to a point on the axis of direct vision and also depends on the state of adaptation of the peripheral cones and rods of the retina. The value of the coefficient diminishes as the angular displacement of point n from the center point increases. When any given point in a photograph is being viewed, the other points in the photograph become part of the surround, but the total surround extends far beyond the photograph.

IMAGE REQUIREMENTS RELATED TO VISUAL ADAPTATION

The experimental method used to obtain the preferred image curves, A and B of Fig. 10-1, has the shortcoming

that the available photographic materials and equipment may have had limitations that prevented the production of ideal images to show to the observers for their judgments of subjective tone reproduction quality. Consequently, it is of interest to supplement this approach by means of an independent derivation in which the optimum objective tone reproduction characteristics are calculated on the basis of the requirements imposed by the visual adaptation properties indicated by the brightness-vs-log luminance curves for the human eye.

In applying this method we shall assume that the brightnesses of the various elements of the photograph should be equal to the brightnesses of the corresponding elements of the original sunlit scene. The pertinent brightness-vs-log luminance curves for the eye have been extracted from Fig. 10-2 and are shown in Fig. 10-3. The curve at the left applies to the viewing of a projected slide transparency in a dark surround, and the curve next to it involves the viewing of a reflection-type print in a fully lighted room. The curve for the eye viewing the original scene is shown at the right. The brightnesses of seven different points in the scene are indicated as small circles on the ordinate scale and also on the three brightness-vs-log luminance curves. The log luminances or optical densities required in the reproductions if they are to provide the desired brightness values are then found as the small circles on the horizontal lines labeled transparency and print, respectively. When these log luminances, or the corresponding optical densities required to give these luminances under the specified illuminance levels, are plotted against the scene log luminances indicated by the small circles on the horizontal line at the right, the objective tone reproduction characteristics required for exact brightness reproduction are obtained as shown by curves A and B in Fig. 10-4.

The curves of Fig. 10-4 are seen to be very similar to the curves of Fig. 10-1. Curve A, which applies when the surround is dark, still calls for a middletone gradient of about 1.6 and a gradient considerably above 1.0 at all densities. A significant discrepancy is found, however, when the new curve B is compared with curve B in Fig. 10-1. Curve B in Fig. 10-4 has a higher gradient in the highlight region and calls for "densities below zero." This remarkable requirement can be interpreted as follows. When a reflection-type print is viewed in ordinary room light, the print luminances that represent the semispecular highlights of the scene (the ripples on water, the catch lights on shiny leaves and on eyes, hair, jewelry, and many other interesting objects) should be greater than the print luminances that represent the diffuse white highlights of the scene. This important requirement, which is sometimes called "sparkle" by professional photographers, is achieved in the transparencies represented by curve A in Fig. 10-1 and is a consequence of the accurate reproduction of scene brightnesses. It is well known that reflection-type prints often tend to look dull in comparison with transparencies of the same scene. The main reason is that the dark area surrounding the projected transparencies allows the eye to increase its brightness response enough to permit the use of the optimum gradients throughout the whole tonal scale,

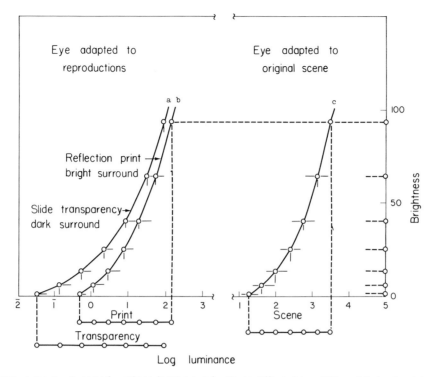

Fig. 10-3. The brightness-vs-log luminance functions for the eye for three different conditions: (a) viewing a transparency in a dark surround; (b) viewing a reflection-type print in a bright surround; (c) viewing the original sunlit scene. The reproduction densities required for exact brightness reproduction are derived from the small circles at the bottom of the graph.

including the highlight region where semispecular highlights should be reproduced with lower densities than those chosen for the diffuse highlights.

Much thought and effort has been expended by photographic scientists and engineers in attempting to overcome this deficiency of reflection-type prints. Prints

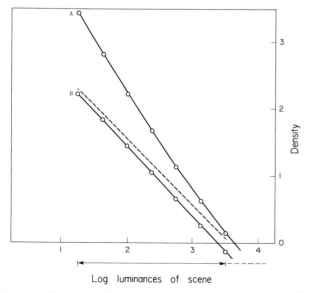

Fig. 10-4. The objective tone reproduction characteristics required for exact reproduction of the brightness of the original sunlit scene. Line A: For slide transparency viewed in a dark surround. Line B: For slide transparency or reflection-type print viewed in a bright surround.

made with higher densities at all density levels than those indicated by curve B do allow the possibility of providing the desirable increase in highlight gradient, but then the prints are usually rejected because they appear too dark to most observers. The use of lower middle-tone and shadow gradients also allows the highlight gradient to be increased, but the prints then usually are rejected because they appear too flat, i.e. too low in subjective contrast. A remedy that is promising in principle but provides only a slight improvement in practice is the use of fluorescent brighteners in photographic papers.

A very successful but inconvenient solution to the highlight problem has been to use special lighting on dense reflection-type prints that have a gradient approaching 1.00 in the highlight region and densities in the middletone and shadow regions that are about 0.3 greater than those indicated by curve B in Fig. 10-1. A dye image can provide the high maximum densities required in order to minimize shouldering of the curve. The special lighting required when viewing these dense prints can be obtained by means of a spotlight that illuminates the image area and provides an illuminance at least two times greater than the general illuminance in the room. It is important, of course, that the illumination be strictly confined to the image area or that the print not have a white border. A black cloth panel surrounding a borderless print is very effective. Surrounding objects or walls in the room should be relatively dim.

Another method of achieving optimum subjective tone reproduction with photographs that are to be viewed in fully lighted rooms is to use color or black and white sheet film transparencies having an objective gradient of

about 1.2 throughout most of the tonal scale and view them on a high-brightness transparency illuminator of sufficient wattage so that the semispecular highlights in the transparencies have a luminance at least two times greater than the luminance of the diffuse white objects in the room. An alternative method is to make slide transparencies with appropriate gradients and project them with high brightness achieved by using a high-efficiency screen[38] that makes it feasible to operate in a normally lighted room.

It is sometimes difficult to obtain the high levels of illuminance or luminance required if the photographs are to provide optimum tone reproduction quality. Fortunately, the decrease in subjective quality that occurs at a somewhat lower levels of mean luminance is usually not great. The relative brightness criterion of tone reproduction proposed by Bartleson[24] is helpful as a guide in preparing photographs that are to be viewed under less-than-optimum lighting levels. The optimum objective tone reproduction curves published by Clark[11] for slides viewed with high, medium, and low screen luminances are also very useful. At some of the low levels of open-gate screen luminance that he used (1 to 5 millilamberts, also found in some motion picture theaters) his observers reported a distinct preference for reproductions having higher brightnesses in the middletone and shadow regions than the relative brightness criterion[24] would have specified.

Clark's studies also indicate that photographs of studio scenes should provide reproductions not of the actual brightnesses usually obtained in such scenes but rather of the brightnesses such scenes would have had if they had been lighted to the higher levels commonly found in daylighted scenes.

Mathematical formulas have been devised by Simonds[9,10,14] and Clark[11,14] that use the objective tone reproduction curve as the basis for calculating subjective tone reproduction quality numbers. The reader is referred to the original publications for the details involved in applying these formulas.

OBJECTIVE TONE REPRODUCTION DIAGRAMS

A tone reproduction diagram of the type originally proposed by Jones[39,40] is a convenient way of expressing the relation between the tone reproduction curve for the final photographic image and the sensitometric characteristics of the various components of the photographic system. The pertinent data and component characteristics for a negative-positive system, for example, are: (1) The luminances or log luminances of the scene, (2) the effect of the camera flare light on the tonal range of the camera image, (3) the D-log E curve for the negative material, (4) the effect of the enlarger flare light, (5) the D-log E curve for the positive material, and (6) the effect of the surface glare or flare light involved in viewing the print.

A diagram that illustrates an analysis of this kind is shown in Fig. 10-5. The indicated log luminances of the scene correspond to actual measurements of a particular sunlit scene. The log luminance ranges of 126 outdoor scenes were measured by Jones and Condit[41] and found to vary from about 1.5 to 2.9. Ranges of 2.0 to 2.4 were especially frequent. The mean log luminance range for all these scenes was 2.2. This corresponds to a luminance ratio of 160:1. The log luminance ranges of studio scenes and other indoor subjects have not been studied as fully, but they are believed to be approximately the same as those of outdoor scenes.

In Fig. 10-5, the log luminance range of the chosen scene is 2.1. Eight equally spaced points in this range are indicated by the small black dots on the horizontal line just below the log luminance scale. Because of flare light in the camera, the corresponding eight points on the log exposure scale of the camera image are not equally spaced. Note that the spacing of the points in the shadow region is compressed more than the spacing in the highlight region. The image contrast in the highlight region is scarcely affected by flare, but the middle-tone and shadow contrasts are lowered appreciably. The effect of flare and other stray light on the contrast of images will be discussed in greater detail in connection with Fig. 10-6.

The dotted curve shown in quadrant 1 of Fig. 10-1 is the D-log E curve of the negative film expressed in terms of the diffuse densities generally measured by conventional densitometers. The solid curve is the negative film's D-log E curve expressed in terms of the semispecular densities that are effective when the film is used in a semispecular, condenser-type enlarger. The higher densities and gradients represented by the solid curve are the result of light losses caused by the scattering of light by the silver grains in the black and white film negative used in this example. A fully specular printer, such as a point-source enlarger, would (as indicated by a Callier Q-factor of about 1.5 for such a film) give even higher gradients than those shown by this solid curve. If the film had been a color negative material, the dye image would have scattered very little light and the solid curve would have been nearly coincident with the dotted curve.

The transfer line in quadrant 2 of Fig. 10-5 is a means of moving the density scale of the negative to the abscissa scale of the quadrant in which the D-log E curve of the photographic paper is found. If there were no flare or other stray light falling on the enlarger image, the semispecular density differences of the negative would be equal to the corresponding differences in log exposure on the positive material. Because of the stray light arising partly from interreflections between elements of the enlarging lens and partly from other sources, such as the mechanical parts of the enlarger, the semispecular densities of the negative are related to the log exposures of the positive by means of the dotted lines in the flare grid lying between quadrants 2 and 3.

The D-log E curve for a black and white photographic paper with a glossy surface is shown in quadrant 3 of Fig. 10-5. The corresponding curve for the gray scale of a color photographic paper with a glossy surface would not be greatly different except that the maximum density of a

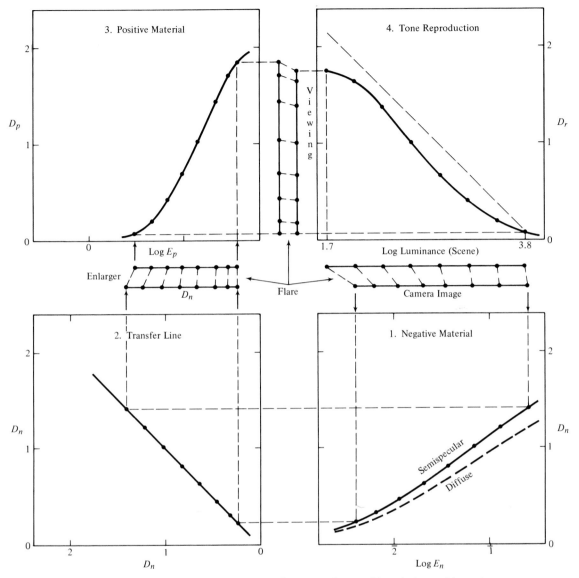

Fig. 10-5. Tone reproduction diagram for a negative-positive photographic system.

dye image is often greater than that of a silver image. The reflection densities in Fig. 10-5 are those measured by a conventional 45°:0° reflection densitometer. Because such an instrument does not take into account the effect of surface glare light in viewing the print with typical room lighting, a correction of the densities for the effect of the surface reflections is introduced by means of the grid inserted in the space between quadrants 3 and 4. This correction is, of course, omitted whenever the plotted reflection densities for the photographic paper have been measured with a densitometer[37] that takes this surface effect into account.

In quadrant 4 of Fig. 10-5, the appropriate reflection densities are plotted against the log luminances of the original scene. The result is the objective tone reproduction curve for the photograph.

Tone reproduction diagrams of the type just described are useful as a means of testing and demonstrating the

capabilities of various photographic materials for which the D-log E curves are available. For the photographic materials on the market, the pertinent curves usually are published in data booklets issued by the manufacturer. The graphic procedure of this tone reproduction analysis can be utilized to derive families of objective tone reproduction curves for combinations of materials used under several conditions of exposure and processing. Among the resulting curves, at least one usually can be found having an approximation of the desired gradient and density characteristics. The desired characteristics may be the unique specifications of a particular user, or they may be taken to be those of one of the curves in Fig. 10-1 for images that scientific studies have shown to be of excellent subjective quality for given viewing conditions (see the first part of this chapter for a discussion of preferred tone reproduction characteristics).

The procedure for using the tone reproduction dia-

grams can, of course, be reversed. If this method is chosen, the desired tone reproduction curve is inserted in the upper right-hand quadrant. The required D-log E curve for the positive material can then be derived graphically if the flare data and the curve of the negative material are given, or the required D-log E curve for the negative material can be derived if the flare data and the curve of the positive material are given.

Before considering specific applications of the tone reproduction analysis, we shall review in some detail the procedures used to determine and express the quantitative effects of flare or stray light in the photographic process. The flare grids introduced in Fig. 10-5 are based on a suggestion of Dorst[42] and are a substitute for flare curves of the type shown in Fig. 10-6. Obviously, there is no room in a four-block diagram, such as that shown in Fig. 10-5, for the three additional curves required to express the flare effects. A diagram involving seven or more blocks is sometimes used successfully, but we shall instead consider only the four-block diagram and show how the flare grids of the type used in Fig. 10-5 can be derived from photometric measurements that are often expressed in terms of flare curves like those in Fig. 10-6.

The stray light that is incident on an image formed by the lens of a camera, an enlarger, or a projector is called flare light or often simply flare. This stray light may be approximately uniform over the whole image area, and it is common practice to express it mathematically or graphically as though it were uniform. This stray light generally arises from interreflections between the various glass-air surfaces of the lens and from light reflected by the interior walls or bellows of the device, the edges of the diaphragm blades, the lens barrel, the film, and other areas. In the case of enlargers and projectors, room light may contribute to the flare on the image.

If the image-forming light is designated as an illuminance, I_i, in the image plane and the flare light is an illuminance, I_f, the total illuminance, I, in the image is given by

$$I = I_i + I_f \qquad (4)$$

For any given $f/$ number setting of the lens diaphragm, the illuminance, I_i, at any given point in the image is proportional to the luminance, L, of the corresponding point in the scene if a camera is involved, or the luminance, L, of the corresponding point in the illuminated negative or positive if the image is one that has been formed by the lens of an enlarger or a projector. Consequently

$$I = kL + I_f \qquad (5)$$

where the constant k depends on the $f/$ number setting of the lens, the bellows factor, and the units used. For an axial point in a camera image focused on a distant or semidistant object, k is approximately equal to $2.5/f^2$ when L is in millilamberts and I is in metercandles or lux. The flare, I_f, is sometimes expressed as a fraction of the maximum illuminance in the image. Thus, the formula

$$I = kL + 0.01 I_{max} \qquad (6)$$

indicates that the flare illuminance is one-hundreth the maximum image-forming illuminance. These simple formulas would suffice if the sensitometric characteristics of the photographic films and papers were usually expressed in arithmetic units. But because logarithmic quantities such as density, log illuminance, and log exposure are especially convenient to use in the science of sensitometry and tone reproduction analysis, it is common practice to deal with flare in terms of a formula obtained by taking the logarithm of both sides of Eq. 10-5. The resulting formula

$$\log_{10} I = \log_{10} (kL + I_f) \qquad (7)$$

is the basis for the curves in Fig. 10-6, where the log illuminances in the image plane of the camera, enlarger, or projector are plotted against the log luminances in the scene or in the input to the enlarger or projector.

The uppermost (dashed) curve in Fig. 10-6 is obtained when a relatively large value for the flare ($I_f = 0.023 I_{max}$) is inserted in the formula. The 45° line is obtained when the flare illuminance is zero. The use of an antiflare coating on the lens reduces the flare but does not eliminate it. The solid curve ($I_f = 0.007 I_{max}$) is typical of an average camera with a coated lens. The black dots represent equally spaced points on the log luminance scale. The unequal spacing of the corresponding points on the log illuminance scale is the consequence of flare and is very significant. The gradient or objective contrast in the shadow region of the image has been reduced from 1.0 to approximately 0.5 by the flare light, according to the solid curve. The contrast in the middletone region has also been reduced appreciably, but the highlight contrast

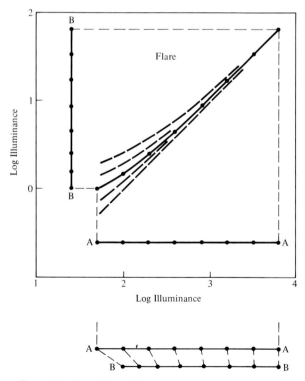

Fig. 10-6. The effect of flare or stray light on an image.

has scarcely been affected. In practice, the flare varies from camera to camera and also depends on the proportions of light and dark areas in the scene being photographed.

It has been found that the various flare curves are simply different portions of a single, generalized flare curve which can be moved to any position along the 45° line in the graph. For example, if the uppermost curve in Fig. 10-6 is moved bodily downward and to the left by sliding it down the 45° line, it will successively fit each of the other curves. Furthermore, the flare curves are almost coincident at the upper end of the tonal scale. Because of these simplifying characteristics, it is possible to define the flare for almost any practical situation by making photometric measurements of the illuminance of only two points in the image and the luminance of the two corresponding points in the scene or input. One point should be in the highlight region and the other in the shadow region. Only one of the possible flare curves will fit the logarithmic values of these measurements. The appropriate flare curve, which will then apply to all the tones in the image, can be chosen or interpolated from a family of standard flare curves. The flare grids of the type required in the tone reproduction diagram in Fig. 10-5 are derived by a method illustrated in Fig. 10-6. The black dots representing equal steps in log luminance are marked on the chosen curve and the corresponding log illuminances and log luminances are then used to draw the flare grid shown on the bottom of Fig. 10-6.

Three flare grids are, of course, required in Fig. 10-5. One applies to the camera image, another to the enlarger, and the third to the effect of the surface reflections or glare in viewing the reflection print. The latter is derived in a manner similar to that just described for a camera or an enlarger. The input for the surface reflection effect, however, is a set of density values for the print as measured with a conventional reflection densitometer. Again, it is sufficient to use only two values, the maximum and minimum densities. The log luminances of the corresponding two points in the print should then be determined with the aid of a telescopic photometer when the print is being viewed. Within the complete family of standard flare curves there is only one curve that will fit these data. Measurements at several other points on the print are, of course, desirable in order to increase the accuracy with which the proper flare (or glare) curve can be chosen.

Excellent examples of the effects of equipment flare and viewing glare on the tone reproduction obtained in color transparencies and reflection-type color prints have been given by Hunt, Pitt, and Ward.[33] They concluded that surface glare in the viewing of reflection-type prints is especially important. The amount of glare they encountered in viewing their prints was greater than that illustrated in Fig. 10-5. The effects of ambient light and flare in television have been discussed by Novick,[43] DeMarsh,[44] and Hunt.[32]

The study made by Jones and Condit[41] of camera flare is a basic reference in photography. They defined a "flare factor" as the ratio of the luminance range of the scene

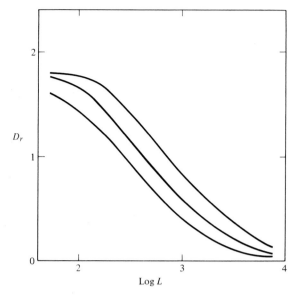

Fig. 10-7. Tone reproduction obtained with three different levels of printing exposure.

to the illuminance range of the image. The flare factor for their particular camera varied from 1.2 to 10, depending on scene type, and had an average value of 2.5 for outdoor scenes. The flare factor depends on the relative areas of the light and dark parts of the scene and its surround. The flare factor for a camera is usually greater than the flare factor for an enlarger because large bright areas, such as the sky, often surround the portion of the view being photographed. These bright areas are generally imaged on the camera's interior walls, and some of this light is reflected to the photographic film.

The tone reproduction curve shown in Fig. 10-5 represents only one condition of photographic printing. It is instructive to consider also the consequences of using several levels of printing exposure, as shown in

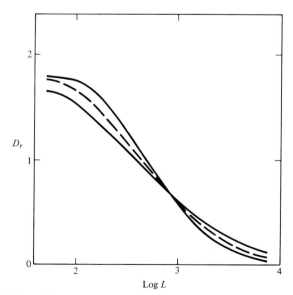

Fig. 10-8. Tone reproduction obtained by the use of three different contrast grades of photographic paper.

Fig. 10-7. The uppermost curve is typical of prints that usually are rejected because they are too dark and have poor shadow detail. The lowest curve is typical of prints that are rejected because they are too light and have "washed out" highlights. Methods of determining printing exposures from photoelectric measurements of light transmitted by the negative are described in the literature.[45,46]

The consequences of changing the contrast grade of the photographic priting paper are shown in Fig. 10-8. The high-gradient curve is characteristic of prints that are often described as "harsh." Such prints usually have

gradients that are too high in the middletones and too low in the shadows and highlights. The low-gradient curve in Fig. 10-8 represents prints that are described as "too flat."

Fig. 10-9 is a tone reproduction diagram for a slide transparency made with a color reversal film. Because the number of stages in this system is less than that required in a negative-positive process, there is room in the diagram for the camera image flare curve. The tone reproduction curve represents a slide projected on a screen in a darkened room. The flare involved in the viewing situation includes the flare from the projector

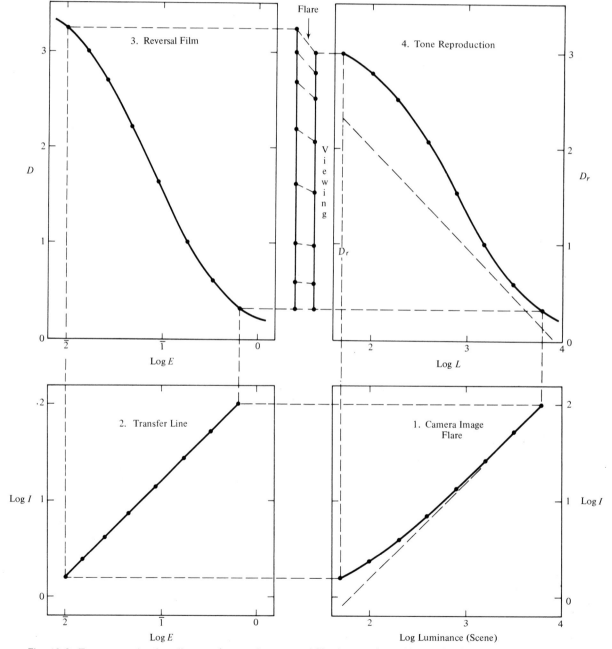

Fig. 10-9. Tone reproduction diagram for a color reversal film image viewed by projection in a darkened room.

lens and a small amount of unwanted room light super-imposed on the screen image. The average gradient of the curve is 1.3 and its maximum gradient is about 1.7. The curve is similar to that of the preferred slides discussed in the early parts of this chapter. The effect that superimposed uniform light or "veiling illuminance" has on the subjective quality and objective characteristics of screen images has been determined by Bartleson[47] and Estes.[48] Schumann[49] explored the consequences of varying the shape of the D-log E curve of color reversal films.

The scope of tone reproduction analysis is often limited, arbitrarily, to a study of the reproduction of the luminances and brightnesses of the various neutral or gray tones ranging from black to white that occur in original scenes or of the neutral tones introduced by placing a gray scale in the scene for test purposes. Tone reproduction analysis must, if it is to be complete, also be concerned with the reproduction of the luminances and the brightnesses of the colored areas of the scene. This part of the problem involves specifying the spectral sensitivities for black and white camera films, for which a relative spectral sensitivity equal to that of the average normal human eye is usually assumed to be desirable, and specifying appropriate spectral sensitivities, dye characteristics, color balance, and interimage effects for color photographic materials.[31,50-52]

The preferred objective tone reproduction gradient for color television has been determined by DeMarsh[44,53] who found that the optimum gradent is about 1.5 when the surround is dark, 1.2 when the surround is dim, and 1.0 when the surround is bright. These results are in good agreement with those reported by Novick[43] and also with those obtained in the photographic experiments described in connection with Fig. 10-1 of this chapter.

Unsharp masking[54,55] is a means of increasing the micro tone reproduction gradient (contrast of the small areas) in a photographic image without increasing the macro tone reproduction gradient (contrast of the large areas). A similar effect can be obtained by the use of scanning-beam printers with electronic feedback control.[56] Adjacency effects in development also provide a means of increasing the small-area gradients without increasing the large-area gradients.[57,58] The small-area gradient depends on the size of the detail, and the ratio of the small-area gradients to the large-area gradient is related to the modulation transfer function of the image.[58]

Examples of the application of tone reproduction analysis are found in studies of aerial photography,[59] a lunar orbiter system,[60] photography related to the earth resources technical satellite project,[61] graphic arts,[26,62-64] and many other recording systems. The subjective quality of images as a function of camera exposure has been determined for still-camera photographs[27,40,65] and motion pictures.[66] Image granularity can have a large effect on tone reproduction gradients and densities if the grain pattern of the negative is imaged sharply in a contact print or an enlargement, but the effect is usually very small because of the finite width of the light spread function at the printing stage.[67,68]

REFERENCES

1. C. E. Shannon, *Bell System Tech. J.*, **27**: 379, 623 (1948).
2. B. P. Lathi, *Communication Systems*, Wiley, New York, 1968.
3. M. Schwartz, *Information Transmission, Modulation, and Noise*, McGraw-Hill, New York, 1971.
4. R. C. Jones, *J. Opt. Soc. Amer.*, **51**: 1159 (1961).
5. R. Shaw, *Photogr. Sci. Eng.*, **6**: 281 (1962).
6. J. H. Altman and H. Zweig, *Photogr. Sci. Eng.*, **7**: 173 (1963).
7. C. N. Nelson, *Appl. Opt.*, **11**: 87 (1972).
8. L. D. Clark, *J. Soc. Motion Picture Television Engrs.*, **61**: 241 (1953).
9. J. L. Simonds, *Photogr. Sci. Eng.*, **5**: 270 (1961).
10. J. L. Simonds, *J. Photogr. Sci.*, **11**: 27 (1963).
11. L. D. Clark, *Photogr. Sci. Eng.*, **11**: 306 (1967).
12. L. A. Jones, *Photogr. J.*, **89B**: 126 (1949).
13. L. A. Jones and C. N. Nelson, *J. Opt. Soc. Amer.*, **32**: 558 (1942).
14. C. E. K. Mees and T. H. James, (eds.), *The Theory of the Photographic Process*, 3rd Ed., Macmillan, New York, 1966, Chapt. 22.
15. C. J. Bartleson and E. J. Breneman, *Photogr. Sci. Eng.*, **11**: 254 (1967).
16. H. K. Hartline and F. Ratliff, *J. Gen. Physiol.*, **40**: 357 (1957).
17. F. Ratliff, H. K. Hartline, and W. H. Miller, *J. Opt. Soc. Amer.*, **53**: 110 (1963).
18. S. S. Stevens and J. C. Stevens, *J. Opt. Soc. Amer.*, **53**: 375 (1963).
19. S. S. Stevens and J. C. Stevens, *Psychophysics Laboratory Report PPR-246*, Harvard University, 1960.
20. S. S. Stevens and A. L. Diamond, *Vision Res.*, **5**: 649 (1965).
21. S. S. Stevens, *J. Acoust. Soc. Amer.*, **39**: 725 (1966).
22. E. J. Breneman, *Photogr. Sci. Eng.*, **6**: 172 (1962).
23. C. J. Bartleson, *Photogr. Sci. Eng.*, **12**: 36 (1968).
24. C. J. Bartleson, *J. Opt. Soc. Amer.*, **58**: 992 (1968).
25. C. J. Bartleson and E. J. Breneman, *J. Opt. Soc. Amer.*, **57**: 953 (1967).
26. C. J. Bartleson and F. R. Clapper, *Printing Technlogy*, **11**: 1 (1967).
27. C. J. Bartleson, *Photogr. Sci. Eng.*, **9**: 174 (1965).
28. D. Jameson and L. M. Hurvich, *Science*, **133**: 173 (1961).
29. C. A. Padgham and J. E. Saunders, *Trans. I. E. S.*, **31**: 122 (1966).
30. J. W. Onley, *J. Opt. Soc. Amer.*, **51**: 1060 (1960).
31. R. W. G. Hunt, *J. Photogr. Sci.*, **18**: 205 (1970).
32. R. W. G. Hunt, *Brit. J. Kinematogr., Sound, Telev.*, **51**: 268 (1969).
33. R. W. G. Hunt, I. T. Pitt, and P. C. Ward, *J. Photogr. Sci.*, **17**: 198 (1969).
34. R. W. G. Hunt, *Royal Television Soc. J.*, **11**: 220 (1967).
35. D. Jameson and L. M. Hurvich, *Vision Res.*, **4**: 135 (1964).
36. A. M. Marsden, *Vision Res.*, **9**: 653 (1969).
37. W. H. Carnahan, *Photogr. Eng.*, **6**: 237 (1955).
38. J. S. Chandler and J. J. DePalma, *J. Soc. Motion Picture Television Engrs.*, **77**: 1012 (1968).
39. L. A. Jones, *J. Franklin Inst.*, **190**: 39 (1920).
40. L. A. Jones, *Photogr. J.*, **89B**: 126 (1949).
41. L. A. Jones and H. R. Condit, *J. Opt. Soc. Amer.*, **38**: 123 (1948) and **38**: 94 (1949).
42. P. W. Dorst, *J. Opt. Soc. Amer.*, **34**: 579 (1944).
43. S. B. Novick, *Brit. J. Kinematogr., Sound, Telev.*, **51**: 268 (1969).
44. L. E. DeMarsh, *J. Soc. Motion Picture Television Engrs.*, **81**: 784 (1972).
45. C. J. Bartleson and R. W. Huboi, *J. Soc. Motion Picture Television Engrs.*, **65**: 205 (1956).
46. J. G. Stott, W. R. Weller and J. E. Jackson, *J. Soc. Motion Picture Television Engrs.*, **65**: 216 (1956).
47. C. J. Bartleson, *Photogr. Sci. Eng.*, **9**: 179 (1965).
48. R. L. Estes, *J. Soc. Motion Picture Television Engrs.*, **61**: 257 (1953).
49. G. W. Schumann, *Photogr. Sci. Eng.*, **6**: 146 (1962).
50. R. M. Evans, W. T. Hanson, Jr. and W. L. Brewer, *Principles of Color Photography*, Wiley, New York, 1953.

51. D. L. MacAdam, *J. Photogr. Sci.*, **14:** 229 (1966).
52. P. Kowaliski, *J. Photogr. Sci.*, **11:** 169 (1963).
53. L. E. DeMarsh, *Proc. of Conf. on Optimum Reproduction of Color*, Intersociety Color Council, M. Pearson (ed.), Rochester Institute of Technology, 1971.
54. J. A. C. Yule, *Photogr. Soc. Amer. J.*, **11:** 123 (1945).
55. J. A. Eden, *Photogram. Record*, **1:** 5 (1955).
56. A. C. Webster, *Image Dynamics in Science and Medicine*, p. 6, (Journal) Aug (1969).
57. R. S. Barrows and R. N. Wolfe, *Photogr. Sci. Eng.*, **15:** 472 (1971).
58. C. N. Nelson, *Photogr. Sci. Eng.*, **15:** 82 (1971).
59. J. L. Tupper and C. N. Nelson, *Photogr. Eng.*, **6:** 116 (1955).
60. B. L. Elle, C. S. Heinmiller, P. J. Fromme and A. E. Neumer, *J. Soc. Motion Picture Television Engrs.*, **76:** 733 (1967).
61. R. M. Shaffer, *Image Technology*, p. 18, April–July (1973).
62. R. E. Maurer, *Gravure*, p. 22, August (1961).
63. R. E. Maurer, *Proc. Tech. Assoc. Graphic Arts* (1963).
64. J. A. C. Yule, *Advances in Printing Science and Technology* (Proc. 7th Intern. Conf. of Printing Res. Institutes, London, 1963) Vol. 3, p. 17, Pergamon Press, New York, 1964.
65. C. N. Nelson, *Photogr. Sci. Eng.*, **4:** 48 (1960).
66. A. L. Sorem, *J. Soc. Motion Picture Television Engrs.*, **62:** 24 (1954).
67. L. D. Clark and C. N. Nelson, *Photogr. Sci. Eng.*, **6:** 84 (1962).
68. J. H. Altman and R. M. Peden, *Photogr. Sci. Eng.*, **6:** 130 (1962).

11

SILVER REPROGRAPHIC* AND WEB IMAGE—TRANSFER PROCESSES

Thomas T. Hill

This chapter reviews reprographic and web image transfer processes which provide a positive print by transferring a silver image from a silver halide negative layer to a separate layer in a rapid manner. These processes utilize nonviscous processing solutions; other silver image transfer processes and dye image transfer processes utilizing viscous processing solutions are discussed in Chapter 12, "One-Step Photography."**

Image transfer processes which result in positive prints have often been referred to as diffusion transfer reversal (DTR) processes. The following description is a general statement of a silver DTR process. An exposed silver-halide emulsion layer is developed with a special processing solution that contains a silver-halide solvent (such as hypo), while this original exposed emulsion layer is in contact with another layer that is not light sensitive (but which is usually specially prepared). While the negative image is being developed in the exposed layer, the silver halide solvent complexes and dissolves *unexposed* silver halides (representing the positive image desired), which are then diffused or transferred to the second layer and there developed up into a silver positive image, aided by substances contained in the second, non-light-sensitive layer. The negative, commonly supplied on an inexpen-

sive paper base, is usually discarded, although in some special cases it may be fixed out and saved for further use. See Fig. 11-1 for illustrations of both the two-sheet and the one-sheet variations.

Some references[13] describe the processing solution used in DTR as a "monobath." While it is indeed single solution processing, the amount of silver halide solvent, such as sodium thiosulfate (hypo), is usually much less than is necessary to completely fix a negative layer, as is done in standard monobath processing. This processing solution is otherwise similar to a standard print developer.

HISTORICAL***

Early observations of image transfer phenomena, as well as a chronology of commercial applications are outlined in the chart on pp. 256–257. The principal inventors in this field are Andre Rott, Edith Weyde and Edwin H. Land. Chapter 12 of this volume, co-authored by Land, includes an account of his early image transfer research at Polaroid. *Photographic Silver Halide Diffusion Processes*, by Weyde and Rott, covers their respective work

*Reprography. General term applied to photographic techniques of reproducing flat originals (documents, photographs, printed matter, pictures, etc.) Its scope covers copying as well as graphic arts processes. (from the Focal Encyclopedia of Photography)

**The chart on pp 256–257 outlines the principal materials and processes covered in one or the other of these chapters.

***Much of the history of *Diffusion Transfer Processes*, along with extensive lists of the early patents involved, is discussed in detail in the chapters on this subject entitled: "Diffusion Transfer Reversal Materials," in earlier editions and will not be repeated here.[3]

DIFFUSION-TRANSFER-REVERSAL (DTR)

STAGE 1—The exposed but undeveloped negative.

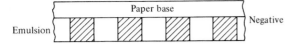
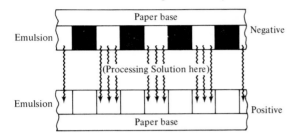

STAGE 2—Processing. The exposed (background) areas of the negative are developed. Transfer of a positive image by diffusion from the text areas begins to take place.

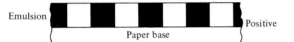

STAGE 3—The positive image after transfer is completed and the two sheets have been separated.

Fig. 11-1A. Three stages in the formation of a DTR image. When the negative and receiving sheets are coated on separate bases, as in the Office-copy materials.

in the laboratories of AGFA in Germany and Gevaert* in Belgium.[1]

Both European inventors had observed peculiarities during unrelated investigations which indicated that images were being diffused out of an exposed silver halide layer during development and being deposited in another layer. In the case of Weyde's observations, the deposition was in the baryta coating under the emulsion layer of a photographic printing paper. Rott described the observation of a faint positive image on the paper support under a negative layer which had partially come off during fixing.

The technical description of these processes in the literature was confused by the problems of communication during World War II. Very little commercial application was attempted before 1947. The history of many silver reprographic processes marketed, particularly in the United States, was also confused by the fact that many marketeers obtained paper and processing solutions from either AGFA or Gevaert, or from one of several later manufacturers in the United States.

TECHNICAL ASPECTS OF DTR REPROGRAPHIC PROCESSES

The main reprographic application of DTR processes has been in office copying, and this application will be described in detail.

*AGFA and Gevaert merged in 1964, and have since marketed a series of DTR materials based on work earlier in their individual laboratories, and newer work since in the merged organization.

Stage I—Exposed but not processed

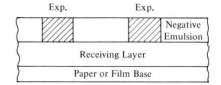

Stage II—Processing and transfer

Stage III—Washing-off of the negative layer

Stage IV—Completed processing leaving only positive image

Fig. 11-1B. Stages in formation of a positive DTR image when both emulsion (negative) and receiving (positive) layers are coated over each other on a single support, or base.

In office copy work, the paper-based negative is exposed to an original, usually by reflex contact-printing—that is, with the light passing through the sensitive sheet and reflected from the white areas of the original being copied to expose the corresponding portion of the negative emulsion. This exposed negative sheet is then placed in contact with a prepared receiving sheet, which is to become the positive print. The superposed sheets are inserted, as in the Eisbein-type machine,[4] Figs. 11-2 to 11-8, into a tray of processing solution in such a way that the processing liquid wets the facing surfaces of both sheets. The sheets are then carried through the machine to a pair of squeezing rollers, which squeeze out excess processing solution, ensure intimate contact between the positive and negative layers, and deliver the sheets outside the machine. After 15 to 30 sec the two sheets are stripped apart by hand and the negative discarded. The receiving sheet bears a positive reproduction of the original. The procedure described is illustrated in Fig. 11-1a (first example). AGFA marketed their copy materials under the trade name "Copyrapid," and Gevaert under the names "Transargo" and "Gevacopy," while both supplied materials to others under different labels.

In the early years of their use for office copying, when offices were lighted by tungsten illumination only, fast photocopy papers were satisfactory as negatives, but with the advent of higher intensity fluorescent illumination having a higher proportion of blue light, these papers

BASIC CHEMISTRY OF THE SILVER IMAGE DIFFUSION PROCESS

The following simplified outline covers the basic chemistry involved but there are many variables, and many chemicals added to either or both of the negative and positive layers, as well as in the solution.

For a fuller discussion, see the 70-page Chapter VI in the Rott-Weyde Monograph[1] and the papers by Land and other Polaroid workers.

The development of the exposed negative image is essentially the same as in the standard photographic silver halide processes. In the following equations, Ag refers to silver, X to any of the halides (Chloride, Bromide or Iodide or mixtures of them), S and O refer to sulfur and oxygen, and $Na_2S_2O_3$ to sodium thiosulfate. DA refers to the developing agent(s).

$$AgX + DA = Ag + Oxidized\ DA + X^-$$

In normal processing, the *unexposed* AgX would not react until put into a fixing bath, but since a very small amount of a fixing agent (thiosulfate) is present in the processing solution, some of the unexposed AgX is complexed by the thiosulfate:

$$2\,AgX + 2\,Na_2S_2O_3 = Ag_2S_2O_3{\cdot}Na_2S_2O_3 + 2\,NaX$$
$$\text{(the Complex)}$$

This complex is soluble and is in solution. In the presence of some colloidal silver nuclei (or other nucleating agent) it can be reduced (developed):

$$Ag_2S_2O_3\ Na_2S_2O_3 + 2\,DA + Na_2CO_3$$

$$= 2Ag + 2\ Oxidized\ DA + 2\,Na_2S_2O_3 + CO_2 + H_2O$$

and the complexed siver-thiosulfate is split, the silver becoming the positive image desired, and the sodium thiosulfate released in soluble form to diffuse back into the negative layer to complex more unexposed silver halide. Because it is used and reused repeatedly, only a very small amount of thiosulfate is needed overall.

Fig. 11-2. Cross-sectional view of the original design for a processing machine for DTR office-copy papers. Note 4 separators making 3 slots so 2 negatives could be inserted facing a double-coated positive. (U.S. Patent 2,657,618[4] to Dr. Walter Eisbein.)

transfer agent (sodium thiosulfate or its equivalent) was incorporated in the receiving sheet, which allowed more of the negative image to develop before the thiosulfate dissolved into the processing liquid and then solubilized some of the unexposed silver halide in the negative sheet to initiate diffusion transfer.

Unprepared receiving sheets were used in the earlier days, and it was even possible to use cheap sulfite notebook paper and get a readable copy. However, it was soon found that improvements could be made in two ways in the receiving sheet. First, "nucleating agents" such as colloidal silver or other metals, metal sulfides, and other materials which would attract the complex of thiosulfate and silver being diffused from the negative sheet, gave improvement in image sharpness. Secondly, the addition of "blue black agents" such as benzotriazole, resulted in a blacker or more "neutral" color image. Usually these materials were coated onto the positive receiving paper base in a suspension of gelatin. Some manufacturers mixed synthetic polymers with the gelatin or even tried to replace it completely in order to speed the drying of the sheet after separation from the negative.

AGFA[15] and Lumoprint[16] in Germany have also marketed variations** of the DTR office copy system, in which the processing solution is eliminated and the

fogged quite easily in room light and slower emulsions were adopted. Other than this change, there was no major difference between these office copy negative papers and other photographic papers, except that the barium sulfate (baryta) underlayer used for quality photographic prints was not used.

Some of the original versions of copy materials had the developing agents incorporated into the negative emulsion. In other cases, developing agents were incorporated into the receiving sheet to simplify the processing solution and increase its tray life.* In still other versions the

*Such a solution without developing agents is referred to as an "activator" and contains only the alkali, some restrainer, and a small amount

of preservative. It will last much longer in the tray or machine than a "processing solution" containing developing agents, and is similar to the "activator" used with currently available stabilization processing papers which also have "incorporated developing agents" in the emulsions. However, in that process a second bath is necessary (the "stabilizer"), and for prints to be used longer than a short time, fixing and washing are required. No such after-treatment is necessary in the DTR systems.

**AGFA "Copyrapid Dry" in 1966, and AGFA "Copyrapid Mono Dry;" the latter having both negative and receiving layers on one base sheet.

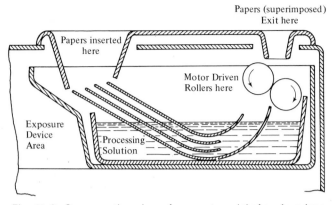

Fig. 11-3. Cross-section view of a recent model of an American version of the Eisbein design for processing reprographic DTR papers.

Several DTR products have been marketed with both the negative layer and the receiving layer coated upon the same support. Gevaert introduced a pictorial material called Diaversal,[5] Fig. 11-1b, in which an unhardened negative layer was coated over a hardened receiving layer on a single paper base. The paper after exposure was processed to a negative and then put through a "transfer bath" containing sodium thiosulfate, which transferred undeveloped silver halide (which had not been exposed) from the upper negative layer, by diffusion into the lower, receiving layer. Following this step the upper layer was washed off in warm water, and the paper retaining a positive image dried. Early forms of this material gave a light brown positive image which was then toned in a selenium or other toner to give higher density and a neutral color to the image. A similar high-contrast material was introduced in about 1961 by Anken and others and supplied by Anken to the Photostat Corporation for use in large "photostat" copying machines. In this case, wide rolls could be used and the processing was completely automatic. The same arrangement of a hardened receiving layer beneath an unhardened negative layer was used.[6]

"development" consists of running the two sheets (negative and positive) between heated rollers. This is possible because the developing agents are incorporated into the negative-emulsion layer, together with a dry, relatively weak, alkali. When dry, no reactions occur, but when the paper is heated, another ingredient, a water-containing inert salt, decomposes to yield enough moisture to activate the development and transfer processes. Such a salt, normally "dry," would be sodium sulfate hydrate, or sodium acetate hydrate, in which the water of crystallization is bound loosely to the salt and can be removed by heating.*

Many specialized types of supports for receiving layers were marketed. Examples include card-stock; very thin paper base for use in airmail correspondence; translucent or transparent bases for use as "masters" for inexpensive diazo copying procedures, and heavy paper or aluminum sheets for use as offset plates in office-size printing equipment.

As with any chemical reaction, DTR processing is faster at higher temperatures, limited, of course, by increased softening or damage to the gelatin of the emulsion layers.

*Both sheets are therefore dry to the touch both before and after processing, as is the single sheet of the Copyrapid Mono Dry. This completely eliminates the tray of processing solution or "activator" used with earlier versions.

Fig. 11-4. Photograph of a modern reprographic processing machine based upon the Eisbein design; made in Holland for A. B. Dick. Tray and separators laid out.

Fig. 11-5. Photograph of same A. B. Dick Machine partly assembled.

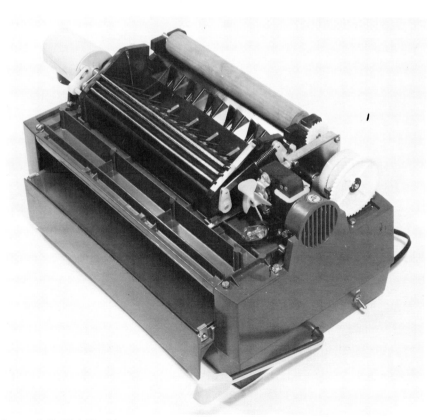

Fig. 11-6. Photograph of same A. B. Dick Machine more completely assembled; separators into tray at left (front); tray placed upon base which is exposure-unit and contains motor drive. One of two rollers in place at rear (top right) slots for second roller seen adjacent. Supply bottle of processing solution fits onto connection at far left. Plastic cover with inlet and outlet openings completes the machine.

Fig. 11-7. Photograph of assembled Eisbein-type DTR processing machine shown in previous pictures, with both rollers in place. See next picture for same with cover in place.

Fig. 11-8. Fully assembled Eisbein-type DTR processing machine (of A. B. Dick) ready for use.

The office-copy materials were intended for short term use and were not considered to be archival in quality, compared to properly processed regular photographic papers. Many users, however, have kept them much longer than was originally intended by the manufacturers and have found that, depending upon the stage of exhaustion of the processing solution, brown stains would slowly appear in the clear (white) areas of the prints due to oxidized developing agent. However, in the DTR processes no *fixing* of the positive is necessary because no silver salt is present in the print except that which transfers across and then is immediately developed up to a silver image by the processing solution. Thus, the papers dry immediately upon stripping the negative away and are usable within a minute or two. Since these processes are usually performed in room-light conditions the negative is of course, fogged after stripping off and is usually discarded. It is possible, however, if working in a darkroom, to put the stripped negative into a tray of normal photographic fixer, fix out and wash it and use it as a "paper negative."

VALUE OF OFFICE-COPY DTR PROCESSES

Although considered almost obsolete today, in the decade of 1950–60 over a billion dollars worth of these materials, solutions, and machines were sold in the United States,[8] which shows the economic importance of both the processes and the processing equipment. The DTR office-copy processes, together with Kodak's "Verifax" (gelatin stratum transfer) and Minnesota Mining's "Thermofax" (thermographic) processes, had produced an entirely new market which had not existed in the forties: office-copying. Photostat and other wet-process copying processes in use earlier cost much more, and results weren't obtained quickly, nor were they as suitable for office use.

With the advent of the completely dry processes, such as the electrostatic types (see Chapter 13), which give a clean, dry print immediately and are much more convenient for making multiple prints from one original, the decline of the DTR reprographic copy process was rapid. DTR materials are still available, however, and thousands of the machines are still in use. One reason for this is that the DTR process, based on silver halide, gives a much better rendition of continuous tone (pictorial) illustrations than do most electrostatic ones. This is because the silver halide material, even though high in contrast, has a longer "tone-scale" than do the nonsilver systems currently available.

WEB TRANSFER PROCESSES

Except for Gevaert "Diaversal" paper, the materials discussed to this point have been low speed, high contrast types, mainly for line copying uses. In addition to the Polaroid Land films (see Chapter 12), there have been other pictorial, continuous-tone, high-speed materials available more recently.

Although not involved in the DTR office copying systems (except as manufacturer of CT papers* in Europe), Eastman Kodak has done considerable work in the web processing field, and materials of this type were provided to the military organizations in the early 1960s; the name "Bi-Mat" was applied to one of these systems in 1963.[9] For various reasons, Kodak did not market equipment for use with Bi-Mat materials, so several other firms developed such processing equipment, notably Mark Systems in California, and HRB-Singer in State College, Pennsylvania. Later Merrick Photo in San Jose, California, introduced small volume user processing equipment aimed at professional and amateur photographers. Bi-Mat was provided in long rolls of 35 mm and 70 mm widths, as well as wider rolls for military applications.

A unique aspect of Bi-Mat was its elimination of the processing solution as a separate component. The processing solution, in carefully measured amounts, was imbibed into the gelatin of the receiving layer (coated either on transparent film base or on opaque photopaper); while the layer was dry to touch, enough moisture was present to accomplish processing when this layer was rolled under pressure against the exposed silver halide negative material. The imbibed positive material had to be packaged in a hermetically-sealed can to keep its properties. When loaded into a processor along with a matching roll of exposed negative material, it provided an immediate positve and a usable negative. The negative could be rolled up damp and stored for several hours before being fixed out, washed and dried, after which prints and enlargements could be made by the usual photographic procedures.

In these continuous-tone images made by the Bi-Mat processes, good resolution and excellent pictorial quality were obtained.

It was found by experimentation that the imbibed web of processing solution in the receiving layer could be used to process a large number of negative materials, and this was the basis of the system worked out for the user of short lengths of film (36 35 mm exposures, for example) by Merrick Photo. They gave instructions for the processing of any of over 20 types of negative films, from litho and microfilms to standard high-speed films such as Kodak's Tri-X.

In the web transfer process trademarked "Ditrecon" by HRB-Singer,[10] Fig. 11-9, the negative could be given additional development before fixing; if the positive formed on the "web" was not suitable, longer development or developers which would change the contrast could be used. After fixing, washing and drying the negative, new prints and enlargements of improved quality could be made. Obviously the Bi-Mat web with imbibed developer can be, and has been used as a convenient "dry" source of developer for processing long rolls of film, and if the user doesn't need the immediately avail-

*"Chemical Transfer" papers.

Fig. 11-9. Cross-section view of one of the HRB-Singer "Ditrecon" processing systems for the Kodak "Bi-Mat" materials.

able print, exposure and processing can be adjusted to give the best possible negative, for later printing or enlarging by normal photo methods on regular print paper.

Bi-Mat has been discontinued by Kodak, and its variants are not available.

GRAPHIC ARTS APPLICATION

Many graphic arts applications of the DTR principles have been described, and some have been on the market. One due to Rott of Gevaert is Contour Film,* described with illustrations in earlier editions of this work, as well as in the monograph by Weyde and Rott.[1] Contour-film had a negative layer coated over an unhardened receiving layer, as in Diaversal paper, but in this case a positive emulsion was included in the lower layer. The two emulsions had different spectral sensitivity; the top, negative

emulsion being orthochromatic, and the lower, positive emulsion being blue-sensitive. Internegative effects during exposure and development (Mackie line; Sabattier and other image enhancement effects) made it possible to alter tone and line aspects of pictorial images, or to "dress up" graphic arts type faces. It was also promoted for applications in textile printing, where contoured effects and "shadowed" images are used.[1] The product has been discontinued.

Gevaert was the first producer of DTR aluminum offset plates for graphic arts use; the development of these materials is described in detail by Rott.[7] Eastman Kodak more recently introduced "PMT" aluminum offset plates of this type, as well as PMT (Photomechanical Transfer) papers,[11] and Kodak Ltd. has distributed similar materials in Europe under the name Instafax.

Paper-based receiving sheets are used either with slow negatives designed for reflex printing or with negatives of enlarging paper speed ("camera speed" to graphic arts workers). Transparent positives are also possible with a variety of film base supported receiving layers. With a graphic arts type screen (line or dot) over the negative

*Not to be confused with a later product, Agfacontour, a high contrast "equidensity" film processed by conventional tank development.

emulsion, continuous tone images are copied for use in offset printing. Processing is identical to that of the earlier "office-copy" papers; many dormant Eisbein-type processing machines have been reactivated to use these new products.

In conclusion it may be noted that in spite of the decrease in use of reprographic, or office-copy uses, some of the DTR applications superseded in the United States are still in use elsewhere, since machine costs are much lower than with the electrostatic processes.

In addition, some of the discontinued DTR variations which are among the more technically interesting, such as Bi-Mat and Contour film, may well be reactivated for new applications. These processes can often do a "job" in a simpler and less expensive manner than methods now in use. Finally, there are many patents for variants never marketed, which have attractive possibilities. One described by Roth utilizes as the negative material a print-out type of emulsion containing water-soluble silver salts, rather than the usual type of developing-out emulsion, which permits the processing solution to be simply water.[14]

REFERENCES

1. Andre Rott and Edith Weyde, *Photographic Silver Halide Diffusion Processes*, Focal, London and New York, 1972.
2. E. H. Land, H. G. Rogers and V. K. Walworth, "One-step Photography," Chapt. 12 in this volume.
 E. H. Land,, "A New One Step Photographic Process," *J. Opt. Soc. Amer.*, 37 (2): 61–77 1947.
3. L. Varden, "Diffusion Transfer Reversal Processes," Chapter 16 in the Fifth Edition, and Chapter 28 in the Sixth Edition (1962) of this volume.
4. W. Eisbein, U.S. Patent 2,657,618 and corresponding patents (1953).
5. T. T. Hill, "The Diaversal Process," *Photogr. Eng.*, 2 (2): 192 (1951).
 B. Meerkamper, "Diaversal Reversal Paper," *Camera* (Lucerne), 28: 78–80 (Mar 1949).
6. Anon., "Integral Diffusion Transfer," *Perspective*, 4 (4): 223 (1962) (Newsnote on Anken's Ankopositive materials).
7. A. Rott, "The Gevacopy Aluminum Offset Process," *J. Photogr. Sci.*, 8 (1): 26–32 (Jan/Feb 1960).
8. (a) Anon: Transcript of Testimony in trial in Chicago Federal Court, Mar 1959, of Copease vs. American Photocopy Equipment Co. (APECO). Brief for Appellant #13296-12296, p 151; quotation re: sales during 1952 of over one million dollars for one company alone.
 (b) H. J. Sanders, "The Revolution in Office Copying," *Chem. Eng. News* (ACS), 42: 115–129 (July 13, 1964), 84–96 (July 20, 1964) (esp. p. 116).
9. L. W. Tregillus, et al., U.S. Patent 3,179,517 (1965) (appl. 1959). R. Tarkington, The Kodak Bi-mat Process, Photogram Engr. 31 (1): 126–30 (Jan 1965); also Preprint, A New Kodak Processing Method for the Aerospace Age: SPIE 1963 Annual Conf.
10. J. B. Taylor, "Moving Window Displays . . . *SPIE J.*; 4 (June–July 1966), and technical reports of HRB-Singer 1965–70. Also paper presented to SPSE Annual Conf., 1967.
11. Anon, Kodak PMT Photomechanical Transfer Materials, EK Publication #H3-183, May 1972.
12. T. T. Hill, Diffusion Transfer Reversal as Applied to Photocopying, *Photogr. Eng.*, 4 (4): 214 (1953).
13. Grant Haist, Monobath Manual, Morgan & Morgan, Hastings-on-Hudson, N.Y., 1966, pp. 127–140.
14. Curt B. Roth, U.S. Patent # 3,042,514, Material and Process for Forming a Positive Silver Image, assg. Ansco.
15. L. A. Mannheim (Ed.), Perspective World Report, 1966–1969 Focal, London and New York, 1969, p. 138.
16. Rudolf Wendt, U.S. Patent #3,211,551 (1965) and corresponding Ger., Fr. and Brit. Patents (APSE 1331/66P, etc.).

EARLY EXAMPLES OF IMAGE TRANSFER PHENOMENA

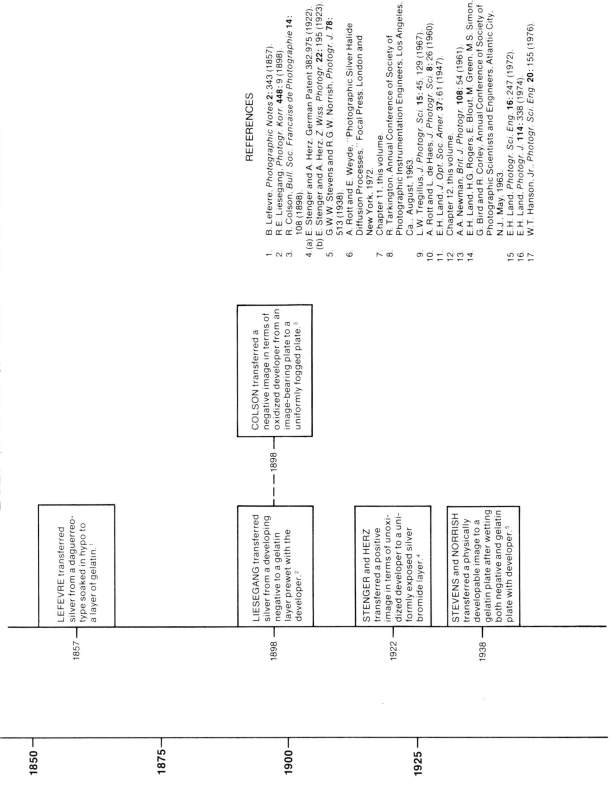

REFERENCES

1. B. Lefevre. *Photographic Notes* **2**: 343 (1857).
2. R. E. Liesegang. *Photogr. Korr.* **448**: 9 (1898).
3. R. Colson. *Bull. Soc. Francaise de Photographie* **14**: 108 (1898).
4. (a) E. Stenger and A. Herz. German Patent 382.975 (1922).
 (b) E. Stenger and A. Herz. *Z. Wiss. Photogr.* **22**: 195 (1923).
5. G. W. W. Stevens and R. G. W. Norrish. *Photogr. J.* **78**: 513 (1938).
6. A. Rott and E. Weyde. "Photographic Silver Halide Diffusion Processes." Focal Press. London and New York, 1972.
7. Chapter 11, this volume.
8. R. Tarkington. Annual Conference of Society of Photographic Instrumentation Engineers. Los Angeles. Ca., August, 1963.
9. L. W. Tregillus. *J. Photogr. Sci.* **15**: 45, 129 (1967).
10. A. Rott and L. de Haes. *J. Photogr. Sci.* **8**: 26 (1960).
11. E. H. Land. *J. Opt. Soc. Amer.* **37**: 61 (1947).
12. Chapter 12, this volume.
13. A. A. Newman. *Brit. J. Photogr.* **108**: 54 (1961).
14. E. H. Land, H. G. Rogers, E. Blout, M. Green, M. S. Simon. G. Bird and R. Corley. Annual Conference of Society of Photographic Scientists and Engineers. Atlantic City. N.J. May, 1963.
15. E. H. Land. *Photogr. Sci. Eng.* **16**: 247 (1972).
16. E. H. Land. *Photogr. J.* **114**: 338 (1974).
17. W. T. Hanson. Jr. *Photogr. Sci. Eng.* **20**: 155 (1976).

1857 — LEFEVRE transferred silver from a daguerreotype soaked in hypo to a layer of gelatin.[1]

1898 — COLSON transferred a negative image in terms of oxidized developer from an image-bearing plate to a uniformly fogged plate.[3]

1898 — LIESEGANG transferred silver from a developing negative to a gelatin layer prewet with the developer.[2]

1922 — STENGER and HERZ transferred a positive image in terms of unoxidized developer to a uniformly exposed silver bromide layer.[4]

1938 — STEVENS and NORRISH transferred a physically developable image to a gelatin plate after wetting both negative and gelatin plate with developer.[5]

1850 1875 1900 1925

CLASSIFICATION AND CHRONOLOGY OF PRINCIPAL IMAGE TRANSFER SYSTEMS

PROCESSING MATERIALS	Multiple Solutions and Washes	Single Solution		Pod/Viscous Reagent
PROCESSING EQUIPMENT	Tanks or Trays	Tank/Rollers	Web Transport/Rollers	Camera with Rollers
FILM PROPERTIES	Low Speed Materials for Use in Reprography		High Speed Materials for Camera Originals	
	Continuous Tone / High Contrast (Line Copy)		Continuous Tone	High Contrast

1940 **TRANSARGO** (Gevaert)[6]
VERIFLEX (Agfa)[6]

1947 **DIAVERSAL** (Gevaert)[6,7]

1947 LAND demonstrated one-step camera and film, sepia print process.[11,12]
1948 **TYPE 40**, speed 100 (Polaroid)[12]

1949 **COPYRAPID** (Agfa)[6,7]

1950 **GEVACOPY** (Gevaert)[6,7]

1950 **TYPE 41** Black and White, speed 100 (Polaroid)[12]

1955 **TYPES 42, 43, 44**, speeds 200, 400 (Polaroid)[12]

1957 **TYPE 46** Transparency, speed 800 (Polaroid)[12]

1958 **CT**: Chemical Transfer (Kodak)[7]
1958 **GEVACOPY** Aluminum Offset (Gevaert)[6,7,10]

1959 **TYPE 47**, speed 3000 (Polaroid)[12]

1960 **CT** Offset Aluminum Plates and Paper (Kodak)[13]

1961 **TYPE 55 P/N** Positive/ Negative (Polaroid)[12]

1961 **TYPE 146L** Polaline (Polaroid)[12]
1961 **TYPE 410** Polascope, speed 10,000 (Polaroid)[12]

1963 TARKINGTON demonstrated continuous web processing of negative and positive: **BIMAT** (Kodak)[6,7,8,9]

1963 LAND et al. demonstrated one-step color print process. **POLACOLOR** (Polaroid)[14]

1965 **DITRECON** (Singer)[6,7]

1967 **COPYRAPID DRY** (Agfa)[6,7]
1967 **INSTAFAX** (Kodak)[7]

1969 **PMT**: Photomechanical Transfer (Kodak)[7]

1972 LAND demonstrated fully integral color film, metallized dye developers: **SX-70** (Polaroid)[12,15,16]

1975 **POLACOLOR 2** (Polaroid)[12]
1976 **PR10** (Kodak)[17]

1940
1945
1950
1955
1960
1965
1970
1975

Fig. 12-1. Reproductions of the first published SX-70 prints, used as illustrations in Ref. 3a.

12
ONE-STEP PHOTOGRAPHY*

Edwin H. Land,
Howard G. Rogers
and Vivian K. Walworth

INTRODUCTION

Polaroid one-step photography combines into a nearly simultaneous set of operations the taking of a photograph, the processing of negative and positive images and the viewing of the finished print or transparency. Processing in a single step is accomplished by incorporating a photosensitive emulsion, an image-receiving system and a minute amount of totally enclosed viscous pro-

*In the previous edition one-step photography was discussed together with document copy photography in a chapter entitled "Diffusion-Transfer Reversal Materials" because processes in both fields involved reversal by transfer of soluble silver images. From the start, however, the two fields have differed significantly in characteristics ranging all the way from initial emulsion requirements and processing mode to final image properties; continuing growth and development in both fields has served to increase the distinction. Color processes, which now predominate in one-step photography, have no parallel in document copying, and the respective black and white processes have little in common.

In this edition the two fields are accordingly discussed in separate chapters. The earlier title is not used, as it does not adequately define the subject matter of either chapter. The preceding chapter, "Reprographic and Web Image Transfer Processes," covered contributions in the copying field, principally by Agfa-Gevaert, and in rapid, continuous image transfer systems, such as those of Kodak and Singer. This chapter will describe Polaroid's contributions in one-step photography. The chart on pp. 256–7 outlines in chronological and schematic form early observations of image transfer phenomena and the development of major products and processes covered in both chapters.

cessing reagent into a film assembly and including in the camera or film carrier a mechanism for releasing and applying the reagent. Once applied, the reagent concomitantly develops the negative and deposits the positive image, each in the appropriate layer or layers of a multilayer system. Although this outwardly dry processing operation involves an intricate family of carefully controlled physical, chemical and mechanical events, they proceed automatically and the user need not be aware of their complexity.

The one-step systems readily yield pictures having excellent image quality. The film speeds are high, so that the camera may usually be hand-held. With most of the one-step cameras exposure is controlled automatically. The photographer can make pictures quickly and easily; given the opportunity to view immediately picture and subject together, he can fully evaluate his work and proceed creatively on the basis of his own evaluation.

With one-step pack and roll film cameras the photographer, after making an exposure, initiates processing by pulling a paper tab or leader. Inside the camera this action draws negative and positive sheets together through a pair of pressure rollers, releasing and spreading reagent between the two sheets. After a short, specified interval the photographer peels the sheets apart and views the photograph.

The newest Polaroid one-step system, SX-70, completely automates the procedure. To make an SX-70 picture the photographer simply presses the shutter release

button. Exposure and processing follow in sequence, with the film unit ejected from the camera between motorized pressure rollers which release and spread the reagent. Image formation proceeds to completion within the ejected film unit. There is no timing or peeling apart; the photographer may watch the emerging image or may immediately take another picture.

Land first described and demonstrated one-step photography in February, 1947, before the Optical Society of America.[1] He outlined the theoretical considerations involved in designing one-step systems, broadly describing the entire field in addition to the process shown. The discussion delineated the practical requirements and the resulting plan which had been chosen to provide the desired simplicity of taking and viewing pictures.

In introducing one-step photography to the Royal Photographic Society in 1949,[2] Land stressed the opportunity afforded the creative photographer by the new medium and described the primary specifications for camera and process:

By making it possible for the photographer to observe his work and his subject simultaneously, and by removing most of the manipulative barriers between the photographer and the photograph, it is hoped that many of the satisfactions of working in the early arts can be brought to a new group of photographers.... From this photographic purpose there follows a chain of consequences, aesthetic, mechanical, and chemical, that direct and restrict the design of the camera and the character of the process. The picture must be available promptly after it is taken, and must be large enough for evaluation.... The camera should be as small and as light as is consistent with the picture size chosen, and should be dry and easy to load. The process must be reliable, safe, dry or apparently dry....The process must be concealed from—nonexistent for—the photographer, who by definition need think of the art in *taking* and not in *making* photographs....In short, all that should be necessary to get a good picture is to *take* a good picture, and our task is to make that possible.

With this aggregation of desiderata in mind, the camera and process were contemplated as interwoven fields of investigation.... the decision that the camera must be really dry—having neither fountain pen sacs, nor damp sponges, nor sprays, nor wet rolls—took some courage, because it implied that what the camera was to do to the film must be done with extraordinary simplicity, and that what the film was to do itself was to be unusual. Thus, the camera in our initial consideration was permitted to contain, beyond the ordinary possessions of any camera, a pair of small-diameter pressure rollers, and a flat, dry, dark chamber into which the film passed after traversing the gap between these rollers. The pressure during this traversal was to convert the exposed negative into the finished, positive, stable, dry picture.

CURRENT ONE-STEP PHOTOGRAPHY*

The SX-70 System

In May, 1972, Land reported to the Society of Photographic Scientists and Engineers on a new camera, new film and new process.[3a] Together these comprise the SX-70 system, described as "Absolute One-Step Photography" because it reached for the first time and indeed transcended the earliest objectives. The new system was a marked advance in one-step photography using in combination innovative camera design and greatly advanced technology in optics, electronics and chemistry.[3a,b]

With the SX-70 camera the photographer, after composing and focusing through the single lens reflex viewer,[3a,4a,b] touches an electric trigger. Within four-tenths of a second after the shutter closes, the film unit emerges from the front of the camera. The film unit is hard, dry, shiny, flat—and the image is invisible. Initially, the image area—within a white border—is a uniform pale green. Over the next minute or two a visible image materializes with enough color and definition for judgment of its merit. The materialization continues over a few minutes to provide the final full-color picture. Since the picture emerges from the camera directly into the light, with nothing to be peeled away, the photographer has the opportunity to observe the whole process of materialization. The photographer is not concerned with wet processing of negatives or timing of prints; therefore, he is free to take his next picture as soon as he wishes. Indeed, he may take another within 1.5 sec.

The images have no visible grain; the outer surface is also free from structure, and the density range in the image is high. The result is an interesting sense of tone continuity and a feeling of space in the shadows. Figure 12-1 reproduces pictures made by the SX-70 process, and Fig. 12-2 demonstrates the materialization of an image from the initial, invisible state to its final full color.

The SX-70 Film. The picture unit which is expelled from the camera is rectangular with three narrow borders and one wide border around a picture, ca. 8 by 8 cm. The film pack contains 10 of these units, a dark slide which is the same size as the unit, and a fresh battery[5] which is also the size and shape of the film unit. Since there are no accessory papers, leaders or connectors between picture units, the total pack is relatively thin. Furthermore, the picture units fit snugly in the pack, allowing it to be compact in all dimensions.

Structure and Components of Picture Unit. At the time of exposure each picture unit[6] consists of an integral

*This section discusses the present-day scope of Polaroid one-step photography, with particular emphasis on the SX-70 system and its components. The following section covers concepts basic to the design of one-step cameras and image processes, along with an account of Land's early experiments in image transfer and a summary of the resulting specifications for a practical one-step process. The last two sections trace the parallel evolution of the Polaroid silver image processes and dye image processes, respectively, and describe research relating to their design and performance.

Fig. 12-2. Stages in the materialization of an SX-70 image. The color print becomes visible as the opacifying dyes become colorless. The subject is crystalline silver nitrate between crossed polarizers, photographed at 80X.

(a) Before spreading reagent (b) After image formation

Fig. 12-3. Schematic cross sections of SX-70 film unit (a) before and (b) after development, drawn approximately to scale.

multilayer structure. (See Fig. 12-3). The outer two layers comprise most of the thickness, their thickness being selected as the minimum necessary to give a good feeling of rigidity and flatness. One of these two outer sheets is transparent, so that the light for exposure can penetrate through it into the integral structure, and the other one is opaque black. Both the clear and black-pigmented sheets are polyester, and the resulting structural symmetry ensures that the pictures stay flat under all conditions.*

The wide border of the picture unit conceals a very thin version of the Polaroid pod.** The borders are made of materials that are tough and accurately dimensioned. This material serves the aesthetic function of providing white margins, holds the integral structure intact, and helps to determine the distance apart of two inner layers of the integral structure when the viscous reagent within the pod is redistributed throughout the whole area in the processing mode. To achieve well-controlled processing under the special conditions defined by the compact film design, both the pod and the reagent spreading system had to undergo what Land called a forced evolution. He described the exigencies this way:

> We had to learn precision in filling the pods far beyond what we had previously regarded as precision. We had to learn to make a thin spread between layers already in place. We had to learn to make a square spread. We

*The improved SX-70 film introduced in 1976 includes a durable optical quarter-wave anti-reflection coating on the outer surface of the clear polyester sheet.[7] The reduced reflectivity minimizes flare and increases the efficiency of transmission both in exposure of the negative and in viewing of the final image.
**Pod structures and functions are discussed in detail on page 282.

had to learn to keep the residue at the end of the spread miniscule, and we had to learn to conceal this miniscule residue.[3a]

The integral picture unit contains no air spaces,[8] either before or after processing, as shown in the schematic drawings of Fig. 12-3. The whole inner structure within the two heavy layers has a total thickness of less than 2 mils (50 μm). Of this, the layers which constitute the negative are less than a third. The compactness of the SX-70 picture unit at each stage emphasizes the precision required. Nothing is added and nothing is discarded. Each component is present in the appropriate amount, and the total structure so composed is internally compatible and stable both as an unprocessed picture unit and as the finished full color picture.

The positive image-forming components of the SX-70 film unit are dye developers,[9] molecules which combine the light-absorbing properties of subtractive image dyes with the reactive functions of silver halide developing agents. Solubilization and diffusion of a dye developer are controlled by reactions of the developer portion of the molecule. The dye developer is initially insoluble in water. In aqueous alkali the developer forms a soluble salt; in the course of reducing exposed silver the developer moiety is oxidized, and its oxidation product has very low solubility. The chromophores of the highly stable dye developers used in the SX-70 negative are metallized dyes, and the developer moiety now used is hydroquinone.***

Each of the dye developers is initially positioned in a layer just behind a silver halide emulsion by which it will be controlled during processing. In each case the spectral sensitivity of the emulsion is complementary to the absorption of the dye developer it overlies. The color negative thus comprises three monochrome units—a blue-sensitive emulsion overlying a yellow dye developer, a green-sensitive emulsion over a magenta dye developer and a red-sensitive emulsion over a cyan dye developer. In addition there are spacer layers to control interactions between the three monochrome units. Figure 12-4 shows the spectral response of an SX-70 picture film unit in terms of the three transferred dye developers. The spectral response of each emulsion is a consequence of both its spectral sensitivity and optical filtration by the overlying structure.

Image Formation. When the SX-70 film unit passes through the rollers immediately after exposure, the pod sealed within the unit ruptures and the small quantity of viscous reagent forces its way between two layers of the integral structure, forming immediately a new integral structure with an inner stratum of white pigment, water, opacifying dyes,[10] an alkali, such as potassium hydroxide, and other photographically active materials. The potassium hydroxide penetrates the layers of the negative in about a second. It dissolves the dye developers by ionizing the developer groups and similarly solubilizes a small, mobile auxiliary developer molecule, such as

***Dye developers are discussed further in the section on Dye Image Processes, p. 318.

Fig. 12-4. Spectral response of an SX-70 film unit, displayed in terms of transferred dye developer. Each curve shows the spectral distribution of exposures corresponding to transfer of an amount of dye developer equivalent to that contained in a neutral gray area of density 1.0. The curve shape for each dye developer is a consequence of both the spectral sensitivity of the emulsion which controls that dye and optical filtration by the overlying layers of the integral structure.

methyl phenyl hydroquinone (MPHQ), which may be included either in the structure of the negative or in the reagent (Eqs. (a) and (b), Fig. 12-5). The auxiliary developer is similar in structure to the dye developers but, since it does not have a large dye moiety, this developer can move rapidly through all of the layers of the negative.

As soon as the alkali reaches and solubilizes the dye developers they are capable of moving from their original layers throughout the structure. In each emulsion layer, where the silver halide has been fully exposed, the auxiliary developer, which may be regarded as a "messenger," transfers an electron to a silver ion of the exposed silver halide, reducing the silver halide to silver and generating a semiquinone ion radical. The semiquinone radical, which lacks one electron, in turn takes an electron from a dye developer molecule, thus returning to its original state and leaving the dye developer in the semiquinone state. (Eqs. (c) and (d), Fig. 12-5). The process may be aided by a quaternary salt, originally present in the reagent, which "insolubilizes" the oxidized dye developer. Although the reaction between oxidized dye developer and quaternary yields a precipitate *in vitro*, it is sufficient if in the developing areas the dye developer, in association with the quaternary, forms a much less mobile molecule.*

In unexposed regions the solubilized dye developer passes through the overlying emulsion and on through the other layers into the image-receiving layer, where it is captured by a polymeric mordant.

*Though quaternaries are very useful, they are not necessary. Figure 12-80d (page 320) reproduces a print from a preproduction Polacolor film (1957), an example of a system in which dye developers are well controlled without the use of quaternaries. Interlayers of the negative comprising cellulose acetate hydrogen phthalate and cellulose acetate provided a hold-release mechanism.

Fig. 12-5. Chemical steps of the SX-70 process include (a) formation of a soluble salt of the auxiliary developer, (b) formation of a soluble salt of the dye developer, (c) reduction of exposed silver halide by the auxiliary developer, and (d) oxidation of dye developer by the semiquinone ion radical of the auxiliary developer.

Potassium hydroxide, of great importance to all of the processes being discussed, diffuses from the reagent toward all the layers of the film unit. It permeates the layers of the negative in a second, whereas its migration to the polymeric acid layer on the positive support sheet is inhibited initially by a timing layer. The polymeric acid is present as a mechanism for decreasing the alkalinity of the developing picture, as well as for providing a sink from which the potassium ions cannot escape. When potassium ions reach the polymeric acid they are captured, forming an immobile salt of the high polymer.

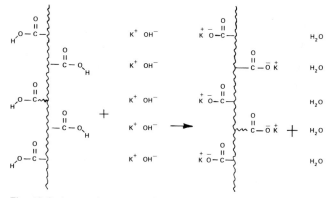

Fig. 12-6. Ion exchange reaction between alkali and an immobile long-chain polymeric acid, mechanism for decreasing alkalinity.

CLEAR POLYESTER PLASTIC

Polymeric Acid:	HOOC HOOC COOH / COOH COOH
Timing Layer:	
Image Receiving Layer:	
Processing Fluid:	OPACIFIERS K⁺OH⁻ K⁺OH⁻ K⁺OH⁻ K⁺OH⁻ K⁺OH⁻ TITANIA
Anti-Abrasion:	HO—OH
Blue Sens. Ag.:	Ag X
Yellow Dye Dev.:	OH—OH
Spacer	
Green Sens. Ag.:	AgX
Magenta Dye Dev.:	HO—OH
Spacer	
Red Sens. Ag.:	AgX
Cyan Dye Dev.:	HO—OH

OPAQUE POLYESTER PLASTIC

A. A stratum is inserted. This portion of the film has been exposed to green light.

CLEAR POLYESTER PLASTIC

Polymeric Acid:	HOOC HOOC COOH / COOH COOH
Timing Layer:	
Image Receiving Layer:	K⁺OH⁻ K⁺OH⁻
Processing Fluid:	OPACIFIERS K⁺OH⁻ K⁺OH⁻ K⁺OH⁻ TITANIA
Anti-Abrasion:	K⁺OH⁻
Blue Sens. Ag.:	K⁺OH⁻ Ag X
Yellow Dye Dev.:	K⁺OH⁻
Spacer	K⁺OH⁻
Green Sens. Ag.:	K⁺OH⁻ AgX
Magenta Dye Dev.:	K⁺OH⁻
Spacer	K⁺OH⁻
Red Sens. Ag.:	K⁺OH⁻ AgX
Cyan Dye Dev.:	K⁺OH⁻

OPAQUE POLYESTER PLASTIC

B. The potassium ions permeate the negative, ionizing the dye developers and the MPHQ.

CLEAR POLYESTER PLASTIC

Polymeric Acid:	HOOC HOOC COOH / COOH COOH
Timing Layer:	
Image Receiving Layer:	K⁺OH⁻ K⁺OH⁻
Processing Fluid:	OPACIFIERS K⁺OH⁻ K⁺OH⁻ TITANIA
Anti-Abrasion:	K⁺OH⁻
Blue Sens. Ag.:	K⁺OH⁻ Ag X
Yellow Dye Dev.:	K⁺OH⁻
Spacer	K⁺OH⁻
Green Sens. Ag.:	K⁺OH⁻ ...+ AgX → ... + Ag° + K⁺x⁻
Magenta Dye Dev.:	K⁺OH⁻
Spacer	K⁺OH⁻
Red Sens. Ag.:	K⁺OH⁻ AgX
Cyan Dye Dev.:	K⁺OH⁻

OPAQUE POLYESTER PLASTIC

C. The MPHQ is oxidized by the exposed silver halide.

CLEAR POLYESTER PLASTIC

Polymeric Acid:	HOOC HOOC COOH / COOH COOH
Timing Layer:	K⁺OH⁻ K⁺OH⁻
Image Receiving Layer:	K⁺OH⁻ K⁺OH⁻
Processing Fluid:	OPACIFIERS K⁺OH⁻ K⁺OH⁻ K⁺OH⁻ TITANIA
Anti-Abrasion:	K⁺OH⁻
Blue Sens. Ag.:	K⁺OH⁻ Ag X
Yellow Dye Dev.:	K⁺OH⁻
Spacer	K⁺OH⁻
Green Sens. Ag.:	K⁺OH⁻ Ag°
Magenta Dye Dev.:	K⁺OH⁻ ... + QUATERNARY SALT → INSOLUBLE
Spacer	K⁺OH⁻
Red Sens. Ag.:	K⁺OH⁻ Ag X
Cyan Dye Dev.:	K⁺OH⁻

OPAQUE POLYESTER PLASTIC

D. The dye developer is oxidized by the oxidized MPHQ and the latter is reduced.

CLEAR POLYESTER PLASTIC

Polymeric Acid:	HOOC HOOC COOH / K⁺OH⁻ COOH COOH K⁺OH⁻
Timing Layer:	K⁺OH⁻ K⁺OH⁻
Image Receiving Layer:	K⁺OH⁻ K⁺OH⁻
Processing Fluid:	OPACIFIERS K⁺OH⁻ K⁺OH⁻ TITANIA
Anti-Abrasion:	K⁺OH⁻
Blue Sens. Ag.:	K⁺OH⁻ Ag X
Yellow Dye Dev.:	K⁺OH⁻
Spacer	K⁺OH⁻
Green Sens. Ag.:	K⁺OH⁻ Ag°
Magenta Dye Dev.:	K⁺OH⁻ INSOLUBLE
Spacer	K⁺OH⁻
Red Sens. Ag.:	K⁺OH⁻ Ag X
Cyan Dye Dev.:	K⁺OH⁻

OPAQUE POLYESTER PLASTIC

E. The cyan and yellow dye developers, unoxidized, transfer; the magenta dye-developer, oxidized, is immobilized in or near the green sensitive emulsion.

CLEAR POLYESTER PLASTIC

Polymeric Acid:	HOOC COO⁻K⁺ COOH COO⁻K⁺
Timing Layer:	
Image Receiving Layer:	OH—OH OH—OH
Processing Fluid:	OPACIFIERS H₂O TITANIA
Anti-Abrasion:	HO—OH
Blue Sens. Ag.:	HO—OH AgX
Yellow Dye Dev.:	HO—OH
Spacer	HO—OH
Green Sens. Ag.:	HO—OH Ag°
Magenta Dye Dev.:	HO—OH INSOLUBLE
Spacer	HO—OH
Red Sens. Ag.:	HO—OH AgX
Cyan Dye Dev.:	HO—OH

OPAQUE POLYESTER PLASTIC

F. The Sea of Tranquility: the potassium ions now reach the polymeric acid and are captured. All significant components throughout the whole 17 layer structure are immobilized.

Fig. 12-7. Conceptual diagram of the sequential steps involved in formation of an SX-70 image.

The long chain polymer acts as an ion exchanger. As the potassium ions form the salt of the polymer, freed hydrogen ions react with the hydroxyl ions to form water (See Fig. 12-6.) The water is a useful reaction product, for it diffuses and helps to keep the process going.

The reduction of alkali concentration accomplishes two important functions simultaneously: the transferred image is stabilized as the image-forming dyes become less mobile, and the opacifying dyes are decolorized. Figure 12-7 presents in diagram form the sequence of reactions which take place from the time that alkali ions, initially present in only the reagent layer, begin to permeate the negative until they are finally captured in the polymeric acid layer.

The three transferred dye developer images together form the final positive image which is seen against the background of the white titania pigment. Figure 12-8 shows the individual spectra of three dye developer images which together form a neutral image of density 1.0. Figure 12-9 illustrates the formation of color images schematically, and Fig. 12-10 shows actual cross sections of an SX-70 negative before and after processing.

Opacification. In order that the developing film may exit from the camera while still sensitive and not be fogged by ambient light, which may be several hundred

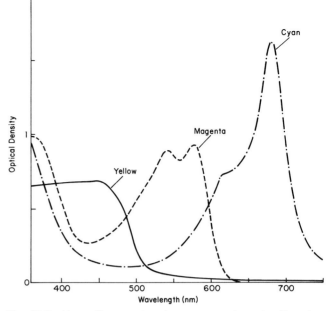

Fig. 12-8. Absorption spectra of cyan, magenta and yellow dye developer images which together form a visually neutral image of density 1.0.

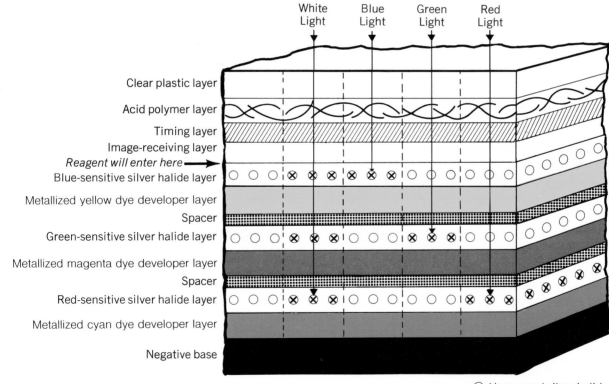

○ Unexposed silver halide
⊗ Exposed silver halide

Fig. 12-9a. Schematic sections of an SX-70 integral film unit during exposure. Color components are metallized dye developers, molecules capable of acting both as photographic developers and as image dyes. Overlying each dye developer is an appropriately sensitized emulsion, which during processing controls the reactions of that dye developer.

Thus the blue-sensitive emulsion controls the yellow dye developer, which, because it absorbs blue light, may also be designated *minus blue;* the green-sensitized emulsion controls the magenta (*minus green*) dye developer; and the red-sensitized emulsion controls the cyan (*minus red*) dye developer. The vertical arrows represent incident light during exposure. The horizontal black arrow at the left of the initial integral structure indicates the interface which will be cleaved and entered by the reagent as it is spread during processing.

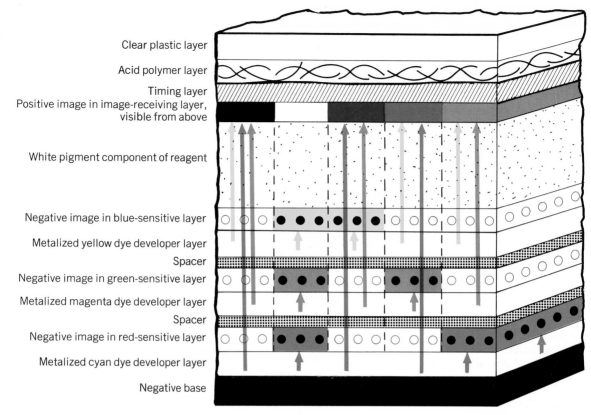

Clear plastic layer
Acid polymer layer
Timing layer
Positive image in image-receiving layer, visible from above

White pigment component of reagent

Negative image in blue-sensitive layer
Metalized yellow dye developer layer
Spacer
Negative image in green-sensitive layer
Metalized magenta dye developer layer
Spacer
Negative image in red-sensitive layer
Metalized cyan dye developer layer

Negative base

● Developed silver

Fig. 12-9b. Schematic section of the integral structure after spreading, with the white pigment of the reagent shown as a new inner stratum. During processing the alkali of the reagent dissolves the dye developers, and each diffuses toward the overlying emulsion layer, as indicated by the colored arrows. In the fully exposed regions of each emulsion, reduction of silver halide results in oxidation and immobilization of the associated dye developer, which therefore remains in the negative. In unexposed regions each dye developer transfers through the emulsion, through the layers above it and through the pigment to the image-receiving layer, where it may be viewed from above against the white pigment. Thus, in the region exposed to red light, the cyan (*minus red*) dye developer is concealed from view; the yellow and magenta dye developers form the visible image, which absorbs blue light and green light but reflects red light and therefore appears red, as shown.

Similarly, green exposure results in immobilization of the magenta dye developer beneath the pigment and transfer of yellow and cyan dye developers to form an image which appears green; and blue exposure results in immobilization of the yellow dye developer beneath the pigment and transfer of magenta and cyan dye developers to form an image which appears blue. In regions of white light exposure, all three dye developers remain in the negative, as shown; and where there is no exposure all three transfer to produce an image which appears black.

Shown above the image-receiving layer in both Figures 12-9a and 9b are the transparent polymeric acid layer, which effects pH reduction by capturing alkali ions, and the timing layer, which by its rate of permeability to alkali ions determines the time of initiation of pH reduction.

The photographic layers are idealized in these figures for convenience in describing the process. See also Fig. 12-3, which shows schematic sections approximately to scale, and the micrographs of Fig. 12-10.

million times as much light as was used to take the picture, unusual protection is required. Both surfaces of the negative within the film unit must be protected from the light. Most important, protection of the negative surface through which the camera exposure is made cannot be provided until after exposure has taken place.

Several configurations were considered for the integral film system. In one, the film unit is exposed through one surface and the image viewed through the opposite surface.* An opacifying layer is brought into position after exposure by application of a processing composition con-

taining carbon black over the exposed surface of the negative, while a preformed opaque carbon black layer, concealed by a reflective white pigment layer,[11] protects the developing negative from exposure through the viewing surface of the film unit.

In the configuration chosen for the SX-70 system, exposure and viewing take place through the same surface of the film unit. Protection of the exposed negative is accomplished by opacifying materials incorporated in the reagent spread to form a layer between negative and image-receiving layers as the exposed film unit passes through the processing rollers. The black polyester negative support protects against exposure of the negative through the opposite surface of the film unit.

*Such a configuration is used in the Eastman Kodak PR10 Instant Print Film introduced in 1976.[12]

(a)

(b)

(c)

Fig. 12-10. SX-70 negative in cross section, (a) before processing, (b) and (c) after completion of process. Each negative was stripped away from the overlying layers before sectioning. Section (b), from a region of maximum exposure, shows retention of dye developers in the layers of the negative, and Section (c), from an unexposed region, shows only slight residual dye developer. The dark layers at the top surfaces of (b) and (c) are adhered titania pigment; it appears dark by transmitted light.

Fig. 12-11. Effect of hydrogen bonding on the pK_a values of phenols. Opacifiers with high pK_a's employ this principle.

In reporting on the SX-70 opacification system, Land said:

> From the point of view of systems planning, the assumption that we could solve this problem was probably our most adventuresome step. We designed the camera as if we had solved the problem, and carried the camera all the way through engineering while doing the basic research on the chemical task of bringing the picture directly into the light.[3a]

A variety of approaches was studied and a large array of opacifying materials examined and synthesized. The method chosen uses a new class of indicator dyes[10b] having high absorption coefficients at very high pH and becoming colorless and remaining colorless at predetermined lower pH. The indicator dyes are included in the viscous reagent, rendering it opaque when first spread. Shortly after spreading, as pH is reduced by the capture of alkali ions in the polymeric acid layer, the indicator dyes become colorless. The success of this opacifying system made it possible to build a camera without a dark chamber* and to build a film pack of great simplicity.

The opacifying indicators are phthalein dyes which react in the same manner as familiar pH-indicating dyes of this class. A solution of such an indicator is highly colored when the dye is at or above its pK_a value, pK_a be-

*Compact cameras also have been designed for integral film units which do not have such an opacification system.[13]

Fig. 12-12. A series of naphthalein opacifying indicators, showing the increase of pK_a value by use of hydrogen bonding substituents in positions X and Y.

X	Y	pKa
H	H	11.1, 13.8
CO₂H	CO₂H	13.2, > 15
CO₂H	-NH SO₂C₁₆H₃₃	12.9, > 15
CO₂H	-SO₂NH C₁₈H₃₇	12.9, > 15

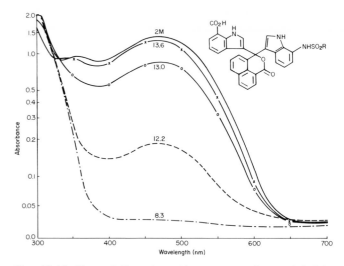

Fig. 12-13. The solution absorption spectra of a naphthalein opacifying indicator at several pH levels. The dye is intensely colored in 2M alkali and close to colorless at pH 8.3.

ing a measure of the pH at which half the removable hydrogen is ionized. The solution becomes progressively less colored as the pH is reduced below the dye's pK_a value. Among the properties of the special opacifying indicators designed for the SX-70 system are their unusually high pK_a values, ranging to about 13.5, which have been

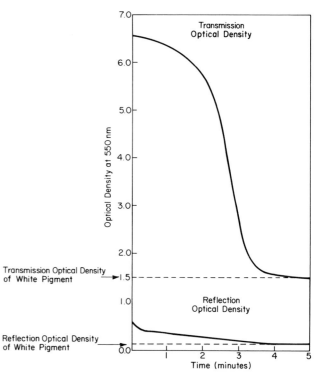

Fig. 12-14. Transmission and reflection densities of the opacifying reagent system plotted against time after spreading. The two curves together show that the reflectance from the front is high even when the transmission is very low indeed. Consequently the dyes in the image-receiving layer are seen against a background adequately light for the image to be visible while the negative is still protected.

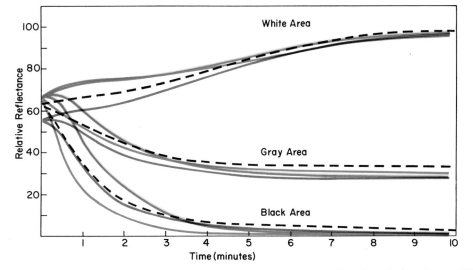

Fig. 12-15. Materialization of SX-70 image in white, gray and black areas. The opacifiers lose their color as pH is reduced by capture of alkali in the polymeric acid layer, and dye images continue to intensify. The color curves show the change of relative red, green and blue reflectances with time, and the dotted black curve indicates reflectance observed visually.

achieved by introducing hydrogen bonding groups into the dye molecule in juxtaposition with the removable hydrogen. Figure 12-11 illustrates the effect of hydrogen bonding on the pK_a of phenols, and Fig. 12-12 shows the increase of pK_a values of a naphthalein opacifying indicator by means of hydrogen bonding substituents.

A very high concentration of alkali is thus required to free the hydrogen ions and to produce the highly colored form of the indicator. This principle is demonstrated by the solution absorption spectra of a naphthalein opacifying indicator, Fig. 12-13, at several pH levels. The indicator is highly colored in 2 molar alkali and close to colorless at pH 8.3. Additional important properties of the opacifying dyes are their stability over prolonged periods in the highly alkaline environment of the reagent prior to processing and their spectral absorption in the colored state appropriate to provide protection to the negative.

Opacification is achieved by a synergistic optical effect of the opacifying dyes and the titanium dioxide pigment. Mixing the dyes with the highly reflective titania pigment greatly extends the path length of light passing through the layer, thus increasing the amount of light absorbed by a given quantity of dye.

Figure 12-14 shows the transmission and reflection densities of an SX-70 opacification system at 550 nm as a function of time following the initiation of processing. The transmission density, which is a measure of the light passing through the reagent layer to the negative, is initially over 6.5, so that the amount of light incident upon the negative is less than a millionth of the ambient level when the developing film unit exits the camera. Because of the high reflectivity of the pigment, the *reflection* densities are low throughout the process and the transferring SX-70 image becomes visible against the pigment before the opacification system has been fully decolorized.

Image Materialization. Figure 12-15 shows the concurrent changes of red, green and blue reflectance in each of three picture areas, areas which will become white, gray and black, respectively, as the dye image is formed and the opacifiers lose their color. The color curves show the change in relative red, green and blue reflectances with time, and the dotted black curve indicates reflectance observed visually.

The gray area has reached its asymptote in about four minutes, and the area of maximum density continues to grow in density for several minutes more. In this system pictures become sufficiently visible to judge focus, exposure and composition within one to three minutes.

The SX-70 Camera. In introducing the SX-70 camera, Land commented:

In retrospect I notice that within the framework of our overall objective, in which camera and film would cooperate, the camera concept and the film concept took on independent individuality. We dreamed of a camera, and even designed one, that would not have to open at all to take a three inch square picture, and which would, nevertheless, be thin and flat. The model we have demonstrated does indeed open from a flat position, so simply and so directly and to a shape so appealing, that we quickly adopted it. Fortunately, we had trouble finding a good place for the viewer. We solved the problem by realizing that the very special shape of the camera lent itself to the design of an equally unusual single lens reflex viewer.[3a]

Fig. 12-16. Cross section of SX-70 camera in closed position, with outline of film cassette in place. Both the viewer assembly and the lens-shutter assembly are articulated so that the camera can fold flat.

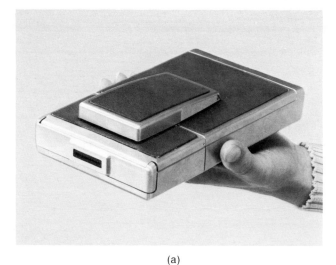

(a)

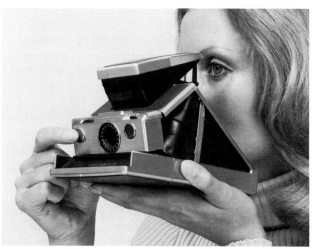

(b)

(c)

Fig. 12-17. (a) SX-70 camera in closed position; (b) photographer adjusts focus with forefinger while viewing subject through the single lens reflex viewer. Electric trigger button is just below forefinger. (c) Photographer presses trigger to expose film; developing film unit is ejected from the camera within 0.4 sec after the shutter closes.

Fig. 12-18. Diagram of SX-70 lens design, a patent illustration.[14a] The dotted outline at the left indicates the furthest extension of the front element. Total travel of the front element to focus from infinity down to 10 in. is 0.23 in., and the total distance from front to back when the front element is fully extended is 0.67 in. The compact design permits the camera to be closed even when the lens is fully extended.

Folding the light path between lens and film with a mirror permitted a longer focal length lens for a given size film, and a mirror led to a more compact camera. Using the mirror provided two principal advantages. The first was that it reversed the image laterally, thus meeting the requirements of the new pack for a laterally reversed image.* The second advantage was that it facilitated a compact design for a folding camera. A radically new assembly including new lens, new shutter, new diaphragm, new focusing, new electromechanical control, new solid state electronics, conceived as a unitary design, made possible an extremely compact lens-shutter housing; this compact housing made it feasible to take full advantage of the folded light path.[6] All this made possible a camera for a large image, compact enough and light enough (about a pound and a quarter) to be carried in a coat pocket or purse, as shown in Figs. 12-16 and 12-17a. Figures 12-17b and 12-17c show the camera in use.

Baker's singular lens design[14a] is shown in Fig. 12-18. The $f/8$ lens, which is focused by displacement of the front element, operates at front focal distances from infinity all the way down to 10 in. Its focal length is 116 mm. The total length of the lens is only one-eighth of its focal length. A simple auxiliary lens provides for closeups in the range 5 to 10 in.

The reflex viewing system[4] includes a hinged decentered Fresnel mirror [14b] and a fixed mirror inside the camera back. Figure 12-19 is a schematic ray diagram and

*Integral films providing exposure through one surface and viewing of the image through the opposite surface, as described on page 266, do not require laterally reversing mirror optics.

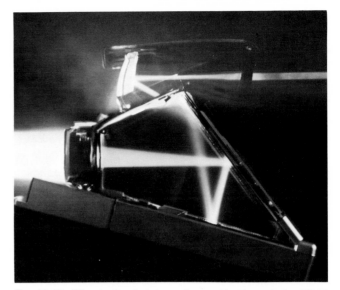

Fig. 12-19. Path of rays in viewing mode. The rays pass through the lens to the permanent mirror (a) on the sloping face. They are reflected from this mirror downward toward the image plane, where they strike the surface of a decentered front surface Fresnel mirror (b), are directionally reflected by the Fresnel upward for a second reflection from mirror (a), pass through a tiny aperture (c) at the top of the camera, strike an aspheric concave decentered mirror (d), and pass through the aspheric decentered eyepiece (e) to the eye; all rays through the lens to the image plane meet with an analogous fate, and all converge behind the pupil of the eye. The concave mirror forms an image of the focal plane about the size of a small postage stamp about one-half of the way between the eyepiece and the concave mirror (dotted line).

The surface of the Fresnel mirror is roughened to form a focus screen, so that the eye receives light originating from the entire area of the taking lens as with a conventional ground glass focus screen. The roughness of the Fresnel is carefully controlled; it is made sufficiently rough to prevent the eye from accommodating to an incorrectly focused image and to include light from the margin of the lens, but still not rough enough to make the image dark. This compromise can be arranged so that the relative focusing effectiveness and the relative brightness are both above 84%.

The single-lens reflex system enables the photographer to frame and focus accurately using the full area of the focus screen at ordinary light levels. To assist in focusing under low light level conditions, the focusing screen includes a split image range finder. The photographer sees the range finder as a small circular region slightly below the center of the screen, crossed by a horizontal division line. When the camera is being focused, the parts of the image above and below the division line move in opposite directions, and they match only when the camera is focused correctly. The range finder, which replaces a small circular portion of the Fresnel mirror, comprises two Fresnel sections that have been decentered. Decentering these small pieces of the focusing screen is optically equivalent to tilting them, and the split image behavior is thus equivalent to that produced by a pair of thin prisms in a conventional reflex camera.

Fig. 12-20 a "smoke box" picture of the ray paths during viewing. In the viewing mode the Fresnel overlies and shields the film units, as shown in Fig. 12-19. When the electric trigger is touched, the Fresnel mirror swings up to rest upon the permanent mirror, as in Fig. 12-21. The other side of the Fresnel carries the taking mirror. Before the Fresnel moves, the shutter will have been closed

Fig. 12-20. "Smoke box" picture of ray paths through the SX-70 camera in viewing mode.

electronically. It will open again to take the picture when the taking mirror is in place. Light rays passing through the lens are now reflected by the taking mirror to the film in the focal plane. After the correct exposure the shutter will close, the taking mirror and the Fresnel will return to their positions covering the film pack, and the shutter will return to the open position for viewing. Within a fraction of a second after the shutter closes, the top film unit is ejected through the motor-driven rollers and the whole cycle of picture taking is ready to be repeated.

The SX-70 camera itself contains no batteries, the motor, the shutter and the electronics drawing their re-

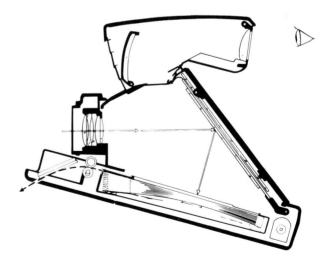

Fig. 12-21. Path of rays in taking mode. Pressing the trigger raises the hinged unit carrying the Fresnel, occluding the viewing mirror and presenting the taking mirror. Light entering the camera through the lens strikes the taking mirror and is reflected downward to the uppermost film unit. After exposure the film unit will follow the path indicated by the dotted line between the rollers and out of the camera. See also Fig. 12-23c.

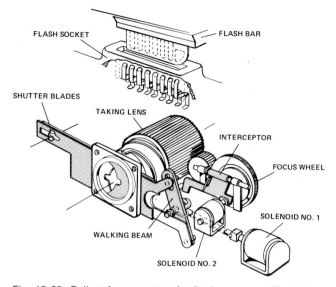

Fig. 12-22. Follow-focus system for flash exposure. The follow-focus circuit is put into service by the insertion of the flash bar. Solenoid No. 1, the principal shutter solenoid, drives the shutter blades. The blades are opened and closed at a predetermined speed; thus exposure is a function of aperture. Solenoid No. 2 puts the interceptor into operating position, and the interceptor pin determines the maximum travel of the walking beam during exposure; the walking beam, in turn, determines the maximum aperture reached by the shutter blades.

quired power from the battery in the film pack. Integrated circuits control all the operations of the camera and automatically determine the exposure when the electric trigger is touched. The shutter blades, shaped to define the lens aperture, are opened and closed by the action of an electronically controlled solenoid.

In available light photography the system operates in the integrating mode, using as light sensor a tiny photodiode. The surface area of the photodiode is less than .006 in.2 (4 mm^2), and it generates extremely small currents (10^{-12} to 10^{-9} amp). During exposure, light sensed by the photodiode generates a current which charges a capacitor to a predetermined level. When the capacitor reaches that level it discharges and its circuit instructs the solenoid to close the shutter blades, thus terminating the exposure. If the light level is too low to charge the capacitor sufficiently, the shutter is closed automatically after approximately 20 sec.

The following table shows combinations of aperture and shutter speeds included in the program of ambient light exposures:

Average Scene Luminance (candles/ft^2)	Equivalent f/Number	Effective Shutter Speed (sec)
800	22	1/180
400	16	1/140
200	14	1/120
100	11	1/90
50	8	1/70
25	8	1/35
12	8	1/18

For short exposure times the equivalent f/number is held during only a very small fraction of the time, so that a significant portion of the total exposure occurs at smaller apertures. Hence motion-stopping ability is somewhat better than that indicated by the total exposure time, and depth of field is somewhat greater than that indicated by the peak aperture.

When the flash array is plugged into the top of the shutter housing the circuitry converts exposure control from the integrating mode to the follow-focus mode, illustrated in Fig. 12-22. Once in this mode the shutter speed is fixed and aperture is determined by the position of the focus wheel.* The programmed exposures in follow-focus mode are illustrated in the following table.

Distance to Subject	Equivalent f/Number	Shutter Speed (sec)
10.4 in.	96	1/40
12.0 in.	90	1/40
3.0 ft.	32	1/40
6.0 ft.	19	1/40
15.0 ft.	9	1/40
20.0 ft.	8	1/40

The flash control circuit chooses from the five bulbs in each side of the linear flash array the next to be ignited, and prevents firing when it senses that the film pack is empty. The circuit also prevents firing of a flashbulb during ejection of the dark slide when the camera is being loaded with a new pack of film.

Further functions of the electronic circuitry include the control of the mirror action, the automatic ejection of the dark slide after the film pack is inserted into the camera, as in Figs. 12-23a and 23b, and the command of the motor action which passes the film unit between processing rollers and out of the camera, as shown in Fig. 12-23c. In addition there is an electronic brake which brings the motor from 13,000 rpm to a standstill in less than 10 revolutions. The substitution of electronic control and switching for mechanical elements, plus the thin lens design,[13] make possible the compact shutter housing.

The result of the new technology in film, camera and process was a system which could readily establish the direct relationship set forth as a goal in the earliest work—the relationship between subject, photographer and finished picture. The simple, automatic operation of the SX-70 makes possible a wide range of new applications in both general and technical photography.

Scope of One-Step Photography

Land's report on the SX-70 system marked the introduction of a greatly advanced photographic medium in a field

*In the later SX-70 cameras integrating exposure control is superimposed on the follow-focus mode, so that when flash is used, after aperture has been determined by the focus wheel position, the electric eye monitors the scene and closes the shutter as soon as it has received sufficient light. This combined control system makes the focusing less critical and helps to compensate for scene brightness variations.

(a)

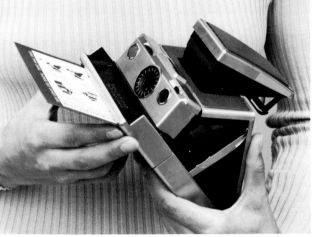

(b)

(c)

Fig. 12-23. (a) Film pack being inserted into camera; (b) automatic ejection of cover sheet after film pack is inserted; (c) ejection of film unit following exposure, photographed in cutaway camera model as seen from the side opposite that shown in (a) and (b).

already characterized by innovation and rapid growth. In its first 25 years, one-step photography had grown from a laboratory achievement into an industry which accounted for a significant fraction of both amateur and professional photography.

One-step processes had been introduced for black and white photography and for color photography, first in roll film cameras which completely processed the film inside the camera,[15] later in packet holders[16] and pack[17] and roll film[18] cameras permitting processing outside the camera. The materials introduced during this period include films for black and white prints, color prints, transparency films, films of ultrahigh speed, films for X-ray and for infrared, and professional positive-negative film.* At the end of 1976, 7.2 billion black and white pictures and 5.7 billion color pictures had been made with these materials by users of more than 62 million cameras. More than 1.4 billion of these prints were made in 1976, and over 68% of the 1976 pictures were in color.

Simultaneous observation of an object and its photographic record is widely recognized as a powerful tool for workers in a variety of scientific, educational and industrial fields. Polaroid one-step processes and cameras have been adapted to many laboratory instruments; in some fields of laboratory science the whole method of operation has been radically changed by utilizing the flexibility and immediacy of the photographic result. Polaroid one-step cameras are standard accesories in microscopy and oscillography, and in many cases they are integral parts of such instruments as scintillation cameras, scanning electron microscopes, photoelastic stress analyzers and infrared microscanners. Figure 12-25 outlines major technical applications, and examples of results are shown in Figs. 12-26 and 12-27.

EVOLUTION OF ONE-STEP PHOTOGRAPHY

Initial Specifications

When, in 1943, Land undertook the design of one-step systems to produce pictures which could be viewed immediately after taking them, he set the following specifications: a hand-held camera would yield finished pictures instantaneously, replacing the many time-consuming steps of classical wet process photography. Film speed would be high enough to permit hand-held pictures at modest lens apertures. The processing, to be practical for incorporation in a camera, needed to be dry or apparently dry. The system had to operate effectively over a temperature range extremely wide compared with the range useful in ordinary darkroom processing. The pictures had to be of suitable size and quality for direct viewing. Film, process and camera

*Figure 12-24 lists all Polaroid films for reference. Representative films will be further described in the discussions of one-step mechanisms in later sections.

Picture	Film Type*	Special Purposes and Characteristics	Spectral Sensitivity	Equivalent ASA Speed**	Date of Introduction
Sepia	*40*		*Ortho*	*100*	*1948*
Black and White	*41, 31*		*Ortho*	*100*	*1950*
	42 (Polapan 200)		Pan	200	1955
	32, 52		Pan	400	1955
	43, 53 (Professional Pan)	*Negative on transparent base*	*Pan*	*200*	*1955*
	44 (Polapan 400)		*Pan*	*400*	*1955*
Normal Contrast Range for Continuous Tone	47, 37, 57, 107, 20, 084 (Polaroid 3000)	High speed films	Pan	3000	1959
	87, 20C, 107C, 667	Coaterless	Pan	3000	1970
	55 P/N (Professional Positive/Negative)	Positive plus	Pan	50	1961
	105 P/N	fixed negative	Pan	75	1973
	1001	X-ray films: TLX	*Ortho*	*100*	*1952*
	1001	is provided on	Pan	200	1958
	3000X	translucent base	Pan	3000	1961
	TLX	for viewing by transmission or reflection	Ortho	1500	1966
	413 Infrared Film		*Infrared*	*800*	*1965*
High Contrast	410 (Polascope)	Very high speed for	Pan	10,000	1961
	510	rapid oscillography and halftone	*Pan*	*10,000*	*1964*
	51	Medium speed for halftone	Blue	320	1967
Black and White Transparency	*46, 46L*	Normal contrast for continuous tone	Pan	800	1957
	146L (Polaline)	High contrast for line copy	Blue	200	1961
Color	*48, 38, 108, 58, 88, 636 (Polacolor)*		*Daylight*	*75*	*1963*
	SX-70		Daylight	150	1972
	108, 88, 58, 668 (Polacolor 2)		Daylight	75	1975

*Film Type denotes format, as well as photographic characteristics:

"40," "30" and "20" series are roll films, for picture sizes 3¼" x 4¼", 2½" x 3¼" and 2½" x 3¼", respectively (including border).

46 and 46L refer to square and lantern slide format transparencies, picture areas 2¼" x 2¼" and 2⁷/₁₆" x 3¼", respectively.

"50" series are packets for use with 4" x 5" Film Holder; picture area 3½" x 4½".

"100" and "80" series are pack films for picture sizes 3¼" x 4¼" and 3¼" x 3⅜", respectively (including border).

1001, 3000X and TLX are packets for use in 10" x 12" X-ray cassettes; picture area 9⅜" x 10½".

SX-70 integral film units are 3½" x 4¼" overall, with picture area 3⅛" x 3⅛".

Italics: Discontinued

**ASA standards have not yet been established for Polaroid one-step films. "Equivalent ASA speed" indicates the exposure index to which a meter calibrated in ASA speed units should be set for proper daylight exposure.

Fig. 12-24. Polaroid films.

Visible Signal From Subject Photographed Directly

Photoelastic Stress Analysis Units

Plano Interferometers

Laser Energized Interferometers

Thin Film Interferometers

Emission Spectrographs

Monochromators

Fabric Control Cameras for Clothing
Patterns

Sequencing Cameras

Photomicrographic Cameras

Fundus Camera for Retinal Photography[19a]

Keratoscopes for Plotting Contours of the
Human Eye

Field Plotting Units for the Human Eye

Extra-Oral Dental Cameras

Immunodiffusion Cameras

Endoscopes[19b]

Non-Visible Signal Converted to Light for Recording on Film

Oscilloscopes

Scanning Electron Microscopes

High Speed Image Converter Cameras

Interval Timer-Recorders for Seismography

Digital Print Recorders

Thermographic Scanning Units

Ultrasonic Scanners for *in Vivo* Testing

Scintillation Cameras for Nuclear Medicine

Spirometers for Pulmonary Function Testing

Electromyograph Recorders

X-Ray Images Recorded on Film

Portable X-Ray Generators for
Radiographic Analysis

Crystallographic Orientation Cameras[19c]

Cassette Processor for
Medical and Industrial X-ray[19d]

Fig. 12-25. Major industrial and scientific applications of one-step photography, utilizing specialized film holders and cassettes, integral camera backs or special purpose cameras. Camera backs include both pack and roll-film models. Special purpose Polaroid Land cameras include the MP-3 and MP-4 industrial view cameras, the CU-5 close-up camera, the CR-9 oscilloscope camera, the ED-10 instrument camera, and the ID-2 identification camera. Since the literature in some of these fields is extensive, only representative papers and bibliographic references have been noted. Reference 20 is a periodical devoted to technical applications. Further references and detailed information are available through the Polaroid Corporation's technical staff and from manufacturers of the specific instruments.

evolved as a chain of consequences of this set of photographic precepts.

The Photosensitive Material. Silver halide was the photosensitive medium preferred for a hand-held camera process because of its high sensitivity to light and the extraordinary amplification of the latent image by development. For uses other than a hand-held camera a variety of photosensitive systems could be considered seriously; for the sensitivity required in a hand-held camera the only candidate was silver halide. Given a silver halide emulsion as starting material, the task was to exploit during the course of development the difference between exposed and unexposed silver halide grains as a means of forming a final positive image. The positive image could be of dye, of silver, or of the two in combination.

Reference 2 points out that the treatment of an exposed emulsion with a developer containing conventional components initiates a series of reactions which vary from point to point as a function of exposure. Each reaction thus produces a set of images in terms of materials consumed or altered and a corresponding set in terms of unreacted materials.

Thus we can tabulate a series of "images," many of them invisible, and such a table is shown below*. . . . Most of these ten images are chemical types, and each of the images is a candidate for being instrumental in forming the positive. The odd numbered images are associated with the highlights in the original scene, and the even numbered with the shadows. Therefore, in making the positive, the odd must either do nothing with relation to a white surface or else whiten a black surface. The even must either do nothing to a black surface or else blacken a white surface.

In conventional tank or tray development of negatives and prints, the image comprising exposed grains is converted to a final image of developed silver. None of the other images listed in the table is used. In one-step processes, as in certain of the multistep reversal processes, it is possible to utilize many of the other images, including those which are soluble. If the system transfers an image to a separate sheet or a separate layer, it may make effective use of each of those shown in the table, either alone or in combination.

*Figure 12-28 reproduces this table (page 280).

(b)

(a)

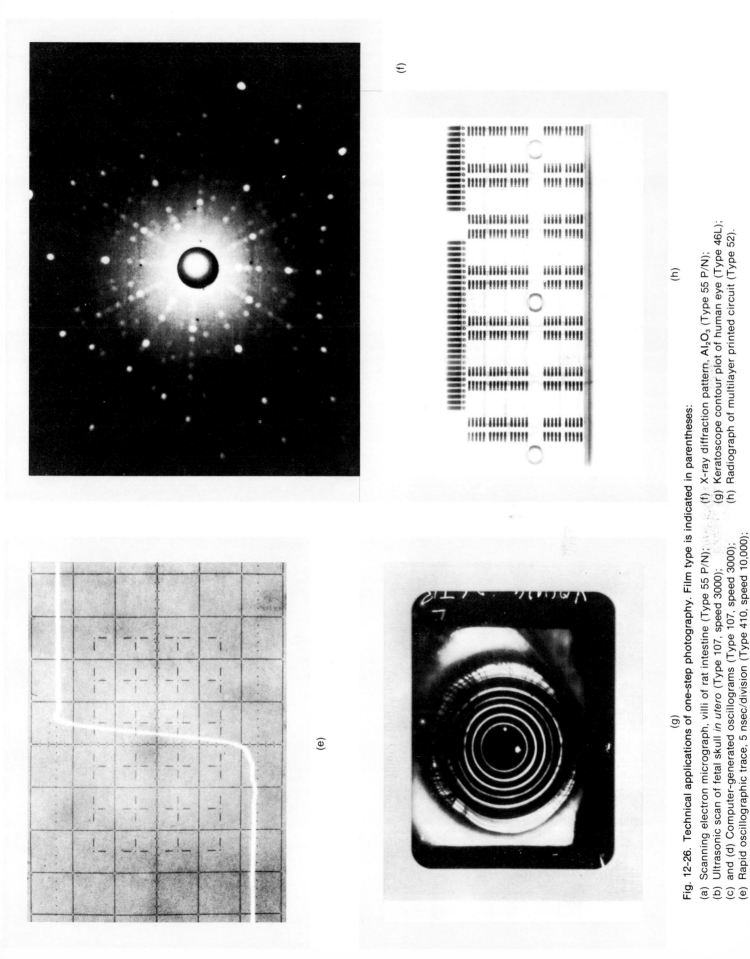

(e)

(f)

(g)

(h)

Fig. 12-26. Technical applications of one-step photography. Film type is indicated in parentheses:

(a) Scanning electron micrograph, villi of rat intestine (Type 55 P/N);
(b) Ultrasonic scan of fetal skull *in utero* (Type 107, speed 3000);
(c) and (d) Computer-generated oscillograms (Type 107, speed 3000);
(e) Rapid oscillographic trace, 5 nsec/division (Type 410, speed 10,000);
(f) X-ray diffraction pattern, Al$_2$O$_3$ (Type 55 P/N);
(g) Keratoscope contour plot of human eye (Type 46L);
(h) Radiograph of multilayer printed circuit (Type 52).

(a)

(b)

(c)

(d)

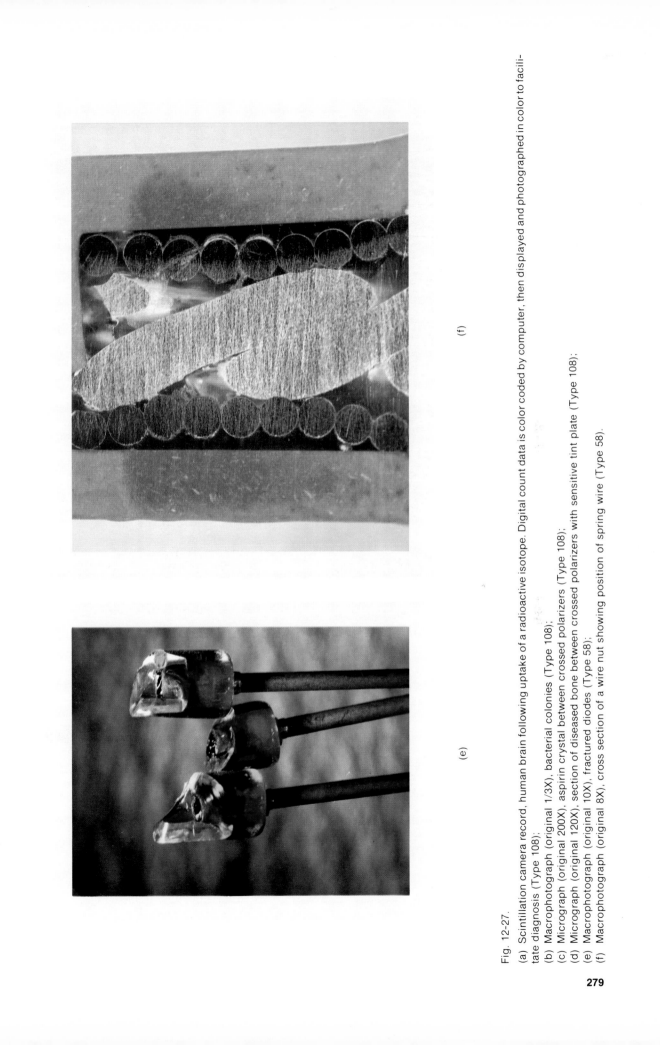

(f)

(e)

Fig. 12-27.

(a) Scintillation camera record, human brain following uptake of a radioactive isotope. Digital count data is color coded by computer, then displayed and photographed in color to facilitate diagnosis (Type 108);
(b) Macrophotograph (original 1/3X), bacterial colonies (Type 108);
(c) Micrograph (original 200X), aspirin crystal between crossed polarizers (Type 108);
(d) Micrograph (original 120X), section of diseased bone between crossed polarizers with sensitive tint plate (Type 108);
(e) Macrophotograph (original 10X), fractured diodes (Type 58);
(f) Macrophotograph (original 8X), cross section of a wire nut showing position of spring wire (Type 58).

1. The exposed grains of the latent image	2. The unexposed grains of the latent image
3. The developed silver	4. The undeveloped silver halide
5. The oxidized developer	6. The developer which is not oxidized
7. The neutralized alkali	8. The alkali which is not neutralized
9. The hardened gelatin	10. The unhardened gelatin

Fig. 12-28. Table of "images" present in silver halide emulsion exposed and treated with developer.[2]

Reference 2 *continued:*

One direct approach is to form the positive on that second sheet which we are using to confine the viscous liquid when it is being spread. If we can somehow print on this sheet from the negative immediately after the viscous reagent is applied to it, then we are free to try to use any of the images—even including the silver—as an intermediary in forming our positives.

Reference 1, which remains a basic reference on one-step image transfer, includes a comprehensive discussion of possibilities for processes based on the utilization of several of the above images, classified as follows:

A. Exhausted developer processes
B. Oxidized developer processes
C. Soluble silver complex processes
D. Coupler processes.

Exhausted developer processes are defined as those which use the unoxidized developer (6) in Fig. 12-28 to form a positive image in the receiving layer. This class includes the Polacolor and SX-70 dye developer processes.

Oxidized developer processes utilize the oxidized developer (5) directly to form the final positive image, either by bleaching a dye or by forming a white pigment against a dark background.

Soluble silver complex processes transfer images of silver, utilizing images (4), (6) and (8)—that is, the undeveloped silver halide, the unoxidized developer and the alkali not neutralized. This class includes both the initial one-step process and the current black and white processes.

The coupler processes of Class D comprise the coupling developer analogs of Classes A, B and C. Examples of one-step color coupler processes are described in the later section on dye image processes.

Reference 1 includes a comprehensive discussion of the inherent advantages and limitations of processes of each class and describes devices for optimizing each, with attention to their application to both color and black and white systems.

The Camera. The camera for one-step processes yielding direct prints must provide precisely controlled exposures over a long range. Since the range of light intensities which a print can provide is usually less than 100 to 1 and since the range of light intensities (the product of illumination and reflectivity) encountered in most scenes is many times that, the exposure must place the subject accurately within the useful response range of the positive process. The degree of control of exposure which suffices in ordinary negative-positive photography does not suffice in a direct print process, and the techniques used in multi-step processes to compensate for errors in negative exposure are not possible in a one-step process. To avoid the errors which accrue in sequentially reading an exposure meter and setting lens aperture and shutter speed, as well as to avoid the inherent variability of conventional between-the-lens shutters, the earliest one-step camera design simplified exposure control by coupling shutter speed and aperture. A single setting of the Model 95 camera exposure value (EV) scale set the speed of a high precision pendulum shutter and selected one of a series of fixed apertures.[21]

In succeeding one-step camera designs new devices evolved, ranging from automatic galvanometer-controlled shutters[22] and extremely accurate photometers to fully automatic electronically controlled sensor and shutter systems.[23] Figure 12-29 shows in schematic form the controls and shutter of the Model 100 camera, the first camera to control automatically the duration of exposure by measuring and integrating light intensity during exposure. Electronic circuitry performs the integration and actuates the closing of the shutter at the end of the exposure interval. The automatic shutter thus shares with the photographer the burden of retaining tonal gradation in highlights and shadows for that portion of the scene of particular interest to the photographer.

An important mutation in shutter design opened the field of very low cost one-step cameras. The remarkably simple, yet highly accurate, photometer[24] incorporated in the Swinger camera (1965) was the first to use the principle that one can perceive readily only one gestalt at a time in a given area. One of the gestalten is a checkerboard that reverses from black on white to white on black, vanishing at the reversal point, when there is a photometric match between one set of squares. illuminated by an internal light source, and the other set of squares, illuminated by the scene. Superimposed on the checkerboard is a lightly engraved word, "YES." When the checkerboard is visible the "YES," though present, cannot be perceived; when the checkerboard vanishes the "YES" appears vividly. The trigger knob, as it is rotated, closes down the shutter diaphragm in unison with the diaphragm admitting light from the scene to the photometer. The trigger knob is rotated until the "YES" appears and then the trigger knob is depressed to take the picture. About 13.7 million cameras using photometers of this type had been manufactured by the end of 1975.

A further special requirement for the one-step camera was, of course, provision for the independent processing of each film unit immediately after exposure. Figure 12-30a, taken from Ref. 1, shows an early schematic plan for a one-step camera equipped with a pair of steel pressure rollers, through which the film was to pass

Cocked Position

Closing blade is out of light path.

Solid side of opening blade blocks light path.

Switch 2 is closed; capacitor is discharged.

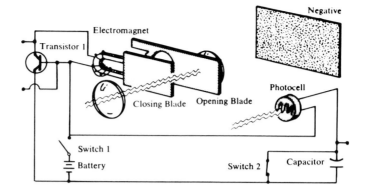

Start of Exposure

Aperture of opening blade moves into light path; exposure begins.

Switch 1 closes; electromagnet holds closing blade in cocked position.

Switch 2 opens; current flowing through photocell charges capacitor.

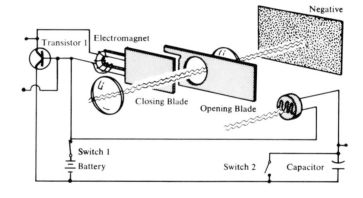

End of Exposure

When capacitor is charged, spillover current activates transistor 2.

Transistor 1 loses base current and breaks electromagnetic circuit, releasing closing blade.

Closing blade moves into light path.

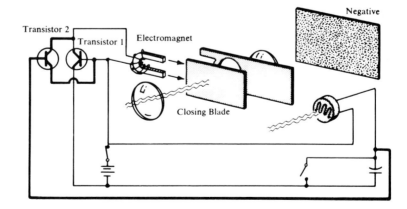

Fig. 12-29. Automatic shutter control system of the Model 100 camera, first camera to control exposure duration by measuring and integrating light during exposure.

after exposure in order to convert the image carried by the exposed grains into a finished picture. The operation of the system was described as follows:

> The camera . . . has the usual lens, bellows and film cartridge for the negative. An additional sheet . . . feeds out of the camera, along with the exposed negative, through a pair of pressure rolls. A reagent, in the form of a minimum amount of liquid, is fed between the two sheets just before they enter the pressure rolls, so that it is spread as an extremely thin layer between the two sheets, temporarily bonding them together. The sheets have outer surfaces opaque to actinic light to protect the negative from being fogged. The thin reagent layer develops the negative and forms the positive on one of the inner surfaces.[1]

Figure 12-21 and Figs. 12-30b through 12-33 illustrate the principal processing formats. The earliest cameras completed the processing inside a dark chamber; later camera models provided for drawing the sandwich of film, pod and receiving sheet between the rollers and out of the camera.* Finally, the SX-70 camera, described in the first section, automatically ejects each picture unit, passing it between the rollers as soon as its exposure

*Instead of rollers, nonrotating spreaders have been used in some cameras.[25]

is completed. In each case the reagent-spreading system is an integral part of the camera design.

One-Step Processing; The Pod. The important concept of processing in a single "dry" step was fulfilled by a series of interacting measures, which included packaging the liquid reagent in an elongated container or pod[26] as long as the width of the picture, raising the viscosity of the liquid by adding a high molecular weight, film-forming polymer,[27] and distributing the liquid in a viscous state. All of this made possible frame-by-frame processing and the use of fresh reagent for each frame. A vital aspect of the idea of the pod was to attach it to one of the sheet components so that the pod and sheet are transported together; the pod seal ruptures and reagent spreads between two sheets as they pass together through the rollers.

The design of viscous reagents and sealed pods for use in conjunction with a camera having pressure rollers is described as follows in Ref. 2:

> A useful approach is to assume that an amount of liquid that will develop a given area of negative will suffice to form a positive by whatever process we later devise. It is easily shown that a negative can be developed by a very thin layer of strong developer and the experimental results are consistent with the computations for the required amount of developing agent. . . . The amount of developing agent, the

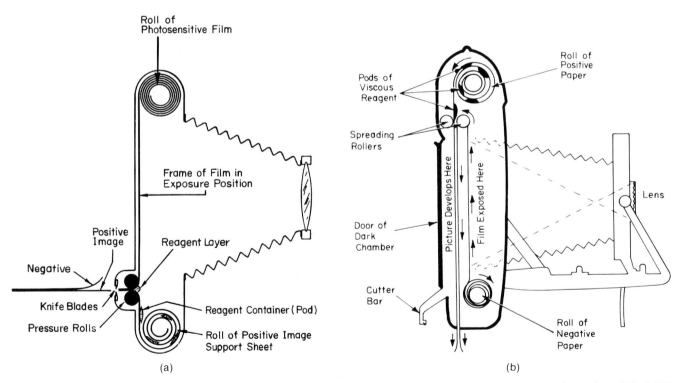

(a)　　　　　　　　　　　　　　　(b)

Fig. 12-30. (a) An early schematic diagram of a camera to produce one-step positive prints (1947);[1] (b) schematic section of Model 95 camera (1948). With the Model 95 and subsequent roll film cameras using "40" and "30" series films, processing is completed inside the camera. A paper leader which extends outside the camera is pulled forward to draw the negative and the positive sheet (to which the pod is affixed) together between the rollers. The pod ruptures, and a thin, uniform layer of the viscous reagent spreads between the two sheets. When the specified period has elapsed, the user opens the latching camera back and peels the positive print away from its negative. After the first picture has been processed, the portions of the two rolls between picture areas serve as leader.

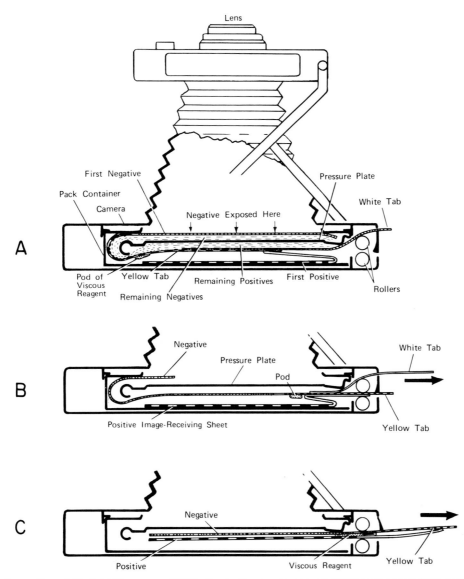

Fig. 12-31. Schematic section of Model 100 camera (1963), illustrating processing of "100" series pack films outside the camera. Both negative and positive sheets have opaque outer surfaces. (A) Pack with each element in the position it occupies at the time of exposure; (B) after exposure a paper tab is pulled to lead the negative into a new position opposite a positive image-receiving sheet; (C) pulling a second paper tab (to which the pod is attached) leads the entire unit between the pressure rollers and out of the camera, rupturing the pod and spreading reagent between the two sheets.

amount of alkali, and the amount of liquid are determined by the requirements of the *single area of negative with which these reagents are associated. . . .* It turns out that when a developer is prepared for use in this way, 0.05 cc per square inch* is adequate to develop a negative, corresponding to a layer a few thousandths of an inch thick. This then is the order of quantity of liquid per unit area which we must confine within our film and which must be released and uniformly distributed by the pressure rolls to perform the processing.

A number of methods were studied in which the liquid was pre-spread at the time of manufacture

and simply made available to the negative by the pressure rolls. In one of those methods, the developer is contained in minute frangible cells which are ruptured either by pressure, or by tension produced by bending around a roll with a small radius. These frangible cells reside in one stratum of the film and their liquid contents, after they are broken, migrate to other strata.

An entirely different method was actually selected for initial use. . . . In this method the developer is not pre-spread but resides in flat, folded, hermetically sealed pods, one for each frame. In addition to the negative, a second sheet of film or paper is used, and the pods lie between the negative and this second sheet. The pressure transmitted from the rollers through the sheets

*0.008 ml/cm².

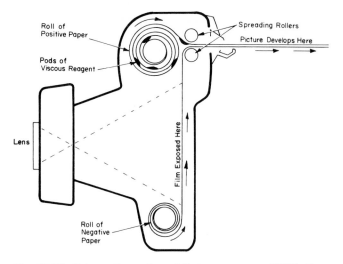

Fig. 12-32. Schematic section of Swinger camera (1965), illustrating processing of "20" series roll film outside the camera. Both sheets have opaque outer surfaces. The user draws the "sandwich" between the rollers and out of the camera in a single motion. Compare with Fig. 12-30a.

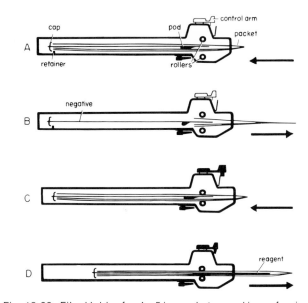

Fig. 12-33. Film Holder for 4 × 5 in. packets, used in professional press and view cameras and in the Polaroid MP-3 and MP-4 industrial cameras. Processing rollers are contained within the holder, and each film packet is a light-tight unit. When the packet is inserted into the holder (A), a spring-loaded retainer engages a cap on the end of the packet, so that the outer envelope may be partially withdrawn and the film exposed (B). The photographer then reinserts the envelope (C) and sets the control arm to processing position, which brings the rollers into position against the packet and retracts the retainer. He then pulls the entire packet through the rollers and out of the holder (D). The packet is stripped apart after the appropriate processing time.

to the liquid content of the pod builds up the hydraulic pressure within the pod to burst the leading edge* along its whole length. The contents of the pod are discharged parallel to its leading edge and transported over the area of the negative as the two sheets continue through the camera rollers. The liquid is immediately imbibed by the adjacent inner surfaces and proceeds to carry out the photographic processes. The *outer* surfaces of the sheets, even when porous material is used, remain dry because of the small amount of liquid required.

One would wonder if it is possible to confine and control a liquid spread in this way. . . . It is made entirely feasible by increasing the viscosity of the liquid. By adding thickening agents to the liquid content of the pod its viscosity is increased to the order of 30,000 centipoises. At this viscosity, the liquid can be spread as a layer of controlled thickness between the two sheets. This viscous layer, about 0.003 inch thick, serves many purposes: it is a reservoir of known volume for metering reagent and solvent to the sheets; it provides a temporary adhesive to hold the two surfaces in flat face-to-face relationship; it can be made to collapse in thickness rapidly so that, when desired, an image-forming interaction between the surfaces may operate over a short working distance; if a plastic is used as the thickening agent, it can be left as a lacquer on one of the sheets; the image can, if desired, be formed in this plastic layer or the image can be formed under it. The thickening agent can serve as a protective colloid during the period of image formation, and it can serve as a sink for holding salts in solid solution on the finished picture or for removing them from the picture when

the other sheet is stripped away. . . . We are enabled to use a metered amount of fresh reagent for each reaction and to provide these strata (the surfaces of the two sheets and the layer of viscous liquid) as loci for reagents which can be brought together at will to initiate their interaction.

The sealed pod of viscous reagent thus conceived has been an essential part of each of the one-step products. Despite serious efforts to develop alternatives the very reliable and highly versatile pod remains a preferred reagent carrier for dry film assemblies.** A typical pod structure is illustrated in Fig. 12-34.

*In some systems the rollers are transported over a stationary assembly of negative, positive and pod; early work of this type led to defining the leading edge of the pod as the edge through which the viscous reagent was ejected.

**The pod lining must be inert to concentrated alkali and reducing agents. Even though it is a solid film, the lining must not be a solvent for reagent components. The lining must not contain plasticizers which could hydrolyze or be emitted into the reagent. The pod must be sealed in such a way that it is opaque to water vapor and to oxygen over a period of years, yet in such a way that the seal will rupture over its whole length simultaneously; if one portion ruptured first, the liquid would all go through the orifice created by the local rupture. The seal must not become brittle at low temperature or tacky at high temperature; it must be strong enough not to rupture when film units are rolled or stacked, yet not so strong that the pod will pass through the rollers without opening at all.

One of the earliest pod designs comprises a layer of paper on which is a layer of lead foil and then a layer of polyvinyl butyral. The edge is striped on one side with ethyl cellulose. At the short edge the polyvinyl butyral provides a thermoplastic seal; along the long edge it provides the peelable bond with ethyl cellulose. Both the polyvinyl butyral and the ethyl cellulose are stable to alkali. Most modern pods are lined with polyvinyl chloride.

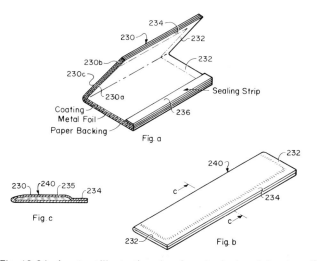

Fig. 12-34. A patent illustration showing a typical pod structure.[26]

Pods opened a new domain of developer activity and film speed. It was found possible to make the reagent* highly alkaline and much more strongly reducing than conventional developers. Reagents too reactive to be stable in open tank processing are readily preserved by confinement in pods; each pod is a container for fresh reagent in the amount required to process a single picture, and each portion is used only once. The pod and sheet system makes possible exclusion of oxygen from the time the reagent is sealed in the pod until the final image is complete.

The reagent within the pod may include any or all of the chemicals used for developing a negative image and depositing a positive image quickly and virtually simultaneously, each in the proper location. The pod reagent may include such addenda as antifoggants and development accelerators. It is particularly useful to incorporate and isolate within a pod components which would be unstable or incompatible in a sheet structure, just as it is useful to incorporate in the sheet components which would be unstable in the liquid developer. If a silver image is to be formed in the layer of reagent, as is the case in the transparency version of black and white films, the reagent may contain nucleating materials as well. In the SX-70 color film structure the pod contains the white pigment and indicator dyes, as described earlier.

Polymers suitable as thickeners for pod reagents include the alkali-soluble salts of carboxymethyl cellulose, hydroxyethyl cellulose and carboxymethyl hydroxyethyl cellulose. These polymers are often used in the highest molecular weight—i.e., highest viscosity—grades. The quantity used is a function of the desired viscosity and the viscosity of the polymer, the higher viscosity grades permitting the use of smaller concentrations of polymer, frequently with attendant increases in transfer rates of image-forming components.

*The term "reagent" is used broadly to describe the total liquid processing composition rather than an individual reactive chemical component.

Early Image Transfer Experiments

Dye Images. In devising processes for the one-step camera, Land drew upon his background in the development of image transfer processes for making Vectograph prints; (1938).** To test the principle of controlling imagewise transfer of dye by an intermediate image in tanned gelatin, a paper-based emulsion was exposed in a camera, developed in a tanning developer and immediately passed through a wringer in contact with a layer of blotting paper saturated with a solution of an acid dye. When the two layers were separated after a minute, dye had transferred through the differentially hardened emulsion layer to form a positive image in dye in the paper base; the emulsion layer bearing the negative image in silver was subsequently stripped away.*** One of the earliest such pictures, made in 1944, is reproduced in Fig. 12-35†.

Silver Image. The next experiments examined the transfer of silver from a developing negative to a hardened gelatin layer. The gelatin layer was prehardened with formaldehyde and presoaked in a solution containing both developer and fixer. When the presoaked gelatin layer was passed through the wringer in contact with an exposed negative, a brown, continuous tone positive image of finely divided silver was deposited in the gelatin within one to two minutes. Figure 12-35b is reproduced from a picture made in 1944 by this procedure.‡

**Polaroid Vectograph prints comprise oppositely polarized image pairs—i.e., images in terms of vectorial inequality which, when viewed through oppositely oriented polarizing filters, yield three-dimensional images.[28] In the Vectograph process, paired positive gelatin matrices, prepared by conventional tanning development, are soaked in a solution of a dichroic dye or iodine, and the imbibed images in dye or stain transferred to layers of polyvinyl alcohol oriented at 90° to one another. Transfer is accomplished by passing a "sandwich" of the wet reliefs with the Vectograph sheet between them through a wringer. Vectograph transfer images have also been made using an original negative directly as a printing matrix. In this process, the developed negative is dipped into an iodine solution, iodine is abstracted imagewise by reaction with the silver of the negative image, and the unreacted iodine is transferred to form a positive image in the vectograph sheet.

***A process based on similar principles is described by Schering-Kahlbaum A. G. in a 1931 patent.[29]

†All of the reproductions of early photographs included in this chapter were made in 1976. They were prepared directly from the original photographs, which are still in excellent condition in the Polaroid Corporation archives.

‡Other processes which utilize undeveloped silver halide by dissolving, transferring and reducing it have also been derived independently by Weyde at Agfa and by Rott at Gevaert.[30] Rott applied for a British patent in 1939 and obtained a U.S. patent in 1944 on processes based on the transfer of soluble silver complex from a negative after it had undergone substantial development.[31] Transargo, a document copy material using this princple, was marketed by Gevaert in Belgium during 1940 and 1941; its positive sheet contained hypo and silver sulfide nuclei, and transfer was followed by a selenium after-toning step.

Weyde's early work resulted in Norwegian patents issued in 1942 and 1944 to I. G. Farbenindustrie for processes using organic sulfur compounds, sulfides or colloidal silver with gelatin receiving layers.[32] Agfa's first silver transfer product, Veriflex, was produced during the war years. This material was described as a two-layer reflex copy film with silver chloride coated over a layer containing silver

(a)

(b)

(c)

(d)

Fig. 12-35. Examples of early image transfer processes: (a) Dye image transferred through negative layer hardened imagewise (1944); (b) Silver image deposited in gelatin (1944); (c) Silver image deposited in α-cellulose blotting paper (1944); (d) Silver image formed in crosslinked polymeric reagent, using as receiving sheet baryta paper impregnated with lead acetate (1945).

Image and Process Specifications. Having devised working transfer processes for images both in silver and in dye, Land addressed his next experiments toward outwardly dry, one-step processes yielding silver images of neutral tone and dye images suitable for three-color subtractive photography. Whether in black and white or in color, continuous tone photographs would require images of constant hue at all densities. For use in a one-step process, a film of suitable speed and its accompanying reagent would need to be self-contained and stable in storage. The system would need to complete the single processing step rapidly and to produce pictures which would be stable without washing. New materials and new methods were required to provide one-step cameras and processes which could effectively meet these specifications.

The following pages describe and illustrate the principles involved in fulfilling the requirements of one-step camera processes. The section on *Silver Image Processes* will be devoted to the development of the initial one-step film system and of subsequent black and white products; the section on *Dye Image Processes* will cover the concurrent development of one-step color systems.

SILVER IMAGE PROCESSES

Image Formation; Color and Structure

One of the first problems to which Land directed his attention in the development of silver processes was the influence of the method of formation of the image deposit upon its structure and upon its spectral characteristics.

Images in Thick Gelatin Layers. The brown color of the transfer images formed in a gelatin receiving layer, as in Fig. 12-35b, was attributed to a distribution of small particles spread far apart.* Recent microscopy of the 1944 images in gelatin shows those deposits to comprise fine particles 10 to 30 nm in diameter formed into aggregates of a wide range of sizes, from 20 to 300 nm in diameter. The aggregates are distributed throughout a 10 to 12 μm depth, and neighboring aggregates are 1 to 6 diameters apart, as shown in Fig. 12-36a.

The gelatin matrix could evidently influence both nucleation and growth of the image aggregates. The action of gelatin as a highly protective colloid is essential in the emulsion to prevent premature decomposition of the soluble silver complex within that layer; a gelatin receiving layer would similarly inhibit formation of the positive silver aggregates. In the same gelatin layer, however, impurities could concomitantly serve as sites for nucleation—the greater the number of sites, the smaller the aggregates thus formed. The gelatin layers first used as receiving layers had been prepared by fixing and washing sheet films, so that residues might have served as nuclei.**

Formation of Compact Images. The image problem at this stage was twofold: to grow particles in an image-receiving layer directly from solution and to grow them as nearly as possible to a uniform and appropriate size. A thin image layer would provide a close-packed deposit, so that the particles could interact electromagnetically, approaching the conductive properties of a metallic layer. Ideally, the layer would be expanded just enough to be a black absorber rather than a mirror.

To demonstrate that precipitation would occur spontaneously without the protection of the gelatin and to facilitate the growth of a compact layer of large particles, Land used a nonprotective receiving layer of α-cellulose blotting paper, which is readily penetrable but insoluble. Once the silver complex left the emulsion layer it would be free to precipitate within the surface of the α-cellulose paper. When an exposed negative was pressed against a sheet of the α-cellulose blotting paper which had been prewet in a solution containing developer and hypo, a positive image outstanding for its

nuclei and zinc oxide; after a positive image had formed in the nucleating layer, the negative was washed off with warm water and the zinc oxide dissolved by acetic acid to leave a positive transparency.[33]

Further work by both Rott and Weyde led to successful two-sheet document copy processes, both introduced subsequent to the first Polaroid one-step camera process. Agfa's Copyrapid was first marketed in 1949 and Gevaert's Gevacopy in 1950. In Copyrapid and Gevacopy processing, an exposed low speed, high contrast negative sheet was introduced into a liquid activator bath simultaneously with a positive sheet having a gelatin receiving layer containing nuclei; the two sheets were thereafter brought into contact between pressure rollers and then stripped apart, yielding a transferred positive image. Unlike the Polaroid process, the copy processes were based on emulsions of low speed. They produced image deposits having line rather than continuous tone images, and the image hue was thus not critical. Document copy materials and processes are discussed in detail in Chapter 11 and in Ref. 30.

Earlier workers had described different image transfer phenomena in silver halide systems. The transfer of soluble silver salt images from unexposed areas of a developing silver chloride emulsion into a gelatin layer containing the developer had been reported by Liesegang in 1898.[34] Other early observations included those of Lefevre, who in 1857 transferred silver from a daguerreotype soaked in hypo to a layer of gelatin;[35] of Colson, who reported in 1898 the transfer of a negative image in terms of oxidized developer,[36] of Stenger and Herz, whose 1922 German patent claimed processes for the transfer of positive images in terms of unoxidized developer;[37] and of Stevens and Norrish, whose 1938 paper described transfer of an image from a silver halide negative to a gelatin-coated plate after wetting both with developer and subsequent physical development of the transferred image.[38]

*The 1911 data of Chapman Jones[39] had indicated the dependence of color upon size of silver particles suspended in gelatin; Jones had enlarged fine silver particles by coating them with mercury and had observed transmission colors from yellow to gray over a calculated range of diameters from 100 to 190 nm. He reported that he found no correlation between particle separation and color for particles between 1 and 10 diameters apart.

**To examine the question of nucleation by impurities, images formed in gelatin layers of this type were recently compared with images formed in coatings of refined gelatin deionized to minimize impurities. The images in the deionized gelatin comprised larger aggregates, as if indeed there were fewer points of initiation. In this purified gelatin the aggregates ranged up to 400 nm in diameter, and the image tone was bluish. Figure 12-36b shows the structure of the image in deionized gelatin, and Fig. 12-37 compares transmission spectra of images in the two gelatins.

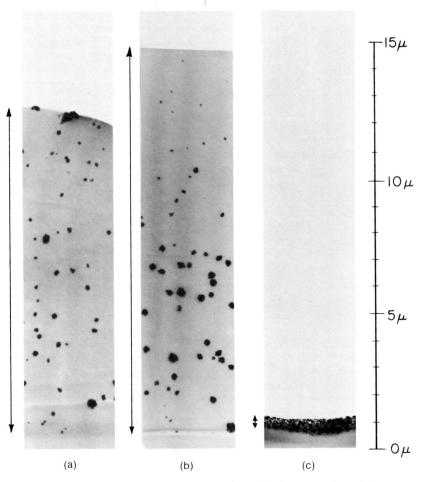

(a) (b) (c)

Fig. 12-36. Comparison of images deposited in impure and purified gelatin and in the pores of α-cellulose paper. Length of arrow beside each cross section shows thickness of region populated by silver particles: (a) is from a picture such as the one reproduced in Fig. 12-35(b), with the deposit in a thick layer of gelatin prepared by fixing and washing a sheet of commercial film; (b) is from a deposit in a thick layer of highly purified gelatin; and (c) is from an image formed in α-cellulose blotting paper; (c) is shown at higher magnification in Fig. 12-38. Spectra of (a) and (b) are shown in Fig. 12-37, and the spectrum of (c) in Fig. 12-39.

neutral tone was deposited in the near surface of the paper. A picture made in 1944 in this manner is reproduced in Fig. 12-35c.

Figures 12-36c and 12-38 are electron micrographs

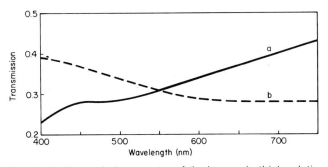

Fig. 12-37. Transmission spectra of the images in thick gelatin layers shown in Figs. 12-36(a) and (b).

showing in cross section an image deposit recently prepared by the above procedure. The image comprises single crystalline particles rather than aggregates, the individual crystals being closely packed in a layer only 400 nm thick, less than 1/25 the thickness of the earlier image deposits in gelatin, to form a near-continuum of silver at maximum density. The single crystals in the α-cellulose paper measure 15 to 150 nm in diameter, somewhat smaller than the aggregates in gelatin. Figure 12-39 shows the strikingly uniform spectral reflectance of this compact positive image.

In succeeding experiments spectrally neutral silver images were deposited in regenerated cellulose layers prepared by the alkaline hydrolysis of cellulose acetate sheet. The image deposits comprised aggregates ranging up to 300 nm in diameter, with most of the silver in the larger aggregates in a 2–2.5 nm stratum close to the sheet surface.

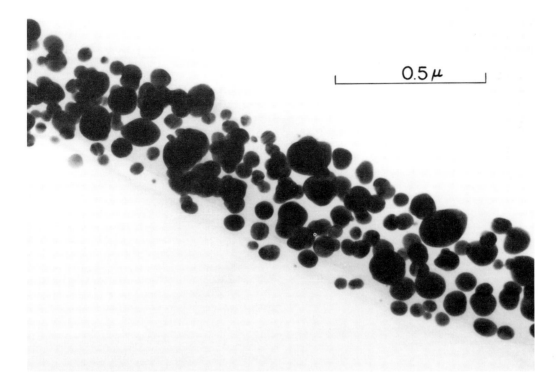

Fig. 12-38. Cross section of neutral image in α-cellulose blotting paper. Note that the deposit of crystals is compact but not solid, an ideal condition for blackness. Reflectance spectrum is shown in Fig. 12-39.

In both the pure α-cellulose blotting paper receiving layer and the regenerated cellulose receiving layer the deposition process, characterized by Land as "concentration and condensation," depends on the local concentration of soluble silver complex becoming sufficiently high to initiate precipitation. As no nucleating materials are added, the soluble silver is presumably nucleated—much as raindrops are—by sites accidentally present in low concentration in the capillaries of the blotting paper or within the regenerated cellulose layer. These are powerful examples of receiving systems not seeded with nuclei and not inhibited by a protective colloid.

Processing with Viscous Reagent. The compact silver layers in α-cellulose blotting paper and in regenerated cellulose had been identified as structures suitable for neutral, continuous tone images, but the procedures which were used to form them did not lead directly to a one-step camera process. The next step toward the camera process was to produce such an image using a viscous reagent which could be sealed in pods and incorporated in the self-contained film units described earlier.

An important consequence of using a reagent made viscous with a polymeric thickener is that the polymer retards precipitation of silver from the soluble complex. In order to achieve reduction and precipitation in an image-receiving layer, it is necessary to overcome this retardation.

Approaches proposed by Land to induce the release of silver from its hypo complex in the presence of a retarding polymer include: (a) precipitation of thiosulfate ion,[40] (b) precipitation of a hypo-insoluble, readily reducible silver salt,[41] and (c) nucleation by a colloidal heavy or noble metal.[42] These reactions could be used alone or in combination. Figure 12-40 outlines reactions of types (a) and (b), and processes based on these principles are discussed below.

Precipitation of Thiosulfate. To remove thiosulfate ion, a soluble salt of a metal which forms an insoluble thiosulfate could be added to an image-receiving sheet. Reaction with the soluble silver complex would precipitate the metal thiosulfate salt and free silver ion, which is readily reducible.

A process of this type[40] used as the receiving sheet baryta-coated paper which had been impregnated with lead acetate and dried. When the lead-treated receiving sheet and an exposed negative were passed together

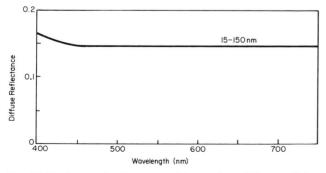

Fig. 12-39. Spectral reflectance of image deposit in α-cellulose blotting paper, shown in cross section in Figs. 12-36(c) and 12-38.

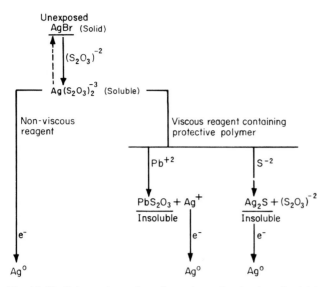

Fig. 12-40. Schematic outline of transfer and reduction of soluble silver complex images. With a nonviscous reagent, reduction and deposition of silver proceed rapidly. In reagents made viscous by the addition of a polymer, reduction and deposition of silver from the thiosulfate complex are retarded. This retardation may be overcome through the addition of ions which destroy the complex by precipitating either silver or thiosulfate.

between pressure rollers, spreading between them a viscous reagent containing developer and hypo, an image of neutral tone and excellent pictorial quality resulted. This process is another example of "concentration and condensation" deposition, as no nucleating materials are added.

Figure 12-35d is a recent reproduction of a print made in 1945 with the lead acetate receiving sheet. Figure 12-41

shows the structure of an image deposit of this type, and Fig. 12-42 shows its nearly uniform reflectance spectrum. The image silver comprises aggregates 20 to 300 nm in diameter, similar in individual appearance to those formed in the gelatin layers of Fig. 12-30. Unlike the aggregates in the thick layers of gelatin, these aggregates are arranged compactly. They are confined within the 2 μm layer of crosslinked polymer formed by reaction of lead ion with the viscous reagent; the aggregates thus comprise a nearly continuous image deposit at high densities. The fine crystals in this deposit form dense aggregates of about the same size as the large, single crystals in α-cellulose blotting paper, as described above, and, like them, behave optically as black absorbers. The lead acetate receiving sheet used with viscous reagent yielded images with a full range of densities when a fine-grained chloride, bromide or chlorobromide emulsion of low or moderate speed was used as the negative component. The higher speed silver iodobromide negative emulsions transferred considerably less silver.

Precipitation of Silver. Sulfides or selenides could be used in the receiving layer to precipitate silver from the soluble hypo complex, forming reducible silver sulfide or silver selenide. Such removal of silver ion from the thiosulfate complex frees thiosulfate for further extraction of silver ion from the remaining silver halide.

When soluble sulfides were added to the receiving system, deposition of positive silver from the complex was indeed increased, but a new gamut of problems, described as follows in Ref. 2, resulted:

(1) Sulphide (sic) ions in solution provide so many points of initiation that an enormous number of

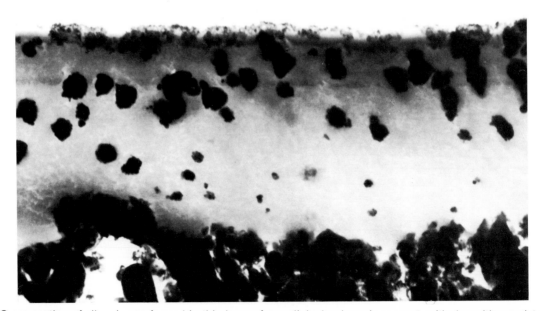

Fig. 12-41. Cross section of silver image formed in thin layer of crosslinked polymeric reagent, with deposition assisted by soluble lead ions in positive sheet. The large particles seen in the lower region of the section are barium sulfate pigment in the baryta coating.

Fig. 12-42. Reflectance spectrum of the silver image of Fig. 12-41. The image comprises aggregates 20–300 nm in diameter.

Fig. 12-43. Reflectance spectra of images transferred by viscous reagent to silica-sulfide receiving sheets, comparing the images formed when the receiving layer contains (a) soluble sulfides, (b) uniformly distributed fine crystals of a metal sulfide of low solubility, and (c) and (d) *galaxies* or clusters of very small crystals of a metal sulfide precipitated in a colloidal suspension of silica.

grains start growing. If these become large the whole picture will be too dense. If they remain small, the picture will be bright yellow (you will recall that the colour of silver colloids depends on the particular size).

(2) There is a tendency for the grains in the shadows, opposite the unexposed portions of the negative, where much silver is available, to grow larger than the grains in the medium tones, where the available silver concentration is low, producing an unpleasant combination of blue shadows and yellow highlights.

(3) Some of the sulphide ions migrate into the negative, dropping the concentration in the positive and fogging the negative.

Thus, having determined how to extract silver ions from the appropriate part of the negative, and how to reduce them to silver atoms, we are still confronted with the problem of how to build these atoms into arrays of the correct diameter for absorbing visible light.

Greater control of the size and number of image deposit sites was achieved by incorporating in the receiving layer a small amount of a finely divided crystalline metal sulfide of low solubility.[41] Sulfide ions would remain localized until complex silver ions from the negative reached them and could thus initiate precipitation of small clusters of silver sulfide particles. The clusters would serve as loci for the deposition of silver in masses appreciably larger than those obtained with the uniformly distributed soluble sulfides.

Silica-based Metal Sulfides. A significant advance in the control of image deposition was the precipitation of the insoluble metal sulfide in a colloidal suspension of very finely divided silica.[43a] The silica, being insoluble and nonswelling, limited the volume within the layer available for precipitation of the sulfide as well as for deposition of silver. Sulfides precipitated in this matrix readily formed fine aggregates or galaxies,[43b] comprising a positively controlled population of active sites.

The sulfide ions were essentially bound in place until they reacted with the soluble silver complex to form silver sulfide. As an additional measure to avoid the release of soluble sulfide ions upon reduction of silver sulfide, an excess of soluble metal ions capable of forming sulfides more soluble than silver sulfide, but still

not appreciably soluble in the developer, was included in the receiving sheet.[44] Sulfide ion freed at its original site could thus be at once reprecipitated *in situ* and the diameter of the cluster maintained. The silver image deposits produced in this system were of well-controlled size and distribution and brown or brown-black throughout their entire density range.

At this point, sulfides had been used to produce image colors from yellow to brown to nearly neutral, as the sulfides were added (a) in solution, (b) as fine crystals uniformly distributed and (c) as galaxies of microcrystals formed in the presence of silica. Figure 12-43, taken from Ref. 1, shows reflectance spectra of such a series of images. It is evident that image color was predetermined by the nature of the sulfide used and that the preferred near-neutral sepia image could best be formed when metal sulfides were precipitated in silica.

The siliceous metal sulfide receiving layer was a fundamental component of the sepia film system first put into production, and newer silica-based receiving layers continue to have a vital role in contemporary black and white systems.[45]

The Sepia Process. The sepia one-step process, publicly demonstrated in 1947,* produced pictures outstanding in pictorial quality at exposure levels equivalent to ASA

*The demonstration used an 8 x 10 in. view camera equipped with motorized processing rollers and a dark chamber (Fig. 12-44). The film assembly for each picture comprised a silver halide emulsion, a positive image-receiving sheet and, affixed to the positive sheet, a sealed pod filled with viscous reagent. Processing involved simply passing this assembly through the motorized rollers into the dark chamber. The roller pressure ruptured the pod, releasing and spreading the processing reagent between the two sheets, which formed negative and positive images on their respective surfaces. Pictures were taken, and each photograph was displayed 1 min after exposure, its one-step process having thus taken place automatically inside the camera. Figure 12-45 shows a picture of this type being stripped apart after processing through demonstration rollers outside the camera.

Fig. 12-44. 8 × 10 in. view camera with motorized processing rollers and dark chamber, used in the first public demonstration of one-step photography, February 1947.

Fig. 12-45. Separation of 8 × 10 in. negative and positive sheets after processing in camera of Fig. 12-44, photographed during February 1947 demonstration by Land.

Fig. 12-46. A 1976 reproduction of the 1946 sepia one-step photograph used as an illustration in the first paper on one-step photography.[1] This picture was the first published one-step photograph. The picture, which had no post-treatment and was kept in an ordinary office file, appears unchanged after 30 years.

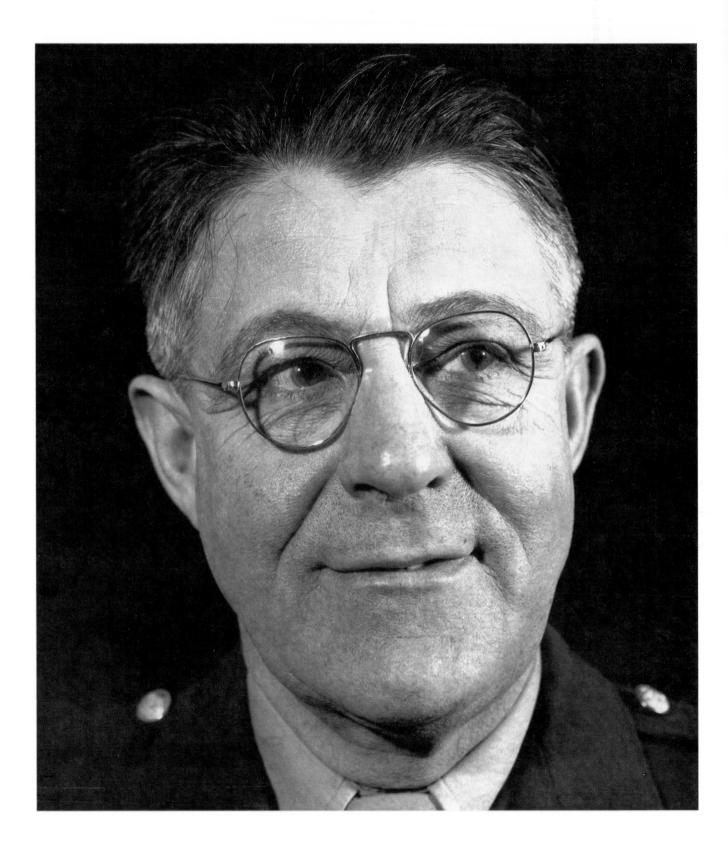

Fig. 12-47a. General George Goddard (1947). Photographed and processed in the camera shown in Fig. 12-44.

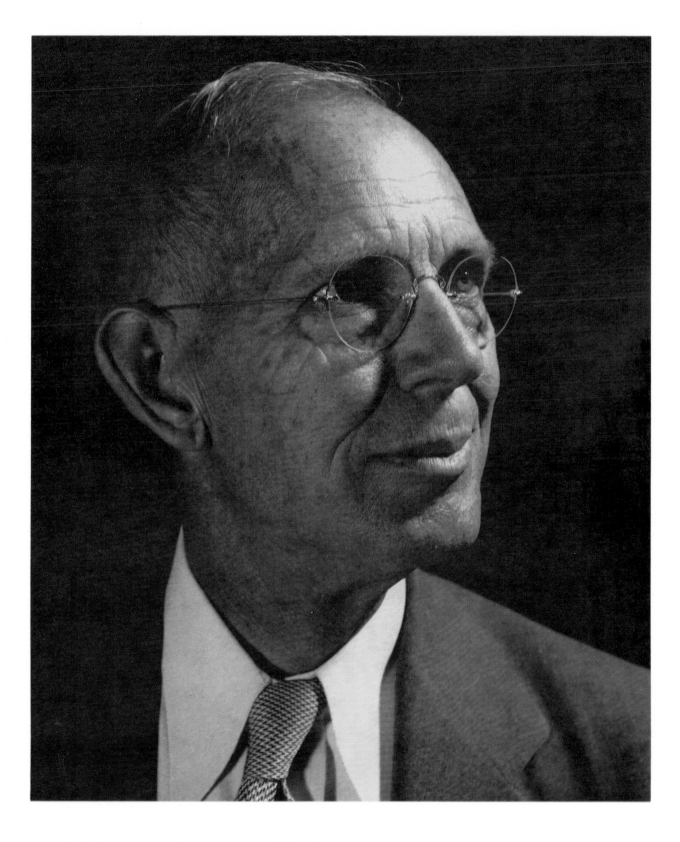

Fig. 12-47b. Professor Clarence Kennedy (1947). Photographed and processed in the camera shown in Fig. 12-44.

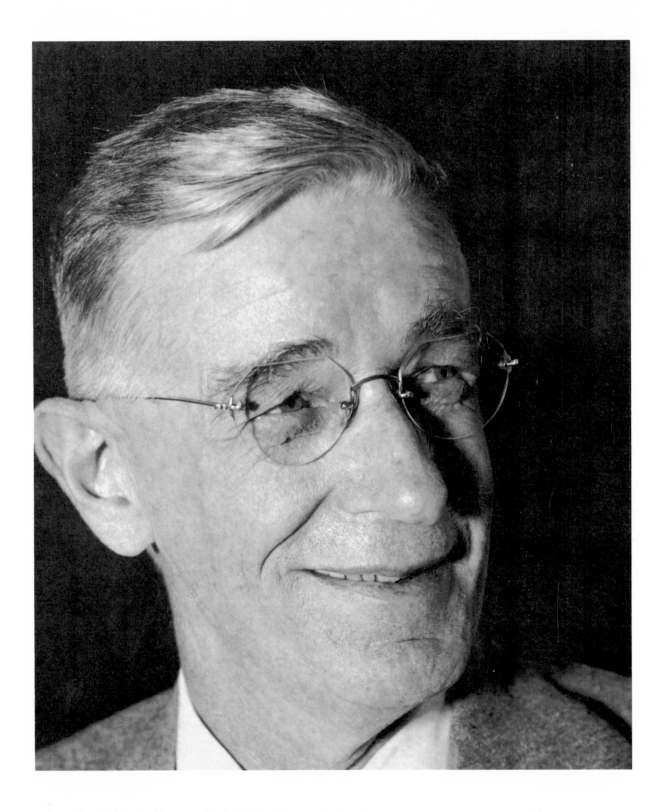

Fig. 12-47c. Dr. Vannevar Bush (1947). Photographed and processed in the camera shown in Fig. 12-44.

Fig. 12-47d. Dr. William David Coolidge (1947). Photographed and processed in the camera shown in Fig. 12-44.

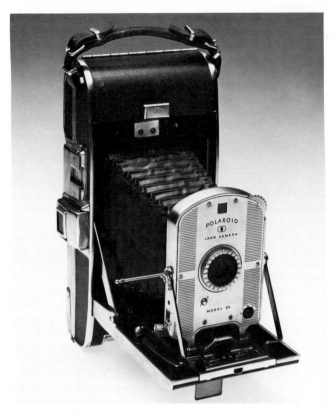

Fig. 12-48. The Model 95, first of the Polaroid Land cameras (1948).

speed 100. These untreated and uncoated images are remarkably stable, as evidenced by Figs. 12-46 and 47, which are 1976 reproductions of prints made and exhibited in 1946 and 1947. Type 40, the sepia roll-film product, was introduced along with the first one-step camera, the Model 95, in late 1948. (Fig. 12-48).

Black and White Processes. The transition from sepia to black and white reflection prints was accomplished by Land and Morse between 1948 and 1950, when Type 41 film was introduced. They precipitated metal sulfides in a silica hydrosol and coated the resulting suspension in a thin layer over baryta paper bearing a waterproof layer of polyvinyl butyral. Image deposition was restricted to the interstices of the silica-based receiving layer, and the image silver formed aggregates measuring 100 to 160 nm in diameter, each comprising many fine particles 10 to 30 nm in diameter. The aggregates were large in comparison with the Type 40 image particles, which measured 25 to 125 nm. The electron micrographs of Figs. 12-49 and 50 show the fine structure of the respective sepia and black and white images, and Fig. 12-51 compares their reflectance spectra.

Subsequent silica-metallic sulfide receiving layers have formed still larger image aggregates. Figures 12-52a and b are electron micrographs of image deposits of high and intermediate optical densities in a current receiving layer of this class (Type 107), showing in cross section the configuration of image silver aggregates in their silica matrix. Figure 12-53a shows a maximum density area as viewed through the layer, and Fig. 12-53b

$$0.5 \, \mu$$

Fig. 12-49. Cross section of image layer of Type 40 sepia print. As in Fig. 12-41, the large particles in the lower portion of the section are barium sulfate pigment in the baryta coating; above the baryta is the deposit of silver in silica.

Fig. 12-50. Cross section of Type 41 image, showing silver aggregates restricted to thin layer of silica. Type 41 was the first Polaroid black and white film (1950).

shows a flake of silver aggregates separated from the silica matrix, demonstrating the continuous nature of a high density image deposit; Fig. 12-54 shows a single aggregate at higher magnification. The aggregates average 150 to 300 nm in diameter; each comprises about 40 closely associated particles 15 to 20 nm in diameter. Figure 12-55 shows the consistent neutral reflectance spectra of a Type 107 image over its full density range.

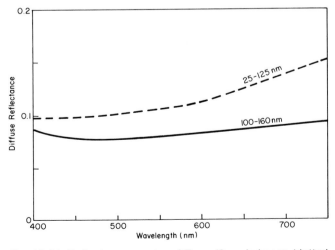

Fig. 12-51. Reflectance spectra of Type 40 sepia image (dotted line) and Type 41 black image (solid line). Numbers printed over curves indicate range of image aggregate diameters.

Nucleating Sites in Regenerated Cellulose. As noted earlier, regenerated cellulose was one of the first materials found suitable as a matrix for neutral silver image deposition. Using nonviscous reagents, nucleation and growth of silver took place readily in the absence of added nuclei.

Nuclei found suitable for incorporation into regenerated cellulose layers for use with viscous reagent systems include colloidal metals and colloidal metal sulfides and selenides. Image-receiving layers of regenerated cellulose having nuclei of well-controlled size and distribution are obtained by hydrolyzing a cellulose acetate layer containing the desired nuclei.[46] With sheets of this type image silver is deposited beneath the surface of the regenerated cellulose layer, and the resulting print is glossy and durable without the later application of a protective coating.

Regenerated cellulose receiving layers of this type are used in Polaroid "coaterless" black and white systems.* Figure 12-56 shows in cross section a high density area of a reflection print image formed in such a layer (Type 87), with palladium sulfide particles the active sites. Most of the silver image lies within a stratum 0.04 to 0.4 μm beneath the surface. The image depth corresponds approximately with the depth to which the layer had been hydrolyzed prior to image formation. The image silver includes both large aggregates of fine crystals and large single crystals, with deposits of each type ranging up to 200 nm in diameter.

*"Coaterless" systems are those yielding positive prints which are stable without coating or other aftertreatment. Further discussion is included in the section "Stabilization of Transferred Images," p. 318.

(a)

(b)

Fig. 12-52. Type 107 image silver, (a) cross section of a maximum density area (1.65) and (b) cross section of a density 1.14 area. The aggregates are embedded in silica; the dark regions are silver, the light gray silica.

Fig. 12-53a. Type 107 image silver in maximum density area, as viewed through the layer. The magnification here is somewhat lower than in the cross section of Figs. 12-52(a) and (b) to provide a more extensive field of view.

Fig. 12-53b. Type 107 positive image silver removed from a maximum density region and treated with hydrofluoric acid to remove silica from the interstices; the aggregates are sufficiently interconnected to remain in "flakes." This figure illustrates the concept of the metallic network that leads to the neutrality of Type 107 images at all densities.

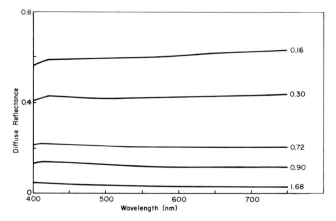

Fig. 12-55. Reflectance spectra of Type 107 images over a wide density range. The neutrality of all densities, as shown by these curves, was a terminal product of research from 1944 to 1950; the system has been in use in the basic black and white product from then to the present (1976). Since the curves are flat over the visual range, each can be characterized by a single reading of diffuse reflection density. These densities are shown to the right of the curves.

Fig. 12-54. A single Type 107 image aggregate at high magnification. Aggregates average 150 to 300 nm in diameter, and each comprises about 40 closely associated fine particles, which are individual crystals of silver.

Fig. 12-56. Cross section of an image in regenerated cellulose (Type 87). The depth of the image is approximately the depth to which the layer of cellulose has been regenerated.

(a)

(b)

Fig. 12-57. Transparency image deposits: (a) brown image formed in mercaptan-free reagent; and (b) black image formed in reagent containing cysteine.

Fig. 12-58. Transmission spectra of brown image (dotted line) and black image (solid line) of Fig. 12-57. Range of diameters of particles and aggregates is indicated over each curve.

Nucleation in Viscous Reagent. The blotting paper, regenerated cellulose and siliceous networks described above all provide environments in which the large single crystals can be aggregated or the aggregates of very small single crystals can be aggregated to satisfy the requirements for blackness; and in these environments the precipitation of the image in the desired state is achieved with remarkable independence of the chemistry of precipitation. In general, the most primitive reduction of silver ion is all that is required. When these environments or their equivalent are not available—for example, when the image is to be precipitated in the viscous reagent—simple precipitation will lead to single crystals too small and too far apart to satisfy the large single crystal condition, but too large to enter into spontaneous clustering. Figure 12-57a shows such a deposit.

In the black and white transparency systems in which a viscous reagent containing nuclei becomes the matrix for growth of image aggregates[47] (Types 46L and 146L), the formation of small particles which readily form

(a) (b)

Fig. 12-59. (a) Single agregates of Type 46L image silver washed free of polymer (120 keV electron micrograph); (b) aggregates like those shown in (a) sectioned while in place in the finished image layer (200 keV electron micrograph).

Fig. 12-60. Transmission spectra of Type 46L transparency images at several densities. Since the curves are flat over the visual range, each can be characterized by a single reading of diffuse transmission density. This density is indicated to the right of each curve.

"large" aggregates is assisted by mercaptans included in the reagent. To demonstrate this effect, Fig. 12-57 compares the structures of image deposits formed in a viscous reagent (a) without and (b) with a mercaptan component.[48,49] The mercaptan-free reagent used as control produced a brown image comprising particles 50 to 100 nm in diameter, many of which appear to be single crystals. A reagent containing the mercaptan cysteine[50] produced a black image comprising 120 to 200 nm aggregates, each including 50 or more fine particles in close association. The spectra of these two images are compared in Fig. 12-58.

The silver aggregates which make up the Type 46L image deposit, shown at high magnification both entire and in cross section in Figs. 12-59a and b, measure 150 to 250 nm in diameter, and each aggregate includes about 50 fine particles 10 to 25 nm in diameter. The extinction bands visible in the fine particles of the sectioned aggregate are indicative of their crystallinity. The transmission spectra of Fig. 12-60 demonstrate the near-neutrality of a Type 46L image over a wide density range.

Although they are formed in a completely different environment, the image aggregates of the transparency positive show a great structural similarity to the black

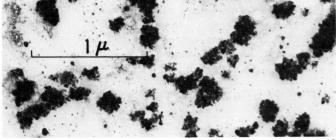

d = 0.42

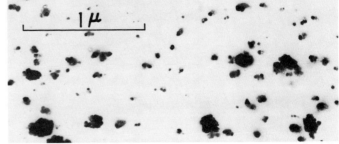

d = 0.35

d = 0.90

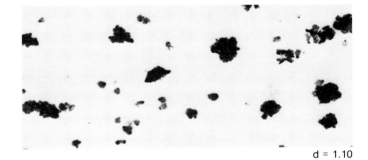

d = 1.10

d = 1.35

d = 2.00

d = 1.66

d = 2.70

(a)

(b)

Fig. 12-61. "Step wedges" illustrating the approximation to uniformity of aggregates for (a) Type 107 and (b) Type 46L images over the full range of optical densities.

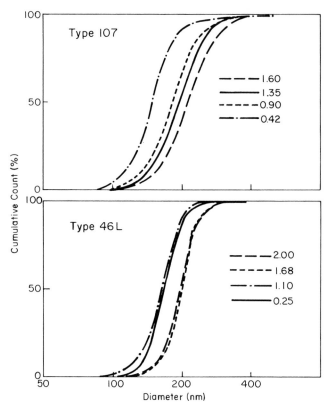

Fig. 12-62. Size distribution of aggregates comprising Type 107 and Type 46L images over a wide range of densities. For each density indicated, cumulative percentages of aggregates, sized from electron micrograph counts, are plotted against diameter (log scale) corresponding to calculated aggregate volume. In both cases most of the silver is in large aggregates.

and white Type 107 reflection print image aggregates already described. In the black and white transparency processes mercaptans, often referred to as blue-black toners, are used to induce rapid formation of small particles which readily collect into an aggregate. The resulting aggregate is similar in size and form to the aggregate which in the reflection print forms spontaneously with or without a mercaptan present.* The dramatic similarity in diameter of the total aggregates, in the structure of the aggregates, in the size and number of constituent particles and in the flatness of the absorption spectra for these two quite different systems supports the hypothesis that the ultimate role of the toner is not to alter the chemical composition within the aggregate but rather to bring into being an aggregate of appropriate size and configuration for uniform light absorption.

Neutrality of Images. In both the reflection and transparency systems the growth of compact arrays of large aggregates (100 nm or more) accounts for the spectral neutrality of the images.** Neutrality of aggregate images

requires the fine particles within each large aggregate to be in contact or in close proximity, acting together as a single unit of appropriate size and conductivity; acting individually, the 10 to 30 nm particles would produce yellow or orange images.

The spectral curves and corresponding electron micrographs of the compact images described here have demonstrated a consistent size-color relationship for silver deposits formed in very different thin layer environments. In all cases, from the close-packed single crystals of the 1944 images in α-cellulose blotting paper (Fig. 12-38) to the Type 46L aggregates of 50 or more fine crystals (Fig. 12-59), the images are black when the crystals or aggregates of crystals are tightly packed together and greater than about 100 nm in diameter.*** Sepia pictures, on the other hand, comprise either considerably smaller single crystals, in the range of 50 to 100 nm, spaced at least as far apart as the crystal diameter (as in Fig. 12-57a) or loosely packed aggregates of very fine crystals (as in Fig. 12-49).

In the black and white processes consistently neutral hue at all densities is achieved by producing large particles or aggregates over the entire density range, as illustrated by the micrographs of aggregates from representative steps of Type 107 and Type 46L images presented in Figs. 12-61a and b, respectively. Figure 12-62 shows corresponding size distribution curves of the aggregates comprising images at several density steps. In both systems most of the silver at each density step is in aggregates 150 to 300 nm in diameter, large enough to produce neutral spectra in a compact layer; the small aggregates included at the lower densities account for only a very small amount of silver and do not materially affect the absorption.

The Fate of Silver During Processing

In silver transfer processes leading to positive images, the silver of both exposed and unexposed grains undergoes development concomitantly in different strata. While the exposed grains are developing in the emulsion layer, the silver of grains which have been exposed is involved in a rapid train of events: the unexposed grains dissolve, and the resulting soluble silver complex transfers to the receiving layer, where it immediately develops to form the crystals of silver which comprise the positive image.

*The effect of mercaptans in this process is unlike that characterized by Cassiers, who described a mercaptan-induced shift from brown to black in Gevacopy transfer images comprising silver particles of approximately 65 nm in diameter. Cassiers reported that this color shift was accompanied by changes of crystal order and surface crystalline

state, with no significant change in overall dimension or distribution of silver particles.[51]

**This observation is based on the correlation of microscopic and spectrophotometric data. Calculations based on the classical Mie equation for scattering and absorption by isolated metallic spheres, often useful in characterizing the optical properties of loosely packed silver image deposits,[52] are not applicable to these compact images.

***A 1962 paper of Weyde, Klein and Metz[53] describes shifts from brown to black for silver deposited in thick gelatin layers as the packing density of silver is increased. The color shift is attributed to increasing incidence of twin- and triple-particle aggregates of particles; the illustrations show that even their most densely packed deposits are much more dilute and much less aggregated than the compact deposits discussed here.

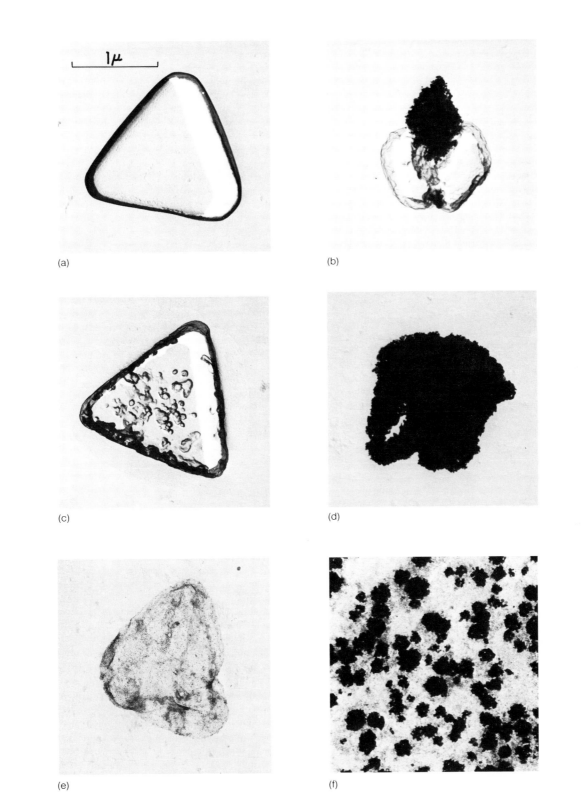

Fig. 12-63. Stages in processing of Type 107 grains: (a) is replicated from an unexposed undeveloped grain, (b) and (c) from grains processed 1/10 sec; (b), an exposed grain, is partially developed; (c), an unexposed grain, is partially dissolved; (d) is a fully developed grain; (e) the imprint of a dissolved grain as it appears after the gelatin is removed; (f) is positive image silver derived from a single grain such as (a) and transferred to an image-receiving layer, shown at the same magnification as the negative grains (a) through (e).

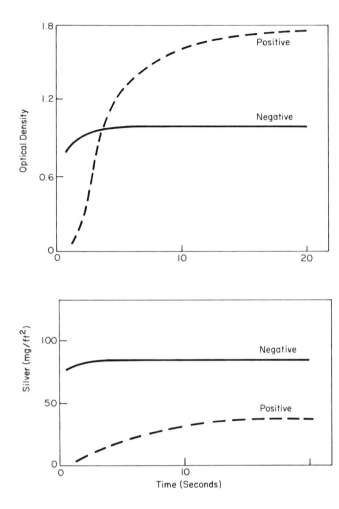

Fig. 12-64. Rates of formation of Type 107 negative and positive image deposits. The upper curves show image growth in terms of optical density, and the lower curves show growth of the same images in terms of the amount of silver developed. Comparing the two dotted lines, on the one hand, and the two solid lines, on the other, note the greater covering power of the positive silver.

Image Formation in the Type 107 Process. The electron micrographs of Fig. 12-63 illustrate the changes which take place in individual silver halide grains as they participate in the formation of negative and positive images in the Type 107 process. The exposed grains show appreciable development after only 1/10 sec and full development within 15 sec; the unexposed grains show considerable etching after 1/10 sec and leave only empty "shells" after 15 sec. The final figure of the series is a micrograph of the central portion of the deposit of positive silver derived from a single Type 107 grain. (See also Fig. 12-73c.)

The rapid deposition of Type 107 negative and positive silver is further illustrated in Fig. 12-64, which shows the rates of formation of negative and positive images of maximum density in terms of both optical density and silver coverage. Each image reaches asymptotic values within 20 sec. Figure 12-65 shows maximum density areas of the positive image at several stages during its growth.

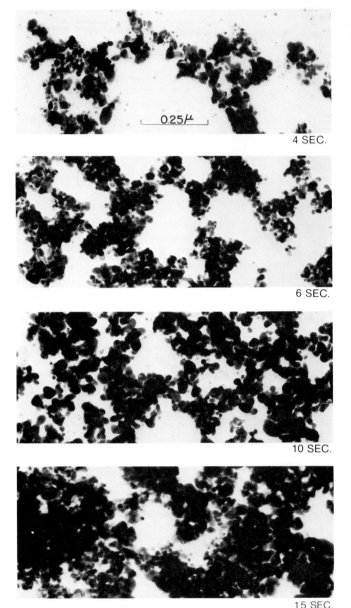

Fig. 12-65. Stages in the growth of a Type 107 positive image deposit of maximum density, transferred from an unexposed region of the negative. Note that the silver is deposited in a network from the start.

Solubilization by Incipient Development (SID). Recent work of Land, Farney and Morse[54] provides a deeper insight into the fate of silver in soluble silver complex systems. They had observed that weak negative images resulting from very low exposures often accompanied the usual positive images of the black and white transfer processes, as shown in Fig. 12-66. Land suggested that the weak negative image could form only if the slightly exposed grains were rendered preferentially soluble during early development.

The phenomenon, designated "Solubilization by Incipient Development," is enhanced by reagents which include both a high solubility (HS) ligand and a low solubility (LS) ligand for silver ion. The HS ligand is

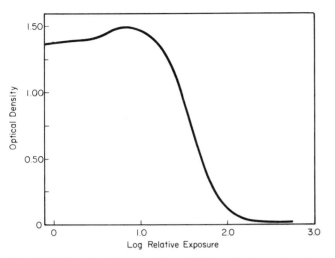

Fig. 12-66. *D vs.* log *E* curve of Type 107 transfer image showing, in addition to a normal positive, a weak negative image at very low exposure level.

defined as a compound—such as hypo—which forms a highly water-soluble complex and the LS ligand as a compound—such as 1-phenyl-5-mercaptotetrazole (PMT)—which forms a sparingly water-soluble complex or salt with silver ion. In the presence of such a pair of ligands and the developing agent, grains which have received low level exposure may be more readily dissolved than either the unexposed grains or the more fully exposed grains, so that a negative image may be transferred.

The development of the slightly exposed grains was found to be characterized by the violent extrusion of filamentary silver from a single development center, as shown in Fig. 12-67; the rest of the grain is propelled in the opposite direction, fragmented and readily dissolved without reduction. Since the soluble silver complex is formed at a distance from the developing filaments, it is not reduced; it is free to diffuse towards whatever nucleating system is made available to it and to give up its silver by reduction upon arriving at these nuclei.

With grains which receive more exposure, development originates at multiple centers, which serve as nuclei at the original site of the grain. The amount of silver that is reduced while in contact with already reduced silver increases with the amount of exposure the grain receives. Furthermore, the hydromechanical thrust in any one direction is balanced by thrust in other directions, with the net result that few complexed ions are freed to diffuse from the original site.

Whether transfer of a negative or a positive image prevails in SID processing depends on the relative concentrations of the two ligands, processing time and exposure level as shown in Figs. 12-68, 12-69 and 12-70, respectively. As the weakly exposed grains are the ones used in the negative transfer process, the effective film speeds are high. Equivalent ASA speeds up to 20,000 are obtainable. Figure 12-71 shows negative and positive images produced with emulsion and reagent of identical composition, using camera exposures five stops apart, as described by the curves of Fig. 12-70.

The following working hypothesis was supported by the experimental data derived from tests with many ligands and a variety of emulsions, from single grain observations and from reaction rate studies:

PMT, an LS ligand, coats all grains with a sparingly soluble layer, and this impedes their dissolution by the thiosulfate, an HS ligand.

The negative transfer image comes about for two reasons. First, during the period allowed for the developer to act, unexposed grains will not dissolve because a sparingly soluble crust forms around them. Second, one has to assume that as development begins on weakly exposed grains, it is not carried to completion but causes the sparingly soluble crust to break open and dissolution of the silver halide to take place: under the quite violent exothermic conditions of development a soluble complex with silver ions is produced. The reason why development of weakly exposed grains is not carried to completion rapidly presumably is that development is slowed down by the LS ligand and that the soluble complex formed is not readily reducible. Therefore the dissolved complexed silver ions can get away from the donor grains without being reduced and diffuse to the receptor sheet where they are reduced to metallic silver at the nuclei.[54a]

The fact that hypo alone can, under carefully controlled conditions, be made to produce the SID phenomenon suggests that a single complexing agent is all that is required and that an HS and LS ligand pair—e.g., PMT and hypo—produce a mixed complex or a mixture of complexes which forms a crust with just the right low solubility characteristics.

Reference 54a also discusses SID as a participating mechanism in other development processes. The phenomenon was readily produced with all of the many emulsions and developing agents tested. Furthermore, the latent image utilized in the SID process gave every evidence of being the ordinary latent image. It was very similar in reciprocity failure characteristics, in effective film sensitivity and in stability at both room temperature and 120° F to the latent image operative in the positive image transfer process with the same emulsion.

Process Symmetry. In both the SID processes and the conventional positive silver transfer processes, final disposition of the silver depends upon a balance among rates of the several concurrent reactions. Such balance also facilitates consistent performance over a wide range of temperatures, as was recognized in the earliest work. Figure 12-72 from Ref. 1 shows the symmetry of negative and positive development rate curves at 30 and 70° F for the Type 40 process.

The cyclic use of silver halide solvent is a significant means of achieving balance between the rates of dissolution and development of silver halide grains in the emulsion. With hypo the cycle is effected by the release of thiosulfate ion as silver is precipitated from the soluble complex in the image-receiving layer, making the thiosulfate ion again available as a solvent so that it may

Fig. 12-67. (a) Silver halide grains developed under SID conditions. Fine threads of silver are about one nm in diameter. During development each grain moves with considerable force, leaving in its wake a growing mass of threads. The arrows show the direction of motion, observed by infrared cinemicrography, of the developing grains. (b) Cinemicrographic frames showing progressive stages in the SID development of a single grain. The interval between frames is 1 sec. (c) Travel of the developing grain of Fig. 12-67(b). The grain's velocity as it left the field of view was approximately 2.3 μm/sec. (d) Rate of growth of the mass of filaments extending behind the developing grain of Fig. 12-67(b).

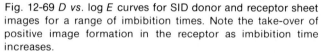

Fig. 12-68. Family of curves demonstrating transition of image in the SID receptor sheet from positive to negative with increasing ratio of PMT to hypo in the reagent. Hypo is held constant as PMT is varied; numbers on curves indicate concentration of PMT in mg/ml reagent. The donor is the light-sensitive emulsion layer, and the receptor is the layer to which dissolved silver is transferred. In this case the donor image is formed in a layer with a large excess of silver halide over what is required to form the receptor image, and the positive donor images corresponding to the negative receptor images cannot be discerned.

Fig. 12-69 *D* vs. log *E* curves for SID donor and receptor sheet images for a range of imbibition times. Note the take-over of positive image formation in the receptor as imbibition time increases.

dissolve and transport more silver. The cyclic use of the thiosulfate ion makes possible efficient silver transfer with a minimum concentration of hypo in the reagent; even more important, it facilitates precise control of the relationship of rate of transfer and rates of development in both negative and image-receiving layers and hence leads to precise control of speed and characteristic curve shape. Hypo concentrations may be as little as 0.25 times the stoichiometric equivalent of the transferred silver.

The ejected ions form complex in solution, whereas the grain, being coated with a crust of the complex, cannot dissolve until the crust dissolves. The finite time required for this dissolution permits a negative to be formed by abstracting the silver ions in complex form from the exposed grains during the time that precedes the dissolution of the silver halide in the exposed grains, protected as it is by the crust. At the end of this finite time, however, the crust will have been dissolved and the unexposed grains will go into solution to be transferred and precipitated, forming a positive in the same surface in which the negative had been formed. Depending on the mass of silver halide in the donor originally, the densities of the positive may dominate those of the transferred negatives. Thus, with short times of imbibition the receptor will have received the silver for a negative; with longer times, enough silver for a *net* positive.

Lateral Diffusion; Resolution. Resolution of the positive images resulting from transfer of soluble silver complex is a function of both the initial resolving power of the emulsion used and the lateral diffusion of image-forming silver during the transfer process. The lateral diffusion of the image in soluble silver is, of course, minimized by increasing the rate of precipitation relative to the rate of ionic diffusion, by decreasing separation between the emulsion and the receiving layer, and by restricting the thickness of both the emulsion and the receiving layer.

The diffusion which does occur is shown in the micrographs of positive images resulting from the transfer of single isolated grains to preformed receiving layers, Fig. 12-73a, b and c. Images (a) and (b), both transferred from 0.8 μm grains, differed in the distance between emulsion and receiving layer at the start of transfer, in case (a) the maximum distance being less than 3 μm and in (b) approximately 15 μm. The diameters of the two transferred images differ approximately in proportion to these distances. These well-resolved positive image "fields" give an indication of the fates of individual grains

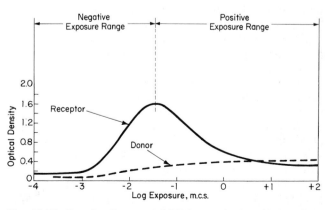

Fig. 12-70. *D* vs. log *E* curves of SID images in donor and receptor sheets over a wide range of exposures, using a single reagent and hence a single ratio of PMT to hypo.

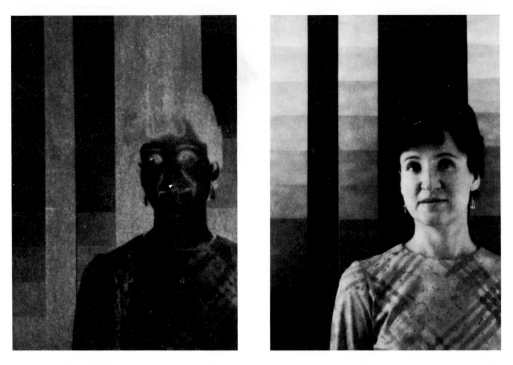

Fig. 12-71. Negative and positive SID transfers produced with identical components, but with in-camera exposures differing by five stops. See also Fig. 12-70.

in silver transfer systems with emulsions of normal con-concentrations. Image (c) is from a somewhat larger grain of Type 107 emulsion coated and processed as was (b), with initial separation approximately 15 μm. The broad distribution of grain sizes characteristic of this emulsion makes it impossible to designate the diameter of the grain which yielded image (c). This image nevertheless is an example of the pattern of positive silver derived from a larger single grain.

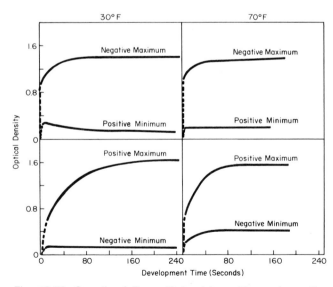

Fig. 12-72. Growth of Type 40 (sepia) positive and negative images in both maximum and minimum exposure regions, at 30°F and at 70°F. (The difference of covering power between negative silver and positive silver does not show because the mass of silver chosen for the negative in the Type 40 process is far greater than the amount transferred for a good positive.)

The Type 46L transparency images, which form in the reagent layer with moderate lateral diffusion, resolve 32 to 35 line pairs/mm, and Type 107 reflection print images 22 to 28 line pairs/mm. The resolution of an image which has undergone very little lateral diffusion, as in Fig. 12-73a, is as high as 200 line pairs/mm or more.

Efficiency of High Speed Films.* The high speed films take particular advantage of the rapid and efficient extraction and deposition of transferred silver by using, in conjunction with a highly sensitive negative, developing agents which are extremely active at high pH. Much of the silver halide, exposed and unexposed, would develop if left too long in such a vigorous reducing environment. The unexposed silver halide is simply dissolved, transferred and redeposited before it can be reduced to fog in the emulsion layer. The process thus involves a critical rate of fog development, in addition to the critical rates of negative image development, silver halide

*Polaroid 3000 Film (Types 47, 107, etc.), rated at ASA equivalent speed 3000, is the fastest material available for general purpose photography. It was the first film fast enough to permit the great depth of field afforded by very small apertures—as low as $f/90$—in a format producing pictures large enough for direct viewing. The high speed film makes it practical to take pictures indoors by available light, as well as outdoors over a wide range of lighting conditions, and to stop motion with a rapid shutter at high light levels. Its speed has also made the 3000 film very important for many scientific applications; Figure 25 describes many such uses. Examples of photographs made possible by the high speed film are shown in Figs. 12-26 and 12-74.

An ultrahigh speed film, the high contrast Polascope (Type 410) for rapid oscillograph trace recording, is rated at equivalent ASA speed 10,000; it is a special-purpose film capable of recording cathode ray tube transients too rapid to be discerned by eye, as shown in Fig. 12-26e, and effective at extremely low light levels.

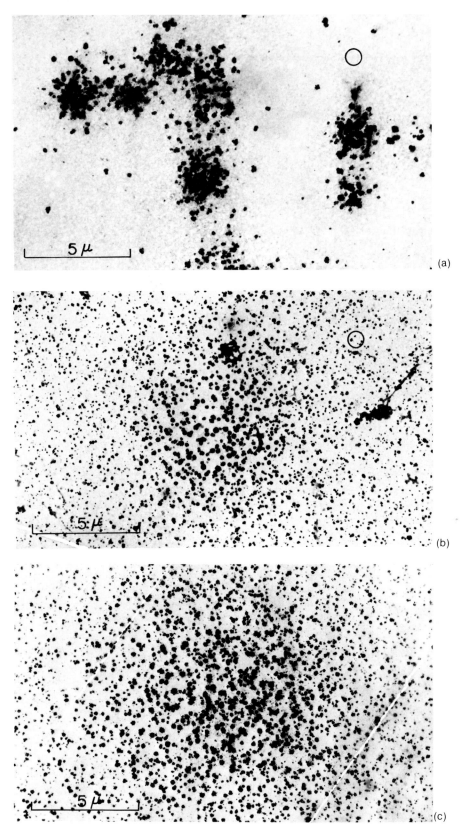

Fig. 12-73. Positive images transferred from single grains, isolation of the grain being obtained by using very dilute emulsion layers. Maximum distance between emulsion and receiving layer was 3 μm for (a), in which the emulsion was coated directly over the receiving layer, and 15 μm for (b) and (c), where the emulsion was on a separate support. The emulsion used for (a) and (b) had uniform grains of 0.8 μm diameter. (c) is from an emulsion with grains of larger size and broader distribution than the one used for (a) and (b). The circles represent the diameter of a single grain in the negative before development.

Fig. 12-74. Photographs with Type 107 film, speed 3000. See also Fig. 12-26.

dissolution, and positive silver image deposition. The entire process can be completed in as little as five seconds.*

Figure 12-75 shows the characteristic curves of Type 107 negative and positive images; both optical density and silver coverage are plotted against relative log exposure to illustrate the difference in covering power of the two silver image deposits. (See also Fig. 12-64.) Covering power—i.e., ratio of optical density to mass of silver per unit area—is seen to relate inversely to unit particle size. The positive silver image, which is high in covering power, comprises a very thin layer of aggregates, forming a mattresslike continuum at high densities, as shown earlier in Fig. 12-53b. The negative image, which is low in covering power, is made up of the somewhat expanded developed grains of the original emulsion, as in Fig. 12-63d, which are about ten times as great in diameter as the positive image aggregates. Because the covering power of the positive silver is high, a useful image is obtained with relatively little silver. The negative itself can therefore contain much less silver than would ordinarily be required to produce a useful negative by tank processing, and the effective speed of the film is enhanced by the efficient utilization of silver halide in the thin emulsion layer.

Design of Positive/Negative System (P/N). The design of a material suitable to produce simultaneously both a permanent negative suitable for making enlargements of high quality and a useful transfer positive** required selection of an emulsion of covering power properties different from those of Type 107. Not only must the amount of silver be appropriate for making a good positive image; here the negative grains upon development must also be of appropriate size and covering power to achieve a useful negative curve with the same amount of silver. The emulsion thus chosen is relatively fine-grained. Figure 12-78 compares the grain size distributions of the Type 107 and Type 55 P/N negative emulsions. The mean diameters are 1.01 and 0.36 μm, respectively. The projected area of a fully developed grain of a 55 P/N negative is approximately 0.4 μm^2, or about one-eighth that of the developed grain from Type 107 negative shown in Fig. 12-63d. Figure 12-79 shows characteristic curves of a 55 P/N positive and negative image pair in both optical density and silver; the positive silver covering power is similar to that of the Type 107 positive,

*The accomplishment of rapid processing of the high speed film led to the revision of the reagents for the earlier black and white processes. The processing time for both the 3000 speed film and the Polapan films was reduced from 60 seconds to 10 to 15 sec shortly after the introduction of Polaroid 3000 film in 1959.

**Polaroid Type 55 P/N film, a 4 × 5 in. packet material, yields both a positive print for immediate use and a fully developed and fixed negative of outstanding quality and high resolution (150-165 line pairs/ mm). Figure 12-76 shows such a positive/negative pair, and Fig. 12-77 reproduces an enlargement made from a 55 P/N negative. The equivalent ASA speed of 55 P/N is 50, and its processing time is 20 sec. Type 105 P/N, rated at equivalent ASA speed 75, is a positive/ negative film in pack format (Fig. 12-31). A removable opaque back coating on the negative sheet permits processing outside the camera.[55]

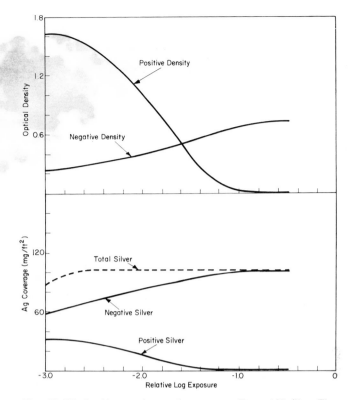

Fig. 12-75. Positive and negative curves, Type 107 film. The upper curves show optical reflection densities and the lower curves show the mass of silver required for each of these densities. Note the relatively small mass of positive silver required to produce the high positive density and the relatively high mass of silver involved in producing the low negative density.

and the negative curve shows significantly higher covering power than that of the Type 107 negative.

Image Stability

An important specification in the design of the first one-step process was that the print not require washing afterwards to be stable and free from undesired residue or stain. This was a particularly demanding requirement in view of the presence of the concentrated reagent, with its potential for further reaction with image silver and its susceptibility to aerial oxidation.

In most instances the viscous reagent forms a thin layer which adheres to the negative and is removed with the negative when it is stripped from the positive. However, whether or not a layer of reagent is removed, the reagent residual in the image layer must be rendered inert if not already inert. One such technique is to incorporate into the receiving sheet one or more components which will diffuse into the image-bearing layer toward the end of image deposition and decrease the reducing power of the reagent by lowering its pH.[56a]

Type 40 sepia images were stabilized by hydrolyzable esters[56b] and soluble lead salts incorporated in the receiving support. These compounds diffused into the image layer as image deposition reached completion and reacted

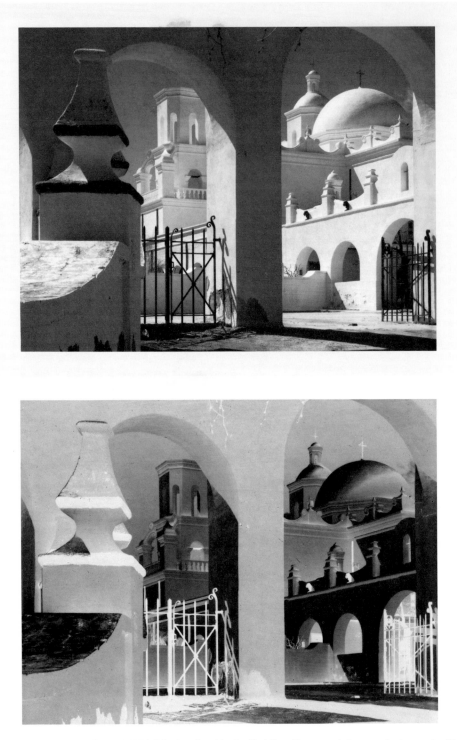

Fig. 12-76. Positive and negative pair, Type 55 P/N. Mission San Xavier Del Bac, Tucson, Arizona, photographed by Ansel Adams (1965).

Fig. 12-77. A gallery print made from a 55 P/N negative. Mission San Xavier Del Bac. See Fig. 12-76.

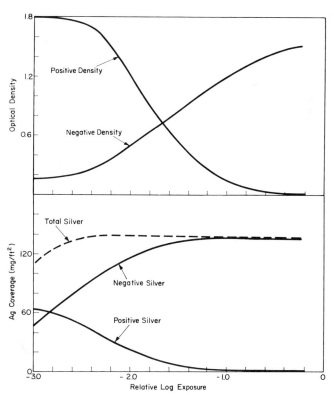

Fig. 12-79. *D vs.* log *E* curves of negative and positive silver, Type 55 P/N. The upper curves show optical transmission density of the negative image and optical reflection density of the positive image vs log exposure. The lower curves show the distribution of silver in the negative and positive images.

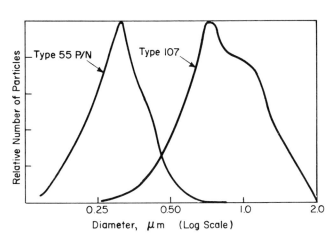

Fig. 12-78. Grain size distributions of Type 55 P/N and Type 107 emulsions.

with excess alkali, lowering the reducing power of the developing agent and inhibiting formation of its quinone reaction product as well. The lead salt further served as a crosslinking hardener[40] for the polymeric component of the viscous reagent, forming of the reagent a thin, protective layer which remained on the print surface.

The silica receiving layers introduced for black and white images (Type 41) were less readily penetrable by stabilizers incorporated in the paper base, and new structures and techniques were consequently developed. A waterproof layer of cellulose acetate beneath the receiving layer confined both the image and other reaction products to a thin, rapidly penetrable surface stratum. This image layer, which was only about 0.4 μm thick, was readily washed free of residual salts by simple swabbing with water, an instant procedure as compared with the extended washing usually given tray-processed prints. While concentrating the deposit close to the surface made the image easy to wash, its vulnerability to abrasion and to attack by active chemicals in the atmosphere was increased, so that it became necessary to provide protection beyond the removal of residues. Durable lacquers coated from organic solvents protected the image from abrasion but neither removed water-soluble residues nor protected the silver from the atmosphere. Simultaneous coating and stabilization were finally accomplished by using a durable film-forming polymer dissolved in an aqueous medium.[57] The print coater introduced for Type 41 and subsequent black and white systems is a swab saturated with an acidic alcohol-water solution of a basic polymer. Swabbing the print both rinses residual reagent away from the image silver and deposits a coating which quickly dries to a tough, impermeable polymeric layer. Prints so protected are durable and stable; they have demonstrated outstanding stability under severe archival test conditions.

Polaroid coaterless 3000 films,* yielding prints which are stable without after-treatment, deposit image silver in depth well within a receiving layer of regenerated cellulose,[46] where the silver is protected from surface abrasion and atmospheric attack. The viscous pod reagent employs as developing agents substituted hydroxylamines[58] with colorless, inert oxidation products, and as silver halide solvents sulfur-free cyclic imides[59] which leave no surface residue. Additional protection may be effected by auxiliary silver image stabilizers in the receiving sheet[60] and an underlying layer of an immobile polymeric acid[46] to abstract and neutralize excess alkali.

The Type 46L and 146L transparency images, formed in the layer of viscous reagent rather than in a preformed layer, are stabilized by momentary immersion in a solution of stannous chloride, which renders residual developer inactive by neutralizing the alkali, reduces quinone and crosslinks the polymeric thickener to form a tough and durable layer.[61]

*Types 20C, 87 and 107C.

Offset Printing from One-Step Images

The recognition that transferred image silver exists as a near-continuum at high densities led to the design of a system for making offset printing masters directly from materials exposed and processed in a one-step camera. For this purpose the image silver is confined to a very thin surface layer of the receiving sheet. When printing ink is applied to the image layer, the silver image and image-free areas accept the ink differentially, and the silver image, bearing an image in terms of ink, may then be used for printing.[62] If exposures are made through a halftone screen located at the focal plane of an amateur or professional camera, offset masters and prints are readily prepared from continuous tone images.

Additive Color Processes

The SX-70 process and the other one-step color processes discussed in the section on *Dye Image Processes* are subtractive processes in which positive images are formed of the subtractive primary colors—cyan, magenta and yellow—and superimposed to produce a full color image. One-step additive color processes, which use positive images of silver to modulate the additive primaries—red, green and blue—have also been described and successfully demonstrated.

One example is a lenticular color process,[63] in which both emulsion and receiving layer are coated on a base bearing minute lenticules on its opposite surface. The film is exposed by passing light through a banded color filter and through the lenticules to form separately positioned sets of color records behind each lenticule. The film is then processed to yield a positive image in silver in the image-receiving layer, and the positive image is viewed in full color by projection through the banded color filter. An analogous lenticular system for black and white stereoscopic photography and projection uses oppositely oriented polarizers in place of the color bands.

Bases bearing additive color screens of red, green and blue line or grid elements may also be used as support for an emulsion and an adjacent image-receiving layer to form additive color transparencies.[64] The emulsion is exposed through the additive color screen and then processed to deposit a positive silver image in the receiving layer. The positive image and the additive screen are projected in registration to produce an additive color image.

In these projection systems the developed emulsion layer may be separated from the positive image-bearing layer after transfer or it may be retained[65] and the image viewed in its presence.[66] Indeed, the positive image may be formed in the emulsion layer. Systems of the latter types take advantage of the high covering power of transferred positive silver images, which is typically five to six times that of the developed negative images and in special cases as high as nine or ten times the negative covering power.

DYE IMAGE PROCESSES

The first one-step color film, Polacolor Land Film, was introduced in 1963, following more than 15 years of experimentation, synthesis and invention. Land, Rogers and several of the other scientists who participated in the Polacolor research effort reported jointly on this work before the Society of Photographic Scientists and Engineers in May, 1963.[67] The report included a discussion of the earlier one-step color processes investigated and described the evolution of many of the unique features of the working Polacolor process.

Coupler Processes

As early as 1947 Land had described one-step processes based on the imagewise distribution of exhausted developers and exhausted color-forming couplers,[1] and the 1944 experiments described earlier had also demonstrated the feasibility of transferring positive dye images through developed or developing negatives. Intensive work toward a three-color, one-step process was begun by Land and Rogers in 1948.

Monochrome Image Transfer. The first processes investigated were exhausted coupler processes based on developing the exposed grains of a negative with a color developing agent in the presence of a color-forming coupler. The color components could be incorporated in the emulsion, in a separate layer or in the reagent. Upon development an immobile negative image in dye and silver formed in the emulsion layer; at the same time a positive image in terms of unoxidized developer and unused coupler was transferred to an adjacent layer. Here the transferred developing agent was oxidized and coupled with the transferred coupler to form a positive dye image.[68] Colorless, immobile oxidizing agents were incorporated in the receiving layer to make this a one-step process, and many successful monochromes were produced by this method.* Figure 12-80a is a reproduction of such a monochrome prepared in 1951. When one-step monochromes in cyan, magenta and yellow produced by the exhausted coupler process were superimposed in register the combined three-color subtractive

*Another useful coupler dye process transferred a positive image in terms of unoxidized color developer, using a receiving layer containing coupler and oxidizing agent. Similarly, a positive image in terms of unused coupler only could be transferred and then coupled. A positive image in terms of unoxidized developer and unused coupler could also be transferred to a fogged emulsion, which served as an oxidizing receiving layer; this procedure formed a positive dye image in a single step but left the silver halide and reduced silver to be removed in a later step.

In another coupler system, a polymeric coupler was used to provide an imagewise impermeable membrane by reaction with oxidized color developer in the regions of exposure; the negative image in impermeable polymer could then be used to control diffusion of a dye through this layer to form a positive image in an adjacent layer. Color transfer systems using developing agents containing coupling moieties have also been proposed.[69]

positive was of excellent color quality. Three such monochromes could also be formed successively in register in a single receiving layer to comprise a full three-color print.[70]

Three-Color Prints from Striped Negative Elements. The next objective was to form the three dye images simultaneously and in a single sheet. While it was recognized that subtractive dye images were needed to provide white highlights in a positive reflection print and that the three positive dye images must be superimposed and continuous in order to produce saturated colors, these requirements for the positive image did not mean that the negative needed to form three continuous images. Land therefore proposed the use of an array of side-by-side or crossed stripe elements in the negative,[71a] with the elements of such size that the transferred images would diffuse laterally during transfer to overlie one another fully. With the stripe arrangement negative image formation could take place in each element independently and simultaneously. A suitable element width would be of the order of the diffusion distance, or approximately .004 in. (0.1 mm), corresponding to 250 elements/in. (10 elements/mm).

There were several new problems associated with constructing a set of stripes, each containing all of the components required to make a monochrome image. To make each stripe an integral single layer element would require the incorporation into the emulsions of components which might be inimical to emulsion sensitivity; the coupler and developer would tend to transfer prematurely when alkali reached the element, so that imagewise control of the dye formed and transferred would be impaired; and single-layer elements could not efficiently provide the yellow filtration required to protect the red- and green-sensitive emulsions from exposure to blue light. To avoid these problems each of the side-by-side elements was coated as a multilayer structure. The construction of these multilayer elements by a series of embossing and coating operations[71b] is illustrated in Fig. 12-81. When the first such striped three-color negatives were processed, the disparate rates of reaction of the three couplers led to serious interactions between the individual color elements. The most reactive of the couplers, the cyan-forming substituted phenols and naphthols, readily reacted with oxidized developer from the adjacent elements, leading therefore to reduced color isolation and color balance.

Preformed Coupling Dyes. To overcome the problem of disparate coupling rates, Rogers sought a single reaction which would control each of three dyes independently and at a uniform rate. He tested the use in each element of an already formed soluble dye bearing a coupler group which would effect dye precipitation by reacting with oxidized developer in regions of exposure; the dye would transfer freely in unexposed regions.[72] Each of the three dyes could thus be controlled by reaction of the same coupling group, permitting their precipitation in the negative or their transfer to the receiving layer at comparable rates. The use of preformed dyes

(a)

(b)

(c)

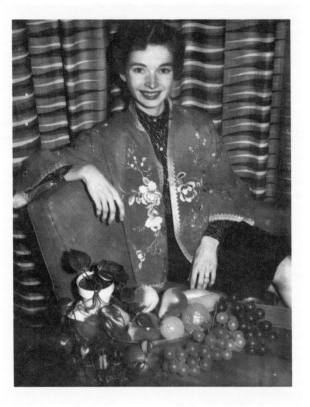

(d)

Fig. 12-80. (a) Monochrome made by exhausted coupler process (1951); (b) monochrome in dye controlled by negative images of bubbles (1953); (c) 3-color print using dye developer in striped negative format (1955); (d) 3-color dye developer print from continuous multilayer negative (1957).

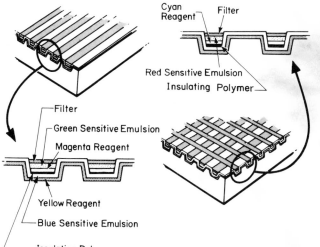

Fig. 12-81. Construction of striped color negative. First a continuous coating of the components needed to form a yellow image is prepared, and over it is coated a continuous layer of blue-sensitive emulsion. The resulting monochrome negative is embossed to form a set of grooves and the grooves are filled by successive coating and doctoring with the layers required to form the second color. The two-color assembly is again embossed to form a new set of grooves at right angles to the first set, and the components of the third monochrome unit are coated in these grooves. Each of the grooves contains in order an insulating polymer layer, a layer containing color developer and coupler, a sensitized emulsion layer and a yellow filter layer.

of this type* eliminated the disparity of reaction rates and reduced the unwanted interactions.

*There are additional preformed dye systems of interest for one-step processes. One class involves alkali exhaustion,[73] that is, the consumption of alkali in the regions of negative image development, which leaves unexhausted alkali free to implement transfer of a positive image in dye.

Exhausted developer processes have used reducible image dye precursors,[74] such as colorless triazolium or tetrazolium bases, reduced by unexhausted developer to their colored forms. These bases can also be used as temporary mordants for acid dyes, which are released imagewise upon reduction of the base by the unexhausted developer. Indophenols, which are colored in oxidized form, can also be reduced and solubilized by an unexhausted developer, then transferred and oxidized to form a positive dye image.

Bubbles formed upon oxidation of a developing agent such as bis-(benzene-sulfonyl) hydrazide are sufficient to prevent the transfer of a soluble dye, so that a positive image may be transferred through the unexposed regions of the developing layer.[75] Figure 12-80b is reproduced from a monochrome prepared in this way in 1953.

Dye-dropping systems[76] are based on attaching a dye to an immobile reducing agent which, upon its oxidation by an oxidized developer, will release a mobile dye. This mechanism may be used to form either negative or positive transfer images. A negative is obtained by transfer from developing areas. Development of a direct positive emulsion results in a transferred positive image. Another way of obtaining a positive is to put a dye bound to an immobile reducing agent into a layer adjacent to the emulsion, along with silver-precipitating nuclei, as are used in the silver transfer systems, and to use a reagent containing hypo; in the unexposed regions, unoxidized developer and soluble silver complex diffuse into this layer, whereupon the silver is reduced and precipitated, the developer oxidized, the dye-holding compound in turn oxidized and the dye released and transferred to a receiving layer as a positive image. Release of a dye or a dye inter-

Dye Developer Processes

To obtain greater control of the three image-forming reactions, Rogers proposed to incorporate the developing function into preformed dyes, providing for each color component a single molecule—a *dye developer*—which could act both as a developer and as an image-forming dye.[9] Before oxidation the dye developer would be insoluble in water but soluble in aqueous alkali. Dye developer undergoing oxidation as a result of development of exposed silver halide would be immobilized, and transfer of the remaining unoxidized dye developer would produce a positive image.

Hydroquinone was recognized as a particularly useful developing group for incorporation into dye developers; its weakly acidic phenolic groups are not very solubilizing, and hydroquinones are very weak reducing agents in water. Hydroquinonyl dye developers are thus inert as developers in contact with an emulsion under neutral or acidic conditions. Aqueous alkali readily solubilizes hydroquinone, which is a strong reducing agent at high pH. Furthermore, when hydroquinone is used as the developer part of a dye developer its solubilization and oxidation reactions confer the desired solubility characteristics upon the entire molecule.

Development with Dye Developers. *Dyes with Developing Function Directly Linked.* The first dye developers synthesized were azohydroquinones, the azo group being substituted directly on the hydroquinone ring, and hydroquinone-substituted aminoanthraquinones, as shown in Fig. 12-82. These dye developers were vigorous developing agents, and they transferred to form excellent positive images. The spectra of the dyes, however, were subject to variation due to reactivity of the hydroquinone portions of the molecules, showing color shifts with oxidation of the hydroquinone and with pH change.

Insulation of Chromophore from Developer. Dye developers with insulating links to interrupt the conjugation between the developing group and the dye chromophore were synthesized to solve the problem of unwanted color shifting; and these dye developers provided excellent monochrome images with colors essentially independent of pH and state of oxidation.[78] Many insulated dye developers,[9b] including metallized dye developers,[9b,79] have been designed and synthesized to achieve desired combinations of solubility and diffusion properties, development characteristics, spectral absorption and light stability. Figure 12-83 shows the structures of dye developers with insulating links, such as were first used in Polacolor film, and Fig. 12-84 shows

mediate from an immobile compound may also be effected by soluble silver ions, e.g., by the silver-assisted cleavage of a thiazolidine group.[77] An advantage to dye-dropping processes is that each of the released dyes in a three-color film is unreactive, so that there are no unwanted interactions involving the diffusing dyes.

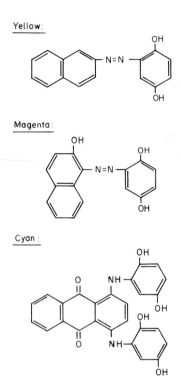

Yellow:

Magenta:

Cyan:

Fig. 12-82. Early dye developers.

Yellow:

Magenta:

Cyan:

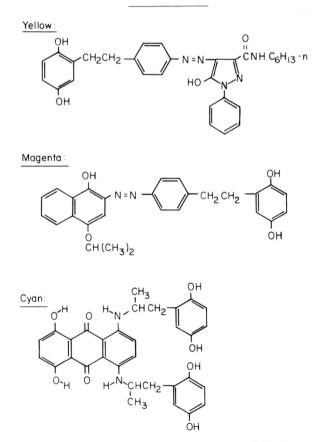

Fig. 12-83. Dye developers with insulating links between chromophores and developing moieties, as used in first Polacolor film.

insulated metallized dye developers of the types used in the SX-70 and Polacolor 2 color negatives.*

Metallized Dye Developers. The metallized dye developers used in both the SX-70 and Polacolor 2 processes yield brilliant images of outstanding stability to light.[80] The metallized cyan dye developer is based on copper phthalocyanine, a pigment well known for its stability. Addition to the molecule of solubilizing groups and developer groups converts the pigment into an alkali-soluble developer.

The chromophores of the magenta[81] and yellow metallized dye developers (Fig. 12-84) are chromium complexed dyes. While chromium is capable of forming complexes with either one or two azo dye molecules per chromium atom, the 1:1 complexes exhibit superior spectral purity. A colorless, modified acetylacetone ligand is introduced to occupy two of the remaining coordination sites of the chromium atom, in order to minimize reactions with gelatin that might hamper diffusion of the dye through gelatin-containing layers of the negative. The colorless ligand also serves as a convenient site for attachment of the developer moiety.

A general structure for the class of naphtholazopyrazolone dyes from which the magenta dye developer was derived is:

X, Y and Z in this general structure are substituents which may be varied to influence the spectral absorption of the magenta chromophore. The color is also influenced, but to a lesser extent, by the choice of colorless ligand. The yellow dye developer is similarly derived from the 1:1 chromium complex of an o, o'-dihydroxyazomethine dye, using the same modified acetylacetone ligand.

Auxiliary Developers. The efficiency of development and image formation with dye developers may be increased by the addition of small auxiliary or "messenger" developer molecules of greater alkali solubility and higher diffusion rate than the dye developers. Because of its superior mobility an auxiliary developer can more quickly reach the exposed grains to initiate development, and its oxidation product can in turn oxidize and immobilize the slower moving dye developer.[9a] (See Figs. 12-5 and 12-7, included with earlier discussion of

*The Polacolor film introduced commercially in 1963 will be referred to hereafter in this chapter as Polacolor 1, for convenience in distinguishing it from Polacolor 2, introduced in 1975. The use of metallized dye developers in the SX-70 process dates from its introduction in 1972.

SX-70 system.) Phenidone (1-phenyl-3-pyrazolidone) and Metol (N-methyl-p-aminophenol sulfate) were among the first auxiliary developers used; later systems included highly active substituted hydroquinones,[82] both alone and in combination with Phenidone.[83]

Negatives Incorporating Dye Developers. *Three-Color Striped Dye Developer Negative.* When early dye developers were substituted for couplers and color developers in the striped three-color negative configuration, color balance and isolation were vastly improved. Figure 12-80c is a reproduction of a color print from a striped dye developer negative made in 1955. Prints of this type, although promising in color isolation, were subject to some inherent limitations. Colors were not highly saturated, being somewhat handicapped by the restriction of each dye to one-third of the area of the negative, and there was still some interaction between the elements at their common edges.

Hold-Release Processing with Dye Developers; Continuous Layers. Images from continuous monochrome dye developer negatives offered considerable advantage in color saturation over images from striped units of restricted area. Rogers and Land recognized that it would be feasible to use a stack of three such monochrome negatives coated sequentially if unwanted interactions could be avoided. They conceived holding each dye developer in the vicinity of its assigned emulsion until substantial development had taken place and then allowing it to transfer.[84] This type of hold-release action was facilitated by the selection of dye developers capable of developing rapidly and diffusing relatively slowly, as illustrated in Fig. 12-85, which shows characteristic rates of development and positive image formation of a monochrome using a Polacolor 1 magenta dye developer.

When an integral, three-color, "stacked" negative formed of three continuous monochrome units was processed, the sequential penetration of alkali through the layers assisted in color discrimination by providing stepwise initiation of development in the three monochromes. Furthermore, diffusion of the dye developers through the layers was much slower than the diffusion of alkali, and this rate difference facilitated the initiation of development in each of the monochrome units before the start of dye transfer.

Barrier Interlayers. Unwanted interactions between the dye developers of one monochrome unit and the exposed grains of another were further reduced by the auxiliary developers and by the intercalation of temporary barrier coats which introduced time delays.[84] Useful barrier layer mechanisms for providing appropriate delays included the controlled rate of hydrolysis or rate of solution of the barrier material and the degree of spatial separation. Among suitable barrier materials were cellulose esters and permeable polymers such as polyvinyl alcohol and gelatin.

Figure 12-80d reproduces a 1957 print transferred from a negative in which barrier interlayers comprising

Yellow:

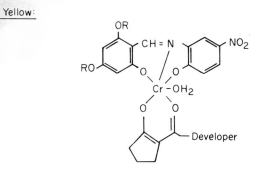

Magenta:

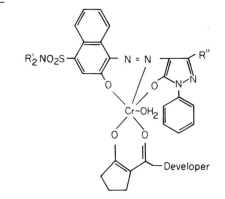

Cyan:

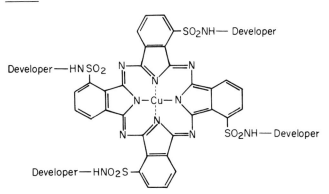

Fig. 12-84. Metallized dye developers of types used in the SX-70 and Polacolor 2 processes.

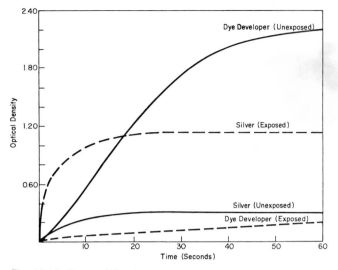

Fig. 12-85. Rates of development and of dye image formation in a Polacolor 1 magenta monochrome, in regions of no exposure and full exposure.

cellulose acetate hydrogen phthalate and cellulose acetate were used to provide hold-release action during processing. Pictures made from negatives of this type were characterized by high color saturation and good isolation and balance. Gelatin interlayers,[84,85] which operated primarily by spatial separation, were utilized in the Polacolor 1 negative to avoid the large-scale use of organic solvents in the negative coating facilities which were then available. In SX-70 and Polacolor 2 negatives, water-based barrier layers comprising combinations of latices and water-soluble polymers are used.[86]

The Polacolor Process. *Polacolor Negative.* Polacolor negative structures are shown in cross-section in Figs. 12-86 and 12-87. In these negatives, as in the SX-70 negative described earlier, each of the dye developers is initially positioned in a layer just behind the silver halide emulsion layer of complementary spectral sensitivity by which it will be controlled during processing. The dye developer may be coated as an oil dispersion[9a] or as a solid dispersion[87] in an alkali-permeable polymer— e.g., gelatin. The three monochrome units, in the order encountered during exposure, comprise a blue-sensitive emulsion overlying a yellow dye developer layer, a green-sensitive emulsion over a magenta dye developer and a red-sensitive emulsion over a cyan dye developer.

Formation and Distribution of Polacolor Images. During Polacolor processing the viscous alkaline pod reagent forms a thin layer which temporarily laminates the negative and the positive receiving sheet together. The liquid of the reagent is rapidly absorbed and the sheets are correspondingly swelled, reducing the reagent layer to a small fraction of its original thickness and bringing the surfaces of negative and positive sheets into close contact. As the negative swells, each of the

solubilized dye developers moves into its associated silver halide emulsion and the auxiliary developer permeates all the layers of the negative. Where the emulsion has been exposed, the silver halide is reduced and the dye developer oxidized and immobilized. In unexposed areas, the dye developer remains soluble and passes through the emulsion toward the positive image-receiving layer, where it is made fast. Figure 12-87b shows a Polacolor 2 negative in cross section after partial swelling by aqueous alkali, and Fig. 12-87c shows a section of a Polacolor 2 positive image at the same magnification.

Color Isolation and Balance. The control of relative rates of development and transfer is critical for color isolation and balance; as mentioned earlier, the exposed grains of each emulsion must be substantially developed before a dye developer assigned to a different emulsion reaches them, and both barrier coats and auxiliary developers assist in effecting appropriate hold-release action. Additional steps are taken to prevent the undeveloped grains in each emulsion layer, whether exposed or not, from undergoing development after the dye developers have begun to move through the layers. Deactivation of the emulsions after a predetermined time period may be accomplished by the release of a low solubility silver ligand, such as a mercaptan.[88]

Still another hazard to color isolation in the multilayer structure is the possibility of reaction of dye developers with one another. Even if development is completed independently in each emulsion before unoxidized dye developer from another monochrome unit reaches it, the arriving unoxidized dye developer may reduce and release the already oxidized dye developer and thus exchange with it. The use of quaternary compounds, which may react with oxidized developer to form a less mobile species, assists in minimizing interactions of this type.[89,90]

The Image-receiving System; Stabilization. Image-receiving layers for the earliest dye developer systems included polyamides, polyvinyl alcohol and gelatin. Particularly useful receiving layers were water-swellable polymers containing mordants for the dye developers.[9a,91] Following transfer of the dye developer images to the image-receiving layer further steps were needed to stabilize the print. Swabbing its surface with a print coater wet with dilute acid after separation from the negative was the first stabilization procedure used.[92] Initial production of Polacolor roll film (Type 48) included such a print coater.

Shortly before the commercial introduction of Polacolor 1, major innovations provided a self-washing receiving sheet[93] which eliminated the need for the print coater and at the same time produced prints of increased luminosity and improved stability to light. The receiving sheet which performs these functions has three active layers, shown in schematic form in Fig. 12-88. Closest to the surface is the polymeric receiving layer containing a mordant for the image dyes. Below the mordant layer is a layer of a timing polymer,[93,94] which determines the

(a)

(b)

Fig. 12-86. Cross sections of Polacolor 1 negative. The upper interlayer contains an auxiliary yellow filter dye. (a) Unprocessed negative;
(b) negative after partial swelling with aqueous alkali.

(a)

(b)

Fig. 12-87. Cross-sections of Polacolor 2 negative and positive sheets. Section (a) is from an unprocessed negative; (b) shows a negative partially swelled with aqueous alkali; and (c) is a section of a positive image of maximum density. Note that this negative is considerably more compact than the Polacolor 1 negative shown in Fig. 86.

(c)

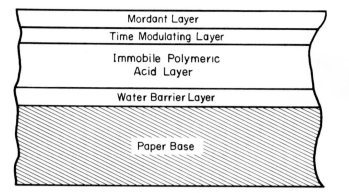

Fig. 12-88. Schematic cross section of Polacolor receiving sheet.

length of time the process will remain alkaline. Below the timing layer is a layer of an immobile polymeric acid. The immobile polymeric acid captures alkali ions and retains them, so that a buffering salt is not returned to the system as it would be with a nonpolymeric acid. The net result is that water is returned in place of alkali. The dye developers are rendered immobile and inactive as the result of the reduction of pH, and the irreversible entrapment of the alkali ions deep within the structure prevents the salting out of residues on the print surface upon separation from the negative.

The Processing Step. Figure 12-89 demonstrates the rapid rates of development of the three silver images in a Polacolor 1 negative and the less rapid rates of deposition of the three positive dye images. As image deposition in the mordant layer of the receiving sheet nears completion, the timing layer permits the polymeric acid layer to begin alkali extraction, as described above, which continues over several minutes. Figure 12-90 shows the rate of pH reduction in a Polacolor 1 positive print after separation from its negative.

Despite the requirements of concomitant developing, dissolving, transferring, mordanting and stabilizing components of three independent monochrome images which initially overlie one another, Polacolor processing is operationally simple. The negative and positive sheets are peeled apart after 60 sec imbibition and the negative discarded. The full color print is ready for immediate viewing with no further manipulation; its surface quickly dries to a hard gloss, and the finished print is durable and stable.

The Polacolor one-step process remains a significant departure from conventional color processing technology. The wet processing of conventional color films and prints involves lengthy multistep darkroom procedures, critical in both time and temperature and inherently limited to the professional finisher or the advanced amateur with a well-equipped darkroom.

The Polacolor process has made it possible for the photographer to obtain a full color print of high quality under ambient conditions, and to obtain it rapidly enough to permit simultaneous observation of print and subject. These capabilities have provided important new opportunities for creative color photography by both

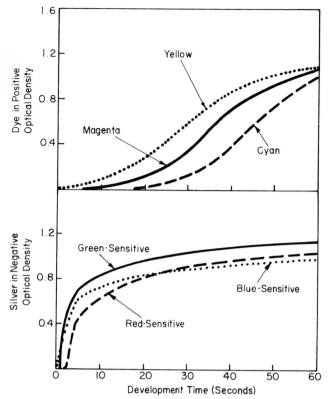

Fig. 12-89. Relative rates of image formation in the Polacolor 1 process. Upper curves show dye deposition in the positive image-receiving layer for regions of no exposure. The lower curves show development of silver in the negative in regions of full exposure.

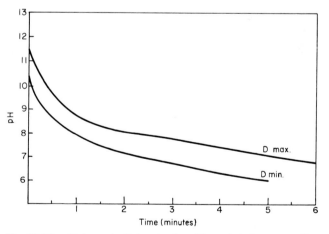

Fig. 12-90. pH drop of a Polacolor 1 positive print after separation from its negative. The pH at the time of separation will have dropped from 14 to between 11 and 12, a pH low enough to inhibit many undesirable oxidation phenomena.

amateur and professional and for scientific color photography in many fields. In April, 1976, the making of 8 × 10 in. and 20 × 24 in. Polacolor 2 photographs was demonstrated, and replicas of museum paintings as large as 3 × 6 ft photographed at actual size, using Polacolor 2 film and process in a full size camera (40 × 80 in. image

Fig. 12-91. Reproductions of Polacolor photographs. See also Figs. 12-10, 27, 86 and 87.

area), were exhibited.[95] Figures 12-27 and 91 are examples of Polacolor photographs, as are the optical micrographs shown in Figs. 12-10, 86 and 87.

Some Major Differences Between Polacolor and SX-70. Both the SX-70 color process described in an earlier section of this chapter and the Polacolor process utilize dye developers, but the two films differ in major respects.

The requirement that the SX-70 film unit be in its final format from start to finish means that all of the reactive materials must be present within the unit from the time of manufacture. The entire structure must, of course, be stable over a wide range of ambient temperatures. Furthermore, after exposure of the negative the complex set of reactions which are involved in forming the negative and positive images and stabilizing the system must be well coordinated over a wide temperature range. Following completion of these reactions, all of the reaction products must coexist in a new stable structure.

Whereas in the Polacolor system the positive image-forming reactions are terminated by stripping away the negative, thereby preventing continued transfer of solubilized dye developer, the SX-70 integral structure requires that these reactions, as well as others, be brought to completion at the appropriate stage without removing or discarding anything at all. Stabilization of an SX-70 film unit thus involves all of the layers of the negative as well as the positive. In addition to providing a stable environment for the positive image dyes, as in Polacolor, the reactions which take place during pH reduction must render immobile the dye developer which is left in the negative, so that unwanted further transfer cannot take place, and render inert all other reactants and reaction products. Many of the stabilizing reactions, which are not discernible to the observer, take place within the film unit concomitantly with the conversion of the opacifying indicator dyes from colored to colorless state. All of these reactions accompany the visible materialization of the final, full-color positive image.

REFERENCES*

1. E. H. Land, *J. Opt. Soc. Amer.*, **37:** 61 (1947).
2. E. H. Land, *Photogr. J.*, **90A:** 7 (1950).
3. (a) E. H. Land, *Photogr. Sci. Eng.*, **16:** 247 (1972).
 (b) E. H. Land, *Photogr. J.*, **114:** 338 (1974).
4. (a) J. G. Baker, presented at Annual Meeting of the Optical Society of America, San Francisco, California, Oct., 1972; Abstract, *J. Opt. Soc. Amer.*, **62:** 1403 (1972).
 (b) W. T. Plummer, *ibid.*
 (c) E. H. Land, U.S. Patent 3,672,281 (1972).
5. Brit. Patent 1,230,886 (1971).
6. E. H. Land, U.S. Patent 3,415,644 (1968).
7. E. H. Land, U.S. Patent 3,793,022 (1974).
8. E. H. Land, U.S. Patent 3,793,023 (1974).
9. (a) H. G. Rogers, U.S. Patent 2,983,606 (1961).
 (b) S. M. Bloom, M. Green, E. M. Idelson and M. S. Simon, in *The Chemistry of Synthetic Dyes*, Vol. 8, K. Venkataraman, ed., Academic, New York, in press, Chapter 9 "Dye Developers."
10. (a) E. H. Land, U.S. Patent 3,647,437 (1972).
 (b) S. M. Bloom, presented at Annual Conf. of Soc. Photogr. Sci. Eng., Boston, Mass., 1974.
11. (a) H. G. Rogers, U.S. Patent 3,594,165 (1971).
 (b) H. G. Rogers, U.S. Patent 3,689,262 (1972).
12. J. Erlichman, U.S. Patent 3,702,580 (1972).
13. W. T. Hanson, Jr., *Photogr. Sci. Eng.* **20:** 155 (1976).
14. (a) J. G. Baker, U.S. Patent 3,619,036 (1971).
 (b) N. Gold, U.S. Patent 3,690,240 (1972).
15. (a) E. H. Land, U.S. Patent 2,435,717 (1948).
 (b) J. F. Carbone and M. N. Fairbank, U.S. Patent 2,455,111 (1948).
16. A. J. Bachelder and V. K. Eloranta, U.S. Patent 2,933,993 (1960).
17. (a) E. H. Land, U.S. Patent 2,495,111 (1950).
 (b) J. A. Hamilton, U.S. Patent 3,161,122 (1964).
 (c) R. R. Wareham, U.S. Patent 3,079,849 (1963).
18. V. K. Eloranta, U.S. Patent 3,382,788 (1968).
19. (a) R. P. Blau and H. S. Sugar, *Arch. Ophthalmol.*, **86:** 552 (1971).
 (b) W. Boyce and D. Bishop, *Gastrointestinal Endoscopy*, **14:** 186 (1968).
 (c) E. T. Peters and S. A. Kulin, *Rev. Sci. Instrum.*, **37:** 1726 (1966).
 (d) D. W. de Poto and M. R. Barnes, *Amer. J. Roentgenol. Radium Therapy, and Nucl. Med.*, **107:** 881 (1969).
20. "Close-Up," periodical publication; Polaroid Corporation, Cambridge, Mass.
21. M. N. Fairbank, U.S. Patent 2,504,312 (1950).
22. J. W. Lothrop, E. M. Purcell and S. B. Whittier, U.S. Patent 2,995,071 (1961).
23. D. S. Grey, U.S. Patent 3,205,795 (1965).
24. E. H. Land, U.S. Patent 3,323,431 (1967).
25. E. H. Land and V. K. Eloranta, U.S. Patent 3,485,155 (1969).
26. E. H. Land, U.S. Patent 2,543,181 (1951).
27. E. H. Land, U.S. Patent 2,603,565 (1952).
28. E. H. Land, *J. Opt. Soc. Amer.*, **30:** 230 (1940).
29. Schering-Kahlbaum A. G., Fr. Patent 716,428 (1931).
30. A. Rott and E. Weyde, *Photographic Silver Halide Diffusion Processes*, Focal, London and New York, 1972.
31. A. Rott, U.S. Patent 2,352,014 (1944).
32. (a) Norw. Patent 66,994 (1942).
 (b) Norw. Patent 69,510 (1944).
33. (a) Belg. Patent 457,478 (1944).
 (b) Ref. 30, p. 19.
34. R. E. Liesegang, *Photogr. Korr.*, **448:** 9 (1898).
35. B. Lefevre, *Photographic Notes*, **2:** 343 (1857).
36. R. Colson, *Bull. Soc. Francaise de Photographie*, **14:** 108 (1898).
37. E. Stenger and F. Herz, Ger. Patent 382,975 (1922).
38. G. W. W. Stevens and R. G. W. Norrish, *Photogr. J.* **78:** 513 (1938).
39. C. Jones, *Photogr. J.*, **51:** 159 (1911).
40. E. H. Land, U.S. Patent 2,584,029 (1952).
41. E. H. Land, U.S. Patent 2,698,238 (1954).
42. (a) E. H. Land and M. M. Morse, U.S. Pat. 3,234,022 (1966).
 (b) E. H. Land, U.S. Patent 3,295,972 (1967).
43. (a) E. H. Land, U.S. Patent 2,698,245 (1954).
 (b) E. H. Land, U.S. Patent 2,698,237 (1954).
44. E. H. Land, U.S. Patent 2,698,236 (1954).
45. E. H. Land, U.S. Patent 3,567,442 (1971).
46. (a) E. H. Land, U.S. Patent 3,671,241 (1972).
 (b) E. H. Land, U.S. Patent 3,772,025 (1973).
47. E. H. Land, U.S. Patent 2,662,822 (1953).
48. E. H. Land, V. K. Walworth and R. S. Corley, *Photogr. Sci. Eng.*, **16:** 313 (1972).
49. G. R. Bird, M. Morse, H. Rodriguez, P. E. Bastian, J. Johnson and W. E. Gray, *Photogr. Sci. Eng.*, **15:** 356 (1971).
50. M. Morse, U.S. Patent 2,984,565 (1961).
51. P. M. Cassiers, Wissenschaftliche Photographie (Ergebnisse der Intern. Konf. für Wissenschaftliche Photographie, Köln, 1956). W. Eichler, H. Frieser, and O. Helwich, eds, Helwich, Darmstadt, 1958, p. 285.
52. (a) G. Mie, *Ann. Phys.*, **25:** 377 (1908).
 (b) E. Klein and H. J. Metz, *Photogr. Sci. Eng.*, **5:** 5 (1961).
 (c) Berry and Skillman, *J. Photogr. Sci.*, **17:** 145 (1969).
 (d) R. C. Jones and G. R. Bird, *Photogr. Sci. Eng.*, **16:** 16 (1972).
53. E. Weyde, E. Klein and H. J. Metz, *J. Phot. Sci.*, **10:** 110 (1962).
54. (a) E. H. Land, L. C. Farney and M. M. Morse, *Photogr. Sci. Eng.*, **15:** 4 (1971).

*References have been selected only to provide the reader illustrative sources of additional information.

(b) E. H. Land, M. M. Morse and L. C. Farney, U.S. Patent 3,615,438 (1971).

55. R. W. Young, U.S. Patent 3,881,932 (1975).
56. (a) E. H. Land, U.S. Patent 2,584,030 (1952).
 (b) E. H. Land, U.S. Patent 2,635,048 (1953).
57. E. H. Land, U.S. Patent 2,719,791 (1955).
58. M. Green, A. A. Sayigh and H. Ulrich, U.S. Patent 3,362,961 (1968).
59. E. H. Land, E. R. Blout, S. G. Cohen, M. Green, H. J. Tracy and R. B. Woodward, U.S. Patent 2,857,274 (1958).
60. (a) R. W. Young, U.S. Patent 3,607,269 (1971).
61. E. H. Land and V. K. Eloranta, U.S. Patent 2,873,660 (1959).
62. E. H. Land and M. M. Morse, U.S. Patent 3,220,837 (1965).
63. E. H. Land, U.S. Patent 2,726,154 (1955).
64. E. H. Land, U.S. Patent 2,614,926 (1952).
65. E. H. Land, U.S. Patent 3,894,871 (1975).
66. E. H. Land, U.S. Patent 3,536,488 (1970).
67. E. H. Land, H. G. Rogers, E. Blout, M. Green, M. S. Simon, G. Bird and R. Corley, presented at Annual Conf. of Soc. Photogr. Sci. Eng., Atlantic City, N.J., May, 1963.
68. (a) E. H. Land, U.S. Patent 2,559,643 (1951).
 (b) E. H. Land, U.S. Patent 2,661,293 (1953).
69. (a) M. S. Simon, U.S. Patent 3,537,850 (1970).
 (b) S. M. Bloom, U.S. Patent 3,537,852 (1970).
70. E. H. Land, U.S. Patent 2,647,049 (1953).
71. (a) E. H. Land, U.S. Patent 2,968,554 (1961).
 (b) H. G. Rogers, U.S. Patent 3,019,124 (1962).
72. H. G. Rogers, U.S. Patent 3,087,817 (1963).
73. (a) Intl. Polaroid Corp., Brit. Patent 860,234 (1961).
 (b) Intl. Polaroid Corp., Brit. Patent 860,233 (1961).
74. H. G. Rogers, U.S. Patent 3,185,567 (1965).
75. H. G. Rogers, U.S. Patent 2,774,668 (1956).
76. (a) H. G. Rogers, U.S. Patent 3,245,789 (1966).
 (b) S. M. Bloom and H. G. Rogers, U.S. Patent 3,443,940 (1969).

77. R. F. W. Cieciuch, R. R. Luhowy, F. Meneghini and H. G. Rogers, U.S. Patent 3,719,489 (1973).
78. E. R. Blout and H. G. Rogers, U.S. Patent 3,255,001 (1966).
79. E. M. Idelson, Annual Conf. of Soc. Photogr. Sci. Eng., Boston, Mass., May, 1974.
80. H. G. Rogers, E. M. Idelson, R. F. W. Cieciuch and S. M. Bloom, *J. Photogr. Sci.*, **22:** 138 (1974).
81. E. M. Idelson, I. R. Karday, B. H. Mark, D. O. Rickter and V. H. Hooper, *Inorganic Chemistry*, **6:** 450 (1967).
82. H. G. Rogers and H. W. Lutes, U.S. Patent 3,192,044 (1965).
83. H. G. Rogers and H. W. Lutes, U.S. Patent 3,039,869 (1962).
84. E. H. Land and H. G. Rogers, U.S. Patent 3,345,163 (1967).
85. R. W. Becker, U.S. Patent 3,411,904 (1968).
86. J. A. Avtges, J. L. Reid, H. N. Schlein and L. D. Taylor, U.S. Patent 3,625,685 (1971).
87. S. Kasman and H. G. Rogers, U.S. Patent 3,438,775 (1969).
88. (a) H. G. Rogers and H. W. Lutes, U.S. Patent 3,265,498 (1966).
 (b) W. J. Weyerts and W. M. Salminen, U.S. Patent 3,260,597 (1966).
 (c) D. O. Rickter, U.S. Patent 3,785,813 (1974).
89. M. Green and H. G. Rogers, U.S. Patent 3,173,786 (1965).
90. (a) W. J. Weyerts and W. M. Salminen, U.S. Patent 3,146,102 (1964).
 (b) W. J. Weyerts and W. M. Salminen, U.S. Patent 3,253,915 (1966).
91. (a) H. C. Haas, U.S. Patent 3,148,061 (1964).
92. (a) H. G. Rogers, U.S. Patent 3,239,338 (1966).
 (b) S. Dershowitz, U.S. Patent 3,287,127 (1966).
 (c) W. M. Salminen, U.S. Patent 3,212,893 (1965).
93. E. H. Land, U.S. Patent 3,362,819 (1968).
94. J. A. Avtges, J. L. Reid, H. N. Schlein and L. D. Taylor, U.S. Patent 3,785,815 (1974).
95. Presented at Polaroid Annual Meeting, Needham, Mass., Apr. 27, 1976.

13

ELECTROPHOTOGRAPHIC PROCESSES AND SYSTEMS

Donald R. Lehmbeck

INTRODUCTION

Electrophotography holds a significant economic and technical position in today's photographic community. Its application to copier and duplicator products is responsible for four billion-dollar revenues each year. Its speed and resolution is comparable to conventional photographic materials in certain special cases. Its exploration as a technical discipline is responsible for hundreds of patents and for scores of technical papers each year. The growth in size and diversity of both the electrophotography business and the supporting scientific literature points to the need for a comprehensive technical survey. This chapter provides such a review.

It begins with an overview of electrophotography followed by a summary of the basic physics of the process. Various embodiments of electrophotography are described, including both the classic copier/duplicator systems and certain unconventional forms of electrophotography. The chapter ends with an analysis of classic electrophotography cast in familiar photographic terms of tone reproduction and image evaluation.

Throughout the chapter, explanations of various topics have been oriented toward readers familiar with conventional photography. Where possible, direct analogies are given. An attempt has also been made to give thorough references, although most foreign language and patent literature have been avoided. A reader particularly interested in more detailed explanations and further references on the topics covered here would profit by reading the two reference books in the field[1,2] and by examining other review articles.[3,4,5] The journals most frequently cited are *Photographic Science and Engineering, Journal of Applied Physics, Applied Optics* (especially Supplement 3 on electrophotography), *The Physical Review* and various publications of the Institute of Electrical and Electronic Engineers. The Japanese journal on electrophotography, *Denshi Shashin*, is another good source of information.

GENERAL ELECTROPHOTOGRAPHIC PROCESSES AND SYSTEMS

Most electrophotographic systems may be considered as assemblies of the basic elements shown in Fig. 13-1. First, there must be a camera to convert the input object into an aerial image of the necessary irradiance. This image exposes an element, the photoreceptor, which has been made light-sensitive by an electrical process. Exposing the sensitized photoreceptor to the aerial image creates an electrostatic latent image on the photoreceptor. The latent image can be converted to a visible or otherwise physically detectable image by a wide variety of development methods. Finally, to have a useful output often requires manipulating the developed image in some manner. This may include, among many possibilities, transferring the image to a new support, fixing the developed image, transporting the fixed image to the user, or providing particular arrangements for viewing the image. Some systems require several additional steps, for example, cleaning, to prepare the photoreceptor for a second exposure.

By referring to Fig. 13-1, we can discuss the key ele-

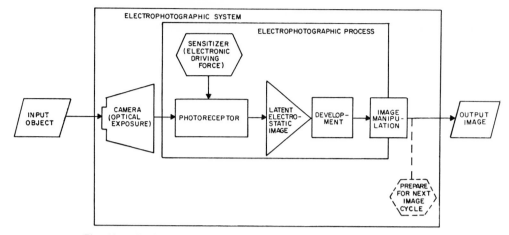

Fig. 13-1. Basic elements of electrophotographic systems and processes.

ments that distinguish the electrophotographic process from the silver halide processes. The first key element, the electrical driving force, is unique to electrophotography. The second key element is the photoreceptor. It is a coating of photoconductive insulating material on a relatively conductive substrate.

While no silver halide or gelatin is used in electrophotography, the key difference is that the electrophotographic latent image is electrostatic while the silver halide latent image is atomistic. Finally, development in electrophotography is a physical rather than a chemical process. For example, the latent image may be developed by attracting a light-absorbing material, called toner, to the photoreceptor by electrostatic forces, or development may be by causing these same forces to induce a physical change in a nearby material layer. Chemical reactions are never directly involved in the development step.

The distinction between an electrophotographic *process* and an electrophotographic *system* is illustrated in Fig. 13-1. The *process* is part of the *system* but includes only those elements essential to forming the image. In other words, the *process* is equivalent to the film and processing portions of a conventional photographic system. The basic physics for each element in the electrophotographic *process* will be described later in the chapter. Details of the *system* components will not be described unless needed to explain a particular system.

Note that the image manipulation block in Fig. 13-1 is largely, but not completely, on the system side. It is split because the fixing and transfer steps (if they are used in the system) are normally treated as a part of the process. These two steps will be discussed only briefly. While they are important to the process of image formation, they are not of as much interest in the context of this book as the sensitizing of the photoreceptor, creation of the latent image, or the steps used in the various development methods. Other elements of some systems, e.g., the mechanisms for transporting the image through a copier or special optical systems for viewing a thermoplastic image, are not essential to formation of the image. Since they are clearly not a part of the process, they will

not be included in the separate discussions of the elements of the process.

The cameras in electrophotographic systems are similar to those used in ordinary photography. The difference is that for most copier applications it is a scanning system which is physically attached to the other subsystem to make an automated complete package.

A complete electrophotographic system, of course, includes many essential elements not shown in Fig. 13-1. For example, special components are required in an automatic copying machine to prepare the system for making subsequent copies. These elements of the system, indicated by the dashed lines in Fig. 13-1, might include subsystems for cleaning residual toner from the photoreceptor, i.e., toner used to develop the image but not transferred to the output copy. Another element within the dashed lines might be a system for uniformly discharging the photoreceptor before resensitizing it for the next copy cycle. While these additional steps are important, they will not be discussed in the section on electrophotographic principles.

While in the broadest sense, electrophotographic systems and processes may be construed to include development forms which are self-illuminating, such as television, image intensifier tubes, etc., we exclude these devices from our definition. For convenience, we separate the discussions on electrophotography into two major categories: classical and unconventional.[3] By classical we mean those toner-developed systems that are commercially available and for which there is an extensive body of scientific literature. Everything else is considered unconventional.

We will first discuss the physics of each of the electrophotographic elements or building blocks, with major emphasis on the classical systems. Then, several significant electrophotographic systems and processes, both classical and unconventional, will be examined briefly, with a description of how each system works. The concepts defined in analyzing the building blocks will be used in these system descriptions. Finally, we will review the overall characteristics of common electro-

photographic systems. We will emphasize tone reproduction and image structure analysis, again making use of the elements depicted in Fig. 13-1.

HISTORICAL

Electrophotography has its roots in several quite separate scientific phenomena. No extensive effort had been made prior to Carlson's invention of xerography[8] to apply these phenomena, which include electrostatics and photoconductivity, to imaging systems. Indeed, some of the processes used in electrophotography had, until quite recently, been considered scientific curiosities, e.g., triboelectrification and corona emission. George Christoph Lichtenberg in 1777 applied electrostatics to recording processes in his experiments with various powders for developing discharge patterns on cakes of resin.[6] Sometime prior to 1842, Ronalds,[7] using Lichtenberg's discoveries, built the first electrostatic recording machine, a machine which recorded changes in atmospheric electricity. The history of the events leading from these early electrostatic experiments to the electrophotographic systems of the 1960s was reviewed by Carlson;[8] many of the events described is this section are from that work.

Between 1900 and the late 1930s, a number of electrostatic processes had been invented which could produce pleasing patterns on tiles, fabric, and paper. Techniques for printing and for recording electrical signals by various applications of electrostatics had also been demonstrated. Photographic film was often used as the recording medium and various electrode arrangements were proposed. A Hungarian, Paul Selenyi, developed a series of recording methods which he called "electrography;" these involved the use of an electron or ion beam to write on insulating surfaces; the surface images were subsequently developed by a powder.[9,10]

Some of the early work in photoelectric image formation can be traced to Gabritschewsky, who, in 1905, succeeded in making images of objects superimposed on polarized ebonite plates by using radium rays and developing with a minium-sulfur powder.[11] Within a few years, such experiments had been extended by others to include X-rays and UV radiation. From the turn of the century to the mid-30s, a number of inventions in photoemissive recording and electrochemical electrophotography were proposed. In the former, electrons emitted in an image pattern from photo-emissive surfaces are caused to fall on photographic or electrosensitive paper. Electrochemical electrophotography used a photoconductive layer to discolor specially made papers by electrochemical action; however, none of the electrochemical schemes were reduced to practice.

In 1935, Chester F. Carlson, a physicist-turned-patent attorney, set out to invent or discover a process which he could use as the basis for an office copying machine. By 1938, with the help of an assistant, Otto Kornei, he had made the first electrophotographic image, combining for the first time electrostatics and photoconductivity.[12]

Carlson's photoreceptor was a photoconductive layer of pure sulfur which had been fused and spread onto a small zinc plate. It was electrostatically charged by rubbing with a handkerchief. Contact exposure for a few seconds was made with an incandescent lamp. Lycopodium powder was used for a developer. The images were made permanent by transferring the powder images to wax paper and heating the sheets to melt the wax. Carlson subsequently demonstrated a more sensitive system, using anthracene as his photoconductor.

Carlson obtained a basic patent on electrophotography in 1942 and on an automatic copying machine in 1944.[13] He tried to interest several manufacturers in his inventions but failed. Then, a meeting in 1944 with Dr. Russell W. Dayton, an engineer at The Battelle Memorial Institute, Columbus, Ohio, led[12,14] to an agreement by which the Institute's Graphic Arts Research Division under Dr. Roland M. Schaffert would develop the process. In 1947, the Haloid Company of Rochester, New York (now Xerox Corporation) acquired a license and began supporting research at Battelle. Battelle and Haloid first publicly announced and demonstrated the process in 1948.[15] They called it "xerography," the name being derived from the Greek "xeros" meaning "dry" and "graphos" meaning "writing." Its first commercial use was Haloid's Xerox copier in 1950. This copier employed several significant improvements over the original patents. These included Bixby's discovery of selenium photoreceptor plates;[16] Carlson's corona charging device,[17] which was further perfected by Battelle; Walkup and Wise's cascaded granular carrier development;[18] and Schaffert's invention of an electrostatic means of transferring toner images from the photoreceptor to paper.[20]

Since 1950 there has been a tremendous growth in the commercial use of electrophotography and in research and invention and proposals of totally new electrophotographic imaging technologies. For example, a variety of organic and inorganic photoconductive materials (see Table 13-1) and photoreceptor formats have been explored. Particularly noteworthy was an invention involving various photoconductive layers formed from inorganic powders in a binder. These photoconductive systems have been studied extensively.[19,20] One species announced in 1954[21] under the name "Electrofax"* employed a paper base coated with a white zinc oxide (ZnO) resin binder layer which was directly developed (by magnetic brush) and fused to produce the output copy. Such zinc oxide binder papers are widely used today in nontransfer-type xerographic copiers and microfilm enlargers.[1,2] Improved selenium and some of its alloys, and certain new organic materials dominate in the transfer-type imaging systems.

Magnetic brush and liquid development were also introduced during this period. The focus of much research and development has been on dye sensitization to extend the basic UV response of ZnO materials through-

*Registered trademark of Radio Corporation of America.

TABLE 13-1. SOME PHOTOCONDUCTIVE MATERIALS USED IN ELECTROPHOTOGRAPHY.

Material	References
Elemental materials	
Amorphous selenium	35, 36, 37, 38, 39, 40, 41, 42, 43, 24, 25, 44, 45, 46, 47, 48, 49
Sulfur	
Crystalline selenium	
Selenium pigments	50
Alloys and other mixtures containing selenium	
Selenium-tellurium	5, 51, 52, 53, 55, 56, 96
Selenium-sulfur	54
Selenium-arsenic	51, 57, 58, 59, 26
Selenium-arsenic trisulfide	60, 61, 48
Selenium-arsenic-iodine	58
Selenium-metal vitreous films	62
Inorganic compounds	
Zinc oxide (incl. sensitizers)	63, 64, 65, 66, 67, 68, 69, 70, 71, 72, 73, 21, 74
Cadmium sulfide	73, 75, 74, 76, 77
Zinc sulfide: cadmium sulfide	78
Zinc cadmium sulfide	19
Mercuric sulfide in zinc oxide	79, 80
Cadmium sulfo selenide	73
Titanium dioxide	81, 82, 83
Arsenic trisulfide	83a
Organic compounds	
Poly(n-vinylcarbazole) (PVK)	48, 49, 84, 28
Poly-n-vinylcarbazole and 2,4,7-trinitro-9-fluorenone (1:1 TPC)	85, 29
Poly-3,6-dibromo-N-vinylcarbazole sensitized with triarylcarbonium	33
Phthalocyanine	86, 87, 88, 49
2,5-Bis-(4'-dimethylaminophenyl)-1,3,4 ozadiazole	89
1,3-Diphenyl-5-(p-dimethylaminophenyl) pyrazoline	89
1,3,5-Triphenyl-4-(p-dimethylaminophenyl) imidazolethione	89
Benzylidenebenzhydrazide/methyl violet	89
2,4,7-Trinitro-9-fluorenone anthracene	91

out the visible region and on discovery of new photoconductive materials. New insight into the science and technology involved in all phases of classical electrophotography was obtained during the 1950s and 1960s, and entirely new concepts in electrophotographic imaging were invented. A few of these will be discussed later under unconventional systems.

THE PHOTORECEPTOR AND PHOTOCONDUCTIVITY

The central element in the classical electrophotographic process is the photoreceptor. This element's photoconductive properties are used to produce a latent image. The discussion which follows will focus first on a simplified description of photoconductivity. It will be followed by a discussion of the electrophotographic characteristic that describes this property, namely, the photodischarge cycle. A classified list (Table 13-1) of available pertinent photoconductive materials is presented. Important characteristics of photoreceptors will be discussed with emphasis on the performance of a few specific but representative materials. Finally, more detail will be given on the mechanisms of photoconductivity; particular emphasis will be placed on selenium, a very common photoreceptor.

Photoconductivity

When a photon strikes a photoreceptor, it may be reflected, transmitted, or absorbed. Photoconductivity involves those events occurring within the photoreceptor

after photon absorption which, as a result, produce additional free carriers and therefore cause a change in the electrical forces on the photoreceptor. Generally, these events include the photogeneration of holes and/or electrons and their transport across the photoreceptor. These carriers generated by photon absorption are used to discharge a previously created, uniform, electrostatic charge distribution on the photoreceptor surface. (The separate step which provides this distribution will be described later.) Since absorption and photoconductivity are the processes connecting the incident illumination with the latent image, they play a central role in determining sensitometric characteristics of the electrophotographic process.

It is possible to measure directly both the radiant energy falling on the material and the large-area latent image. Therefore, the sensitometric characteristics of the photoreceptor may be completely specified without considering the development part of the process. This makes the study of the fundamental properties of electrophotographic processes easier in many ways than studies of comparable silver halide processes in which it is not possible to directly measure the latent image.

General Photoconductive Discharge Cycle

The time-dependent latent image formation process in electrophotography is referred to as a photoconductive discharge cycle. Its measurement and description are fundamental to understanding the behavior of photoconductors as used in electrophotography.

Three basic steps[22] are involved in the discharge cycle. First, a spatially uniform electric field, typically on the order of $10^5 \mathrm{V/cm}$, is placed across the photoconductive insulating layer. Corona charging is often used for this sensitization step; it will be discussed in a later section. Then, in the photoelectric step, light, or some other form of radiation such as X-rays or UV, is absorbed by the photoconductive material. This absorption produces a number of free carriers (holes and/or electrons). The third step, which involves electrical transport phenomena, distributes the photogenerated carriers to the appropriate surfaces, under the force of the above electric field, where they diminish the uniform charge pattern to form a developable electrostatic latent image.

Several types of events compete with or otherwise complicate this process including: recombination of holes and electrons, trapping of carriers, release of trapped carriers, thermal release of carriers within the layer, and injection of carriers at the free or interface surfaces of the photoconductor. Many photoconductors[23] have been found to have field-dependent carrier emission efficiencies[24-26] and field-dependent carrier mobilities.[26-28] The depth at which the radiation is absorbed and the efficiency of this process is governed by the optical characteristics of the photoreceptor layer and by the spectral characteristics of the radiation. Although strongly absorbed light has been used in conventional xerography, some recently developed photoconductors[29] have optical densities of the order of 1.0 in the visible;

hence a considerable number of carriers are emitted in the bulk of the plate.

Each photoconductive material and process configuration behaves somewhat differently with regard to the above factors. Even the type of carrier varies among materials. For example: in selenium, both the holes and the electrons move; in vitreous As_2Se_3, only the holes have significant range; and in photoreceptors where ZnO and CdS particles are dispersed in a binder, only the electrons move between pigment particles. The entire process can be indicated phenomenologically by a plot of plate potential versus time, as illustrated by Fig. 13-2.

At the start of the process (the extreme left in Fig. 5-2) the photoconductive plate is in the dark, and a source of charge, usually a corona device, begins to create a potential (positive in Fig. 13-2) on the surface. A charge, opposite in polarity, is created on the grounded, conductive base. When no more charge can accumulate, the acceptance potential of the material has been reached. In typical applications, a maximum charge well below the acceptance potential of the material is used. However, the general shape of the curve is as shown. Under many conditions, a few charges will "leak" across the photoconductor, partially discharging the plate. This dark decay is shown by an arrow in Fig. 13-2.

Upon exposure to light, holes and electrons are generated in the photoconductor and, driven by the electric field, travel to the appropriate surfaces, thus partially discharging them and producing a diminished plate potential in rough proportion to the amount of incident light. Frequently, some of the carriers are trapped in the material, thus preventing complete discharge. The voltage at which the rapid light decay becomes relatively slow is called the residual potential.

We can obtain an elementary quantitative description of the process depicted in Fig. 13-2 by considering the photoconductive layer—whatever the material—as the dielectric in a simple, parallel-plate capacitor. The layer has a high resistance in the dark; in the light it conducts charge, creating a current. As the light-induced current flows, charge is drained from the surface, thus reducing the surface potential, V. This, in turn, reduces the driving force for the current. A knowledge of the time dependence of both the current $J(t)$ and the surface potential $V(t)$ is important in describing photoconductive behavior.

For the parallel-plate capacitor model, the change with time, t, of the effective potential across the layer is given by the functional relationship:

$$V(t) = \frac{Q(t)}{C} \qquad (1)$$

where C is the capacitance/cm^2 of the photoconductor and $Q(t)$ is the instantaneous charge. Then, we can use the simple derivative:

$$\frac{dV}{dt} = \frac{J(t)}{C}, \qquad (2)$$

where $J(t)$ is the instantaneous current.

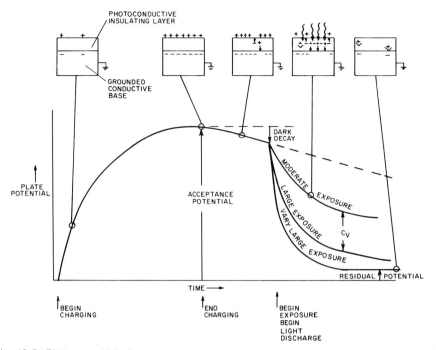

Fig. 13-2. Plate potential of an electrophotographic plate during the charge-expose cycle.

It is possible to compute the instantaneous current from such a model. Only two easily measured characteristics of the photoreceptor are required, namely, the voltage discharge curve and the capacitance. Commerically available electrometers (described later) equipped with transparent probes[30] are frequently used to measure the time-dependent voltage drop, shown as the right portion of Fig. 13-2. The slope of this curve at any point in time provides the dV/dt term. This can be measured electronically or by a point-by-point numerical differentiation. The capacitance per unit area can be measured by several methods. One technique[31] is to place the photoconductor between two parallel conducting plates, one of which is a special, accurately smooth probe and the other the conducting substrate. A frequency-dependent comparison circuit[31] is used to determine the capacitance in this arrangement. Another technique[32] measures surface voltages with an electrometer while incrementally discharging the previously charged photoconductor with a known quantity of opposite-sign corona charge.

The capacitor model can be used to derive an analytical expression for the V versus t discharge curve. This may be done by integrating Eq. (2) as follows:

$$t = -C \int_{V_0}^{V} \frac{1}{J(t)} dV \qquad (3)$$

where V_0 is the initial surface voltage, V is the voltage at any time t, and J is the current in the photoconductor. To solve this integral in a useful way, we use some understanding of the mechanisms of charge generation and

transport to arrive at a voltage- and light-flux (exposure)-dependent expression for the current, J. Equation (3) is then directly integrated to obtain a relationship between time, exposure and voltage. Several specific photodischarge mechanisms have been explored[23] with this end in mind and will be discussed later. For the present, it should be noted that such a method gives good agreement between theory and measured values. A typical discharge curve for selenium is shown in Fig. 13-3 along with the theoretical results.[23]

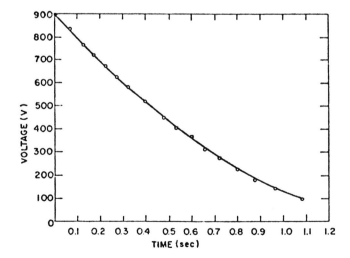

Fig. 13-3. Discharge data (circles) of amorphous Se compared with theoretical calculations, Eq. (6b), (solid line) with $F = 1 \times 10^{12}$ photons/cm^2 s, $\epsilon = 6.3$, photoconductor thickness, $L = 45\,\mu$, $E_n = V_n/L = 2.8 \times 10^5$ V/cm, $P_e = \frac{1}{2}$, (From Chen, et al., Ref. 23).

Variety and Classification of Photoreceptors

The electrophotographic properties of a great many photoconductors have been reported in the literature. In 1964 Schaffert[2] listed 81 U.S. patents on electrophotosensitive materials and structures. Many of the separate patents contained claims covering a wide variety of materials. The physical and chemical journals abound with detailed investigations of those and many newer materials. A great deal of interest in organic photoconductive materials and methods for extending the long wavelength sensitivity of other materials has made this list considerably longer in recent years. One author[33] reported using 27 different sensitizers for a single organic photoconductor. It is beyond the scope of this paper to list all the materials which have been explored. A number of others have reviewed many of these.[1-4,34] Here we can only mention and discuss the important characteristics of a few representative photoreceptors.

There are several different approaches to the classification of photosensitive elements in electrophotography. Throughout, it is important to distinguish between the photoconductor, which is a material, and the photoreceptor, which is a structure containing photoconductor material(s). From the systems engineering point of view there are two major classifications of photoreceptors, the reusable ones such as amorphous selenium drums and plates and the consumable materials such as zinc oxide-resin binder-coated papers. In a composition sense, photoreceptors may be divided into homogeneous films which are often of the reusable class, heterogeneous layers wherein photoconductive particles are dispersed in a binder matrix, and layered structures using homogeneous films. Finally, from the materials standpoint, photoconductors are divided into: elemental substances, including selenium and sulfur; alloys and other mixtures of elements, including Se-S, Se-As, Se-Te; inorganic compounds such as zinc oxide; and organic compounds such as anthracene and polyvinyl carbazole. Table 13-1 (p. 334) lists a number of photoconductors with references to more complete information. They have been grouped according to major material classifications; no attempt has been made to differentiate between other classifications or structures.

Performance Characteristics of Photoreceptors

Selenium xerographic photoreceptors in their simplest form consist of a base electrode, usually metallic, which has been coated with a layer of vitreous selenium by vacuum evaporation. To facilitate analysis of photoreceptor behavior and to provide concepts with which to consider new photoreceptor forms, it has been desirable to distinguish and define the various layers and their functions, as in Fig. 13-4. However, in many present commercial photoreceptors, there is no real distinction between the photoconductor top-surface layer and the semiconductor storage layer; both are selenium. The protective overcoating is at present in commercial use

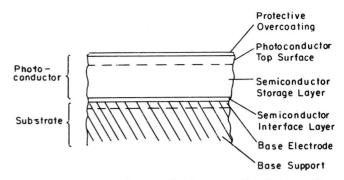

Fig. 13-4. Structure of generalized xerographic photoreceptor (From Hope and Levy, Ref. 112).

only in x-ray or xeroradiographic plates. A single aluminum plate usually serves as both the support and the base electrode; the semiconductor electrode interface layer is usually aluminum oxide. In photoconductive pigment binder papers, the photoconductor is usually a mixture of small zinc oxide particles in a resin binder. The base support is a paper coated with specially selected interface materials. Sometimes an aluminum coating on the paper serves as the base electrode.

There are several characteristics which describe the performance of an electrophotographic photoreceptor. Schaffert[92] lists the important measurable xerographic characteristics as:

1. Charging rate with various corona-charging devices.
2. Charge acceptance—the maximum surface charge density that can be applied to the layer.
3. Charge retentivity as determined from the dark decay of surface charge.
4. Photosensitivity to various light sources and photosensitivity as a function of the wavelength of incident light.
5. Residual potential as determined by the surface potential remaining after exposure to light.
6. Fatigue (for reusable materials) as determined by the increase in the rate of dark decay after continued cycles of charging and exposing or after storage in room light.

Felty[93] expands this list for practical commercial products to include:

7. Electrical stability and thermodynamic stability over extended periods.
8. Latitude—to variations in exposure.
9. Physical properties—the ability to resist surface damage, to adhere to substrates, and to withstand thermal and mechanical shock.

There are some parallels between these properties and the important properties of silver halide emulsions. For example, spectral sensitivity (Item 4) and latitude (Item 8) are fairly direct analogs. Charge retentivity before exposure and electrical stability are somewhat similar to the shelf life of a sensitized emulsion; charge retentivity is, of course, on a much shorter time scale. Residual potential is similar to fog in that it represents an always present, uniform, developable image. Charge

retentivity after exposure may be considered as something like a lack of latent image decay. There is no parallel for fatigue since silver halides are not capable of being used over and over in a cycled mode or of being stored in room light. Charging rate and charge acceptance have no direct analogs.

Many of the photoreceptor characteristics listed above can be obtained from the charge/discharge curves shown in Figs. 13-2 and 13-3. Charging rates are indicated by the rate at which the first portion of the curve in Fig. 13-2 rises. Total times are on the order of a few seconds[94] and are a function of the charging method as well as of the photoreceptor materials. Charge acceptance for a given charging situation is inferred from measuring the peak to which this curve rises. Typical peak voltages for 50 μm amorphous Se layers are 500–1300 V, depending on the charging conditions,[94] and 100 to 800 V for Electrofax ZnO binder layers.[95,96] Actual charge densities of 0.5 to 1.5×10^{-7} C**/cm^2 are desirable.[94] Maximum voltages are often not controlled by the photoconductor but rather by the charging step which will be discussed later (see Electrical Sensitization, page 345).

Dark decay is of considerable importance in describing both the physics of a particular photoconductor and its usefulness in a practical system. It is generally thought that dark decay to one-half the initial potential should require several minutes; however, this is obviously a function of the application. This characteristic is controlled by the rate of generation of free carriers within the photoconductor or at its surface. They may come from thermal release within the layer or by injection, either at the free surface or at the interface with the conductive substrate.[97,98] The latter source is often the major contributor. To overcome the problem, photoconductive layers are often used with blocking air and substrate interface layers that prevent injection of at least the most significant sign carrier.[112,65] Al_2O_3 is a typical electron blocking electrode for an aluminum-selenium interface.[93]

The dark discharge curves for selenium can be described[98] by:

$$V = V_0 \exp\left[-\frac{A_1}{a}(1 - e^{-at}) - A_2 t\right] \quad (4)$$

Where A_1, A_2 and a are constants chosen for the fit (can be expressed in terms of basic electronic properties of the photoconductor), V_0 is the initial voltage and t is time in seconds.

Photosensitivity is of great concern; it may be described in a variety of ways. A plot of residual potential, V, at some appropriate fixed time after exposure *versus* the amount of exposure producing the residual is a type of electrostatic, sensitometric characteristic curve. This is particularly true for electroded development systems*

where large area density is approximately proportional to plate potential. In any event, such curves represent the sensitometry of the latent image. The curves can be normalized by dividing V by the initial potential V_0. This is advantageous since it allows comparing the photosensitivities of a great many different materials and conditions on a single set of coordinates. Figure 13-5a (page 339) is a set of such curves taken from published data. The spectral emittances of the light sources are not the same in all cases (see caption), so that the plots indicate overall response rather than sensitivity to a common source. It must also be realized that this technique only approximates the output sensitometry and is valid to the extent that one may compensate for the normalization by adjusting the development to give a similar D_{max} at any V_0. Unfortunately, the time after exposure when the measurements in Fig. 13-5a were made was not always identified; however, one may assume it to be approximately that during which development can be carried out. In Fig. 13-5b, for reference, characteristic curves of typical silver halide films A, B, and C have been shown on the same exposure axis.

The curves in Fig. 13-5a are all of positive working systems, using V/V_0 as the ordinate. Those in Fig. 13-5b are negative working and use density as the ordinate. The selenium curves 1 and 12 are often used as references. The characteristics of several thermoplastic, electrophotographic materials, employing charge transfer and measured in a Schlieren optical system, are shown as curves 12, 13 and 14 in order to include properties of Se-Te more completely and to show how variations in development affect results. Charge transfer and thermoplastic development will be discussed later and should be regarded here only as an efficient way to translate a voltage characteristic curve to a negative working characteristic curve in density units.

Several important aspects of electrophotographic photosensitivity can be seen by comparing all of these curves. First, it should be noted that most of the electrophotographic curves are relatively steep and have short exposure scales. This accounts for the overall observation that electrophotography is generally a high contrast process. Second, it can be seen that development can alter the apparent photosensitivity considerably. Note, for example, the differences in position on the exposure axis between curves 11, 13, and 14 for selenium-tellurium and between curves 1 and 12 for selenium (which also includes a difference between tungsten and daylight illumination). Finally, it can be seen that the absolute sensitivity of selenium and selenim-tellurium approaches that of the medium and slow-speed silver halide camera films. Other materials, for example certain organic photoconductors, exhibit response not unlike that of the very slow-speed, high resolution, spectroscopic film (curve C, Fig. 13-5b).

There have been attempts to characterize various photoconductors by a single photographic speed number. Frequently, these have taken the form of so-called equivalent ASA speeds. Of course, while assigning ASA speeds to such processes is not strictly valid, it does have some merit since it permits a relative ordering on a com-

**C is the symbol for the *unit* "coulomb" and should not be confused with the *variable* C used for capacitance.
*A particular electrostatic development configuration in which a conducting plate is held above and close to a surface where development occurs. See development section for details.

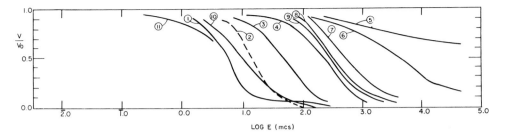

(a)

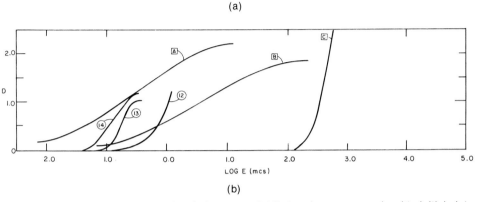

(b)

Fig. 13-5a (top). Photosensitivity expressed as the ratio of plate potential V at a given exposure level to initial plate potential V_0 where exposure is given in meter candle seconds for the following photoconductors and light sources

1. Vitreous selenium, 50μ thick, with white light at $2640°$ K color temperature (Ref. 91)
2. zinc oxide, dye sensitized, with white light (Ref. 254)
3. Organic photoconductor binder plate ("Eflo" xerolithographic Plate) with $2640°$ K color temperature white light (Ref. 254)
4. Unsensitized zinc oxide binder paper as in 2 (Ref. 254)
5. Benzylidenbenzhydrazide, as in 2
6. 2,5-bis-(4'-dimethylaminophenyl)-1,3,4-oxadiazole as in 2
7. 1,3-diphenyl-5(p-dimethylaminophenyl) pyrazaline as in 2
8. 1,3,5 triphenyl-4-(p-dimethylaminophenyl) imidazalethione as in 2
9. Same as 5 but sensitized with 2% methyl violet dye
10. Typical example of a poly-3,6-dibromo-N-vinylcarbazole layer (3μ thick) sensitized with triarylcarbonium salts, source unspecified (Ref. 33)
11. 40% Selenium tellurium alloy, 0.2μ thick, daylight illumination, assuming a series capacitor model applies to given situation (Ref. 52)

Fig. 13-5b (bottom). Photosensitivity of various developed negative working materials plotted on the same absolute exposure to daylight, developed by thermoplastic "frost" deformation and measured for projection density (Ref. 105) include:

12. Conventional selenium
13. Selenium tellurium photoreceptor with frosting of lines
14. as in 13 for frosting in the background. Conventional silver halide materials include:
A. Panatomic X sheet film (ASA50) exposed to daylight and developed in DK50 (1:1) at $68°$ F for 10 min (γ = .8)
B. Commercial sheet film (ASA 16) exposed to tungsten and developed to a gamma of 0.7
C. Spectroscopic plate 649 GH, exposed to tungsten light and developed in D19, $5\frac{1}{2}$ min. at $68°$ F.

monly published sensitivity scale of various photoconductors and various conventional films. Some of these previously published "speed values" are given in Table 13-2.

Speed numbers are best assigned to an entire electrophotographic system wherein the spectral nature of the illumination on the object, the charging conditions, the development and subsequently the image manipulation are specified. All of these parameters of the system have a marked effect on the resultant apparent speed. This is demonstrated by the selenium and selenium-tellurium entries in Table 13-2, each of which indicate an order of magnitude difference, depending on conditions. One is used to thinking about tungsten and daylight speeds for conventional silver halide films, and of "pushing" the film

speed by increased development. Similarly, in electrophotography each photoreceptor material has many speeds; however, the range is larger and the number of controls is much greater.

The spectral sensitivities of photoconductors vary considerably between different materials. The spectral sensitivities for several different materials, as measured by several different authors and using somewhat different techniques and various sensitivity criteria, are given in Fig. 13-6a–f.

Figure 13-6a shows the amounts of surface charge dissipated per unit of incident energy (C/erg) for a surface contrast of 3.5×10^{-8} C/cm^2. The figure (see Schaffert, Ref. 29) compares the spectral sensitivity of a 1:1 molar ratio of trinitro-9-fluorenone (TNF) and poly-N-vinyl

**TABLE 13-2. PUBLISHED "SPEED VALUES" FOR
ELECTROPHOTOGRAPHIC PHOTOCONDUCTORS.**

Photoconductor	Special factors	Approx. speed reported	Reference
Sulfur		0.002	100
Anthracene		0.008	100
Polyvinyl carbazole (PVK)		0.014	101
Zinc oxide in binder		0.1	34
Phthalocyanines		0.2	21
Most organic photoconductors	(even dye sensitized)	less than 0.1	102
Dyed ZnO (Rose Bengal)		1.0–2.0	21
Zinc cadmium sulfide phosphor resin mix		1.0	19
Selenium (amorphous)		2.0	100, 103
	• Frost,* high resolution, charge transfer	0.3	104
	• Frost,* higher speed, charge transfer	2.8	104
Cadmium sulfo selenide	• Photoelectrolytic	8	73
Selenium Te alloy	• General	20.0	96, 105
	• Frost,* high resolution. 35% Te alloy, charge transport	10.6	96, 105
	• Frost,* high speed, 35% Te alloy, charge transport	100.0	96, 105
Cadmium sulfide	Doped with manganese and oxygen	10.0–30.0	19
Cadmium sulfide	2 electrode sandwich type less than 1/400 sec without blocking	200.0	102, 104

*Frost: A class of thermoplastic deformation development explained later on page 372.

carbazole (PVK)* with a 50 μm-thick selenium layer, and a ZnS:CdS binder plate (30% ZnS, 70% CdS). Curve 1 in Fig. 13-6a is for negative charging; curve 2 is for positive

*Schaffert (see Fig. 13-6a) refers to a 1:1 molar ratio of TNF and PVK as "1:1 TPC."

Fig. 13-6a. Spectral sensitivity of 1:1 TPC (20μ) compared to amorphous Se (50μ) and ZnS:CdS (25μ; 70% CdS). Curve 1, negative charging: curve 2, positive charging. The sensitivity units are given in terms of the amount of surface charge dissipated per unit of incident light energy (C/erg) for a surface charge contrast of 3.5 × 10^{-8} C/cm^2. (Ref. 29, Schaffert)

charging. Figure 13-6b gives percent quantum gain (exact units not defined) with a –10 V/μm field on the photoconductor for a 1/50 sec exposure through a glass substrate for the following: a 0.2μ, 40% Se-Te plate; a 0.1μ, 50% Se-Te plate; and a pure Se plate (see Neyhart, Ref. 52). Efficiency is plotted in Fig. 13-6c in terms of charges neutralized per photon absorbed at 20 V/μm fields; various arsenic and selenium combinations are given, including one doped with iodine (see E. J. Felty,

Fig. 13-6b. Spectral sensitivity of rear exposure Se-Te plates. (Ref. 52, Neyhart)

Fig. 13-6c. Photoconductor efficiency at 20V/micron fields for various As concentrations. Data for 30% and 50% As follow the same curve within experimental error (Ref. 58, Felty)

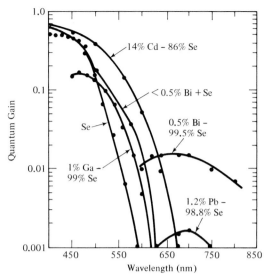

Fig. 13-6e. Quantum gain vs. wavelength at 2×10^5 V/cm applied field (noninjecting contacts for several selenium-metal vitreous films. Compositions are expressed in at.%. (Ref. 62 Schottmiller, et al.)

Ref. 58). In Fig. 13-6d the characteristics of a zinc-cadmium sulfide binder are compared to Se and Electrofax. The reciprocal of the exposure required to decay surface potential to one-half the residual potential is plotted in units of $cm^2/\mu W$-sec for the indicated potentials (see Chapman and Stryker, Ref. 78). Figure 13-6e shows quantum gain, defined such that unity gain would result if each incident photon resulted in a hole-electron pair collected at the electrodes. It gives results for several selenium-metal vitreous films at 20 V/μm applied field (noninjecting contacts) with compositions expressed in atomic percent (see Schottmiller, Bowman, and Wood, Ref. 62). Figure 13-6f is a plot of quantum efficiency in carriers per incident photon for ZnO binder papers dyed with rose bengal and fluorescein in the amounts shown. Quantum efficiencies are calculated from discharge

measurements and a simple capacitor model, Eq. 2. (see Comizzoli, Ref. 72 for more details).

All of the individual plots in Fig. 13-6, except for Fig. 13-6f, contain a selenium curve to facilitate comparisons. In many instances, a material giving extended red sensitivity offers less blue sensitivity. The ordinates in parts 13-6b, c, e, and f are each some form of quantum efficiency, either number of carriers per incident (b, e, f) or per absorbed (c) photon. It is interesting to note that in the blue region (in particular) many of the materials exhibit high, often near unity, quantum efficiencies. Dyed ZnO layers are seen to exhibit this characteristic at 380 nm but to be down an order of magnitude at 400

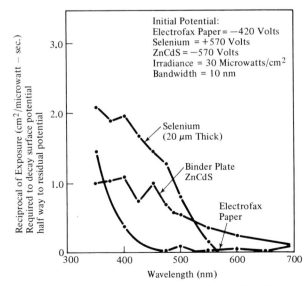

Fig. 13-6d. Spectral sensitivity (a comparison of reciprocal exposures). (Ref. 78, Chapman and Stryker)

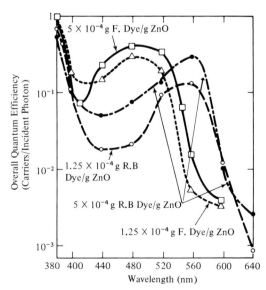

Fig. 13-6f. Quantum efficiency for rose-bengal-dyed (R.B.) and for fluorescein-dyed ZnO binder layers. (Based on data from Ref. 72, Comizzoli)

nm. Such high quantum efficiency represents at least an order of magnitude improvement over the latent image-forming process in conventional photography.

Studies of wavelength dependence of photosensitivity along with spectral absorption studies have provided valuable insight into the mechanisms of basic photoconductivity and of photoconductor sensitization. One of the principal motivations for exploring dye sensitizers and doping materials has been to extend sensitivities of many otherwise blue-, and UV-sensitive materials into the green and red regions of the spectrum. Increased red sensitivity is an obvious advantage when predominantly red light falls on the photoconductor, as in the case of tungsten illumination.

The adherence or failure of the Roscoe-Bunsen reciprocity law for the product of intensity and time is another aspect of the photosensitive characteristics of materials. Tabak and Warter[24] found that the law applies for selenium over changes in light intensity of 6 powers of 10 and for observations made on time scales from microseconds to many seconds. Similar results were reported by Blakney and Grunwald.[106] Schaffert[29] indicates that reciprocity is fairly good for 1:1 TPC over the range 3 μ sec to 1 sec. Reciprocity law failure, however, has been reported in ZnO binder papers by Comizzoli and Ross.[66] It leads to differences on the order of a factor of 2 or 3 from a few seconds (microwatts/cm²) to several microseconds (watts/cm²). Others[107] using much lower intensities found an order of magnitude decrease in sensitivity for about a 10^4 increase in intensity for similar ZnO binder-type materials. Reciprocity failure has also been found in ZnCdS binder plates.[78]

The next characteristic of interest is residual potential. In a fully exposed photoreceptor area it causes a decrease in the electrostatic contrast, C_v, between exposed and unexposed areas (see Fig. 13-2). This is a particularly important problem with continuous-tone imaging, but it can be partially compensated for in development by biasing a development electrode to effectively neutralize the remaining potential. Residual potentials may be caused by trapping. Local defects in the photoconductive layer act as traps for photogenerated charge carriers. If the traps are deep, that is, if the escape probability is low, then the carriers remain in the bulk, producing a potential which appears to the development subsystem as if the plate, although fully exposed, were not fully discharged. Other causes include: the development of a dipole layer of finite thickness at a nonideal back contact, a fall-off in the efficiency of the photogeneration process and internal barriers to charge transport or injection.[97]

Another characteristic, light fatigue, is also related to carrier trapping. It manifests itself as an increase in dark decay with continued cycling. If a great many carriers are generated by a large exposure, it is possible to fill a great many traps, especially those near the conductive substrate. If the traps remain filled between cycles, there will be a high field at the substrate interface producing more injection of carriers, thus increasing dark decay. If the high exposure is localized, then that area will have a higher dark decay or lower initial potential. This pattern

will be superimposed on the next image, producing a ghost. Fatigued photoreceptors can recover if the traps can be emptied. This can be accomplished thermally by letting the plate stand idle. Sometimes recharging with the appropriate polarity can be used to empty the traps.

Both fatigue and residual potential characteristics are influenced strongly by the manufacturing or laboratory techniques used to prepare the photoreceptor. Evaporation and other coating techniques and minute amounts of impurities in the raw materials are involved. Figure 13-5 and other such curves (see, for example, Refs. 85, 41, 65) show that the minimum residual potentials of many common materials are often considerably less than 10% of the maximum potential. Many materials, including Se,[24,44] Se-As,[58] Electrofax,[78] ZnCdS,[78] and 1:1 TPC*[29] exhibit insignificantly low (or zero) residuals when fully exposed. Fatiguing effects are particularly important in situations where the photoreceptor is to be reused. Such effects are large in ZnO binder papers; but in carefully made layers of selenium, its alloys, and in certain organic materials the effect is small.[24,44,97,100,108]

For an electrophotographic process to exhibit repeatable performance over long periods, the photoreceptor, itself, must be stable. It is difficult to discuss, in general terms, the stability of electrophotographic photoreceptors because their stability is very much associated with the chemical, electrical, and physical details of the individual structures and systems. We can, however, illustrate with a couple of examples. Vitreous photoconductors are thermodynamically unstable with respect to crystallization; the crystalline forms exhibiting different, poorer xerographic properties. However, additives can alter this instability; for example, the addition of small amounts of arsenic has been shown to reduce instability in vitreous selenium.[104] Chemical or thermal aging effects can produce changes in overall performance.[58] An undesirable aging of vitreous arsenic-selenium photoconductors has been observed[59] with surface oxidation proposed as the probable mechanism. ZnO binder paper photoreceptors (e.g., Electrofax) are not generally reusable because of high light fatigue; however, even though the same sheet is not usually imaged repeatedly, its characteristics must remain predictable. A major problem here is that the electrical conductivity of such papers varies with humidity. This causes increased speed and electrostatic contrast with increasing moisture content.[109,110]

An important characteristic of a photoreceptor to be used in an automated copying machine is its tone reproduction latitude. By this we mean the discharge voltage changes for various steps on a grey scale as the overall exposure incident on the photoreceptor is changed. A convenient way of displaying this characteristic is shown in Fig. 13-7 for selenium and for arsenic-selenium photoreceptors. This is a plot of the contrast potential, C_v, (see Fig. 13-2) for the indicated neutral or colored object relative to a white reference. C_v is measured at a

*See footnote on page 340.

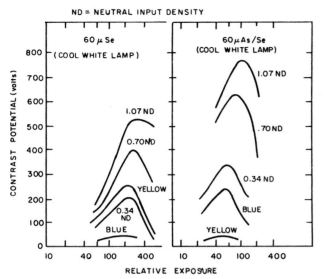

Fig. 13-7. Tone reproduction latitude for Se and As-Se photoreceptors.

fixed time on the discharge curve. Each point on these curves may be visualized as a voltage difference derived from curves like those in Fig. 13-5a. The voltage difference, C_v, is for two points of a fixed log exposure difference. They represent the density difference between white and the density indicated in the figure. C_v is plotted as a function of a varying mean exposure. Thus, as one end or the other of this fixed log exposure difference enters the toe or shoulder of the electrostatic D log E curve as a result of an exposure change, the difference in potential decreases considerably. The shape of the peak is determined both by the size of the log exposure interval (or equivalently by the optical density of the object) and by the shape of the electrostatic H & D curve. To obtain an absolute contrast potential, the latter curves should not be normalized as they are in Fig. 13-5. Each curve in Fig. 13-7 is for a different log exposure interval and is indicated by the equivalent density difference relative to a reference white.

The pronounced peak in each curve shows that there is a best exposure for the largest contrast potential. Although both materials exhibit good latitude, the range of contrast potentials is both larger and more constant over a larger exposure range in the As/Se data. This indicates that it has a larger latitude. A large latitude is desirable in that it relieves sensitometry-related tolerances in the overall design of systems. Such a criterion can be applied to color on a white background as indicated. This comparison between Se and As/Se is somewhat unfair in that the lamp chosen does favor the spectral sensitivity of the As/Se alloy. However, the difficulty in reproducing blue copy on Se and yellow on As/Se photoreceptors is real. Although As/Se materials have much higher dark decay rates than Se, higher contrast potentials are obtained by virtue of extremely low residuals in the exposed areas.

A photoconductor must have certain physical and mechanical properties to be included in a working system. These include those characteristics leading to its ease of manufacture and its wearability and compatibility with end-use conditions. As an example, mismatch in thermal expansion coefficients between an As-Se alloy photoconductor and its aluminum substrate has been found to create cracking problems in the cooling phase after vacuum evaporation deposition.[58] The scratch resistance of a reusable photoconductor is, of course, important if mechanically abrading development or other process steps are anticipated. Where the photoconductor is to serve as the developed image substrate, as with ZnO papers, its whiteness and smoothness are important. The color that dye-sensitizers impart to this material, therefore, creates a certain restriction on choice of sensitizing materials.

Models for Photoconductive Discharge

Considerable research has been devoted to exploration of the detailed mechanisms involved in the photoconductive discharge cycle. This research may be viewed as attempts to understand the source and nature of the electron and hole densities in the photoconductive layer and to study their motion. Such studies are attempts to obtain the information required to solve Eq (3). Because of the possibility of trapping carriers and releasing trapped carriers and the nonphotogeneration of other carriers, all of which are material-controlled effects, it becomes necessary to focus on the mechanisms of photogeneration and transport in a specified material. The study of selenium photoreceptors illustrates this.

Two effects have received considerable attention in attempts to define the mechanisms determining selenium photosensitivity. These are (1) a mismatch between spectral absorption and spectral sensitivity, and (2) a field dependence of photosensitivity. A summary of much of the work on the spectral sensitivity of selenium is given in Fig. 13-8. The absorption/sensitivity mismatch shown in this figure is also illustrated in Fig. 13-9 which, in addition, illustrates the field dependence of photosensitivity.

The first significant effort to describe xerographic discharge characteristics was that by Jaenicke and Lorenz[127] who considered only the role of bulk deep trapping of mobile carriers. An important modification was introduced by Li and Regensburger.[41] They considered carrier recombination in the generation region, defined by the absorption depth of the light, together with bulk deep trapping, as determining the shape of the discharge curve. Li and Regensburger specifically addressed themselves to explaining quantitatively the discharge curve for amorphous selenium. They employed a field-dependent carrier range.

Subsequently several others investigated photoelectronic effects in amorphous selenium.[24,25,36,43,44] Tabak and Warter[24] made a direct and unambiguous determination of the deep hole trapping lifetime. Values of the hole lifetime ranging from 20–100 times larger than that determined by Li and Regensburger were found.

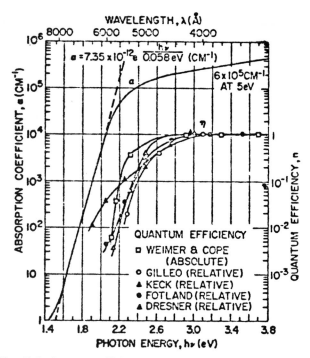

Fig. 13-8. Quantum efficiency and optical absorption measurements for amorphous selenium at room temperature (after Hartke and Regensburger, Ref. 36).

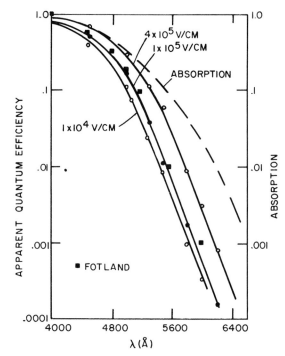

Fig. 13-9. Apparent quantum efficiency (solid lines, left ordinate) and absorption (dashed line, right ordinate) as a function of wavelength showing the dependence of the photoresponse spectrum on applied field. Fotland's results (Ref. 39) are shown by the squares.

This new value of the hole lifetime implied that the normal xerographic discharge characteristics of amorphous Se would not be affected by bulk trapping. Their measurements of the photocurrent/applied field characteristic demonstrate that the current depends primarily on the magnitude of the electric field and not on the thickness of the photoconductor. A bulk trapping model requires thickness dependence.

In addition, to explain the voltage-dependent sensitivity, Tabak and Warter[24] gave arguments for a field-dependent photogeneration process, involving geminate recombination as opposed to the more conventional recombination of free carriers envisaged by Li and Regensburger.[41] Because the complicating effects of bulk trapping can be neglected, the discharge characteristic of amorphous Se can be satisfactorily explained in terms of an emission-limited or injection-limited discharge. Independent work by Chen and Mort[99] and Seki, et al.[128]

showed excellent agreement between the experimental discharge characteristic of amorphous Se and that calculated from a pure emission-limited model (see Fig. 13-3). Some important room-temperature transport parameters from studies of amorphous selenium[24] are given in Table 13-3.

It has been shown[24] that at fields up to 10^4 V/cm, peak photocurrent is proportional to the field. Above that, it is proportional to the square root of the field. In this, the high field region case, a simple expression,[97]

$$J \propto \frac{dE}{dt} = -K(\lambda) F E^{1/2} \tag{5}$$

describes the relationship between the photocurrent (which is proportional to dE/dt) and the incident photon flux F, where E is the field and K is a constant dependent

TABLE 13-3. SUMMARY OF ROOM-TEMPERATURE TRANSPORT PARAMETERS FOR AMORPHOUS SELENIUM FILMS.

Sample	Thickness (μm)	Hole drift mobility (cm^2/V sec)	lifetime lifetime (μsec)	Hole range (cm^2/V)	Electron drift mobility (cm^2/V sec)	Electron lifetime (μsec)	Electron range (cm^2/V)
S1	16	0.13	10	1.3×10^{-6}	6.3×10^{-3}	50	3.2×10^{-7}
M1	108	0.16	32	5.1×10^{-6}
M3	54	0.16	30	4.8×10^{-6}	8.3×10^{-2}	40	3.3×10^{-7}
A6	40	0.14	45	6.3×10^{-6}	6.0×10^{-2}	40	2.4×10^{-7}

[a]From Ref. 24.

on wavelength, λ. This was documented over thicknesses from 2 to 108 μm of selenium and for wavelengths from 400 to 575 nm.

Such an expression for the photocurrent can be substituted in Eq. (3) to yield

$$t = \frac{CK'K(\lambda)}{F} [V_0^{1/2} - V^{1/2}] \qquad (6a)$$

for selenium where K' is a constant including a photoreceptor thickness factor to convert from field E to surface potential V. A more general solution of Eq. (3) for the emission-limited case[23] is

$$t = \frac{C}{eF} \frac{V_n}{(1 - P_e)} \left[\left(\frac{V_0}{V_n}\right)^{1-P_e} - \left(\frac{V}{V_n}\right)^{1-P_e} \right] \qquad (6b)$$

where e is the electronic unit of charge, F is the radiant flux, V_n is the potential at and above which the quantum efficiency is unity and P_e is the field dependence of the emission-limited current. For this solution, $P_e \neq 1$ and is taken for selenium photoconductors and $1/2$ (discussed later). This equation applies to emission-limited discharges where bulk trapping of carriers can be neglected, where all the light is absorbed in a depth small compared to the sample thickness, where the amount of charge in transit is small enough that it does not distort the electric field, where the reciprocity between light intensity and time holds, and where $V_0 \leqslant V_n$.

An example showing the excellent agreement between calculated and measured values for a typical selenium photoreceptor is shown in Fig. 13-3. Transposing the flux term, F, in Eq. (6) gives the relationship between exposure (tF) and V. If the log of this expression is then plotted against V, the electrophotographic equivalent of an H & D curve for the above conditions is obtained. The expressions for this and other situations have been published elsewhere.[23]

Tabak and Warter[24] proposed that the photoelectronic properties of amorphous selenium are those of a molecular solid where the excitation occurs within a molecule and the transport is governed by the comparatively weak overlap between molecular wave functions. Such reasoning led them to suggest a field-aided, thermal dissociation version of the Poole-Frenkel expression yielding the following model for the quantum efficiency η at fields above 10^4 V/cm:

$$\eta = \left[1 + \frac{1}{\tau_r \nu} \exp \left(\frac{\xi_t - e\beta E_0^{1/2}}{kT} \right) \right]^{-1} \qquad (7)$$

where

ξ_t = binding energy of excitation
$1/\tau_r$ = rate of nonphotoconductive decay of an excitation
ν = the attempt-to-escape frequency
e = the electronic unit of charge
β = a constant
E_0 = the applied field
k = Boltzmann's constant
T = absolute temperature in degrees Kelvin.

Reasonable qualitative agreement between this model and experimental results has been shown, thus explaining several of the features of the photogeneration process.

Experimental work by Pai and Ing[25] gives a similar result also based on the Frenkel effect; it shows, in addition, a wavelength dependence. In the high field region, they found the quantum efficiency for 540 nm to 600 nm wavelengths is given by

$$\eta = \exp (\beta_\lambda E_0^{1/2}/kT - E_a/kT) \qquad (8)$$

using the same notation as above with E_a being an activation energy. Values for β_λ were found to be a constant equal to 2.85×10^{-24} Jm$^{1/2}$/V$^{1/2}$ from 580 nm to 560 nm and then to decrease, giving 2.29×10^{-24}, 1.75×10^{-24} and 1.03×10^{-24} for 540, 500, 450 nm, respectively. For long wavelengths and high fields, the functional form of this model fits experimental data fairly well, but there is no agreement at shorter wavelengths.[24,25] It must be emphasized that none of the above models suitably accounts for the detailed nature of the mechanisms for field-controlled photogeneration in vitreous selenium; however, they do describe some of the characteristics of such a model.

Work on other photoconductors has been pursued by many. The mechanisms involved in the zinc oxide binder papers has been reported by Amick[65] and more recently by Hauffe and Strechemesser.[63] The latter report that the light decay can be explained by the theories of Li and Regensburger[41] with a supplement by Schaffert for a retarded desorption of oxygen. Theories of several European investigators are also discussed in their paper. Much work has taken place in the dye sensitization[66-69,72] and supersensitization[64] of zinc oxide, which further complicates the modeling of practical ZnO electrophotographic systems. Cadmium sulfide binder paper systems have been studied by Smith and Behringer[75] and were also found to obey a modification of the Li-Regensburger model. Models and mechanisms for other materials have been reviewed by Weigl[49] and Tweet.[3]

Of particular interest are the experiments in which various photoconductors are used in layered structures to separate photogeneration and transport phenomena.[3,49] For example, experiments by Tutihasi[3] using this technique have shown charge generation and retardation are field dependent in dye films and that various dye materials differ considerably in the range of transported carriers.

ELECTRICAL SENSITIZATION OF THE PHOTORECEPTOR

One of the most important general aspects of electrophotography is the ability to "turn on" its sensitivity just prior to exposure. This has many practical and theoretical advantages, permitting, in many instances, handling the light-sensitive element in room light up to exposure time, and enhancing shelf life. As Bird[111] points out, in high quantum efficiency processes like electro-

photography, it effectively combats the serious limitation of thermal fog. This is achieved by drastically reducing the time interval in which the low probability thermal excitation can occur. In short, the system is only sensitive to thermal fog during the interval just prior to exposure.

The process by which electrophotography "turns on" is aptly referred to as the electrical sensitization step.[112,113] Its basic purpose is to apply a field across the photoconductive element and, thus, to provide the driving forces for photogeneration and transport. In all cases, the photoconductor may be considered the dielectric in a capacitor. The capacitor configuration may be obtained either by means of a transparent electrode technique or by charging the surface of the photoconductor directly.

The transparent electrode arrangement is primarily a laboratory device for studying model systems. It has also been proposed for some unconventional electrophotographic processes (described later) such as elastomeric deformation, photoelectrophoresis, and persistant internal polarization. In this configuration, one of the capacitor electrodes is transparent to allow exposure of the photoconductive layer. The other electrode is often an opaque metal plate. (Figure 13–40, page 000) shows such a transparent electrode used in the photoelectrophoretic process). The transparent electrode is usually a thin transparent metal coating on glass; tin oxide layers are common. Such a configuration is sold commercially under the name Nesa*—coated glass. Since image-forming light must pass through this layer, its optical characteristics as well as electronic and mechanical properties become important. Uniformity of all three characteristics is usually required and electrical blocking characteristics described earlier are important.

In classical electrophotographic systems, a photoconductive layer coated on an opaque conducting substrate is sensitized by uniformly spraying charge on the photoconductive surface. Again consider the photoreceptor as a capacitor in which the conductive substrate is one plate and the photoconductor is the dielectric. The other plate normally present in a capacitor is missing. It is replaced by a sheet of charge. The free surface of the photoconductive layer is not laterally conducting; therefore to build up a uniform charge, it is necessary in the charging step to use special means for carrying charges in equal amounts to all parts of the surface. Several methods including corona discharge, induction, friction, and even radioactive sources,[114] can be employed for depositing charge on this surface. Corona charging, however, is by far the most widely used method.

Corona discharges in air are used to spray the surface of the photoconductive element with gas ions. The ions are created when a potential (to ground) on the order of several kilovolts is applied to a thin wire, about 3½ mil in diameter.[113] It is tightly stretched and centered in a grounded metal channel (see Fig. 13-10). Air breakdown occurs, generating gaseous ions, but only in the vicinity

Fig. 13-10. Schematic cross-section of electrical elements of a corotron.[113]

of the wire because of the very high fields there. Ions of the same electrical sign as the wire move toward the grounded channel. Some pass through the opening in it, falling on the photoreceptor surface. Thus, the sign of the potential on the wire determines whether the charge on the surface of the photoreceptor is positive or negative.

If the wire is positive, electrons are accelerated through the high field regions, gaining enough energy to ionize the air molecules and generate avalanches.[115] The source of primary electrons that maintain the discharge in positive corona is thought to be photoionization of air molecules by UV radiated from the glow region around the wire.[115,116,117] Mass spectrometer experiments with positive corona identified a hydrated proton of the general form $(H_2O)_n H^+$ as the predominant ionic species.[116,118] The value of n depends on relative humidity. It varies from 1 to 9. At water concentrations below 3×10^{-2} mole %, $NO^+ - (H_2O)_n$ and $NO_2^+ - (H_2O)_n$ dominate.

Similarly, in a negative corona the majority of the ionization occurs by electron collision with gas molecules in the active glow region. However, in this case the wire acts as a source of feedback electrons to maintain the corona through secondary electron emission at the wire surface, both by positive ion impacts and by the photoelectric effect.[116,117] Stability of such coronas depends strongly on the presence of an electron-attracting gas such as oxygen. At atmospheric pressures, the dominant ionic species in negative coronas is CO_3^-, with only about 10% of the ions being hydrated at 50% relative humidity.

Corona currents increase with voltage[115,119] and are affected by many factors such as wire diameter, shield size and shield shape.[92,113,119] For a single wire in a concentric cylinder and for high currents typical of electrophotographic applications, corona current, J_c, may be approximated[92,116] by:

$$J_c = AV_c(V - V_0) \qquad (9)$$

where V_c is the voltage applied between the wire and the shield; V_0 is the voltage at which significant current begins to flow as a result of onset of corona; and A is a constant which is usually determined by experiment—although it can be derived for a shield coaxial with the corona wire. Modifications to this form have been suggested, including a simple quadratic on V[113] and others which account for specific physical factors.[117,120] Figure 13-11 shows empirical data for the corona current as a function of corona voltage. It was taken from a non-

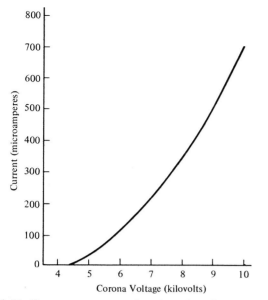

Fig. 13-11. Corona current as a function of applied voltage.[113]

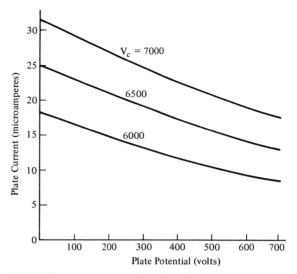

Fig. 13-12. Plate current as a function of the bare plate potential for a corotron with three values of corona voltage.[113]

concentric wire and shield array.[113] Note the threshold at about 4.4 kV (i.e., V_0). This threshold has been the subject of much study.[92,113] Empirically, the corona voltage, V_0, for threshold has been found[113] to be a linear function of wire diameter:

$$V_0 = 0.44d + K \qquad (10)$$

where d is the wire diameter in mils and V_0 is in kilovolts. K is a constant dependent on corona current which, for example, is 2.85 for a 3.5-mil wire ½ in. from a flat grounded surface.

The corona current is only the means by which a specific charge or surface voltage is placed on a photoreceptor. These are the quantities of electrophotographic significance. The photoreceptor is a capacitor-like device; therefore, as corona current flows, the charge and its associated surface potential build up. The increased surface potential decreases the potential difference between the fixed corotron voltage and the plate. This, in turn, decreases the corona current. Figure 13-12[113] displays the relationship between corona current and plate potential for a particular corotron at three values of corona voltage. The plate in this case is a conductor. To find the voltage on the photoreceptor, V_s, at some given time, t, one can employ the capacitor model for the photoreceptor:

$$J_s = C\frac{dV_s}{dt} \qquad (11)$$

where C is the capacitance of the photoreceptor and J_s is the current to the photoreceptor surface. Substitution of a voltage-dependent expression for the current obtained from empirical data and integration gives values for V_s. Similarly, one can find the time, t_p, required to reach a particular voltage. Such a solution[113,114] has the general form:

$$t_p = \int_0^t \frac{CV_s}{J_s}. \qquad (12)$$

This solution has been shown to agree with experimental values for t_p. It must be pointed out that there may be leakage current through the photoreceptor even in total darkness. Consequently, the simple assumption that a photoreceptor is a perfect insulator in the dark may be incorrect for some materials. This must be considered in deriving an accurate expression of the charging times and voltages. As a result, the above approach is an approximation for materials where dark current is significant and more detailed calculations are required.

For a uniform photoresponse, it is necessary that the distribution of charge be uniform over the area of interest. For a single corona wire, the lateral distribution of current reaching a plane has been found theoretically and empirically to have a half-width, W, related to the wire-to-plane spacing S by

$$W = 1.4S \qquad (13)$$

It is comparatively insensitive to current and polarity.

In the other direction, that is, along the length of the wire, good uniformity is found for positive coronas while marked nonuniformity is exhibited by negative coronas.[121] It has been found that the negative corona nonuniformity diminishes with increasing separation of the plane and wire and that both high and low humidity make the nonuniformity greater. The nonuniformity in negative coronas is associated with bright spots on the wires known as Trichel pulses.[119] A technique[122,122a] for dramatically improving the uniformity of negative coronas consists of driving the corotron with a 4kVac-to 6kVac-potential (peak-to-peak) riding on a several-hundred Vdc potential. Frequencies from 1 to 100 kHz are used. This essentially turns the corona on and off cyclically and is thought[116] to result in dissipating the space charge and reducing the probability for localized dominant emitters on the wire. In any case, it interferes with the normal sequence of events which give rise to the nonuniformity.

Coronas not only give off ions for charging but they

emit electromagnetic radiation which can discharge the plate as well. The energy falls between 290 nm and 440 nm and has been identified with excited nitrogen molecules.[123] Its spectrum is given in Fig. 13-13. This is uncorrected for the spectral sensitivity of the measuring instrument (see caption).

The electrophotographic effect of this radiation in a particular commercial processor has been studied. The positive corona glow itself was found to discharge a selenium plate in 38 sec, while a negative corona took only 7 sec. Because of the competing charge and discharge rates, the glow reduced the efficiency of positive charging by about 10% and was estimated as being much more for the negative corona with equally sensitive plates. While representative, the above data are only intended to give the reader an approximate feeling for the quantities involved. Other experimental factors can be adjusted to change the details of the results.

In practical corotron devices,[114] the wires are maintained at a potential above 6000 V, usually charging the photoconductor surface to several hundred volts (10^{11} to 10^{12} ions/cm²).[4] Sometimes more than one corotron wire is used in a single shield, in which case their separation becomes critical. If they are too close, emission from each wire can be affected adversely by nearby wires, even to the point of extinction. Typical spacings are about ½ inch.

A scorotron, a screen-controlled corotron (see Fig. 13-14), is a corotron with a screen or grid of wires placed about 3/32 of an inch apart and imposed between the corona source and the photoreceptor. The screen is operated at a (selected) potential between zero and several hundred volts, depending upon the potential desired on the photoconductor and the speed of charging. As the photoconductor potential increases, more current

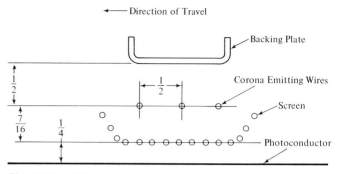

Fig. 13-14. Schematic cross section of electrical elements of a screen-controlled corona charging device.[113] The dimensions are given in fractions of an inch.

flows to the screen and less to the plate until eventually all of the current flows to the screen and no further charging occurs. The screen also acts to improve uniformity of charge by suppressing the electric field between the charged plate and the corona wires. It, of course, markedly reduces the current flow to the plate. The screen in the scorotron device and the shield that surrounds the wire in the corotron device each attract much of the generated corona current. This allows use of wire voltages much greater than the corona threshold without danger of overcharging the photoconductor. Higher voltages reduce the nonuniformities resulting from wire differences and from inhomogenieties and local discontinuities in individual wires.

Both types of charging devices are normally operated in a scanning mode, with either the photoreceptor or the device moving. The corona-wire voltage is then set to achieve the desired plate potential in the allowed scanning time. For scorotrons the higher the screen voltage, the more rapidly one can move the charging device, relative to the photoreceptor, to achieve a given potential. The question of charging rates is difficult to answer in a general quantitative manner because it depends on many details of the surface of the photoconductor,[116] of the electronics of the charging device, and of the environment.

What happens to the ions when they reach the photoconductor surface? So far, the evidence strongly suggests a charge exchange process occurs, as opposed to a simple surface absorption by the photoconductor. Without appropriate surface treatments, the dark decay of surface charge from a photoconductor such as selenium is very fast. It is argued by Vance[126] that such a high dark decay can be explained by charge exchange with surface atoms followed by transport through the bulk to the base electrode. Models for the exact mechanism of charge exchange have been proposed by Shahin[116] and by Gallo, et al.[125]

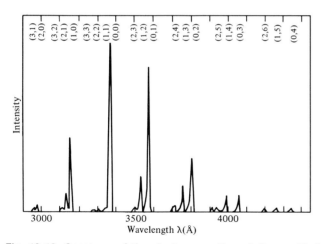

Fig. 13-13. Spectrum of the electromagnetic radiation emitted from a positive wire-to-plane corona in air. The spectrum for a negative corona is identical although more intense than the positive corona. The spectral intensity is uncorrected for the spectral response of the Cary Model 14 scanning spectrophotometer used to obtain the data. The emission lines result from electronic transitions between vibrational levels (v', v'') within the $C^3\pi\mu \rightarrow B^3\pi g$ (second positive electronic system of "nitrogen molecules." (see Ref. 123).

THE ELECTROSTATIC LATENT IMAGE

The latent image in *classical* electrophotography may be considered either as the charge pattern on the surface or

in the bulk of the photoreceptor or as the electric field above the photoreceptor. Clearly, the charge produces the field, but often by a complex interaction with other elements. However, it is the field rather than the charge which directly controls the development; that is, it controls how and where the toner is deposited. The classic definition of a photographic latent image[129] centers on charges which directly increase development probability. Therefore, in this chapter the latent image will be considered as the field and not as the charge. Generation and transport mechanisms which control the charge distribution were discussed in the previous section.

Just as in conventional photography, the electric field latent image is defined only with regard to a specific set of development conditions. For example, the presence, absence, or spacing of a development electrode has a major effect on the field patterns. This will be discussed shortly. Some forms of development proceed until all charge is neutralized, in which case the fields change considerably during development, eventually going to zero. Such development is, of course, *limited* by the charge pattern, but it is still fields which *govern* the process.

In *unconventional* electrophotography, there are a number of distinctly different *kinds* of electrophotographic latent images[4] including fatigue effects, electrothermal effects, photocharge effects, photochemical effects, and persistent internal polarization effects. These are mentioned here only to show the wide range of possibilities for electrophotographic latent images; they will not be discussed further in this section.

Some researchers believe that development is controlled by the normal component of the electric field intensity of the electrostatic latent image;[130] others that it is by the intensity of the electric field associated with that image,[131] or by the configuration of the field in the developer zone.[132] Exactly which characteristic of the fields acts as the real latent image remains somewhat ambiguous. The ambiguity is produced by the incomplete understanding of the mechanisms of development for any of the variety of development methods available. This will be elaborated on later in the discussion on development.

Characterization of the electrical field latent image is a multidimensional problem including time, distance, direction of force, and field magnitude. It is sensitive to a number of process parameters, particularly the electrical and physical configuration of the development subsystem, the geometry and materials characteristics of the photoconductor and, to the extent that they effect the photoconductor, the environmental conditions.

The time dimension is essentially controlled by the dark decay of the photoconductor as discussed earlier. In a practical system, the significance of this decay depends on the total time elapsed between exposure and end of development. The image on some selenium plates, for example, may take as long as two or more hours to decay to one-half its original field strength, while images on many zinc oxide binder papers may exhibit half-magnitude decay in 20 sec or so.[4] Increased life may be achieved by surrounding the image with a similar

magnitude potential or by using special overcoating layers or near contacting sheets.[4] Also, since development continues in time, the first toner deposits have an effect through field changes on subsequent toner deposits.

The magnitude and direction of the electric field is determined not only by the magnitude of the exposure and the initial charge but by dimensions of the charge pattern and the electrostatic environment during development. The two major development configurations found in classical processes are shown in Fig. 13-15. Case I represents the electrical environment for typical nonelectroded cascade development and Case II, an electroded development system, is important where control of large-area tone reproduction is desired.

The theoretical description of the *initial* field patterns for each of these situations has been carefully explored for certain types of charge distributions. Neugebauer[133,134] has calculated the fields in both cases. He paid particular attention to edge, bar, and circular images and examined lines of force, lines of equipotential and both normal and tangential field components; he employed the method of dielectric images.[135] Schaffert[136] has examined a model for predicting the field lines and the normal field component for sinusoidal charge patterns of various spatial frequencies for both cases. The sinusoidal patterns, while representative of some practical charge distributions, also permit relatively simplified closed-form mathematical solutions using Laplace's equation. Both Neugebauer and Schaffert show results for the effect of photoreceptor thickness, electrode spacing, and the height above the photoreceptor where the field is calculated. All such calculations, however, show only the fields present at the onset of development. As development proceeds, the fields, thus the latent image, change. The physics of this change is highly complicated and does not lend itself to easy mathematical or experimental analysis. No one has published a model for these changes. However, the existing models for the initial latent-image fields offer considerable insight and are reviewed below.

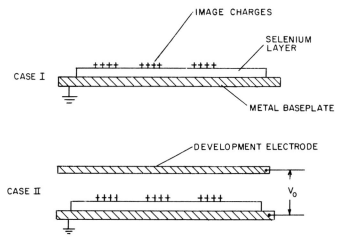

Fig. 13-15. Two major classical development configurations. Case I: nonelectroded; Case II: electroded (see Ref. 136).

If one imagines that the exposure incident on the photoreceptor resulted in a plate discharged on one side of a boundary and uniformly charged on the other, that is, resulted in a sharply bounded, half-plane of charge, the electrical lines of force and equipotential lines would appear as in Fig. 13-16a. For the examples shown, the photoreceptor is a 25μm selenium layer bounded by metal on the bottom and air on the top. The photoreceptor is charged such that the potential at the center of a large uniform area would be 100V. Note that the lines of force are approximately arcs of circles from the charged to uncharged regions. The shape of the pattern is symmetric about the edge; however, the value of the equipotential lines increases monotonically as indicated.

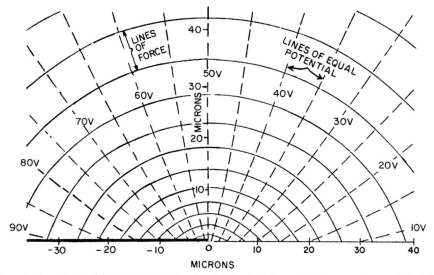

Fig. 13-16a. Lines of force and equal potential for halfplane (after Neugebauer, Ref. 34).

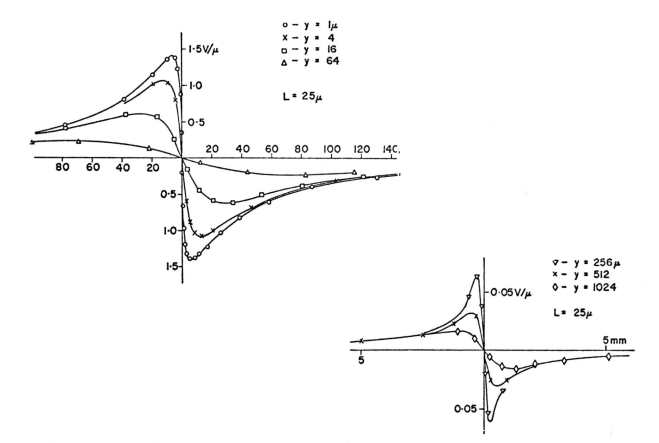

Fig. 13-16b. Perpendicular field component for halfplane plotted against x for different distances, y, above plate.

From such information, one can obtain the component of the field normal to the surface. This is plotted as a function of distance across the photoreceptor for different heights above the photoreceptor in Figs. 13-16a and 13-16b. Note the peaks on opposite sides of the boundary which resemble the classic photographic development adjacency effect.

Similarly, one can examine the lines of force and equipotential for a narrow strip of charge. These are depicted in Fig. 13-17 for a 30 μm-wide strip. There are many lines in the vicinity of the edges of the strip. A comparison in this region to the lines of force on the edge reveals some similarities. A clearer, more development-oriented comparison is obtained by examining the normal field components. Neugebauer has shown these for various line widths evaluated at 1 μm above the surface. His results, redrawn in Fig. 13-17b, are adjusted so the centers of the lines are superimposed. Comparing these with the 1 μm observation in Fig. 13-16a suggests that a 200 μm and wider line approximates the field conditions for the semi-infinite half plane. Note that both figures are for 25μ think photoconductors. One micron above the plate is probably too close for a practical development condition with particles whose

mean size is much larger, but this shows the general principal that Case 1 exhibits very strong fringe fields or edge effects. Furthermore, it gives some quantitative understanding of the size of the edge effects. For example, note that the maximum normal field strengths for the 10μm, 20 μm, and 40μm lines are considerably greater than the maximum for the edge. For the narrowest strips, the maximum occurs at the center. For wider lines it occurs at the edge. In neither the lines (strip) nor the half-plane condition is there a normal field component just over the edge of the line; however, calculations indicate a very large horizontal component.

Calculations using the above conditions also suggest two rules regarding plate thickness:[134]

1. The field near the edge of a solid area is almost independent of plate thickness for the same charge density difference.
2. The field far away ($>$80μm for 12–50μm plates) from the edge is almost independent of plate thickness for the same potential difference. (It is also very small.)

Rule 1, stated another way suggests the fields near the edge, observed a few microns above the surface, scale roughly as the plate thickness for a constant surface

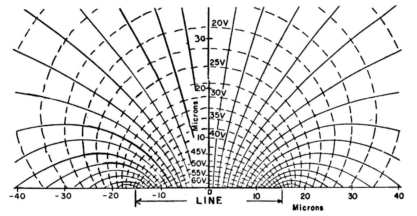

Fig. 13-17a. Lines of force and equal potential for linear charge of width = 30μ (after Neugebauer, Ref. 134)

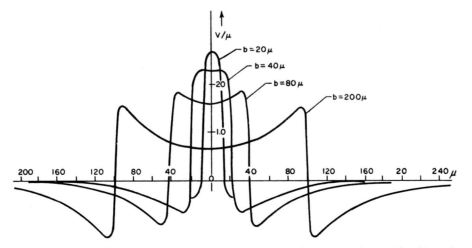

Fig. 13-17b. Perpendicular field component against x for linear charges of different widths (after Neugebauer, Ref. 134).

potential. So, with a limited surface potential, one can obtain a stronger latent image for edges and narrow lines by increasing thickness and the charge. However, if one is limited by charge density, thickness changes are of little benefit.

If we now place a development electrode at some finite, fairly close distance above the photoreceptor and assume a dielectric constant of 1.0 for the material between the photoreceptor and electrode, we have the electrostatic conditions of Case II (Fig. 13-15). The resulting lines of force and equipotential lines undergo a radical change. The lines of force bend upwards towards the electrode as shown in Fig. 13-18a and 13-18b. Thus, in large areas, such as over the charged half-plane, the normal component of the field is increased greatly by the presence of the electrode which permits wide solid

areas to be developed. For narrow lines, the pattern is only changed slightly, especially near the plate surface; thus line development which had been strong without an electrode remains largely unchanged. The presence of an electrode may have other effects on the mechanism of development. These will be discussed in the development section.

Instead of half-planes or narrow strips of charge, one may consider patterns which while constant in one direction along the surfae are sinusoidal along the surface at right angles to this. Now, a somewhat simpler mathematical solution can be found for the field.[136] Figure 13-19 is a summary plot of the amplitudes of the resulting sinusoidal normal field components, plotting peak-to-peak amplitude of the field against the spatial frequency of the sinusoidal charge pattern for the electroded situation (Case II). The calculations for fields at the surface with various electrode spacings are shown in Fig. 13-19a, while in 13-19b and 13-19c there are observation points both at the surface and 5μ above the surface. It is important to note that the units of 13-19a are amplitude or field contrast (which is defined as the difference between the maximum and minimum values of the image field) and that spatial frequency is plotted logarithmically. In Fig. 13-19b and 19c, the units are peak intensity of the electric field, and the spatial frequency axis is linear. Again, a selenium photoconductor 25μm-thick was used as the photoconductive layer, and air (dielectric constant = 1.0) is the material between the selenium and the development electrode.

An analysis of these data indicates that the intensity of the normal field component is independent of spatial frequency when the electrode is the same distance above the photoconductor surface as the substrate electrode is below it (i.e., as the thickness of the photoconductor). This is only true at the surface (Fig. 13-19a and 13-19b). For electrode spacings equal to or less than the photoconductor thickness, field strengths observed above the surface decrease monotonically with increasing frequency. For large electrode spacings, there is a definite

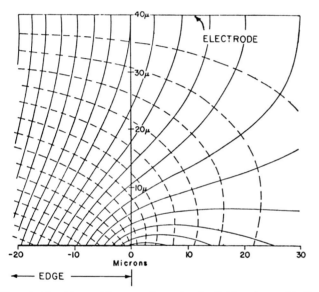

Fig. 13-18a. Lines of force and equal potential for charged half-plane with development electrode (after Neugebauer, Ref. 134).

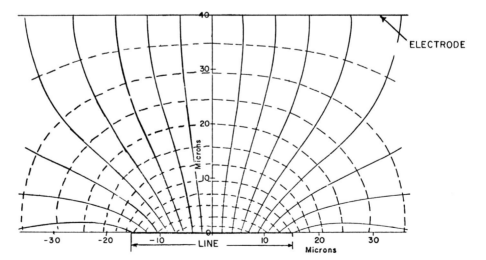

Fig. 13-18b. Lines of force and equal potential for discharged line 30μ wide and development electrode (bias potential = 1000V) (after Neugebauer, Ref. 134).

maximum in peak field intensity—somewhere around 5c/mm. Notice that Case I is given by curve e in Figs. 13-19b and 13-20c for the infinite electrode spacing.

Some caution must be exercised in interpreting the results. These curves were derived for infinitely extended, sinusoidal charge distributions of the amplitude shown in Fig. 13-20. The response to other forms of charge patterns can be derived from them but must make use of the entire spatial frequency spectrum of that pattern. For example, a periodic pattern of charged and dis-

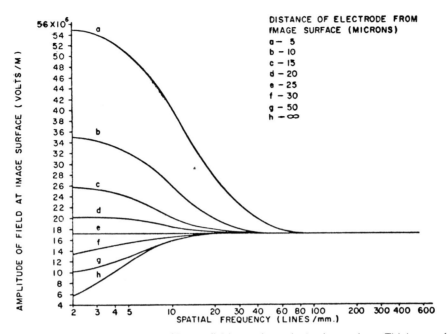

Fig. 13-19a. Effect of spatial frequency on amplitude of image field at various electrode spacings. Thickness of Se layer is 25μ (from R. Schaffert, Ref. 136).

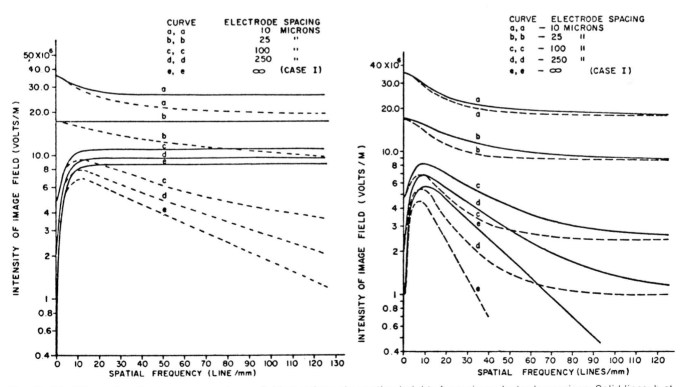

Fig. 13-19b. Effect of spatial frequency on image field at various observation heights for various electrode spacings. Solid lines: b at image surface, c at 5 μ above image surface; broken lines: b at 2.5 μ above image surface, c at 10 μ above image surface; selenium thickness = 25μ: maximum charge density is 11.15 × 10⁻⁴ coulombs/m² (from R. Schaffert, Ref. 136).

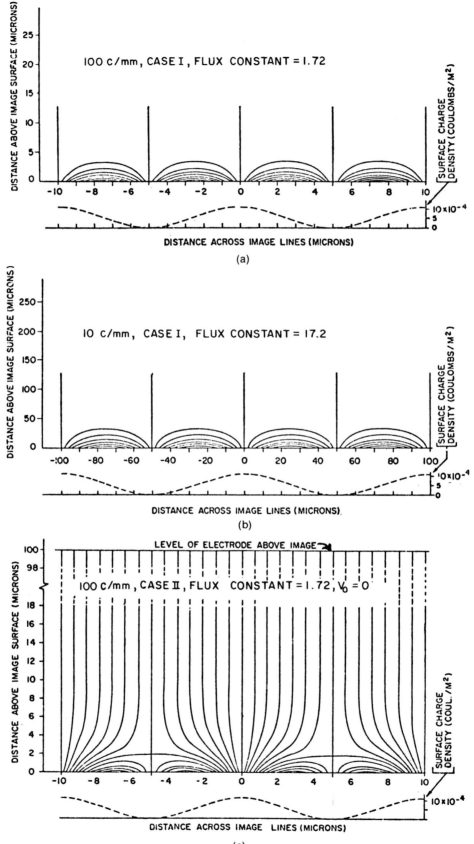

Fig. 13-20. Field lines of flux for various examples of Cases I (a, b) and II (c) for 100 c/m (a, c) and 10 c/mm (b) sinusoidal charge distributions of maximum density $11.15 \times 10^{-4} C/m^2$ shown by dashed lines at bottom of each field diagram (from R. Schaffert, Ref. 136).

charged bars would have to be broken down into its spatial frequency components, each of which must be multiplied by the correct value for that frequency from the appropriate curve. These would then be combined to compute the field for the bar pattern. One cannot use the fundamental frequency for the bar pattern alone. Compensation for absolute charge levels must also be made, since the given curves apply to a particular charge. Neugebauer has extended this work to include effects of certain forms of charge trapping in the bulk.[130]

From the foregoing theoretical results, it is seen that the fields which control development may bear only slight resemblence to the charge pattern on the surface of the photoreceptor. The presence of a development electrode helps to produce a normal field component over highly charged but uniform areas, thus ensuring development of these areas. Otherwise, in Case I, the normal component of the electric fields is only strong in the vicinity of edges or of very fine lines. Even in the case of a far-spaced (>5 times plate thickness) development electrode, the electric fields near the surface are largely controlled by nonuniformities of charge created by small details. In other words, the electrostatic latent image itself exhibits strong adjacency effects, except in the special cases noted. Because electrophotography has been used primarily in line-copying applications and because the adjacency is not objectionable except for lines somewhat wider than those normally copied, this effect has been regarded as a desirable form of image enhancement.[137] For continuous-tone and large-area image development on the other hand, the electrostatic latent image can be arranged by spacing of the development electrode to exhibit to the developer little or no adjacency effect.[130] If the development electrode is closer to the photoreceptor surface than the conductive substrate is, then the adjacency effect is completely eliminated, as evidenced by the monotonically decreasing functions in Fig. 13-19. A peak at greater than the 0 c/mm in such curves is a classic way of detecting adjacency effects.[130] In practice, it is difficult both to achieve such a close-spaced electrode (25–50 μm) and to keep it uniformly spaced over format sizes encountered in classic copying applications. It is also important to note, as will be explained in the development section, that not all development effects can be explained by the normal component of the *initial* electric field. For example, eliminating the adjacency effect may cause changes in developed line width and some toner may follow nonnormal field lines.

Having explored the theoretical characteristics of the latent image itself, it is appropriate to mention the methods for measuring that image. Such measurements are often made by using the latent image, or any charged photoreceptor for that matter, to induce a charge on the probe of an electrometer. By a calibration procedure, this induced charge may be translated to an absolute potential at the plate. Since time after exposure is an important dimension in electrophotographic latent images studies, the samples, probe, and exposure station are often mounted in a device which scans one rapidly past the other two. An alternate approach, mentioned earlier, is to expose through a transparent probe.[30]

A typical commercially available electrometer,[2,113] manufactured by Monroe Electronics Laboratory, employs a feedback mechanism to maintain a shield surrounding the probe at the sample potential. This makes the probe insensitive to as much as 3 mm of variation in height above the photoreceptor when the probe is within 6 mm of the surface. The same probe has an accuracy of 0.2% (5 V out of 1000 V) and a resolution of 4 c/in.[138] Electrometers are very useful for measuring the large area characteristics of the latent image and are responsible for nearly all of the data on photoconductor performance given earlier.

A technique for directly measuring microscopic electric fields is to scan the latent image pattern with a calibrated, charged, quartz fiber whose deflection is proportional to the field strength.[139] The fiber is typically 30–40 μm in diameter, 1 cm to 2 cm long and supported in a cantilever fashion on a glass slide. Typical deflection sensitivity is of the order of 60 μm in a field of 10^{-2} V/μm. The mechanical motion is optically magnified and photoelectrically converted to an oscilloscope display. A major improvement in measurement resolution (about 200 c/mm) can be achieved for many photoconductive materials by examining the secondary emission of electrons from a charge pattern using the Scanning Electron Microscope (SEM).[140] Such a technique is strongly influenced by the fields just above the photoreceptor and, consequently, may be more directly related to latent image studies than electrometer measurements which effectively measure the charge on the plate. The SEM technique destroys the latent image and has some time and environmental constraints which make it cumbersome to use on a routine basis.

DEVELOPMENT

General

The electrostatic latent image is converted into a more usable physical form by development. There are a great many, quite different development processes from which to choose. Each of them converts the electrostatic image into a physical image, usually by depositing material from powders or liquids. While many employ black developer material, colored or fluorescent materials are available as are materials for selective adhesion, etch resistance, or electrical conductivity. There are systems which produce positive or negative first-generation images.

Because of the complexity of the electrostatic and physical interactions involved in each process, electrophotographic development is largely an empirical technology with qualitative or phenomenological models describing each method. Detailed quantitative understanding of mechanisms has been worked out only for a few of the diverse methods and usually only for parts thereof.

The methods by which development is achieved may be conveniently divided into the several categories shown in Table 13-4. While this list is not all-inclusive, it does

TABLE 13-4. CLASSIFICATION OF DEVELOPMENT METHODS.

a. Simple powder development[1]
b. Carrier development[2]
 1. Granular carrier[3]
 2. Fiber brush carrier
 3. Magnetic brush carrier
 4. Loaded sheet carrier
c. Aerosol[2]
d. Insulating liquid suspension[2]
e. Deformation of thin sheets[4]
f. Migration of photoconductor or other electrically photosensitive particles
g. Electrolytic
h. Electric-field-induced optical changes in developer materials

[1] As used in Carlson's invention (see p. 333) and other early experiments.
[2] May be subdivided into electroded and nonelectroded cases (see previous section).
[3] Usually employed in cascade development.
[4] Produces optical phase images.

cover all of the classical methods of development (Items a–d in Table 13-4) and many of the unconventional methods (Items e–g), several of which will be discussed in a later section in the context of specific electrophotographic processes. The classical methods involve selective deposition of imaging material on a surface in response to electric fields. The unconventional methods usually involve changes in already present materials or layers. In passing, it should be noted that thermoplastic development, a subcategory of Item e, has been the subject of active research for nearly a decade but has, as yet, seen no large scale commercial success; it is sufficiently different from the first group to be considered unconventional here.

Of the first group in Table 13-4, only three have enjoyed sufficient commercial success to warrant discussion in this chapter. These include the granular and magnetic-brush carrier systems and the insulating liquid suspension systems.

In each of these systems, charged, light-absorbing material, called toner, is attracted to the photoreceptor surface by the fields in the latent image. It is deposited in such a way as to produce a negative or positive image, depending on the sign of the charge on the toner and on the photoreceptor.

Granular Carrier-Cascade Development

Granular carrier systems are two-component developers, one part being small toner particles, the other being much larger insulating granules. Although it is possible to use such developers in a variety of ways, they are usually poured or "cascaded" over an inclined photoreceptor. Hence, such processes are commonly referred to as cascade development. This process, as disclosed by E. N. Wise of Battelle Memorial Institute,[139] is the most widely used development method for document copying today despite numerous attempts to find a replacement.[141]

Basically, the cascade method involves mixing small particles of plastic toner with larger, heavier carrier particles having a different triboelectric (contact charging) value. The toner will acquire a preferred charge by triboelectrification when the two components are mixed. The carrier particles acquire the opposite charge. Being oppositely charged, the toner particles stick to the larger carrier beads. This mixture, referred to as the "developer," is then poured over the surface of the photoreceptor which bears a charge pattern. The toner-covered beads roll along and bounce over the surface experiencing various electrical and mechanical effects. The image-induced charge on the photoreceptor is the opposite sign to that on the toner. The image creates field forces (described in the last section) which strip the toner from the carrier as it passes by and attract it to the photoreceptor producing a physically detectable, usually visible, image. Simultaneously, toner which happens to get on uncharged or weakly charged areas will be attracted to the carrier as it passes by, thereby cleaning up areas containing unwanted toner. Thus, gravity delivers the granular developer to the latent image areas and the electrostatic forces cause the deposition or cleaning up action necessary for image formation.

The detailed mechanisms involved in this process are very complicated and as yet are not thoroughly understood. They include triboelectrification of the developer materials, various electrostatic interactions and other forces involved in selective deposition of toner.

The remainder of the section is devoted to highlighting what is known about the process, beginning with a description of the materials used. The basic interactions between the materials and various forces are then described to provide background for a more detailed look, first at the static forces holding the toner to the carrier and then at the mechanical forces involved in the dynamic case. This is followed by a discussion of how free toner particles arrive at the photoreceptor surface. Finally, the effect that the development system configuration has on density and other factors is reviewed, relying solely on experimental findings.

Materials. Some insight into the complexity of the mechanism(s) of commercial cascade-granular carrier development can be obtained by describing the materials. The carrier particles are approximately spherical beads of sand or glass about 700 to 750 μm in diameter;[141,142a] or, they may be steel shot about 450 μm in diameter, which are usually plastic-coated. The toners are much smaller particles made of a great variety of materials. Black toners used in commercial xerography consist of carbon black dispersed in thermoplastic polymer. Their size is not constant but follows a distribution with, in one case cited, a number-average of 6 to 7 μm in diameter.[143] This results in resolution on the order of 8–10 c/mm with 28 c/mm being possible with care.[143] A number of electrical, chemical and physical properties determine which polymer to use. These include its triboelectric characteristics, its thermal properties for fusing, its non-adhesion to the photoreceptor (for cyclic systems), melt viscosity, molecular weight distribution, and stability before and after development.

The charge on the toner is generated by the triboelectrification between toner, carrier and photoreceptor[144] and, therefore, may be changed by changing either carrier or toner material characteristics. It is not necessary and it is often impossible to change the photoreceptor surface. In commercial systems, it may be desirable to change the sense of the image (positive or negative), thus to change the sign of the toner charge. This is usually accomplished by changing the carrier material, using a carrier coating which exhibits either positive or negative triboelectric relationship with a single toner.[141]

Developer Forces and Interactions. The developer particles are subjected to many electrical and physical forces as they cascade over the photoreceptor. Cassiers and Van Engeland[144] have listed seven electrostatic contact interactions which can be generalized as follows:

1. Carrier and toner,
2. Carrier and photoreceptor,
3. Carrier and charged, partially developed photoreceptor,
4. Carrier and light-discharged photoreceptor,
5. Toner and charged photoreceptor,
6. Toner and charged, partially developed photoreceptor,
7. Toner and discharged photoreceptor.

These forces are depicted in Fig. 13-21. In addition, there are other forces such as: polarization forces on the particles in an electric field, gravitational forces, frictional forces at the photoreceptor surface, air drag and collisions involving carriers, toner particles, the photoreceptor, and, if present, the development electrode.

Items 5, 6 and 7 in the above list are directly responsible for depositing toner on the image surface. The other

forces have varying degrees of importance in determining the efficiency and quality of the process. The seven interactions listed have been studied for their effects on the electrification of developer.[144] One important variable revealed by these studies was the change in contact charge of zinc oxide by illumination.

Physics of Microscopic Development Mechanisms. A major question in quantifying cascade development is the nature of the forces which hold the toner particles to the carrier and those involved in breaking this bond. Toner particle adhesion to carriers has sometimes been explained as a combination of electrostatic and van der Waals forces. The latter may be thought of as the attraction of a positive atomic nucleus for electrons beyond its own radius, including those of other atoms and particles.[145] However, Donald[146] has shown that these forces can be neglected when compared to the electrostatic forces of attraction. Both centrifuge experiments and bouncing contact studies[147] were used to confirm that the force of attraction, F between toner and carrier can be represented by

$$F = Q^2 / Kr^2 \qquad (14)$$

where

Q is the charge at the center of the toner particle,
r is the radius of the spherical toner particle, and
K is the dielectric constant of the toner.

In this model, the counter charge on the carrier is located at its surface where localized triboelectric charging occurs, and the toner particle is treated as a point charge.

Equation (14) applies to forces necessary to strip toner particles from carrier beads under static conditions.

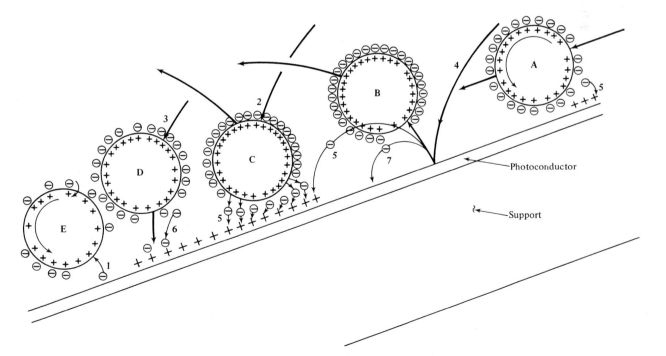

Fig. 13-21. Forces in granular carrier cascade.

Frequently during cascade development, collisions result in mechanical forces which can strip electrostatically bound toner particles. It has been found that electrical fields dramatically assist this force. For example, a field of as little as 0.1 V/μm can increase by 5 times the amount of toner dropped by a bouncing developer particle.[147]

Limiting specific impulses required for a toner particle to escape from a carrier bead have been calculated for various conditions using a simple escape velocity model.[147] For no field, an impulse

$$V_0 = \sqrt{2a_0 r} \qquad (15)$$

is required for escape where

a_0 is the adhesion of the toner particle in its rest position, and
r is the radius of the toner particle.

When a field is present, one can use approximate solutions to the field-assisted particle acceleration model. Here the acceleration, a, is given by

$$a = a_0 r^2/x^2 - QE/m, \qquad (16)$$

where

x is the electrical separation of charge and counter charge during separation
Q is the toner charge,
E is the electric field and
m is the mass of the toner.

At a field of 0.1 V/μm, where QE/m is about 12% of a_0, the escape impulse is reasonably approximated by $a_0 r$. At 0.2 V/μm, where $QE/m \cong 25\%$ of a_0, the escape impulse becomes $2a_0 r/3$. These give free-fall heights for constant toner deposition of $1/2$ and $1/3$, respectively, of that for the field-free case. This is in rough agreement with experimentally observed facts.[147]

Having considered the forces involved in removing toner from carrier beads, it is appropriate to examine how the freed toner finds its way to the plate surface where it forms the image and, sometimes, results in other, unwanted, deposits. Four types of events may be considered. Two of them involve development of charged areas and are referred to as contact and airborne development. They are illustrated in Fig. 13-21 by toner paths from carrier C and B, respectively. The other two types of events involve nonimage activity and are called dusting and scavenging. Dusting of the surface is indicated by toner from carrier bead B following path 7 to the uncharged photoreceptor. Scavenging of previously dusted, uncharged areas by charged carrier is shown at bead E. It is a toner-carrier interaction indicated by the arrow at the left labeled "1." These events are shown by frames from a high speed movie of cascade development in Fig. 13-22.

Contact development occurs whenever a toner particle is transferred from carrier to image while the carrier is in contact with the image area. This may occur by such mechanisms as rolling or bouncing, with toner stripping being governed by either the pure electrostatic or the field-assisted elastic-impact mechanisms above. Fields, at a distance of the order of a toner particle radius, or less, above the photoreceptor, are thought[130] to govern this process.

The force of attraction between a toner particle in contact development and the charged surface of the photoreceptor can be computed from simple electrostatics. The normal component of the strongest edge-fields in an electrostatic latent image vary with height above the photoreceptor. See Fig. 13-16b. At 1024μm above and just inside the charged portion of this edge, the field is 0.01 V/μm. It increases to about 0.1 V/μm at 64 μm, 1.0 V/μm at 4 μm and 1.4 V/μm at 1 μm above the surface. The charge of a typical 8 μm-diameter toner particle is of the order of 4×10^{-15} C.[141] This corresponds to a charge-to-mass ratio of 10×10^{-6} C/g which may also be considered representative.[148] Since the coulomb force normal to the surface is just the product of the field and the charge, it follows that the forces are approximately 4.0×10^{-11} N, 4.0×10^{-10} N, 4.0×10^{-9} N and 5.6×10^{-9} N for particles at 1024, 64, 4 and 1 μm, respectively. These values apply to the particular conditions given earlier with Fig. 13-16 and 17, namely a 100 V surface potential over the charged region and a 25 μm selenium photoreceptor. N is the unit of Newtons.

The gravitational force on such a particle (about 0.4×10^{-9}g) is 2.5×10^{-12} N.[141] Therefore, even at 1mm from the surface, electrostatic forces dominate, and in the region of contact (1–4 μm), they are nearly 3 orders of magnitude greater than gravity. From the above, it is clear that while gravity is important in getting developer to within a few millimeters of the surface, it has a negligible effect in the actual deposition process.

Polarization forces on typical toner particles have been calculated for regions of the *highest* electrophotographic field gradients such as near an edge.[256] Here they are on the order of 5×10^{-10} N at 10 μm above the photoreceptor. For large toner particles, this force (α r^2) may compete with the coulomb force and its effect will be to enhance edge development.* However, they may often be neglected.[149] Frictional forces of the air create relatively large viscous drags. For example, a 3 μm-diameter toner particle suffers a deceleration from air drag to $1/10$th its original speed in 0.1 millisecond.[149]

The airborne portion of cascade development involves remotely freed toner particles which are carried to the image area under the influence of the electrostatic fields originating in that area. Unlike the events associated with contact development, airborne development depends on the actual configuration of the fields in the developer zone as well as on their intensities.[150] The airborne particle-field configuration model[150] predicts density distributions and toner particle size distributions within the image which are somewhat different than those expected from contact development. If one assumes that the number of airborne particles is uniformly distributed

*T. L. Thourson, *IEEE Trans. on Electron Devices*, **ED-19**, 495 (1972).

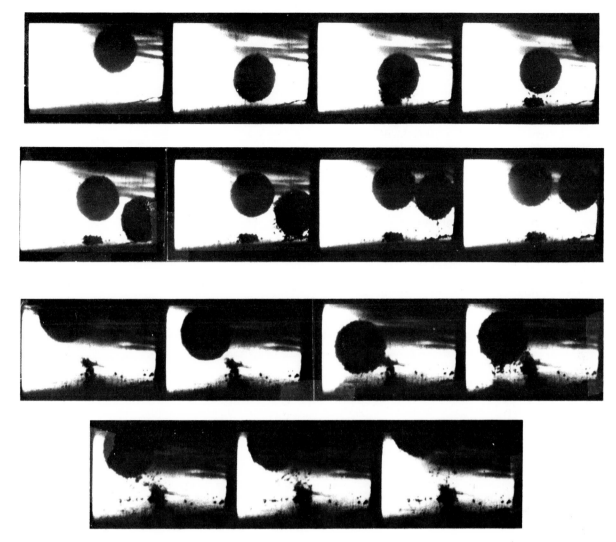

Fig. 13-22. Two series of pictures taken from a movie of cascade development. (original frame rate: 5000 frames/sec.) A strip of the photoreceptor in the middle of each frame is charged. In the first frame in the first series, no toner has been deposited on the image area. The carrier bead, covered with toner, moving right to left, actually impacts in the image area and toner is directly deposited. The second carrier bead bounces on the photoreceptor surface before reaching the image area and some of the toner that is released by the impact is drawn along field lines to the image. This latter effect can be seen more clearly in the second series where the carrier bead impacts the photoreceptor after the image area. In frames three, four and five of the second series, the movement of toner back to the image area can be seen. (from A. J. Montgomery, Proceedings SPSE Symposium on Image Quality Evaluation, Rochester, N.Y. Sept. 1970)

over the photoreceptor, then, referring to the latent image field lines in Fig. 13-17a, (page 351) we can see the center of the image area attracts toner from larger areas than that near the edge. Hence, it produces more density at the center.

While the line in Fig. 13-17a is considerably narrower than encountered in practice, it illustrates the nature of the effect. The airborne toner from a 13 μm-wide strip centered at about 34 μm from the line center would be attracted to a 2 μm strip of the image centered at 11 μm from the line center. However, toner from a strip only 6μm-wide centered at 22 μm is attracted to a similar 2 μm strip at the edge of the line image. Thus, assuming a uniform distribution of free toner at the surface, approxi-

mately twice as much toner is deposited at 11 μm as at the edge.

Another interesting aspect of the airborne model is that the effect of the field on stripping toner from carrier is less in these larger, more distant regions. Since, as we have seen, the electrostatic portion of the stripping force is the product of the field and the charge, in the more distant regions only the larger, more highly charged particles will become airborne because of the weaker fields there. Consequently, the average size of the particles will be larger in the center of a wide line image to which the distant particles are attracted.

Sullivan and Thourson proposed a theoretical model[150] to describe these effects and demonstrated qualitative

agreement with experimental results for a 3/8-in. wide electrostatic image. Their model included an adjustable term for background development but omitted viscous forces and contact development effects altogether. Since the experimental results also included contact development, the importance of the airborne development component has been established. However, the relative contribution of each to any of the various cascade configurations has not been determined. Because the toner trajectory in this process is considerably longer than in contact development, viscous forces are relatively more important and are not as yet quantitatively understood.

Configurational Studies. So far we have explored some of the physics of the microscopic mechanisms involved in granular carrier-cascade development. A large body of empirical information about the many complex factors affecting cascade development has built up; this gives further qualitative insight into the mechanisms involved. Some of the more significant findings to date are those described in configurational studies of cascade development by Bickmore et al.[151] and will be reviewed here.

A variety of physical situations are included under the heading of configurational factors. The ramifications of the presence, absence or spacing of a development electrode, already discussed, are configurational factors. The effects of developer flow rate, toner concentration, developer zone angle, average image potential, and the various interactions of these are also, significant.

Consider, for example, the four configurations shown in Fig. 13-23. In Part A, called open cascade, developer is dropped from a hopper onto an inclined-plane photoreceptor surface. One may add a large metal plate at some slight distance above the photoreceptor to obtain the conventional cascade case displayed in B. Reversing the position of the photoreceptor and electrode, shown as Part C, creates what is known as inverted cascade. A physically more complicated configuration is shown in D. Here the electrode is curved around the development end of a moving photoreceptor. In the first three cases it is possible to change the zone angle shown in A, and in the last three, it is possible both to alter the spacing between the photoreceptor and the development electrode and to vary the potential between them.

It can be seen from Fig. 13-24 that if one varies the development zone angle and measures the resulting density; the solid area densities, the integrated density of the background, and the fine image density vary. In Fig. 13-24a the solid area is a 2-in.-wide black area. The "image" is a long column of equally spaced, parallel, dark lines and spaces. The density of this image, when integrated over several cycles, should be 0.3 (reflectance of 50%). Background density refers to the large-area integrated density of portions which are essentially discharged and which would represent exposure to white paper in a typical copying application. It represents an average value for additive noise in the absence of a

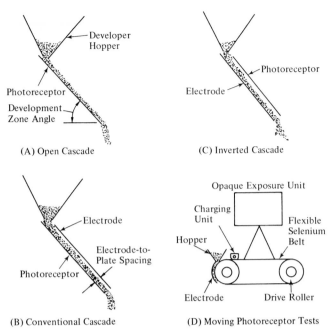

(A) Open Cascade

(C) Inverted Cascade

(B) Conventional Cascade

(D) Moving Photoreceptor Tests

Fig. 13-23. Schematic diagrams of cascade-development configurations (Ref. 151).

signal. It is seen that background increases up to an angle of about 60° and then diminishes while the density in the solid areas and image detail decrease monotonically.

A development electrode is employed with granular carrier cascade development to change the field patterns. However, the minimum practical spacing is about 1.5 mm because of developer flow rate considerations.[151,152] This separation lies between the 250 μm and ∞ curves of Fig. 13-19b, page 353. Thus, while it is possible to obtain solid area development with an electrode, practical limitations on spacings and photoconductor thickness prevent one from using it to eliminate the effects of fringe fields in the vicinity of the photoconductor surface.

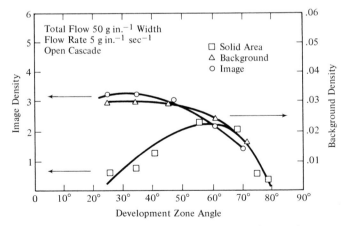

Fig. 24a. Reflection densities of solid areas, background areas and ladder charts as a function of development zone angle in an open development system (Ref. 151)

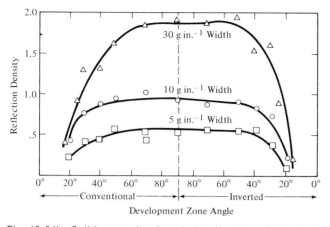

Fig. 13-24b. Solid area developed density as a function of development zone angle for various total developer flows in an electroded system. (The parameter is the total developer flow per inch width) (Ref. 151)

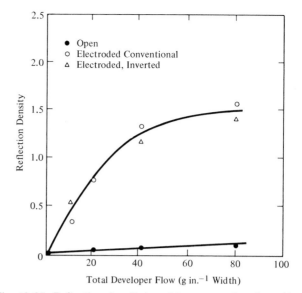

Fig. 13-25. Reflection density in solid areas as a function of total developer flow for open and electroded (both conventional and inverted) development configurations.

As a result, images of fine detail and edges generate much larger normal field components than centers of large solid areas do. Consequently, such structured image areas always receive more development in a cascade system.

With such a development electrode in place, Fig. 13-24b shows that a very much larger range of the steep angles produces maximum large area densities. This includes a large range in the inverted cascade configuration where the electrostatic forces oppose gravity. These results can in part be explained by increased flow rates at steeper angles. The width of the image of lines comparable to normal size type also varies continuously as the development zone angle changes. This is shown in Fig. 13-24c where the developed width is given as a percentage of the original stroke width. In this case, all development conditions except angle were held constant. In practice, other factors such as developer flow and concentration or

image potential could be used to obtain optimum stroke widths for a given angle.

The effect of flow rate on development is given in Fig. 13-25. It has been suggested that the developer beads act independently of one another at low flow rates while at high rates the developer moves as a blanket with less energetic bounces.

Optical density is also a function of toner concentration, as indicated in Fig. 13-26. However, it is a complex nonlinear function.

Figures 13-27a and 13-27b show that density varies nearly linearly with the difference in potential between the photoconductor and the electrode. Figure 13-27a shows that this function shifts with the bias voltage. This

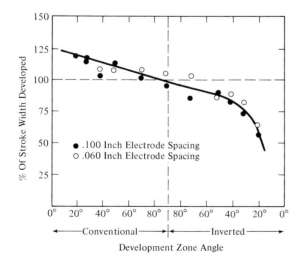

Fig. 13-24c. Developed image stroke as a function of development zone angle (Ref. 151)

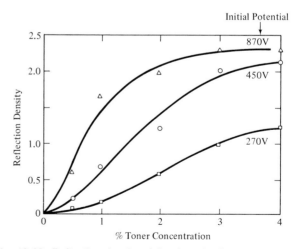

Fig. 13-26. Reflection density of developed solid areas as a function of percentage of toner concentration for various initial potential differences between electrode and photoconductor (Ref. 151).

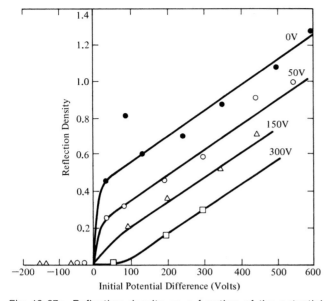

Fig. 13-27a. Reflection density as a function of the potential difference between photoconductor and electrode before development for various bias potentials; stationary photoconductor (Ref. 151).

is for a stationary photoconductor and an electrode which is cleaned after every development cycle. The shift is the result of developer depletion of relatively larger fractions of toner on the electrode at higher bias voltage. Figure 13-27b shows the effect of a moving photoconductor. The deposition and subsequent remobilization of toner on the electrode are thought to minimize developer depletion effects in practical development sys-

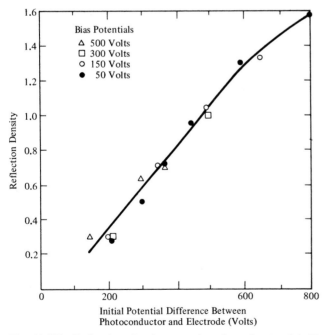

Fig. 13-27b. Reflection density as a function of potential difference between photoconductor and electrode before development for various bias potentials; moving photoconductor (Ref. 151).

TABLE 13-5. IMPORTANT VARIABLES AND SOME TYPICAL VALUES FOR PROCESS USED IN FIGS. 13-23–13-27.

Electrode-to-photoconductor spacing	0.06 in.
Electrode angle from horizontal	45°
Initial photoconductor potential	650V
Electrode bias potential, relative to photoconductive substrate	150V
Background potential of exposed photoconductor	50V
Toner concentration	1.5 g 914 toner per 100 g carrier
Development time	1 sec

tems by augmenting the toner carried at any given time by the developer. Details of the cascade system described in Figs. 13-24 through 13-27 are given in Table 13-5.

Aerosol Development (Powder Cloud Development)

In aerosol development, a stream of air or other gas carries extremely small toner particles toward the photoreceptor. Its primary commercial application has been in an unelectroded form for xeroradiography.[177] Several aerosol systems, particularly the electroded ones, have been explored in the literature.[149,153-159] They offer a number of enhanced image quality and analyzable physical characteristics worthy of brief consideration in this chapter.

As explained earlier, a plane electrode, spaced a distance equal to the photoconductor thickness above the photoconductor, is required to produce a uniform spatial frequency response for the surface fields (e.g., see Fig. 13-19). For dry development such a separation is too close except for a carrierless aerosol type of development system. Thus aerosol systems can produce high quality continuous tone reproduction.[155,157] With electroded aerosol development systems, it has been shown that very fine, dry toner particles (0.1 μm to 0.8 μm diameter) can produce resolved images of bar patterns in the range of 140 to 200 c/mm.[156]

Physical studies have shown that the rate of decrease of plate potential during development due to the deposition of powder is a linear function of the difference between the photoreceptor plate potential and the development electrode potential.[156] Evidence also indicates that as development fields decrease because of the deposition of charged toner, a larger fraction of the more highly charged toner is deposited.[156] It has also been shown that the reflection density of the charcoal toners (used in aerosol development) transferred to paper is approximately proportional to the mass of the toner up to a density of about 2.0[155,157] Typically 40 μg/cm^2 of such toner yield a reflection density of about 1.0.[157] This may be contrasted with 1 mg/cm^2 of cascade toner required to obtain a reflection density of 1.0.[148,151]

While it is possible, in some cases, to extend powder cloud results to the physics of cascade development, the

above indicates the caution that should be used since both the nature of the toner particle and its method of delivery to the image are different.

Magnetic Brush Carrier Development

Another important carrier process is magnetic brush development. Magnetic carrier allows magnetic forces rather than gravity to be used to move developer through the development zone. This lends itself to mechanized developer-transport schemes.[21,148,149] Once near the latent image, toner particles are stripped from the magnetic carrier by electrostatic and, possibly, by mechanical forces. They are subsequently deposited in accordance with the latent image fields. As described for cascade carrier systems, triboelectrification between toner and carrier creates charged toner particles of the appropriate sign. Iron filings have been extensively studied as a carrier material.[21,65,141,144,158] Steel is also used.[159] The particles forming the carrier are small, 25 to 150 μm,[21] and tend to align themselves along the lines of magnetic force. This creates long, chain-like bristles, hence the name, magnetic brush. The toner particles are attached to and coat the bristles. Figure 13-28 shows a schematic of a magnetic brush unit.[149] Here, a roughened tube contains stationary internal magnets. Rotation of the tube carries magnetic developer near the photoconductor. The magnet inside forms the developer into a brush (see magnified section) which wipes across the photoconductor and develops it. The used developer is then dropped off, mixed with other developer, and reformed into a brush on the roller.

One of the features of magnetic brush development is that the mass of magnetic carrier particles can be electrically conductive, provided they are insulated at their points of contact by toner or by some other means. The developer mass can then couple capacitively to ground so that it is equivalent to a development electrode spaced very close to the photoconductor. This "development-electrode effect" of magnetic brush allows the reproduction of large solid areas.

The spacing of this electrode can be quite close since only the toner particles separate the carrier-electrode from the photoreceptor. However, because of its somewhat random distribution through the bulk of the developer, the exact location of the development electrode is not clear; therefore, no particular electrode spacing, such as those shown in Fig. 13-20, page 354, may be thought of as being correct. Nonetheless, it is possible that an effective spacing approximately equal to or less than the photoreceptor thickness can be achieved by this method. Thus, development with a magnetic brush may sometimes be considered a method of absolute development; that is, a method in which development is proportional to the potential on the photoreceptor surface. It has been shown both in the laboratory and in commercial processes that magnetic brush development gives excellent solid area development, resembling what one would expect from contact development with a closely spaced electrode. It has also been suggested[160]

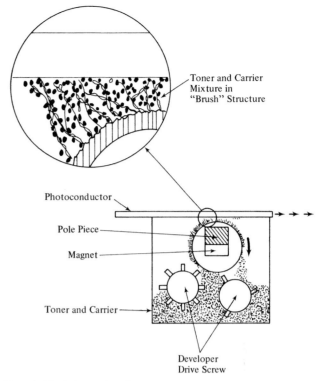

Fig. 13-28. Schematic of a magnetic brush development unit. (after Ref. 149).

that a bias potential placed on the magnetic brush would result in improved control of contrast and reduction of unwanted background deposition of toner.

Relatively little research has been published on magnetic brush development. The mechanisms of developer charging and toner-carrier attraction are thought to be similar for magnetic brush and cascade developers.[144,148,161]

One study[158] using magnetic brush techniques has shown that the type of iron filings and amount of relative humidity have strong effects on triboelectric charging and, consequently, on the relationship between the amount of toner deposited on a paper surface and the stripping voltage required to achieve that deposit. If all the toner-carrier forces were equal, one would find that no toner would be deposited until a threshold voltage were reached, and, above that threshold, all available toner would be deposited. This is the "ideal" (dashed) curve in Fig. 13-29. Instead, in practice, one finds typical toner mass versus stripping voltage curves such as 1 and 2 in Fig. 13-29. Curves 1 and 2 are representative of the range of variations one might expect either with different commercial brands of iron filing carriers or with different humidities (in the range of 30 to 80%) using a single carrier. These differences are attributed to the variation in charge and size from particle to particle.

Until recently magnetic brush development was used with photoconductor-binder plate photoreceptors and as early as 1954[21] was advocated as the best development process for ZnO binder papers.

For such ZnO binder papers the images are produced by negatively charged areas requiring positively charged

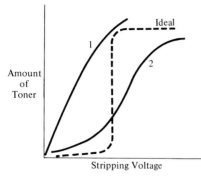

Fig. 13-29. Effects of stripping voltage, humidity, and different brands of carriers on toner deposition in magnetic brush development.[158]

toner. Triboelectrification of certain toner and magnetic carrier results in positively charged toner.[53,137,152] This is attracted to the negatively charged unexposed areas by the same electrostatic forces that control contact development as described earlier. Conducting carrier, however, creates special situations. Amick[65] suggested that the iron filings in a magnetic brush are capable of injecting electrons into the conduction band of the binder layer; however, no evidence was given to support his theory. If the theory is correct, the positive charges of the support layer are effectively transferred by the injection process to the developer, and the carrier is subsequently removed by the magnet, leaving toner in negatively charged, unexposed areas. Gillespie,[159] studying mechanisms in reversal magnetic brush development, proposed that positive and negative charges in steel carriers are separated by induction resulting from charges in the ZnO layers and that the separated negative charges are drained off when they contact leakage paths that exist in corona-charged ZnO layers. This leaves net positive charge, thereby increasing the toner-carrier force and resulting in loss of development, especially at a leading image edge.

Cassiers and Van Engeland[144] studied contact charging between iron filings, certain toner materials,* and exposed and unexposed ZnO layers. They suggest that rubbing contact with exposed ZnO causes some toner particles to reverse their sign and become negative. They claim that subsequent contact between iron and the unexposed (charged) areas gives the iron an additional negative charge which is sufficient to repel the negative toner, producing a halo around charged areas which is indeed observed. No toner is deposited right at the border, presumably because of the strong horizontal fields which drive the toner away from the border. Furthermore, they have unambiguously established that the sign of the toner in the observed halo is opposite to that of the toner in the image area, and they have shown that the particles of the wrong sign were not originally present in the charged developer. In a directional process, such as with a rotating magnetic brush, these time-dependent effects are sensitive to the orientation of the

*Including mixtures of carbon black, nigrosine and Pentalyn resins.

image areas. For example, the halos will occur behind (with respect to developer flow direction) the image of a wide uniform pattern and not in front of it.

Cassiers' and Van Engeland's studies also indicate that triboelectrification between dark ZnO and iron creates slightly negative iron particles while exposed ZnO creates slightly positive iron particles. This may be explained by the rectifying characteristics of the iron-dark ZnO contact reported by Amick.[65] It has also been noted that different methods of sensitizing (charging) result in different developed densities when ZnO paper is used.[162] Variations in the internal charge distribution are offered as the explanation.

Consequently, it is seen that while the basic mechanism of magnetic brush development may bear strong similarities to granular-carrier cascade development, its application to development of ZnO binder papers adds a degree of complexity not normally encountered in cascade development of other photoconductors.

Liquid Development

Another commercially successful development method employs toner particles suspended in an insulating liquid. Liquid development is the most commonly used development method for systems based on ZnO papers.[4] It is capable of either positive or negative first generation images with solid area development, high resolution, control of contrast, and color reproduction.[163] While the chemistry of the materials is important in determining developer properties, liquid development is a physical process. The charged toner particles move through the liquid under the influence of the electric fields associated with the latent image and are deposited on the appropriate surface, usually the photoconductor, to produce the desired image. Such field-controlled movement of charged particles in a fluid is known as electrophoresis. It has been in general use since the early 1900s for applying coatings to various metal surfaces but has only been considered for electrophotographic use since the mid-1950s.[163,165]

Materials and Composition. The ideal liquid developer for commercial applications has been described[163,166] as one which is stable, cheap, odorless, nonflammable and nontoxic. The liquid medium should evaporate rapidly, and the toner should be "self-fixing." The composition should be stable in terms of shelf life with respect to both suspension and charge polarity. The developed images should, of course, be high quality, and development results should be reproducible.

Typical formulations (which can be prepared in a simple chemistry lab) have been published[163,167,168] and are given below:

A. Mayer's[167] positive liquid developer:

1. Add 40g Versamid 930 to 75cm³ Solvesso No. 100; heat until melted and homogeneous.
2. Add 60g charcoal powder (size = 10 μm) to hot solution and mix thoroughly.

3. Cool; crush in mortar; sift through a 20-mesh screen.
4. Put into 200cm^3 Solvesso No. 100 and ball mill down to 7 μm maximum particle size (1-1/2 hr).
5. Rinse out ball mill with another 100cc Solvesso No. 100 and combine.
6. Dilute to 3 l.

B. Metcalfe's[168] negative liquid developer:

1. Make paste from 25g boiled linseed oil, 75g lead chromate and 0.5g lead naphthenate drier.
2. Store in paste form until just prior to use.
3. Stir paste into n-pentane, cyclohexane or other suitable insulating solvent.

Solid-liquid combinations which have been used or examined for use as liquid developers are listed in Table 13-6 along with observed charge polarities.[163]

In general, there are four components in a liquid developer: toner particles, a liquid medium, a fixing agent (not required) and a control agent (not required). The roles of the toner and liquid medium are obvious. The control agent, a material such as an alkyd resin or linseed oil, is added to control the polarity and magnitude of the toner particle charge. The fixing agent fastens the toner particle to the paper, or other final support, by leaving a hard plastic film after evaporation of the liquid. Drying oils or resins which oxidize in air to crosslink and harden are sometimes employed. The alkyd resins[163,169] and polystyrene[4] which function as control agents may also serve as fixing agents.

The toner materials may be organic or inorganic pigments (see Table 13-6 for examples) with adequate color and density having diameters varying typically from 0.2 μm for some material to 10 μm for others. They must be of a single polarity, have a narrow particle-size distribution, and be of uniform chemical composition.

TABLE 13-6. ELECTROPHORETIC RESPONSE OF SUSPENDED PARTICLES.[163]

Preparation, 0.5% suspensions	Suspending liquid	Toner charge, % +	−	N or R*
Vinylite VYNS-3	Sohio Solvent		100	
Vinylite VYNS-3 + Litho Maroon Red	Sohio Solvent	30	70	
Vinylite VYNS-3 + Rhodamine	Sohio Solvent	X	X	Small
Vinylite VYNS-3	Freon 113	5	95	
Charcoal	Sohio Solvent	60	40	Small
Charcoal + Gilsonite	Sohio Solvent	20	80	
Gilsonite	Sohio Solvent		100	
Gilsonite	CCl$_4$			100
Gilsonite	Toluene			100
Charcoal	Toluene	10	90	
Polymethyl Methacrylate	Sohio Solvent	50	50	
Polymethyl Methacrylate + Water	Sohio Solvent	100		
Exon 450	Sohio Solvent		100	
Exon 470	Sohio Solvent		100	
Exon 481	Sohio Solvent		100	
Neospectra Mark III Carbon Black	Trichloroethylene		10	90
Magnetic Iron Oxide (gamma)	Sohio Solvent	50	50	
Hydrafine Kaolin	Sohio Solvent	50	50	
Cupric Hydroxide	Sohio Solvent	40	60	
Esterfied Iron Oxide	Sohio Solvent	30	70	
Activated Charcoal	Sohio Solvent	20	80	
Black Ease Enamel TIAO	CCl$_4$	100		
Cardinal Red Ease Enamel	CCl$_4$		10	90
DuPont Tartrazine	CCl$_4$	40	60	Small
Special Maroon	CCl$_4$	100		
Ultramarine Deep	CCl$_4$		X	X
Covarnishblak BJ	CCl$_4$		10	90
Covarnishblak BK	CCl$_4$	10	10	90
Polyamide 93 + Charcoal	Sohio Solvent		100	
Epolene E	Sohio Solvent		100	
Versamid 930 + Charcoal	Sohio Solvent	10	90	
MW American Vermilion Red	Sohio Solvent	70	30	
MW American Vermilion Red + Tergitol NP-27	Sohio Solvent	100		
Prussian Blue	Sohio Solvent	Small	Small	80
Prussian Blue + Tergitol NP-27	Sohio Solvent	Small	Small	80
Fast Yellow GLF	Sohio Solvent	Small	Small	80
Cadmium Red	Sohio Solvent	Small	Small	

*Neutral or Reciprocating.

The liquid medium (see Table 13-6) must be highly insulating, with resistivity greater than 10^{10} ohm-cm and dielectric constant greater than 2.5. It cannot act as a solvent for the toner nor can it react with the photoreceptor. Its specific gravity must be equal to or greater than that of the toner. Other desirable characteristics include: quick drying (high vapor pressure), nontoxicity, being odorless, and having high flash and boiling points. Other materials include: cyclohexane and various fluorinated hydrocarbons (nonflammable), silicones, and some aliphatic hydrocarbons. Special formulating techniques such as matching of specific gravities of particle and medium, use of dispersing agents, or reduction of particle size are necessary to produce stable suspensions.[163]

Development Configurations. A number of different configurations for accomplishing liquid development exist, but they are mostly engineering variations of a few basic types. The simplest form merely involves submerging the latent-image-bearing surface into the developer, a system wherein development is most sensitive to fringe fields. Rollers may be used to transport the developer to the image surface. These may be either insulating or conducting. In the latter the roller can serve as a closely spaced development electrode with the advantages previously discussed in terms of large solid area development.

Physics of Microscopic Development Mechanisms. The mechanisms involved in charging toner particles in a liquid suspension are not completely understood. The adsorption of ions on the surface of the toner particle, is

widely accepted as being a controlling factor although other mechanisms have been proposed.[161] The diffuse double-layer model[163,170] for adsorption suggests that every particle is covered by a fixed monomolecular layer of ions and a diffuse layer of oppositely charged ions in the bulk of the liquid. Thus, the potential falls off gradually as one moves further from the solid surface into the liquid.

The diffuse double-layer model described by Spitze[170] is illustrated in Figure 13-30. A rigid layer of ions is attached to the toner particle and held by the oppositely charged electronegative toner particle. The outer boundary of this rigid layer is a surface of shear, where the particle and rigid boundary separate from the surrounding medium when the particle moves under the influence of an outside force. At this surface, the value of the electric potential is defined as the zeta potential, ζ, also known as the electrokinetic potential. This potential is useful in describing the physics of liquid development.

The transport of toner particles to the charged photoreceptor surface is through the mechanisms of electrophoresis, dielectrophoresis and diffusion. Electrophoresis is the dominant process. Since development is a time-dependent process, the physics controlling the rate of development are important.

The electrophoretic velocity, v, is given by:

$$v = \frac{A\zeta KE}{\eta_\varrho},$$ (17)

where:

K = the dielectric constant of the medium,
η = the liquid viscosity.
A = a constant set equal to $1/4\pi$ when the thickness of the double layer is small compared to the radius of the particle and $1/6\pi$ when the thickness is large compared to the particle radius

The zeta potential itself is defined as:

$$\zeta = \frac{4\pi qd}{K},$$ (18)

where

q = the charge per cm^2, and
d = the distance between the two layers of charge (thickness of rigid layer).

The usual range of mobilities corresponding to typically encountered zeta potentials between 0.01 V and 0.05 V is 7×10^{-5} to 35×10^{-5} cm/sec in a field of 1 V/cm.[163] Since this is similar to ionic mobilities, electrophoresis is seen to transport matter much more efficiently than electrolysis. The efficiency can be kept high, provided the concentration of ions is minimized.

The second mechanism by which liquid toner particles move is dielectrophoretic attraction of polarizable, uncharged particles with dipole moments higher than the medium.[161] This requires nonuniform fields. A third mechanism of importance is diffusion.[161,171]

Many authors have described electrokinetic theories of liquid development.[148,163,170,171,172,173,174,175] Most of

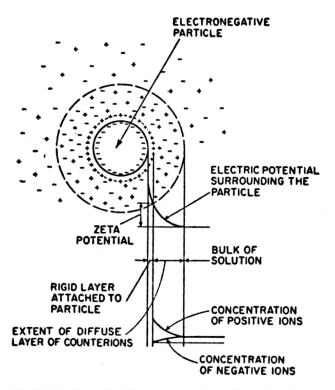

ELECTRONEGATIVE PARTICLE

ELECTRIC POTENTIAL SURROUNDING THE PARTICLE

ZETA POTENTIAL

BULK OF SOLUTION

RIGID LAYER ATTACHED TO PARTICLE

CONCENTRATION OF POSITIVE IONS

EXTENT OF DIFFUSE LAYER OF COUNTERIONS

CONCENTRATION OF NEGATIVE IONS

Fig. 13-30. Concept of the zeta potential and ionic double layer as depicted by Spitze (see Ref. 170)

them[148,170,171,172] have found that the time variation of density, D, could be described by an equation of the form:

$$D = D_m [1 - e^{-t/\tau}]$$

where

D_m = the maximum density after prolonged development,

t = time, and

τ = a development time constant.

D_m will depend on the conductivity of the liquid, the applied voltages, the image charge density, agitation of the developer, and the optical characteristics of the deposited toner layer.

It has been suggested[148,171] that τ may, in fact, be two time constants, one for the diffusion process and the other for the electrophoretic motion. The former may be as large as 160 sec and the latter may be in the vicinity of 1 to 100 msec. Both types of mechanisms are operative. Therefore, the actual time constant lies somewhere between these extremes. Typical overall experimentally determined time-constants for a carbon black with control resin toner dispersed in Isobar G using an electroded development scheme are on the order of 5 sec.[172] It is also interesting to note that optical density for many electroded liquid development situations is linearly related to the initial charge density on the receiving surface up to a density of 1.0[171,172,174] at least for relatively short development times where saturation effects are avoided.

Dahlquist and Brodie[171] have shown that the charge on each toner particle in the liquid developer system they studied (Phillip A. Hunt Chemical Corp., Liquid Toner 27-10), consisted of a single positive electronic unit of charge, e. Since the zeta potential contains a term, q, for charge per cm^2 and the charge is seen to be constant, the zeta potential, hence the rate of development, increases if the particle size goes down, other factors remaining constant. For a given charge density and complete development, however, less maximum developed density results because each neutralized surface charge would have less absorbing material associated with it. Thus, larger particles give greater sensitivity. It is possible to increase the effective density of a given size particle by carefully selecting its material or by treating it with dyes, but this must be done without altering the other characteristics such as the zeta potential.

It is important to note that liquid development is often paired with ZnO binder layer photoreceptors. As in the earlier discussion of magnetic brush development, the interaction of this paper with the developer complicates the physical mechanisms involved in development. For example, the possibility of toner injecting charge into the photoreceptor may increase the effective quantum yield of the photoreceptor[173] by effectively producing more charges at the photoreceptor. Steady "leakage" currents through the ZnO binder papers have been observed with reversal development,[173,174] i.e., where dark parts of the object become light parts of the image which tend to limit the minimum density, increasing the density in the otherwise white background. Microscopic

areas of high electrical conductivity in the paper during toning are said to be the cause of this leakage.[173]

For reversal development with a negatively charged photoreceptor, a negative bias electrode is used to induce a counter charge in the photoconductor. This neutralizes the previously negatively charged areas and produces a net positive charge in the light-discharged areas. Negative toner is thus attracted to the exposed areas which are now positively charged. Toner is not attracted by the unexposed neutral areas. This procedure may be applied to any development system. (For positively charged photoreceptor, a positive bias is used.) It exhibits interesting results for ZnO binder papers and commercially available negative liquid developers. Plots of density versus pre-development photoreceptor voltage are shown in Fig. 13-31. They are based on data taken from Hutter and Giaimo[173] for Electrofax paper and a commercial liquid toner suspended in Freon TF (Cl_2FC-CF_2Cl), made by the E. I. Dupont Company. Note the high minimum density especially for the larger bias voltages and the linear central regions in each curve. Note also that some reversal development occurs even without a bias voltage ($V_B = 0$ case).

Some useful quantitative models for liquid development systems take the form of electrical circuits employing the equivalent capacitances and resistances of the photoreceptor and developer.[172-174] It is, thus, possible to analyze rate relationships in these systems by conventional electrical engineering techniques. The equivalent circuit of Fig. 13-32a may be used to explain the reversal development. Simultaneous closing of switch SW1 and SW2 represents the paper entering the toning

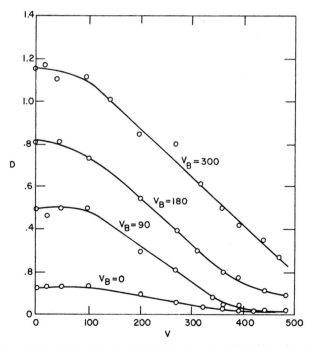

Fig. 13-31. Plots of developed density as a function of pre-development photoreceptor voltage for reversal development. V_B is the bias voltage on the development electrode (Hutter and Giaimo.[173])

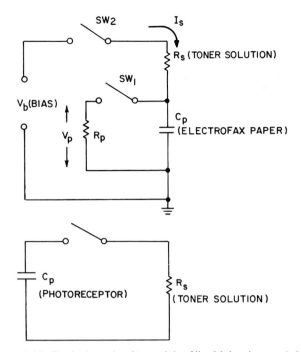

Fig. 13-32. Equivalent circuits models of liquid development. (a) for a biased ZnO binder layer development system where V_b is the bias potential in volts V_p is the potential in volts above ground of the surface of the photoreceptor R_p is the resistance in ohm-cm² of any effective electrical shunt across a unit area of the photoreceptor, R_s is resistance in ohm-cm² of a unit area of a column of developer extending from the photoreceptor surface to the bias electrode, and C_p is the capacity in farads/unit area of the active photoreceptor layer (after Refs. 173, 174), (b) for an unbiased electroded system where C_p and R_s are as given for a and the initial charge Σ is placed on the photoconductor is discharged through the toner resistance R_s (after Ref. 172).

solution. After time t, the paper is removed from the developer and both switches are opened. It is found that only an increase in C_c and a decrease in R_p with exposure can explain the behavior of this equivalent circuit while being consistent with measurement of time constants and surface voltages before and after development.[173,174] It also has been found that the surface potential, V_p, of the exposed layer cannot be measured while in the developer and it drops considerably after emerging.[174] A useful equivalent circuit for an insulating surface and no bias on the electrode is given in Fig. 13-32b for comparison.[172]

IMAGE MANIPULATION

At this point in the xerographic process (following development), we have an image formed by toner deposited on a photoconductor. For classical cycling systems in which the photoreceptor is reused, the image must be transferred from the photoconductor to another support, and, for all systems, the image must be made permanent by fixing.

There are other problems connected with this part of the process, for example, how to move the image-bearing sheet to the user, and, in general, such overall systems

engineering problems as replenishing developer, cleaning, and paper handling. Space does not permit, nor do we believe it appropriate, to address these problems in detail here. They have been reviewed elsewhere.[1,2] However, since we have followed the zinc oxide binder layer image through the process to its final support, it seems appropriate to comment on how a toner image on a reusable photoreceptor may be transferred.

The most widely used method is electrostatic transfer. In usual practice, a sheet of plain paper is placed over the powder image and a corona unit (corotron or scorotron) passed over the back of the sheet. This subjects the sheet to a uniform electrostatic charge of polarity opposite to the charge on the powder image on the plate. As a result, the upper layers of the powder deposit are attracted more strongly to the transfer sheet than to the xerographic plate. When the sheet is peeled away from the plate, the powder image comes with it. A thin layer of toner is left behind on the plate; this must be removed before the photoconductor can be reused.

An example of the efficiency of the transfer process is given in Fig. 13-33. It indicates the mass of toner required to produce a certain reflection density on paper after fusing. The mass before transfer is measured on the photoreceptor; the mass after transfer is measured on the paper.

Fixing, which bonds the loosely attached powder image to the paper, is the final step in the production of an electrophotographic print. Xerographic toners melt at temperatures between 225° and 325° F.[176] The image can be fixed, therefore, by placing the image-carrying sheet in a regulated oven held at about 400° F for 5 to 15 sec. In automatic machines, the sheet, or web, is usually passed under a radiant fuser at a constant speed; thus the geometry of the fuser and the speed of the sheet are important. Hot rollers are also used. The physics of these processes is beyond the scope of the present chapter.

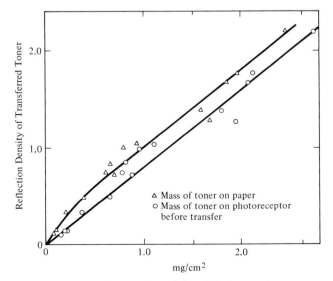

Fig. 13-33. Reflection density of fused 914 toner images as a function of the amount of toner deposited. Some toner is not transferred. (From Bickmore et al.[151])

Liquid-developed images are usually permanently fixed after the liquid medium has been evaporated. This is a matter of chemistry and drying and is usually discussed in the literature on liquid developer composition.[163]

ELECTROPHOTOGRAPHIC PROCESSES AND SYSTEMS

Having discussed some of the scientific principles on which the classical electrophotographic process is based, let us now examine some classical systems used in machines on the market and review, briefly, some unconventional processes.

Classical Electrophotographic Systems

The electrophotographic systems now widely used for copying and duplicating constitute the "classical" systems. These may be conveniently subdivided into *transfer* and *nontransfer* systems depending on whether the original toner image is transferred to another substrate or left on the photoconductor.

Transfer Systems. The first commercial electrophotographic copying equipment was introduced by the Haloid Company (now Xerox Corporation) in 1950. This, as discussed earlier, was a transfer system. Since the introduction of that first machine, numerous improvements have been made to the process. Features have been added and the process automated, but the basic steps involved in the operation of both the earlier equipment and of more recent automatic xerographic equipment are essentially the same.

A schematic of a typical system is given in Fig. 13-34. First, a corotron is used to deposit a uniform charge on a photoreceptor bonded to the outer surface of a drum. The drum is rotated past a camera exposure station where it is imagewise-discharged in rough proportion to the intensity of the light (from the image) falling on it. A commonly used optical scanning system is shown in Fig. 13-34. The document to be reproduced is held stationary while mechanical linkages, synchronized with the drum, move the lens and, in some systems, the illuminating lamps. Thus, the continually moving image in the slit is stationary with respect to the rotating drum. For any narrow strip of the image, then, each step in the process occurs at the same elapsed time from charging as for any other strip.

After charging and exposure, the drum passes through a cascade development station. Here, a conveyor belt arrangement pours a continuous stream of granular developer over the surface of the photoreceptor. The

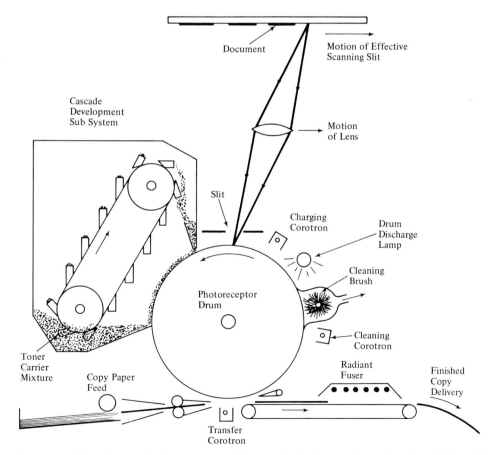

Fig. 13-34. Automatic xerographic equipment for the copying of documents. Similar equipment has been designed for reproducing from microfilm and for printing for aerial negatives.

development system in Fig. 13-34 also catches the developer after cascade and stirs the mixture continuously—usually while adding toner. This stirring accomplishes two functions: (1) it maintains the triboelectrification of the developer despite the selective withdrawal of material of one sign, namely toner, and (2) maintains the toner concentration level. The substrate material, usually paper, for the eventual copy is introduced at the next station. It passes between the developed image on the photoconductor and the transfer corotron. The latter charges the paper with a polarity opposite that of the toner thereby electrostatically attracting the toner to the paper. The paper is separated from the drum in the next stage and passed through a radiant fuser which causes the toner particles to melt. The particles first wet each other then wet the paper, causing some penetration into the paper fibers and creating a permanent bond. This fixed image is then moved, mechanically, to a delivery station.

Not all of the toner forming the developed image is transferred to the support material so what remains must be removed before the photoconductor can be used for the next image. This is accomplished by first weakening the electrostatic forces binding the toner to the drum by applying a corona charge opposite in sign to that used in charging and then by mechanically removing the particles with a fur brush and vacuum system. Removing toner from the photoreceptor to prepare it for subsequent images may also be achieved in other ways, for example, with wiper blade or a web. The photoconductor is then completely discharged by a large exposure to a uniform light. This discharging is necessary to prevent "ghosting."

Transfer systems have some inherent advantages. In particular, the use of a recyclable photoconductor is important for lowering costs and providing enhanced, repeatable performance, while permitting the use of more expensive photoreceptor materials and structures. Transfer systems also allow the user some flexibility in selecting the form of output.

There are a great many variations on the basic process as outlined above. Full-frame exposure systems employing flat photoreceptor plates have been widely used to transfer images to paper offset plates for use as masters in lithographic printing. X-ray exposures will produce a latent image on conventional photoreceptors, thus flat plate photoreceptors can be substituted for large, conventional x-ray film; semiautomatic equipment is in use for developing such images. Normally developed (nonelectroded powder cloud) xeroradiograms enhance edges, thus are particularly suited for industrial testing and for some medical applications.

Other variations include the use of different substrate materials; for example, clear acetate is used for making transparencies, and copper-clad plastic sheets are used to produce printed circuits by etching around the toner. A vapor-fixing system is used in the variations mentioned above. The substrate bearing the toner image is placed in a closed chamber containing the vapor of an organic solvent, such as trichloroethylene or Freon, for a few seconds. The toner absorbs the solvent, becoming tacky or liquid. When the sheet is removed from the chamber, the solvent quickly evaporates, leaving the toner bonded to the sheet.

Various optical systems may be used to enlarge or reduce the input image. For example, a number of microfilm enlarging systems are available, and there are several machines which reduce engineering drawings.

The spectral characteristics of the photoreceptor may vary from blue-sensitive to panchromatic depending on the particular photoreceptor material, and both negative and positive developers are available. A variety of photoreceptors have been employed with the most common being selenium or selenium alloys in cylindrical drum form. Other variations include 1:1 TPC in a roll which is gradually unwound and replaceable and dyed ZnO binder paper panels in a belt.

Some equipment uses a development-electrode configuration to achieve development of solid areas. Certain systems have been built to record continuous tone pictures. These, which have been developed primarily for experimental evaluation in government or military applications, commonly employ aerosol development. The typical aerosol development system has an aerosol generating chamber located at the bottom of the photoreceptor drum from which the aerosol passes upwards between the exposed photoreceptor and a closely spaced electrode just beneath it. The result is toner deposited in proportion to the photoreceptor surface voltage. A variety of techniques employing screens at the photoreceptor and at the object have been described.[2,141,177] Object overlays of white dots and line screens in the exposure plane have been the most successful.[177] Contact printing of halftone positives is also possible.[142]

Most commercial systems transfer the toner to the substrate electrostatically; however, there are other methods. For example, a pressure-sensitive adhesive layer may be used to remove the toner from the photoreceptor; this, in fact, was the method first used by Carlson. High quality powder-cloud developed images have been transferred to a dye-transfer paper simply by moistening such paper and pressing it onto the developed plate.[155]

Nontransfer (Direct) Systems. In practice, nearly all of the commercial electrophotographic copying systems which produce final output images directly on the photoreceptor use zinc oxide (ZnO) binder papers. They utilize either liquid development or magnetic brush development. In 1972, Business Automation Product Information Services[176] listed 29 manufacturers or distributors of electrostatic photocopiers. Twenty-five of these marketed direct, nontransfer electrostatic copiers; well over 100 models were listed. It is impossible here to review, even briefly, all the variations in such a collection of copying systems. Consequently, we have selected one unit, the Apēco Model 281 as a typical example of such systems; a schematic of this system is given in Fig. 13-35.

A document to be copied is placed between a glass platen and a rubber mat. Platen motion provides a scanning action. A folded, stationary projection system projects the image onto the ZnO binder paper (photoreceptor) which is traveling in synchronism with the

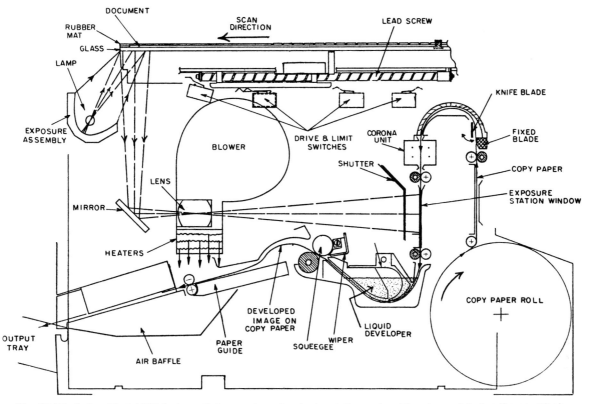

Fig. 13-35. Apēco Model 281 (schematic), a nontransfer electrostatic copier. (*Courtesy of Apēco Corporation*)

moving image. The paper photoreceptor is contained within the system in roll form. It is cut and then negatively charged by a corona unit just prior to exposure. The exposed paper is passed through a development chamber containing a close-spaced electrode and a liquid dispersion of charged toner particles. To hasten drying, the developed photoreceptor passes through a chamber where heated air is blown on it just before reaching the output port where it is caught in a receiving tray.

Other variations for nontransfer systems include liquid development by spray methods and dry magnetic brush development followed by radiant fusing. Optical systems for reduction and enlargement and for scanning fixed-position originals on glass platens are also in use. Some systems do not use platens but transport a single sheet input document past a scanning system. A number of systems are sold as microfilm enlargers and reader/printers. Negative and positive developers are available and some models operate with a closely spaced development electrode thereby giving good solid area development and continuous-tone capability. As discussed earlier, dye sensitization of the basic UV-sensitive ZnO layer can extend its spectral response to the red and even near IR.[21]

The different properties that can be built into a coating mixture by changing the composition give nontransfer electrophotography a flexibility similar to that of the transfer form. For example, swabbing certain types of ZnO binder surfaces with a chemical solution can make them water receptive, which makes them suitable for use as offset masters.[178] Modified ZnO binders may also be used as coating for a variety of surfaces other than paper. As a result, it is possible to select binder-developer combinations which give insoluble images. If the non-transferred image is on an appropriate substrate, the undeveloped binder may then be dissolved away. Thus, the process can act as a photoresist.[178]

Color Systems. Developer materials can be made in any color so multicolor prints may be created by repeating the charge-expose-develop cycle with the same photoreceptor using different separation images or separation filters on the color original along with the appropriate developer color. Automatic copying machines of the transfer and non-transfer type are available to make color prints.[259,260,261,262] One can get either flat color reproductions (called functional color) for charts and graphics[260] or more accurate renditions including projecting color slides through a halftone screen on the document platen.[263,264]

Unconventional Electrophotographic Processes

It is possible to change the fundamental nature of each of the basic elements of the electrophotographic processes from the descriptions given above and yet not change the fact that an electrophotographic latent image is involved. Numerous processes have been described over the years in which one or more of these basic elements is different

from classical processes and systems. The principle variations are in the use of nontoner development techniques and photoreceptors other than the ones we have been discussing. Many unconventional electrophotographic processes have been proposed. We can touch upon only a few in this chapter, but we believe the systems described below are representative of the variety of electrophotographic processes reported in the literature.

Thermoplastic Deformation Imaging. Forming images by the selective deformation of a viscous material by electric fields was first demonstrated in the early 1940s. These were the Eidophor T.V. display systems which used oil and electron beams.[179] Permanent images of television-type electron-beam patterns using heat-developed thermoplastics were reported by Glenn[180] in the late 1950s. Early in the 1960s two electrophotographic thermoplastic structures were introduced (see Fig. 13-36). In the first case, hereafter called "Type *a*" (Fig. 13-36a) a thermoplastic is coated on top of a photoconductor supported by a substrate.[181] In the second structure, called "Type *b*" (Fig. 13-36b) a photoconductive thermoplastic is coated on a substrate.[182] A broad range of photoconductors and thermoplastics may be used in the Type *a* structure. Photoconductors, however, must lend themselves to being coated in a flat, glossy configuration. Thermoplastics having a bulk resistivity in excess of 10^{14} ohm/cm are usually selected.[181] In the Type *b* structure, the required

thermoplastic and photoconductive properties must be combined in a single material, greatly limiting the available choices. In both cases, the photoreceptors are charged by corona and then exposed to light. In Type *a* systems, photogenerated charge migrates from one side of the photoconductor to the other leaving the surface charge and electric field across the thermoplastic unaltered but lowering the surface potential in exposed regions. To a rough approximation (neglecting fringe fields), deformation is governed by charge density—not voltage. Consequently, a second charging step creates an equipotential on the surface by forming greater charge density and electric field in the more exposed regions. Type *b* structures are electrically discharged in accordance with the exposure pattern much like classical binder photoreceptors discussed earlier. Both the charge density and the surface potential are lowered by exposure. The final steps for both configurations are heating to soften the thermoplastic, allowing it to deform in response to the electric field, and cooling to harden or fix the images.

The resulting surface deformation images alter the phase of light incident upon them but not its intensity or amplitude. Consequently, they must be used in conjunction with phase-sensitive, readout optics. The exposed and, consequently, most deformed parts scatter or diffract light out of collimated or other well-directed beams of light. They, therefore, have no diffuse density but may have a high specular density depending on the angular distribution of scattering and on the densitometer or viewing collection angles. It is customary to use the ratio of deviated-to-total transmitted or total reflected light as a measure of sensitometric response. This quantity is called modulation efficiency.[183] If the image is periodic, such as a Ronchi ruling or sine wave image, diffraction efficiency is used. This is the ratio of diffracted light in a *given diffraction order*, or orders, to the total transmitted or reflected light. Phase-sensitive readout systems include Schlieren optical systems which transmit or reflect only the scattered light, hence producing a positive image, and highly specular projection systems which produce negative images by excluding the scattered light. Various coherent optical systems have also been proposed.[184]

Claus[4] distinguishes between three types of plastic deformation: (1) relief; (2) Frost; and (3) screened thermoplastic. Relief deformation occurs at the edges of charged areas or in regions of large charge gradients when a charged plastic sheet is softened by heat or vapor. With proper choices of thickness of the thermoplastic, threshold potential, and characteristics of the plastic, and by use of greater surface charge, a random surface deformation (ripple) pattern can be produced throughout broadly charged areas. This has been termed Frost deformation. The Type *a* structures are commonly operated in the Frost mode[181,185,186,188] while Type *b* are frequently used in the relief mode.[182]

Frost is inherently a continuous tone process with solid area response because it responds to absolute charge densities, whereas relief deformation is primarily an edge-development process because it responds to

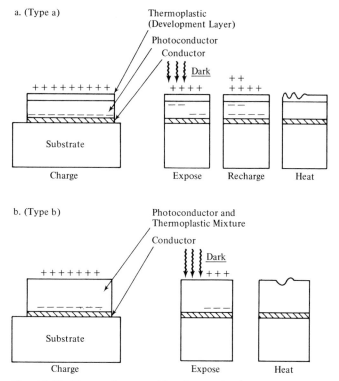

Fig. 13-36. Electrophotographic thermoplastic structures. a. "type a," thermoplastic coated on a photoconductor supported by a substrate. b. Photoconductive thermoplastic coated on a substrate.

charge gradients. Relief deformation is, therefore, best suited for recording line images. Screened plastic deformation images are created by superimposing a periodic pattern (screen) on the image. This is frequently accomplished by recording the image through an optical line screen such as a Ronchi ruling. A regular pattern of charge gradients results everywhere in the image including the large uniformly exposed regions. Both Type *a* and Type *b* structures are used in this mode.[183,184] In this case, the screening periodicity may be selected to correspond with the preferred periodicity of deformation of the plastic layer which is called the quasi-resonant frequency.[184] An inverse relationship exists between this frequency and the thickness of the layer.[184,188] The screen acts like the spatial frequency analog of a carrier wave in radio communications with the lower frequency image information modulating it and appearing as side bands.[184]

Frost deformation acts as a random carrier for image information. The spatial frequency spectrum of Frost is sharply peaked within 10% of the quasi-resonant frequency.[184] The use of a periodic screen suppresses the randomness and, therefore, vastly improves the signal-to-noise ratio at low frequencies. The deformations produced on a Type *a* structure with a very thin (1.1 μm) thermoplastic by sinusoidal images of various spatial frequencies and constant modulation are shown[189] in Fig. 13-37. This is conceptually similar to a modulation transfer function. The right-hand ordinate indicates the phase shift in radians for a beam of red light transmitted through the sample. The right-hand ordinate is the actual deformation on the surface in microns. Note the peak at 400 c/mm which is the quasi-resonant frequency for this sample. Thermoplastics have been used for holography[190] where the periodicity of the interference pattern of the hologram itself, in effect, acts as the screening technique, thus providing periodic modulation.

To a large extent, the sensitivity and micro-image structure characteristics (resolution, etc.) of these materials are independent, being controlled by the photoconductor and thermoplastic, respectively. This is particularly true of the Type *a* materials. Resolution on

the order of hundreds of c/mm are not uncommon,[191] and resolution at 1000 c/mm has been observed holographically with Type *a* structures.[184] Equivalent ASA speeds of approximated 25 have been reported in Type *b* structures using copper phthalocyanine mixed with thermoplastic polymers[192] and in Type *a* structures on selenium.[191]

There are a number of other advantages to thermoplastic imaging. All aspects of the process are dry. Development can be very rapid. Images can be erased and/or updated. The medium is reusable within limits set by dirt buildup. Color or black and white is possible.[191] Media can be sensitive to either light or electrical charges, and, requisite materials can be relatively inexpensive.

The main disadvantages of thermoplastics are the additional optical complexities required for readout and for producing a screened image if continuous-tone is desired. Furthermore, with many systems, the dynamic range is somewhat limited by the phase nature of the image; Gaynor[191] claims a 10:1 input contrast is frequently an upper limit. Dirt is also a problem.

Other Photoconductor/Development Layer Sandwich Structures.

A number of other unconventional electrophotographic processes have the Type *a* structure in common. They all use imagewise fields generated in a photoconductive layer to create an optically detectable change in an adjacent development layer.

Elastomeric Deformation Imaging Devices (Ruticon).

In 1970, Sheridon[193] announced an electrophotographic process bearing some resemblance to the Type *a* materials described above, but which replaced the thermoplastic layer with a deformable elastomer layer and employed several ways to create a voltage across the elastomer and photoconductive layers. He named it Ruticon from the Greek words *rutis* (wrinkle) and *icon* (image). When the photoconductor is exposed to a pattern of light, usually through the transparent, conductive substrate, the voltage distribution across the photoconductor changes; this, in turn, causes changes in the electric field across the elastomer. The resultant forces cause the elastomer to wrinkle or deform into a phase-modulated, surface-relief pattern corresponding to the incident light pattern. The deformation persists, within limits set by the photoconductor dark decay, while the field is maintained even after the light pattern (input image) has been removed. Quick erasure of the image is accomplished by removing the field. Subsequent reapplication of a uniform field and exposure will allow reuse of the device in a cyclic fashion.

Several structural forms have been demonstrated, each using a different means to provide the fields across the device.[194,195] A Ruticon may be continuously charged by a corona device; however, this is an awkward arrangement and not often used. The elastomer layer may be covered by a conductive (usually opaque) liquid, commonly mercury or gallium-indium, and then by a window. A voltage is applied between the liquid and the substrate conductive coating. This is called the α-Ruticon and must be read-out by reflection through the substrate and a

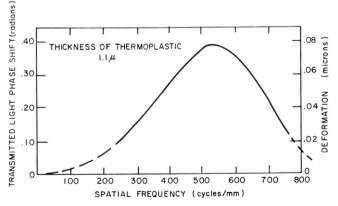

Fig. 13-37. Deformation of a type "a" electrophotographic thermoplastic by sinusoidal images of various spatial frequencies.[189]

transparent photoconductor. A β-Ruticon employs a glow discharge above the elastomer to create an ionized gas (commonly argon) plasma inside a cylinder. The Ruticon substrate serves as one end and a transparent conducting window the other. By an external voltage between the ion source (a discharge ring) and the Ruticon substrate, ion currents of either polarity may be drawn to the elastomer surface. A transparent photoconductor allows transmission readout. The γ-Ruticon variation consists of a thin, mirrorlike, flexible layer of conductive metal coated directly on top of the elastomer. A dc voltage is applied between the metal layer and the substrate electrode. The metal layer, which may be a gold alloy, has a high level of opacity. Consequently, the γ-Ruticon is operated with the input image and the readout light effectively isolated from each other.

A quantitative comparison between the diffraction efficiencies of the α-, β-, and γ-Ruticons is given in Fig. 13-38 using unity modulation and sinusoidal exposures of various frequencies as inputs. It has been shown that the peak of the γ-Ruticon frequency response and its bandwidth are inversely related to surface tension.[196] γ-Ruticons with built-in screens have been made to exploit this resonant frequency. The γ-Ruticon has erasure times to 20% of peak on the order of 10 milliseconds, suggesting 30 frames/sec cycle times are possible. In excess of 10,000 image cycles have been observed on single γ-Ruticons without noticeable degradation. The γ-Ruticons have been used holographically at spatial frequencies in excess of 850 c/mm, while β-Ruticons so far have been operated a little beyond 300 c/mm.

Liquid Crystals. Liquid crystals may serve as the development layer in a Type *a* structure where the development layer is bounded on its top side by a transparent electrode. The fields produced by the photoconductive layer are used to change optical properties of various types of liquid crystals in the adjacent layer. One system[197] uses currents produced by exposing a zinc sulfide photoconductor to induce a disorganization of nematic liquid crystals thereby producing scattering which is approximately proportional to the exposure. When the current stops, the scattering state relaxes, and the image disappears. This is known as the dynamic scattering mode and occurs at fields > 3kV/cm. Another system uses certain pleochroic dye molecules in nematic crystals.[197] These orient themselves strongly in the presence of an electric field. By selecting the dye molecules carefully, large optical densities and various colors can be achieved. These are sometimes called dichroic molecule devices.

Certain cholesteric liquid crystals are capable of existing in two major configurations called Grandjean and focal-conic textures. They can be changed from one to the other by electric fields. Both textures are made up of localized regions of helical-shaped scattering structures which resemble, to some extent, the scattering surfaces responsible for Bragg diffraction in ordinary crystals. However, in the Grandjean texture, the helical axes are normal to the layer surface while in the focal-conic configuration the axes are randomly arranged in the plane of the layer.[198] The Grandjean texture is transparent. However, the focal-conic texture is not because the random orientations of the optic axis of the transparent, microscopic helical structures causes light to be scattered. A texture change from Grandjean to focal-conic is brought about by the application of strong electric fields associated with the electrostatic latent image in the photoconductor.[199,200] Both textures are dynamically stable, thus the image remains up to several days after the field is removed. Erasure is accomplished by applying an ac electric field at frequencies in the audio range which restores the layer to its original form.

Ferro Electric Devices (Ferpics). Another device for storing graphic information, called a "ferpic" is being explored.[201,202] The development layer is a thin plate of ferroelectric ceramic materials such as titanate ceramic overcoated with a photoconductive film such as PVK.[203] Both are sandwiched between transparent electrodes with a voltage across them. The latent electrostatic image produces fields that control the birefringence of the ceramic. These are read out with polarized light. The images remain stored after the field is removed and may be erased by flooding with light in the presence of a reversed field; 25 μm resolution is claimed.[204]

Particle Orientation Devices. Small flakes of opaque graphite material imbedded in a thin, deformable thermoplastic development layer may also be used.[205] When heated under the influence of image-induced

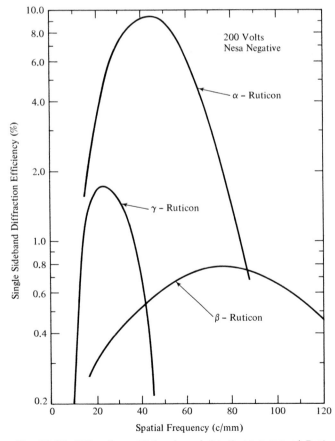

Fig. 13-38. Diffraction efficiencies of the three types of Ruticons.[195]

photoconductor fields, the graphite particles orient themselves with their long axis parallel to the field lines thus becoming transparent. This device modulates the intensity rather than the phase of the viewing light.

Other Configurations. *Pocket Effect Devices.* In these devices, a single layer of $ZnS^{206,207}$ or $Bi_{12}SiO_{20}^{3,208}$ crystals which combine a large coefficient of birefringent retardation and good photoconductive response is placed between two electrodes. It serves as both the photoreceptor and the development layer. A pattern of ultraviolet radiation causes photogenerated charges to traverse the layer and deposit on a blocking electrode. This decreases the voltage in the exposed areas, causing electric fields across the crystal thickness corresponding to the image pattern. These fields produce a linear (i.e., Pockels) electro-optic effect in which birefringence is induced along certain axes in the crystals. Polarized light is used for readout as with the ferpic. It is phase-modulated by the birefringent image and converted to an intensity display by a crossed polarizer. Red light may be used for a nondestructive read-out. Sensitivity on the order of 20 erg/cm^2 for a 2:1 change in readout intensity and high-contrast resolving power of 85 c/mm have been reported.[207] Diffraction efficiencies of $10^{-3}\%$ are reported for ZnS devices and $10^{-2}\%$ seems possible.[206] Image stability of over 100 hr has been observed.[207]

Photoelectrophoresis. Photoelectrophoresis is a special form of electrophoresis (described under liquid development) employing light-sensitive particles whose charge-exchange properties are altered by the absorption of radiant energy. It was described by V. Tulagin in 1968.[209] Many organic pigments when dispersed in a highly insulating liquid sandwiched between two electrodes and exposed simultaneously to the action of an electric field and radiant energy will move toward one of the electrodes (see Fig. 13-39).

In this figure, a suspension of pigment covers a transparent conductive electrode through which it is exposed. The exposed particles become conductive. The pigment particles will exchange charge with the electrode leaving the particles charged, in this case with a positive sign. The pigment particles are then repelled by the positive electrode and driven toward the negative electrode. Since the receiving electrode is covered by an

insulating blocking layer, further charge exchange is prevented, and the optically-exposed particles are held firmly in place. In this case, the negative electrode contains a negative image of the original, and the positive electrode shows a positive image. If a single organic pigment is used, monochromatic images can be formed with densities well in excess of 1.4 and resolution in some cases over 100 c/mm. A characteristic reflection curve which has been published shows a gamma of −2.0. If certain mixtures of pigment particles are used, a system uniquely suited to color reproduction is obtained. Exposure of this mixture to light of wavelengths restricted to the absorption band of just one type particle selectively removes that type of particle from the transparent conducting electrode in the presence of the field. If the absorption spectra of the various pigments are reasonably separated, the remaining particles will absorb primarily the wavelengths of light other than those corresponding to the exposure. Thus, for example, red light is absorbed by the cyan particles which are driven toward the negative electrode leaving behind yellow and magenta particles. If the yellow and magenta particles are transparent, white light passing through them will appear red, the color of the exposing light. In general, the color of the pigment mixture remaining after exposure and particle movement would be approximately the same as that of the exposing light. The well-known principles of subtractive color photography can be applied to this process even though the absorption bands are very broad. Materials have been found[209] which sufficiently meet the following requirements to establish laboratory feasibility: (1) for each pigment, the response to charge exchange at the injection electrode (+ in Fig. 13-39) must correspond to its main optical absorption band, (2) the pigment material must act both as a light-sensitive element and as an image-forming element, and (3) the components of a mixture consisting of several different pigments must act independently of each other.

Photographic Migration Imaging. In 1971, W. Goffe described a family of photographic, migration-imaging processes. These produce visible images by positioning particles imagewise in depth in a softenable layer.[210] Two basic structures were described, both of which involve photosensitive particles, a softenable layer containing the particles, and the base which supports the softenable layer. In one structure, the particles are arranged as a layer one or more particles deep; in the other, they are dispersed throughout the softenable layer. Imaging with many different particle and softenable layer materials has been demonstrated. The images are formed by a three-step process: (1) electrostatic charging, (2) imagewise exposure, and (3) development by decreasing the resistance of the softenable material to migration of the particles. Exposure produces a latent electrical image which results in selective particle charging. Development results in selective migration of the particles as a result of the selective forces from the photo-induced charge pattern.

One particular experimental type of microfilm has been described in the literature.[210,211] In this film (see Fig. 13-40), vacuum-deposited selenium particles averag-

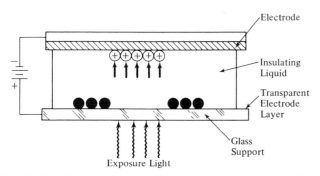

Fig. 13-39. Photoelectrophoresis—upon exposure to radiant energy in an electric field, conducting particles exchange charge and migrate to the opposite electrode.[209]

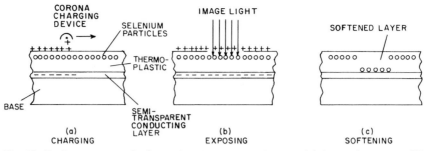

Fig. 13-40. Process steps for formation of a migration image with layered structure.[210]

ing ¼ μm in diameter are distributed in a near mono-layer at the top of the thermoplastic layer. The thermoplastic layer is about 1.5 μm thick. The base has a thin, semitransparent conducting layer such as vacuum-deposited aluminum. The processing steps include: corona charging to 80-200 V (negative or positive), image exposure from the thermoplastic or base side, and development either by heating (80–120° C for 1–30 sec), by exposing to a solvent vapor (room temperature for 1–30 sec) or by contacting with solvent liquid (room temperature 1–3 sec). Photographic characteristics for this film include: sensitivity to visible light equivalent to a mid exposure of 1 erg/cm² at 400 nm (fast enough for use in some cameras), spectral sensitivity resembling that of selenium (see Fig. 13-6), resolution in excess of 200 c/mm, a density above background of 2.0, and gamma varying from 1-3. The heat-developed images appear reddish orange in unmigrated areas while partially migrated particles are bluish. Thus, density differences are a function of viewing light wavelength. Heat- or vapor-developed images have a positive image sense with areas of partially migrated particles having more transparency than unmigrated. The liquid solvent method dissolves the upper layer of the dielectric, and, thereby, removes the unmigrated particles leaving a negative image.

Transfer of the Electrostatic Image (TESI) It is possible to move the source of the electrostatic latent image, that is the charge pattern on the photoreceptor, to another surface where it can be developed. This is known as a TESI process for *t*ransfer of the *e*lectrostatic *i*mage.[2,212] The receiving surface must be a good insulator such as Mylar,* polystyrene, polyethylene, or dielectric-coated papers. The receiver may be developed by one of the classical methods described earlier or even by a thermoplastic technique.[105]

There are a variety of procedures for transferring the electrostatic image. They may conveniently be divided[2] into two categories: (1) the electrostatic image is first formed on a photoconductor surface then transferred, usually across an air gap, to a dielectric, and (2) the electrostatic image is formed while the dielectric film is in contact with the electrophotographic plate.

A typical form of a TESI system[213] of the first type involves a substrate coated with a photoconductor such as selenium. This is corona-charged and exposed in the

normal manner, resulting in an imagewise surface charge pattern. A dielectric sheet, coated on one side with a conductive material (for example, aluminized Mylar), is brought into contact with the photoconductor bearing the charge pattern. A small but definite air gap exists between these layers under normal contact. A potential, typically 1000–2000 V, is applied between the two. The two surfaces are then mechanically separated. At a point during separation and just prior to air breakdown, an imagewise discharge current will flow across the air gap, creating a similar charge pattern on the dielectric. The conductive backing is then grounded, and the charge pattern is developed. Variations on this process include: corona charging of a dielectric receiver, filling the air gap with a liquid to increase resolution, and oppositely charging the dielectric side of the conductor-dielectric layer to produce a reversal, image-bearing negative charge where the photoconductor had been neutral. These and other techniques have been described in detail elsewhere along with considerable theoretical analysis.[2,212,214] In particular, attention has been given to the mechanism of charge transfer across the air gap which involves air breakdown phenomena based on a modified Paschen curve[214] and the electrostatics pertaining to such situations.

Processes based upon TESI techniques have sensitivities controlled by the characteristics of the particular photoconductor employed with selenium results having been commonly reported in the literature. The electrostatic contrast in the transferred image, that is, the maximum difference in voltage between exposed and unexposed portions of the original pattern, is seen to be a function of applied voltage. The form of this relationship depends on the detailed nature of the materials and methods used. Peeling techniques where the applied voltage is maintained during separation have a peak in electrostatic contrast as a function of applied voltage while pressure techniques where the voltage is removed prior to separation merely show a fall-off at higher applied fields. Resolution of fine-toner-developed images using the peeling technique was found to be 33 c/mm at best; pressure techniques produced a maximum of 90 c/mm. One of the obvious advantages of TESI techniques is that the development does not interact directly with the photoconductor, thus avoiding abuse of the photoconductor. Constraints on the development system are also relaxed, for example, eliminating worry over: light leaks, chemical and electrostatic compatibility with

*Trademark: E. I. DuPont Company.

the photoconductor, and dirt contamination in certain parts of systems.

Using a variation on the TESI process, it has been theoretically shown[215] that photoconductive gains greater than unity can be expected if an external bias voltage is created during exposure between a photoconductor on a conducting substrate and a thin insulating film also on a conductive substrate and in initimate contact with the photoconductor. This is accomplished by the second conductor injecting carriers into the photoconductor. However, experiments have failed to show such photoconductive gains.

Persistent Internal Polarization (Photoelectrets).

Persistent internal polarization (PIP) involves the polarization or separation of charge carriers in a photoconductor, wax, or plastic by the simultaneous or sequential application of electric fields and optical radiation. A photoelectret[216] is the name often given to devices that create such permanently polarized images by trapping separated, photogenerated charges in the bulk in the presence of an electric field. This process has been extensively explored in the literature.[119,216-223]

Typically, the process works as follows. An image is projected through a transparent electrode onto a photoconductor sandwiched between two electrodes with a voltage across the electrodes. This separates the photogenerated charges which are eventually trapped; the material characteristics govern trapping. The light and the applied voltage are both turned off, and both electrodes are grounded. One electrode is removed to permit powder development of the photoconductor. The powder image is transferred to a substrate and fixed. The photoconductor is then cleaned and made ready for reuse by replacing the electrode and depolarizing with an infrared exposure. Many variations on this process have been described, for example, using various sequences of applied exposure and applied voltages, or using uniform polarizing exposures followed by imagewise depolarizing exposures.

Photoconductive materials suitable for PIP effects include anthracene dispersed in dielectric resins,[219] sodium chloride, potassium chloride and silver chloride,[220] and ZnS-CdS in a silicone resin,[221] CdS, and SeTe,[222] and even certain forms of vapor-deposited selenium.[223] In general, sensitivity to light is extremely low, but 0.05 to 0.1 lux-sec has been sufficient exposure for a particular SeTe PIP process.[222] Very high resistivity is usually required of the material along with possession of photoconductive properties. A material having a high density of electron and hole traps is also needed.

Other Processes. There are numerous variations on the above processes as well as many completely different processes, each of which uses electrical fields and electrophotographic latent images. We are limited here by space to a simple listing of a few of these which have been cited in the literature. These include: light fatigue effects, also known as persistent conductivity processes;[2,4,224,225,65] imagewise heating of a charged plastic layer, called electrothermography;[2,4,226,227] exposing n-type photoconductors to obtain weak separation of

charges without an initial charging step, known as chargeless electrophotography;[4,228-230] and chemography, which involves an irreversible photochemical decomposition resulting in a persistent conductivity pattern.[231] Others are: photoelectrolytic systems wherein a photocurrent created in a photoconductor initiates polymer formation in an image recording layer;[73] electrolytic or electrocatalytic photography systems employing electrolysis between a photoconductor and a lueco dye in an electrolyte;[2,77,232] and electrochromics involving color-center formation in the presence of a field.[233] Also of some note[2] are the following: Berchtold's Process,[234] the Jacobs-Frerich's process,[235] the General Dynamics Process,[236] and the smoke printer, or Photronic Reproducer.[237]

TONE REPRODUCTION, IMAGE STRUCTURE, AND IMAGE QUALITY IN ELECTROPHOTOGRAPHY

Electrophotographic systems as a group produce images with a large variety of characteristics. Negative or positive continuous-tone reproduction with adjustable contrast[238] or high-contrast line copying are possible, as are color systems,[2,292] phase imaging, microfilm, and reusable materials with eraseable images. It is even possible to create halftone images in the conventional sense by contact-printing halftone positives[142] or by an equal-dot-area scheme.[255] A resolution of 1000 c/mm for thermoplastic materials[184] and for liquid development of selenium[240] and 120 c/mm for magnetic brush development of ZnO coated papers[241] have been reported. A normal resolution range for cascade development of selenium is 10–15 c/mm, while powder cloud development yields 140–200 c/mm.[156] Some specific characteristics of unconventional processes and descriptions of the processes have been given, so we shall concentrate on the classical systems here.

It is traditional in the photographic literature to discuss the subject of tone reproduction separately from that of image structure. While the two are more noticeably linked together in many electrophotographic systems, especially in line copying applications, we shall attempt both to preserve the distinction here and to point out the limitation of this approach.

Tone Reproduction

Two types of electrophotographic tone reproduction nomographs have appeared in the literature: one is for "absolute" development[238,242] where a close-spaced electrode is used; the other is for "differential" development[143] where no electrode is used. The two types of nomograph can be combined in a single series of functions but using different graphical methods of cascading for the two basic development types. Such a tone-reproduction cycle is shown in Fig. 13-41 for a hypothetical, yet typical, situation. A third type of development exists; it involves a far-spaced electrode.

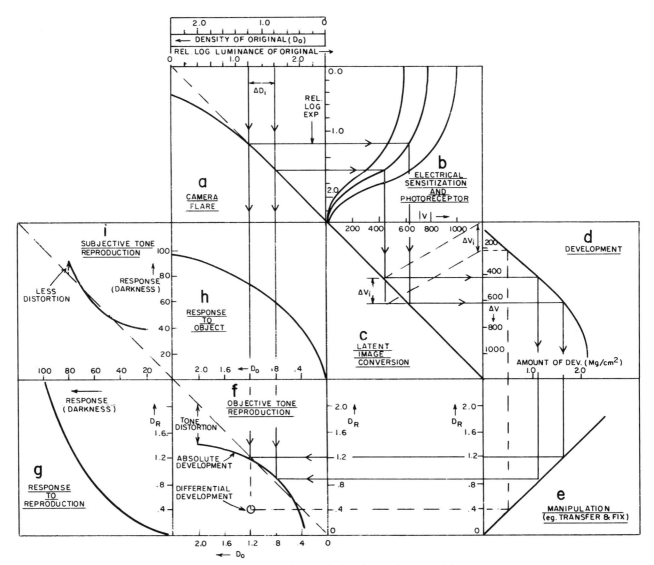

Fig. 13-41. Tone reproduction cycle for electrophotographic systems.

This may be considered as a combination of the two cases above, so it will be called a "hybrid" here.

The method for quantitatively combining the two basic cases has not been investigated; however, the single nomograph will help make the concepts involved more evident. In Box a of Fig. 13-41, the flare curve for the camera system is shown connecting the original object radiance axis at the top with the photoreceptor exposure axis on the right. It is the same as that employed in regular photography.[243]

It should be noted, however, that the flare characteristics will vary with the type of object intensity distribution. It is worse when there is an abundance of high intensity regions as with white paper with writing or typing on it.[243] It is also important to recognize that the size of the object governs, to some extent, the position on the log-exposure axis as a result of the MTF (Modulation Transfer Function) of the intervening components.

Box b shows the photoreceptor surface voltage, V, as a function of exposure for typical photoreceptors. For

selenium, this follows the approximate relationship:[238]

$$V = (V_0^{1/2} - kE)^2 \qquad (20)$$

where

V_0 = the initial photoreceptor potential,
E = the exposure, and
k = a constant.

This may be simply derived from Eq. 6b. The relationship for other photoreceptor materials may also be found in the literature.[23] The sensitizing element in our model controls V_0, thus the contrast of the reproduction[238] while k is a property of the photoreceptor. Other examples of photoreceptor characteristic curves are given in Fig. 13-5 and spectral sensitivity data are given in Fig. 13-6.

Box c is the key to the multipurpose, tone-reproduction nomograph. At this point, we must consider which type of development process is of concern. If the system employs a grounded, close-spaced electrode, a 45° transfer curve is used as shown. In this case, the photo-

receptor absolute voltage $|V|$ is transferred unmodified to the development absolute voltage $|V_0|$. This is shown by the solid lines in Box c. If the electrode is biased, the transfer curve is translated left or right until it intersects the photoreceptor voltage axis at the bias voltage. This will cause the development system to "see" zero voltage when the absolute photoreceptor voltage is equal to the bias voltage. All other voltages will be shifted accordingly.

If the system does not employ an electrode, development at any one point will be a function of the difference in voltage between that point and nearby points. In line copy applications, for example, it has been found[143] that one can predict development reliably using the voltage difference between the characters and the background. To use the latent image conversion curve for differential development of such images, one may use the technique shown by the dashed lines in Box c. The photoreceptor voltage difference is projected onto a vertical line, and, then, two parallel lines are drawn to the development voltage axis, making sure that the smaller valued voltage line passes through zero development volts ($V_D = 0$). The larger development voltage will then represent the voltage difference. This is the voltage which accounts for the field that drives the development. It will be noted that, if the background is uniform, all the darker portions of the original will produce voltage differences measured against a common reference and, thereby, will maintain their relationship to each other. A unique tonal rendition is thereby achieved. If, however, the background voltages vary, there will be no unique tone reproduction. Also note that exposure shifts which move absolute development voltages up and down may not significantly alter differential development voltages so long as the slope of the photoreceptor curve generating the voltage difference does not change. This is the same effect discussed earlier in connection with photoreceptor latitude and Fig. 13-7.

Development is often characterized (see Figs. 13-27, 13-29, and 13-31) as the relationship between the development potential, V_D, and the density of the fixed output copy. While this approach has merit, more insight is obtained by breaking this aspect of the process into component steps, such as development at the photoreceptor, transfer if applicable, fixing, etc. The component step shown in Box d consists of depositing some amount of toner in proportion to development potential. As discussed earlier, this is a function of many variables. Density on the photoreceptor or mass of toner per unit area are typical development units.

Box e represents the effect of distortions introduced when developed image material is manipulated to get it to the observer. For example, in many cases it must be transferred to the final support, and it is fixed in all cases. Special viewing optics are sometimes required. The manipulation process alters, sometimes only slightly, sometimes significantly, the optical properties of the initially developed images. The toner transfer characteristics shown in Fig. 13-33 are examples of a typical small change introduced at this point. In Fig. 13-41, no distortion was used, hence the straight line at 45° slope.

Box f is the so-called objective tone reproduction curve in which the abscissa from Box a and the ordinate from Box e have been extended to give a plot of density (or log luminance) of the original against density of its reproduction. (The straight, diagonal line represents an exact reproduction.) Again, it should be noted that such a single tone-reproduction curve is only valid for absolute development or differential development wherein all original density differences are related to a common surrounding density. It is not unique for unrestricted differential development or for hybrid systems where the differential aspect dominates. It is also generally restricted to a specific width of line—as will be discussed later.

Examples of objective, tone-reproduction curves are shown in Fig. 13-42a for magnetic-brush-developed zinc oxide paper and in 13-42b for transferred images from electroded-aerosol-developed selenium plates. Both are examples of absolute development systems. The zinc oxide curves show normal development for curve A. The effect of subsequently brushing three times with carriers of different mesh sizes is shown in curves B, C and

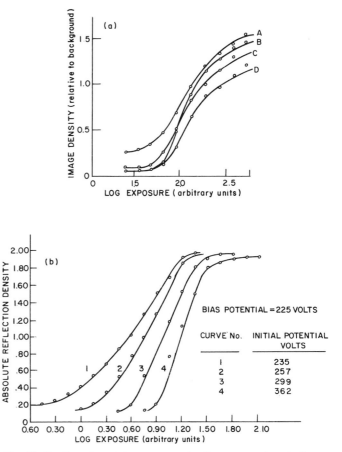

Fig. 13-42. Experimental tone reproduction curves for a) zinc oxide binder paper developed by normal brush (A) and by subsequent brushing with various carriers (B, C and D) and for (Ref. 142) b) transferred images from an aerosol developed selenium place using contact exposures to a photographic step table (Ref. 155). The initial potentials were arbitrarily chosen to approximate photographic enlarging paper characteristics.

D—note that the minimum density is decreased. The aerosol curves show the effect on the D log E curve slope of changing the initial charging potential.

As described elsewhere,[243] for conventional photography, the objective, tone-reproduction curve must be examined in regard to its interaction with the visual system. In conventional photography, the subjective tone-reproduction cycle is normally used for this purpose and may be used here. Since the classical application of electrophotography is 1:1 copying of reflection documents, the visual process will operate in exactly the same manner when viewing both the original and the reproduction. Note that the original and the copy may be, and frequently are, held side-by-side for comparison. The nature of the visual process for viewing sharp, narrow, dark lines on a large white field is somewhat different from that encountered in viewing a continuous-tone pictorial scene or its reproduction. Here, therefore, while a subjective-response description is somewhat simplified, since the same response applies to viewing both the copy and the original, the result is somewhat uncertain since the exact nature of this response is not known for the typical line subject matter. To this author's knowledge, no work has been published discussing details of the subjective, tone reproduction of line originals. The curve used in Box g for the response to the reproduction and the Box h for the response to the original are from unpublished work by Malone.[244] Using subjective evaluation of the darkness of a line as a criterion, Malone studied the response of observers to a matrix of ¼ mm by 2-½ mm, straight, sharp-edged lines made of fused toner on white paper. These results should not be thought of as rigorously accurate or perfectly general but as indicative of the shape of the curve of subjective response to line-copy. What is important to observe here is that, even though the objective tone reproduction curve departs considerably from an exact reproduction, and, even though the reproduction itself may be compared side-by-side with the original, the subjective response tends to minimize the distortions in the high density region. There are, of course, other applications of electrophotography and, therefore, other types of subjective responses and subjective tone reproduction cycles. Some of these may well follow the details of the subjective tone reproduction found in the literature on conventional pictorial photography.

Effect of Line Width

It is well known[143] that the width of a line has a significant effect on the electrophotographic reproduction of its original density. Figure 13-43 shows, in a general way, how the reproduced density varies with original line width for cascade-developed images. For the densities in Fig. 13-43 measured at the center of the line, the density increases to a peak. The line width at which peak density occurs may vary from 0.007 to 0.075 in.[143] depending on which commercially available toners, processing equipment, and techniques are used. The density

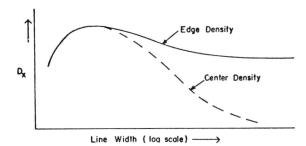

Fig. 13-43. Developed density as a function of original line width.[143]

at the center of the line then decreases with increasing width, eventually reaching zero density. However, the density at the edge of a line decreases only a small amount and then maintains a fairly constant level as the line width increases. This is characteristic of differential development. It is largely attributed to the latent image electrostatic fields, the predevelopment configuration of which was discussed earlier; for example see Fig. 13-17b.

Electrophotographic Modulation Transfer Functions

Jones' original concept of a tone reproduction nomograph[243] was directed toward large area measurements. It has been shown, in certain cases, to work reasonably well for differential development of lines of a fixed width. However, density of fine detail in the output of cascaded images of lines of different widths cannot be predicted in this manner. To solve this problem for conventional photography, linear systems theory and the concepts of optical and modulation transfer functions have been used extensively.

There has been some discussion in the literature of applying these concepts to electrophotography.[130,245,246] Such techniques depend on whether the system to which they are applied is either linear or can be readily linearized by a numerical or analytical method. In conventional photography, the major nonlinearities are the broad-area sensitometric response and the chemical adjacency effects, both of which can be linearized.[247,248] The spreading produced in the photographic image is considered to be the light scatter in the emulsion which can be cascaded with the optical spreading in all previous elements of a photo-optical system.

In electrophotography, light scattering in photoreceptors is not generally considered as a degradation in the microstructure of the image. Certain photoconductor/binder layers are a possible, although undocumented, exception. Instead, development and the associated electrostatic latent image are considered to be the primary degrading factors. While it is possible that photogenerated charges may spread laterally (parallel to the photoreceptor surface), the high normal-fields associated with the charge tend to minimize this. Consequently, it is usually neglected in the literature on electrophotographic MTF. Details of the lateral spreading of charge have been treated theoretically elsewhere[249]

The major nonlinearities in electrophotography are the photodischarge curve (see Eqs. (6a) and (6b)), the adjacency effect in the initial electrostatic field (see section on electrostatic latent image page 348), and certain factors in development including trajectory effects and the change in the fields with development.[245]

No rigorous attempt has been made to handle these nonlinearities in describing an electrophotographic/ xerographic MTF other than to calculate the adjacency effect from the initial field patterns[130,246] and to point out that absolute development systems can be approximately linearized by correcting for the large-area voltage versus development curves.[245,246] In these systems, a unique continuous relationship exists between the normal-field component and the developed density. In hybrid and differential development systems, the relationship is neither unique nor continuous.

It was demonstrated earlier that the latent image electric fields associated with this charge distribution are very much dependent on the form of distribution and on the configuration of both the development system and the photoreceptor. In fact, data such as those plotted in Figs. 13-19a and 13-19b have been considered as a describing function analogous to an MTF for the electrostatic latent image element in the system. Neugebauer[130] has derived a series of such curves for the nonelectroded differential development case. Neugebauer's describing function C_N is plotted against spatial frequency in c/mm in Fig. 13-44 for various photoconductor thicknesses, L and for different observation heights, Y. θ is the ratio of Y/L. Also shown by the dashed line is his calculated curve for a 25 μm-thick photoconductor, a 50 μm electrode spacing, an observation height of 0.25 μm and a

field of 10 V/ m. The effects of bulk charge trapping are included in this example.

Figure 13-44 curves a–f show that there is no response at low spatial frequencies when no development electrode is present. In fact, the increasing portion of these curves is much like a differential operator in frequency space, hence the name, differential development. The spread function* in distance space corresponding to these curves shows a narrow central core surrounded by a very large region of small field with a sign opposite to that of the central core. These negative, side-lobes balance the central core thus yielding zero low frequency response while producing strong fields for objects whose size approaches the core diameter. This also has the effect of emphasizing edges to a much greater extent than classical photographic adjacency effects. Figures 13-16b and 13-17b illustrate this. As seen in Figs. 13-19a and 13-19b, a development electrode spaced at exactly the photoconductor thickness above the photoconductor surface produces at the photoconductor surface a constant initial latent image MFT at all frequencies. When the electrode is spaced at some greater distance, a hybrid latent image MTF is obtained as in the dashed line in Fig. 13-44. It has a finite value at low frequencies and then rises above this before diminishing. In this case, the side lobes on the spread function are still negative but do not offset the effect of the central core. Such a process exhibits adjacency effects as well, but they are not as pronounced. Before turning to the development process, we should note that the exposure pattern is approximately related by the nonlinear Eq. (6) to the voltage which produces these fields. If, however, the exposure differences in the sinusoidal exposure components of an input image are relatively small, producing no more than 50% discharge, this relationship is approximately linear, and one may, with reasonable validity, cascade the optical image MTF with the electrostatic latent image to obtain an overall system response. Beyond this discharge, the V to E curve becomes less linear, and the MTF's become appropriately invalid.

It is the development stage in the process which causes the most difficulty in terms of linear systems analysis. For the close-spaced electrode, it can be shown that the developed density is directly proportional to the normal-field component.[242,245,246] Since there are no negative side-lobes on the spread function, there will be no negative fields present in the image. This means that a sinusoidal charge distribution will map directly to a sinusoidal field distribution and then to a sinusoidal density distribution. This last step is highly nonlinear, although easily and uniquely cascadeable mathematically. For differential development, a common application is line-copy imaging. In this case, the latent image comes from narrow, charged lines on broad, discharged areas. Convolving the differential-development, latent-image spread function containing negative side-lobes with the image distribution will result in a pattern containing a large percentage of negative fields.

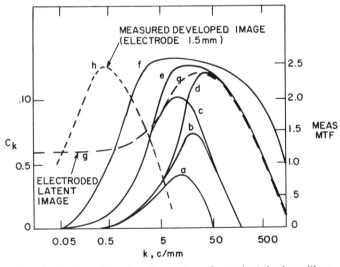

Fig. 13-44. Describing function values C_k against the logarithm of spatial frequency for different plate thicknesses L in microns, and observation heights y in microns where $\theta = y/L$: (a) $\theta = 1$, L = 7.5, y = 7.5; (b) $\theta = 0.3$, L = 7.5, y = 2.5; (c) $\theta = 0.1$, L = 25, y = 2.5; (d) $\theta = 0.03$, L = 7.5, y = 0.25; (e) $\theta = 0.01$, L = 25, Y = 0.25; (f) $\theta = 0.001$, L = 100, y = 0.1 (Ref. 246). Dashed line (g) is C_k for an electrode at 50μ, $\theta = 0.01$, L = 25, y = 0.25. Dotted line (h) is Roetling's measurement (Ref. 245) of the modulation transfer function of electroded cascade development.

*See Chapter 9 for definitions of spread function and MFT.

These actually repel the developer. This is an obviously nonlinear situation and cannot be simply handled in a frequency space cascade.[245] It is, therefore, necessary to obtain the field distribution for the image and convert it point-by-point to density by the appropriate development curve, setting the negative fields equal to zero density. As we have seen earlier, nonelectroded cascade development is a highly complex event involving airborne development following non-normal field components and requiring mechanical collision forces. Furthermore, developer trajectory effects are involved.[246] It is, therefore, unlikely that normal initial field models can do much more than give a qualitative feel for possible structural trends in cascaded, differential development. A similar problem exists for hybrid systems, although it is not as serious since many applications involve reproducing detail in nonwhite areas such that negative toner repelling fields need not be present.

To date, only one report of experimental measurements of an electrophotographic MTF have been published. These were performed by Paul Roetling at Xerox and described by A. Montgomery.[245] Roetling used an edge gradient technique to obtain the result shown as the dotted line in Fig. 13-44. The images were made with a selenium, flat plate camera, Xerox 914 toner, granular cascade development, and an electrode spaced 1.5 mm above the plate. This development system would come under the heading of a hybrid system using a distant electrode. The curve peaks at 0.5 c/mm and is in obvious disagreement with the electrostatic latent image theory. Similar results were obtained with sine wave exposures. This gives rise to speculation about additional spreading in the development system from trajectory effects and from other mechanisms and in the transfer and fuser systems.

It is easily seen that development is a dynamic process wherein the initial deposition of toner alters the field pattern seen by future toner particles while toner-free carriers may scavenge already deposited toner. Thus, the question of the spread functions associated with the development and manipulation steps are important, and, as yet, have not been studied except for some work by Thourson and Sullivan on cascade development[150] mentioned earlier.

It must be noted that while the adjacency effect may be undesirable for some applications it is of significant value in line copying because it creates sharper letters by surrounding each character with a border that repels toner; it also increases the exposure latitude.

Noise in Electrophotography

Noise in electrophotographic images may be treated somewhat as granularity in conventional photography is treated except that the particle sizes in electrophotography are much larger. However, this has not been widely pursued in the literature except for a few special cases. Urbach[184] and Heurtley[250] have considered the case of noise in thermoplastics using various spatial frequency descriptions while Neugebauer[251] has shown theoretically that a classic visible xerographic record can be considered as an example of modulated noise carrier. Schmidlin[252] has investigated the effects of noise sources on the ultimate sensitivity of model electrophotographic systems. He shows that the inherent noisiness of toner-type adhesion severely limits photographic sensitivity in certain idealized processes. It should be mentioned that line-copy applications of electrophotography are very sensitive to one form of noise, namely, the appearance of background. Background is a phenomena characterized as the random deposition of toner particles in regions which are thought to be completely and uniformly photodischarged. Line-copy applications reveal this form of noise because of the large percentage of photodischarged regions corresponding to the white paper parts of the original.

Microstructure of Electrophotographic Images

Photomicrographs of two cascade developed unelectroded line and edge images (b and c) and a cascade-developed distant-electrode transfer image (d) are shown in Fig. 13-45, along with the original printed line and edge objects (a). The original objects were both the same density, $D(5°; 2800° K:45° \pm 5°,$ Visual$) = 0.78$. The photomicrographs were made using 53–77° annular illumination and 5° collection angles and identical exposures. All toner images were made with commercial copying machines in good adjustment. They were transferred to ordinary paper and fused according to normal practice.

These photomicrographs show several interesting features. First, note that the images are composed of glossy fused toner particles situated on a diffuse paper substrate. The specular highlights on the toner are particularly noticeable in Fig. 13-45b. Second, note that the edges are ragged with no intermediate densities. Thus, even though microdensitometer traces or human vision may show a gradual change in density at the edge, this is only true because both tend to integrate over many particles. Also note that the individual toner particles tend to bunch up forming conglomerations or clusters. These photomicrographs all illustrate the presence of the edge effect, or adjacency effect mentioned earlier; however, they show it in varying degrees, with the hybrid system (d) showing less edge effect and more solid area response. The density enhancement of these copies is also apparent especially in the line images on the left.

Fundamental image evaluation research on xerography has begun to appear in the literature as this book goes to press. For example, Shaw[257] has shown samples of screened laboratory xerography give a peak signal to noise ratio of .005 Noise Equivalent Quanta (NEQ)/μm^2 as compared to 0.2 to 0.9 NEQ/μm^2 for conventional photography. Others[258] working on selected cases of magnetic brush development have reported MTF's of 4.0 at peaks near 2 c/mm and granularities in excess of 1000 $m^2 D^2$ at densities of 1.0.

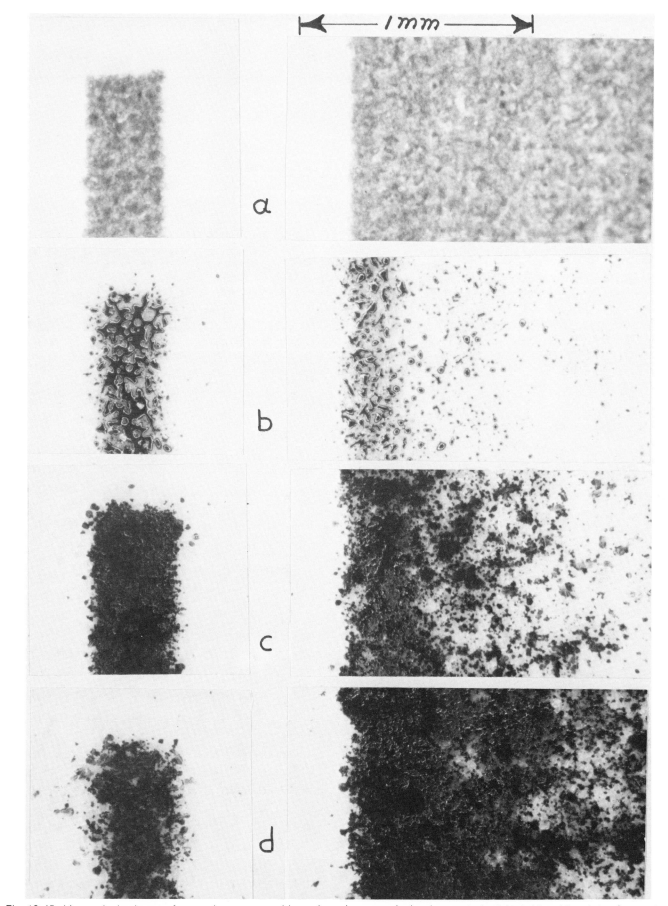

Fig. 13-45. Line and edge images from various xerographic copies using cascade development: a) original object, b) and c) are examples of different forms of nonelectroded copier images and d) is an example of an electrode developed image.

Image Quality

While it is possible to measure a variety of specific objective quantities such as resolving power and tone reproduction for electrophotographic imaging systems, Malone[253] has demonstrated a measurement method for the overall evaluation of xerographic line copy which has a correlation coefficient of 0.98 with subjective impressions of quality.[245] This work makes use of a reflection microdensitometer slit scan along the length of the image of an artesian letter *i*. The slit is oriented perpendicular to the scan line (and the major axis of the *i*) and is somewhat wider than the *i*. Principle component analysis of this microdensitometer scan yielded five principle components (shape factors) which when combined with the appropriate weights and statistical estimate of background fluctuations give a quality equation which is able to predict the subjective quality of line copy. Since the shape factors have no identifiable physical significance, Malone was able to predict image quality without the need for understanding what it is in the complex process of electrophotography that was primarily responsible for the perceived quality.

REFERENCES

1. Dessauer and Clark, *Xerography and Related Processes*, Focal, London, 1965.
2. R. M. Schaffert, *Electrophotography*, Focal, London, 1965.
3. A. G. Tweet, *Proc. SPSE Symp. III on Unconventional Photographic Systems*, Washington, D.C. (1971) p. 16.
4. C. J. Claus, *Image Technology*, pp. 12–29 (Feb/Mar 1969), pp. 29–34 (Apr/May 1969), pp. 16–30 (June/July 1969).
5. C. J. Claus, *Photogr. Sci. and Eng.*, 7: 6 (1963).
6. G. C. Lichtenberg, *Novi Comment*, Gottingen 8: 168 (1777).
7. Encyclopedia Brittanica, (Edinburgh, 1842), 8, 661.
8. Dessauer and Clark, (Ref. 1) op. cit. (C. F. Carlson, Chapt. 1).
9. P. Selenyi, *Wireless Engineer*, 15: 303 (1938).
10. P. Selenyi, *Z. Tech. Phys.*, 16: 607 (1935).
11. Gabritschewsky, *Z. Phys.*, 2: 33 (1905).
12. A. Dinsdale, *Photogr. Sci. and Eng.*, 7: 1 (1963).
13. C. F. Carlson, U.S. Patent 2,297,611 (Oct 6, 1942), Electrophotography. U.S. Patent 2,357,809 (Sept 12, 1944), Electrophotographic Apparatus.
14. Annon., *Photogr. Sci. and Eng.*, 12: 273 (1968).
15. R. M. Schaffert and C. D. Oughton, *J. Opt. Soc. Amer.*, 38: 991 (1948).
16. W. E. Bixby and A. U. Ullrich, Jr., U.S. Patent 2,753,278 (July 3, 1956; to the Haloid Company), "Method for the Production of a Xerographic Plate."
 W. E. Bixby, U.S. Patent 2,970,906, (Feb 7, 1961; to Haloid Xerox, Inc.), "Xerographic Plate and a Process of Copy Making."
17. C. F. Carlson, U.S. Patent 2,588,699 (Mar 11, 1952), "Electrophotographic Apparatus."
18. (a) E. N. Wise, U.S. Patent 2,618,552 (Nov 18, 1952; to Battelle Development Corp.), "Development of Electrophotographic Images."
 (b) L. E. Walkup, U.S. Patent 2,618,551 (Nov 18, 1952; to the Haloid Company), "Developer for Electrostatic Images."
 (c) L. E. Walkup and E. N. Wise, U.S. Patent 2,638,416 (May 12, 1953; to Battelle Development Corp.), "Developer Composition for Developing an Electrostatic Latent Image."
19. E. Wainer, *Photogr. Eng.*, 3: 12 (1952).
20. R. M. Schaffert, U.S. Patent 2,576,047 (1951; to Battelle Development Corp.) "Method and Apparatus for Printing Electrically." Middleton and Reynolds, U.S. Patent, 3,121,006 (1964; to Xerox Corp.).
21. C. J. Young and H. G. Greig, *RCA Rev.*, 15: 469 (1954).
22. M. D. Tabak, *Proc. SPSE Symp. III on Unconventional Photographic Systems*, Washington, D.C. (1971) p. 27.
23. I. Chen, J. Mort and M. D. Tabak, *Trans. IEEE, Electron Devices*, ED-19, pp. 413–421 (1972).
24. M. D. Tabak and P. J. Warter, *Phys. Rev.*, 173: 899 (1968).
25. M. D. Pai and S. W. Ing, *Phys. Rev.*, 173: 729 (1968).
26. M. E. Scharfe, *Phys. Rev. B*, 2: 5025–5034 (1970).
27. J. Mort and A. I. Lakatos, *J. Noncryst. Solids*, 4: 117–131 (1970).
28. D. M. Pai, *J. Chem. Phys.*, 52: 2285–2291 (1970).
29. R. M. Schaffert, *IBM J. Res. Develop.*, 15: 75 (1971).
30. L. F. Sherw, *Photogr. Sci. and Eng.*, 8: 282 (1964).
31. R. M. Schaffert, *Method of R. E. McCurry Reported in Electrophotography* Focal, London, 1965, p. 180.
32. R. B. Comizzoli, *Photogr. Sci. and Eng.*, 14: 1, 210 (1970).
33. K. Morimoto and Y. Murakami, *Appl. Opt.*, Supplement 3, p. 50 (1969).
34. Dessauer and Clark, (Ref. 1) op. cit., (C. F. Carlson, Chapt. 1.)
35. M. A. Gilleo, *J. Chem. Phys.*, 19; 1291 (1951).
36. J. L. Hartke and P. J. Regensburger, *Phys. Rev.*, 139: A970 (1965).
37. K. J. Siemsen and E. W. Fenton, *Phys. Rev.*, 161: 632 (1967).
38. W. E. Spear, *Proc. Phys. Soc.*, London B70: 669 (1957); B76: 826 (1960).
39. R. A. Fotland, *J. Appl. Phys.*, 31: 1558 (1960).
40. J. L. Hartke, *Phys. Rev.*, 125: 1177 (1962).
41. H. T. Li and P. J. Regensburger, *J. Appl. Phys.*, 34: 1730 (1963).
42. R. M. Blakney and H. P. Grunwald, *Phys. Rev.*, 159: 664 (1967).
43. M. D. Tabak, *Trans. AIME*, 239: 330 (1967).
44. M. D. Tabak, *Appl. Opt.*, Supplement 2, p. 4 (1969).
45. Schaffert, (Ref. 2) op. cit., pp. 203–234, 265–285.
46. Schaffert and Oughton, (Ref. 15) op. cit.
47. Dessauer and Clark, (Ref. 1) op. cit., E. M. Pell, pp. 65–88, W. D. Hope and M. Levy, pp. 89–117.
48. Tabak (Ref. 22) op. cit.
49. J. W. Weigl, address presented at 3rd International Conf. on Photosensitization in Solids (to be published), Sorlat, 1971.
50. Schaffert, (Ref. 2) op. cit., p. 261.
51. H. W. Albrecht, P. G. Andrus, et al., Interim Progress Report (Aug 1950, Dec 1951) pp. 22–36, Battelle Memorial Institute Contract No. DA36-039 sc.-123, (AT1176932).
52. J. H. Neyhart, *Photogr. Sci. and Eng.*, 10: 26 (1966).
53. W. E. Bixby and P. G. Andrus, Tenth and Final Progress Report (Dec 1952) pp. 18–25, also Fourth and Final Progress Report (Jan. 1954) pp. 5–25 Battelle Memorial Institute, Signal Corps Contract Nos. DA36-039 sc 123 and DA36-039 sc-42612 (AD Nos 14092 and 28276).
54. V. M. Fridkin, Yu.N. Barulin Fizika Tverdogo Tela 4: 2978 (1962); English Translation in *Soviet Phys.-Solid State*, 4: 2183 (1963).
55. S. G. Gernishim and I. A. Aerkasov, Zh. *Nauchn. i. Prikl. Fotogr. i Kinematogr.*, 5: 433 (1960) in Russian, 7: 123 (1962).
56. Keck, *J. Opt. Soc. Amer.*, 42; 221 (1952).
57. Fotland, (Ref. 39) op. cit.
58. E. J. Felty, In Reprographic II, *Ber. Intern. Kongr. Reprogr.*, 2nd Cologne, p. 40, (1967).
59. M. P. Trubisky and H. H. Neyhart, *Appl. Opt.* Supplement 3, p. 59 (1969).
60. R. M. Schaffert, U.S. Patent 2,863,786 (filed 1955, issued 1958; to Haloid-Xerox Corp.)
61. R. M. Schaffert and J. F. Hansen, U.S. Patent 2,901,349 (filed 1957, issued 1959; to Xerox Corp.)
62. J. C. Schottmiller, D. L. Bowman and C. Wood, *J. Appl. Phys.* 39: 1663–1669 (1968).
63. K. Hauffe and R. Strechemesser, *Photogr. Sci. and Eng.*, 11: 145 (1967).
64. S. Namba and Y. Hishiki, *J. Phys. Chem.*, 69: 774 (1965).
65. J. A. Amick, *RCA Rev.*, 20: 753,770 (1959).
66. R. B. Comizzoli and D. A. Ross, *Photogr. Sci. and Eng.*, 13: 265 (1969).
67. K. Hauffe, V. Martinez, H. Pusch, J. Range, R. Schmidt and R. Slechemesser, *Appl. Opt.*, Supplement 3, p. 35 (1969).
68. S. Kikucki, Y. Takakashi, and T. Sakata, *Appl. Opt.*, Supplement 3, p. 43 (1969).
69. S. Larach and J. Turkevich, *Appl. Opt.*, Supplement 3, p. 45 (1969).
70. D. G. Brubaker, *Tappi*, 46, 312 (1963).

71. C. J. Claus, (Ref. 4) op. cit. (Feb/Mar 1969, p. 16); see also Refs. 1, 21.
72. R. B. Comizzoli, *J. Appl. Phys.*, **41:** 4148 (1970).
73. M. C. Zerner, J. F. Sobreski and H. A. Hodes, *Photogr. Sci. and Eng.*, **13:** 184 (1969).
74. Dessauer and Clark, (Ref. 1) op. cit. (C. Wood, Chapt. 5).
75. M. Smith and A. Behringer, *J. Appl. Phys.* **36:** 3475–82 (1965).
76. Aftergut, Bartfai and Wagner, *Appl. Opt.*, Supplement 3, p. 161 (1960).
77. R. D. Weiss, *Photogr. Sci. and Eng.*, **11:** 287 (1967).
78. D. W. Chapman and F. J. Stryker, *Photogr. Sci. and Eng.*, **11:** 22 (1967).
 A. E. Middleton and D. C. Reynolds, U.S. Patent 3,121,006 (1964), 3,121,007 (1964) (to Xerox Corporation).
79. W. Van Dorn and O. Ullrich, U.S. Patent 2,937,944 (1957; 1960).
80. Schaffert, (Ref. 2) op. cit. (p. 261).
81. Schaffert, (Ref. 2) op. cit. (p. 262).
82. T. Lida, S. Nozisi, Y. Mori and H. Nozaki, Denshi Shashin (*Electrophotography*) **6:** 22 (1965).
83. H. Nozaki and T. Lido, *Ber. Intern. Kongr. Reprogr. 2nd Cologne*, 1967, p. 63.
83a. S. W. Ing, J. H. Neyhart and F. Schmidlin, *J. Appl. Phys.* **42:** 696 (1971).
84. W. J. Wagner and E. L. Gasner, *Photogr. Sci. and Eng.*, **14:** 205 (1970).
85. C. A. Quenner, *Photogr. Sci. and Eng.*, **15:** 423 (1971).
86. J. J. Bartfai, V. Ozarow and J. Gaynor, *Photogr. Sci. and Eng.*, **10:** 60 (1966).
87. P. Day and R. J. P. Nillians, *J. Chem. Phys.*, **37:** 567 (1962).
88. J. W. Weigl, Proceedings 3rd European Colloquium on Current Problems in Electrophotography, Zurich 1971, paper VI.2.
89. H. G. Greig, *RCA Rev.*, **23:** 413 (1962).
90. P. J. Regensburger and J. J. Jakubowski, *J. Chem. Phys.* (submitted for publication).
91. Dessauer and Clark, (Ref. 1) op. cit., M. Smith and J. W. Weigl, p. 169.
92. Schaffert, (Ref. 2) op. cit., p. 175.
93. E. J. Felty, the Xerographic Photoreceptor, Visual Encyclopedia Unit 20, Part 2 (Rochester, N.Y. Chapter, SPSE, 1968) (circulated by the Audio Visual Department of the Rochester Institute of Technology Library, Rochester, N.Y.)
94. R. M. Schaffert, (Ref. 2) op. cit., pp. 181–193.
95. Ross, *Proc. of the First Reprography Inst.* (Most Associates, Marblehead, Mass., 1968) p. 125.
96. Amick, (Ref. 65) op. cit., p. 770.
97. P. J. Warter, *Appl. Opt.*, Supplement 3, p. 65 (1969).
98. Schaffert, (Ref. 2) op. cit., pp. 266–268.
99. I. Chen and J. Mort, *J. Appl. Phys.*, to be published.
100. J. H. Dessauer, G. R. Mott and H. Bogdonoff, *Photogr. Eng.* **6:** 250 (1955).
101. Private communications to: R. Schoffert from: H. C. Medley, IBM Corp., San Jose, Cal. as given in ref 2, p. 43.
102. C. J. Claus, (Ref. 4) op. cit., p. 31 (Apr./May 1969).
103. P. H. Keck, *J. Opt. Soc. Amer.* **42** (4): 221 (1952).
104. J. Schottmiller, M. Tabak, G. Lucovsky and A. Ward, *J. Noncryst. Solids*, **4:** 80 (1970); M. B. Myers and E. J. Felty, *Mater. Res. Std. Bull.*, **2:** 535 (1967).
105. J. T. Bickmore and C. J. Claus, *Photogr. Sci. and Eng.*, **9:** 283 (1965).
106. Blakney and Grunwald, (Ref. 42) op. cit.
107. For example, J. Kosteler, *J. Appl. Phys.*, **31:** 441 (1960).
108. Dessauer and Clark, (Ref. 1) op. cit., pp. 95, 107, 160, 451.
109. S. Kikuchi and T. Sakata, *Ber. Intern. Kongr. Reprogr.*, 1st Cologne, pp. 137–40, 1963 (published in 1964).
110. M. L. Sugarman, *J. Photogr. Sci.*, **10:** 4 (1962).
111. G. Bird, Preprints of SPSE Symp. on Unconventional Photographic Systems, Washington, D.C. (1971) p. 4.
112. Dessauer and Clark, (Ref. 1) op. cit., W. D. Hope and M. Levy, p. 89.
113. Dessauer and Clark, (Ref. 1) op. cit., R. G. Vyverberg, Chapt. 7.
114. See, for example, Ref. 4 (pp. 13, 14) or Ref. 2 (p. 26).
115. L. B. Loeb, *Electrical Coronas*, University of Cal., Berkeley, 1965.
116. M. M. Shahin, *Photogr. Sci. and Eng.*, **15:** 322 (1971).
117. H. J. White, *Industrial Electrostat Precipitation*, Addison-Wesley, Palo Alto, 1963, Chapt. 4.
118. M. M. Shahin, *J. Chem. Phys.* **45** (7): 2600–2605 (1966).
119. R. M. Schaffert, *Photogr. Sci. and Eng.*, **15:** 148 (1971).
120. R. M. Schaffert, Proc. Intern. Congr. Photogr. Sci., Moscow, 1970, p. 45.
121. C. F. Gallo, J. E. Germanos and J. E. Courtney, *Appl. Opt.*, Supplement 3, p. 111 (1969).
122. M. M. Shahin, *Appl. Opt.*, Supplement 3, p. 106 (1969).
122a. R. H. Epping, U.S. Patent 3,390,266 (1968); C. Gallo, U.S. Patent 3,433,948; J. E. Germanos, U.S. Patent 3,492,476.
123. C. F. Gallo, A. G. Leiga and J. A. McInally, *Photogr. Sci. and Eng.*, **11:** (1967).
124. W. Lama and C. Gallo, *Bull. Amer. Phys. Soc.*, **16:** 212 (1971), **17:** 390 (1972), **17:** 351 (1972).
125. C. Gallo, "Optical Xerography," *Trans. IEEE, IGA*, 1972; C. Gallo and A. G. Leiga, *Photogr. Sci. and Eng.*, **15:** 158 (1971).
126. D. W. Vance, *J. Appl. Phys.*, **42:** 5430 (1971).
127. W. Jaenicke and B. Lorenz, *Z. Electrochem*, **65:** 493 (1961).
128. H. Seki, I. P. Botra, W. D. Gill, K. K. Kanazawa and B. H. Schectman, *IBM J. Res. Develop.*, **15:** 213 (1971).
129. C. E. K. Mees and T. H. James, *The Theory of the Photographic Process*, 3rd ed., Macmillan, New York, 1966.
130. H. E. J. Neugebauer, *Appl. Opt.*, **4:** 453 (1965).
131. Schaffert (Ref. 2) op. cit., p. 24; and (Ref. 136) p. 201.
132. W. A. Sullivan and T. L. Thourson, *Photogr. Sci. and Eng.*, **11:** 115 (1967).
133. H. E. J. Neugebauer, *Appl. Opt.*, **3:** 386 (1964) and *J. Opt. Soc. Amer.*, **51:** 482 (1961) (Abstract of talk).
134. Dessauer and Clark, (Ref. 1) op. cit., H. E. J. Neugebauer, Chapt. 8.
135. M. Abraham and K. Becker, *The Classical Theory of Electricity and Magnetism*, (Blackie and Son, London, 1947), pp. 77–79.
136. R. M. Schaffert, *Photogr. Sci. and Eng.*, **6:** 197 (1962).
137. H. E. J. Neugebauer, *Appl. Opt.*, Supplement 3, p. 76 (1969).
138. Dessauer and Clark, (Ref. 1) op. cit., p. 99.
139. P. Thurlow, *Proc. SPSE Symp. II on Unconventional Photographic Systems*, Washington, D.C. 1967, p. 84.
140. G. F. Fritz, D. C. Hoesterey, and L. E. Brady, *Proc. SPSE Symp. III on Unconventional Photographic Systems*, Washington, D.C., 1971, p. 30; also, *Appl. Phys. Letters*, **19:** 277 (1971).
141. Dessauer and Clark, (Ref. 1) op. cit., R. W. Gundlach, Chapt. 9.
142. T. Ikeda, T. Murakami, and A. Inaba, *Denshi Shashin* (Electrophotography), **3** (3): 49–54, 55–58 (1961). (Japanese)
142a. Schaffert, (Ref. 2) op. cit., p. 47.
143. Dessauer and Clark, (Ref. 1) op. cit., E. H. Lehman and G. R. Mott, Chapt. 10.
144. P. M. Cassiers and J. Van Engeland, *Photogr. Sci and Eng.*, **9:** 273 (1965).
145. H. Krupp, *Advan. Coll. Interface Sci.*, **1:** 111 (1967).
146. D. K. Donald, *J. Appl. Phys.*, **40:** 3013 (1969).
147. D. K. Donald and P. K. Watson, *Photogr. Sci. and Eng.*, **14:** 36 (1970).
148. T. L. Thourson, Preprints of paper summaries, 23rd Annual Conf., Photogr. Sci. and Eng., SPSE, Washington, D.C., May 1970, p. 105.
149. J. T. Bickmore, "Xerographic Development," *Visual Encyclopedia*, Rochester Chapter, S.P.S.E., Rochester, N.Y., 1968, Unit 20, Part 3.
150. W. A. Sullivan and T. L. Thourson, *Photogr. Sci. and Eng.*, **11,** 114 (1967).
151. J. T. Bickmore, K. W. Gunther, J. F. Knapp and W. A. Sullivan, *Photogr. Sci. and Eng.*, **14:** 42 (1970).
152. Schaffert, (Ref. 2) op. cit. (p. 30).
153. W. E. Bixby, P. G. Andrus, and L. E. Walkup, *Photogr. Eng.* **5,** 195 (1954).
154. Dessauer and Clark, (Ref. 1) op. cit. (R. E. Hayford and W. E. Bixby, p. 173).
155. J. T. Bickmore, R. E. Hayford and H. E. Clark, *Photogr. Sci. and Eng.*, **3:** 210 (1959).
156. J. T. Bickmore, M. Levy, and J. Hall, *Photogr. Sci. and Eng.*, **4:** 37 (1960).
157. Dessauer and Clark, (Ref. 1) op. cit., (J. T. Bickmore, Chapt. 11, p. 309).

158. R. Seimiya and Y. Mitsuhashi, *Denshi Shashin* (Electrophotography), **7** (1): 31–36 (1966). (Japanese)
159. H. C. Gillespie, Proc. SPSE Symp. II on Unconventional Photographic Systems, Washington, D.C. (1967) p. 86.
160. H. G. Greig, U.S. Patent 3,117,884 (Jan 14, 1964, to Radio Corp. of Amer.).
161. G. S. Lozier, *Proc. of SPSE Symp. III on Unconventional Photographic Systems*, Washington, D.C. 1971, p. 32.
162. Y. Moradzadeh and D. Woodward, *Photogr. Sci. and Eng.*, **10**: 96, (1966), also *Appl. Opt.*, Supplement 3, p. 172 (1969).
163. Dessauer and Clark, (Ref. 1) op. cit., C. J. Claus and E. F. Mayer, Chapt. 12, p. 341).
164. K. A. Metcalfe, *J. Sci. Inst.*, **32**: 74 (1955).
165. E. F. Mayer, U.S. Patents 2,877,133 (1959) 2,892,709 (1959) V. E. Straugham U.S. Patent 2,899,335 (1959).
166. D. B. Alnutt, *Reproductions Review*, p. 28 (Jan 1962).
167. E. F. Mayer and V. E. Straughan, U.S. Patent 2,891,911.
168. K. E. Metcalfe, U.S. Patent 3,058,914.
169. K. A. Metcalfe, *Paper Market*, p. 30 (Jan 1961).
170. Schaffert, (Ref. 2) op. cit., Part II, Chapt. 5, p. 362.
171. J. A. Dahlquist and J. Brodie, *J. Appl. Phys.*, **40**: 3020 (1969).
172. H. M. Stark and R. S. Menchel, *J. Appl. Phys.*, **41**: 2905 (1970).
173. E. C. Hutter and E. C. Giaimo, *Photogr. Sci. and Eng.*, **14**: 197 (1970).
174. E. C. Hutter, *Photogr. Sci. and Eng.*, **15**: 251 (1971).
175. E. Mohn, *Photogr. Sci. and Eng.*, **15**: 451 (1971).
176. Business Automation Product Information Services, Hitchcock (Now Alltech) Publishing Company, Pennsauken, N.Y. 1972, Part II T.
177. Dessauer and Clark, (Ref. 1) op. cit., J. T. Bickmore, C. R. Mayo, G. R. Mott and R. G. Vyverberg, Chapt. 18, p. 467).
178. M. L. Sugarman, Proc. Tech. Assn. Graphic Arts, p. 59–70 (1955).
179. E. I. Sponable, *J. Soc. Motion Picture Television Engrs.*, **60**: 337 (Apr 1953).
180. W. E. Glenn, *J. Appl. Phys.*, **30**: 1870 (1959).
181. R. W. Gundlach and C. J. Claus, *Photogr. Sci. and Eng.*, **7**: 14 (1963).
182. J. Gaynor and S. Aftergut, *Photogr. Sci. and Eng.* **7**: 209 (1963).
183. S. Aftergut, J. Gaynor and B. C. Wagner, *Photogr. Sci. and Eng.*, **9**: 30 (1965).
184. J. C. Urbach, *Photogr. Sci. and Eng.*, **10**: 287 (1966).
185. P. J. Cressman, *J. Appl. Phys.*, **34**: 23 (1963).
186. R. W. Gundlach, "Xerographic Frost Imaging," Ber. Intern. Kongr. Reprogr., 1st Cologne (1963).
187. W. A. Sullivan and J. J. Kneiser, *Photogr. Sci. and Eng.*, **8**: 206 (1964).
188. H. F. Budd, *J. Appl. Phys.*, **36**: 1613 (1965).
189. J. C. Urbach, "Thermoplastic Xerography," *Visual Encyclopedia*, Rochester Chapter, SPSE, Rochester, N.Y., 1968, Unit 20, Part 5 (See Ref. 93).
190. J. C. Urbach and R. W. Meier, *Appl. Opt.*, **5**: 666 (1966).
191. J. Gaynor, Preprints of SPSE Symposium II on Unconventional Photographic Systems, Washington, D.C. (1967) p. 25.
192. J. J. Bartfai, V. Ozarow, and J. Gaynor, *Photogr. Sci. and Eng.*, **9**: 80 (1965).
193. N. K. Sheridon, "Cyclically Reusable Holographic Recording Device," talk presented at Spring Meeting of Opt. Soc. of Amer., Philadelphia, Pa. (Apr 1970).
194. N. K. Sheridon, "A New Optical Recording Device," talk presented at 1970 IEEE International Electron Devices Meeting, Washington, D.C., (Oct 28, 1970).
195. N. K. Sheridon, (accepted for publication, *Trans. IEEE, Electron Devices*).
196. D. Kermisch, "The Image Formation Mechanism in the Gamma Ruticon," to be published.
197. J. D. Margerum, et al., *Appl. Phys. Letters*, **17**: 51 (1970).
198. W. E. Haas, J. E. Adams, *Xerox Tech. Rev.*, **D**: 13 (1971).
199. W. Haas and J. E. Adams, Jr., *J. Electrochem. Soc.*, **118**: C220 (1971).
200. W. Haas and J. E. Adams, *Appl. Opt.*, **7**: 1203 (1968).
201. A. Meitzler, J. R. Maldonado, and D. B. Fraser, *Bell System Tech. J*, **49**: 953 (1970).

202. A. H. Meitzler and J. R. Maldonado, *Electronics*, p. 34 (Feb 1, 1971).
203. W. D. Smith and C. E. Land, *Appl. Phys. Letters*, **20**, (4): 169 (1972).
204. Annon., Electro Optical Systems Design, p. 7 (1971).
205. B. Kazan, et al., *Proc. IEEE*, **56**: 338 (1968).
206. D. S. Oliver, "An Optical Image Storage and Processing Device Using Electro Optic ZnS," Itek Corp., Lexington, Mass., 1970.
207. D. S. Oliver, et al., *Appl. Phys. Letters*, **17**: 416 (1970).
208. S. L. Ho and D. S. Oliver, *Appl. Phys. Letters*, **18**: 325 (1971).
209. V. Tulagin, *J. Opt. Soc. Amer.*, **59**: 328 (1969) and paper presented to Optical Society of America (Mar 13, 1968).
210. W. L. Goffe, *Photogr. Sci. and Eng.*, **15**: 304 (1971) and U.S. Patent 3,520,681, Photoelectrosolography (to Xerox Corp.) (1970).
211. A. Pundsack, *Proc. of SPSE Symp. III on Unconventional Photographic Systems*, Washington, D.C. (1971) p. 37.
212. Dessauer and Clark, (Ref. 1) op. cit., J. F. Byrne and P. F. King, Chapt. 15, p. 405.
213. L. E. Walkup, U.S. Patent 2,833,648 (1958) and U.S. Patent 2,937,943 (1960) (both to Xerox Corp.).
214. Schaffert, *IBM J. Res. Develop.*, **6**: 192 (1962).
215. G. F. Day and R. L. Jepsen, Preprints of Paper Summaries, 23rd SPSE Annual Conf., Washington, D.C., 1970, p. 182.
216. V. M. Fridkin and I. S. Zheludev, *Photoelectrets and the Electrophotographic Process*, Van Nostrand Reinhold, New York, 1961 (English translation from the Russian original).
217. H. Kallmann and B. Rosenberg, *Phys. Rev.*, **97**: 1596 (1955).
218. H. P. Kallmann, J. Rennert and M. Sidron, *Photogr. Sci. and Eng.*, **4**: 345 (1960).
219. S. Kasu, et al., *J. Soc. Electrophotogr. Japan*, **4**: 2 (1962).
220. V. V. Pospelov and V. M. Fridkin, *Zh. Nauchn. i Prikl. Fotogr. i Kinematogr.*, **10**: 118 (1965).
221. A. B. Dick Co., Neth Patent appl. No. 6,540,112 Oct 4, 1965.
222. K. Yoshida, K. Kinoshita and T. Kawamura, *Appl. Opt.*, Supplement 3, p. 170 (1969).
223. K. Nakamura and M. Veno, *Appl. Opt.*, Supplement 3, p. 170 (1969).
224. E. G. Johnson and B. W. Veher, U.S. Patent 3,010,833 (1956; to Minnesota Mining and Mfg.).
225. H. Kallman, U.S. Patent 2,845,348 (1952; to USA).
226. P. M. Cassiers, *Photogr. Sci. and Eng.*, **4**: 199 (1960).
227. J. C. Jarvis, U.S. Patent 3,132,963 (1964; to Eastman Kodak Co.).
228. Gevaert-Agfa, Neth. patent Appl. 6,608,816 (Nov 1966).
229. K. A. Metcalfe and R. J. Wright, Austral. Patent 243,184 (1963).
230. J. Gaynor and G. J. Sewell, *Photogr. Sci. and Eng.*, **11**: 204 (1967).
231. Claus, (Ref. 5) op. cit. (p. 5).
232. S. Tokumoto, E. Tanaka, C. Hara, O. Ogasawara and S. Murata, *Photogr. Sci. and Eng.*, **7**: 218 (1963).
233. S. K. Deb, *Appl. Opt.*, Supplement 3, p. 192 (1969).
234. J. Berchtold, *Sci. Industr. Photogr.*, **26** (2nd series 465 (1955).
235. J. Jacobs and R. Frerichs, U.S. Patent 2,764,693 (1956).
236. B. P. Spec 797,027, General Dynamics Corp. (1958).
237. *Business Week* (Feb 27, 1954) p. 41, and W. C. Huebner, U.S. Patent 2,676,100 (1952).
238. Bickmore, Hayford and Clark (Ref. 155), op. cit.
239. W. L. Rhodes, *Image Technology*, **12** (5): 13 (1970).
240. K. A. Metcalfe and R. J. Wright, U.S. Patent 2,907,674.
241. H. Kiwaki, S. Komeiji, and H. Nakasone, *Denshi Shashin* (Electrophotography) **3** (1): 27–31 (1961). (Japanese)
242. Bixby, Andrus, and Walkup, (Ref. 153) op. cit. (p. 198).
243. Mees and James, (Ref. 129) op. cit., Chapt. 22, p. 464.
244. David Malone, Xerox Corporation, Private Communication.
245. A. J. Montgomery, SPSE Seminar on Image Quality Evaluation, Rochester, N.Y., Sept 1970 (SPSE, Washington, D.C.) to be published.
246. H. E. J. Neugebauer, *Appl. Opt.*, **6**: 943 (1967).
247. C. N. Nelson, *Photogr. Sci. and Eng.*, **15**: 82 (1971).
248. G. C. Higgens, ibid, p. 106.
249. F. W. Schmidlin and H. M. Stark, "Lateral Conduction Mechanisms in Xerography and their Limitations on Resolution," Annual Conference on Photogr. Sci. and Eng., May 12–16, 1969.
250. J. C. Heurtley, *Appl. Opt.*, Supplement 3, p. 137 (1969).

251. H. E. J. Neugebauer, ibid, p. 130.
252. F. W. Schmidlin, Preprints of Paper Summaries, SPSE Annual Conf. (SPSE, Washington, D.C., Apr 20–23, 1971) p. 19 and *Trans. IEEE Electron Devices*, **ED-19,** p. 448 (1972).
253. David Malone, Preprints of Paper Summaries of the 24th Annual Conf. on Photogr. Sci. and Eng. SPSE, Washington, D.C., 1971, p. 81.
254. H. G. Greig, *RCA Rev.*, **23**: 414 (1962).
255. H. Neugebauer, *Proc. Tech. Assn., Graphic Arts*, p. 57–58 (1961) or in Ref. 7, p. 52.
256. T. L. Thourson, *Trans. IEEE, Electron Devices*, **ED-19:** 495 (1972).
257. R. Shaw, *Journ. Appl. Photog. Eng.*, **1**(1): 1–4 (1975).
258. R. Goren, *Journ. Appl. Photog. Eng.*, **2**(1): 17–27 (1976).
259. R. A. Eynard, Color: Theory and Imaging Systems (Society of Photographic Scientists and Engineers, Washington, D.C. 1973), H. Bogdonoff, Chapter 17 "Rapid Access" Color Hardcopy— An Overview, p. 362.
260. *Ibid.*, W. L. Rhodes, Chapter 18, Color Xerography, p. 383.
261. Photo Methods for Industry, 14, pp. 40–42 (1971).
262. R. Lehman, Optimization of Spectral Response of an Automatic Color Copier, Proceedings of the Reprography Conference, Technical Association of Pulp and Paper Industry, 1972, p. 191.
263. L. D. Mailloux and J. E. Bollman, 6500 Slide Adapter, Paper Summaries—29th Annual Conference and Seminar on Color Reproduction, (Society of Photographic Scientists and Engineers, Washington, D.C., 1976), p. 65.
264. N. Rothschild, *Popular Photography* (March 1976).

14

COLOR NEGATIVE AND POSITIVE SILVER HALIDE SYSTEMS

Hobson J. Bello

Even as black and white photography was emerging in the nineteenth century from a curiosity and hobby to a marketable product, a number of people were already writing down schemes for producing photographs in color. James Clerk Maxwell, basing his experiments on Young's theory of vision, presented his famous demonstration of a photograph in color in 1861. He used an additive technique involving three positive photographic transparencies in different projectors with red, green, and blue filters in their respective paths. By 1862, Ducos du Hauron had forecast all the color processes which have since been invented. These processes were invented many decades after the original disclosures.

Color photography is a means of recording scenes in the real world and reproducing the equivalent visual experience at a later time, whether that time be one minute or many years after the original visual experience. Thus, color photography must start and end with the color perception mechanism of the human eye. The aim is to have the color process see the scene approximately as the eye sees it and reproduce that scene in a way that the eye will accept as plausible.[1]

Since most photochemical reactions are essentially negative-working (that is, some event is caused in direct proportion to exposure), it is not surprising that the negative-positive system is the oldest method of photography. In this system, a negative film records the scene through the lens of a camera. After the negative film is developed and processed, it is printed onto a positive material, which is really another negative-working element. It may be coated on either a paper or a transparent support. In the case of a paper print, the positive image thus obtained reflects the reproduction of the original scene back to the eye. In the case of a transparency, the reproduction of the scene is either transmitted directly to the eye by viewing it through a light source, or it is projected to a reflecting screen by means of a light source and lens, so that it may be viewed by the eye.

THE COLOR NEGATIVE FILM

The schematic structure of color negative film used in a camera (Fig. 14-1) is basically the same, no matter what system the negative is designed for. First, there is usually a clear gelatin overcoat to protect the emulsion layers from scratches and digs during handling. This coating may contain other substances, such as lubricants, filter dyes, etc. The three emulsion layers are each sensitized to roughly one-third of the visible spectrum of radiation. The top-most emulsion layer is sensitive to blue light. Beneath this layer is a yellow filter layer which is necessary because the sensitivity of the lower layers has been extended into the red and green regions by dyes and still retain their native blue sensitivity. The yellow filter layer absorbs the blue light not absorbed by the blue-sensitive layer and transmits the red and green light to which the lower layers are sensitive.

Just below the yellow filter layer is the green-sensitive layer. Between the green- and red-sensitive layers is a gelatin interlayer that helps to prevent interactions between the two layers during coating operations and helps to prevent color contaminations by oxidized

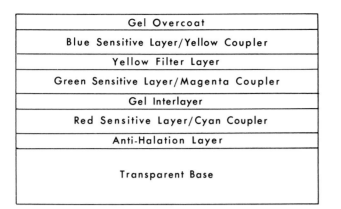

| Gel Overcoat |
| Blue Sensitive Layer/Yellow Coupler |
| Yellow Filter Layer |
| Green Sensitive Layer/Magenta Coupler |
| Gel Interlayer |
| Red Sensitive Layer/Cyan Coupler |
| Anti-Halation Layer |
| Transparent Base |

Fig. 14-1. Schematic structure of a color negative film.

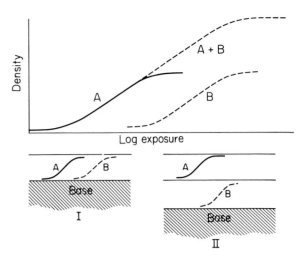

Fig. 14-2. Extending exposure latitude by using two emulsions of different speeds in a single layer (I) and in two layers (II).

developer wandering from one layer into another during the development reaction. The lowest emulsion layer is sensitive to red light.

Beneath this red-sensitive layer is an antihalation layer, which may consist of silver coated in gelatin or may be a mordanted dye. The blue or neutral hue of this layer must have density sufficient to absorb the light reaching it and prevent its being reflected from the film base and causing spurious images in the emulsion layers. In some films, the antihalation layer is on the opposite side of the base from the emulsion layers. It may consist of dyes in gelatin or finely dispersed neutral material (such as carbon) in a vehicle that can be removed during processing.

The superposition of these emulsion layers is a characteristic of the subtractive system of color formation. In subtractive systems, each dye subtracts one third of the visible spectrum and transmits the other two thirds. Blue light is absorbed in proportion to the concentration of yellow dye, which transmits green and red light. Green light is absorbed by the magenta dye, which transmits blue and red light. Red light is absorbed by the cyan dye, which transmits blue and green light. Thus, each of the additive primaries, blue, green, and red, is controlled by its complementary absorbing dye: yellow, magenta, and cyan. In the multilayer structure of a negative material, therefore, each light-sensitive element contains a color former or coupler that forms a dye with a hue complementary to the sensitivity of that layer. The red-sensitive layer controls the cyan dye concentration in proportion to red exposure; the green sensitive layer, the magenta dye; and the blue sensitive layer, the yellow dye.

Single photographic emulsions rarely have the exposure latitude needed for camera negative films. Most often, two or more emulsions of different speeds are blended to achieve the desired latitude (Fig. 14-2). Instead of being blended and coated in a single emulsion layer, the components are sometimes coated in separate layers—usually, a fast component over one or more slower components—to achieve latitude aims, unique sensitometry, and improved speed-grain characteristics. Instead of only three emulsion layers, a film may thus contain six or more layers if each light-sensitive element is separated into its fast and slow emulsion components.

Sensitometric curves (Fig. 14-3), for which density is plotted against the logarithm of exposure, show the basic characteristics of a photographic product: exposure latitude, minimum densities, and gamma. These characteristics vary according to the use for which the product is intended.

Strictly speaking, latitude is the exposure range over which the sensitometric curve is linear. This linear portion reproduces the original scene without distorting the tonal relationships. In another sense, latitude is the exposure range that gives acceptable prints. This broader definition includes some of the nonlinear portions of the sensitometric curve that do distort the tone relationships of the original scene.

The minimum densities of a film occur in those regions that received no exposure. Minimum density or Dmin is the sum of base density, fog density, and colored coupler density. The density of the base is very low, except in those cases where the base contains a colorant for a specific reason. Fog is usually kept low for easier process

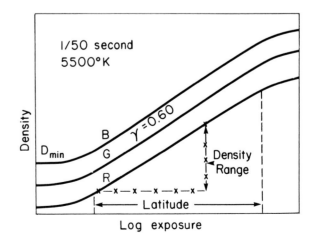

Fig. 14-3. Sensitometric curve of a camera negative film balanced for daylight illumination. The density range of a normal exposure is indicated.

control. Colored couplers are used in most modern color negative materials to correct for the unwanted blue absorptions of cyan and magenta dyes and the unwanted green absorption of cyan dyes (Fig. 14-4). The couplers impart high green and blue densities to the negative. The level of Dmin contributed by colored couplers is determined by their hue and reactivity and by the level of color correction desired. Since these couplers increase the overall density of the negative, the speed of the print material and the printer characteristics also need to be taken into consideration in determining the desirable Dmin for a color negative material.

Gamma is defined as the slope of the straight-line portion of the sensitometric curve. Gamma is an important determinant of the visual contrast of a film system; that is, the rate at which the reproduction system goes from white to black.

It is important to know the printing gamma of a camera negative film because it predicts the influence of the negative image on the exposure of the print material. Printing gamma specifies the gamma of the negative film in accordance with the sensitivity distributions of the photographic material on which it is designed to be printed. Camera films, which see the real world, must have broad, overlapping sensitizations to record all the colors of the real world (Fig. 14-5). Print or intermediate materials see the dye sets of other films. Their spectral sensitizing dyes are usually narrower in bandwidth than camera film sensitizers, and their peak sensitivities are selected to correspond as closely as possible to the wavelengths at which the image dyes of the camera negative film have maximum absorption. Such narrow, properly selected spectral sensitizing dyes record the least amount of the unwanted absorptions of the image dyes of the negative film. They also record the negative image dyes near maximum gamma, which decreases the amount of image dyes required to obtain a desired printing gamma.

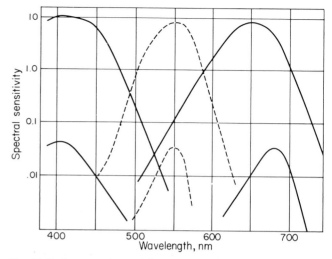

Fig. 14-5. A comparison of the spectral sensitivities of a camera negative and an internegative film. The negative film has higher sensitivity (speed) and broader sensitizations than the internegative film.

Once the negative image dyes and the spectral sensitizers of the print material have been selected, printing gamma is determined by photographic photometry. It may also be calculated from the spectral densities of the negative image dyes, the spectral energy distribution of the printer illumination, and the sensitivity distributions of the spectral sensitizers of the print material. Printing gamma is usually directly proportional to the gamma obtained by reading the negative image dyes with a set of densitometer filters. Once this relationship is established, the densitometer readings are used for convenience in photographic research and manufacturing operations.

The gamma of a negative-positive photographic system is the product of the printing gamma of the negative material and the gamma of the print material. If more than two photographic materials are involved, the system gamma is the product of the gammas of all components.

The matter of gamma or contrast level for a specific color system is more complicated than for a black and white process, where the contrast level is decided wholly by the requirements for pleasing tone reproduction. Color systems are complicated by the fact that color saturation increases with system contrast. A low-contrast system allows more latitude and gives pleasing tone reproduction but poorer color saturation. Thus, an acceptable compromise between system contrast and color saturation must be obtained.

In a relatively high-contrast color system, more desirable tone reproduction may be obtained by using a lower lighting ratio than normally used for black and white photography. This is usually possible in motion picture studios and in portrait studios where lighting can be carefully controlled.

Color correction or masking is another way of decreasing the contrast requirement for a color system. If the unwanted absorptions of photographic image dyes are

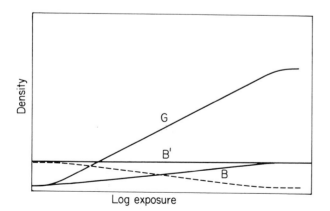

Fig. 14-4. Correction of the unwanted blue absorption (B) of a magenta dye (G) with a colored coupler. The yellow hue of the colored coupler is discharged as the coupler reacts with oxidized developer (----). The sum of the colored coupler curve and the unwanted absorption curve produces B', which is the equivalent of a magenta dye having no blue absorption.

corrected by colored coupler masking[2] or by interlayer interimage effects,[3] color saturation of a system can be greatly improved. By these means, acceptable color saturation can be obtained at a lower, more pleasing system contrast than without them.

The printing gamma of color camera negatives has traditionally been between 0.60 and 0.70. At this gamma, it is easier to achieve long exposure latitude with relatively low colored coupler minimum densities than at higher gamma. For example, if the negative gamma were raised to 1.20 and latitude not changed, Dmins would have to increase by 100% to maintain the same color correction as the lower gamma negative. The density range, the difference between highlight and shadow densities of the negative, would also be doubled. A higher speed print material or a higher speed printer would be required to equal the printing speed of the low gamma system. The print material would also have to have lower gamma to maintain constant system contrast and wider latitude to accommodate the increased density range of the negative. A negative gamma lower than 0.60 would, of course, reverse the requirements for the print material. However, the substantial increase in the gamma of the print material would make printing control much more difficult than it is now because small exposure errors would cause even greater density errors.

Another element that must be considered for camera negative films is color balance. Color balance, for a reversal material, refers to the accuracy with which various grays are reproduced. The eye adapts to lighting conditions so that grays are seen as grays whether they are viewed under tungsten, dayight, or fluorescent illumination. Color films do not have this flexibility and must have their relative red, green, and blue speeds adjusted to reproduce grays accurately for a given illuminating condition. Thus, we speak of film being balanced for daylight, Type B (3200°K) or Type A (Photoflood) illumination.

The red, green, and blue speeds of camera negative films are adjusted to be equal for a given type of illumination (Fig. 14-3). Negative films are not quite as sensitive to color balance requirements as reversal films because the negative films have more exposure latitude and some corrections can be made in printing to adjust for illuminant quality.

These basic parameters—gamma, exposure latitude, minimum densities, color balance—plus film speed, graininess, and sharpness are varied according to the needs of each color system. The goals for graininess and sharpness of a film (often referred to as the image structure characteristics) are largely determined by the magnifications required in the particular system. For example, the graininess and sharpness requirements of an 8 × 10-in. negative film from which a contact print is made are not nearly as stringent as those of a 16 mm negative motion picture film, the prints from which are magnified 6 to 12 times for viewing. Minimum film speeds are sometimes determined by the limitations imposed by the lens systems of certain cameras. Maximum film speeds are usually determined by the speed-grain charac-

teristics of the negative emulsion; that is, speed is determined by the fastest emulsions that provide the graininess acceptable for a given system.

THE COLOR POSITIVE MATERIAL

The other half of the negative-positive system, the print material, often has a different structure from the negative film. In one typical color photographic paper (Fig. 14-6), the red sensitive layer is on top, the green-sensitive layer is in the middle, and the blue-sensitive layer is nearest the highly reflective base. Of course, the upper two layers are also sensitive to blue and ultraviolet radiation.

This layer order was largely determined by dye stability considerations. Dye stability of prints is important because, besides being kept in albums, prints are also hung on walls or are used in displays where they are subject to the action of daylight, tungsten, or fluorescent illumination for long periods of time.

The cyan dyes have generally been the most stable to light, and having the cyan layer on top protects the bottom two layers from the fading action of incident illumination. A UV absorbing layer may be coated between the cyan and magenta layers to give further protection to the magenta and yellow dyes.

Because color negative films use colored couplers and have minimum densities highest to blue light and lowest to red light (Fig. 14-3), the color paper on which such negatives are printed have relative speeds in the same order: highest speed to blue light, next highest to green light, and lowest to red light. With this speed relationship, color prints can be made at reasonable printing times.

In addition to the blue-speed requirement imposed by the minimum density of the color negative, still higher blue speed is needed to provide adequate speed separation between the blue-sensitive layer and the blue sensitivity of the other two layers. Since this product has no yellow-filter layer, the additional blue speed prevents exposure or "punch-through" of the other two layers by blue light during the printing operation. With this speed

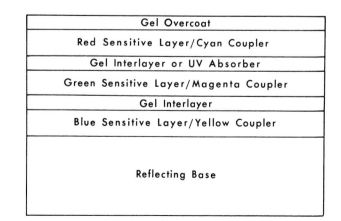

Fig. 14-6. Schematic structure of a reflection print material.

relationship, the low intensity of blue light required to give adequate yellow density in a print causes little or no exposure in the magenta and cyan layers (Fig. 14-7).

Exposure separation may be further improved by using in the cyan and magenta layers emulsions that have little native sensitivity beyond 400 nm. When an ultraviolet filter is used in the printer filter pack, the effective blue sensitivity of these layers is quite low.

If the user of a negative-positive system desires, he may request that a transparency rather than reflection print be made from the negative. The transparency may be a large sheet size, or it may be a 2×2-in. slide. The relative speeds of the sensitized layers of the transparency or print film are similar to those of the color paper. The layer order, however, may be different; often it is like that of the negative film. Light stability requirements, especially for slides, are usually not quite as stringent as for paper prints because each slide is exposed to light for a very short time. Also, transparencies are usually illuminated through the base. The print film may or may not have a yellow-filter layer depending on the blue sensitivity of the emulsions used in the cyan and magenta layers.

Some print films have a layer order that maximizes sharpness (Fig. 14-8). The magenta layer, which carries 60 to 65% of the visual sharpness information of an image, is coated on top to minimize the effect of light scattering by silver halide emulsions. Next comes the cyan layer and finally, the yellow layer, which carries the least sharpness information.

The emulsion-grain size of positive materials is small compared to negative emulsions, and these materials are quite slow in speed (Fig. 14-9). Positive materials are usually so fine grained that they do not add appreciably to the graininess of the final print, except perhaps when viewed at extremely high magnifications (such as 8mm or super 8).

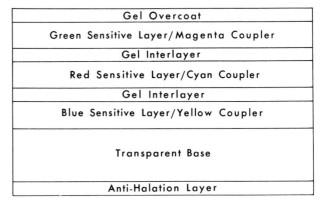

Fig. 14-8. Schematic structure of a print film having the layer order that maximizes sharpness.

The contrast of the print material is determined by the tone reproduction and the color saturation which is desired for the system. For current systems (Fig. 14-10), the gamma of print materials is between 2.2 and 3.0.

The amount of each dye in a reflection print material is about half the amount in a transparency material. The reason for this is that light passes twice through the dye image of a reflection print: once as it enters the print and again as it leaves the print after being reflected from the backing. In a transparency material, light passes through the dye image only once.

Because a reflection print is usually viewed in normal room illumination and is only one of the objects in the general field of view, it has no more effect on the adaptation conditions of the eye than do other nearby objects. For this reason, deficiencies of a color print are more readily apparent than those of a color transparency which is viewed under dark-adapted conditions.

The two things about which the viewer of a color print is most critical are color balance and stain. Since it is seen in relation to other objects in the field of view, exceedingly small errors in color balance are perceptible and often objectionable. If the print contains stain or has a high minimum density, it will not reproduce white objects with enough brightness, and the print

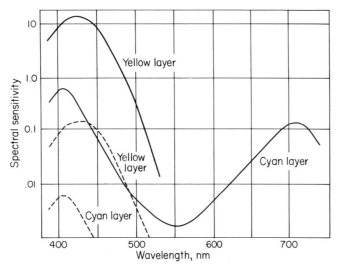

Fig. 14-7. The high blue speed of the yellow layer of a reflection print material (- - -) permits the use of a low intensity of blue light in making a print (——) and thus minimizes exposure of the cyan layer by blue light.

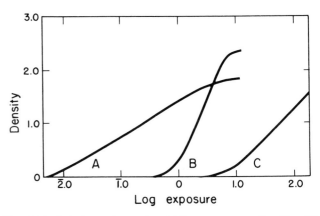

Fig. 14-9. Relative red speeds of (A) camera negative film, (B) reflection print material, and (C) intermediate film at a common exposure condition.

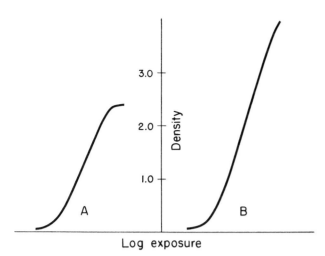

Fig. 14-10. Sensitometric comparison of (A) reflection print material (reflection densities) and (B) print film (transmission densities).

will appear dark and muddy. Transparencies can tolerate much larger variations in minimum density, stain, and color balance.[4]

COLOR NEGATIVE-POSITIVE SYSTEMS

The above description is a general review of the elements of the negative-positive system: a low gamma, long-latitude negative film designed to be printed onto a high gamma, short-latitude reflection or transparency print material. Within this general system, there are several specific systems.

For the Amateur Photographer

The system that is used in greatest volume is the one designed for the amateur photographer: the weekend, vacation, and holiday snapshooter; the recorder of family milestones and festive occasions of all sorts.[5] For these relatively simple, inexpensive cameras, moderately high-speed films balanced for daylight illumination or blue flash bulbs are required. Because of this type of equipment and/or inexperience with photography, the negatives are often underexposed or overexposed by two or more stops. Under such conditions, the only way to be sure that a printable negative will be obtained most of the time is to provide a negative film having a very wide exposure latitude. This negative should be a little higher in gamma than is really necessary for the system to correct for flare in inexpensive cameras and to compensate for never cleaning the camera lenses at all.

Most often rather small reflection prints and a few enlargements are selected for viewing. Sometimes, slides are requested from negatives. The slide print film for this use is higher in contrast than it theoretically needs to be. But its high contrast compensates somewhat for many underexposed, and thus low contrast, negatives that the amateur regularly shoots.

The amateur film user also requires other things from a negative film, but these are things about which he is scarcely conscious. It is simply taken for granted that film can be mishandled, so one tortures it by keeping the loaded camera in the car trunk or glove compartment or incubates it on the shelf under the rear window. Too often one roll of film is kept in a camera from Christmas to Christmas, one year to another. After all this rough handling, decent pictures are still expected from these abused negatives. Therefore, it is up to the film manufacturers to make photographic emulsions that retain their characteristics reasonably well under all sorts of conditions. The recorded image (latent image) must also be reasonably stable during the sometimes long periods before the film is developed. These important requirements, good emulsion and latent image keeping qualities, do not show up on the ordinary sensitometric curve, but they are nevertheless important to the success of the negative-positive system for the amateur photographer.

For the Professional Photographer

Another important user of the negative-positive system is the professional photographer, the individuals who make their living by making and selling photographs. They may specialize in taking portraits; or may work exclusively in the commercial field, photographing fashion designs or advertising lay-outs of many types, which are used in magazines, catalogues, and advertising brochures. Sheet-film sizes were once used almost exclusively; but with improvements in negative quality, more roll and 35mm film are used. The portability and flexibility of these small cameras, as well as the variety of lenses and other accessories, give much more technical and artistic freedom.

The negative films that the professional requires differ from the amateur films in several respects. The films do not require as much exposure latitude because there is usually much more control over exposure and lighting conditions. Also, the professional is more careful about keeping film under controlled conditions, and usually processes it soon after exposure. Therefore, for the professional photographer, emulsion keeping and latent image keeping requirements need not be so strict as for the amateur's mistreated negative.

The professional photographer must use a wide range of exposure times that is not compatible with the reciprocity characteristics of silver halide emulsions; that is, a short exposure time with high intensity illumination usually does not give the same results as an equivalent exposure at a long time with low intensity illumination. Therefore, the professional photographer finds that no single negative film has satisfactory color balance, speed, and gamma characteristics for all types of work. The portrait and fashion photographers, for example, need a film that can be used at short exposure times, as little as 1/1000 sec and usually no more than 1/10 sec. They often use electronic flash units for illu-

mination, and it is desirable to have the film balanced for that light source. (Film balanced for electronic flash may also be used in daylight illumination.) For other work, such as photographing a furniture display for a manufacturer or designer, great depth of field is required, so he stops down his lens and uses long exposure times, as much as 30 to 60 sec. For this type of job, tungsten illumination and a film balanced for 3200° K illumination and capable of maintaining that balance at long exposure times is used.

For these photographers, the positive materials are also different from those used by photofinishers for the amateur prints. They usually like lower contrast and a softer toe-shape to obtain more pleasing portraits. For commercial or advertising work, a relatively sharp toe and higher contrast provide more crispness and "snap" to prints. Transparencies, are often made for display or for photomechanical reproduction. This print film is usually in sheet form and has lower contrast than the similar slide print film made for the amateur market.

The dye stability of both the professional paper and print films must be better than their amateur counterparts because they are usually displayed for longer times and under more severe lighting conditions. Dye stability is improved by choosing color formers that form the most stable dyes and by incorporating chemicals that improve stability in both the film and the process.

For Photo-Identification Purposes

A special type of negative film is useful for identification photos, passes, drivers' licenses, etc., where a picture and printed or written material must appear on the photographic print. These require a way of increasing the density range of the negative between the white or pastel background of the printed material and the typewritten or handwritten matter, such as an ink signature. This may be accomplished by coating over a negative film an additional emulsion layer that is sensi-

Fig. 14-11. "Upswept" curve shape useful in some negative and internegative applications.

tive to most of the visible spectrum ("pan-sensitized"). The speed of this overcoat is slow enough so that it does not begin to be exposed until about two-thirds of the way up the sensitometric scale (Fig. 14-11). The image in this overcoated layer consists of a dye or a combination of dyes that gives a neutral image. The increased density range that this provides increases the whiteness of the background in the final print and greatly improves the legibility of the written or typed characters. There may be some loss in saturation in the picture area because of the addition of the neutral dye image to all colors. However, color discrimination rather than accurate color reproduction is more important in an identification photo system.

For Professional Motion Pictures

Another complete system of negative-positive photography is the one used in professional motion picture production. Agfacolor products of this type were introduced perhaps as early as 1939;[6] the Eastman Kodak Company introduced Eastman Color films in 1950.[7] The original Eastman Color negative and print films have been replaced with improved products many times.[8-12] There are also camera negative and positive materials manufactured for motion picture use by the Fuji Film Company, Agfa-Gevaert, and others.

Structurally, the motion picture negative is similar to the negative used by the amateur and professional photographers. The film is balanced for 3200° K illumination because it is used more often in studios than outdoors. Also, when the negative must be exposed to daylight, the speed loss incurred with the conversion filter is much less going to daylight from Type B than vice versa.

For motion picture use, the negative film must be finer grained and sharper than negative films for most other systems because more than one printing operation, each of which can degrade the original image, is usually necessary before making the final print. Also, rather high image magnification is used in some motion picture projection systems. Like other professional films, motion picture negatives require less exposure latitude than amateur negative films because of greater control over lighting conditions and the care used in obtaining proper exposure.

Motion picture negative films are printed for theatrical or television release on color print films. These print films utilize the layer order described earlier for maximizing sharpness; that is, magenta layer on top and yellow layer on the bottom (Fig. 14-8). They also contain intergrain absorbing dyes in the emulsion layers to minimize the effects on sharpness of light scattered by the silver halide particles. These dyes are removed during processing.

However, a professional motion picture system is not complete with only a camera negative and print film. Quite often, special effects are needed for dramatic emphasis or mood enhancement, or background material

shot on location must be combined with foreground action shot in the studio. Most of these special effects cannot be handled easily or at all on the original film in the camera. Therefore, an intermediate film is necessary to handle the special effect work.[13, 14]

For those portions of a motion picture or a TV commercial for which special effects are desired, the camera negative is first printed onto an intermediate film. The resulting print is called a master positive or interpositive. The master positive is sent to a special laboratory where the effects are put in, using precise and complex optical printing equipment. The special effects may require only one or perhaps dozens of printing operations. The final result, however, is that the master positive is printed onto the intermediate film again. The result is called a duplicate negative or simply "dupe." The duplicate negative is then spliced into the original negative at the appropriate places. The final release print is made from this composite of original and duplicate negatives.

Sometimes, still another duplicate is made of the combined original and duplicate negatives. This is done to permit high-speed printing at a single printing condition; to protect the valuable original negative; to print in a reduced format; or to print at more than one laboratory. This is accomplished by using a reversal intermediate film.[15] This film, the reversal intermediate, accomplishes in one printing stage what the negative intermediate does in two printing stages.

Both intermediate films are quite slow compared to the original negative material (Fig. 14-9). They must also be sharper and finer grained than the original negative in order to minimize the changes in sharpness and graininess that occur when one film is printed on another. The ideal color correction for the intermediates is complete correction for their own dyes so the color characteristics of the original negative are not distorted by the intermediate. However, this ideal has not yet been achieved, and some hue and saturation errors occur in the dupe negative on intermediate film. The intermediate films must have a printing gamma of 1.00 to make the gamma of the duplicate negative equal to that of the original negative.

The intermediate film also offers a way of protecting the valuable original negative.[13, 14] Black and white separation positives can be made through red, green, and blue filters with gammas appropriate for printing onto the color intermediate film to make a duplicate negative of the camera original. These silver positives can be stored for a longer time without deterioration than the camera original or a color master positive made from it.

For Systems Using Reversal Originals

Some systems of photography that begin with reversal films require a negative film for large volume, relatively inexpensive distribution of color prints or color transparencies. These negative films are called internegatives because they come between the original reversal and the final print. An amateur photographer, for example, may want color prints of his reversal transparencies. Or a professional photographer may want to make large editions of color prints or color transparencies at a reduced or enlarged size from reversal originals. In either case, they will make an internegative, which can then be printed on color paper or color print film. This film is also useful in making additional prints from all types of reflection color originals, including oil paintings and photographic color prints where the negative does not exist.

The internegative film has a low gamma in order to bring the system gamma to approximately that of an original negative film. The gamma of the reversal original is, of course, quite high since it is designed for direct viewing.

This internegative film has higher upper scale gamma than lower scale gamma. In this respect, it is similar to the photo-identification negative film mentioned earlier (Fig. 14-11). However, instead of a single, pan-sensitized overcoat, this internegative has three high-contrast layers; one sensitive to red light, another to green light, and another to blue light. In this way, the saturation errors referred to earlier to not occur. This "upswept" shoulder acts as a highlight mask. It compensates for the rather low contrast toe of the reversal original and gives a more pleasing rendition of highlight detail.

Another type of internegative film is used in the professional 16 mm motion picture field where the camera original is a reversal film.[16, 17] This reversal film is designed not for direct viewing but to serve as a printing master. Its gamma is lower and latitude longer than the originals with projection gamma. Because of the lower gamma of the original, the gamma of the motion picture internegative is higher than that of the internegative described above. It has no upswept shoulder because the camera original has a more straight-line characteristic curve and a sharper toe than other reversal films (Fig. 14-12). The motion picture internegative must have better image structure than the

Fig. 14-12. Sensitometric curves of an internegative film used in the professional 16mm motion picture system where the camera original is a reversal film.

other internegative because it is used in a higher magnification system (12–24×). It can be quite slow because it is used on high-intensity motion picture printing equipment.

The reversal original is printed by contact onto the internegative film. The resulting internegative is printed onto motion picture print film by contact for 16 mm or by optical reduction for 8 mm. If the print is to be released in the 35mm format, the blow-up to 35mm occurs in the reversal-to-internegative printing stage, and the release is done on a 35mm contact printer.

CONCLUSION

This paper has summarized the color negative-positive silver halide systems in current use. What of the future? The trend has been toward smaller format systems that can be used in more portable, less expensive equipment. In the amateur photographic area, the trend is shown dramatically by the decrease in negative size from 620 to 126 to the new 110 size, which is only 16mm wide. This format required the development of a new negative film so that 7× enlargements from it would be comparable in quality to 3× enlargements from the 126 format. In the motion picture field, producers are now more interested in the 16 mm format, especially for television production, for economic reasons and for the greater portability and flexibility of 16mm equipment compared to the traditional 35mm system. There is also increasing use of and demand for the 8mm format in industrial and educational fields. The smaller formats increase the need for improved image structure of original, intermediate, and print materials.

Practical systems of negative-positive color photography have been around for less than 40 years. Because of their great flexibility, these silver halide systems will surely be around for many more years as speed/grain characteristics, sharpness, and color quality are improved.

REFERENCES

1. W. T. Hanson, Jr. and F. A. Richey, "Three-Color Subtractive Photography," *J. Soc. Motion Picture Television Engrs.*, **52**: 119–132 (1949).
2. W. T. Hanson, Jr., "Color Correction with Colored Couplers," *J. Opt. Soc. Amer.*, **40**: 166–171 (1950).
3. W. T. Hanson, Jr. and C. A. Horton, "Subtractive Color Reproduction: Interimage Effects," *J. Opt. Soc. Amer.*, **42**: 663–669 (1952).
4. R. M. Evans, W. T. Hanson, Jr. and W. L. Brewer, *Principles of Color Photography*, New York, 1953, pp. 158–163.
5. C. E. K. Mees, "Direct Processes for Making Photographic Prints in Color," *J. Franklin Inst.*, **233**: 41–50 (Jan 1942).
6. A. Cornwell-Clyne, *Colour Cinematography*, 3rd ed., Chapman and Hall, London, 1951, pp. 353–388.
7. W. T. Hanson, Jr., "Color Negative and Positive Films for Motion Picture Use," *J. Soc. Motion Picture Television Engrs.*, **58**: 223–238 (1952).
8. W. T. Hanson, Jr. and W. I. Kisner, "Improved Color Films for Motion Picture Production," *J. Soc. Motion Picture Television Engrs.*, **61**: 667–701 (1953).
9. M. L. Dundon and D. M. Zwick, "A High-Speed Color Negative Film," *J. Soc. Motion Picture Television Engrs.*, **68**: 735–738 (1959).
10. W. I. Kisner, "A Higher Speed Color Print Film," *J. Soc. Motion Picture Television Engrs.*, **71**: 779–781 (1962).
11. W. I. Kisner, "A New Color Negative Film for Better Picture Quality," *J. Soc. Motion Picture Television Engrs.*, **71**: 776–779 (1962).
12. R. L. Beeler, R. A. Morris and C. W. Simonds, "A New Higher Speed Color Negative Film," *J. Soc. Motion Picture Television Engrs.*, **77**: 988–990 (1968).
13. C. R. Anderson, N. H. Groet, C. A. Horton and D. M. Zwick, "An Intermediate Positive-Internegative System for Color Motion Picture Photography," *J. Soc. Motion Picture Television Engrs.*, **60**: 217–225 (1953).
14. H. J. Bello, N. H. Groet, W. T. Hanson, Jr., C. E. Osborne and D. M. Zwick, "A New Intermediate Positive-Intermediate Negative Film System for Color Motion Picture Photography," *J. Soc. Motion Picture Television Engrs.*, **66**: 205–209 (1957).
15. C. Beckett, R. A. Morris, R. K. Schafer and J. M. Seeman, "Preparation of Duplicate Negatives Using *Eastman* Color Reversal Intermediate Film," *J. Soc. Motion Picture Television Engrs.*, **77**: 1053–1056 (1968).
16. H. J. Bello, C. E. Osborne and D. M. Zwick, "A 16mm Color Internegative Film for Use in Color Motion Picture Photography," *J. Soc. Motion Picture Television Engrs.*, **65**: 426–427 (1956).
17. R. C. Brown, R. A. Morris and R. J. O'Connell, "An Improved Color Internegative Film," *J. Soc. Motion Picture Television Engrs.*, **77**: 990–994 (1968).

BIBLIOGRAPHY

R. M. Evans, W. T. Hanson, Jr. and W. L. Brewer, "Principles of Color Photography," Wiley, New York, 1953.
T. H. James (ed.), *The Theory of the Photographic Process*, 3rd Ed., Macmillan, New York, 1966.

15

SILVERLESS IMAGING SYSTEMS

Richard D. Murray
Institute for Graphic Communication

PART I

Some General Considerations on Silver Halide-Less Imaging Processes

Elsewhere in this voluminous work, the reader will discover information in great detail on essentially two imaging processes, namely, the silver halide process and the electrophotographic process. Although these two processes are most important and well known, there are at least 15 other major classifications of imaging processes. The purpose of this chapter is to discuss these 15 imaging processes—their history, technology, characteristics and applications. Since the emphasis in this book is on materials and processes, specific hardware embodiments of processes to be described will be held to a minimum.

Before specific materials and processes are described, some general thoughts will be presented for consideration. This preface will treat the synthesis of new processes, reprographic process design, classical trade-offs, and the future for permanent imaging systems.

SYNTHESIS OF NEW PROCESSES

Dr. Robillard in his article, "New Approaches in Photography," which appeared in the January-February 1964 issue of *Photographic Science and Engineering*, distinguishes the following steps which apply equally to old or new processes:

1. A triggering step or formation of a latent image.
2. An amplification step, where external energy is added to the system, or internal energy is supplied by the light-induced reaction.
3. A fixing step to render the visible image permanent.

These steps do not necessarily occur in discrete phases, but may occur simultaneously. The first step involves a photosensitive phenomenon such as photolysis, photoconductivity, photopolymerization, and the like. The second step could be energy added to the system in the form of chemical, electrostatic (charged particles), electronic (electrons), electromagnetic, or heat. This energy could be introduced prior, during, or after the photosensitive step. The third step, if necessary, could be chemical fixing (silver halide), thermal fixing (Xerography), etc.

Table 15-1 reproduced from Dr. Robillard's article, reviews physical and chemical phenomena susceptible to use in the different steps of photo-imaging processes. Of course, this could be adapted to non-light-sensitive imaging systems; for starters, lop off the "photo-" of each phenomenon listed in column 1.

It is not known whether any of the speakers at the 1969 S.P.S.E. "Novel Imaging Systems" seminar were influenced by this article, but their systems do indeed represent a diversity of possible combinations suggested by the above table—and even some not clearly suggested! One system has the same combination as silver halide, namely Itek RS, even though different materials act in RS as the light sensor and imaging material. The phenomena involved are as follows:

1st column—photoconductivity/photolysis
2nd column—chemical
3rd column—reduction
4th column—chemical

TABLE 15-1. STEP IN THE PRODUCTION OF AN IMAGE.

Photosensitive phenomena (triggering or latent image)	Amplification (development) nature of energy added to the system	Image-formation phenomena		Image fixation
Photoabsorption	Chemical	Changes in color due to chemical reaction	Oxidation Reduction Dissociation Synthesis	Chemical
Photoadsorption	Electrostatic (charged particles)			Electronic
Photocatalysis	Electronic (electrons)			Electromagnetic
Photoconductivity	Electromagnetic (RF, radiations)			Heat
Photodesorption	Heat			
Photodichroism			Absorption	
Photodielectric effect		Changes in optical properties	Birefringence	
Photoelectromagnetic effect			Dichroism	
Photoemission			Reflection	
Photodissociation ⎫			Scattering	
Photo-oxidation ⎬ Photolysis				
Photoreduction ⎪				
Photosynthesis ⎭				
Photomagnetic effect				
Photopolarization (electrolytic)				
Photopolarization (optical)				
Photopolymerization				
Photosensitization				
Photovoltaic effect				

Another system has the same combinations as xerography, namely, the Sun Chemical/SRI photoelectric electrostatic printing process, even though the method of toner transport is markedly different. The phenomena involved for both are as follows:

1st column—photoconductivity
2nd column—electrostatic
3rd column—reflection
4th column—heat

There the similarity with existing, conventional systems ends.

Table 15-2 below summarizes the phenomena involved in the remaining systems.

REPROGRAPHIC PROCESS DESIGN

If we can assume for the moment that an application for any one of these imaging processes has not been established, then there are at least two methods of approach, namely:

(1) If specifications for an imaging system (device plus media) are *mostly defined*, then one can determine which available, reprographic process provides the best fit or the most useful engineering compromise. This is not as easy to do as it may appear on the surface, for there has been a proliferation of reprographic processes in the past decade—all with their own set of characteristics, their ad-

TABLE 15-2. PHENOMENA FOR SPECIFIC SYSTEMS.

Steps in the Production of an image	EK Dry Silver	Dupont Dylux	S.D.W.1264	American Can Nitrone	Nashua Photo-electrolytic	Carter's Ink Electrophoretic	Hughes' photo-polymerization
Photosensitive Phenomena	Photolysis	Photolysis	Photolysis	Photolysis	Photoconductivity	Electrophoresis	Photopolymerization
Amplification (development)	Electromagnetic		Heat		(Electro-) Chemical	Electromagnetic	Chemical (self-contained)
Image-Formation Phenomena	Reduction	Oxidation (of Leuco dyes)	Synthesis (dye formation)	Dissociation	Oxidation	Reflection	Scattering
Image Fixation	Heat	Electro-magnetic	Heat	Heat	None Needed		Electromagnetic

vantages and disadvantages. Experimental as well as paper analyses usually must be made.

(2) If one is particularly enamored with one specific process—perhaps it is proprietary or can do something no other process can (all else being equal)—then the question naturally arises, "For what can we use this process?" Hopefully the strength or uniqueness of the process will lead to product concepts and then products which the world will decide it wants.

Thus we have two methods of approach in reprographic design—one based on a knowledge of what is needed now, and the other perhaps oriented to future needs not yet well defined. Approach (1) could be referred to as the deductive method, and approach (2) as the inductive method. From the media point of view, the latter approach of course is preferable because the hardware is built around the process and not vice versa.

CLASSICAL TRADE-OFFS

More times than not, one process will not meet all the specifications as laid down. Trade-offs must then be carefully considered before reaching any final determinations. The final choice may depend on what trade-offs can be best afforded.

Classical trade-offs in liquid processing systems likely will occur between the number of baths, the latitude of temperature dependency, solution toxicity, and processing time. In a dry processing system, conflicts frequently arise when one attempts to simultaneously satisfy requirements for light sensitivity, processing ease, image tone, and material cost.

Some specific classical trade-offs which still hold water are:

1. Processing convenience is at the expense of light sensitivity.
2. An increase in the number of processing steps yields an equivalent increase in electromechanical complexity.

From all of this will be derived, hopefully, the most useful engineering compromise.

REPRESENTATION OF GRAPHIC SYSTEMS

At this juncture, let us review the various possible functions of acquisition, communication, and storage/retrieval which can precede hard copy readout in a graphic system, as represented in Table 15-3. This representation indicates the four basic functions as well as illustrative subfunctions within each of the major func-

TABLE 15-3. GRAPHIC SYSTEM-GENERALIZED REPRESENTATION.

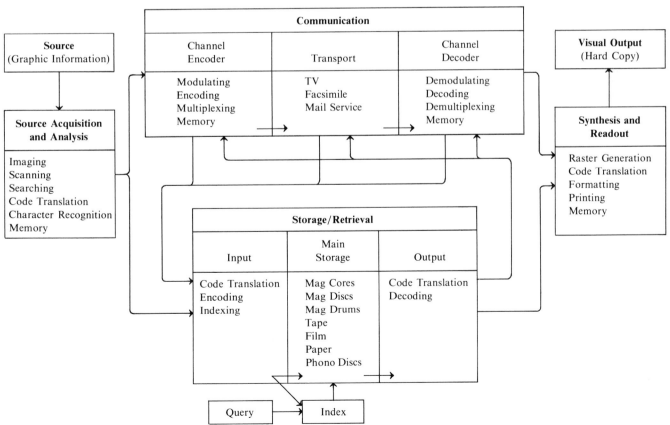

tional blocks. This relatively simple representation is actually very comprehensive. Entire industries can be considered to be represented within this figure, including the industries associated with photography, television, motion pictures, microfilm, libraries, printing and publishing, facsimile, graphic arts, office copy, map making, video recording, visual presentations, and CPO.

FUTURE FOR PERMANENT IMAGING SYSTEMS

A proper question to ask ourselves now is, "What is the future of these permanent imaging systems," or in the engineers' lexicon, "What does the future hold for hard copy systems?"

There are at least two ways to predict the future—one by an analysis of the recent past and the other by an analysis of likely future developments which relate to the need for hard copy systems.

Fifteen short years ago, many classes of such systems, which today are commonplace, did not exist or were in their infancy. Today we see an office copy market of $3 billion; we see a microfilm market of $600 million (services excluded); we see a rapidly growing CPO market which will be at the $1 billion level shortly; and the medical/industrial x-ray film market of over $200 million. According to the U.S. Department of Commerce, the value of shipments of the Printing and Publishing industry exceeded $24 billion in 1974 and shipments of photographic equipment and supplies amounted to $6 billion. Why should this strong growth trend for hard copy systems mysteriously slow down or plateau out?

In regards to future trends, allow me to quote the abstract from the most stimulating article on the subject matter I've seen, "Communications," by Kenneth Fischbeck, Manager of RCA's Graphic Systems Research Laboratory. His remarks were made at a "Panel on Communicating—1978" and reprinted in *Tappi*, September, 1968. The abstract states that, "by 1978, printing will no longer be done almost exclusively on huge printing machines but will also be done on thousands of smaller machines in offices, schools, and homes—information appliances coupled into information networks. In spite of spectacular developments in telecommunications, limitations of the human brain as an information absorber ensure the continued importance of the print-on-paper as an economical and efficient way to communicate to people."

There can be no doubt that we are in the midst of a communications revolution—witness television, the computer, communications satellite, and the laser. The shipping efficiency of communication channels is improving at such a rate that soon the primary cost of communication will be the cost of the terminal device. For example, 50 magazine pages per second can be transmitted by microwave, 150 pages per second by satellite, 500 by wave-guide, and experimentally, the laser can send 5×10^6 pages per second. The laser can

give man control of light as an information carrier. Technology is creating a situation of "absolute communication abundance."

Mr. Fischbeck suggests we now look at the human being who is on the receiving end of this information flood. Psychophysical tests have shown that the human brain can process original nonredundant information at only 40 bits/sec, yet in TV this human being is bombarded with 6×10^6 bits/sec. It would appear that just as the computer has outstripped his ability to calculate, so do communication channels already deliver to him more information than he can absorb.

Electronic telecommunications has the advantage of timeliness, but the disadvantage of consumer convenience and ease of referral. TV news broadcasts haven't yet replaced the newspapers in our homes, because a paper can be picked up and read at any time—at the consumer's convenience—and later referred to again.

Life and the world have, are, and will continue to be full of graphic systems. Hard copy is here to stay until someone finds a better way to make available understandable information, on demand, to the user. Thus there may be new sources of hard copy such as from computers, microfilm, and graphic transmission systems—and there may be new tools employed to transmit such information, e.g., communication satellites, wave guides, and lasers—but hard copy itself is here to stay for our foreseeable future.

In the world of today, the designer of a system, whose output value is permanent marks or images on a suitable media such as paper or film, examines all available imaging processes to determine which one provides the most useful engineering fit to the stated requirements. Thus both light and non-light sensitive imaging processes are considered. Why, in some cases, different designers choose in one case a light sensitive solution and in the other case, a non-light sensitive solution to the same problem. For example, the facsimile wire recorders of the future are a Dry Silver Photographic unit for Associated Press, and a dielectric recording unit for United Press. Since the common denominator is a process which forms images, the author proposes in Table 15-4 a new classification for commercial imaging processes, all of which can be included under the term "Imageography."

The variety of permanent, imaging systems which will now be described attests to the intense interest of many companies in the rapidly growing reprography markets. Although considerable research continues on silver-based systems, a wide spectrum of organic compounds are being investigated for their light sensitivity. In addition, nonsilver inorganic materials are being closely scrutinized, particularly for use in electrophotographic systems. Non-light-sensitive processes which respond to many different forms of energy have been developed. If we assume the ratio of permanent, graphic information required to total information will remain fairly constant for the foreseeable future, we can then reason that the growth of the market for such hard copy producing systems will be directly affected by the so-called

TABLE 15-4. PROPOSED CLASSIFICATION FOR PERMANENT IMAGE FORMING PROCESSES

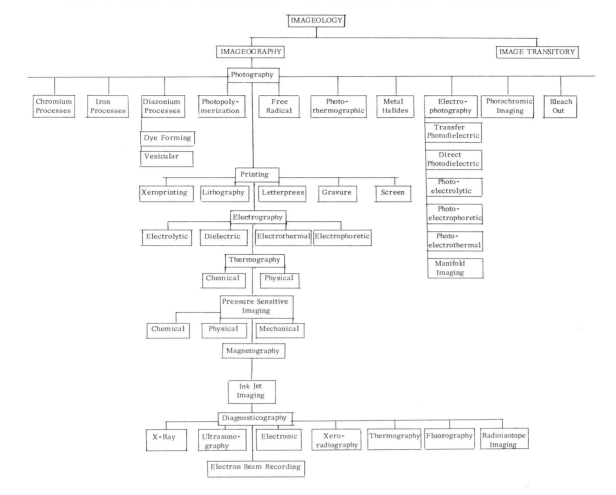

"information explosion" and its growth should be significantly greater than that of the GNP.

PART II

Non-Light Sensitive, Silverless Imaging Processes

A more apt title for this part of the chapter might be, "Imaging by the Selective Application of Electrical Energy or Heat or Pressure or Magnetic Fields." This obviously then eliminates photosensitive imaging processes which have been discussed at great lengths throughout the rest of this book. These "photographic" processes are, in part, widely recognized since most of us are amateur photographers and have used office copying equipment. However, the real world of imaging is indeed much broader and depends on a multitude of different imaging processes which respond to a variety of stimuli to form permanent graphic marks on suit-able recording media. In this part, the attempt will be made to provide some recognition to these often overlooked (and perhaps unappreciated) non-light sensitive imaging processes which are so important in a wide variety of recording and imaging applications, such as:

1. Facsimile image transmission for wire "photos," business documents, fingerprints, weather maps, negatives for satellite printing plants, library documents, engineering drawings, and the like.
2. Computer printers and plotters.
3. Calculating machines.
4. Oceanographic recorders.
5. Voiceprint recorders.
6. Carbonless and carbon copy papers.
7. ECG and EKG recorders.
8. Business forms of multiple ply.
9. Visual transparency makers.
10. Stripchart recorders.
11. Thermal copiers with which overhead projection transparencies, stencil masters, and copies can all be made.

Annual equipment and supply sales in the U.S. for the above is greater than $2 billion dollars.

ELECTROLYTIC PAPERS

History

Electrolytic recording appears to have first been reported by Bain in 1842-7 who marked paper saturated with ferrocyanide solution with an iron anode.[1] This method of printing using easily controlled voltage and current attracted some of the big names. T. A. Edison was granted 10 patents for electrolytic systems in 1875,[2] and Friese Greene patented a system in 1901.[3] The first patent of practical importance is that of Zwerykin, Elsey, et al., to Westinghouse in 1933[4] in which silver is electrolysed from an anode and reduced by catechol. This was followed by Elsey (Westinghouse) in 1936[5] where silver is reduced by formaldehyde. The first practical photo-quality system was disclosed by Hogan, et al. (Faximile, Inc.) in 1944[6] using a steel anode with catechol. This is the system which was first adopted by the press services for their wire photo networks. Subsequently, variations and improvements on this system have largely been kept secret. Minor ingredients which improve response, definition, and storage life are not normally disclosed. A 1965 French patent[7] (British (1967)) describes an improved pyrocatechol paper. Recent patents in this field are extensions of the Elsey silver formaldehyde system. Lieblich[8] and Barnes, et al.[9] have disclosed the use of sulfites and sulfoxylates of aldehydes in almost simultaneous and conflicting patents.

The present commercial position is divided between the iron-catechol, iron-MDA, and silver-aldehyde systems. All types are used for document and line-drawing transmission. The iron-catechol system provides all of the electrolytic press wire-photo requirement. Both iron-catechol and iron-MDA are used for weather chart reception. Silver-aldehyde is used almost entirely for document reception. Major producers are:

Muirhead, Inc., Mountainside, New Jersey,
Alfax Paper and Engineering Company, Westboro, Massachusetts,
Telautograph, Inc., Los Angeles, California.

Electrolytic Recording—Chemistry

In electrolytic recording moist paper is drawn between two electrodes. Power requirements are 30–70 V dc at 100–250 mA for full intensity. The anode is a metal which is electrolysed into the solution with which the paper is moistened. The cathode is a noble metal such as platinum, and does not enter into the reaction. The paper, made of alpha cellulose pulp, is typically 30×10^{-3} in. thick, absorbent, and wet-strengthened. It is moistened with an aqueous solution such as potassium nitrate to provide electrical conduction, and a "marking compound." The marking compound is selected to precipitate the ions of the anode metal in a colored form, or as a colored compound.

The systems in commercial use are:

Anode	Marking Compound	Cathode
Steel	Catechol	Inert
Steel	M.D.A.	Inert
Silver	Formaldehyde Complex	Inert

The inert cathode should ideally be platinum or gold, but stainless steel and nickel are serviceable. Catechol is 1:2 benzenediol $C_6H_6O_2$. M.D.A. is methylene disalicylic acid $C_9H_{12}O_6$. Formaldehyde is used as a complex such as sodium formaldehyde sulfoxylate or sodium formaldehyde bisulfite.

Characteristics by which selection should be made are:

System Property	Iron Catechol	Iron M.D.A.	Silver Formaldehyde
Density (D. max)	1.2	1.0	1.2
Gray scale response (dynamic range)	good	fair	unstable
Shelf life at 75° (months) (sealed prior to recording)	9–24	36+	9
Copy stability	fair	good	poor
Definition	good	fair	very good
Color of print	blue/black	red/brown	black/brown
Major use	wire-photo	weather chart	inter-office document

In many applications the catechol system would be preferred, but it has the disadvantage of the slight volatility of catechol which reacts with nearby paint and paper, causing discoloration. Attempts have been made to avoid this by use of nonvolatile substituted catechols, such as protocatechuic acid, but cost restricts these products to special applications.

For optimum results, the paper is made with high-purity alpha cellulose paper of high wet strength. The solutions are prepared and applied to the paper by techniques which are closely guarded secrets of the individual manufacturers. However, experimental quantities can be prepared in the laboratory by saturating wet-strengthened filter paper (Whatman #5) with the following solutions. Excess solution is removed by pressing between several sheets of dry paper.

Catechol Solution:

Sodium nitrate	50 g
Sodium chlorate	50 g
Catechol	50 g
Sodium phosphate	3 g
Thiourea	3 g
Water	to 1 l

M.D.A. Solution:

Potassium chloride	100 g
Potassium hydroxide	26 g
Methylene disalicylic Acid	60 g
Water	to 1 l

Prepare, heat to 70°C, add:
hydrochloric acid-10 ml, water-90 ml.

Formaldehyde Solution:

Sodium formaldehyde sulfoxylate	80 g
Sodium nitrate	60 g
Sodium carbonate	3 g
Water	to 1 l

Advantages of these papers are their low cost (1–3 cents per ft²), simplicity of operation, no processing after recording, and modest electrical requirements. Disadvantages are the use of moist paper and restrictions on paper thickness and texture.

Critique

Certain deficiencies are apparent in each of the three systems above described. The system which requires the least erosion and utilizes a low cost mark producing compound produces a mark which is too diffused and of too light a color for generally accepted contrast. The system which permits relatively good laydown of the mark requires much greater erosion of a relatively expensive anode with consequent inefficiency, and the system which provides a mark of good density without excessive anode erosion lacks the capability of producing either a stable mark or one without diffusion due to chemical action.

Other systems have been used to a limited extent in order to overcome some of the deficiencies of the above described systems, but, where the mark produced is of a comparably acceptable density, the cost of the mark producing compound still far exceeds that used in any of the three more commonly used systems. Diffusion of the mark produced has, in acid systems, been partially limited by the addition of antioxidants which act to limit the discoloration of the area fringing that where the mark first appeared. Humectants have also been added to prevent deterioration in the mark produced in low spot speed applications. Anodes of narrower than normal width have also been used to control the area of the diffused mark produced, but their use results in excessive scolloping of the medium's surface which in turn causes a deterioration in the laydown of the mark.

Practical Considerations

There must *always* be good electrical contact between the electrodes and the surface of the paper when recording is taking place. When the marking spot area is in the order of .01 × .01 in.², a minimum contact pressure of around 10 g usually must be maintained to obtain good marking at spot velocities up to possibly 10 or 15 in./sec. At higher marking speeds, still higher pressures may be necessary.

Since the marking of electrolytic papers is an electrolytic deposition process, the marking is essentially a *current* or charge-passed phenomenon. It has been shown that around ½ C/in.² is adequate for a good black marking at spot velocities up to 50 or so in./sec. The impor-

tant point to keep in mind is that the primary effect is produced by the current and that any effects of the voltage drop (and hence the actual power input), ion transmit time, etc., are secondary. These secondary effects may become important to the copy quality at the higher spot velocities. At spot velocities up to possibly 50 in./sec, any effect on copy quality other than by charge passed is negligible.

The voltage drop for a given current through the paper is subject to wide variations. Electrode area in actual contact, electrode pressure, exact moisture content of the paper at the time of recording, all tend to affect the voltage required to force a given current through the paper. Therefore, the ideal marking source is a *constant current* generator.

How far one can depart from this ideal marking source without encountering trouble depends upon many factors. If a given current produces a reasonable black mark at a fixed spot velocity, increasing the current by a considerable amount will only result in a slight increase in mark density and possibly a slight increase in apparent size of the mark. In this case, the designer need only be certain that adequate voltage is available to produce the required minimum current under the *worst* conditions and that the current overshoot encountered under good conditions will not get to the point of actually scorching the paper.

The production of copy covering the full range of white to black with faithful rendition of many shades of gray is a more difficult problem. Here something that approaches close to a constant current source *must* be used. It has been found in practice that control of all the factors that can influence the voltage drop for a given current is in most cases impossible. Hence this most important rule—use a *constant current* source when gray linearity must be preserved.

The question of what is the highest practical marking spot velocity comes up frequently. This appears to boil down to a problem of how high the current can be pushed without paper destruction. The combination of high current and the resulting high voltage increases dissipation at the point of marking until the paper is literally burned through. Increasing the electrode pressure lowers the voltage drop and minimizes the burn tendencies up to a point. Excessive electrode pressure tends of itself to cut through the paper so a limit is reached on how far the pressure can be increased.

Good marking with a single spot recorder has been obtained with catechol papers at velocities in excess of 200 in./sec. The mechanical problem of maintaining *uniform* optimum electrode *pressures* and *contact* areas is the most severe obstacle to attaining still higher marking speeds.

What is the shortest pulse that can be recorded? This question is closely akin to the one discussed above. Square current pulses of 17 μsec produce marks which are not immediately visible (or are barely visible) but which are plainly visible after the paper is heated as described above. Pulses as short as this call for currents of one ampere or more for a 0.001 in.² area. The chem-

istry of high speed electrolytic recording has been discussed by Grieg.[10]

REFERENCES

1. A. Bain, U.S. Patent 6328 (1849).
2. T. A. Edison, U.S. Patents 160,402 (1875), 160,403 (1875), 160,404 (1875), 160,530 (1875), 166,859 (1875), 166,860 (1875), 166,861 (1875), 168,465 (1875), 168,466 (1875), 168,467 (1875).
3. W. Friese-Greene, U.S. Patent 670,510 (1901).
4. Zwerykin, et al. U.S. Patent 1,909,142 (1933).
5. E. M. Elsey, U.S. Patent 2,063,992 (1936).
6. Hogan, et al. U.S. Patent 2,339,267 (1944).
7. A. Goldstein, French 1,393,448 (1965).
8. I. Lieblich, U.S. Patent 3,332,857 (1967).
9. Barnes, et al. U.S. Patent 3,349,013 (1967).
10. H. G. Grieg, "The Chemistry of High-Speed Electrolytic Facsimile Recording," Proceedings of the IRE, October, 1948, pp. 1224–1235.

In all, over 60 U.S. patents which pertain to the electrolytic recording process have been issued since Edison's time.

ELECTROSENSITIVE "BURN-OFF" PAPERS

Like electrolytic, these papers have been with us for some time. Most of you are familiar with Western Union's Teledotos used in their desktop message facsimile unit, DeskFax. Over 40,000 of these were installed at their peak.

The world's largest manufacturer of such papers is Fitchburg Coated Products, a division of Litton Industries. Their papers are used in facsimile equipment manufactured by Litton, Graphic Sciences, 3M, and Xerox, as well as many other types of recorders, including oceanographic, strip printers, high speed recorders (LASL), voiceprint recorders, and nondestructive test recorders.

Although burn-off is more expensive than electrolytic, it is dry and yields excellent black and white copy. However, it does have some odor, is pressure sensitive, and generates RF energy. Two advantages of the process are: (1) intermediate tone reproduction and (2) minimum paper-wrinkling problems.

FCPI papers are manufactured by coating a white bond paper with conducting layers of carbon and then applying the top white masking coat. The bond paper is coated with three separate coatings: a base coating consisting of a binder in which is dispersed a high percentage of electrically conducting carbon; an intermediate coating applied over the base coating consisting of a binder in which is dispersed a low percentage of electrically conducting carbon; and a top coating, white or light in color, applied over the intermediate coating, consisting of a binder in which is dispersed a white electrically conducting pigment such as zinc oxide. These papers are discussed in several patents by Dalton and Cooley.[1-5] These patents pertain to FCPI papers, and most have been updated. This section will concentrate on FCPI papers although others manufacture such papers. Much of the early work was done by the Times Facsimile Corporation, which eventually was acquired by Litton Industries.

History

The general design of FCPI papers was arrived at after extensive searches that began in 1923. The first recording was accomplished by high voltage discharge from a stylus point. The discharge was not a spark but in the form of a corona that had sufficient power to properly affect slow photographic papers such as Azo IV. The papers had to be developed photographically after exposure.

A few weeks after the first recording was made by this process, the search for a good dry recording paper began. The plan was to coat papers with a light colored salt which would break down and change color under the influence of the electrical discharge. The only salt that looked encouraging in 1923 was mercuric sulfocyanate which had to be ruled out for obvious reasons.

The Eastman Kodak Company was asked to assist in the development of a satisfactory recording paper. The equipment supplied Eastman Laboratories for testing their papers produced an electrical discharge having less than one watt of power. In 1926 one watt of power supplied by a tube amplifier was considered to be close to a practical limit as the amplifiers were operated on B batteries. With this small amount of power the results were not very encouraging. The only papers which looked promising discolored after a few months of storage. Many papers of the so-called dry electrolytic type were developed between 1930 and 1940.

While most of the papers produced very good recordings at high speed and with low power consumption, they all failed to operate when in equilibrium with an atmosphere of about 20% relative humidity or less. They also became very damp and limp when in equilibrium with an atmosphere above 80% relative humidity. Over the operating range of relative humidity from about 20% to 80%, they gave good results in general although the contrast or density of the recorded area varied somewhat with the amount of moisture present in the paper.

In developing a recording paper for Western Union (around 1935) Wise contrived to deliver considerable power at the recording stylus point by using an electrically conducting paper and matching the contact resistance load with the impedance of the output amplifier. The paper was made electrically conducting by impregnating the entire sheet with carbon. A light top coating was applied but in such amount that some of the conducting paper fibers projected through to the surface of the coating. The top coating disintegrated when current passed between the stylus tip and conducting paper due to heat dissipated through the contact resistance. At first, red mercury salts were used for the top coating but it was soon found that white zinc salts could also be decomposed or marked under the influence of the electrical discharge. The Western Union papers bearing the trade name Teledeltos were the first commercially successful dry recording facsimile papers.

In the subsequent work on dry recording papers by Times Facsimile Corporation, it was found that if the nonconducting white coating were applied in a layer heavy enough to produce a good white appearance,

relatively high voltage was required at the stylus point to break through the coating. The point of breakthrough was generally small and ragged, producing a salt and pepper appearance rather than a good solid black line. To reduce this effect it was necessary to use a very thin coating which developed a shrivelled paint appearance on drying. The electrical discharge then could easily start in the cracks of the coating. This arrangement resulted in sharp recording but the paper appeared as gray rather than white because of thickness of coating.

The development of a semi-conducting white pigment eliminated the need for the cracks in the coating and permitted the use of a thicker coating. This resulted in a recording paper that had an almost white appearance. Such electrosensitive "burn-off" papers are marked by placing a voltage on the writing surface. The voltage is placed on the paper usually through a tungsten or iron stylus. The paper turns black only in the stylus contact area and only when voltage is applied, which causes the top layer to volatilize or "burn-off," revealing the black under layer. The recording paper is dry and is not affected by radiation, light or changes in humidity or temperature under normal operating conditions. No special handling or conditioning is needed before or after its use. The copy is clear, dry, legible, and permanent and is ready for immediate use without processing or developing.

Physics and Theory of Operation

Any attempt to describe the operation of FCPI papers[22] on considerations based on condenser breakdown alone meets with many objections. The paper appears at first sight to be a multilayer condenser of the type discussed by Maxwell.[6] However, since some of the layers consist of a dielectric containing electrically conducting particles, considerations must be given to the work of Wagner[7] on dielectrics containing conducting spherical particles and of Sillars[8] on dielectrics containing conducting spheroidal particles. The situation, however, appears to be more complex than would be suggested by any of this work although the ideas put forth have a considerable bearing on explaining the initial current flow and dielectric losses that might be responsible for the start of the breakdown process.

If for the moment the top coating is assumed to be absent and the recording is taking place between the immediate coat and the drum or grounding surface, the theory of semi-conductors developed by Wilson[9] can be applied to best explain the observed effects taking place during the recording process.

While any breakdown process must be considered in the light of the materials involved, experimental evidence indicates that it is fundamentally electronic in nature. The fact that breakdown takes place in approximately 10^{-8} sec would seem to preclude any other concept. However, failure may finally result from impurities or cavities in the medium, chemical instability, heat developed as by the interaction of electrons, by the interaction of electrons and lattice, Joule heat, photoelectric effects, etc.

It is known from the work of Block[10] that the possible energy levels of an electron in a crystal may be divided into allowed bands separated by bands of forbidden energy. Such a scheme to show the characteristics of electrons in solids is represented in von Hippel.[11]

The same considerations apply to dielectrics of a nonpolar or homopolar nature such as high polymer resins, only the character of the atomic groups makes the situation much more complicated. It is expected that since the atoms of such compounds are arranged in a somewhat irregular order, centers would be created in which large numbers of electrons could be trapped introducing levels close to the conduction band. Such centers should exist at some critical temperature Tc and increase as this temperature increases. Tc is difficult to define but is the temperature in the range of which the structure changes from crystalline to amorphous. It is analogous to the temperature in semi-conductors at which conductivity is observed from electrons associated with p-type or n-type substances. They should also increase with the molecular weight of the polymer. Work at Times Facsimile and that of Austen and Pelzer[14] on the breakdown strength of paraffin and polyvinyl chloride-acetate resins would tend to bear out this theory. Attempts however to produce appreciable electronic conduction in substances of this type, with small fields at room temperatures, have been unsuccessful except where colloidal carbon or colloidal metals have been used and are uniformly dispersed in the compounds. Films made from compounds of this character have properties very similar to conductors or semi-conductors depending upon the relative ratio of two materials used. These films appear to be like the alkali halide crystals investigated by Lehfeldt.[15] Colloidal metal contained within these crystals was found to act as trapping centers for electrons.

It has been shown by means of the electron microscope that electrically conducting carbon particles are spherical and in many types arranged in chains or clusters. If these groupings are separated as by mechanical working, a reduction in conductivity results. If sufficient work is applied, the carbon may lose practically all of its conductivity. In any event, it would appear from the recording characteristics of carbon films examined that free electrons exist in the conduction levels of the carbon free portions of the films and are produced in great numbers immediately before breakdown.

The ideas discussed above can be used to explain the recording properties of FCPI paper. The base coat is a relatively good conductor and consists of a dielectric in which colloidal carbon is uniformly dispersed. The intermediate coat, however, consists of a good dielectric in which a small percentage of colloidal carbon is uniformly dispersed. The resistance of a film 0.001 in. thick and 1 cm^2 in area of several megohms is a typical case.

Two conditions which would ultimately lead to breakdown when a field is applied between the intermediate coat and the grounding surface are possible:

1. The density of electrons in the conduction band and excited levels is sufficiently high that collision between electrons takes precedence over collision between electrons and lattice.

2. The density of electrons is so low that collision takes place between electrons and lattice.

From the nature of the films involved, it is evident that a large number of free electrons are present and it can be anticipated that as the field increases, the electronic temperature will increase relative to that of the lattice for strong fields. Also, for strong fields the rate of transfer of energy from the field to electrons is greater than from the field to the lattice. Since no stabilizing effect is present, the electronic temperature will continue to rise at the same time, raising more electrons into the conduction levels until breakdown occurs. The small starting current necessary to bring about the production of an electron avalanche at the low field strength (200–500 V) employed is supplied by the capacity effect of the paper. The breakdown path is restricted by the character of the film, the shortest path perpendicular to the surface. Since the stylus is in contact with the point of breakdown for less than 10^{-3} sec, only a small hole is produced through the films. For longer periods of stylus contact, a larger hole will be produced, or by proper modifications in the base and intermediate coats the hole size can be controlled within certain limits. The effect of pulse duration is quite important as shown by Plessner.[16] Translated into recording speed (inches/second), this work would indicate that for good sharp recording, a limit exists which should not be exceeded. This limit will depend upon the frequency of the signal current, wave shape, etc., and has not been thoroughly investigated. However, it would seem that it is in the range of 10 to 50 in./sec or a pulse duration of 10^{-3} to 10^{-4}.

In order that the recording be made easily visible, provision must be made to produce maximum contrast between the perforated and nonperforated areas in the intermediate film. This is accomplished by means of a top coating applied over the black intermediate film. From what has already been discussed, it becomes obvious that for best results the electronic nature of this top coating should be as near white as possible so that when breakdown takes place, the perforated areas will appear black against a white background.

To produce a pigment of the type required, zinc oxide—an ionic crystalline material—was chosen and processed to produce a pigment of good whiteness and proper conductivity so that when incorporated into a binder and applied to the intermediate coat, it will function as already discussed.

Utilizing the concepts outlined above, it has been possible to devise other products of commercial importance such as the electronic stencil know as the Stenafax stencil, the offset printing plate known as the Planofax plate, and methods of engraving rolls for lithographic printing, etc.

The Stenafax stencil is basically an electrically conducting polyvinyl film about 0.0015 in. thick which provides a quick and economical means of duplicating letters, legal papers, office forms, advertising layouts, etc., by means of a mimeographic machine. The recording process consists in electronically perforating small holes in the stencil so it may then be used on a mimeograph machine in the same way as a regular typed stencil.

The equipment used for electronically perforating the stencil is similar to regular facsimile equipment except that the transmitting and receiving units are built into a single unit with two drums rotating on the same shaft. It is called a Stenafax machine. As many as 10,000 copies can be obtained from one stencil.

Power Required

Direct, alternating or pulsed dc may be used for recording. DC recording results in better marking with the positive side on the stylus. Recording with pulsed dc or ac results in a series of dots which will appear as a continuous line if the frequency and scanning rate are in proportion. In certain types of recording, it may be desirable to use a frequency which separates the dots. This can be accomplished by decreasing the frequency, increasing the scanning rate, or both, whichever may be desirable. The black mark produced is limited to the contact area between the stylus and the recording surface on through conductive papers. In the Timemark series, the base sheet is relatively low resistance, therefore a grounding roller or plate on the back of the recording paper is suitable for completing the recording current path. FCPI's Timefax series papers are specially constructed so they may be grounded on the top. This permits the electrosensitive coatings to be placed on virtually any surface including papers, films, and three dimensional objects.

The recording surface is of relatively high resistance and so acts as a nonconductor at potentials less than about 50 V. This threshold breakdown effect tends to limit the size of the mark to about 0.010 in. The use of a larger diameter stylus does not produce a larger mark.

Potentials of 70–500 V are used for marking. The actual voltage or power required in a particular instance depends on several factors, including recording speed (relative motion between stylus and recording surface), recording current frequency and stylus shape and pressure. The mark is always black, but the apparent density changes as the size of the mark varies. The mark varies basically as voltage varies. As a result, tonal variations may be reproduced. This variable tone density or shading characteristic is important in many applications.

A higher voltage is needed to start the recording action than is needed to make a continuous mark. For this reason it is desirable to provide an open circuit stylus voltage well in excess of that required to maintain recording current after initial breakdown. The current is limited by impedance in the marking circuit, usually a resistor just before the stylus.

Recording Methods

Several techniques have been used for recording on FCPI electrosensitive papers, including stylus (single and multistylus) fixed or oscillating pen methods and spiral and bar. The stylus method has been found to produce the more superior copy in terms of sharpness, resolution, and tonal response.

Stylus Conditions

The appearance of the recording trace is also affected by the diameter of the stylus and by the contact pressure. A tungsten wire stylus of 6–10 mils diameter is often used because of its strength and hardness. As even finer stylus is used where exceptional sharpness is desired, as with 200 line facsimile recording apparatus. A light stylus pressure is desirable and though tungsten is preferred for long life, a stainless steel or iron stylus is often used.

Contact pressure ranges between 3–15 g (averaging 1–1.5 g. per mil of stylus diameter). The power required for a trace of maximum density varies from less than a watt at low voltage and low recording speed to 7–10 W at higher speeds. A current-limiting resistance of several thousand ohms is usually placed in series with the stylus. Equipment using single as well as multiple stylus systems is in use.

Marking Speeds

Up to 1000 in./sec writing speeds have been employed. As speed increases, density decreases unless more power is put to the paper. Careful control over the contact between the stylus and paper must be exercised at speeds over 100 in./sec to be sure that proper contact is maintained.

Tonal Response

Varying the recording voltage results in a change in the size of the recorded dot. Though the dot is always black, larger dots will make the resultant copy look darker than if smaller dots are recorded. This tonal response is often used to obtain information in the third dimension. Facsimile recorders, ocean depth recorders, ultrasonic x-ray recorders, radar recorders, and many other applications make use of the tonal response. Approximately 15 shades, from white to black, can be recorded.

Typical Recording

A typical recording situation might be as follows:

Seven watts at 450 V (for ac-2000 Hz), stylus speed of 20 in./sec, stylus pressure of 7 g, stylus diameter of .008 in., and a line feed of 100 lines to the inch. These conditions would result in a copy density of about 1.6 taking into account the surface characteristics of the paper. Varying the voltage varies the density or shading of the copy.

Recent Developments

Several organizations have been developing low voltage, electrosensitive recording papers which can successfully image in the 10–50 V region. Most of these papers involve very thin, metallic top coatings which have been pro-duced by vacuum metalizing techniques. Materials such as aluminum and rhodium have been tried. Features include high writing speeds, low power consumption, and little dust or odor. To date such papers have a gray or metallic appearance. Applications include CRT hard copy, calculators and minicomputer and microprocessor output.

Dry Electrochemical Media

At least two dry electrical recording papers have been introduced which give immediate images without need for moisture and with little or no burnoff. Both involve the reduction of a pigment such as zinc oxide to its elemental state which will appear colored. 3M and Hewlett Packard produce such papers.

In the 3M case, Clark's patent 3,138,547 describes the media. An electrosensitive layer composed of an electrically reducible metal compound and binder is coated on an electrically conductive layer of vapor deposited aluminum on a paper base. It currently is used in Motorola and Control Data nonimpact printers and at one time was seriously considered for use in Western Union's Deskfax machines. This ESP is lightly colored and forms marks of moderate contrast up to 300 in./sec if some odor and arcing is tolerable. Papers have been formulated for continuous and pulsed. Some acetylene is given off during recording. It is not pressure sensitive. Maximum image density is around .9, which is considerably less than dielectric or burn-off can do. The stylus is not consumed by the process and usually is of negative polarity. About eight shades of gray are obtainable; density is proportional to power past a certain threshold up to the arcing point.

Hewlett Packard has developed a similar line of electrosensitive papers for use in their graphic recorders and calculators. Conductive zinc oxide—available from New Jersey Zinc and others—is dispersed in an organic binder and coated onto aluminum laminated or vacuum metalized paper. The passage of current through the coating reduces the zinc oxide in the layer to free zinc, thereby forming the mark. The mark is in the coating, unlike other electrosensitive systems where the mark is the result of erupting the coating from its base and exposing a black sheet. To prevent carbonization of the coating materials, the coating is designed so that its resistance increases when the mark is made. Both very high and very low writing speeds are possible without degradation of the mark. As a consequence, the writing process is clean and dry.

Writing rates as high as 200 in./sec and as low as ½ in./hr are practical with some papers of this type. These papers are particularly useful in those applications where a permanent, rugged copy is required, where record cleanliness is important, and in those areas where rapid start up and reliability are of importance. The paper cannot be marked by pressure, heat, light, or moisture. The marks are smudge resistant and reasonably contrasting.

Some RFI is generated during marking, but good

instrument design reduces the radiation to a level low enough that interference with other equipment is not a problem. Some odor is generated during marking that is detectable when writing at higher speeds. The vapors given off during writings are nontoxic. Image tone is brown–dark brown.

REFERENCES

1. H. R. Dalton, et al., U.S. Patent 2,238,779 (1946).
2. H. R. Dalton, et al., U.S. Patent 2,554,321 (1951).
3. H. R. Dalton, U.S. Patent 2,554,017 (1951).
4. H. R. Dalton, U.S. Patent 2,664,044 (1953).
5. A. G. Cooley, et al., U.S. Patent 2,638,422 (1953).
6. J. C. Maxwell, *Electricity and Magnetism*, Clarendon, Oxford, 1892, Vol. 1, p. 452.
7. K. W. Wagner, *Die Isolierstoffe der Elektrotechnik*, H. Schering (ed.), Buhn, Springer (1924).
8. R. W. Sillars, *J. Inst. Elec. Engrs.* (London), **80**: 378–394 (1937).
9. A. H. Wilson, *Proc. Roy. Soc.*, (A) **133**: 458 (1931); also *Semi-conductors and Metals*, Cambridge, 1939.
10. F. Block, *Z. Physik:* **52**, 555 (1928).
11. R. von Hippel, *Dielectrics and Waves*, Wiley, New York, 1954.
12. J. Frenkel, *Z. Physik*, **35**: 652 (1926).
13. C. Wagner and W. Schottky, *Z. Phys. Chem.*, (B) **11**: 163, 1930.
14. A. E. W. Austen and H. Pelzer, *J. Inst. Elec. Engrs.*, (London) (I) **93**: 525 (1946).
15. W. Lehfeldt, "Göttringer Machrichten," *Fochgruppe* II, **1**: 171 (1935).
 W. Lehfeldt, "Göttinger, Machrichten," *Fochgruppe* **2**: 91 (1936).
16. Plessner, *Proc. Phys. Soc.*, **60**: 243 (1948).
17. F. Seitz, *The Modern Theory of Solids*, McGraw-Hill, New York, 1940.
18. N. F. Mott and R. W. Gurney, *Electronic Processes in Ionic Crystals*, Clarendon, Oxford, 1946.
19. W. Shockley, *Electrons and Holes in Semi-conductors*, Van Nostrand Reinhold, New York, 1950.
20. R. J. Wise, U.S. Patent 2,694,146 (1942).
21. B. L. Kline, U.S. Patent 2,251,742 (1941).
22. H. R. Dalton and A. G. Cooley, "Times Facsimile Recording Papers," a paper presented at the A.I.E.E. Winter General Meeting, New York, N.Y., Feb 4, 1955.
23. Michael C. Ellison, "Paper Problems of High-Speed Alpha-Numeric Recording," *Tappi* pp. 89A–92A (Oct, 1966).
24. J. H. Hackenberg and F. L. O'Brien, "Recording on Teledotos," *Western Union Tech. Rev.*, Apr 1962.
25. Proc. 1st Tappi Reprogr. Conf., 1971 (excellent references on dry electrosensitive and other recording papers).

DIELECTRIC RECORDING

The next process to be described, dielectric recording, is essentially the nonphotographic analog of Electrofax, which could be thought of as photodielectric recording. The application of this process to facsimile recording has been pioneered by A. B. Dick for high speed (wire matrix CRT) and EG&G for low-medium speed (bug-on-a-belt). EG&G uses the process in the 19 in. AF Weathergraphics recorder and the UNIFAX recorder which is being developed for future United Press wire photo requirements. In the computer printout area, three companies have pioneered in the use of this process, namely Versatec, Varian, and Gould. In all cases, the recording medium consists of a thin dielectric coating on a conductive base paper.

History

As long ago as 1777, George Lichtenberg, a professor of physics at Gottingen University, discovered the first electrostatic recording process, by which he produced the so-called "Lichtenberg figures." He observed that dust settling onto a cake of sparked resin formed starlike patterns. This observation started him on a series of experiments developing discharge figures with various powders.

In 1788, Villarsy described a two-component powder mixture consisting of minium (red lead) and sulfur flowers that could reveal the polarity of charge of Lichtenberg figures. When sprinkled through the meshes of a muslin bag, the sulfur adhered to positively-charged lines, making them appear yellow, while the minium adhered to negatively-charged lines, turning them red.

During the early part of the nineteenth century, the first recording devices invented put Lichtenberg's discovery to work recording changes in atmospheric electricity. Ronalds produced an instrument he called an "electrograph" in which a contact connected to a lightning rod was moved by clockwork in a spiral path over a resinous surface. After some time of operation the surface was sprinkled with powder to develop the spiral line which would exhibit configurations varying in shape and breadth according to the intensity and nature of the electricity the surface had received from the moving contact.

In 1838, Riess noticed that glass or mica plates placed between sparked discharge points show branched patterns when breathed upon. He concluded that the type of moisture condensation depended upon the presence or absence of foreign matter or dirt on the surface. Moisture condensing on a very clean surface forms a continuous invisible film while the presence of foreign matter causes the moisture to collect in tiny droplets which appear as a whitish or fogged area.

In 1899, Konig invented a recorder for measuring the period duration of alternating currents. A pen point attached to a tuning fork and connected to the current source to be investigated was placed in contact with a lacquer surface and moved over it to describe a wavy line. When this surface was dusted with Villarsy's red lead and sulfur mixture, the color of the powder that adhered to each section of the wavy line indicated the duration of each cycle of the alternating current.

In 1900, Burker obtained an improvement in the clarity and distinctness of Lichtenberg and similar powder images. He used a ternary mixture of sulfur, lycopodium, and a pigment such as carmine, ultramarine, cinnabar, or Schweinfurt green.

An interesting group of electrostatic recording methods was developed in the 1920s and 1930s by Paul Selenyi, a physicist at the Tungsten Research Laboratories in Budapest, Hungary. These processes, which he called "electrography," involve writing with an electron or ion beam on an insulating surface and then developing the images with powder. For example, he demonstrated the recording of facsimile pictures which resulted from

scanning with a triode in air followed by powder development.

In 1948, a xeroprinting machine was demonstrated which comprised a rotating printing drum carrying on its surface an insulating medium, a row of pointed character electrodes for spraying corona charge onto the drum, a developer station where a powder mixture was cascaded over the drum, and a transfer zone where a paper web was led around an arc of the drum surface and a heat fuser. However, to date there has been no commercial development of xeroprinting.

Much work on dielectric recording was performed at Burroughs Corporation in the 1950s and early 1960s. Several printers which utilize dielectric recording were built, including the Whippet, an electrostatic teletypewriter. It was designed to operate at 3000 words/min in a weather communications network. Recording was accomplished with a row of 72 print heads, 35 insulated wire pin electrodes/head in a 5×7 matrix. Each pin, when pulsed, deposited a small circular dot of electrical charge onto a dielectric surface. Development was then achieved by drawing the latent imaged medium through a free-flowing reservoir of conductive toner. The copy was made permanent with the application of heat and pressure by which the thermoplastic dielectric coating and the toner are bonded together. Another machine, the RO-92, printed spots in a digital code on a tape, and also the equivalent alphanumeric character alongside each digital character for easy operator readout. The tape could be read at high speed with photoelectric reading equipment in the same manner as punched tape. However, it could be printed much faster electrostatically than a tape could be punched in the conventional manner. The READ machine was an interesting variation from the other printing devices. It printed on an endless belt which moved past a window for visual observation. The images were not fixed. When a new message was to be printed on the belt, the charge pattern of the old message was erased and the toner wiped off and returned to the developer hopper. The READ machine was designed to operate for a period of one month before it became necessary to replace the recording belt and the toner. Uses anticipated for this printer included printing news reports, stock quotations, weather reports, and similar publications.

Dielectric recorders for computer printout which employed flying recording heads of seven styli were also built. Moving across the page, the head recorded seven lines simultaneously. This head obviously was much cheaper than that used for the Whippet. Around 150 Whippets were sold to the Air Force. Thirteen U.S. patents on electrographic recording had been issued to Burroughs up to August 1, 1964 and more have been issued since. Burroughs ceased work in these areas in the early 1960s. It seems that the market at that time was not big enough for them. It was more ideally suited to smaller organizations interested in custom development contracts.

Several other companies were also active during the 1950s and 1960s in the dielectric recording area. In 1959, Teledynamics, under an AFCRL contract, recommended implementation of a matrix dielectric (electrostatic) recording approach for the facsimile recording of weather maps. They named the proposed system "Televelofax." It consisted of 106 printing blocks, each containing a 7×7 matrix of firing pins. United Aircraft Corporation had a $4.1 million prime contract on the Air Force 433L Air Weather Service in the mid 1960s and was engaged in applying a video-electrostatic technique to the production of weather charts. Stromberg-Carlson, Motorola, and Adtrol were also reported active in the development of dielectric recorders.

In 1955, A. B. Dick initiated a study to identify and develop a practical means for electrostatically printing with a CRT which had an array of wires embedded through its faceplate for conducting the energy of the electron beam outside the tube. Stanford Research Institute was chosen to evaluate this technique and develop the tube and its driving circuits. By the fall of 1957, their results indicated that the pin-tube technique provided a practical means for producing high-speed printing of good quality from pulsed electrical signals. Early in 1958, a program was initiated at A. B. Dick to design and construct prototype equipment. Applications for this equipment today include computer printout and facsimile recording. The Videograph Address-Label Printer is employed by many of the magazine publishers such as Time/Life, Readers Digest, National Geographic, Esquire, Sports Illustrated, TV Guide, and Good Housekeeping to print their address labels from magnetic tape input. The Videograph facsimile system is also used by the Denver & Rio Grande Railroad. A. B. Dick also provides Videograph supplies for custom government systems which were designed by companies such as Ampex (NASA), Lockheed (printer plotter designed by Beckman for missile testing, e.g., speed, thrust and fuel consumption) and Boeing (8½ in. page printer for missile tracking). Other noncommercialized electrostatic recording methods and devices have been described in patents issued to Bell Labs, RCA, Honeywell, General Dynamics, General Telephone, NCR, and Addressograph-Multigraph.

Toward the end of the 1960s, a number of companies commenced active development and marketing of equipment employing electrographic imaging on dielectric paper for use in computer printout, analog recording, and facsimile transmission. Fixed styli systems are used in Varian, Gould, Honeywell, and Versatec equipment for analog recording and computer printout. Moving styli are used by EG&G, Visual Sciences, and Litton for facsimile recording. Photoconductors have also been used as modulators for charge transfer to dielectric surfaces in photographic processes developed in Varian, Photophysics, and Electroprint. Applications include microfilm reader-printer, display terminal reproduction, computer and COM printout and copying.

The companies mentioned above are based in the United States. However, the Japanese have done much to further the art of dielectric recording. Prominent equipment manufacturers such as Matsushita, Ricoh, Nippon

Electric, and Nippon Telegraph and Telephone Corporation either have or are about to introduce a number of electrographic imaging devices. The prominent Japanese dielectric recording paper converters are Tomoegawa Paper Manufacturing Co., General Corporation, and Kanzaki.

Chemistry and Paper Characteristics

In dielectric recording, the recording medium consists of a base paper which is electrically conductive and which is coated with a dielectric material of very high resistivity, e.g., a thermoplastic material. A stylus at a potential of several hundred volts with respect to a backing platen is used to charge the dielectric layer. As charges accumulate on the dielectric surface, charges at the paper-dielectric interface flow through the conductive paper to or from the base electrode and finally back to the stylus through the pulse circuitry and printer frame. The accumulation of charges on the dielectric surface and the induced opposite charge at the dielectric-base paper interface create a strong field through the dielectric coating. The latent electrostatic image produced above is converted into a visible image by the application and adherence of a triboelectrically-charged, pigmented, plastic powder (toner) whose charge is opposite to that on the dielectric surface. The toner becomes charged when it is mixed intimately with another material, referred to as a carrier, e.g., iron filings. This material, when properly selected, is not attracted to the latent electrostatic image.

Fixing of the visible image is accomplished by heating the toner to the melting point of the plastic component which, upon cooling, solidifies and causes the toner to adhere to the dielectric surface.

Manufacturing techniques are considered proprietary but, in general, the dielectric layer can be applied before or after the conductive base treatment.

Dec papers employ a conductive base sheet coated with an insulating polymeric formulation. Basically, there are two types of dec papers: a double layer and a triple layer. The double layer consists of a dielectric recording, or image-retaining coating, deposited on a supporting base. An intermediate layer of low electrical resistance is present in the triple layer paper. The base papers utilize a mixture of bleached chemical pulps as furnishes, with pigments added during the beater preparation, if required. The conductive materials are usually salt-humectant mixtures or vinylbenzyl quaternary ammonium compounds. A conductive paper is needed to allow the dielectric to become selectively charged at reasonable web speeds or charging rates. The highly conductive papers allow a faster charging rate, but electrical flaws in the dielectric layer are more detrimental. Relative humidity must be controlled since it affects conductivity.

The dielectric polymer determines the electrostatic charge acceptance and its ability to hold the charge at various relative humidities and temperatures. Pigment is present to reduce the gloss (to make it look more like bond paper), to increase toner smudge resistance and to provide pencil and ink acceptance.

U.S. Patent 3,075,859 mentions a dielectric coating of Bakelite VMCH 16.7, acetone 33.3, $BaSO_4$ 16.7 and Xylene 33.3 parts by weight. The conductive treatment is glycerine 25, H_2O 63, KCl 10, and butanol 2 parts by weight. U.S. Patent 3,110,621 mentions an aqueous dielectric formula of a copolymer of vinyl acetate and crotonic acid 20, 28% ammonia 10, H_2O 70 parts by weight.

The following typical properties are representative of commercial products; resistivities are within one order of magnitude:

Product 566 is a white, high brightness, high contrast, good density at low and medium R.H., medium priced, fast pulse response electrographic paper.

Product thickness	3.3 ± 0.2 mils
Sheffield smoothness	
Coated side	90 max.
Back side	90 max.
Surface resistivity of back side at 50% R.H. using 100 V	8×10^7 ohm/sq
Bulk resistivity of product at 50% R.H. using 100 V \div area	4.4×10^7 ohm/cm^2
% Moisture at 50% R.H.	6.0
Brightness	97 min.
Opacity	91 min., 94 max.

Product 563 is a white, medium bright, good contrast, good density at low and medium R.H., fast pulse response, and costs less than Product 566 electrographic paper.

Product thickness	3.1 ± 0.2 mils
Sheffield smoothness	
Coated side	120 max.
Back side	120 max.
Surface resistivity of back side at 50% R.H. using 100 V	1.3×10^8 ohm/sq
Bulk resistivity of product at 50% R.H. using 100 V \div area	2.8×10^5 ohm/cm^2
% Moisture at 50% R.H.	4.7%
Brightness	83 min.
Opacity	85 min., 93 max.

For the optimum dielectric layer, the polymers such as polyvinyl acetate, polyvinyl chloride, polyvinyl butyral, and polymethyl methacrylate are the most popular as insulating media. Other ingredients which have been used successfully are waxes, polyethylene, alkyd resins, nitrocellulose, ethyl cellulose, cellulose acetate, shellac, epoxy resins, styrene-butadiene copolymers, chlorinated rubbers or polyacrylates. Whatever the insulator system used, the following criteria control performance:

1. A definite relationship exists between the thickness of the coating and the electrical properties of the

insulator. Materials with dielectric constants of between 2 and 4 seem to function best.

2. The insulating materials must be able to withstand the solvents and temperatures in liquid toner applications and fixation.
3. They must be flexible but strong.
4. They must withstand high voltages during the creation of latent images.
5. Polymers selected must adhere well to base papers or intermediate coatings.
6. The ingredients must not block at temperatures of 40–50°C.
7. Coating components should be colorless and transparent.
8. The insulating materials selected must be low in cost.

As for resistivity, volume measurements must exceed 10^{11} ohms/cm at 50% relative humidity with the optimum range falling between 10^{12} and 10^{15} ohms/cm. The correct balance of resistivities between the dielectric coating and the conductive base paper is vital not only to the attainment of good image quality, but also to ensure that toner will not be attracted to the back side of the base paper. Induced electrical forces of opposite charge to the surface voltage can cause objectional back imaging if not dissipated by a base paper having sufficient electrical conductivity.

Theory of Operation

This was described in an excellent review paper on dielectric recording by Norman A. Nielsen,[1] and summarized below.

To form an electrostatic image, a voltage pulse is applied between the writing electrode and the backing electrode. Ionization occurs in the small air gap between the printing electrode and the surface of the dielectric film and the ions migrate to the dielectric paper surface. Even with a pressure contact such an air gap exists due to irregularities in the paper surface.

Below a certain threshold voltage there is no ion flow across the air gap. Any charging that occurs below this voltage is by charge displacement only, with the dielectric layer acting as a simple capacitor. Usually charging by this method is too slow to be useful. When the voltage on the electrode is raised above the threshold voltage, ionization occurs and the simple capacitor model no longer is adequate. When the applied voltage is raised too high, dielectric breakdown occurs and destruction of the dielectric surface is observed.

Charging times vary with the writing speeds of the particular hardware employed. Similarly, the time between application of a charge pattern to the dielectric surface and the toning step may vary over a broad range. This depends somewhat on whether a single character, a single line, or a complete page is imaged before development of the latent image is begun. Each different set of writing conditions may require special properties of the dielectric coating and the conductive base paper on which it resides.

Some insight into the nature of these requirements may be obtained by consideration of the electric circuitry represented by each case. Both the conductive support, usually paper, and the dielectric coating can be treated as imperfect capacitors, C_p and C_d, which leak charge through the resistors R_p and R_d, respectively.

The voltage build-up across the dielectric layer when a voltage pulse is applied across the electrodes can be expressed by the equation:[2]

$$V = V_0 \frac{R}{R_1 + R_2} \left[1 - e^{\frac{-t(R_1+R_2)}{R_1 R_2 (C_1+C_2)}} \right] \qquad (3)$$

where

V_0 is the applied voltage
R_1 is the resistivity of the dielectric layer in ohm-centimeters
C_1 is the capacitance of the dielectric layer in farads
R_2 is the resistivity of the conductive layer in ohm-centimeters
C_2 is the capacitance of the conductive layer in farads

In order that current flow through the base paper does not limit the build-up of charge on the dielectric layer, the paper is treated with a material to make it more conductive. Typically, it is far more conductive than the dielectric layer and hence $R_1 > R_2$ and $C_1 > C_2$. This reduces Eq. (3) to the form:

$$V = V_0 \left[1 - e^{\frac{-t}{R_2 C_1}} \right] \qquad (4)$$

High speed instruments require that charging of the dielectric layer be accomplished in a few microseconds. Since R_2 and C_1 in Eq. (4) are the resistance of the conductive base paper and capacitance of the dielectric layer, rapid layer charging occurs when the paper is designed to make the product R_1 and C_1 as small as possible. Practically, it is easiest to control the resistivity of the base paper so this value is made as low as possible to facilitate rapid charging.

Since the level of charge on the dielectric layer is related to its ability to attract toner, it is important to ensure that this layer holds its charge until the toning process is completed. In some devices this may be only a few seconds, while in others—those which image an entire sheet before toning—the dielectric layer must hold its charge for several minutes.

The amount of charge, q, remaining on the dielectric layer at time, t, may be expressed in terms of the initial charge Q by:

$$q = Q e^{\frac{-t}{R_1 C_1}} \qquad (5)$$

where R_1 and C_1 are the resistance and capacitance of the layer, respectively. The quantity, t, is expressed in seconds; R_1 in ohm-centimeters, and C_1 in farads.

To ensure that the layer once charged retains charge over an appropriate period of time, the sheet is designed so as to make the values of R_1 and C_1 as large as possible.

Toning studies[3] have shown that the optical density of the image formed after toning is principally dependent upon the potential difference across the dielectric layer rather than upon the absolute amount of charge residing there. This means that the developed optical density associated with a latent electrostatic image is really a function of the electric field seen by the toner particles in the development process.

A consideration of the electrical field associated with an image leads to the observation that this field is most intense near the boundary between image and non-image.[4,5] Toning of the simple latent images results in an uneven deposition of toner with the darkest portion corresponding to the image boundaries for large solid images. This is the well-known "edge effect" phenomenon.

Typically, the toning process will employ some form of development electrode to increase the electrical field over charged image areas and make it more uniform over the entire charged area.

The electric field, E, acting on a toner particle in the image region between the dielectric surface and development electrode can be represented by:[3]

$$E = \frac{V_D - V_B}{d + \dfrac{1}{K_d}} \qquad (6)$$

where

V_D = the potential on the surface of the dielectric
V_B = the bias voltage
1 = the thickness of the dielectric coating
d = distance between development electrode and dielectric surface
K_d = the dielectric constant of the dielectric coating

If the base paper is not sufficiently conductive, the charging process will place the initial electrostatic charge across both the dielectric layer and the resistive base layer. This has the effect of increasing the effective thickness of the layer across which the charge resides and to a lesser extent lowering the effective dielectric constant of that layer.

From Eq. (6) the net effect is one of lowering the electrostatic field seen by the toner and hence the resulting optical density of the developed copy. Since the developed density of the finished print is proportional to the electric field seen by the toner particles, at equal V_D and V_B, this property is dependent upon the thickness and dielectric constant of the coated dielectric layer.

One method of ensuring that the delivered image charge resides across the thin dielectric layer is to make the charge decay constant for the conductive base much shorter than the imaging time. Usually this condition exists when writing time pulse exceeds the paper decay constant by a factor of ten or greater.

The time constant for a poor dielectric such as conductive base paper can be described by the expression:[6]

$$t_p = 8.85 \times 10^{-14} \, RK \qquad (7)$$

where t_p is the time in seconds required for the charge to decay to 37% of its initial value; R is the volume resistivity of the paper in ohm-centimeters, and K is the dielectric constant of the base paper.

Suppose, for example, that a particular dielectric writing stylus delivers 500 V in a 50 μsec pulse to the paper. The device utilizes a dielectric sheet which has a conductive base with a dielectric constant of 1.3 and a dielectric coating with a capacitance of 5 pF. The resistivity of the conductive paper is 4.2×10^6 ohm-cm and that of the dielectric layer 1×10^{14} ohm-cm.

The minimum useful resistivity of the conductive layer can be estimated using Eq. (7):

$$t_p = 8.85 \times 10^{-14} \, RK$$

$$R = \frac{5 \times 10^{-6} \text{ sec}}{(8.85 \times 10^{-14})(1.3)}$$

$$R = 4.3 \times 10^7 \text{ ohm-cm}$$

This minimum value is greater than the actual resistivity of the sheet and therefore the charging time is greater than ten times the decay constant of the conductive layer. The charge should reside across the dielectric layer only with this dielectric sheet and the charging conditions described. The voltage available on the layer after one charge pulse of 50 μsec can be estimated using Eq. (3);

$$V_t = 500 \text{ V} \, (1 - e) \frac{- 5 \times 10^{-5} \text{ sec}}{(4.6 \times 10^6 \text{ ohm-cm})(5 \times 10^{-12} \text{ F})}$$

$$V_t = 454 \text{ V}$$

Assuming that this dielectric paper is capable of 454 V charge acceptance, then the time required for the layer to decay to 167 V (one time constant) approximates

$$t = RC$$

$$t = (1 \times 10^{14} \text{ ohm-cm})(5 \times 10^{-12} \text{ F})$$

$$t = 5 \times 10^2 \text{ sec or 8.3 min}$$

If the imaged paper is toned within a minute or so of charging, there will still be adequate charge available to attract toner.

Summary

In conclusion, if immediate image appearance is not important, then this process is superior to electrolytic and/or burn-off in the following ways:

1. Paperlike in feel and appearance and handling.
2. Higher practical writing speeds.
3. No odor or fumes evolved.
4. Not pressure sensitive.
5. Truly dry process.
6. Little or no R. F. generation.
7. Can serve as diazo master.
8. Inexpensive.
9. Electrode not consummable.

REFERENCES

1. Norman A. Nielsen, "Dielectric Recording—A Tutorial Review," Proc. Tappi Reprogr. Conf., Oct 1973 (includes 70 Refs).

2. S. Kineri and Y. Okajima, *Denshi Shashin*, 7 (3):151 (1967).
3. Y. Moradyadeh and D. Woodward, *Photogr. Sci. Eng.*, **10**: 96 (1966).
4. H. Neugebauer, *J. Appl. Opt.*, **3**: 385 (1964).
5. R. Schaffert, *Photogr. Sci. Eng.*, **6**: 197 (1962).
6. P. Stowell, AIEE Conf. Paper, CP61-441 (1959).
7. Special Issue on Electrographic Processes, *IEEE Transactions on Electron Devices*, v. ED-19, no. 4, April 1972 (Editors Rice and Shaffert).

PRESSURE SENSITIVE RECORDING MEDIA

There are three general classifications for pressure sensitive recording media, i.e., papers that develop a visible image on the application of localized pressure, namely:

1. Blush
2. Chemical
3. Carbon

Blush papers are nontransfer types which have some similarity in construction to electrosensitive burn-off papers. An aerated, white-appearing, opaque organic coating conceals a black undercoating which in turn is on the paper base. When pressure is applied to the topcoating, the coating of waxlike spheres collapses and forms a translucent window of uniform refractive index through which the black undercoating is visible, thereby forming an image. Contrast is very good, paper-feel is fair. This type is currently used in chart recorders where its simplicity of operation is most attractive.

Chemical papers involve the production of a visible image by the reaction of relatively colorless materials which come into contact under pressure. Both non-transfer and transfer types are available.

3M markets a nontransfer chemical type called Action Paper, which forms a purple, spiritlike image upon the application of pressure. This 3M Brand Carbonless Paper, Type 100, is a noncoated, self-contained carbon-less paper which forms its own blue-purple image in response to concentrated pressure. The product is simple in makeup—consisting of millions of tiny microcapsules blended with ordinary chemical pulp fibers. Each microcapsule contains a tiny amount of image forming dye, surrounded by a shell which ruptures in response to pressure. The image-forming chemical is released and reacts with a mating chemical outside the microcapsule to form a blue-purple image. 3M also has a two-component variety, designated Type 200.

NCR, of course, has marketed a carbonless, transfer, chemical type for over 20 years. Its biggest application is for multiple-copy business forms. Appleton Coated Paper has produced it for NCR since 1953. This paper utilizes a two-coating system. The donor sheet back has an emulsion coating of microscopic capsules containing colorless dye. This is placed in contact with the mineral acid clay-coated front of the receiver coating to produce an image. The number of copies in an NCR form commonly ranges to eight. Other manufacturers include Mead, Nashua, and Champion.

The third type, carbon transfer, has found application in computer impact printers and slow scan facsimile, including Litcom Weathergraphic Equipment, and Magnafax and Xerox Telecopier gear. The paper is either a double separable carbon and paper arrangement or a single more expensive sheet. The transfer of a black colorant from a donor sheet to a specific receptor sheet is the mechanical transfer type. Marking in the facsimile application is accomplished by indenting areas with an electro-magnetically controlled stylus. Advantages include low paper cost production and instant visibility. Disadvantages include low writing speed, low resolution, and poor dynamic range. In computer printers a wide variety of electromechanical techniques have been employed to cause character formation.

History and Chemistry

Pressure sensitive papers vary from carbon paper used long ago by Willis (U.S. Patent 843,189) and Dubuse (U.S. Patent 2,662,828), to wax-coated as described by Sheppman (U.S. Patent 1,726,126), to polyvalent metal soap by Dalton (U.S. Patent 2,313,808), to the acetylide papers of Pessel (U.S. Patent 2,661,998), which respond to ultrasonic vibrations of approximately 20,000 Hz.

In the chemical type papers, the key to success is the encapsulation of image forming dyes. The basic approach of encapsulation is described by B. K. Green of NCR (U.S. Patent 2,800,457) and L. Schleicher of NCR (U.S. Patent 2,800,458). These patents describe the art of inducing coacervation in a hydrophilic colloid system. It consists of three essential steps:

(1) A three phase emulsion with a liquid vehicle such as mineral oil as the continuous phase, and encapsulating and color-forming chemicals as the disperse phases.
(2) Emulsion dilution, pH and temperature adjustments which will cause the encapsulating material to form a film around droplets of the color forming chemicals, partly because of electrostatic attraction and partly because of solubility changes.
(3) Gelation of the capsules which may be dried or left in slurry form.

A mechanical process of encapsulation is based on centrifugation. Droplets of the chemical to be encapsulated are flung by centrifugal force toward orifices over which a thin continuous fluid film has formed. As each droplet hits the film and continues through the orifice, it takes some of the film forming material with it. Surface tension forces this into a coating. At the same time the continuous film covering the orifice reforms, so there is steady capsule production. Perhaps the largest use of these capsules has been as insecticides.

U.S. Patent 2,969,331 to Brynko and Scarpelli uses the basic art of coacervation to encapsulate capsules containing an oil solution of leuco base within vinyl polymer walls, specifically those of styrene/divinylbenzene, in a hydrophilic gellable polymer. U.S. Patent 3,205,175 to T. Maierson discloses the use of ethylcellulose to obtain an interior lining of the hydrophilic gellable polymer capsule walls which is selfsealing if water penetrates through the hydrophilic polymer. U.S. Patent 3,494,872 to T. Maier-

son uses alkylbenzene—and alkylnaptholene—sulfonic acids in combination with gelatin as encapsulant and achieves coacervation through pH adjustment. Other significant patents are listed in Refs. 1–10.

The dye imaging system that historically was used by NCR—and probably others—consists of a combination of the leuco forms of benzoyl methylene blue (BMB) and crystal violet lactone (CVL). Dissolved in an oily dye carrier (now an alkylated diphenyl or partially hydrogenated terphenyl) and encapsulated, they are coated onto paper. Color is developed through contact with an acid reacting surface which converts the CVL into the colored form. In a slower hydrolysis/oxidation reaction, the more lasting color of methylene blue develops. This art is old, and patents have expired. Recent patents of interest are listed in Refs. 11–19. More recently a single dye image has been employed by NCR.

The shortcomings of the triphenly-methyl type dye systems—namely, purple color and somewhat limited light and storage stability—have prompted considerable research into alternate systems. Selected patents are listed in Refs. 20–29. NCR now has a black image system. In all, there are several hundred U.S. patents which relate to the chemical type papers.

Summary of Current Technology

One of the basic technical problems related to both chemical and physical carbonless papers is that of having sufficient sensitivity to mark with an imaging device, yet being insensitive enough to resist unwanted marks. NCR solved this problem, for the most part, by employing a two-coating system for applications in manifold business forms. Other chemical and physical varieties utilize similar concepts. Illustrations follow.

The proper function of a two-coating system is dependent upon the mating of two separate and dissimilar surfaces, along with the exertion of pressure to create an image. Figure 15-1 illustrates the component paper grades that would be used to manufacture a three-part business form of chemical transfer carbonless papers.

More Part II sheets will be required when more plies are desired in a forms set.

In the two-component system the underside of the transfer sheet contains a coating of encapsulated colorless dye intermediates, while the surface of the receptor sheet

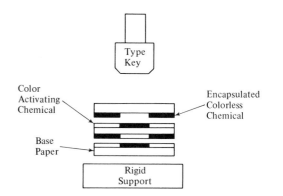

Fig. 15-2. Chemicals transfer, react and produce colored image.

is coated with an acid-yielding composition which is needed to develop a colored image. The receptor/transfer sheet, of course, is a sheet which contains both donor and receptor coatings.

Pressure applied by handwriting, typewriter, or machine printing will cause rupture of the capsules, allowing the chemicals contained therein to mingle, transfer, and react upon the receptor surface. Figure 15-2 depicts this reaction, and resultant image formation.

Historically, an attapulgite clay-based formulation was used as the receptor coating. Now, a kaolinphenolic coating is used on NCR receptor sheets. The actual coating is only one-third the weight formerly required, and the printing characteristics have been improved vastly over the previous sheet. The surface properties of this new sheet are also much superior to those of the previous type. Organic acid materials and mineral pigments have been used by others.

In 1963 the 3M Company introduced a self-contained carbonless copy paper known as "Action" paper. This product had no need of the manifolding concept described above and utilized by NCR. No coating of capsules or special receptor coatings were required for Action to function effectively. Action paper contained encapsulated color-formers and activators, but they were incorporated into the base paper at the wet end of the paper machine during manufacture.

Figure 15-3 provides a schematic diagram which illustrates the steps involved in the imaging process for a self-contained carbonless paper such as 3M's Type 100.

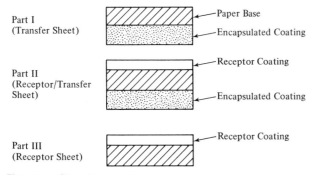

Fig. 15-1. Chemical transfer paper—three part business form.

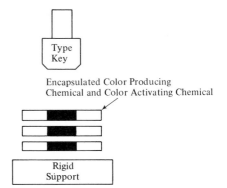

Fig. 15-3. Self-contained paper—chemicals react producing colored image.

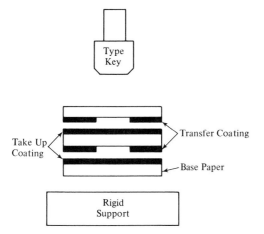

Fig. 15-4. Physical transfer system—colored coating image transfers to receptor coating.

Figure 15-4 depicts a mechanical or physical transfer system based on the transfer, receptor/transfer and receptor sheet.

Frye's Impact, Kores' KCC, and UARCO's Impresto grades all resemble the technology illustrated above. The pressure of mechanical impacted type causes a dark coating from the donor sheet to transfer to the surface of the specially treated receptor sheet.

Eugen Strauss' U.S. Patent 3,169,880 issued February 16, 1965, and U.S. Patents 3,256,107 and 3,256,108 issued June 14, 1966, provide good examples, but not necessarily the specifics, of this type of imaging concepts.

The transfer coating applied to the back of a mechanical transfer could include:

A polymer such as polyvinyl acetate.
A resin plasticizer.
An organic fixing agent such as tannic, phthalic, or gallic acids.
An inorganic colloidal metallic material such as iron, cobalt, nickel, etc.
A dark colored pigment, such as carbon black.
An inorganic nonmagnetic colloidal pigment such as bentonite, clay, or kaolin.

The receptor sheet should have have a somewhat tacky coating such as might be prepared from polyethylene, stearic acid, and paraffin wax.

Of all the non-light-sensitive imaging media discussed so far, the chemical pressure sensitive media (know as carbonless copy papers) are by far the most widely used. Worldwide sales for these papers in 1974 were almost half a billion dollars, with a similar number of tons produced. Most of it is the two-coating system. These papers utilize 25% less pulp than for the interleaved carbon/paper sets. Small wonder that there are 16 major producers of such papers worldwide.

REFERENCES

1. G. Baxter, U.S. Patent 3,578,605.
2. A. E. Vassilades, U.S. Patent 3,418,656.
3. G. W. Matson, U.S. Patent 3,516,846.
4. G. W. Matson, U.S. Patent 3,516,941.
5. N. H. Yoshida, U.S. Patent 3,607,775.
6. Bayless and Emrick, U.S. Patent 3,656,818.
7. Bayless and Emrick, U.S. Patent 3,574,133.
8. M. Karr, U.S. Patent 3,432,327.
9. N. Macauley, U.S. Patent 3,016,308.
10. P. S. Phillips, Jr., U.S. Patent 3,627,581.
11. P. S. Phillips, Jr., U.S. Patent 3,427,180.
12. C. H. Lin, U.S. Patent 3,540,909-913.
13. C. H. Lin, U.S. Patent 3,450,914.
14. S. Kimura, U.S. Patent 3,501,331.
15. S. Kimura, U.S. Patent 3,551,181.
16. S. Kimura, U.S. Patent 3,617,335.
17. U.S. Patent 3,619,238.
18. U.S. Patent 3,669,710-712
19. U.S. Patent 3,244,728.
20. L. Harbort, U.S. Patent 3,293,060.
21. H. Imamiya, U.S. Patent 3,463,655.
22. C. Osada, U.S. Patent 3,619,239.
23. H. C. Haas, U.S. Patent 3,287,154.
24. P. S. Phillips, U.S. Patent 3,558,341.
25. P. A. Ostlie, U.S. Patent 3,481,759.
26. R. N. Hurd, U.S. Patent 3,492,145.
27. A. Watanable, U.S. Patent 3,535,139.
28. M. Tsuboi, U.S. Patent 3,592,677.
29. J. M. Billet, U.S. Patent 3,450,553.

THERMAL/HEAT SENSITIVE IMAGING

Heat sensitive papers (and films) which form thermally induced images by the selective application of heat have been known for a long time. Such media have been used in chart recorders, teleprinters, computer terminals, calculators, office copiers, and projection transparency makers. There are generally two types, namely, blush and chemical.

Chemistry

The most common heat sensitive writing method used in chart recording uses a heated stylus which melts a thin white waxlike blush coating on a black paper base. The preparation of this type of paper is almost identical to the preparation of a waxed pressure sensitive material that melts at low temperature. This type of system circumvents many of the problems inherent in both ink and pressure sensitive papers. The stylus system is quite reliable and high contrast traces are easily made. The paper is clean to handle and no objectionable by-products are generated during its use. Although some heat sensitive papers are quite easily marked in casual handling, most papers of this type do not mark easily with pressures normally encountered. Larsen[1] describes a suitable recording material coated from a solution of ethyl cellulose (ethoxy content 44.5-49%), a solid polyoxyalkylene surface active material as plasticizer, and a mixture of volatile organic solvent and volatile organic nonsolvent for ethylcellulose—the nonsolvent being miscible with and having a boiling point higher than the solvent and having a kauributanol number less than about 60. When such a coating is dried, a blushed opaque coating is produced.

Heat sensitive papers are commonly used in industrial and medical instruments, where environmental conditions are not severe and where rapid start-up is of prime importance. A less common type of heat sensitive paper is based upon a chemical reaction between two colorless, heat sensitive materials in the coating that forms a third colored material. This sytem is not pressure sensitive, but is less efficient (i.e., more energy is required to mark a given area) which limits the writing rate. Some of these papers lack long term stability, gradually turning dark. Others give off an unpleasant odor when marked. These papers are particularly suited to those applications where the range of writing speeds is not great, where the writing rate is below 2 in./sec, where rapid start-up is important, where the record will be handled a great deal, and where the record is not needed longer than about 6 months.

Techniques for using a heated stylus are described by Shardlow[2] and Faus.[3,4] Kallock[5] and Rolle[6] describe a heat sensitive paper composed of a black or dark coated paper over which is applied a resin coating in which is dispersed finely divided air cells which give the surface film a whitish appearance. The coatings have been called blushed lacquer coatings since they are purposely made to have a whitish appearance without the use of pigment. The whitish coating is made from a resin-solvent mixture in which water is dispersed in a finely divided form. After the solvent and water have evaporated, a film remains with cells or cavities of air in which the water was formerly held. The blushed film on these papers softens or records at approximately 125°C. It is believed that the Larsen[1] approach forms the basis for current products.

Green[7] discloses a paper containing an eosin compound made slightly alkaline with a mild alkali. The paper is slightly yellow, but when heated to approximately 140°C, as by means of a stylus, it turns red in color.

Miller[8] describes a paper which is light in color and produces a dark gray mark at approximately 60-120°C. It consists of a hexamethylenetetramine-gallic acid reaction product, a metallic soap such as silver behenate, and a binder. The ingredients are applied to the paper with a solvent. This patent formed the basis for 3M's very successful Thermofax line of office copiers. The two basic criteria necessary for successful generation of copy is that the base substrate for the thermosensitive coating be infrared (IR) transmitting, and the original to be copied has infrared absorbing images, such as from pencil and black ink. IR is passed through the heat sensitive sheet onto the material to be copied. In white areas, the IR is scattered. In image areas, IR is absorbed, causing a build-up of heat. This heat in turn is transferred by conduction to the thermosensitive paper, causing image formation. Throughout the 1960s, a great number of patents were issued on thermosensitive paper for copier applications. Almost all involved solvent coatings, but one described by Murray[9] involved the imbibing of paper in a simple, clear aqueous solution of metal thiosulfates which upon the application of heat produce black images comprised of metal sulfides on a truly white background. Most of the earlier work is described in a review paper contained in the Proceedings of the 1964 SPSE Symposium on Unconventional Photographic Systems.[10] References since then may be found in the SPSE monthly publication, *Abstracts of Photographic Science and Engineering Literature.*

More recently, heat sensitive papers have been employed in teleprinters for message/data communications and for local or remote computer printout. In thermal writing of this sort, the writing depends on a stylus which can provide a rapid temperature fluctuation. This stylus is in contact with a specially coated paper. When the stylus is heated it produces a contrasting dot on the paper. One would expect that there would be a high inertia involved with a heat stylus system because the stylus could not heat and cool fast enough to do a reasonable job. The fact is that there are some machines today which work very well using this principle. One can use one stylus or a multiplicity of styli to scan across the page, or one recording head, where many styli in the form of a matrix (e.g., 5×7) are activated to do the job. Texas Instrument, NCR, Anderson Jacobson, and others are marketing machines which operate on this principle. In these cases a matrix of heated styli moves across the page. A chief advantage of the machine is the silence of operation.

Thermally sensitive paper for such printers is manufactured by NCR and 3M. Advantages of thermal printing systems include: low cost system; no developer or toner; immediate imaging; bond paper—no apparent overcoating; paper delivered dry; no flaking, cracking, etc; available blue or black image (NCR); relatively high speed—equal to line printers; some papers are not pressure sensitive. The disadvantages are: limited shelf life— 1 year; image fading; colored image; availability of color formers.

Based on their technology for encapsulation of leuco dye and dye couplers, NCR developed the 260 thermal printer, which uses a paper coated with encapsulated color-forming materials and which, on application of heat from a heating element, ruptures the capsules to effect a color reaction. Included in the coating formulation are color precursors, crystal violet and phenols (or spiropyrans and diphenols), a fixing agent and binding resin.

Disadvantages to the system include: reproduction of final copy is in a dot matrix; paper is sensitive to heat and must be stored away from heat. Note that NCR has two types of paper in which the thermal sensitivity of the coating has been adjusted. Being an encapsulated coating, the coating is subject to abrasion and will, if marked with sufficient pressure, turn color.

Market growth for the product, in the short time it has been on the market, has been very good. Today, approximately 8000 tons annually are used in the U.S.

Thermal Printing

This topic is now discussed in more detail since thermal printing has become a very important technique the past few years.

The heart of any thermal printer is the thermal printhead. The majority of thermal printheads are of the dot matrix variety. Popular sizes are 4×5, 5×5, 5×7, and 5×8. Each dot is represented by a separate heating element. In matrix thermal printers the elements are selectively energized to form permanent characters on a heat sensitive paper. The elements reach a surface temperature of from 300° to 500° F and generally are energized for a period of from 3 to 12 msec. These wide ranges result from the variety of both printheads and papers available. In general there are two basic design approaches to matrix thermal heads. One approach is a planar monolithic IC head utilizing a transistor-resistor pair for each heating element. This type of head generally includes a ceramic substrate with the integrated circuit chip bonded to the large flat planar surface. Electrical connections are brought out to an edge of the substrate, at which point a flexible circuit cable is either soldered or mechanically clamped to terminations on the substrate. The other design approach is strictly a thick film resistive element deposited on the edge of a small ceramic wafer. Each wafer has a column of elements out of the matrix and the wafers are stacked side by side to achieve the number of rows desired in the matrix. Electrical connections are made in a similar manner to the first approach. One of the major problems of all matrix thermal printheads is the fact that as continuous printing takes place there is a gradual buildup of latent heat in the printhead that causes the print to become darker. There are a number of ways to compensate for this undesirable phenomenon. One technique is a temperature sensing diode that regulates the input voltage to the head. Another technique uses a unique circuit that senses the power dissipation in the printhead and uses the data to regulate the time that the heating element is energized. A third technique is to sense the print rate and use that data to time compensate. There are a number of other thermal printheads on the market today besides the conventional single character dot matrix heads. One design uses resistive elements deposited on glass in the form of a bar segment character similar to the LED readout on many calculators. Another design uses a long row of dots and simultaneously prints one row of each character in a line and steps the paper a small increment for each row until the full line of characters is printed.

Some clever electronics and mechanics were applied to these printers to solve problems associated with movement of the printout from character position to character position, paper drive, signal processing, and printer timing.

Thermal papers are available at a number of different development temperatures and therefore the correct paper must be used with a given printhead. Most manufactureres specify the type of paper to be used as a part of the warranty agreement. Development temperatures (that is, the temperature at which the paper completely changes color) range anywhere from about 200° F to approximately 300° F. There are both advantages and disadvantages for the high and low temperatures. The low temperature has the advantage of being able to print with less power in the printhead while the high temperature paper has the advantage of being able to be stored in a much higher temperature environment. The paper is coated in large mill roll sizes and then converted to the proper size rolls and in some cases preprinted to a customer's specification. Fifteen pound white bond paper is the most commonly used for coating.

A typical example of such a paper is Style 2/3 of NCR 15# thermal paper with the TPX 052 coating. The coating comprises a dispersion of dye and a phenol coreactant in wax, clay, and binders. The heat from the printhead melts the phenol coreactant which in turn contacts and reacts with the dye to cause the coating to turn blue or black depending on the dye. This formulation is economical in that it requires only one single coat and it can be coated on anything from Number 10 onion skin paper to 7½ point tag stock. The Style 2/3 has a threshold temperature of 200° F and a full development temperature of 280° to 300° F. By adding modifiers to the standard formulation, an intermediate temperature and a low temperature paper have been developed. The intermediate paper has a threshold of 185° F and reaches full development at 245° F. The low temperature paper has a threshold of 155° F and full development at 215° F. The other major manufacturer of thermal paper in the U.S. is the 3M Company. This style of thermal paper involves a chemical conversion quite different from that of the thermal paper of the NCR Corporation.

Research is presently being done on a two-color (red and black) thermal paper. What actually takes place is that the coating turns red at a given temperature ~245° F and then turns black at around 300° F. This paper could open up a whole new market for thermal printers. Another major new development in thermal paper is the two-copy paper recently announced by the Jujo Paper Company in Japan. This paper looks very promising as far as achieving good print quality on both copies. They are using a thin onion skin sheet sandwiched with approximately a Number 15 sheet. The coating is on the inner side of both sheets and separated by some type of wax or bonding agent that also serves as a means of adhering the two sheets together for good thermal conductivity. The printhead comes against the uncoated side of the thin paper and develops the dye on both sheets. After printing, the sheets must be physically separated.

Until recently, thermal printers (nonmilitary) were limited to a writing speed of 30 characters per second. NCR has recently announced a 120-character-per-second thermal printer to the OEM market. This printer is being offered in an 80 column and 132 column platen length. Many features will be included such as a 4K byte buffer and serial interface as well as a cabineted version with a power supply included. This printer is considered a major breakthrough in thermal printing technology and should make thermal printers real contenders as hard copy output devices for CRT terminals. Another factor affecting the growth of thermal printing is the industrywide acceptance of matrix printing. As was mentioned earlier the thermal paper people are anticipating breakthroughs in both multiple copy and multicolor paper in the near future.

The use of sublimable dyes which transfer from a felt

to plain paper under the influence of heat, e.g., from a thermal printhead or an intense laser beam, is currently under investigation.[11]

The author gratefully acknowledges the assistance of Gerald Hemmelgarn of NCR Corporation in supplying information on thermal printing.

REFERENCES

1. G. H. Larsen, U.S. Patent 3,031,328.
2. L. R. Shardlow, U.S. Patent 2,628,104.
3. H. T. Faus, U.S. Patent 2,454,966.
4. H. T. Faus, U.S. Patent 2,647,033.
5. W. F. Kallock, U.S. Patent 2,299,991.
6. C. J. Rolle, U.S. Patent 2,665,262.
7. B. K. Green, U.S. Patent 2,675,332.
8. C. S. Miller, U.S. Patent 2,663,657.
9. R. D. Murray, et al. U.S. Patent 3,169,067.
10. Dr. R. Gold, "Thermography—State-of-the-Art Review," 1964 SPSE Symp. on Unconventional Photographic Systems, pp. 1–53 (137 references).
11. Private Communication, Gorham International, Inc.

MAGNETIC IMAGING

Although many major firms have investigated magnetic imaging[1] over the years, the only known commercial embodiment is the unit developed by Data Interface which was acquired by Inforex, Inc. in November 1974. A great deal of work has also been done by Lyne Trimble over the years (initially at NCR) on magnetically-responsive, encapsulated materials, but full production scale-up has not yet been accomplished.

Technology

In the Inforex unit, the following operational steps occur:

1. An endless magnetic belt is "written" in dot matrix fashion to create the desired line of print, consisting of latent magnetic images.
2. The belt is developed or "decorated" with dry magnetic particles or toner.
3. The print line is transferred to plain paper by applying contact pressure.
4. The paper is advanced a line, and passes over a fuser as it exits the printer box.
5. The belt is cleaned and degaussed, with excess toner being recirculated to the decorator.

Such a unit is simple, quiet, and uses plain paper rather than coated or treated paper. Applications include computer terminals, CRT hard copy, and message communications.

Next, a magnetic imaging system is discussed where visible images are formed as the result of spontaneous chemical reactions triggered by a magnetic field. The reactions occur in tiny liquid droplets suspended in a resin film.

Each transparent droplet contains color forming chemicals and a tiny magnetic particle that has been over-coated by electroless plating with a brittle protective layer. The applied field magnetizes the particle and causes it to expand. The expansion is sufficient to break the protective coating and expose the particle to the surrounding color forming chemicals. A reaction follows and continues until one of the reactants is consumed, thus filling the droplet with color. The variables influencing triggering can be balanced and related back to magnetic pulse strength and duration. Thus one or more primary colors can be selectively exposed to generate an additive three-color display in a film containing a mixture of primary color forming droplets. U.S. Patents 3,281,669 and 3,512,169 describe the system in greater detail.

Some characteristics of the process are now given. It is activated by pulses of three μsecs duration at a threshold energy of 250 oersteds (Oe). Sensitivity does not deteriorate with time. Image formation is automatic. No processing is required, and images appear within 3 sec after pulse and reach full brilliance within 30 sec. The actuating field can be from signals recorded on magnetic tape, permanent magnets, electromagnets, helix and magnetizable bar, segmented magnetic heads, and electron beam conversion. The resulting imagery is permanent, with very good resolution (up to 250 lines/in.) and contrast.

Applications under consideration include graphic recording and plotting, CRT hard copy, teleprinting, facsimile, scan conversion, color printing, security ID, visual alarms, instant x-rays, and specialized printing and marking. In the graphic recorder, tiny electromagnetic styli have been successfully employed.

The concept and prospect of automatic color generation certainly is exciting, but questions remain on cost and ability to manufacture effectively in large scale.

REFERENCES

1. "Magnetographics," multiclient study prepared by Diamond Research Laboratories, Rolling Hills, Calif. 1975.

INK JET PRINTING

Ink jet printers are to pen and ink recorders as a modern automobile is to a Model T Ford. By sophisticated electronic circuitry and innovative electromechanical design, ink jet printers can do things that an old-fashioned pen and ink recorder would never have dreamed of, such as printing variable taxpayer information on millions of tax forms, printing codes on cans, doing high speed noncontact and nonimpact computer printing, multicolor graphics, and printing on irregular, contoured, and even delicate surfaces. Since new characters can be formed at the speed of electronics, it is particularly suited for printing variable or constantly changing information, as opposed to conventional printing processes which are primarily suited for printing many copies of the same or of fixed information.

Ink jet printers are essentially an outgrowth of earlier machines developed in Germany for oscillographic recording. In the early units, droplets of ink played the

same role as electrons in a cathode ray tube. The droplets were charged and were, therefore, sensitive to electric fields. They were ejected from a capillary source in a manner analogous to electrons emitted from an oxide coated cathode accelerated by an appropriate change in potential and deflected in the X and Y direction as they traveled toward the paper. The X and Y directions were determined by electric fields which corresponded to the incoming signal.

Newer ink jet systems use piezoelectric materials to eject an ink droplet from a nozzle on demand. These techniques eliminate the need for pressurized ink supply, complex deflection means, etc. The main advantage to ink jet systems resides in the possibility of using low-cost substrates and plain paper.

There is considerable current interest in these ink jet systems. The A. B. Dick "Ink Jet" printer and Mead's "Digit" printer are gaining considerably in importance. IBM has licensed technology from A. B. Dick and is reportedly working on a multifunctional office terminal printer. The basic systems are being employed by Moore Business Forms for forms printing. Other applications are for printing plastics, metals, and address labels. The U.S. Postal Service has applied it to the mails. The system which was developed at Stanford Research Institute prints by propelling charged liquid ink droplets to the surface of a substrate and by means of electronic deflection controlling the character generation. Though it has been claimed that the system can print on most any surface, it can be appreciated that the condition of the substrate will influence the image quality. The more porous the substrate, the poorer the print quality. Nevertheless, the system is being investigated for the printing of newspapers. Its attractiveness lies in that input is computer controlled and can be updated as needed.

Technology

Much of the information in this section has been obtained from Dr. Robert Carnahan of Gould Inc., for which the author expresses his sincere appreciation. Thanks are also extended for contributions from Dr. E. L. Kyser of Systems Industries, Professor C. H. Hertz of the Lund Institute, Professor E. Stemme of Chalmers University of Technology, Goteborg, Sweden, Mr. E. Bacher of Hermes Precisa Intl. S.A., T. Stansfield of Mead DIJIT, J. J. Stone of A. B. Dick Corporation, C. Kopp of Moore Business Forms, and S. Zoltan, D. Koneval, and W. Koeblitz of Gould, Inc.

There are basically three ink droplet generating approaches currently in vogue including: high frequency, pressurized, and electrostatically deflected systems, low frequency, pressurized, electrostatically gated and deflected systems, and low to medium frequency nonpressurized impulse or ink-on-demand systems. We restrict ourselves in this review to systems in which the printing or writing is done by ink droplets as opposed to a continuous ink stream such as in the Elmqvist jet oscillograph.[1]

The high frequency-pressurized jet method utilizes an electrically conductive writing fluid, a pressure ranging from nominally 2 atmospheres to 30 atmospheres, an applied charge on the ink stream, and a deflection electrode scheme as its basic elements. The first practical application was made by R. G. Sweet[2] using a pair of deflection electrodes to sweep the jet in response to an oscillating electrical input signal which was recorded continuously on a strip of paper passing beneath the droplet stream. The basic system also incorporates a means of regulating the droplet size which is achieved by modulating either the jet tip or supply reservoir with a superimposed high frequency mechanical perturbation. The latter was shown by Rayleigh[3] to be related to the jet orifice diameter, d, and stream velocity, v, by:

$$f = \frac{v}{4.5\,d} \qquad (1)$$

fixing the frequency of operation or droplet generation for a given orifice diameter and pressure of operation. The magnitude of charge is deduced from the equation developed by Sweet[4] to describe the droplet trajectory:

$$X = \frac{10^7 qEZ^2}{2mv^2} \qquad (2)$$

where

X = the deflection amplitude at the recording surface
q = the droplet charge
E = the deflection field
m = droplet mass
v = stream velocity
Z = distance from deflection field entrance to recording surface.

As pointed out by Stone,[5] the deflection amplitude is very sensitive to changes in the squared terms and since hydraulic pressure must be accurately regulated because of its influence on velocity, Z and m are generally maintained constant and E maintained below the breakdown potential for high voltage in air. Thus "q" takes on values proportional to the video potentials and provides the means for modulating the ink jet system.

Specific systems based on this approach and modifications of it will be discussed later in this section.

The low frequency-pressurized jet method differs basically in two ways from the previous approach in that: the formation of an ink droplet or needlelike mass of ink is signaled by application of the appropriate voltage to a gating electrode making it an asynchronous device. It operates at a much lower effective frequency than the previous type ~ 3 kHz or lower. The mechanism of producing droplets is such that character printing rate is more meaningful than frequency per se. The system is weakly pressurized to a level of ~ 1 cm H_2O causing the formation of a convex meniscus of the electrically conductive writing fluid. Printing is initiated by application of an electric field to the gating electrode and nozzle tip. At a sufficiently high dc potential difference (~ 2000 V) an ink mass is torn from the meniscus and accelerated toward the printing surface by a dc potential difference (7000 V) between the nozzle and printing platen. X and Y modulation is achieved from 2 pairs of

intermediate electrostatic deflection plates. The electrostatic valving can be varied to produce droplets, line segments, or a continuous character line if desired. Because of the mechanism of generation and relatively low pressure of this system, the inner diameter of the nozzle tip can be quite large—~0.15 mm.

The method of low/medium frequency-impulse jet printing represents the newest approach to ink jet printing and has been developed during the past 5 years. It differs in some fundamental ways from the two prior approaches. It utilizes a pressure wave or pulse as the primary means of producing the droplet and the writing fluid is not required to be electrically conductive. A typical means of applying the pressure pulse is by a piezoelectric driver coupled to the system behind the jet nozzle. A single droplet is generated on demand by pulsing the transducer with an appropriately shaped drive pulse. For continuous or burst mode operation the jet can have a repetition rate or frequency of up to 10 kHz. Nonpressurized systems are refilled by capillary action which nominally limits operation to the upper frequency cited. The droplet size is influenced by pulse amplitude, such that for a given writing fluid and jet tip geometry an envelope of operating conductions describing allowable frequency and droplet size is described.

The rudimentary development of synchronous-electrostatically deflected system is the R. G. Sweet system which has been commercialized by A. B. Dick, incorporating features developed by Lewis and Brown,[6] Bischoff,[7] Stone and Bischoff,[8] and others, as the Videojet system. The approach taken by Mead Corporation in their DIJIT system uses charging and electrostatic deflection as a means of simply directing a percentage of the droplets to a sump and therefore as a means of causing the system to function as an on/off binary printer.[9] Yet another approach has been taken by C. H. Hertz[10] in using electrostatic charging as a means of controlling dispersion of a high velocity stream of droplets and thereby modulating intensity of the recorded image.

The most familiar system is the A. B. Dick Video jet developed subsequent to licensing the Sweet and Lewis and Brown patents. Their initial efforts centered on a medium speed line printer developed as a computer peripheral. The printer introduced as the model 9600 operated synchronously at a rate of 250 Hz using an alphanumeric character generator. A single jet operating at 66 kHz was transported by a novel mechanical mechanism from left to right with videolike electrostatic deflection of the droplets over the vertical dimension of a single character position; thus a full character line was generated for each horizontal sweep of the jet. To minimize charge interaction between sequential droplets, the guard drop technique[7] of charging alternate droplets was used with the result that 50% of the ink was automatically recycled in addition to the fraction of droplets not used for writing. The net effect was to reduce the effective rep rate to 33 kHz and to make it necessary to recirculate approximately 95% of the writing fluid in the system.

American Can Corporation is currently marketing to the food packaging industry a system based on this process for dating beverage cans and other food products. The basic system incorporates two writing heads that are capable of being controlled independently and will write up to 10 digits serially as the article passes beneath the head on a packaging conveyer line. The system operating at the indicated rate of 66 kHz tends to be limited only by the product throughput.

A second application of the same writing head is in the Compurite system developed by Moore Business Forms. The system is currently finding increased usage in the entry of variable information such as addresses on IRS forms at rates of 700 ft/min. Typical system parameters include an orifice diameter of ~.0015 in., or less, an operating pressure of ~30 psi, a droplet velocity of 400 to 800 ips, video voltage levels up to 300 V, and fluid viscosities of ~1.5 centipoise (cP). Basic refinements of the system have led to electronic compensation techniques to account for electrostatic and aerodynamic wake interactions[5] that now permit the frequency of droplet generation to equate with the writing speed. Additional features include methods of continuous droplet detection and monitoring of discrete droplet charge levels.

The approach used in the original development of the Mead-DIJIT system was to print or write with neutral droplets using the electrostatic deflection scheme as a means of control to direct charged droplets back to the supply system. The initial area of application was digitally enhanced image reproduction and digital graphics.[12] Very accurate control of gray scale was achieved by printing dot matrices consisting of 3×3, 4×4, 5×5 spot arrays and by using two matrices side by side to control overlap. The typical system developed is used to produce a facsimile copy 60×40 with the binary information generated using either a memory buffer or a directly coupled optical scanning device. A number of systems based on this concept have been developed for use by NASA.

A major distinction between the emphasis at Mead and in other ink jet development, however, has been their predilection for complex line arrays of jets. One system contains 100 jets/in. with the entire array consisting of 512 individually addressable ink jets.

The array head design is unique in that a pressurized plenum chamber ink fluid reservoir is common to the orifice plate containing the array of openings. A longitudinal ultrasonic wave is propagated in the orifice plate at a frequency above 50 kHz to ensure uniformity in droplet size and formation time.[9] The absence of charge on the neutral writing droplet is an important consideration especially for writing at high speeds on a rapidly moving surface where static charge can be a problem. Those droplets selected for return to the system are charged, deflected, and returned to the reservoir.

Designed to be used as a continuous web printer, this system has an effective web width of 13 cm and can operate at a maximum speed of 45,000 lines/min or 48,000 Hz. A wider head consisting of a 1024 jet array will ultimately permit a web width up to about 13 in. Systems now under development are expected for application to a variety of high volume printing requirements including such applications as computer letters, address

labels, invoices, and computer reports as well as other areas.[13]

The third variation on high frequency electrostatically charged droplet systems has been developed by Prof. C. H. Hertz and co-workers.[10,14,15] The basic concept is the utilization of a much smaller capillary orifice for the jet than in the Sweet approach, e.g.d. = 10 mm or .0004, and a very much higher pressure, approaching 450 psi. The droplet velocity is correspondingly higher, reaching 35 m/sec. Under these conditions the jet stream breaks up into a droplet stream of 5×10^5 drops/sec, which may or may not be regulated by a superimposed ultrasonic vibration. The system is typically charged to cause mutual repulsion of the droplets to form a conical spray. Voltage level ranges from 100 V to 500 V at which level the jet is entirely dispersed into a fine spray. Gray scale modulation is obtained by control of dispersion level and printing through a controlled diameter orifice placed between the printing platen and/or a collection electrode. The result is an essentially complete range of tonal quality from pure black to white. Pulse duration modulation is also used as a technique for gray scale control with voltage level switching between 0 and 500 V (essentially on/off) at a frequency of 10 kHz for pulse lengths varying from 0 to 100 μsec.

Various systems developed at the Lund Institute have included facsimile copy machines, a high speed alphanumeric line printer using 5 heads, and an intensity modulated oscillographic recorder used for EKG and pulse echo cardiological recording.[16]

Recent development has been applied to three-color computer graphic recording. Three such systems are currently in use in Sweden, two at the Lund Institute Computer Center and a third for printing remote sensing data at the Swedish Defense Research Institute in Stockholm.[17]

A similar instrument is being built for exclusive use in scintigraphy by the Siemens Company. Typical uses are the color graphic display of organic activity levels subsequent to radiological injections. The Sicograph system can produce 1, 4, or 16 separate plots on a sheet of paper 35 × 42 cm. Organs can therefore be reproduced at a scale of 1:1 or less and time delay sequence plots can be generated to show rate of uptake. Printing time is nominally 90 sec to produce a full image.[18]

One of the first data terminal printers utilizing an ink jet printing scheme was the Inktronic low frequency-deflected jet stream marketed by Teletype. Based on Winston's patent[19] for a new method and apparatus for transporting ink, the printer was a rather direct device for asynchronous generation of characters of speeds up to 120 Hz. It utilized 40 in-line nozzles each addressing two adjacent character positions. With the asynchronous mode of writing, no buffer storage was required for incoming data and paper motion posed the only requirement for mechanically moving parts. As discussed previously, a voltage potential of ~ 2000 V established between the ink jet and a valving or gate electrode caused a droplet or streamer of ink to be pulled from the jet and accelerated in the direction of the charged platen (the latter had a dc potential difference of ~ 7000 V relative

to the jet). Horizontal and vertical deflection electrodes positioned the ink in the desired location to form characters. A distinction from other modulation schemes lay in the fact that as implemented in the Inktronic the jet was valved on for the full duration of time required to print the line making up a character and thus traced the character in sequence rather than row by row or column by column as is conventional for dot matrix character generation.

A modification of this method was developed by Hermes Precisa International in Switzerland in the late 1960s based on developments by Ascoli.[20] With the objective being the development of a low cost machine, the Hermes HR-3 calculator printer was introduced having a 19-column capacity, a printing rate of 70 Hz at 2 to 5 lines/sec, and a character set of 22. It utilized a novel single nozzle head configuration in which all of the elemental components were integral, i.e., jet tip, valving electrode, X and Y deflection electrodes, in a ruggedized simple structure.

Apparently the most successful venture with this approach is the Typuter developed and marketed by Casio under license from Paillard. Primary attention has been given in the development of this system to reliability and low cost. Novel features in the ink supply system include special electrically sequenced valving to permit the elimination of air and other gases trapped in the fluid and special materials and surface treatments of the jet nozzle to eliminate or preclude wetting problems. The system operates in a serial line printing fashion at a nominal speed of 33 Hz. Both dot and stroke segments are used in character generation modulated by control over the valving pulse.

Conceptually the simplest device for generation of ink droplets in response to an electronic signal is the impulse jet. Functioning like a microscopic pump, each mechanical impulse gives rise to formation and ejection of an individual droplet of fluid.

As an antecedent to earlier research that led to development of character generation using the electrostatically deflected jet,[6] Zoltan[22] developed the first ink-on-demand jet. Its inherent simplicity lay in the fact that neither complex deflection electronics nor a pressurization or recirculating flow system as used in the other jet systems was required. The basic device consists simply of a capillary tube with an orifice, a cylindrical piezoelectric driver element which transmits a pressure pulse directly to the fluid on trigger, and a supply line leading to an ink reservoir. Application of a voltage pulse of ~ 50 V results in the generation of a fluid droplet of a diameter approximately equivalent to that of the orifice and with a velocity of 1 to 20 m/sec. Refill of the evacuated volume takes place by capillary action, tending to limit the rep rate frequency to ~ 10 kHz depending on fluid characteristics and geometric considerations. Droplet size is a function not only of the jet geometry but also of the substrate on which writing occurs. For example, bleeding in a coarse paper will result in a larger spot size than the same droplet produces on a chromecoat paper.

Facsimile reproduction and character generation have both been carried out using a rotating drum printer. The

drum incorporates a shaft encoder and synchronized stepper mechanism to advance the jet one dot row position per revolution. Shaped voltage pulses are fed to the jet driver in increments determined by the shaft encoder such that nominal driver frequency is a direct function of drum speed. In the facsimile mode, a photocell is mounted in an equivalent position to scan an image (raster fashion) producing an output signal for the driver circuit. Gray scale is controlled by pulse height modulation and variable half tone quality is achieved by printing on either a regular square or diamond dot matrix. Three and four color facsimile have also been demonstrated successfully using both sequential overlay of the subtractive colors and simultaneous mixing of four colors by a four jet head with each jet aimed at a common point. Alphanumeric asynchronous printing has been demonstrated using a seven jet array to generate characters using a 5×7 dot matrix.

Kyser and Sears of Systems Industries have developed an impulse jet that utilizes a bimorphic piezoelectric disc as one wall of a thin cylindrical reservoir or chamber having an inlet feed tube and nozzle outlet.[23] Droplet size is governed by the pulse amplitude, typically less than 100 V, and the nozzle diameter, normally .002 in. I.D. The range of operation is dc to ~ 8000 drops/sec. As in the Casio System, a chemical treatment is applied to the nozzle tip to prevent weeping of the system when positively pressurized. The mechanism can be operated at a slight negative head owing to the fact that replenishment of the fluid occurs due to capillary forces. A seven jet array has been developed as the writing mechanism for a medium-speed printer, 200 Hz, that Systems Industries expects to release.

Stemme-Larrson developed concurrent with the aforementioned system a similar pulsed jet asynchronous writing device[24] referred to as a piezoelectric capillary injector for dot pattern generation. The basic mechanism differs in that an axially polarized dielectric plate serves as the driver which acts on a metal plate to transmit a shock wave to the fluid reservoir. The capillary aperture then functions effectively to permit a prismatic element or column of fluid to be punched out forming a droplet due to surface tension forces. Following the application of a pulse, the plate returns to its equilibrium position and refill of the evacuated volume takes place by capillary action. Typical voltage levels are up to 130 V with a 40 μsec pulse duration. Alphanumeric character generation has been demonstrated using a 7-jet experimental printing head to print serial characters. A single head has been used to print a serial column at a speed of 1000 Hz. parallel printing has been demonstrated using a 5-jet array that fits into a standard character position of 0.1 in.

Picture generation has been demonstrated in the facsimile mode using either pulse amplitude modulation or pulse duration modulation.

Problems and deficiencies have been cited which are the focus of continued applied research and development not only by the organizations discussed but also within IBM[25,26] and Xerox, as evidenced by abundant recent patent activity in their respective organizations. A

TABLE 15-5.

Problems and Limitations

Electrostatic Deflection

Improper phasing of droplets and charge levels.
Electrostatic interaction, e.g., repulsive coulombic charges.
Droplet gathering prior to deflection coalescence.
Aerodynamic wake interaction.
Speed is limited by frequency.
Higher speed—higher frequency—smaller droplet size.
Paper fogging due to droplet explosion (with increase in droplet mass and velocity splash effect).
Satellite droplets.
High voltage requirement relative to pulsed jet.
Relatively larger ink supply.
Requires conductive inks or fluids.

Pulsed Jets

Acoustic—hydrodynamic interactions.
Refill limitations.
Upper frequency limit nominal 10 kHz.
Lower velocity of droplet.
Satellite formation (some conditions).
Speed limitations—paper proximity—air disturbance.
Air bubble formation resulting in loss of priming.
Inertial delay or initiation for larger droplets.

summation of some of the reorganized problem areas is presented in Table 15-5.

SUMMARY

Recording and writing by means of an ink jet device clearly offers a simple and direct method of marking that is not influenced by the limitations imposed on many, if not most, other approaches. As a silent, non-

TABLE 15-6.

—Computer output line printing/interactive hard copy/terminal printer.
—Calculator printer.
—Encoding of containers or packages on conveyer.
—Bar code printing.
—Tax stamp printing.
—Stamp canceling.
—Computer controlled addressing of mail pieces.
—Printing variable information on forms, e.g., the Moore Business Forms Compurite for addressing IRS forms.
—Variable value component marking.
—Facsimile.
—Computer graphics.
—Check encoding.
—4-color facsimile.
—Color mixing.
—Fluid dispensing or metering in close precision process control.
—Computer coded pricing in supermarkets on variable measure items to supplement RCA Universal Product Code readable only by OCR.
—Automated titration in chemical reactions.
—Low cost—low speed hard copy point of sale and communications terminal printer.

contact, nonimpact plain paper printing device, imaginative uses will certainly be found to take advantage of its features. For economical printing on a variety of surfaces and surface conditions, and particularly for the recording of variable input data from both analog and digital sources, ink jets offer an almost unique approach. An outline of applications, some of which have been discussed in the systems context, is presented in Table 15-6.

An earlier review of ink jet printing by Kamphoefner[27] will provide the interested reader with a further and complementary reference bibliography to this text.

REFERENCES

1. R. Elmqvist, "Measuring Instrument of the Recording Type," U.S. Patent 2,566,443 (Sept 4, 1951).
2. R. G. Sweet, "High Frequency Recording with Electrostatically Deflected Ink Jets,' Rev. Sci. Instr., 36: 131–136, (Jan 1965).
3. J. W. S. Rayleigh, Proc. London Math. Soc., 10: 4 (1878).
4. R. G. Sweet, "High Frequency Oscillography with Electrostatically Deflected Ink Jets," Stanford Elect. Labs. Report No. 1722-1, Mar 1964.
5. J. J. Stone and R. I. Keur, "Some Effects of Fluid Jet Dynamics on Ink Jet Printing," IEEE Transactions on Industry Applications, v. IA-12, no. 1, Jan–Feb, 1976.
6. A. Lewis and D. Brown, "Electrically Operated Character Printer," U.S. Patent 3,298,030 (Jan 1967).
7. V. Bischoff, "Guard Drop Technique for Ink Jet Systems," U.S. Patent 3,562,757 (Feb 1971).
8. J. J. Stone and V. E. Bischoff, "Drop Phasing in Ink Drop Writing Apparatus," U.S. Patent 3,562,761 (Feb 9, 1971).
9. R. H. Lyon and J. A. Robertson, "Apparatus and Method for Generation of Drops Using Bending Waves," U.S. Patent 3,739,393 (June 12, 1973).
10. C. H. Hertz, A. Mansson and S. I. Simonson, "A Method for the Intensity Modulation of a Recording Ink Jet and Its Applications." Acta. Univ. Lund. Sec. 2, No. 15, pp. 1–16 (1967).
11. Private communication.
12. "Description and Technical Specifications, Models BP 7004 and BP 7005," Data Corporation, Dayton, Ohio, Tech. Note DTN-71-4, July 1971.
13. "Mead DIJIT Image System," technical specifications and product description, Mead DIJIT Image Centers, Dayton, Ohio, Aug 1974.
14. C. H. Hertz and S. I. Simonson, "Ink Jet Recorder," U.S. Patent 3,416,153, (Dec 10, 1968).
15. B. Smeds, "A 3-Color Ink Jet Plotter for Computer Graphics," BIT 13, pp. 181–195 (1973).
16. K. Lindstrom, N. G. Holmer, R. Eriksson, and B. Gudmundsson, "The Recording of Echocardiograms with an Intenstiy Modulated Ink Jet Oscillograph," Trans. IEEE Biomedical Engineering, BME 20 (6): 421–26 (Nov 1973).
17. Private communication from Prof. C. H. Hertz, Sept 24, 1974.
18. Siemens Sicograph Technical Data Sheet, Siemens, Medical Engineering Group, Erlangen, Germany.
19. C. W. Winston, "Method and Apparatus for Transferring Ink," U.S. Patent 3,060,429 (Oct 23, 1962).
20. E. Ascoli, "Procede d'Ecriture HWP par Emission et d'Eflexion Electrostatique d'un Jet d'Encre," Ind. Org. No. 4, 1968.
21. Product Description Brochure, Casio.
22. S. Zoltan, "Pulsed Droplet Ejecting System," U.S. Patent 3,683,212 (Aug 8, 1972).
23. E. Kyser and S. Sears, "Method and Apparatus for Recording with Writing Fluids and Drop Projection Means Therefor," Brit. Patent 1350836 (June 1974).
24. E. Stemme and S-G. Larsson, "The Piezoelectric Capillary Injector-A New Hydrodynamic Method for Dot Pattern Generation," Trans. IEEE Electron Devices, ED-20 (1): 14–19 (Jan 1973).
25. "Ink Jet Copier," IBM Tech. Disclosure Bull., 16 (4): 1254–1255 (1973).
26. "Ink Jet Copier Nozzle Array," IBM Tech. Disclosure Bull., 16 (4): 1251–1253 (1973).
27. F. J. Kamphoefner, "Ink Jet Printing," Trans. IEEE, Electron Devices, ED-19 (4) (Apr 1972).

ELECTROPHORETIC PRINTING AND OTHERS

Electrophoresis is the movement of charged particles in a unidirectional electromagnetic field. In a typical electrophoretic separation a solution containing two or more ionic solutes is spotted on a strip moistened with a solvent. A dc potential is applied across the strip and the ionic species begin to migrate toward one end or the other depending on what charge the ion carries. The movement of an ion in a given matrix-substrate system is usually characteristic and is called its mobility.

Technology

Electrophoresis, although dating back to 1892, was not considered as a printing system until recently, as it was considered too slow and the power consumed seemed rather high. For example, Lennon[1] points out that at 700 V and 9.8 mA, FD&C Yellow #5 migrated 8 cm in one hour. The power requirements were therefore 0.86 W-hr/cm of movement at a speed of 2.2×10^{-3} cm/sec. Clearly, this is not what one would expect in the way of power requirements and speed for an imaging system.

There are, however, several factors which favor its use as a printing system. The first is the small distances involved in the transfer of dye from a ribbon to an image sheet. The distance the imaging dye has to travel is only about 0.005 in. at the most. The second is that due to the short distance traveled, the pulse moving the dye may be short (e.g., 3 msec), thus permitting the use of high power pulses by the system. A third is the possibility of using dyes of opposite polarity whose direction of movement is dependent on the direction of the field. This, if dyes of different color as well as polarity are used, permits bicolor printing by changing the input pulse from positive to negative.

Lennon[1] discusses a scientific approach to the selection of dyes for use in such a system. Additional information can be found in Refs. 2, 3, and 4.

Much research has been carried on by Xerox Corporation to develop a light-sensitive imaging process based on the principles of electrophoresis. Since this work is described elsewhere in this book, only Refs. 5, 6, 7, 8, 9, and 10 will be cited, except to say that the key lies in the use of photoactive particles which can accept charges.

Others

Another process was developed by Horizons Inc., in Cleveland, Ohio, and is referred to as Contrography.[11] It uses a paper having a mineral spirits barrier treatment. The paper is floated over the mineral spirits and by

electrophoresis, the carbon particles are deposited on the paper where charge is applied. To my knowledge there is no commercial equipment on the market using this process. Basically, the paper can be made at very low cost comparable to a high grade bond.

In the ElectroPrint computer printout process, electrostatic fields are used to project and control ions. Instead of using an optically-activated photoconductive screen, this process uses an electrically addressed row of holes as the gating mechanism for ions. The holes are drilled into a multilayered plate consisting of a layer of insulating material, a continuous layer of conductor on one side of the insulating layer, and a segmented layer of conductive material on the other side. Each segment of the segmented-conductive layer is insulatively isolated from each other segment in the layer. At least one row of apertures is formed through the multilayered modulator so that a portion of the segmented-conductive layer surrounds each aperture.[12]

The row of holes is set up between a corona source and a back plate so that an electrostatic propulsion field is set up. Programmed electrical potentials are applied to one side of the hole while a fixed potential is applied to the continuous conductive layer. The electrical signals sent to the holes set up blocking fields within the holes. Each hole will pass or block a charged particle. The entire row of holes can be activated simultaneously with each hole acting independently of the other.

The paper to be printed is passed between the row of holes and the back electrode. A mist of ink produced by supersonic means and consisting of uniformly sized, uncharged, spherical liquid particles of about 5 μm in diameter passes through the space between the paper and the holes. If there is no signal to the hole and, therefore, no electrostatic fields to block the passage, the ions stream through the hole, collide with and charge the ink particles, which then become controlled by the external electrostatic propulsion field and are attracted toward the back plate. Since the plain paper is traveling over the plate, the ink is deposited on the paper and a visible dot is formed.

RCA developed a simulated dry ink propulsion system referred to as MTR Printing (Material Transfer).[13,14] The process depended upon literally blasting a layer of ink from a coated plastic web with a laser beam to the surface of a sheet of paper. Again, ordinary paper could be used. Because of the many problems encountered, among which was charring, the process has not been developed commercially.

A review of the patent literature will reveal many more ingenious imaging processes that do not require light.

REFERENCES

1. D. J. J. Lennon, "Multicolor Electrophoretic Printing," *Novel Imaging Systems*, SPSE, 1969.
2. D. J. J. Lennon, U.S. Patent 3,326,793.
3. D. J. J. Lennon, U.S. Patent 3,372,102.
4. D. J. J. Lennon, U.S. Patent 3,409,528.
5. V. Tulagin, "Imaging Method Based on Photoelectrophoresis," *J. Opt. Soc.*, **59**: (3): 328-331 (1969).
6. R. Egnaczak, et al., U.S. Patent 3,647,290.
7. R. Gundlach, U.S. Patent 3,663,396.
8. W. Goffe, "Photographic Migration Imaging-A New Concept in Photography." *Photogr. Sci. Eng.*, **15** (4): 304-307 (1971).
9. John Holmes, "Instant Imaging," *Photo Methods for Industry*, pp. 49-50, Jan 1971.
10. A. Pundsack, "Phenomenological Theory of the D Log E Curve for Migration Imaging," 1971 SPSE Symp. on Unconventional Photographic Systems, pp. 37-39.
11. R. A. Fotland, "Imaging on Plain Paper," *Ibid*, pp. 51-54.
12. "Non-Impact Printing," *IGC Monthly*, May, 1975, pp. 14-15.
13. M. L. Levene, R. D. Scott, and B. W. Siryi, "Material Transfer Recording," *Applied Optics*, Oct. 1970, pp. 2260-2265.
14. M. L. Levene and B. W. Siryi, "Equipment Applications for Material Transfer Recording," *Record of IEEE 11th Symposium on Electron, Ion, and Laser Beam Technology*, pp. 69-76.

PART III

Light Sensitive, Silverless Imaging Processes

Shown below are some excellent general references on light sensitive, silverless processes:

1. Light Sensitive Systems, J. Kosar, Wiley, 1965 (very extensive references to patent literature).
2. Unconventional Photographic Systems: A Bibliography of Reviews, P. P. Hanson, PS&E, V 15 (1970), p. 438-42, 134 reviews, indexed by subjects.
3. SPSE Symposia on Unconventional Photographic Systems, 1964, 1967, 1971, 1975; on Novel Imaging Systems, 1969.
4. Proceedings of TAPPI Conferences on Reprography, 1970, 1971, 1972, 1973; on Coating and Graphic Arts, 1974, 1975.
5. Annual TAGA Proceedings.
6. Annual NMA Proceedings.
7. Photographic Science and Engineering, bimonthly journal of the SPSE.
8. W. Thomas, Jr., Ed., SPSE Handbook of Photographic Science and Engineering, Section 5, "Radiation-Sensitive Systems" and Table 9-2, "Non-Silver Halide Photographic Processes," John Wiley & Sons, 1973.

The silverless and non-electrophotographic processes to be discussed in this section are used commercially in many important imaging applications, including engineering drawing reproduction, microfilm duplication, printing plates, color proofing, graphic arts proof prints, office copying, projection transparencies, and others.

Although there has been a proliferation of new light sensitive materials and processes in recent years, no one process is ideal for all recording systems, or even a majority of the main applications. Generally processing ease is at the expense of light sensitivity, and an increase in the number of steps for whatever reason buys an equivalent increase in electromechanical complexity. The charts on the following page summarize some of

the more important properties for both silver and silverless light sensitive materials. Some of the material in Table 15-7 was provided by Dr. Peter Walker of DuPont.

Certainly many of the silverless systems have attained great commercial importance and success—so much in fact that certain systems discussed at the first "Unconventional Photographic Systems" symposium in 1964 cannot properly be called "unconventional" any longer. Prime examples are xerography, direct electrophoto-graphy, or Electrofax, diazo, photopolymerization and thermography. Admittedly, some persons persist in using the words "unconventional" and "non-silver halide" synonymously, but this just is not factually accurate. To be "non-silver halide" no longer means to be unconventional. In fact, in the office copier industry, to be "silver halide" is to be "unconventional!" Even Eastman Kodak now has introduced a copier based on the electrophotographic process, and a Kodak rep-

TABLE 15-7.

Process	Approx. sensitivity ergs/cm^2	Processing	No. steps	Resolution (1/mm)	DMAX
Polaroid Type 410	.0001	Polaroid	3	22–28	
Royal-X Pan (Kodak)	.001	Wet		56–68	1–2
Electrophotography	1	Dry	4–5	8–50	1–1.5
Itek RS	1	Wet	4–5	500	2–3
Silver Halide Litho Film	1–10	Wet	4–6	200	4
Silver Halide Printout	5	Wet	4–6	50	1
Dry Silver-Type 777	200	Dry	2	>100	1.5
Type 649 (Kodak) Lippmann	10^3	Wet		>225	>2
Cromalin ® Photopolymer	2 × 10^4	Wet	3	100	2
Free Radical (Horizons)	5 × 10^4	Wet or Dry	2	>500	1.5
Dylux Free Radical (DuPont)	2 × 10^5	Dry	1–2	100	~1
S. D. Warren 1264 Free Radical	2 × 10^5	Dry	2	100	1.5
Thermography	5 × 10^5	Dry	1	low	1.5
Photochromics	10^6	Dry	1	1000	
Vesicular	2 × 10^6	Dry	3	500	1.2
Diazo/Bluprint/Bichromated Processes	~10^7	Wet or Dry	2	500	1.5

TABLE 15-8. ECONOMICS OF PHOTOGRAPHIC RECORDING AND REPRODUCTION PROCESSES.

	Cost/ft^2 (¢)	Exposure power	Process power	Ecology problems	Manpower and skill levels	Commercial availability	Sources
Conv Ag-halide	minimum 18¢ + processing	low	medium	chemicals, water, silver	high	yes	3
3M dry silver	28	low	low	silver	low	yes	1
DuPont Dylux	18	high	low	NH$_4$ fumes	low	?	1
Diazo	18	high	high	NH$_4$ fumes CHOOH fumes	low	yes	7
Electrostatic E	30	medium	medium	none	medium	yes	1
Free-radical	29	high	high	I$_2$ fumes	low	yes	1
Vesicular	14	high	high	none	low	yes	3

Courtesy of Mr. Jack Lewis Avionics Laboratory, WPAFB.

TABLE 15-9. POTENTIAL APPLICATIONS FOR UNCONVENTIONAL PHOTOGRAPHIC PROCESSES.

	Optical photo	CRT photo	Laser line scan	Roll to roll duplication	Projection duplication
3M Dry Silver	good	good	capable	capable	capable
DuPont Dylux	poor	poor	possible	good	possible
Diazo	poor	poor	possible	capable	possible
Electrostatic	good	good	good	possible	good
Free-radical	possible	possible	good	capable	possible
Vesicular	poor	poor	possible	good	possible

Courtesy of Mr. Jack Lewis Avionics Laboratory, WPAFB.

resentative indicated that photography, xerography, and reproduction are all part of and comprise "reprography."[1]

The past fifteen years certainly have been the age of silverless imaging processes; this trend can be expected to continue. A proliferation of books, articles, and seminars on such processes has occurred. A course titled, "Theory of Non-Silver Photographic Processes" is now offered at the Rochester Institute of Technology by Dr. Ronald Francis, Chairman of the Photographic Science and Instrumentation Division. Although recognition was slow in coming, most would now agree that the world of photography is far broader than just the silver halide process.

As can be seen in Table 15-7, those processes with sufficient sensitivity to be used in hand held cameras for photographing dynamic scenes are still limited to silver halide-based ones. Disadvantages of the classical silver halide processes are legion—such as inconvenient and lengthy wet processing, large number of steps, and cost of materials—but until another process can rival it in sensitivity, it will remain unchallenged in those applications where sensitivity is paramount.

The silverless processes have scored their biggest success in applications which involve the duplication of information that already exists in a permanent form, or a non-dynamic state. Typical examples would be business documents, engineering drawings, artwork in graphic arts, microfilm, and silver halide negatives from which silverless printing plates or prints are made.

To date, only silver halide processes have operated with amplification of the light signal up to $\times 10^9$. Therein, of course, lies the key to their impressive sensitivity. By contrast, organic photosystems with amplification have stopped at about $\times 10^3$. Individual vinyl polymerization systems have shown higher gains but only with irreproducible results. For example, it has been reported that Yamada's work at Bell & Howell on such systems has led to camera speed materials with an ASA of 50–60 and direct image formation with results equivalent to early Polaroid B&W materials. However, these materials have very poor shelf life and the image browns. Although commercial electrophotographic processes are rated up to an ASA as high as 5 (not suitable for camera speed), ASA's of 20 have been reported experimentally, with definite promise of higher ratings in the future. Significant research continues in this direction.

The next fifteen years of photographic research may well turn out to be more exciting and also more demanding than the last fifteen. During this period, silverless processes will begin to be used for camera speed applications. Photographic prints for the consumer may well be made by silverless processes, although the consumer may not be aware of the switch. Then again, many now don't know which process is utilized to produce their prints!

In the remainder of Part III, several imaging processes will be described which either have been used commercially, or are in the advanced development stage. If one were to describe the hundreds of "new" photo-

graphic and silverless imaging processes actually investigated as revealed in the patent and trade literature, and at conferences, there would be room only for this chapter in this volume. For further information than provided in this chapter, one can consult cited references herein, search "Abstracts of Photographic Science and Engineering Literature" and finally, "The Graphic Arts Abstracts" from RIT.

REFERENCES

1. *Reprographics*, **13** (no. 5) 1 (June 1975).

HISTORICAL PROCESSES

Space does not permit us to dwell on these early processes, but as an introduction to the more modern processes, some will be briefly reviewed. Greater detail may be found in earlier editions of Neblette and in Kosar's book, previously referenced.

Most noteworthy is the well-known Blueprint process developed by Sir John Herschel in the middle 1800s. Its use is almost exclusively for line originals and produces white lines on a blue background.

The process is based on the light sensitivity of certain iron compounds such as ferric ammonium citrate and ferric oxalate. Upon exposure to much light, sufficient ferric salts are reduced to ferrous salts that during a water development wash, the ferrous ions react with ferricyanide ions to produce insoluble Turnbull's Blue, i.e., ferro-ferricyanide. The ionic reactions are shown below:

$$Fe^{3+} \xrightarrow{\text{light}} Fe^{2+} \tag{1}$$

$$3\,Fe^{2+} + 2\,Fe(CN)_6^{3-} \xrightarrow{\text{water}} Fe_3\underline{(Fe(CN)_6)_2} \tag{2}$$

Another process which has been used commercially is the Brown Tone or Brownprint Process. It too is based on the light sensitivity of iron compounds, e.g., ferric ammonium oxalate. Upon exposure to light, the ferric ions are reduced to ferrous ions which act as a reducing agent for metal ions such as silver, which results in images of elemental silver. The ionic reactions are shown below:

$$Fe^{3+} \xrightarrow{\text{light}} Fe^{2+} \tag{1}$$

$$Fe^{2+} + Ag^+ = \underline{Ag^\circ} + Fe^{3+} \tag{2}$$

In addition to silver, salts of platinum, gold, palladium, copper, and mercury have been used.

Considerable work was done by Lyman Chalkley on the light sensitivity of phosphotungstic acid. An imaging process based on this is shown below:

$$H_3PW_{12}O_{40} \xrightarrow{\text{light}} H_4PW_{12}O_{40}^+ + e^- \tag{1}$$

$$Ag^+ + e^- \longrightarrow \underline{Ag^\circ} \tag{2}$$

Many workers have investigated the light sensitivity of halides other than silver such as: mercury (Flannagan);

copper, mercury, and indium (Hillson and Ridgway); lead (Malinowski). So far none have proved a suitable substitute for silver halide; see Refs. 1–4 and Kosar.

Many silverless imaging processes are employed as photoresists for the manufacture of electronic circuits (including integrated), printing plates, reticles, precision scales for instrumentation purposes, fine-mesh screens, and the photofabrication of a variety of hardware components. The following materials have been used to form resist images:

1. Iodoform sensitized phenol-formaldehyde resins-production of etched glass reticles (1955 NBS Report).
2. Sensitized colloids and resins
 a. Dichromated gelatin.
 b. Dichromated glue—also known as glue-silver process for reticle production.
 c. Dichromated shellac.
 d. Diazo resin sensitized colloids.
 e. Organic azide sensitized colloids.
3. Photocrosslinkable polymers.
 a. Polyvinyl cinnamates, e.g., Kodak Photo Resist (KPR) and variations.
 b. Polyvinyl alcohol.
 c. Polyamides.
 d. Polyethylene oxide (Union Carbide).

Additional sensitizers are usually present to increase the light sensitivity, e.g., quinones, nitro compounds, and ketones with (a), dichromate with (b), and diazo in general.

4. Photopolymerization, e.g., acrylamides as used in Dupont Dycril plate or Templex PR coatings.
5. Positive working resists, e.g., Shipley/Azoplate.
 a. Quinone diazides.
 b. Diazo-oxides.
6. Silver halide/gelatin with tanner components, e.g., Kodak Relief Plate.

An excellent review article on photoresist materials was written by M. Hepher;[5] for additional references, see 6–17 and Kosar. Since most of these materials are also discussed later in this section, mention will be made only of the oldest resist process, the bichromate process. Many polymeric materials—including proteins, gelatin, albumen, glues, polyvinyl alcohol, shellac, and others—undergo crosslinking when exposed to light in the presence of bichromate ions. Although the basis for such reactions is not fully understood, it has been postulated that bichromate in the presence of water is reduced by exposure to light as follows:

$$2H_2O + Cr_2O_7^= \longrightarrow Cr_2O_4^= + 2H_2O + 1.5O_2 \uparrow$$

The chromous ions so produced will tie up certain chemical groups, including carboxyl and amide groups on suitable polymeric materials causing crosslinking. The bichromate solution must be coated just before use since it also reduces at a slower rate in the dark. Its stability is very pH dependent.

In addition to the resist application, bichromated gelatin solutions containing powdered carbon have formed the basis for the "carbon printing" method. Color printing methods have also been derived from it, as have photomechanical printing processes, such as photo-engraving, photogravure, silk screen process, wash-off process, and the deep etch lithographic process. Ninety pages in Kosar are devoted to the bichromate process and its applications.

REFERENCES

1. J. Malinowski, "Possibilities," *Photogr. Sci. Eng.*, **15**: 175–80 (1971).
2. M. R. Tubbs, "High-resolution recording on photosensitive halide layers," *J. Photogr. Sci.*, **17**: 162–9 (1969); see also *Brit. J. Appl. Phys.*, **15**: 1553–8 (1964); *Phil. Mag.*, **8**: 1003–8 (1963); *Proc. Roy. Soc. (London A)*, **284**: 272–88 (1965)
3. P. J. Hillson and M. Ridgway, "Dismutation: A new development reaction for photographic systems," *J. Photogr. Sci.*, **18**: 110–2 (1970).
4. G. N. Flannagan, "Developable Latent Images with Hg_2X_2," *Photogr. Sci. Eng.*, **13**: 335 (1969).
5. M. Hepher, "The Photo-Resist Story-from Niepce to the Modern Polymer Chemist," *J. Photogr. Sci.*, **12**: 181–90 (1964).
6. D. W. Woodward, V. C. Chambers, C. A. Thommes, "Image-forming Systems Based on Photopolymerization," *Photogr. Sci. Eng.*, **7**: 360–8 (1963).
7. P. Walker, V. J. Webers, C. A. Thommes, "Photopolymerizable Reproduction Systems—Chemistry and Applications," *J. Photogr. Sci.*, **18**: 150–8 (1970).
8. Technical Conferences on Photopolymers, Ellenville, N.Y., 1967, 1970, and 1973, proceedings published by the Society of Plastics Engineers.
9. Photosensitive Resists for Industry, Eastman Kodak Co.
10. J. F. Rabek, "Photosensitized processes in polymer chemistry," *Photochem. Photobiol.*, **7**: 5–57 (1968) 555 refs.
11. L. Minsk, et al., "Photosensitive polymers I Cinnamic acid esters of polyvinylalcohol and cellulose II Sensitization of polyvinylcinnemate," *J. Appl. Polym. Sci.*, **2**: 302–11 (1959).
12. C. C. Schenck, "Photosensitization," *Ind. Eng. Chem.*, 40–3. (1963).
13. N. T. Notley, "Photopolymerization imaging and the reaction between 9-vinyl carbazole and carbon tetrabromide," *Photogr. Sci. Eng.*, **14**: 97–100.
14. Proceedings of Kodak Seminars on Microminiaturization.
15. Proc. SPSE Seminar on Ultramicrominiaturization, 1970.
16. G. Stevens, *Microphotography*, Wiley, New York, 1968.
17. Proc. of the SPSE Seminar on Microphotofabrication, 1975.

DIAZONIUM IMAGING PROCESSES

The diazo process is the oldest organic-based photo-imaging process in use today. It was introduced in the United States in 1923 by Kalle as the Ozalid process. Today it is widely used for engineering drawing reproduction, microfilm duplication, lithographic printing plates, office copying (primarily Europe and Japan), and projection transparencies.

The process is based on the light sensitivity of certain diazonium salts to ultraviolet radiation. Where struck by light, the diazonium decomposes into colorless by-products. If the coating is then made alkaline by solution or wet ammonia, a coupler (usually phenols or aromatic amines) becomes activated to form a dye with any undecomposed diazonium. Unfortunately, diazo and the

other organic-based imaging processes to be described are generally rated as moderately to highly insensitive to light versus silver halide and electrophotographic processes. A simplified chemical reaction is shown below:

(1) Light-struck areas

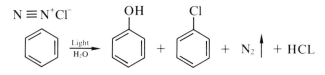

(2) Non-light-struck areas

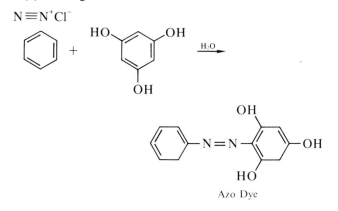

Azo Dye

History

Diazo is a process that grew deliberately out of a need. Koegel, a German monk, whose lot was to transcribe endless pages of handwritten text, concluded that there must be some method of reproducing these pages by a direct photocopying means. As he set to work he felt the need for special chemicals and ultimately went to beg them from a nearby chemical house which just happened to be Kalle of Biebrich am Rhein. They not only gave him the chemicals he required, but gave him laboratory space in which to work: the only stipulation being that such patents as he was granted be assigned to Kalle. The first such patent came out (in the United States) in 1923 under the names of Koegel and a Kalle representative and covered a diazo-type product still used and popular in Europe—and for good reason. Its long scale and low contrast gave it maximum opportunity of holding even the faintest lines in the original. True, it was a purplish red line on a dirty background, but it was the diazotype that many Europeans grew up with and they loved it and remained loyal.

As a diazo this first product involves 2-diazo 1-naphthol 5-sulfonic acid which has in recent years found wide use in lithographic and photoresist applications. The coupler was, of all things, phloroglucinol—about the most active coupler there is. No wonder the backgrounds were dirty!

The base, of course, was paper—ordinary paper—and there hangs quite a tale. It started with 100% rag paper which was impossibly expensive. Then ultimately the finger was pointed at iron. Not because of any reaction with the diazo, sensitive as it is, but with the coupler. Simple tests show strong color reactions of most

couplers with traces of iron. Today the specifications for diazotype base call for not more than 20 ppm of iron though the furnish has shifted from all rag to essentially all wood pulp. Some manufacturers still throw in a little rag or cotton linters with the hope of building up the physical strength.

Hard coating surfaces marked the beginning of sophistication—acetate, tri-acetate, polyester, glass and cloth. Problems centered around adhesion, freedom from crazing, and getting the right penetrating agents. Polyester presented a whole new ball game, opening the way to the vesicular explosion to be described later.

In 1974, diazo sales in the United States exceeded $100 million.

Technology

There are four variations of the diazo process in use today, namely, dry, moist or semi-wet, heat developable and pressure developable.

In the dry process, the coupler is contained in the sensitizing solution which is impregnated into the substrate. The solution is acidic so that coupling cannot occur until the pH is shifted into the alkaline region by passage through a hot, moist, ammonia-water atmosphere which is contained in the developing section of the diazo machine.

In the moist process, the coupler is applied as a thin film from solution onto the surface of the exposed diazo material.

In the heat developable process, the substrate is coated with a diazonium salt, a coupler and a material that provides an alkaline environment upon heat. The coupling reaction is thus initiated by the application of heat after the imagewise exposure. During the past 30 years, there have been many disclosures of heat-developable diazo papers. The papers most often described comprise a diazonium salt, a coupler, a stabilizer, and an inert material capable of releasing an alkaline material when heated. For example, U.S. Patent 2,732,299 (Morrison) cites the use of urea as a material which will release ammonia upon heating. French Patent 1,249,913 (Bauchet and Co.) discloses the use of thiourea as the ammonia-producing constituent.

Separate developing sheets, multilayer coating, and the use of compounds such as the diazosulphonates all have been revealed as the means for making thermally-developable systems in the Journal of Photographic Science and Engineering (Vol. 5, pp. 239–243, 1961). Nashua Corporation has patented the use of amine-containing inclusion compounds (U.S. Patent 3,076,707) and quaternary ammonium salts (U.S. Patent 3,135,607) as alkaline release materials.

During the 1960s, Post and Dietzgen both introduced diazo equipment based on heat-developable diazonium materials. Patents granted to Klimkowski (assigned to Dietzgen originally) formed the basis for a new company in 1969, known as Canadian Thermal Images, Ltd. Itek developed a product based on the use of N,N¹ disub-

stituted ureas which was characterized as of commercial potential, but for nontechnical reasons the company decided not to manufacture the product (U.S. Patent 3,238,047). 3M currently markets a heat developable diazo film, named "Therma-Tone" Film-Type 7889 which is a high resolution duplicating film.

Diazosulfonates can also be used in thermally-sensitive diazo systems. Compounds such as phloroglucinol, 1-amino-2,3-dihydroxynaphthalene, B-naphthol and 2,3-dihydroxynaphthalene can be used as couplers. The 2,3-dihydroxynaphthalene is preferred. The system can be stabilized with citric acid which keeps the pH on the acid side or with borax which improves the stability by forming a complex with the 2,3-dihydroxnaphthalene. The relatively low light sensitivity of the diazosulfonate as compared to the diazonium ion, and the better heat-coupling ability of the diazosulfonate, are process advantages. Itek investigated the use of such materials in a fixable, thermographic copy system where a thermal copier was used to form diazo images, and a post-UV exposure employed to destroy remaining diazosulfonate, thereby rendering the sheet thermally stable. Commercial thermographic copy systems remain heat sensitive after imaging.

In the pressure development process, the application under pressure of an extremely thin layer of an alkaline material is sufficient to cause coupling. A pint of the alkaline activator will produce from 3,000 to 4,000 $8\frac{1}{2} \times 11$ prints. Bruning's first unit, th PD80, resembles any modern diazo printer in exterior appearance, having separate exposure and development sections. After exposure by the usual means, the exposed sheet is fed into the developer section in which a Teflon-coated metering blade measures out a tiny amount of activator onto an applicator roller. The exposed paper is placed in pressure contact with this roller and the action of the blade pressing against the roller squeezes the activator onto the coated paper to develop a latent image. Approximately 1 g of activator fluid is metered out for each 1000 in.2 of paper. This approach eliminates the need for ammonia vapors with the attendant ecological problems *without* the wetness of the moist process. Since the paper substrate has been sized before the diazo coating is applied, the imaging compounds sit on the surface ready for rapid and full image formation. This diazo process, has been warmly received by users.

Advantages of the diazotype process include the following:

1. Low cost materials.
2. Proven, reproducible process.
3. Simplicity requiring minimum of equipment.
4. Extremely fine grain imaging possible. A silver image unit is about 3000Å wide, and a dye molecule is only about 15 Å wide. This difference will be a significant advantage in the future for microform duplication where the data are being reduced to ever-smaller images.
5. Images on diazo film are often formed within the film base, rather than on the film surface. Thus, the image is protected somewhat from scratches.

As described, the diazo process is simple in theory. The actual practice in manufacture is complex. Literally thousands of diazos might conceivably be used for diazotype reproduction, and dozens actually are in current use. The characteristics of the final product strongly depend upon the diazo, or combination of diazos, selected for a particular application, as well as the choice of coupler. For example, those diazo products which produce black images are actually blends of blue, brown, and yellow dyes.

Some diazos and some couplers, which would otherwise have excellent characteristics, are insoluble in water or in the particular solvent which might be best to use with the other ingredients. Some of the dyes formed are acceptable when first produced but must be eliminated because of subsequent fading, "bleeding," color shifting, or other undesirable traits. A given combination of diazo and coupler may yield excellent results with some papers, under some sensitizing conditions, but wholly unsatisfactory results under other circumstances. If a consistently satisfactory product is to be achieved, then good formulation practice requires a painstaking correlation of diazo, coupler, paper, coating technique, and end use.

Ammonia-developing diazotype materials contain other ingredients in the sensitizing formulas, in addition to the diazos and couplers. Present in nearly all diazo-sensitized products are a stabilizer, usually an acid (e.g., citric acid or tartaric acid) to prevent precoupling of the diazo and coupler while the material is in storage. Certain metallic salts (e.g., zinc chloride) strongly affect the color of the ultimate dye image, and contribute in other ways to product quality.

Antioxidants (e.g., thiourea) help prevent yellowing of the print, and decomposition of the diazo. Humectants are also generally included in sensitizing formulas. These materials (e.g., glycerine or glycol) absorb moisture from the atmosphere and from the developer section of the machine to promote reaction between the diazo and the coupler. They also affect the curl and flatness characteristics of the finished product.

Other ingredients are often employed. They contribute to the finer details of print quality, but are not really necessary in the formulation of good diazotype paper, nor is their use standard with all manufacturers of diazo-sensitized materials.

In the metal diazonium process a suitable base material is coated with a diazo compound and a metallic salt (e.g., mercurous nitrate). Upon imagewise irradiation of the coating, a latent image comprising minute particles of mercury is produced in the light-struck areas. The latent image is physically developed (intensification) and an exceptionally fine grain image results.

In a typical metal diazonium system a hydrophilic support is coated with a solution of a light-sensitive, water soluble diazonium compound and a mercurous salt. The action of actinic radiation decomposes the diazonium compound and the light decomposition product reacts with mercuric ions which are present in equilibrium in the solution of mercurous salt; e.g., mercurous nitrate. Since the mercuric ions are removed

by combining with the light-decomposition product, only mercury atoms remain. The mercury atoms form a latent image that can be developed with a physical developer containing a silver salt and a reducing agent, creating a silver image.

Quantum efficiencies up to 0.5 are claimed. The speed of the system is considered quite slow for photographic purposes, although it is from 5 to 30 times faster than are other diazotype systems.

Maximum sensitivity occurs at 3800Å, and resolutions up to 1200 lines/mm have been reported. Gammas from 1.0 to 1.6 can be obtained by varying printing light intensity, humidity, time of development, or developer formulation. The material will produce positives from negatives. Philips Laboratories, who developed this process, currently uses it as a photoresist in some manufacturing operations.

Diazo in Lithography

In the present context "lithography" must include not only plates such as are run on a 1250 but resists for circuitry and microcircuitry where it can really shine. Those tough little images are as sharp as the projected image and so tough they can withstand the harshest etches.

Most of them are derived from:

or one of its many isomers. For these purposes the molecular weight is built up by the formation of esters or amides at the SO_3H site.

Why the 2-1-5 acid rather than some one of its many isomers? This is purely and simply a matter of light sensitivity. The exposure rate of all the isomers has been measured and the 2-1-5 is better by an appreciable margin.

A typical ester is:

A typical amide is:

These compounds are insoluble in water or alkali. However, after exposure to strong radiation something happens to them that renders them, to a degree, water soluble or at any rate, soluble in alkali, leaving a clean cut, grease receptive image in the areas which were shielded from light.

So far "positive working" sensitizers have been discussed, i.e., those in which light creates the colorless area. However, there are also negative-working sensitizers. One of the more popular of these is the formaldehyde polymer of p-diazo-diphenyl amine:

When light strikes this polymer, it becomes an insoluble gunk which is grease receptive, and firmly anchored to the base. Meanwhile the sensitizer in the light protected areas can be washed away with suitable solvents to reveal a water receptive surface beneath.

Applications

In addition to those cited earlier, much work has been done by Scott Graphics (formerly Plastic Coating) on continuous-tone negative-working films for aerial film duplication. These films are based on diazosulfonate materials, and have been tested by the Air Force, other government agencies, and private companies. A gamma of 1 and a maximum density of 2.2 have been reported.[10,11]

Acknowledgements

The author gratefully acknowledges significant contributions made to this section on the diazo process by Leonard Ravich of the Institute for Graphic Communication and Charles Benbrook, a noted diazo specialist.

REFERENCES

1. M. S. Dinaberg, *Photosensitive Diazo Compounds*, Focal, London and New York, 1964.
2. D. Habib, "The Diazotype Process," 1964 SPSE Symp. on Unconventional Photographic Systems, p. 133; 1967, p. 4; 1971, p. 87.
3. R. Landau, P. Pinot de Moira and A. S. Tannenbaum, "Diazo Compounds in the Photocopying Industry," *J. Photogr. Sci.*, **13**: 144–51 (1965).
4. H. Jonker, et al., "Physical Development Recording Systems," *Photogr. Sci. Eng.*, **13**: 1–49 (1969).
5. H. Jonker, L. K. H. van Beck, C. J. Dipple, C. J. G. F. Janssen, A. Molenaar and E. J. Spiertz, "Principles of PD Recording Sys-

tems and Their Use in Photofabrication," *J. Photogr. Sci.*, **19**: 96 (1971).

6. H. Jonker, L. K. H. van Beck, H. J. Houtman, F. T. Klostermann, and E. J. Spiertz, "PD Processes for Photography at Extreme Resolution: I. PD-MD Based on Diazosulphonate," *J. Photogr. Sci.*, **19**: 187 (1971).

7. H. Jonker, L. K. H. van Beck, H. J. Houtman, F. T. Klostermann, and E. J. Spiertz, "PD Processes for Photography at Extreme Resolution: II. PD-D Based on Diazosulfide," *J. Photogr. Sci.*, **20**: 53 (1972).

8. Kosar, *Light Sensitive Systems* (Chap. 6 and 7), Wiley, New York, 1965 (over 600 diazo references).

9. L. E. Ravich, "Diazotype Image Forming Systems," *IGC Monthly*, Apr 1971.

10. W. A. Benz and J. C. Lewis, "A Continuous Tone Reconnaissance Image Diazo-Reproduction System," 1971 SPSE Symp. on Unconventional Photographic Systems, pp. 96–98.

11. D. Habib, "Dry Negative-Working Image System Based on Diazosulfonates," *Ibid*, pp. 98–100.

VESICULAR IMAGING

The vesicular process—like diazo—is based on the use of diazonium compounds. Image formation differs radically and is accomplished by light scattering rather than light absorption. The thermoplastic used consists of crystalline and noncrystalline regions which are randomly dispersed. In this condition the refractive index of the film can be considered to be uniform and visually the film is uniformly transparent. When the film is exposed, the diazo compound decomposes as was the case with the diazo process. The reaction releases nitrogen, water, and carbon dioxide, which increase the internal pressures by a factor of about three. The film is then developed by heating at 240° F for about 2 sec. This development step alters the random dispersal pattern so that the crystalline matter assumes a definite pattern, usually spherical. It now has a different refractive index from the surrounding noncrystalline material. This spherical structure acts as a scattering center and becomes the basis of variations in density. This crystal change occurs when the internal pressures built up by the exposure are released by the thermal development step. The boundary of the pressure areas is pushed out and forms a vesicle or light-scattering center.

These changes are shown in Fig. 15.5.

The fixing technique consists of an overall exposure to UV of about two times the amount employed in the initial imaging exposure. This causes complete de-

Before Exposure After Exposure After Development

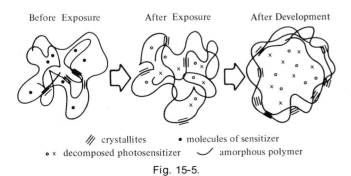

/// crystallites • molecules of sensitizer
○ × decomposed photosensitizer ⌄ amorphous polymer

Fig. 15-5.

composition of the residual diazonium compound. The gaseous products released will diffuse completely from the film so long as it is protected from temperatures in excess of 150° F for a few hours. Thus it is a simple, three-step and totally dry process which has proven very popular for microfilm duplicating.

History

Vesicular was first called bubble process by Andre Schoen who introduced it in this country in the mid 1940s and was its only champion until Kalvar came along. Kalvar did several significant things: took it out of gelatin and into a moisture resistant carrier, although Schoen knew about the use of Saran and polyvinyl alcohol as carriers, put it on polyester (Mylar) rather than acetate, and learned to control the gamma at will. They never, to my knowledge, introduced any new or significantly faster gas formers. They did invent:

Vesicular diazotype is recognized to be somewhat faster than normal diazotype, and indeed it is—in effect. It is a negative working process whereas normal diazotype is positive working.

In positive working systems one must expose until the background in clear. In negative systems such as vesicular, the light builds the image and one need expose only until sufficient image is created, and this is normally considerably less than "complete" exposure.

Before Schoen (GAF patent) and Kalvar, however, came a Kalle Scatter Photography disclosure by way of British Patent 402,737 which contains the earliest teaching of vesicular photography. The film used gelatin as a vehicle and was developed by water. Upon exposure, light sensitive substances yield gas which inflates the colloidal material.

In order to fix the picture, the light-sensitive compound, which is still underexposed, may be washed out from the layer, after the exposure, by means of a suitable solvent; at the same time the colloid particles are loosened and the inflation and/or dulling effect is strengthened. If it is desired to avoid washing with water the picture may, after the removal of the pattern, be cautiously further exposed to diffused light so that the gases set free can escape without further dulling the colloidal material.

The inflation of the colloidal material produces not only a dulling effect, but also, according to the kind of colloid used, a more or less strong relief effect. The latter effect is weak when, for instance, foils of regenerated cellulose are used; when layers of gelatin, glue, or gum are used, it is sometimes strong. The relief effect produced and the dulling of the material depend furthermore upon

the thickness of the layer and the strength and nature of the sensitization.

The relief effect and the dulling effect can be considerably intensified by loosening the colloidal particles subsequent to the exposure so that the bases formed in the layers by the exposure can expand. This process can, for instance, be effected by slightly moistening the layer which has been exposed to light or by treating it with an aqueous organic solvent or by steaming it.

The first U.S. patent (2,699,392) was awarded to GAF (Herrick) in 1955. This system included a gelatin-thermoplastic mixture and was developed by heat instead of water.

In 1959 Kalvar was awarded their first patent (U.S. 2,911,299). Their system included an all-thermoplastic vehicle that was developable by heat alone. Kalvar was the only manufacturer of vesicular film up to 1970. In the interim, other vesicular patents had been awarded to IBM, Kodak, 3M, Xidex, and Kalvar.

Ravich[1] has analyzed the vesicular patents and concluded that the Kalle disclosure of vesicular or bubble photography was so basic and complete that the U.S. Patent Office has used the reference successfully in denying broad claims to vesicular imaging to later workers in this art from sources including Schoen (originally General Aniline & Film, now GAF Corporation), Herrick (GAF), Baril (Kalvar Corporation) and James (Kalvar).

Today Kalvar, Xidex, Photomedia, and Memorex manufacture vesicular materials.

Technology

The vesicular process is based on the use of diazonium compounds, but it is quite unlike other diazo processes and is also markedly different from all other copying processes. In the vesicular process, a very thin diazonium emulsion layer (approximately 0.0003 in.) is coated on a polyester film base. When a sheet of this material is placed in contact with a translucent original and exposed to ultraviolet light in a range from 3400Å to 4400Å, the diazonium compound decomposes and liberates nitrogen in the form of gas.

The image is developed as the film passes over heated rollers. The heat causes the gaseous nitrogen to expand and form tiny vesicles (bubbles) in the plastic coating. These vesicles, which range in size from 0.5 to 2 μm in diameter, act as light-scattering centers causing a light pattern that is different from that of the unexposed areas. Since light-sensitive compounds are still present in unexposed areas, development must be followed by a "fixing" step. This is accomplished by exposing the entire film to ultraviolet light for approximately two times as long as required for the initial exposure. This completely decomposes the residual light-sensitive compounds. When viewed by reflected light, the exposed areas made up of these light-scattering centers are whitish in appearance, and the unexposed areas appear dark. When viewed by transmitted light (e.g., in a microfilm reader), light is transmitted by the unexposed areas but is dispersed by the light-scattering centers in the exposed areas so that these areas appear dark. The high light intensity required to expose vesicular material limits the process largely to contact copying from translucent originals. But its high resolution, 300 line pairs/mm, along with other characteristics, make it a very useful process for duplicating micro-transparencies.

Vesicular film undergoes three processing stages: exposure, developing, and fixing. Each of these processing steps will be discussed at length in the following paragraphs.

Vesicular materials are sensitive to light in the near ultraviolet region. The photo-sensitivity curve shows the response extends from below 3400Å to above 4400Å with maximum photosensitivity at 4000Å. Vesicular film is not photographically sensitive to ordinary levels of visible light for short periods of time. The energy required to expose vesicular film is 0.05 J/cm^2.

In use, the vesicular film and the original are held closely together (contact printing process) so that the light shines through the original onto the vesicular. Wherever the original is black, the vesicular film is shielded from the light and the diazonium compound remains intact. Where the original film is clear, the ultraviolet light destroys the diazonium compound and releases nitrogen, water, and carbon dioxide and the number of molecules is increased. The free molecules which are released increase internal pressure by a factor of approximately three.

Exposures longer than 60 sec are useful, but the density obtained is no longer directly proportional to the exposure time. For long exposure times, there is a slight loss in maximum density because of the gas generated diffuses during the prolonged exposure. Temperature of the film over 110° F during exposure will also cause a high diffusion rate of the latent-image-forming gas with a subsequent reduction of the maximum density. The latent image diffusion time varies with different vesicular types.

The film is developed by applying sufficient heat momentarily to soften the emulsion vehicle whose strands are pushed out by localized internal gas pressure to form a bubble, or vesicle. At the perimeter of this vesicle, the polymer strands have been forced into close alignment with each other.

When the heat is removed, the softened emulsion vehicle crystallizes again, but this time the arrangement of crystallites in a thin shell around each individual vesicle produces a scattering center. These sub-micron-sized bubbles, .5 to 2.0 μm in diameter, become the permanent vesicular image.

Methods of Development. Heat is all that is really necessary to develop a vesicular image. Any method of heating the film sufficiently will produce a permanent, high quality image. Three methods are used:

1. Conduction—The heat necessary for development may be conduction into the film by a heated drum, roller, platen, or a liquid heat-transfer medium such as glycerin.
2. Convection—The heat may be a stream of hot air or

the convection currents from either a heated oven or a heated platen in close proximity to the film.

3. Radiation—Development by infrared radiation is possible because of the absorption spectrum of the film. This method, however, is not recommended except where the environment may be controlled precisely so that a combination of convection and radiation, detrimental to the formation of the image, does not occur.

Energy of Development. The calculated energy required to develop the vesicular image is approximately 0.13 cal/cm^2/mil (total thickness which includes the base material plus emulsion thickness). The only requirement is that the vesicular emulsion layer come to a temperature of 270° F. The temperature of the heat source to achieve this requirement will depend upon the dwell time and the rate of heat transfer. Much higher temperatures of development can be used with the proper decrease in development (dwell) time.

Latent Image Fade. The latent image in vesicular films will decay at an exponential rate depending upon the temperature. At normal room temperature, the gas which forms the latent image will diffuse from the film over a period of several hours, leaving an undevelopable latent image. At higher temperatures, the process takes place at a more rapid rate. Noticeable density loss may occur if excessive time elapses between exposure and development.

In development, the vehicle temperature is brought very rapidly through this diffusion range to a temperature above the softening point of the plastic, so that the predominant reaction is nucleation of the dissolved nitrogen and vesicle formation. Development should always follow as soon as practicable after exposure for normal processing.

Background Density. As the temperature increases, the background or density decreases until 220° F is reached. Therefore, 220° F, the starting point for development, must be reached for the background density to be at a minimum and cause the greatest possible contrast.

Projection Densities. At lower temperatures, from approximately 190° F to 230° F, a "sepia" image may occur. At this low development temperature, the bubbles or vesicles formed are of such small diameter that they change from Mees scattering to Raleigh scattering, the violet to blue component of white light is selectively attenuated, and the result is a sepia or pink tone to the image. At about 240° F, the maximum scattering density is obtained and the density increases only slightly with increasing temperature.

Thermal Resistance. The higher the development temperature (up to 265° F), the greater the thermal resistance. Above 265° F, for 2 sec some image degradation occurs. This degradation has little effect in making line copies but causes serious degradation in continuous tone copies.

One theory to explain the dependence of thermal resistance upon development temperature is that if the polymer chains forming the scattering centers are not pressed closely together to realize the full force of the van der Waal attraction, this outer shell will collapse upon heating, and the scattering centers will consequently decrease in size or completely disappear.

Permanence. Vesicular film is stable under all normal conditions and even in a hot reader at 160° F for more than 24 hr.

After exposure and development, the unexposed or clear sections of the vesicular film still retain light-sensitive diazo. The fixing technique consists of exposing the film over-all to ultraviolet light and applying about two times the amount required for a maximum exposure, to completely decompose the sensitizer.

About 10 min after the fixing exposure, the gas which was formed as a result of the decomposition of the diazo compound starts to diffuse out through the plastic, and after a few hours there is nothing left to form bubbles. The film, during its diffusion period, should be kept below 100° F (about 3 hrs).

In summary, as a precaution against subsequent and simultaneous exposure to light and heat which could fog the background, the vesicular film is fixed with an overall exposure to an ultraviolet light source. When fixed, the residual sensitizer is decomposed and its nitrogen gases diffused from the film without being developed.

Advantages of the vesicular process include:

1. Complete dryness
2. Simplicity which uses inexpensive equipment
3. No darkroom
4. Sharp images—high resolution
5. Permanent images
6. Easy cleaning

Acknowledgements

The author gratefully acknowledges contribution of much material to this section on vesicular imaging by B. J. Cassin of Xidex. Other contributors include Leonard E. Ravich[1] and Charles Benbrook.

REFERENCES

1. L. E. Ravich, "Vesicular imaging: is it exclusively a Kalvar story?," *IGC Monthly*, (Mar 1971).
2. Anon., "The Kalvar Photosensitive Emulsions," *Brit. J. Photogr.*, **110**: 976–81 (Nov 8, 1963).
3. M. Anderson, "Stability of Vesicular Microfilm Images," *Photogr. Sci. Eng.*, **8**: 353–8 (1964).
4. M. Anderson and E. Sandlin, "Vesicular Systems for High-Resolution Generation Printing," NMA Proc., 1964 Convention, p. 13 (1964).
5. J. D. Fleming, Jr., "Microreprography with Light-Scattering Images (Kalvar Vesicular Films)," Proc., Microphotography Fundamentals and Applications, S.P.S.E., Washington, D.C., 145–59 (1968).
6. J. Forkner and D. Lowenthal, "A Photographic Recording Medium for 10.6μ Laser Radiation," *Appl. Opt.*, **6**: 1419 (1967).
7. K. Hauffe, "Reprographic Processes Using Non-Silver Systems," *Ber. Intern. Kongr. Reprogr.*, Cologne, pp. 25–35 (1963).

8. H. Inaba, et al., "Direct Observation of Output Beam Patterns from N_2-CO_2 Laser at 10.6 μ by Thermal Development Method," *Infrared Physics*, 7: 145–9 (1967).
9. W. Lawton, "Recent Advances in Organic-Based Imaging Systems," Proc. SPSE Novel Imaging Systems, Seminar, p. 63–77 (1969).
10. R. Nieset, "The Basis of the Kalvar System of Photography," *J. Photogr. Sci.*, 10: 188–95 (1962).
11. R. Nieset, "The Kalvar System of Photography," *Litho-Printer*, 7: 1.29–30 (May 1964).
12. R. Nieset, and N. Notley, "Vesicular Photography for the Motion Picture Industry," *J. SMPTE*, 74: 786–8, (Sept 1965).
13. R. Nieset, "What's New at Kalvar," *Reproduction Methods*, 5: 42–3 (Mar 1965).
14. N. T. Notley, "The Direct Image in Vesicular Photography," *Photogr. Sci. Eng.*, 10: 3–7 (Jan–Feb 1966).
15. R. O'Lone, "Cathode Ray Display Speeds Scram Data," *Aviation Week and Space Technology* (Mar 1967).
16. M. Rabedeau, "The Microimage Characteristics of Kalvar Film," *Photogr. Sci. Eng.*, 9: 58–62 (Jan–Feb 1965).
17. K. Reynolds, "Unconventional Photographic Processes," *Rep. Progr. Appl. Chem.*, 51: 194–203 (1966).
18. E. Schalk, "The Kalvar System Applied to Film Printing," *Kep-es. Hungtech.*, 14: 27–32 (Feb 1968).
19. V. Sheberstov, et al., "Replacement of Silver Halides by Non-Silver Materials in Photographic Systems," *Zh. Nauch. Prikl. Fotogr. Kinematogr.*, 7: 61–70 (1969).
20. W. Ueno, "Applications of Polymers to Photographic Materials," *Sci. Publ. Fuji, Photogr. Film Co Ltd*, 13: 1.105–18 (1965).
21. GAF, Herrick and Balk, U.S. Patent 2,699,392, "Production of Vesicular Prints." (1955).
22. GAF, Herrick and Balk, U.S. Patent 2,703,756, "Production of Vesicular Prints," (1955).
23. GAF Sehoen, U.S. Patent 2,908,572.
24. Kalvar, Baril, et al., U.S. Patent 2,911,299.
25. Kalvar, Bruni and Morgan, U.S. Patent 2,923,703.
26. Kalvar, Glavin, et al., U.S. Patent 2,950,194.
27. Kalvar, Baril, and Klein, U.S. Patent 2,976,145.
28. Kalvar, Oster et al., U.S. Patent 2,996,381.
29. Kodak Ltd., Merrill and Ungruh, U.S. Patent 3,002,003.
30. Kalvar, James, and Parker, U.S. Patent 3,032,414.
31. Kalvar, Neth, U.S. Patent 3,037,862.
32. Kalvar, Parker et al., U.S. Patent 3,081,169.
33. Kalvar, H. McMahon, U.S. Patent 3,108,872, "Photo-Thermolytical Vesicular Composition," (Oct 29, 1963).
34. Kodak Ltd, S. Merrill and C. Unruh, U.S. Patent 3.002,003, "Light Sensitive Azido-Phthalic Compounds," (Oct 1961).
35. IBM, R. Lindquist, U.S. Patent 3,120,437, "A Reversal Vesicular Photo-Reproduction Material," (Feb 4, 1964).
36. Eastman Kodak, Paest et al., U.S. Patent 3,143,418.
37. Kalvar, A. Baril, et al., U.S. Patent 3,149,971, "Method for Improving Gradation of Light-Scattering Photographic Materials," (Sept 22, 1964).
38. IBM, J. Adkisson, et al., U.S. Patent 3,158,480, "Spark Development of Small Kalfax Film Areas," (Nov 24, 1964).
39. Kalvar, R. Parker and B. Mokler, U.S. Patent 3,161,511, "Production of Vesicular Images in Water-Insensitive Photographic Materials," (Dec 15, 1964).
40. IBM and W. Peticolas, U.S. Patent 3,171,743, "Forming Latent and Visible Images in Refractive Image Film," (Mar 2, 1965).
41. IBM, W. Peticolas and U. Vahtra, U.S. Patent 3,171,744, "Forming Latent and Visible Images in Refractive Image Film," (Mar 2, 1965).
42. IBM, A. Sporer and C. Allman, U.S. Patent 3,183,091, "Nondiazo Vesicular Photographic Film," (May 11, 1965).
43. Bunker-Ramo and R. Koster, U.S. Patent 3,184,753, "Apparatus for Exposing Photosensitive Material," (May 18, 1965).
44. Kalvar and A. Daech, U.S. Patent 3,189,455, "Vesicular Photographic Materials Containing a Polyamide Vehicle," (June 15, 1965).
45. Kalvar and IBM, R. Baus and R. Lahr, U.S. Patent 3,194,659, "Reflex Copying Method Using Heat-Developable Light-Scattering Material," (Aug 13, 1965).
46. Kalvar and A. Daech, U.S. Patent 3,208,850, "Vesicular-Type Photographic Materials, (Sept 28, 1965).
47. Kalvar, F. Neth and A. Critchlow, U.S. Patent 3,215,529, "Color Photographic Material Capable of Dry Processing," (Nov 2, 1965).
48. Allied Paper, B. Growald and R. Levy, U.S. Patent 3,244,523, "Photosensitive Vesicular Print Material," (Apr 5, 1966).
49. Kalvar, R. Parker and B. Mokler, U.S. Patent 3,251,690, "Image Producing Vesicular Materials Having Good Stability in Conditions of Heat and Moisture," (May 17, 1966).
50. IBM, R. Lindquist and E. Ryskiewicz, U.S. Patent 3,252,796, "Materials for a Vesicular-Type Process," (May 24, 1966).
51. 3M Co. and R. Lokken, U.S. Patent 3,260,599, "Vesicular Diazo Copy Sheet Containing a Photo-Reducible Dye," (July 12, 1966).
52. Metro-Kalvar, Inc., K. B. Curtis, U.S. Patent 3,323,434, "Apparatus for Sound and Image Printing of Irradiation Sensitive Film," (June 6, 1967).
53. 3M Co., R. Lokken, U.S. Patent 3,260,599, "Vesicular Diazo Copy Sheet," (July 12, 1966).
54. IBM, W. L. Peticolas, U.S. Patent 3,342,618, "Thermographic Images and Printing Plates," (Sept 19, 1967).
55. Eastman Kodak, W. J. Priest, U.S. Patent 3,355,295, "Vesicular Photographic Materials," (Nov 28, 1967).
56. IBM and C. M. Aebi, U.S. Patent 3,408,192, "Visible-Recording Diazonium Materials," (Oct 29, 1968).

PHOTOPOLYMERIZATION IMAGING

Photopolymerization is a light induced, chemical reaction in which molecules become linked together to form a material of much greater molecular weight, known as a polymer. There have been several excellent review articles and conferences on the subject of photopolymerization imaging systems.[1-6]

The term "photopolymer" is not considered a descriptive term that defines a precise chemical category. Essentially, it is a commonly used contraction for a number of related terms: "photo-(polymerizable)-polymers," "Photo-(dimerizable)-polymers," "photo-(crosslinkable)-polymers," and "photo-(solubilizable)-polymers." These reactions, however, have much in common. They all involve a change in molecular weight and physical properties upon exposure to light.

A polymer is essentially a large molecule built up by the linking of small units called monomers. Polymerization will only take place when an initiator is present in the system. The initiator can be either a monomer molecule that has received enough energy to combine with another molecule or, most often, a different molecule which is added to the system because it is more easily activated than the monomer. The activation takes place through the absorption of energy from light and is accompanied by the formation of intermediate products with a very short lifetime. These intermediates are called free radicals.

History

Photopolymerization was employed several thousand years ago by the ancient Egyptians. Oil of lavender and Syrian asphalt, which crosslinked when dried in the sun, were used for mummy wrappings. Photosensitive polymers, passing through various stages of fish glues, bitumens, and bichromates, have evolved in the highly sophiscated photoresists, printing plates, and photographs of today.

The beginning of photopolymerization imaging can be traced back to a French inventor who possessed considerable curiosity, along with moderate artistic capability. Lithography was invented in Munich in 1796, but initially was not considered to be a useful technique. In 1800 the music publisher, Pleyel, brought the process to Paris, but abandoned the system after two years of unsuccessful experimentation. Although many Frenchmen tried to perfect the process, there was no lithographic printing plant in Paris until 1814. The Germans were more successful and the lithographers of Munich and Stuttgart prospered. The Germans kept their art a secret, until 1810 when the first printed information about their technique was made available and lithography became a fashionable hobby.

The intellectual class in France became interested in lithography in about 1813. One of the early practitioners of the art was the French inventor Nicephore Niepce. This discovery, which he considered quite marvelous, made a profound impression on him. He was not content to consider the system as merely a hobby and became interested in industrial applications of the process. He produced some fine lithographs but since the chemical side of lithography interested him more than the artistic, he searched for different protecting varnishes which would better resist the action of acids used in etching. He attempted to reproduce an etching outline on a light-sensitive resist painted on stone, glass, or metal. He then tried to etch through a varnish, hardened by light, with acid and thus obtain a plate suitable for a printing press.

During the course of his investigations Niepce prepared a varnish containing an asphaltic material called Bitumen of Judea. He dissolved the bitumen in petroleum and found that a thin film coated on a stone or a glass plate and exposed to light was difficult to remove in the light-struck areas. The image, which was barely perceptible on the stone, became quite clear when viewed as a transparency and led Niepce to adopt glass as the support. Thus was the first photographic image prepared in 1822. Niepce did not know that he was working with photocrosslinkable polymers and that the first photograph ever created was based on the mechanism of photopolymerization.

Of course the Niepce work was not identified as photopolymerization in 1822 and it wasn't until 1945 that image formation by photopolymerization was first described (British Patent 566,975). The inventor, W. E. F. Gates, formed shallow relief images in methyl methacrylate using a combination of ultraviolet, radiation, and heat. Since that time photopolymers have become well accepted as photographic image-forming materials.

Today photopolymerization is one of the most widely studied photochemical reactions. It involves a primary reaction, initiated by an absorbed photon, followed by a chain reaction in which a monomer is converted to a polymer. The reactions thus created provide a built-in amplification. One of the outstanding features of this chain reaction is that it can be effectively controlled and can be inhibited to achieve practicable stability with a shelf life of several years. Thus, photopolymer systems contain the basic elements required to design rapid access, dry photoreproduction materials with useful photographic speeds.

Technology

Free Radical Initiated Polymerization. The generation of free radicals at room temperature occurs when various organic or inorganic compounds are exposed to light. In addition to acting as a direct source of free radicals capable of initiating polymerization, a number of compounds also act as sensitizers; that is, upon exposure to light they are excited to a higher energy level and induce the decomposition of a radical precursor. Typical photoinitiators (or photosensitizers) include benizon, benzophenone, benzoyl peroxide, benzyl disulfide, ethyl thiocarbamate, azobisisobutyronitrile, diazonium salts, chlorine, carbon tetrabromide, manganese carbonyl, zinc oxide, ferrous oxalate, and uranyl nitrate.

The light sources used to expose photopolymerizable materials include mercury, carbon and xenon arcs, tungsten lamps, and lasers. Sensitivity can be extended through the visible region of the spectrum with the use of dyes such as rose bengal, erythrosine, methylene blue, eosine, acriflavin, and thionine. These "photoreducible" dyes also provide free radicals for the polymerization reaction.

A two-step process for photoinitiated polymerization is possible when light induces the reduction of an inorganic salt dispersed in a monomer to a component of a redox system. For example, under the influence of light, ferric oxalate is reduced to ferrous oxalate. Although radicals are generated from the oxalate ion, more significantly, the ferrous ions are generated in the exposed areas providing the basis for a latent image. When the substrate containing the vinyl monomer and the ferrous ions is washed with hydrogen peroxide, radicals are generated and polymerization is initiated.

When "photoreducible" dyes are used to extend the light sensitivity of a photopolymerization system to the visible portion of the spectrum, free radicals can be produced. In dye-sensitized reactions, a dye and a weak reducing agent, or electron donor, are dispersed in the monomer. Upon exposure to light, the dye is brought to an excited state which reacts with the reducing agent to generate radicals from the dye which revert to the leuco form. In the presence of ambient oxygen, free radicals are produced which are capable of initiating polymerization. The photosensitizing dyes listed above can be used along with reducing agents including stannous chloride, ascorbic acid, and allyl thiourea.

There has been considerable controversy concerning the role of oxygen in photopolymerization reactions. It was originally believed that the direct interaction between the excited dye and the monomer initiated the polymerization. Subsequently it was thought that the hydroxyl radical derived from the reaction of the leuco dye with oxygen provided the initiating species. Finally, it was decided that the free radical from the electron donor initiated the reaction.

If oxygen is not present, acrylamide, acrylonitrile, and

acrylic acid and its salts are polymerized by the interaction of the dye and the reducing agent. The addition of β-diketones as electron donors improves the efficiency, but the number of polymerizable monomers remains unchanged. The free radical from the electron donor is the initiating species when acrylates are used. Oxygen acts as an inhibitor causing quenching of the dye-excited state, inactivation of the initiating radical, and termination of the propagating polymer chains. Addition of strong oxidizing agents such as sodium periodate has increased efficiency, presumably by suppressing leuco dye formation and promoting radical generating potential from the leuco dye-oxidizing agent redox system.

Photosensitized Charge Transfer (Ion Radical Initiated Polymerization. The scope of photopolymerization is considerably widened by the use of another system in which the photoinduced generation of species is capable of initiating the polymerization of monomers that are insensitive to radical polymerization but susceptible to ionic polymerization.

It has been shown that the interaction of an electron donor and an electron acceptor plays an important role in monomer homopolymerization and copolymerization. The interaction of such species results in the formation of a charge transfer complex and, upon exposure to light, an electron transfer reaction occurs and a species capable of initiating polymerization is generated.

The complex may comprise two components not readily capable of conventional polymerization (for example, phthalic anhydride-dimethylaniline dioxane-maleic anhydride, propionaldehydechoranil) but capable of generating a species which can initiate radical or ionic polymerization of suitable monomers.

The complex may contain a polymerizable monomer and a compound which is either not normally a catalyst or not a catalyst for that monomer. The polymerizable monomer may be an electron donor such as N-vinylcarbazole or β-propiolactone, and the coreactant in the formation of the complex may be an inorganic salt such as sodium chloroaurate or uranyl nitrate, or an organic electron acceptor such as nitrobenzene. Alternatively, the polymerizable monomer may be an electron acceptor such as methyl methacrylate or acrylonitrile and the coreactant may be a metal salt (uranyl perchlorate or zinc chloride) or an organometallic compound (e.g., triethylaluminum or triphenylphosphine).

The photoinduced polymerization of a donor monomer-acceptor complex may yield a homopolymer and/or copolymer through an ion-radical intermediate (for example, N-vinylcarbazole-acrylonitrile or isobutyl vinyl-acrylonitrile).

Photocrosslinking of Polymers. Photocrosslinking of a polymer may be achieved by several different methods. However, in all cases preformed polymers are converted into higher molecular weight, generally insoluble products by a nonchain process which is terminated when two polymers containing functional groups subject to photosensitized dimerization are exposed to light. Similarly, crosslinking results upon photolysis of polymers containing groups which are photolabile and

under the influence of light are converted to crosslinkable groups. A third approach to crosslinking involves the generation of multiple crosslinking functionality on additives which are mixed with a crosslinkable polymer. The photocrosslinking of a polymer has the objective of insolubilizing the exposed areas of a polymer substrate. The result is achieved by photodimerization of a polymer or the photoinduced formation of reactive sites on a polymer or an additive present in the polymer.

Multiple dimerization reactions between polymer chains result in the formation of multiple crosslinks. The attachment of photodimerizable functional groups to a polymer backbone therefore provides a means to crosslink and insolubilize the polymer upon exposure to light.

The most widely used photodimerizable group is the cinnamoyl group which undergoes cyclodimerization to form a cyclobutane ring between chains containing the group. The reaction leads to a three-dimensional soluble network as a result of multiple dimerization reactions.

The most frequently used "backbone" polymers are cellulose and poly (vinyl alcohol). The photocrosslinking of a cellulose cinnamate and poly (vinyl cinnamate) is greatly enhanced by the presence of photosensitizers which extend the sensitivity of the polymers to a broader wavelength range. Effective sensitizers include nitro and keto compounds.

Polymeric chalcone derivatives, stilbazole derivatives and coumarin derivatives apparently undergo photocrosslinking through the formation of cyclobutane rings.

The photodecomposition of azides results in the liberation of nitrogen and the formation of imidogen radicals or nitrenes which can subsequently add to double bonds or insert into labile -CH or -NH groups in polymeric substrates.

Photosensitive azido groups include azides $-N_3$, sulfonyl azides $-SO_2N_3$, and acyl or carboazides $-CON_3$. Bis-azido derivatives can be used as crosslinking additives to polymers containing residual unsaturation, e.g., cis-1,4-polyisoprene, cyclized rubber or cyclized polyisoprene, chlorinated rubber of poly (butadiene-costyrene) or labile $-CH$ or $-NH$ groups such as rubbers containing allylic methylene groups or polyamides. When the azido groups are appended to a polymer backbone, photocrosslinking occurs.

α-Diazoketones and aryldiazo derivatives undergo photolysis to carbenes which insert into $-CH$ bonds, add to multiple bonds, react with compounds containing lone electron pairs, dimerize or rearrange to reactive ketones. Bifunctional derivatives containing these groups can therefore lead to photocrosslinked structures when used as additives for various polymers.

System Characterization

A photopolymerization imaging system can be best described by analyzing its six major characteristics:

1. *Spectral Response.* Although a number of photopolymer systems have been reported in the literature with spectral sensitivities ranging from the ultraviolet to the infrared, most practical applications

have been confined to materials with ultraviolet sensitivity.

2. *Sensitivity.* Photopolymerization reactions are slower than those of silver halide systems or electrophotography, but are faster than those of other nonsilver systems. The materials are used mostly for contact printing applications although some techniques for projection printing have been reported, and all applications require ultraviolet radiation. Low light intensity reciprocity failure occurs in most materials due to the inhibiting effects of oxygen and other compounds added to stabilize commercial systems. High intensity reciprocity failure also occurs because of the recombination effects of radicals at high concentration.

3. *Polymer Properties.* The properties of a polymer are important in matching the right characteristics of the compound with the desired image-forming reaction. Image formation in a polymer system is dependent on the physical change which occurs when a polymer compound is formed, modified, or degraded by the action of light. The durability, insolubility, and flexibility of polymers have made them particularly attractive for printing and photofabrication applications.

4. *Physical Structure.* Photopolymer formulations are usually supplied as coated films ready for use or as liquids to be applied by the customer to any surface desired.

5. *Photographic Characteristics.* Photopolymeriza-tion imaging systems exhibit a wide range of characteristics similar to those of silver halide systems. Resolution, D_{max} D_{min} and contrast compare favorably with the range available with silver systems. Of course, the type of polymerization reaction and the readout method used will have an important effect on the characteristics provided. Most systems are high contrast, but some contiuous-tone imaging has been reported.

6. *Readout Methods.* A number of readout methods are employed in photopolymerization systems; all depend upon recognizing differences between exposed and unexposed areas of the polymer layer. The differences may be distinguished by changes in solubility, tackiness, thermal transitions, adhesion, cohesion, light scattering, and diffusion. These physical property changes are used as the basis for readout methods which include washoff with solvents, thermal transfer of softened regions to a suitable support, dust-on of a pigment, thermal delamination, peel-apart of a film sandwich, modulation of the passage of inks or chemicals through a film layer or by differences in light scattering (see Table 15-10 below).

Applications

The wide variety of photopolymerization applications discussed below emphasizes the importance of photopolymer technology in practical photographic imaging as

TABLE 15-10. PHOTOPOLYMERIZATION IMAGING SYSTEMS.

Physical State	"Readout" Procedure	Type of Image	Applications	References
Solubilty	Wash-off	Relief	Letterpress Printing	U.S. Patents 3,081,168; 2,760,868; 2,791,504; 2,760,863.
Solubility	Wash-off	Hydrophilic/ Hydrophobic Surface	Lithography	*J. Photogr. Sci.,* **18:** 155–6 (1970).
Solubility	Wash-off	Self-supporting Polymers	Templates	Belg. Patent 596,378 (1960).
Solubility	Etching	Resist	Printed Circuits, Integrated Circuits, Chemical Milling	J. Kosar, *Light Sensitive Systems,* Wiley, p. 141 (1965).
Adhesion	Peel-apart	Pigment	Engineering Reproduction	*J. of Photogr. Sci.,* **18:** 156–7 (1970).
Tackiness	Toner Dust-on	Pigment	Image Transfer Color Proofing	*TAGA Proc.,* Vol. 9 (1968).
Viscosity	Diffusion	Dye Imbibition Color Formation	Imaging Color Prints	Brit. Patent 893,063 (1962) *Photogr. Sci. Eng.,* **13:** 84 (1969).
Thermal Transitions	Thermal Transfer	Pigment	Imaging	U.S. Patents 3,060,025 (1962); 3,060,026 (1962); 3,085,088 (1963).
Conductivity	Electroylsis Wash-off	Pigment	Imaging	*Photogr. Sci. Eng.,* **13:** 184 (1969).
Light Scatter	Projection	Diffraction	Holography	*Appl. Phys. Letters,* **14:** 159 (1969).
Light Scatter	Projection	Scatter	Imaging	*Photogr. Sci. Eng.,* **12:** 177 (1968).

From Dr. P. Walker, "Applications of Photopolymers—A Preface," Proc. SPSE Seminar on Application of Photopolymers 1970, p. 5.

well as for a variety of other industrial processes. The continuing expansion of the demand for information generation and for sophisticated industrial processes will only increase the need for improved photopolymerization materials and processes to play an ever increasing role in the future of industry.

Colored Images

A number of systems have been disclosed that provide a means for rendering photopolymeric images visible. In British Patent 980,286, Burrows and Schwerin disclose a system involving the addition of a fatty acid to a clear photopolymerizable layer. After imaging exposure to actinic radiation, the layer is washed to remove the non-lightstruck areas. The polymeric relief image thus obtained is then colored by immersion in a solution of a basic dye. Colored originals can be reproduced by preparing polymeric relief images as described above from each of three color separations prepared from the original image, and dying each image with the appropriate subtractive dye. The images are then superimposed in register and viewed through an appropriate light source.

In British Patent 905,182, Schwerin discloses a method of preparing colored images by photopolymerization. Oil soluble dyes are dissolved in high boiling solvents and dispersed as droplets in water soluble binders. The material is coated on a suitable substrate, exposed through a mask to actinic radiation, and the unexposed portions washed out. A high contrast, high resolution image is thus prepared. In U.S. Patent 3,244,518, Schwerin and Dumers disclose means for the production of multicolored images by localizing different dyes in separate layers.

In U.S. Patent 3,406,067, Cerwonka covers the preparation of colored polymeric images. A relatively colorless color generating component is included in the photopolymerizable layer. Upon exposure to imaging actinic radiation, oxidation of the color-forming compound provides the colored form. Nonpolymerized areas of the layer are removed by washing with water. The color forming component may be a leuco form of thionin or methylene blue and the oxidizing agent may be hydrogen peroxide.

In U.S. Patent 3,070,422, Cohen and Firestine disclose the preparation of a number of addition polymerizable dye-forming monomers. These are mixed with non-dye-forming monomers, an addition polymerization initiator and a binder. The mixture is coated on a suitable substrate and dried. After exposure to actinic radiation through a suitable mask, the "latent" image is developed in a suitable developer to provide the color. Unexposed areas are then washed out and a colored, polymeric relief image results.

The systems described above require wet-processing to produce the colored image. In a system disclosed in U.S. Patent 3,060,025 by Burg and Cohen, images are produced by a dry photopolymerization process. The photopolymerizable layer comprises polyethylene oxide, polyethylene glycol diacrylate monomer, anthraquinone as a source of free radicals and p-methoxyphenol to inhibit thermal polymerization. The layer is exposed through a positive mask to a source of actinic radiation and then a coating of carbon particles on a polyethylene terephthalate film support is pressed onto the surface of the imaged layer (at 72° C). The two layers are then separated to provide a positive image in the photopolymerized surface. The carbon coating remaining on the terephthalate film provides the negative image. Additional copies of the original image can be made by pressing the thermoplastic positive onto paper receiving sheets while heating.

Another dry photopolymer imaging system is disclosed in U.S. Patent 3,245,796. The photopolymerizable element comprises a suitable support coated with a mixture of an ethylenically unsaturated compound, a sublimable dye, a polymeric binder, an addition polymerization initiator that is activated by actinic radiation, an addition polymerization inhibitor to prevent thermal polymerization during the heat process step, and a chain transfer agent. After the imagewise exposure of the layer to actinic radiation, it is pressed against a sheet of paper. The assembly is heated to from 50° to 300° C and, while still warm, the two surfaces are separated. During the heating cycle the dye in the imaged layer sublimes and passes through the unexposed image areas to the receiving sheet. Multiple copies can be made by repeating the subliming step with a new receiving sheet for each copy desired.

A photopolymerization imaging process developed by the Bell & Howell Company, and first disclosed in 1969, combines the direct formation of colored images with high speed and dry processing. N-vinylcarbazole (NVC) and carbon tetrabromide (CBr_4) are dispersed together as fine particles in a gelatin matrix. An imagewise exposure of the emulsion to visible (blue) light initiates colorless polymerization with quantum amplification. When this initial exposure is followed by a more intense overall white light exposure and heat, the unreacted monomer in the emulsion is caused to undergo a color reaction. The color density developed in any given small area varies inversely as the extent of polymerization brought about in that area by the initial exposure. The result is a direct positive photograph which has been prepared by completely dry processing means.

Due to the formation of a yellow charge transfer complex between NVC (donor) and CBr_4 (acceptor), the emulsion is sensitive to blue light as well as to near-ultraviolet radiation. The use of a monomer which can undergo a color reaction in addition to the usual colorless polymerization for vinyl monomers solves the problem of forming colored images which usually is associated with photopolymerization imaging systems. The concentration of the monomer in a particulate structure facilitates polymerization and, therefore, the positive working mode of the emulsion.

The emulsion is sensitive enough to be exposed in a camera with shutter speeds of 1 to 5 sec at $f/4.7$ in

bright sunlight. It is claimed that this sensitivity can be increased by more than 10^2 times by a process of red light latensification.

Plate Making

The use of photopolymerization for plate-making has been one of the important improvements in graphic arts production. The older dichromated colloid coatings were relatively insensitive to light by photographic standards. With photopolymerization it is possible to use shorter light exposure time and there is a great difference in solubility, between the unexposed and the exposed polymerized areas, to permit easy development.

In practice, however, there are several problems in employing polymers for making plates. Since monomers are small molecules, they tend to be gases or liquids. Neither form is convenient to handle during plastic printing plate preparation or for coating a light-sensitive layer. One procedure used to overcome this problem is to incorporate the monomer liquid into a second polymer material. On exposure to light the monomer links with itself and also with the surrounding polymer, thus changing the mixture's solubility. Also included in the monomer coating is an initiator, a type of catalyst which improves the efficiency of the process in which light initiates the polymerization reaction.

Photocrosslinkage

The principles of photopolymerization are also utilized in another group of materials used in photoengraving and litho plate-making. These are long chain polymers whose molecules are able to crosslink under the action of light to form a three-dimensional molecular network. The original polymer is insoluble in some of the common organic solvents. After exposure to light and the formation of bridging links between the chains, the polymer ceases to be soluble except in the powerful solvent mixtures of the type used in paint stripping.

One of the polymers, polyvinyl cinnamate, has a structure related to that of polyvinyl chloride, but in place of the chlorine atoms there are side chains. Polymers like polyvinyl cinnamate have low sensitivity to light when used on their own, but the addition of various organic substances has made it possible to develop coatings which are several times faster than the dichromated colloids.

Materials of this type are the basis for some of the photosensitive resists manufactured by Eastman Kodak Company. Stencils produced using these materials are highly resistant to all commonly used solutions and will withstand electroplating and electroetching processes. Similar light-sensitive resins are employed in the so-called "polymer sensitized" negative working litho plates. On exposure, crosslinkage takes place in the image areas of the plate to form a hard but greasy surface. Solvent development is used to remove the original long chain polymer from the nonimage areas.

Photopolymer Printing Plates

One of the first photopolymer printing plates, Dycril,* was introduced in 1959 by the E. I. du Pont de Nemours Company. This product is based upon the differences in solubility which result in a photopolymerizable layer upon exposure to actinic radiation (U.S. Patent 2,760,863). The material comprises a sheet of plasticized polymeric binder mounted on a support which can be aluminum, steel, or polyester film base. The photopolymerizable layer comprises a binder (an alkali soluble form of cellulose acetate), a monomer (acrylomide) and a photoinitiator. A removable polyester film cover sheet protects the plate prior to use.

Before imaging exposure, oxygen is partially removed from the plate either by conditioning for several hours in carbon dioxide atmosphere or by "photoconditioning," a process involving overall exposure to green light to consume oxygen uniformly through the sensitive layer in photochemical reactions.

During the imaging exposure, ultraviolet radiation completely penetrates the photosensitive layers in imaging areas to provide reliefs with sharp edges. Unexposed areas of the photopolymerizable layer are then washed out using very dilute alkali. Up to 500,000 impressions have been obtained in flatbed applications and over 1,000,000 impressions in rotary printing.

Relief plates using polyamides as the preformed polymer have been described by Leekly and Sorensen in U.S. Patent 3,081,168. With this material a photopolymer image is prepared so that it is hydrophobic (it is not wet by water but is wet by oily materials, such as printing ink). This Lydel photopolymer lithographic plate comprises a photopolymerizable layer containing a monomer, initiator and binder, coated on a grained, chemically treated aluminum and protected by an oxygen barrier overcoat. The plate is exposed to a carbon arc for about one minute through a line or half-tone negative. Polymerization occurs in the light-struck areas. Unexposed areas on the plate are removed with an aqueous solvent developer. Concurrently, an additional color-forming reaction takes place to enable the platemaker to see where the plate has been exposed.

The developed Lydel plate is handled like any other lithographic plate. In use, the plate is first coated with water which wets the aluminum but not the image and it is then contacted with a roller which inks only the photopolymer image. The inked plate then contacts a rubber blanket which in turn transfers the ink image to the desired material. Similar photopolymer lithographic plates are available from other companies, including Kodak, Azoplate, and Polychrome.

W. R. Grace & Company has developed a photosensitive plate system, called LETTERFLEX, which was designed to link photocomposition with letterpress printing. The economics and performance of the system were specifically designed to match the needs of the news-

*Registered trademark of DuPont.

paper industry. Recently a new LETTERFLEX plate was developed for commercial printing applications.

A sheet of polyester film is coated with a viscous plate-making material and exposed through a photographic negative to a source of ultraviolet radiation. After imaging exposure, the plate is placed on a sheet of glass and an exposure is made through the back of the plate. This second exposure is required to increase the physical bond of the polymer to the polyester film. The plate is then immersed in an etch bath comprising an aqueous detergent solution which is ultrasonically agitated around the plate. The plate is oscillated mechanically in a vertical motion normal to the direction of the ultrasonic energy during the etching process. After etching, the plate is given a third ultraviolet exposure through the top side to further harden the materials. It is then inspected, trimmed, and is ready for the press.

Several other companies have recently developed photopolymer printing plates for the letterpress printing process, including Napp, Hercules, and BASF. Similar technology has been exploited by DuPont, Uniroyal, and Polychrome to develop flexographic photopolymer printing plates.

Dye Sensitized Photopolymerization

In 1928 M. Mudrovic (*Z. Wiss. Photogr.*, **26:** 171–192) first observed that certain dyes will, in the presence of electron donors, undergo reduction to their leuco form when illuminated by light. A number of other investigators also reported the same effect on a wide variety of dyes. In the *Journal of the American Chemical Society* (**78:** 913–16 (1956)) G. Oster and A. H. Adelman reported that the rate of photoreduction of the dye is proportional to the intensity of the light absorbed and the concentration of the reducing agent. In 1958 Oster received U.S. Patent 2,850,445 on a photopolymerization process in which a photoreducible dye and a mild reducing agent are mixed with a vinyl monomer in aqueous solution. The dye is reduced to its leuco form upon exposure to light and polymerization results from the reaction of the leuco dye with oxygen to form the semiquinone and hydroxyl free radicals. This system became the basis for U.S. Patents 2,875,047 and 3,097,096, also granted to Oster covering imagewise polymerization.

The Oster process, as a means for preparing three-dimensional terrain maps, was investigated by C. J. Claus, I. T. Krohn, and P. C. Swanton of Xerox Corporation, (*Photogr. Sci. Eng.*, **5:** 211–215 (1961)). In their process a photopolymerizable mixture is exposed through a variable contrast contour transparency to form a relief image which, after washing and further hardening by additional exposure to light, is used to prepare silicone rubber mold. This negative relief image of the contour terrain is then used as the master from which bas-relief replicas can be cast.

Light Scattering Imaging

Hughes Aircraft Company, Culver City, California, has developed imaging systems in which the dye-sensitized photopolymerization of aqueous acrylate solutions is used for the direct formation of either light-scattering or perturbation type images.[41]

In a typical system the photosensitive material comprises an aqueous solution of an acrylate monomer, an organic sulfinate catalyst, and a dye sensitizer. In the photo-initiation process, light is absorbed by the dye cation which undergoes efficient intersystem crossing from its excited singlet state to the metastable triplet state. This triplet undergoes a rapid oxidation-reduction reaction with the sulfinate ion to form free radicals which are the polymerization initiators.

The photopolymerization can be terminated by heating or by an optical fixing procedure. Thermally fixed images are more permanent, but require processing times lasting from several seconds to a few minutes. The heating causes depletion of the sulfinate ion by nonphotochemical addition of the elements of the sulfinic acid to the monomer double bond to form a sulfone.

Optical activation and optical fixing require different wavelengths of light. The image is formed by visible light and fixed by ultraviolet light. Nitro compounds, from which aci-nitro intermediates can form efficiently by photochemical reactions, are used as optical fixing agents. Aci-nitro anions are reactive-reducing agents and are effective in reducing the sensitizing dye to the colorless leuco form.

In a typical imaging technique a solution, comprising a monomer (barium diacrylate), a sensitizing dye (methylene blue), a catalyst (sodium p-toluenesulfinate), a fixing agent (sodium p-nitrophenylacetate) and water (pH 6.7) is used for preparing light-scattering images. A cell, comprising two flat glass plates separated by plastic shims about 7 mils thick, is filled with the sensitizing solution and exposed to imaging radiation. As the photo-induced polymerization proceeds, a polymer gel is formed which serves as an opaque light-scattering image. The image is then fixed by exposing the cell to ultraviolet radiation.

Projected images appear brown and white because the light-scattering centers have an average diameter comparable to the wavelength of visible light.

Engineering Reproduction Film

Crolux* is a photopolymerizable engineering reproduction film which changes adhesion upon exposure to suitable radiation (U.S. Patent 3,353,955). In a typical structure, a .00025 in. photopolymerizable layer is sandwiched between a polyethylene terphthalate cover film and a base support. The surface of the base support is roughened so that the unexposed pigmented photopolymerizable layer will adhere preferentially to the base instead of the cover film. The photopolymerizable layer

composition is adjusted so that its cohesive strength is greater than the adhesions to either of the attached film surfaces. Therefore, when an unexposed sandwich is peeled apart, the photopolymerizable layer adheres to the base support. However, upon exposure to ultraviolet radiation through the cover film, the adhesion to this surface increases and, upon peeling, the surface breaks at the base support. A direct positive reproduction of the original results, which has the practical advantage of being able to be erased and thus the material is particularly suitable as a drafting intermediate. The material can also be employed in a negative-working mode by first giving an image-wise exposure through a negative on the drafting film support side. The behavior of this film is attributed to the viscoelastic properties of the polymerizable layer and the changes in adhesion which result upon exposure.

Custom-Toning Film

DuPont has developed a Custom-Toning Film which is an application of photopolymerization that provides a combined change of adhesion and melting point. The material and application techniques comprise a 0.3 mil photopolymerizable layer sandwiched between a support (4 mil polyethylene terephthalate) and a cover sheet (1 mil polyethylene terephthalate). The unpolymerized layer is very tacky. Upon imagewise exposure to ultraviolet radiation from a carbon or xenon arc, for example, polymerization occurs, the layer hardens and is no longer tacky. The cover sheet is then removed and a pigment is dusted on the imaged film. It sticks only in the unpolymerized areas to provide a direct positive reproduction of the original transparency. Since the pigmented areas of the image are still unpolymerized, they can be transferred to any suitable substrate by passage through heated rollers. Color pictures can be produced by the transfer of a multiplicity of colored images to a single base.

In commercial practice, this positive working process is used for gravure proofing and is known as Cromalin.[1] One laminates, exposes, and tones for each color. It takes about ½ hr to produce a finished color proof versus 4–5 hr to proof on a gravure press. Small wonder it has been accepted.

Photoelectropolymerization

In photoelectropolymerization, image formation occurs when polymerization initiators are formed at the light-struck areas of a suitable layer during electrolysis. A typical photoelectrolytic imaging device is essentially an electrolytic cell in which a photoconductor forms one electrode and the conducting support the other, and the monomerelectrolyte layer is sandwiched in between.

A steel substrate is coated with the monomer (1 to 2 mils thick). The photoconductive layer is about 8 mils thick. A wet junction is used to obtain uniform contact between the monomer and the photoconductor. A few drops of water containing sodium or potassium chloride is quite satisfactory. The moistened halves of the sandwich are pressed together and clamped into a support bracket.

In an early patent on a positive-working photoelectric polymerization process (A. S. Deutsch, U.S. Patent 3,409,431) a metal salt in its lower valence state is included in the polymerizable layer. When a current is passed through the sandwich in areas of imaging irradiation, the metal ions are reduced to free metals by cathodic reduction in the exposed areas. The top photoconductive layer is then removed and the polymerizable layer is treated with a per compound, such as hydrogen peroxide or sodium persulfate, to oxidize the metal ions left intact in the image areas during electrolysis. This operation produces hydroxyl free radicals which then initiate the polymerization reaction. The unpolymerized portions of the layer are washed out and the relief image is dyed.

In U.S. Patent 3,436,215, S. Levanos and A. S. Deutsch describe a negative-working photoelectropolymerization imaging system. Both organic and inorganic compounds are incorporated in the polymerizable layer to provide free radicals at the anode surface of the sandwich assembly upon electrolysis. Imaging exposure to actinic radiation, while maintaining an electrical field between the two electrodes, initiates formation of a polymer in the light-struck areas at the interface of the electrically conductive support (the anode) and the electropolymerizable layer. The sandwich is separated and the polymerizable layer is washed to remove the unpolymerized material to make a relief image to be dyed as desired.

A novel imaging system was developed by the Fuji Photo Film Company, Ltd. and disclosed in British Patent 1,136,209. An aluminum support is first coated with a photoconductive zinc oxide film and then with a gelatin layer. After drying, the structure is exposed to imaging radiation from a suitable light source. An insulating tape is then applied to the aluminum support to protect it from electrolytic action and the structure is immersed in an electrolyte comprising a vinyl monomer, water, and a salt such as sodium chloride. The aluminum plate is made the negative electrode of a system in which a platinum electrode, spaced about 2 cm away, serves as the anode. Electrolysis is carried out for about 10 min at a dc voltage of 10 V. The light-sensitive structure is then removed from the bath, dried, and wiped with a dye solution to render the polymeric image actinically opaque.

In a system developed by H. Hodes, M. Zerner and J. Sobieski of the U.S. Army Electronics Command, Fort Monmouth, New Jersey, the composition of the emulsion coating comprised 10% 304 Bloom gelatin, acrylamide, N,N′-methylene-bisacrylamide, N,N′-trimethylenebisacrylamide and omega acrylamido-

*Crolux is a registered trademark of DuPont.

[1] Registered trademark of DuPont.

caproic acid. The concentration of each acid depends upon its solubility in the emulsion and ranges from 5% for acrylamide down to 0.5% for the methylenebisacrylamide. About 0.10% of diphenylcarbazide is added to reduce the ferric ion formed during electrolysis. Glycerine is added as humectant, potassium chloride as the electrolyte, and the pH range is 4.5–5.0.

After exposure, the halves of the sandwich are separated. The photoconductive layer is rinsed off and is ready to be used again. The monomer coating, containing the imagewise dispersion of ferrous ion, is dipped for about 10 sec into 0.1% hydrogen peroxide. During this step free radicals are generated and polymerization actually occurs. The gelatin coating is also insolubilized in imagewise fashion because of the injection of chromic acid into the emulsion. Next, the unpolymerized monomer coating is washed away with hot water and the image is made visible by immersion in a dye such as methylene blue or Congo red. The above-described system is reported to have a photographic speed equivalent to ASA 8.

Future Possibilities

New applications under consideration include computer printout, microfilm blowback, CRT imaging, hologram recording, laser recording, and color print materials.

Acknowledgments

An invaluable contribution to this section has been made by my colleague at the Institute for Graphic Communication, Leonard Ravich, through his article in the IGC Monthly.[1] The author also acknowledges many significant contributions to this section from Dr. Peter Walker of DuPont.

REFERENCES

1. L. E. Ravich, "Photopolymerization—Imaging Systems with a Future," *IGC Monthly*, pp. 4–20, July 1971 (60 references).
2. Walker, Webers, and Thommes, "Photopolymerizable Reproduction Systems—Chemistry and Applications," *J. Photogr. Sci.*, **18**: 150–158 (1970) (50 references).
3. Proc. SPSE Seminar on Applications of Photopolymers, 1970.
4. A. B. Cohen, "Photopolymer Imaging Systems," Proceedings of 1967 S.P.S.E. Symposium on Unconventional Photographic Systems, pp. 122–132 (58 references).
5. J. Kosar, *Light Sensitive Systems*, Wiley, New York, 1964 (Chapt. 5, 213 references).
6. Woodward, Chambers and Cohen, "Image Forming Systems based on Photopolymerization," *Photogr. Sci. Eng.*, **7**: 360 (1963).
7. Anon., "Multicolored Images from Black and White Positives," *Design News*, **24**: 22–23 (July 7, 1969).
8. Anon., "Photochemical Machining: Thin Parts Fabrication," *Photochemical Machining—Photochemical Etching Journal.* (Dec 1968).
9. Anon., "Photofabrication of Printed Circuits," Kodak Publication No. P-125 (see also publications P-131, P-91, P-7, P-192, P-89, P-77, P-79), Eastman Kodak Co., Rochester, N.Y.
10. Anon., "Photopolymers—Principles, Processes and Materials," Proc. Society of Plastics Engineers, Mid-Hudson Regional Technical Conference. Ellenville, N.Y., Nov 1967.
11. Anon., "Ultramicrominiaturization," Proc. of Seminar, SPSE (1968).
12. J. Bulloff, "Photopolymers for Photoengraving and Photolithographic Printing Plates," Paper Presented at the Technical Conference of the Society of Plastics Engineering, Mid-Hudson Section, pp. 187–223 (1967).
13. J. Bulloff, "Printing and Photopolymers: Towards 2000 A.D.", Proc. SPSE Seminar on Applications of Photopolymers, pp. 14–17 (1970).
14. M. Burg, et al., "Custom Toning Film," Proceedings of SPSE Seminar on Applications of Photopolymers, pp. 91–101 (1970).
15. R. D. Burr, "Photoresists—Past, Present and Future," SPSE Conference on Microphotography Fundamentals and Applications, pp. 139–44 (1968).
16. H. R. Camenzind, "A Guide to Integrated Circuit Technology," *Electrotechnology*, p. 49 (Feb 1968).
17. P. Cassiers, "The Development of Nonsilver Photographic Systems," 10th Photographic Science Symposium, Paris, pp. 169–85 (1965).
18. J. Celests, and R. Heiart, "Unique Properties and Uses of Photopolymer Film Resists," Proc. SPSE Seminar on Applications of Photopolymers, pp. 42–53 (1970).
19. E. Cerwonka, et al., "Investigation of the Photopolymerization Process," Interim Final Report #8, Nov. 14, 1964. USAECOM Contract DA 36-039-AMC-00119(e).
20. E. Cerwonka, et al., "Investigation of Photopolymerization Processes," Final Report, Contract DA 36-039-AMC-00119 (E).
21. B. K. Choudhuri, "Photopolymerization as a Method of Photography," Labdev, Part A, **6**, 26–8, (1968).
22. D. H. Close, "Hologram Recording on Photopolymer Materals," *Appl. Phys. Letters*, **14**: 159–60 (1969).
23. A. Cohen, "Photopolymers—Where We are—Where We're Going," Proc. SPSE Seminar on Applications of Photopolymers, pp. 159–161, (1970).
24. G. Delzenne, "Sensitizers in Photopolymerization," *Ind. Chim. Belge*, **24**: 739–64, (1959).
25. D. Elliot, "Applications and Techniques for Photosensitive Polymers," Proc. SPSE Seminar on Applications of Photopolymers, pp. 32–41 (1970).
26. N. Gaylord, "Donor-Acceptor Interactions in Photo-Initiated Polymerizations," *Polymer Preprints*, **10**: 277 (1969).
27. H. Hodes and M. Zerner, "Electropolymerization—Photographic Applications and Techniques," Proc. SPSE Seminar on Applications of Photopolymers, pp. 102–112 (1970).
28. N. Gaylord, "General Principles of Photopolymerization as Related to Imagewise Exposure Processes," Proc. SPSE Seminar on Applications of Photopolymers, pp. 7–13 (1970).
29. R. Huckle, "Litho Plate Making Materials: Definitions and Materials," *PIRA Printing Journal*, **1**: 17–21 (1968).
30. D. Ilten and K. Patel, "Standing Wave Effects in Photoresist Exposure," Proc. SPSE Seminar on Applications of Photopolymerization, pp. 82–90, (1971).
31. M. Imoto, "Photopolymerization," *Kagaku* (Kyoto), **18**: 1019–27 (1963).
32. E. Inoue, "Unconventional Photography," *Bull. Soc. Sci. Photogr. Japan*, **15**: 43–7 (1965).
33. G. W. Jorgensen and M. H. Bruno, *The Sensitivity of Bichromated Coatings*, Lithographic Technical Foundation, New York, (1954).
34. H. Kokado, "Unconventional Photography," *Bull. Soc. Sci. Photogr. Japan*, **16**: 58–61, (1966).
35. H. Ku and L. Scala, "Polymeric Electron Beam Resists," *J. Electrochem. Soc.*, **116**: 980–5 (July 1969).
36. S. Levanos, "Photopolymerization—Present and Future," Proc. SPSE Symp. Unconventional Photographic Systems, pp. 145–52 (1964).
37. H. B. Lovering, "Direct Exposure of Photoresist by Projection," *Solid State Technology*, **11**: 39 (1968).
38. R. O. Lussow, "Photoresist Materials and Applications," *Photochemical Machining—Photochemical Etching Journal*, Nov 1969.
39. K. Lyalikov, "Light Sensitive Polymers," *Zh. Nauchn. i Prikl. Fotogr. i Kinematogr.* **14**: 71–8 (1969).
40. K. Lyalikov and G. Gaeva, "Study of the Spectral Sensitivity of

Light-Sensitive Polymers," **Trudy Leningrad Inst. Kinoinzh.**, 12: 147–52 (1967).

41. J. Margerum, et al., "Rapid Access Photopolymerization Imaging," Proc. SPSE Seminar on Applications of Photopolymers, pp. 113–32 (1970).
42. M. Michiels, "Macromolecular Light Sensitive Systems," 10th Photographic Science Symposium, Paris, pp. 86–105, (1965).
43. L. J. Miller, et al., "Imaging by Photopolymerization," *J. Soc. Motion Picture Television Engrs.*, 77: 1177–84 (1968).
44. A. Mistr, and V. Laznicka, "Organic Light-Sensitive Substances for Photomechanical Reproduction," *Chem. Listy.*, 60: 479–98 (1966).
45. S. Doue, "Unconventional Photographic Materials," *Sci. Publ. Fuji Photo Film Co, Ltd*, 14: 48–56 (1966).
46. G. Oster, "Photopolymerization and Photocrosslinking," Encyclopedia of Polymer Science and Technology, Wiley-Interscience Div. of Wiley, New York, 1969, Vol. 10, p. 145.
47. G. Oster and N. Yang, "Photopolymerization of Vinyl Monomers," *Chem. Rev.*, 68: 125–51 (1968).
48. G. Pogany, et al., "Studies of Light-Sensitive Monomers," *Plaste Kautschuk*, 15: 886–9 (1968).
50. J. Rabek, "Photosensitized Processes in Polymer Chemistry," *Photochem, Photobiol*, 7: 5–57 (1968).
51. L. Ryabova, et al., "Thermoplastic Polymers, Photopolymerization and Degradation in Photographic Processes, II. Optically Sensitized Photopolymerization in Photographic Processes," *Zh. Nauchn. i Prikl. Fotogr. i Kinematogr.*, 11: 68–77 (1966).
52. A. Schoenthaler, "Lydel and Dycril Photopolymer Printing Plates," Proc. SPSE Seminar on Applications of Photopolymers, pp. 18–22, (1970).
53. A. Sluckin, et al., "Use of Silver Salt-Free Light-Sensitive Materials in the Polygraphic Industry," *Poliografija*, Moscow, 10: 28–30 (1968).
54. S. Tazuke, "Photosensitized Charge Transfer Polymerization," *Advan. Polym. Sci.*, 6: 321, (1969).
55. Y. Tomoda, "Photosensitive Polymers," *Sci Publ Fuji Photo Film Co., Ltd.*, 12: 101–5, (1964).
56. Y. Tomoda, "Sensitive Materials," *Bull. Soc. Sci. Photogr. Japan*, 16: 48–9 (1966).
57. T. Tsunoda, "Unconventional Photography," *Bull. Soc. Sci. Photo. Japan*, 17: 64–5 (1967).
58. T. Tsunoda, "Unconventional Photography," *Bull. Soc. Sci. Photogr. Japan*, 18: 61–62 (1968).
59. A. Tyrrell, "Non-silver Sensitizing Systems," *Perspective: World Report 1966–69*, Focal, London, 1968, pp. 362–73.
60. P. Weiss, "Photoinduced Polymerization," *Pure Appl. Chem.*, 15: 587–600 (1967).
61. R. White, "Unusual Applications of Photofabrication," Proc. SPSE Seminar on Applications of Photopolymerization, pp. 54–67, (1970).
62. W. Williams, "Aspects of Photochemistry," *Pharm., J.*, 188: 407–10, (1962).
63. T. Tamaoka and T. Tsunoda, "A Study of Crosslinking of PVA by Light-Sensitive Tetrazonium Salts," *Bull. Tech. Assoc. Graphic Arts, Japan*, 9: 38–47 (Sept 1964).

FREE RADICAL DYE FORMING IMAGING PROCESS

Free-radical photography is defined[1] as "a process whereby dye molecules are produced or destroyed permanently as the primary photoprocess resulting from the formation of a one electron species through the action of electromagnetic or corpuscular radiation, such as red and infrared light, visible light, ultraviolet light, x-rays, electron beams, and alpha particles. Chemically, free-radical photography may be defined simply as the formation of dye as a consequence of exposure to electromagnetic or corpuscular radiation of a composition containing a dye intermediate and a free-radical progenitor. In some cases, the dye intermediate itself may be the free-radical progenitor. On this basis, literally thousands of compounds may be designated properly as dye intermediates and possibly an equivalent number of materials may be designated as free-radical progenitors. The determination as to whether any combination of these two basic classes of materials will be effective is a function of the mechanism of the reaction which takes place as a consequence of the exposure of the mixture in a suitable substrate to a suitable dose of radiation."

History

The history of free radical photography[1] may be separated into three reasonably well-defined stages. Between 3000 and 5000 years ago, the Phoenicians discovered a means for producing a deep purple dye by exposing certain essentially colorless materials to sunlight and applying this dye in patterned form to cloth made from flax, or linen as it is called today.

The second period of development was disclosed by M. C. Beebe in 1921 when he used mixtures of polyhaloalkanes, principally iodoform, and aromatic amine compounds for the production of image formation on exposure to light.[3-10]

The third period of development commenced somewhat over 25 years ago with the discoveries of Kharasch[11,12] and Huyser[13] which together made many of the subsequent imaging applications possible. In 1947 M. S. Kharasch reported that polyhalogen compounds such as carbon tetrachloride, carbon tetrabromide, and the like, are split into free-radical fragments on irradiation with ultraviolet radiation. This reaction was used in photopolymerization processes where the free-radicals thus formed initiated a chain reaction which produced polymers of high molecular weight. E. Huyser used carbon tetrabromide to introduce bromine atoms into other organic compounds under the influence of ultraviolet light.

Light-generated free radical systems were described by Lyman Chalkley in numerous patents and papers published in the mid-fifties.[14] Most of his systems used triarylmethane leucocyanides in polar solvents to produce colored photo-reactions. R. Sprague, E. Wainer, and others at Horizons, Inc. disclosed imaging systems comprising organic halogen compounds in combination with arylamines, leuco triphenylmethane dyes, leuco cyanine dyes, leuco styryl dyes, and leuco xanthene dyes.[15] Horizons since 1958 has continued to the current period to investigate free radical photography, the majority of which has been under contracts with the Air Force Avionics Laboratory at Wright Patterson Air Force Base. To date, Horizons has been issued and applied for well over 100 patents. Other companies which have explored free radical photography include: DuPont, S. D. Warren, Bell & Howell, Agfa Gevaert,

Kalle, NCR, American Cyanamide, 3M, GE, Itek, Konishiroku, and Fuji.[16-21]

There are products based on free-radical imaging being used today from three companies. DuPont has their Dylux products which are used for graphic arts proofing, particularly in the book printing industry. S. D. Warren's Fotoproof is also used commercially for black and white proofing. Horizons supplies the Air Force with aerial duplicating films.

Technology

An astonishing number of chemical and physical reactions have been reasonably clearly identified as taking place in the gamut of free-radical photochemical reactions which have thus far been disclosed.[1] Included are the following reactions:

1. Condensation.
2. Acid-base reactions.
3. Redox reactions.
4. Abstraction.
5. Addition.
6. Division of dissociation.
7. Chain propagated reactions.
8. Dimerization.
9. Molecular coupling (color coupling).
10. Energy transfer reactions (development).
11. Inhibition for stabilization purposes.
12. Combinations of two or more of the foregoing.

Some of the more interesting systems are described below. The light sensitivity of halogenated hydrocarbons forms the basis for many of these systems as shown below:

$$CBr_4 \xrightarrow{h\nu} CBr_3 \cdot + Br \cdot$$

where

$$h\nu \cong light/photons$$

Irradiation causes the carbon tetrabromide to form the tribromomethane and bromine free radicals. The free radicals can be used to initiate many imaging reactions such as listed above.

Eastman Kodak developed systems based on the reactions of indoles with ferrocenes and iodoform. Miehle-Goss-Dexter (now MDG Graphic Systems) used polynuclear triarylmethane leuco dyes with halogenated organic compounds. NCR used 4-(p-dimethyl-aminostyryl) quinolines or leuco crystal violet with carbon tetrabromide (CBr_4). S. D. Warren division of Scott Paper Company developed systems based on furfurylidine compounds and iodoform.

Free-radical imaging reactions were also developed to provide latent images comprising areas of different conductivities. Xerox Corporation[22] used halogenated hydrocarbons such as CHI_3 (iodoform) in a thermoplastic coating. Imaging exposure to ultraviolet radiation produced areas of differential conductivity. A visible image was produced by normally used electrostatic toner means. RCA[23] disclosed an imaging system using leuco triarylmethane dyes in a polyvinylchloride binder. Upon impingement of imaging radiation, the light-struck areas became more conductive than the unexposed areas. The latent image was then developed with conventional electrostatic toners. A German patent[24] described the combination of organic halogen compounds with iminoquinone diazides to provide electrosensitive compounds. Belgian patents[25] disclosed electro-photoconductive imaging systems using the reaction products of secondary aromatic amines with aryl halides. Semiquinone free-radical photoelectrosensitive systems are produced by light exposure of 2,3-dichloro-5,6-dicyano-1,4-benzo-quinone.[26] Use of stable free-radicals in photoelectrosensitive imaging systems are also described.[27] The systems were claimed to have both positive and negative imaging capacities and could be developed by conventional electrostatic toners.

Imaging systems utilizing free-radicals generated from polyhalogen compounds by near ultraviolet radiation that react with arylamines to form a direct print-out dye image have been disclosed.[13]

From a study of various polymerization initiators, it has been found that near-visible utraviolet irradiation of a mixture of CBR_4 and diphenylamine in benzene solution gave an intense blue coloration. Other secondary and tertiary arylamines also give colors with polyhalogen compounds.[13]

In a typical imaging system, a mixture of diphenylamine and CBr_4, in a solution of polystyrene is coated on a suitable substrate. After drying, the film is exposed with ultraviolet imaging radiation for up to 60 sec. A blue image is obtained that is fixed by solvent extraction of the unreacted materials or by heating to drive off the volatile sensitizer. Sprague suggested[28] that the relatively high photographic speeds obtained would seem to indicate that a chain reaction was involved in the image formation. He proposed a theoretical mechanism for the chain reaction that involves initial formation of active radicals from diphenylamine, followed by condensation of these with CBr_4.

Wainer[29] prepared a table showing that the color of the image could be changed by substituting another aryl amine for diphenylamine. Some of the arylamines with a more complex structure will provide black or very dark images. Black can also be obtained by using mixtures of the aryl amines.

Sprague and Roscow[30] emphasized the importance of image color on films to be used for subsequent printing on orthochromatic material. They disclosed new ultraviolet-sensitive, heat-fixed print-out films suitable for high-resolution aerial-film reproduction. The film was a modified diphenylamine/CBr_4 system in which diphenylamine is replaced by an indole. Use of indole itself gave a yellow-orange image which proved especially suitable for printing on orthochromatic silver halide film. 3-Methylindole resulted in an intense black, of lower contrast. The formulations had printing speeds in the diazo range.

It was found that tertiary amines were substantially faster than the primary amines in forming the dye images. To achieve some degree of stability, the

secondary arylamines were considered the most suitable although combinations of some primary amines were found to provide comparable sensitivities. For example, a mixture of aniline, p-toluidine, and o-toluidine.

The halogenated compound chosen also has an effect on image color. For example, 4,4'4"-methylidenetris-(N,N-dimethylaniline) used with carbon tetrachloride produces a violet image. Carbon tetrabromide will provide a blue image and carbon tetraiodide a green image. The optimum halogenated compounds are alkyl derivatives that have been halogenated to their maximum extent. For example, CCl_4 is a most effective material but chloroform does not work at all. The preferred agents are aromatic compounds having more than one halogen attached directly to the aryl ring. The dissociation energy of the halogenated compound indicates the effectiveness of radical formation in a particular system.[29] Wainer also claimed[31] that the light sensitivity could be enhanced by including several halogenated compounds. For example, a typical mixture proposed was CI_4 + C_2Cl_6.

The instability of the Horizons imaging systems was a serious problem in the early development phase. In some cases premature dye formation was prevented by the addition of zinc oxide or alkyl amines. Aromatic reducing agents such as hydroquinone and phloroglucinol were added to reduce fogging. Wainer[32] also proposed the use of organic or inorganic sulfur compounds such as thiourea, metallic sulfides or thiols. It was claimed that heat fixing was no longer required if the sulfur compounds were used and it was sufficient to merely expose the imaged layer to moist air for a few hours. In another patent Sprague[33] suggested that stabilization of the unexposed areas could also be accomplished by acylation of the unchanged amine by heating it for one minute at 95°C in the presence of maleic or other carboxylic acid anhydride that is solid at room temperature.

Spectral sensitivity of the systems can be somewhat controlled by the choice of the organic halogen compound in the formulation. For example, halogenated methane compounds in which at least one hydrogen has been replaced by iodine are claimed to be sensitive in a spectral range from 510 to 550 nm.[31] Other sensitizers for visible light include amines which form yellow or red dyes, for example, p,p'-amino (N,N-dimethylaniline). Polyphenylmethane carbinols have been claimed as sensitizers.[34] Longer wavelength sensitivity has also been obtained with the addition of yellow azo compounds such as N,N'-dimethylphenylazoaniline or 4-phenylazodiphenylamine.[32] Saturated straight-chain or branched-chain hydrocarbons of the normal and iso-paraffin type have been claimed for use with a N-vinyl compound.[35]

Some of the Horizons patents cover formulations particularly suitable for production of lithographic plates and photoresists.[36] The hydrophobic-hydrophilic relationship is obtained by replacing the aromatic amines with styryl dye bases and their higher vinylene homologues. These are used in combination with suitable organic halogen-containing compounds and a film-forming binder.[37]

Increased light sensitivity, improved contrast, enhanced spectral sensitivity, and increased response to post-exposure red light intensification are advantages claimed for the addition of a leuco base or a carbinol base of a triphenylmethane dye to the styryl base/CBr_4 photosystem.[38,39] The sensitivity of the leuco bases to light is enhanced if the CBr_4 is substituted with tribromoacetophenone compounds, e.g., α,α,α-tribromoacetophenone and its substitutes.[40]

Most of the Horizons systems have a relatively low sensitivity and require exposures in the range of 1 to 120 sec depending, of course, on the light source used. A system claiming to require only a few milliseconds exposure was patented by Wainer.[41] The materials disclosed contain, in addition to the halogenated compound, the arylamine, an N-vinyl compound in which the vinyl grouping is directly attached to the nitrogen atom. N-vinylimide, N-vinylamine, N-vinylamide, N-vinylcarbazole, or N-vinylpyrrole were suggested compounds. A latent image formed upon a short exposure is developed to a high image density by heating. The addition of alkaline earth iodides along with citric or other weak organic acids is claimed to substantially increase the sensitivity of the system.[42]

Wainer also disclosed print-out compositions using acid-base type indicators.[43] The dye formation is based on the generation of free radicals from CBr_4 which in turn reacts with an organic binder such as polyvinyl acetate. The acid liberated changes the pH of the layer and initiates a color change of the indicator dye. Dry films made from combinations of these systems involving the acid-base type indicators, organic halogen compounds, and polymeric compounds containing hydrogen and oxygen, are capable of color changes upon irradiation, particularly ultraviolet. The water-soluble, water-miscible acid-base type indicators yield a distinct color change over a narrow pH range in the presence of at least a trace of water. The color changes are generally equivalent to those which may be anticipated in the usual water solutions on titration with acid or base. For example, a coating consisting of Congo Red and carbon-tetrabromide in a binder is violet in color and, upon exposure to a quartz mercury lamp, becomes light green; with addition to the same mixture of 10cc of a 10% solution of oxalic acid, the coating is blue and turns pale yellow upon exposure.

The Warren 1264 heat-fixable photographic material is based on the light sensitivity of iodoform. Essentially the system comprises a polymeric film containing, in transparent solid solution, a furfurylidene color forming ingredient, a primary aromatic amine, and a lower haloalkane sensitizer (e.g., iodoform) coated on a suitable substrate. The system is negative working.

Permanent black or colored images can be produced by short exposures to light in the wavelength range from 300 to 500 nm. After exposure there is a faintly visible latent image. The image is fully developed and fixed by heating to 150–170°C.

A typical system will include a polymeric binder, polystyrene, a protected aldehyde, difurfurylidene pentaerythritol, a primary amine (aniline), and iodoform. The iodoform decomposes under the action of light to

TABLE 15.11. IMAGING CHARACTERISTICS OF WARREN 1264 MATERIAL

Amine	1264 image color	Stenhouse dye color
Aniline	red	red
α-naphthylamine	red	red
o-phenylenediamine	very weak image	no Stenhouse dye
m-phenylenediamine	black	black
p-phenylenediamine	black	black
4,4'-dithiodianiline	purple	purple

The table shows the relationship between the aromatic amine and the final image color after heating to fix the system. Blends of two or more amines can be used, each one imparting special characteristics to the resultant image.

release hydrogen iodide. The HI then cleaves the acid-sensitive difurfurylidene pentaerythritol into a reactive furan and the original alcohol. The furan then reacts with the aromatic amine to form a Stenhouse dye.

Table 15-11 shows the relationship between the aromatic amine and the final image color after heating to fix the system. Blends of two or more amines can be employed to advantage; each imparting special characteristics to the resultant image.

Figure 15-6 shows the spectral sensitivity curve for a coating comprising 4-chlorometaphenylenediamine, difurfurylidene pentaerythritol, iodoform and polyphenylene oxide. Maximum spectral sensitivity is observed at a wavelength of 350 nm. Response into the visible can be obtained by changing the amine used in the formulation.

The Warren 1264 materials are commercially available and used principally for photographic proofing applications. The system is negative working, grainless and developed and fixed by heat. Black or colored images can be obtained. Photographic speed is comparable to diazo systems and the peak spectral response is about 350 nm with response limits between 300 and 500 nm. The light

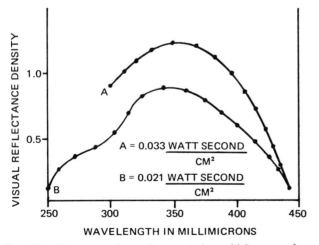

Fig. 15-6. The curve shows the spectral sensitivity curve for a Warren 1264 system: 4-chloro-metaphenylenediamine + difurfurylidene pentaerythritol + iodoform + polyphenylene oxide. Maximum spectral sensitivity is seen at 350 nm.

sensitive coatings are clear and can be applied to paper or film substrates.

The most important variable in the process is the particular primary amine employed. Image color, contrast and photographic speed is determined largely by the amine chosen and many factors must be considered in selecting one for the system. For example, the amine must not spontaneously discolor; it must have good solubility properties and low toxicity. It also must have a suitable vapor pressure so that it does not leave the emulsion during shelf storage but must be driven off rapidly during the fixing operation.

Prereaction of the amine with the iodoform is a major problem, leading to background discoloration prior to use. Some interesting systems have been developed in the search for better amines. A good system employs two amines, one of which is highly brominated, such as 3,5-dibromo-2,4-toluenediamine in combination with smaller amounts of a much less substituted amine, like 2-bromo-1,4-phenylenediamine. In this system the less substituted amine seems to be important in the photoactivation of the iodoform in producing acid. The highly brominated amine undergoes intensive color-forming reactions with furfural derivative, utilizing the acid as catalyst. The presence of bromine in the final dye structure contributes stability to light and heat.

In DuPont's Dylux imaging system, color formation occurs through a free-radical process by which organic dyes with high extinction coefficients are formed from colorless precursors by exposure to ultraviolet radiation. The quantum yield of color formation is near unity. Activation of the color forming reaction has been extended to 550 nm with sensitizers. Peak sensitivity is near the 365 mercury emission line. Photodeactivation is accomplished by overall irradiation with visible light to generate compounds that interfere with the color forming chemistry.

In one of the earlier patents[44] the material disclosed is colored through exposure with light of wavelength W_1 and is deactivated through light of wavelength W_2. Positive as well as negative images can be made depending upon the exposure with light of the two different wavelengths which are both between 250 and 550 nm. The product contained (1) an organic color former in the form of a mainly colorless, nonhygroscopic precursor, (2) a photo-oxidizer, sensitive to light of wavelengths between 220 and 550 nm, and (3) a redox composition, consisting of a reducing compound and an oxidizing compound able to provide a light-initiated redox reaction. Examples of the color former are leuco dyes, e.g., bis(4-diethylamino-2-methylphenyl) - (4-benzylthiophenyl) methane. Examples of the photo-oxidizer are halogen compounds, e.g., 2,2'-bis(o-chlorophenyl)-4,4',5,5'-tetraphenyl-biimidazole. An example of a redox composition is 2,5-diethoxy-p-benzoquinone and a polyethylene glucol.

The system now used comprises a bi-imidazole and a leuco dye which is exposed to imaging UV radiation to provide a print-out color. The sheet is then exposed to visible light and the redox composition present provides the photo-deactivator.[45,46]

Kalle disclosed novel free-radical print-out materials and printing plates in a Netherlands Patent Application published in 1965.[47] The imaging layer comprised an arylamine of an N-vinyl compound and a compound yielding a free halogen radical. Cyanuric chloride may be applied in vapor form at 60° C prior to the exposure, together with the halogen compound. In the combination, diphenylamine-CBr₄, it effects a shift from a bluish to a violet shade, while with the N-vinylcarbazole-CBr₄, an undesirable discoloration of the unexposed areas during fixation by heating or during storage is avoided. For example, paper coated with a solution of 5 g. N-vinylcarbazole, 8 g CBr_4, and 2 g cyanuric chloride in 25 cm³ trichloroethylene and dried at room temperature requires only about 1/3 the exposure as a similar formulation without the cyanuric chloride. The image is fixed by heating for three minutes at 110° C. A German patent application disclosed a similar mechanism.[48]

In another patent[49] heat-fixable light-sensitive ferrocene layers are disclosed. Mixtures of ferrocene and halogenated hydrocarbons (e.g., CBr_4) are known to react under the influence of ultraviolet or visible radiation to form brown negative images which can be fixed by heating at 80–120° C. The light sensitivity of the system is improved in the presence of amines or phenols which form dyes when exposed with CBr_4. Substituted ferrocenes, e.g., diacetylferrocene, can also be used. Synthetic resins or waxes can be added to improve adhesion of the coatings to smooth-surfaced substrates. For example, paper is impregnated with a solution containing 3 g each of ferrocene and CBr_4 and 0.1 g of 1-naphthylamine dissolved in a mixture of 15 cm³ each of Me_2CO and trichloroethylene, and exposed for 15 sec after drying, through a suitable transparency to a 200 W tungsten lamp. The brown-violet image is then fixed by exposure to an infrared source.

Higher sensitivities were achieved for ferrocene-containing imaging systems by the addition of indole, substituted or unsubstituted, in any position but the 3 position.[50] The principal advantages of the system are its higher sensitivity, especially in the visible region of the spectrum, and the fact that the color of the copy can be varied by addition of different aldehydes.

Copying materials of high sensitivity which provide odorless prints were disclosed in 1966.[51] The photosensitive component of the coating is the product obtained by condensing certain N-containing heterocyclics, e.g., substituted or unsubstituted indoles, pyrroles, pyrazoles, imidazoles, trazoles, tetrazoles, or pyrazolones with aromatic aldehydes. CBr_4 and aromatic aldehydes are added as sensitizers. Ferrocene or its derivatives can be added to extend the spectral sensitivity of the material into the visible region of the spectrum. After exposure the material is fixed by heating to 80–120° C. In an example, a solution of 2 moles of 2-methylindole and 1 mole of dimethylaminobenzaldehyde in ethyl alcohol was heated with concentrated HCl on a water bath and the crystalline condensation product precipitated. 0.2g of the condensation product, 1 g CBr_4 and 0.3 g ferrocene were dissolved in 10 cm³ methyl alcohol. The solution was coated on paper and the solvent evaporated. After drying, the coated material was exposed to a 200 W lamp for 10 sec and then heated for 2 min at 100° C to provide an odorless negative copy with a red dye image.

In the Bell & Howell system, when N-vinyl carbazole (NVC) and carbon tetrabromide (CBr_4) are dissolved in ethyl acetate, for example in a mole ratio of 2:1:2, a complex forms which extends the light absorption into the visible to 450 nm. In the dark, photomerization and color formation occur rapidly and the system is not satisfactory for a stable imaging system.

A photosensitive system was examined in detail which apparently overinhibits the uncontrollable reactions of the NVC and CBr_4, and provides a stable imaging system.[52] Two moles of NVC, 1 mol of CBr_4, and 20 g of polyvinylidine chloride/acrylonitrile (saran) copolymer are mixed together in a solvent and applied to a suitable substrate. After exposure to actinic radiation the latent image was stable and was developed conveniently by contact heat for a half second at 120° C. The quantum yield expressed as molecules of NVC reacted was about 6 through the near ultraviolet range (350–390 nm).

A coating of higher photographic speed was reported by Yamada and Garland.[53] In one embodiment of the system a mixture of NVC and CBr_4 is homogeneously dispersed in a gelatin binder to provide blue-green negative images on exposure to ultraviolet radiation and heat or direct positive images on a white background if pre-exposed to visible light. In one example, 5 g NVC and 8 g gelatin in 29 ml water are stirred vigorously and heated to 70–72° C to give an emulsion and 5 g CBr_4 is then added. The emulsion is coated on baryta-coated paper. After cooling and drying, an almost homogeneous mixture of NVC and CBr_4 separate as spherical particles of approximately 2-4 μm diameter. The background of the coating is pale yellow.

Imagewise exposure to light of wavelength 400–780 nm, followed by exposure to ultraviolet radiation (300–400 nm) and heating at 70° C for 10 sec yields a blue-green positive image on a white background.

An improved system was described[54] in which the coating components comprise a monomer, an organic halogen compound and a dye base latensification agent. The color forming function as well as the colorless polymerization is carried out by a combination of monomer and halogen compound (the photopolymerization system). This limits the choice of these components to those which can participate in a color reaction. In the latensification process, an overall red light exposure is used to amplify the initially weak latent image and to expose the photopolymerization system by a red-sensitization mechanism. Therefore, the photopolymerization system, usually sensitive to blue and near-ultraviolet light, had to be sensitizable to longer wavelengths. Since the C-halogen bond dissociation energies are generally greater than those available in red light, some change in the initial reactants, such as by formation of a charge transfer complex between the monomer and halogen compound, is required to facilitate initiation. All of these requirements must be met by a single combination of monomer and halogen compound in the emulsion.

The dye base in the emulsion should respond to very low levels of exposure to blue light (imaging exposure) and must produce a red sensitizer for the photopoly-

merization system. A wide range of dye bases, leuco dyes, and dyes show some latensification effect. However, 4-(p-dimethylaminostyryl) quinoline used in conjunction with NVC and CBr₄ showed an outstanding effort. For example:

is melted together or dissolved in a solvent and dispersed in aqueous gelatin and coated on a suitable substrate. The response to light depends on the imaging light intensity used. A low light intensity provides a colorless polymer and high light intensity yields a colored dye. The camera speed of the system depends on the use of the styryl dye print-out image formed during the imaging exposure to form a sensitizer for the formation of the colorless polymer in the light struck areas. The almost invisible trace of the styryl dye formed is "latensified" by overall red light exposure. Enough dye is thus formed to sensitize the polymerization of the NVC in the exposed area. Finally, exposure to strong white light and heat develops the positive image.

Free radical imaging systems specifically designed for full color printing and for color proofing applications have been developed by Itek Corporation; it claims that the films are capable of high fidelity color rendition, free from fixing problems and have greatly improved dye stability. The light sensitive materials are color formers derived from indole complexed with activators such as carbon tetrabromide or tribromoacetophenone.[55]

As in previously reported free-radical imaging systems, exposure to light of a mixture of color former and CBr₄ generates HBr which adds to the dye precursor forming the colored dye salt. The solubility change from a toluene soluble color former to a toluene insoluble dye makes possible solvent fixing for a negative system or solvent transfer of unconsumed material for a direct positive system. Coatings are usually made with polystyrene as the film-forming binder applied to polyester film. Color formers are transferred to a receptor sheet for the positive image; the receptor sheet comprises a suitable substrate coated with polyvinyl-butyral coating containing an acid mordant (such as phthalic acid) that ensures the complete removal of the color former from the negative film.

The intrinsic sensitivity of the color former-CBr₄ complexes extends from the ultraviolet into the blue; maximum sensitivity is at 390 nm for yellow, 425 nm for magenta and 445 nm for cyan. The coatings are also sensitive in the visible to the wavelengths absorbed by the corresponding dyes. This is due to the trace of dye always present as "fog" dye which acts as a powerful

sensitizer on the color former-CBr₄ complex. Strong sensitivity thus extends into the visible as far as 495 nm for yellow, 600 nm for magenta and 700 nm for cyan color formers. The hues of the print-out dyes, each absorbing one-third of the spectrum, are almost the ideal yellow, magenta and cyan colors needed for subtractive color reproduction.

Both single layer and multilayer films have been coated incorporating these color formers. An application for the single layer films is color proofing of positive graphic arts color separations, where cyan, magenta, yellow, and black images are transferred in register to a paper receptor sheet. Using a conventional high intensity tungsten light source, contact printing exposure time ranges from 30 to 90 sec. The film bearing the negative dye image is then rolled down on a receptor sheet which has been preconditioned with a small amount of a viscous toluene-silicone transfer fluid. Transfer of the positive image is complete in 1 to 2 sec. The remaining colors are transferred in register in the same fashion resulting in a high fidelity color proof in about 8 min. After the last transfer, the surface film of greasy fluid is removed from the print with a tissue moistened with a hydrocarbon solvent. This also extracts any remaining traces of activator which might otherwise cause fading of the image dye. The continuous tone characteristics of these films make them suitable for gravure proofing as well as halftone work.

For negative separations the printing procedure is the same, but a quick solvent rinse is needed to remove the unconsumed color former from the film. The print-out positive dye image is then transferred to a mordanted receptor sheet as before, this time an aqueous alcoholic transfer fluid is also added.

The Konishiroku photosystem uses halosulfone derivatives to replace the organic halogen compounds such as carbon tetrabromide usually employed in free-radical imaging systems.[56] The halosulfones are preferred because of their high stability and low toxicity. Exposing the system to near ultraviolet light initiates the formation of a triphenylmethane dye such as crystal violet.

Typical compounds used in the reactions are tribromomethylphenylsulfone (TBPS) and diethanolaniline (DEA). After exposure the image is fixed by reducing agents, for example, sodium sulfite. The photosystem is claimed to have excellent stability, low toxicity, and higher sensitivity than formulations containing carbon tetrabromide.

The effective light absorption of the system is affected by the formation of charge transfer complexes between halosulfones and arylamines. The introduction of electron-attracting radicals to the halosulfones shifts the charge transfer band to the longer wavelengths and consequently increases the sensitivity. A similar effect was observed when amines of smaller ionization potential were used.

Pyrazoline derivatives such as 1,5-diphenyl-3-biphenyl pyrazoline effectively sensitized the system in the spectral region between 330 and 550 nm without significant increase in background coloration.

In one Kodak System disclosed in 1964[57] monoacetyl-ferrocene and derivatives are treated with a benzaldehyde or cinnamaldehyde in the presence of a strong base to give vinyl ketones which are photosensitive; mixtures with iodoform can be used to prepare photographic products.

In a 1965 disclosure[58] polycyclopentadiene plus CBr_4 are coated on a suitable substrate and exposed to ultraviolet imaging radiation to provide a blue image. The image is then solvent-fixed. Photolytically generated HBr is believed to protonate the polymer which makes the double bond system "mobile." The result is the formation of a long chain of conjugated double bonds which absorbs visible light. A 60 sec exposure to a sunlamp at a few inches provides a blue colored image. Subsequent heating to 150°F converts it to a stable brown image.

A variety of activators have been disclosed (MGD Graphic Systems) in the literature to increase sensitivity of triphenylmethane dye leuco compounds to ultraviolet radiation and improve print-out image stability. M. Agruss[59] discloses halogen-containing phosphorous compounds, e.g., chloromethyl phosphorodichloridate or trialkoxyboroxines which, upon irradiation, are decomposed to acidic compounds. A typical coating solution comprises 5–10% of an organic film former (e.g., cellulose acetate butyrate), 0.5–1.5% leucocyanide, 5–12% heterocyclic activator, and 0.5–5.0% halogen-P compounds. The substrate is given a thin cellulose acetate butyrate barrier coating.

In another disclosure[60] a photosensitive composition is described which comprises a substantially colorless quaternary ammonium triphenylmethane carbinol and an activator, preferably an alkoxyboroxine, which under ultraviolet irradiation, produces acidic products to cause color formation in exposed areas. Background areas are claimed to be stable in the dark or in ambient room light aging conditions.

In a third patent[61] it is claimed that the background darkening after aging may be reduced by (1) employing a transparent organic plastic substrate, e.g., cellulose acetate butyrate, beneath the sensitive coating, (2) incorporating titanium esters of tetra (hydroxyalkyl) derivatives of alkylene polyamines, e.g., N, N, N′, N′-tetrabis (hydroxyethyl) ethylenediamine, and (3) incorporating aryl esters of hydroxybenzoic acid of certain substituted benzophenones, e.g., phenyl salicylate and 2,4-dihydroxybenzophenone, respectively.

The systems described provide improved shelf life since they are neutral before imaging exposure.

In a 1966 patent[62] IBM disclosed a system in which imagewise exposure of a film containing either a halogenated polyketone (prepared, for example, from the monomer $MeCOCCl:CH_2$) or a mixture of polyketones (prepared, for example, from $MeCOCH:CH_2$) and a compound which releases a H halide on exposure to light (for example, polyhalogenated, long chain hydrocarbons such as Halowax or carbon tetrahalides), optionally in conjunction with H-donating compounds such as Ph_3CH, releases H halide in the exposed areas. Subsequent heating to 100–150°C then leads to the imagewise formation of stable colored compounds due to H halide-catalyzed aldol condensation of the ketone polymer. The light absorption and hence the sensitivity of these photographic materials may be increased by the addition of sensitizers such as aryl ketones (e.g., Ph_2CO) or aryl thioketones (e.g., thioxanthone).

In a typical application a 0.04 mm coating on glass was prepared from a solution containing polymethyl isopropenyl ketone (16.67% by weight), a chlorinated paraffin, e.g., Hydrowax 4010A (16.67% by weight), dioctylphthalate (16.7% by weight), and Saran 220 (50% by weight). Imagewise exposure of the coating to a G.E. UV arc lamp for 30 sec at a distance of 1 m and subsequent heating at 100°C for 60 sec provided a fixed image having a diffuse transmission density of 0.51.

J. Gaynor[63] reported on a system developed at G.E. in which direct color positives can be obtained by intense exposure of an optically transparent organic synthetic polymer coating containing an oxidizable organic dye and a polyhalogenated organic compound. A mixture of iodoform, indophenol blue and polystyrene (mol wt 20,000) is coated on glass and exposed through a negative by a 300 W tungsten lamp for 60 sec. A positive blue image results which can be fixed by heating at 120°C for 10 min.

In a system assigned to Polacoat[64] homologs of Michler's Hydrol Blue are treated with potassium hydroxide in ethoxyethanol and the solution is imbibed in a polyvinyl butyral resin. The wet sheet is then laminated between mylar films and exposed while wet. A density of 4.0 can be produced by a high intensity flash. Other activators that can be used include Br_3C-Ch_2OH, $BrCHCl_2$, CCl_4, Cl_3C-CCl_3 and CH_2Br_2.

G. Huett of Dietzgen[65] developed imaging systems based on the perchlorate salts of protonated leuco cyanides. The formulations can be used without added activators.

The NCR free radical imaging systems[66] use 4-(p-dimethyl-aminostyryl) quinoline or leuco crystal violet with CBr_4. The system is imaged with blue light and the latent image is then optically developed with red light.

Keuffel and Esser have supported considerable work in Japan on the Horizons-type materials.[67] Reference 68 lists some recent patents issued to Horizons.

Although slower speed free-radical papers and films have been refined to where there are no significant failings, high speed (10^4 ergs/cm^2) materials still possess one or more of the following problems:

1. *Shelf life:* highest speed film must be exposed immediately after coating while still wet; medium speed materials fog rapidly on keeping.
2. *Activator volatility:* CBr_4 evaporates from coatings with loss of sensitivity; iodoform is objectionable when film is heat-fixed.
3. *Stability of image dyes:* unless stabilized by use of a mordant, the image dyes fade rapidly in strong light.
4. *Image hue:* a black image is difficult to achieve in high speed films.
5. *Machine design:* processors for red-light developed films are bulky and require high-wattage lamps.

Application—Product Characteristics

Sensitometric properties of DuPont's photodeactivatable paper, Dylux 503, are given below:

PROPERTY	RESPONSE
Color Formation	
Image color	Blue
Spectral sensitivity	200–380 nm
Energy to yield optical density at 365 nm, I = 0.9 mW/cm² to indicated O.D.	O.D. = 0.3 7 mJ/cm²
	0.7 25 mJ/cm²
	1.0 125 mJ/cm²
Maximum optical density	1.0–1.2
Gamma	0.6–0.75
Gray scale	13 out of 21 2-steps
Optical density minimum (unimaged background)	0.12
Background color	Yellow
Deactivation	
Background color on deactivation	White
Spectral sensitivity	390–500 nm
Energy required for complete deactivation at 436 nm, I = 15 mW/cm²	1000 mJ/cm²
Gamma	0.45–0.75

The convenience and short access time of this paper, when exposed with relatively simple and inexpensive equipment, are valuable in the graphic arts field, especially for proofing in the printing and publishing industries. Films based on this technology are expected to be useful in cathode ray tube generated displays and in the duplication of aerial reconnaissance negatives.

The S. D. Warren Fotoproof material—used for similar proofing purposes—was fully described earlier. It is utilized in a proofing system, marketed by S. D. Warren as the 842 Fotoproof Dry System. Warren sees it as a replacement for the slower silverprint and brownprint processes, and as superior in imagery versus blueprint. Features claimed include:

1. Black images.
2. Excellent resolution with faithful rendition of type, line copy, and halftone dots from coarse to 300-line screen.
3. Good gray scale.
4. Two-step, simple, completely dry process.
5. Complete processing in less than 3 min.
6. Two-sided reproduction available—useful for "dummies."
7. Paper can be handled in ordinary room light.
8. Very good dimensional stability.
9. Up to 42-in. wide proofs.
10. Easily written on.

Below are specifications for a Horizons free radical film used for aerial film duplicating. It is understood that this film has been superseded by improved ones.

E-714 Film

Spectral sensitivity—3800–5000 A (Peak 4050A)
Speed-100 times faster than diazo
Energy requirements
 By direct printout 300 mJ/cm²

With optical develop (red light)
 Imaging 5 mJ/cm²
 Develop with 6000–8000 A light
Free-radical precursor—Iodoform
Fixing—removal of iodoform by heating 150°C for 80 sec
Final image color—blue black
Resolution—600 to 1500 line pairs/mm
Visual maximum optical density 2.5
Gamma—3.0

Robert Sprague—noted inventor of free radical photographic systems—recently listed the following prospective applications:

1. Microfilm blowback—both Horizons and Itek films and paper are candidates here but an inexpensive processor is not yet available.
2. Multigeneration printing of high-resolution films—same comment.
3. Color proofing—again the processing machine is needed.
4. Color film duplication and color prints from color negatives—multilayer Itek films would be suitable here.
5. Paper prints in real or false color from ERTS satellite separation films from multilens cameras
6. Laser printing—many companies are looking at this.

Acknowledgements

Much of the material in this section was taken from Ref. 2; my sincere appreciation to Leonard Ravich for this invaluable contribution. A good deal of information contained herein was also supplied by Robert Sprague of Itek, whose help is gratefully acknowledged.

REFERENCES

1. "Free-Radical Photography: History and Status," Eugene Wainer, Proc. 1971 SPSE Symp. on Unconventional Photographic Systems.
2. Leonard E. Ravich, "Free Radical Imaging Systems," *IGC Monthly* (Aug. 1972).
3. M. Beebe, U.S. Patent 1,574,258 (2/23/26)—A photocopying process using a composition including a hydrophobic gel-like material such as gelled tung oil, sensitive to the action of light, and a catalytic accelerator such as CHI₃ or AlCl₃.
4. M. Beebe, U.S. Patent 1,574,356 (2/23/26)-A composition adapted for reproducing designs on metal, glass, etc. comprises a varnish containing a light sensitive oil such as tung oil and an accelerator, for example iodine, which serves to accelerate the selective action of light upon the varnish.
5. M. Beebe and A. Murray, U.S. Patent 1,574,357 (2/23/26)-Specifies a composition including a hydrophobic gel-like material such as gelled tung oil, sensitive to the action of light, and a catalytic accelerator such as CHI₃ or AlCl₃.
6. M. Beebe and A. Murray, U.S. Patent 1,574,359 (2/23/26)-Specifies a hydrophobic colloid such as tung oil composition and a sensitizer containing lead triethyl iodide.
7. M. Beebe and A. Murray, U.S. Patent 1,575,143 (3/2/26)-A sensitizer is formed of a hydrophobic protective colloid such as asphalt in naphtha solution and a halogen-liberating compound, e.g., lead triethyl iodide and CHI₃.
8. M. Beebe and A. Murray, U.S. Patent 1,587,271 (6/1/26)-A selected asphalt is mixed with a colloidal halide composition such

as CHI₃ mixture, exposed to a light image, and the print is developed by a suitable solvent which removes variable solubility parts of the impressed image.

9. M. Beebe, et al., U.S. Patent 1,587,272 (6/1/26)-A synthetic resin compound such as a condensation product of benzaldehyde capable of being condensed by the action of light is used with a sensitizing agent such as CHI₃.
10. M. Beebe, et al., Canad. Patent 263,646 (8/17/26)-A photographic medium comprises a phenolic condensation product and a sensitizer which comprises a halogen source.
11. M. D. Kharasch, *J. Amer. Chem. Soc.*, **68:** 155 (1946).
12. M. S. Kharasch, et al., *J. Amer. Chem. Soc.*, **69:** 1100 (1947).
13. *Photogr. Sci. Eng.*, **5:** 98–103 (1961).
14. Lyman Chalkley, U.S. Patents: 2,325,038; 2,366,179; 2,441,561; 2,528,496; 2,676,887; 2,829,052; 2,839,542; 2,839,543; 2,844,465; 2,855,300; 2,855,303; 2,855,304; 2,864,751; 2,864,752; 2,864,753; 2,877,166-169; 2,829,148; 2,936,235; 2,936,276; 2,951,855; 3,071,464; 3,122,438.
15. Horizons, U.S. Patents: 3,042,515–519; 3,046,125; 3,046,209; 3,047,515; 3,056,673; 3,082,086; 3,045,303; 3,100,703; 3,102,027; 3,102,029; 3,102,810; 3,104,973; 3,106,466; 3,109,736; 3,113,024; 3,112,200; 3,114,635; 3,121,632–35; 3,140,948; 3,140,949; 3,147,117; 3,154,416; 3,164,467; 3,221,632; 3,284,205; 3,287,744; 3,272,635; 3,342,595; 3,342,602–604; 3,351,467.
16. Bell & Howell, Patents: 3,503,745; 3,600,179; 6,405,024 (Neth.).
17. MGD, U.S. Patents: 3,079,258; 3,121,012; 3,123,473; 3,131,062; 3,205,072; 3,285,743.
18. S. D. Warren, U.S. Patents: 3,394,391–395; 3,410,687; 3,413,121.
19. Kodak, Patents: 3,201,240; 672,733 (Belg.); 1,361,470 (Fr.); 1,639,723 (Fr.).
20. Konishiroku, 3,502,476.
21. NCR: 3,140,947.
22. J. P. Ebert, U.S. Patent 3,081,165.
23. H. G. Grieg, RCA Rev., 413–419 (Sept 1962).
24. Ger. Patent 1,104,824.
25. Belg Patents 626,527; 626,528.
26. Neth. Appl. 6,515,380.
27. Chem. Eng. News, 51 (Oct. 24, 1966).
28. R. Sprague, U.S. Patent 3,046,209 (1962).
29. E. Wainer, U.S. Patent 3,042,515 (1962); Belg. Patent 600,757 (1961); Fr. Patent 1,289,654 (1961).
30. R. Sprague and M. Roscow, *Photogr. Sci. Eng.*, **8:** 91–95 (Mar–Apr 1964) Belg. Patent 641,329 (1963).
31. E. Wainer, U.S. Patent 3,042,516 (1962); Fr. Patent 1,313,761 (1963).
32. E. Wainer, U.S. Patent 3,042,516 (1962), Fr. Patent 1,302,610 (1962); Ger. Patent 1,172,115 (1964).
33. R. Sprague, U.S. Patent 3,082,086 (1963); Jap. Patent 39-17701 (1964).
34. H. Fichter Jr. and W. Hamilton, U.S. Patent 3,102,029 (1963); Fr. Patent 1,329,807 (1963).
35. E. Wainer, U.S. Patent 3,042,519 (1962): Brit. Patent 959,035 (1964).
36. R. Sprague and H. Fichter Jr., *Photogr. Sci. Eng.*, **8:** 95–103 (1964).
37. R. Sprague, et al., U.S. Patent 3,095,303 (1963); Brit. Patent 959,037 (1964).
38. R. Sprague, et al., U.S. Patent 3,102,810 (1963).
39. H. Fichter Jr. and W. Hamilton, U.S. Patent 3,102,029 (1963).
40. R. Sprague and P. Sprague, U.S. Patent 3,121,633 (1964); Fr. Patent 1,364,896 (1964).
41. E. Wainer, U.S. Patent 3,042,517 (1962); Brit. Patent 959,034 (1964); Fr. Patent 1,303,075 (1962); Ger. Patent 1,175,986 (1964).
42. E. Wainer, U.S. Patent 3,042,518 (1962): Brit. Patent 959,034 (1964); Fr. Patent 1,313,083 (1962).
43. E. Wainer, U.S. Patent 3,112,200 (1963); Brit. Patent 949,033 (1964); Fr. Patent 1,302,010 (1962).
44. Neth. Patent Appl. 6,505,529 (1965).
45. R. Dessauer, U.S. Patent 3,390,994 (1968).
46. R. Dessauer, U.S. Patent 3,579,342 (1971).
47. Neth. Patent Appl. 6,410,921 (1965).
48. E. Hackman, Ger. Patent Appl. 1,214,084 (1966).
49. Neth. Patent Appl. 6,504,126 (1965).
50. Neth. Patent Appl. 5,508,274 (1966).
51. Neth. Patent Appl. 6,510,549 (1966).
52. N. Notley, Preprints, SPSE Annual Conference, p. 122 (May 1969).
53. Neth. Patent Appl. 6,405,024 (1964).
54. Y. Yamada, U.S. Patent 3,503,745 (1970); U.S. Patent 3,600,179 (1971).
55. R. Sprague, U.S. Patent 3,598,583; 3,764,319–320.
56. K. Itano, et al., U.S. Patent 3,502,476 (1970).
57. J. Dubose, Fr. Patent 1,261,470 (1964).
58. J. Faber, U.S. Patent 3,201,240 (1965).
59. M. Agruss, U.S. Patent 3,121,012 (1964).
60. M. Agruss, U.S. Patent 3,123,473 (1964).
61. M. Agruss, U.S. Patent 3,131,062 (1964).
62. C. Allman and A. Sporer, U.S. Patent 3,268,333 (1966).
63. J. Gaynor, Fr. Patent 1,384,957 (1964).
64. H. Kosenkranius, U.S. Patent 3,275,442.
65. G. Huett, U.S. Patent 3,418,128.
66. U.S. Patent 3,140,947; Belg. Patent 613,013.
67. Keuffel and Esser, Patents: 3,547,634; 3,560,216; 3,582,342; 3,615,478; 3,630,735; 3,667,954; 3,695,887.
68. U.S. Patents: 3,624,228; 3,620,748; 3,615,553; 3,578,456; 3,578,455; 3,576,799; 3,573,911; 3,573,046; 3,560,211; 3,558,317; 3,510,309; 3,510,300; 3,493,376; 3,486,898; 3,443,945; 3,450,532; 3,424,580; 3,374,094; 3,377,167.
69. R. A. Forland and E. B. Noffsinger, "A Look at Free-Radical Films," *Laser Focus*, p. 38, July 1970.
70. A. C. Hazy and V. P. Petro, "Free-Radical Film for Data Storage," *Laser Focus*, p. 32, Feb 1972.
71. "Resolution for 1971: Very High!," *Photomethods for Industry*, Jan 1971.
72. E. B. Noffsinger, "Biomedical Microimagery via Organic Free-Radical Films," *Photographic Applications in Science, Technology and Medicine*, p. 25, Jan 1971.

Several papers were presented by Horizon's staff at the Third S.P.S.E. Unconventional Photographic Systems Symposium held October 20–23, 1971 in Washington, D.C.:

E. Wainer, "Free-Radical Photography: History and Status."[1]

D. R. Schaller, "Image Fade and Scratch Resistance of Type 2000 Free Radical Film."

W. H. Low, "Preliminary Image Information for Free-Radical Film."

V. P. Petro and A. C. Hazy, "Laser Recording Materials."

F. Schmidt, "Red Light Development of Latent Images."

R. Sprague and P. Rourke from Itek Corporation also presented "New Free Radical Color Films" at this meeting.

There is a section in Kosar, *Light-Sensitive Systems*, (Wiley, 1965. pp. 361–370), which reviews the patent and technical journal literature through December 1964.

PHOTOCHROMIC IMAGING PROCESS

Introduction

A photochromic imaging process is based on the ability of certain compounds to undergo a molecular rearrangement under the action of light which results in a change in color. This rearrangement can involve an isomeric

one between the cis and trans forms. The change is of a reversible nature. References (1)–(9) list some excellent sources of information.

Technology

Photochromism is a special case of the more general phenomenon, phototropy. Phototropy is defined as a reversible change of a chemical species between two states having distinguishably different electromagnetic radiation absorption spectra, such change being induced in at least one direction by the action of electromagnetic radiation.

The actinic radiation, as well as the absorption spectra changes, is usually but not necessarily in the infrared, visible, and ultraviolet regions and may induce a change in one or both directions. The change in one direction is generally (but not necessarily) thermally induced and therefore usually occurs spontaneously. The nature of the change of state causing the change in the absorption spectrum is immaterial if the reversibility criterion is met.

Photochromism is now defined as the special case of phototropy in which a distinguishable change in visible light absorption takes place. A working definition of photochromism is therefore simply a "reversible change of color induced by electromagnetic radiation."

Fundamental to an understanding of these materials is the realization that reversibility implies an equilibrium process—the material will change its state in order to reach an equilibrium with its environment. When the environment is changed, changes in the characteristics are inherent in the definition of photochromism and cannot be lumped into a category of troublesome side effects. An example is the optical density of a photochromic material under a steady-state illumination spectrum; as the temperature is allowed to change, most photochromic materials will show a change in optical density, because the process of changing from colored to uncolored is thermally induced, and changing the temperature changes the balance between the forward and reverse reaction rates.

The reversal from the activated or unstable state (which, in most cases, is the strongly colored state) to the unactivated or stable state may be induced by (1) thermal processes (thermal reversal), or (2) by absorption of a photon (photoreversal), or (3) may be accompanied by the emission of a photon (phosphorescence).

Thermal processes are the most common. Some materials (the spiropyrans, for example) exhibit photoreversal processes which are apparently not merely due to the heat generated by absorbing the photon, although the exact nature of the process is not clear.

The spontaneous thermal reversion of the irradiated to the stable state may take place over time spans ranging from microseconds to years. Reversion rates for organics in solution may be anywhere in this range, but the reversion rates for crystalline solids are commonly slow—requiring hours or longer. For organics in solutions (including films), the reversion rate is quite

readily controllable. The important factors controlling the rate are (1) the structure of the photochromic material, (2) the temperature of the solution, (3) the viscosity of the solvent, and (4) the polarity of the solvent. As expected, increasing the temperature will increase the fading rate and increasing solvent viscosity will decrease the rate; however, no general statements concerning the magnitudes of this effect can be made.

Table 15-12 below lists classes of compounds which have exhibited phototropism.

TABLE 15-12.

Organic Compounds	
anils	anthrones
hydrazones	spiropyrans
osazones	polypyrrole pigments
semicarbazones	phosphonium ylids
stilbene derivatives	merocyanine dyes
fulgides	cyanine dyes
thiosulfonates	phthalocyanine dyes
aromatic azo compounds	indenone oxides
thioindigo dyes	quinoline derivatives
triarylmethane dye derivatives	halonitromethionates
camphor derivatives	phenazine dyes
ortho-nitrobenzyl derivatives	acylaziridine derivatives
sydnones	

Inorganic Compounds	
metal dithizonates	molybdenum compounds
copper chelates	chromium complexes
oxides	cerous complexes
mercury compounds	silver halides
titanium compounds	alkaline earth titanates
zinc sulfide	and sulfides
alkali halides	sulfide-iodide complexes
minerals	

To the present, the most widely studied class of photochromics have been the spiropyrans because:

1. high optical densities at R. T.
2. not as thermochromism.
3. spectral shifts (coloring) from UV to visible.

A typical one is shown below:

colorless

color

1,2,3-trimethylindolinonaphthospiropyran

Although one of the attributes of photochromic systems which have been applied to special purposes is the ability to erase the image and reuse the material to record later images, there has also been a desire to render the images permanent. Various methods have been proposed for this including:

1. Low temperature to retard the fading of the image.
2. Addition of a color reactant to the photochromic material and fuming with SO_2 or NO_2 gas and heating.
3. Encapsulation of the photochromic material and a volatile solvent, rupturing the capsules and allowing the solvent to evaporate.
4. A transfer method in which the dye in the capsules is transferred by contact to a receiving sheet.
5. A transfer method in which the photochromic layer is exposed to give an ionic (water soluble) image which can be transferred by contact to a mordanted receiving sheet.
6. Complexing the photochromic compound to give a photodissociable complex, such that after exposure one of the components can be removed, reacted to give a colored compound, or reacted with silver nitrate to give a silver image.
7. Conversion of the photochromic compounds to act as agents for chelating metal ions and so stabilizing them.
8. Use of stabilizing additives.

Organizations—Applications

A great amount of research has been devoted to the study of photochromism, particularly in the past 25 years, with special attention being given to the mechanism of the reactions, the search for photochromic materials, and the possible practical applications.

In the United States, much of the research on applications has been sponsored by the government and has been conducted internally by government laboratories or, under contract, by university and industrial laboratories. Much of this material is "classified" and not available to the public. On the other hand, many industrial concerns have been interested in the potential of photochromic systems for their own business developments. Among these companies are the following, arranged in alphabetical order:

1. American Cyanamid Co.
2. American Optical Co.
3. Chalkley
4. Copymation, Inc.
5. DuPont
6. Eastman Kodak Co.
7. Litho Chemical & Supply Co.
8. Arthur D. Little, Inc.
9. Lockheed Aircraft Corp.
10. LogEtronics, Inc.
11. Marks Polarized Corp.
12. Marquart Corp.
13. 3M
14. Monsanto
15. National Cash Register Co.
16. Perkin Elmer Corp.
17. Polacoat Inc.
18. Polaroid Corp.
19. Radio Corp. of America (RCA)
20. Sperry-Rand Corp.
21. Vari-Light Corp.
22. Westinghouse Corp.

Of these, the National Cash Register Co. and the American Cyanamid Co. have been the most active. In addition, many companies have investigated the applications of photochromic glass and photochromic film for optical filters. The Corning Glass Works has been the leader in this field.

The only imaging application to date for photochromic materials is National Cash Register's Photochromic Micro-Image (PCMI) system, introduced in 1962. Its function is to provide microform reproduction of documents at high reduction ratios (say 200 times) on film sheets. Original photography is done on 35mm high-resolution silver photographic film at a reduction of $10\times$. These images are reduction printed in sequence in a step-and-repeat manner, by UV, on a sheet of photochromic material in a camera held below $0°C$, and at the desired second reduction ratio, say $20\times$. The direct image on the film can be inspected at this stage, bleached by appropriate exposure, and re-exposed if necessary to correct errors. (Note: this feature obviously cannot correct for errors in the original microfilm.)

In the third stage, the photochromic sheets are contact printed, again at low temperature, onto high-resolution silver film to give masters from which miltiple copies can be made for distribution. Other applications that have been considered include:

1. Proofs from negatives.
2. Photographic masking.
3. Memory devices—limitation here is number of reversals.
4. Displays—Corning introduced and later withdrew a display terminal with a photochromic faceplate.
5. Ultraviolet dosimetry.

Limitations of Photochromic Systems

The mechanism of most photochromic systems is not well understood from the chemical and physical points of view. Many factors control the response, and they are not well known, especially the relation of structure and environment to behavior. The sensitivity to radiation is low, being of the same order as that of diazo and vesicular materials. The effective spectral response range is limited. Photochromic response is reversible and, with repeated reversal (at least with the organic materials), fatigue occurs. The reverse reaction affects the forward reaction. In contact and projection printing of photochromic materials, and in projection for viewing, the heat accentuates the reversal of the image, and the process must resort to cooling.

There is basically the problem of combining in one system a capability for instantaneous darkening and lightening and infinite reversibility.

REFERENCES

1. Kosar, *Light-Sensitive Systems*, Wiley, New York, 1963, p. 370–386.
2. Brown, *Phototropy—A Literature Review*, WADC Technical Report, pp. 59–436 (tabulation of photochromic compounds principally).
3. MacNair, "Photochromism in Triarylmethanes," *Photochem. Photobiol.*, **6:** 779 (1967).
4. Exalby and Grinter, "Phototropy," *Chem. Rev.* **65:** 247 (1964). (General).
5. Dessauer and Paris, "Photochromism," *Advances in Photochemistry*, Interscience, 1963, Vol. 1, p. 275. (General)
6. Cohenand Newman, "Inorganic Photochromism," *J. Photogr. Sci.,* **15:** 290 (1967).
7. Dorian and Weibe, *Photochromism*, Focal, London, 1970.
8. Brown, *Photochromism*, Wiley, New York, 1971.
9. Smith, "Photochromic Silver Halide Glasses," *J. Photogr. Sci.,* **18:** 41 (1970).

PHOTOTHERMOGRAPHIC AND OTHER IMAGING PROCESSES

Photothermographic

These processes image by an imagewise exposure followed by a thermal development step which results in visible image formation. Substances are considered photothermographic if they can be decomposed by heat in areas previously exposed to radiation. (References 1–18)

Sheppard and Vanselow[1] studied the catalytic decomposition of mercuric oxalate which in the presence of excess oxalate results in images of elemental mercury. Paul Gilman at Rutgers followed by Paul Sullivan at Itek further studied these reactions.[10,11] The light produces latent amounts of mercury which catalyse the thermal decomposition of the mercuric oxalate. The excess oxalate increases the sensitivity. Mixtures of silver and mercury oxalate have been investigated.

Brinckman[18] reported that the reaction product of lead (II) oxide and triisopropanolamine when heated to 80–100°C during an imagewise exposure in the presence of a photoconductor, e.g., a small excess of lead oxide, produces black images. A fixing step is not needed. Unfortunately it is very insensitive, requiring 10^7 ergs/cm^2.

The well-known 3M Dual Spectrum process, which is widely used in office copying and production of projection transparencies, is a photothermographic process. It requires two sheets of paper, namely an intermediate and a receptor sheet which bears the final imaged copy. The process involves exposing the intermediate sheet, coated with a photosensitive compound, in reflex position to the graphic original and then contacting the intermediate sheet with the receptor sheet coated with silver salt composition, which when heated is reduced by a volatile photosensitive hydroxy compound to form black images. The intermediate, light sensitive sheet

contains 4-methoxy-1-napthol.[19] When light struck, the material decomposes, rendering it incapable of reducing image former in the receptor sheet. The receptor contains a heat sensitive silver behenate/behenic acid compound which is reducible when heated by undecomposed 4-methoxy-1-naphthol. Also included in the receptor coating are phthalazinone (toning material), zinc oxide (appearance), terpene resin (appearance), and a binder.[20]

Other Processes

References 21–26 describe some other imaging processes of note, such as liquid crystals, zinc oxide nucleation imaging, and the bleach-out process. Others are described in the references contained in Part II of this chapter.

REFERENCES

1. S. E. Sheppard and W. Vanselow, *J. Amer. Chem. Soc.,* **52:** 3468 (1930).
2. A. Benton and G. L. Cunningham, *ibid.,* **57:** 2227 (1935).
3. S. E. Sheppard and W. Vanselow, U.S. Patents 1,976,302 (1934); 2,019,737 (1935); 2,095,839 (1937); and 2,139,242 (1938).
4. B. V. Erofeev, P. I. Bel'keukh, and A. A. Volkova, *Zh. Fiz. Khim.,* **20:** 1103 (1946).
5. F. C. Tompkins, *Trans. Faraday Soc.,* **44:** 206 (1948).
6. L. Suchow and S. L. Hersh, *J. Phys. Chem.,* **57:** 436 (1953).
7. P. A. van der Meulen and R. C. Countryman, *Photogr. Eng.,* **4:** 104 (1953).
8. A. Finch, P. W. M. Jacobs and F. C. Tompkins, *J. Chem. Soc.,* **2053** (1954).
9. P. A. van der Meulen and R. H. Brill, *Photogr. Sci. Eng.,* **2:** 121 (1958).
10. P. B. Gilman, Jr., P. A. Vaughan, and P. A. van der Meulen, *ibid.,* **3:** 215 (1959).
11. P. Sullivan, "Photothermography," Proc. 1964 SPSE Symp. on Unconventional Photographic Systems, pp. 57–59.
12. J. Kosar, *Light-Sensitive Systems*, Wiley, New York, 1965, Chapt. 1.
13. A. G. Leiga, *J. Phys. Chem.,* **70:** 3254, (1966).
14. A. G. Leiga, *ibid.,* **70:** 3260 (1966).
15. M. S. Borodkina, S. A. Neduzhii, V. I. Sheberstov, and O. A. Yatskevich, *Zh. Nauch. Prikl. Fotogr. Kinematogr.,* **12:** 127 (1967).
16. H. E. Spencer, "Some Aspects of the Photothermographic Behavior of Potassium Trisoxalatocobaltate (III) Trihydrate," *Photogr. Sci. Eng.,* **13:** 147 (1969).
17. H. E. Spencer and J. E. Hill, "Photothermographic Studies of Two Inorganic Oxalates," *Photogr. Sci. Eng.,* **16:** 234 (1972).
18. E. Brinckman, "Photothermographic Lead Oxide Material," Proc. 1971 SPSE Symp. on Unconventional Photographic Systems, p. 13.
19. Brit. Patent 1,172,425.
20. U.S. Patents 2,910,377; 3,031,329; 3,080,254; 3,094,417; 3,094,619; 3,218,166.
21. J. D. Margerum, "Organic Based Imaging Systems," Proc. 1971 SPSE Symp. on Unconventional Photographic Systems, pp. 54–63 (90 references).
22. J. Kosar, "Light Sensitive Systems," Wiley, New York, 1965, p. 387–401.
23. P. A. Sullivan, "Applications of Nucleation Imaging Media," presented at SPIE Photo-Optical Display Recording Seminar, Los Angeles, April 26, 1971.
24. P. A. Sullivan, "Electron Beam Image Recorder," *Trans. IEEE, Electron Devices,* **ED-18** (9): 777–785 (Sept 1971).
25. A. F. Kaspaul and E. E. Kaspaul, "All About Atoms and EV's; Image Recording Using Atoms and Electron Beams, "Research Report 445, Hughes Research Laboratories, Oct 1971.
26. U.S. Patents, 3,664,249; 3,671,238; 3,721,496.

Concluding Remarks

In addition to the silver halide and electrophotographic processes, the 15 major imaging processes discussed in this chapter find use in the real world. Thus we have a myriad of imaging processes fulfilling a myriad of imaging needs. Each process has its own set of advantages and disadvantages, and as a result each has found a home. It is unlikely in the near future that the number employed will diminish, since increasing demands for rapid, simple, convenient, and dry imaging processes will occur. For example, one military branch needs a totally dry imaging process that both takes and duplicates, is panchromatic, is capable of $1/2\mu$ resolution, has archival quality, good stability before and after imaging, can be blown up 100–200×, and is silverless. Any takers?

GENERAL ACKNOWLEDGMENTS

This chapter could not have been written without the tutoring of 16 years given the author by his colleague and founder of the Institute for Graphic Communication, Leonard E. Ravich. Much of what has been learned about the technology and applications for image-forming processes is attributable to him. I would like to express my sincere appreciation to him for his continuing help, advice, and guidance. I would also like to thank Dr. Ronald Francis of the Rochester Institute of Technology for many contributions throughout the chapter, particularly many of the references cited herein. Finally, may I express my gratitude to Jan Tillinghast who patiently and painstakingly prepared the entire manuscript for this chapter.

16

THE MEASUREMENT OF COLOR PHOTOGRAPHIC PRODUCTS

William F. Voglesong

There will no be difficulty in seeing how and by what mixtures the colors are made . . . He however who should attempt to verify all this by experiment would forget the difference of the human and the divine nature. For only God has the knowledge and also the power that are able to combine many things into one and again to resolve the one into many. But no man is, or ever will be, able to accomplish either the one or the other operation. The law of proportion, according to which the several colors are formed, even if a man knew, he would be foolish in telling, for he could not give any necessary reason nor, indeed, any tolerable or probable explanation of it. Plato.

The problems encountered in the measurement of color are similar for negative/positive systems, transparency systems, graphic arts and color television. The generalized system includes any process in which three color components of light from an original subject are individually recorded as separation images. These may be processed in various ways to form a final image. The colorants formed in the final image are a function of the wavelength and intensity of the exposing light. Color recording and reproduction may be thought of as two steps, analysis and synthesis, coupled by a black-box process. It is essential to measure and to monitor all stages of this color rendering system.

ANALYSIS AND SYNTHESIS

Analysis provides for the separation of color into three components. The color is recorded as three separation images by the spectral response functions of the photographic receiver. These response functions are commonly called "Spectral Sensitivity." In photographic materials the spectral response is provided by sensitization of the individual layers with the addition of optical sensitizers. The spectral response functions for the film are chosen in accordance with the nature of the record sought. Two classes of sensitization are shown in Figure 16-1.

If the photographic product is intended for the analysis of many spectral variants, such as a camera film recording all the colors found in the real world, the response functions should be broad and overlapping to provide discrimination of small differences. If the photographic product is designed to analyze a fixed family of colorants, such as printing from photographic or photomechanical images, the spectral response functions provide the best discrimination when they approach a narrow spectral band with wavelengths chosen to fall at the peak absorptance of the subject colorants. Camera films for pictorial recording should have overlapping spectral sensitivities with their range limited to the visual region of the spectrum in order to produce color analysis corresponding to human observation. Print materials and some data recording products such as aero reconnaissance films frequently have improved discrimination by being sensitized outside of the visual region of the spectrum.

Synthesis provides a color image from the three data records. In subtractive photography colorants are formed to modulate the red, green, and blue components of the incident light thereby reconstructing

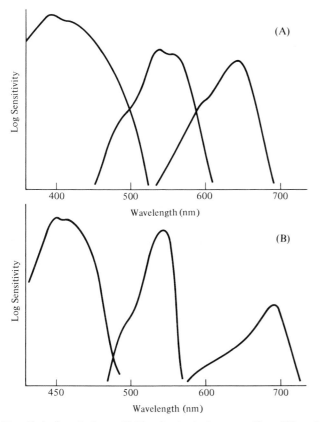

Fig. 16-1. Spectral sensitivities for typical camera films (A) and Spectral Sensitivities for typical print materials (B).

FUNCTIONAL vs. STOICHIOMETRIC MEASUREMENTS

The essential feature of photographic systems is the recording and reproduction of information. The nature of the subject and the intended use of the reproduction determine the design characteristics of the photographic system and the method of evaluation. Where the scene information and the reproduction is pictorial in nature, evaluation is based on an aesthetic appraisal. Recordings of discrete data are frequently evaluated using the techniques of character recognition. If the record is analog, where the quantity of matter in the image is a function of the exposing energy, the evaluation is an analytical measurement.

Functional measurements provide data that imply the appearance of overall effect of the photographic image. These measurements predict answers to the questions: "How does it look to an observer? How will it print on another photographic material? How will it transmit on telecine equipment? How will it reproduce by graphic arts processes?" Where the photographic system is used to record and reproduce the world of reality it is functional in nature. These photographic systems should be evaluated in terms of the effects that the image produces.

Stoichiometric measurements provide data separating components in terms of their chemical or spectral properties. These measurements are essential to describe the chemical or physical changes in the color process during its various stages from input to output. A photographic process may be thought of as a stoichiometric recording medium when there is a single valued relationship between information recorded from the real world and the molecular record in the photographic system. The output of such a photographic recording is evaluated in terms of the material changed in the recording process, not in terms of its overall effect.

Both measuring techniques and the limitations of the photographic product frequently make the functional and the stoichiometric frames of reference incompatible. For instance, the complete specification of an image from single layer components will not provide all information concerning the appearance of the superposed image when interlayer processing effects are present.[3] The interpretation of individual layer data in terms of the integrated visual response is usually accomplished only by experience. Some general rules are formulated by looking at many photographs and their corresponding sensitometric curves. This oversimplification makes color sensitometry more of an art than a measurement science.

Sensitometric tests should be designed with care in order to choose all parameters featuring either the functional or the stoichiometric nature of the recording. Stoichiometric measurements are derived from physical data. They indicate the composition of a substance in proportion to its molecular ratios. These measurements may be normalized to compare information on a more meaningful basis. Such information is not directly and easily related to effect. While functional measure-

the colored image. Subtractive photographic systems have colorants complementary to the spectral analysis functions, and the exact specification of the color reproduction may be computed by various optimization processes using the CIE color matching functions. Yule[1] and Marriage[2] were some of the first to develop these techniques. These optimization processes essentially treat the three records as independent information channels; i.e., the red light record is assumed to control only red light in the reconstruction, etc.

Classical color sensitometry also treats the three records independently, and accepts any departure from independence as an anomoly or deficiency. In practice one finds not independence but considerable spectral crosstalk in modern color photographic materials. The existence of spectral crosstalk causes information recorded in one spectral band to affect the output of another. This crosstalk will affect saturation, color reproduction, and color discrimination. It may introduce good as well as bad effects. One thing is certain, it is not only necessary to accept and define the spectral crosstalk, it is essential to provide measurement techniques that permit the separation and quantization of the three records. The complication of data analysis in the presence of crosstalk makes color sensitometry more complicated than black and white sensitometry replicated three times then plotted on the same sheet of paper.

ments are also derived from physical data, they produce values indicating the effect the sample will produce. Functional measurements are verified only by another experiment, such as printing, psychophysical testing, etc. Their acceptance depends upon the confidence established in previous evaluations, and upon the continued agreement with presently observed effects.

CROSSTALK

A conventional sensitometric description of three color photographic systems treats the layers of a tripak photographic product as three independent communication channels. The input to each channel is described in terms of the intensity and exposure time in the spectral band associated with that channel. The output from a channel is described by a density measurement made in the corresponding spectral passband. This is shown schematically in Fig. 16-2. Since the system records signal differences, the three independent channels may be described by the set of equations:

$$\Delta O_r = K_r \Delta I_r + 0 \Delta I_g + 0 \Delta I_b \quad \text{etc., or}$$

$$\begin{bmatrix} \Delta O_r \\ \Delta O_g \\ \Delta O_b \end{bmatrix} = \begin{bmatrix} K_r & 0 & 0 \\ 0 & K_g & 0 \\ 0 & 0 & K_b \end{bmatrix} \begin{bmatrix} \Delta I_r \\ \Delta I_g \\ \Delta I_b \end{bmatrix} \quad (1)$$

Where the ΔO's represent the output from each channel, and the ΔI's represent the inputs. The ΔK's represent the transfer functions for each channel.

All color photographic products show some degree of crosstalk. That is the output of each channel is dependent upon the signal present in another channel. For example, the blue absorption of the magenta dye introduces crosstalk because it produces modulation to the blue channel image based on information recorded in the green channel. This may be diagramed as interconnected output as shown in Fig. 16-3. This crosstalk also introduces non zero off diagonal terms in the transfer matrix as shown in Eq. (2)

$$\Delta O_r = K_r \Delta I_r + 0 \Delta I_g + 0 \Delta I_b$$

$$\Delta O_g = 0 \Delta I_r + K_g \Delta I_g + 0 \Delta I_b$$

$$\Delta O_b = 0 \Delta I_r + \alpha K_g \Delta I_g + K_b \Delta I_b$$

Fig. 16-2. The tripak as three independent information channels.

Fig. 16-3. The tripak showing crosstalk introduced by the unwanted absorption of magenta dye for blue light.

or

$$\begin{bmatrix} \Delta O_r \\ \Delta O_g \\ \Delta O_b \end{bmatrix} = \begin{bmatrix} K_r & 0 & 0 \\ 0 & K_g & 0 \\ 0 & \alpha K_g & K_b \end{bmatrix} \begin{bmatrix} \Delta I_r \\ \Delta I_g \\ \Delta I_b \end{bmatrix} \quad (2)$$

Crosstalk is noted whenever the transfer functions defining the color system are not orthogonal. The process dyes introduce crosstalk by their minor absorption since the dye formed to modulate one spectral region will control a fraction of the light outside of the major absorption band. Processing effects that make adjacent layers dependent upon each other also produce crosstalk. Interlayer interimage effects such as the classical cyan undercut[4] produce light modulation as a function of the image recorded in the adjacent layer. Oxidation products from the development of a dense image in one layer may diffuse to an adjacent layer and produce an image of the wrong colorant. This is also crosstalk. Masks are used in some color processes as intentional or controlled crosstalk designed to cancel the effects of the unwanted crosstalk. Overlapping spectral sensitivity functions are considered crosstalk when they record information not intended for the channel of major sensitization. The total crosstalk is represented by the minor coefficients in the transfer equation.

$$\begin{bmatrix} \Delta O_r \\ \Delta O_g \\ \Delta O_b \end{bmatrix} = \begin{bmatrix} K_r & \alpha & \alpha \\ \alpha & K_g & \alpha \\ \alpha & \alpha & K_b \end{bmatrix} \begin{bmatrix} \Delta I_r \\ \Delta I_g \\ \Delta I_b \end{bmatrix} \quad (3)$$

Crosstalk complicates the simple linear modeling of a photographic system, but may be a real aid to the pictorial aspect of photographic quality. In order to have control of product and process design, the photographic scientist must be able to identify, localize, and quantize the crosstalk. This separation of variables and assessment of functional effects is the full role of sensitometry as a tool for description, design, and control in color photography.

EXPOSING THE TEST

The purpose of sensitometric evaluation is to provide a photographic record that may be physically measured. These measurements serve as a data base to describe the photographic material and process. The test targets and the exposure conditions may also be classified as being either functional or stoichiometric.

Functional tests should provide exposures that closely approximate practical product use. Since many photographic products have pronounced edge or adjacency effects, the prediction of appearance may depend upon the image size.[5] Thus, the area of test measurement should be reasonably near that expected in practice. For functional evaluation the spectral quality, intensity, and time for the exposure should match that for which the product was designed. Common exposing sources are Xenon flash and modified Black Body radiation. Xenon flash is used in a sensitometer for best functional simulation of flash exposing conditions. Black body radiation from either conventional or Tungsten-Halogen lamps is used to simulate printer exposure. Filters[6] may be used to modify this light to approximate average daylight. ANSI Daylight[7] is one such lamp-filter combination. The time of exposure should be as close as possible to the time found in the camera or printer. Mechanical shutters have increasing precision at longer exposure times, 1/100 sec being a practical lower limit. Flash exposures lose precision at longer times because of the relatively slow decay of the flash, 1/1000 sec being a practical upper limit.

Stoichiometric exposures often provide the ability to separate variables not easily measured after normal exposure and process. Where some aspect of the photographic material or process is to be studied without regard to how it would be formed in practice, a stoichiometric exposure is very useful. Stoichiometric exposure may be illustrated by considering single-layer exposure providing an isolated image for the measurement of dye fading. The important variable for this test is the change in the concentration of the dye, rather than how it was formed. X-rays may be used to produce a non-scattering exposure so that the image spread introduced by the processing chemicals may be studied without regard to the light-scattering properties of the emulsion.[8]

The design of the experiment begins the sensitometric test program. Proper design and optimum specification of test target and exposure provide the conditions that will improve the resolution of data. Inadequate consideration of these elements may confound the variables.

MEASUREMENT-GEOMETRY

Optical geometry is a major specification of the measurement system. A photographic image modulates light by scattering and absorption. Since a densitometer measures the attenuation of light by both means, the choice of measurement geometry logically precedes the choice of spectral response. The selection of geometry depends upon whether the test is stoichiometric or functional in nature.

Stoichiometric measurements made with the densitometer depend upon the optical absorption being related to the chemical concentration. Densitometers cannot be used for stoichiometric measurement of some materials. Vesicular photographic products and phase holograms are two special examples of images made without absorption, and thus insensitive to absorption measurement. Because stoichiometry is based on the Beer-Lambert law it is essential either to select a collection geometry insensitive to scattering, or to introduce assumptions about the nature of the scattering.

For stoichiometric measurement of transmission samples the optical geometry known as ANSI Diffuse-Integrating sphere[9] is insensitive to light scattering since the complete collection of the transmitted flux assures measurement of attentuation caused by absorption alone. Typical sphere collection is shown in Fig. 16-4.

The sphere geometry is preferred to opal glass collection because no interaction is caused by multiple reflections between the sample and the collector. Where the restrictions of available instrumentation or the requirements of size and light level make the use of opal glass collection necessary, the compromises in measurement of absorption should be understood.

A densitometer cannot be used for direct stoichiometric measurement of reflection samples because of the failure of the Beer-Lambert law caused by multiple internal reflections in the gelatin coating and by the first surface reflection at the air-gelatin interface. Williams and Clapper[10] produced a mathematical model accounting for multiple reflections and absorption. This model assumes optical homogeneity and isotropism. When there is evidence of scattering or anisotropism, the direct application of the model must be validated by experiment. Schemes to make analytical measurement from density data obtained in the reflection mode all require some assumptions about the relationship between the light absorbed in the emulsion and the light reflected. An indirect approach was devised by Pinney and Voglesong[11] to offset the nonlinear effects introduced by both the first surface reflection and multiple internal reflections. Ohta[12] has applied this empirical transfer function approach to mathematical modeling for color reproduction of reflection print materials. All of these empirical corrections require the assumption of isotropism and are more precise in correcting for the internal reflections

Fig. 16-4. Diffuse density—integrating sphere collection geometry.

than for correcting the errors introduced at the air-gelatin interface. Correction schemes based on assumptions must be used with caution and the validity of the assumption reestablished with each change in structure. The only valid geometry for direct stoichiometric measurements is Specular Transmission Density.[13] Illumination should be made through the base of the sample, where the subbing layer or Baryta serves as the diffuser. Diffuse collection at the densitometer would provide for a doubly diffuse measurement. Note that multiple reflections caused by the gelatin-air interface still produce an error at low densities analogous to that observed with the ANSI Diffuse Density-Opal Glass collection.

Functional measurements are best obtained by a geometry made virtually identical to the system to be described or modeled. Since this would give rise to an almost infinite number of different instruments, several standards have been devised, and the practical approach is to choose an accepted standard which is a reasonable approximation of the system to be functionally simulated.

1. ANSI Diffuse Density—Opal Glass[14] simulates both the contact printing of photographic materials and the viewing of large transparencies on an illuminated surface. Printers for photofinishing and professional use frequently use a diffuser near the negative for defect and dirt elimination. Such printers collect the light transmitted by the negtive with a lens having an aperture of approximately $f/4.5$ to $f/8$. These systems are nearly diffuse in their specification. When no reflection occurs between the diffuser and the photographic material being printed, as in some enlargers, sphere geometry may be a better simulation.

2. ANSI Projection Density[15] defines the geometry for measurement of a sample with an $f/4.5$ influx and $f/4.5$ efflux beam. This collection geometry provides an average simulation of motion picture and still slide

Fig. 16-6. Collection geometry for ANSI diffuse reflection density.

projectors, as well as microfiche readers. While this geometry is also used in the sensitometry of certain vesicular materials, it should not be considered a means of obtaining stoichiometric measurement.

3. Specular Density provides a reasonable simulation of optical motion picture printers. Some condenser enlargers used in both professional and graphic arts printing are also simulated by this geometry.

4. Average Room Viewing geometry was suggested by Carnahan[16] to provide measurements in better agreement with observation. This collection geometry simulates the viewing of reflection photographic print materials in a room having average wall reflectance and having the major source of illumination positioned so that no specular highlight is seen on the print surface. A typical "room viewing" sphere is shown in Fig. 16-5.

5. ANSI Diffuse Reflection Density[17] simulates the viewing of reflection prints when illuminated at 45° to the normal. This simulates gallery illumination. The multiazimuth collection is used to remove some surface graininess or structure defects from the measurements and is shown in Fig. 16-6.

A working understanding of the assumptions and restrictions introduced by scattering, reflection and absorption will aid in establishing a simulation which is more likely to provide an acceptable functional measurement. The knowledge of geometric optics will aid in the analysis of the system being simulated as well as in designing the simulation.

Fig. 16-5. Collection geometry for "room viewing" integrating sphere.

MEASUREMENT—SPECTRAL RESPONSE

The energy absorbed by the photographic emulsion must be evaluated with some spectral weighting. It is

naive to assume that the red, green and blue density measurements adequately represent the amount of colorant in a layer. Arbitrary spectral weightings will not indicate how colorants modulate light as sensed by the next receiver in the system. The colorants of typical photographic systems have spectral characteristics as shown in Fig. 16-7. The absorption of these colorants outside of the principle spectral region makes the spectral response of the desitometer an important variable in the evaluation of the image. The choice of spectral response depends upon the nature of the test—whether it is stoichiometric or functional. While modern computation methods make the conversion of measurements from one response to another easy to accomplish, it must be remembered that the calculation transforms but does not improve the data. All such transformations require knowledge of the spectral properties of the colorants measured.

Stoichiometric measurements should be made by acquiring data having the greatest independence of variables. Where the spectral nature of the dyes is known, the best stoichiometry is made with narrow band measurements at wavelengths providing the most separation between the component to be measured and the remainder of colorants. In practice it is possible to select any wavelength using a spectrophotometer. Because densitometers are abridged spectrophotometers,

their response should be chosen to provide good separation of the spectral variables and to have high rejection outside of the major passband. As a general rule narrower passbands and the higher rejections produce data that best conform to the Beer-Lambert law and thus are most suited for computation of stoichiometry.

Functional measurements demand the densitometer to have the same spectral response as the intended receiver to meet the requirements of a good simulation. For example, the visual or luminous density measurements are valid if, and only if, the total response of the densitometer matches the CIE luminosity function weighted by the intended viewing illuminant.

$$D_v = \mathrm{Log}_{10} \frac{\int Q_\lambda\, e_\lambda\, \bar{y}_\lambda\, d\lambda}{\int Q_\lambda\, e_\lambda\, t_\lambda\, \bar{y}_\lambda}\, d\lambda \qquad (4)$$

where D_v is luminous density, Q_λ is the spectral radiant energy distribution for the densitometer lamp, e_λ is the spectral efficiency of the optical system, t_λ is the transmittance or reflectance of the sample, and \bar{y}_λ is the luminosity function as described by CIE colorimetry standards.

A densitometer may be defined in terms of functional elements, as shown in Fig. 16-8. The densitometer may be considered as: a light source having spectral radiant energy distribution (Q_λ); an optical system with spectral efficiency (e_λ); a set of filters with spectral transmittance (f_λ); a photoreceiver having both spectral response (S_λ) and radiometric response [$g(1)$]; signal processing that inverts the transmittance signal [$g(2)$]; a logging conversion [$g(3)$]; and finally a meter for readout.

Each of these elements of the densitometer may be described in terms of electrical transfer and spectral response functions. The overall densitometer is described as composite transfer and response functions. The spectral response for the color densitometer has been documented in detail by Dawson and Voglesong[18] and may be written as:

$$\phi = \int Q_\lambda\, e_\lambda\, f_\lambda\, s_\lambda\, d\lambda \qquad \text{Spectral Response}$$

$$G = g(1)\, g(2)\, g(3). \qquad \text{Electronic Signal Processing}$$

$$(5)$$

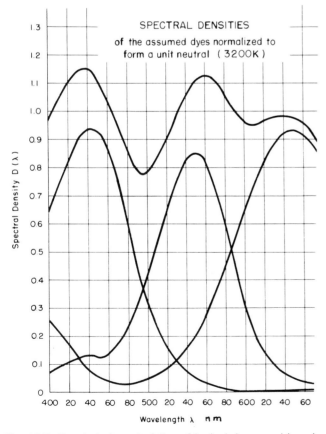

Fig. 16-7. Spectral characteristics of typical dyes used in subtractive color photography.

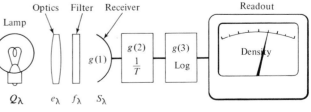

Fig. 16-8. The Schematic Densitometer.

TABLE 16-1. INTEGRAL DENSITIES OF NEUTRAL APPEARING DYE AREAS ON SEVERAL COLOR FILMS.

Densitometer response		KODAK® Ektachrome®-X (5027)	GEVACHROME® Film (Type 6.00)	EASTMAN® Color Print Film (5381)	GEVACOLOR® Print Film (Type 9.85)
	R	0.99	0.89	1.07	1.28
A	G	1.02	0.98	1.07	1.08
	B	1.10	1.02	1.06	1.01
	R	1.06	0.90	1.12	1.74
M	G	1.04	1.00	1.05	1.04
	B	1.06	1.04	1.18	0.99
W92	R	1.05	0.93	1.11	1.59
W93	G	1.06	1.00	1.07	1.07
W94	B	1.06	1.07	1.12	0.98

Note that the transfer functions for the electronic signal processing are not spectrally dependent.

By chosing filter and phototube combinations it should be possible to adjust the densitometer response to meet any functional condition such as printing density, visual density, exposure density, colorimetric, etc.

Limitations of the light source, filters and phototubes make an infinite variety of functional responses impossible to obtain in the design of practical and workable instruments. The tradeoff made necessary in hardware design has resulted in several filter-phototube combinations being accepted as standard.

A common misconception is that equal red, green, and blue densities will result from the measurement of a neutral photographic image. Color density is determined by the spectral product of the transmittance of the photographic image and the densitometer's response. Density measurements of dye images are highly dependent upon the densitometer spectral response. The integral densities of several color films all having a visual density of 1.00 and all appearing neutral to their intended illuminant are shown in Table 16-1. It is evident from these data that neutral samples seldom have equal red, green, and blue densities.

Filter Design Criteria

Densitometer filters are designed to meet the following requirements:

1. Spectral Zones are chosen so that the peak transmittance of the filter is located near the peak absorptance of the photographic image. The choice affects the sensitivity of dye measurements.

2. The passband should be either sufficiently narrow to isolate the response of the major dye being evaluated or wide enough to include overlapping functions, as does the spectral sensitivity of print materials. The passband depends upon whether the density analysis is primarily stoichiometric or functional. Stoichiometric measurements are intended to determine the amount of a compound in the image, either as a dye concentra-

tion or as a mass of silver per unit volume of emulsion. Functional measurements are intended to indicate how the image will appear to a human observer or how it will print in a later stage of the photographic system.

3. Rejection must be high outside the intended passband. Since the densitometer response is the integrated energy at the receiver, a small amount of unwanted signal at many wavelengths is significant. Photographic dyes transmit or reflect much of the near infrared energy. Because there is frequently a window in the green and blue filters, it is essential that the energy outside of the passband be well blocked. As a rule of thumb, the rejection must be two density units above the maximum sample density. Conversely, density measurements within two units of the filter rejection become nonlinear.

4. Repeatability in filter fabrication is a concern when manufacturing more than one densitometer. Absorption filters in glass or gelatin currently show a lower manufacturing variability than do thin film coated filters. Perhaps improved technology of coating will change this generalization.

5. Stability is important if the densitometer response must be constant from day to day. Absorption filters made with some organic dyes tend to be unstable and are affected by heat, light, moisture and oxygen. Cementing filters in glass provides a heat sink and reduces the exposure to both moisture and oxygen. A densitometer designed with the filters in a dark location increases filter life.

DATA REDUCTION—STOICHIOMETRIC

Stoichiometric measurements are needed to isolate mechanisms of the photographic process to one layer or colorant. Such measurements may be derived from integral density readings which serve as abridged spectrophotometry. When the complete spectral specification of the dyes is known, a computational procedure may be used to determine the dye concentration in various mixtures given the integral density values.[19] This

mathematical separation of the dyes provides a stoichiometric measurement for the cyan, magenta and yellow components of the image. A complete spectral specification of the dye image may be obtained by adding the spectral densities of the three component dyes at each wavelength. This synthesized spectrophotometry is frequently a very valuable data set for computation of derived measurements and more comprehensive analytical systems. Special definition of dye concentration may permit some visual significance to be inferred with limited restrictions.

The linear combination of the dyes whose unit amounts are defined to sum to a visual neutral of density 1.0 has been described by Sant[20] and is referred to by the acronym UNNAD. The mathematical process for determination of this metric assumes conformance to the Beer-Lambert law. This assumption may be tested by spectrophotometry or filter densitometry of single dye samples at major and minor absorption wavelengths. If the ratio of densities for major to minor absorption remains independent of concentration over the range of linear response, the assumption is justified. This condition is also referred to as Log D law conformity. It is essential that the UNNAD's be limited to the density domain of Log D law conformity in order to retain the stoichiometric properties of the calculation. In this domain the UNNAD's for any test target may be used as coefficients in normalizing the dyes standardized by the unit neutral definition. The sum of these normalized dyes at each wavelength provides the complete spectral description of the test target. The UNNAD's have the property of having equal cyan, magenta and yellow coefficients for neutral targets and match the visual contrast criterion. UNNAD's are stoichiometric (in contrast to END's) but are limited to the range of densities defined by Log D law conformity.

When the spectral characteristics of the dyes are known, either by measurement of physical samples or by a statistical process applied to a color gamut, an objective set of measurements may be used to describe various mixtures of the dyes in terms of their Equivalent Neutral Densities. It should be noted that procedures such as these do not provide stoichiometric measurements since the modeled spectrophotometry of each test target is adjusted to meet Evans[21] operational definition of Equivalent Neutral Density which states: "The equivalent Neutral Density of a dye in a dye set is numerically equal to the visual density of the neutral that will result when the remaining dyes are adjusted in just required amounts to produce a neutral." Since the END definition requires the adjustment of the remaining dyes rather than the synthesis of the three, these measurements may be applied over an extended density range. The values of the END and the dye concentrations that they represent are dependent upon the color character of the viewing illuminant. This definition is a powerful tool to define neutrals and visual contrast but is not capable of predicting the appearance of a non-neutral sample or of providing a truly stoichiometric measurement.

DATA REDUCTION—FUNCTIONAL

Functional measurements are needed to predict the manner in which some part of a photographic system will affect another stage, or how it will be recorded by some photoreceiver external to the system. A necessary but not sufficient condition for validating functional measurements is the specification of geometry and spectral response. Having obtained measurements intended for functional evaluation, it is essential to calibrate or standardize them by further experimentation.

Colorimetry and photometry are two measurement sciences in which the accepted values are defined in terms of human visual equivalence. Because color matches and intensity matches are based on experiments or standards in which two beams are compared using a split field or photometric cube, the standards traceable to these experiments are essentially visually based. A colorimeter is shown schematically in Figure 16-9. These measurements provide numbers that specify a condition in which the sample C is visually matched by the amounts a_1, a_2, a_3 of the primaries P_1, P_2, and P_3 respectively. It must be noted that this match was derived by mixing light and comparing uniform fields of the stimulus in the aperture of an optical instrument. These matches do not necessarily predict the appearance of colors of real objects as viewed under a recognizable source. Evans[22] has described the role of texture and illuminant recognition as a major factor in determining the appearance of a color. There is more information processed by the eye and brain than is contained in three coefficients which describe the condition of a color match.

A densitometer intended for functional measurements to predict colorimetry and photometry should have geometry and spectral response approximating the colorimetric and photometric standards. Since there are always compromises in the design of instruments, the densitometer is finally calibrated by experiment. A series of samples is selected spanning the color gamut to be measured. These samples should have surface, support and colorant characteristics virtually identical to the material to be evaluated in routine test. The calibrating samples are then read both on a standard colorimeter or visual photometer and on the routine test instrument.

A correlation derived using either simple linear[23] or multiple regression[24] techniques is an accepted calibra-

Fig. 16-9. Mixing of primary colors to form a Color Match.

tion procedure. When there are no cross terms, a plot of test instrument readings as a function of standard instrument or calibrated values will show little deviation from a calibrating equation of the form:

$$S_i = mT_i + b \qquad (6)$$

where S_i is the calibrated standard value and T_i is the test instrument reading for the corresponding or ith patch. If a simple regression of the tabulated data does not produce a good fit to the linear relationship between S_i and T_i for each set of corresponding color responses, as indicated by a small standard deviaton σ, multiple regression techniques may be required. For this process T_1, T_2, and T_3 are multiply regressed with their corresponding standard values S_1, S_2, and S_3. The cross-talk terms are now compensated by the simple matrix transformation:

$$\begin{bmatrix} S_1 \\ S_2 \\ S_3 \end{bmatrix} = [a_{ij}]_{3 \times 4} \begin{bmatrix} T_1 \\ T_2 \\ T_3 \\ 1 \end{bmatrix} \qquad (7)$$

This calibration technique empirically compensates for compromises introduced in instrument design. It is essential that the calibrating samples be close to the material to be tested in every aspect lest the compensation be exaggerated by the multiple regression technique. Multiple regression equations are valid only over the range of the calibrating samples.

When it is desirable for the measurement to functionally simulate an attribute of the system that is not objectively measurable, a subjective ranking experiment[25] is required. As an example the average room viewing densitometry was defined by Carnahan as a system providing a numerical value capable of ranking print contrast in the same order as human observers. Another example is monitoring density response used for preprint evaluation of negatives. This may be considered to be a subjective rather than a physical measurement in order to provide the greatest yield of acceptable prints. Printing density may predict the printing of test patches and still not be the optimum metric for predicting the exposure leading to the best yield of acceptable prints. For subjective evaluation a sample gamut is prepared and ranked by observation. The numerical ranking serves as the standardizing value set S in Eq. (7).

Printing Density measurements are functional, and thus must be made with a collection geometry chosen to simulate the particular photographic system being simulated. The spectral response of the instrument should approximate the spectral sensitivity of the print material. The calibration of the densitometer is effected by the use of calibrated samples spanning the color gamut and made from the intended preprint material. These calibrating samples are prepared by printing the gamut samples along with a nonselective calibrating

scale. Printing density for the sample is defined as being the numerical value of the visual density of the nonselective patch that prints equivalent to the gamut sample being calibrated. For color materials, in general, there will be three conditions of equivalence—thus three printing densities for each patch being calibrated. The conditions for equivalence are not unique since they are, at least to the second order, dependent upon the definition of the densitometry used on the print material. This equivalence will be slightly different when the definition is based on integral densitometry than when it is based on stoichiometry. This calibration process is called "Photographic Photometry" and is defined in the ANSI Standards as the "Carbon Step Tablet Method[26] for determining printing density. Having calibrated the samples of the color gamut, regression techniques are used to establish the calibrating equations for functional densitometry.

A degree of caution must be exercised with all functional densitometry based on empirical relationships and subjective ranking. Variables in the system not readily apparent at the measurement stage may destroy the fragile basis of the subjective ranking and thus reduce the meaningfulness of the final measurement.

OTHER MEASUREMENTS

Spectral sensitivities are defined for color products in terms of the reciprocal energy required to produce a specified output in each layer. They are thus defined by stoichiometry from a definition which assumes Van Kreveld's law and constant processing or at least constant process interaction. Process interlayer interactions and spectral sensitivity cannot be separated by stoichiometry.

Image structure analysis makes use of test targets and microdensitometry methods like those used for black-and-white photographic metrology. The common assumption that visual densitometer response is a proper definition because the three colorants will be weighted as they are by observation seems logical, but is untested. Three color microdensitometry is used for some analysis, but is not founded in psychophysical experiment, and thus lacks the proper calibration.

REFERENCES

1. J. A. C. Yule, "The Theory of Subtractive Color Photography. I. The Conditions for Perfect Color Rendering," *J. Opt. Soc. Amer.*, **28**(1): 419–430 (1938).
2. A. Marriage, "Subtractive Colour Reproduction," *Photogr. J.*, **88B**: 75–78 (1948).
3. H. D. Meissner, "On the Mechanism of Interimage Effects." *Photogr. Sci. Eng.* **13** (3): 141–143 (May-June 1969).
4. W. L. Brewer, R. M. Evans and W. T. Hanson, *Principles of Color Photography*. J. Wiley, New York, 1953.
5. C. N. Nelson, "Prediction of Densities in Fine Detail in Photographic Images," *Photogr. Sci. Eng.*, **15**(1) 82–97 (Jan-Feb 1971).
6. D. Hoeschen and G. Vieth, "Calculation and Preparation of a

Glass Filter for Photographic Sensitometry," *Optik*, **31**: 449–456 (1970).

7. ANSI Standard PH2.29-1967 "Simulated Daylight Source for Photographic Sensitometry," American National Standards Institute, New York.

8. H. F. Sherwood, "Apparatus for Making Sharp Photographic Images with X-Rays," *Rev. Sci. Instrum.*, **38**(11): 1619–1621 (Nov 1967).

9. ANSI Standard PH2.19-1976 "Diffuse Transmission Density," American National Standards Institute, New York.

10. F. R. Clapper and F. C. Williams, "Multiple Internal Reflections in Photographic Color Prints," *J. Opt. Soc. Amer.*, **43**(7): 595–599 (1953).

11. J. E. Pinney and W. F. Voglesong, "Analytical Densitometry of Reflection Color Print Materials," *Photogr. Sci. Eng.* **6**(6): 367–370 (Nov-Dec, 1962).

12. N. Ohta, "Reflection Density of Multilayer Color Prints," *J. Opt. Soc. Amer.*, **62**(2): 185–191 (Feb 1972).

13. A working definition of specular density is stated in the international standard document ISO/R5 "Diffuse Transmission Density," (photography) 1954, and in the publication by C. S. McCamy "Concepts, Terminology and Notation for Optical Modulation," *Photogr. Sci. Eng.*, **10**: 314 (1966).

14. ANSI Standard PH2.19-1976 "Optical Transmission Density— Opal Glass," American National Standards Institute, New York.

15. ANSI Standard PH2.37 (1975 proposal) "Optical Projection Transmission Measurement—Projection Density," American National Standards Institute, New York.

16. W. H. Carnahan, "A Curve Tracing Densitometer for Average Room Viewing Densities of Photographic Prints," *Photogr. Eng.*, **6**(4): 237–243 (1955).

17. ANSI Standard PH2.17-1976 "Diffuse Reflection Density" American National Standards Institute, New York.

18. G. H. Dawson and W. F. Voglesong, "Response Functions for Color Densitometry," *Photogr. Sci. Eng.* **17**(5): 461–468 (Sept-Oct 1973).

19. "An Objective Method for Determination of Equivalent Neutral Densities of Color Film Images," *J. Opt. Soc. Amer.*, I: W. L. Brewer and F. C. Williams, **44**: 460 (June 1954): II: R. H. Morris and J. H. Morrisey, **44**: 530 (July 1954); III: F. H. Holland, R. A. Mickelson and S. A. Powers, **44**: 534 (July 1954).

20. A. J. Sant, "Procedures for Equivalant Neutral Density Calibration of Color Densitometers," *Photogr. Sci. Eng.*, **14**(5): 356–362 (Sept-Oct 1970).

21. R. M. Evans, "A Color Densitometer for Subtractive Processes," *JSMPE* **31**: 194–201, 1938.

22. R. M. Evans, "Perception of Color," Wiley, New York; 1974, pp. 191–200.

23. N. R. Draper and H. Smith, "Applied Regression Analysis," Wiley, New York, 1966, Chapt. 1.

24. N. R. Draper and H. Smith, "Applied Regression Analysis," Wiley, New York, 1966, Chapt. 2.

25. S. Segal, "Ranking Subjective Responses & Parametric Statistics for the Behavorial Sciences," McGraw-Hill, New York, 1956, Chapt. 3.

26. ANSI Standard PH2.25-1965 "Photographic Printing Density-(Carbon Step Tablet Method)," American National Standards Institute, New York.

17

COLOR REPRODUCTION IN THE GRAPHIC ARTS

J. A. C. Yule

Photomechanical color printing consists of transferring colored ink from a printing plate to a receiving surface which is usually white paper. The reason for using these processes is that, although it would cost hundreds of dollars to produce a single print, many copies can be produced at a low cost per copy. Color printing, therefore, is used to make many reproductions of an existing picture, and, unlike color photography, is rarely used to reproduce a live scene directly.

Original pictures for reproduction may be either artwork or color photographs. Most of these color photographs are transparencies, and in recent years there has been a trend towards the use of small transparencies—often 35 mm. Artwork and color prints are known as reflection copy, since in the printing industry the word "copy" means that which is to be copied.

All three of the major printing processes (relief printing, planography, and intaglio printing) by which ink is transferred to paper are widely used for color reproduction.

The steps involved in making a color reproduction vary according to the printing process, but the major steps are often as follows for a lithographic reproduction of a color transparency:

1. Make a color-correcting mask and combine it with the original transparency.
2. Make four continuous-tone color separation negatives, by contact printing or in a process camera or enlarger, and perhaps also an "undercolor removal" mask.
3. Make halftone positives from the negatives using a contact halftone screen.
4. Make a color proof and evaluate it.
5. Adjust the halftone positives by dot etching until an acceptable proof is obtained.
6. Make negatives and arrange them in the desired layout, with negatives of the type matter.
7. Make contact positives from the negatives.
8. Make printing plates from the positives.
9. Print the desired number of copies.

This typical example will be described later in greater detail. Before this is done, some of the basic principles of color separation, masking, screening, etc., will be discussed.

COLOR SEPARATION METHODS

In color photography, emphasis has been placed on obtaining a good result with the minimum expenditure of time and effort, since usually only a single copy of each picture is required. The object of printing processes is to make many copies—sometimes millions of copies—so that the cost of the preparatory work is only a small proportion of the total cost, even if it involves many steps. Consequently, it pays to spend more time and effort on these preparatory steps for the sake of improving the result, especially as the best possible printed result is none too good. Printing processes, which depend on the mechanical transfer of ink and usually contain a halftone pattern, never have the smoothness of tone which is seen in color photographs.

For example, photographic masks (or their equivalent in electronic color separation by scanners) are always

used in color separation for printing. As many as eight masks or even more may be used. Also, a black image is used in addition to cyan, magenta, and yellow, to provide higher maximum density, better shadow detail, and better color balance in the shadows.

MASKING METHODS

A printed color reproduction made by a simple process in which the printing plates are made from color separation negatives, without any local adjustment of the tones in the negatives or plates to ensure more accurate reproduction, is unsatisfactory chiefly because of the overlapping spectral absorption bands of the inks. This color correction was originally achieved by locally etching the printing plates or the halftone positives so as to change the dot size. Many hours of laborious handwork were needed for each picture. Dot etching is still used to make final adjustments, but the major part of the color correction is now done by masking or by a color scanner. Although the use of masks for color correction was invented before the turn of the century, they were not widely used until the 1940s. At first, a positive mask with a gamma of about 0.4, made from one of the color separation negatives, was combined with another negative. This was called *positive masking.* Another more complex method, known as *two-stage masking,* involved making a positive from one of the negatives, combining it with a second negative, and making a color-correcting mask from this combination. The mask was then combined with the first negative. This method has several advantages, but it is no longer widely used because it involves an additional step.

Nowadays, *negative masking* is mostly used, both for transparencies and reflection copy. Two or three negative masks with a gamma of about 0.4 are made from the original through color filters, and the appropriate one is registered with the original when each of the color separation negatives is made. With transparencies, the masks are made by contact printing; but if the original consists of reflection copy, the masks are made in the process camera, and after processing they are replaced in the camera back in their original position, so that the light from the original passes through the mask before reaching the color separation film. This is called *camera-back masking.* The original camera-back method (now obsolete), called *magenta masking,* used glass plates developed to a magenta dye image.

To avoid making and registering several masks for each subject, *colored masks* were designed (Yule, 1940).[1] If each of the masks is developed to a dye image which only absorbs light corresponding to one of the color-separation filters, they can all remain in place when all the color-separation negatives are made, since each one will only affect one of the color separation negatives. A single film with three or more emulsion layers can be used, such as Gevaert Multi-Mask® (Gevaert Photo-Producten N.V., 1959)[2] or Kodak Tri-Mask® film (Eastman Kodak Co., 1962).[3]

Multimask and Tri-Mask film are similar in structure except that two of the Multimask layers are sensitive to more than one region of the spectrum as shown at the bottom of Table 17-1, while the corresponding emulsions of Tri-Mask film have been separated into two layers, each sensitive to a single spectral region. Thus, the Tri-Mask film contains the equivalent of five separate masks, as shown at the top of Table 17-1.

A mask (for example, a negative mask combined with a positive image) reduces the contrast of the image with which it is combined, except in the case of a two-stage mask. This lowering of contrast must be compensated for at some stage of the reproduction process—usually by increasing the development of the separation negative. This contrast adjustment is usually done in such a way that the contrast and color balance of the reproduction of a gray scale is unaffected by the mask (although there may be some change in the shape of the tone reproduction curve if the mask image has a toe or shoulder).

In fixed-contrast reproduction processes, such as conventional color films, this contrast adjustment is not available. In this case, a mask is often used more for contrast adjustment than for color correction. For example, a duplicate made from a color transparency, using a conventional color film which is likely to have a gamma of at least 1.5, will be excessively contrasty in the middle tones. If a single 30% negative mask is combined with the original transparency, the duplicate will have normal contrast and moreover its highlight and shadow detail will be improved because they will be reproduced on higher-gradient parts of the characteristic curve.

Another useful effect of single contrast-reducing masks is that of relative color lightness correction. Cold colors are often too dark, and warm colors too light, in color films. If an orange or red filter is used for making the mask, warm colors will have a high density in the mask, and cold colors a low density, so that their darkness will be correctly rendered in the duplicate.

Contrast-reducing masks are not usually needed in making printed reproductions, because the contrast is usually adjustable by other means. They are sometimes used for the red-filter separation, which needs little color correction. In fact, if a single gray mask is used in reproducing a transparency, it is used primarily for color correction and for curve shape correction rather than for contrast reduction. (If it is unsharp it will also improve the sharpness of detail in the reproduction). It is often said that such a mask does no color correction, but what is meant is no hue correction. It can still correct the other two attributes of color, namely saturation and lightness. Relative color lightness was discussed in the previous paragraph; and although the single gray mask does not directly affect color saturation, it does increase the color saturation of the reproduction because it permits the contrast of some step in the process to be increased to compensate for the flattening effect of the mask. This contrast change increases the difference in density between the individual colored images in a colored area, and therefore increases the color saturation.

TABLE 17-1. STRUCTURE OF KODAK TRI-MASK FILM AND AGFA-GEVAERT MULTIMASK FILM.

Kodak Tri-Mask film	Color sensitivity	Color coupler	Purpose
Emulsion 1	Blue	Magenta	Corrects green absorption of yellow ink.
Yellow Filter			Prevents blue exposure of lower layers.
Emulsion 2	Green	Cyan	Corrects red absorption of magenta ink.
Emulsion 3	Green	Yellow	Corrects blue absorption of magenta ink.
Emulsion 4	Red	Cyan	Contrast-reducing mask for red-filter separation.
Emulsion 5	Red	Magenta	Corrects green absorption of cyan ink.

AGFA-Gevaert Multimask film	Color sensitivity	Color coupler	Purpose
Emulsion 1	Blue, Red	Magenta	Corrects green absorption of cyan and yellow inks.
Emulsion 2	Blue, Green, Red	Cyan	Corrects red absorption of magenta ink and reduces red-filter contrast
Yellow Filter			Prevents blue exposure of bottom layer.
Emulsion 3	Green	Yellow	Corrects blue absorption of magenta ink.

In addition to the masks already described, which correct for the overlapping absorption bands of the inks, two other kinds of masks are commonly used. These are highlight masks and undercolor removal (UCR) masks.

Highlight masks are of two kinds. Sometimes a highlight premask (consisting of a very underexposed high contrast negative) is made from the original, registered with it while the color-correcting or principal masks are made, and then discarded. Alternatively, the highlight mask is placed in register with the separation negatives while the positives are being made. The sensitometric characteristics of these two types of highlight masks are illustrated in Figs. 17-1 and 17-2. A single highlight mask will improve highlight detail but will not restore the color saturation which is lost because of flat highlights. In order to restore the color saturation, three highlight masks, made through the color-separation filters, must be used.

It is best to produce the dark tones with a considerable proportion of black and less of the other three colors. That is, instead of merely adding black to increase the maximum density of a three-color print, black ink should be substituted for a certain proportion of the other inks where they all occur together. This is called "undercolor removal." To accomplish this, an *undercolor-removal mask*, which is an underexposed positive made from the black printer negative, is combined with each of the other three negatives when these positives are being made. The use of a UCR mask is particularly desirable for four-color wet printing, especially in the letterpress process. In four-color wet printing, all four inks are printed in rapid succession in a single run through the press. The sensitometric characteristics of UCR masks are illustrated in Fig. 17-3.

In color scanners, a result equivalent to the use of all these masks is accomplished by means of an electronic analog computer. Some scanners simulate the two-stage

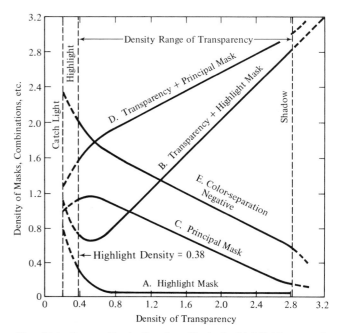

Fig. 17-1. Curves illustrating the effect of a highlight premask.

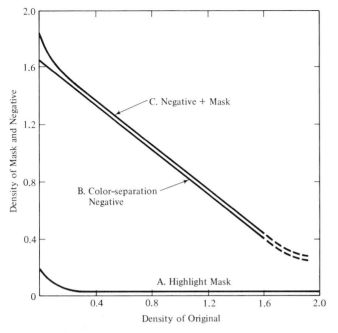

Fig. 17-2. Reproduction curves of a highlight mask, a separation negative, and the combination of the two.

masking method rather than negative or positive masking, and some use basically different methods of computation.

COLOR SEPARATION AND REPRODUCTION

Roughly speaking, the object of color reproduction is that the reproduction should reflect or transmit the same proportion of red, green, and blue light that is received from each area of the original scene or picture. If so, a reasonably good facsimile of the original will be obtained. By red light we mean the long-wavelength region of the visible spectrum. Similarly, green and blue light

respectively refer to the medium and short wavelength regions of the spectrum. For a simple explanation it is sufficient to divide the spectrum into only three regions since the eye contains three types of receptors which are predominantly sensitive to red, green and blue light respectively.

To make a photographic record of the red light received from the original, we photograph it through a color filter that transmits the red region of the spectrum—that is, a red filter. We then have to use this red-light record to control the amount of red light reflected or transmitted by the reproduction. To do this, we convert it to an image consisting of a dye or pigment that absorbs red light in accordance with its concentration—that is, a cyan image. This cyan image is supposed to control red light only and to have no effect on blue and green light. If this cyan image is properly made, it will control the amount of red light reflected or transmitted by the reproduction so that it corresponds to the red light received from the original.

Similarly, the green- and blue-filter records are converted to green- and blue-absorbing dye images respectively. The color of these images (magenta and yellow) is complementary to the color of the light that they absorb. It is easier to understand color reproduction if one thinks in terms of the color of the absorbed light rather than the color of the dye.

Unfortunately, the dyes and pigments do not behave as simply as this, and this is why masking is necessary, as explained in the next two sections, which deal with the filters used for color separation and the contrast of the masks.

FILTERS FOR MASKING AND COLOR SEPARATION

The most commonly used red, green, and blue filters for color separation are Kodak Wratten Filters Numbers 25, 58 and 47. In reproducing color transparencies, it used

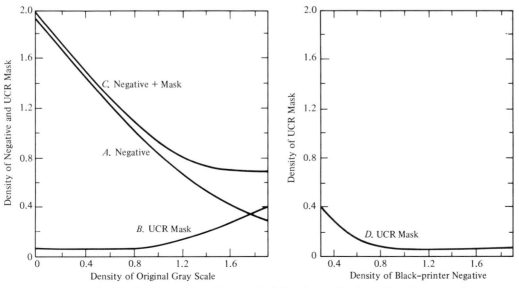

Fig. 17-3. Undercolor removal mask characteristics for moderate undercolor removal.

to be customary to use narrow-band filters (Numbers 29, 61, and 49 or 47B) on the principle that these would restrict the response to the wavelengths of maximum absorption of the transparency dyes and therefore increase the efficiency of color separation. Color separation efficiency is no longer a problem now that masking is used, so the present tendency is to use wide-band filters since they correspond more closely to the spectral responses of the human eye. With the narrow-band filters, dyes of different brands of color transparencies or retouching dyes which look alike may photograph differently. This is an example of metamerism. Even the broader-band red filter, Number 25, is not as broad as it should be, so that the still broader Number 23A filter is often used.

The ideal filter for the black-printer negative would be one with which all pure colors would photograph as if they were white, since no black ink should be present in the reproduction of a pure color. This is theoretically impossible, but a broad-band, light yellow filter comes closest to it. Alternatively, the black printer may be given successive exposures through the three color separation filters. This is called the *split-filter* technique. Some improvement in the result is possible if different masks are registered with the original when these exposures are made. This is sometimes known as the *split-mask* method.

To understand the filters used for the color-correcting masks, we must consider the reasons why color correction is necessary. The cyan ink, which is supposed to absorb red light, also absorbs some green light—that is, it behaves like a perfect cyan ink contaminated with a little magenta ink. Consequently, we must print less magenta ink wherever cyan ink will be printed. Now the red-filter image is a record of where cyan ink will be printed; consequently, we make a mask with red light and use this mask to modify the magenta printer (green-filter) separation—that is, we combine a red-filter mask with the original when making the green-filter separation. This mask reduces the amount of magenta ink to be printed in cyan-containing areas, compensating for the imperfection of the cyan ink. Thus, we always use a mask exposed with red light to correct the green-filter separation. In practice, we may add a small amount of blue light to the exposure of this mask (using Kodak Wratten Filter Number 33) to compensate for the slight imperfection of the yellow ink.

Similarly, the magenta ink is like a perfect magenta ink contaminated with yellow ink. To compensate for this, the yellow printer separation is modified by the use of a green-filter mask, which fortunately compensates also for the slight absorption of blue light by the cyan ink.

The cyan printer or red-filter separation needs little color correction, and in the early days of masking a red-filter mask was used merely to reduce the contrast. However, the magenta ink absorbs a little red light. Using the same reasoning as before, a low-contrast green-filter mask would be used for the red-filter separation. The contrast of this mask would, however, be so low that it would not have enough contrast-reducing effect. If a mixture of red and green light, transmitted by an orange-

colored filter (Number 85B), is used to expose the mask, its contrast can be made high enough without overdoing its color-correcting effect.

A film whose characteristic curve has a short straight-line portion is used for making negative masks. The low contrast of the mask in the highlights due to the shoulder of the curve prevents the mask from lowering the highlight contrast, and in this way satisfactory reproductions can usually be made without the use of a highlight mask. Masks are also made slightly unsharp by exposing them through a diffusion sheet, and this not only makes it easier to register them with the original, but also, paradoxically, results in sharper detail in the reproduction (Yule, 1944).[4]

MASK CONTRAST

Since the object of the color-correcting masks is to correct for the unwanted densities of the inks, the required mask contrast can be approximately determined from density measurements of the inks. For example, the main object of the green-filter mask for the blue-filter negative is to correct for the absorption of blue light by the magenta ink. Suppose that the blue- and green-filter densities of the magenta ink are 0.54 and 1.20 respectively. Then the required mask contrast is about 0.54/1.20, or 0.45. This is usually expressed as a percentage (45%) and it is measured between two fixed points of a gray scale which is mounted beside the original when the masks and color separation negatives are made. For example, if the chosen gray-scale steps have densities of 0 and 1.30, and the density range of the mask between these two points is 0.52, it is said to be a 40% mask.

Determining the required mask percentage by measuring ink densities through the mask filter and the separation filter only gives an approximate answer because the spectral response of the film is not the same as that of the densitometer, and because the optimum mask represents a compromise between the reproduction of various colors. However, this method helps one to understand the basic principles of masking and how the masking would need to be changed for different ink sets.

The effect of varying mask percentage can be most clearly seen by means of the graph shown in Fig. 17-4. Suppose that a green filter negative mask is to be combined with the original when the blue-filter separation is made. Let us consider the reproduction of a blue color in the original. The blue-filter (separation filter) and green-filter (mask filter) densities of the blue color are 0.57 and 1.54 respectively.* These are plotted on the appropriate scales on the graph and joined by a line that is extended to the right as shown. The fact that the line slopes downwards to the right means that less yellow will be printed in the reproduction of this blue color as the mask percentage is increased.

The horizontal scale of mask percentage at the bottom is nonlinear. This is derived from the linear scale at the

*Strictly speaking, these should be actinic or printing densities. However, densitometer densities can be used to illustrate the principle.

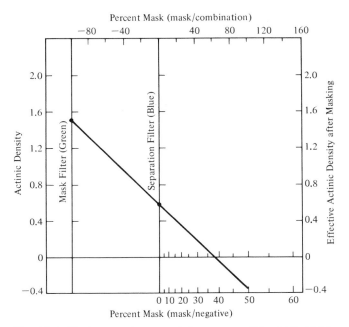

Fig. 17-4. Mask percentage graph for a green filter mask and a blue filter (yellow printer) separation, showing the effect of masking on an "unwanted" color (blue).

top in which the density range of the mask is expressed as a percentage of the density range of the masked negative (Yule, 1968, p. 241).[5] The latter is obtained by subtracting the density range of the mask from that of the negative.

The scale on the right is labeled "effective actinic density after masking," and it is important to understand clearly what this means. The actinic density of a color (with reference to a particular recording medium, filter and light source) is determined by photographing the color with a nonselective gray scale or wedge mounted beside it. In the resulting image, the spot on the gray wedge that has the same density as the color patch is located, and the density of the corresponding spot in the original wedge is measured. This is the actinic density of the original color. If the actinic density is 0.60, for example, this means that when it is photographed with this particular film-filter-light-source combination it will be recorded as if it had a density of 0.60. The exact value will, of course, depend on the spectral characteristics of all the elements in the system.

In a process whose tone reproduction characteristics are to be adjusted for accurate gray-scale reproduction, the actinic density of the original color will determine how much of the dye or ink in question will be printed in the reproduction of this color.* This will be true provided no complications such as masking or interimage effects are present. If masking is used, we can allow for it as follows. Apart from its contrast-lowering effect (which is going to be compensated for) the effect of the mask is to change the density relationship between a specific color and the gray scale. (The gray scale provides an anchor,

*Actually, the equivalent neutral density (END) in the reproduction will be equal to the actinic density of the original color, but we need not concern ourselves with END units at this point.

because it is to be kept constant.) It is as if the mask had changed the actinic density of the original color. This is literally true when the mask is combined with the original, but the final effect is similar if the mask is combined with a separation negative. This modified actinic density is what has been called "effective actinic density after masking" on the right hand scale of Fig. 17-4. This effective actinic density is what controls the amount of the colorant in question in the reproduction of this color. Again, the amount of the colorant in the reproduction, in terms of END, will be equal to the effective actinic density of the color if the gray scale is accurately reproduced.

Going back to the blue color indicated by the solid line in Fig. 17-4, we see that its effective actinic density becomes zero when the mask percentage is 37%. In other words, if this is a color which needs no yellow ink in its reproduction, we should use a 37% green filter mask for the blue filter separation.

How do we know that this blue color needs no yellow in its reproduction? We can use a blue color produced by the magenta and cyan inks of the reproduction process. The color reproduction guides commonly mounted beside reflection copy for controlling the photographic steps consist of color patches of this type produced from typical sets of inks. Gamut charts (Elyjiw and Yule, 1970)[6] provide a wider selection of such colors.

One more example—a yellow color indicated by a solid line in Fig. 17-5—will be considered. In this case, increasing the mask percentage increases the amount of ink in the reproduction. The line slopes upwards, of course, because this color has a higher density through the separation filter than through the mask filter. This brings us to an important generalization, which is of immense value in understanding masking systems:

If the color to be reproduced has a higher density measured with the separation filter than with the mask

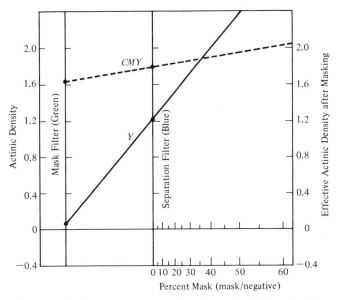

Fig. 17-5. Mask percentage graph as in Fig. 17-4, showing the effect of masking on a "wanted" color (yellow).

filter, then increasing the mask percentage will increase the amount of ink printed in the reproduction; and vice versa.

In the case of this yellow (which we call a "wanted" color in the color separation for the yellow image), how do we know when the mask percentage is appropriate? To determine this we have to compare it with another color, requiring the same amount of yellow, which is unaffected by the mask percentage. This is provided by an approximate gray produced by superimposing all three colored inks, shown by a broken line in Fig. 17-5. In the conventional color separation guide, such a three-color solid is provided, and this can be used for comparison with the solid yellow ink. It is assumed that if these ink colors are accurately reproduced, similar or neighboring colors in the picture will also be satisfactory.

These two colors, then (the yellow ink and the cyan-magenta-yellow combination) require the same amount of yellow ink in the reproduction. To accomplish this, their actinic densities after masking must be equal. This will occur with the mask percentage where the two graph lines cross—that is, with a 35% mask. This happens to be almost the same as the mask percentage required by the blue color.

In Fig. 17-6, the remaining solid colors and their overlaps have been added. In this example, a mask percentage of about 40%, indicated by the broken vertical line, would provide a satisfactory compromise. Similar graphs are used to evaluate the masking requirements for the other color separations.

One factor that complicates this analysis is the addition of a black image in four-color printing. In this case, the intersection with the four-color black line (CMYB) rather than the CMY line is more appropriate, unless an undercolor removal mask is to be used. It should also be re-membered that the graph represents an idealized situation in which the D log E curves of the masks are straight lines.

A TYPICAL REPRODUCTION PROCESS

The steps of a typical reproduction process will now be outlined. In the process chosen as an example (reproducing a color transparency by offset lithography) a colored mask film will be used for color correction. A sensitometric analysis of the process is shown in Fig. 17-7.

A 21-step silver gray scale, a 3-step (A, M and B steps) gray scale, and a strip of polyester-base film (part of a discarded negative) are attached to the 5 × 7 transparency. Holes are punched in the strip of film for registration of masks, etc. A sheet of Kodak Tri-Mask or AGFA-Gevaert Multimask film, with register holes, is exposed by contact printing through the transparency, with a diffusion sheet between the two films, and processed as recommended. A pin bar is used to maintain register. The densities of the A, M and B steps of the resulting mask are read and the readings compared with the aimpoints.

The four continuous-tone separation negatives are made by contact printing from the transparency and the mask on sheets of panchromatic polyester film punched with register holes. After processing, the densities of the A, M and B steps are read and compared with the aimpoints.

A positive undercolor removal mask with a gamma of about 1.0, underexposed so that it contains no highlight detail, is made from the black printer negative, and this is registered with each of the other negatives when the half-tone positives are being made. These are made in an enlarger or a process camera* through a 150 line/in. magenta positive contact screen, using an orthochromatic "lith" film of extremely high contrast. The screen is held in contact with the film by vacuum. The cyan positive is made first, since it is easiest to judge whether this one is properly exposed. The exposures of the magenta and yellow positives are adjusted so that the gray scale, or gray areas in the picture, are in proper balance. To achieve a neutral gray, the magenta and yellow dots have to be somewhat smaller than the cyan dots (Elyjiw and Archer, 1972).[7] If a contrast adjustment is needed, this is achieved by exposing through a yellow or magenta color-compensating filter, which affects the contrast of the magenta screen.

The halftone positives are evaluated by visual examination of the dots through a magnifier, and a color proof is then made either on an offset press or by means of one of the special processes described on page 478. The proof may show that one or more of the positives needs to be remade. If not, they are given to the dot etcher with instructions as to what changes should be made, or shown to the customer's representative, who will specify what local or overall color changes are required. After the dot etcher has made these adjustments, a second proof is

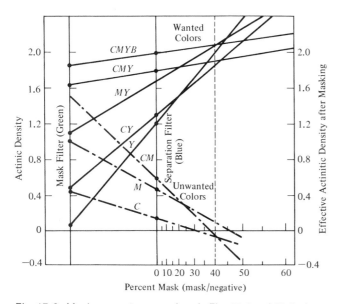

Fig. 17-6. Mask percentage graph as in Fig. 17-4 and 17-5, showing the effect of masking on the solid ink colors and their overlaps.

*If the separation negatives are of the correct size, the positives can be made by contact printing.

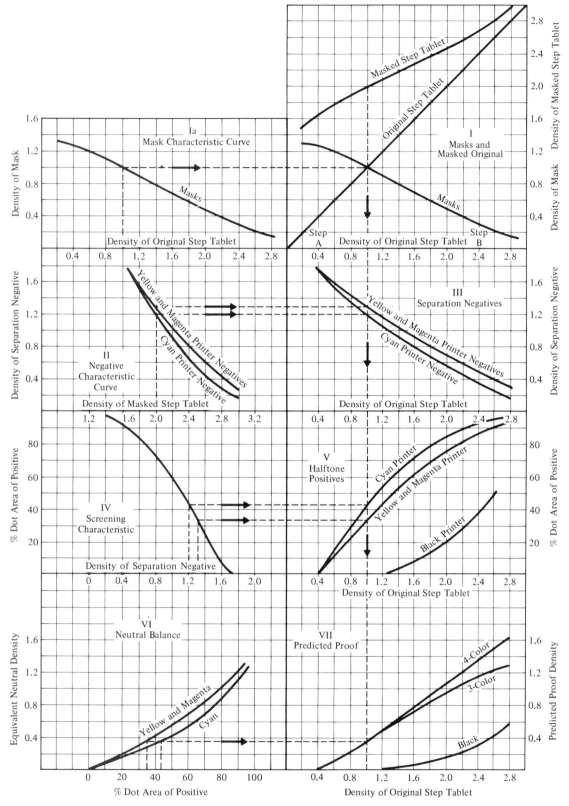

Fig. 17-7. Sensitometric analysis of a typical color reproduction process.

made, and this will be repeated if the customer is not satisfied.

Halftone negatives are then made by contact printing from the halftone positives, and these negatives are assembled in the required layout for the complete page, or for a number of pages. Negatives of the type matter and black and white illustrations are included in the layout for the black printer. A paper proof is made from the black layout to check for errors.

Contact positives are now made from the negatives, printing plates are made from the positives, and the job is ready to be printed. The pressman's job is to match the color proof. Since the ink distribution on the press has to be readjusted for every job, and since it takes time for each adjustment to take effect, many unsatisfactory sheets have to be discarded before acceptable printing is achieved. In making these adjustments, the pressman has to allow for the fact that the ink density will become lower after it has dried. This drydown can be minimized by using a densitometer equipped with crossed polarizing filters (Hull, 1959).[8]

All that remains, after the required number of sheets have been printed, is the trimming, folding, binding, etc.

The reproduction process we have just described was an example of offset lithography. The photographic color separation method would be similar for the other printing processes, but the preparation of the halftone images would be somewhat different.

In letterpress or relief printing, a very similar method can be used when the printing plates are made by the so-called "powderless etching" process, in which the etching of the plate has very little effect on the dot size. However, in letterpress printing it is necessary to print halftone dots throughout the whole area of each of the four images, even in the highlights. Consequently, there is a certain minimum size for the highlight dots in the positive. This limits the brightness in the highlights of the reproduction, and is unnecessary in lithographic printing, in which large white areas are permissible.

If the powderless etching method is not used, it is necessary to make continuous-tone instead of halftone positives. The halftone negatives are made from these positives. Otherwise it would be difficult to produce the correct tone scale to allow for the large decrease of dot size, especially in the light tones, which occurs during the etching of the printing plate.

The gravure process also requires a continuous-tone positive, and in "conventional gravure" no halftone image is used. In the United States, conventional gravure is rarely used for color work. Instead of this, a halftone positive and a continuous-tone positive are both used, and successive exposures are made through the two positives on the "gravure tissue" which is the light-sensitive material used for preparing the printing plates or cylinders. By using the two positives, a bigger and better-controlled range of tones is produced, since the ink-carrying cells on the plate vary in diameter as well as depth. Originally, in the so-called Dultgen process, both positives were made from the continuous-tone negative. Now, halftone negatives are usually made from the continuous-tone positives and contact (hard-dot) posi-

tives are made from the halftone negative. By the use of a special material such as DuPont Rotofilm® instead of carbon tissue, it is possible to introduce both the continuous-tone and halftone characteristics without making separate halftone negatives or positives.

In the case of gravure printing, the shadow end of the scale must be carefully controlled so that no dots larger than a certain maximum size are present.

OTHER METHODS OF COLOR SEPARATION

We have described one typical method of color separation, but there are several other alternatives. One efficient method (Inst. of Printing, 1968)[9] consists of making duplicate transparencies of the required final size from all the originals (both from transparencies and reflection copy). These can then be mounted in the required arrangement, and the masks and color separations for a complete page or sheet can be made on single sheets of film. The halftone positives can be made by contact printing, instead of using a process camera or an enlarger. Variations in density or color balance can be eliminated by adjusting the duplication step, so that all the duplicate transparencies can be treated in the same way. The efficiency of this method makes up for the cost and the inevitable slight loss of quality in the duplicating step.

Another alternative is direct screening (Inst. of Printing, 1967)[10] in which halftone negatives are made directly from the masked original on panchromatic lith film through a gray contact screen. However, the most important alternative method of making color separations is with a color scanner, described in the next section.

Scanners

The color separations for a considerable, and increasing, proportion of color work are now made on color scanners, invented by Murray and Morse, and independently by Hardy, in the late 1930s. The basic principles of a scanner are illustrated in Fig. 17-8 and a picture of a

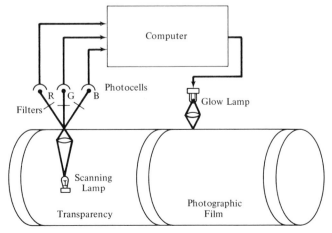

Fig. 17-8. Block diagram of simple color scanner.

scanner is shown in Fig. 17-9. Light from a small spot on the original, which is attached to a rotating drum, is picked up by three photocells after passing through red, green, and blue filters respectively. The amounts of red, green and blue light, and the resulting photocell responses, represent the color of the original at this point. An analog computer operates on these signals to calculate the amount of cyan, magenta, yellow, and black ink required to reproduce this color, and the computer output controls the intensity of four lamps which expose a corresponding small spot on each of four photographic films. All this takes place in a few millionths of a second, before the scanning motion has appreciably moved the spot. This is continued for each spot on the original until the whole picture has been scanned. Four color separation negatives or positives are thus produced, although many scanners only make one separation at a time. The exposure of the cyan-printer separation depends primarily on the red-light signal from the original, as in photographic color separation methods. However, the green and blue signals also modify the output in a way that corresponds roughly to the effect of color-correcting masks. The main advantage of the scanner, therefore, is that it eliminates the necessity for making masks. Moreover, the analog computer in the scanner can make quite complex calculations and the color correction can therefore be more accurate than is possible with photographic operations. This improved color correction is, however, not always evident because it depends on the appropriate setting of 40 or more control knobs on the scanner.

One possible answer to this difficulty is to make the setting of most of the control knobs automatic. The scanner now being developed by Ventures Research and Development (Korman and Yule, 1971)[11] first scans a color chart printed by means of the printing process in question, and computes the transfer function needed to give accurate reproduction with this process. This is made possible by the use of a digital rather than an analog computer. In addition, a rapid preliminary scan of the picture is made to determine how to handle this particular original.

Another problem with scanners has been the difficulty of providing continuously variable magnification. This was ingeniously solved in the Crosfield Magnascan (Wilby, 1970)[12] by briefly storing the picture information for a single scanning revolution and releasing it onto the film immediately afterwards at a rate that depends on the desired magnification.

To return to the conventional scanner, the functions performed by the analog computer should be described in more detail. This computer can be divided into several stages as shown in Fig. 17-10: the nonlinear preamplifier (the compression stage); the color correction stage; the black computer and undercolor removal stage; and the final nonlinear amplifier for gradation control.

The nonlinear amplifier operates on the individual signals without combining them. It amplifies them to a manageable level and compresses their range, which may be more than 1000:1 from highlights to shadows. This compression corresponds to lowering the contrast in a photographic process. A "logger" is also included if

Fig. 17-9. Color Scanner, showing the scanning drum on the left and the exposing drum (for making one separation at a time) on the right. (*Courtesy of HCM Corporation*)

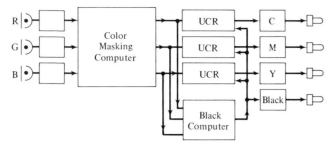

Fig. 17-10. Scanner computer showing separate color masking, black computation, and undercolor-removal sections.

logarithmic instead of linear signals are to be used. This makes it easier to stimulate the effects of photographic masking.

In the color correction stage, linear combinations of the three logarithmic signals may be computed in a way that corresponds to photographic (usually two-stage) masking. For example, the green-filter signal can be modified by adding to it a certain proportion of the difference between the red- and green-filter signals. At this stage, color-corrected cyan-, magenta-, and yellow-printer signals are produced.

The black-printer signal is next produced, and one way of doing this is to select the strongest of the three color-corrected signals at each moment. Undercolor removal is then accomplished by subtracting some proportion of the black signal from each of the other three signals. In this way, black ink is substituted for part of the cyan, magenta, and yellow inks in the regions of the picture in which all three inks are present.

Finally the gradation of each of the four signals is adjusted to provide the proper tone reproduction and color balance. At this stage, fine detail can also be enhanced, either by a method analogous to unsharp masking, using an extra large-spot photocell, or by electronic peaking. The resulting signals control the intensity of lamps which expose film to produce color-separation negatives or positives, simultaneously or one at a time.

A somewhat more detailed review of the principles of color scanners can be found in "Principles of Color Reproduction" (Yule, 1968).[5]

GRAY BALANCE AND TONE REPRODUCTION

In most processes of color photography, the color film and the processing are standardized. The tone rendering and color balance are built into the film, and the amount of exposure is the only normal means of adjustment. In printing processes, on the other hand, there are many points—too many, in fact—at which the shape of the tone reproduction curve and the color balance can be adjusted. This is one of the main reasons for poor reproductions, since these adjustments are frequently inappropriate. Also, while there are only a few color films, every printing plant, and sometimes every press in one plant, has its own printing characteristics, which are not easily standardized and controlled.

There are three ways of handling this problem. One is

to adjust all the steps of the process by trial and error until reasonably satisfactory results are obtained; the second is to standardize the photographic steps to fit average printing conditions, and to adjust the printing to conform to this; the third is to determine the characteristics of the specific printing process and adjust the photographic steps to conform to the printing with the aid of sensitometric analysis. The first method has been most widely used, often with rather poor results. The second method—standardizing the photographic steps—is perhaps the easiest to accomplish since the Eastman Kodak Company has published instructions for the photographic steps that fit average printing conditions, at least for offset lithography (this information is given in their data books for the graphic arts). The third method is difficult without a thorough understanding of the principles of color reproduction. Perhaps a combination of the second and third approaches, aided by test targets developed by the Graphic Arts Technical Foundation and others, is the most satisfactory (Elyjiw and Archer, 1972).[7]

No matter what approach is used, good tone reproduction and color balance are of the first importance. To help control this a gray scale or steptablet is usually mounted beside the original. In production work, it is not practical to plot complete tone reproduction curves, however, so Kodak recommends the use of a 3-step gray scale—the steps being referred to as A (highlight), M (middletone) and B (shadow). In a negative or positive the density difference between A and B is used to indicate the contrast, and the difference between the M and B and A to M density ranges indicates the tone reproduction curve shape. With these three steps of the tone scale under control, the remainder of the tone scale is usually satisfactory, and in any case conventional photographic procedures do not usually permit the independent adjustment of more than three steps in the tone scale. In four-color printing, however, independent control of the shadow contrast is made possible by adjusting the characteristics of the black image.

Variations of the printing process make it difficult to obtain good color balance and tone reproduction, even if all the other steps in the process are carefully controlled. The two chief variables are the ink-film thickness and the variation in the size of the printed dots, known as "dot gain." Variations in ink-film thickness are detected by measuring the density of solid patches of the inks through a complementary filter. These densities are, of course, unaffected by dot size since no halftone pattern is present. In making color proofs, color bars of each ink are printed along with the picture for this purpose. This is also done in production printing if space permits the color bars to be placed where they can be trimmed off. Various kinds of test targets for checking dot gain are also included.

EVALUATION OF ORIGINALS AND REPRODUCTIONS

In large-volume photographic printing each picture is put through a routine printing process, obvious failures are

weeded out, and the prints are remade if the customer complains. In photomechanical printing each picture represents considerable expense, so it is worthwhile for the printer to make some attempt to find out what the customer wants. Viewing standards have recently been set up (Am. Nat. Standards Inst., 1972)[13] so that the printer and the customer can at least view the picture under similar conditions, but these are often disregarded.

When the customer does not want the original reproduced exactly, he will usually make vague qualitative statements about the desired changes. Adjustable viewing conditions which can provide a quantitative answer about color balance, for example, have been suggested (Ahrenkilde, Archer, and Yule, 1971).[14] The ideal answer would be to provide a closed-circuit color television instrument to simulate the desired result (Thaxton, 1971),[15] but such instruments are, of course, very expensive.

The chief difficulty in evaluating reproductions is that exact reproductions are usually impossible because of colors in the original which are outside the color gamut of the printing inks. Some compromise has to be made, and it is difficult to guess what will be the best compromise. This is what makes it so difficult to set up a color scanner to produce the best possible result.

The problem is particularly difficult in the case of a color transparency, since it is impossible to reproduce the brilliance of a strongly illuminated transparency by means of a paper print. The usual practice is to view the transparency against a bright border, which degrades its colors so that most of them become reproducible. Unfortunately, most colors become undesirably dark when this is done.

To make a quantitative analysis of the relationship between the colors of the reproduction and the original is laborious (Pobboravsky, Pearson, and Yule, 1971)[16] and is complicated by the fact that the characteristics of the optimum reproduction are unknown when compromises have to be made because of ink gamut limitations. The usual practice, therefore, is to evaluate the reproduction visually, comparing it with the original.

In setting up a new reproduction process, or in troubleshooting to find the cause of unsatisfactory reproductions, the tone reproduction curve of the gray scale can be plotted, and the reproduction of the ink patches reproduced along with the picture can be studied. However, the reproduction of these may not correspond exactly to the reproduction of the picture because of metamerism and unevenness. A thorough quantitative analysis of the reproduction characteristics is usually too time consuming except for research investigations. Moreover, a densitometer (which is usually the only instrument available for making quantitative measurements on pictures) is not a colorimeter and may give inaccurate results in comparing original and reproduction colors.

INKS

Although printing inks are not part of the photographic steps of the color printing process, they should be mentioned here because the photographic steps, and especially the masking requirements, depend on the colors on the inks. This is to be expected in view of the

TABLE 17-2. DENSITIES OF CONVENTIONAL PROCESS INKS AND "IDEAL" INKS.

		Red Density[a]	Green Density[a]	Blue Density[a]
Conventional Inks	Cyan	1.30	0.41	0.15
	Magenta	0.11	1.05	0.57
	Yellow	0.01	0.07	1.00
Ideal Inks	Cyan	High	0	0
	Magenta	0	High	0
	Yellow	0	0	High

[a]Kodak Wratten Filters Nos. 25, 58, and 47, Welch Densichron reflection densitometer.

fact that the primary object of color correction is to compensate for the unwanted spectral absorptions of the inks. For example, the magenta ink absorbs some blue light; that is, it acts as if it were contaminated with yellow ink. Consequently, less magenta ink must be printed when yellow ink is present, and this is accomplished by masking.

These unwanted spectral absorptions can be detected by measuring the densities of the inks through red, green and blue filters, as indicated in Table 17-2. With so-called "ideal" inks, two of these densities would be zero, for each ink. Table 17-2 shows that the red-filter density of the yellow ink is the only one that approaches zero. The major unwanted densities are the green-filter density of the cyan ink and the blue-filter density of the yellow ink, and the masking is mainly to correct for these two.

Inks are often evaluated by measuring densities in this way, using the system of "hue error" and "grayness" developed by F. Preucil (1960).[17] This works quite well in spite of inaccuracies due to the variation in spectral sensitivity of different densitometers. Colorimetric measurements of the inks would be more accurate, but the relation between the usual colorimetric parameters and the requirements of the reproduction process is not a simple one, so they are difficult to use in adjusting the process, unless rather complex computations are carried out (Gutteridge, 1972).[18]

The colors of process inks are primarily chosen to produce a favorable gamut of colors, although some consideration is given to ease and accuracy of color correction. The so-called ideal or "block" dyes or inks, each of which would absorb one-third of the visible spectrum, would probably eliminate the need for color correction, although a UCR mask would still be desirable to allow for the addition of the black image. However, such coloring materials do not exist and even if they did they would not give the most useful color gamut.

The colors of the cyan and magenta inks seem to be chosen chiefly for the purpose of obtaining sky blues and strong, bright reds, respectively, even though magentas, purples, and violets are degraded by the reddish magenta ink, which is far from the theoretical "ideal" color.

COLOR PROVING

A color proof is nearly always made and approved by the customer before the production run is made. Proofs are

usually made from the halftones of each picture before the complete layout is assembled, and sometimes several proofs are made, with additional corrections made by dot etching, until the customer accepts the result.

For the most reliable results, proofs are printed on the kind of press that is to be used for production; but time and money are saved by the use of a smaller press. Proof presses are available which print only one sheet at a time, since a regular press may require the printing of several hundred sheets before normal printing is produced. When the production run is to be made on a multicolor press in which ink is printed over wet ink, it is important that this be done also in making the proof.

Many photographic proving processes have been developed to avoid the expense of making press proofs. As might be expected, it is difficult to match the photomechanical printing process exactly in this way. These processes are, however, very useful because of their speed, convenience, and low cost. They mostly fall into three categories: (1) the colorants are produced by exposure to light followed by chemical treatment as in the diazo process; (2) a pigmented film is solubilized, made insoluble, or hardened by exposure to light, followed by washing out the soluble parts or transferring unhardened parts to a receiving sheet, sometimes with the aid of heat; (3) the image is produced by electrostatic or electroconductive methods and usually transferred to a receiving sheet. No attempt will be made to describe the many commercially available processes, since such a description would soon be out-of-date. Examples of the three main types are the Azochrome® process, 3M Color Key®, and the Remak® process.

MATHEMATICAL ANALYSIS OF COLOR REPRODUCTION

We shall not go into any mathematical details, but it may be of interest to indicate how the reproduction process can be analyzed.

The first step in analyzing the reproduction requirements should be to decide whether the reproduction should match the original, and if not, how the reproduction colors should be related to the original colors. There may be differences in viewing conditions, preferences for certain hues of skin, sky, and foliage, nonreproducible colors in the original outside the gamut of the reproduction process, or intentional changes of various kinds. These factors do not lend themselves to mathematical analysis, so it is usual to exclude nonreproducible colors and to assume, in the mathematical analysis, that a colorimetric match of the original colors is required.

One problem is that the color separation film usually does not "see" the colors in the same way as the human eye does, because of its spectral response. That is, the color separation process differs from the CIE system, and has its own color matching functions. The best we can do, as a first approximation, is to make the reproduction match the original in terms of the color matching functions (that is, the spectral responses) of the color separation system. Visually, the match will not always be perfect but it will be quite good. The color separation process sees the original in terms of its red, green, and blue actinic densities or printing densities, which depend on the spectral response of the system. The actinic densities of the original and of the reproduction colorants are the quantities that are manipulated in the mathematical analysis.

It can be shown that if there are linear relationships between the densities throughout the system, exact reproduction (as the color separation responses see it) is possible by using two color correcting masks for each of the three separation negatives. (Fortunately, under favorable conditions, three or even four of these masks turn out to be almost negligible.) The contrast of the masks is given by the "masking equations." The masking equations which express the required colorant amounts C, M and Y as a function of the red, green, and blue densities of the original, are of the form shown in Eq. (1):

$$C = a_{11} D_r + a_{12} D_g + a_{13} D_b \tag{1}$$

There are two similar equations for M and Y. The coefficients, which represent the contrasts of the color separation images and masks, can be calculated from the red, green, and blue densities of the three colorants of the reproduction system (Yule, 1968, p. 268).[5] The masking and color separation process acts as an analog computer for calculating the required colorant amounts in each area according to the equation, the answer being provided in the form of the amounts of colorant in the final color image.

The relationships between the densities of the colorants, combined in various proportions, are usually not linear, as required by the masking equations. Additivity and proportionality failure occur, in which case accurate reproduction of only four colors (for example, white, yellow, magenta and cyan) can be assured by the use of two masks for each separation negative. These can be any four selected colors (such as white, skin, foliage, sky) for which you know (1) how much of the three colorants is needed to match them and (2) what their actinic densities are (Marriage, 1948).[19] However, a compromise solution for a larger number of colors can be obtained by the method of least squares. (Brewer, Hanson and Horton, 1949).[20]

A more accurate result, which allows for additivity and proportionality failure of the colorant densities, can be obtained by including additional terms in the equations (Clapper, 1961;[21] Pobboravsky, 1964).[22] "Density squared" terms will allow for proportionality failure, and correspond to the use of nonlinear characteristic curves for the masks and separation negatives. Cross-product terms, containing $D_r D_g$ for example, can be added to allow for additivity failure. The coefficients in the equations can be found as before by a least-squares analysis of a large number of colors.

In halftone processes, the colors produced by given combinations of dot areas of the colorants can be calculated from the Neugebauer equations. Since these equations have not been solved explicitly to give the required dot areas to produce a given color, it is difficult

to use them in designing a color reproduction process, although Pollak (1955)[23] has worked out a partial solution.

The analysis described up to this point strictly applies only to duplication processes, in which the colorants in the original are the same as in the reproduction. Other colorants in the original, with spectrophotometric curves of different shapes, may not be accurately reproduced because the spectral sensitivity of the eye does not correspond to that of the photographic material with its color filters. For reproducing originals containing other colorants, slight adjustments of the process might be needed.

The analyses described have mostly been restricted to processes with linear characteristics. With the aid of a computer, the characteristics of nonlinear steps of the process can easily be included (Gutteridge, 1972).[18]

In order to ensure accurate reproduction of a variety of different colorants, a further condition—the Luther-Ives condition—must be met. This states that the spectral responses of the color separation system must correspond to the visual color mixture functions or linear combinations of them. This ensures that colors that match each other in the original will be similarly recorded and will match each other in the reproduction. The analyses already described have shown how to accurately reproduce one set of colors (those containing the reproduction colorants). Any color, no matter what its composition, that matches some combination of these colorants will also be reproduced accurately provided the Luther-Ives condition is satisfied.

Unfortunately the visual color-mixture functions are broad and overlapping, the least overlapping set being shown in Fig. 17-11 (Pearson and Yule, 1973).[24] The use of overlapping spectral sensitivities does not lead to efficient color separation. Consequently, this condition is usually disregarded in designing color films, and this is the reason why sky blue flowers such as the morning glory often appear pink in a color photograph. The cyan layer is sensitive to longer wavelengths than those to which the eye responds. These wavelengths are reflected by the blue flower but are absent from the blue sky.

Use of the overlapping spectral sensitivities called for by the Luther-Ives condition leads to higher coefficients for the mask terms in the masking equations. This means that higher contrast masks have to be used for accurate color reproduction, and this makes the reproduction process much more critical. Consequently, even in printing processes where elaborate masking is used we still do not fulfill this condition, although we have gone in this direction by using broader-band filters in recent years. We pay for this failure by finding that dyes used for retouching color photographs do not reproduce like the dyes of the photograph, so that retouched areas are often incorrectly rendered.

The earlier work on spectral sensitivities contained much discussion of the theoretical need for negative sensitivities (which are impractical) in some spectral regions. This was apparently due to the habit of regarding subtractive color photography as an attempt to imitate additive processes. The real primaries which are used in additive processes, such as color television, do theoretically need negative spectral sensitivities or their equivalent, and this is quite feasible with electronic circuits. In subtractive processes, the negative sensitivities are unnecessary because the colorants can be considered to control imaginary primaries of higher purity than the spectrum colors.

In the past, color reproduction processes have been adjusted by trial-and-error methods, and mathematical analyses like those outlined in this section have chiefly been used to provide understanding of the processes so that the adjustments can be more intelligently planned. The availability of large computers has now made it possible to use mathematical models in place of much of the trial-and-error experimentation of the past.

CONCLUSION

The foregoing brief description of photo-mechanical color reproduction processes provides a general guide to the methods used. For more detailed descriptions of the photographic steps the reader is referred to publications by manufacturers of the materials used and by graphic arts research organizations. Most of the subjects referred to in this chapter have been discussed in greater detail in the author's book, *Principles of Color Reproduction* (Yule, 1968), which also contains a more complete list of literature references.

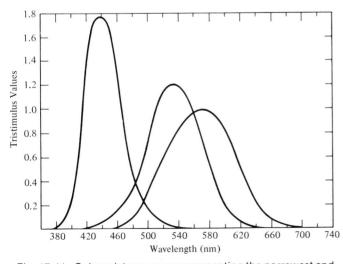

Fig. 17-11. Color mixture curves representing the narrowest and least overlapping transformations of the CIE color mixture functions that contain no negative values.

REFERENCES

1. J. A. C. Yule, U.S. Patent 2,367,551 and 2,382,696 (1940).
2. Gevaert Photoproduction N.V., Reprorama No. 10, Antwerp (1959).
3. Eastman Kodak Company, *Color Correction with Kodak Tri-Mask Film*, Kodak Publication No. Q-6A, Rochester, N.Y. (1962).
4. J. A. C. Yule, "Unsharp Masks," *Photogr. J.*, **84**: 321–327 (1944) (reprinted in *J. Photogr. Soc. Amer.*, **11**: 123–132).

5. J. A. C. Yule, *Principles of Color Reproduction*, Wiley, New York, 1968.

6. Z. Elyjiw and J. A. C. Yule, *A Color Chart for Representing Process Ink Gamuts*, Proc. Pira/Iarigai Conf. Appl. Lithogr. Technol., Paper No. 35, (1970).

7. Z. Elyjiw and H. B. Archer, "A Practical Approach to Gray Balance and Tone Reproduction in Process Color," *TAGA Proc.*, **24**: 78–97 (1972).

8. H. H. Hull, "A Reflection Densitometer Head for the Control of Ink Amounts on Proofs," *TAGA Proc.*, **11**: 149–155 (1959).

9. Institute of Printing, *Duplication and Conversion of Colour Transparencies*, Institute of Printing, London, 1968.

10. Institute of Printing, *Colour Reproduction by Direct Screening*, Institute of Printing, London, 1967.

11. N. I. Korman and J. A. C. Yule, "Digital Computation of Dot Areas in a Color Scanner," 11th IARIGAI Conf., Rochester, N.Y. See also *G.T.A. Bull.*, **22**: 85–88 (1971).

12. W. P. L. Wilby, "Color Scanning and Digital Image Processing," *TAGA Proc.*, **22**: 353–370 (1970).

13. ANSI, *Viewing Conditions for the Appraisal of Color Quality and Color Uniformity in the Graphic Arts*, PH2.32 (1972).

14. S. Ahrenkilde, H. B. Archer and J. A. C. Yule, "Evaluation of the Lightness and Color Balance of Color Transparencies," *TAGA Proc.*, **23**: 172–187 (1971).

15. K. L. Thaxton, "An Electronic Color Previewer for Four-Color Process Printing," Conf. on Optimum Reproduction of Color, M. L. Pearson (ed.), *ISCC Proc.*, 145–148 (1971).

16. I. Pobboravsky, M. L. Pearson and J. A. C. Yule, "The Relationship Between Photomechanical Color Reproductions and the Original Copy." Conf. on Optimum Reproduction of Color, M. L. Pearson (ed.), *ISCC Proc.*, 159–190 (1971).

17. F. Preucil, "Color Diagrams." *TAGA Proc.*, **12**: 151–155 (1960); see also Research Progress No. 53, Lithographic Technical Foundation (now GATF), Chicago.

18. C. Gutteridge, "A Method of Computing the Mask Characteristics Required for Accurate Color Reproduction in Photomechanical Processes." *Photogr. Sci. Eng.*, **16**: 214–220 (1972).

19. A. Marriage, "Subtractive Colour Reproduction," *Photogr. J.*, **88B**: 75–78 (1948).

20. W. L. Brewer, W. T. Hanson, Jr. and C. A. Horton, "Subtractive Color Reproduction. The Approximate Reproduction of Selected Colors," *J. Opt. Soc. Amer.*, **39**: 924–927 (1949).

21. F. R. Clapper, "An Empirical Determination of Halftone Color-Reproduction Requirements," *TAGA Proc.*, **13**: 31–41 (1961).

22. I. Pobboravsky, "Transformation From a Colorimetric to a Three- or Four-Colorant System for Photomechanical Reproduction," *Photogr. Sci. Eng.*, **8**: 141–148 (1964).

23. F. Pollak, "The Relationship Between the Densities and Dot Sizes of Halftone Multicolor Images," *J. Photogr. Sci.*, **3**: 112–116 (1955).

24. M. L. Pearson and J. A. C. Yule, "Transformations of Color Mixture Functions Without Negative Portions," *J. Col. Appearance*, **2**: 30–35 (1973).

18

PHOTOMECHANICAL PRINTING PROCESSES

Michael H. Bruno

The processes of printing employed for the reproduction of photographs, line drawings, sketches, etchings, paintings, and other pictorial media are termed *photomechanical processes* because photographic processes are employed in preparing the printing surfaces for use on the press while mechanical processes are involved in making the plate, the application of ink to the plate and the transfer of ink to the printed page.

The invention of printing from movable type is generally credited to Johannes Gutenberg of Mainz, Germany about 1450. Practical photomechanical processes were not developed until the middle of the last century and the processes in use today were developed after 1880.

Printing, which includes publishing and packaging, is a big business in the United States representing about 5% of the gross national product. In 1975, printing and publishing produced products estimated at $39 billion and packaging $32.5 billion. The annual increase in the value of shipments of printed material is estimated at about 8% until 1980. Among all U.S. manufacturing industries, the printing and publishing industry ranks first in the total number of plants, fourth in average hourly wage paid to employees, seventh in total payroll, eighth in value of shipments, and twelfth in dollars reinvested in capital expenditures.[1]

THE PRINTING PROCESSES

In all printing processes the image carrier or printing plate consists of two areas: (1) image or printing areas which are inked to produce the image, and (2) nonimage or nonprinting areas which represent the clean or unprinted areas of the paper. There are four ways of printing (Fig. 18-1): (1) *relief*, in which the image area is raised and the nonimage is depressed, (2) *intaglio*, in which the image consists of small wells in a plate or cylinder which contain the ink and the nonimage areas are kept clean with a metal scraper or doctor blade which is in contact with the smooth outer surface of the plate or cylinder, (3) *planographic*, in which the image and nonimage areas are essentially on the same plane but differ in their receptivity to ink, the ink being accepted by the image areas and repelled by the nonimage areas, which are wet by a water solution, and (4) *stencil* or *porous*, in which a metal, nylon, silk screen or fibrous material is used on which the nonimage areas are made nonporous so the ink goes through the porous areas.

Plates or image carriers can be made manually, mechanically, or photomechanically. All printing processes use some form of photomechanical plates on which the images are made by using photosensitive materials. Relief printing (letterpress) can print from hand set or machine set raised type but a photographic process (photoengraving) must be used to reproduce pictorial material. Flexography, used principally in packaging, is a method of relief printing using rubber relief plates and solvent inks. The best known of the intaglio methods, gravure and rotogravure, and the planographic methods, offset lithography, both employ photomechanical plates exclusively for both illustrations and type. Collotype (photogelatin) is also a

Fig. 18-1. The four major printing processes: relief (letterpress), intaglio (gravure), planographic (lithography), and porous (screen process). (*Courtesy The Printing Industries of America*)

planographic process but is not important in modern printing and reproduction. The stencils used in screen printing can be made by hand but most are produced photomechanically. The mimeograph is an example of screen or porous printing.

In printing, ink may be transferred directly to the paper or from the inked plate to a cylinder covered with a rubber blanket which takes the ink from the plate and transfers it to the paper or other substrate. This is known as offset printing. Letterpress, gravure and screen printing are almost exlusively methods of direct printing. Lithography, on the other hand, is almost all offset printing; in fact, lithography is often referred to as offset (Fig. 18-2). The advantage of offset is that the rubber blanket can transfer the ink to rough surfaces so that high quality printing can be done on special papers.

Presses may be flatbed or rotary. In the flatbed press the type or plate is on a flat bed, which may either be horizontal or vertical. Flatbed presses are used chiefly for letterpress and screen printing, and for proofing. In a rotary press, the plate is mounted on a cylinder.

Presses may also be classified as sheet-fed and web-fed. With a sheet fed press, the sheets of paper are fed one at a time, the impression made and the sheet removed. On a web press the paper is fed from a roll and printing is continuous as the paper passes under the inked plate on the rotating cylinder. All of the major printing processes can be printed on sheet-fed and web-fed presses.

At the present time about 50% of commercial printing is by letterpress, much of which is newspaper and magazine printing; 35% is lithography which is used for books, magazines, business forms, greeting cards, catalogs and packaging; 10% is gravure which includes catalogs, magazines, newspaper supplements, packaging, wall paper, linoleum, floor tiles and plastics. Screen and other processes make up the remaining 5%.

The printing process is conveniently divided into two parts: (1) the preparatory operations which consist of copy preparation, typesetting, photography, assembly of the films into a layout or form, and plate-making; and (2) printing and finishing which consist of the actual printing and converting the printed sheets into the final form for use. Only the first part will be considered here.

PREPARATORY OPERATIONS

There must be an *original* or copy for *reproduction*. This can be in many and varied forms. It can consist of type matter as letterheads, books, advertisements, posters, etc.; it can consist of illustrations, photographs, line drawings, sketches, art paintings, etc.; or it can be a combination of both as in books, encyclopedias, magazines, newspapers, advertising brochures, etc.

All copy must be examined for clarity or sharpness, cleanliness, freedom from blemishes and other defects. If new copy cannot be obtained and reasonable quality is expected, illustration material should be retouched by artists to correct the defects. Also all copy must be marked for size and shape indicated by crop marks. Type matter should be read for continuity and accuracy. It should also be examined and marked for size and spacing to make sure the copy will fit in the space alloted. If there are too many corrections and it will be reproduced by a typesetting system using optical character recognition (OCR), it may need to be retyped with a special typewriter face that reads well in these machines.

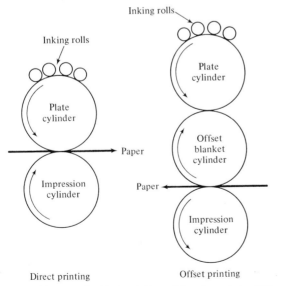

Fig. 18-2. Direct and offset printing. (*Courtesy John Wiley & Sons*)

TYPESETTING OR COMPOSITION

Most typesetting or composing in the past has been done by handsetting of individual metal type characters

(much as it was done by Johannes Gutenberg) and by machines such as the Linotype invented by Ottmar Mergenthaler in 1886, the Monotype invented in 1887, the Intertype (similar to Linotype) invented in 1911, and the Ludlow machine also invented in 1911. Machine composition is known as line-casting as the machines cast one line at a time. The Monotype and Ludlow are slightly different. The Monotype uses a keyboard (like a typewriter) to produce a punched tape which operates a casting machine that casts individual characters, but composes them into lines. In the Ludlow machine, a line is set by hand and cast in a machine. This differs from the other machines in that it is used mainly for casting headings or lines for advertising. Linotype and Intertype machines can also be operated by punched tape which is produced on a keyboard or a computer. All these processes, which are referred to as *hot metal*, produce raised cast-metal type consisting of an alloy of lead, tin and antimony known as *type metal*. Average machine speed is from about 6 characters per second (cps) for manual operation to about 20 cps for tape operation.

There are two other forms of typesetting in use. These are known as *strike-on* composition and *phototypesetting* which is sometimes called *computersetting* because most phototypesetters use computers for various functions. Strike-on composition can be produced on typewriters, but usually special typewriters are used with several typefaces, symbols, spacing, etc. Strike-on composition is more reasonable in cost than cast metal or phototypesetting, but the quality of the composition is not as good. Most computer printout systems use strike-on printers and considerable specialty printing is now being done directly from these computer printouts.

Phototypesetting is a means of producing type photographically thereby shortening the number of production steps leading to the complete film master required in the platemaking for every major printing process. Even letterpress, especially for newspapers, uses phototypesetting for producing tapes for metal linecasting machines and especially for photopolymer and other photomechanical plates.

Phototypesetting

The first phototypesetter was the Intertype Fotosetter which was introduced in 1948. It was similiar to the Intertype cast metal machine except that (1) the metal matrix in the hot metal caster was replaced with a photographic negative of the characters and (2) the casting operation was replaced with an optical system for forming the characters on film or paper. Later developments included equipment using computers for justifying lines and hyphenating words and cathode ray tubes for displaying characters at speeds exceeding 1000 cps. Despite these developments, none of these machines could make headway against the machines casting in hot metal mainly because the metal casting

machines set the type in single lines which were easy to handle for corrections.

The situation changed in 1970 with the introduction of *optical character recognition* (OCR) and the *video display terminal* (VDT). These were combined to produce corrected phototypesetting tapes. Corrections can be made mechanically without requiring manual manipulation of the copy. Since 1970, phototypesetting has been increasing at a rapid rate and the use of cast metal is decreasing.[2] By the end of 1975 it was estimated that less than 60% of the type set in the United States was cast metal.

How a Phototypesetting System Works

The more than three dozen different phototypesetter models commonly used all share the principle of imaging from some kind of negative photo-matrix that holds an assortment of characters in a number of different typeface designs or fonts. Most phototypesetters can hold a number of fonts at one time, and this multiplied by the number of sizes of each typeface that can be imaged by the lens system in the machine, determines the total number of fonts available for mixing in a single machine setup.

Almost all phototypesetters are driven by perforated paper tape produced by keyboards or computers, or supplied by wire services. Several of these machines also can be driven by computer magnetic tape. All the

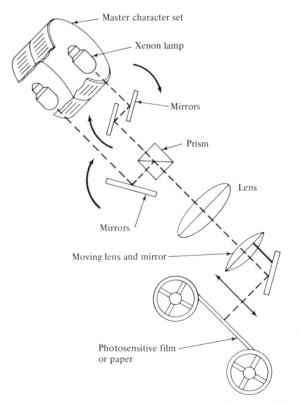

Fig. 18-3. The Photon 713 imaging system. (*Courtesy Frank J. Romano—Handbook of Composition Input*)

tapes require special coding and programming and the paper ones are similar to those originally developed to operate Linotype and Intertype linecasters. The punched tape can be produced by special typewriters or by OCR. The tape can be read and corrected on special equipment using cathode ray tubes (CRT) known as VDT's. The VDT produces a corrected tape with all proper codes for operating the phototypesetter or computersetter.

Character selection in a typical second generation phototypesetter consists of a light source, photo-matrix, and control logic to synchronize the light source and the photo-matrix. The light source is of high intensity and can be continuous or flash. Most use Xenon flash lamps. As the tape is read by the phototypesetter, the control logic actuates the photo unit. The drawing (Fig. 18-3) shows how one kind of photo unit operates. The photo-matrix is on a drum. As the logic unit recognizes the character and font code, it locates it in relation to the light source. At the same time, the logic unit positions the apertures, mirrors, and lenses needed to produce the character in the proper position and size. These operations can be carried out in microseconds, which accounts for the speed of photo and computer typesetting. Exposures can be made on either paper or film and stabilization processing is used. Several phototypesetting machines are designed to use lasers instead of the Xenon flash lamps. These can use low sensitivity papers that eliminate chemical processing as they can be dry-processed by heat.

PROCESS PHOTOGRAPHY

Process photography is the name given to the photographic techniques used in the graphic arts process. Some platemaking processes require negatives and some positives. Some require correct reading on the plate and others reverse reading. The negatives or positives can be line, continuous tone, or halftone.

Any picture or scene consists of a number of different tones or gradations of tones known as continuous tone. In a photographic print these are represented by varying amounts of silver in the print. The more silver the darker the tone, and vice versa. In letterpress or lithography, these tones cannot be represented by varying amounts of ink with a single impression on the press. In order to produce the tones necessary to reproduce a picture, these processes must use the *halftone* principle. This is an optical illusion in which the tones are represented by solid dots which all have equal spacing and ink density but vary in area (Fig. 18-4). These dots are too small to be seen individually at the usual reading distance, but it is possible to see them by close examination of a halftone newspaper illustration or with a magnifying glass.

The dot image is usually obtained by photographing the original through a halftone screen placed either

Fig. 18-4. Halftone tints.

in contact with the film or a short distance in front of it although there are other methods which will be described later. The making of line, halftone, and color separation negatives (see Color) is usually termed process photography.

There are several nonscreen printing processes that can print varying densities of ink and use continuous tone negatives but they are difficult to work with and not widely used. These include conventional gravure, screenless lithography and *collotype*, or *photogelatin*. Conventional gravure and lithography will be described later. In collotype the image consists of reticulated gelatin which prints ink directly in proportion to the amount of exposures from a continuous-tone negative.

Equipment and Materials

Process photography is done on large cameras with suspension systems to eliminate the effects of vibration on the images as long exposures are used in comparison with amateur or commercial photography (Fig. 18-5). Cameras can either be horizontal or vertical. Horizontal types have bed or overhead suspension. Cameras can either be *gallery* or *darkroom* types. Darkroom cameras are by far more popular. In this type the copy board, lens, and bellows are in the camera room while the camera back is usually built into the darkroom wall. Enlargers are also used especially for making color separations for color reproduction.

Lenses for process work are coated to reduce flare and are usually of symmetrical design to eliminate distortion in the images. Because of the requirements for high resolution and minimum aberrations, process lenses have fairly small maximum apertures—from $f/8$ to $f/11$. Optimum apertures for best overall resolution over the whole field are usually about 2 stops smaller than the maximum apertures. Focal lengths range from 8-in. for wide angle lenses for 20-in. cameras to as long as 48-in. for a 40-in. camera. Some cameras use prisms for reversing the image laterally as is required for photoengraving.

The films used consist of special high contrast, usually orthochromatic, emulsions of silver halides in gelatin on stable film base for line and halftone photography, and continuous tone panchromatic film for color separations and masks. Special infectious type formosulphite developers are used for high contrast. A very important and significant trend in recent years has been the increased use of automatic processing machines which are capable of developing, fixing, washing and drying film in less time and with less variation than hand processing.

Fig. 18-5. Diagram of horizontal (bed and overhead types) and vertical cameras. (*Courtesy The Printing Industries of America*)

D log H and time-gamma curves of a typical emulsion for process photography are shown in Fig. 18-6.

Line Photography

Line copy is that which consists entirely of solids, drawings, and text matter. In photography, the copy is placed on the copyboard of the camera; illuminated by high-intensity lights—pulsed xenon, or quartz-iodine (carbon arcs are almost obsolete); and focused to the correct size on a ground glass in the back of the camera. The film is placed on the vacuum back of the camera which is put in place of the ground glass; the aperture is set on the lens; and the exposure is made through a solenoid shutter operated manually using a stop watch, or automatically by a timer or a light integrating meter. Processing produces a negative which is reverse reading on the emulsion side.

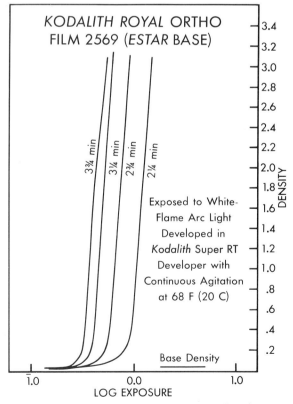

Fig. 18-6. Time-gamma curves for a typical film for process photography (*Courtesy Eastman Kodak Co.*)

Halftone Photography

Henry Fox Talbot in 1852 patented a halftone process in which a "ruled screen on glass or a woven mesh" was placed between the negative and the printing plate during the exposure. The invention of the modern halftone process (1886) using the glass crossline screen, however, is generally credited to Frederick E. Ives of Philadelphia and Max Levy who perfected a way of making the screen in 1891. The crossline screen consists of two sheets of glass, each ruled with parrallel lines which are approximately equal in width to the spaces between them, and cemented together at right angles to one another. The number of lines per inch is termed the screen ruling. Newspapers printed by letterpress commonly use screens with rulings of 65-80 lines while those printed by offset lithography employ screens with rulings from 100-133 lines to the inch. For magazines and much commercial printing by both letterpress and offset lithography, screen rulings normally are between 133-150 lines per inch.

A 133-line screen halftone is just beyond the resolving power of the eye at normal reading distance. Screens with finer rulings are generally used only for printing on semigloss or glossy papers. As a general rule the finer the screen ruling the sharper the rendition of detail in the reproduction. Usually there is little advantage, however, in using a screen finer than 150 lines to the inch for a black and white, or a single color reproduction, because there is a minimum dot size that can be printed in the highlights of the reproduction and, with finer screens, the step from the white of the paper to the first printed dot is too great and tone reproduction in the highlight suffers. This can be avoided, however, by using a *Respi* screen which drops out the intermediate dots in the highlights so a 200-line screen produces highlights equivalent to a 100-line screen while the rest of the picture is similiar to a 200-line screen (Fig. 18-7). In color reproduction the finer the screen the purer the colors because more of

Fig. 18-7. Respi dual dots, with conventional square dots.

the image is covered with ink and the graying effect of white paper is reduced.

Photography With a Crossline Screen

Photography with a crossline screen is done by placing the screen in the back of the camera a very short distance from the film known as the *screen distance* which varies with the screen ruling of the screen. With a 133-line screen it is usually less than ¼ in. or 6 mm. During exposure, each opening in the screen acts like a pinhole and produces diffraction patterns on the film which result in dots proportional in size to the amount of light reflected from the corresponding area of the copy (Fig. 18-8). The lighter the area of the copy, the more light is reflected, resulting in larger diffraction patterns and larger dots. The darker areas reflect less light producing smaller diffraction patterns so the dots are smaller. All dots have the same spacing but vary in area as shown in Fig. 18-4. Good halftone photography with the glass screen requires extreme skill in the operator and precision in the screen mechanism in the camera. Screen distance is very critical as is lens aperture and exposure, as these control the contrast and tone reproduction of the printed result. There are a number of different systems for producing glass screen halftones using different ratios of screen distance to lens aperture, short screen distances, single apertures, multiple apertures, and flashing. In general, shorter screen distances and larger lens openings produce sharper images with higher resolution.

Photography With a Contact Screen

Contact screens are now more widely used than the crossline screen. The contact screen is on film base and is made from a glass screen. It consists of vignetted dot elements with variable density across each dot, all with equal spacing corresponding to the ruling of the glass screen from which it is made (Fig. 18-9). There are gray screens in which the dots consist of the silver images developed in the screen after exposure, development and fixing. There are also dyed screens, usually magenta, in which dye-coupling development is used and the silver in the dots is replaced by magenta dye. In addition, there are special screens such as the

Fig. 18-9. Contact screen.

chain dot screen which has elliptical dots, (Fig. 18-10) and the *Respi* screen in which the highlight dots have double the spacing of the middletone and shadow dots (Fig. 18-7).

Photography with a contact screen is much simpler and much less skill is required than photography with a glass screen. The screen is placed in contact with the film. Because of the variable density across each vignetted dot in the screen, the dots on the film in contact with the screen vary in size according to the amount of light reflected from the copy. The contrast of reproduction can be varied within limits by techniques known as *flashing* and *no-screen* exposures. Flashing is done by giving the film an overall exposure through the screen using a yellow light. The *no-screen* exposure is made by removing the screen during a short part of the exposure to the copy. With dyed screens there is additional control of contrast by using different colored filters during part of the exposure.

Contact Printing

For some processes contact negatives or positives are needed. These are made by placing the negative over an unexposed film, usually colorblind, in a vacuum frame in which contact between the film is maintained by exhausting the air between a plate covered

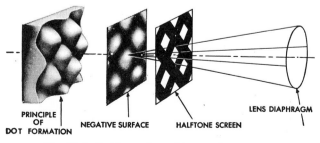

Fig. 18-8. Dot formation with crossline screen.

Fig. 18-10. Chain dot halftones.

with a ribbed rubber blanket and a sheet of flawless plate glass. When the films are placed emulsion to emulsion, the image on the positive will be straight reading. If the positive needs to be reverse reading as for the *deep etch* and some of the *bimetal* plate-making methods of lithography, the negative is placed so that its emulsion side is away from the emulsion side of the unexposed film. A point source of light is used for the exposure, which is timed accurately, and the development is controlled with targets like the GATF Sensitivity Guide, Star Target, and Dot Gain Scale.[3] Contact printing techniques and equipment are also used for making color separations and masks.

Other Methods of Making Halftone Images

The simplest way of producing halftones is with pre-screened film such as Kodak Autoscreen Ortho Film. When this is used properly in an ordinary camera, a 133-line halftone negative is produced directly without the use of a screen. Two exposures are necessary: (1) a detail exposure to the copy, and (2) a flash exposure with a flash lamp all over the film. The detail exposure produces different size dots according to the amount of light reflected from the copy. The flash exposure is to ensure that the inertia of the film is overcome and a dot is produced all over so that there will be adequate detail in the shadows. Autoscreen film requires less exposure and is capable of higher resolution, especially of type images, than glass or contact screens.

There are two other methods for producing screened prints directly in the camera. One is to use Kodak PMT Negative paper with a contact screen. After exposure in the camera, the PMT Negative paper is placed in contact with a Kodak PMT Receiver Paper and processed in a special diffusion transfer processor. The product is a screened print in the screen ruling of the contact screen used.

Another method is to use the Polaroid MP-3 Copy Camera System. This system comes with a selection of four screens, a special aperture control, and a high contrast print film which produces 4 × 5 in. screened prints in 15 sec. This system also uses diffusion transfer to produce a positive correct reading halftone in the screen ruling of the screen selected.

Screened prints are useful for pasting up with other copy to make a complete mechanical layout that can be photographed as a line shot in the camera thus eliminating the need for stripping the halftone negatives. This technique is used for printing newspapers, house organs, school annuals, and other types of work which contain many halftones where the quality requirements are not very critical.

Tone Reproduction in Halftone Production

Tone reproduction and *contrast* are two important conditions that determine the quality of the reproduc-tion. If a stepped gray scale is considered (as in Fig. 18-4) *good tone reproduction* in halftone photography is achieved when the darkest area of the subject (shadow) prints as a solid on the press sheet and the lightest area (highlight) as a white with no evidence of a screen in either tone. The intermediate tones of the gray scale should have varying sizes of dots from about a 2–5% dot area in the highlight end to about an 80–95% dot area in the shadows, with a checker-board pattern in the 50% middletone area. The minimum printable dot sizes depend on the conditions of print-ing and whether the printing is on smooth or rough papers—the smooth coated paper giving the longest scale and range of dot sizes when printed properly. These also determine whether the negatives or positives should have pinpoint dots in the highlights and shadows which disappear or fill-in during printing.

High contrast exists when two or three steps in the shadow end print solid and/or several steps in the highlight end print white with a corresponding increase in density difference or gamma between the other steps of the scale. In glass screen photography con-trast can be deliberately increased by making part of the exposure with a large lens aperture. In contact screen photography contrast can be increased with the *no-screen* exposure, turning the screen over and shooting with the back of the screen in contact with the film emulsion, and, with magenta screens, making part of the exposure through a magenta filter like the Wratten No. 33.

When the deepest blacks contain 80%–90% dot area and/or the highlights 10–20% dot area with reduced density differences in the rest of the scale, the reproduc-tion has low contrast. When a crossline screen is used, contrast can be reduced by using smaller apertures throughout the exposure or flashing to a white sheet over the copy or a flash lamp which exposes a screen pattern all over the film independent of the image. With a contact screen, contrast is also reduced by flashing, but with an overall exposure of the film through the screen using a yellow light. Contrast can be lowered even further with magenta screens by making part of the exposure through a yellow filter like the Wratten No. 12. With Autoscreen film, PMT and the Polaroid system contrast can also be affected by changing the exposures.

STRIPPING OR FILM ASSEMBLY

After the films are all completed for a job, they must be opaqued to remove pinholes and other unwanted defects and assembled into a form so that they can be exposed onto a plate. This is a tedious and time-consuming job and is often a serious bottleneck in production.

In stripping for photomechanical plates, the imposi-tion is done on a *flat* with film taped into position on a sheet of colored masking (goldenrod) paper or on special orange plastic sheets if color or close register is involved. When all the film is in place, the stripper cuts windowed

spaces from the masking sheet, permitting light to pass through the film during exposure to the plate. The stripper also puts together all elements of a page if they are in separate pieces. If positives are needed for the platemaking process a contact exposure is made of the flat film.

Step and Repeat

When a large printing is required of a relatively small label, a matchbook cover, a wrapper for a tin can and the like, press time is saved by combining a number of duplicate negatives or positives on a plate. This is done oridinarily with a *step and repeat* machine. A step and repeat machine produces multiple images of negatives or positives on a printing plate according to a predetermined layout. It consists of a bed for mounting the plate; a chase for mounting the film; means for traversing the chase accurately in the X and Y directions; a high-intensity lamp like pulsed Xenon or metal halide for exposure, and an integrating device for controlling exposure.

Some step and repeat machines have devices for advancing the chase in the X and Y directions automatically using programmed punched tape or punched cards. Some are also equipped with special programmed film cassettes that operate completely automatically by rejecting one film after all the exposures with that film have been completed and picking up the next film for continuing the exposures on the plate. Automatic step and repeat machines are useful in book production where the negatives are programmed in advance for exposure in the proper position on the plate.

Projection Stripping

The latest development in stripping is reducing the images 2×–8× on the negatives, programming them and projecting them back to correct size on the plate in the proper order and correct position for printing. In such systems, stripping of repetitive subjects as in packaging, and layouts as in book printing, can be speeded up and appreciable savings in the cost of film can be made. At 1/3 reduction, the saving in the film is about 67% and at 1/8 reduction the saving is 88%.

Up to 1/8 reduction, there is little loss in the quality of line or text images. Highlight and shadow dots in fine screen halftones, however, are lost, so the system is only useful, at present, for line work or reductions not greater than 1/4. Reprojection of the images also poses several other problems. There are presently two systems in use. (1) Use of quartz optics which transmit UV light and exposure onto conventional diazo presensitized plates. There are not many projectors using quartz optics and these are expensive. (2) Use of regular optical systems and projecting the image onto special projection speed photographic plates like Kodak Verilith which are not available in large sizes. The new Kodak PMT process offers considerable promise. In this process, the exposure is made onto PMT Negative paper which is then transferred to a specially coated grained anodized aluminum printing plate in a special diffusion-transfer processor. Quality is good and plate life is expected to be about 25,000 impressions.

PLATEMAKING

Each printing process uses a plate, or some form of image carrier, which transfers the image to the paper during printing. With the exception of handmade stencils for screen printing and some steel die engraving, hand and machine set cast-metal type which are still used for some printing by letterpress, most image carriers are made by photomechanical means. The plates used for letterpress printing are made by *photoengraving* or *photopolymer* processes. The plates used for lithographic printing can be *surface*, *deep etch*, or *bi-metal* depending on the length of the press run. Gravure plates or cylinders can be *conventional, direct transfer* or *variable area— variable depth.*

Light Sensitive Coatings for Photomechanical Plates

The history of photomechanical plates is a long one beginning with Niepce in 1824, but all practical processes have been developed since 1880. Photomechanical plates are possible because of the use of light sensitive materials or coatings which change in physical properties after exposure to light. Most of the materials in use change solubility in water, or other solutions, so that the unexposed areas dissolve and leave the exposed portions to serve as the image or a stencil, or resist, for forming the image. The most important types of coatings in use include bichromated colloid, diazo, and photopolymer. Silver halide, and electrostatic coatings are also used for special purposes especially in duplicating.

Bichromated Colloid Coatings. Bichromated coatings date back to Poitevin in 1855. Until 1950, practically all the coatings used for photomechanical plates were bichromated colloids. Some are still in use. The bichromate is usually ammonium bichromate, but potassium bichromate is sometimes used to sensitize gelatin for the collotype process and carbon tissue for gravure. The colloids in use for photoengraving are shellac, glue, albumin, and polyvinyl alcohol (PVA); for lithography, albumin, casein, alpha protein, PVA, and gum arabic; and gelatin for gravure tissue, screen printing and collotype. The coatings are usually applied to the metal plates in a machine called a *whirler* which spreads the coating over the plate as it rotates.

While bichromated colloids have been known and used for a long time, their use requires considerable skill and judgement since their light sensitivity is affected by a number of factors including temperature, relative humidity, pH and coating thickness, which, itself, is affected by surface roughness or grain of the plate,

relative humidity, rate of application of coating, coating temperature and viscosity.[4] Because of the difficulty of controlling these factors, there has been a definite trend away from the use of bichromated coatings and toward the use of presensitized and precoated plates for all processes.

Diazo Coatings. Diazo coatings used for presensitizing lithographic plates were introduced about 1950.[5] They are also used for lithographic wipe-on plates, in which the coating is wiped on with a sponge or applied on a simple roller coater instead of using a whirler. Diazo coatings are applied to relatively smooth or very fine-grained pretreated or anodized aluminum surfaces to prevent a reaction with the metal. The usual pretreatment with a silicate also renders the metal receptive to water. Anodized surfaces are more effective and longer lasting. The diazo coatings are thin, so they are susceptible to abrasive wear on the press. For this reason these plates are not suitable for long runs. There are some pre-lacquered plates and also plates that are heated in an oven during processing which have better resistance to abrasion and these are used for runs in excess of 100,000.

Most diazo plates are for use with negatives. (There are some that can be used with positives and some diazos are used to sensitize other colloids for positive plates. Diazo coatings are also used to presensitize deep-etch and bi-metal plates.) The main advantage of diazo coatings is that under normal conditions of use they are not affected appreciably by temperature and relative humidity so that they have a storage life of about a year. Exposure to temperatures above 125° F can permanently damage plates and cause them to scum, or take ink in the non-printing areas. Also diazo coated plates can be processed in processing machines which speed up plate-making and make results more consistent, as in photography where automatic processors are used extensively.

Photopolymer Coatings. Semantics in platemaking has become quite garbled with the introduction of so many new photosensitive systems which are all being referred to as *photopolymer* plates. Leonard and Traskos[6] suggest the following terminology for the photoreactions in present-day platemaking: *photopolymerization; photocrosslinking; photorearrangement;* and *photo-degradation.* It is difficult to apply these terms properly to the commercial products in use without a careful study of the patent literature and sufficient knowledge of the product to identify it with particular patents. In this text some products will be called photopolymers which should be identified as others because of lack of information about the product. In general, organic soluble coatings, like Kodak Photo Resist (KPR) which contains cinnamic acid esters and is used for all three major printing processes and for printed circuits, are of the photocrosslinkable type. Many of the other polymer coatings used in letterpress and lithography contain methacrylates, polyamides, and polyurethanes and most of these are photopolymers. Some new lithographic plates made from positives are of the photorearrangement and photo-degradable type.

The main advantage of photopolymer and other photosensitive plates of these types are their abrasion resistance and insensitivity to changes in temperature and relative humidity so that they have good wear characteristics in printing and long shelf life in storage before use. Some have good solvent resistance for use in processes like flexography that use solvent inks.

Photoengraving Platemaking

The plates used for letterpress printing can be *original, duplicate,* or *wraparound. Original plates* are made on zinc, magnesium or copper of about 16 gage or 0.065 in. (1.65 mm) in thickness. There are two general types of engravings, *line* and *halftone.* In the U.S., original line engraving plates are made on zinc and magnesium and original halftone plates are made on copper. Some aluminum is also used. In Europe zinc and magnesium are used for both types of engravings. Negatives are used and they must be straight reading on the emulsion side as the image on the plate must be reverse reading for direct printing on the paper.

Duplicate plates are plastic, rubber, stereotypes, or electrotypes, depending on the materials used and the mold from which they are made. Most original and duplicate plates are made in small pieces or page sizes for assembly onto a form or the printing cylinder of the press.

Wraparound plates are made in one piece to be wrapped around the plate cylinder of the press. All the copy is in the proper position for printing reducing the time for set-up or *makeready* as it is called. The plates are plastic or metal from 0.017 in. (0.43 mm) to 0.030 in. (0.76 mm) in thickness so they can be bent to fit into the cylinder clamps and conform to the cylinder during printing. Most wraparound plates are used for offset letterpress or letterset printing. All lithographic plates and gravure plates for sheet-fed gravure are wraparound plates.

Conventional Etching. The sensitizers used in conventional photoengraving are bichromated coatings usually bichromated shellac for zinc and magnesium and bi-chromated glue for copper. After the plate has been coated, exposed and processed, the metal in the non-printing areas is removed by chemical etching and mechanical routing in the large areas. Nitric acid is used to etch zinc and magnesium, and ferric chloride solution is used for copper. Depth of etching can vary in 133 line halftone engravings from 0.0014 in. (0.036 mm) in the shadows to 0.0029 in. (0.074 mm) in the highlights; and on line engravings from 0.020 in. (0.50 mm) for a high finish paper to 0.040 in. (1 mm) for flexographic printing on rough papers like the liner for corrugated board.

The main problem in conventional etching is to maintain the correct dot and line width at the proper etch depth. This is done by *scale compression* in the negative and by *four-way powdering.* Much larger dots are left in the highlights on the negative to compensate for the lateral etching that reduces the size of the highlight dots, but it is difficult to control middletone and shadow dots

Fig. 18-11. Principle of powderless etching. (*Courtesy Gravure Research Institute, GRI*)

this way. Four-way powdering is done with acid resistant materials like *dragon's blood* (a form of bitumen) which is baked in an oven to protect the sides of etched image elements from attack by the etch. This is a manual operation that is time consuming and requires considerable skill and judgement. Until recently all photoengravings were made using these techniques. Since the advent of *powderless etching* these methods are rarely used[7] and are practically obsolete.

Powderless Etching. In this method, the plate is prepared as in the conventional process, but a special etching machine is used and the etching bath is an emulsion consisting essentially of nitric acid, dioctylsodium succinate, diethylbenzene, gelatin and a wetting agent that continuously applies an acid resistant coating known as a *banking agent* to the sides of the image elements to control sidewise etching and depth of etch (Fig. 18-11). The first system was developed for magnesium and was adapted for use on zinc. A mechanically similar system has been developed for copper.[8] In this system, ferric chloride is the etchant and one of the film forming additives used is formamidine disulfide. These systems can be used for wraparound plates as well as original plates.

Photopolymer and Other Plates for Letterpress Printing

The photopolymer plates are precoated and can be used as original or direct and wraparound plates. There are a number of these plates in use and in development. Two examples in general use are the DuPont Dycril® plate and the BASF Nyloprint® plate. At the present time, the Nyloprint® plate, on a steel base and mounted on magnetic cylinders, is the most popular plate used in letterpress for magazine and commercial printing.

Two photopolymer plates used extensively in newspaper printing are the W. R. Grace *Letterflex®* plate and the *Dynaflex®* plate. Over 200 daily newspapers are using these plates either exclusively or experimentally. The Letterflex® plate is also used almost exclusively on the Cameron belt press which prints complete books in one pass through the press, eliminating the present practice of printing large signatures which need to be folded, stored, or stacked, and later collected or collated into the final book.

Letterflex® plates consist of a liquid unsaturated photosensitized polyester, which is coated in a special machine on a polyester sheet, exposed to a negative and processed in the same machine. The Dynaflex® plate consists of a dry prepolymer photosensitized coating which must be kept under refrigeration until exposure. During exposure in contact with a negative the image areas are polymerized and hardened and the nonimage areas are removed by development in water.

During the past several years, six new Japanese photopolymer plates have been introduced for direct letterpress printing as well as a plastic molded plate. The new Japanese plates are the Sonne *KPM #2000*, which is a photosensitive polyurethane resin layer bonded to a steel base; the *Napp®* plate, which is a denatured polyvinyl alcohol bonded to steel or aluminum; the *APR* plate, which is an unsaturated polyester liquid, like the W. R. Grace *Letterflex®* plate; the *Toplon* plate, which is a solid polyamid material bonded to a tin plate or aluminum; the *Tevista* plate, which is also a liquid polyester but is bonded to a metal base after processing; and the *Torelief* plate, which is a solid nylon material mounted on aluminum or steel. The Napp® plate is manufactured and marketed in the U.S. by Napp Systems, a joint venture of Nippon Paint Company, Ltd. (Osaka, Japan) and Lee Enterprises (Davenport, Iowa) which is marketing the plates to a number of newspapers. The APR plate is made and known in the U.S. as the *Merigraph®* plate and is marketed by Hercules, Inc. (Wilmington, Delaware) to a number of newspapers. The Japanese have also developed a new plastic molded relief plate known as *Asahi Rollflex* which is polypropylene that can be molded from specially treated ordinary stereo mats. It has one hundredth the weight of conventional stereos and should allow 30% higher press speeds on newspaper presses.

Duplicating Plates

Original photoengravings can be used directly for printing. Generally, however, the original plates are used to make molds from which duplicate plates are made for the actual printing.[9] This is desirable for long runs and is necessary where the plates are made on flat metal and the printing plates need to be curved for mounting on the cylinders of rotary presses. Also the original and mold are always available in case printing plates are damaged. The four types of duplicate plates in use are *stereotypes*, *electrotypes*, *plastic*, and *rubber* plates.

Stereotypes are used almost exclusively for letterpress newspaper printing. A matrix, or *mat* as it is called, is made from the original plate using a special papier-mâché and the printing plate is cast by pouring molten metal into the mold. For long runs the plates can be nickel or chromium plated. Once the mat is made, duplicate plates can be made in less than a minute and at costs under a dollar per square foot. For economical substitution of direct photopolymer plates for newspaper printing they

must compete with these time and cost schedules. In newspaper printing, the presses are seldom run over two hours in which time about 100,000 newspapers are printed. If more papers are needed, more presses are used.

Electrotypes are used for high quality letterpress, commercial, book and magazine printing. An impression is made of the original engraving in hot plastic which is plated with silver to make it conductive, after which a thin shell of copper or nickel is plated by an electrolytic process. The shell is backed with molten metal and the face can be nickel or chromium plated for long runs up to several million.

Plastic and rubber plates have the advantage of lightness in weight and low cost. They are made from molds similar to those used for electrotypes. Plastic plates are molded from thermoplastic vinyl resins and are used for some types of commercial printing. Rubber plates are molded from either natural or synthetic rubber or combinations of them depending on the solvents used in the inks for printing. Rubber plates are used exclusively in flexography for printing envelopes, bags, tags, wrapping paper, corrugated boxes, milk cartons, etc., where the resilience of the rubber is of help in printing on the relatively rough surfaces. It is also used for printing on extensible films for flexible packaging on special central impression presses. Paperback books are printed from rubber plates, but the process is essentially letterpress as oil base inks are used instead of the solvent inks used in flexography.

Gravure Plate and Cylinder Making

Printing Surfaces. Modern gravure printing is done principally on web presses from images etched in copper plated cylinders, and is generally referred to as rotogravure. These cylinders can vary from 3 in. in diameter by 1 in. wide for printing special labels to 17 or 18 ft wide by 3 ft in diameter for printing floor coverings. Magazine presses range from 6 to over 8 ft wide. On sheet-fed presses the printing element is a thin copper plate wrapped around the cylinder. Preparation of the printing surface is essentially the same for both cylinders and plates.

There are three different types of systems used for gravure: (1) conventional, (2) direct transfer or variable area, and (3) variable area—variable depth (Fig. 18-12).[10]

Conventional Gravure. For printing by conventional gravure, bichromate-sensitized carbon tissue or special photographic transfer film is used as an etching resist. It is first contact printed through a continuous-tone positive, and then given a second exposure in contact with a screen consisting of transparent lines and dots, 150 or 175 to the inch. The ratio of line to dot width is usually 1:3. The exposed carbon tissue or transfer film is then moistened and squeezed into contact with the clean copper surface of a copper plated cylinder or a copper plate. Warm water is applied and the paper of the carbon tissue or backing of the film is peeled off. The gelatin thus transferred to the copper surface is further developed with warm water to produce a gelatin relief resist. Etching is done with 37–45° Be (35–43%) ferric chloride solutions. These solutions etch the copper to different depths, depending on the thickness of the gelatin resist in the different tone areas. Solutions of different densities are generally used to control etching times and depths. The areas corresponding to the screen lines remain unetched and provide "lands" to support the doctor blade in printing. For long runs, the etched cylinder or plate is chromium-plated to resist wear.

Direct Transfer. In the *direct transfer* or *variable area* process a special halftone positive is made with a lateral dot formation which is similar to conventional gravure in the shadows, but with varying dot sizes in the other tones as in letterpress and lithography. This is contact printed directly onto the copper cylinder previously sensitized with a photopolymer of the cinnamic ester type. This is why this type of gravure is usually called a direct transfer process. After being etched, the printing surface consists of disconnected ink cells of varying size but approximately the same depth. These cylinders have a limited tone scale and are used mainly for packaging.

Variable Area-Variable Depth Gravure. For multicolor printing in the United States, especially for catalog, magazine, and newspaper supplement printing, the principal process consists in making both special halftone positives, as in direct transfer gravure, and a continuous-tone positive as in conventional gravure for each color. These are contact-printed successively, in register, onto a sheet of carbon tissue or transfer film, and the gelatin is transferred to the copper cylinder as in the conventional process. In publication printing, the resists are usually transferred in page sizes. Development and etching are essentially the same as for conventional printing cylinders. The printing surface thus consists of disconnected ink cells of varying size and depth corresponding to the tone desired. The tone scale is between that of conventional and direct transfer gravure.

Other Methods

One serious problem with gravure cylinder-making has been the difficulty in reproducing cylinders from the same originals. This is due to differences in materials, etching solutions, impurities in the copper, environmental conditions and other factors affecting bichromated colloids or silver halide chemistry. Other methods have been developed to try to control the tone reproduction

| Conventional Gravure | Variable Area Variable Depth | Variable Area (Direct Transfer) |

Fig. 18-12. Three types of gravure cylinders. (*Courtesy Pocket Pal, International Paper Company*)

Fig. 18-13. Diagram of an electromechanical engraver. (*Courtesy Gravure Research Institute*)

of gravure cylinders. These have included controlled etching, powderless etching, similar to that used in etching copper photoengraving plates, and electromechanical engraving. Of these the latter has been the most successful.

The Hell *Helio-Klischograph* is an example of electromechanical engraving (Fig. 18-13).[11] It scans a copy and signals from a photoelectric pick-up are used to actuate an electromechanically driven diamond stylus that cuts pyramidal shaped cells into the surface of the copper cylinder at the rate of 4000 cells a second. Multiple scanning heads and styli can be used so that large cylinders can be made in less than an hour. Research is also being done with lasers and with electron beam etching which is capable of speeds ten times those of electromechanical engravers or about 40,000 cells per second,[12] but these will take some time before they are developed for practical use.

Lithographic Platemaking

Lithography dates back to about 1800 when Senefelder discovered that if he drew characters on smooth Solenhofen limestone with a greasy crayon and dampened the surface with gum water, he could repeatedly ink the design and pull impressions on paper.[13] Stone was replaced by metal about 1900. On a lithographic plate the separation between image and nonimage areas which are essentially on the same plane, must be maintained chemically by the principle that grease and water do not mix. The image area on a lithographic plate must be ink receptive and refuse water; the non-image area must be water receptive and refuse ink. Actually grease and water do mix to a small extent. If they did not lithography would not be possible. If they mix too much there are problems. The wider the difference that can be maintained between ink receptivity of the image areas and water receptivity of the nonimage areas, the better the plate will be, the easier it will run on the press, and the better printing it will produce.

Ink receptivity is achieved by use of the inherently oleophilic (oil-loving) photosensitive resins like diazos, cinnamic ester resins or other polymers; vinyl or epoxy lacquers and/or copper or brass on the image areas which is oleophilic in the presence of phosphate and nitrate ions which are usually used in the fountain solutions on the presses. Water receptivity of the non-image areas is regularly achieved by the use of inherently hydrophilic (water loving) metals like aluminum, chromium, or stainless steel and treating them with silicate and/or phosphate ions. Properly treated anodized aluminum has especially good water receptivity in addition to good wear characteristics on the press.

The water receptivity is maintained in platemaking and printing by the use of natural and synthetic gums. The most widely used gum is gum arabic. Synthetic gums are being produced that are more consistent in properties than the natural gums presently used. The gums are modified in dilute solution with phosphate, nitrate and bichromate ions and are maintained at a pH value of about 2.0 as a plate desensitizer, or "etch" as it is called, and at a pH value of between 4.5 and 5.0 as a fountain etch for dampening the plates on the press.

There are a number of types of lithographic plates and different processes by which they are produced. Plates are classified as *surface*, *deep-etch*, and *bimetal*. *Surface plates* are those in which the light sensitive coating eventually becomes the ink-receptive image area on the plate. *Deep-etch plates* are those in which the coating is removed from the image areas and these are then chemically coppered and/or lacquered and inked so that they are ink receptive. *Bimetal plates* are similar to deep-etch plates in that the coating is removed from the image areas, but these areas consist of copper or brass either as a base metal or copper electroplated on another metal. The base metal for surface and deep-etch plates is almost exclusively aluminum. Zinc, stainless steel, and monel metal have been used but these are practically obsolete now. There are two types of bimetal plates: Type I in which copper is plated on stainless steel or aluminum; and Type II in which chromium is plated on copper or brass which can be the base metal or on copper which can be plated on zinc, aluminum, stainless steel, or mild steel as the base metal.

Since most lithography is done by the offset process, the plates must be straight reading so the films used for making them must be reverse reading on the emulsion side. In platemaking, it is important that the emulsion side of the film face the emulsion of the plate during exposure or undercutting of the light will occur causing sharpened images (smaller dots) on deep-etch and either sharp or spread images on bimetal plates depending on whether the plates are made from positives or negatives.

In the United States, about 65% of the plates are surface, 30% are deep-etch and the remainder are bimetal. This does not include the plates used for office duplicating or reprography which are mostly surface plates. In Europe the story is quite different. In England, about 80% of the plates are deep-etch on anodized aluminum; about 15% are surface; and the remainder are bimetal. On the continent about 30% of the plates are bimetal; about 60% are anodized deep-etch and the remainder are surface plates. The reasons for the preferences are not known for sure but, platemaking being more of an art than a science, they could be associated with the types of plates that were most popular in the particular areas at the time

when industry converted from zinc based plates which were almost universally used before 1950.

Most surface plates are made from negatives. A few are made from positives. Until recently all surface plates were for short and medium runs up to about 100,000 impressions. All deep-etch plates are made from positives and they are capable of runs up to about 400,000. Type I bimetal plates are usually made from negatives, but there are some processes for making them from positives. Type II bimetal plates are always made from positives. Bimetal plates are the most durable of lithographic plates and are capable of runs of over a million impressions.

One of the big advantages of the lithographic process is the ease with which corrections can be made on the plates. Images can be readily added or deleted on all types of plates without extensive and intricate hand tooling as is required on letterpress plates and gravure cylinders. Plates are less expensive than for other processes. Also, automatic processors exist for every platemaking process or plate.

Surface Plates. Until the advent of presensitized metal plates practically all surface plates were zinc, coated with bichromated albumin or bichromated casein. These plates are now obsolete. They have been replaced by diazo presensitized and wipe-on plates which are used for runs up to about 75,000 impressions. There are also pre-lacquered diazo presensitized surface plates which are capable of runs in excess of 100,000.

Diazo presensitized and coated wipe-on plates are easy to process. After exposure to negatives they are treated with a developer which consists of a lacquer and a gum etch in acid solution. As the unexposed diazo is dissolved by the acidified gum, the gum deposits on the non-printing developed areas ensuring their water receptivity and lacquer deposits on the exposed images. After rinsing with water, the plate is gummed with a gum arabic type solution. These are known as *additive* plates as the lacquer or image material is *added* to the plate.

Prelacquered plates are developed with a special solvent, washed and then gummed. These are known as *subtractive* plates as the unexposed areas in the case of negative plates are removed or *subtracted* in the special solution which leaves the exposed prelacquered image intact. Plates made from positives require extra steps as the unexposed portions eventually become the printing image which must be stabilized while the exposed areas are removed and desensitized.

Some diazo sensitizers have a rather long scale of reproduction and plates sensitized with these coatings are used with continuous tone negatives or positives for screenless lithography. The process, however, is critical to carry out and is not used much.

Other surface plates are of the photopolymer type. Most are made from negatives. Plates of the organic soluble type are made with cinnamic esters of epoxy resins. Polymer type plates are characterized by better abrasion resistance and longer life on the press with runs of over 250,000 impressions.

Deep-etch Plates. There are several presensitized deep-etch plates, but by far the majority of these plates are made using grained aluminum plates and bichromated gum arabic coating. Most deep-etch plates in England and on the European continent are made on anodized aluminum. The most popular plate in the United States is the "copperized aluminum" plate, in which the image areas are copperized chemically during the plate-making process. Anodized aluminum plates cannot be chemically copperized.

The procedures for making deep-etch plates are rather involved and require considerable skill and judgment. After the plates are thoroughly cleaned, coated and dried, they are exposed to positives. The film edges, unexposed borders, and other areas that are not to print are post-exposed or painted over with a special lacquer. When the post-exposure is complete or the lacquer is dry, the plates are developed in a special developer consisting of an organic acid like lactic acid in an almost saturated salt solution of calcium or magnesium chloride which dissolves the unexposed bichromated gum arabic corresponding to the image areas. After this is all removed, the plate is treated with a deep-etch solution consisting of ferric chloride in calcium chloride solution which dissolves some of the metal in the image areas. The plate is cleaned thoroughly with anhydrous alcohol and the image areas chemically copperized with a solution of cuprous chloride in alcohol. After the copper is deposited, the plate is cleaned again with alcohol and a thin film of a special vinyl lacquer is applied all over the plate and dried. A liquid greasy ink is also applied and dried after which the plate is soaked in warm water (about 100° F) until the gum stencil on the nonimage areas softens. This is scrubbed off with a bristle brush. After the plate is thoroughly cleared of the gum stencil, a gum etch is applied to render the nonimage areas more water receptive, after which gum is dried on the plate to protect it from damage due to handling.

The plate then consists of image areas which have copper, lacquer and ink on them, and nonimage areas which are densensitized and protected with gum arabic. The making of anodized aluminum deep-etch plates is similar except special chemicals and lacquer are used and the plates cannot be copperized. A number of suppliers have developed simplified deep-etch processes in which the deep-etching and alcohol rinsing steps have been eliminated, cutting the platemaking time almost in half.

With targets like the GATF Sensitivity Guide, Star Target, and Dot Gain Scale,[3] the tone values on these plates are reasonably easy to control. Also the plates themselves have rugged images and are well desensitized so they are preferred for color reproduction runs in excess of 50,000 to 75,000 impressions. Up until the introduction of photopolymer plates, deep-etch plates had undisputed claim to all medium and longer runs up to about 400,000 impressions. Some plates have run well over a million impressions. They are consistently dependable for the medium run field. Some positive presensitized plates of the photodegradable type have been developed which are commanding some of the deep-etch plate market.

They are easy to make and give runs up to and exceeding 250,000 impressions.

Bimetal Plates. These are the most rugged and also the most expensive of the lithographic plates, but they are capable of runs in excess of a million impressions so the increase in cost is not significant when they are used on long runs. As already mentioned, there are two types of these plates in use.

Some Type I plates are presensitized but most bimetal plates are inplant coated. The materials and processing are similar to the deep-etch process. The major differences are: (1) an actual metal etch is used in place of the deep etching step and (2) the copper is sensitized to take the ink. On the Type I plate the copper must be removed from the nonimage areas of the plate. It is done with a solution of ferric chloride on the stainless steel based plate and ferric nitrate on the aluminum based plate. In the Type II plate after development the chromium must be dissolved from the image areas with solutions of hydrochloric acid in other chemicals.

Driography. Driographic plates are planographic plates in which the image areas consist of ink and the nonimage areas are silicone rubber.[14] No water is needed. The silicone rubber has a low surface energy so it does not wet by ink. The process, however, requires a special ink since under the pressure of printing ordinary lithographic ink spreads over the silicone rubber causing scum or *toning* as it is called. The special ink has lower surface energy and high cohesive forces which also result in higher separation forces or tack. It works fine for several hours on a press until the rollers heat up and the ink breaks down which causes toning.

If and when this problem is solved, Driography can be the most important innovation in printing in the past half century. It does away with all the disadvantages of lithography caused by the need for the ink-water balance, but retains all its advantages of low plate costs, ease of makeready, high speed, and good print quality. It also eliminates the disadvantages of slow makeready and differential pressures of letterpress while retaining its advantages of ease of printing and low waste.

The answer to eliminating the problems of Driography may be the formulation of new inks, and it could be as simple as water cooling the ink rollers on the press. A run of over 90,000 impressions has been made using these plates on a web press at Rochester Institute of Technology which has water-cooled ink vibrator rollers.

Handling Lithographic Plates on the Press

Bimetal plates are the easiest plates to run on the press because they are almost indestructible. If anything happens to the plate on the press, it can be fixed relatively easily as a single treatment usually restores it to its proper printing condition. If the copper refuses to take ink (blinds) and/or the nonprinting area, whether it is chromium, stainless steel or aluminum, takes ink (scums) a treatment with about 5% phosphoric acid usually renders the copper ink receptive and the nonimage metal

water receptive. Sometimes a treatment with nitric acid is also necessary. But the important feature of bimetal plates is that the one treatment restores the image and nonimage metals to their respective receptivities and maintains them when phosphate and nitrate ions are used in the fountain solution on the press.

With other types of lithographic plates, the treatments used on the press to help one area are generally injurious to the other area. Treatments to make the image more ink receptive are apt to cause the nonimage areas to scum if the pressman is not careful. Treatments designed to make the nonimage areas water receptive are apt to blind the image areas.

Screen Printing

There are many methods for making screens for screen printing. As already mentioned, the screen is porous and the image is produced by blocking the pores in the screen in the nonprinting areas. This can be done manually by cutting out templates and mounting them to the screen. It can be done photomechanically by coating the screen with a sensitizer, exposing a positive so the nonprinting areas are hardened and developing out the image areas. It can also be done by using a material like carbon tissue, or special transfer film as used in gravure and transferring these to the screen instead of the copper cylinder, and then washing out the unexposed areas which represent the image.

Rotary Screens. The latest method is rotary screens which are made by plating the cylinder electrolytically on a steel cylinder, removing the plated cylinder, applying a photomechanical coating to it, exposing it through a positive and a screen and etching out the image areas to form pores in the cylinders. On rotary screen presses the ink is pumped into the cylinder and the squeegee is also inside the cylinder.

Electrophotographic Plates

For duplicating, or *reprography* as it is called, some printing systems use plates made by electrophotographic means. One is the *Xerox* method which uses a selenium plate or drum. The other method uses the *electrofax* principle in which zinc oxide or an organic photoconductor is dispersed in a binder and coated on paper or metal. In both methods the plate or drum is charged with a corona discharge and exposed in a camera to produce the printing image. Toner is applied to the exposed plate and in the case of selenium, the image is transferred to a paper or metal plate. After development, the toner on the image is fixed by heat or solvent vapor and the nonimage area is treated with a special fountain solution which contains a ferrocyanide in the case of an electrofax zinc oxide plate to make it water receptive. There are a number of *Copier/Duplicators* on the market that use this type of plate to print from.

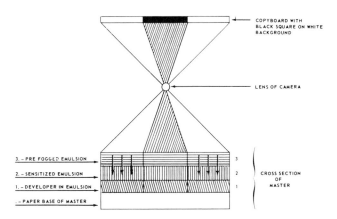

Fig. 18-14. Relationship of copy, lens, and master in a typical direct photographic platemaking unit. (*Courtesy Addressograph-Multigraph Corp.*)

Other Plates for Reprography

Direct image plates can be prepared by typing, drawing or lettering directly onto a paper master. Special ribbons, pencils, and inks are used. Although inexpensive and easy to make, these plates are limited in quality and are used only for short runs.

There are two types of *silver emulsion plates* used for reprography. One is the *3M Camera Plate System* in which the plate is made directly in the camera, processed and mounted on the press. Several plates are available for different run lengths.

The other is based on the Kodak *Verilith* plate which consists of two photographic emulsions, one of which is fogged and a third coating containing photographic developer coated on a paper base (Fig. 18-14). During exposure the light from the white portions of the copy penetrates the fogged layer to the second emulsion while the black image area does not produce any exposure. After exposure the plate is placed in an activator solution that activates the developer which diffuses through the adjacent photographic emulsion developing the silver where it was exposed. The developer is exhausted in these areas so the top fogged layer does not develop whereas the developer penetrates the second emulsion layer in the image areas which did not expose and develops the silver in the fogged layer corresponding to the image areas. After fixing, the developed areas in the fogged layer are ink receptive, while the undeveloped areas remain water receptive. The plate has a rather ticklish ink-water balance, but it is used extensively as the basis for the Itek *Platemaster*, Addressograph-Multigraph *Photo-Direct* and the A. B. Dick *Photomat* systems and has produced runs in excess of 10,000 impressions.

Diffusion Transfer Plates

Diffusion Transfer is the principle of Polaroid film. A number of plates using this principle have been developed and used for reprography. The latest in this area is the Kodak PMT family of materials. The letters PMT stand for **Photomechanical Transfer**. The family consists of a PMT Negative paper for making exposures in a camera; a PMT Reflex paper for making exposures by contact; PMT Receiver materials, and a PMT Metal Litho Plate. The receiver materials and plate have a special coating which receives the image from the exposed Negative or Reflex paper. A special processor and solutions are used. The new Kodak PMT Metal Litho is capable of runs up to 25,000 and can become an important factor in the successful use of the new projection stripping method described earlier.

PRINTING AND FINISHING

Printing and *finishing* are specialized operations which do not use photomechanical techniques so they are not discussed in this text. They are related to the cost and quality of the final product so they are as important if not more so than the preparatory operations discussed. Press time is the most expensive cost item in a printing plant. The more that is done in the preparatory operations—in photography to make sure the type and tone values are correct, and in platemaking to make sure the images are in correct position, the proper plate is selected and is treated, or madeready, to print properly—the less down time there will be on the press, and the higher will be the production and return on investment. Also the press and finishing operations are becoming automated which places even more emphasis on improving, speeding up, and reducing the cost of the preparatory operation.

REFERENCES

1. "U.S. Industrial Outlook 1976 with Projections Through 1980," U.S. Department of Commerce, U.S. Government Printing Office, Washington, D.C., 1973.
2. Frank J. Romano, "New Trends in Photocomposition," Inland Printer/American Lithographer, Chicago, Dec 1972, pp. 52–53.
3. M. H. Bruno, "The Platemaking Department," Lithographers Manual, Graphic Arts Technical Foundation, Pittsburgh, p. 10:15.
4. Ibid., pp. 10:10–10:15.
5. A. H. Smith, "The Use and Application of Synthetic Coatings in Photolithography," Printing Technology, Institute of Printing, London, Apr 1967, pp. 19–39.
6. R. F. Leonard and R. T. Traskos, "Photosensitive Polymers for Printing Plates—A Review," New Photo-Technology Trends in Graphic Arts, SPSE, Washington, D.C. Oct (1972) pp. 133–139.
7. J. A. Easley, "The Dow Method of Etching Magnesium," Penrose Ann., **49:** 87–89 (1955).
8. P. Borth and M. C. Rogers, "Powderless Etching of Copper," *TAGA Proc.*, pp. 1–8 (1961); U.S. Patents 3,033,725; 3,033,793 (1962).
9. J. S. Mertle and G. L. Monsen, "Photomechanics and Printing," Mertle, Chicago, 1957, pp. 205–207.
10. V. Strauss, "The Printing Industry," Printing Industries of America, Roslyn, Va., 1967, pp. 30–35, 235–252.
11. H. F. George, "Electro-Photo Optical Engraving of Gravure Cylinders," New Photo-Technology Trends in the Graphic Arts, SPSE, Washington, D.C., (Oct 1972), pp. 19–27.
12. U. Gast, "Helioklischograph—Present and Future Generation," Gravure Research Institute, Port Washington, N.Y., GRI Newsletter No. 31 (Sep 1974).
13. A. Senefelder, "The Invention of Lithography," J. W. Muller (Trans.), Fuchs & Lang Manufacturing Company, New York, 1911.
14. John F. Curtin, U.S. Patent 3,511,178; Harry F. Gipe, Brit. Patent 1,146,618.

19

AUTOMATED PROCESSING

A. F. Gallistel

Automatic processing machinery was developed first solely for volume production; i.e., to process more exposed film or paper than could be handled efficiently by manual processing. It soon became evident, however, that automatic processing can result in a higher degree of uniformity in the finished product than manual processing, which is subject to all the limitations of any system that depends on human beings for the precision control of operations with many variables. Automatic processing was first adopted on a large scale for the processing of motion picture film because of the thousands of feet of film that must be processed daily and because, with the advent of the sound picture, manual processing lacked the precision necessary for the proper reproduction of the sound track. Machines also protect the film from accidental damage such as fingerprints, scratches, and dirt that plague manual handling.

Modern processing machines operate with a precision beyond the capabilities of hand processing. Solution replenishment can be automatically metered by the amount of film processed. Temperature of the different solutions can be maintained to $\pm 0.25°C$ and time in solution timed accurately. Humidity and temperature controls standardize drying. Today machines so dominate the field that it is estimated that 90% of all silver halide materials are processed on automatic machinery. Manual processing is now practiced only by the amateur and the professional studio whose volume does not warrant the purchase of automatic processing equipment, or whose demand for special processing requires hand work.

The widespread use of automatic processing machinery has had its effect on films and papers. Modern films have thinner emulsions than those of a few years ago for several reasons, but a major consideration is that the thinner emulsion holds less water and can be dried more rapidly. Developing papers on waterproof base paper are growing in popularity for the same reason.

Designing a good processing machine requires the reconciling of many factors that interrelate in very complex and subtle ways. For example, the production capacity of a machine depends on the time required for the film to pass through the machine, but the speed of the film in the solutions affects the amount of agitation and, therefore, the degree of development.

TYPES OF PROCESSING MACHINES

Over the last 50 years many different machine designs have appeared, but four basically distinguishable types dominate the field. These are described as (1) Dipping machines, (2) Helically threaded machines, (3) Festoon-type machines, and (4) Roller transport machines. Other types of machines are used for special applications. For example, rotating drum processors with several subtypes exist, as do several types of reel machines; but the large volume processors fall generally into the four groups. Each has found a place because it has some particular advantage in an important area of mass production processing. No one type of machine has been able to supplant the others because each has some inherent limitations that tend to prevent this.

As the science of photography advances the camera, film and processor become system components—one dependent on and related to the other. It is in the light of the interdependence of the sensitized material and its

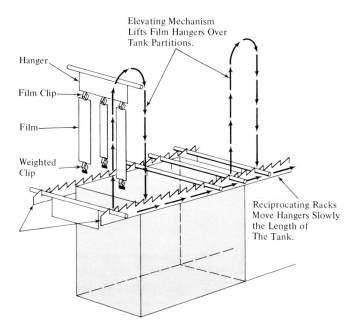

Fig. 19-1. Schematic illustration of progressing type of dipping processor.

process parameters that we should look at the fundamental advantages and disadvantages of the dominant types of machines. For this purpose a clear description of the functioning of each type of machine is desirable, but it will be limited primarily to the differences and, for the moment, similarities will be ignored. For example, all of these types have tanks to hold the various solutions and all have accurate temperature control systems; but these may be very similar, or even identical, in the different types of machines and can be considered on their own merits apart from machine type.

Dipping machines (Figs. 19-1, 19-2, and 19-3) imitate hand tank processing in that the film or paper is lowered into a tank of solution, held there for the proper time, and then raised and transferred into the next solution tank. The process is repeated as often as is necessary to complete all the steps in the processing cycle.

Helically threaded machines (Figs. 19-4, 19-5, 19-6 and 19-7) are basically for long lengths of film and dominate the cine processing field entirely. The basic concept is that the film is threaded onto a series of rollers in such a manner that the emulsion of the film is always out, away from contact with the roller surface. To do this it is necessary that the path of the film essentially be a helix, but to reduce space the locus of the helix is not cylindrical but is greatly elongated in the vertical plane.

Fig. 19-2. Dipping type processor showing rack of suspended roll films being transferred from one tank to the next. Drier in cabinet at right.

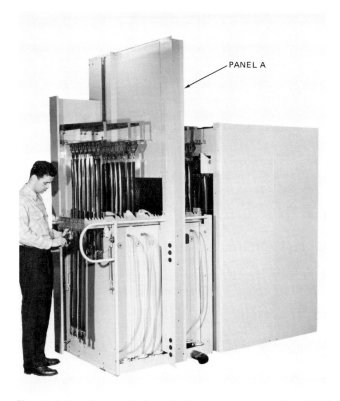

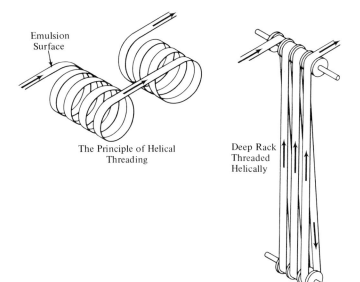

Fig. 19-4. Schematic illustration of helically threaded processor.

Fig. 19-3. Loading end of small dipping processor. Panel "A" installs in dark room wall so loading end is in dark but rest of machine may be in daylight.

Fig. 19-5. Small cine processor. Normal installation would have supply reel and processing section in dark room with instrument panel flush with darkroom wall. Drier and take-up at right would be in lighted area.

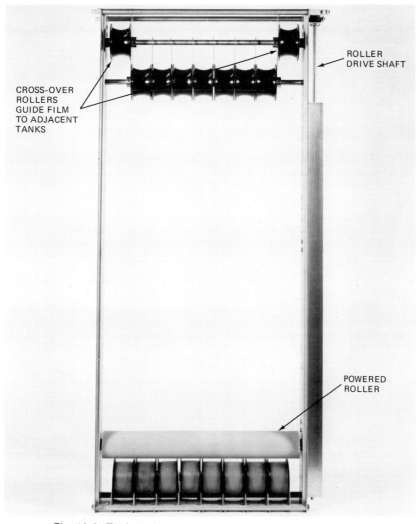

ROLLER
DRIVE SHAFT

CROSS-OVER
ROLLERS
GUIDE FILM
TO ADJACENT
TANKS

POWERED
ROLLER

Fig. 19-6. Typical cine rack before threading. (for 46mm film)

The festoon type of machine (Figs. 19-8 and 19-9) is also for long lengths of material, but it simply runs the web over an upper pulley or roller, then down and under a lower roller which is near the bottom of a solution tank, then back up over an upper roller, and so on until the entire sequence of immersions is accomplished. The web at all times lies in essentially the same vertical plane and does not travel back and forth across the machine as in a helically threaded machine.

In roller transport processors (Figs. 19-10, 11, 12, 13) the film travels in essentially the same path as in festoon processors but, instead of a top and bottom roller on each loop, the material is constantly confined between fairly closely spaced pairs of rollers that completely define the path of the film. Rotation of the rollers transports the film through the successive baths. A "belt" or blanket may be used on the base side of a film to improve the guidance, or rigid guide members span the spaces between roller pairs to ensure that limp or curling films do not stray from the intended path.

Dipping Processors

The two major limitations of the "dip" type of machine are the fact that it cannot readily handle long lengths of film and the fact that the lower end of the suspended film enters the solution first and leaves it last so that it is impossible to achieve identical times of processing on the top and bottom. When the times of immersion are relatively long this is not serious. If the depth of the tanks is increased to accommodate longer rolls of film, the time error becomes greater; so these machines have reached an optimum compromise using tanks that are about 38 or 40 in. deep. This depth is adequate for all widely used amateur films. Films longer than 36 in. are hung in a double strand with the bend around a special spool designed to avoid emulsion contact and minimize draining effects.

Dip machines exist in two distinguishable types. The rack *progressing* type machine has a lift mechanism at each partition in the tank system that lifts the rack of

Fig. 19-7. Helically threaded film rack for cine machine. (16mm film)

Fig. 19-9. Festoon type of paper processor, showing filters that are essential to clean processing.

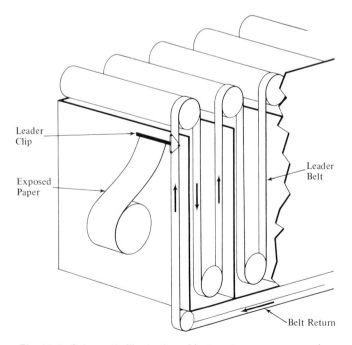

Fig. 19-8. Schematic illustration of festoon type processor using leader belt and clip.

film out of one tank, moves it across the partition, and lowers it into the next. (See Figs. 19-1, 19-2 and 19-3). The racks are progressed in each solution by a horizontal transport mechanism (reciprocating sawtooth or screws) which moves the rack of film from drop-in point to lift-out point.

The moving gantry type of machine (Fig. 19-14) has only one elevating means which moves on tracks from one tank to the next. It lowers the material into the first tank and leaves it there for the required time as preset on a timer mechanism. At the end of this time it lifts it up, rolls to the next tank, and lowers it into that. The process is repeated until the processing cycle is complete. The times in different baths usually differ considerably, and the time sequence may be set on dials or may be controlled from "cards" where the sequence of times are "punched" or otherwise encoded in a means that the timer can interpret. This system offers great flexibility and can readily skip one or more solutions entirely or develop for longer or shorter times as required.

The progressing machine can keep all tanks full for maximum production capacity. The gantry type has maximum flexibility but lower capacity. With the progressing machine the size of the tank—in the direction the film travels—varies with the time required in a given

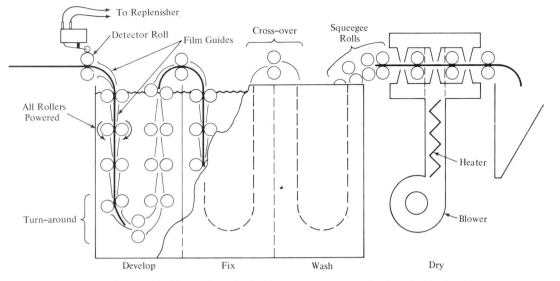

Fig. 19-10. Schematic illustration of roller type processor used primarily for sheet film.

solution, so it necessarily becomes considerably longer than in the gantry type. The progressing machine is widely used in processing amateur roll film where its high capacity justifies the greater cost, and the gantry type finds favor in professional or industrial studios because it can process either roll or sheet film, and provide the variations required for different films.

The functioning of either type is largely independent of the load; the operation is the same for half a dozen films as for a full load.

Within limits, the times in various tanks of the progressing machine can be varied by simple "skip" devices that in effect shorten the horizontal travel; but major time changes may require longer or shorter tanks. The construction is usually sufficiently modular to permit this, because the trend is to shorter times and a reduction in the length of the machine.

One other limitation of the dip machine that must receive consideration is that the processing time must include the time of transfer. Not uncommonly the time

Fig. 19-11. Roller processor rack removed from processing tank, showing rollers with film guides between.

Fig. 19-12. Roller processor rack being reinstalled in machine.

Fig. 19-13. Exterior view of roller type processor. Only the loading table at right is in the darkroom. Cabinet containing the rest of the machine is light tight so may be in normally lighted area.

from emergence of the top of the film from one tank until submergence in the next solution is of the order of 30 sec. This is a significant time. It has a favorable factor in that it partially tends to offset the time errors due to the first-in last-out type of cycle inherent in these machines; but it is a troublesome factor in that processing occurs

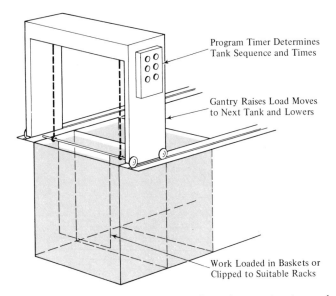

Program Timer Determines
Tank Sequence and Times

Gantry Raises Load Moves
to Next Tank and Lowers

Work Loaded in Baskets or
Clipped to Suitable Racks

Fig. 19-14. Schematic illustration of moving gantry type of dipping processor.

during this transport time, however, at a different rate than when the film is fully immersed in the processing solution.

Helically-Threaded Processors

Helically threaded continuous web machines predominate in the processing of cine (movie) film. Their preference stems from their unequaled ability to immerse a great length of film in a reasonably sized tank. A processing machine for motion picture film must process several hundred feet of film per minute and as development may require 6 or 7 min, it is evident that several hundred or even thousands of feet may have to be in a given bath at one time. For example, a machine running at 200 ft/min and requiring 7 min. development time requires 1400 ft of film in the developer tank. A developer rack may have 18 strands at 8 ft per strand and would thus require 10 racks with one only partially threaded. It is obvious that such machines can become quite large and complex. Inherently this is a "head first" machine where the end of film first into a solution is the first out and into the next bath. Thus the immersion times for all portions of the film are constant, and an excellent replenishment system is an absolute necessity because the very large amount of film could unbalance the developing solution if not continuously replenished with fresh developer. The considerable speed and short travel over partitions in the tank system render the "air transfer"

time quite insignificant and also constant for all portions of the film, so it is not a serious factor as it is in a dip machine.

Problems with Helically-Threaded Processors. Problems inherent in these machines are: (1) Drive synchronization and tension problems,[1] (2) threading problems, (3) replenishment, (4) film breaks, and (5) splicing.

A large helically-threaded processor or, for brevity, *cine* machine, with a speed of 200 ft/min may have about 3100 spools or pulleys, and typically half of these spools would have some type of power transmission. Commonly the other half would be idlers. This is obviously a fairly demanding drive system, but the problem is greatly magnified by the fact that the film is expanding and contracting in a very complex way as it progresses through the machine. Immersion in the first bath creates a swelling and stretching of the film. If the exit drive is exactly synchronized with the input speed in feet per minute, it is obvious that this expansion will accumulate, in the example given, in this first tank. If the swell is only 1%, the accumulation will amount to 10 ft of film for every thousand feet processed; and obviously the film will slacken and be out of control. If in a later bath the film shrinks, an intolerable tension will be caused and the film may break. The drive obviously must compensate for these swellings and shrinkings, and it must at the same time preserve a very accurate average speed for the whole machine so that immersion times in each bath are correct.

In essence the machines function by using a "pacer roller" at or near the discharge from the machine. This roller is accurately driven to achieve the desired average speed. All driven rollers that precede this pacer roller have a drive which senses film tension and become idlers when there is no film tension (or the film itself disengages from the driven pulley and thus loses traction). When the pacer roller has taken up the slack the drive (or film) again engages and thus the entire drive system is under the control of the pacer roller (Fig. 19-15). Means for achieving these demand drives vary quite widely but are generally based on the pulley that engages the film having a certain amount of travel parallel to the film strands. Stretching of the film permits the pulley to drop out of engagement and shrinkage causes it to engage, applying power to the film. The amount of tension on the film is controlled by the force necessary to engage the pulley with the powered shaft. The shaft may be internal to the pulley or external where friction means engage the rim of the pulley. Tension control may lie in the weight of the pulley, in external weights added to the pulley or in spring systems including involute springs in the pulley core. Short machines can function without such drive systems, but longer and higher speed machines require them because a certain minimum tension is necessary to prevent slack film from making damaging contact with stationary machine members. Tension must not be permitted to build up or film may break. This tension should stay within a range of perhaps 5 to 10 oz/strand and

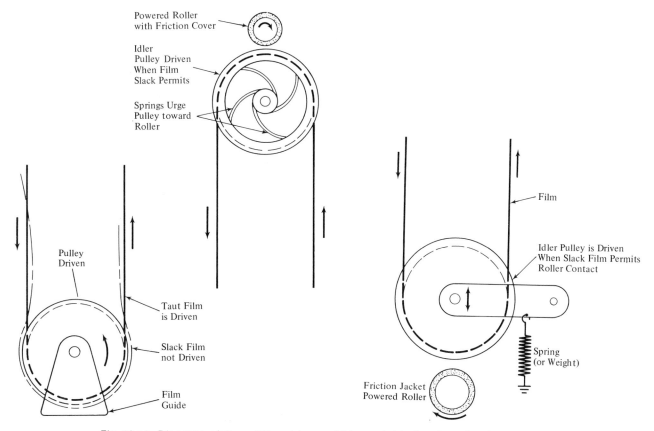

Fig. 19-15. Diagrams of three different types of "demand drive" systems for cine processors.

should be uniform throughout the entire machine. Maintaining such control is difficult because many of the chemicals used are corrosive and metal parts tend to deteriorate. Dried chemicals accumulate on working parts that are not submerged and they lose their freedom of action. Elastomers used for the friction drive surfaces tend to swell (or less frequently to shrink), or they tend to deteriorate and become too slippery to drive effectively. Careful maintenance is an absolute must for troublefree operation of these machines.

Because a large cine machine may contain several miles of film, it is obvious that threading it is an arduous task. Typically the racks can be raised out of the solution to facilitate this, but it is quite essential to maintain continuity once the machine is threaded. To achieve this a "leader" is used which is a plastic web similar physically to the film for which the machine is designed. The machine is first threaded with leader and may be run with leader until it is tracking well and tension is properly adjusted. The film is spliced onto the leader at the entrance end of the machine and when all the film has entered the machine, leader is again spliced onto the tail end of the film. When the film is processed and dried the machine has rethreaded itself with leader and may be shut down until there is more film for processing. Barring a film break, threading is always preserved. To permit time for splicing, the loading end of the machine is equipped with an "elevator." This consists of numerous long strands of film progressing over fixed upper pulleys and under a lower pulley system, the axle of which can move up against the resistance of a weight (Fig. 19-16). In normal operation this weighted pulley system is in its low position; but when the infeeding tail end is stopped to permit a splice to be made, the processing section continues to feed itself in a normal manner, drawing film from the elevator and forcing the lower pulleys to travel upward. When the splice is finished and film can again feed into the elevator the lower system drops down, ready for the next splicing.

Replenishment of cine[1] machines presents some special problems. Two quite different conditions exist when the machine is running leader and when it is running film. The leader typically has no emulsion and uses no chemicals. There is a certain amount of mechanical entrainment—particularly with perforated leader*—and the carryover of solution from one tank to the next imposes some chemical demand which must be made up by replenishment, but the demand is far below that imposed by the film itself. The large areas of film demand rapid and continuous input of chemicals, so typically a cine machine will provide continuous input of all replenishers through accurate flow meters; and they require two different rates, one for leader and one for film. As the head end of the film progresses through the machine, the flow is set up to the "film" rate, and as the tail end progresses through the machine it is cut back to the "leader" rate. Secondary solutions which can tolerate excessive re-

*Most machines in use do not require perforations and will use imperforate leader, but some machines use a sprocket drive of the film and must have a perforated leader.

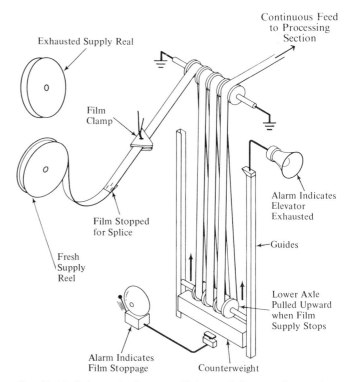

Fig. 19-16. Schematic diagram of "elevator" that permits supplying continuous feed to cine processor while end of film is stopped for splicing.

plenishment may utilize only the film rate, but the developing solution will typically require two different rates.

Film breaks during processing are a very serious affair in a high-speed cine processing machine. The film, if it is original camera film, may have cost many thousands of dollars to shoot or may be irreplaceable at any cost. For this reason as many critical variables on the machine as practical are equipped with alarms that sound in a case of malfunction. One that gets instant action is the alarm indicating a film break. Because the drive is on a demand basis, paced from the head of the machine, the film that is ahead of the break will continue on through the machine and receive normal processing, but that behind the break stops entirely and must have prompt attention if it is to be salvaged. Feeling his way in the dark down the machine (or preferably using an infrared viewing device) the operator finds the trailing end of the broken film and splices a spool of leader onto the end so that the machine does not come unthreaded. Spools of leader for this purpose are usually kept mounted above the machine. Next he quickly finds the head end of the dead strand and splices this onto the end of the leader if it appears that this will restore normal function. Frequently, however, it is necessary to relieve a jam in the machine, or to restring a rack that has been emptied by the accident. It is a good practice on machines with removable racks to have one fully strung at the machine at all times; this can be used for an empty rack—a quick interchange of racks and a couple of splices will restore full function. This has the advantage that, if the break was due to a jammed

pulley in the rack, that too is removed. If restringing, or other repairs, are necessary then the film must be cut, where it enters the first solution and manually pulled through to the point of breakage. This partially processed film is then fed into large tanks of water (garbage cans are popular for this) and it is held immersed there until repairs have been made. When rethreading is complete up to the point where the emergency leader is feeding into the machine then the salvaged film may be spliced into the strand so that processing of the film will finally be completed. When the salvaging is complete it is prudent to check the machine over thoroughly before starting film into it again to make sure there are no malfunctioning parts and that, in the hasty work in the dark, no twists have occurred in the film.

Breaks occur for many reasons. Poor splices between rolls are probably the leading source. A film that is nicked or torn along the edge can quickly tear the rest of the way. In handling amateur film it is not uncommon to find that the photographer broke the film and has spliced it back together with gummed tape that soaks off.

Breaks on a good machine should occur very infrequently and it is surprising how prompt action may salvage all but a foot or two of film in such a break. The salvaged film may suffer little loss of quality, depending of course, on where in the processing sequence the break occurs.

Commonly splices for cine processing are made with pressure-sensitive tapes, with staples or with eyelets. The tapes are usually used for splicing short rolls, amateur Kodachrome 35mm film, for example. These tapes must be carefully chosen to resist the chemistries they encounter and tape that is correct for Kodachrome processing solutions may not be suitable for Ektachrome. Hand application of the tapes is possible but a jig, to accurately align the two films, is necessary. In any case it is imperative that the splice be securely made and that it is neat and accurate or it will surely cause trouble in the processor. The short rolls are almost invariably pre-spliced into master rolls of a 1000 ft or so and not spliced "on the fly" going into the processor. A 3-ft roll of film on a 60-ft/min machine would require a splice every 3 sec which is impractical. If roll length and machine speed are such as to allow 30 sec per splice then splicing on the fly is practical as the loading elevator on a cine machine will typically have around 1-min capacity. Splicing in this manner is usually done with a hand stapler however and not with tape. A short overlap of the films is simply stapled 3 or 4 times in a spread out pattern to distribute the strain. This works well on 35mm but on 16 and 8mm eyelets are generally preferred as providing a better bearing area. In all cases the films must be accurately aligned.

The helical threading requires a skewed tracking of the film between upper and lower rollers, and theoretically the axis of each pulley should be angled in the direction of this skew, or pitch, of the helix. The mechanical difficulties of such construction, however, are against this; and as the width of film increases this "error" becomes more and more significant, and a tendency to stretch the edges of the film finally limits the width of

film that can be processed safely. Seventy millimeter wide film and 90mm are practical, but wider film might well require a special design. Machines without sprockets usually can handle narrower widths than they are basically designed for; i.e., a machine for 35mm film can run 16mm or 8mm, but there is an obvious loss of productivity when narrow widths are run.

Festoon-type Machines

Festoon types of machines are free of the skew problem limitation, and the web is always bent around rollers normal to its axis so there is no edge stretch tendency. There is no theoretical reason why a festoon type of processor cannot be made of any width, and machines are available for widths as great as 4 ft.

Two slightly different types of the Festoon machine are in wide use. One is maintained always in a threaded condition by splicing the sensitized material to a leader similar to the manner in which a cine machine is maintained fully threaded. Typically, however, the machine is running at a rate slow enough so that splices can be made on the fly; and a loading end elevator is not required.

The second type of machine is threaded with endless plastic belts which progress continually through the machine.[2] The leading end of the exposed material is attached to the belt with metal or plastic clips, and the film trails behind the leading end. Narrow machines may have a single belt, while wider ones will usually have two. For wide sheets of material the clip will usually anchor on both belts, spanning between them.* Their capability for handling wide webs has lead to wide adoption of this type of machine for processing continuous rolls of paper, a field they dominate.

Either type of machine can handle full rolls of paper in lengths of 750 or 1000 ft, and the machine is fully threaded throughout its length with paper in various stages of processing. Under these circumstances the tracking, tension, and drive problems are similar to those encountered in cine processors but usually less severe because the length of material in process is not as great. Typically, however, the diameter of the driving pulleys for the plastic belts will be slightly different than the pulleys over which the paper is trained. This is necessary to compensate for the difference in thickness between the paper and the leader as well as for the swelling and shrinking of the paper. To avoid excessive tension on the paper (which is not strong enough to drag long lengths through the machine), many of the rollers contacting the paper are powered. The power transmission is usually through controlled-slip clutches to allow for the synchronization errors due to shrinking and swelling. Preferably the power is applied to the rollers contacting the back of the paper and not on those contacting the emulsion side in order to reduce the danger of damaging the emulsion.

*In some machines a plastic sprocket chain serves as the leader belt and has an advantage in remaining positively in synchronization.

The spliced web machines have a replenishment problem in that the machine does not degrade the solutions in the same manner when threaded with leader as it does when threaded with paper. If porous paper leader is used, it should not be used more than once to avoid contamination of the solutions. Plastic leader belts are nonabsorbing and the washing baths are adequate to prevent any serious contamination. The multiplicity of roller axles and the length of the machine preclude the possibility of getting all axles exactly parallel, so tracking errors may result which will cause the paper to wander from side to side or to track off consistently in one direction. A consistent error can usually be corrected by deliberately skewing one or more axles to correct the tracking, and various combinations of crowned rollers and edge guides can control random excursions. These corrections typically are quite subtle, and experience with the particular machine is necessary to understand what will best handle a particular problem.

Roller-Transport Processors

Roller transport processors are popular because they can handle sheet film or paper without the use of clips, leader belts, or spliced webs.[4,5] Many photo applications demand, or at least prefer, the use of sheet materials. If this were not true there would be little justification for building roller processors. They can process continuous web materials, but if only continuous rolls are handled they would not be the best choice. For a given processing cycle, they are inherently more expensive to build because of the great number of rollers involved. This handicap is magnified by the fact that the massive contacting of the delicate emulsion by the rollers demands that the rollers be very accurately made and that their surface finish be close to optimum. Too smooth a roller may not drive the slippery film or paper, and too rough a surface will result in nonuniform development.

As the x-ray field is almost completely dominated by use of sheet film, roller type processors became prevalent first in x-ray processing. They spread next into the graphic arts field and they are making further inroads into processing of aerial color film, color prints, large black and white prints, dental x-rays, and many other areas. They range in size from small table-top machines with a 3-in. wide processing path to machines 4-ft wide or more. Roller processors include simple stabilization processors having a processing cycle of only a few seconds or color processing machines many feet long with a processing cycle of an hour.

While their reason for being is the use of sheet film or paper, they have a certain capability for handling continuous rolls; but it is not a universal and unlimited capability for interchanging the two forms. Sheet film or paper demands a highly confined path to prevent it from straying from the designated course. The accumulation of excess length due to swelling of the material in a long roll is in conflict with such confinement. A roller processor that is intended to handle small sheets of thin base material,

particularly if it has curling tendencies or has been stored in a roll form at some point, must control the path very rigidly.

A roller processor designed for the handling of a continuous roll performs much better if some provision is made for the accumulation of the excess material resulting from swelling of the web and for relief of the tension that will result from shrinkage of the web, for it must be remembered that in a multibath process the web will swell and shrink several times in the total process. A common means of providing relief is to have some, or all, of the rollers in a web type of machine reduced in diameter in the actual film path by an amount about equal to the film thickness. Thus the rollers barely touch the film and do not engage it sufficiently to create loops from swelling or excess tension from shrinkage. The amount of relief in the roller system must reflect the thickness of the material in the swollen condition, which is difficult to measure at best and not necessarily reproducible from batch to batch, so it is usually arrived at pretty much on a trial and error basis. Some machines also have drives for the rollers that permit some to "free wheel" to aid this problem. Elastomeric roller surfaces and lightly spring-loaded rollers are also used frequently in these machines.

This basic conflict between the need for firm contact to handle small sheets, and freedom to swell and shrink for the processing of long rolls, becomes most acute in machines that are designed for both film and paper, as is fairly common in photo typesetting operations. The paper base and the film swell differently and their thickness is also different.

The complexities of the roller transport problem have led to the development of several differences in the roller arrangements. Three of the most successful are (Fig. 19-17):

1. The "opposed roller" machine where the material is driven between pairs of rollers that oppose each

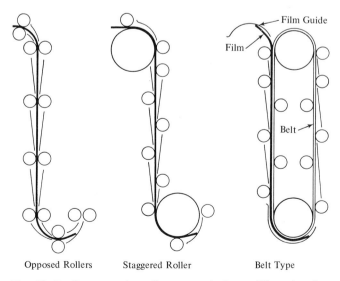

Fig. 19-17. Cross-section diagrams of three different roller arrangements used in roller transport machines.

other. Usually one roller in each pair is spring loaded.

2. In the "staggered roller" machine the straight portion of the film travel is between rollers that are arranged alternately. Usually in the "turn around" section at the bottom of the tanks and in the "cross over" section where the film travels from one tank to the next it is necessary to have the rollers in opposing pairs, as the staggered arrangement may not provide sufficient drive to the film.

3. In belt-type machines the back side of the film is contacted by a flexible web or "blanket" that covers the rollers on that side. Turn arounds and cross overs may again be of the opposed roller type, though the straight travel portions will typically be staggered.

One of the most intriguing aspects of the roller-type machines is the critically important, and highly complex, relationship between agitation of the chemistry, film transport speed, and roller contact with the emulsion. It is well known that the degree of agitation of the developer has a profound effect upon the speed of development and the photographic speed of the film.

The effect of agitation is due to several different phenomena, but unquestionably one of the most important is the chemical exchange which must occur at the actual interface between the emulsion surface and the solution. Here fresh solution must enter the emulsion and the by-products of development be removed. When a film enters the nip of a pair of rollers, the squeegee action of the rolls tends to remove all of the partially spent developer clinging to the interface, and on leaving the nip the area is immediately flooded with fresher solution. The direct effect of the rollers is more effective as a means of agitation than can be obtained by moving the solution through solution pumps. Agitation with rollers, however, is highly directional. All developed images exhibit to some degree adjacency or fringe effects; i.e., density differences at the boundary between an area of high and low density. The unidirectional progression of the film through the solution and the directional nature of the squeegee action of the rollers distort this adjacency effect, elongating it in the direction of the travel; and frequently this renders it more noticeable and objectionable. The vigor of the squeegee agitation poses another problem in that the nip pressure of the rollers must be maintained very uniformly. Slight variations in the roller pressure, due to the rollers not being perfectly straight or being slightly out of round, will appear on the film as "roller" marks. These will be lines of plus or minus density that are repeated at a distance on the film equal to pi times the roller diameter. (They are sometimes called "pi marks.") Total elimination of all roller marks is probably impossible of attainment but in practice with a good machine properly maintained they are rarely a serious problem with continuous-tone subjects or in the processing of x-ray film. In graphic arts reproduction roller marks may be objectionable, particularly in the pro-

duction of screen tints exposed for a 50% dot. The drive mechanism must be uniform and free of any slow downs or jerks.

CONSTRUCTIONAL MATERIALS FOR PROCESSING EQUIPMENT

As we have just noted, there are some significant differences between the predominant types of processing machines; but there are many areas common to all of them. The materials of which they can be constructed are all subject to the same limitation that they must be able to withstand the corrosive nature of photographic solutions. By far the most widely used material is type 316 stainless steel. Titanium and Hastelloy C are also satisfactory in corrosion resistance and in fact they exceed the resistance of 316 stainless steel but their much higher cost has tended to limit their use to critical areas such as pump shafts, etc. Both are usable in ferro- or ferricyanide solutions, while type 316 is not. Tanks for these bleaches are usually made of a brass or bronze alloy.[6]

Any of these alloys should be accorded a good passivating treatment after all fabricating operations are complete. Failure to do so invites early failure from electrolytic attack even though the alloy itself when clean is adequately resistant. The exterior surfaces of tanks for processing machines should be painted with a good coat of a baked epoxy enamel. The tanks are necessarily closely spaced in a machine so that it is not practical to clean their abutting surfaces, and inevitably dried chemicals from splashes or spills will accumulate here. If they are in direct contact with the metal, an electrolytic cell can appear locally that will quickly eat small holes through a tank from the outside.

Many plastics find appropriate uses in film processing machinery. Polyethylene is almost universally resistant to all photo solutions, and if machine parts are well designed in terms of the quite low physical properties of this material, it serves excellently. Phenolics are good in the compression-molded form, and rollers for roller processors are commonly faced with a paper-base phenolic laminate. This is a practically serviceable material, but racks should have regular maintenance and the rollers replaced if they show any signs of swelling or blistering after prolonged use. Polyurethane is practical in many applications, and polyvinyl-chlorides are almost universally used for the plumbing of machines and for piping the solutions as well as for mechanical parts. In selecting materials for certain solutions, it is well to contact the supplier for his recommendations. The chemical resistance to the material is not the only consideration: the solutions must not be affected by the material. The solutions used in the processing of color films and papers can be upset easily by contamination. A metal that is unsuitable can cause staining and discoloration of the image even if present in only very small amounts. Plastic hoses have been found to degrade some color developers

over a period of time because of particular plasticizers that were used in their formulation.

REPLENISHMENT OF SOLUTIONS

Replenishment systems are a necessity for automatic processors as they are handling large quantities of sensitized goods, and it is imperative that the activity of the solutions be maintained. Quite commonly the replenisher used is *not* the same formula as the original solution. The chemical formulation for a machine is designed, as far as possible, to run for months, or even years, and not be replaced. The replenisher is designed to achieve a kind of dynamic balance that will produce a satisfactory result in processing. The "aged" solution obviously contains products of its own reaction with the emulsion plus remaining portions of the original chemistry plus contaminants carried in from the preceeding bath minus fractions that are carried out on the film or paper or lost by evaporation.[7-10] The replenisher therefore will normally include the basic chemicals which are being applied to the emulsion plus agents to neutralize the contaminants, or reaction by-products, that are detrimental to the process or cause staining, and the concentration is intended to replace water lost and to keep the pH in the desired range. It has been found necessary to replenish water separately for some of the higher temperature processes that suffer heavier evaporation losses.

Sensing means for determining the amount of replenisher required by a solution are, unfortunately, rather crude approximations where the need is really for very precise metering. For example, the degree of acidity, or alkalinity, of most photo solutions is important to their proper function. It is tempting, therefore, to consider using electro-chemical automatic pH controls to monitor the solutions and add the replenisher as required. Automatic pH equipment is well established and dependable, but in almost all instances its use to sense replenishment need has been a failure. Solutions can get so far out of balance that they are useless for their intended purpose even though the pH may have been held within close limits. Similarly oxidation potential, which can be measured with suitable electrodes, appears tempting but fails for the same reason. Specific ion electrodes (to measure bromine ion concentration in a developer, for example), are also too limited in their interpretation to offer a useful index. Efforts to establish a direct correlation on some measurable parameter continue and will someday yield a practical solution, but at this writing they are not very successful.

If continuous monitoring of the chemistry is not practical, can the photographic effect be monitored and used as a basis for replenishment? In the case of black and white developers, this is being done commercially. The process consists of providing a test film in narrow rolls (8mm is convenient) and applying an accurately controlled exposure to the film. This exposure then is developed in a sample of solution representative of the solution in the machine, and its density is read on an automatic densitometer. The density measurement indicates the need for higher, or lower, replenishment rate to maintain the required activity. Until more direct sensing means are discovered, this is the best that can be done, but it still leaves much to be desired. The time interval is undesirably long, and when large quantities of film are going through fairly small tanks the solution can depart from the control point before the instrumentation responds and adds replenisher. There is further delay in thoroughly and uniformly incorporating the replenisher in the solution. To offset this, the sampling of the solution by the sensor should be as rapid as possible; and the densitometer reading should be made with the least possible delay.

Methods of regulating replenishment based on the measurement of the density of the image during development (using infrared radiation, for example), or with an automatic integrating densitometer at the end of the machine, are unreliable when negative exposure and subject matter vary widely, because the measured density bears no relation to the degree of development or the rate of replenishment. The time lag inherent in tests of the completely processed film is, in nearly all cases, too great for effective control of the developing solution.

The simplest system, and the most widely used, is merely to provide some approximate means of sensing the area of the sensitized material going through the machine and to provide replenishment proportional to this area. On web machines processing film of constant width at a constant speed, this can be done quite accurately by merely sensing the presence or absence of the web. If there is a web present, then the machine is processing at a known number of square feet of material per hour. If there is no film, then it is not processing anything. All that is necessary, then, is to use a microswitch to sense the web and to add replenishment when there is film present. In development it is absolutely necessary, however, to monitor the process by test strips at appropriate intervals. These test strips contain a uniform set of exposures and after processing the densities are read on a densitometer. Increases in density suggest a reduction in the rate of replenishment while lower densities on the test strip indicate a need for a higher rate of replenishment. With experience in adjusting developer replenishment to variations in densitometer readings, this method is quite satisfactory.

When film width is not constant further refinements may be necessary. They are not always needed, however, for in many instances (i.e., in a graphic arts sheet film processor) many different widths of film may be run through a system which is only sensing the length of the film; but the *average* width in the course of a short time interval may balance out so well that no correction is necessary, assuming a conscientious use of test strips. If additional refinements are necessary, they may take the form of multiple sensors that make approximate measurement of widths as well as the length of the film.

The detector which actually determines whether film or paper is present varies considerably. It may be a simple microswitch, an infrared beam that is interrupted by the film, an ultrasonic signal that is interrupted, or an airstream or "fluidic" sensor that detects film or paper. Any of these can be made to work well, and perhaps the only reason that the others are used in preference to the microswitch is that the finger or roller of the microswitch may leave a mark on the film or paper. The microswitch has the virtue of simplicity, but there is always the danger of pressure marks and, in periods of low relative humidity, markings from the discharge of static electricity.

TEMPERATURE CONTROL

Temperature control demands are quite stringent, and few processes are controlled as closely as the developing baths in good commercial film processors. A tolerance of $\pm 0.25°C$ is usually held—probably not on an absolute basis, but on a repeatability basis—and this is more important than the absolute temperature. Repeatability is the important factor because the entire basis for control of the process is the ability to repeat the desired result on a test strip. If the controller is off by a degree or two in absolute terms, it may be within the range of tolerance for the process; but if the temperature fluctuates from one test to the next, the densitometer readings are affected by both the difference in temperature and the replenishment rate, and the need for a change in the rate of replenishment cannot be determined accurately.

Good liquid-filled thermometer systems operating the thermostats can meet the requirements, as can thermistor sensors if they are thoroughly stabilized. It is a common practice to equip a developer tank for both cooling and heating operating directly on a low volume of a heat transfer liquid, usually water. This small volume of fluid then is circulated in a water jacket or heat exchanger on a far larger volume of active solution. The primary liquid is sensed by a thermostat that has no dead space at all so that the medium is always being either heated or cooled. The result is that the temperature of the primary liquid is fluctuating quite rapidly about the control point, but the processing solution has so large a thermal inertia that it holds an extremely stable temperature. An ordinary recording thermometer typically will show no deviation at all from the desired solution temperature. While the results are excellent when heat input and extraction are well balanced, the system is grossly inefficient and the total energy expended may be hundreds of times the amount actually needed. The total energy demands for any one processing bath are typically very small. A bath meant to operate at 87° F will be typically in an ambient of 80° F, and even an uninsulated tank at that small differential loses very little heat. Open-top areas are small so evaporation heat loss is minor. The total demand of a few watts may be met by a system that is using 500 to 1000 watts continuously. Modern thermistor controls can have a sensitivity that

will permit a dead space of much less than the desired 0.1° C so that a very small heater could supply the demand and give equally good control. "On-off" controls can be economically replaced by circuits which electronically proportion input to demand. The trend toward such control is being accelerated by two other factors: (1) The processing temperatures have been steadily going up, and (2) more and more plants are being completely air-conditioned. These two things have combined to almost eliminate the need for direct artificial cooling of the processing baths because the baths are always just a little warmer than the surroundings and a small heat input is all that is required.

Commonly only the developers in a process require such close control of temperature, and the so-called secondary solutions are held to a range of one or two degrees. Particularly for processes such as fixing, which goes to completion, temperature is less critical. Developers require such close control because they do not go to completion and higher temperatures will cause serious over-development.

WASHING

Proper washing of the processed material is of great importance if the finished product is to be reasonably permanent. A few so-called *stabilization* processes require no washing, but are relatively impermanent as compared with a thoroughly washed film or print. The American National Standards Institute[3,11,12] has defined standards for the allowable remaining chemicals in an adequately washed image. Allowance is also made for the fact that absorbent base materials such as paper will not permit as complete removal of substances causing deterioration of the image as an acetate or polyester base film.

Washing should be done in several cascaded counter-

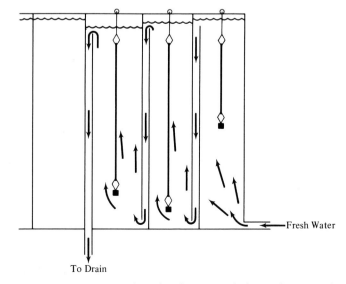

Fresh Water

To Drain

Fig. 19-18. Cross section showing cascaded counter-current washing system.

current wash baths, with the fresh water flowing into the last bath the film is immersed in and then flowing into preceding wash baths (Fig. 19-18). Our concern for water conservation must eventually make this an absolute demand, and current practices of using but a single wash bath and flooding it with such huge amounts of water as to achieve a decent wash by "brute force" and a gross wastage of water is reprehensible. Carefully controlled and monitored washing tests have shown that three cascaded wash tanks can be equivalent to a single bath system using eight times as much water. Film processors are a major user of water; large operations may consume half a million to a million gallons of water a day—most of it for washing—and 80% of it is sheer waste.

The economy alone should demand a better utilization of the water, as the cost of unnecessary water would pay many times over for the added capital equipment. With the present national concern for the ecology, such a course will ultimately be forced upon us from without if we do not as an industry take the responsibility ourselves.

AGITATION OF SOLUTIONS

Agitation of the solutions is essential in nearly all processing machine tanks. Agitation is necessary (1) to prevent any stratification of the solution in the tank; (2) to promote access of fresh solution to the emulsion and remove spent solution from it; (3) to prevent any accumulation carry-over from one tank to another, and (4) to rapidly and uniformly incorporate the replenisher into the replenished solution. The degree of agitation varies widely in different tanks. In the least demand, the simple transporting of the sensitized material may create sufficient agitation; but development, for example, may require pump recirculation, recirculation with "spray bars" directing the fluid for optimum impingement effect, or a variety of other refinements that have proven practical. Pump recirculation systems offer a further advantage in that they facilitate filtering, which is desirable to remove particulate contaminants.

Gas burst agitation is widely used and consists of suddenly introducing a sizeable volume of gas at the bottom of the processing tank. This causes the solution to surge upward briefly and then subside again as the bubbles rise and dissipate. The gas burst is repeated at timed intervals. The gas must be inert in the solution in which it is used. Air will serve for some solutions, but nitrogen is used for readily oxidizable solutions, such as developers.

Agitation has an optimum level, and either too much or too little will have a bad effect. This is particularly true of roller processors processing graphic arts films. Up to a point, increasing the agitation reduces roller marks, and the tendency to drag out the adjacency effects and improves uniformity. Increasing the agitation beyond this point creates "flow marks" which seriously degrade the image. Obviously the characteristics of the

film are important, and it may be necessary to "fine tune" a machine so that the agitation is at optimum for a particular film. Fortunately, this is not usually necessary.

DRYING PHOTOGRAPHIC MATERIALS

Drying is the final step in the machine processing of photographic materials. Three methods predominate in commercial practice. These are: (1) air convection; (2) conduction from a hot surface, and (3) radiation.[13] Air convection is widely used because it is applicable to either porous or nonporous base materials, easily controlled, and relatively inexpensive. The drying cabinet may be little more than simply a cabinet into which a blower is discharging air heated in the range of 55°C to 95°C. The film, or paper, is trained on pulleys through a path that will keep it in the cabinet long enough to remove the surplus water and then exits to a rewind. Smaller cine machines commonly use such a system (Fig. 19-19). It is highly desirable to have the air plenums arranged so that the air can be recirculated to hold the relative humidity (RH) at about 35 per cent. If the RH is not controlled, it is very easy to over-dry the film and this is very detrimental. A residual moisture content of about 7% in the emulsion is usually desirable. A "bone-dry" film has a bad tendency to curl, is brittle and easily crazed or broken, and, because of excessive static electrical charge, will attract dust and dirt. Proper adjustment of thermostats and humidity to achieve just the proper drying are of great importance.

On larger machines a simple cabinet would tend to become rather large, so to increase the drying efficiency the air is brought into the cabinet through a series of jets arranged so that they impact directly on the film and the efficiency is thus increased considerably. This is in essence the system that is used on virtually all roller type processors. In these machines, which typically dry large areas of film, it is important that the impinging air be very evenly distributed over the sheet, as uneven drying produces differences in density and, in extreme cases, will distort the film base (Fig. 19-19).

The drying of print papers has for many years been mainly on heated drums. When ordinary papers are used, the drum has a highly polished chrome-plated surface which imparts a gloss to the image. If a paper with a water-resistant base is used this type of glazing is impractical, as the moisture cannot escape. These papers are usually air-dried by forced convection in a manner similar to that used for film or may be augmented by radiant drying with infrared heaters. The drums are preferably heated by an internal hot water system that can be controlled quite accurately. Smaller units, or intermittently used drums, may be heated by radiation heaters inside the drum.

Direct infrared heating is capable of adding energy to a wet material at very high transfer rates but is very difficult to control. To be effective the elements must be close to the web, and they must operate in the tem-

Fig. 19-19. Drying cabinet and rewind of cine processor.

perature range above 550° or 600°C. With extremely uniform load conditions it is theoretically possible to accurately balance the heat input to the requirements for proper drying, but in practice this is not easily achievable and infrared is usually confined to the role of a booster or predryer, with the final drying by a forced air convection system. Even under these limitations it is found that a sudden load reduction, such as an accidental stoppage of the machine so that no water is being carried into the dryer, will cause charring of the paper in a few seconds. On an unattended machine it is not unusual for radiant heaters to set paper or film on fire if there is an accidental stoppage.

Although not yet widely used, there is considerable interest in the use of high frequency for drying photographic film and paper. It has some characteristics that are very attractive. The heat is actually created in the water molecules only so that as the water evaporates the heating effect diminishes and is hence self-limiting, and the heating stops entirely at close to the optimum residual moisture. There are no hot elements, so the equipment is not uncomfortable to be near. The biggest problems so far are (1) the capital investment for equipment to generate the high frequency required; (2) the difficulty of evenly distributing the electrical field to the web being dried, and (3) the shielding necessary to avoid radio interference.

There are two different frequency bands that have promise in this area. A "dielectric" range of 13 to 40 megahertz is effective, but the installations tend to be rather bulky and involve wave guides to handle the output. The microwave band uses equipment more nearly like microwave cooking equipment, which is smaller and in general less costly; but even distribution over the area is more difficult to achieve. Both methods are being experimented with and may become important methods of drying on the processors of the future.

REFERENCES

1. C. A. Feichtinger and L. R. Witherow, "A New Demand System for Processing Machines Using Spring-Centered Spools," *J. Soc. Motion Picture Television Engrs.*, **78:** 712 (1969).
2. G. M. Dye, C. M. Knudsen and J. J. Braden, U.S. Patent 2,770,179.
3. ANSI Standard PH4.30-1969, *Method of Determining Residual Thiosulfate and Thionate in Processed Photographic Papers.*
4. C. J. Kunz, "Self Threading Processor and Dryer," *Photogr. Sci. Eng.*, **8** (1959).
5. R. W. F. Conway, "A Continuous Belt Processor for Photographic Sheet Materials," *Photogr. Sci. Eng.*, **9:** 78 (1965).

6. *Constructional Materials for Photographic Processing Equipment*, Pamphlet K 12, Eastman Kodak Co., Rochester, N.Y.

7. C. E. Ives and F. W. Jensen, "The Effect of Developer Agitation on Density, Uniformity and Rate of Development," *J. Soc. Motion Picture Television Engrs.*, **40:** 107 (1943).

8. L. F. A. Mason, *Photographic Processing Chemistry*, Focal, London and New York, 1966.

9. P. Carlu, "Replenishment of Solutions in Batch Processing," *J. Photogr. Sci.*, **12:** 61 (1964).

10. R. W. Henn, "Calculation of the Condition of Used Processing Solutions," *Photogr. Sci. Eng.*, **9:** 154 (1965).

11. ANSI Standard PH1.28-1969, *Specifications for Photographic Film for Archival Records, Silver-Gelatin Type on Cellulose Ester Base.*

12. ANSI Standard PH4.8-1958, *Determining the Thiosulfate Content of Processed Black and White Photographic Film and Plates.*

13. I. G. Ryman and W. K. Overturf, "A Review of the Drying of Silver Halide Photographic Film," *J. Soc. Motion Picture Television Engrs.*, **78:** 3 (1969).

20

CINEMATOGRAPHY

Gordon A. Chambers

When Thomas Edison began his motion picture experimental work in the fall of 1889, the film which he used in the camera to make the negative was also used for the prints. It was some years later before a film designed for prints became available. This latter positive film continued almost unchanged until the introduction about 1940 of the fine-grain type now used.

The film used by Edison was not color-sensitized. It had an emulsion speed about one-twentieth that of the modern negative. It was used in direct sunlight at first and later under carbon arcs and Cooper Hewitt mercury lamps. In part because of the low speed of the film, it was developed fully with the result that for many years motion pictures were quite contrasty.

In 1917 an orthochromatic negative was introduced which had about four times the speed of the earlier film. This was supplemented a few years later with a "Super-Speed" film, also orthochromatic, which added a stop in speed.

Experimental panchromatic films had been made as early as 1913 in order to provide a suitable negative for use with the three-color additive processes which were the first attempts at color motion pictures. Panchromatic negative was first used for a complete black and white picture in 1922 by Ned Van Buren, A. S. C., for the production, "The Headless Horseman." He took advantage of the improved color sensitivity for cloud effects and even for night effects photographed in daylight.

The year 1928 was a fruitful one for progress in the motion picture industry. With the introduction of sound recording, it became necessary to replace the then noisy arc lamps with tungsten lamps. The change in color quality of the light brought panchromatic negative into general use. Continuous processing machines were introduced along with sensitometric control to replace visual inspection. At least one Hollywood laboratory had used a two-solution developer with a desensitizer in the first bath so that the developing negative could be inspected with a red handlight during treatment in the second solution. A lower contrast developer using borax as the alkali began to be used. The high sulfite content of this developer, acting as a silver halide solvent, also improved graininess. The improvement in photographic quality was dramatic. Metol-hydroquinone-borax developers have been used for black and white negatives almost exclusively since that time.

New sensitizing dyes capable of markedly increasing the overall speed of the negative began to be used in 1931 with a great improvement in the speed-graininess ratio. Modifications since that time have continued to improve graininess on the screen while emulsion speeds have increased. A comprehensive history of black and white motion picture films has been published by Mees.[1]

Prior to modern color processes, tinted base film was used to enhance the mood of the scene. With the introduction of sound, however, it became more difficult to splice large numbers of release prints and these tinted base films fell into disuse. The gray base to reduce halation, introduced in the 1930s, continues to be used. It has been replaced by a removable jet backing on modern color films.

One other fundamental change has been made in motion picture film. Nitrate base was discontinued in the United States in 1951 so that today all film is of the safety type. "Safety Film" is described and defined by American National Standard PH1.25-1965 (R1969). Both the triacetate and polyester base films meet this standard.

Edison's original film was 1-3/8 in. wide (almost exactly 35mm) but many other widths have been used. It is customary to describe the nominal width in millimeters. Some of the widths in current use are 8, 16, 32, 35, 65 and 70mm, although other intermediate sizes have been used in the past.

BLACK AND WHITE NEGATIVE FILMS

Camera negative films usually have two emulsion layers. The first one coated on the support is not color-sensitized. Its primary function is to control halation. This undercoat is slower and finer grained than the panchromatic overcoating. By skillful adjustment of the speed of the undercoat with respect to the speed and thickness of the overcoat, it is possible to extend the latitude of the film. In such a case the toe of the curve of the undercoat begins to be exposed as the shoulder of the curve of the overcoat is reached.

Halation is further controlled by a gray dye in or on the base. This dye has a visual density of about 0.23, a limit being set by the fact that it adds to the amount of printer light required and the fact that the art of visual timing for printing is still practiced.

Finally, on top of the panchromatic emulsion there is usually an extremely thin transparent layer containing a lubricant. This layer minimizes the effect of abrasion and facilitates movement of the film in the camera. The overall thickness of all of the coatings amounts to a little over 0.001 in. when dry.

Panchromatic negative is available in a variety of speeds. The choice for a particular use is made on the basis of graininess in most cases. The highest speed films, having greater graininess, are used only where inadequate light requires them. The lowest speed films are used normally for those scenes which are to be duplicated for the final release negative, such as scenes to be used in background projection or for optical effects.

Emulsion Speed

There is no American National Standard which describes a method for determining the speed of black and white motion picture negative film. The Exposure Index values given by the manufacturers are determined empirically. Using an exposure meter such as the photoelectric type described in American National Standard PH2.12-1961, to establish the light level, a series of exposures is made at, above and below the expected correct level. After processing and printing with the necessary light changes for the best print, the scenes are evaluated on the screen and the optimal exposure level determined. This method has been described by Sorem.[2] As exposure is increased above the minimum, photographic quality increases. As overexposure is reached, quality deteriorates, particularly in the highlights and graininess increases. Choice of the best exposure can then be related to the exposure meter reading and a suitable "Exposure Index" assigned to the film.

It is general practice to control exposure level on the set by means of incident light measurements of the keylight on the face. Relatively large lens apertures, of the order of $f/2,3$ to $f/3,5$, are used to minimize depth of field which serves later to concentrate audience attention on the plane of action. Data sheets for camera films usually contain a table of incident light values required at various lens apertures, based upon an assumed exposure of $1/50$ sec, resulting from a 170° shutter opening and a camera speed of 24 frames/sec. Such a table of incident light values can be calculated from the following equation:

$$I_0 = \frac{1250 \times F^2}{\text{Index}}$$

where

I_0 = incident illumination in foot-candles
F = lens aperture number
Index = Exposure Index for the film

Contrast

Picture negative film is usually developed to a gamma of 0.65 to 0.70 depending on the characteristics of the particular film. The fine grain positive print film is usually carried to a gamma of 2.2 to 2.4. The product of the negative and positive gammas divided by the "projection factor" of about 1.6 gives an overall contrast of unity. The "projection factor" represents the effect of the quasi-specular density of the print in the projection system. The gamma values cited above are determined from diffuse density measurements.

The metol-hydroquinone-borax developers used for machine processing have formulas similar to the following. Formulas for a particular machine are adjusted to give the desired contrast at the machine speed chosen.

Metol	1.5 g	1 lb 8 oz
Sodium Sulfite (desiccated)	75.0 g	75 lb
Hydroquinone	1.5 g	1 lb 8 oz
Borax (decahydrated)	4.5 g	4 lb 8 oz
Potassium Bromide	0.4 g	6.5 oz
Water to make	1.0 l	120 gal

Such a developer will have a pH of 8.90 to 8.95. The bromide is used only in the original mix. Replenisher solution uses 5% more metol, sulfite and borax with 1/3 more hydroquinone. Replenisher should be added at the rate of 1 gal for each 200 ft of 35mm negative processed. This is equivalent to 60 ml/m or 18 ml/ft.

In devising a replenishment system it must be borne in mind that development of the silver image releases bromide into the developer. In order to maintain bromide concentration constant, it is necessary to add a certain amount of water. The amount of the several ingredients consumed is determined by analysis and these must be added to the requisite amount of water. The figures given above resulted from such analysis of processing conditions in a major laboratory and can be taken as a general guide.

Chemical Control

The basic papers describing analytical methods for photographic solutions are those of Baumbach[3] and of Atkinson and Shaner.[4] When the basic system has been worked out for a given process, the maintenance then requires only a minimum of simple analytical control.

Methods of Negative Processing

Two methods of negative processing are in current use. In the time-temperature system, all negative is developed for a fixed time in the chemically maintained solution having excellent temperature control. Such processing results in a constant process as measured by the gamma value obtained. The second method is the "test system". Sample lengths of the scenes are developed for normal time and subsequently inspected visually. The time for the processing of the balance of each scene is estimated in order to correct for variations in the lighting contrast of the original photography. Each of these methods has its stout adherents.

Sensitometric Control

In sensitometric control the laboratory places stress on the maintenance of both constant gamma and density. The latter, in effect, controls effective emulsion speed. Even when the "test system" is used, sensitometric control is used to assure constant gamma and density at normal development time. When a time-gamma series is run on a continuous developing machine, the method commonly used is to vary machine speed. At low speeds, giving longer developing times, the decrease in agitation may well result in a lower gamma being obtained. Many machines show a directional effect because of the unidirectional movement of the film. For the sake of uniformity, it is common practice to splice sensitometric strips into the machine with the end having the least exposure entering the solution first.

MOTION PICTURE NEGATIVE FILMS

Fig. 20-1 shows a family of $D \log E$ curves together with time-gamma and time fog-data, for a typical motion picture negative film. The sensitometric exposures were made at $1/50$ sec on an intensity scale to daylight-quality radiation. The sensitometric process simulates that of a continuous processing machine. Normal development time for black and white negative is about 7 min at $20°C$ ($68°F.$). It is rare that a motion picture laboratory uses sensitometry except at normal gamma. As sensitometry is used only for control purposes, a laboratory finds no use for average contrast or gradient measurements, the gamma value being adequate for its purpose.

The color sensitivity of motion picture film is shown either by wedge spectrograms or spectral sensitivity

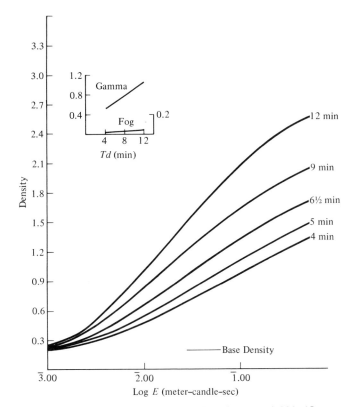

Fig. 20-1. Eastman Double-X Negative Film 5222/7222. (Courtesy Eastman Kodak Company)

curves in which the reciprocal of the exposure in ergs/cm^2 required for a particular density, usually 1.0, is plotted against the wavelength. The spectral sensitivity curve of a typical negative film is shown in Fig. 20-2. In the past panchromatic negative films were more sensitive to red than they are now. Some difficulties were experienced with the older films in undue lightening of the lips and unpleasant rendering of the mouth in the case of singers.

At one time infrared film was used by some cinematographers for night-effects exposed in daylight but it was found that the chlorophyl in vegetation photographed almost white. Common practice today is to use regular panchromatic negative film with a narrow band yellow filter made by combining Wratten Filters Nos. 23A and 56, or their equivalent. The darkening of the sky is obtained (when the sky is blue) and face makeup and vegetation do not photograph too lightly.

Graininess, which produces the boiling effect often seen in early motion picture films, is an important characteristic of motion picture negative film. Granularity, the physical correlate of graininess, is usually given in the data sheets of the manufacturer as the RMS granularity.

Various methods have been used in an attempt to measure in the negative image some characteristic which would indicate the sharpness to the eye. Resolving power is the oldest of these methods but this has been shown to be more closely related to the ability to define fine detail than to image sharpness. Acutance is a measure of the sharpness of the edge of the image, however the modula-

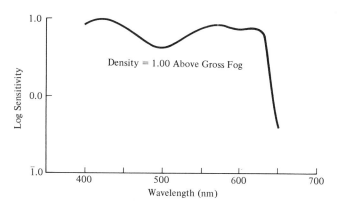

Fig. 20-2. Eastman Double-X Negative Film 5222/7222, (*Courtesy Eastman Kodak Company*)

tion transfer curve is being used more and more by manufacturers as an indication of the sharpness-capability of an emulsion. All of these are discussed at length in Chapter 9. Fig. 20-3 shows the modulation transfer curve of a typical motion picture negative film.

Exposure, choice of developer, the contrast to which the negative is developed and the characteristics of the positive film are all factors in the graininess and sharpness of the image on the screen. The negative, however, is a more important factor than the positive which has less granularity, higher resolving power and acutance than the high speed negative film.

Typical motion picture negative films (16 and 35mm) include Eastman Plus-X Panchromatic Negative Film with an exposure index of 80, and in the higher speed group, Eastman Double-X Panchromatic Negative Film (E.I. 250), and Eastman 4-X Panchromatic Negative Film (E.I. 500).

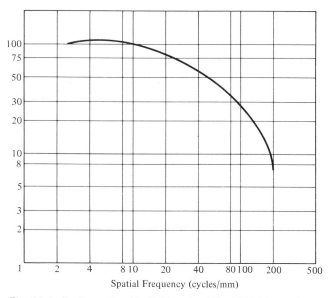

Fig. 20-3. Eastman Double-X Negative Film 5222/7222. (*Courtesy Eastman Kodak Company*)

SOUND RECORDING NEGATIVE FILMS

Variable Area

In variable area recording the image of a triangular mask is moved on the vertical axis of the recording slit by the modulating galvanometer. The image on the film varies in width (or area, considering that the slit is of finite height). The objective on the final print is a track which is "black" on one side and "clear" on the other. Early tracks were unilateral, having modulation on one edge only. Modern recorders lay down a bilateral track.

In order to determine the characteristics needed in the negative, it is necessary to work back from the print. Experience has shown that the black area of the track print ought to have a minimum density of 1.2. At this density there is so little leak light through the "black" area that no substantial noise results from this leak light modulated by the graininess of the black portion of the track. Equally, the clear area should have no fog density to modulate the signal with noise.

At a desirable print density, the *area* of the black image on the print is greater than the clear area of the negative from which it was printed. This is due to image spread. The density at which there is no image spread, the "crossover density", is about 0.6 for most print films. In order to offset or cancel the image spread in the print at a useful density such as 1.2, it is necessary to create, by a proper choice of density, an equal and opposite image spread in the negative. Thus the photographic image on the negative is larger than the optical image of the slit which exposed it. In printing, it masks this greater area, reducing the area exposed on the print. With the image spread of the print film, a final track is obtained which accurately reflects the optical image of the recorder slit.

The fine grain negative used for variable area recording has a blue and ultraviolet sensitive emulsion coated on a gray base. These fine grain emulsions are sufficiently transparent that the gray base to control halation is important. This was not true with the older type emulsions. The film is normally developed in the black-and-white positive developer for about 50% longer than for a picture print. Some laboratories, for convenience, have a separate processing system for variable area negative.

Image spread is affected by the negative development. It is also affected by printer contact. Poor contact in the printer introduces some image spread which must be offset by lowering the negative density. Since this could introduce noise, good printer contact is necessary.

Modern fine grain variable area recording films operate at a density of 1.9 to 2.5 at a gamma of 3.1 to 3.3, including the gray base. The proper choice of negative density for a given print density is effected by a "crossmodulation" (X-Mod) test, originally described by Baker and Robinson.[5] The equipment for recording and measuring cross-modulation products as used for 16mm film is described in American National Standard PH22.52-1960 (R1967). A high frequency signal (9 KHz for 35mm recording) is modulated by a low frequency, 400 Hz. The resulting frequencies, 8600 and 9400 Hz, are recorded.

When the negative and positive densities produce equal and opposite image spread there will be a minimum of cross-modulation product (400 Hz) in the output. Measurements are made through a 400 Hz band-pass filter to eliminate the high frequencies. At higher or lower densities, cancellation will not take place and some 400 Hz signal will appear in the output.

At the present time no films specifically intended for variable density recording are available on the American market. This type of recording is not currently being used. Were it to be, a fine grain release positive film could be used with development in a very low contrast developer.

	Types	
	16mm	35mm
Variable Area Negative Films		
Agfa-Gevaert Sound Recording Film, ST8	258	258
Eastman Fine Grain Sound Recording Film	7375	5375
3M Sound Recording Film	401	401

It is common practice in the motion picture industry today to make all original sound records magnetically. In most cases perforated film carrying magnetic oxide is used. In some portable equipment, unperforated tape is preferred and in this case it is the usual practice to record a constant frequency along the edge of the tape in addition to the separate voice track. The constant frequency signal is used later to control tape speed in reproduction in order to control synchronism with the picture. Such a control frequency is often referred to as "magnetic sprocket holes."

When photographic sound is used on the release prints, a negative is recorded from the assembled magnetic tracks. At this time sound effects may be added in what is known as "dubbing," or more properly, rerecording.

In some cases, a magnetic stripe on the positive print is used as the medium to carry the sound. The release print preparation can be simplified by the use of print raw stock carrying the magnetic stripe applied by the film manufacturer. The sound record can be transferred during the picture printing operation. In the case of 35mm four-track magnetic and 70mm six-track magnetic prints, the stripes are applied in the laboratory after picture processing. The sound records are transferred from the master tracks to several prints simultaneously.

BLACK AND WHITE REVERSAL CAMERA FILMS

Black and white reversal camera films, as well as similar films intended for reversal duplicates, are processed by chemical reversal to yield a positive image. While almost any black and white film can be reversed, those designed for the purpose give positive images of good contrast and quality.

Reversal camera films today are panchromatic. During those years when such films were processed by the manufacturers, a removable jet backing was often used on the base not only to minimize halation but to facilitate daylight loading of the camera as well. During World War II, these films were widely used in gun cameras. The pro-

cessing machines used by the armed forces did not allow easy removal of the jet backing and accordingly the films were coated on gray base. This continues at present so care in loading is required in "subdued light."

Reversal Processing

The chemical reversal process consists essentially of five steps. They are: (1) first development in an extremely active developer giving little fog; (2) bleaching of the negative silver image leaving a positive image in silver halide; (3) reexposure of this remaining halide; (4) development of the positive image, and (5) fixation to remove any unused halide to provide a stable image. Of course, rinses are used between the several steps and a final wash is required.

Details of the reversal processes used for gun camera films by the U.S. Navy have been published by Dearing.[6] Modern processes, including studies of the individual steps and the functions of the ingredients in the several solutions, are the subject of an extensive paper by Zuidema, Ives, Exley and Wilt.[7] Zuidema has also dealt with the bleach problem, a critical step in the reversal process.[8]

In order to obtain a positive image which has enough density and latitude, the film-process combination should provide a maximum density for unexposed areas of 2.1 to 2.5, including the density of the gray base.

As the larger emulsion grains are the more sensitive, they form the negative image. The smaller grains form the positive. Hence for a given Exposure Index, a reversal film will give a positive of lower graininess than is obtained on a print from a negative.

It should be borne in mind that a reversal film is an original and that projection may damage it. Also, the tone-reproduction from a negative-positive system is generally superior to that from a reversal system. It is for these reasons that the reversal process has been used for the 16 and 8mm films but not for professional production in 35mm or wider films.

Control of the second exposure prior to redevelopment has been used in the past as a means to correct for original camera exposure. This form of control does not work well with modern films and processes. Instead, the first development time can be increased or decreased to compensate for under or overexposure. This control is often used for sports films which are known to be underexposed as in the case of night football on poorly lighted fields. Lengthening first development time is more effective in correction for underexposure than is shortening it for overexposure.

Reversal films can, of course, be developed to a negative. In this case the development time will be shorter than that used for a negative film having the same Exposure Index and the effective emulsion speed of the film will be reduced about one stop. This fact has been used to save valuable films known to be overexposed.

Some black and white reversal camera films are hardened in manufacture thus allowing them to be processed at elevated temperatures. This shortens the pro-

cessing cycle making the film more immediately available.

The following is the processing cycle used for most of the black and white reversal camera and duplicating films at 21°C (70°F).

		Time in Min
1.	First development	2
2.	Rinse—running water	1
3.	Bleach	2
4.	Rinse—running water	1
5.	Clear	1
6.	Rinse—running water	1
7.	Reexposure (about 800 foot-candle-sec)	
8.	Redevelopment	1
9.	Rinse—running water	1
10.	Fixation	1
11.	Wash—running water	3
12.	Dry	6

Black and white reversal films are available from the Eastman Kodak Company and the GAF Corporation.

Exposure Index		
Daylight	Tungsten	
50	40	Kodak Plus-X Reversal Film 7276
64	50	GAF Black and White Reversal Film Type 2955
200	160	Kodak Tri-X Reversal Film 7278
400	320	Kodak 4-X Reversal Film 7277
500	400	GAF Black and White Reversal Film Type 2962

BLACK-AND-WHITE DUPLICATING FILMS

Prints from duplicate negatives invariably have greater graininess than prints from original negatives. The films used for black and white duplicating were among the first films of the fine grain type. The film used for the master positive would ordinarily have high contrast because of its fine grain but this is decreased by the use of an absorbing dye. Further control of the contrast can be achieved by the use of a conventional borax negative type developer although this is not mandatory.

As seen in Fig. 20-4 the characteristic curve of a fine-grain duplicating positive has a fairly high breaking toe. In order to obtain good photographic quality in the duplicate, similar to that of the original negative, it is necessary to expose the master positive sufficiently to obtain a minimum density of the order of 0.6 in the highlights. The processed master positive, because of its exceedingly fine grain, has a warm-toned image which accounts for the name "red master," sometimes used to describe it. Prior to the advent of the fine-grain type, the positive film used for the master positive was coated on a lavender base. The color of the base had nothing to do with the photographic quality but it served to identify the master and indicate that it ought not be projected.

The emulsion speed of the film used to make master positives is considerably less than that of the release positive film. Whereas the latter is printed with a 100-watt lamp, for example, a 500-watt lamp is required in the same printer to obtain the exposure necessary on the fine-grain duplicating positive.

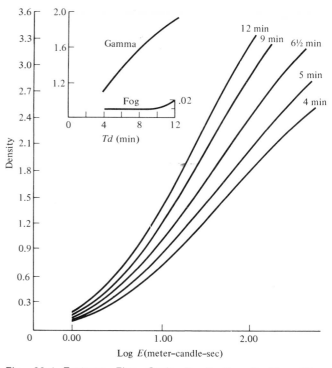

Fig. 20-4. Eastman Fine Grain Duplicating Positive Film 5366/7366. (*Courtesy Eastman Kodak Company*)

The master positive is ordinarily developed to a gamma of 1.2 to 1.6, the lower gamma being used when the exposure has been made optically rather than by contact. Optical printing increases the effective contrast of the negative which must be offset by a lower development contrast.

Fine grain duplicating negative emulsions are normally panchromatized in order to increase their effective speed to tungsten light in the printer. By so doing, it is possible to use an inherently lower speed, finer grained emulsion. These films are usually coated on the same gray base as original negative so that duplicate negatives can be spliced with original negative.

Several methods of intercutting are used and the particular case may affect the choice of density to which the duplicate negative is printed. Duplicating negative emulsions have a short toe on the characteristic curve like that of original negative. For the best tone reproduction, the "dupe" negative ought to be printed to a density which brings the extreme shadows to a density above toe density. The resulting duplicate negative will then have an overall density requiring an increase in exposure in printing amounting to several printer lights as compared with the original negative. Sometimes, in inserting a dissolve for example, it is desired to insert only that part which contains the actual dissolve. In such a case of "jump cutting," the duplicate negative ought to be exposed so as to obtain a density matching the scenes immediately before and after the jump cut. Then no printer light change will be required after the jump cut. It is better practice to duplicate the entire scene before and after the dissolve when the best quality is desired.

Fine grain duplicate negatives are developed in the

normal picture negative developer to a gamma of 0.6 to 0.7, that is, to a slightly lower gamma than original negative. The overall contrast should be one but this is difficult to calculate in the case of optical printing where contrast varies with the specularity of the printer light. Also, gamma values are ordinarily determined by time-scale sensitometric strips which do not necessarily reflect the actual intensity-scale contrast resulting from printing. Laboratories have learned by experience with the particular films they use just what desirable negative and positive gamma values should be on the master positive and duplicate negative.

Black and White Reversal Duplicating Film

It was mentioned previously that there is a reversal duplicating film. Such a film is used to make duplicates from a reversal original, either black and white or color. The duplicating film may be orthochromatic and contain an absorbing dye to control contrast. As the film is processed in the same solutions for the same times as original reversal camera film, the duplicating process is a simple one for the laboratory.

As the preparation of such a duplicate by contact printing ordinarily provides a positive with the opposite emulsion orientation to the original, this fact must be taken into account. In order to obtain original emulsion position, printing must be done optically or through the base of the original. Contact printing through the base of the original to the emulsion of the duplicate would have been avoided by most laboratory men in the past. In recent years, however, continuous printers have eliminated ground glass diffusion. The resulting specular light allows contact printing through the support with results which are satisfactory in most cases.

Fine-grain negative and positive duplicating films are produced by the Eastman Kodak Company.

Reversal duplicating films are available, as 16mm film only, from the Eastman Kodak Company as Reversal Black and White Print Film and the 3M Company as B. W. TV Reversal Print Film.

BLACK AND WHITE POSITIVE FILMS

The group of films termed "positive films" includes a number of materials used for different purposes. They have in common the fact that they are generally developed in a solution giving higher contrast than is used for negative. With the single exception to be noted later, they are not color-sensitized, have low speed and can be handled under relatively bright safelights in the laboratory.

Fine-Grain Release Positive Film

This is the material used for picture and sound prints. It was introduced just prior to World War II to replace the original film which had been in use since the earliest days.

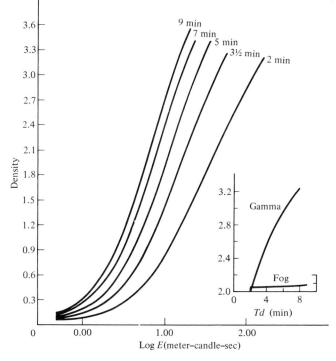

Fig. 20-5. Eastman Fine Grain Release Positive Film 5302/7302. (*Courtesy Eastman Kodak Company*)

The fine-grain type is about one-tenth the speed of the older film but the improvement in graininess made a marked improvement in picture quality. Printer illumination was increased by the use of projection type lamps and the ground glass diffusion was removed from the printer beam in most cases.[9]

The fine-grain type positive is developed to a gamma value of 2.2 to 2.4 for theatrical prints. For television prints a slightly lower contrast is used, the gamma value being between 2.0 and 2.2. Print density is chosen by projection of prints under standardized projection conditions.[10]

Figure 20-5 shows a family of $D \log E$ curves together with a time-gamma and time-fog curve for a release positive film. Exposure was made on an intensity scale to tungsten light at 1/50 second. A sensitometric process similar to that in a continuous processing machine was used. It will be seen that the developers are compounded to reach normal gamma rapidly and that much more contrast is available than is used. Normal positive developing time on a machine is about 3-1/2 min at 20°C (68°F).

High Contrast Positive Film

High contrast positive type films are used primarily for the making of mattes such as are used in optical printing and other special effects work. They are used also for making the title negative for super-imposed titles such as are used on foreign language films. These films are developed to a gamma of 3.0 to 3.3 in picture positive developer.

Special Positive Film

One film with rather unusual characteristics, Eastman Direct MP Film 5360 (7360 in 16mm) is used for making black and white work prints and music scoring prints. These are printed directly from color work prints and are processed in the normal positive developer. When printed from a positive, a positive image is obtained without the use of chemical reversal processing such as has been described earlier. This film is orthochromatic and must therefore be handled under darker safelights than are normally used in a black-and-white printing room.

The photographic quality obtained is not of the highest and the use of this type film is justified on the basis of low cost and the ability to produce a print quickly in a single step from the daily color prints.

Processing

Normal positive developers used for continuous machine processing have formulas similar to that given below. At 20°C (68°F) the normal development time for picture prints is 3–½ min. Sound negatives of variable area track are developed for 5 min.

Metol	1 gm	1 lb
Sodium Sulfite (desiccated)	40 gm	40 lb
Hydroquinone	4 gm	4 lb
Sodium Carbonate (monohydrated)	25 gm	25 lb
Potassium Bromide	2 gm	2 lb
Water to	1 liter	120 gal

The above table illustrates also a simple method of conversion of formulas from metric to English units or *vice versa*. It will be seen that the quantities of solid ingredients are numerically the same in grams per liter and pounds per 120 gal. This applies also to ounces per 7½ gal.

Vesicular Film

All of the previous discussion with respect to motion picture films has referred to films having a sliver halide as the light-sensitive salt. An entirely new material has been described by Bacon and Lindemeyer[11] which uses a diazonium salt as the sensitive material. Sensitivity is in the near ultraviolet range from 350 to 430 nm. After exposure, the image' is developed by the application of heat. The image consists of vesicles or bubbles within the resin layer containing the diazonium salt. The vesicles contain nitrogen and other volatile products which have a different index of refraction than the surrounding medium. They scatter light incident upon them and thus constitute the image.

In use the film is subjected to three processing steps. Exposure is accomplished by the use of a mercury capillary lamp, rich in ultraviolet. The image is then developed by heat after which it is fixed by a second exposure to ultraviolet light to decompose the residual diazonium salt.

The following is a tabulation of the various positive films currently available on the American market.

	Types	
	16mm	35mm
Eastman Fine Grain Release Positive Film	7302	5302
3M Fine Grain Release Positive Film, Type 150	150	150
Eastman High Contrast Positive Film	7362	5362
Eastman Direct MP Film	7360	5360
Vesicular Films		
Metro-Kalvar Television Release Positive Film	223	
Metro-Kalvar Filmstrip Print Film		28

Although no films wider than 35mm are shown in the tables of black and white film stocks, many of them are available on special order in 65 or 70mm widths. It should be noted also that in the various widths, a variety of perforation formats can be obtained. These formats are so numerous today, especially in positive and duplicating films, that the manufacturer should be consulted as to availability. Note also that many positive print films are available from the manufacturer with a magnetic stripe or stripes on the raw stock to allow preparation of prints with magnetic sound records. These are used for making 16mm and super 8 magnetic sound prints.

MOTION PICTURE FILMS FOR COLOR

Color photography has been attempted with varying degrees of success since the earliest days of motion pictures. Additive systems were first to be used but today all color motion pictures use the subtractive system. Each method involves the making of color separations but the prints made and the projection systems differ.

Additive and Subtractive Systems

In the additive system, the black and white prints of the color separation negatives are projected in register through the appropriate filters. The print of each color separation is projected through a filter of the same color as was used to make that separation in the camera. Usually, in order to gain more light on the screen, the projection filters have wider transmission bands than the taking filters.

The earliest color motion pictures used three color separations made on successive frames of the film. The exposures were made through rotating filters and the film was run at thrice normal speed. A similar system was used for projection. Later, an additive process enjoyed some success in the 16mm field under the name of Kodacolor. This process used a film having cylindrical lenses embossed on the base side. When exposed through this base, three separation images were formed under each lenticule by means of the three strip filters over the lens. On projection, the three images were recombined through a similar strip filter over the projector lens.

Additive processes were not commercially successful for professional motion pictures because of the low light

level on the screen due to the absorption of the color filters required. Early workers turned their attention to the subtractive process in order to gain screen luminance and simplify projection. In this case, the color was in the images on the film and no special projection equipment was necessary.

Two- and Three-Color Systems

Two-color subtractive processes enjoyed a wide vogue in the early days of the industry. Separation negatives were made using a twin lens camera exposing the separation negatives on adjacent frames or a beam-splitter was used behind the lens for the same purpose. The Kodak Wratten Filters Nos. 25 and 60 were used for such a process. Two-color separation negatives were also made by the use of "bi-pack" films in standard cameras. In this process, two films were run through the camera face-to-face. The film nearest the camera lens was exposed through the base side. It recorded the blue-green separation since the film was orthochromatic. The orange-red separation was recorded on the rear panchromatic film which was screened by a red dye overcoating on the surface of the front film. During the subsequent processing operation, the red dye was bleached from the film using sodium hydrosulfite after a rinse following fixation. Two varieties of bi-pack negative were available. One had a pair of films balanced in speed for exposure to daylight or white flame arc. The other pair was balanced for tungsten light.

Color Print Processes

Prints from two-color separation negatives were made by a variety of processes. The commonest ones involved printing from the separations onto a positive film having a yellow-dyed emulsion on each side of the support. The yellow dye not only minimized print-through from one side to the other but also reduced the emulsion contrast. This latter was necessary as the subsequent toning of the images about doubled the contrast of the silver images. The prints were toned after black and white processing. An iron tone was used to convert the image from the orange-red separation negative to blue-green. The red-orange tone of the image from the blue-green separation negative was obtained at first using a uranium tone. After World War II this tone was obtained with a dye tone using, for example, chrysoidine and safranine.

There were many combinations of negative and print processes for both two- and three-color photography in the years prior to the emergence of the color development process films. Matthews published a description of early processes in 1931.[12] The literature on the subject is extensive and an exhaustive study has been prepared by Ryan as doctoral thesis at the University of Southern California.[13] An abstract of this was presented at the 100th Technical Conference of the Society of Motion Picture and Television Engineers in Hollywood on October 4, 1966.

Color Development Systems

Modern color films, all of which utilize the subtractive process, are based upon color development to produce dye images. Rudolph Fischer in 1912[14] discovered that if a latent image in a silver halide emulsion is developed by a developing agent such as p-phenylenediamine or a related compound, in the presence of another compound called a coupler, there is formed along with the silver image, a dye image in porportion to the amount of silver present.

During development of the silver image, reaction products of the developing agent are formed. These oxidation products combine with the coupler to form dye. By proper choice of the coupler and the developing agent, a variety of dyes can be obtained. A study of the chemistry of color development has been published by Vittum.[15]

Three components are required, the silver halide, the developing agent and the coupler. The emulsion of the film contains the silver halide while the developing solution contains the developing agent. The coupler may be incorporated in the emulsion or be included in the developing solution. In the latter case, three color developers are required, one for each of the color forming layers of emulsion. The molecular structure of couplers for use in the emulsion is different from that required in a coupler to be used in a developer. Such differences have been pointed out by Vittum.[16]

The Kodachrome Films are examples of films processed with the couplers in the developing solutions. The color negative and print films used in 35mm production are examples of films having incorporated couplers.

In all color development type films, the silver images and any unused silver halides are removed from the film after color development by the use of a ferricyanide or dichromate bleach. The bleach converts the silver to a salt soluble in the fixing bath. The final images consist of dye only. When unused coupler remains in a coupler-incorporated film after processing this may be treated with a stabilizing bath so that it will not subsequently change color. In some films the couplers themselves are colored and it is important that they should not later change color.

Emulsion Layer Arrangement

The conventional arrangement of emulsion layers is to have the red-sensitized layer (which forms the cyan image) on the bottom; the green-sensitized layer (which forms the magenta image) is in the middle; the blue-sensitive layer (which forms the yellow image) is on top, separated from the green-sensitized layer by a yellow filter layer. This filter prevents blue light from reaching

the green- and red-sensitive layers, both of which are inherently blue-sensitive also. This yellow filter layer may be colloidal silver in which case it is removed during processing along with the silver images.

Emulsion Sensitivity and Dye Density

Figure 20-6 shows the sensitivity of the three layers of a daylight type camera color reversal film. The absorption curves for the three dye layers of this film formed during processing are shown in Fig. 20-7. The manufacturer balances the speeds of the three emulsion layers taking into account the lighting conditions of intended use and the dye characteristics after processing to give an essentially neutral balance under the viewing conditions to be used for the positive transparency.

Films are supplied for daylight exposure and also for tungsten illumination at 3200K or 3400K. In some cases, only one balance is supplied in which case a color temperature conversion filter is used for other light sources. In some cases the compensating filter may include additional absorption required for a particular film. It is more efficient to use a film balanced for 3200K with a yellow compensating filter for daylight exposure than to use a daylight balanced film with a blue compensating filter under 3200K lighting.

Camera color reversal films have been used mostly in 16mm width. The color balance of the processed films has been adjusted by the manufacturer for a tungsten lamp projection light source at a color temperature of about 3400K. Recently the television industry has adopted a color temperature of 5400K for both 16 and 35mm color film in the TV film chain. This change is easily accommodated in making prints by altering the filter balance in printing. The manufacturers have altered the balance of the original camera films in some cases so that a number of camera films are now available for television news work which are in balance for 5400K

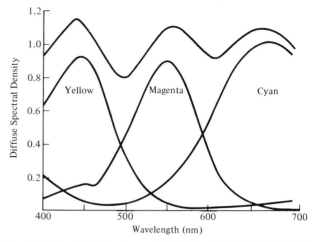

Fig. 20-7. Kodak Ektachrome EF Film 5241/7241 (daylight). (*Courtesy Eastman Kodak Company*)

projection. These films are indicated in the table of camera reversal color films.

Print and duplicating films have their sensitivities adjusted in each layer to peak as closely as possible at the same wavelength as the peak of absorption of the dyes in the film to be copied. At the same time sensitizing dyes are chosen to hold the bandwidth of sensitivity as narrow as possible. By these means, the information in each layer of the film to be copied is transferred to the corresponding layer of the print or duplicating film.

Colored Couplers

The best dyes available in the color development system have some unwanted absorptions. If the film is to be used solely for printing, as in the case of color negative for example, the visual appearance is unimportant. It has been found possible to improve color quality by the use of colored couplers which act as masks to offset the unwanted absorption of the image-forming dyes. The use of colored couplers for color correction has been described by Hanson.[17]

Colored couplers are ordinarily used in only two emulsion layers. The green-sensitized layer contains a yellow-colored coupler which forms magenta dye upon exposure and development. There remains the unused yellow-colored coupler which forms a positive mask to correct for the unwanted blue absorption of the magenta dye. The red-sensitized layer contains a pink-colored coupler which forms cyan dye upon development. There remains the unused coupler which forms a positive mask to correct for both the blue and green unwanted absorption of the cyan dye.

CAMERA COLOR REVERSAL FILMS

Color reversal films for camera use are available in two contrasts. The higher contrast films, which includes

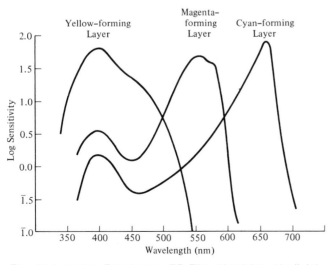

Fig. 20-6. Kodak Ektachrome EF Film 5241/7241 (daylight). (*Courtesy Eastman Kodak Company*)

the greater number, are intended for use in making pictures for projection. The low contrast original films are intended for making originals from which prints will be made for release use. As prints are not often made from local television news film, the films used are of the projection contrast type.

Camera color reversal films are widely used in 16mm width although many of them are available in 35mm also. These latter are used for special purposes. As in black and white, professional production methods are geared to the negative-positive process in the 35mm field.

Camera color reversal films having incorporated couplers can have their emulsion speed increased by special processing (usually involving increased first development). As this may result in some mis-match in contrast between the several layers, there may well be some sacrifice in color quality.

The following table lists the camera color reversal films available at the present time.

Camera Color Reversal Films

Exposure Index			Types	
Daylight	Tungsten		16mm	35mm
		Non-Coupler-Incorporated Type		
25	8*	Kodachrome 25 Film (daylight)	7267	
25*	40	Kodachrome 40 Film (Type A)	7268	
		Coupler-Incorporated Type		
16*	25	Eastman Ektachrome Commercial Film	7252	
64	16*	Kodak Ektachrome MS Film	7256	5256
	80	Gevachrome S Film (tungsten)	700	
64*	100	Fujicolor Reversal TV Film RT-100	8426	
	125	Gevachrome Film (tungsten)	710	
80*	125	Kodak Ektachrome EF Film (tungsten)	7242	5242
80*	125	Kodak Ektachrome Video News Film (tungsten)	7240	5240
125		Gevachrome D Film (daylight)	720	
160		Eastman Ektachrome Video News Film (daylight)	7239	5239
160	40*	Kodak Ektachrome EF Film (daylight)	7241	5241
250*	400	Fujicolor Reversal TV Film RT-400	8425	

*With compensating filter.

Processing

Kodachrome Films are processed in a system in which the three couplers required are provided in three separate color developers. Following development of the negative silver image in a conventional developer, the top layer is reexposed to blue light and the yellow image developed in the first color developer which contains the yellow coupler. The cyan image is formed in the bottom layer by reexposure to red light followed by the cyan coupler developer. The magenta image is then formed either by reexposure to white light and magenta development or the use of a fogging magenta developer. Since it is important in the final color developer that only silver halide in the middle layer be redeveloped and magenta dye formed, any unused halide in the top and bottom layers is developed to silver by a noncoupling developer immediately after coupler development. These "clean-up" developers are referred to as auxiliary developers. The use of auxiliary developers improves color quality by minimizing color contamination by magenta in the yellow and cyan layers.

In the incorporated-coupler type process, only a single color developer is necessary. The film is reexposed after the black and white negative developer or a fogging redeveloper is used. In either event, the silver is removed by the bleach and fixing baths, leaving only the dye images.

The following table shows the basic steps in the two types of reversal color process. It is understood, of course, that water rinses are used between many of the steps in the processes. In most cases, packaged chemicals are available from the manufacturers in order to simplify processing in commercial laboratories.

Basic Process Steps

Incorporated-Coupler Type	*Nonincorporated-Coupler Type*
Prehardener	Prehardener
Backing removal	Backing removal
First development (negative)	First development (negative)
Reexposure to white light[1]	Reexposure of top layer to blue light
Color development	Yellow development
Bleach	Auxiliary development
Fixation	Reexposure of bottom layer to red light
Wash	Cyan development
Stabilization	Auxiliary development
Dry	Reexposure of middle layer to white light[1]
	Magenta development
	Bleach
	Fixation
	Wash
	Dry

[1]Reexposure unnecessary if the following color developer is a fogging developer.

COLOR REVERSAL DUPLICATING FILMS

The first duplicates of color reversal original films were made using Type A camera film. Since the contrast of this film is intended for making originals for projection, it resulted in duplicates of abnormally high contrast. Eventually a duplicating film of somewhat lower contrast was introduced which also used emulsions having narrow bandwidths of sensitivity.

As color reversal duplicating films are to be used in printers, they are balanced for exposure to a light source of about 3000K which is screened by 4 mm of Pittsburgh Heat Absorbing Glass No. 2043. Minor modifications in print balance are accomplished by timing of the three beams in additive printers or by the use of color correction filters in subtractive printing. In some cases, particular films may require also the insertion of an ultraviolet absorbing filter in the printer beam.

As with the case of original reversal camera films, the color duplicating films are also available in two contrasts. The lower contrast type is intended for duplicating originals of projection contrast. The higher contrast duplicating film is for use with low contrast original films. In this latter case, it is the objective that the duplicate have normal projection contrast.

In any duplicating process there is always some loss in scale, that is, of density range. With the reversal color films, the best print results are obtained when the original film is of low contrast. Projection contrast original films should be used when it is not expected that prints will be needed.

Prints from original reversal camera films can also be made by the preparation of a duplicate negative from which color prints are then made. These films will be discussed later under the general heading of negative-positive color films.

The following table lists the several color reversal duplicating films which are available at present. The Eastman Reversal Color Print Film 7387 uses a process similar to that required for Kodachrome Film. Processing service is provided by the manufacturer and also by licensed laboratories. The several manufacturers of coupler-incorporated duplicating films offer processing service for their products as do many commercial laboratories.

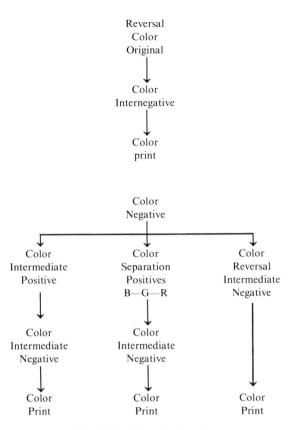

Fig. 20-8. Color Duplication.

In color duplicating some new names have been introduced for the several steps and the films used for them. *Internegative* is the term used for a color duplicate negative made from an original color reversal film. *Intermediate* is the term used for color master positives, duplicate negatives made from them and for a new color reversal duplicating film for making a duplicate negative in a single step from a color negative. Figure 20-8 shows a block diagram of the various stages leading to a color print.

Color Reversal Duplicating Films

	Types	
	16mm	35mm
Noncoupler-Incorporated Type		
Eastman Reversal Color Print Film[a]	7387	
Coupler-Incorporated Type		
Eastman Ektachrome Reversal Print Film[a]	7390	
Eastman Ektachrome R Print Film[b]	7389	5389
Gevachrome Print Film	780	

[a]High contrast type for prints from low contrast originals.
[b]Low contrast (unity) type for prints from projection contrast originals.

As mentioned previously, 35mm (and 70mm) production is based upon the negative-positive process. The films used for color are all of the incorporated-coupler type, which simplifies processing. Color developing and printing services are available in commercial laboratories on a world-wide basis, the formulas for the solutions and instructions for control and analysis being supplied by the film manufacturers who do not themselves offer this service.

The films for professional use form a family based upon color negative as the camera film. Color print film is used both for daily and release prints.

COLOR NEGATIVE FILMS

The color negative films available on the American market at present are as follows:

Exposure Index			Types	
Daylight	Tungsten		35mm	16mm
64*	100	Eastman Color Negative Film	5254	7254
64*	100	Eastman Color Negative II Film	5247	7247
64*	100	Fujicolor Negative Film	8516	8516
80	20*	GAF Color Negative Film	CF705	
64*	100	Gevacolor Negative Film	680	680

*With recommended compensating filter.

With the exception of the GAF Color Negative film, the others may all be processed in the same solutions.

Note also that the GAF film is balanced for daylight exposure and requires a compensating filter when exposed to 3200 K lighting.

Layer Arrangement

Color negative has the conventional layer arrangement with the red-sensitized layer on the bottom, the green-sensitized layer in the center and the blue-sensitive layer on top. Colored couplers of the kind described earlier are used in the green- and red-sensitized layers. A yellow filter layer is coated between the top and middle layers. Color films represent a triumph of the emulsion coater's art in that the multiple coatings when dried have a total thickness only slightly greater than that of black and white films.

Processing

The following is an outline of the processing of color negative film. Of course, water rinses or washes are used between the several steps of the process.

Prebath
Color Developer
First fixing bath
Bleach
Second fixing bath
Hypo clearing bath
Stabilizing bath
Dry

Color negative, as well as the other negative-positive type films, has a jet backing which is softened in the prebath and removed with a jet spray before the film enters the color developer. The color developing agent used in this process is 4-amino-N-ethyl-N [β-methane-sulfonamidoethyl]-m-toluidene sesquisulfate monohydrate. The first fix acts as a stop bath and also removes the unused silver halide. The silver in the image is then bleached to a compound soluble in the second fixing bath. The main wash follows the hypo clearing bath prior to stabilization of the unused coupler still present in the film.

The sensitometric and chemical analytical control methods are outlined in the manual supplied by the film manufacturer.

The color negative process is used also for color intermediate film. Since the different films have different sensitivities to departures from normal in the several solutions, it is important that the solutions be maintained accurately if uniform results are to be obtained.

COLOR DUPLICATING FILMS

Internegative Film

As internegative film is used for making color duplicate negatives from original color reversal films, its use is mostly in the 16mm width. The contrast of the film is adjusted to be correct when the original is on a low contrast original film. When used to make duplicates from projection contrast originals, its contrast will be a little high.

The sole variety of internegative currently available on the American market is Eastman Color Internegative Film 5271 (7271 in 16mm). The green and red sensitized layers contain colored couplers similar to those in color negative. The film is designed for processing in the color print process. Thus, with a single color process, a small laboratory can make duplicate negatives and release prints from reversal color originals.

When color negative first began to be used, the only method then available for duplication was the making of black and white color separations which were then printed with the requisite filters to an internegative film. This is still done in some special effects work. If a color picture is to be preserved for posterity, the best method to use would be to make the three black and white color separation positives, wash them well and store them carefully.

Intermediate Film

Color intermediate film is a single film which is used to make both the color master positive and the color duplicate negative therefrom. The film has unity contrast. Eastman Color Intermediate Film 5253 (7253 in 16mm) is a coupler-incorporated film having colored couplers like those in color negative film. Since it is used in two stages, the cancellation of unwanted absorptions in the image is important. The film is processed in the color negative process with minor modifications. The recommended ferricyanide bleach is important in order to avoid the tanning action on the image which is characteristic of dichromate bleaches (such as are used for color print film) which would result in undesirable edge effects.

During printing a Kodak Wratten No. 2E ultraviolet absorbing filter is used together with the conventional 4 mm Pittsburgh Heat Absorbing Glass No. 2043. As in the case of black and white duplicating, it is desirable to keep the density range of the image on the straight-line portion of the characteristic curve. A well-made duplicate negative will be denser than the original negative from which it was made.

Intermediate film can also be used to make a color duplicate negative from black and white separations made from an original negative. In this case a film such as Eastman Panchromatic Separation Film 5235 (7235 in 16mm) is used to make the separation positives. Filters such as the Kodak Wratten No. 98 (blue), No. 99 (green) and No. 70 (red) can be used. The contrast of this film is such that a gamma of unity can be obtained on the separations by development in a conventional borax picture negative developer at development time comparable to that used for production black and white picture negative.

When the black and white separation positives are printed to Intermediate Film, the Kodak Wratten No. 29 (red), No. 99 (green) and No. 98 (blue) filters are used for the register printing operation.

COLOR REVERSAL INTERMEDIATE FILM

Color reversal intermediate film is a colored-coupler film having incorporated couplers intended for making duplicate negatives in a single printing and processing stage. The only film of this kind currently available on the American market is Eastman Color Reversal Intermediate Film 5249 (7249 in 16mm). It has an overall contrast of one. It is intended for use in a printer equipped with a light source of about 3000K screened by the usual 4 mm Pittsburgh Heat Absorbing Glass No. 2043 with the addition of an ultraviolet absorbing filter such as the Kodak Wratten No. 2E. During the printing operation light changes can be made to produce a duplicate negative which will print at substantially one light change. As in the case of any duplicating operation, the density of the duplicate negative should be such as to place the picture densities on the straight-line portion of the characteristic curve. This produces a duplicate negative somewhat denser than the original.

A special color reversal process, CRI-1, is specified for this film. It is analagous to the reversal processes used for the camera reversal films. It is operated at elevated temperatures in order to shorten the overall process time. Developer temperature is 110°F (43.3°C) while other solutions are used at 95°F (35°C) and 100°F (37.8°C). The first solution in the process is a prehardener which reduces the amount of emulsion swelling during processing. The color developer contains a fogging agent which eliminates the necessity of a second exposure prior to color development.

With the use of the reversal color intermediate film, it is necessary to be careful of emulsion orientation. No difficulty is experienced in optical printing as the emulsion position of the original negative can be reversed in the optical printer. When printing is done on the usual contact printer, it is common practice to turn the original negative over and print through the base. Modern contact printers, especially of the additive type, have specular printing light at the aperture and satisfactory definition is obtained.

COLOR PRINT FILMS

Color print films are supplied by several manufacturers as listed below. They are all intended for processing in the same color print process. Basically, color print film is balanced for exposure with a printer light at about 3000K screened with the 4 mm Pittsburgh Heat Absorbing Glass No. 2043 and an ultraviolet absorbing filter such as the Kodak Wratten No. 2B.

Layer Arrangement

Color print films differ in their layer arrangement from other color development type films. The magenta image is on top with the yellow image on the bottom. The magenta image has the highest visual contrast while the yellow has the lowest. By using this unconventional arrangement, overall definition is increased.

Processing

The color process for color print film is analogous to that for color negative except to have provision for sound track development. The developing agent used is 2-amino-5-diethylaminotoluene monohydrochloride which is a more allergenic compound than the negative developing agent. Care must be exercised in the mixing and handling of the material or solution to avoid contact with the skin.

In order to provide a silver sound track (which also contains some dye), the sound track is printed using a blue-absorbing filter such as the Kodak Wratten No. 12, which restricts the exposure to the top two layers, the green- and red-sensitized layers. After the first fixing bath, a dye plus silver track exists in the film. The silver is converted to a salt soluble in the hypo by the bleach. At this point the film is surface dried and the track area only redeveloped to silver by a line of viscous developer laid down by an applicator wheel. The viscous developer is removed from the film by a water spray before the film enters the second fixing bath. The print densities used for the sound track are closely comparable to those used on black and white print films.

The following is a tabulation of the color print films currently available on the American market.

	Types	
	35mm	16mm
Eastman Color Print Film	5381	7381
Eastman Color SP Print Film	5383	7383
Fujicolor Print Film	8819	8829
Gevacolor Print Film	9.86	9.86

The two Eastman Color Print films require different processes.

GENERAL

As will be seen from the above, the trend in color processing during recent years has been toward the use of higher temperatures in order to shorten the overall processing time and minimize the size of processing machines. All color processing requires accurate chemical control of solutions. The film-process combination must be considered as a unit in that the film will yield the desired results only when the correct processing is carried out. This is a far cry from the old days when black and

white films were developed on racks and visual inspection with a hand safelight was the means of control. That the desired control is possible is evidenced by the uniformly high print quality that is seen on the screen today.

STANDARDS

There are more than 100 American National Standards relating to cinematography. An annual index of these is published by the Society of Motion Picture and Television Engineers, 862 Scarsdale Avenue, Scarsdale, N.Y., 10583, the sponsor of the PH22 group of standards. The American National Standards Institute, Inc., 1430 Broadway, New York, N.Y., 10018, also holds the secretariat for Technical Committee 36 (Cinematography) of the International Standards Organization. Copies of American National Standards and of International Standards can be obtained from the ANSI.

Standards describe the specifications for slitting and perforating of motion picture films in all the various widths and perforation configurations. Many of these American National Standards are represented by International Standards also. In fact, the actual films themselves are interchangeable on a world-wide basis even where International Standards have not yet been completed.

Reference has been made to 70mm film in the preceding text. When the American Optical Company and Todd-AO began using wide film, they started with 65mm, as described in ANS PH22.145-1965 (R1969). Subsequently, with the development of six-track magnetic sound, the present 70mm motion picture film was designed (PH22.119-1967). This 70mm film is similar to the 65mm in the perforation size and spacing. In effect, it has 2.5mm of additional margin outside the perforations on each edge. This gives space for the multiple magnetic tracks. In the United States 65mm film is used for original negative and duplicating films. Prints are on 70mm. It is interesting to note that in the U.S.S.R. 70mm film is used for all wide film.

There is another American National Standard, PH1.20-1970, which describes two other 70mm perforation configurations which are used for instrumentation photography. The PH1.20 perforations are not compatible with the PH22.119 motion-picture type. Those wishing to use a 70mm film for any purpose are advised to consult the two standards mentioned to ensure that film of the correct perforation configuration is chosen.

REFERENCES

1. C. E. Kenneth Mees, *History of Professional Black and White Motion Picture Film, J. Soc. Motion Picture Television Engrs.*, **63:** 134 (Oct. 1954).
2. Allan L. Sorem, "The Effect of Camera Exposure on the Tone Reproduction Quality of Motion Pictures," *J. Soc. Motion Picture Television Engrs.*, **62:** 22 (1954).
3. H. L. Baumbach, "Chemical Analysis of Hydroquinone, Metol and Bromide in a Photographic Developer," *J. Soc. Motion Picture Engrs.*, **33:** 517 (1939).
4. R. B. Atkinson and V. C. Shaner, "Chemical Analysis of Photographic Developers and Fixing Baths," *J. Soc. Motion Picture Engrs.*, **34:** 485 (1940).
5. J. O. Baker and D. H. Robinson, "Modulated High-Frequency Recording as a Means of Determining Conditions for Optimal Processing," *J. Soc. Motion Picture Engrs.*, **30:** 3 (1938).
6. L. M. Dearing, "Fleet Processing of 16-Mm Gun Camera and Combat Films," *J. Soc. Motion Picture Engrs.*, **44:** 231 (1945).
7. J. W. Zuidema, C. E. Ives, N. A. Exley and C. C. Wilt, "Processing Methods for Use with Two New Black-and-White Reversal Films," *J. Soc. Motion Picture Engrs.*, **66:** 1 (1957).
8. J. W. Zuidema, "The Sulfuric Acid-Potassium Dichromate Bleach in the Black-and-White Reversal Process," *J. Soc. Motion Picture Television Engrs.*, **72:** 485 (1963).
9. C. E. Ives, C. J. Kunz and H. E. Goldberg, "Improvement in Illumination Efficiency of Motion Picture Printers," *J. Soc. Motion Picture Engrs.*, **42:** 294 (1944).
10. American National Standards, PH22.133-1963 (R1969), Screen Luminance and Viewing Conditions for 35mm Review Rooms, and PH22.100-1967, "Screen Luminance and Viewing Conditions for 16mm Review Rooms," American National Standards Institute Inc., 1430 Broadway, New York, N.Y. 10018.
11. Noel R. Bacon and Robert R. Lindemeyer, "A New Heat-Developable Motion-Picture Print Film," *J. Soc. Motion Picture Television Engrs.*, **73:** 213 (1964).
12. G. E. Matthews, "Processes of Photography in Natural Colors," *J. Soc. Motion Picture Engrs.*, **16:** 188 (1931).
13. Roderick T. Ryan, "History of Color Motion Pictures," Publication No. 67-5307, University Microfilms Library Services, Xerox Corp., Ann Arbor, Mich., 48106.
14a. R. Fischer, Ger. Patent 253,335 (1912).
 b. R. Fischer and H. Siegrist, *Photogr. Korr.*, **51:** 18 (1914).
15. P. W. Vittum, "Chemistry and Color Photography," *J. Soc. Motion Picture Television Engrs.*, **71:** 937 (1962).
16. P. W. Vittum, *loc. cit.*, p. 938.
17. W. T. Hanson, Jr., "Color Correction with Colored Couplers," *J. Opt. Soc. Amer.*, **40:** 166 (1950).

21

AERIAL PHOTOGRAPHY AND PHOTOGRAMMETRY

A. Anson

DEVELOPMENT OF PHOTOGRAMMETRY AND AERIAL PHOTOGRAPHY

Arago, in presenting the daguerreotype process to the French Academy of Sciences included, among other possible applications of the new process, "the rapid method which topography may borrow from the photographic process." It was not until 1851 however that the first steps were made towards the use of photography in map making by Aime Laussedat[1] an officer in the engineering corps of the French army. His measurements of photographs exposed in an ordinary view camera using the wet collodion process were the beginnings of photogrammetry. He was active in the field until his death in 1907 and for his researches was made a commander of the Legion of Honor in 1879. Other pioneers were Meydenbauer in Germany, Scheimpflug in Vienna and Porro in Italy.[2] In 1900, E. Deville, a Canadian, employing a stereoscopic pair of photographs made with phototheodolites (cameras mounted on rigid tripods at each end of a carefully measured base line) devised a simple machine for plotting the intersection of the light rays and the construction of maps from the stereoscopic photographs. Carl Pulfrich of Carl Zeiss in Jena[2] designed the stereocomparator the same year. In it two stereophotographs are viewed stereoscopically enabling the positions and heights of all points which are included in both photographs to be determined. In 1905 E. von Orel in Vienna designed the photogrammetric stereoautograph with which contour lines could be drawn mechanically. It was later greatly improved by Pulfrich.

After this, development in ground-based photogram-

metry took place primarily in Europe where it was used particularly in the Alps where the steep terrain afforded long range views and ground survey was difficult. With the invention of the airplane there was increased interest in aerial photography but almost all of the developments before World War I were based on the use of stereophotographs from the ground. There was considerable experimentation in this field by U.S. Army Engineers and ground photogrammetry was used extensively in a U.S. Geological Survey study of Alaska.

The first successful aerial photograph was made by Gaspard Felix Tournachon, better known as Nadar, from a balloon in 1859.[3,4] The photograph of Paris (Fig. 21-1) was made on a wet collodion plate coated and processed in a darkroom built into the cage of the balloon. S. A. King and J. W. Black made a photograph of Boston the following year (Fig. 21-2), and it is claimed that photographs from balloons were used to direct military operations in the American Civil war but this cannot be confirmed.

Kites were used as well as balloons.[4] The pioneer in this field was the Frenchman, Arthur Batut (1889) but the most successful was the American, George Lawrence, who made a detailed picture of the Chicago stockyards in 1901 using a lightweight camera which he had designed to make 20×24 in. pictures. This was eclipsed, in size at least, in 1906 with an 18×48 in. photograph of San Francisco after the earthquake and fire. This picture is reproduced in *Airborne Camera* by Beaumont Newhall which is a detailed survey of early aerial photography from balloons and kites.

Photography from balloons is not obsolete. In Project

Fig. 21-1. The Arch of Triumph photographed by Nadar (Gaspard Felix Tournachon), probably from Henri Gifford's captive balloon in the Hippodrome. (Reprinted from "Eye in the Sky," J. R. Quick)

Stratoscope[25] photographs of the sun were made at an altitude of 82,000 ft and again in 1971 photographic balloons were used to study light flashes which had been observed by the astronauts.

World War I Reconnaissance Photography

The value of photographs made from airplanes was quickly realized by military intelligence staffs and thousands of photographs of troop movements, supply facilities, bridges, railways, docks and bomb damage assessment were made each day. The cameras were usually hand held because suitable mountings had not been developed and in the early years of the war glass plates were used in magazines which limited the number of exposures and were cumbersome and unreliable to use. The emulsions were slow and in the French army at least the need for panchromatic materials and filters

Fig. 21-2. Photograph of Boston from a balloon. (*Photograph courtesy Library of Congress*)

was not recognized until it was shown that they were used by the German army. Reconnaissance photographs made at low altitudes in an attempt to obtain more information were often blurred from movement of the airplane during the exposure. Mapping from aerial photographs was handicapped by lack of knowledge of the altitude of the airplane at the time of exposure.[5,6]

With all its drawbacks, aerial photography was still superior to any ground method for obtaining enemy intelligence. Highly detailed topographic maps had to await the development of precision stereoplotters. Between the years 1918 and 1945, aerial camera and photogrammetric plotter development moved slowly. Dr. Otto Von Gruber[4] and Dr. Carl Pulfrich were

translating theory into practice in manufacturing plotters and Drs. Wild and Schmidtheini worked with the Wild Company in Heerbrugg, Switzerland, in the design of aerial cameras. Other plotters were developed in France by Poivilliers and by Bausch and Lomb in the United States.

World War II Reconnaissance and Mapping

A most ingenious use for aerial photography which was not dependent upon measurement was adopted during World War II, namely *strike* photography. A simple idea, it required the bore sighting and synchronization of

a motion picture camera with the aircraft's machine guns. The trigger of the machine gun operated the camera and resulted in target motion pictures as each gun was fired. This was a valuable method of checking the effectiveness of the gunner's fire as well as a source of target military intelligence. The state-of-the-art of motion picture cameras was sufficiently advanced to obtain excellent target records in this manner.

The design of aircraft advanced sufficiently during World War II for camera windows to be fitted into the belly of high flying aircraft in order to obtain vertical aerial photographs; such photographs are simpler to measure than oblique photographs for bomb damage assessments and target information. If thousands of photographs were made each day during World War I, millions were made each day during World War II, and 80% of the information concerning the enemy was derived from aerial photos.[3,7] In addition to reconnaissance photographs made during the day from high flying fast reconnaissance aeroplanes, techniques were also developed for night photography with the aid of large flash bombs[8,9] whose trajectory was designed to explode at the edge of the vertical camera field of view.

With the advent of vertical aerial photography and improved cameras, lenses and films, mapping photography was also improved and special plotters were developed for paper prints and glass diapositives. A special method of mapping by combining vertical and oblique photography was developed and termed TriMetrogon Aerial Photography. Trimet photography was exposed from a group of three cameras—one vertical and two wing cameras, each tilted 60° from the vertical camera and including the horizon on each side.[3]

It soon became apparent that the global nature of World War II required rapid mapping of vast stretches of unknown areas with little or no ground control. The threat of Japan to the northwest required the building of the Alcan Highway and hasty small-scale mapping of Alaska. The TriMetrogon system was brought into use for this mapping job in 1944 and 1945 and a large part of the work was done by the Corps of Engineers in conjunction with the U.S. Geological Survey in aircraft flown by the Air Force at altitudes above 30,000 feet. Many of the techniques of aerotriangulation and topographic mapping developed during World War II are still used for mapping remote areas.

Rocket Photographs

Soon after Dr. Von Braun and the men who assisted him in the rocket program were organized at the White Sands Proving Grounds, cameras were installed in the experimental rockets* from which it was demonstrated that aerial photographs at high altitudes could be taken. It had been postulated that the speed of the rocket would affect the imagery so that photographs would be unsharp

*The German army had experimented with photo rockets as early as 1912. Beaumont Newhall, *Airborne Camera*, Hastings House, New York, 1969.

but photographs exposed at the top of the trajectory retained good, clear imagery.

During the early Lunar Exploration period at the National Aeronautics and Space Administration, unmanned satellites were launched toward the moon to specific landing sites to determine their characteristics prior to dispatching manned satellites. The first successful Ranger series was the Ranger VII (1964), VIII, and IX (1965), which were aimed at the moon and crash landed, the cameras operating just prior to the landing and transmitting two sets of TV pictures, a wide angle and a narrow angle photograph which were received as electronic signals at the Deep Space Tracking Station operated by the Jet Propulsion Laboratories. The next series, Surveyor I, soft landed on the moon, thus showing the bearing strength of the lunar soil. By transmitting TV signals on command and scanning the site, it also showed the appearance of the surrounding terrain.

The successful Gemini flights were Gemini III in March 1965 through Gemini XII in November 1966. Original predictions had been made that satisfactory aerial photographs of the Earth would be difficult to attain from the capsules moving through space and that color photography would not be acceptable because the haze and moisture in the earth's atmosphere would hide detail and diminish color contrast. It was soon discovered that the haze layer was low in the earth's atmosphere, not extending much above 20,000 feet; as the vehicles soared higher the vacuum of space caused no interference to the transmission of light and reflectances from the earth. The atmosphere close to the earth acted as a sheet of translucent vellum which transmits images when placed in contact with the surface of an image (Figs. 21-3 and 21-4).

By now the Apollo flights have become history; not only have telecasts with TV cameras on the moon been returned to earth; but hand-held standard cameras have also taken color and black and white photography; returned the film for processing; and the prints have been widely distributed. It is worth noting that a hand-held camera with its own light source has been designed to take photographs of the lunar soil at 6 in. The first lunar photographs were taken with a hand-held camera by Astronaut Armstrong. The first photographs on the moon were taken by Astronauts Stafford and Young in December 1968.

APPLICATIONS OF AERIAL PHOTOGRAPHY

The Coast and Geodetic Survey, now known as the National Ocean Survey (NOS), part of the National Oceanographic and Astronautic Administration (NOAA) uses aerial photography extensively for mapping coastlines, for preparing maps of navigation aids and for hydrography,[10,11] In preparing hydrographic charts, the Ocean Survey requires accurate and highly detailed maps of shoreline features. Aerial photography is usually exposed on color, infrared, and black and white films at different time periods. At high tide, the infrared black and white

Fig. 21-3. U.S.-Mexico, Tucson, Arizona area. Light patches near Keystone Peak are tailings ponds from smelters. Apparent tone difference outlining the international boundary probably reflects different range management practices. The road to Kitt Peak observatory is visible as well as Route 286, an unpaved road. Gemini 4. (*NASA Photograph*)

pictures define the mean high water line, which is shoreline for charting. Tide control color photography is exposed at mean low water and is the best known means for delineating shore and offshore features. The color of the water in a single photograph may change gradually from grey clay soil near river mouths to green and clear in shore areas, blue, blue-green and blue-violet as greater depth of water is shown. Aerial color photography is also used to locate buoys, channel lights and day beacons. These can be located without a trip to the field. Since the

United States has approximately 40,000 navigational aids this saves much time and money.

The first evaluation of color aerial photography for geologic exploration was made by the U.S. Geological Survey in 1955 in the Furnace Creek Area, Death Valley, California.[12] The second evaluation was made of areas near Tonopah and Goldfield, Nevada, in October 1958. Aerial photography color sequences could be correlated with ground color which characterize an undisturbed area. The absence of a specific color in an established

photography and ground color sequence suggested a stratigraphic or structural complexity. This was used to detect a low angle fault in the Funeral Mountains. Offsets, or interruptions, of established color sequences suggested high-angle faulting. Strata different in age, but similar in rock type, could be recognized by color differences. Concentrations of ground color in the yellow range cause dense areas on the same film. Preliminary results indicated that most of the lithologic units pre-

viously mapped could be recognized by color on aerial color photographs.

In 1960 Minard reported that interpretation of aerial color photographs in the Piedmont Coast Plain facilitated the mapping of two formational contacts which were extremely difficult to locate other than by extensive drilling.[11]

In 1962 Fischer reported that aerial color photography was helpful in New Mexico in mapping the distribution

Fig. 21-4. South West Africa, Walvis Bay and Swakopmund. The Kuiseb R. in center, Swakop and Khan R. to the north. The coastal area is part of the Namib Desert. Gemini 5. (*NASA Photograph*)

of residual soil, recognizing relic sink holes and determining the origin of drifting sand onto a limestone capped mesa.[12]

The Water Resources Division of the Geological Survey has found that the use of black and white infrared photographs helps to locate stream channels further upstream and in locating many less obvious streams because of the absorption of infrared rays by moist areas. With the use of Anscochrome D/200 aerial photographs taken at 5000 ft, underwater detail of the Florida Everglades is shown in full color. From the size and shape of the hammocks, the direction and magnitude of stream flow was shown. Vegetation color also indicates which hammocks are above water at certain seasons. Coastline photographs of the Everglades indicate the extent of salt water infiltration by the boundaries of the mangrove tree clusters, easily spotted on color infrared photographs.

The U.S. Forest Service in December 1946 located yellow pine trees killed by bark beetles.[13] The dead trees were quickly spotted by their grey color in the aerial photographs. In 1947, aerial color photographs made over San Jose National Park were used to locate timber damaged by the tussock moth; the damaged trees could be individually located on the color photographs. Other areas in the Black Hills were seriously affected requiring that every single infested tree be located. This was done successfully by aerial color photography. The Forest Service has found that identifications of tree crowns are 15% more accurate with color photographs than with black and white photographs.

The Department of Agriculture has used color infrared photography as an indication of healthy and diseased trees for orchardists. The broad-leaved, healthy trees appeared red; the dead and dying trees were more yellow or blue. They could be detected much more quickly from infrared photographs than on the ground.[14]

SATELLITE MAPPING

The first weather satellite, TIROS I, was launched in April 1960 under the aegis of the National Operational Meteorological Satellite System. Tiros X was launched in 1965. With the gradual evolution of the satellites the Tiros Operational System is the first national weather satellite system and is part of the World Weather Watch System (WWWS) being developed by the World Meteorological Organization, a part of the United Nations. In the automatic picture transmission system, photographs made by the satellite are transmitted to the ground by electronic scanning. On the ground the photographs are printed line by line at local stations within range. Photographic data reaching the ground from a satellite equipped with an advanced VIDICON camera system are recorded on magnetic tape and sent by wire to the satellite center where the picture signals are displayed on a kinescope and recorded on film along with latitude and longitude. Every day the data for the entire earth are computed to present the weather over the globe. One series, the Applications Technology Satellites (ATS)

produce color photographs of the earth with three light detectors of the photomultiplier type sensitive to wavelengths of red, green and blue. On the ground the output of each tube is recorded on color film to achieve a color photograph of the earth's weather. The ATS altitude is 22,300 miles with an orbital period of 24 hours synchronous with the earth's rotation.

Space photographs have been made of Venus and Mars by satellites flying by in a planned orbit which eventually sends them off into space. Picture transmission is by camera image scanned and sent back to the earth as electronic signals which are reconverted to photographic images. Photography which began as a chemical discovery, now enters the age of electronics to be converted to electromagnetic energy and reconstituted as an image.

AERIAL CAMERAS

Cameras designed to be used for aerial photography can be divided into three general classifications: (1) reconnaissance cameras (principally military), (2) precision cartographic cameras (mapping—civil and military), and (3) space cameras. Reconnaissance cameras obtain information on troop dispositions, bomb damage assessments, and other tactical and strategic military information. The cameras must be operable in high speed aircraft flying at low levels while employing evasive action. The lenses must have maximum light gathering capability for obtaining acceptable photographs regardless of the time of day or the type of weather. Image motion compensation (relating film movement to scaled down ground speed) must be provided and the camera magazine requires a large film capacity. The entire system is operated electronically by remote control. Cartographic (mapping) cameras require maximum average resolution over the entire field and absolute minimum distortion in order to retain accurate geometry of the terrain photographed. The format of the cartographic camera is large; the gradual evolution of the square format increased from $4\frac{1}{2} \times 4\frac{1}{2}$ in. to 7×7 in., then to 9×9 in., which is in general use at the present time. Space cameras for lunar and planetary missions are especially constructed to withstand extreme temperature and pressure changes, while lending themselves to remote operation from earth based stations.

Reconnaissance Cameras

The wide variety of configurations and large number of reconnaissance cameras developed for military use can be characterized by a description of each of several types: (1) framing cameras, (2) rotating prism panoramic cameras, (3) scanning lens panoramic cameras, and (4) continuous strip cameras.

A typical reconnaissance framing camera is shown in Fig. 21-5.[17] Focal plane shutters are most often used. The fields of view are from 10° to 104° and the focal lengths range from 1 3/4 in. to more than 3 ft. Six-inch and 12 in. focal lengths are common. Film widths range from 70 mm

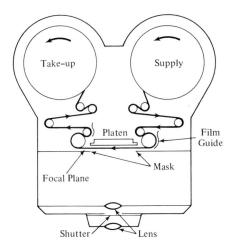

Fig. 21-5. Film advances frame by frame framing camera.

Fig. 21-7. Geometry of the panoramic aerial photograph. (*Courtesy American Society of Photogrammetry*)

to 9 1/2 in. and a common format size is 4 1/2 × 4 1/2 in. on roll film. Since large numbers of exposures are made during each mission, while flying at high speed, the cycling time for each exposure is adjustable from 1 to 6 cycles/sec and the film capacity is approximately 250 ft. All of the mechanical operations are electrically powered from the aircraft power source. Data is recorded for each mission on each frame, such as exposure number, mission, altitude, etc., by means of a Cathode Ray Tube (CRT) exposure at the moment of film exposure. The resolving power of reconnaissance cameras vary widely; however 75 lines/mm Area Weighted Average Resolution (AWAR)* is common. The gyrations of the aircraft usually require that reconnaissance cameras be fixed in a gyro stabilized mount over a camera window in the belly of the aircraft.

The small instantaneous field of view of the rotating prism panoramic camera, as shown in Fig. 21-6[17] yields

*The Area Weighted Average Resolution (AWAR) is a single average value for the resolution for a lens over the picture format for any given focal plane.

higher resolving power than the framing camera for the same focal length. The rotating prism panoramic camera employs an exaggerated rectangular format with a length 4× or more than its width in order to record the image from the rotating prism as it sweeps across the flight path of the aircraft so as to "paint" an image of a wide swath of ground onto the film. The lens is stationary and the fixed focal plane slit does not move. The slit is adjustable in size in order to control exposure time as the film moves synchronously with the scanning prism at the same velocity as the ground image. The most common focal length is 3 in. at f/4.5 with a picture format 4 1/2 × 12 1/4 in. covering 180° laterally (from horizon to horizon) and 74° fore and aft. Operation in a high speed aircraft requires a cycling rate of 1 to 6 cycles/sec and exposures of 1/90 to 1/5000 sec with Automatic Exposure Control (AEC). The film capacity is 1000 ft by 5 in. wide and the camera weighs 85 lb when loaded with film. Since the center of the prism rotates with the moving film, the sharpness of the image does not vary across the field. However, the panoramic picture is distorted with the largest images directly under the center and the horizon images compressed on each side (Fig. 21-7).

Another type of panoramic camera has a film surface curved along its length with the radius of curvature equal to the focal length of the scanning lens as illustrated in Fig. 21-8.[17] The exposure is controlled by the slit width. A typical rotating lens panoramic camera is the KA-55 which has a 12 in. focal length lens operating at f/5.6 over

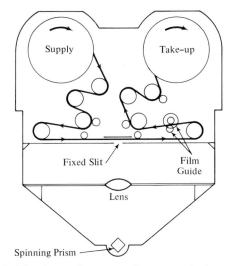

Fig. 21-6. Film in continuous motion except when recording data—rotating prism panoramic.

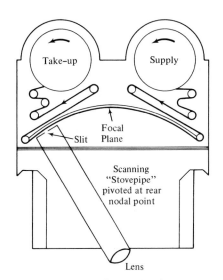

Fig. 21-8. Film advances frame by frame—scanning lens panoramic.

a picture format of 4 1/2 × 20 in. covering 90° laterally by 21° fore and aft. The cycling rate is 1/2 cycle/sec and exposures from 1/100 to 1/3,000 sec with Automatic Exposure Control (AEC). Film capacity is 1000 ft by 5 in. wide and the camera weighs 82 lb loaded with film. Data is recorded on each frame automatically to include frame counter, cycle counter, elapsed time meter and other mission data.

A fourth type of reconnaissance camera is the continuous strip camera illustrated in Fig. 21-9.[17] Known as the "Sonne" camera, the continuous strip camera was first used in 1932 and further developed during World War II. It was originally planned for low altitude, high speed reconnaissance because the camera exposes a continuous photograph of the terrain by passing the film over a stationary slit in the focal plane of the lens at a speed synchronized with the velocity of the ground image across the focal plane. The rays from any point will be focused as a single point on the film throughout the time of exposure. The duration of the exposure depends on the film speed and the width of the slit, as follows:

$$\text{Exp} = \frac{W}{V_F}$$

where

Exp = exposure time in seconds
W = slit width in inches
V = film velocity (inches/second)

The slit width is small (0.010 to 0.020 in.) so that at any instant a narrow ribbon of the terrain is exposed. As the aircraft moves forward, a long continuous photograph is "painted" on the film by the successive integration of narrow ribbons. Strip cameras may be used with a single lens cone, or with a dual lens cone where each lens covers one half of the film width. In using the dual lens cone, a stereobase is obtained by displacing the right lens forward and the left lens aft; thus creating a stereobase in the direction of flight. This lens offset is adjustable and is calibrated to give a "parallax angle." Larger parallax angles increase vertical exaggeration and the ability to

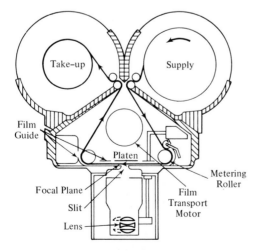

Fig. 21-9. Film in continuous motion—continuous strip camera.

measure object heights. Strip cameras are the simplest of the image motion compensating aerial cameras and are generally trouble free because shutters are not used. Banding sometimes occurs during cyclic changes of exposure if the film velocity is unsteady with worn gear teeth or excessive vibration inside the camera. The KA-18 strip camera is capable of producing a single strip or stereo strip negative 500 ft long with automatic or manual operation. Film cassettes contain 250 or 500 ft of film and operate on 28 V dc. The KA-18 has three lens cones: (1) a 6-in. single lens cone $f/6.3$, (2) a 6-in. stereo lens cone with two lens $f/2.5$ and a parallax indicator, and (3) a 3-in. stereo lens cone with 2 3-in. lenses and parallax angle indicator normally set at 6°.

Most reconnaissance cameras with complex electronic firing mechanisms and shutter controls are mounted in gyrostabilized mounts to counteract the roll and pitch of the aircraft. Complete camera systems with remote control instrumentation and intervalometers are bulky and vary in weight. When the speed of the aircraft (400–600 knots/hr) and the reaction time of the gyros are considered, it becomes apparent that even high quality reconnaissance photographs made from high speed aircraft are not usually suitable for topographic mapping since the geometry of the photograph is affected by the pitch and roll of the aircraft. The frame reconnaissance cameras are designed to operate with shutter speeds of 1/60 to 1/3000 sec, whereas panoramic cameras require higher shutter speeds such as 1/100 to 1/10,000 sec. When black and white infrared film is used camera lenses often require refocusing because of the longer wavelengths unless the lens is specially corrected.

Cartographic Cameras

The principal differences between reconnaissance and cartographic cameras are the format size (9 × 9 in.) and the geometry requirement which is much stricter for the cartographic camera (Fig. 21-10). Distortion in a precision cartographic camera causes image displacement of the true position; thus causing faulty geometry in the map—unless corrected by rectification. Users of reconnaissance imagery are concerned with information content and are not too concerned with the precise position of the image on the photograph, whereas the users of mapping photography are concerned that the distortions are minimal and can be corrected through calibration of the aerial camera or stereo plotter.

The requirements for lens performance of cartographic cameras are more stringent than for reconnaissance cameras because of the many design compromises required to achieve a low distortion cartographic lens. The development costs for cartographic lenses are very high. The most efficient lenses developed for cartographic cameras have a 6 in. focal length designed to cover the 9 × 9 in. format with resolutions varying from 35 to 45 lines/mm, AWAR, over the entire 81 sq in, distortions under 10 μm and an angular field of 90° on the diagonals which reduces to 73° 44′ for the square 9 × 9 in. format. Exposures are slower than for the reconnaissance camera

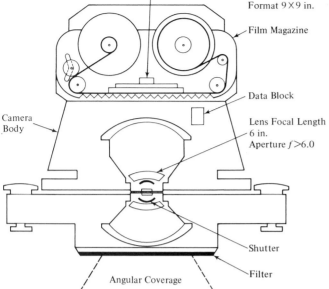

Platen and Reseau

Format 9 × 9 in.

Film Magazine

Data Block

Lens Focal Length
6 in.
Aperture $f > 6.0$

Camera
Body

Shutter

Filter

Angular Coverage

Fig. 21-10. Cross section of typical cartographic aerial camera.

and occasionally with a grid reseau, are exposed with each photograph to enable precise positioning of the photograph in the instrument used for subsequent plotting.

Details of some of the best known aerial cameras are given below:

1. *Fairchild KC-4B Cartographic Camera:* The KC-4B (Fig. 21-11) is a further development of the T-11 and KC-1 cameras which have been used extensively in topographic mapping activities by the U.S. Department of Defense. The major difference between the three cameras is in the lens. The T-11 has a *Metrogon* lens with distortion across the field on the order of 120 μm and an AWAR resolution of 25 lines/mm; the KC-1 has the *Planigon* lens known as a distortion-free lens with distortions across the field of ± 10 μm and an AWAR of 30 lines/mm and the KC-4B has the *Geocon I* lens specifically designed for distortion of ± 10 μm in addition to corrections for the optimum plane of focus for all visible wavelengths of light with an AWAR of 44 lines/mm. Thus, the KC-4B can be used for obtaining black and white infrared as well as color photography without refocusing the lens system.

2. *Zeiss RMK A 15/23 Cartographic Camera:* The RMK A 15/23 camera is illustrated in Fig. 21-12 and represents the latest development in the line of Zeiss cameras. It is equipped with the *Pleogon* lens with a focal length of 153 mm (6 in.). The camera cones are interchangeable to use a *Topar* 610-mm (24-in.) long focal length lens, a 305-mm (12-in.) focal length lens, a 210-mm (8 1/4-in.) focal length lens as well as a short focal length 85-mm (3.5 in.) lens for ultra wide angle coverage. All lenses are equipped with rotating between-the-lens shutters. The lenses are fully color corrected and require no refocus for infrared photography. Resolution is high and distortion less than ± 7 μm. Cameras are equipped with automatic exposure control to operate the diaphragm and shutters. The camera with intervalometer weighs 230 lb and operates on 24–28 V dc.

and vary from 1/25 to 1/1,000 sec with between-the-lens shutters to obtain uniform exposures. The lenses and antivignetting filters are coated to prevent internal reflection from degrading the image and to spread the light uniformly across the field. Cartographic cameras are operated at flying heights from 5000 to 30,000 ft and as a rule do not have image motion compensation. The cartographic camera with control box, intervalometer and special mounts, weighs from 100 to 240 lb and requires a 28 V dc power source. Since the camera body is larger than the reconnaissance camera, more space is available for data recording. Precise fiducial marks in the center border of each frame, sometimes in the corners

Fig. 21-11. Fairchild KC-4 Aerial camera with control box and intervalometer. (U.S. Army Photograph)

Fig. 21-12. Zeiss RMK A 15-23 cartographic camera. (*Courtesy Carl Zeiss Company*)

3. *The Wild RC-10 Aerial Camera:* The Wild RC-10 aerial camera is the latest in the series of Wild mapping cameras and is illustrated in Fig. 21-13. The illustration contains the electronic circuitry box, the camera body, the exposure control box and a navigation sight and view finder. The Wild RC-10 camera is equipped with the *Universal Aviogon* lens with interchangeable lens cones to accept the 88.5-mm (3.5-in.) super-wide angle lens, the 153-mm (6-in.) wide angle lens, or the 305-mm (12-in.) long focal length lens. All of the lenses are fully color corrected and have a rotary between-the-lens shutter. The lens resolutions are high and the distortions less than $\pm 10\mu$m. Both the Zeiss and Wild cameras are much heavier than the Fairchild camera. The Wild Camera weighs 275 lb with its associated equipment and operates on 24–28 V dc electrical current.

4. *Space Cameras:* The most noted space camera which was not specifically developed for space operation is the Hasselblad 500C equipped with the 80 mm (3 in.) Zeiss *Planar* lens and the 250 mm (10 in.) Zeiss *Sonar* lens. It was employed on the NASA Gemini missions. It was also equipped with a 38 mm Zeiss *Biogon* lens and encased for Extra Vehicular Activity (EVA) in a space atmosphere. The other hand-held camera adapted for space use is the Maurer 200G; both cameras have a 70-mm format.

The six cameras on the Ranger VII satellite which crashlanded on the moon were television cameras. Two had wide angle lenses of 1 in. focal length and the other four cameras had narrow angles of 3 in. focal length with all six furnishing overlapping fields of view. On July 31, 1964, Ranger VII began transmitting pictures at 2096 Km above the moon's surface and continued on down to 480 m. which was the last transmission.

Surveyor I landed on the moon's surface on 2 June 1966. It was also equipped with a television camera system with a zoom lens, an interchangeable filter wheel, and a mirror assembly which rotated about the vertical axis enabling the camera to scan the horizon and transmit the signals to earth.

The Lunar Orbiter, which accomplished its first mission in August 1967, was equipped with two separate optical cameras operating on a single web of 70 mm film; one camera had an 80 mm (3 in.) focal length lens with a picture format of 55 x 65 mm; the other camera had a 610 mm (12 in.) focal length lens with a picture format of 55 x 210 mm. The photographic film was fed across the focal plane of the two lenses through a looper to permit the film to accumulate, through an on-board processor (developing system) a dryer, another storage looper, through a video scanner and take-up reel. To transmit the pictures to earth, the light from the scanning tube was focused on the film by a lens, a collector lens directed the light, the intensity was modulated by the varying density of the developed image and transformed the light intensity to a variable electric signal which was

Fig. 21-13. Wild RC-10 aerial camera. Upper left: Electronic circuitry box. Upper right: Exposure control unit. Lower right: Navigation sight. (*Courtesy Wild Heerbrugg Instruments*)

transmitted to earth. There the signal was received and forwarded to ground reconstruction equipment which reproduced the image.[17]

Resolution and Geometry of Aerial Cameras

The scientific determination of resolution and distortion of cameras and lenses is performed according to strictly controlled procedures for government purchased equipment outlined in the literature.[15] The essential elements of these techniques is that the resolution for frame cameras are determined over the entire field of the lens and camera systems in lines per millimeters rather than at any one point. This determination is the Area Weighted Average Resolution (AWAR). This type of measurement is peculiarly effective for a square format since measurements are made along 4, 6 or 12 diagonals. Panoramic cameras which have a long rectangular format require that a linear determination be made and averaged; a Linear Weighted Average Resolution (LWAR). Lens distortion measurements are made in an extremely precise collimater, a large inverted shell on top of which the camera is placed and telescopic readings are made along diagonals radiating from the center. Although the resolution cannot be increased after a photograph is processed (except for enhancement by contrast treatment), distortion can be corrected by the use of correction plates.

FILMS FOR AERIAL PHOTOGRAPHY AND PHOTOGRAMMETRY

The requirements of a negative material for aerial photography and photogrammetry are different in a number of respects from those for portrait, news or illustrative photography. The available contrast must be much higher as the image is of low contrast because of (1) atmospheric haze, and (2) the illumination, a larger portion of which is reflected skylight than is usual in terrestrial photography. The contrast of the subject is reduced further by (1) industrial haze, (2) the altitude of the sun above the horizon (sun angle) and (3) the altitude of the airborne vehicle. It is of course much lower when the sun is partly or wholly obscured by clouds. To compensate for the lower subject contrast aerial films are developed to relatively high gammas (1.1 to 1.8) and a panchromatic emulsion with extended red sensitivity is used with a blue-absorbing filter to reduce atmospheric haze. The requirements for speed and contrast, however, must be balanced against the need for an emulsion of reasonably low granularity, high resolving power and a high sharpness factor for a sharp image of a low contrast subject on a small scale.

Another requirement, particularly of films for cartographic purposes, is a dimensionally stable base. Film expands or contracts with a change in temperature, which can affect exposures made in unheated cameras at high altitudes; with changes in humidity and in processing

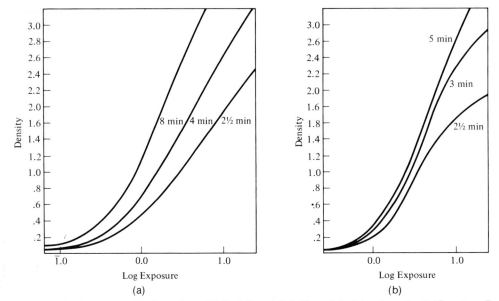

Fig. 21-14. (a) Kodak aerial plotting plate (glass) medium; (b) Kodak aerial plotting plate (glass) contrast. (*Courtesy Eastman Kodak Co.*)

and drying. Polyester bases have much higher dimensional stability than cellulose acetate bases and are now generally used for aerial photography and photogrammetry. See Chapter 00.

The speed of American-made films for aerial photography is determined in accordance with American National Standards (ANSI) specification PH234.1969. This defines speed as $3/2 E$ when E is the exposure in meter-candle seconds for a density of 0.3 greater than the base-fog density when the film is processed as specified in the standard (Fig. 21-14). With machine processing, the effective film speed depends upon the machine, the chemicals used and the degree of development (gamma).

The resolving power of emulsions for aerial photography is usually in lines/mm for a low-contrast target with a range of 1:1.6. Acutance is usually represented by the modulation transfer curve. The RMS granularity values are for a density of 1.0 excluding the density of the support. The RMS granularity value represents 1000× the standard deviation in density produced by the granular structure of the silver deposit.

Mapping Films

D log E curves for a typical mapping film (Kodak Plus-X Aerographic film #2402) are shown in Fig. 21-15. The curves are for development in a Versamat® continuous processor with #641 developer at 85°F. The gammas vary with the time of development from 1.10 to 2.00 and the effective aerial film speed from 80 to 250. The resolving power for a 1:1.6 test object is about 50 lines/mm and the RMS granularity is 28. All values naturally vary with the developer, the method of development and the gamma.

The gamma to which aerial film is developed depends upon the subject and the altitude from which photography is done. Subject contrast tends to decrease with

increased altitude and as a general rule photography at an altitude of 3000 ft or less is processed to a gamma of about 1.0, photography at 10,000 ft to a gamma of about 1.6 and above 20,000 ft to a gamma of 2.0 or higher.

A film of higher speed for use at lower levels of illumination or when red filters are necessary is shown in Fig. 21-16 (Kodak Tri-X Aerographic film #2403). Under the same processing conditions, this film has an effective aerial film speed from 320 to 800 at gammas of 0.75 to 1.45. The RMS granularity is about 60 and the resolving power in lines/mm is 25.[2]

Both of these are thin-emulsion films and are coated on polyester-type (Estar®) film base having a thickness of 4 mils and the emulsion is hardened for rapid processing

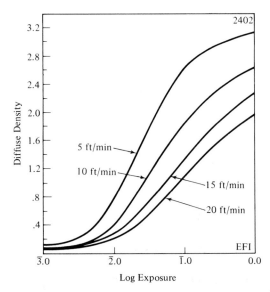

Fig. 21-15. D log E curves for Kodak Plus-X Aerographic Film #2402. (*Courtesy Eastman Kodak Co.*)

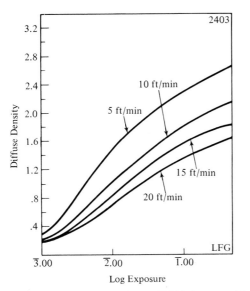

Fig. 21-16. *D* log *E* curves for Kodak Tri-X Aerographic Film #2403. (*Courtesy Eastman Kodak Co.*)

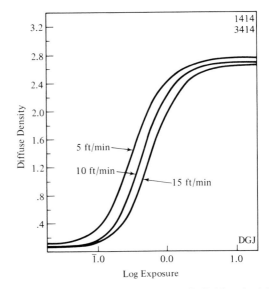

Fig. 21-17. *D* log *E* curves of Kodak High Definition Aerial Film #3414. (*Courtesy Eastman Kodak Co.*)

at temperatures up to 95° F and have a fast-drying backing.

Reconnaissance Films

For high-altitude reconnaissance photography with smaller size formats emulsions with higher resolution and gammas are used. Kodak Panatomic-X aerial film #3400, for example, when developed under the same conditions as the two mapping films, has an effective aerial film speed between 32 and 80 at gammas varying from 2.20 to 2.90. The RMS granularity is 18 and the resolving power 63 lines/mm. These values are exceeded by a still slower film, Kodak High Definition aerial film #3414 (Fig. 21-17) which, under the same processing conditions, has an aerial film speed of 6.4 to 16 at gammas from 3.20 to 2.90. The RMS granularity is 8 and the resolving power 250 lines/mm.

Infrared Films

Infrared photography is employed to reduce the effect of haze in long distance oblique photography and in specialized applications such as agricultural, archaeological, forestry and geological surveys, in oceanography, hydrology and in multispectral photography. There are two types of infrared film for aerial photography: (1) for black and white photography and (2) a "false color" film in which there are three emulsion layers as in an ordinary color film but the three emulsions are sensitive to green, red and infrared radiation instead of the usual blue, green and red. This film is included with the color films.

The spectral sensitivity of the typical black and white infrared film is shown in Fig. 21-18 and it is used with deep yellow or red filters to confine the exposure to the far red and infrared. Processed under the same conditions as the films described previously, the aerial film speed, without a filter is from 160 to 320 for gammas from 0.90 to

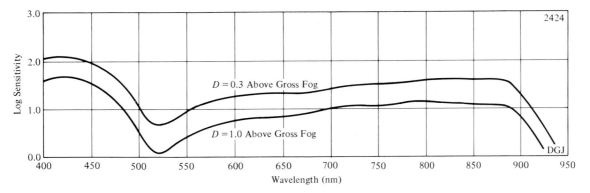

Sensitivity = Reciprocal of the exposure in ergs/cm² required to produce the indicated density (*D*) above gross fog.

Fig. 21-18. Spectral sensitivity curve of a typical infrared film for aerial photography.

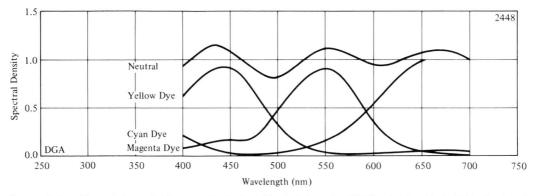

Spectral densities of dyes yielding an Equivalent Neutral Density (END) of 1.0 with D 5000 viewing illuminant. Measurements were confined to the 400 to 700 nm region.

Fig. 21-19. Curves of the spectral absorption of the dye images of Kodak Ektachrome MS Aerographic Film #2448. (*Courtesy Eastman Kodak Co.*)

1.90. The red filter employed with this film has a multiplying factor of 2.0 so that the actual camera speed is from 80 to 160.

Processing Aerial Film

Short lengths of 70mm film can be processed on reels similiar to those used in developing ordinary roll film. Long rolls—125 to 500 ft in length—are processed in rewind processors or in automatic processors. During development the film is wound from one roll to the other by an electric motor. Depending upon the film the developer and the gamma required, the film may be wound from one reel to the other (one pass) or the motion may be reversed for a second pass rewinding on the first reel.

Multilayer Color Films for Aerial Photography

Multilayer color films for color photography are available in three types: (1) reversal films for color transparencies, (2) negative films for color prints or black and white prints, and (3) infrared sensitive color film.

Color films are not widely employed for aerial mapping and photogrammetry because of the cost and because atmospheric haze and the small areas reduce the effect of color. An added problem is the variation in color from the center of the image to the edge due to the difference in illumination over the image field with wide angle mapping lenses. When used at relatively low altitudes, however, color materials are useful in crop and forestry studies, in geological, archaeological and pollution surveys and for city planning, highway location and traffic control.[17]

Fundamentally the color reversal films supplied for aerial photography do not differ from those used in general photography. A typical example is Kodak Ektachrome MS Aerographic film #2448 which, like the other aerographic films, is coated on a polyester-type base with an antihalation undercoating and a fast-drying backing.

The emulsion is abrasion resistant and hardened for high temperature processing in continuous processors. Curves of the three dye images are shown in Fig. 21-19 and the D log E curve in Fig. 21-20. The aerial film speed is 32. Haze filters may be used if it is necessary to reduce the effect of atmospheric haze. Two GAF reversal films for aerial photography have effective speeds of 125 and 320. The resolving power of these reversal color films is about 20 lines/mm and the RMS granularity varies with the film speed from 12 to about 50.

Kodak Aerocolor film #2445 is a typical negative color film on a polyester base for aerial photography. Unlike Ektacolor films it does not have integrated color masking so color interpretation directly from the color negative is possible. The film is part of an aerial color negative system that includes a color paper, color transparency film and a black and white printing paper as described in Ref. 18. Newer color films are being developed.

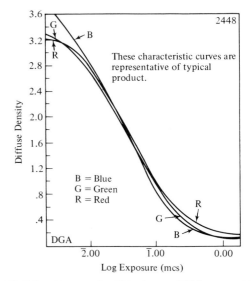

Fig. 21-20. *D* log *E* curves for Ektachrome MS Aerographic Film. (*Courtesy Eastman Kodak Co.*)

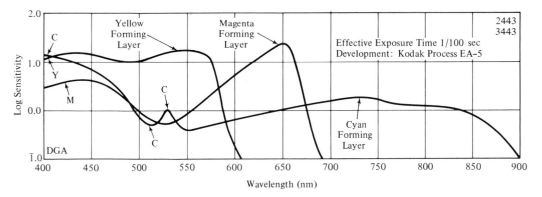

Sensitivity = Reciprocal of the exposure (ergs/cm²) required to produce a density of 1.0 above D min. Measurements were confined to the 400 to 900 nm region.

Fig. 21-21. Spectral sensitivity of Kodak Infrared Film #2443. (*Courtesy Eastman Kodak Co.*)

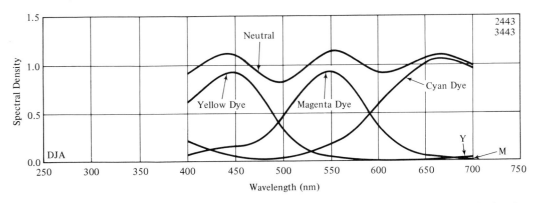

Spectral densities of dyes yielding an Equivalent Neutral Density (END) of 1.0 with D 5000 viewing illuminant. Measurements were confined to the 400 to 700 nm region.

Fig. 21-22. Spectral dye density curves. (*Courtesy Eastman Kodak Co.*)

Continuous processing machinery for the processing of aerial color film is available from several sources including the Eastman Kodak Company.

The so called "false" color film was developed during World War II for camouflage detection because it can differentiate between live vegetation and most green paints as these do not reflect the infrared. It has since become useful in the detection of live and dead trees and crops and the differentiation of narrow-leaved coniferous and broad-leaved deciduous trees because of the difference in infrared reflection. When the film is processed to a positive in a color developer, the green-sensitive layer is developed to a yellow image; the red-sensitive layer to a magenta image and the infrared-sensitive layer to a cyan image. Blue, green and red appear in the image but with false color values; the blue is produced by the green light exposure, the green by the red light exposure and the red by the infrared light exposure. Spectral sensitivity and dye density curves for this product (Kodak Aerochrome Infrared film #2443) are shown in Figs. 21-21 and 21-22. The characteristic curve is shown in Fig. 21-23.

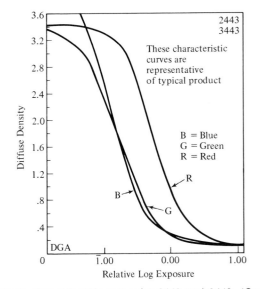

Fig. 21-23. Characteristic curve for 2443 and 3443. (*Courtesy Eastman Kodak Co.*)

Duplicating Films

Duplicate positives or negatives on film are readily made on an aerial printer and provide protection against damage to the original negative. Duplicate copies may also speed up the process of map making from the photography. The special duplicating films are relatively slow, fine-grain, blue-sensitive emulsions with gammas between 1.5 and 2.5 and high acutance and resolving power.[16] They are available on polyester bases with a thickness of 4–5 mils for use in rolls or, in one case, on a 7 mil base for use in sheet film form in direct view plotters.

Plates and Films for Diapositives

Diapositives for use in plotting instruments are usually made on glass plates because glass has the lowest thermal coefficient of expansion of any substance used as a base for a photographic emulsion and because, unlike film or paper, it has no humidity coefficient whatsoever. A slow, high contrast, fine-grain, blue-sensitive emulsion is used for this purpose and is coated on flat glass, ultra-flat glass or micro-flat glass, depending upon the requirements of the user. The micro-flat glass is exceeded in flatness only by the plane surfaces of high grade optical flats.

The advent of mapping from color aerial photographs led to the development of a diapositive with a glass base upon which the multilayer color emulsion was laminated. This, however, did not prove satisfactory and was replaced with a special color print film coated on a polyester base 7.0 mil thick which is cut into sheets for use. Film diapositives are printed individually with an exposing light of 2900° K or 3200° K color temperature.

Photographic Printing Paper

Paper prints are used extensively in the mapping process. Immediately after the aerial mission is complete strip mosaics are prepared with the photographs and the location of required control indicated on each aerial photograph. Field engineers are given the photographs and are required to locate all vertical elevations and horizontal positions to be plotted on each photograph in the field with precise control information. Standard photographic papers are used but they must be manufactured to withstand considerable handling and varying weather conditions. Surfaces must be able to take pen and pencil notations without obliterating photographic detail.

The Eastman Kodak Company supplies a special paper (Kind 1594) which is matte on both sides and has a resin coated water-resistant base. The water resistant base provides greater flatness and strength, has good dimensional stability and is especially adapted to rapid processing. It is available in four different contrast grades with log exposure ranges from 1.25 to 0.70.

Almost any standard color print material can be used to make aerial color photographs; however, some manufacturers make special bases of plastic material, such as the GAF and the Cibachrome®-Print material.*

PHOTOGRAMMETRY AND STEREOPLOTTING

The American Society of Photogrammetry defines photogrammetry as "the science or art of obtaining reliable measurements by means of photographs.[19] *Terrestrial* photogrammetry is based on photographs made on the ground. *Aerial* photogrammetry covers the use of vertical or oblique aerial photographs in preparing maps or making terrain analyses. A special application of photogrammetry which is coming into general use is *analytical* photogrammetry. In this procedure, measurements of image points are performed on a stereocomparator and the coordinates are mathematically transformed from image point to object point. Otto von Gruber's *Photogrammetry-Collected Essays*, published in 1930, contains all the principles that are in use today.[20-23]

Stereoplotting, as the name implies, is the employment of stereoscopic viewing instruments to plot maps or plans onto a base grid. It also includes the use of elaborate projection instruments and stereocomparators in which an overlapping pair of photographs can be placed for plotting. Images in the plotters are viewed in the third dimension and specific details such as roads, houses and streams are plotted in x, y and z coordinates. Images can also be drawn to a specified scale on a cordinatograph which is linked to the plotting machine by means of a pantograph.

Error Factors in Photogrammetry

The basic error factors in photogrammetry occur in three areas: (1) collecting the original photography; (2) processing and duplicating the aerial photographs, and (3) transferring the information required from the photograph to a map or other useable form.

The same problems that beset Nadar in obtaining aerial photographs over Paris in 1860 are still in existence; namely, controlling the airborne vehicle in motion, obtaining a satisfactory exposure and using stable base, high resolution, low distortion film. Although the airborne vehicle and aeroplane, or satellite, is more easily controlled than the balloon, and cameras are often mounted in gyroscopically controlled mounts, the aircraft are moving at high speeds (200 to 600 miles/hr). The camera in a jet aircraft moves more than 4 ft during an exposure of 1/200 sec, as follows:

$$D = \frac{600 \times 5280}{60 \times 60 \times 200} = 4.4 \text{ ft}$$

The resultant image is "smeared" the equivalent of more than 4 ft on the ground by the relative movement of the aircraft to the ground. If the taking altitude is high (above 30,000 ft) and the photography at small scale, the effect

*See Chapter 18.

is not appreciable. However, this becomes a limiting factor at low altitudes (1500–2000 ft). These effects are reduced in reconnaissance cameras which have image motion compensation and larger lens apertures for more light and faster emulsions for reconnaissance work.

The original photographs are rarely used in the plotting instruments; therefore the processing of original and the preparation of duplicate photographs and transparencies are critical to the final product. Some of these errors are reduced by controlled laboratory procedures, automatically controlled electronic printers and the more recent manufacture of stable base materials for original film and duplicates.

Highly skilled, trained operators of the stereoplotting instruments are necessary for the delineation of maps from aerial photographs; they must possess good technical judgment and acute stereoscopic vision. A considerable effort has been expended to develop automatic stereoplotters in which light ray intersections are performed without human intervention, but those machines are very expensive. However, no stereoscopically compiled map can be more accurate than the ground horizontal and vertical control which has been established and recorded prior to the aerial flights.

The relief of the terrain affects the accuracy of the photographic record in a vertical aerial photograph. For example, an aerial camera with lens point 0 in Fig. 21-24 registers images on the negative as follows: a Tower BC rising above flat ground MB, in nature MB equals NC; however on the negative the distances are recorded as M′B′ and M′C′ respectively. The distance M′C′ is inconsistent with the scale of the other imagery because of the elevation of C above the terrain. This displacement of the terrain because of relief is the basis for determining elevations and contours from aerial photographs.

Stereoplotters

Photogrammetry attained a rapid growth in the United States through the introduction of the *Multiplex Stereoplotter*. This double-projection instrument was invented by Zeiss Aerotopograph, Germany, in 1934. The multiplex utilizes direct projection of the photographic image through transparent glass diapositives and recreates the terrain as a model on small scale. It is made visible by utilizing the anaglyph principle, where one image is projected with a red filter, the alternate image with a blue filter and the operator wears a pair of glasses with a corresponding red lens covering one eye and blue lens over the other. By manipulating controls on the projector the two stereo images are brought into congruence with each other and the images focused onto a tracing table. The geometry of the images is shown in Fig. 21-25.

The transparent glass diapositives used in the multiplex are $2\frac{1}{2} \times 2\frac{1}{2}$ in. with an image area $1\frac{5}{8} \times 1\frac{5}{8}$ in. In order to reduce the $9\frac{1}{2} \times 9\frac{1}{2}$-in. mapping photography to multiplex size, a special reducing printer is used. The reduction printer also introduces a calculated distortion so that the resultant distortion of the aerial camera, reduction printer, and multiplex projector combined are as near zero as possible. Figure 21-26 illustrates the printing head of the reduction printer with the focal length of the camera lens, shown on the left, and the principal distance of the multiplex projector

Fig. 21-25. Geometric parallelism between aerial photography and multiplex reconstruction. Top: Terrain in nature. Bottom: Multiplex model. (*Courtesy U.S. Geological Survey*)

Fig. 21-24. Displacement of the image caused by relief.

Fig. 21-26. Printing stage diapositive printer. (*U.S. Army Photograph*)

Fig. 21-27. Principle of the ER-55. (*Courtesy U.S. Geological Survey*)

on the right. The ratio for reduction printing of diapositive plates are as follows:

$$\text{Ratio} = \frac{\text{focal length of camera lens}}{\text{principal distance of projector (multiplex)}}$$

Figure 21-27 illustrates the principle of the multiplex plotter as well as the ER-55 plotter. The tracing table on the right relates the stereoscopic model projected through the two projectors to the map manuscript below. A small circular screen is provided for viewing the stereo model through the anaglyphic red and green glasses. In the center of the screen, an illuminated floating mark is used for setting precise elevations; the counter provides a height scale, and the plotting pencil directly beneath the floating mark is used to draw planimetry or contours. The plotting table itself glides over the map sheet on three agate bearings.

Improvements in the lighting source and the capability of using diapositives twice the size of the multiplex led to the development of the ellipsoidal reflector. Brighter illumination and the larger diapositives enabled the stereoplotter operator to view at larger scales and increase the accuracy of plotting as well as the speed at which maps can be prepared.

The Kelsh plotter is a stereoscopic mapping instrument of the double projection anaglyphic type conceived and developed by Harry Kelsh. The basic prin-

Fig. 21-28. Kelsh plotter-KPP-3. (*U.S. Army Photograph*)

Fig. 21-29. Kelsh plotter with Pantograph. (*U.S. Army Photograph*)

ciple is the same as the Multiplex except that contact sized 9½ × 9½ diapositives are used and a moving illumination system which concentrates light on that part of the diapositive that is projected onto the tracing table at a 5× enlargement. The tracing table is linked to the scanning light source by space rods (Fig. 21-28). The third projector shown in the illustration is used to transfer the stereoscopic image from a left to a right image. Two stereomodels can then be projected alternately from three aerial photographs. The pantograph attachment shown in Fig. 21-29 is used to reduce the scale of the projected image.

Photogrammetric Stereoplotting Procedures

Map compilation from photogrammetric instruments follows standard mapping procedures as listed below:

1. The stereo model is oriented by matching a pair of projected stereo images through the overlapping pair of transparent diapositives and by manipulating the x, y and z controls on each projector to recover the aircraft attitude in flight. Meanwhile the matching of the stereomodel is observed through the anaglyphic (red and green (cyan)) spectacles on the surface of the tracing table (Fig. 21-30). After the stereo model is observed, it is made to fit plotted observable points on the base map by enlarging or reducing the image with the aid of x and y controls on each projector.

2. Once the stereo model is oriented to the base map manuscript, the compilation of a topographic map is divided into two phases; compilation of planimetry (roads, streams, railroads, houses, etc.) and the compilation of contours. Within each stereo model, covering a specified area depending upon the scale, the planimetry is always compiled first so that the contours can be shaped to conform to the planimetric features. The pencil point on the tracing table below the floating mark (Fig. 21-31) is used to trace the planimetry by following their outlines.

All main roads are usually compiled first, then all secondary roads, trails, buildings, drainage, fence lines and woodland boundaries. Railroads, shore lines and each bank of wide streams are of primary importance.

3. The tracing operation is performed as follows: Place the floating mark seen in the center of the tracing table platen, upon the image of the feature to be traced; lower the pencil point (directly beneath the floating mark) onto the base map sheet, slide the tracing table so as to follow the outline of the image with the floating mark. The height of the platen must be continuously regulated with one index finger, so as to keep the floating mark always in contact with the stereo model surface (this eliminates the displacement of the feature caused by relief (Fig. 21-24), as discussed previously.

Each feature should be completely traced with a continuous line; retracing in the opposite direction provides an accuracy check. When plotting objects such as trees

Fig. 21-30. Observing the anaglyphic model through anaglyphic (red-green) glasses. (*Courtesy U.S. Geological Survey*)

Fig. 21-31. Plotting procedure with model shown on tracing table with image being sketched below on the manuscript. (*Courtesy U.S. Geological Survey*)

and buildings which project above the ground, care should be exercised that the object itself rather than its shadow is traced. High buildings in cities may be plotted by their roof lines since their bases may be obscured. It is most important that the floating mark be in contact with the object traced at the correct elevation.

4. Contouring skill comes after weeks of practice and requires a special kind of visual ability that must be innately possessed. Stereo compilers should be selected after tests to measure their ability to perceive a depth difference between two points in space and their ability to perceive the shapes of larger masses.

After checking the orientation of the model to the base map, the operator assumes an index reading based upon the scale of the model and the contour interval; he then sets the scale index on the vertical elevation indicator of the tracing table and is ready to begin contouring. The platen is clamped at the selected index; as each contour is drawn the index is changed a specific amount for the height of the next contour.

The contouring is generally done by following a feature such as a stream or a ridge; best results are obtained by beginning at the bottom or top of a slope and building up the contours by keeping the floating mark in contact with the ground image until the contour line runs off the

model area or it closes upon itself. As each contour is completed the index is changed and the next higher or lower contour is drawn; in this manner the contours are drawn over the entire stereomodel.

Areas that are densely wooded, flat, in shadow or of excessive contrast are difficult to contour. When the ground is completely covered by trees it is difficult to obtain accurate contours, therefore aerial photography is obtained when the leaves are off in early spring. Coniferous areas are contoured by tracing cleared areas and estimating the heights of the trees. There are many devices employed by experienced photogrammetrists to contour difficult areas, these devices such as "bumping" the floating mark against a slight rise in the ground image of a stereo model are part of the skills developed in the course of time. Further information regarding photogrammetric stereo compilation can be obtained from the Topographic Instructions of the U.S. Geological Survey.[24]

REFERENCES

1. J. M. Eder, *History of Photography*, Columbia University, New York, 1945.
2. Ibid.

3. Beaumont Newhall, *Airborne Camera*, Hastings House, New York, 1969 (extensive bibliography).

4. J. R. Quick, *Eve in the Sky*, International Archives of Photogrammetry, Vol. XV, 6th International Congress of Photogrammetry, Lisbon (1965).

5. F. C. V. Laws, *Aeronautical Photography*, Chapt. X, "Photography as a Scientific Implement," D. Van Nostrand, New York, 1923.

6. L. P. Clerc, "Aerial Photography and Photopography," *Photogr. J*, **61**: 382 (1921).

7. Constance Babington-Smith, *Air Spy, The Story of Photo Intelligence in World War II*, New York, 1957.

8. James R. Quick, *Despite the Night*, Vol. 1, "The Goddard Era," James Quick, Dayton, Ohio, 1964.

9. George W. Goddard, *Overview*, Doubleday, Garden City, 1969.

10. L. W. Swanson, "Photogrammetric Surveys for Nautical Charting, Use of Color and Infrared Photography," *Photogrammetric Eng.*, **26**: 137 (1960).

11. James P. Minard, "Color Aerial Photographs Facilitate Geologic Mapping of the Atlantic Coastal Plain of New Jersey," *Photogrammetric Eng.*, **26**: 112 (1960).

12. W. A. Fischer, "Color Aerial Photography in Geologic Investigations," *Photogrammetric Eng.*, **28**: 133 (1962).

13. W. J. Schneider, "Water Resources in the Everglades," *Photogrammetric Eng.*, **32**: 958 (1966).

14. Abraham Anson, *The Status of Aerial Color Photography in the Government Agencies*, TB-1 U.S. Army Engineer Topographic Laboratories, Ft. Belvoir, Va.

15. *Military Standards, Photographic Lenses*, MIL-STD-150A, U.S. Government Printing Office, Washington, D.C.

16. *Kodak Data for Aerial Photography*, Eastman Kodak Co., Rochester (N.Y.) (1971).

17. J. T. Smith and Abraham Anson (eds.), *Manual of Color Aerial Photography*, American Society of Photogrammetry, Falls Church, Va., 1968.

18. Kodak Aero-Neg. Color System, Eastman Kodak Co., Rochester (N.Y.).

19. *Manual of Photogrammetry*, American Society of Photogrammetry, Falls Church (Va.), 3rd Ed. (1968).

20. Otto Von Gruber, *Photogrammetry—Collected Essays*, English translation published by American Photographic, Boston, 1932.

21. Bertil Hallert, *Photogrammetry*, McGraw-Hill, New York, 1960.

22. Howard Oakley Sharp, *Practical Photogrammetry*, Macmillan, New York, 1951.

23. Francis H. Moffitt, *Photogrammetry*, International Textbook, Scranton, Pa. 1959.

24. *Topographic Instructions*, U.S. Geological Survey, Department of the Interior, Washington, D.C. 20244 (1960).

25. Manual of Remote Sensing, R. Reeves, A. Anson, D. Landen, eds., American Society of Photogrammetry, Falls Church, Va., 1975, Ch. 10.

22

RADIOGRAPHY

Herman E. Seemann

PRINCIPLES AND APPLICATIONS

Radiography is a specialized photographic technique in which penetrating radiations, viz., x-rays or gamma rays, are used to produce "shadow" images of objects on a film. These penetrating radiations are not refracted by lenses; the image is formed by the direct, straight-line passage of the radiation through the object. Hence, the image pattern on the film is determined by the relative absorptions of the various parts.

Absorption by the human body or industrial materials is determined by their thickness, density and atomic number. The relationship is further complicated by the variation in absorption with wavelength (*quantum energy*) of the radiation and the many wavelengths in a given x-ray beam. Of course, absorption increases with thickness of material and density, but it increases *very rapidly* with atomic number in the wavelengths used in medical radiography. In general, absorption increases with increasing wavelength of the radiation. The fleshy tissues of the body only show in low contrast, but bone images show plainly against the surrounding tissues because of the calcium (atomic number 20) and phosphorous (atomic number 15) content of bone. The further complication, that there are different quantum energies in a given x-ray beam, means that exposures are not readily calculated from the absorption data in handbooks and are therefore determined empirically.

After processing the exposed film, the resulting *radiograph* is a "black and white" record of the radiation intensities transmitted. The higher photographic densities in the radiograph thus indicate the regions in which the transmission was the greater. Although prints are sometimes made from these "negatives," it is common

practice to view the original radiograph by transmitted light while mounted on an illuminator fitted with a diffusing glass.

The most common application of radiography is in medical diagnosis.[1] Radiographs are made of the human chest (Fig. 22-1) to detect lesions due to tuberculosis or to determine the extent of silica dust in the lungs. Medical radiography is also used to observe the progress of healing of bone fractures. In regions, like the abdomen, where x-ray transmission is too nearly uniform for rendition of details of diagnostic value, a highly absorbing material, such as barium sulfate (barium atomic number 56), is swallowed by the patient to outline features in the stomach or intestines. Other *contrast media* are used for other regions. These examples of medical radiography only illustrate but give no adequate view of the great value and widespread use of this system in diagnosis.

Dental radiography (Fig. 22-2) is closely allied to medical radiography and is a common diagnostic procedure.[2] There are few people who have not been in the dentist's office for a dental radiograph. Such radiographs show, to the trained observer, unsuspected tooth decay, impacted and buried teeth, and abscesses.

Industrial radiography[3] plays an ever increasing part in the nondestructive testing of industrial products (Fig. 22-3). The range of objects is from small aluminum parts for aircraft to heavy steel castings and welds in high pressure boilers and other vessels used at high temperatures. The range of radiation transmissions required for industrial materials is greater than that needed for the human body. Small aluminum, magnesium and plastic items can be radiographed within the energy range of medical diagnostic x-rays, i.e., those generated between about 30

Fig. 22-1. Radiograph of normal human chest. The ribs, spine and heart are more radiopaque than most of the lung tissues. The heart appears on the right side of the spine because the patient was facing the x-ray tube.

Fig. 22-2. A dental radiograph. The lightest areas represent the metallic fillings in the teeth. Boney structures of the jaw bone can be seen around the roots of the teeth.

and 125 kilovolts, while large steel castings require the more penetrating x-rays generated at 200 kilovolts and higher. The very penetrating gamma rays from iridium 192, cobalt-60 and other radioisotopes are also used.

X-RAY PRODUCTION

X-rays are produced when electrons, traveling at high speed, collide with matter. In the usual type of x-ray tube, an incandescent filament supplies the electrons and thus forms the cathode, or negative electrode, of the tube. A high voltage applied to the tube drives the electrons to the anode, or *target*. A small area of the target on which the electrons are focused is called the *focal spot* (see Fig. 22-4). The sudden stopping of these rapidly moving electrons in the surface of the target yields the penetrating x-radiation.

The range of wavelengths,[3] or quantum energies, in the x-ray spectrum depends upon the kilovoltage applied between the anode and cathode terminals of the tube. The higher the kilovoltage the higher the quantum energies in the spectrum and the more penetrating is the radiation.

Fig. 22-3. Radiograph of weld in ½ in. steel. The weld is lighter than the surrounding metal because it is thicker. Bubbles of gas (the small dark spots) weaken the weld. Lead numbers ".50, 3, 4" show to the inspector that the metal is .50 in. thick and that this view is at the 3—4 location.

(See Fig. 22-5.) This is the reason for the choice of very high kilovoltage in the radiography of thick steel, for example. Relatively low kilovoltage is used for radiography of the human body or other objects composed of the lighter elements.

Gamma rays are emitted during the decay of radioactive isotopes. A wide range of energies is available among the various isotopes. The properties of their radiations are similar to those of x-rays. Radiography with gamma rays has the advantages of simplicity of the apparatus used, portability and independence from power supplies. Thus, examination of assemblies in which access to the interior is difficult is facilitated and field radiography is made possible. Exposure times may be as short as a few minutes or as long as a few days because the sources, although emitting penetrating radiations, are usually low in output intensity compared to x-rays.

GEOMETRY OF IMAGE FORMATION

Since x-rays and gamma rays cannot be focused with a lens, as is ordinary light, image formation is the result of direct geometric projection. This is illustrated schematically in Fig. 22-6. The focal spot (target) of the x-ray tube is of finite size and consequently the "shadow" outlines have a penumbra "P". In practical radiography, therefore, the object is placed as near the film as possible and the target-film distance made as great as practicable. The smaller the focal spot the better, but there is a limit to this factor because of the heat generated at the target when the impinging electrons are stopped. The focal spot must be large enough to dissipate this heat to the anode without actually melting it—tungsten with its high melting point is used for the focal spot area of radiographic x-ray tubes. Focal spots with fractional millimeter diameters are commonly used in medical radiography,

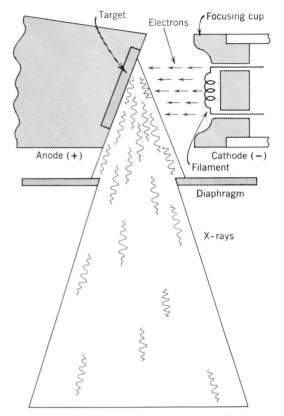

Fig. 22-4. Schematic diagram of an x-ray tube with short arrows representing electrons that strike the target, thus causing the emission of x-rays as wave packets or photons. The x-rays go out 'in all directions, but to simplify the drawing this is not indicated in the diagram. By permission of John Wiley & Sons, Inc.

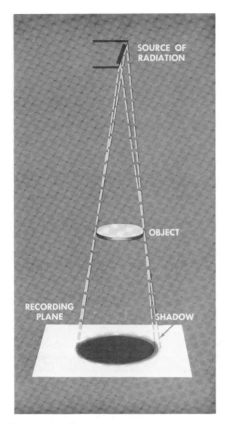

Fig. 22-6. Schematic diagram illustrating the geometric principles of radiography.

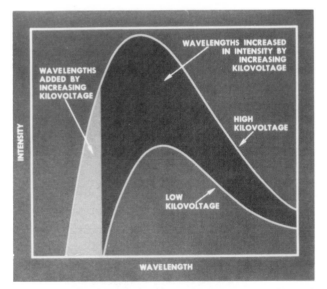

Fig. 22-5. Spectral distribution curves showing the effect of a change in kilovoltage on the intensity and spectral composition of an x-ray beam. (After Ulrey.) By permission of John Wiley & Sons, Inc.

but somewhat larger focal spots are satisfactory in industrial radiography where the object-film distance can usually be made small.

RADIOGRAPHIC EXPOSURES

The conditions for a good medical radiographic exposure are determined partly by calculation and partly empirically. As in photography, $E = It;$ the exposure is proportional to the intensity and the time. X-ray intensity is directly proportional to the current through the tube, (electron stream in Fig. 22-4) and the exposure is therefore said to be "E milliampere-seconds". However, this does not take account of the fact that the intensity increases very rapidly with kilovoltage (see Fig. 22-5). For example, a thick body part requires roughly 100 times as much exposure in milliampere-seconds at 50 kV as it does at 125 kV, all other factors being the same. Exposure tables or slide rules are used to select techniques, but the experienced operator has most of his techniques memorized.

In the radiography of uniform steel plates, such as in pressure vessels, radiographic exposures may be found in a set of graphs, one graph for each of several kilovoltages. Milliampere-minutes are the ordinate on a logarithmic scale and steel thickness the abscissa on a

linear scale. To a good approximation, these graphs are straight lines. Such a chart shows, for example, that for a certain film and target-film distance, 1 in. steel requires 70 milliampere-minutes (mam) at 160 kV, 23 mam at 180 kV, 12 mam at 200 kV and 9 mam at 220 kV. Thus, the penetration of the x-rays increases very rapidly with increasing kilovoltage (quantum energy).

The "focal spot" for gamma ray sources is a "pill" of the radioactive material a few millimeters in diameter. Its shape is usually a cylinder whose height and diameter are equal. It is usually encased in a thin stainless steel capsule to facilitate mounting in a mechanical holder. Image formation in the radiograph is determined by the same geometrical considerations as for x-ray sources discussed in the preceding paragraph.

Various systems are used to make sure that objects can be set up and radiographed without exposure of personnel to excessive amounts of radiation. When not in use, the pill is stored in a lead safe whose walls are several inches thick or it may be kept in a hole in the ground several feet deep. In either case, remote control systems are used for its removal and replacement. Several objects may be radiographed simultaneously if they are arranged in a circle around the source as a center.

For the purpose of calculating the variation in exposure with distance, the source of x-rays or gamma rays may be considered as a geometrical point and the inverse square law applied; i.e., the intensity of radiation is inversely proportional to the square of the distance of the target from the film. Atmospheric absorption is negligible in practice.

X-RAY FILMS AND SCREENS

X-ray films may be broadly divided into two types; (1) those for use with intensifying screens and (2) those for direct exposure to x-ray radiation.[4,5,6] Intensifying screens consist of a phosphor, such as calcium tungstate or activated zinc sulfide, which fluoresce when irradiated with x-rays emitting blue light. Two such screens are used, one on either side of the film, which is coated with emulsion on both sides, in a light-tight cassette. Under these conditions, about 95% of the exposure is produced by the light emitted by the phosphor and 5% by the x-ray radiation absorbed by the emulsion. Good contact between the screens and both sides of the film is essential or the details of the image will be diffused.

The developed image of a film exposed between intensifying screens has a mottled appearance.[5,6] The mottled appearance is not film graininess although it is sometimes erroneously referred to as such. Film graininess does contribute to the mottle but this is minor compared to the variations in local density due to differences in the number of x-ray quanta absorbed over a given area of the intensifying screen. As only the x-ray quanta absorbed by the phosphor can produce light, any variation in the impact of x-ray quanta and the phosphor result in local exposure differences and consequently in variations in density. The mottle is, other conditions being equal, greater with fast emulsions than with slow.

The developed image on a film exposed to x-ray radiation (without screens) is more grainy than if ex-

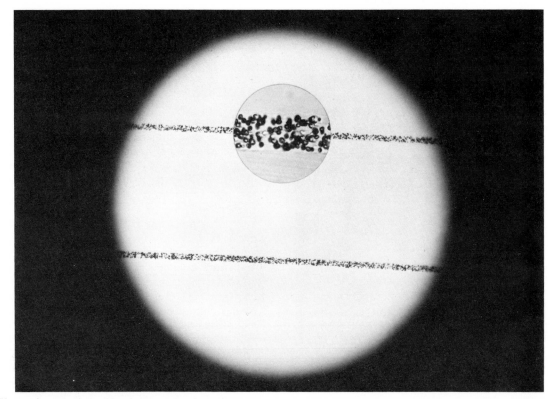

Fig. 22-7. Photomicrograph (×140) of a cross section of an x-ray film, showing the coating of sensitive emulsion on both sides of the base. Inset (×700) shows silver halide grains in the emulsion. By permission of Radiography Markets Division, Eastman Kodak Company.

posed to light, but finer than when exposed to intensifying screens. X-ray quanta have enough energy to expose several grains of silver halide but several quanta of light are required to expose one grain. This difference in the energy of x-ray and light quanta results in a difference in the distribution of the exposed grains of silver halide and therefore in variations in density or graininess. The graininess of the image increases with the kilovoltage applied to the x-ray tube; in other words, with the quantum energy.

Exposures using intensifying screens are about 1/20 that required with the same film used without screens. The fastest film for direct x-ray exposure is about twice that of the screen film used without screens, so the exposure differential in favor of screen film and screens is about 10X. These differences are only approximate and vary with the kilovoltage at which the x-rays are generated and the reciprocity characteristics of the different emulsions. In general practice screens are necessary for exposures short enough to stop the motion of a beating heart or peristalsis.

The principal disadvantage in the use of intensifying screens is that some of the screen light diffuses in the screens, their phosphor coating being a few thousandths of an inch thick, so the radiographic image is not quite as sharp as in the case of exposure with x-rays alone. This "unsharpness" is more or less offset by the greater contrast of the image.

In industrial radiography, whenever high kilovoltages are used, lead foil commonly serves as an intensifying screen.[3] The thickness of the foil is a few thousandths of an inch for the front screen and more for the back screen. Under x-ray excitation, the lead emits photo- and Compton recoil-electrons which are strongly absorbed in the emulsion and thus intensify the image. A further action of the lead is to decrease the effect of scattered x-rays which have a contrast-reducing effect analogous to that of atmospheric haze in photography.* The speed gain rarely exceeds a factor of about 3 but the contrast increase due to scatter removal is worthwhile even when there is no gain in speed. For the best definition, good contact between foils and emulsions is essential. The emission of electrons under the conditions of medical radiography is too small an effect to be of practical value. Some industrial x-ray films are supplied by the manufacturer in a package with a lead oxide-coated interleaving paper. This is a convenience which lessens the chance for dirt to be held between the electron

emitter (lead) and the emulsion. The paper is, of course, removed before processing.

Silver bromide absorbs x-ray radiation strongly with the result that the speed of an emulsion exposed to x-ray radiation alone increases with the amount of silver bromide present. Emulsions for use without intensifying screens have a high concentration of silver bromide in proportion to the amount of gelatin and are thickly coated, usually on both sides of the support. Double coating reduces the thickness of the emulsion layer by one half, reducing the problems which arise in the processing of thick emulsion layers, particularly at high temperature for rapid access to the finished radiograph.

In medical radiography direct exposure, or no-screen, films are used primarily where immobilization is possible and the longer exposure is practical. In industrial radiography, direct exposure type films are used almost exclusively as the time of exposure is not critical. Slow fine-grained direct exposure types are frequently used for their better definition.

Although somewhat oversimplified, Table 22-1 shows the relation between film speed and image quality in radiography.

In Table 22-2, "Emulsion Characteristics, Films for Radiography," are given some of the parameters of typical radiographic films. The values are ranges for classifications shown in the first column and therefore do not necessarily represent a specific product supplied under a trade name by a particular manufacturer.

It may be noted that each film has the same emulsion coated at the same thickness on both sides of the support or base.

Reasonably accurate silver halide figures may be obtained from the "Coated Silver" by assuming that the silver is coated as silver bromide.

"Average Grain Diameter" values are approximate peak values taken from the size frequency distribution curves of the various films of the types listed. Number average or weight average grain sizes would differ slightly from these figures.

The data given for industrial x-ray films do not include the ultra-fine grain films which are now being produced by several manufacturers but which have relatively limited usage.

It may be noted that the silver coverage for the rapid processing film is less than it is for the regular processing yet the average grain diameter and the relative speeds are the same. This reflects the fact that less gelatin is used in the rapid processing films, which promotes higher covering power. Thus, less silver is needed in the more compact layer.

*Scattered x-rays are a serious problem in medical radiography.[6] Several methods used to reduce scatter are discussed in detail in Ref. 6.

TABLE 22-1. FILM SPEED-QUALITY BLOCK DIAGRAM.

Screen film with intensifying screens 1.	Fastest direct exposoure type 2.	Screen film without screens 3.	Fine-grain direct exposure type 4.	Intermediate D. E. type 5.	Intermediate D. E. type 6.	Finest Grain and emulsion on *one* side 7.

←——INCREASING SPEED IMPROVING QUALITY——→

TABLE 22-2. EMULSION CHARACTERISTICS, FILMS FOR RADIOGRAPHY.

	Emulsion thickness (μm)	Coated silver (mg/cm^2)	Avg. grain diameter (μ)	Relative speed (direct X-ray F)
Medical Screen X-ray Films (Regular Processing)	7.5–10.0	.50–.60	1.1–1.8	100–200
Medical Screen X-ray Films (Rapid Processing)	5.0–6.5	.43–.53	1.1–1.8	100–200
Medical Nonscreen X-ray Films	16–30	1.30–2.00	1.0–1.3	300–500
Industrial Direct X-ray Films	10–20	.75–1.00	0.25–0.7	25–125
High Speed Negative Photographic Film	13.0	.71	.6–.9	6–10'

'The speed value shown for the high speed photographic film is not a valid difference because the contrast is much lower than that of the x-ray films.

SYSTEMS USING A CAMERA

The image on an intensifying screen, instead of being recorded on film in contact with the screen, may be photographed with a camera (*photofluorography*). In such a system, the screen is commonly referred to as a fluoroscopic screen since it is a descendant of the screen used by radiologists for visual examination (*fluoroscopy*). The system may consist of either a blue- or green-emitting screen and a camera film with a corresponding spectral response. Film sizes may be as small as 70 mm, usually in roll film, and 4 × 5 in. in sheet film.

The economy and convenience of photofluorography has led to its wide use in chest surveys even though the time of exposure is about 5× that required by a film and screen in contact. This is because light collection by the lens is less efficient than the film-screen system. Photofluorography is used routinely as part of the patient admission examination in many hospitals. Although the image quality is not as good as with film and screen in contact, it serves the very useful purpose of taking care of large numbers of people who would not normally have a radiograph made. Usually, when a "mini-film" examination indicates a questionable situation, a full-size chest radiograph is made of the patient for a more detailed study.

Attempts to make x-ray motion pictures, (*cinefluorography*), date from the early days of the diagnostic use of x-rays.[7] It was realized that motion studies of body organs would give a new dimension to radiography. Within the technological framework of those times, motion picture cameras with the fastest lenses, e.g., $f/0.85$, were used to photograph the image on a fluorescent screen. However, in spite of intensive work on the part of several competent investigators nothing was accomplished that could be classed as useful for routine diagnostic application. X-ray tubes could not stand the power load needed, screens did not emit enough light, films were too slow, lenses had already been pushed practically to the theoretical limit of aperture, and radiation exposure of the patient was greater than permissible for routine use.

The scene changed with the advent of image intensifier tubes. In the various systems using such tubes the light image on the output phosphor is photographed by a 16 or 35mm motion picture camera. The brightness of the image is many times greater than in the best of the earlier systems and diagnostically useful films are obtained. Commonly, a few feet of film are exposed. After processing, the ends are spliced together and the loop run through the projector several times for intensive study.

The films used must be of high contrast and speed, and processed so that these characteristics are fully realized. Films such as **KODAK** Cineflure® Film are successfully used in cinefluorography.

The high intensification necessary to obtain x-ray motion pictures results in images on the film which suffer considerably from mottle, q.v. In other words, image intensification acts statistically as if a super-fast x-ray film were being used with intensifying screens.

MANUAL PROCESSING OF RADIOGRAPHIC FILMS

Radiographic films have an emulsion on both sides of the film base and are developed in tanks on hangers of stainless steel with a clip on one side, in the case of small dental films, or at all four corners with large sheet films. The processing tanks are generally enclosed in a water tank with the temperature maintained at 68° F. The low contrast of the image produced by x-ray radiation, or with intensifying screens, requires emulsions and developers that produce high contrast readily. The developer is usually a Metol-hydroquinone formula with a high ratio of hydroquinone to Metol in a solution with a pH of from 10 to 11. During development the technologist lifts the film clear of the solution briefly once every minute permitting the solution to drain from one corner. This amount of agitation is generally sufficient for uniform development with solutions in good condition. The developing and fixing solutions are replenished according to directions supplied by the manufacturer of the film. Solutions replenished in this way are usually replaced after two or three months because of discoloration from oxidation which would result in staining and the accumulation of sludge in the solution. After washing in running water, the film is dried by suspending the hanger in air or in drying cabinets with circulated heated or dehydrated air.

AUTOMATIC PROCESSING OF RADIOGRAPHIC FILMS

One of the most important advances in the application of radiography has been the introduction of automatic film processing (Fig. 22-8). The time from insertion of a dry exposed film to the removal of a dry radiograph need be only 1½ min, a particular medical screen film being designed for this system, as compared with approximately 30 min in manual processing. The economy of the automatic system is obvious but it has another advantage, *control*, which results in properly exposed films being turned out as uniformly good radiographs. The processor maintains the chemical solutions at the proper temperature, agitates and replenishes them automatically, and transports the films mechanically at a carefully controlled speed throughout the processing cycle.

High temperature of the solutions is necessary for fast processing. This imposes severe demands on the film and the processing equipment. Not only must developing and fixing be highly concentrated, but the emulsion must not swell unduly or become slippery or tacky. The film must pass through the processor without sticking or otherwise being damaged. Hardeners are essential in developers and fixers to protect the film from abrasion and limit swelling of the gelatin emulsion for rapid washing and drying.

Direct-exposure films have thicker emulsions[5] than films for use with intensifying screens and consequently require longer developing, fixing, washing and drying times. Moreover, the requirements for uniformity in processing and the avoidance of machine-produced physical defects necessitates lower processing temperatures than for screen films. Machine processing times for direct exposure films are therefore much longer than for screen type films.

Photofluorographic *sheet* films may be processed in the standard tanks. *Roll* film may be processed in flat spiral reels or continuous automatic processors.

X-RAY SENSITOMETRY

In x-ray sensitometry,[4] the film holder may be moved in a series of timed steps behind an opening in a sheet of lead, e.g., a slit ½ in. wide. A ⅛ in. thickness of lead is normally enough to protect the film for radiations in the medical range of kilovoltages but considerably more is required in the industrial range. Another arrangement involves the rotation of a lead sectored disk in front of the film holder. The disk is laminated with steel or brass for rigidity. The use of lead to protect the film from radiation is the principal difference between x-ray and light sensitometry. The film may be exposed to x-rays alone or with the blue-emitting intensifying screens.

The sensitometers mentioned in the preceding paragraph are time-scale instruments and for *direct x-ray* exposures the shape of the sensitometric curve is the same

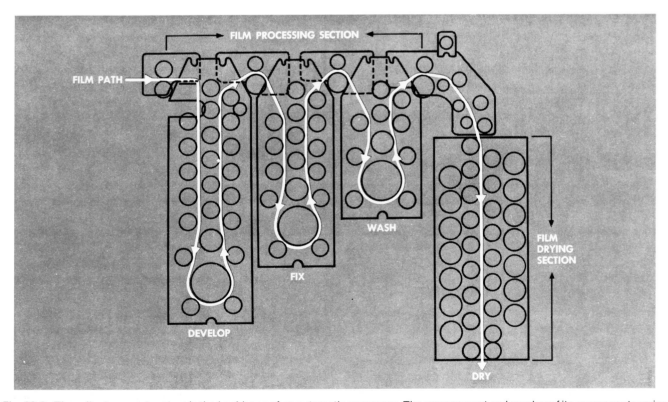

Fig. 22-8. The roller transport system is the backbone of an automatic processor. The arrangement and number of its components varies but the basic plan is virtually the same. By permission of Radiography Markets Division, Eastman Kodak Co.

with an intensity scale. The reciprocity law[5] is valid for direct x-ray exposures and presumably so for exposure with lead foil screens which emit high energy electrons when irradiated with high energy x-rays. The reciprocity law is not valid however when an intensifying screen is used as most of the exposure is made with blue light.

An intensity scale exposure may be made with a stepped wedge built up of sheets of aluminum. Such a wedge must be carefully built and calibrated so that the log E difference per step is a constant. It is useful for films for direct x-ray exposure or with intensifying screens. With gamma rays, small pieces of film may be distributed around the source at various known distances and exposures calculated from the inverse square law.

The sensitometric characteristics of a film are affected by the processing, especially development, and processing conditions must therefore be specified. Further, great care in design and use of sensitometric processors must be applied in order to obtain reproducible results.

A committee of the American National Standards Institute has formulated methods for the sensitometry of x-ray films.[9] Included in the method for use with medical x-ray films are the specifications for a tungsten lamp and filter which gives a good approximation to the blue light emitted by calcium tungstate intensifying screens. Thus, for "screen light exposure," conventional light sensitometry is applicable.

Sensitometric Characteristics of X-ray Films

The most important sensitometric difference between x-ray films and films for general photography is the contrast.[4] X-ray films are designed to produce high contrast because the density differences of the subject are usually low and increasing these differences in the radiograph adds to its diagnostic value. Thus, what is recorded by a film exposed with screens is an exaggeration of the brightness differences in the screen. The brightnesses in the screen have the same relationship as the x-ray intensities impinging on the screen. If a radiograph on an illuminator yielded a one-to-one reproduction of the image produced by the intensifying screen it would be far less useful as a diagnostic aid than with this "contrast amplification."

X-ray films have differently shaped curves depending on whether they are exposed with or without intensifying screens. (See Figs. 22-9 to 22-12.) Typical direct-exposure films have a still different curve. It will be noted that the screen-type film exposed to screen light has a very high contrast and a much lower contrast when exposed to x-rays only. The direct-exposure film has a long sweeping toe, but attains very high contrast in the higher densities. If the sensitometric data for the direct-exposure film are plotted as density against exposure rather than *log* exposure the lower part of the graph is a straight line.

The shape of the characteristic curve for direct x-ray exposures is independent of the spectral quality of the radiations used in medical and industrial radiography. A change in kilovoltage causes a change in inensity as well

Fig. 22-9. Characteristic curves of a typical screen-type x-ray film exposed to calcium tungstate intensifying screens (A) and to direct x-rays (B), and of a typical direct exposure film exposed to direct x-rays (C). By permission of Radiography Markets Division, Eastman Kodak Company.

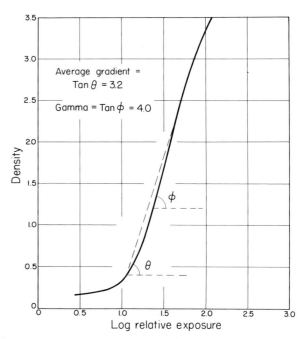

Fig. 22-10. Characteristic curve of a screen-type x-ray film, exposed with calcium tungstate intensifying screens. The averge gradient has been calculated over the density range 0.25–2.00 above base and fog; gamma (the slope of the approximately straight portion of the curve) is also indicated. By permission of Radiography Markets Division, Eastman Kodak Co.

Fig. 22-11. Characteristic curves of a typical screen-type x-ray film, developed for a series of times at 68°F. By permission of Radiography Markets Division, Eastman Kodak Company.

as in quality and simply shifts the curve along the log E axis. A change in the spectral composition of the x-rays does not change the spectral quality of the light emitted by intensifying screens.

Radiographs ordinarily contain densities ranging from 0.5 to over 3.0 and are most effectively examined on an illuminator with adjustable light intensity. A spot light

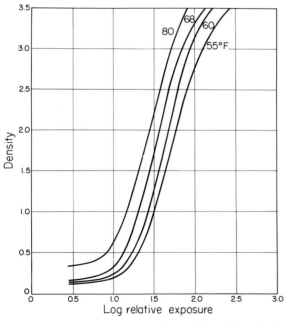

Fig. 22-12. Characteristic curves of the film of Fig. 22-11, but developed for 5 min. at a series of developer temperatures. By permission of Radiography Markets Division, Eastman Kodak Co.

will be found useful for the highest densities. At a low level of illumination, high density regions will appear completely black and therefore lacking in image detail. These same areas may be found to have detail when viewed with sufficient light. This is the advantage of an illuminator with a means of controlling the light intensity. Unless applied to a very limited density range the printing of radiographs on photographic paper is ineffective because of the narrow range of densities in the density scale of papers.

RADIATION MONITORING

In addition to their usual radiographic applications, direct-exposure films are useful in *radiation monitoring.*[5] If the radiation intensity is very low the films are exposed for a long enough time to attain a significant density, and for a short time, of course, if the intensity is high. There is no reciprocity failure with direct x-ray exposures so a given density represents the same amount of radiation whether the exposure is made at high or low intensity. Films are commonly worn on the person of workers in radiation areas and are processed with calibration films which have been exposed to known amounts of radiation having a similar spectral quality.

Fig. 22-13. Microradiograph (35×) of an excised section of lung tissue. The light areas are due to the x-ray absorption of iodine, a heavy element constituent of the organic compound with which the specimen was treated.

TABLE 22-3. SPEED-ENLARGEMENT TABLE.

Material	Relative speed	Approximate maximum enlargement (diameters)
Kodak Industrial X-ray Film, Type M [one emulsion]	100*	25
Kodak Projector Slide Plates (Medium)	60	25
Kodak Industrial X-ray Film, Type R (Single-Coated)	50	35
Kodak Fine Grain Positive Film 7302	20	50
Kodak High Resolution Plate, Code CD	1	400

*Arbitrarily assigned a speed of 100.
By permission of Radiography Markets Division, Eastman Kodak Company.

MICRORADIOGRAPHY

X-rays generated at kilovoltages lower than the lowest used in medical radiography are useful for the radiography of insects, microtome sections of biological tissues (Fig. 22-13) and thin metallurgical specimens. The composition of the specimen determines the radiation quality chosen; x-rays generated as low as a few hundred volts are used for the thinnest of organic layers.

Reference to Fig. 22-6 will clarify the technic of *contact* microradiography. A specimen with fine structures to be shown must be radiographed so that these structures will not be blurred in the radiograph. Hence, the specimen must be in contact with the film emulsion and the value of P, the penumbral width, is essentially zero. If the specimen is warped it can be held in contact by placing both in a vacuum cassette designed for the purpose. The resulting radiograph can then be enlarged photo-

Fig. 22-14. Autoradiograph of an ashtree seedling after take-up of phosphorous 32. (The young leaves are shown darker than the older ones because the former have taken up more radioactive phosphorous.) By permission of Kodak, Ltd., England and John Wiley & Sons, Inc., New York.

graphically up to the limit set by the graininess of the film or it may be studied through a microscope.

Table 22-3 illustrates the speed-enlargement relationships of materials for contact microradiography made by the Eastman Kodak Company. It will be noted that there is a qualitatively reciprocal relationship between speed and degree of enlargement. These data are based on the use of KODAK Rapid X-ray Developer at 68°F for 5 min. The data may also be considered as a guide when using KODAK Liquid X-ray Developer and Replenisher.

In the use of KODAK Industrial X-ray Film, Type M for contact microradiography, the emulsion to the rear should be protected from the action of the developer if the best image is to be obtained.

Projection microradiography is a magnification technic in which the radiographic image is a direct enlargement obtained by suitable choice of the geometric conditions of the exposure. In Fig. 22-6, it will be seen that the image is always larger than the orthogonal projection of the object. If the object is moved much nearer the focal spot, the image will be still larger and it is this principle that is the basis for projection microradiography. However, the focal spot must be exceedingly small if the enlargement is to be free from serious penumbral shadow. Special x-ray tubes have been designed with focal spots so small that direct enlargements have been successfully made at several hundred diameters of direct magnification.

Projection microradiography has the disadvantage that the apparatus used is expensive but there is the advantage that the choice of photographic material is not critical. On the other hand, contact microradiography requires care in the choice and handling of the photographic material, but the x-ray equipment is simple and relatively inexpensive.[8]

AUTORADIOGRAPHY

As the name implies, in autoradiography[5] the object "takes its own radiograph." Thin biological materials absorb a radioactive isotope from a solution or, in the case of metallurgical specimens, from a melt. Another method is to make the material of the specimen itself radioactive by pre-exposing it to neutrons. The specimen is then placed in intimate contact with a photographic emulsion which is exposed by the nuclear radiations emitted. In this way, for example, the distribution of an element, such as phosphorous 32, in a growing plant may be determined by the photographic density mea-

sured in the processed film (Fig. 22-14). The film may be one of the fast direct-exposure types and would be processed as usual.

It is seldom advantageous to make enlargements of more than a very few diameters because the radioactive source is distributed throughout the specimen and the boundaries of the image are not very sharp.

If the radioactivity is of very low intensity, the photographic density may be insufficient for measurement of its distribution. In such cases, and indeed for most autoradiographic applications, special nuclear track emulsions are used. These are fine grain emulsions, with a low fog characteristic, and the concentration of silver halide in the gelatin is higher than in conventional emulsions. After exposure and processing the film is examined under the microscope and the results expressed in terms of the number of grains exposed per unit area, the number of tracks of exposed grains made by the nuclear particles, or the actual photographic density of the exposure if it has been sufficient.

REFERENCES

1. *Fundamentals of Radiography*, Eastman Kodak Co., Rochester, N.Y.
2. *X-rays in Dentistry*, Eastman Kodak Co., Rochester, N.Y.
3. *Radiography in Modern Industry*, Eastman Kodak Co., Rochester, N.Y.
4. *Sensitometric Properties of X-ray Films*, Eastman Kodak Co., Rochester, N.Y.
5. R. H. Herz, *The Photographic Action of Ionizing Radiations*, Wiley, New York, 1969.
6. Herman E. Seemann, *Physical and Photographic Principles of Medical Radiography*, Wiley, New York, 1968.
7. *Cinefluorography*, A symposium edited by George H. S. Ramsey, et al., Charles C. Thomas, Springfield, Ill., 1960.
8. V. E. Cosslett and W. C. Nixon, *X-ray Microscopy*, Cambridge University Press, London, 1960.
9. American National Standards Institute (1964), *Method for the Sensitometry of Medical X-ray Films*. A.S.A. PH2.9; American National Standards Institute (1964), *Method for the Sensitometry of Industrial X-ray Films for Energies up to 3 Million Electron Volts*, A.S.A. PH2.8; American National Standard Institute (1965), *Method for Evaluating Films for Monitoring X-rays and Gamma Rays Having Energies up to 3 Million Electron Volts*, A.S.A. PH2.19.

ACKNOWLEDGMENT

The author is grateful to John Wiley & Sons, Inc. and to the Radiography Markets Division, Eastman Kodak Company for permission to use certain illustrations from their publications. Also, he appreciates the help given by former colleagues.

23

SCIENTIFIC APPLICATIONS OF PHOTOGRAPHY

H. W. Hoadley

Photography is an extremely useful tool in scientific and engineering endeavors. Basically, it is used for record purposes, metrology, and analysis. It includes man's visual world, but it extends his vision beyond his normal, unaided perception. In addition, it enables him to determine, measure and compare incidence, sequence, duration, direction, interaction, amplitude, size, velocity and a host of other characteristics.

The three chief purposes of photography in science are as follows:

1. To render visible, objects or conditions whose relationship to the human visual/mental process cannot normally be "observed" because of size, speed, spectral output or amplitude, life cycle or other physical characteristics.
2. Qualitative analysis.
3. Quantitative analysis. (For quantitative analysis, we calibrate our system to obtain a numeric value.)

Using the photographic medium for observation or for analysis, we record phenomena as true to form as possible and/or enhance it by making the invisible visible; expanding and compressing time; increasing or decreasing scale; varying contrast, color, etc.; and by using combinations of two or more of the above.

BACKGROUND

In 1801, J. W. Ritter discovered the ultraviolet from experiments with the prismatic spectrum on paper coated with silver chloride. This was the first application of the

photographic process to science and preceded the first practical process of photography (Daguerreotype) by almost forty years. The year of the Daguerreotype (1839), J. B. Reade made photomicrographs of a flea on silver chloride paper and a year later Draper obtained a good Daguerreotype of the moon. In 1851 Fox Talbot made the first high speed photograph using an electric spark as a source of illumination. In 1857 Kew Observatory began a daily photographic record of sunspots using the wet collodion process. The following year Tournachon (Nadar) made the first successful photograph from a balloon followed a year later by Black with a photograph of the city of Boston. (See Chapter 21). In 1864 Huggins photographed stellar spectra but with the wet collodion process only the brightest blue and violet lines were recorded. In 1874 Janssen made a multiple exposure camera which he used to photograph the transit of Venus and shortly afterward Muybridge began his famous photographic studies of the horse in action.

After 1880 the gelatin dry plate greatly increased the number and the importance of the applications of photography. Unlike wet collodion, which had to be prepared in advance, the dry plate was always ready and required none of the experienced manipulation of the wet plate process. The dry plate was more convenient, required less exposure and in a few years was sensitive to the whole of the visible spectrum, to the infrared and to the ultraviolet. In 1950, Sir Ben Lockspeiser, Secretary of the Department of Scientific and Industrial Research, speaking at a meeting of the Royal Photographic Society, said, "...there is no doubt about the contribution photography has made, and is making, to scientific research. I do not know of a single technique which has

done so much; the contribution is so great that any thought of realistic evaluation would be impossible."

This chapter will discuss specialized scientific and engineering photography, materials and processes as used for data recording, time-lapse and high speed photography, density measurements, spectrography, the invisible spectrum, photomicrography, and astronomical and space photography.

PHOTORECORDING QUANTITATIVE DATA

Photodata and Computers

A few years ago, it was necessary to translate and encode data manually from photorecordings for entry into the computer and subsequent mathematical analysis. Today, direct entry from sensors to computer is possible through suitable interfaces. Thus, the requirement for photorecording of data panels or oscillograph analog recording for certain types of data is less for organizations equipped with such interfaces.[1,2]

Nevertheless, photopanel and oscillograph recording systems remain in use for a number of reasons. Photo systems are sometimes used as backup for magnetic tape systems. In addition, camera monitoring is useful because cameras lend themselves to sporadic or temporary service, mobility, low acquisition and installation costs, and the minimum equipment necessary for retrieval of information. They are ideal for low budget projects and for field use. Often, the same equipment can have multiple uses, and can be used for recording instrument readings as well as shadowgraph and Schlieren, combustion studies, infrared, and other visual phenomena. In other instances, pictorial photographs are combined with photorecorded quantitative data in the same or adjacent film area. Unattended and remote control are other photorecording advantages offered by some camera systems.[3]

In nonscientific applications, photorecording is used in commercial applications, such as telephone monitoring and fault recording in electric utilities systems.

Photodata Systems

Photorecording for analytical purposes may comprise pictorial records or data records, or both. Where both are involved, they may be integrated or separate.

Integrated Systems. The simplest quantitative record is one that correlates pictorial information with an event or with time within the same picture. Such information may be included in the field of view of the camera; for example, a slate, card, or letter board, bearing the date, conditions, etc., a timer, a timing light or other device. However, it is not always possible, or convenient, to include indicators in the field of view. In addition, more accurate, repetitive or changing data may be required, perhaps associated with every photo or with every frame in a motion picture. This is accomplished with a "pip" or a data chamber.

Pip lights record an event or time correlation by exposure on the film, usually in an area that is not used by the pictorial data. Frequently, the light is "piped" from the lamp, through a plexiglass rod, glass probe, or fiber optics, to the film surface. In some cases, a pattern of exposure may be set up to binary-code the data. Neon, EL and LED alpha-numerics are also used.[4-7]

Data chambers usually contain a timing device such as a watch, a card on which the date, identification, and other data are typed, and perhaps a lamp or other event marker. This group of devices is recorded through a separate optical channel on the same frame, adjacent to, but separate from the pictorial information.

Nonintegrated Systems. Separate data channels are used when there is a large volume of data for each pictorial record.

Separate systems include a camera to record the pictorial channel, and an oscillograph or magnetic tape system to record the associated data. There must also be a method of correlating the two.

Instrumentation Recording System Requirements

Instrumentation systems sense a physical condition such as pressure, temperature, vibration, acceleration, strain, etc., and transduce it into displacement, mechanical motion, or an electrical signal. Displacement may appear as movement of a mercury column in a thermometer or manometer; mechanical action as movement of a pointer on a gage. These devices are *visual indicators* and do not directly record their movements. When the transducer output is an electrical signal, a visual indicator, such as a meter or oscilloscope, may display the condition for monitoring or for photopanel recording. The signal may also be recorded directly in an oscillograph, on magnetic tape, or both. If recorded magnetically, the magnetic tape may be played back later and photorecorded in an oscillograph or on a graphic COM (computer output microfilm) system.

Advantages and Limitations of Photopanels

Indicators are necessary for monitoring laboratory experiments but are not always satisfactory for recording data; for example, instruments having slow response time may result in inaccurate data.

The camera recording system may also have its limitations. It may be (1) too large; (2) may not cycle fast enough, and (3) may produce blurred pointer images or imprecise readings due to distortion or parallax. There is also a lag time between the recording and the availability of the data. Many of these problems can be overcome by proper selection of equipment and installation in a well-designed panel.

Photopanel Design. Correct design of the photopanel is important for good photographic images and accurate data. Instruments should be closely grouped so that meter faces will be as large as possible on the film. Correct photopanel design ensures that (1) the width-to-

height ratio of the panel matches the proportions of the film format; (2) that there is no glare from the instrument faces, or cover glasses; (3) that instruments not on the axis of the camera lens are mounted in a plane tangent to the lens; and (4) that the illumination is even and does not cast shadows or cause reflections that make data reduction inaccurate or impossible.

Under certain conditions, for example, in airborne panels, space is so critical that the entire photopanel is a modular plug-in package containing camera, lighting and instruments. This approach makes it possible to relocate an entire instrument recording system with ease, remove it for servicing, and put it in areas not suitable for attaching a group of components. In addition, the entire assembly can be shock-mounted if necessary. A further advantage is that the camera can be mounted behind the instrument panel with the lens operating through an opening in the panel, with a mirror reflecting the image of the instrument dials back to the lens. This sytem may shorten the distance between the camera and instrument panel by more than 50%.[8]

Choice of Camera. The choice of camera, or cameras, for photopanel recording is determined from the following considerations: (1) Whether access to the camera is necessary during recording or only between recording periods; (2) size and shape of the area to be included in the recording and the distance between the camera and the panel; (3) size and type of instruments; (4) cycle rate (frequency of recording); (5) time correlation; (6) power available; and (7) shutter/flash synchronization (if needed).

Manual Cameras. Hand-held cameras may be satisfactory for intermittent recording if experienced operators are available. Automatic cameras, however, are less subject to human error and are generally recommended.

Cine Cameras. For panels up to about 3 ft in size with dials 2 to 4 in. in diameter a 16mm or 35mm camera can be used. For most requirements, cameras should be electrically driven and operated but in some cases spring-driven cameras are satisfactory if they can be electrically triggered.[8a] In some cases, spring driven, manually operated cameras will suffice.

Pulse Cameras. Pulse cameras are available in a wide range of types and sizes. Smaller size cameras generally use 35mm or 70mm film; the larger cameras are often aerial reconnaissance cameras adapted for close range recording.

Recycling rates range from 1 frame in several seconds to 2 or 3 frames per second (fps) in most cases but some cameras are capable of 10 to 12 frames per second.

Pulse cameras are usually electrically actuated by a preset intervalometer.

Lens Selection. Frequently, when the distance available from the instrument panel to the camera is short, a wide angle lens will be required. If the lens is not fast, lamps of higher intensity or a faster film must be used. A well-corrected lens is very important; a test should be made under the conditions of actual usage and the film examined critically to determine its suitability.

Illumination. Ambient illumination is sometimes inadequate and may be detrimental causing reflection from instrument cover glasses. In some cases monitoring lights are adequate or a simple change to lamps of higher intensity is all that is necessary. In general, however, special lighting will be required or desirable. The lighting requirements to be considered are: (1) static condition or movement of pointers during recording affecting the time of the exposure; (2) shutter type and speeds available; (3) diaphragm opening; (4) film speed; and (5) camera recycle rate.

Types of Illumination. Two basic types of illumination are employed for photopanel recording; continuous and electronic flash. For continuous illumination incandescent lamps are generally used. In some installations the heat generated by tungsten lamps may be objectionable. Fluorescent lamps are ordinarily suitable only for small installations but they have the advantage of producing little heat and, in some cases, the tubular shape of the light source is helpful in obtaining the proper lighting. However, proper orientation of tubular lamps is necessary to minimize reflections.

Continuous illumination is used when the camera has a focal plane shutter or when camera recycle rates are faster than the recycle rate of small electronic flash systems. Electronic flash is used with cameras having between-the-lens shutters and has the advantage of stopping motion as the duration of the flash is the actual exposure time and this is usually less than with a continuous light source. Thus the higher exposure speed of electronic flash lamps often results in sharper images than photographs made with continuous sources of illumination. Electronic flash sources are especially useful in airborne applications where space is limited and power may not be adequate for continuous sources. Rapid recharging and high repetition rates enable some units to be synchronized with pulse or cine cameras.

MULTICHANNEL DYNAMIC DATA RECORDING

Oscillographs record an electrical signal, transduced from some physical parameter, against a time base.[9,10] The information is usually in analog form, but digital information is sometimes recorded. The x-axis, or length of the oscillograph roll, represents time, and the width, or y-axis, represents amplitude. One trace or many may be recorded in the same x, y format.

The graphic descriptive analog data presented on an oscillogram must be converted into numerical values to be useful for engineering purposes. Points on the analog must be "read" to obtain quantitative data in digital form that can be used in calculations. Points are read and logged manually, or are digitized on semiautomatic or automatic systems.

In a typical semi-automatic reader the oscillogram, on either paper or film, is threaded across a viewer, and the operator positions a set of crosshairs on each point to be read. Distances along the two axes are electrically measured from fixed references and the elec-

trical signals are fed into a digitizer. There the voltage, or pulses, are converted into a digital output that may be read out, typewritten, punched, or otherwise stored.

Fully automatic film reading involves scanning the record with an optical or electronic device, feeding the scan information into amplifiers and then processing the output to obtain digital data. Data may then be delivered to on-line processing equipment or off-line mass storage media.

Oscillograph Recorders

Trace-recording instruments in present use fall into two general categories: (1) light-beam recorders, which use tungsten or gaseous discharge illumination and create a trace by a mirror galvanometer that reflects light onto a moving strip of light-sensitive material; (2) electron-beam instruments which use cathode-ray tubes. Hoadley comprehensively covers equipment, materials and procedures in *Manual of Oscillography*.[11]

Light-Beam Oscillographs. The advent of light-beam photo-oscillography overcame the low frequency-response limitation of pen, electric, or heat-sensitive recorders, and made it possible to record as many as 60 channels on 12-inch wide sensitized paper by overlapping the traces. One channel of a typical light-beam oscillograph is shown schematically in Fig. 23-1.

The trace-creating element is the mirror-galvanometer shown schematically in Fig. 23-2. There is one mirror-galvanometer for each channel, but all are mounted in a common permanent-magnet block in the oscillograph housing. The mirror galvanometer consists of a tiny mirror mounted on a coil that is suspended and free to rotate in the magnetic field of the permanent magnet. Current from the sensing device passes through the coil and develops a magnetic field porportional to the applied

Fig. 23-2. Mirror-galvanometer principles.

current. Magnetic attraction between the developed field and permanent poles rotates the coil and appended mirror, causing light reflected from the mirror to form a trace on the moving photosensitive paper. As the coil rotates, torsion is created in the suspension, which acting like a spring, tends to retard rotation. When torsion equals the rotational force, the mirror stops. The trace, at that point, is at its peak and, when suitably calibrated, is a measure of maximum current at that instant. The time reference is obtained from fixed timing lines perpendicular to the x axis across the width of the paper created by a separate optical channel.

The traces produced by light-beam oscillographs may be recorded on (1) special printing-out papers producing a visible image without chemical processing; (2) on developing paper, or film, which must be developed, fixed, washed and dried; or (3) by an electrophotographic process. (Refer to contents). A light source of higher intensity than for developing paper is required to expose print-out paper. For rapid access with developing papers, a special recorder-processor may be used so that the paper is automatically processed following exposure.[12,13]

Papers and Films for Oscillograph Recording. Roll paper is generally used in recording oscillograph traces but film is preferred in some cases, particularly in seismic and well-logging applications.

Paper or film emulsions should have (1) adequate sensitivity for the desired writing speed; (2) good latitude in exposure; (3) good contrast between trace and background, and (4) low fog density.

Thin papers have the advantages of increasing the capacity of the magazine and, in the case of developing papers, requiring less time in processing because of faster drying. Duplicate copies by diazo or other methods

Fig. 23-1. Schematic of one channel in a typical lightbeam recorder. Light from the lamp A passes through optics B and C and falls on mirror galvanometer D at the left. The tiny mirror on the galvanometer throws a spot of light through additional optics and onto the recording paper F. As the mirror position is changed by the galvanometer element, a trace is created. Timing lines are also recorded by light falling on the rotating mirror G and fixed, plane mirror H, where they are reflected to the paper.

of printing are made more readily from originals on thin paper and, usually, are of better quality.

Print out papers are widely employed. As these papers require only a second exposure to produce an image, access time is relatively short and the complications of chemical processing are avoided. The trace color is usually blue, with a density of 0.40–0.75 against a tan, yellow or pink background. Print-out paper images are not permanent and are studied under gold fluorescent lighting, under yellow plastic sheeting or sprayed with a yellow stabilizing lacquer. Some printing-out materials may be chemically processed for increased stability but some cannot be chemically processed.

Print-out papers are capable of writing speeds up to 100,000 in./sec. Writing speeds of high intensity tungsten lamp recorders seem higher but are actually lower than those using Xenon or mercury vapor lamps; the apparently higher speed in recorders using high intensity tungsten lamps is due to shorter optical paths and larger galvanometer mirrors (Fig. 23-3). Two exposures are required with print-out papers; the first is the exposure of the trace, the second the image-development exposure, a step sometimes termed *latensification* (or photo-development, or photolysis). The latent image of the trace exposure acts as a catalyst for the conversion

Fig. 23-4. Density versus latensification time.

of additional silver halide to silver amplifying the initial exposure from 500–1000 times. Exposure to 30–50 footcandles of white fluorescent lighting produces an image in 15–30 sec at room temperature (Fig. 23-4). The time can be reduced by increasing the temperature[14] as shown in Fig. 23-5, and commercial equipment (CEC Dataflash System) is available which develops in 1–2 sec.

The amount of print-out paper used probably exceeds developing paper but the latter has the advantage of higher quality and longer life. In addition, some recorders are designed only for developing paper. Developing papers can be used with either tungsten or CRT sources and at least one type can be used in a closed magazine in a direct-write recorder with a mercury light source. Since developing papers require chemical processing, it is important for accurate data that the paper stock return after drying as nearly as possible to its original size. Emulsions for oscillograph recording are coated on rag paper stock or include special formulations to keep the dimensional change in processing at a minimum.

At least two papers are available that have the developing agents incorporated in the emulsion for stabilization processing.

Most of the available developing papers are orthochromatically sensitized for higher writing speeds with the light sources used. Paper speed is usually expressed in terms related to writing speed; low speed papers have

Fig. 23-3. Comparison of paper exposed in tungsten and xenon recorders.

Fig. 23-5. Density versus transport speed at elevated temperature.

writing speeds* below 6000 in./sec, medium speed papers have writing speeds between 6000 and 20,000 in./sec, and high speed or fast papers from 20,000 to 75,000 in./sec.

The processing of oscillograph records is covered in a later section.

Color papers, similar to those used in printing from color negatives, are available for recording traces in different colors for easier identification (GAF *Color Trace* and Kodak *Linagraph* 705.[15,16] The oscillograph must be adapted to color recording by inserting color filters obtainable from the manufacturer. After exposure the papers are processed in a four-step processor as recommended by the manufacturer of the paper.

Electron-Beam Oscillography. The chief advantage of electron beam recording over light beam and other recording methods is that the electron displacement is virtually inertialess. For this reason, very high frequency recording is possible and the performance of the electron beam instrument is believed to be the highest of any existing method. Recording can take place either by direct exposure to electrons, or indirectly by photographing the fluorescent trace on the face of the cathode ray tube. The latter method is more common and the sensitized material is exposed by the luminescent emission from the cathode-ray tube (CRT) when its phosphor coating is activated by electrons.

Cathode ray tubes are widely used for both display and recording. Although visual observation is sufficient for many purposes, measurement and comparison may be difficult or impossible. Photographic records can be examined at any time, records made at different times or under different conditions compared, and, if necessary, enlarged copies made for detailed study and mensuration. In addition, transients may be recorded whose duration is too short to be observed or measured. In some cases, recording can be automatic, thus eliminating the need for constant monitoring.

However, there is a considerable loss of energy with CRT conversion of electrons to light and in the use of a camera to photograph the luminescent image. Tests by Evans and Tarnowski[17] on a number of Eastman films showed that films too slow for use with CRT screens could be exposed with low current electron beams. The resolution and graininess of the slow films when exposed to 14–20 kV electrons far exceeded that of the medium to high speed films necessary for adequate exposure with phosphor-screen recording.

Direct exposure equipment, in effect, increases film speed, improves resolution, and eliminates the phosphor grain and other inherent phosphor limitation characteristics.

Current interest in direct-exposure recording may be attributed to television recording[18,19] and to recording techniques suited to computer systems.[20] Electron beam sensitometry has been advanced by these studies; in turn,

films with improved electron sensitivity have become available.

A direct exposure oscillograph for very fast transient electrical phenomena is manufactured by Trub, Tauber & Co., Zurich 37, Switzerland. In this system, data may be recorded on a stationary film, or on film attached to a rotating drum. Three viewing ports permit observation of the data on a fluorescent screen.

Poch describes a direct-recording instrument for 5-in. wide film.[21]

Significant advances have been made recently that enable sensitized material to be taken from room atmospheric pressure into the vacuum area of the CRT where the film is exposed and back into room atmosphere. Such a system is represented by the 3M Electron Beam Recorder (EBR). Two models are available; one for television recording and a second unit that converts computer-generated digital information stored on magnetic tape into 16mm microfilm. (More recently, 3M has introduced the Laser Beam Recorder which will replace the EBR).

Using the stroke method, the recorder writes directly on the electron sensitive film; i.e., 3M Dry Silver Film which is processed by heat alone. The film is threaded through a film chamber located directly beneath the electron gun housing. The small amount of air leakage occurring through the seals at the entrance and exit slots is exhausted by pumps which maintain the vacuum in the electron beam recording chamber. Figure 23-6 shows schematically a comparison of the electron beam and conventional CRT recording systems.

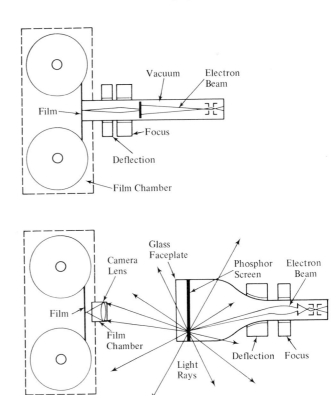

Fig. 23-6. Kinescope recording. Top: Electron recording. Bottom: CRT recording.

Writing Speed is the rate of trace movement, not the speed at which the paper travels through the recorder. Writing speed is relative; for a given paper it depends on the model of the oscillograph, the lamp, and voltage.

Recording CRT Images

In addition to oscillographic recording,[22-25] CRT photo-recording applications include television recording, COM and phototypesetting, radarscope,[26] display systems and computer terminals.

The exposure,[27,28] and indirectly the film speed, required in recording the CRT image depends upon (1) the spectral output of the phosphor; (2) the decay time of the phosphor; (3) the spot intensity; (4) the spot size; (5) the lens aperture; and (6) the image-object size ratio.

Phosphor characteristics are based on the Joint Electron Device Engineering Council (JEDEC).

Writing Speed. Writing speed, the rate of trace movement, is determined from the formula

$$V_s = 2\pi f A$$

where V_s is the writing speed at its maximum velocity, f is frequency in cycles per second, and A is ½ the peak-to-peak amplitude.

The nomograph in Fig. 23-7 relates writing speed to lens aperture and object-image ratio and is based on the formula

$$V' = \frac{V_{max}}{f^2}$$

where f is the aperture at infinity, M the image-to-object ratio, V_{max} the maximum writing speed at $f = 1$ and $M = 1$, V' is the writing speed at any aperture and V is the writing speed at object-to-image ratio M and aperture f.

To determine maximum writing speed experimentally, the film is tested by recording a damped sine wave. After being processed, the writing speed is determined at that portion of the first sine wave that is recorded in its entirety. This test includes all the variables of the CRT and the optical characteristics together with the film and processing variables.

Photographic Efficiency of Photographic Emulsions. Film speed and spectral sensitivity that match CRT output are the chief factors in the choice of a film for CRT recording. For many years manufacturers listed relative CRT speeds of various films compared to a standard film. More recently a CRT Exposure Index system has been developed and is described in Ref. 29. Values shown

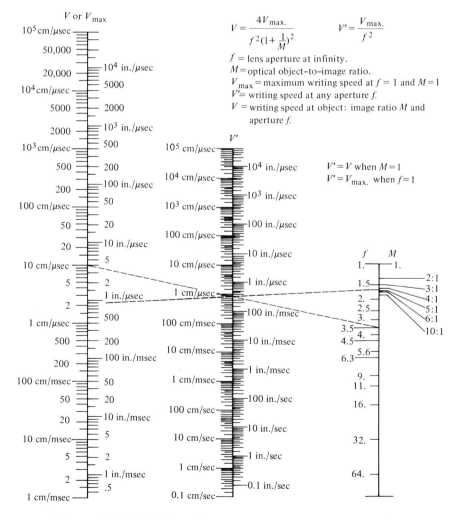

$$V = \frac{4V_{max.}}{f^2(1+\frac{1}{M})^2} \qquad V' = \frac{V_{max.}}{f^2}$$

f = lens aperture at infinity.
M = optical object-to-image ratio.
V_{max} = maximum writing speed at $f = 1$ and $M = 1$
V' = writing speed at any aperture f.
V = writing speed at object : image ratio M and aperture f.

$V' = V$ when $M = 1$
$V' = V_{max.}$ when $f = 1$

μsec = 1 microsecond = 1/1,000,000 second 1 msec = 1 millisecond = 1/1,000 second

Fig. 23-7. Nomograph for determination of speed with respect to optical variables.

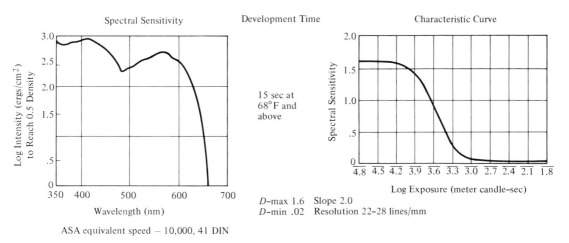

ASA equivalent speed – 10,000, 41 DIN

D-max 1.6 Slope 2.0
D-min .02 Resolution 22–28 lines/mm

Fig. 23-8. Characteristics of Polascope Type 410 Material.

in the tables are expressed as the reciprocal of the exposure in ergs/cm^2 required to produce densities of 0.10, 1.00 and 2.00 with a given phosphor simulation, film and processing. The new values represent conversion of the *radiant energy output;* older relative values represented the conversion of a phosphor's *electron beam input* energy into film density.

CRT recordings can be made with single frame cameras focused on the CRT screen or with moving film cameras. CRT'S are also the basis of various display systems, phototypesetters,[30] and computer output microfilmers (COM).[31,32]

CRT Recording Materials. Photosensitive materials for recording CRT images include sheet film and roll film, print-out and develop-out papers, dry silver papers and film, and Polaroid Land sheet and roll materials. In addition, there are special-purpose films for microfilm use and for photo-typesetting.

Roll films are available in 16, 35 and 70mm widths and for oscillography in wide rolls from 8 to 42 in. in width. The film base varies in thickness from 2.5–5.5 mils: the thinner usually being polyester, the others cellulose acetate. Some products employ gray bases, others an antihalation backing which in addition may be static

FILTER FACTORS: Increase exposure by the amount indicated.

Wratten Filter	#6 K-1	#8 K-2	#15 G	#11 X1	#25 A	#29 F	#58 B	#47 C5	Polascreen
Filter Factor	2X	2X	3X	4X	8X	16X	8X	8X	4X

Film	Format	Image	Area
47	Roll	2.875 x 3.75"	(7.35 x 10.55 cm.)
107	Pack	2.875 x 3.75"	(7.35 x 10.55 cm.)
57	4x5 Packet	3.50 x 4.50"	(8.9 x 11.5 cm.)

Speed equivalent – 3000 ASA, 36 DIN

D-max 1.6 Slope 1.3-1.4
D-min .02 Resolution 22-28 lines/mm

Fig. 23-9. Characteristics of Polaroid Land Types 57, 47, and 107 materials.

resistant and have a matte surface for pencil notations on the record.

The emulsion may be blue sensitive, orthochromatic or panchromatic but in any case it is typically a high gradient, high density emulsion which, with the high contrast developers used, readily produces a maximum density between 2.5–3.0 and a gamma of 1.5–3.0. Low contrast developers, or monobaths, can be used when images of lower contrast are suitable. The resolving power of these materials for a contrast range of 1000:1 is usually between 95–150 lines/mm. Nearly all emulsions suitable for CRT recording are prehardened for rapid access processing at temperatures up to 125–130° F.

The speed may be expressed in several ways:

1. In ASA speed numbers where the emulsion is designed primarily for other purposes but may be used for CRT recording.

2. In photorecording sensitivity values based on the reciprocal of the tungsten exposure in mcs. for a density of 0.1 above fog at an exposure time of 1/10,000 sec and recommended development.

3. Relative CRT speeds based upon a density of 1.0 after recommended development as compared with a control film exposed and developed under recommended conditions.

4. The CRT Exposure index at three densities, 0.10, 1.00 and 2.00 after specified exposure to a given phosphor simulation and specified processing.

Polaroid Land materials are convenient and provide rapid access where sheet or roll film can be employed. Type 410 is a high speed material with an ASA equivalent of 10,000. (Fig. 23-8). It can be used for photographing from blue, green or yellow phosphors but is most effective with a blue P 11 type phosphor. Type 47 (roll) and 107 (pack) has a speed equivalent to ASA 3000 (Fig. 23-9), while Type 410 is a high contrast material with a coarser grain.

Dry Silver Materials. Two types of dry silver materials which are developed thermally are available: one type produced both as film and paper by the 3M Company* requires only heat; the other, produced by the Eastman Kodak Company is first stabilized by heat (230°–240° F) and then photodeveloped by exposure to an ultra-violet source, to fluorescent lamps, or to high intensity tungsten radiation. The image on either of these papers is stable without further treatment. Spectral sensitivity curves and D-log E curves for 3M Dry Silver film are shown in Fig. 23-10, and similar curves for 3M Dry Silver paper in Fig. 23-11. Curves for Eastman Kodak Kind 1991 paper are shown in Fig. 23-12.

3M equipment utilizing dry silver paper includes a direct-exposure computer-output-microfilmer, a direct-exposure television recorder, a CRT display/print module for hard copies of terminal displays, microfilm and office copiers, and printers.

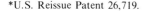

*U.S. Reissue Patent 26,719.

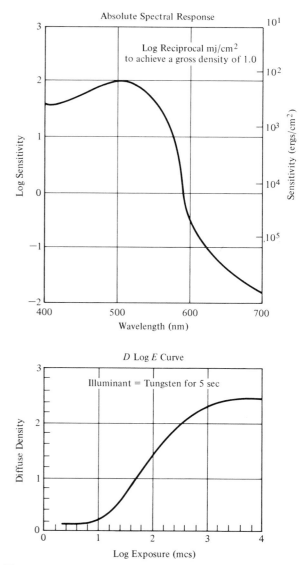

Fig. 23-10. Characteristics of 3M Type 7859 Dry Silver Film.

Processing Photopanel, Oscillograph and CRT Recordings

Films or papers may be processed on a batch or continuous basis, depending upon the type of material and quantity. Sheet material may be processed in trays or tanks and rolls in spiral reel tanks, or in manual- or motor-rewind multiple tank processors. Large quantities suggest continuous processors. Most materials are now prehardened for processing at high temperature for rapid access.[33-35] If archival quality is not required, and early access is important, stabilization processing may be employed. Stabilization processing is not recommended for trays, however, because of contamination problems. Typical stabilization processors for oscillograph papers are: Bell & Howell 23-109, Viewlex Processor EH-5(2), the Sprengnether processor and the Ektaline 200 processor of the Eastman Kodak Company.

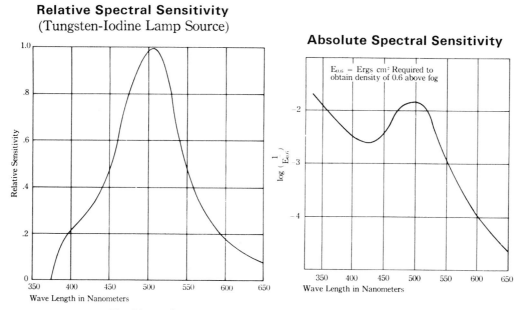

Relative Spectral Sensitivity
(Tungsten-Iodine Lamp Source)

Absolute Spectral Sensitivity

$E_{0.6}$ = Ergs cm² Required to obtain density of 0.6 above fog

Fig. 23-11. Characteristics of 3M Type 777 Dry Silver Paper.

Two solution stabilization processes are used for papers with incorporated developers, such as Linagraph Type 1830, 1843, and 1855 of the Eastman Kodak Company.

Some print-out materials may be chemically processed for greater stability or for a different type of image. In such cases, processing chemicals and instructions can be obtained from the manufacturer of the film or paper.

Monobath processing[36-38] provides rapid access and near archival quality with short washing times.

TIME-MOTION ANALYSIS

Time/Motion Relationships

There are four time-related characteristics inherent in every photograph: two direct and two implied. The direct time characteristics are event time and exposure time. The implied times are related to movement or change of the subject; primarily, they allow interpretation (and sometimes mensuration) of what happened before, and what could, would, or did happen after the picture was taken.

As a starting point, let us analyze a simple example for its time-motion characteristics. The example is a picture of a man diving from a tower into a pool. First, we have a dynamic rather than static condition—the man is pictured part way down in his dive. This fact establishes an event time (it can be roughly calculated from physical laws and size relationships) and implies that the man started his dive from the tower. It also implies that he is going to plunge into the water below; and this time can be roughly determined. The remaining factor, exposure duration, provides a clue to his speed within a

framework of direction of movement and distance (reduction ratio).

Let us take another example, slightly more complex, a man driving a golf ball. In this case the figure of the man remains in relatively the same position. He is not falling, so physical laws cannot be used to determine speed or acceleration. If a single photograph is taken in the middle of the swing, we cannot deduce precisely where it started or where it will end. However, we can take a long exposure, allowing the resultant image smear to provide an envelope of movement, or we can take multiple exposures on one frame to record incremental steps of the complete movement.

Multiple-exposure photography, particularly when made with stroboscopic flash arranged to edge light the subject, is a useful tool for situations of the type just described. In such instances, the duration of time *between* exposures is often significant so that movement or displacement occurring between exposures can be measured and rate of change established. Thus, a single frame of film can yield graphic information of the complete event, an advantage for analysis and documentation.

Multiple frames are an extension of the above method, and may be indicated when subject matter, lighting, backgrounds or area covered by the event, precludes a fixed camera position. A sequence camera or motion picture camera can be used, the choice depending on the repetition rate, number of frames, and resolution required.

The methods just described are useful for mensuration or analytical procedures but may not completely convey the way something happens. Often it is useful to see action. In some cases, action happens too slowly to be observed and must be speeded up to be understood. In other cases, action is seen as a blur, a composite of an infinite number of subject positions, and must be slowed

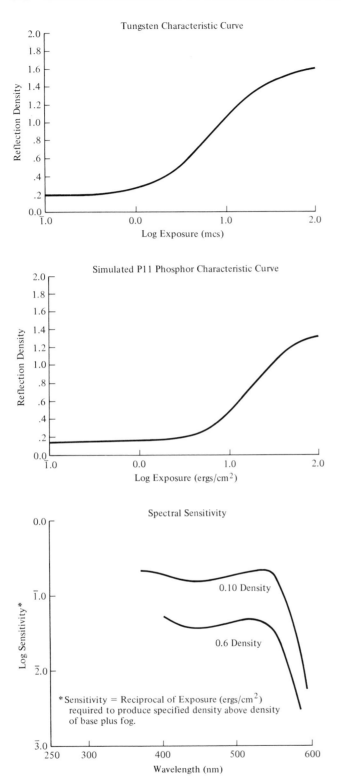

Fig. 23-12. Characteristics of Eastman Kodak Kind 1991 Paper.

Background of Photography for the Analysis of Motion

Fox-Talbot, in 1851, photographed a page of *The Times* fastened to a rapidly revolving wheel, using an electric spark as the source of illumination. By 1860 it was possible to make exposures with the wet collodion process which would stop the motion of a person walking and Oliver Wendell Holmes used photographs made on the streets of New York to study the act of walking. These studies were undertaken to aid in the designing of artificial limbs for amputees of the Civil War then raging (1863). This is the first recorded instance of the use of photography for the analysis of motion.[39]

Much more important, however, is the work of Eadweard Muybridge beginning in 1877. The work was undertaken at the request of former governor Leland Stanford of California to prove that a galloping horse has, at times, all four feet off the ground. Muybridge used 24 separate cameras placed at fixed intervals along the track with threads across the track so the galloping horse would break the thread and actuate a shutter which he had designed for exposures of about 1/2000 second. The photographs were no more than silhouettes but they showed all 4 feet of the horse off the ground but only when they were gathered underneath the belly.

Muybridge continued his work on animal locomotion at the University of Pennsylvania in 1883–1885 with improved apparatus and the new faster dry plate. In 1887 he published *Animal Locomotion* in 11 volumes, containing 781 plates of various animals and the human figure walking, running, jumping, climbing stairs, fencing, etc. His purpose was to provide artists with a guide to the representation of the human figure and animals in action.

At about the same time the physicist, Ernst Mach, was using the electric spark to photograph projectiles for studies in ballistics and in France, Marey was using single lens cameras with mechanisms of his own design for making a number of exposures in rapid succession to study the flight of birds. His *Chronograph* of 1894 used roll film and made 700 exposures per second.

The pioneering of high speed photography for the analysis of motion is much too extensive to be discussed here. The bibliographies of Garvin[40] and Boni[41] are the most convenient reference to later work in this field.

Contemporary Motion-Analysis Photography

A review of Table 23-1 will aid in establishing a framework for the following subsections. As shown in the table, time/motion analysis makes use of both still and moving film (or moving image) photography and uses a wide variety of equipment and techniques. Photographic analysis is relatively inexpensive for solving problems related to time, motion, sequence, space relationships and mechanical failures. It has been used for medical, chemical, mechanical, electrical and many other applica-

down to be comprehensible. This also applies to cyclic movement; any repetitive movement that has a rate of 10 or more cycles per second must be slowed down to be comprehensible.

TABLE 23-1. SUMMARY OF STILL AND MOVING FILM TECHNIQUES USED IN SCIENTIFIC PHOTOGRAPHY.

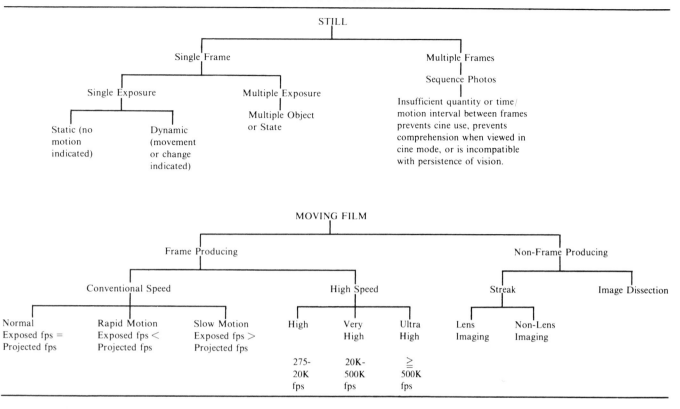

tions including natural phenomena. Not all applications can be discussed here; a review of the literature for methods used in solving problems is advisable.[42-51]

Single-Frame Techniques. Single frame photography at normal or high shutter speeds employs both single and multiple exposure techniques. When normal shutter speeds are unsatisfactory, high speed shutters or electronic flash may be employed. Since most high speed photography requires exposures of less than 1 msec ordinary camera shutters are not suitable; however, shutters such as the *Uniblitz®* or *Impulsphysik®* which exposures of 0.5–1.5 msec and multiple exposure operation may be suitable for some athletic events. For shorter exposures the choice of equipment depends on the nature of the subject: selfluminious subjects require a shutter; nonluminous subjects can be photographed at high speed with (1) a short duration explosive light source; (2) a short-duration spark or an electronic flash; or (3) with a longer duration flash lamp, or (4) a pulsed or continuous high-intensity light source combined with a suitable shutter. Choice of shutter depends on exposure duration: when flash duration equals exposure duration, the shutter has only a capping action; when exposure duration is less than flash duration, an electronic shutter is generally used. These are magneto-optical, electro-optical, and electronic image-converter tube devices. Magneto-optical (Faraday) shutters and Kerr cells operate on the principle of rotation of the plane of polarization.

Magneto-Optical Shutters. The magneto-optical shutter consists of a polarizer, a dense glass cylinder surrounded by a magnetic coil, and a second polarizer crossed at right angles to the first polarizer. No light passes through the shutter when no current flows through the coil. When a high amperage pulse at high voltage from a capacitor is applied, the plane of polarization is rotated and light passes through the second polarizer.

Kerr Cell Shutters. A typical Kerr cell is a double window container filled with a fluid such as nitrobenzene which exhibits strong bi-refringence in the presence of an electric field. Outside each window is a polarizer. The two polarizers have their planes of polarization crossed at right angles to each other. Inside the cell are two electrode plates connected to an external high voltage source. When no voltage is applied, light is unable to pass through the crossed polarizers. When a suitable voltage is applied, a phase change occurs allowing light to pass through the second polarizer (Fig. 23-13).

Solids can also be used in the Kerr cell. Crystals such as ammonium dihydrogen phosphate exhibit a pronounced effect.

Kerr cells are now used in conjunction with lasers and laser pulses can be used instead of electrical pulses to activate the shutter. While the electronically switched Kerr cell is capable of framing times as fast as 1 nsec, a Kerr cell without electrodes, and using CS_2 as a medium rather than nitrobenzene, has produced framing times of 10 psec.[52,52a,53]

Fig. 23-13. Kerr Cell details. 1. Optical axis. 2. Front polarizer. 3. Rear polarizer. 4. Quartz glass housing. 5. Planar electrode. 6. High voltage connector. 7. Teflon expansion bellows.

Image Tubes. Image converter tubes used alone or followed by image intensifiers are used for ultrahigh-speed photography.[54]

An image converter tube contains a semi-transparent photocathode on which the subject is imaged by a lens. When suitable electric and magnetic fields are applied, electrons are emitted from the photocathode, travel to a phosphor screen, and create a luminescent picture which is then photorecorded. Exposure time is a function of the photo-emission at the cathode and is dependent on the duration of the electric pulse. The duration of the luminescent image is considerably longer than the pulse thus allowing photorecording on films and Polaroid Land materials.

Light amplification through the use of a single image intensifier or by means of cascaded image intensifiers is used to gain higher light output from low light-level subjects.

Image converter cameras have typical exposure times as short as one to a few nanoseconds in some models. Cameras are available from Cordin, Red Lake, TRW, Philips and others. Typically, cameras are equipped with Polaroid sheet or roll backs, and Graflex backs. Film sizes range from 70 mm to 4 × 5 in.

High Speed Flash. Short-duration, high-intensity flash sources include electric spark, electronic flash tubes, pulsed x-rays and pulsed lasers. Chemical flash techniques, such as electrically exploded metal film and wires, or explosive tubes containing gases, are also used.

The electric spark method is used for very short duration flashes, typically less than 1 μsec, and in situations where a point light source is preferred. Submicrosecond flash equipment and other flash methods, employing electrical discharge or chemical means, and having various durations are described in the bibliographic references. Super Radiant Light (SRL) using semiconductors has also been described.[54]

Electronic flash tubes offer longer duration light sources, in the range of less than 1 μsec to 1 msec or longer.[55] The flash lamp is a glass or quartz envelope containing a suitable gas or gases. An intense flash is produced when a high-voltage, high-energy pulse from a condenser is discharged through the tube.

Specially designed electronic flash tubes operating from controlled repetitive power sources are frequently used in a stroboscopic mode.[56,57] The repetitive flashes at selected frequencies enable studies of cyclic phenomena to determine if events are truly repetitive. The technique can also be used to furnish sufficient illumination for high speed photography of cyclic motion by repetitive flashing with the subject details superimposed. Stroboscopic studies are useful for studying many human and animal movements as well as mechanical devices.

Another technique, "slip-sync" strobe, produces a slow motion effect to aid in studies such as vibration analysis.

Stroboscopic light sources are also used with moving film cameras and videotape recorders. Hyzer[58,59] describes the use of a standard VTR and conventional stroboscope used in combination for motion analysis. The instant replay feature enables on-the-spot evaluation from a variety of "takes" to solve the problem.

In the same references, Hyzer describes the INSTAR system produced by Video Logic Corporation. The slow-motion, stop-action video tape unit records at 120 frames per second (fps) and has an effective "shutter speed" of 10 μsec provided by a synchronized stroboscopic source.

Time Lapse Photography. If event differences occur slow enough to use a still camera, separate images may be recorded with a still camera on a tripod and used for measurement after processing. However, biological specimens such as germinating seeds, and various photomicrographic phenomena may require too many exposures, over too long a period of time, for a manual approach to be practical; usually some automatic method will be needed. This can range from the use of a still pulse camera to an automatic cine camera.[60,61,61a]

In addition to the camera, an automatic reset timing and sequencing control is required. This consists of a setable mechanical or electrical clock mechanism controlling a series of switches. At the end of the preset time, lights are turned on, the camera shutter is actuated, film advanced, and the lights turned off.

When a motion picture camera is used, projection of the film at the usual rate provides a time-accelerated presentation of the event; minutes, hours or days are contracted to seconds. If detailed measurements must be made of each image to detect changes a pulse camera is often used.

Cinematography. A substantial number of human, animal, mechanical and other scientific subjects can be better understood when exposed at normal frame rate and then studied with the aid of a stop-motion projector. The projector enables athletic events, manufacturing production time studies, and other motion-analyses to be viewed at normal speed or slower, or a frame at a time, or in reverse motion. The repetitive study of sequences using this technique may obviate the need for slow-motion or high-speed motion pictures. The recording-speed criteria must be based on the ability of an individual

exposure to resolve the movement occurring within the duration of that exposure; if it is not sufficiently resolved in the recording, the stop-frame method will not improve it.

A large number of subjects that cannot be understood when photographed and analyzed at normal speed may be comprehensible with a small amount of time magnification; i.e., 2 to 10 times.

Many cine cameras are capable of 48, 64 or 128 frames per second and these, used with an analysis projector, form a relatively simple and exceedingly useful research tool.

When it is necessary to use an exposing rate greater than about 500 fps for the analysis of movement, the conventional motion picture camera with its intermittent film movement cannot be used. In high speed motion picture cameras the film moves continuously and the image is moved at the same speed as the film by a rotating prism. Cameras of this type are widely used in motion analyses research and some models attain a speed of 45,000 fps.

For higher speeds, drum cameras have been used where only a few feet of film are required as in the detonation of explosives. The film is attached to a drum which is rotated at the desired speed by an electric motor. A shutter opens for one revolution of the drum preventing double exposure. Simple drum cameras can be used when image motion can be synchronized with drum speed. When this cannot be done, a framing drum camera can be used. This has a series of lenses, one for each frame, to image the subject on the film behind a slit which acts as a focal plane shutter. Typical recording rates are about 8,000,000 fps, useful for investigations of explosives, aerospace research and the fracture of glass and metals.

Another type of multiple-lens camera uses film in a stationary position. A high-speed rotating mirror images the subject through a series of framing lenses onto the film. Multiple rotating mirrors have been used to increase frame rates. Rotating drum and rotating mirror combinations have also been used.

Another high-speed technique is the "streak" camera. This transports the film continuously past a narrow slit so that all details in one dimension are examined against a time base. The resulting photograph is a smear perpendicular to the slit and is a record of *all* the changes in the subject during the exposure unlike framing cameras which may miss changes occurring between frames. Framing cameras have been combined with streak cameras; one commercial framing-streak camera produces 24 frames at 7,840,000 fps with an exposure time of 54 nsec and a streak record at 27.6 mm/μsec.

The methods described so far have involved moving the film, or the image, by a distance equivalent to one dimension of the image. Thus, individual film or image movement times are serially added and produce a long total movement for the entire sequence. Since movement for one complete picture takes a relatively long time, other means than complete picture movement must be used if this time is to be shortened.

One such method is image dissection.[62] With this method the picture is divided into elements each of which is recorded in separated but precisely spaced positions on the film. The next recorded series of image elements is then displaced only one element, a very short distance as compared with total picture size. This is repeated until the film is entirely filled with scrambled images. After the film is processed it is put back into the camera and each image is successively reassembled from the separated elements.

Battaglia[63] describes a commercially available camera of this type, the Megadyne 303 High Speed Camera manufactured by Photosystems Corporation, shown in Fig. 23-14. The camera uses a lens array containing 80,000 elements covering a 4 × 5-in. area. A 12-in. objective lens images the subject immediately in front of the lens array. Between the elements of the objective are a movable aperture and scanning disc driven by a 2.5 hp motor. One revolution of the disc produces 3000 images. Framing rates can be varied from 30 to 1,000,000 fps.

Chief advantages of the camera are long recording time, continuous recording so that nothing is missed, and quick access because only one 4 × 5 plate must be processed to obtain the data. For most applications Eastman Type SO 243 plates are satisfactory.

A bibliography of image dissection methods in high speed photography is given by Courtney-Pratt.[64]

Analytical Methods. Analysis of finished photographs extends from simply viewing the pictures to computerized data reduction. For still pictures examination and measurements can be made from prints or the original film. Measurements are simplified when a scale or grid has been photographed along with the subject. Projection of the original aids in reducing the error when measurements are made. There are many types of projection viewers for analysis.

Extremely close measurements are made with measuring engines, typically able to measure to one micrometer. Coordinate-point readout data are then fed into a computer.

Recently, computer animation techniques have been combined with high speed photography and mathematical models to produce visual simulation of a complete motion sequence. Data, in the form of a few high speed photographs provide the known factors. Programming this data into the mathematical model enables the computer to output a slow motion animated version of what happened before, during, and after the high speed frame sequence.

Sensitive Materials for High Speed Photography. Usually the most important requirement is emulsion speed and, as the reciprocity failure may be considerable at the high speeds employed in time/motion studies, speed must be defined in terms of the actual exposure. The emulsion with the highest ASA speed may not be the best[65] (1) because, owing to reciprocity failure, it is slower than other films with a lower ASA speed, and (2) because the graininess and low contrast of the image make interpretation difficult. Recommendations can be

Fig. 23-14. Optical diagram of image dissection camera.

obtained from the manufacturers, but if the exposing conditions are different, tests should be made. Experimentation is desirable particularly if prolonged development (pushing), or special high energy developers, are to be used for added speed or contrast.

While high speed panchromatic emulsions are generally useful, in some cases other sensitizings with higher response to the exposing source may offer advantages.

Except where an emulsion of the highest available speed is necessary to get any image at all, the choice is usually a compromise between speed and image quality (i.e., graininess, density and contrast.)

With rotating prism cameras and in some other exposing apparatus, the tensile strength and flexibility of the film base is very important. Such cameras create stresses that can cause breakage of the film with the destruction of the film and damage to the camera. Again the recommendations of the film manufacturer should be followed. Polyester bases have greater strength and dimensional stability and have the advantage of more footage in a given size spool.

If machine development at high temperatures is to be employed, the film must be suitable for the machine and type of processing to be employed.

Many scientific and industrial applications require rapid access processing of at least a portion of the film. If this is the case suitable arrangements will have to be made for any necessary variations in routine, marking, analysis of processed film, etc. Polaroid Land materials are inherently rapid access and are useful for recording data in which the next experiment in a series is dependent upon the data obtained from the previous experiment. High speed Polaroid Land materials are discussed in Chapter 12 ("One-Step Photography").

Some materials can be processed to a negative or reversal processed to yield a positive directly. The emulsion speed may or may not change with the processing mode depending on the film. This fact must be known prior to making the exposure.

When high speed color materials have sufficient speed to be used, they will, at times, aid in data reduction because of color differentiation. Ordinarily, even high speed color films will have to be processed for higher than recommended speeds. Good color reproduction is not to be expected under these conditions of exposure and processing but the color differences often increase the information content of the image.

High speed photography requires large amounts of film. To ensure consistent quality a single emulsion number or a minimum number of different emulsions is recommended. These should be stored in facilities which will prevent emulsion change before use.

FLUID-DENSITY-VARIATION PHOTOGRAPHY

Visualization of fluid differences or flow utilizes variation in density, and hence the refractive index, to create visible patterns. Three methods are in use to record density variations; (1) *shadow* photography, (2) *schlieren* photography, and (3) *interferometric* photography.

Density-variation photography is applied to airflow research in wind tunnel and in-flight aircraft tests; shock wave studies of aircraft, spacecraft (when in the atmosphere), and ballistics; thermodynamic investigation in combustion and heat transfer; and the mixing of different gases or liquids.

Since the optical techniques employed cause no interference with the test condition or test specimen, they have numerous advantages over other methods used to indicate or record flow phenomena. For example, if test probes are inserted in a high velocity gas stream, the interference can cause inaccurate or useless data to be obtained under certain conditions.

Shadow Photography

Shadowgraphs are photographs of density-variation shadows made by passing collimated light through the test field. They are produced by *direct*, *screen*, and *con-*

Fig. 23-15. Methods of Shadow Photography. (a) Direct shadowgraph method. (b) Screen shadowgraph method. (c) Condenser shadowgraph method. (A Fresnel lens can be substituted for condenser.)

denser methods shown in Fig. 23-15, and described in the following paragraphs.

Direct Shadowgraphs are made by light from a point source casting a shadow of the disturbance directly on photosensitive material of sufficient size to cover the area under investigation. This method requires a darkened room.

Screen Shadowgraphs are made by substituting a translucent screen or ground glass for the film or paper in the direct example above and then photographing the screen with a camera.

Condenser System Shadowgraphs are made by inserting a condenser lens (es) between the light source and test specimen. Light-to-condenser and condenser-to-camera lens distances must be carefully adjusted to cover the entire film. The camera lens is then focused on the plane in which the specimen is to appear. The field cannot exceed the area of the condenser. Alternately, a Fresnel lens may be used.

The direct method essentially produces a 1:1 size relationship and has the limitations of a darkened room and size of film. These problems generally preclude moving-film photography. The screen method requires a darkened or low light level area, but any size film can be used. Screen and condenser methods both permit moving film photography with any size test specimen, but light loss in the screen limits speed.

Shadowgraphs are the simplest and least costly of the three methods but are qualitative. If quantitative data are required the schlieren or interferometric method is preferrable. Obtaining quantitative data from shadowgraphs is a complex data-reduction process.

Shadowgraph System Variations. A variation of the method that uses condenser lenses, shown in Fig. 23-15 (c), is described by Hyzer.[66] The method consists of substituting a thin Fresnel lens for the large heavy condenser lenses. Novak[67] describes the use of a 42-in. diameter, 36-in. focal length, thin plastic Fresnel lens for recording shockwaves of vehicles traveling in excess of 3000 ft/sec.

Novak, in the same reference, describes another technique which makes use of highly reflective Scotchlite #3280 reflective sheeting, used as either a reflector or as a black and white grid, to record shock waves from a high speed sled. A flashlamp is located as close as possible to the lens axis at the camera on one side of the vehicle track. The camera is focused on the theoretical plane of the vehicle as it will move through the field of view. The Scotchlight reflector is placed on the opposite side of the track and oriented so that its highly-directional reflection will be beamed into the camera lens. This "two-pass" system records the shock wave from the nose cone as it passes through the test field.

Flow Visualization. Photorecording is often used to produce permanent records of flow direction and velocity in aerodynamic and hydrodynamic research. Tracers, such as dyes, smoke, oil, air, plastic and chemical particles, are introduced into the stream being investigated and photographs are made. In other types of studies, coatings of substances such as oil, lamp black, or Zyglo are coated on the subject undergoing aerodynamic testing. The pattern remaining on the surface shows regions of separated flow. Hyzer[67a] discusses various techniques commonly used in such testing.

Schlieren Photography

Schlieren is a German word for streaks or striations in minerals. In transparent fluids and gases it has come to be applied to density differences which result in changes in refractive index and to an optical system which reveals these differences. The term is also used, but less frequently, to describe the effect produced with an optical system by the reflection of light from an irregular surface.

The schlieren method, described by Toepler in 1866[68] has since developed into numerous configurations, each however with a common component, i.e., a knife-edge or diaphragm. Two separate superimposed optical systems are employed; the first illuminates the field; the second converts local density changes (and hence changes in refractive index) in the test field into changes in light intensity and/or color. The knife edge in the second system is the component that converts the refraction into an intensity change. Knife edge placement and adjustment are critical; it must be set so that diffraction of light in one direction increases intensity and in the opposite direction, decreases it. Light continuing past the knife edge forms an image of the density variations in the schlieren field which can be viewed or photographed.

There are several typical schlieren configurations, the

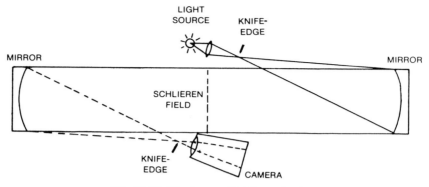

Fig. 23-16. Single-pass Schlieren System.

simplest being to insert a knife-edge ahead of the camera in the shadowgraph system shown in Fig. 23-15.

An improvement on the above system, and one of the most widely used schlieren configurations, consists of two concave mirrors on opposite sides of the test field, as shown in Fig. 23-16. Light from a source on one side of the mirror axis is collected by the first mirror and reflected in parallel rays through the test area. The second mirror collects and focuses the light at the knife-edge. There, light refracted in one direction is stopped, unrefracted light is allowed to pass, and light refracted in the opposite direction adds to the total illumination. A camera is located beyond the knife-edge. In some systems, a two-position first-surface mirror is interposed between the camera and knife-edge; when the mirror is set at a 45° angle, light not stopped by the knife-edge is reflected to and focused on a screen for viewing. When the mirror is moved out of the light path, the rays pass directly into the camera to record the image. This system is popular because the parallel rays produce excellent resolution and allow adequate distance between the mirrors and the schleiren field; coma is cancelled because the light source and imaging points are on opposite sides of the mirror axis; and switching from viewing to recording is easily accomplished.*

The two configurations described are called "single-pass" schlieren systems. Other configurations, called "multiple-pass" systems, increase the sensitivity because the light path traverses the disturbance more than once. An example of a double-pass configuration is shown in Fig. 23-17. This so-called "coincidence" method may have less resolution than a single-pass system because the two paths through the disturbance are not precisely coincident. The method is best suited to small deflections so that the result will be, in effect, an amplification of the results obtainable in a single-pass system. However, if deflections on the first pass are large and they are again deflected on the second pass by a different disturbance, the result will be difficult to translate.

*The viewing mode requires a continuous light source. If this is not compatible with the illumination requirements for photography, a separate light source and means for switching must be provided.

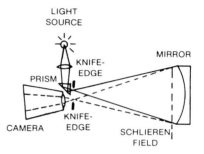

DOUBLE SENSITIVITY

Fig. 23-17. Double-pass Schlieren System.

Schlieren System Design. The literature[69-75] discusses applications and describes principles used in setting up schlieren systems. In general, each application has its own requirements and the system must be designed to fulfill those requirements. Nonstandard components are used and extremely high quality is required of some components.

The type of photographs to be taken, i.e. (1) still with continuous light source; (2) still with high-speed light source; or (3) motion pictures at normal speed, (4) high-speed, or (5) ultra-high speed, will determine design criteria. In addition, there may be requirements for color, or stereo, or for recording the test subject in addition to the effect in fluid flow that it creates. These special considerations will affect the design and choice of components.

Light Source. Monochromatic or white light, from a point- or (preferably) line-source such as through a slit, is used for illumination. The orientation of the light-source, slit, or diaphragm, and the knife-edge must be parallel.

Knife Edge Adjustments. The knife-edge is perpendicular to the optical axis, but may be rotated about this axis to study various flow directions if more than one direction is to be studied. The light source orientation must match the knife-edge setting.

Knife-edges must be capable of three adjustments with respect to the light beam; rotation, transverse

movement, and interception of the beam at various positions at or near the focal point. Micrometer-type adjustment mechanisms are used for these critical adjustments which determine brightness and sensitivity.

Grid. The schlieren systems described provide qualitative data. If quantitative data are required systems such as the Ronchi grid may be employed. This method uses a wire grid instead of the first knife-edge at the light source.

Mounts. Schlieren components must be capable of precise alignment and then be firmly mounted and vibration free. For large systems this means heavy pedestals, properly anchored; or, if components are to be moved, three-point casters and jackscrew leveling mounts.

Optical Components. Mirrors or lenses in the schlieren optical system must be of high quality without imperfections that would cause field or image variations. Typically, telescope mirrors are suitable for use in schlieren systems.

Any glass used in the system, such as wind tunnel windows, must be flat, uniform and free of flaws.

The camera lens should be a first quality anastigmat preferably mounted in a shutter capable of synchronization with a high speed light source. The focal length is generally long to produce an adequate-size image. The diameter of the diaphragm should be sufficiently large to accept the entire bundle of light rays. Since the rays diverge, it is important to locate the camera lens close to the knife-edge so that excessively large aperture lenses are not required.

Camera. For still photography, cameras that accept films measuring 4 by 5 in. or larger are advised.

If rapid-sequence still photographs are to be taken, 70mm film is suitable, or larger size aerial reconnaissance cameras can be modified for use in the system.

In installations where the schlieren field is fixed, for example a wind tunnel, a light-tight enclosure can be substituted for a camera.

Motion picture cameras, high speed cameras, drum cameras and other special purpose camera systems are also used in schlieren photography.

Color Schlieren Systems. Holder and North[76] describe a color schlieren system with a constant-deviation dispersion prism located between a white-light source and the first mirror in a two-mirror parallel beam system. A spectrum is formed at the plane of focus of the second mirror. The knife-edge normally used at that plane is replaced with a slit which is adjusted to pass light of only one color when there is no gradient in the field. Changes in density then produce changes in color.

Single- and double-pass color systems have achieved color through the use of multicolored filters in adjacent strips or concentric rings. The use of an interference filter was described by Meyer-Arendt, Muncey and Montes.[77]

Color schlieren offers easy recognition, rapid identification, and qualitative analysis of gradient differences. There is, perhaps, warranted validity to the claim that the system can be made quantitative. One quantitative method is suggested by Meyer-Arendt, Muncey and Montes.

Kelsey and Cook have described color schlieren output to visualize ultrasonic waves.[78]

Interferometric Photography

The interferometer is used to obtain direct quantitative density values by measurement of differences in interference fringes.

There are numerous types of interferometers all of which are relatively complex and costly when compared with shadowgraph and schlieren systems. Diagrams of various types of interferometers are shown in *Photographic Instrumentation.*[46] The reference discusses the three density measurement systems.

The interferometer functions on the principle of separating a single light beam into two beams, one of which passes through the density variations in the test field. The two beams are then recombined, forming fringes.[79] Density variations in the test field cause fringe displacements proportional to the density variations, which are direct measurements of the differences in index of refraction.

A comparison of shadowgraph, schlieren and classic interferometric methods is presented in Table 23-2.

Rowe[80] discusses the modification of large schlieren systems of wind tunnels to interferometers through

TABLE 23-2. COMPARISON OF SHADOWGRAPH, SCHLIEREN AND INTERFEROMETRIC METHODS.

	Complexity and cost	Field size	Sensitivity	Gradient-type suitability	Data interpretation and analysis
Shadowgraph	Low	Large	Low	For rapid, sharp, gradients. Best suited to intense gradients.	Rapid visual interpretation. Complex data reduction to obtain quantitative data.
Schlieren	Medium	Medium	Medium	For rapid, continuous changes. Variable sensitivity from small to intensive differences.	Ease of visualization and identification. Quantitative data possible.
Interferometric	High	Small	High	For slow, continuous changes.	Directly quantitative. May be difficult to interpret.

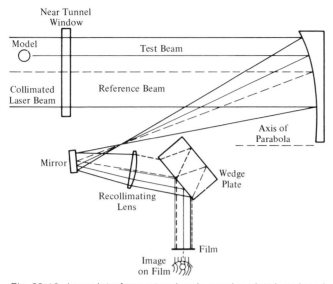

Fig. 23-18. Laser interferometer showing wedge plate in reduced beam.

the use of a small wedge plate, as shown in Fig. 23-18. The modification cost is minimal when compared to the cost of designing, building, and adjusting a Mach-Zehnder interferometer. In wind tunnels, where there is no relative motion between the model with its attached flow pattern and the interferometer, simple gas lasers and mechanical shutters may be used. The shortest exposure of any interferogram in the Rowe paper was about 1/300 second.

Density Measurement Photorecording Materials

Materials for density measurement photography are available among the types discussed for other data recording purposes. Since large fields are common to shadowgraph systems, paper is sometimes used instead of film.

High-speed develop-out photorecording papers typically have contrasts suitable for this application. Moderate to relatively high contrast photorecording films in the Eastman Kodak RAR group are also suitable, together with comparative materials having similar characteristics.

For schlieren photography, moderate sensitivity and contrast are suitable for continuous light sources. When extremely short duration light sources are used, high speed films may be required. Such films as Eastman Kodak 2479 RAR, Kodak 2475, and Kodak 2484 are typical of films suited to high speed use in these applications.

For sheet film cameras, moderate to high speed commercial films are satisfactory.

There are no unusual requirements for processing. Generally, instructions of the manufacturer for standard processing should be followed. Typically, wind tunnels will be checked out or calibration tests done during which optimum exposure and development can be determined for the film type, processing and suitability

to the test objective and condition. Frequently, rapid processing may be required, and photorecording materials with hardened emulsions lend themselves to rapid access processing at elevated temperatures.

The selection of motion picture films for density-measurement cinematography follows the requirements outlined for still photographs; namely that higher speed materials will most frequently be needed for other than continuous light sources.

Standard color materials can be used for color schlieren photography and cinematography. The ability to "push" development to obtain higher effective emulsion speeds with some materials may be helpful under certain test conditions.

SPECTROGRAPHY

Sir Isaac Newton, in 1666, was the first to produce a spectrum by passing a beam of light through a prism. About 1826 Fraunhofer discovered lines in the spectrum of the sun which could not then be explained but, in 1859, Kirchoff discovered that the lines in the spectrum of a body, heated to incandescence, represent the elements in the body and that each element has its own characteristic lines. Some elements have simple spectra of only a few lines; others have complex spectra with many lines, some much brighter than the others.

The spectrum of a body containing a number of elements is still more complex as it contains the lines of all the elements in the body. As the wavelength of each line must be determined to identify the element, or elements, present, it is clear that a photographic record of the spectrum can be measured, and the wavelengths of the lines determined, much more accurately than by visual observation. Visual observation, in fact, is practical only with very simple spectra consisting of a few bright lines.

Kirchoff's discovery added a new dimension to astronomy—the study of the composition of the stars. Nine years later (1868) Sir Norman Lockyer discovered a new element, helium, in the sun. Later it was found on the earth and used to inflate balloons and lighter-than-air airships. From studies of the spectra of the stars, astronomers were able to determine their temperatures and from this the age and life cycle of stars from youth to old age. Indeed most of what we know about the stars, other than their position in the sky and their brightness, has been learned from the analysis of their spectra.

As a method of chemical analyses in the laboratory, spectrum analysis has the advantage of showing in the one spectrum all the elements present: chemical analysis may indicate only one requiring further tests for other elements. The extraordinary sensitivity of spectrum analysis makes it particularly useful in detecting small quantities, e.g., trace elements, often difficult to detect by chemical analysis. A further advantage is the small quantity required for a complete test; a few drops, for example, is sufficient for a determination of the mineral content of water.

For years spectrum analysis was only qualitative; the elements present in a sample could be determined but not the amounts. Later it was found possible to correlate the density of the spectrum lines on a photographic plate with the amount of the element and spectrum analysis became quantitative.[81-86] In some cases highly precise analyses can be made by spectrum analysis where chemical analysis would be impossible. In steel-making, for example, samples may be taken directly from the furnace, spectrograms made and the composition at that stage determined in a few minutes by comparing the spectrogram with a set of reference spectrograms.

Spectra Types

Emission spectra occur when a solid or liquid becomes incandescent, or when a gas becomes luminous.

Absorption spectra occur when radiation passes through a substance that absorbs certain wavelengths. The dispersion and recording of the remaining energy produces a spectrogram indicative of the absorbing material. The classical Fraunhofer lines show the absorption (by hot gases) of radiation from a continuous source. These correspond to the same wavelengths which would be emitted by the gas in the same state of excitation.

Three types of spectra are produced from luminous sources: continuous, line, and band.

Continuous spectra contain all wavelengths, and therefore, have the appearance of a rainbow. Continuous spectra are formed by molten metals, lamp filaments, and liquids. Generally, continuous spectra are used for absorption spectrography.

Line spectra are formed from luminous gases. They may be produced by heat or electrical discharge as in a gaseous tube. Each line in the resulting spectrogram is the image of the slit produced by one wavelength.

Band spectra are closely spaced groups of lines that appear so closely integrated that greater dispersions are necessary to resolve the band into its components.

Spectrographs

Any nonluminous body must be heated to incandescence to determine its spectrum. This is done with an electric spark, an electric arc or a laser pulse. Self-luminous objects, such as the stars or molten metals and alloys, require no excitation.

The spectrum may be formed with a prism or a diffraction grating. In a prism spectrograph (Fig. 23-19) light from the sample passes through a condensing lens, a narrow entrance slit, typically variable in width from a few micrometers to 1000μm in width, a collimating lens, the prism and an imaging lens to the photographic plate or film. The prism is typically a 60° prism, or a 30° prism with one face silvered to reflect the light back through the prism. This type of prism produces the same dispersion as a 60° prism with half the glass

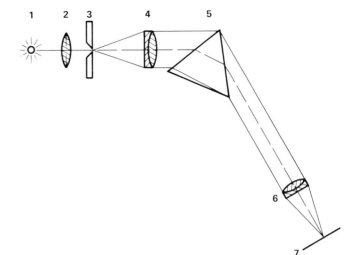

Fig. 23-19. Prism spectrograph. 1. Source. 2. Condenser. 3. Slit. 4. Collimator. 5. Prism. 6. Imaging lens. 7. Film or plate.

and by folding the optical path shortens the instrument— an important feature when high dispersion is required to separate spectral lines which are very close together. Glass prisms and lenses may be used for the visible spectrum but quartz optics must be used for the ultraviolet and crystals of germanium or rock salt for the infrared beyond 1200 nm.

A diffraction grating is a flat or concave mirror engraved with from 300–1200 parallel lines per millimeter which produces a spectrum by diffraction and interference. The optics of typical spectrographs employing a diffraction grating is shown in Fig. 23-20. The prism

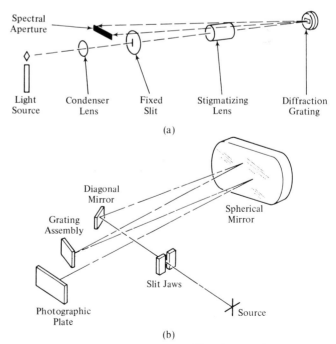

Fig. 23-20. Optical diagrams of diffraction grating spectrographs. (a) Stigmatic grating spectrograph. (b) Path for one grating of dual-grating spectrograph.

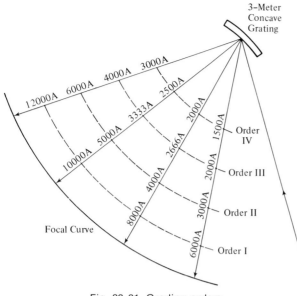

Fig. 23-21. Grading orders.

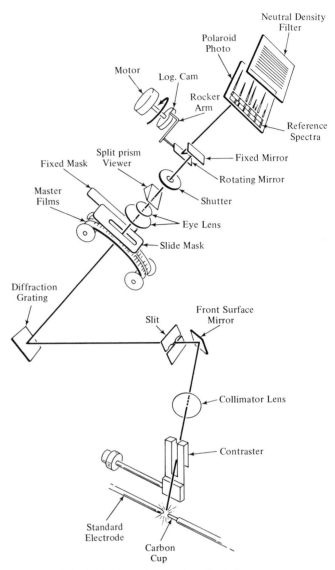

Fig. 23-22. Spectrograph optical diagram.

produces a brighter image than the grating and is generally used for faint sources, but the dispersion varies with the wavelength being much less for the long wavelengths than for the short. The grating on the other hand produces a regular spectrum, i.e., one in which any wavelength distance is represented by a constant difference in the spectrum. The grating also produces greater dispersion which, for many purposes, is a decided advantage. On the other hand, the grating produces a number of spectra which may overlap, as shown in Fig. 23-21. The overlapping is usually minimized or eliminated with filters.

A grating spectrograph must diffract in parallel lines, producing clearly defined lines with adequate resolving power for the intended purpose. The resolving power is obtained by dividing the wavelength by the separation of the two lines in angstroms.

A direct reading spectrograph (Vreeland) is shown schematically in Fig. 23-22. Two master spectrograms, recorded on transparent mylar films, on each side of the spectrum being analyzed, are illuminated by continuous spectra generated by the electrode tips so that the spectrum lines appear in their true colors. The dials are turned until the films display a matching spectrum. At this point the lines in the master film and those of the sample match. The matching spectra can be recorded on a panchromatic 35mm film or on Polaroid Land film.

For quantitative data a Quantrex attachment is used.[87,88] This uses a synchronous motor to drive a logarithmic cam which, in turn, drives a rocker arm connected to a highly reflective mirror. The spectrum to be analyzed is projected to the mirror and from there to the film. The oscillating mirror elongates the lines of the spectrum and, because the motion of the mirror is logarithmic, the lines are tapered and their lengths are quantitative measurements of the elements which produced them. To record the data two exposures are

made, one of the spectrum to be analyzed, the other of the reference films using a fine grain 35mm film or Polaroid Land film.

Photographic Materials for Spectrography

A large variety of spectroscopic films and plates are available from the major manufacturers of photographic materials. The Eastman Kodak Company, for example, supplies 11 different emulsions and 12 different spectral sensitizings, a total of 34 on plates and 25 on film. Data on these special films and plates, including sensitometric curves, spectral sensitizing, reciprocity characteristics, gradient wavelength relationship, and modulation-transfer functions, are published by the manufacturers and these should be followed in the choice of materials and processing.[89] It should be noted, however, that the data published are

representative only and that these special emulsions, being made in relatively small quantities, are subject to variation, and for studies involving high precision may require separate calibration of each batch for the conditions under which the film or plate is used. The methods for doing this are far too varied and involved for discussion here.[90,90a,90b]

Films and plates are spectrically sensitized for the ultraviolet, for different selected areas of the visible spectrum as well as panchromatic sensitizing for the visible spectrum as a whole, and finally for the infrared.

Because short wave ultraviolet radiation is absorbed by gelatin, films and plates for use in the ultraviolet are coated with an emulsion having a low gelatin content. These emulsions are very delicate and require careful handling to avoid abrasion marks. Some of these films are supplied with an overcoating which fluoresces strongly in the ultraviolet, reducing the exposure. The solution used for overcoating is available separately and may be applied to films and plates that are not available with an overcoating.[91]

The films and plates for use in the visible region differ in the distribution of spectral sensitivity, in speed, contrast, granularity and resolving power and the choice depends upon the relative importance of these characteristics to the application and to the equipment used.

Films and plates for spectrography in the infrared are usually supplied in at least two sensitizings; one for the near infrared to about 975 nm and the other for the far infrared to about 1150 nm.

In general, emulsions for spectrography are of the high contrast, fine-grain type. There are differences, however; granularity, high contrast, and low fog level must be sacrificed in some applications for a higher speed.

Both films and plates are used although glass plates are preferable for research work requiring the highest precision because of the greater dimensional stability. The humidity coefficient of glass is zero and the temperature coefficient of expansion is about 0.00045% per degree F.

High contrast Metol-hydroquinone developers are generally used and for quantitative analysis, temperature, condition of developer, time of development and agitation must be carefully controlled for uniformity and repeatability. Good repeatable agitation is particularly important for consistent results. Tanks with well-designed nitrogen burst equipment are usually adequate.[92]

Photo-Electronic Instruments

Using photographic techniques, quantitative analysis takes on the order of 20 to 30 min. Direct-reading photo-electronic spectrographs can provide quantitative data in less than 1 min. In addition, film calibration is eliminated, light intensity range is greatly increased, and precision is improved for trace analysis.[93-100]

For direct-reading operation, the camera is replaced with a direct-reading head consisting of exit slits and photomultiplier (PM) tubes or detectors specifically selected for the spectral band of interest. The exit slits are locked in position for the spectral lines of interest, with the sensors oriented to pick up light passing through each slit. During operation, light energy is converted into a proportional amount of electrical energy and stored in a capacitor. An internal channel is used as a control with which each spectral line is compared. Output may be displayed or printed out.

Other methods employ sequential scanning, or by multiplexing, allow the photodetector to simultaneously sense the range of wavelengths under investigation. Encoding masks or an interferometer are commonly used for analysis.

Generally camera heads may be interchanged with direct-reading photo-multiplier tube assemblies, so that the same spectrograph can be converted in a few minutes to either operating method.

X-ray Spectrography

When a beam of x-rays passes through a crystal, the atoms of the crystal act as a three-dimensional grating scattering the x-rays in much the same way as light rays are scattered by a diffraction grating. The diffracted x-rays can be recorded on an x-ray film, or with longer exposure on a fine-grain, high contrast film for higher image resolution, or with an ionization spectrometer. From the diffraction pattern the atomic structure of the crystal, or powdered crystal, may be obtained. X-ray diffraction is an exceedingly useful tool in both science and industry in the study of substances in the crystalline state.[101]

The trend to automation and direct reading systems has produced equipment and materials for automatic analysis and readout. A nonphotographic system using a mini-computer to control x-ray analysis and process the resulting data has been described in Ref. 102.

ULTRAVIOLET AND INFRARED PHOTOGRAPHY

The sensitivity of photographic materials extends from the cosmic rays, through the wavelengths associated with radiation of radioactive materials, the x-rays, the ultraviolet, the visible region and the infrared to about 1350 nm.

Ultraviolet and infrared spectrography were discussed earlier and radiography in Chapter 22. This section will consider ultraviolet and infrared photography and imaging methods by which a photographic record can be made. A state-of-the-art review of infrared practices is given in Ref. 126.

Ultraviolet Photography

Glass absorbs all ultraviolet radiation below 350 nm, so without quartz objectives photography is restricted

to the wavelength band between 350–400 nm. It is necessary to exclude visible light with a filter such as the Wratten 18A of the Eastman Kodak Company or its equivalent.[103] Daylight, or such artificial sources as the mercury arc, fluorescent lamps, electronic flashlamps and flashlamps may be used. The low emission of incandescent tungsten lamps in the ultraviolet makes them generally unsuitable for ultraviolet photography.

The focal length of camera lenses is less for the ultraviolet than for light but the difference is small and in most cases stopping down the lens two or three stops will increase the depth of focus sufficiently to take care of the difference.

Either blue sensitive or panchromatic emulsions may be used, preferably those of rather high contrast, as ultraviolet photographs of most subjects are of low contrast. High contrast developers are often useful.

Fluorescence Photography

Of far greater importance in practice is the photography of objects which are rendered fluorescent by ultraviolet radiation, or the bioluminescence of some bacteria, plants, insects and sea life. If the subject does not contain materials that fluoresce, a fluorescent material can sometimes be added. Fingerprints, for example, can be dusted with a powder that will fluoresce in the ultraviolet. The subject is illuminated with a source rich in untraviolet radiation, such as the mercury arc, with a filter absorbing all radiation, except that producing fluorescence. A second filter absorbing all radiation except the fluorescent band is placed over the lens. Either panchromatic or color films may be used to record the fluorescence.

Fluorescent photography has many applications. It is particularly useful in criminology for the examination of erasures, signatures and other writing removed by chemical bleaching, fingerprints, seals, to differentiate between precious stones and imitations, natural and artificial pearls, traces of oils and greases, laundry marks, dyes and stains. It is also useful in the examination of oil paintings which are suspected of having been restored, body fluids on clothing, and fungous infections on the skin.[104–106] In many of these applications other methods may also be used to confirm the findings of fluorescence photography. These methods may include radiography, chemical analysis or infrared photography.

Infrared Photography

There are two methods of photographically recording infrared radiation: (1) direct photography on infrared sensitive material and (2) indirect photography, using a system which converts infrared radiation into light which is recorded on ordinary film.

Direct infrared photography is simple and has many important applications. The spectral sensitivity of the infrared films available for general photography extends from the blue-violet through the visible, usually with a depression in the green, through the red and infrared to about 900 nm. For many purposes a filter absorbing the violet and blue is sufficient for a useful result; the usual filter, however, is the tricolor red, such as the Wratten #25 which limits the sensitivity to the red and infrared. With filters transmitting only the infrared the exposure must be increased from two to four times.[107]

Aside from daylight, incandescent tungsten lamps, electronic flashlamps and flashlamps are good sources of illumination.[108]

There are no exposure indexes for infrared films because photoelectric exposure meters respond only to light and the proportion of infrared radiation to light varies. The variation is greater with daylight than with artificial sources so exposure tests with tungsten lamps, or flash sources, are more dependable than test exposures in daylight. Recommendations with respect to exposure, filters and processing are supplied by the manufacturer. From this point, a dependable technique must be established by practical tests.

As the visual focus and the infrared focus for camera lenses are different, a correction has to be made after focusing. Many lenses have an infrared index, reset to the index marking after focusing. With lenses that do not have an infrared index mark either (1) the back of the camera may be extended about 0.25% of the lens-to-film distance, or (2) if the length of exposure is unimportant, a small aperture can be used for the exposure.

Applications of Infrared Photography. Infrared photography is widely used in deciphering worn, faded, dirty, or charred documents and in uncovering passages in medieval manuscripts which were crossed out later by others who disagreed with the statements made. There are many examples of this in documents on the religious controversies of the middle ages.

It has proved useful in distinguishing dyed cloths which look alike but have been dyed with different dyes; in the study of plant diseases where there is a change in pigment or cellular structure, and in examining older paintings to determine if changes have been made later in the original.

Infrared photography reveals blood vessels beneath the skin clearly and is useful in studying blood circulation problems and some skin problems.[109] Clark[110] includes many examples of the use of infrared photography in science and industry.

Multispectral Photography

The recording of two or more images of a single subject at different wavelength regions is called multispectral photography. The method may include one or more regions of visible light and also invisible radiation. Recording can take place through a single optical channel on multilayer film, or through two or more optical

Fig. 23-23. Itek Multispectral Photographic Camera (MPC).

channels on black and white films suitably filtered. Sometimes an additional channel for color is used in conjunction with the black and white.

One of the earliest examples of multispectral photography, other than three color photography itself, was a special color film for the detection of camouflage by aerial photography in World War II. This product, which has since found a number of peacetime applications, is described in Chapter 21. See also Refs. 111, 112.

The Itek Multispectral Photographic Camera (MPC), originally developed for earth resource surveys as part of NASA's Skylab program, is shown in Fig. 23-23. It is a high resolution, multiple-format, mapping camera that simultaneously takes six precisely matched photographs during each exposure. Each photograph records information in a specific portion of the visible-light and infrared-radiation spectra.

Multiband spectral photography using black and white film has several advantages over the use of color film. Black and white films tend to have better spatial resolution than color films and greater latitude in exposure. Furthermore, spectral bands can be chosen to enhance the appearance of certain features for increased discrimination. Considerable data have been compiled on the spectral signatures of different minerals, vegatation (whether healthy or diseased) and bodies of water (whether fresh, salt or contaminated) (Fig. 23-24).

Several reconstruction methods are possible. Qualitative information can be obtained by visual methods. A more discriminating method consists of assigning a different color to one or more of the photographic records and superimposing these to obtain a typical false-color effect with the added advantage that the photoanalyst can, with a multichannel viewer, select the colors which will produce the greatest discrimination of the desired features. Color variation can be used to accentuate the density variations within one spectral band. This technique produces a multicolor display having the appearance of a contour map. Other methods involve the combining of negative and positive images and the use of a scanning densitometer to provide analog density profiles which can be fed to a computer programmed to evaluate density differences.

Applications and methods employed on several multispectral programs are described by Hodder,[113] Shavlach,[114] Soule,[115] Weaver,[116] Shaffer,[116a] and Colwell.[116b]

Photographic Pyrometry

Photographic pyrometry is an extension of brightness pyrometry as practiced with an optical, radiation, or luminance pyrometer. Lord[117] fixes the introduction of the disappearing-filament-type brightness pyrometer at about 1912, following Planck's development of the quantum theory in 1900–1901. Overington[118] traces the use of the photographic process for the detection and estimation of temperature to the work of Hencky and Neubert in the 1930s.

Visual pyrometers have an optical system to collect radiant energy from the source to be measured, filter it to a narrow band of wavelengths ("effective wavelength" λe), usually in the visible spectrum; compare it against a reference in the instrument, generally a tungsten lamp; and read out from a scale the indicated temperature when the brightness of the unknown sample matches the brightness of the calibrated filament.

Male[119] describes a photographic pyrometer developed in 1950 at Lewis Flight Propulsion Laboratory, Cleveland, to determine the apparent surface temperatures in a ramjet combustion chamber. A K-24 camera

500-600 nm 600-700 nm

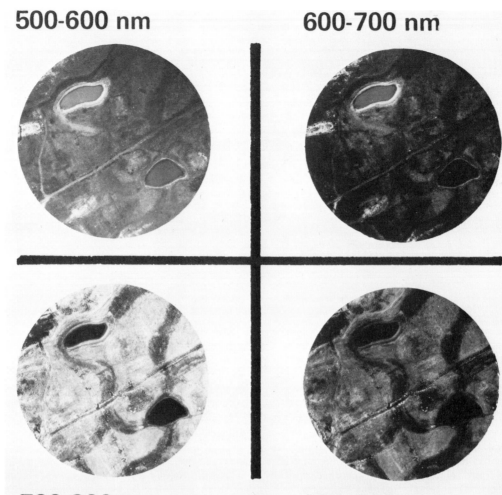

700-800 nm 800-900 nm

Fig. 23-24. Multispectral photographs of a field with two ponds. The appearance of the ponds is particularly differentiated at 600 to 700 nm, indicating varying amounts of mineral or biological suspensions. Also the broad curving stripes in the field are emphasized at 800 to 900 nm, indicating high moisture content (water is a very effective absorber of infrared energy thus appearing darker in this spectral region).

photographed the hot surfaces and comparison filaments. The filaments, whose temperatures were determined through the use of an optical pyrometer, were imaged on the same frame of Kodak Super XX film as the hot surfaces, after passing through a Wratten #29 (red) filter, lens, and shutter. The processed film had varying densities that were proportional to the temperatures for both known and unknown temperatures. Densitometric measurements then enabled a correlation of the two to be made so that apparent surface temperatures of the unknown could be determined.

The upper limit was determined by the sensitivity of the film at about 0.65 μm. Thus, the common area represented the narrow band used for recording, which approximated the same wavelength region seen by the human eye when using an optical pyrometer.

Valentine and French[120] describe a similar system in which improvements over several years resulted in an accuracy of ±2% at 2000° F using infrared film. For this project Hoadley developed a photographic extinction method of obtaining a thermal contour map of the test object that did not involve time consuming densitometric measurements.

In a somewhat similar system at Rocketdyne, temperature measurements were made of luminous exhaust flames. Simmons and DeBell[121] describe a photographic pyrometer in which the calibration lights were integral with the camera (Fig. 23-25)

A photo-pyrometric system developed by Pollack and Hickel at the Lewis Research Center of NASA[122] is shown in Fig. 23-26. Local temperatures on the test body are determined as follows:

1. The relation between relative radiant energy and surface temperature is computed using Planck's fundamental black body law. A typical plot of relative radiant energy versus surface temperature is shown in Fig. 23-27a.

2. The relation between photographic image density and relative film exposure energy is obtained by photographing a conventional calibrated stepped exposure scale illuminated with a constant amount of energy.

Fig. 23-25. Rocketdyne photographic pyrometer.

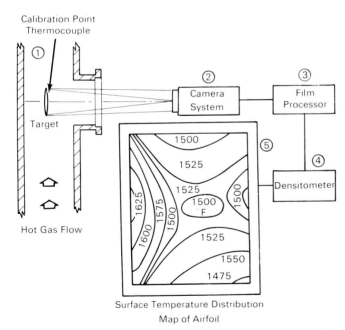

Fig. 23-26. NASA surface-temperature mapping system using infrared photographic pyrometry. Major components include: (1) the heated surface or "target" to which at least one reference thermocouple is attached in the area to be photographed; (2) an optical viewpath and camera for recording the thermal radiation on infrared-sensitive film; (3) a closely-controlled film developing system; (4) a densitometer for measuring and recording the densities of the photograph image and plotting contours of equal density; and (5) a method for converting the image densities to corresponding temperatures.

A calibration is obtained from the step densities of the resulting image. (Note: For accuracy, each film strip used is individually calibrated.) A typical plot of relative film exposure energy versus film density is shown in Fig. 23-27b.

3. The two plots are aligned using a temperature measured by a reference thermocouple on the target surface. The temperature measured by the thermocouple is located on the upper plot; the film density at the thermocouple location on the lower plot. Both plots are drawn with the same abscissa scale. The plots are aligned by matching vertical lines drawn from these two points, as shown by the dashed lines in Fig. 23-27b. With the two plots aligned, density values can be related directly to the corresponding temperatures.

Kemp[123] describes similar methods of photographic pyrometry.

Two photopyrometric developments at the Air Force System Command's Arnold Engineering Development Center, Arnold AFS, Tennessee, have been described in Refs. 124 and 125. The system is used to observe and measure surface temperatures on reentry models flying at speeds up to 12,000 mph through a 1000-ft aeroballistic range. Four high-speed calibrated reference temperature exposures of a filtered carbon-arc source are first made. Then, when the test model is launched its glow is photographed by the image converter camera. Exposed films from the calibrated exposures and free-flight model are processed together to ensure identical development.

Display or print-out techniques involve a scanning

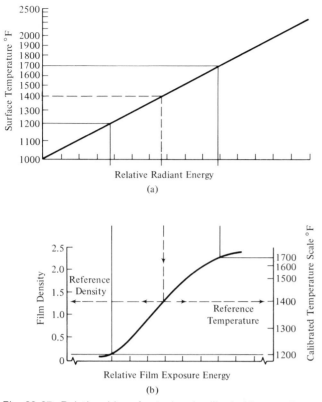

Fig. 23-27. Relationships of actual and calibrated temperatures.
(a) Relative radiant energy vs surface temperature.
(b) Relative film exposure energy vs film density.

microdensitometer and computer printout; or video display via color TV and subsequent rephotographing in color.

Other Photopyrometric Methods. Other heat sensing and recording methods have been described in Ref. 126. Included are photon detectors; color photography of paint compounds which change color when exposed to heat; and direct and indirect methods of photographing heated objects with heat-sensitive phosphors.

A method of determining local temperatures of turbojet components by recording temper colors was developed by Hoadley.

For higher temperature recording, approximately 2000 to 6000° F, a method has been developed in which photographic recording is accomplished on Extended Range (XR) Film, available from Edgerton, Germeshausen and Grier, Inc.

Thermography

The term *thermography* was coined about 1840 by Sir John Herschel, son of Sir William Herschel, who conducted early infrared experiments around 1800. Although the term has been used to describe various heat-imaging methods, contemporary meaning is most frequently associated with infrared-to-visible-light converters. Since the practical limit of direct infrared photographic

pyrometry is about 250° C, thermographs must be used for lower temperatures. Commercial thermographs are capable of recording radiation from sources below zero centigrade. Since animal and human body temperatures are well below the useful band for infrared film temperature recording, the thermograph has become a useful medical instrument. The principal spectral region of interest for self-emission objects near ambient temperature lies from 4 to 20 μm.

Airborne infrared line-scan systems are another application using radiant imagery outside the photographic spectrum. Other advantages of scanning thermography are that the electrical signal is easily transmitted, and can be magnetically recorded, computer-processed, photographically recorded or analyzed.

The infrared spectrum of solar irradiation of the earth's surface has been discussed by Friedman.[127] Most imaging systems have been designed for operation through atmospheric "windows" between 3.0–4.1 μm, 4.5–5.5 μm and 8–14 μm. For ambient temperatures a detector should have maximum sensitivity in the 8–13 μm band. For monitoring volcanic activity where temperatures exceed 1000° K, a detector which peaks in the 4.5 to 5.5 μm band is most useful. At the lowest wavelength most of the radiation is reflected solar energy.

Goldberg[128] lists radiation channels used in meteorological satellite infrared systems and discusses detection equipment.

Thermal Imaging Devices. The principal thermosensitive imaging systems are evaporographs, absorption edge image converters, and thermographs.

The evaporation principle was the result of Herschel's experiments in 1840 in which strips of paper coated with a mixture of lamp black and alcohol were exposed to infrared radiation from the sun. In the 1920s M. Czerney of Germany produced an instrument employing the evaporation principle to record infrared spectra.

In the *evaporograph*, the heat image is focused by an infrared transmitting lens, or mirror optics, onto a nitrocellulose membrane. Oil vapor, from an electrically heated oil-soaked material condenses on the surface of the membrane in a pattern revealing the heat image; the oil film is thinnest where the membrane has the highest temperature.

Illuminated by a white light, the surface reflects a variegated color image due to interference caused by the thickness variation. This pattern is then photographed.

In the absorption edge image converter, the heat image is focused by an infrared lens or mirror optics onto a selenium coated window in an evacuated chamber. The selenium has the property of transmitting light in inverse proportion to its temperature. Light from a source shining through the selenium, produces a heat picture of the object which can be observed or photographed.

Scanning thermographs have been produced by Barnes Engineering Company, AGA, Infrared Industries, Conotron, Philco, Bendix and others.

A typical scanning thermograph is shown in Fig. 23-28. Infrared radiation passes through the infrared transmitting lens and falls on a motor-driven scanning mirror.

Fig. 23-28. Sectional view of Barnes Infrared T-6D Thermograph.

As the subject is scanned, varying intensity infrared radiation is focused on a pyroelectric detector. Associated electronics modulates a light source which is directed by a beam splitter to an imaging mirror mounted on the scanner. The focused beam then scans the photographic recording material.[129,130]

PHOTOMICROGRAPHY, PHOTOMACROGRAPHY AND PHOTOMETALLOGRAPHY

Photomicrography is the process of photographing objets seen through the microscope. It should not be confused with microphotography which is the process of producing photographic images of microscopic size. Photomacrography differs from photomicrography in the degree of magnification, which is lower (usually less than 25X), and in the use of short focus (*macro*) camera lenses. Photometallography is a specialized area of photomicrography limited to metallic specimens.

Wedgwood and Davy claimed to have made photomicrographs before 1802 on paper coated with silver nitrate, but could not fix the image. Fox-Talbot experimented with silver chloride paper in 1835–36 and fixed his images in solution of sodium chloride. J. B. Reade made photomicrographs as early as 1835 and exhibited examples of his work, fixed in hypo, in the summer of 1839.

Alfred Donne exhibited photomicrographs of the eye of a fly on Daguerreotype plates at the Academy of Sciences in Paris in October 1839, only two months after the details of the process were published. Other pioneers in this field were Berres in Vienna (1840), and Dancer in London (1840). All of these used the "solar microscope" (i.e., daylight illumination) and the Daguerreotype process. Donne published an *Atlas of Microscopic Anatomy* in 1844. The illustrations were wood cuts from Daguerreotype plates.

The microscope has many important applications in the biological sciences, in medicine, in chemistry, in geology and in the metal industries. Photomicrography provides a record for study and for comparison. Photomicrographs may be in black and white or in color using modern color films.

Photomicrographic Equipment

The optical system of the compound microscope is shown schematically in Fig. 23-29. The condensing lenses (C) concentrate the light on the specimen (S) which is imaged by the objective lens (O). This image is magnified further by a second magnifying lens known as an eyepiece (E) of ocular. The amount of magnification is the "power" of the objective multiplied by that of the eyepiece. A real image is created when the image projected by the optical system of the microscope is formed on a ground glass screen or on a film or plate.

Photomicrographic equipment ranges from simple cameras that are attached to the microscope when a picture of the specimen is desired to sophisticated re-

Fig. 23-29. Compound microscope optical system schematic.

Fig. 23-30. Kohler Illumination.

search equipment containing the light source, provision for different methods of illumination, the microscope and camera all mounted on a solid optical bench. The light source is usually a concentrated filament tungsten lamp, but zirconium and xenon arc lamps and electronic flash lamps are used for moving objects where short exposures are necessary to stop motion. Graham and Bridges[131] have described a xenon strobe lamp having a 0.2 msec duration. It can be used for single exposures or for observation at 50 Hz.

Methods of Lighting. Some specimens are transparent enough to require no preparation other than mounting on glass slides but thick specimens must be cut into thin sections with a microtome. Some require staining with dyes to increase contrast and to differentiate structural details of the specimen. Opaque specimens, such as metals, must first be ground to a flat surface on one side and then etched with chemical solvents to produce either a slight relief or a color difference which will emphasize the structure of the metal or alloy.

Photometallographs are of importance to the metallurgist because the physical properties depend upon the structure as well as the chemical composition. Steel, for example, is an alloy of iron and carbon and the properties depend not only on the percentage of carbon but on the way in which it is distributed. With special steels containing chromium, molybdenium, etc., it is important to the metallurgist and steel maker to know how these are distributed in the alloy.

For transparent specimens, the most common illumination method utilizes the *Kohler* principle. In such a system, the image of the lamp condenser is focused on the plane of the specimen (Fig. 23-30). Today, many microscopes have this illumination method, or a variation of it, built into the base. For separate illuminators, several steps of adjustment and alignment are required. These procedures are described in the referenced literature.

Image brightness may be varied to suit the type of film and exposures through the use of neutral density filters or variable transformers. However, if color film is being exposed, lamps must be operated at rated voltage during exposure.

Brightfield illumination methods yield an image of dark areas against a light background. Biological stains are frequently used to enhance the contrast. Such measures may not be sufficient to increase subject contrast to a point where it is acceptable. In those cases, some other technique is required, such as *darkfield* illumination, produced by diaphragms or darkfield substage condensers. These allow light scattered by specimen details to enter the objective. The result is a high contrast image of light specimen structure against a dark background.

Smith[132] describes a number of techniques utilizing color contrast.

Phase contrast is the method of increasing contrast by the use of a phase-shifting element in the rear focal plane of the objective. According to Ref. 133, the method was first successfully demonstrated by F. Zernike in 1935. Phase differences in the specimen, which cannot be seen by the eye, are converted by the phase-shifting element in the microscope to amplitude differences.

Polarization is another way of increasing contrast or introducing color differences for certain specimens. While this method is particularly useful for crystals that exhibit birefringence, it is an advantage for many other subjects as described by Abramowitz.[134]

References 135, 136 and 137 further discuss photomicrography.

The examination or recording of opaque specimens requires vertical reflected illumination because light cannot be transmitted. The *metallographic* microscope is equipped with a vertical illuminator which reflects light from an external source along the optical axis of the microscope to the surface of the specimen. A prism or plane-glass is used depending on magnification, location and other factors. Figure 23-31 shows three examples of illumination in metallograph microscopes. Metellography is more fully discussed in Ref. 138.

Interference microscopes utilize the principle of interference fringes to measure thickness of thin film layers, coatings, platings and deposits. To improve analysis of the fringe pattern the Lau-Sabattier process produces a photograph having fine lines representing contours of equal intensity on the original fringe pattern.

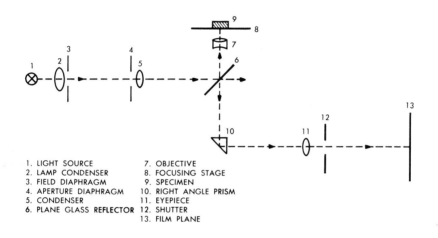

1. LIGHT SOURCE
2. LAMP CONDENSER
3. FIELD DIAPHRAGM
4. APERTURE DIAPHRAGM
5. CONDENSER
6. PLANE GLASS REFLECTOR

7. OBJECTIVE
8. FOCUSING STAGE
9. SPECIMEN
10. RIGHT ANGLE PRISM
11. EYEPIECE
12. SHUTTER
13. FILM PLANE

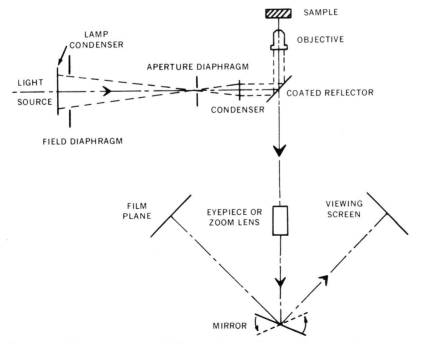

Fig. 23-31. Examples of on-axis illumination used in metallograph microscopes.

Micro-replication. Surfaces of subjects that are impractical to place under a microscope because of size, shape, weight or location can be converted to thin, transparent reproductions by a method known as micro-replication. Smith[139] describes the material and method for accomplishing the replication and subsequent photomicrography of the surface reproduction.

Sensitized Materials for Photomicrography. For photomicrography in black and white fine-grain emulsions of relatively high resolution are generally suitable and may be either sheet or roll film, as required by the camera. Filters will be used as required for contrast and color differentiation. The usual position for the filter is between the light source and the microscope. Emulsions of high contrast may be necessary for subjects of low contrast which cannot be stained, and in metallography. Typical of such plates are the "M" plates and the metallographic plates of the Eastman Kodak Company. Spectroscopic plates may be used for ultraviolet or infrared.

For immediate access Polaroid Land film can be used; the P/N pack being particularly useful as additional prints can be made later from the negative.

For photomicrography in color, the sheet or roll films used in professional photography are suitable, with proper regard to the spectral characteristics of the light source and the reciprocity characteristics of the film. Color compensation filters will usually be required to correct for the light source or reciprocity differences.[139a]

Cinephotomicrography. Cinephotomicrography combines photomicrography and the motion picture. The chief advantages of cinematography are (1) the ability to show movement, such as cell division and growth, and (2) the reproduction of such motion at normal, compressed or extended time rates. Reference 140 and its bibliography review past methods, and current practices are described in Refs. 141 and 141a. Robb and Jabs[142,143]

discuss high resolution and electronic flash in cinephotomicrography.

Electron Micrography

The resolving power of the optical microscope limits the useful magnification to about 2000×, or a little more in the ultraviolet. The electron microscope using an electron beam rather than light is capable of magnifications of 1,000,000×. At the same time, resolving power is about 1000 times greater, with resolutions of 2 to 3Å being repeatedly obtained in crystalline specimens.[144]

The optical light microscope (OLM) and transmission electron microscope (TEM) are compared schematically in Fig. 23-32. The TEM has been commercially available since the 1940s. Black[145] compares the TEM with the scanning electron microscope (SEM), available commercially since 1965, but suggested 30 years earlier by Knoll.[146] References 147 and 148 further describe its development.

The TEM image is created from, and limited to, specimens that are very thin. When scattered electrons from the thin specimen are brought to a focus, an image is created on a screen or film. The SEM image is produced by any signal generated by the interaction of a finely focused beam of electrons scanned over the specimen. Hayes[149] points out that the limitations of OLM and TEM systems lie in the fact that resolution and information content are linked together. The SEM uncouples the functions by localizing a point in time rather than in space. This allows a separation between the localizing radiation and signal radiation. He then describes the techniques made possible by isolating the two functions, resulting in great depth of focus and other advantages. However, the emission microscope is better suited for observations of rapid processes.

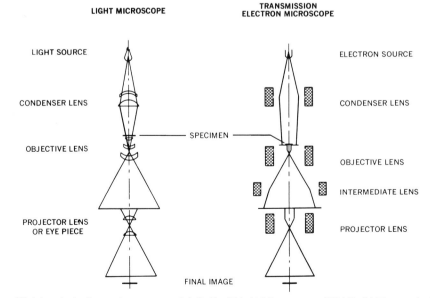

Fig. 23-32. Comparison of light and electron microscopes. (a) Optical Light Microscope (OLM). (b) Transmission Electron Microscope (TEM).

The SEM has the ability to accept bulk specimens with little or no preparation, and surface-replication procedures are unnecessary. It has extraordinary depth of field, which varies inversely with magnification, and which is on the order of 300–500× that of the OLM. In addition, stereo pairs can be prepared which aid in the determination of surface-variation heights. Magnification range is extraordinary, typically 10× to 100,000×.

Sensitized Materials. Both glass plates and films are used for recording TEM images. Typically, fine-grain emulsions of high detective quantum efficiency (DQE) are coated on stable supports. The support not only must be flat, but no volatile material or humidity should be present. When film is preferred to glass plates, polyester-based materials manufactured without solvents eliminate one possible source of contamination in the column of the electron microscope. Thick base (0.007-in.) films are generally supplied. Since materials are typically blue-sensitive, they can be handled under safelights with light red or even amber or greenish-yellow filters. In any case, the safelight recommended by the manufacturer should be followed.

Dyed-gel backings on materials used for electron recording serve only to distinguish the two sides of the material under safelight operations.

Exposures for TEM specimens generally should be as long as possible to increase signal-to-noise ratio. Finer grain and higher resolution are thus obtained. In this case the visible grain is a function of electron fluctuations not an emulsion characteristic. Suitable development for the longer exposures must then follow to produce proper densities and contrasts. Recommendations are given by manufacturers for these adjustments.

Koster[150] advises the use of Kodak D-11 and D-19 developers and describes print making and lantern slide making of electron photomicrographs. SEM materials are essentially CRT recording materials. In addition to Polaroid Land materials, roll films and sheet films are supplied to fit most SEM cameras without special adapters. Exposure methods for obtaining consistent results are given by Nugent[151].

Holographic Micrography

The concept of holography was developed by Gabor in 1947 while he was attempting to improve the resolution limit of the electron microscope. Although the immediate goal has not been attained and holographic microscopes are not a commercial reality, there have been many advances in holographic microscopy in and near the visible regions of the electromagnetic spectrum. Three types of holographic microscopes have been described by Cox[152]. Although speckle or intermodulation noise is considered to be the most serious problem, materials limitations are also considered to be an area requiring further research. Twenty-six references on this subject are cited. Knox and Brooks[153] describe holographic motion picture microscopy.

Photomacrography

For magnifications up to 15-20×, micro lenses, specially corrected for this purpose, are used on cameras with a long bellows extension. The formulas connecting magnification with the lens to object distance, and the lens to image distance, and the focal length of the lens are:

lens-image distance $(Mf + f)$
lens-object distance $(f + f/m)$

Where f is the focal length of the lens and m the magnification. Thus, for a lens with a focal length of 2 in. (50.8 mm) and a magnification of 10× the lens to image distance is 22 in. (55.88 cm) and the lens object distance is 2.2 in. (55.88 mm.). In other words, a 50-mm micro lens on a 35-mm single lens reflex camera would require a bellows attachment of 22 in. to obtain a magnification of 10×. Special lenses designed for photomacrography with shorter focal lengths are available for use on new cameras, or similar cameras with a long bellows extension. Such cameras are much more convenient in use as the image can be focused from the back rather than by moving the lens which changes both the lens-object distance and the lens-image distance.

Small apertures are generally required for sufficient depth of field and exposures are long. Tungsten lamps are suitable for still life but flash lamps are generally required for live insects. Lighting is often a problem because of the close proximity of the lens. Hine[154] and Refs. 155 and 156 give solutions to general problems in photomacrography. Osterloh and Kirschner[157] discuss special problems in dental practice, Wong[158] describes slit-lamp photomacrography in opthalmology, and Malpica[159] describes the photography of the eye.

Since exposures are difficult to calculate, and ordinarily involve trial and error, Polaroid-Land P/N (positive-negative) film pack, affording rapid access, is a convenient photosensitive material if a sheet-film camera is used.

PHOTOGRAPHY IN ASTRONOMY

The Instruments of Astronomy

Before Galileo (1610) the astronomer had only his eyes and simple sighting instruments designed primarily to measure angles and determine the position of a star.[160] With the telescope Galileo demonstrated the existence of valleys and mountains on the moon and from the shadows calculated the heights of some of the taller mountains. By observing sunspots he arrived at a figure of 27 days for the rotation of the sun. Turning his telescope on Jupiter he discovered four satellites that moved around it as the moon around the earth. He saw that there were many more stars than had ever been seen.

Galileo's telescope was a refractor. The refracting type was improved early in the eighteenth century by Dolland who made it achromatic. A reflecting telescope was proposed in 1636 as a means of overcoming chromatic aberration and a reflector with a diameter of 48 in. was

built for William Herschel in the latter part of the eighteenth century and one of 72 in. by the Earl of Rosse in 1840. But the curvature of the mirror varied with the temperature and there were multiple reflections. As a result, the refractor, particularly after its improvement early in the nineteenth century by Fraunhofer, largely replaced the reflector. In 1847 Harvard Observatory obtained a 15-in. refractor which had been made in Munich, and the University of Virginia obtained one with a 26-in. aperture in 1870. The Yerkes Observatory of the University of Chicago installed a 40-in. refractor which is still the largest, and the Lick Observatory in 1881, a 36-in. These were the work of American Opticians Alvan Clark, John A. Brashear and William Mogey. The final triumph of the reflector was due to improvements in the design and to the demand of astronomers for larger instruments to reduce the time of exposure. The first Mt. Wilson reflector with an aperture of 60 in. was installed in 1908; the second, the 100-in., in 1917 and the 200 in. at Mt. Palomar in 1948.[161-164]

In 1932 Bernhard Schmidt developed the Schmidt camera,[165] a wide angle, large aperture reflector with a thin lens to correct spherical aberration. This has proved extremely valuable particularly in star mapping and the study of large areas of the sky.

After the telescope the second most important instrument of the modern astronomer is the spectroscope or rather the spectrograph, as the photographic recording of spectra is now far more important than visual examination. Within a few years after Kirchoff, Huggins was studying the spectra of the stars and finding the same elements there as on earth, but in different proportions; and in 1868 Lockyer discovered a new element, helium, in the spectrum of the sun. Later it was discovered on earth and used to inflate lighter-than-air airships.

The Application of Photography to Astronomy

In 1840, only a few months after the discovery of the Daguerreotype, Draper of New York made a Daguerreotype of the moon. In 1850 Bond, at Harvard College Observatory, made photographs of some of the bright double stars and, in 1857, Kew Observatory near London began a program of photographing sunspots daily, which was maintained for more than 30 years. Eclipses of the sun were photographed and the transit of Venus in 1874. About the same time Rutherford, in America, using a long focus portrait lens photographed the Pleiades and with a micrometer measured the distances of the stars of the group on the plate. Calculations from the measurements were in close agreement with the best that had been made by visual means. Photographs were made in 1879 showing planetary markings on Mars and Jupiter. In 1886 Sir David Gill at the Cape of Good Hope Observatory, impressed by the number of stars appearing in plates of the comet of 1882, proposed a photographic map of the heavens using the new gelatin dry plate. With the cooperation of other observatories the project required nearly half a century but the finished map contained about one hundred

million stars, six million of which had been cataloged. Gill, himself, had contributed 500,000, far more than the 300,000 that had been cataloged before the adoption of photography.

After that the use of photography increased greatly; so much so that the study and measurement of plates in the laboratory largely replaced direct observation at the telescope. Survey cameras were developed and used to make a record of the sky every clear night. Such plates are useful in tracing the appearance of new stars, i.e., stars which suddenly burn much brighter than before, as well as comets, asteroids and meteors. The magnitudes (size) of stars were determined from the diameter of their images on photographic plates and the distances of the nearer stars determined by parallax methods using plates exposed at intervals of six months, using the orbit of the earth as a base line. The movement of stars was measured by comparing their position with more distant stars on plates made months or years apart. Double stars which eclipse one another in their rotation were found to be common rather than rare. The patches of blurred light seen in the telescope (nebula) were revealed by the photographic plate to contain millions of separate suns and the number of nebula increased to millions as larger telescopes, faster plates and long exposures with better driving clocks enabled astronomers to reach out to greater and greater distances.

Methods were developed for the mass recording of stellar spectra enabling as many as a hundred to be recorded on one plate at a single exposure. From these spectra the temperatures existing in the stars were determined and, from the temperature, the life history of the stars from red-hot, firey youth to a diminishing old age. The shift of the lines in the spectra of the distant stars made it possible to determine the distance of stars too far away to be measured by the old-established parallax method. Measurement of the shift in the spectral lines of the distant stars also enabled the speed to be determined. The velocity away from our solar system increases with the distance, leading some to suggest a common beginning in a huge explosion—a proposal that has been referred to as the "big bang" theory. Dark masses in the sky, which had been thought to be spaces empty of stars, were revealed by photography to be masses of light absorbing material (cosmic dust). The photographic plate alone, and with the spectroscope, in half a century added more new knowledge to astronomy than in all its history—a history which is as old as civilization itself. The development of radio astronomy is now extending astrophysics to still greater distances but, in its own sphere, the photographic plate is still unrivaled as a means of accumulating astronomical information.

Loudon[165a] lists several advantages gained through the use of photography in astronomy as compared with visual observation:

1. The cumulative effect of starlight on the photographic plate can record objects too faint for the eye to perceive.
2. For a given date, a permanent record is made of an

entire field of stars simultaneously in which relative bightness and location may be measured.

3. Spectral response of photographic materials can be chosen and can exceed the spectral response of the eye.
4. Reference, measurement, rechecking and comparison from photographic plates are possible.

The history of astronomical photography has been discussed by De Vancouleurs,[164] equipment and methods by Selwyn,[165] Rackham,[166] Miczaika and Sinton,[163] and Heltner.[167] Sensitized materials have been discussed by Capen[168,169] and by Hoag and Miller.[170]

The use of television systems for astronomical observation has been shown to have significant advantages. These and other electronic, instrumentation and automated systems for various astronomical applications are discussed in Refs. 171–176.

Astronomical Photography in Space

Prior to the space program all astronomical photography had been from the earth. Today photographs for astronomical purposes are made from both manned and unmanned space vehicles. Detailed photographs of the lunar surface were made during the Ranger, Surveyor and Lunar Orbiter missions in preparation for the Apollo missions which placed man on the moon. Skylab (1973) contained a special telescope for solar observations.

Late in 1979, in response to the long standing needs of the astronomical community, NASA plans to orbit a large space telescope (LST) of 120-in. aperture and 0.05 arc resolution approximately 350 nautical miles above the earth's surface. The LST will be able to detect stars of the 28th magnitude, 10 times farther away than the 200-in. Hale telescope on Mount Palomar. The LST will be operational for more than 5 years with occasional support from the space shuttle for experimental flexibility and maintenance. During that time, astronomers will be able to probe a volume of space 1000 times greater than is presently available to them. The LST will operate in the wavelength region from 90 to 2500 nm (the visual spectrum extends from 400–700 nm only).[177]

PHOTOGRAPHY IN SPACE

Satellite Photography

On October 4, 1957, Russia launched Sputnik I, and orbiting satellites became a reality. Two years later Lunik III photographed the back side of the moon.[178]

According to Fusca,[179] the concept of satellite reconnaissance in the United States had its origin during the early 1950s in a project called Pied Piper. By February 1962, the testbed program had launched Discoverer 38, when launching announcements were discontinued. Two satellite systems, SAMOS (Satellite and Missile Observation System), and MIDAS (Missile Detection and Alarm System) were surveillance programs of the early 1960s.

Meteorological observations from satellites began with the launching of TIROS I in 1960. Its successful operation was followed by a second-generation meteorological satellite, NIMBUS, which has been described by Stampfl and Stroud.[180]

Earth observation has progressed to include terrestrial and oceanographic data obtained through the use of multispectral sensors on the Agricultural Remote Sensing (LARS), Earth Resources Technology Satellite (ERTS), and Earth Observatory Satellite (EOS) programs. These systems employ electronic scanning and transmission to Earth where data are processed and analyzed.[181]

A cooperative agreement between AT&T and NASA resulted in launching TELSTAR I on July 10, 1962. Communications and transatlantic television in both monochrome and color were demonstrated.[182]

Typical of current activity in communication satellites is the privately owned Intelsat complex. Orbiting satellites relay video and telecommunications throughout most of the world. In the United States ground stations are located at Andover, Maine; Brewster, Washington; Paunalu, Hawaii; Etam, West Virginia; Talkeetna, Alaska; and Jamesburg, California. These are owned and operated by Communications Satellite Corporation (Comsat).

Satellites in orbit are powered by solar cells. Hydrogen peroxide jets automatically reposition the satellite, so that it will remain in longitudinal tolerance within its design life. Twelve television and 5000 telephone circuits are simultaneously available aboard older satellites. Newer models have a greater capacity. Antennae remain pointed at the earth under control of infrared sensors. Communications are beamed by the disc-shaped antennae to a ground-based dish-shaped antenna.

Plans call for expansion to approximately 80 stations serving 60 countries. Medical data, such as electrocardiograms, can be transmitted, a world "library" system is a possibility, and live television is becoming common on a real-time, world-wide basis.

Details of communication and television via satellite are described in Refs. 183–189.

Lunar and Planetary Vehicles

Ranger,[190] Surveyor,[191–195] and Lunar Orbiter,[196–200] were targeted space vehicles to gather information about the moon for a future landing. Results of these programs, together with information from earth observatories, formed the basis of Lunar chartmaking for the Apollo landings.[201]

An outgrowth of the Surveyor television ground data handling system was the system begun in 1971–72 for the Mariner 9 Mars program.[202–207a] The television subsystem consists of wide and narrow angle television cameras. The camera optics and some parts of the supporting electronics are identical to the equipment used on Mariners 6 and 7. The wide-angle camera has a rectangular field of view of 11 × 14° and a focal length of

50 mm. The narrow-angle camera has a rectangular field of view of $1.1 \times 1.4°$ and a focal length of about 500 mm. The resolution of objects in the field of view of each camera is dependent on the line-of-sight range to the object. With the cameras looking vertically downward at the surface and the spacecraft at an altitude of 1250 km, the wide- and narrow-angle cameras can detect objects under about 1 km and 0.1 km, respectively. The television camera parameters are 700 scan lines per frame, 832 picture elements per line, 9 bits per element, and 42 seconds per frame scanning time.

Scan data from the cameras are telemetered to Earth where they are received by the 210-ft diameter Goldstone dish antenna. The amplified data are transmitted to the Jet Propulsion Laboratory (JPL), California Institute of Technology, Pasadena, California. After processing by the Mission and Test Computer (MTC) system, digital video data are recorded on 70-mm photographic film by the Mission and Test Video System (MTVS).

Other tracking stations are located at Woomera, Australia; Madrid, Spain; Johannesburg, South Africa; and other places. These stations can receive data but must record on magnetic tapes and transport them to JPL rather than supply transmitted real-time data.

Frames measuring 55×101 mm are recorded on 70mm Eastman Kodak S.O. 272 perforated polyester-base film. The frame contains the video picture, alphanumeric picture identification data, 9-shade logarithmic gray scale, and histograms of raw video data and dis-

Fig. 23-33. Typical frame of spacecraft video and data display.

played video data. A typical enlarged frame from the spacecraft TV system test is shown in Fig. 23-33. The area showing the video information is comprised of 580,000 picture elements (pixels). Each rectangular pixel is recorded at one shade of a 64 gray-shade capability. This is graphically shown beneath the video pattern by the left histogram titled "Data Input" and the right histogram "Film Output." The lower left histogram shows the percentage of pixels of each of the 512 possible data number (DN) values in the set of 5.8×10^5 picture elements comprising one frame of raw recorded video data. Each 9-bit pixel value is truncated before being output to the 6-bit intensity register of the MTVS

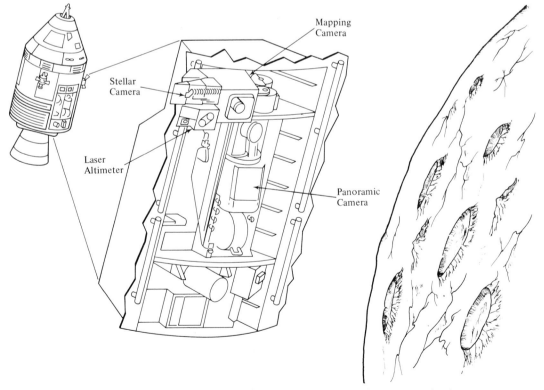

Fig. 23-34. Apollo command module showing cameras in instrumentation bay.

film recorder, so the range of values of the film output histogram is 0–63 DN rather than 0–511 DN as the input data histogram. The ordinate values in the film output histogram are formed from the averaged sum of the 9-bit pixel DN values taken in successive groups of eight. When the input data are transformed by the MTC system according to any of several options to modify picture contrast or size, the output histogram also reflects these operations. Gray scales which display the density corresponding to each DN level represented in the two histograms are located directly below the appropriate histograms. In addition, gray scales representing logarithmic changes in DN are shown on the right side of the picture. The logarithmic scale represents input levels of 63, 38, 22, 13, 8, 5, 3, 1, and 0 DN to the film recording system. Picture size may be modified by specifying an arbitrary set of two lines and two pixels which bound the area of the desired "enlarged" picture. This enables close examination of shading and detail, and helps isolate TV subsystem and MTVS problems.

The MTC, by processing other data contained on the same frame-synchronized log tapes as the video data, provides the picture number, DAS (data automation system) time, essentially an on-board clock, and camera identification information shown on the data frame. The science or engineering data blocks recorded on tape may also be decommutated and extracted to drive the MTVS film recorded to produce plots of UVS (ultraviolet spectrometer), IRIS (infrared interferometer spectrometer), or IRR (infrared radiometer) instrument data, as well as engineering telemetry data, if desired.

The film recorders use special 7-in. round flat face cathode-ray tubes (CRT's) with short-persistence P-16 phosphor for generating the 55 × 101-mm data field on the tube face which is photographed by the film transports. High linearity of spot intensity vs. input voltage is obtained by the use of optical feedback from a photomultiplier tube which senses the actual CRT light output, and a differential amplifier to compare the photomultiplier output with the system input and correct the difference. Networks for first order correction of geometric distortion are also provided. The spot is positioned on the face of the tube by deflection currents determined by an 11-bit digital-to-analog conversion system, thus providing a 2047 by 2047 element field for the display of the picture, histograms, gray scales, and titles. Transmission of a Y-coordinate- and X-coordinate-value from the MTC system starts each line of the picture, and a succession of a 6-bit values defined the intensity of each pixel in the line, since the X-position increments automatically with each word transfer. The spot intensity and 7 μsec shutter (unblanking gate) combine to determine the film exposure for each pixel. The data transfer rate is about 50 μsec/word, and a full field requires about 50 sec to complete. Film advance occurs in 500 msec.

Each film recorder is provided with beam splitters which permit the use of two film transports, plus a Polaroid quick-look camera. The two film transports allow two different types of data, being processed simultaneously, to be segregated on separate films according to data type. The transports accommodate 1000-ft rolls of 70mm perforated polyester-based film.

A system gamma of unity is desirable if the photocopy is to represent accurately the contrast of the original scene. This assumes that the light transfer characteristic of the transducer between the original scene and the system input is linear, otherwise the exposure computer may be required to aid in compensating the characteristic of the transducer.

Continuous processors are used to process cut film

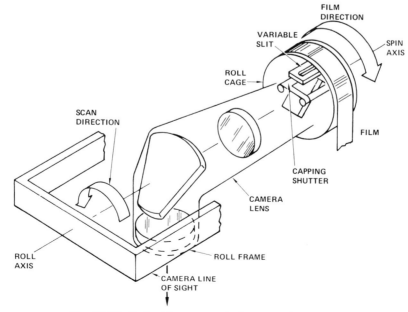

Fig. 23-35. Optical bar concept of panoramic camera.

or 70mm roll film. High-speed duplicators for producing 1-to-1 positives, strip-contact prints, and duplicate negatives provides for producing a predetermined number of copies with preprogrammed exposures, at speeds up to 325 ft/min. A 40 ft/min duplicator is also installed. Strip contact prints are processed by Pakopak or Pakopro Processors. Most enlargements are to 8 × 10-in., however, a 16×20-in. capability exists. An automated enlarger with automatic film and roll-paper transport systems produces 500 8 × 10-in. enlargements/hr on 10-in. roll stock.

Photographic quality assurance (QA) is effected using sensitometers, and transmission and reflection densitometers to measure the density (transmittance) or reflectivity of film or paper photoproducts which have been exposed through sensitometric gray scale wedges. The data are used to set up the exposure computer, select the exposure, processing speed, and temperature, and control material acceptance. Process control is automated through use of digital equipment.

Manned Space Flights

The United States manned space program began with Project Mercury in October 1958. The goal was to launch a man into earth orbit and return him safely to earth. Orbital flights of Project Mercury through 1963 resulted in about 300 photographs.

The two-man Gemini program of 1965–66 consisting of 10 orbital flights resulted in some 2400 photographs of rendezvous and docking, space walks, interiors and exteriors of spacecraft, the earth's surface, weather systems and low-light effects.[208,209]

The first manned lunar orbital flight of Apollo 8 took place in December 1968[210-217] and the first pictures on the lunar surface were made July 21, 1969 by Neil Armstrong with a special Hasselblad Electric Data Camera.

For lunar surface photography Apollo 14 carried Hasselblad cameras, Maurer 16mm data acquisition cameras, and a Kodak close-up stereo lunar surface camera. Additional 70mm cameras, a data acquisition

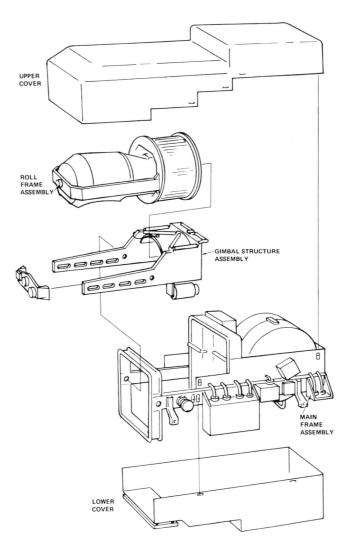

Fig. 23-36. Major assemblies of panoramic camera.

Fig. 23-37. Mariner microfiche with binary-coded clip.

Fig. 23-38. Computer retrieval-display-printer system for mission photographs.

camera and a lunar topographic camera were in the orbiting command module.

Figure 23-34 shows the service bay in the command module of Apollo 15 which contained a panoramic camera, a mapping camera and a stellar orientation camera. The Itek KA80-A panoramic camera[218,218a] shown in Figs. 23-35 and 23-36, produced film frames 4.5 in. wide by 45.24 in. long. Each exposure covered a $13\frac{1}{2} \times 211$ mile strip of the moon's surface. The total coverage amounted to 12% of the lunar surface. Stereo pairs were produced by the camera which tilted forward to photograph an area slightly ahead of the orbiting module, and then backward to take a second picture of the same area over which the module had just flown. Overlap produced continuous coverage of the lunar surface. Some 6700 feet of Kodak Panatomic-X and Plus-X aerial film were exposed in the panoramic camera. The mapping camera exposed more than 1500 feet of Panatomic-X aerial film, and more than 500 ft of 35mm Plus-X aerial film were exposed in the stellar camera.[219] Other data on optics, video, computer processing and pictorial coverage are contained in Refs. 200–228.

Ground Photographic Support

Ground support of missions include photography of launch, oscillograph recording of telemetered information, and rapid-sequence photographs of rocket separation performance from an aircraft flying at 30,000 to 40,000 ft. Typically, more than 200 cameras may cover an Apollo launch. Of these, about 170 are motion picture or sequence cameras. Documentary footage in 16mm commercial film and 35mm negative film are also obtained at each launch.[229–232]

During the mission, data and pictorial telemetry are recorded and processed on earth as previously described.

Return of the missle or space vehicle into the earth's atmosphere is recorded by airborne and ground TV and film cameras, specialized instruments such as cinespectrographic cameras[233,234] and from telemetered data.

Retrieval of Space Photographs

The retrieval of the rapidly increasing volume of space photographs was early recognized to be a problem for which an answer should be sought. In 1968, Hoadley, at the request of representatives from NASA and Lockheed Electronics, produced COSATI[235] microfiche of Lunar Orbiter photographs together with correlative documentation in the form of data and maps. Special processing techniques were used to correctly reproduce the continuous tone pictures.[236] Microfiche (Fig. 23-37) are binary-coded[237] for automatic retrieval in an Image Systems CARD Reader Printer.[238,239] Under computer control, the desired microfiche can be accessed from a keyboard and displayed in approximately 4 sec. The printer module has been modified by Hoadley to

produce continuous-tone electrostatic prints. Special paper and toner yield a 10-step gray scale capability, and dry prints are delivered in 25 sec. (Fig. 23-38).

Baker[240] describes retrieval of photographs for the Pioneer/Jupiter program.

In 1976, two unmanned Viking spacecraft, laden with experimental equipment, landed on Mars after an 11-month, 460-million-mile interplanetary trip. Color and black and white views of the Martian surface were

Fig. 23-39. Mars-to-earth picture taking process using Itek facsimile cameras.

Fig. 23-40. The Martian horizon as seen by Viking 2.

transmitted to Earth by two Itek Lander Camera Systems (LCS), each weighing approximately 15 lb. An image of the Martian scene was scanned in elevation and azimuth to generate pixels (picture elements) transmitted through an objective lens onto a solid-state detector array. Analog signals were produced proportional to the intensity of the incident light energy. The digitized signal was transmitted back to Earth via an orbiter satellite. The transmission received on Earth was recorded on tape and processed by the ground reconstruction equipment to provide on film a photographic reproduction of the scene. Functions are described in Ref. 241 and shown schematically in Fig. 23-39. Ground reconstruction of the Martian scene is shown in Fig. 23-40.

REFERENCES

1. "Data Terminals for Instrumentation," *Electronic Instrument Digest*, 7: 7 (Mar 1971).
2. D. Mc Croskie, "The Automation of Data Acquisition Systems and Transducers," *Electronic Instrument Digest*, 7: 5 (Aug 1971).
3. L. A. Mannheim, "Remote-Control Reflex Systems," *Photogr. Appl. Sci. Tech. Med.*, 2: 40 (May 1969).
4. M. A. Kerr, "Electroluminescent Diodes as Timing Signal Recorders in High-Frame-Rate Cameras," *J. Soc. Motion Picture Television Engrs.*, 78: 631 (1969).
5. C. H. Beal, L. M. Dearing and R. E. Hiller, "Film-Data Record-ing Using Electroluminescent Diodes: Design Considerations," *J. Soc. Motion Picture Television Engrs.*, 78: 961 (1969).
6. L. Baker, "The Electroluminescent Panel as a Binary Light Source," *J. Soc. Motion Picture Television Engrs.*, 79: 600 (1970).
7. L. M. Dearing, "Film Recording of Alpha Numeric Displays," *SPIE J.*, 9: 184 (1971).
8. *Photographing Instrument Panels Inside Out*, Eastman Kodak Co., Rochester, N.Y. (1967).
8a. K. H. Miska, "A Survey of Release Devices for Motor-Driven Still Cameras," *Industrial Photography*, 23 (4): 28 (Apr 1974).
9. *Basic Oscillography*, Eastman Kodak Co., Rochester, N.Y. (1969).
10. "Instruments Selection/Application," *Electromechanical Design*, 15: 16 (Sep 1971).
11. H. W. Hoadley, *Manual of Oscillography*, Focal, New York, 1967.
12. J. H. Jacobs, "Very Rapid Processing of Oscillograph Records," *J. Photogr. Sci.*, 6: 120 (1958).
13. J. H. Jacobs, "Flash Processing; A Rapid Access Photographic Technique," *Photogr. Sci. Eng.*, 1: 156 (1958).
14. J. H. Jacobs, "Rapid Access Methods for Oscillograph Optical Systems," *Instrum. Contr. Syst.*, 34: 1236 (1961).
15. F. A. Pomeroy and M. E. Welch, "A Two-Color Photographic Paper and Rapid Process," *Photogr. Sci. Eng.*, 7: 161 (1963).
16. F. A. Pomeroy, K. L. Wrisley and H. J. Fassbender, "Photo-recording in Color," *Photogr. Sci. Eng.*, 8: 296 (1964).
17. C. H. Evans and A. A. Tarnowski, "Photographic Data Record-ing by Direct Exposure with Electrons," *J. Soc. Motion Picture Television Engrs.*, 71: 765 (1962).
18. P. C. Goldmark, et al., "Color Electronic Video Recording," *J. Soc. Motion Picture Television Engrs.*, 79: 677 (1970).
19. S. P. Robinson and L. S. Horst, "Color Film Recording from TV," *SPIE J.*, 9: 196 (1971).

20. J. E. Wurtz and F. J. Marshall, "The Application of Cathode-Ray Tubes to Film Recording and Scanning," *SPIE J.*, **9**: 186 (1971).

21. W. J. Poch, "The Development of a Feasibility Model of An Electron Beam Film Recorder," *J. Soc. Motion Picture Television Engrs.*, **74**: 778 (1964).

22. L. Beiser, "A Unified Approach to Photographic Recording from the Cathode-Ray Tube," *Photogr. Sci. Eng.*, **7**: 196 (1963).

23. H. F. Nitka, "Sensitivity and Detail Rendition in the Recording of Light Images and Electron Beams," *Photogr. Sci. Eng.*, **7**: 189 (1963).

24. R. A. Stagnol, "Photographing Oscillograph Traces," *J. Environmental Science*, **9**: 18 (June 1966).

25. "C R O'S, Modules and Accessories—A State-of-the-Art Survey," *Electronic Instrument Digest*, **7**: 6 (Apr 1971).

26. J. J. Ferrier, "A Remote Airborne Photographic Mission Recorder," *SPIE J.*, **9**: 179 (1971).

27. J. Wurtz, "Angling for Better C R T Performance," *Electro-Optical Systems Design*, **4**: 13 (Feb 1972).

28. M. C. Taileur (ed.), *Techniques of Photo-Recording from Cathode-Ray Tubes*, Dumont Oscillograph Laboratories Inc., West Caldwell, N.J. (1963).

29. *Kodak Films for Cathode-Ray Tube Recording*, Eastman Kodak Co., Rochester, N.Y. (1969).

30. A. H. Phillips, *Computer Peripherals and Typesetting*, Her Majesty's Stationery Office, London (1968).

31. D. M. Avedon, *Computer Output Microfilm*, 2nd Ed., National Microfilm Association, Silver Spring, Md. (1971).

32. M. K. Muir, "System Requirements for Precision High Resolution Microfilm Recording by Computer," *SPIE J.*, **9**: 210 (1971).

33. Robert P. Mason, "An Advance Technique for Short Delay Processing of Photographic Emulsions," *Photogr. Sci. Eng.*, **5**: 79 (1961).

34. J. R. Mertz, "Ansco Recording Films and Rapid Processing Techniques," *Photogr. Sci. Eng.*, **5**, 93 (1961).

35. Seymour L. Hersh and Frank Smith, "Rapid Processing: Present State of the Art," *Photogr. Sci. Eng.,* **5**: 48 (1961).

36. J. C. Barnes, W. J. Moretti and D. G. Bushman, "A New Film Monobath Combination for Oscillography," *SPIE J.*, **5**: 95 (1967).

37. H. S. Keelan, "Simultaneous Developing and Fixing of Images," *J. Photogr. Sci.*, **5**, 000 (1957).

38. Marilyn Levy, "Combined Development and Fixation of Photographic Images with Monobaths," *Photogr. Sci. Eng.*, **2**: 136 (1958).

39. Beaumont Newhall, *The History of Photography*, The Museum of Modern Art, New York, 1964.

40. E. Garvin, "High Speed Photography," *J. Soc. Motion Picture Television Engrs.*, New York.

41. A. Boni, *Photographic Literature* (I) to 1960; (II) 1960–1970 Morgan & Morgan, Hastings-On-Hudson, N.Y.

42. Proceedings of International Congresses on High Speed Photography.
 1st—*J. Soc. Motion Picture Television Engrs.*, Reprint (1954).
 2nd—Dunon, Paris, France (1956).
 3rd—Butterworths, Bethesda, Md. (1957).
 4th—Helwich, Darmstadt, Germany (1959).
 5th—University Microfilms, Ann Arbor, Mich., (1962).
 6th—H. D. Tjeenk Willink & Zoon, Haarlem, The Netherlands (1963).
 7th—Helwich, Darmstadt, Germany (1967).
 8th—Wiley, New York, N.Y. (1968).
 9th—*J. Soc. Motion Picture Television Engrs.*, New York, N.Y. (1970).

43. J. H. Waddell, "The Rotating Prism Camera: An Historical Survey," *J. Soc. Motion Picture Television Engrs.*, **75**: 666 (1966).

44. D. A. Fatora, "High Speed Camera Survey," *J. Soc. Motion Picture Television Engrs.*, **74**: 911 (1965).

45. W. G. Hyzer, "The Long Road We've Traveled in High Speed Photography," *Photo Methods for Industry*, **16**: 38 (1973); W. G. Hyzer, *Engineering and Scientific High Speed Photography*, Macmillan, New York, 1962.

46. K. Shaftan and D. Hawley, *Photographic Instrumentation*, Society of Photographic Instrumentation, Redondo Beach, Calif. (1962).

47. A. S. Dubovik, *Photographic Recording of High Speed Processes*, Pergamon, Long Island City, N.Y., 1969.

48. W. J. Mc Crea and J. M. Scott, "Freezing Time," *Industrial Research*, **13**: 41 (1971).

49. J. F. Mermoud, "High Speed Photography—Its Utilization in Industry," American Society of Mechanical Engineers Conference (1972).

50. "High Speed Photography Tells Much, Costs Less Than You Think," *Prod. Eng.*, **41**: 80 (1970).

51. E. B. Turner, "High Speed Photography for Plasma Physics Research," *SPIE J.*, **8**: 157 (1970).

52. J. W. Hansen and M. A. Dugey, "Ultra High Speed Photography of Picosecond Light Pulses," *J. Soc. Motion Picture Television Engrs.*, **80**: 73 (1971).

52a. J. S. Courtney-Pratt and P. M. Rentzepis, "Picosecond Photography and Time-Resolved Spectrography," *J. Soc. Motion Picture Television Engrs.*, **84** (6): 478 (June 1975).

53. J. L. Brewster, J. P. Barbour, F. M. Charbonnier and F. J. Grundhauser, "Nanosecond Photography with Super Radiant Light," *SPIE J.*, **8**: 179 (1970).

54. V. A. Babits, "Ultra High Speed Photography," *Photogr. Appl. Sci. Tech. Med.*, **7**: 22 (1972).

55. H. E. Edgerton, "Uses of Electronic Flash with Submicrosecond Duration," *SPIE Newsletter*, p. 20 (Apr–May 1962).

56. F. Van Veen, *Handbook of Stroboscopy*, General Radio Co., West Concord, Mass. (1966).

57. *Handbook of High Speed Photography*. General Radio Co., West Concord, Mass. (1966).

58. W. G. Hyzer, "Videotape in High-Speed Photo Applications," *Photo Methods for Industry*, **15**: 28 (Apr 1972).

59. W. G. Hyzer, "Videotape and Film Join Forces in a Search-and-Solve Research Unit," *Photo Methods for Industry*, **15**: 26 (May 1972).

60. I. A. Moon and F. A. Everest, "Time-Lapse Cinematography," *J. Soc. Motion Picture Television Engrs.*, **76**: 81 (1967).

61. C. G. Lefeber, "Time-Lapse Technique in Biology and Medicine," *J. Soc. Motion Picture Television Engrs.*, **73**: 631 (1964).

61a. W. G. Hyzer, "Methods and Available Hardware for Time Lapse Cinematography," *Photo Methods for Industry*, **16**: 12 (Apr 1973).

62. J. S. Courtney-Pratt, *Image Dissection in High Speed Photography*, Helwich, Darmstadt, Germany (1958).

63. M. P. Battaglia, "Discourse on a High Speed Image-Dissection Camera," *SPIE J.*, **8**: 175 (1970).

64. J. S. Courtney-Pratt, "Image Dissection in High Speed Photography—A Bibliography," *J. Soc. Motion Picture Television Engrs.*, **72**: 876 (1963); "Advances in High-Speed Photography 1957–1972," *J. Soc. Motion Picture Television Engrs.*, **82**: 167 (1973).

65. G. L. Clark, "Light Economics in High Speed Photography," *SPIE J.*, **1**: 111 (1963).

66. W. G. Hyzer, *Engineering and Scientific High Speed Photography*, Macmillan, New York, p. 323, 1962.

67. D. J. Novak, "Recording Effects of Rain Erosion with High Speed Photography, *SPIE J.*, **8**: 187 (1970).

67a. W. G. Hyzer, "Flow Visualization," *Research/Development*, **25** (8): 26 (Aug 1974).

68. V. A. Babits, "Schlieren Photography is Tool for Scientific Investigation," *Technical Photography*, **4**: 1 (Feb 1972).

69. N. F. Barnes and S. L. Bellinger, "Schlieren and Shadowgraph Equipment for Air Flow Analysis," *J. Opt. Soc. Amer.*, **35**: 497 (1945) (with 127 references).

69a. R. E. Hendrix, and P. H. Dugger, "Photographic Instrumentation in Hyperballistic Range (G) of the Von Karman Gas Dynamics Facility," *Photogr. Appl. Sci. Tech. Med.*, **8** (5): 22 (Sep 1973).

70. *Schlieren Photography*, Eastman Kodak Co., Rochester, N.Y. (1960).

71. D. G. Kocher, "A Multiple-Spark Light Source and Camera for Schlieren and Silhouette Photography," *SPIE J.*, **1**: 207 (1963).

72. R. L. Leighton, "High-Speed Photoinstrumentation for a Hypersonic Wind Tunnel," *J. Soc. Motion Picture Television Engrs.*, **73**: 650 (1964).

73. A. Davidhazy, "Applications of Photography in Distillation Research," *Phot. Appl. Sci. Tech. Med.*, **3**: 27 (Nov 1969).

74. F. Detsch, "The Schlieren Recorder 80 in the High Velocity Wind Tunnel," *Jena Review*, **14**: 193 (1969).

75. *A 4-Microsecond Flashing Light Synchronized with Framing of Motion Picture Cameras and its Application in Schlieren Photography.* N70-31798, National Technical Information Service, U.S. Department of Commerce, Springville, Va. (1970).

76. D. W. Holder and R. J. North, "A Schlieren Apparatus Giving an Image in Color," *Nature*, **169**: 446 (1952).

77. J. R. Meyer-Arendt, L. M. Montes and W. S. Muncey, "A Color Schlieren System Without Image Degradation," *SPIE J*, **9**: 18 (Oct 1970).

78. J. F. Kelsey and W. K. Cook, "Metamorphosis from Sound to Sight," *Optical Spectra*, **3**: 60 (Nov 1969).

79. "Stabilization of Interferometer Fringe Patterns," *SPIE J.*, **9**: G-4 (June 1971).

80. R. L. Rowe, "Single Plate Laser Interferometer," Seminar on Applications of Lasers to Photography and Information Handling, Society of Photographic Scientists & Engineers, Washington, D.C. (1968).

81. *Methods for Emission Spectrochemical Analysis*, 4th Ed., American Society for Testing Materials (1964).

81a. M. V. R. K. Murty, "Theory and Principles of Monochromators, Spectrometers and Spectrographs," *Optical Engineering*, **13**: (1): 23 (Jan/Feb 1974).

82. W. R. Brode, *Chemical Spectroscopy*, Wiley, New York, 1943.

83. A. B. Calder, *Photometric Methods of Analysis*, American Elsevier, New York, 1969.

84. G. R. Harrison, R. C. Lord and J. R. Loofbourow, *Practical Spectroscopy*, Prentice-Hall, Englewood Cliffs, N.J., 1948.

85. C. E. Harvey, *Spectrochemical Procedures*, Applied Research Laboratories, Glendale, Calif. (1950).

86. C. N. R. Rao, *Ultraviolet and Visible Spectroscopy, Chemical Applications*, 2nd Ed., Plenum, New York, 1967.

87. W. J. Crook, *Applications for the Vreeland Direct Reading Spectroscope and Spectrograph*, Fabrizio Publications, Palo Alto, Calif.

88. J. M. Hoyte and K. E. Hollenbeck, "A System for Quantitative Elemental Analysis of the Metallic Elements in Solid or Solution Form," Pittsburgh Conference on Analytical Chemistry and Spectroscopy. Reprints from Spectrex Corp., 3594 Haven Ave., Redwood City, Calif. (1971).

89. *Kodak Plates and Films for Science and Industry*, Eastman Kodak Co., Rochester, N.Y. (1970).

90. *Kodak Materials for Emission Spectrography*, Eastman Kodak Co., Rochester, N.Y. (1968).

90a. R. A. Walker, "An Equal-Energy Scanning Spectrosensitometer," *Photogr. Sci. Eng.*, **14** (6): 421 (Nov–Dec 1970).

90b. C. R. Boswell, S. S. Berman, and D. S. Russell, "Photographic Emulsion Calibration with the Use of a Digital Computer," *J. Appl. Spectroscopy*, **23** (3): 268 May–June 1969.

91. *Ultra Violet Sensitizing of Kodak Plates*, Eastman Kodak Co., Rochester, N.Y.

92. *Gaseous-Burst Agitation in Processing*, Eastman Kodak Co., Rochester, N.Y.

93. J. A. Decker, Jr., A Multiplex View of Infrared Spectrometry, *Optical Spectra*, **6**: 26 (Feb 1972).

93a. W. Van Bronswijk, "Identification of Motion-Picture Film Bases by Infrared Spectroscopy," *J. Soc. Motion Picture Television Engrs.*, **84** (6): 476 (June 1975).

94. M. J. Prager, "Pollution Monitoring by Flame Emission Spectroscopy," *Optical Spectra*, **5**: 28 (Oct 1971).

95. N. J. A. Sloane, T. Fine and P. G. Phillips, "New Methods for Grating Spectrometers," *Optical Spectra*, **4**: 50 (Apr 1970).

96. A. Hadni, "Far Red Spectroscopy," *Optical Spectra*, **4**: 57 (Apr 1970).

97. G. A. Vanasse, "The Michelson Interferometer Spectrometer," *Optical Spectra*, **4**: 54 (Apr 1970).

98. A. J. Decker, Jr., "Experimental Hadamard-Transform Spectroscopy," *Optical Spectra*, **4**: 45 (Apr 1970).

99. E. J. Kallet and M. Gurkin, "Fluorescence Spectrometry," *Optical Spectra*, **4**: 60 (Apr 1970).

100. W. F. Ulrich, "Infrared Spectroscopy: On the Move Again," *Optical Spectra*, **4**: 38 (Apr 1970).

101. E. P. Bertin, *Principles and Practice of X-Ray Spectrometric Analysis*, Plenum, New York, 1970.

102. G. A. Brown, D. A. Nelson and W. Ritzert, "Automating an X-Ray Spectroscopy System," *American Laboratory*, **3**: 15 (Mar 1971).

102a. J. P. Vetter, "Fluorescent Photomicrography with Interference Filters," *Photogr. Appl. Sci. Tech. Med.*, **8** (2): 20 (Mar 1973).

103. *Ultraviolet and Fluorescent Photography*, Eastman Kodak Co., Rochester, N.Y. (1968).

104. R. J. Lunnon, "Clinical Ultraviolet Photography," *J. Biol. Photogr. Assn.*, **36**: 72 (1968).

105. J. Jagger, *Introduction to Research in Ultraviolet Photobiology*, Prentice-Hall, Englewood Cliffs, N.J., 1967.

106. L. E. Janicek and G. Svihla, "Ultraviolet Micrography in Biological Research," *J. Biol. Photogr. Assn.*, **36**: 59 (May 1968).

107. *Kodak Infrared Films*, Eastman Kodak Co., Rochester, N.Y.

108. *Applied Infrared Photography*, Eastman Kodak Co., Rochester, N.Y.

109. *Medical Infrared Photography*, Eastman Kodak Co., Rochester, N.Y.

110. W. Clark, *Photography in the Infrared*, Wiley, New York, 1947.

111. J. T. Smith, Jr. and Abraham Anson, (eds.), *Manual of Color Aerial Photography*, American Society of Photogrammetry, Falls Church, Va., 1968.

112. N. Jensen, *Optical and Photographic Reconnaissance Systems*, Wiley-Interscience, New York, 1968.

113. D. T. Hodder, "Multispectral Photography in Earth Resources Research," *Optical Spectra*, **4**: 71 (July 1970).

114. R. Shavlach, "Tiros—A Weather Satellite," *SPIE Newsletter*, p. 8 (Apr 1961).

115. H. V. Soule, "Versatile Multispectral Imaging Systems," *Electro-Optical Systems Design*, **3**: 27 (Apr 1971).

116. K. F. Weaver, "Remote Sensing; New Eyes To See the World," *National Geographic Magazine*, **135**: 46 (Jan 1969).

116a. R. M. Shaffer, "Film/Chemistry Selection for the Earth Recourses Technology Satellite (ERTS) Ground Data Handling System," *Image Technology*, **15** (3, 4): 12 (Apr/July 1973).

116b. R. N. Colwell, "Remote Sensing of Natural Resources," *Scientific American*, **218** (1): 54 (Jan 1968).

117. J. S. Lord, "Brightness Pyrometry," *Instrum. Contr. Syst.*, **38**: 109 (Feb 1965).

118. I. Overington, "Photographic Pyrometry," *J. Photogr. Sci.*, **16**: 199 (1968).

119. D. W. Male, "A Photographic Pyrometer," *Rev. Sci. Instrum.*, **22**: 769 (1951).

120. P. J. Valentine and E. P. French, "Measuring Ramjet Tailpipe Temperatures," *American Society of Mechanical Engineers*, Paper 56-AV-30 (1956).

121. F. Simmons and A. DeBell, "Theory and Design of a Photographic Pyrometer for Temperature Measurements in Luminous Exhaust Flames with some Preliminary Experimental Results," Research Report 57-23, also "Photographic Flame Brightness Measurements," Report R-553. Rocketdyne, 6633 Canoga Ave., Canoga Park, Calif. (1957).

122. F. Pollack and R. Hickel, "Surface Temperature Mapping with Infrared Photographic Pyrometry for Turbine Cooling Investigations," NASA Technical Note D-5179 (N69-23895). National Technical Information Service, Springfield, Va. 22151 (1969).

123. B. Kemp, "A Technique for Temperature Measurement," *Industrial Photography*, **11**: 12 (Mar 1962).

124. "Photopyrometry Aids AEDC," *Technical Photography*, **4**: 29 (Oct 1972).

125. "Television Checks Out Heat Distribution," *Industrial Research*, **14**: 33 (Nov 1972).

126. State-of-the-art-review of infrared sensing systems, *Optical Engineering*, **14** (Jan/Feb 1975).

 5 "Guest Editorial: Infrared Today & Tomorrow—Plus 11 Years," Irving J. Spiro

 6 "Performance Evaluation of Scanning IR Optical Systems," L. G. Neuweg

 15 "Design Trade-Offs for Scanning Infrared Sensors," Rudolf Marloth

21 "Infrared Detectors: An Overview," R. B. Emmons, S. R. Hawkins, K. F. Cuff

31 "Infrared Atmospheric Effects," C. M. Randall

38 "Status of LWIR Spaceborne Sensor Calibration," Rex Lewis, Chris Horgen

46 "Deflection of a Circular Scanning Mirror under Angular Acceleration," D. A. Conrad

50 "State-of-the-Art for Thermal Imaging," J. M. Lloyd

57 "Cryogenic Coolers for IR Systems," R. W. Breckenridge, Jr.

127. J. D. Friedman, "The Infrared Scanner as a Geophysical Research Tool," *Optical Spectra*, **4**: 35 (June 1970).

128. I. L. Goldberg, "Metrological Infrared Instruments for Satellites," *SPIE J.*, **9**: 22 (Oct 1970).

129. R. W. Astheimer, "Infrared to Visible Image Translation Devices," *Photogr. Sci. Eng.*, **13**: 127 (1969).

130. D. H. Whittier, "Medical Diagnosis by Thermography," *Optical Spectra*, **4**: 40 (Jan 1970).

131. R. W. Graham and R. Bridges, "A 0.2 msec Xenon Strobe Lamp for Flash Photomicrography," *J. Photogr. Sci.*, **18**: 244 (1970).

132. R. F. Smith, "Color Contrast Methods in Microscopy and Photomicrography," *Photogr. Appl. Sci. Tech. Med.*, (I) **4** (May 1970); (II) **5** (Sep 1970); (III) **6** (May 1971).

133. *Phase Contrast Microscopy*, Bausch & Lomb Co., Rochester, N.Y. (1962).

134. M. Abramowitz, "Color Photomicrography in Polarized Light," *Photogr. Appl. Sci. Tech. Med.*, **1** (Fall 1967).

135. R. P. Loveland, *Photomicrography, A Comprehensive Treatise*, Wiley, New York (1970) (Two volumes).

136. D. Lawson, *Photomicrography*, Academic, London and New York, 1972.

137. *Photography Through the Microscope*, Eastman Kodak Co., Rochester, N.Y. (1970).

138. *Photomicrography of Metals*, Eastman Kodak Co., Rochester, N.Y. (1966).

139. Robert F. Smith, "Micro Replication," *Photogr. Appl. Sci. Tech. Med.*, **2**: 24 (Winter 1967/68).

139a. John P. Vetter, "Practical Considerations in Color Photomicrography," *American Laboratory*, **5**: 8 (Apr 1973).

140. H. B. Tuttle, "Cinephotomicrography," *Medical Physics Yearbook* (1944).

141. *Cinephotomicrography*, Eastman Kodak Co., Rochester, N.Y. (1970).

141a. J. Schwartz and D. Krebs, "Advances in Cinemicrography," *American Laboratory*, **5**: 73 (Apr 1973).

142. H. J. Robb and C. M. Jabs, "High Resolution Cine Photomicrography," *Photo Methods for Industry*, **10**: 49 (Apr 1967).

143. H. J. Robb and C. M. Jabs, "Electronic Flash for Cinephotomicrography," *Photogr. Appl. Sci. Tech. Med.*, **3**: 34 (Nov 1969).

144. C. E. Hall, *Introduction to Electron Microscopy*, McGraw-Hill, New York, 1966.

145. J. T. Black, "SEM: Scanning Electron Microscope," *Photogr. Appl. Sci. Tech. Med.*, **4**: 29 (Mar 1970).

146. M. Knoll, *Z. Tech. Phys.*, **16**: 467 (1935).

147. M. von Ardenne, *Z. Phys.*, **109**: 553 (1938).

148. C. Oatley, et al., *Advan. Electron. Electron Phys.*, **21**: 181 (1965).

149. T. L. Hayes, "Scanning the Image," *Industrial Research*, **14**: 44 (July 1972).

150. L. K. Koster, "Photography Applied to Electron Microscopy," *Photogr. Appl. Sci. Tech. Med.* (I), **2** (winter 1967/68) (II) (spring 1968) (III) (fall 1968).

151. D. Nugent, "Consistent SEM Exposure," *Photogr. Appl. Sci. Tech. Med.*, **7**: 40 (May 1972).

152. M. Cox, "Close up of Holographic Microscopy," *Laser Focus*, **7**: 41 (Feb 1971).

153. C. Knox and R. E. Brooks, "Holographic Motion Picture Microscopy," *J. Soc. Motion Picture Television Engrs.*, **79**: 594 (July 1970).

154. S. H. Hine, "Technical Photomacrography," *International Photo Technik*, Verlag Grossbild-Technik GmbH, Munich, Germany; I, No. 3, 1971, p 12; II, No. 4, 1971, p 4; III, No. 1, 1972, p 4.

155. *Photomacrography*, Eastman Kodak Co., Rochester, N.Y. (1969).

156. R. F. Smith, "Color Contrast Methods in Microscopy and Photomicrography. Part IV Photomacrography," *Photogr. Appl. Sci. Tech. Med.*, **7**: 21 (May 1972).

157. G. Osterloh and H. Kirschner, "Clinical Photography in Dental Practice," *Photogr. Appl. Sci. Tech. Med.*, **6**: 30 (Nov 1971).

158. Don Wong, "The Fundamentals of Biomicroscopy and Techniques of Slit-Lamp Photography," *Photogr. Appl. Sci. Tech. Med.*, **4**: 28 (Fall 1967).

159. H. Malpica, "Photography of the Eye," *Industrial Photogr.*, **21**: 22 (Aug 1972).

160. Fred Hoyle, *Astronomy*, Crescent Books, London, 1962.

161. G. Buttman, *The Shadow of the Telescope: A Biography of John Herschel*, Scribner's, New York, 1970.

162. T. Cave, "Developers of the Refracting Telescope," *SPIE J.*, **9**: 20 (June 1971).

163. G. Miczaika and W. Sinton, "Tools of the Astronomer," Harvard University Press, Cambridge, Mass. 1961.

164. Gerard De Vancouleurs, *Astronomical Photography, From the Daguerreotype to the Electron Camera*, Macmillan, New York, 1961.

165. E. Selwyn, *Photography in Astronomy*, Eastman Kodak Co., Rochester, N.Y.

165a. J. A. Loudon, "Astronomical Photography," *Photogr. Appl. Sci. Tech.*, **2** (6): 19 (spring 1968).

166. T. Rackham, *Astronomical Photography at the Telescope*, Faber & Faber, London, 1959.

167. W. Heltner (ed.), *Astronomical Techniques, Stars and Stellar Systems*, Vol. II, University of Chicago Press, Chicago, 1962.

168. C. F. Capen, "Filter Techniques for Planetary Observers," *Sky and Telescope*, **17**: 517 (Aug 1958).

169. C. F. Capen, "Simultaneous Multicolor Planetary Photography," *J. of Lunar and Planetary Photography*, **21** (7) (1969).

170. A. A. Hoag and W. C. Miller, "Application of Photographic Materials in Astronomy," *Appl. Opt.*, **8**: 2417 (1969).

171. P. R. Lichtman, "Television Observation of the Planets," *Optical Spectra*, **3**: 83 (Sep 1969).

172. J. R. Hansen, J. deJonge and W. R. Beardsley, "Recording of Star Spectra with a Fiber Optic Electrostatic Image Intensifier," *Image Technology*, **2**: 25 (Aug 1969).

173. L. A. Boyer, L. E. Flory, J. M. Morgan and W. S. Pike, "A Programable Integrating Television Camera for Astronomical Applications," *J. Soc. Motion Picture Television Engrs.*, **74**: 760 (1965).

174. A. D. Cope, E. Luedicke and L. E. Flory, "The Capabilities and Prospects of Television Camera Tubes in Applications for Astronomy," *J. Soc. Motion Picture Television Engrs.*, **74**: 765 (1965).

174a. M. M. Hoffman, W. M. Sanders, D. H. Liebenberg, "An Image Intensification and Video Recording System for Astronomical Observations," *Optical Engineering*, **14**: 76 (Jan/Feb 1975).

175. T. W. Rackham, "Photographic Instrumentation in Astronomy," *SPIE Newsletter* (June 1962).

176. H. E. Gustafson, "Automated Stargazing," *SPIE J.*, **2**: 93 (Feb 1964).

177. "Giant Space Telescope," *Electro-Optical Systems Design*, **4**: 6 (Feb 1972).

178. Y. N. Lipsky, "Charting the Hidden Side of the Moon," *Sky and Telescope*, **21**: 133 (Mar 1961).

179. J. A. Fusca, "Space Surveillance," *Space/Aeronautics*, p. 92 (June 1964).

180. R. A. Stampfl and W. G. Stroud, "Automatic Picture Transmission TV Camera System for Meteorological Satellites," *J. Soc. Motion Picture Television Engrs.*, **73**: 130 (1964).

181. R. L. Kuehn, E. R. Omberg and G. D. Forry, "Processing of Images Transmitted from Observation Satellites," *Information Display*, **8**: 13 (Sep 1971).

182. "The Telstar Experiment," *J. Soc. Motion Picture Television Engrs.*, **72**: 986 (1963).

183. C. A. Siocos, "Broadcasting from Satellites," *J. Soc. Motion Picture Television Engrs.*, **81**: 157 (1972).

184. C. A. Siocos, "Utilization of Domestic Satellites in the Networks of the CBC," *J. Soc. Motion Picture Television Engrs.*, **81**: 93 (1972).

185. R. F. Zeitoun and C. A. Siocos, "Broadcasting from Satellites—

UHF Television Channel Utilization," *J. Soc. Motion Picture Television Engrs.*, **81:** 158 (1972).

186. R. P. Haviland, "Possible Technical Standards for Educational and Community Television by Satellite," *J. Soc. Motion Picture Television Engrs.*, **81:** 162 (1972).

187. R. M. Lester, "Television Distribution by the Canadian Domestic Satellite System," *J. Soc. Motion Picture Television Engrs.*, **81:** 88 (1972).

188. D. R. Wells, "Combined Educational and Television Network Satellite Distribution System," *J. Soc. Motion Picture Television Engrs.*, **81:** 165 (1972).

189. J. E. D. Ball, "Some Technical Considerations in Providing Television Coverage by Satellite," *J. Soc. Motion Picture Television Engrs.*, **81:** 97 (1972).

190. H. W. Hoadley, "Quality Improvement for Ranger I Oscillograph Records," *Private Communication*, report for Jet Propulsion Laboratory, California Institute of Technology, Pasadena, Calif. (May 12, 1961).

191. J. Rennilson, H. Holt, and E. Morris, "In Situ Measurements of the Photometric Properties of an Area on the Lunar Surface," *J. Opt. Soc. Amer.*, **58:** 747 (1968).

192. "Aerospace Television and Surveyor," eleven papers describing Surveyor Program, *J. Soc. Motion Picture Television Engrs.*, **77:** 299 (1968).

193. E. Shoemaker, R. Batson, H. Holt, E. Morris, J. Rennilson and E. Whitaker, "Observations of the Lunar Regolith and the Earth from the Television Camera on Surveyor 7," *J. Geophys. Res.*, **74:** 6081 (1969).

194. L. E. Blanchard, "The Design of Postlanding Television System Photometric Charts for the Surveyor Spacecraft," *J. Soc. Motion Picture Television Engrs.*, **79:** 226 (1970).

195. L. H. Allen and P. M. Salomon, "Operation of the Surveyor Television System in the Photo-Integration Mode," *J. Soc. Motion Picture Television Engrs.*, **79:** 615 (1970).

196. L. J. Kosofsky and G. C. Broome, "Lunar Orbiter: A Photographic Satellite," *J. Soc. Motion Picture Television Engrs.*, **74:** 773 (1965).

197. "Optics on the Lunar Orbiter," *Optical Spectra*, **1:** 38 (1967).

198. "Film and Television in Space Technology," eight papers describing the Lunar Orbiter Program, *J. Soc. Motion Picture Television Engrs.*, **76:** 733 (1967).

199. J. L. Dragg and N. W. Naugle, "Photometric Reduction of Lunar Orbiter Video Tapes," *SPIE J.*, **9:** 159 (1971).

200. "Do We Really Need to go to the Moon?," *Photo Methods for Industry*, **12:** 64 (Mar 1969).

201. G. A. Magnan, "Roadmaps for Astronauts," *Engineering Graphics*, **12** (2, 3) (1972).

202. L. R. Malling, "Space Astronomy and the Slow-Scan Vidicon, *J. Soc. Motion Picture Television Engrs.*, **72;** 872 (1963).

203. J. D. Allen, "A Mars Spacecraft Photographic System," *J. Soc. Motion Picture Television Engrs.*, **74:** 497 (1965).

204. H. Canvel, "A Slow-Scan Television Film Recorder," *J. Soc. Motion Picture Television Engrs.*, **74:** 770 (1965).

205. L. T. Seaman and V. Klemas, "Comparison of Visual Imaging Systems for a Mars Orbiter," *J. Soc. Motion Picture Television Engrs.*, **79:** 7 (1970).

206. P. M. Salomon, "Applications of Slow-Scan Television Systems to Planetary Exploration," *J. Soc. Motion Picture Television Engrs.*, **79:** 607 (1970).

207. "Mariner 9 Mars Photos Aid in Mapping of Planet," *Technical Photography*, **4:** 2 (Feb 1972).

207a. Thomas Vrebalovich, "The Mariner 9 Orbiter Photographs Mars," *The Professional Photographer*, **99:** 43 (July 1972).

208. *Earth Photographs from Gemini VI through XII*, Cat. No. NAS 1.21:171, Superintendent of Documents, Government Printing Office, Washington, D.C. 20402 (1968).

209. A. D. Smith, "Photographic Instrumentation of the Gemini Booster," *J. Soc. Motion Picture Television Engrs.*, **77:** 1061 (1968).

210. L. W. Lockwood, "Visual Simulators for Moon Men," *Optical Spectra*, **5:** 32 (Oct 1971).

211. J. A. La Russa, "Visual Spaceflight Simulators," *Optical Spectra*, **3:** 58 (Sep 1969).

212. M. H. Mesner, "The Television Camera System Used in Apollo 7 and 8 Command Modules," *J. Soc. Motion Picture Television Engrs.*, **79:** 1 (1970).

213. *Lunar Photographs from Apollos 9, 10 and 11*, Cat. No. 1.21:246, Superintendent of Documents, Government Printing Office, Washington, D.C., 20402 (1971).

214. J. L. Lowrance and P. M. Zucchino, "Television Camera System for the Command Module of the Apollo Spacecraft," *J. Soc. Motion. Picture Television Engrs.*, **74:** 79 (1965).

215. "Apollo 11—Television and Photography," *J. Soc. Motion Picture Television Engrs.*, **78:** 790 (1969).

216. "The Apollo 11 Television Cameras," *Optical Spectra*, **3:** 65 (Sep 1969).

217. "Apollo 15 Results," *Technical Photography*, **3:** (Oct 1971).

217a. J. Kammarer, "The Moon Camera and Its Lenses," *Photogrammetric Engineering*, **39** (1): 59 (Jan 1973). Also see *Phot. Appl. Sci. Tech. Med.*, **7** (3): 26 (May 1972).

217b. D. K. McCash, "Apollo 15 Panoramic Photographs," *Photogrammetric Engineering*, **39** (1): 65 (Jan 1973).

217c. C. G. Peterson, "Compilation of Lunar Panoramic Photographs," *Photogrammetric Engineering*, **39** (1): 73 (Jan 1973).

218. H. W. Hoadley, "Optical Bar Camera," *Photogr. Sci. Eng.*, **14:** 213 (1970).

218a. W. C. Kinney, *Panoramic Photography Analysis, Apollo 15*, Itek Corporation, Lexington, Mass. 02173 (1972).

219. W. H. Gregory, "Lunar Photos Reveal New Details," *Aviation Week and Space Technology* (Dec 20, 1971).

220. L. R. Lankes, "The Role of Optics in the Apollo Program," *Optical Spectra*, **3:** (Sep 1969).

221. L. L. Niemyer Jr. and E. L. Svensson, "Apollo Television Cameras," *J. Soc. Motion Picture Television Engrs.*, **79:** 926 (1970).

222. L. Hayen and R. Verbrugghe, "A Comparison of the Signal-to-Noise Ratio and Sensitivity of Film and Plumbicon Camera," *J. Soc. Motion Picture Television Engrs.*, **81:** 184 (1972).

223. "High Resolution From a Small Camera," *SPIE J.*, **10** (1) (Oct–Nov 1971).

224. M. V. Sullivan, "Apollo Black-and-White Television Scan Converter," *J. Soc. Motion Picture Television Engrs.*, **79:** 621 (1970).

225. F. C. Billingsley, A. F. H. Goetz and J. N. Lindsley, "Color Differentiation by Computer Image Processing." *Photogr. Sci. Eng.*, **14:** 28 (1970).

226. F. C. Billingsley, "Computer-generated Color Image Display of Lunar Spectral Reflectance Ratios," *Photogr. Sci. Eng.*, **16:** 51 (1972).

227. *Exploring Space with a Camera*, Cat. No. NAS 1.21:168, Superintendent of Documents, Government Printing Office, Washington, D.C. 20402 (1968).

228. W. Von Braun, S. A. Bedini and F. L. Whipple, *Moon: Man's Greatest Adventure*, Thomas Davis (ed.), Harry N. Abrams, 110 E. 59th St., New York, N.Y. 10022.

229. "Photography Vital and Varied in All Stages of Space Flights," *Kodakery*, **27** (37) (Sep 11, 1969), Eastman Kodak Co., Rochester, N.Y. 14650.

230. M. A. Kerr, "High-Intensity Lighting (HIL) for Photography of Launch Operations, NASA Project Apollo," *J. Soc. Motion Picture Television Engrs.*, **74:** 73 (1965).

231. R. W. Forster, H. P. Bolton and H. R. Van Riper, "Photographic Support at the Kennedy Space Center," *J. Soc. Motion Picture Television Engrs.*, **77:** 1064 (1968).

232. C. N. Brewster, "Technicolor Graphic Services Provides NASA Photo Support," *Technical Photography*, **4:** 1 (Mar 1972).

233. B. D. Plakun and W. C. Schupp, "A Cinespectrograph for Reentry Measurements," *J. Soc. Motion Picture Television Engrs.*, **74:** 25 (1965).

234. W. G. Planet, "Photographic Instrumentation for Reentry Measurements," *J. Soc. Motion Picture Television Engrs.*, **74:** 95 (1965).

235. *Federal Microfiche Standards.* Committee on Scientific and

Technical Information (COSATI), Federal Council for Science and Technology, PB 167 630, 2nd Ed.

236. M. Levy, "Wide Latitude Photography," *Photogr. Sci. Eng.*, **11:** 46 (1967).

237. H. W. Hoadley, "Microfiche Publishing Techniques," *Plan and Print*, **41:** 37 (Oct 1968).

238. H. W. Hoadley, "A Rapid, Compact, Automatic Retrieval-Display System," *Photogr. Sci. Eng.*, **10:** 358 (1966).

239. H. W. Hoadley, "Micrographic Data Processing in Automated Laboratory Information Systems," *American Laboratory*, **4:** 73 (1972).

240. L. Ralph Baker, "Pioneer/Jupiter Real-Time Display System," *J. Soc. Motion Picture Television Engrs.*, **84** (6): 481 (June 1975).

241. F. O. Huck, S. T. Katzberg, and W. L. Kelly, "The Facsimile Camera—Its Potential as a Planetary Lander Imaging System," *Optical Engineering*, **11** (4, 5): 91 (July/Oct 1972).

24

MICROGRAPHICS*

J. M. Sturge

MICROGRAPHY: DEFINITIONS, HISTORY AND APPLICATIONS

Dictionaries define micrography as "the art, or practice, of writing in very small characters" from the Greek *micro*, small and *graphics*, to write. The process of photographing on a greatly reduced scale is termed microphotography and the product is called a *microphotograph*.** Microphotographs were made as early as 1850, but only as novelties. The widespread copying of written or printed matter on a greatly reduced scale for storage did not develop until 1920. In that year, a New York banker, George L. McCarthy, patented a camera for copying bank checks on 16mm film which was placed on the market as the *Recordak*®. The film record provided a bank with a graphic record of the checks passed on to other banks or to its customers and was widely adopted. This application of photography, first known as *microfilming* or *microcopying*, is now known as *Micrographics*, a broader term which includes the equipment, processes and functions served in an information system involving microfilm images.

Information systems in modern businesses include computer input and output systems, engineering drawing files, medical records, and publishing, among others. In these systems, microfilm has been substituted for paper records and paper transactions in many file and administration networks. The increasing use of microfilm

*This chapter is intended as an overview. Specific references are listed. Additional references and guidance to interested subject areas can be obtained from The National Micrographics Association, 8728 Colesville Road, Silver Spring, Maryland 20910.

**Not to be confused with a photomicrograph which is a greatly enlarged photograph made through the optical system of a microscope.

as an active media in administrative and communication systems has led to an enormous expansion in equipment and processes not only in numbers, but in complexity and sophistication.

Figure 24-1 illustrates several variations on modern microfilm systems, where microfilm images are created, processed, stored and retrieved. Note that the systems shown in Fig. 24-1 merge in the processing stage from which a variety of formats for the distribution, storage, and retrieval stages are possible. One system possibility of Fig. 24-1 is for the input information to be on a printed page; another would be the input information supplied by a computer-generated magnetic tape. Typically, the documents (printed pages) contain either or both the alpha-numeric and graphical information. The computer-prepared data, normally on magnetic tape, are first converted from digital-to-optical signals (on a cathode ray tube (CRT) for example) then imaged and photographed onto the microfilm.

Although the two systems illustrated in Fig. 24-1 begin with much different forms of input and can differ widely in the forms of output, the heart of each system is the same: optically reduced graphic information organized on one of several formats—a microform.

MICROFILM ORIGINATION FROM PAPER ORIGINALS

There are two fundamental designs for the microfilm cameras used to expose documents. These are: the *flow camera*, mentioned earlier, and the *planetary camera*. The basic difference between a flow camera (Fig. 24-2a) and a planetary camera (Fig. 24-2b) is that the flow camera

Fig. 24-1. Microfilm is the result of a photographic record being made from either a full-size document or digitally driven light source such as a cathode ray tube. In addition to the creation of the microfilm the generic system involves film formating and coding for distribution, retrieval, storage/retrieval of the specific frame or group of film frames.

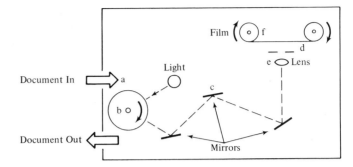

Fig. 24-2a. The basic design of a flow camera. The document to be photographed is inserted at (a). It is wrapped around, and rotates with, a document drum (b). The image of the document is projected by a mirror system (c) and focused through slide (d) by lens (e) onto the moving film (f).

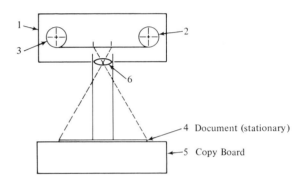

Fig. 24-2b. The film mechanism and lens are located in a camera head. A reel of unexposed film, stored in the camera, is transported across the exposing aperture and metered to a specific length for each picture with the exposed film collected on the take-up spool. The document to be reduced is mounted on a copy board with the reduction ratio determined by the lens and the lens to board distance.

achieves reduction by a technique which requires photographing a moving document—hence, "flow camera"; the planetary camera uses optical reduction in photographing a stationary document.

The flow camera is the most popular camera for high-speed document copying. Recordak* equipment, a pioneer entry in the industry, is a good example of a commercially available flow camera. The film moves during exposure at a speed which is proporationately related to the speed of the document by the reduction ratio. Reduction ratios are changed by adjusting the mirror path lengths, drive rollers and lens setting. Usually, a specific lens is used for each reduction ratio.[4]

While the flow camera has found wide use in the small document market (typically 8½ × 11 in.), the microfilming of large engineering drawings has been done predominantly with planetary cameras. A schematic diagram of a planetary camera is shown in Fig. 24-2b. The exposed film is wound onto a take-up reel.

A typical planetary camera occupies a space 12 ft high,

*Manufactured by Eastman Kodak Company.

5 ft wide and 5 ft deep. The large space is required because of the reduction ratios needed (typically 30×) to put a 36 × 48 in. engineering drawing onto a 35mm microfilm frame.

Several microfilm cameras recently put on the market have been designed specifically for convenient installation and operation in business offices. The exposure step in these designs is completely automated and in-the-camera processing provides "instant" availability of the microfilm. Such cameras, for example the 3M Company's "2000" Camera-Processor shown in Figs. 24-3 and 24-4, provide: ease in positioning the document to be microfilmed, push button operation, an easy-to-load aperture card cartridge, and no-spill chemical loading.[5] This particular camera will expose and deliver a finished aperture card in 40–50 seconds from start of exposure.

MICROFILM ORIGINATION FROM DIGITAL INFORMATION

Recording computer data, however, usually involves imaging data from a cathode-ray tube (CRT) onto

Fig. 24-3. Designed especially to handle full-sized 36-by-48 inch engineering drawings, the 3M 2000E processor-camera delivers a completely processed frame of microfilm mounted in an aperture card in just 40 seconds. The processor-camera is well suited for applications where high-volume and fast-turnaround are basic requirements. (C-30644-7)

microfilm. Not only the output, but the equipment, process, and, in general, the technology associated with such microfilming systems is generally referred to as *Computer Output Microfilm* (COM). The fundamental difference between a COM recorder and a microfilm camera is that the camera begins with a (two-dimensional) field distribution of light recognizable as an image, while the COM must convert electrical-binary signals of digital data created by a computer into a camera-visible image. One approach to digital-to-graphic conversion is the CRT which forms optically recognizable characters on its face plate from the electrical information stored and sent to it by computer control. These characters formed on the CRT are then optically imaged

Fig. 24-4. The 3M brand "2000N/P" processor-camera will produce 1-5/8 in. × 1-3/16 in. images on either direct positive or negative film in only 50 seconds. The unit may be equipped with a backlighting device for copying of X-rays and other transparent materials and/or front lighting for reduction of continuous tone or other opaque materials.

Fig. 24-5. Shown is the complete console incorporating the magnetic tape drive, CRT, controller and optical/film system for integrated printer/plotter operation.

and recorded onto microfilm. A typical COM recorder can record up to 90,000 characters/sec.

Commercial COM's which incorporate a CRT system are classified as: (a) *printer/plotters*, or (b) (straight) *printers*. The important difference involves the resolution of the cathod-ray tube and the technique by which characters and other graphics are created. Printer/plotters are usually high resolution systems employing CRT resolutions of 4000 lines. Printer/plotters are used primarily for scientific and technical applications to create, for example, complex geometric shapes having extremely good image quality. Figure 24-5 illustrates a high quality microfilm printer/plotter, the FR-80, manufactured by Information International, Inc. The CRT in this unit has over 16,000 addressable positions in both the x and y dimensions.

Four techniques for converting digital character codes to optically recognizable characters are described and illustrated below.[6]

The first technique, Fig. 24-6, an array of dots is generated within a dot matrix for each symbol desired. The character "B" is created on the CRT face by tracing the beam and turning it on and off in accordance with the stored dot pattern. In this case, the 35 (5 × 7) dot array is shown with the dominant dots representing those triggered to create the character.

The second approach involves stroke character generators using either straight line segments or a repertoire of analog curves for assembling a series of short stroke line segments into the configuration of the symbol required. The beam of the CRT is stroked much the same as a pen is stroked to construct a letter, number or line (see Fig. 24-6b). Here the spot of the beam is de-

5 X 7 Dot Array

"B" formed by Dot Array

"B" Formed by Stroke Generation. Dotted line traces beam in non-energized state after completion of energized sweep.

Fig. 24-6a and 6b. Dot matrix. Basic 5 × 7 dot matrix used to create characters by specified pattern of dots. Example shown is upper case "B" with 20 dots of the available 35 (5 × 7 = 35). Stroke generation includes sweeping the electron beam of the CRT in the shape of the desired character. Dotted line is continuation of beam sweep.

Fig. 24-6c. Shaped beam character generation. Note: A full character array is maintained in mask form and inserted character-by-character for text generation.

flected to trace the shape of the character desired; in this case, the character is "B". The dotted line shows how the beam continues to sweep, but in a nonenergized condition in completing all segments of its character sweep.

The third technique illustrated is shown in Fig. 24-6c. Here a Charactron tube shapes the electron beam in the form of a character through an optical character matrix.

The electron beam recorder (EBR) (see Fig. 24-7) is a special kind of CRT in which the film is exposed directly by the electron beam of the CRT in which the film passes into and out of the CRT envelope, without, of course, breaking the CRT vacuum. The emulsion side of the film is positioned perpendicular to the direction of the CRT beam and the film is impacted by the electrons. This approach directly records from the electron beam as opposed to other methods that image from the face of the CRT. This direct impact by electrons exposes the specially sensitized dry silver film to the image traced by the beam. Once exposed, the film is transferred directly to a companion film processor where it is developed by heat. After development, the film moves directly to a viewing station. For further information, write the 3M Company of St. Paul, Minnesota.

Light emitting diodes can also be used to form characters in a similar way to the dot matrix in Fig. 24-6b. Fig. 24-8 illustrates this character generation technique. Here, each character is composed from elements of a 5×7 "dot" matrix; again the same approach as the dot matrix. For example, note that the letter E in Fig. 24-8 requires 19 of the 35 dots in the matrix. Each *dot* in the matrix is a diode which is either activated or not in accordance with the character required. The diode in the matrix needed to form a character are activated by control signals pro-

Fig. 24-8. Character generation via LED's and fiber optics.

vided by a character buffer matrix. Fiber optic strands attached to each diode in this control bank conduct the infrared energy emitted by the activated diode to the proper light emitting diode in the character display matrix. When enough characters have been generated, a shutter is activated, and the characters are imaged by a lens onto photographic film. In this figure, only *one* character of a complete array is illustrated to demonstrate the principle. Using a lens and film support assembly, images of the characters on the face of the fiber optic are recorded on microfilm.

The use of a laser to form the symbols and to optically project them onto a photographic film or paper has received considerable attention in the last few years. In one system, developed by Zenith Radio Corporation, a laser light source, acousto-optic deflection techniques, and a photographic paper are combined in a printer capable of printing over 100,000 characters/sec.[7] Figure 24-9 is an example of the laser printing system.

The major advantage of the laser is the energy that it provides—enough to expose even the slowest photographic materials.[8] Work reported by National Cash Register, Inc. (NCR) describes laser imagery[9] for thermal-type recording on metallic thin films. Metallic materials of bismuth, cadmium, cobalt, gold and zirconium were exposed to highly focused laser beams, resulting in the creation of thermal images on the metallic surface. These experiments indicate that a useful microphotographic process can be achieved with this technique. The high power (energy) output of the laser will make practical many imaging processes which are now too slow for conventional exposure.*

*See Chapter 15 for other photographic process discussions and the Index for other references.

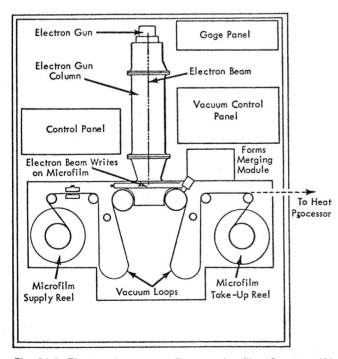

Fig. 24-7. Electron beam recording on microfilm (*Courtesy 3M Co.*).

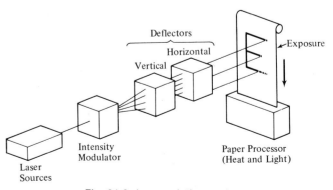
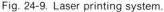

Fig. 24-9. Laser printing system.

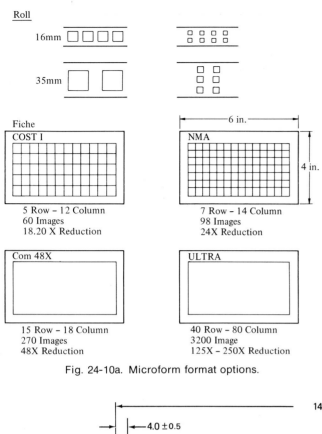

Fig. 24-10a. Microform format options.

FORMATS

There are a number of options available for formating and arranging images on microfilm, i.e., roll, cartridge, microfiche, aperture cards and ultrafiche. Each of these formats was designed originally for specific applications, but though the options appear broad, the basic forms are roll, fiche, and aperture card microformats.

Several format options for roll and fiche are shown in Fig. 24-10a. With 16mm film, either single images or two side-by-side images are possible. COM output on 16mm is normally single row. Figure 24-10b and c are microfiche formats at 24 and 42×, respectively. The microfiche format or tab card size has the images arranged in a matrix of rows and columns with Table 24-1 providing a convenient reference for format planning. Figure 24-11 illustrates an aperture card—the combination of an EAM (Electric Adding Machine) card with an aperture cut-out for mounting a frame of microfilm. Normally, the microfilm frame is 35mm.

The aperture card is used mainly in engineering applications to provide users with large aperture card files as a convenient way to sort and reference microfilm images through electronic sorting and collecting machines. The Hollenth field to the left of the image area is used to code the card for this purpose.

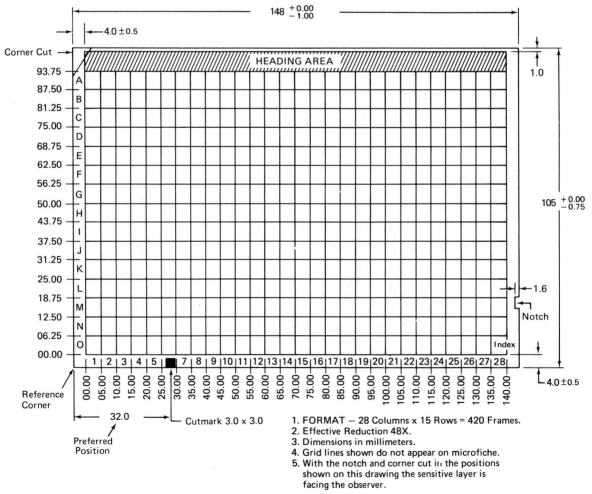

1. FORMAT — 28 Columns x 15 Rows = 420 Frames.
2. Effective Reduction 48X.
3. Dimensions in millimeters.
4. Grid lines shown do not appear on microfiche.
5. With the notch and corner cut in the positions shown on this drawing the sensitive layer is facing the observer.

Fig. 24-10b.

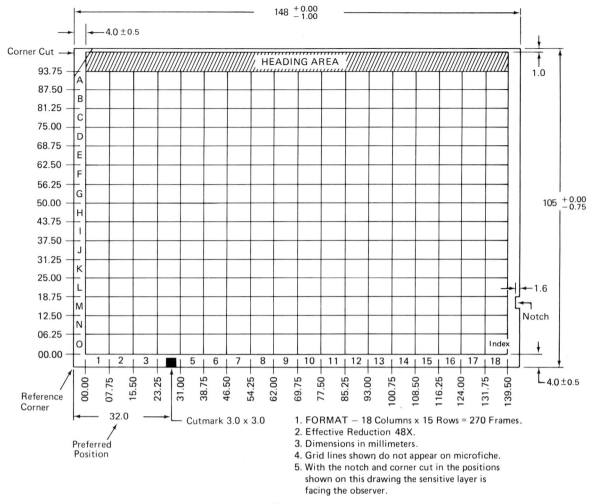

1. FORMAT — 18 Columns x 15 Rows = 270 Frames.
2. Effective Reduction 48X.
3. Dimensions in millimeters.
4. Grid lines shown do not appear on microfiche.
5. With the notch and corner cut in the positions shown on this drawing the sensitive layer is facing the observer.

Fig. 24-10c.

The trend in microformats has been toward increasing reduction ratios as film resolution has improved along with the availability of improved lenses and cameras. One of the first standards for microfiche was 20× reduction providing 60 frames on a 4 × 6 in. format. Since 1970 the reduction ratios have increased providing more available frames. National Micrographics Association standards specify a 24× reduction ratio, providing up to 98 frames per microfiche. COM recorders now provide up to a 48× reduction capability resulting in 200–400 frames per microfiche. Figure 24-12 is for an ultrafiche

format at 3280 images. The extremely high reductions of ultrafiche mean that some 3000 book pages at about 150× may be put on one standard size fiche. With such small images (almost 29/cm² in one example) the ever-present possibility of scratches in the emulsion represents a serious threat to legibility. Some manufacturers have laminated the emulsion side of ultra-high reduction fiche to prevent scratching of the emulsion in normal use. Scratches on this protective layer do not show on the viewer screen because they are not in the focusing field of the emulsion and therefore not visible.

TABLE 24-1.

Arranged for	Reduction	Columns	Rows	No. of Frames 8½ × 11	No. of Frames 11 × 14	Use
8½ × 11 in.	24×	14	7	98	49[a]	Documents or COM
11 × 14 in.	24×	9	7	63	63	Documents or COM
8½ × 11 in.	42×	25	13	325	156[a]	COM
11 × 14 in.	42×	16	13	208	208	COM
8½ × 11 in.	48×	28	15	420	210[a]	COM
11 × 14 in.	48×	18	15	270	270	COM

[a] A single image occupies two frames.

aperture card format

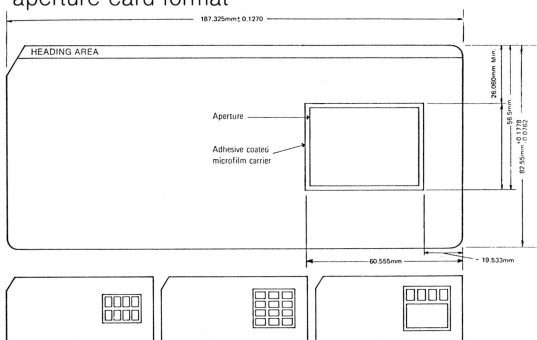

Aperture cards were designed to permit fast retrieval and unit record reproduction and filing of microfilmed documents. They are frequently used as a means of storing large documents such as engineering drawings or many page-size documents. The film is then mounted on an Electric Accounting Machine (EAM) card, upon which appropriate access data may be keypunched and interpreted to an eye-readable identity.

Fig. 24-11.

ultrafiche

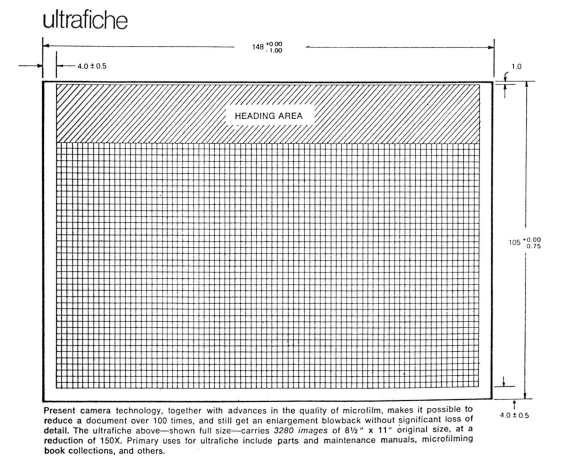

Present camera technology, together with advances in the quality of microfilm, makes it possible to **reduce a** document over 100 times, and still get an enlargement blowback without significant loss of **detail.** The ultrafiche above—shown full size—carries *3280 images* of 8½" x 11" original size, at a **reduction** of 150X. Primary uses for ultrafiche include **parts and maintenance manuals, microfilming book collections, and others.**

Fig. 24-12.

CLASSES OF MICROFILM MATERIALS

Most microsystem processes use one of three different types of film. These are (1) silver halide emulsions specially designed for high resolution and contrast; (2) diazo films; and (3) vesicular films of which Kalvar® is a commercial example.

The initial exposure of microfilm to either documents or CRT's is done with silver emulsion microfilms, except for laser recorders. The reason for the almost exclusive use of silver halide for the original microimage is that photographic higher speed is required to record images within 1 sec or less. There are a number of silver microfilms on the market, each designed to provide the user a different photographic effect based upon differences in application. A typical microfilm with broad market application for document recording is Recordak Micro-File AHU film, type 5459 of the Eastman Kodak Company. Figure 24-13a shows 3 H&D curves for this film; the gamma of 5 or more indicates the desire for high contrast in microfilm systems with little concern for tone reproduction—an important requirement in normal photography.

Another unique requirement of microfilm materials is high resolution. Most typed, written, or graphic text required 4 to 8 lines/mm for acceptable (unaided reading) legibility. An optical reduction of 20× would thus require a microfilm resolution in excess of 160 lines/mm (8 lines/mm × 20 × reduction) in order that the enlarged image be readable.

Because of flare and other image-quality attenuating influences on the imaging system, resolution levels for microfilm are maintained well beyond the limit required. For example, the modulation transfer function of the Recordak Micro-File Film AHU mentioned earlier (see Fig. 24-13b) shows the resolution extending beyond 200 lines/mm, indicating sufficient resolution to retain an eye-readable print.*

Silver emulsions used in micrographic processes normally require different development conditions from other photographic products. Equipment, chemistry, and time-temperature specifications vary widely, depending upon the applications, because the variety of documents, different stock and colors, contrasts, physical conditions, line widths, solids and half tones that affect final image quality.

Different development conditions are also dictated by the end-use requirements. Microfilm for reproduction requires film developed so that the line densities are uniform—this is one reason for high-gamma materials. Microfilm for viewing purposes can exhibit a wide range of line densities without undue discomfort because the eye accommodates and adjusts for density differences not suitable for print making.**

NONSILVER PROCESSES†

Nonsilver film is used principally as duplicating materials in a microfiche system. Diazo, vesicular and photochromic film costs less per frame to use and their slower photographic speed is offset by high-intensity contact printing to control exposure time.

*See Chapters 8 and 9 for more detailed treatment of image quality parameters.

**When microfilming, check manufacturer's specifications for contrast and resolution. Also follow specific directions for proper processing of films for desired resuts.

†Refer to Chapter 15 for a more detailed discussion of nonsilver processes.

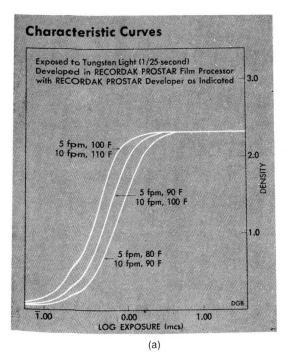

(a)

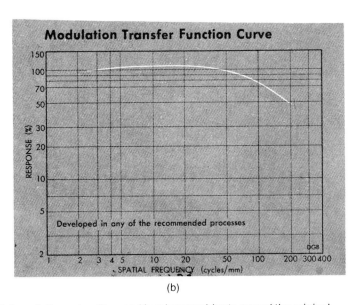

(b)

Fig. 24-13. Kodak Micro-File is used to illustrate the basic characteristics of silver microfilm used in micrographics to record the original image. Other manufacturers of microfilm include 3M Company, Bell & Howell and Ansco.

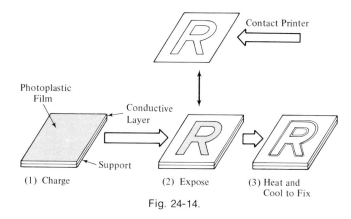

Fig. 24-14.

Photoplastic materials have been studied in connection with microimagery. Xerox and the General Electric Company have been active in this field.* Photoplastic recording is an electrophotographic process, with the steps involved being similar to xerography.[13] As in xerography, the film is first corona charged, making it sensitive to light. The charged film is exposed as usual and the plastic surface layer heated to a flow state. The differential electrostatic forces related to the exposed image produce depressions, or deformations, in the plastic surface and with rapid cooling these depressions become permanent forming an image. Figure 24-14 illustrates the three steps in the photoplastic process.

Photoplastic processes achieve moderate speed indexes with add-an-image capabilities. Other developments are being reported that suggest dry-processable camera speed.[14]

READERS

Readers are used extensively in micrographic systems for the specific purpose of enlarging the microimage for viewing.[13]

Readers enlarge the microimage for projection onto either a translucent or opaque screen. The image on the screen must be sharp and clear, requiring high-resolution optics and a screen capable of forming a brilliant image with a minimum amount of light scatter. There are at least three types of screens in use: (1) Fresnel lenses, (2) diffuse screens and (3) combinations of the two. When a microfilm image is displayed for detailed page-by-page reading, the person reading the material, ideally, must be as comfortable with the viewer as he is with a book or sheet of paper. The inability of early designs to provide comfort factors equivalent to normal printed-page viewing contributed to the slow acceptance of micrographics in such applications as publishing. Significant improvements have occurred in viewer designs over the last few years: the major upgrades being lower cost and improved human factors. The Kodak Ektalite provides acceptable quality, low cost, and

*Refer to Chapter 13 for detailed discussion of Xerox research in this area.

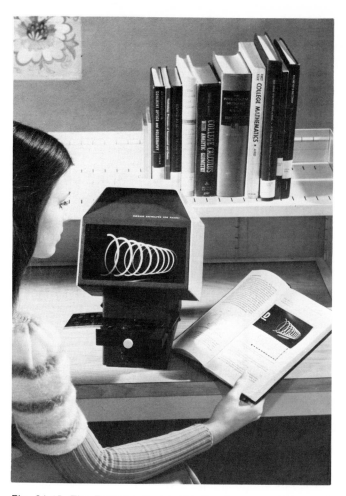

Fig. 24-15. The Eastman Kodak Ektalite viewer provides small compactness/portability and comfortable viewing of microfilms. Image quality is excellent.

is an example of the new generation of viewers for microfiche (Fig. 24-15).[15]

READER/PRINTERS

Extending the capabilities of the readers to include generating a print from specific microfilm frames is obviously an advantage. Early reader/printer designs were based upon incorporating a simple silver-emulsion printing system inside a standard reader. The idea was to take advantage of the enlarged image available for viewing, i.e., to insert photographic paper into the image plane to produce enlargements (so-called "hardcopy"). The result was a dual purpose device which would function as a reader and as an enlarger-printer. Copies are made in reader/printers on either silver halide papers which, with stabilization processing, produce semi-dry prints in less than a minute. Reader/printers employing zinc oxide electrophotographic papers have rapid processing times and produces dry prints. The 3M 400C is typical: it produced 8½ × 11-in. prints in 6 sec (Fig. 24-16). Other commercial reader/printers are described in Ref. 16.

Fig. 24-16. The 3M 400C is representative of current generation reader/printers providing easy visual reference to microfilm through the viewer and hardcopy prints via print button on console.

The Xerox 1824 is widely used to make enlarged copies from 35mm microimages of engineering drawings contained in aperture cards. Figure 24-17 shows the basic components of this printer. The 1824 printer uses a xerographic process and produces dry, ready-to-use prints. The maximum print size is 18 × 24 in.

MICROFILM IN INFORMATION STORAGE AND RETRIEVAL

The progress man has achieved in the arts and sciences is based upon his ability to acquire new knowledge, to record or *store* it, to retrieve it quickly, and to put it to use. Recorded knowledge (information) is increasing at an ever accelerated pace. One measure of the pace is the growth in storage requirements for documents, a requirement which is estimated to double every 8 years. Making the organizational requirements for cross referencing, indexing, selection and retrieval become extremely complex.[7]

The computer provides efficient management of information enabling it to be manipulated, stored, retrieved, and updated within fractions of a second. A computer offers many advantages over microfilm for file and data management but on a cost-per-page basis a computer is generally more costly than microfilm. Information retrieval by computer is measured in microseconds and with microfilm in a range of 1 to 10 sec. The advantages of microfilm are: permanency of records, cost per record stored, and direct human interfacing to the record without the necessity of digital to graphic conversion.

The reduction ratios required for storing data on microfilm are directly related to the information compactness required. As stated earlier, present reductions widely used are 20, 24, and 48×. New developments in lasers, optics, and processes using improved photographic materials will lead to much higher packing densities. Reduction range possibilities are given below.

Reduction Categories for Micro-Images

Term	Abbreviation	Reduction Above	Reduction To Inclusive
Low Reduction	LR	—	15×
Medium Reduction	MR	15×	30×
High Reduction	HR	30×	60×
Very High Reduction	VHR	60×	90×
Ultra High Reduction	UHR	90×	—

High and extreme ranges require photographic processes which will resolve up to several thousand lines per millimeter. The mechanical/optical design parameters are extremely precise, limiting practical use and economic justification to very few applications.

At the present time, the majority of microfilm storage/ retrieval systems on the market fall within the low range reduction ratios. One such automated storage and retrieval system is the Miracode II, manufactured by

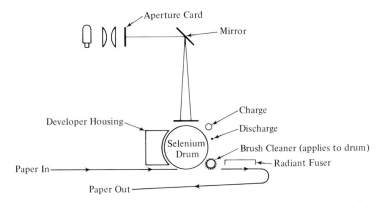

Fig. 24-17. Note: See Electrophotographic section for further details of xerographic process.

(a)

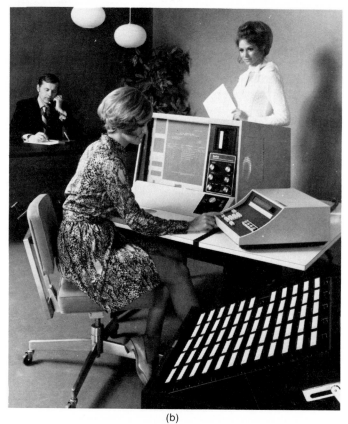

(b)

Fig. 24-18. Retrieval of microfilm on the Kodak Miracode II Microfilmer is accomplished by the Kodak Miracode II Retrieval Terminal and Controller. The retrieval terminal is a self-threading 16mm microfilm unit which searches at the rate of up to 350 documents per second. In addition, dry paper prints of any document can be made on demand.

Eastman Kodak, and shown in Fig. 24-18a. Film stored inside this system is normally coded for reference and retrieval through a keyboard addressing console allowing the operator (Fig. 24-18b) to key in the specific retrieval code and the system subsequently displaying the desired information on the screen to her left.

One of the earlier developments involving automated information systems based upon microfilm was the Walnut system built by IBM for the Central Intelligence Agency.[18] Walnut provides a microfilm-based file with an image capacity of 990,000 images; each image containing a reduced-size document. Documents are optically reduced $13.8\times$ and recorded on silver microfilm; a second reduction of $2.2\times$ achieves $35\times$ overall reduction; the final image is recorded on Kalvar film.

Retrieval of a document involved a computer search of a key word of interest; i.e., photography. The computer prints out location or index data for filed documents of relevant subject matter. The user decides on the specific retrievals desired, and the image location data and name of register are punched into a blank aperture card containing a blank film insert. The card is inserted into the device, its location data used to extract the desired image, and a copy of the image made on the unexposed film in an aperture card. Once heat-processed within the retrieval unit, the image is ready for use.

The unique capabilities of photography to capture and store information in compact and manageable formats is becoming an important tool in commercial and scientific data management applications. As the world doubles the amount of information available every 8 years and that same world demands that information be available on a timely and inexpensive basis, new means are necessary to meet the demands. Computers are being used increasingly to capture, manipulate and provide information in what is called "real time" applications. Microfilm provides an additional dimension to the computer; speed in access (COM), compact data formats (fiche, roll film and aperture cards), and finally economic storage and retrieval (viewers, view/printers and automatic files). Photographic technology, combined with the electronics of computers, is providing major new tools for information science and at the same time major challenges to the photographic scientist.

REFERENCES

1. *The American College Dictionary*, Random House, New York, 1947.
 Glossary Micrographics, 5th Ed., National Micrographics Association.
2. G. W. W. Stevens, *Microphotography*, Wiley, New York, 1968.
3. Ibid, pp. 2–3.
4. Carl E. Nelson, *Microfilm Technology*, McGraw-Hill, New York, 1965.
5. 3M Company International Microfilm Press, 3M Center, St. Paul, Minnesota.
6. Donald Knudson and Albert Vezza, *Remote Computer Display Terminals*, Proceedings of two-day seminar on Computer Handling of Graphic Information, Boston (1970).
7. "Experimental Printer Uses Acoustic-Optic Devices," *Design News*, EONIEEE, p. 15 (Nov 1971).
8. A. L. Harris, M. Chen, H. L. Bernstein, "Continuous Wave Laser Recording on Metallic Think Film," *Image Technology* (Apr/May 1970).
9. Wilbur C. Myers, P. C. M. 1, *Technology and Potential Applications*, National Cash Register Company, 2815 W. El Segundo Boulevard, Hawthorne, Calif.
10. Freeman H. Dyke Jr., *Microfilm and Its Applications*, Industrial Educational Institute.
11. Glen H. Brown and W. Shaw, "Phototropism (Photochromism)," *Rev. Pure Appl. Chem.*, **11**: 2 (1961). Cowlams' literature review from 1880.
12. Op. cit. (11).
13. General Electric "Summary Report," *Photoplastics Recording Film*, Published by the Business Opportunities Service, General Electric (1971).
14. Ovshinsky and Klose, Ovonics Imagery System, Talk at Society for Information Display Symposium, Philadelphia, Pa. (May 1971).
15. A Guide to Microfilm Readers and Reader-Printers, Guildford, England, G. G. Baker and Associates, 1973, 128p. $15.00. Available from G. G. Baker and Associates, 54 Quarry Street, Guildford, Surrey, England.
16. Op. cit., Nelson, p. 71.
17. *Information and Records Management*, **6** (2): 28 (Feb 1972).
18. P. D. Bradshaw, "The Walnut System: A large Capacity Document Storage and Retrieval System," *American Documentation*, pp. 270–275 (July 1962).

OTHER REFERENCES

1. Dale Gaddy, A Microfilm Handbook, Silver Spring, MD, National Micrographics Association, 1974, 96p. $6.00.
 The publication includes an overview of the micrographics field, an explanation of microform basics, and a discussion of specific considerations in designing an educational microfilm system.
2. Woodlief Thomas, Jr. (ed.), SPSE Handbook of Photographic Science and Engineering, New York, NY, Wiley, 1973, 1416 p. SPSE members $31.50, non-members $37.50. Available from Society of Photographic Scientists and Engineers, 1330 Massachusetts Avenue, NW, Washington, DC 20005.
 This reference volume is intended for experienced and practicing engineers and scientists who possess a basic knowledge of their field. The 23 sections include chapters dealing with microphotography, holography, densitometry, processing methods, optics, photographic chemistry, silver halide emulsions, projection and viewing, all accompanied by numerous diagrams and tables.
3. Operational Procedures for the Production of Microforms, MS110, Silver Spring, MD, National Micrographics Association, 1974, 32p. NMA members $4.00, non-members $5.00.
 This NMA standard provides detailed instructions for all types of microfilming.
4. Storage and Preservation of Microfilms, Rochester, NY, Eastman Kodak Company, 1972, 11p. Free. Available from Eastman Kodak Company, 343 State Street, Rochester, NY 14650.
 The booklet discusses the composition an properties of film as related to film permanence and describes the essential requirements of good processing and storage practices, with information on the various hazards to microfilm.
5. Inspection and Quality Control of First Generation Silver Halide Microfilm, MS 104, Silver Spring, MD, National Micrographics Association, 1972, 26p. NMA members $3.50, non-members $4.50.
 This NMA standard covers equipment, supplies, control documents, and test procedures for determining the quality of silver microfilm. Illustrations are provided showing possible defects on film, and a photomicrograph of a resolution chart is provided.
6. Carl E. Nelson, Modern Drafting Techniques for Quality Microreproductions, Silver Spring MD, National Micrographics Association, 1971. 38p. NMA members $3.50, non-members $5.00.
 This book provides basic guidance for the preparation of drawings to be microfilmed. It covers materials, character font and size, spacing, and reduction and enlargement ratios. A discussion of standards includes a table comparing the provisions of government, national, and typical company standards.

NAME INDEX

Abink, H., 46
Abney, W. de W., 5, 8, 11
Abramowitz, M., 590
Adams, A., 316
Adelman, A. H., 440
Agruss, M., 449
Ahrenkilde, S., 477
Akimov, A., 102
Albert, 6, 66
Allen, E., 151
Alles, F. P., 131
Altman, J. H., 194, 220, 224
Amick, J. A., 345, 364
Ammann-Brass, H., 22
Andresen, M., 11, 14
Arago, 4, 528
Archer, F. S., 5, 6
Archer, H. B., 472, 476, 477
Aristotle, 1
Armstrong, N., 531, 598
Arndt, 14
Ascoli, E., 421
Atkinson, R. B., 515
Audran, 32
Austen, A. E. W., 405

Baba, 37
Bacher, E., 419
Bacon, N. R., 520
Baekeland, 10
Bahnmüller, W., 37
Bain, A., 402
Baines, H., 13
Baker, J. G., 270, 516
Baker, L. R., 600
Baker, T., 20
Baril, 432
Barkas, W. H., 31
Barnes, 402
Barnes, J. C., 12, 31, 122
Bartleson, C. J., 237, 240, 245

Bates, J. E., 10, 177
Battaglia, C. J., 38, 119
Battaglia, M. P., 575
Battista, 128
Batut, A., 528
Baumbach, H. L., 515
Bayer, B. E., 61
Beacham, H. R., 177
Beccarius, 1
Becquerel, E., 15, 65
Behringer, A., 345
Beebe, M. C., 443
Benbrook, C., 430, 433
Bennett, C., 8
Bent, R. L., 120
Berchtold, J., 377
Berendsen, R., 38
Berg, W. F., 43, 69
Berkeley, H. B., 11
Berley, E. F., 177
Bernhardt, 130
Berres, 589
Berriman, R. W., 29, 49, 101
Berry, C. R., 34, 35, 49, 50, 115, 116
Berthon, R., 16
Beukers, M. C. F., 11
Bevan, E. J., 14
Bickmore, J. T., 360, 368
Bingham, R., 7
Biot, 2, 3
Bird, G. R., 89, 94, 345
Birr, E. J., 23, 38
Bischoff, V. E., 420
Bixby, W. E., 333
Black, J. T., 562, 592
Black, J. W., 528
Blake, R. K., 23, 37, 124
Blakney, R. M., 342
Blanquart-Evarard, 5
Blau, M., 112
Block, F., 405
Blodgett, K. B., 103

Bogisch, A., 11, 12
Bolton, 6
Bond, 594
Boni, A., 572
Boundy, 129
Bowman, D. L., 341
Boyer, 129
Brady, L. E., 47, 54, 57, 58
Brande, 2
Bransom, S. W., 34
Brashear, J., 594
Breneman, E. J., 237
Brewer, W. L., 478
Bridges, R., 590
Brinckman, E., 454
Brodie, J., 367
Brooker, L. G. S., 9
Brooks, R. E., 593
Brown, D., 420
Brown, F. C., 51
Bruce, J. S., 12, 123
Brynko, 413
Bunsen, 67
Burg, M., 438
Burgess, J., 7, 11
Burker, 408
Burner, W. C., 12
Burness, 24
Burrows, 438
Bush, V., 296

Cady, P. B., 8
Capen, C. F., 595
Capstaff, J. G., 11, 13
Carbutt, J., 8
Carlson, C. F., 333, 356, 370
Carnahan, R., 419
Carnahan, W. H., 154, 236, 460, 464
Carroll, B. H., 35, 82, 85
Cassiers, P. M., 306, 357, 364
Cassin, B. J., 433
Cerwonka, E., 438

SUBJECT INDEX